Art in Theory 1900–2000

436/441
571/573

600-603 625-626 616, 16-25, 519-523, 411-416

779-783
539-549
773-779
670-673

Art in Theory
1900–2000

An Anthology of Changing Ideas

Edited by Charles Harrison
and Paul Wood

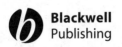
Blackwell
Publishing

Introductions, selection and editorial matter © 1992, 2003 by Charles Harrison and Paul Wood

BLACKWELL PUBLISHING
350 Main Street, Malden, MA 02148-5020, USA
9600 Garsington Road, Oxford OX4 2DQ, UK
550 Swanston Street, Carlton, Victoria 3053, Australia

Art in Theory 1900–1990 first published 1992
First published in USA 1993

New edition (*Art in Theory 1900–2000*) first published 2003

11 2010

Library of Congress Cataloging-in-Publication Data

Art in theory, 1900–2000: an anthology of changing ideas / edited by Charles Harrison and Paul Wood. — 2nd ed.
 p. cm.
 Rev. ed. of: Art in theory, 1900—1990, 1993.
 Includes bibliographical references and index.
 ISBN 978-0-631-22707-6 (hbk.: alk. paper) – ISBN 978-0-631-22708-3 (pbk.: alk. paper)
 1. Art, Modern—twentieth century—Philosophy. I. Harrison, Charles, 1942–
 II. Wood, Paul, 1949– III. Art in theory, 1900–1990.

 N6490 .A7167 2002
 709'.04—dc21

 2002018490

A catalogue record for this title is available from the British Library.

Set in 10.5 on 12.5 pt Ehrhardt
by Kolam Information Services Pvt. Ltd, Pondicherry, India
Printed and bound in the United Kingdom
by TJ International, Padstow, Cornwall

For further information on
Blackwell Publishing, visit our website:
www.blackwellpublishing.com

Summary of Contents

Contents

II The Idea of the Modern World

IV Freedom, Responsibility and Power

V The Individual and the Social

VI The Moment of Modernism

VII Institutions and Objections

VIII Ideas of the Postmodern

Preface and Acknowledgements

This volume replaces *Art in Theory 1900–1990* (first published in 1992). *Art in Theory 1900–2000* thus completes a project which expanded from that first volume to include two companions: *Art in Theory 1815–1900* (1998) and *Art in Theory 1648–1815* (2000), both edited by Charles Harrison, Paul Wood and Jason Gaiger. Taken together, the three volumes now provide materials for the study of the wider modern period from the foundation of the French Academy to the end of the millennium.

Revision of *Art in Theory 1900–1990* has required not simply the addition of a number of texts from the last decade of the twentieth century. It has also involved the insertion of others from earlier decades which have come to our attention since its original publication, through the results of further reading and research, and particularly through work on the two-volume German edition *Kunst/ Theorie im 20. Jahrhundert*, published by Hatje Verlag, Stuttgart, in 1998. Work on that edition introduced us to a quantity of untranslated material from German sources and provided the initial incentive for the present expanded collection. We owe a particular debt of gratitude to Sebastian Zeidler, who acted as editor for Hatje Verlag, and who proved himself not only a proficient and conscientious scholar of modern German art theory and an able translator into English, but a perceptive and sympathetic critic of our work and therefore an effective collaborator in our enterprise. The present volume owes much to his suggestions and to his industry.

We are grateful to those numerous authors and copyright-holders who have permitted us to reproduce the texts here included, and to edit them where we have felt the need to do so. We are also indebted to the translators and editors of more specialized anthologies who have been generous in making material available to us. In the long task of tracing and compiling material we have benefited greatly from the advice and assistance of friends and colleagues at the Open University and elsewhere. We would like to record our particular gratitude to Stephen Bann, David Batchelor, Tim Benton, Gavin Butt, the late Anthony Coulson, Thomas Crow, Steve Edwards, Trish Evans, Briony Fer, Jason Gaiger, Tamar Garb, Bob Graham, Andrew Hemingway, Rosalind Krauss, Fred Orton, Gillian Perry, Paul Smith, Sarah Wilson and Roberta Wood. We also wish to record our obligation to Jane Robertson, formerly Managing Editor at Blackwells, for keeping the initial *Art in Theory* publication on the rails, to Lisa Eaton, for her work on the design and production of each of the *Art in Theory* publications, and to Andrew McNeillie for his continuing support for the expansion of the project.

C. H.
P. W.

A Note on the Presentation and Editing of Texts

Where a published document was originally given a title, this has generally been used for the present publication, in single quotation marks. Titles of books are given in italics. Where a specific subtitle section of a document has been taken, this subtitle is used for the extract. The title of the whole work is then given in the introduction to that text. In the absence of original published titles we have given descriptive headings without quotation marks. The term 'from' preceding a title signifies that we have taken a specific extract or extracts from a longer text, without seeking to represent the argument of the whole. Otherwise texts are given in their entirety or are edited so as to indicate the argument of the whole.

It is the aim of this anthology that it should be wide-ranging. We have therefore preferred the course of including a greater number of texts, of which several must appear in abbreviated form, to the course of presenting a small number in their entirety. Texts have been variously edited to shorten them, to eliminate references which cannot be explained within the space available, and where necessary to preserve the flow of argument. We have provided information as to the sources for complete versions of all edited texts. We have also clearly marked where texts have been edited.

The following conventions have been used throughout. Points of suspension '...' are used to denote the omission of words or phrases within a sentence. Points of suspension within square brackets '[...]' are used to denote omissions extending from a complete sentence to a paragraph. Asterisks '* * *' denote omission of more than one paragraph, and may denote exclusion of a complete subdivision of the original text. It should be noted that a paragraph may end thus [...], either if the last sentence of that paragraph is omitted or if the following paragraph is omitted. A paragraph may also start thus [...], if one or more sentences at the beginning of that paragraph have been omitted, or if a previous paragraph has been omitted.

Notes and references have been included only where we judged them necessary to the text as printed. That there is a greater proportion of notes in the later section of the book is largely accounted for by an increasing tendency during the later part of the century for the theory of art to be treated as an *academic* subject. We have generally avoided the insertion of editorial footnotes, but have supplied essential references in the introductions to individual texts.

We have corrected typographical errors and errors of transcription where we have discovered them in the anthologized texts, but otherwise we have left idiosyncrasies of punctuation, spelling and style unchanged.

General Introduction

The aim of this book and its two companion volumes is to equip the student of art and the interested general reader with a substantial and representative collection of relevant texts, drawn from a wide variety of sources, that will together document the history and development of an idea: the idea of the modern. The literature of modern art now constitutes a massive resource, but it is a resource which presents certain problems to the student who hopes to profit by it. The most immediately evident of these is difficulty of access. On the one hand the modern development of art has been a cosmopolitan business, so that its attendant theory has been extended through a number of different languages. On the other, the decisive moments of that development have often been reserved from public view, as likely to be represented in the private letter or the ephemeral journal as the broadcast manifesto or the printed book. What this means is that for all except those equipped both with considerable linguistic abilities and with the resources of a major library, study of the literature of modern art has necessarily been highly selective. That there exists a prima facie case for a collection such as the present one has been made clear to us in our own daily work of teaching and writing about art in the modern period. It has accordingly been our intention to improve access to the literature of modern art, both by rendering the present materials more generally available to study and by providing indications of the nature and location of other relevant publications.

Of course there exist various specialized collections restricted to particular movements or periods, and to that extent ours has been a task of synthesis. Nevertheless, it has been an ambitious undertaking, and it cannot be expected that the outcome will please all people all of the time. We are aware both that the usefulness of such an enterprise must depend heavily upon the principles of selection, and that agreement on such principles is by the very nature of the subject hard to secure. Anyone seeking to represent the theoretical character of modern art must address two difficult and interconnected questions: how is modern art to be defined, and how is the field of its relevant interests to be circumscribed? To consider the extensive literature and the extended history of modern art is inescapably to feel the force of questions raised in practice, questions about the definition of art itself, and about the lines of demarcation between art and that which art is not. It is also to confront questions about the construction of historical narratives, about the interests which such narratives may be seen to serve and the kinds of exclusion which they involve. And, most tellingly from the point of view of the present project, it is to confront the inter-relationship between the one set of questions and the other: between problems of definition and problems of

historical organization. Any history of art must establish or assume a form of definition of art, while any history of modern art must establish or assume a definition of modernity. Any address to these problems will serve to animate a range of questions: where to draw the line between theory and practice, where to divide art from language or from literature or from politics, and so on.

Modernism and modern art

Our selection is not intended to resolve these problems. On the contrary, we mean to suggest that acknowledgement of the openness of a range of open questions is a condition of any competent study of modern art and of its theory. But we can at least be explicit about our historical parameters, since these are largely decided for us by the current state of art-theoretical debate, and specifically by that interest in the idea of the Postmodern which has developed since the later 1960s. The period we have aimed to survey, then, coincides with the life-span of Modernism as a determining if gradually decaying value in the theory of art. We therefore commence with the end of the nineteenth century, at a time when modern art was being widely advanced as a form of independent culture, its critical bearing upon the world secured not by connections of likeness or of naturalism, but by virtue of the very independence of its values. Art, it was then proposed, is an exemplary realm. What might be done, seen, experienced within this realm would have a critical bearing upon the actual conditions of social existence, but only in so far as art maintained a moral independence from those conditions.

This position, which can be explicitly identified with the tradition of Modernism, was never to go unopposed in the development of modern art. Specifically, it was to be maintained in tension with the variant commitments of Realism, according to which the practice of art constitutes a form of participation or intervention in the social process. If this tension was continual, it was also subject to continual adjustments. At times during the twentieth century the two positions appear irreconcilable. At rare moments they appear virtually to coincide. These adjustments are not simply to be read out of the appearances of art, however. In the history of modern art such commitments to moral autonomy from or to intervention in wider forms of social life have not always coincided with the stylistic forms of practice to which propagandists of both persuasions have frequently tried to reduce them. Such supposed antitheses as 'abstraction' and 'representation' have seldom been adequate to the task of formulating relevant distinctions among the determining commitments of modern art, however familiar they may have become in the literary scaffolding erected around it.

It should be clear, then, that modern art cannot simply be equated with Modernism. Rather, Modernism stands on the one hand for a cluster of notionally independent values associated with the practice of modern art and on the other for a particular form of critical *representation* of the modern in art – a representation in which the pursuit of art's moral independence is taken to be decisive. In saying that we aim to survey the literature of modern art during the life-span of Modernism, then, we mean to acknowledge the historical significance of this system of values and to assist the reader in coming to recognize and to understand it. We mean also to acknowledge other positions, including some that are explicitly hostile to Modernism both as practice and as representation, and some that are intentionally Postmodern.

For our present purposes, one significant feature of Modernism as a form of representation is that it assumes certain kinds of relations between art and theory and between art and language. In the formulation of Clement Greenberg, whose name is virtually synonymous with Modernist criticism, the development of modern art has been 'immanent to practice' and never a matter of theory. It follows that theory must always be *post hoc*, either in the sense that theoretical work is work which attempts to follow and to recount those developments which practice has already initiated, or in the sense that theory is conceived as a form of privileged insight into the psychology of practice, as when the artist offers a retrospective account of the intentions behind some already achieved body of work.

This is a position – indeed an influential form of theory in itself – which tends to privilege the artist as unquestionable author, and to consign theory to the apparatus of documentary ratification. But of course artists do not always do what they intend, nor is what they say they have done always what they have done. From another perspective 'representations are always built out of pre-existing cultural resources, and hence have always to be explained as developments within an ongoing cultural tradition' (Barnes, *Interests and the Growth of Knowledge*, p. 19). The functions of a representation are not to be explained in terms of the intentions of an individual author; rather they can only properly be understood in terms of the objectives of some social group. Whether or not it is always appropriate or rewarding, it is clearly possible to view any and all works of art as representations in this sense. If the meanings of art are thus conceived as forms of social and historical meaning, there will be a concomitant shift in what comes up for the count as relevant theory. For instance, we may find ourselves paying less heed to artists' confessional statements and more to the circulation of ideas in the world which their practices inhabit. If this is not a Realist view of theory, it is at least a view which is commensurable with some Realist critiques of Modernism.

In so far as our selection surveys the field of modern art during the currency of Modernism, it has seemed appropriate to represent the tension between these two ways of conceiving of theory, even to sustain this tension in our own deliberations. To speak in general terms of the 'theory of modern art', we would suggest, is to refer to a body of ideas defined by the continuous interaction of two almost but not quite reciprocal projects: the theoretical critique of art which is based on an understanding of historical process, and the understanding of historical process which is formed by the critical experience of art. The theory we have aimed to represent, then, could be conceived of as that body of thought about art which has been conducted under the conditions of this dilemma. By the same token, we would suggest that if it makes sense to conceive of a Postmodern form of art theory, then we must be referring to some circumstance in which this dilemma, though it may be understood in historical terms, is no longer experienced as an inescapable condition of thought about art.

If an interest in the life-span of Modernism has provided one basis on which to consider our selection, we have also been fortunate in the resource provided by our major predecessor in the documentation of modern art theory. Herschel B. Chipp's *Theories of Modern Art* was first published in 1968, which is to say at the zenith of Modernism – or at least of Modernism considered as an authoritative form of representation of value in modern art. This is not to say, however, that Chipp's selection of texts simply reflects that authority. Even with the benefit of hindsight his survey appears relatively catholic. That is largely why it for so long maintained its standing

as an indispensable accompaniment to the study of modern art and of its history. Among the artists and movements given their due by Chipp were some that had been systematically marginalized by the hardening orthodoxy of a Modernist art history. There were clear omissions, however, many of them in just those areas which the art history of the 1970s and 1980s was to be most assiduous in exploring. For example, we have been able to benefit as Chipp could not from substantial recent publication in the field of Russian art, from a wholesale revision in the art-historical understanding of the Surrealist movement, from a revival of interest in the inter-war debates on Realism and avant-gardism, and, perhaps most significantly, from the growth of a critical self-consciousness about the history of Modernism itself. Regarding the period since the publication of *Theories of Modern Art*, the field was to remain fallow for many years. While there have been numerous collections surveying individual movements and intellectual fashions, there has been no sustained attempt to review the late twenti-eth-century literature of art as a multifarious extension of historical concerns. It must be an important function of such an enterprise – of an enterprise, that is to say, such as the present one – that while volunteering an ordered account of the recent past it serves also to reorient the earlier history and to cast a new light on its characteristic themes. It has accordingly been our aim both to represent the terms of reference on which theoretical debates of relevance to art took place in the earlier years of this century, and to extend the surveying of these debates from the post-war settlement up to the present. This would unquestionably have been a very different and very much more demanding task without the markers established by Chipp's pioneering work.

Obscurity and the sense of practice

Consideration of the problem of access to the literature of modern art has led us to a discussion of the conditions of our selection. The reader's approach to this literature will normally involve a further problem not unconnected to the first: the problem of obscurity. The literature of modern art is by no means uniformly difficult to under-stand, but much of it is. Obscurity can occasionally be deliberate, or at least it can sometimes follow from the refusal of specific concepts and requirements of rationality by artists and their supporters, or – which may be to say the same thing – from a determined attempt to conscript language to the purposes of art. A more general reason for difficulty, however, is that notwithstanding its engagement with historical themes and issues, the development of modern art has been a highly specialized business. For all the claims to immediacy and universality of expression which have accompanied that development, the distinguishing experience of the modern artist has been in large part an experience of technical problems and possibilities.

The problem of the obscurity of art-theoretical texts is thus not one which can be altogether overcome in any representative collection. We have preferred clearer texts to more obscure ones wherever there has been a choice, and we have included nothing unless we believe its place is earned by virtue of what it says. This is not a collection of artists' *obiter dicta*, and no text has been included simply by virtue of the supposed standing of its author. That said, it should be acknowledged that among the texts which we have regarded as sure candidates for inclusion, some just are difficult. On the other hand, though it must be beyond the scope of a large anthology to render such texts entirely transparent, we have aimed to establish a context in which their concerns can at

least be located, both as forms of contribution to a developing body of ideas about art, and as forms of negotiation with a continually changing world. This is to say that the anthology as a whole is designed to furnish a context within which each of its component texts may be better understood.

It needs to be borne in mind, however, that the literature of modern art has developed as an accompaniment to forms of practice, typically standing as justification or explanation of that which, by definition, is supposed to be *seen*. The practical growth of abstract art, for example, was accompanied by a considerable proliferation of theory, much of which was intended to establish the critical character of the appropriate technical procedures and the meaningfulness of specific painterly effects. It is a truism that this theory is obscure, which is to say that its practical character is often hard to recover. If the texts of Kandinsky, of Malevich or of Mondrian are to make sense, the reader must sometimes work to imagine a concrete effect which the artist-as-writer once took to be self-evident. No awareness of the context of debate, however extensive or acute, will serve to substitute for this work. The reading of art theory needs to be accompanied by a calling to mind of art itself; and what this requires is not just recall of the subjects of pictures, but acknowledgement of the distinctive properties of objects and surfaces. Reproductions may serve as *aide-mémoire* in this process, but they cannot replace it. This anthology will be of greatest benefit to those readers who treat it not simply as a resource for the study of art history, but as an accompaniment to the first-hand experience of modern art.

Theory in context

There is more to be said about the question of contextualization, for the common problem of lack of context is the third of the major barriers to the study of modern art which we have tried to bear in mind in the compilation and organization of this book. The nature of the problem is not simply that the literature of art as we encounter it has generally been disconnected from the actual practice of art, but rather that the study of modern art itself tends often to be pursued in isolation from the study of history – and never more so than when it is considered under its theoretical aspect. This tendency has been aggravated to the extent that art history has been subject to the protocols of Modernism. Faced with the dilemma mentioned earlier, the Modernist position has consistently been to affirm the priority of a supposedly empirical aesthetic experience over a theoretically informed historical understanding. After all, what use conceiving of a theory of art in the first place if it is not to be distinguished from political or social theory or from philosophy?

Yet it is a lesson generally well absorbed in recent art history that what may appear as a specialized dispute over technical issues is often only really comprehensible as the specific form of a larger problem. We may need to consider the surrounding historical context if we are to understand the circumstances under which that problem was experienced. The different artistic commitments of Suprematists and Constructivists, for example, follow from different perceptions of the function and direction of cultural activity in Russia during the revolution and its aftermath. It is from historical conditions such as these that the technical issues of practice tend to derive their otherwise inexplicable gravity. The awareness of history animates the understanding of art, just as the critical experience of art sophisticates the understanding of historical process.

It has in fact been one of the principal objects of our enterprise to emancipate the reader from a form of experience familiar under the cultural regime of Modernism: that demeaning combination of unrewarded anticipation and unsatisfied curiosity which can attend on the viewing of works out of context. It may be the case, as the Modernist connoisseur would claim, that works of art do indeed 'speak for themselves' to the adequately sensitive, adequately informed spectator. But the idea needs to be treated with circumspection. Too often in the twentieth century it has been used as justification for treating those lacking in information as if they were deficient in sensitivity. We believe that a careful reading of the theories and debates represented in our collection will serve to discourage too ready an association of art with civility. One history which this book has to tell is the history of a modern art which was offered and renewed in critical response to the hostile conditions of *what passed for civilization* in the twentieth century. If that critical impulse was at various times sapped, marginalized, accommodated or even bought off, this does not seem to us a good reason for denying or forgetting it – certainly not in the name of sensitivity, nor even in the name of the Postmodern.

These are now the best and worst of times for modern art. What was once a marginal aspect of the culture of a few metropolitan centres in Western Europe has effectively achieved the status of the accepted and characteristic art of its time the world over. This is another of the histories which this book has to tell: the story of modern art's move from the margins of public notice to the centre of the cultural economy. After the defeat of Fascism in the Second World War, only those parts of the world which were organized according to the principles of state socialism officially resisted modern art. Even in such places it had subversive, almost mythic status as an index of freedom. In the ideological hall of mirrors which was the Cold War, an autonomous art was widely broadcast as metonymic of international capitalism, in the language of freedom versus totalitarianism. A certain 'Modernistic' representation of modern art, if not necessarily the creature itself, thus completed the trek from margin to centre; from outside to inside, from illegitimacy to acceptance.

This acceptance has itself given rise to problems which a book such as this must attempt to negotiate. In becoming hegemonic, Modernism opened the way for a widespread critical reappraisal of its own principles and assumptions. Modernism had always had its Others, but in the West at least their subordinate status was generally assumed over a long period. During the final quarter of the twentieth century this assumption was widely questioned. The notion of 'pluralism' has been associated with a loosening of the authority of Modernist judgements.

That diversification of practice which is subsumed under the notion of Postmodernism has no doubt been largely animated by a spirit of inquiry. And yet it has also been accompanied by some reoccupation of positions identified as conservative in Modernist terms. In one of those paradoxical developments which seem to mark the recent period, the very success of an art which staked its claim on independence has appeared to justify a widespread scepticism as to the possibility of moral autonomy for art; or, to put the matter slightly differently, as to the possible survival of art as a morally independent cultural practice. This is difficult ground. At times it seems there is little to mark the distinction between, on the one hand, the criticism of an autonomy grown conformist and, on the other, the renewed demand that art serve ends promulgated elsewhere in the social spectrum. The determined defenders of the autonomy of art

were at least proof against one distinctive form of twentieth-century malaise: that species of soft totalitarianism which has a way of creeping to the fore when there is little that is culturally vivid to disqualify and to displace it.

As the new century opens, and the critique of Modernism in art is matched by the collapse of much more widespread social ideologies – representatives of which were regularly numbered among Modernism's opponents – we are witness to a curious mixture of confusion and certainty. In attempting under these circumstances to review the historical narratives of art in theory, we have sought on the one hand to resist the adoption of pluralism as an alibi for confusion, on the other to avoid that species of correctness which would require nothing so much as the abandonment of autonomy at *all* levels.

Selection and organization

We should make clear that while it has been our intention to raise the question of alternative priorities, we have not attempted to arbitrate between them, nor, in the contrast of views between theory as *post hoc* explanation and theory as determining intellectual context, have we meant to privilege one sense of theory at the expense of the other. This is not to claim that we are ourselves theoretically unprejudiced, however. We are as thoroughly inscribed in the indices of commitment as any of those whom we have presumed to represent. This inscription is not merely a matter of orientation with respect to the circumscribed history of art, but of an inscription within history writ large, and it has no doubt been a force in the composition of the book.

Art in Theory 1900–2000 is intended to represent the art theory of the twentieth century as we conceive it, and thus not primarily to represent the positions of individuals. So far as possible we have made our selection with the wider field in mind. That is to say, we have been more concerned to represent a body of ideas than to assemble a corpus of artistic authors, or to do full justice to specific careers. Indeed, we have intended no form of a priori discrimination between authors. A text is a text whether the writer or speaker be a practising artist, a critic, a philosopher or a political figure. Though a number of art historians figure among those included, this is decidely not an anthology of art-historical work. We have excluded texts which are clearly retrospective, except where it can be said that the retrospect has served to enable or to prescribe a significant practical direction – as did various forms of classical revival in the period immediately following the First World War.

Not all the texts we have included were written with art specifically in mind. On the other hand, we would claim that each of them represents some aspect of the diverse intellectual materials from which modern art has been made. This claim also implies a limit. We have not meant to trespass far from the ground of high art and its attendant theories. We have not seen it as our business to engage directly with architecture or with design, though both were profoundly implicated with much theorization of art during the 1920s and 1930s. Nor have we been primarily concerned with the varieties of popular cultural forms, with films, television, advertisements and so forth, though these have lately been much theorized with a rigour previously reserved for accredited 'fine' art, often by writers who have taken the discipline of art history as a starting-point. These limitations are imposed not out of any intentional spirit of conservatism, but out of conviction that for any manageable collection to emerge, its focus must be

restricted. This restriction is signalled in our title. It is art we are concerned with, and the theory it is made of; not the culture it is made of, nor the theory of the culture.

On the other hand, with the importance of context in mind, the anthology has been designed as a whole so as to encourage inquiry into the relations between artistic issues and historical changes. We have divided the material into eight chronological sections: four for the period from the turn of the century to the Second World War, and four for the period since. These overall sections contain the cross-currents of debate, indeed of outright conflict on occasion, as to the proper role and concerns of art. Each section is introduced with an essay outlining major practical developments and theoretical concerns during the relevant period and, where appropriate, relating these to the wider, principally political and economic, forces at work in the contemporary world. Within each of these main sections texts are then grouped under broadly thematic subheadings. Within each subheading the arrangement is generally chronological – the exceptions being where we have grouped a number of texts under a common author, or where we have meant to preserve a sequence of argument or a geographical connection. Each individual text is then provided with a brief introduction, specifying the original occasion of its publication and where appropriate explaining its connection to contemporary events and controversies. A given text may thus be read for its independent content, as a moment in the development of a specific body of argument, or as a possible instance of a larger tendency or body of concerns within a broad historical period.

The practice of modern art has never been untheoretical or without principles, even when these latter have turned on the importance of spontaneity or of freedom of choice. We have not aimed to represent art in theory as a rational and ordered business, however. Though settlements occur in time they can often not be recognized as such until after their time has passed. Nor would we be wise to assume the pedagogic powers of history as ordering principles. It is part of the present meltdown that reason and history are themselves contested as the relevant criteria of intellectual commitments. There is a need, however, for the arguments of the past to be made present, in order that they can be learned from. Walter Benjamin once expressed the desire to produce a book which would be composed entirely of quotations. In a similar spirit, we have tried to refrain from prescriptive ordering and to be inclusive. But we cannot entirely dispense with the supplement: ordering principles are unavoidable if there is to be sense at all. It is within the considerable limits of editorial obligation that we have aimed to let the diverse histories of modern art, and of some of its opponents, speak for themselves.

Charles Harrison
Paul Wood
September 2001

Part I
The Legacy of Symbolism

I
Introduction

At the begining of the twentieth century, to think of modern art was to think of modern French art. This was not because all modern art was French, but rather because France was the acknowledged source of those critical concepts and practical distinctions to which artists of other countries referred when they intended to mark their own work as modern. The artistic culture of late nineteenth-century France was rich and diverse. In the mid-century the authority of an academic tradition, already interrupted by revolution and complicated by the career of Jacques-Louis David, had been further challenged by the Realist work of Gustave Courbet and by the connection of that Realism to the revolutions of 1848. (See *Art in Theory 1648–1815* and *Art in Theory 1815–1900*.) Edouard Manet was no revolutionary, but his pursuit of Realist aims in the 1860s took effect in that palpable self-consciousness about the social forms of modernity on the one hand, and the practical means and conditions of representation on the other, which was subsequently to be defined as Modernism. And in the early 1870s – the time of the Franco-Prussian war and of the formation and suppression of the Paris Commune – those who were to be called the Impressionists converged on the project of a modern Naturalism. In the normal history of modern art the Impressionist movement is established as the prototype for avant-gardism in modern art. This status was achieved not as a consequence of explicit radicalism on the part of the artists involved, but rather because there were several of them, and because a conservative resistance rallied vociferously, though in the end ineffectually, against their project.

Realism, Naturalism, modernity, avant-gardism; these concepts and the forms of nineteenth-century French art associated with them were to be substantial points of reference – positive or negative – for the artists and supporters of the early twentieth-century movements. The relations between these concepts had been subject to various forms of transformation, however. Increasingly after the mid-1880s, the modern was a contested value. The issues at stake are revealed in the alternative conceptions of the Impressionist project and its legacy which were prevalent at the end of the nineteenth century. On the one hand it was seen as a continuing Realist tendency modernized by the adoption of a luminous technique (a view of Impressionism broadly consistent with the work of Camille Pissarro); on the other it was associated with intensification of the autonomous effects of art, and thus seen as tending towards abstraction. (A view of Claude Monet's work along these lines had a decisive effect on the Russian Wassily Kandinsky, according to the latter's own testimony.) The changing interpretations to which Paul Cézanne's work was subject in the years between 1885 and 1910 testify to

the continuing problems experienced in characterizing his 'Post-Impressionism', as Roger Fry was to term it in the latter year.

The view of Impressionism as tending towards abstraction is consistent with the position of the Symbolists, in whose regard the once-binding association between Realism and avant-gardism was transformed into a relationship of virtual antithesis. Symbolism was the avant-garde position of the later 1880s and 1890s. The continuing force of its aesthetic theory can be recognized in twentieth-century deliberations on modern art in France and elsewhere, in the form of a deep and prevalent strain of idealism. The importance of this theory lay in its welding together of a claim for the autonomy of language and art as symbol systems, with a claim for the value of aesthetic experience and artistic insight. In Symbolist theory the meaning of a painting is not in principle any more firmly secured by its resemblance to features of the real world than the meaning of a poem is secured by some independent *causal* connection between its various words and the objects those words happen to signify. In each case, it is the internal relations between the parts that secures the possibility of meaning and effect for the whole. (See *Art in Theory 1815–1900*, section VIC.) Such ideas are nowadays the commonplaces of linguistic and semantic theory. But they remained controversial from the end of the nineteenth century until late into the twentieth. Wherever the effect of these ideas was felt on thought about the arts during this period, the matter of their reception or rejection served more decisively than any other single factor to mark the division between moderns and conservatives.

To this understanding of the autonomy of form, the Symbolists joined a critique of the value of objective perception as a means to knowledge of reality, asserting instead the priority of a disinterested but subjective intuition. Thus Paul Gauguin, who once exhibited with the Impressionists, is to be found at the turn of the century defending himself against criticism of the 'abstraction' of his painting with the assertion that it is 'not a material structure', but rather a 'vision' interpreted 'in an appropriate decor' (IA2). The identification of art with intuition was to be given a philosophical exposition in the aesthetics of Benedetto Croce (IB15), while considerable support for the Symbolists' emphasis on the significance of the 'inner life' was to come from work in the new field of psychoanalysis. Freud was working in Paris in the late 1880s and his *Interpretation of Dreams* was first published in 1900 (see IA3).

It remained only to re-establish the Romantic claim that artists are distinguished as such by the relative vividness of their inner life and the relative strength of their intuitions. The 'abstractions' of the artist could then be advanced as the significant forms of an underlying and enduring reality, their critical potential all the greater for their emancipation from the merely apparent and contingent realities of the physical and social world. Adoption of such ideas inevitably entailed disparagement of Naturalist and Realist techniques for their supposed subservience to the merely superficial. Thus Cézanne's injunction to Emile Bernard to 'treat nature by means of the cylinder, the sphere, the cone' (IA6) was seized on not as an instruction in basic modelling, but as a sign that the older painter's enterprise involved seeing through the accidental forms of nature to an underlying world of geometrical constants.

In fact, as implied earlier, Cézanne's work resists explanation in terms of an antithesis between Naturalism and Symbolism. Rather, it serves as demonstration that a commitment to nature as the origin of sensation can be maintained in face of a

commitment to the decorative autonomy of the painted surface, if by no means with ease, then certainly with critically remarkable results.

Cézanne's rigour was exceptional, however, and the lessons of his painting were not easily learned – as is attested by Rilke's struggle to come to terms with the artist's work at the Salon d'Automne in 1907 (IA7). It was widely assumed among the avant-garde factions of the early twentieth century that attention to the specific details of the natural world was inconsistent with fulfilment of the expressive potential of art. As the form of the modern arts which was most clearly both expressive and abstract – which is to say free from the requirements of description – music came to be seen as the type of all the others. Around the turn of the century, musical theories of expression and composition were adopted as means to the advancement of architecture and painting. (Hence, in large part, the importance of Richard Wagner and of his theories to the artists of the avant-garde at the turn of the century [see *Art in Theory 1815–1900*, IIID2 and VIC2].) August Endell and Kandinsky were among those for whom the apparently 'universal' expressiveness of music held out the possibility of an abstract *visual* art, its validity secured not by reference to the appearances of the material world, but rather by the supposedly basic formal principles on the one hand and by the promptings of 'inner necessity' on the other (IB1 and IB8–9).

In Naturalist theories the effect of the work of art was supposed to be traceable back into the world. That it had its origin in that world – in some direct experience of it – was the guarantee of the work's authenticity. In forms of theory subject to the gravitational pull of Symbolism, on the other hand, the effects of art were signs of the authenticity of an inner life; they were understood, that is to say, as originating in the mind or soul of the artist. There were some clear implications of this position. With the abandonment of naturalistic correspondence as a criterion, a premium was placed on the strength and authenticity of individual responses and feelings. A requirement of vividness of expression tended to supplant the traditional requirement of accuracy of description. 'What I am after, above all, is expression,' Henri Matisse wrote in 1908, and he made it quite clear that he saw pursuit of the ends of expression as justifying any liberties he might take with the appearances of people or objects (IB6).

There was a further important corollary to the increasing relaxation of the requirements of Naturalism. This development in modern artistic theory coincided in the later nineteenth and early twentieth centuries with a rapid growth of anthropological study and collection, as scholars and curators sought to make sense of the various appropriations of empire. For those already engaged with modern art, the association of formal expressiveness with authenticity led to substantial revaluation of the generally non-naturalistic images produced by tribal cultures. Recognition of the formal inventiveness – the originality – of such images involved a reconsideration of their supposed primitivism. Or rather, the concept of the primitive was subject during the period in question to a virtual reversal of its traditional critical function. Formerly a term of disparagement, it came to be used as a measure of vitality, of authenticity and of originality. Following the example of Gauguin, modern artists now claimed kinship with their supposedly unsophisticated counterparts in pursuit of the authentic grounds of feeling and expression hidden behind the veil of appearances and conventions. By the first decade of the century, conviction of the authentic expressive power of so-called primitive art had become an item of avant-garde faith, proclaimed by artists and critics in France, Germany, Russia and England (see, for instance, IA2, IB10–12, 14,

16–18). Maintenance of this faith undoubtedly involved a degree of idealization and abstraction of the art of the colonized cultures, which is to say that those involved in appreciation of the objects in question generally paid scant regard to the conditions of their production. On the other hand it can be said that this appreciation entailed a considerable questioning of those measures of skill and sophistication by which the relative authority of European art had previously been established. One important consequence of such theoretical work as Wilhelm Worringer's was that it served to revise the grounds on which comparisons might be made between the art forms of different cultures and epochs (IB5). At the same time, the work of Freud, Prinzhorn and others encouraged a more literal application of canons of rationality (IA3, IB19).

The critical revaluation of the European tradition was in general an important aspect of early twentieth-century avant-gardism. The supporters of the modern movements reviewed the art of the past in the light of their present enthusiasms, recasting the terms in which it had previously been conceptualized and valued. Thus, for example, the understanding of 'classicism' was divorced by Maurice Denis and Roger Fry from its traditional association with a canon of literary and mythologizing subjects and reinterpreted in furtherance of the perceived commitments of the modern: on the one hand to signify the concentration of original feeling in visual form, and on the other to suggest that pursuit of such concentration had been the persistent preoccupation of the Western tradition – indeed, that it was the true function of the art of all ages and periods. The defence of a historically specific modern movement thus took on the character of a universalizing aesthetic system (see IB7, 16 and 18).

IA
Classicism and Originality

1 **Paul Signac (1863–1935) from** *Eugène Delacroix to*
Neo-Impressionism

The author was a painter closely involved with the Neo-Impressionist or Divisionist tendency. His book was of particular importance in formulating approaches to colour and to expression developed among late nineteenth-century French painters and in transmitting a body of theory to a subsequent generation. His concept of the practice of art as knowledge employed in the service of sensation was to be taken up by the Fauves. Originally published as *D'Eugène Delacroix au néo-impressionisme*, Edition de la Revue Blanche, Paris, June 1899. The present extracts are translated from pp. 74–5, 89–94 and 137–8 of the new edition, ed. F. Cachin, Paris, 1964. (Additional material from Signac's book will be found in *Art in Theory 1815–1900* VIB14.)

For half a century Delacroix tried hard to achieve more brightness and luminosity, thereby displaying to the colourists who would succeed him the path to follow and the goal to attain. He still left them much to do, but thanks to his contribution and his teaching, their task was made easier.

He proved to them all the advantages of a sound technique, of planning and logic, not hindering the passion for painting but strengthening it.

He gave them the secret of the laws governing colour: the harmony of similarities, the analogy of opposites.

He showed them how a unified and dull colour scheme is inferior to the colour produced by the vibrations of different combinations of elements.

He secured for them the resources of optical blending, which gives rise to new colours.

He advised them to banish dark, dull and drab colours as much as possible.

He taught them that it is possible to modify and reduce a colour without tarnishing it with mixtures on the palette.

He showed them the moral influence of colour which could contribute to the effect of the painting; he initiated them into the aesthetic language of colours and tones.

He incited them to dare everything, never to fear that their harmonies might be too colourful.

The powerful creator is equally the great educator; his teaching is as precious as his work.

Nevertheless it must be acknowledged that the paintings of Delacroix, despite his efforts and his knowledge, are not as light nor as coloured as the paintings of his

followers. *The Entrance of the Crusaders* appears dark beside *The Luncheon of the Boating Party* by Renoir and *Circus* by Seurat. Delacroix seized the Romantic palette, over-loaded with colours, some brilliant, others, too numerous, earthy and dark; everything it could give him.

He could not have had a more perfect instrument to suit his ideal. In order to create this instrument, he had only to exclude from his palette the darker colours which were a useless encumbrance. He did violence to them in order to extract from them some brightness, but he never dreamt of painting only with the pure and virtual colours of the prism.

This progress had to be made by another generation: that of the Impressionists.

Everything is both connected to and develops from its own time: first one compli-cates, then one simplifies. If the Impressionists simplified the palette, if they achieved greater colour and luminosity, it is thanks to the investigations of the Romantic master and his struggles with the complicated palette.

* * *

It was in 1886, at the last of the exhibitions of the Impressionist group, that works appeared for the first time that were painted solely with pure, separated and balanced colours, mixing optically according to a rational method.

Georges Seurat, who instigated this step forward, exhibited there the first separated painting. *A Sunday on the Grande-Jatte* was a decisive canvas which testified to the very rare qualities of the painter; grouped around him were Camille Pissarro, his son Lucien Pissarro and Paul Signac, who also exhibited works painted in a more or less similar technique.

The unexpected vividness and harmony of these innovators' paintings was immedi-ately noticed, if not exactly welcomed. These qualities were thanks to the fundamental principles of *separation*. Since then, this technique has not stopped developing, thanks to the research and contributions of Henri-Edmond Cross, Albert Dubois-Pillet, Maximilien Luce, Hippolyte Petitjean, Théo van Rysselberghe, Henry van de Velde and others; this is in spite of cruel deaths, of attacks and desertions. [...]

If these painters, who would be better described by the epithet *Chromo-Luminaristes*, adopted the name *Neo-Impressionists*, this was not to court success (the Impressionists were still in full flight), but to pay homage to the efforts of their precursors, and to emphasize in spite of the differences, the common aim: light and colour. It is in this sense that the title *Neo-Impressionist* must be understood, for the technique used by these painters is not at all impressionistic; to the extent that that of their precursors was based on instinct and the instantaneous, theirs was by contrast based on reflection and the permanent.

The Neo-Impressionists, like the Impressionists, only had pure colours on their palette. But they totally repudiated any mixing of colours on the palette, except, of course, the mixing of colours which were contiguous in the chromatic circle. These, shaded off between each other and lightened with white, tend to reinstate the various colours of the solar spectrum and all their tones. An orange mixed with a yellow and a red, a violet shading into red and blue, a green passing from blue to yellow, are, together with white, the only elements they used. But, by the optical blending of these pure colours, and by varying their proportions, they obtained an infinite quantity of colours, from the most intense to the most grey.

They not only banished from their palettes any mixed colours, they also avoided spoiling the purity of their colours by putting contrary ones together on a canvas. Every touch made purely on the palette remains pure on the canvas.

As they used colours prepared with more brilliant powders, and more sumptuous materials, these painters could claim that their luminosity and coloration surpassed that of the Impressionists, who had darkened and spoiled the pure colours of the simplified palette.

It is not enough for the technique of *separation* to assure, by the mixture of pure optical elements, a maximum of luminosity and coloration; it guarantees the integral harmony of the work by the proportion and balance of these elements, depending on the rules of contrast, shading and radiance.

These rules, which the Impressionists observed infrequently and instinctively, are always rigorously applied by the Neo-Impressionists. It is a precise and scientific method, which does not enfeeble sensation, but guides and protects it.

It would seem that the first question confronting the painter in front of a blank canvas is the decision as to which curves and patterns will divide the surface, which colours and tones should cover it. Quite an infrequent worry at a time when most paintings are instantaneous photographs or useless illustrations.

To reproach the Impressionists for having neglected these concerns would be puerile, for their obvious plan was to seize the patterns and harmonies of nature, as they presented themselves, without any concern for order and combination. 'The Impressionist sits on the bank of a river,' said their critic Théodore Duret, 'and paints that which he sees before him.' They proved that, in this way, one could create marvels.

The Neo-Impressionist, following the advice of Delacroix, will not begin a canvas without having finalized the composition. Guided by tradition and by science, he will harmonize the composition with his idea; that is to say, he will adapt the lines (directions and angles), the light and dark (tones), the colours (pigments) to the character he wants. The dominance of the lines would be horizontal for calm, ascending for joy and descending for sadness, with all the intermediate lines used to depict all the other sensations in their infinite variety. A polychromatic interplay, no less expressive and diverse, joins with this linear interplay: corresponding to the ascending lines are warm colours and clear tones, with the descending lines, cold colours and dark tones predominate; a more or less perfect balance of warm and cold colours, of pale and intense tones is added to the calm of the horizontal lines. Thus submitting colour and line to the emotion he felt and wants to translate, the painter does the work of the poet, of the creator.

In a general way, it is possible to admit that a Neo-Impressionist work is more harmonious than an Impressionist one. Firstly, thanks to the constant observation of contrast, the harmony of detail in it is more precise. Secondly, thanks to the rational composition and to the aesthetic language of the colours, it leads to a harmony of the whole and a moral harmony with which the Impressionist work is deliberately unconcerned.

* * *

It is perhaps easy to paint more luminously than the Neo-Impressionists, but you would lose colour; you can have more colour, but at the cost of darkening. Their colour is

located in the middle of the radius of the chromatic circle which goes from the centre – white – to the circumference – black. This location assures it the maximum saturation of power and beauty. A time will come when one discovers such a combination either from using a better type of colour than those which the painter has now, or from using better substances, or new processes like the direct application of light rays on sensitized surfaces; but it must be admitted that it was the Neo-Impressionists who knew how to exploit the current resources, rendering them at once more luminous and more coloured. Next to one of their paintings, and despite the criticisms which they still encounter, any painting, however great its artistic qualities, will appear dark or lacking in colour. It must be understood that we do not want a painter's talent to depend on how much light and colour there is in his paintings; we know that with white and black one can create masterpieces and one can paint with colour and light without merit. But if this research into colour and light is not the whole of art, is it not at least one of the most important parts? Is he not an artist who endeavours to create unity in the variety of rhythms of pigments and tones, and who employs his knowledge in the service of his sensations?

Remembering the phrase of Delacroix: 'Cowardly painting is the painting of a coward', the Neo-Impressionists could be proud of their austere and simple painting. And if it is passion that makes artists, rather than technique, they can be confident: they have the fertile passion of light, of colour and of harmony.

In any case, they will not have repeated that which had been done before; they will have the risky honour of having produced a new way, of expressing a personal ideal.

They can develop, but always on the bases of purity and of contrast; they knew the importance and charm of these too well ever to renounce them. Gradually freed from the hindrances of their beginnings, the technique of *separation*, which permitted them to express their dreams in colour, became more supple and advanced, promising even more fertile resources.

And if there is no artist among them whose genius allows him to develop this technique further, at least they have simplified his task. The triumphant colourist has only to appear: his palette has been prepared for him.

2　Paul Gauguin (1848–1903) Letter to Fontainas

Written from Tahiti in March 1899, in response to published criticism by André Fontainas of Gauguin's painting *Whence do we come? What are we? Where are we going?*, Fontainas had objected that 'abstractions are not communicated through concrete images unless, in the artist's own mind, they have already taken shape in some natural allegory which gives them life'. Original published in A. Fontainas (intro.), *Lettres de Paul Gauguin à André Fontainas*, Paris, 1921. The present translation is taken from J. Rewald, *Paul Gauguin: Letters to Ambroise Vollard and André Fontainas*, San Francisco, 1943, pp. 21–4. (For further texts by Gauguin see *Art in Theory 1815–1900* VIB18, VIC9 and 13.)

> Un grand sommeil noir
> Tombe sur ma vie
> Dormez, tout espoir
> Dormez, toute envie.
> 　　　　Verlaine

Monsieur Fontainas,

In the January number of the *Mercure de France*, you have two interesting articles, 'Rembrandt' and 'The Vollard Gallery.' In the latter you mention me. In spite of your dislike you have tried to make an honest study of the art or rather the work of a painter who has no emotional effect upon you. A rare phenomenon among critics.

I have always [thought] that it was the duty of a painter never to answer criticisms, even hostile ones – especially hostile ones; nor flattering ones, either, because those are often dictated by friendship.

This time, without departing from my habitual reserve, I have an irresistible desire to write to you, a caprice if you will, and – like all emotional people – I am not good at resisting. Since this is merely a personal letter it is not a real answer but simply a chat on art; your article prompts and evokes it.

We painters, we who are condemned to penury, accept the material difficulties of life without complaining, but we suffer from them insofar as they constitute a hindrance to work. How much time we lose in seeking our daily bread! The most menial tasks, dilapidated studios, and a thousand other obstacles. All these create despondency, followed by impotence, rage, violence. Such things do not concern you at all, I mention them only to convince both of us that you have good reason to point out numerous defects, violence, monotony of tone, clashing colors, etc. Yes, all these probably exist, do exist. Sometimes however they are intentional. Are not these repetitions of tones, these monotonous color harmonies (in the musical sense) analogous to oriental chants sung in a shrill voice, to the accompaniment of pulsating notes which intensify them by contrast? Beethoven uses them frequently (as I understand it) in the 'Sonata Pathétique,' for example. Delacroix too with his repeated harmonies of brown and dull violet, a sombre cloak suggesting tragedy. You often go to the Louvre; with what I have said in mind, look closely at Cimabue.

Think also of the musical role color will henceforth play in modern painting. Color, which is vibration just as music is, is able to attain what is most universal yet at the same time most elusive in nature: its inner force.

Here near my cabin, in complete silence, amid the intoxicating perfumes of nature, I dream of violent harmonies. A delight enhanced by I know not what sacred horror I divine in the infinite. An aroma of long-vanished joy that I breathe in the present. Animal figures rigid as statues, with something indescribably solemn and religious in the rhythm of their pose, in their strange immobility. In eyes that dream, the troubled surface of an unfathomable enigma.

Night is here. All is at rest. My eyes close in order to see without actually understanding the dream that flees before me in infinite space; and I experience the languorous sensation produced by the mournful procession of my hopes.

In praise of certain pictures that I considered unimportant you exclaim: 'if only Gauguin were always like that!' But I don't want to be always like that.

'In the large panel that Gauguin exhibits there is nothing that explains the meaning of the allegory.' Yes, there is: my dream is intangible, it comprises no allegory; as Mallarmé said, 'It is a musical poem, it needs no libretto.' Consequently the essence of a work, unsubstantial and out of reach, consists precisely of 'that which is not expressed; it flows by implication from the lines without color or words; it is not a material structure.'

Standing before one of my pictures of Tahiti, Mallarmé also remarked: 'It is amazing that one can put so much mystery in so much brilliance.'

To go back to the panel: the idol is there not as a literary symbol but as a statue, yet perhaps less of a statue than the animal figures, less animal also, combining my dream before my cabin with all nature, dominating our primitive soul, the unearthly consolation of our sufferings to the extent that they are vague and incomprehensible before the mystery of our origin and of our future.

And all this sings with sadness in my soul and in my design while I paint and dream at the same time with no tangible allegory within my reach – due perhaps to a lack of literary education.

Awakening with my work finished, I ask myself: 'Whence do we come? What are we? Where are we going?' A thought which has no longer anything to do with the canvas, expressed in words quite apart on the wall which surrounds it. Not a title but a signature.

You see, although I understand very well the value of words – abstract and concrete – in the dictionary, I no longer grasp them in painting. I have tried to interpret my vision in an appropriate décor without recourse to literary means and with all the simplicity the medium permits: a difficult job. You may say that I have failed, but do not reproach me for having tried, nor should you advise me to change my goal, to dally with other ideas already accepted, consecrated. Puvis de Chavannes is the perfect example. Of course Puvis overwhelms me with his talent and experience, which I lack; I admire him as much as you do and more, but for entirely different reasons (and – don't be annoyed – with more understanding). Each of us belongs to his own period.

The government is right not to give me an order for a decoration for a public building which might clash with the ideas of the majority, and it would be even more reprehensible for me to accept it, since I should have no alternative but to cheat or lie to myself.

At my exhibition at Durand-Ruel's [1893] a young man who didn't understand my pictures asked Degas to explain them to him. Smiling, he recited a fable by La Fontaine. 'You see,' he said, 'Gauguin is the thin wolf without the collar' [that is, he prefers liberty with starvation to servitude with abundance – John Rewald].

After fifteen years of struggle we are beginning to free ourselves from the influence of the Academy, from all this confusion of formulas apart from which there has been no hope of salvation, honor, or money: drawing, color composition, sincerity in the presence of nature, and so on. Only yesterday some mathematician [Charles Henry] tried to prove to us that we should use unchangeable light and color.

Now the danger is past. Yes, we are free, and yet I still see another danger flickering on the horizon; I want to discuss it with you. This long and boring letter has been written with only that in view. Criticism of today, when it is serious, intelligent, full of good intentions, tends to impose on us a method of thinking and dreaming which might become another bondage. Preoccupied with what concerns it particularly, its own field, literature, it will lose sight of what concerns us, painting. If that is true, I shall be impertinent enough to quote Mallarmé: 'A critic is someone who meddles with something that is none of his business.'

In his memory will you permit me to offer you this sketch of him, hastily dashed off, a vague recollection of a beautiful and beloved face, radiant, even in the shadows. Not a gift but an appeal for the indulgence I need for my foolishness and violence.

3 Sigmund Freud (1856–1939) from 'On Dreams'

Freud was the founder of psychoanalysis, and his theories were instrumental in forming modern concepts of human nature and human motivation. His writings on dreams and on the unconscious changed traditional ideas about the origins of visual imagery and added a new dimension to the problems of its interpretation. The essay from which the present extracts are taken was first published in *Grenzfragen des Nerven- und Seelenlebens*, Wiesbaden, 1901, as a summary of his longer work *The Interpretation of Dreams*, published in 1900. (Section XII of 'On Dreams' was added by Freud in 1911.) The present translation is taken from J. Strachey (ed.), *The Standard Edition of the Complete Psychological Works of Sigmund Freud*, London, vol. 5 (1900–1901), 1953, pp. 633–86.

VI

It is the process of displacement which is chiefly responsible for our being unable to discover or recognize the dream-thoughts in the dream-content, unless we understand the reason for their distortion. Nevertheless, the dream-thoughts are also submitted to another and milder sort of transformation, which leads to our discovering a new achievement on the part of the dream-work – one, however, which is easily intelligible. The dream-thoughts which we first come across as we proceed with our analysis often strike us by the unusual form in which they are expressed; they are not clothed in the prosaic language usually employed by our thoughts, but are on the contrary represented symbolically by means of similes and metaphors, in images resembling those of poetic speech. There is no difficulty in accounting for the constraint imposed upon the form in which the dream-thoughts are expressed. The manifest content of dreams consists for the most part in pictorial situations; and the dream-thoughts must accordingly be submitted in the first place to a treatment which will make them suitable for a representation of this kind. If we imagine ourselves faced by the problem of representing the arguments in a political leading article or the speeches of counsel before a court of law in a series of pictures, we shall easily understand the modifications which must necessarily be carried out by the dream-work owing to *considerations of representability in the content of the dream.*

The psychical material of the dream-thoughts habitually includes recollections of impressive experiences – not infrequently dating back to early childhood – which are thus themselves perceived as a rule as situations having a visual subject-matter. Wherever the possibility arises, this portion of the dream-thoughts exercises a determining influence upon the form taken by the content of the dream; it constitutes, as it were, a nucleus of crystallization, attracting the material of the dream-thoughts to itself and thus affecting their distribution. The situation in a dream is often nothing other than a modified repetition, complicated by interpolations, of an impressive experience of this kind; on the other hand, faithful and straightforward reproductions of real scenes only rarely appear in dreams.

The content of dreams, however, does not consist entirely of situations, but also includes disconnected fragments of visual images, speeches and even bits of unmodified thoughts. It may therefore perhaps be of interest to enumerate very briefly the modes of representation available to the dream-work for reproducing the dream-thoughts in the peculiar form of expression necessary in dreams.

The dream-thoughts which we arrive at by means of analysis reveal themselves as a psychical complex of the most intricate possible structure. Its portions stand in the most manifold logical relations to one another: they represent foreground and background, conditions, digressions and illustrations, chains of evidence and counter-arguments. Each train of thought is almost invariably accompanied by its contradictory counterpart. This material lacks none of the characteristics that are familiar to us from our waking thinking. If now all of this is to be turned into a dream, the psychical material will be submitted to a pressure which will condense it greatly, to an internal fragmentation and displacement which will, as it were, create new surfaces, and to a selective operation in favour of those portions of it which are the most appropriate for the construction of situations. If we take into account the genesis of the material, a process of this sort deserves to be described as a 'regression'. In the course of this transformation, however, the logical links which have hitherto held the psychical material together are lost. It is only, as it were, the substantive content of the dream-thoughts that the dream-work takes over and manipulates. The restoration of the connections which the dream-work has destroyed is a task which has to be performed by the work of analysis.

The modes of expression open to a dream may therefore be qualified as meagre by comparison with those of our intellectual speech; nevertheless a dream need not wholly abandon the possibility of reproducing the logical relations present in the dream-thoughts. On the contrary, it succeeds often enough in replacing them by formal characteristics in its own texture.

In the first place, dreams take into account the connection which undeniably exists between all the portions of the dream-thoughts by combining the whole material into a single situation. They reproduce *logical connection by approximation in time and space*, just as a painter will represent all the poets in a single group in a picture of Parnassus. It is true that they were never in fact assembled on a single mountain-top; but they certainly form a conceptual group. Dreams carry this method of reproduction down to details; and often when they show us two elements in the dream-content close together, this indicates that there is some specially intimate connection between what corresponds to them among the dream-thoughts. [. . .]

* * *

VII

We have not yet come to the end of our consideration of the dream-work. In addition to condensation, displacement and pictorial arrangement of the psychical material, we are obliged to assign it yet another activity, though this is not to be found in operation in *every* dream. I shall not deal exhaustively with this part of the dream-work, and will therefore merely remark that the easiest way of forming an idea of its nature is to suppose – though the supposition probably does not meet the facts – that *it only comes into operation* AFTER *the dream-content has already been constructed*. Its function would then consist in arranging the constituents of the dream in such a way that they form an approximately connected whole, a dream-composition. In this way the dream is given a kind of façade (though this does not, it is true, hide its content at every point), and thus receives a first, preliminary interpretation, which is supported by interpolations and slight modifications. Incidentally, this revision of the dream-content is only possible if it is not too punctiliously carried out; nor does it present us with anything more than a

glaring misunderstanding of the dream-thoughts. Before we start upon the analysis of a dream we have to clear the ground of this attempt at an interpretation.

The motive for this part of the dream-work is particularly obvious. *Considerations of intelligibility* are what lead to this final revision of a dream; and this reveals the origin of the activity. It behaves towards the dream-content lying before it just as our normal psychical activity behaves in general towards any perceptual content that may be presented to it. It understands that content on the basis of certain anticipatory ideas, and arranges it, even at the moment of perceiving it, on the presupposition of its being intelligible; in so doing it runs a risk of falsifying it, and in fact, if it cannot bring it into line with anything familiar, is a prey to the strangest misunderstandings. As is well known, we are incapable of seeing a series of unfamiliar signs or of hearing a succession of unknown words, without at once falsifying the perception from considerations of intelligibility, on the basis of something already known to us.

Dreams which have undergone a revision of this kind at the hands of a psychical activity completely analogous to waking thought may be described as 'well-constructed'. In the case of other dreams this activity has completely broken down; no attempt even has been made to arrange or interpret the material, and, since after we have woken up we feel ourselves identical with this last part of the dream-work, we make a judgement that the dream was 'hopelessly confused'. From the point of view of analysis, however, a dream that resembles a disordered heap of disconnected fragments is just as valuable as one that has been beautifully polished and provided with a surface. In the former case, indeed, we are saved the trouble of demolishing what has been superimposed upon the dream-content.

It would be a mistake, however, to suppose that these dream-façades are nothing other than mistaken and somewhat arbitrary revisions of the dream-content by the conscious agency of our mental life. In the erection of a dream-façade use is not infrequently made of wishful phantasies which are present in the dream-thoughts in a pre-constructed form, and are of the same character as the appropriately named 'daydreams' familiar to us in waking life. The wishful phantasies revealed by analysis in night-dreams often turn out to be repetitions or modified versions of scenes from infancy; thus in some cases the façade of the dream directly reveals the dream's actual nucleus, distorted by an admixture of other material.

The dream-work exhibits no activities other than the four that have already been mentioned. If we keep to the definition of 'dream-work' as the process of transforming the dream-thoughts into the dream-content, it follows that the dream-work is not creative, that it develops no phantasies of its own, that it makes no judgements and draws no conclusions; it has no functions whatever other than condensation and displacement of the material and its modification into pictorial form, to which must be added as a variable factor the final bit of interpretative revision. It is true that we find various things in the dream-content which we should be inclined to regard as a product of some other and higher intellectual function; but in every case analysis shows convincingly that *these intellectual operations have already been performed in the dream-thoughts and have only been* TAKEN OVER *by the dream-content*. A conclusion drawn in a dream is nothing other than the repetition of a conclusion in the dream-thoughts; if the conclusion is taken over into the dream unmodified, it will appear impecable; if the dream-work has displaced it on to some other material, it will appear nonsensical. A calculation in the dream-content signifies nothing more than that there is a calculation

in the dream-thoughts; but while the latter is always rational, a dream-calculation may produce the wildest results if its factors are condensed or if its mathematical operations are displaced on to other material. Not even the speeches that occur in the dream-content are original compositions; they turn out to be a hotchpotch of speeches made, heard or read, which have been revived in the dream-thoughts and whose wording is exactly reproduced, while their origin is entirely disregarded and their meaning is violently changed.

* * *

VIII

Having been made acquainted with the dream-work . . . we shall no doubt be inclined to pronounce it a quite peculiar psychical process, the like of which, so far as we are aware, does not exist elsewhere. It is as though we were carrying over on to the dream-work all the astonishment which used formerly to be aroused in us by its product, the dream. In fact, however, the dream-work is only the first to be discovered of a whole series of psychical processes, responsible for the generation of hysterical symptoms, of phobias, obsessions and delusions. Condensation and, above all, displacement are invariable characteristics of these other processes as well. Modification into a pictorial form, on the other hand, remains a peculiarity of the dream-work. If this explanation places dreams in a single series alongside the structures produced by psychical illness, this makes it all the more important for us to discover the essential determining conditions of such processes as those of dream-formation. We shall probably be surprised to hear that neither the state of sleep nor illness is among these indispensable conditions. A whole number of the phenomena of the everyday life of healthy people – such as forgetting, slips of the tongue, bungled actions and a particular class of errors – owe their origin to a psychical mechanism analogous to that of dreams and of the other members of the series.

The heart of the problem lies in displacement, which is by far the most striking of the special achievements of the dream-work. If we enter deeply into the subject, we come to realize that the essential determining condition of displacement is a purely psychological one: something in the nature of a *motive*. One comes upon its track if one takes into consideration certain experiences which one cannot escape in analysing dreams. In analysing my specimen dream I was obliged to break off my report of the dream-thoughts . . . because, as I confessed, there were some among them which I should prefer to conceal from strangers and which I could not communicate to other people without doing serious mischief in important directions. I added that nothing would be gained if I were to choose another dream instead of that particular one with a view to reporting its analysis: I should come upon dream-thoughts which required to be kept secret in the case of *every* dream with an obscure or confused content. If, however, I were to continue the analysis on my own account, without any reference to other people (whom, indeed, an experience so personal as my dream cannot possibly have been intended to reach), I should eventually arrive at thoughts which would surprise me, whose presence in me I was unaware of, which were not only *alien* but also *disagreeable* to me, and which I should therefore feel inclined to dispute energetically, although the chain of thoughts running through the analysis insisted upon them remorselessly. There is only one way of accounting for this state of affairs,

which is of quite universal occurrence; and that is to suppose that these thoughts really were present in my mind, and in possession of a certain amount of psychical intensity or energy, but that they were in a peculiar psychological situation, as a consequence of which they *could not become conscious* to me. (I describe this particular condition as one of 'repression'.) We cannot help concluding, then, that there is a causal connection between the obscurity of the dream-content and the state of repression (inadmissibility to consciousness) of certain of the dream-thoughts, and that the dream had to be obscure so as not to betray the proscribed dream-thoughts. Thus we are led to the concept of a 'dream-distortion', which is the product of the dream-work and serves the purpose of dissimulation, that is, of disguise.

* * *

X

Hitherto philosophers have had no occasion to concern themselves with a psychology of repression. We may therefore be permitted to make a first approach to this hitherto unknown topic by constructing a pictorial image of the course of events in dream-formation. It is true that the schematic picture we have arrived at – not only from the study of dreams – is a fairly complicated one; but we cannot manage with anything simpler. Our hypothesis is that in our mental apparatus there are two thought-constructing agencies, of which the second enjoys the privilege of having free access to consciousness for its products, whereas the activity of the first is in itself unconscious and can only reach consciousness by way of the second. On the frontier between the two agencies, where the first passes over to the second, there is a censorship, which only allows what is agreeable to it to pass through and holds back everything else. According to our definition, then, what is rejected by the censorship is in a state of repression. Under certain conditions, of which the state of sleep is one, the relation between the strength of the two agencies is modified in such a way that what is repressed can no longer be held back. In the state of sleep this probably occurs owing to a relaxation of the censorship; when this happens it becomes possible for what has hitherto been repressed to make a path for itself to consciousness. Since, however, the censorship is never completely eliminated but merely reduced, the repressed material must submit to certain alterations which mitigate its offensive features. What becomes conscious in such cases is a compromise between the intentions of one agency and the demands of the other. *Repression – relaxation of the censorship – the formation of a compromise*, this is the fundamental pattern for the generation not only of dreams but of many other psychopathological structures; and in the latter cases too we may observe that the formation of compromises is accompanied by processes of condensation and displacement and by the employment of superficial associations, which we have become familiar with in the dream-work.

 We have no reason to disguise the fact that in the hypothesis which we have set up in order to explain the dream-work a part is played by what might be described as a 'daemonic' element. We have gathered an impression that the formation of obscure dreams occurs *as though* one person who was dependent upon a second person had to make a remark which was bound to be disagreeable in the ears of this second one; and it is on the basis of this simile that we have arrived at the concepts of dream-distortion and censorship, and have endeavoured to translate our impression into a psychological

theory which is no doubt crude but is at least lucid. Whatever it may be with which a further investigation of the subject may enable us to identify our first and second agencies, we may safely expect to find a confirmation of some correlate of our hypothesis that the second agency controls access to consciousness and can bar the first agency from such access.

When the state of sleep is over, the censorship quickly recovers its full strength; and it can now wipe out all that was won from it during the period of its weakness. This must be one part at least of the explanation of the forgetting of dreams, as is shown by an observation which has been confirmed on countless occasions. It not infrequently happens that during the narration of a dream or during its analysis a fragment of the dream-content which had seemed to be forgotten re-emerges. This fragment which has been rescued from oblivion invariably affords us the best and most direct access to the meaning of the dream. And that, in all probability, must have been the only reason for its having been forgotten, that is, for its having been once more suppressed.

* * *

XII

No one who accepts the view that the censorship is the chief reason for dream-distortion will be surprised to learn from the results of dream-interpretation that most of the dreams of adults are traced back by analysis to *erotic wishes*. This assertion is not aimed at dreams with an *undisguised* sexual content, which are no doubt familiar to all dreamers from their own experience and are as a rule the only ones to be described as 'sexual dreams'. Even dreams of this latter kind offer enough surprises in their choice of the people whom they make into sexual objects, in their disregard of all the limitations which the dreamer imposes in his waking life upon his sexual desires, and by their many strange details, hinting at what are commonly known as 'perversions'. A great many other dreams, however, which show no sign of being erotic in their manifest content, are revealed by the work of interpretation in analysis as sexual wish-fulfilments; and, on the other hand, analysis proves that a great many of the thoughts left over from the activity of waking life as 'residues of the previous day' only find their way to representation in dreams through the assistance of repressed erotic wishes.

There is no theoretical necessity why this should be so; but to explain the fact it may be pointed out that no other group of instincts has been submitted to such far-reaching suppression by the demands of cultural education, while at the same time the sexual instincts are also the ones which, in most people, find it easiest to escape from the control of the highest mental agencies. Since we have become acquainted with infantile sexuality, which is often so unobtrusive in its manifestations and is always overlooked and misunderstood, we are justified in saying that almost every civilized man retains the infantile forms of sexual life in some respect or other. We can thus understand how it is that repressed infantile sexual wishes provide the most frequent and strongest motive-forces for the construction of dreams.

There is only one method by which a dream which expresses erotic wishes can succeed in appearing innocently non-sexual in its manifest content. The material of the sexual ideas must not be represented as such, but must be replaced in the content of the dream by hints, allusions and similar forms of indirect representation. But,

unlike other forms of indirect representation, that which is employed in dreams must not be immediately intelligible. The modes of representation which fulfil these conditions are usually described as 'symbols' of the things which they represent. Particular interest has been directed to them since it has been noticed that dreamers speaking the same language make use of the same symbols, and that in some cases, indeed, the use of the same symbols extends beyond the use of the same language. Since dreamers themselves are unaware of the meaning of the symbols they use, it is difficult at first sight to discover the source of the connection between the symbols and what they replace and represent. The fact itself, however, is beyond doubt, and it is important for the technique of dream-interpretation. For, with the help of a knowledge of dream-symbolism, it is possible to understand the meaning of separate elements of the content of a dream or separate pieces of a dream or in some cases even whole dreams, without having to ask the dreamer for his associations. Here we are approaching the popular ideal of translating dreams and on the other hand are returning to the technique of interpretation used by the ancients, to whom dream-interpretation was identical with interpretation by means of symbols.

Although the study of dream-symbols is far from being complete, we are in a position to lay down with certainty a number of general statements and a quantity of special information on the subject. There are some symbols which bear a single meaning almost universally: thus the Emperor and Empress (or the King and Queen) stand for the parents, rooms represent women and their entrances and exits the openings of the body. The majority of dream-symbols serve to represent persons, parts of the body and activities invested with erotic interest; in particular, the genitals are represented by a number of often very surprising symbols, and the greatest variety of objects are employed to denote them symbolically. Sharp weapons, long and stiff objects, such as tree-trunks and sticks, stand for the male genital; while cupboards, boxes, carriages or ovens may represent the uterus. In such cases as these the *tertium comparationis*, the common element in these substitutions, is immediately intelligible; but there are other symbols in which it is not so easy to grasp the connection. Symbols such as a staircase or going upstairs to represent sexual intercourse, a tie or cravat for the male organ, or wood for the female one, provoke our unbelief until we can arrive at an understanding of the symbolic relation underlying them by some other means. Moreover a whole number of dream-symbols are bisexual and can relate to the male or female genitals according to the context.

Some symbols are universally disseminated and can be met with in all dreamers belonging to a single linguistic or cultural group; there are others which occur only within the most restricted and individual limits, symbols constructed by an individual out of his own ideational material. Of the former class we can distinguish some whose claim to represent sexual ideas is immediately justified by linguistic usage (such, for instance, as those derived from agriculture, e.g. 'fertilization' or 'seed') and others whose relation to sexual ideas appears to reach back into the very earliest ages and to the most obscure depths of our conceptual functioning. The power of constructing symbols has not been exhausted in our own days in the case of either of the two sorts of symbols which I have distinguished at the beginning of this paragraph. Newly discovered objects (such as airships) are, as we may observe, at once adopted as universally available sexual symbols.

It would, incidentally, be a mistake to expect that if we had a still profounder knowledge of dream-symbolism (of the 'language of dreams') we could do without asking the dreamer for his associations to the dream and go back entirely to the technique of dream-interpretation of antiquity. Quite apart from individual symbols and oscillations in the use of universal ones, one can never tell whether any particular element in the content of a dream is to be interpreted symbolically or in its proper sense, and one can be certain that the *whole* content of a dream is not to be interpreted symbolically. A knowledge of dream-symbolism will never do more than enable us to translate certain constitutents of the dream-content, and will not relieve us of the necessity for applying the technical rules which I gave earlier. It will, however, afford the most valuable assistance to interpretation precisely at points at which the dreamer's associations are insufficient or fail altogether.

Dream-symbolism is also indispensable to an understanding of what are known as 'typical' dreams, which are common to everyone, and of 'recurrent' dreams in individuals.

If the account I have given in this short discussion of the symbolic mode of expression in dreams appears incomplete, I can justify my neglect by drawing attention to one of the most important pieces of knowledge that we possess on this subject. Dream-symbolism extends far beyond dreams: it is not peculiar to dreams, but exercises a similar dominating influence on representation in fairy-tales, myths and legends, in jokes and in folk-lore. It enables us to trace the intimate connections between dreams and these latter productions. We must not suppose that dream-symbolism is a creation of the dream-work; it is in all probability a characteristic of the unconscious thinking which provides the dream-work with the material for condensation, displacement and dramatization.

4 Otto Weininger (1880–1903) from *Sex and Character*

The author became a cult figure in Austro-German intellectual life after his death by suicide in October 1903. His book *Geschlecht und Charakter* had been published a few months earlier in Vienna. Violently misogynistic and anti-Semitic though his own views were, Weininger's acute theorization of the supposed decline of modern civilization had an impact on much wider cultural circles. He was, for example, read in Italian translation by de Chirico, and invoked in de Chirico's essay of 1919 'On Metaphysical Art'. Weininger's work constitutes an early and forceful statement of that influential viewpoint which connects the decay of the spiritual and artistic aspects of life to modern materialism and the rise of science. It also serves to demonstrate the uncomfortable fact that Nazism had a considerable intellectual pedigree. The book was in its sixth edition by 1906, when an authorized English translation was published in London. The present text is taken from that version.

[...] The scientific man ranks ... below the artist and the philosopher. The two latter may earn the title of genius which must always be denied to the scientific man. Without any good reason having been assigned for it, it has usually been the case that the voice of genius on any particular problem is listened to before the voice of science. Is there justice in this preference? Can the genius explain things as to which the man of science, as such, can say nothing? Can he peer into depths where the man of science is blind?

The conception genius concludes universality. If there were an absolute genius (a convenient fiction) there would be nothing to which he could not have a vivid, intimate, and complete relation. Genius, as I have already shown, would have universal comprehension, and through its perfect memory would be independent of time. To comprehend anything one must have within one something similar. A man notices, understands, and comprehends only those things with which he has some kinship. The genius is the man with the most intense, most vivid, most conscious, most continuous, and most individual ego. The ego is the central point, the unit of comprehension, the synthesis of all manifoldness.

The ego of the genius accordingly is simply itself universal comprehension, the centre of infinite space; the great man contains the whole universe within himself; genius is the living microcosm. He is not an intricate mosaic, a chemical combination of an infinite number of elements...he is everything. In him and through him all psychical manifestations cohere and are real experiences, not an elaborate piece-work, a whole put together from parts in the fashion of science. For the genius the ego is the all, lives as the all; the genius sees nature and all existences as whole; the relations of things flash on him intuitively; he has not to build bridges of stones between them. And so the genius cannot be an empirical psychologist slowly collecting details and linking them by associations; he cannot be a physicist, envisaging the world as a compound of atoms and molecules.

It is absolutely from his vision of the whole, in which the genius always lives, that he gets his sense of the parts. He values everything within him or without him by the standard of this vision, a vision that for him is no function of time, but a part of eternity. [...] The scientist takes phenomena for what they obviously are; the great man or the genius for what they signify. Sea and mountain, light and darkness, spring and autumn, cypress and palm, dove and swan are symbols to him, he not only thinks that there is, but he recognizes in them something deeper. The ride of the Valkyrie is not produced by atmospheric pressure and the magic fire is not the outcome of a process of oxidation.

And all this is possible for him because the outer world is as full and strongly connected as the inner in him, the external world in fact seems to be only a special aspect of his inner life; the universe and the ego have become one in him, and he is not obliged to set his experience together piece by piece according to rule. [...] The infinity of the universe is responded to in the genius by a true sense of infinity in his own breast; he holds chaos and cosmos, all details and all totality, all plurality, and all singularity in himself. [...]

* * *

[...] It is notable that the Jews, even now when at least a relative security of tenure is possible, prefer moveable property, and, in spite of their acquisitiveness, have little real sense of personal property, especially in its most characteristic form, landed property. Property is indissolubly connected with the self, with individuality. It is in harmony with the foregoing that the Jew is so readily disposed to communism. Communism must be distinguished clearly from socialism, the former being based on a community of goods, an absence of individual property, the latter meaning, in the first place a co-operation of individual with individual, of worker with worker, and a recognition of human individuality in every one. Socialism is Aryan (Owen, Carlyle, Ruskin, Fichte). Communism is Jewish (Marx). Modern social democracy has moved far apart from the

earlier socialism, precisely because Jews have taken so large a share in developing it. In spite of the associative element in it, the Marxian doctrine does not lead in any way towards the State as a union of all the separate individual aims, as the higher unit combining the purposes of the lower units. Such a conception is as foreign to the Jew as it is to the woman.

* * *

Judaism, at the present day, has reached its highest point since the time of Herod. Judaism is the spirit of modern life. Sexuality is accepted, and contemporary ethics sing the praises of pairing. [...] It is the Jew and the woman who are the apostles of pairing to bring guilt on humanity.

Our age is not only the most Jewish but the most feminine. It is a time when art is content with daubs and seeks its inspiration in the sports of animals; the time of a superficial anarchy, with no feeling for Justice and the State; a time of communistic ethics, of the most foolish of historical views, the materialistic interpretation of history; a time of capitalism and of Marxism; a time when history, life, and science are no more than political economy and technical instruction; a time when genius is supposed to be a form of madness; a time with no great artists and no great philosophers; a time without originality and yet with the most foolish craving for originality; a time when the cult of the Virgin has been replaced by that of the Demi-vierge. It is the time when pairing has not only been approved but has been enjoined as a duty.

But from the new Judaism the new Christianity may be pressing forth; mankind waits for the new founder of religion, and, as in the year one, the age presses for a decision. The decision must be made between Judaism and Christianity, between business and culture, between male and female, between the race and the individual, between unworthiness and worth, between the earthly and the higher life, between negation and the God-like. Mankind has the choice to make. There are only two poles, and there is no middle way.

5 Max Liebermann (1847–1935) 'Imagination in Painting'

During the 1870s and 1880s, Liebermann was drawn to the realist aspects of Dutch painting. In the 1890s he became the dominant figure among those German artists who responded to French Naturalism and Impressionism. His own collection included works by Manet, Degas, Monet and Cézanne. He was leader of the Berlin Secession from 1898 until 1911 and as President of the Deutscher Kunstlerbund took a leading role in opposing the conservative policies of the Emperor William II, who had identified himself publicly with a pronounced neo-classical tendency in German art. Liebermann was President of the Prussian Akademie der Künste from 1920 until 1932, when increasing attacks from the Nazis forced his resignation. 'Imagination in Painting' is the clearest exposition of his views at a time when his work represented a moderate but distinctive synthesis of modern styles, and before his reaction to the work of the German Expressionists marked a limit to his support for new developments. Liebermann here voices a typically Modernist commitment to the priority of imagination over depicted content. His principal concern, however, is not to justify departure from naturalistic canons, but rather to stress the indispensable role of imagination in all painting, naturalist painting included. First published as 'Die Phantasie in der Malerei' in *Die neue Rundschau*, vol. XV, no. 3, Berlin, March 1904, pp. 372–80. Our selections are

taken from pp. 372–5. They were translated for the present volume by Nicholas Walker. ('Imagination' and 'fantasy' are not distinguished in German as they are in English. Lieber-mann's sense is more faithfully translated by 'imagination' – with its connotations of realistic insight – than it would be by 'fantasy'.)

[...] I wish here to speak of painting that has properly 'recovered from all consider-ations of utility', of painting that would be nothing else but – precisely painting; I wish to speak of the spirit of painting, rather than of the way in which it surmounts its purely technical difficulties, although this is where the public, and I fear many a painter too, still believes its true value to lie.

This said, it is quite true that the word *Kunst* (art) derives from the word *können* (ability and facility), and there is no denying that in no other art is ability as crucial as it is in painting.

But however much we may esteem painting that is well-fashioned, good painting remains painting that has been well-conceived. For what is the significance of the most accurate drawing, the most virtuoso execution, the most brilliant colourism, if these extrinsic virtues lack the innermost thing, the dimension of feeling [*Empfindung*]? Otherwise the picture is nothing but a painted canvas. Imagination [*Phantasie*] alone can animate the canvas, and it is imagination that must guide the painter's hand, must literally penetrate to the very tips of his fingers. Although imagination is itself invisible, it makes itself visible in every brushstroke, if only for those with eyes to see, only for those who can sense and feel its presence.

I am not talking about infernal phantasmagoria or extravagant flights of fancy here. For by 'imagination' I understand the animating spirit of the artist that stands behind every brushstroke of his work. Imagination in the visual arts proceeds from purely sensory presuppositions. Imagination is the envisaging of ideal form for the real appearance of things. It is the indispensable criterion for every work of visual art, for the most ideal and the most naturalist work alike. It is only the imagination that can convince us of the truth of Böcklin's chimeras or of Manet's bunch of asparagus

* * *

A bunch of asparagus, a bouquet of roses, can yield a masterpiece; a beautiful girl or an unattractive one, an Apollo or a misshapen dwarf, anything can be made into a masterpiece as long as there is a sufficient amount of imagination at work. Imagination alone transforms a work of craft into a work of art.

[...] Strictly speaking [...] the art manifested in a picture can only be perceived by the inner eye, just as the art manifested in a piece of music can only be perceived by the inner ear. For what is it, if not the imagination of the artist, which distinguishes a work by Phidias from one that is cast from nature? The value of a work of visual art is utterly independent of what it depicts or represents. It is solely the inventiveness and the expressive potential of its form that constitutes its true value.

[...] The specifically painterly imagination of the artist can thus reveal itself more powerfully in a still life than in the representation of a human being precisely because the bunch of asparagus holds our interest solely by virtue of the way it is artistically handled. With a human being, on the other hand, with a head or a beautiful female body, we are also interested, and especially in the latter case, in the represented object itself.

The specifically painterly content [*Gehalt*] of a picture is greater the lesser the interest in the depicted object itself; the more completely the subject-matter [*Inhalt*] of the picture has been absorbed into painterly form, the greater the painter. From a purely painterly point of view, therefore, Velásquez's *Surrender of Breda* is no more intrinsically valuable than any of his kitchen still-life paintings. And indeed the latter would be more valuable in painterly terms if Velásquez had painted the kitchen implements better than he painted the military leaders in his great historical canvas. All that matters here is to state clearly that the value of painting is absolutely independent of its subject-matter and resides solely in the power of painterly imagination itself.

It follows that the exercise of such imagination is most required in naturalist painting in particular. For the latter strives for its appropriate effect solely by means of its own intrinsic virtues, although I realize this is a view that flatly contradicts the common opinion of the general public. Even now educated people continue to regard naturalist painting as an insipid duplication of nature, as an art that will be rendered obsolete once photography has learned how to reproduce colour as well as form. Not so! Even from colour photography we fear no rivalry. For even the most perfect mechanical reproduction of nature will bring us nothing but a perfect collection of waxworks, and will never lead us to art. What the educated viewer misses in naturalist art is simply literary imagination, and that is because he is looking at art with his thinking mind rather than with his eyes. We are still obsessed with Lessing's famous dictum that Raphael would still have become the greatest painter even if he had been born with no arms. He might well have become the greatest poet or the greatest musician, but certainly not the greatest painter. For painting consists not in the invention of ideas, but in the invention of visible form for an idea. Why else are there so few works of art to be found amongst the countless Madonnas with which we are familiar? And what is it that interests us in a portrait [...] other than that art with which the master here has translated what he saw – and the emphasis lies indeed upon what *he* saw – into the medium of painterly form? And by 'form' here I do not mean some pre-existing form that has now become a formula – like Raphael's form once it had degenerated into an academic exercise, or Rembrandt's chiaroscuro which, amongst his imitators, became an empty artistic gesture; I mean the kind of living form which each artist creates anew for himself. It is precisely in the creation of new forms that the proper criterion of the creative artist, of the genius, must be sought. That is why it is nonsensical to talk about a *single* form, of classical form as such. For there are as many classical forms as there were and will be classical artists. Form perfects itself with every artist, and is born anew with every succeeding artist. The paralysis of form into dogma would be the paralysis of art itself, would be its death. Naturally, in speaking of form here I am not referring to the external moment of technique, to something like the artist's handwriting. I am speaking here only of the ideal form which is invisible, as it were, which the artist alone sees, and which indeed each artist sees quite differently. One who sees a cow merely through the eyes of a Potter or a Troyon is no creative artist, but simply a copyist at best.

* * *

It is not only a question of what one sees, but also of who is seeing it. And the old saying that 'No man is great in the eyes of his valet' also holds for art, although I am not of course referring to the little personal weaknesses of great artists here. He who looks

on art with the eyes of a valet will never comprehend it. 'Nothing is beautiful in itself; it is our perceiving that first makes it so.' He who looks on Phidias with the eyes of Professor Trendelenberg may well see the marble statues of the Victory Boulevarde as his work too. Breadth of execution in painting is not enough to make a Velásquez, nor chiaroscuro enough to make a Rembrandt. These are merely, as it were, the earthly dimension of their work.

The imperishable dimension of works of art is the spirit within them, the spirit which presents the finished work to the inner eye of the painter even before he has made the first brushstroke upon the canvas.

And art, like spirit, is unbounded, reaching out as far as the expressive potential of its technical means permit. To extend its expressive potential is to expand the domain of art itself, of the only art that is true, of art that is born of the hand but begotten of imagination.

6 Paul Cézanne (1839–1906) Letters to Emile Bernard

The painter and writer Emile Bernard visited Cézanne in Aix in 1904. In their ensuing correspondence the older artist expounded the priorities of his practice. Bernard drew on these letters in his subsequent writings. His interpretation of Cézanne's work and ideas was all the more influential for appearing to carry the authority of a confidant. From J. Rewald, *Cézanne's Letters*, 4th edition, Oxford, 1976. (For selections from Cézanne's earlier letters See *Art in Theory* 1815–1900 IVA5 and VIB17.)

Aix-en-Provence, 15 April, 1904

[...] I am happy with the expression of warm artistic sympathy which you kindly address to me in your letter.

May I repeat what I told you here: treat nature by means of the cylinder, the sphere, the cone, everything brought into proper perspective so that each side of an object or a plane is directed towards a central point. Lines parallel to the horizon give breadth, whether it is a section of nature or, if you prefer, of the show which the *Pater Omnipotens Aeterne Deus* spreads out before our eyes. Lines perpendicular to this horizon give depth. But nature for us men is more depth than surface, whence the need to introduce into our light vibrations, represented by the reds and yellows, a sufficient amount of blueness to give the feel of air.

I must tell you that I had another look at the study you made from the lower floor of the studio, it is good. You only have to continue to this way, I think. You have the understanding of what must be done and you will soon turn your back on the Gauguins and [*van*] Goghs! [...]

Aix, 12 May, 1904

[...] My absorption in work and my advanced age will sufficiently explain the delay in answering your letter.

You entertain me, moreover, in your last letter with such a variety of topics, though all are connected with art, that I cannot follow it in all its developments.

I have already told you that I like Redon's talent enormously, and from my heart I agree with his feeling for and admiration of Delacroix. I do not know if my indifferent health will allow me ever to realize my dream of painting his apotheosis.

I progress very slowly, for nature reveals herself to me in very complex ways; and the progress needed is endless. One must look at the model and feel very exactly; and also express oneself distinctly and with force.

Taste is the best judge. It is rare. Art addresses itself only to an excessively limited number of individuals.

The artist must scorn all judgment that is not based on an intelligent observation of character.

He must beware of the literary spirit which so often causes the painter to deviate from his true path – the concrete study of nature – to lose himself too long in intangible speculation.

The Louvre is a good book to consult but it must be only an intermediary. The real and immense study to be undertaken is the manifold picture of nature.

* * *

Aix, 26 May, 1904

[. . .] On the whole I approve of the ideas you are going to expound in your next article for *Occident*. But I must always come back to this: painters must devote themselves entirely to the study of nature and try to produce pictures which will be an education. Talking about art is almost useless. The work which brings about some progress in one's own craft is sufficient compensation for not being understood by the imbeciles.

The man of letters expresses himself in abstractions whereas a painter, by means of drawing and colour, gives concrete form to his sensations and perceptions. One is neither too scrupulous nor too sincere nor too submissive to nature; but one is more or less master of one's model, and above all, of the means of expression. Get to the heart of what is before you and continue to express yourself as logically as possible. [. . .]

Aix, 25 July, 1904

[. . .] I have received the *Revue Occidentale*. I can only thank you for what you wrote about me.

I am sorry that we cannot be side by side, for I don't want to be right in theory, but in front of nature. Ingres in spite of his 'estyle' (Aixian pronunciation) and his admirers, is only a very small painter. The greatest, you know them better than I; the Venetians and the Spaniards.

In order to make progress, there is only nature, and the eye is trained through contact with her. It becomes concentric through looking and working. I mean to say that in an orange, an apple, a ball, a head, there is a culminating point; and this point is always – in spite of the tremendous effect; light and shade, colour sensations – the closest to our eye; the edges of the objects flee towards a centre on our horizon. With a small temperament one can be very much of a painter. One can do good things without being very much of a harmonist or a colourist. It is sufficient to have a sense of art – and this is without doubt the horror of the bourgeois, this sense. Therefore institutions, pensions, honours can only be made for cretins, humbugs and rascals. Don't be an art critic, but paint, there lies salvation. [. . .]

Aix, 23 December, 1904

[. . .] I shall not enter with you into aesthetic considerations. Yes, I approve of your admiration for the strongest of the Venetians; we praise Tintoretto. Your need to find a moral, an intellectual point of support in works, which assuredly will never be surpassed, keeps you constantly on the qui vive, incessantly on the search for the means, only dimly perceived, which will surely lead you, in front of nature, to sense

your own means of expression; and on the day you find them, be convinced you will rediscover without effort, in front of nature, the means employed by the four or five great ones of Venice.

This is true, without any possible doubt – I am quite positive: – an optical sensation is produced in our visual organs which allows us to classify the planes represented by colour sensations as light, half tone or quarter tone. Light, therefore, does not exist for the painter. As long as we are forced to proceed from black to white, with the first of these abstractions providing something like a point of support for the eye as much as for the brain, we flounder, we do not succeed in becoming masters of ourselves, in being in possession of ourselves. During this period (I am necessarily repeating myself a little) we turn towards the admirable works that have been handed down to us through the ages, where we find comfort, support, such as a plank provides for the bather.

[...]

* * *

Aix, 23 October, 1905

[...] Your letters are precious to me for a double reason: The first being purely egoistic, because their arrival lifts me out of the monotony caused by the incessant pursuit of the sole and unique aim, which leads in moments of physical fatigue to a kind of intellectual exhaustion; and the second, allows me to reassess for you, undoubtedly rather too much, the obstinacy with which I pursue the realization of that part of nature, which, coming into our line of vision, gives us the picture. Now the theme to develop is that – whatever our temperament or form of strength face to face with nature may be – we must render the image of what we see, forgetting everything that existed before us. Which, I believe, must permit the artist to give his entire personality, whether great or small.

Now, being old, nearly 70 years, the sensations of colour, which give the light, are for me the reason for the abstractions which do not allow me to cover my canvas entirely nor to pursue the delimitation of the objects where their points of contact are fine and delicate; from which it results that my image or picture is incomplete. On the other hand the planes fall one on top of the other, from whence neo-impressionism emerged, which circumscribes the contours with a black line, a fault which must be fought at all costs. But nature, if consulted, gives us the means of attaining this end.

* * *

Aix, 21 September, 1906

[...] I am in such a state of mental disturbance, I fear at moments that my frail reason may give way. After the terrible heatwave that we have just had, a milder temperature has brought some calm to our minds, and it was not too soon; now it seems to me that I see better and that I think more correctly about the direction of my studies. Will I ever attain the end for which I have striven so much and so long? I hope so, but as long as it is not attained a vague state of uneasiness persists which will not disappear until I have reached port, that is until I have realized something which develops better than in the past, and thereby can prove the theories – which in themselves are always easy; it is only giving proof of what one thinks that raises serious obstacles. So I continue to study. [...]

I am always studying after nature and it seems to me that I make slow progress. I should have liked you near me, for solitude always weighs me down a bit. But I am

old, ill, and I have sworn to myself to die painting, rather than go under in the debasing paralysis which threatens old men who allow themselves to be dominated by passions which coarsen their senses.

 If I have the pleasure of being with you one day, we shall be better able to discuss all this in person. You must forgive me for continually coming back to the same thing; but I believe in the logical development of everything we see and feel through the study of nature and turn my attention to technical questions later; for technical questions are for us only the simple means of making the public feel what we feel ourselves and of making ourselves understood. The great masters whom we admire must have done just that. [...]

7 Rainer Maria Rilke (1875–1926) from *Letters on Cézanne*

Though known principally as a poet, Rilke also wrote on the art of his own time. His letters on Cézanne were addressed to his wife, the artist Clara Westhoff. They had been married in 1901, following Rilke's second visit to the artistic community in Worpswede, where Westhoff was then working (see *Art in Theory 1815–1900* VIᴀ7). For nine months in 1905–6, Rilke worked at Meudon as secretary to the sculptor Rodin, on whose work he had previously published a short monograph. The letters on Cézanne were prompted by the large retrospective exhibition of the artist's work staged at the Salon d'Automne in Paris in 1907. Rilke's absorption in Cézanne's work noticeably increases as he reflects on his successive visits to the exhibition. Much space in the earlier letters is taken up with the recounting of anecdotal information about the artist's working circumstances and way of life, but as the month passes, passages of fascinated description expand into reflections on the relations between sensation and creation. A limited French edition of *Lettres sur Cézanne* was published by Editions Corrêa in Paris in 1944, with translation and preface by Maurice Betz. They were first published in the original German in Frankfurt in 1952 as *Briefe über Cézanne*, edited by Clara Rilke (Insel Verlag). Our versions are taken from *Letters on Cézanne*, translated from the German by Joel Agee, London: Vintage, 1991, pp. 28–9, 34, 36, 42–3, 48–51, 79–82. (Paul Cassirer, mentioned in the letter of 10 October, was an art dealer and publisher in Berlin, at whose gallery Rilke had seen work by Cézanne in 1900. The painting described in the letter of 22 October is the portrait of Mme Cézanne in a red armchair now in the Museum of Fine Arts, Boston.)

Paris VIe, 29, rue Cassette,
October 7, 1907 (Monday)

... I went back to the Salon d'Automne this morning, and found Meier-Graefe in front of the Cézannes again ... Count Kessler was there too and told me many beautiful and honest things about the new Book of Images, which he and Hofmannsthal had read aloud to each other. All of this happened in the Cézanne room, which makes an immediate claim on one's attention with its powerful pictures. You know how much more remarkable I always find the people walking about in front of paintings than the paintings themselves. It's no different in this Salon d'Automne, except for the Cézanne room. Here, all of reality is on his side: in this dense quilted blue of his, in his red and his shadowless green and the reddish black of his wine bottles. And the humbleness of all his objects: the apples are all cooking apples and the wine bottles belong in the roundly bulging pockets of an old coat. Fare well ...

Paris VIe, 29, rue Cassette,
October 9, 1907

... today I wanted to tell you a little about Cézanne. With regard to his work habits, he claimed to have lived as a Bohemian until his fortieth year. Only then, through his acquaintance with Pissarro, did he develop a taste for work. But then to such an extent that for the next thirty years he did nothing *but* work. Actually without joy, it seems, in a constant rage, in conflict with every single one of his paintings, none of which seemed to achieve what he considered to be the most indispensable thing. *La réalisation*, he called it, and he found it in the Venetians whom he had seen over and over again in the Louvre and to whom he had given his unreserved recognition. To achieve the conviction and substantiality of things, a reality intensified and potentiated to the point of indestructibility by his experience of the object, this seemed to him to be the purpose of his innermost work [...] While painting a landscape or a still life, he would conscientiously persevere in front of the object, but approach it only by very complicated detours. Beginning with the darkest tones, he would cover their depth with a layer of color that led a little beyond them, and keep going, expanding outward from color to color, until gradually he reached another, contrasting pictorial element, where, beginning at a new center, he would proceed in a similar way. I think there was a conflict, a mutual struggle between the two procedures of, first, looking and confidently receiving, and then of appropriating and making personal use of what has been received; that the two, perhaps as a result of becoming conscious, would immediately start opposing each other, talking out loud, as it were, and go on perpetually interrupting and contradicting each other [...]

Paris VIe, 29, rue Cassette,
October 10, 1907

[...] I again spent two hours in front of a few pictures today; I sense this is somehow useful for me. Would it be instructive for you? I can't really say it in one breath. One can really see all of Cézanne's pictures in two or three well-chosen examples, and no doubt we could have come as far in understanding him somewhere else, at Cassirer's for instance, as I find myself advancing now. But it all takes a long, long time. When I remember the puzzlement and insecurity of one's first confrontation with his work, along with his name, which was just as new. And then for a long time nothing, and suddenly one has the right eyes... [...]

Paris VIe, 29, rue Cassette,
October 13, 1907 (Sunday)

[...] Early this morning I read about your autumn, and all the colors you brought into your letter were retransformed in my feelings and filled my mind to the brim with strength and radiance. Yesterday, while I was admiring the dissolving brightness of autumn here, you were walking through that other autumn back home, which is painted on red wood, as this one's painted on silk. And the one reaches us as much as the other; that's how deeply we are placed on the ground of all transformation, we most changeable ones who walk about with the urge to comprehend everything and (because we're unable to grasp it) reduce immensity to the action of our heart, for fear that it might destroy us. If I were to come and visit you, I would surely also see the splendor of moor and heath, the hovering bright greens of meadows, the birches, with new and different eyes; and though this transformation is something I've completely experienced and shared before, ... nature was then still a general occasion for me, an

evocation, an instrument in whose strings my hands found themselves again; I was not yet sitting before her; I allowed myself to be swept away by the soul that was emanating from her; she came over me with her vastness, her huge exaggerated presence, the way the gift of prophesy came over Saul; exactly like that. I walked about and saw, not nature but the visions she gave me. How little I would have been able to learn from Cézanne, from van Gogh, then. I can tell how I've changed by the way Cézanne is challenging me now. I am on the way to becoming a worker, on a long way perhaps, and probably I've only reached the first milestone; but still, I can already understand the old man who somehow walked far ahead, alone, followed only by children who threw stones . . . Today I went to see his pictures again; it's remarkable what an environment they create. Without looking at a particular one, standing in the middle between the two rooms, one feels their presence drawing together into a colossal reality. As if these colors could heal one of indecision once and for all. The good conscience of these reds, these blues, their simple truthfulness, it educates you; and if you stand beneath them as acceptingly as possible, it's as if they were doing something for you. You also notice, a little more clearly each time, how necessary it was to go beyond love, too; it's natural, after all, to love each of these things as one makes it; but if one shows this, one makes it less well; one *judges* it instead of *saying* it. One ceases to be impartial; and the very best – love – stays outside the work, does not enter it, is left aside, untranslated: that's how the painting of sentiments came about (which is in no way better than the paintings of things). They'd paint: I love this here; instead of painting: here it is. In which case everyone must see for himself whether or not I loved it. This is not shown at all, and some would even insist that love has nothing to do with it. It's that thoroughly exhausted in the action of making, there is no residue. It may be that this emptying out of love in anonymous work, which produces such pure things, was never achieved as completely as in the work of this old man; his inner nature, having grown mistrustful and cross, helped him to do it. He certainly would not have shown another human being his love, had he been forced to conceive such a love; but with this disposition, which was completely developed now, thanks to his strangeness and insularity, he turned to nature and knew how to swallow back his love for every apple and put it to rest in the painted apple forever. Can you imagine what that is like, and what it's like to experience this through him? [. . .]

Paris VIe, 29, rue Cassette,
October 22, 1907

. . . the Salon is closing today. And already, as I'm leaving it, on the way home for the last time, I want to go back to look up a violet, a green, or certain blue tones which I believe I should have seen better, more unforgettably. Already, even after standing with such unrelenting attention in front of the great color scheme of the woman in the red armchair, it is becoming as unretrievable in my memory as a figure with very many digits. And yet I memorized it, number by number. In my feeling, the consciousness of their presence has become a heightening which I can feel even in my sleep; my blood describes it within me, but the naming of it passes by somewhere outside and is not called in. Did I write about it? – A red, upholstered low armchair has been placed in front of an earthy-green wall in which a cobalt-blue pattern (a cross with the center left out ⊹) is very sparingly repeated; the round bulging back curves and slopes forward and down to the armrests (which are sewn up like the sleeve-stump

of an armless man). The left armrest and the tassel that hangs from it full of vermilion no longer have the wall behind them but instead, near the lower edge, a broad stripe of greenish blue, against which they clash in loud contradiction. Seated in this red arm-chair, which is a personality in its own right, is a woman, her hands in the lap of a dress with broad vertical stripes that are very lightly indicated by small, loosely distributed flecks of green yellows and yellow greens, up to the edge of the blue-gray jacket, which is held together in front by a blue, greenly scintillating silk bow. In the brightness of the face, the proximity of all these colors has been exploited for a simple modeling of form and features: even the brown of the hair roundly pinned up above the temples and the smooth brown in the eyes has to express itself against its surroundings. *It's as if every place were aware of all the other places* – it participates that much; that much adjustment and rejection is happening in it; that's how each daub plays its part in maintaining equilibrium and in producing it: just as the whole picture finally keeps reality in equilibrium. For if one says, this is a red armchair (and it is the first and ultimate red armchair ever painted): it's true only because it contains latently within itself an experi-enced sum of color which, whatever it may be, reinforces and confirms this red. To reach the peak of its expression, it is very strongly painted around the light human figure, so that a kind of waxy surface develops; and yet the color does not preponderate over the object, which seems so perfectly translated into its painterly equivalents that, while it is fully achieved and given as an object, its bourgeois reality is at the same time relinquish-ing all its heaviness to a final and definitive picture-existence. Everything, as I already wrote, has become an affair that's settled among the colors themselves: a color will come into its own in response to another, or assert itself, or recollect itself. Just as in the mouth of a dog various secretions will gather in anticipation at the approach of various things – consenting ones for drawing out nutrients, and correcting ones to neutralize poisons: in the same way, various intensifications and dilutions take place in the core of every color, helping it to survive contact with others. In addition to this glandular activity within the intensity of colors, reflections (whose presence in nature always surprised me so: to discover the evening glow of the water as a permanent coloration in the rough green of the Nenuphar's covering-leaves –) play the greatest role: weaker local colors abandon themselves completely, contenting themselves with reflecting the dominant one. In this hither and back of mutual and manifold influence, the interior of the picture vibrates, rises and falls back into itself, and does not have a single unmoving part. Just this for today . . . You see how difficult it becomes when one tries to get very close to the facts . . .

8 Maurice Denis (1870–1943) 'Cézanne'

The French painter-theorist Denis had a role equal to Bernard's in establishing the terms of Cézanne's modern reputation. In this essay he represents Cézanne's work as the essential form of modern painting: an assiduous blending of the naive and empirical with the classic and rational. Originally published in *L'Occident*, Paris, September 1907, in the year after Cézanne's death. The present translation by Roger Fry was published in *Burlington Magazine*, XVI, London, January–February 1910, pp. 207–19 and 275–80. Fry's introductory note voices the avant-garde view that Cézanne's art was central to an epochal new movement. (For further texts by Denis see IA9 below and *Art in Theory 1815–1900* VC10.)

Introductory Note

Anyone who has had the opportunity of observing modern French art cannot fail to be struck by the new tendencies that have become manifest in the last few years. A new ambition, a new conception of the purpose and methods of painting, are gradually emerging; a new hope too, and a new courage to attempt in painting that direct expression of imagined states of consciousness which has for long been relegated to music and poetry. This new conception of art, in which the decorative elements preponderate at the expense of the representative, is not the outcome of any conscious archaistic endeavour, such as made, and perhaps inevitably marred, our own pre-Raphaelite movement. It has in it therefore the promise of a larger and a fuller life. It is, I believe, the direct outcome of the Impressionist movement. It was among Impressionists that it took its rise, and yet it implies the direct contrary of the Impressionist conception of art.

It is generally admitted that the great and original genius, – for recent criticism has the courage to acclaim him as such – who really started this movement, the most promising and fruitful of modern times, was Cézanne. [. . .]

Roger E. Fry.

I

There is something paradoxical in Cézanne's celebrity; and it is scarcely easier to explain than to explain Cézanne himself. The Cézanne question divides inseparably into two camps those who love painting and those who prefer to painting itself the literary and other interests accessory to it. I know indeed that it is the fashion to like painting. The discussions on this question are no longer serious and impassioned. Too many admirations lend themselves to suspicion. 'Snobbism' and speculation have dragged the public into painters' quarrels, and it takes sides according to fashion or interest. Thus it has come about that a public naturally hostile, but well primed by critics and dealers, has conspired to the apotheosis of a great artist, who remains nevertheless a difficult master even for those who love him best.

* * *

At the moment of his death, the articles in the press were unanimous upon two points; and, wherever their inspiration was derived from, they may fairly be considered to reflect the average opinion. The obituaries, then, admitted first of all that Cézanne influenced a large section of the younger artists; and secondly that he made an effort towards style. We may gather, then, that Cézanne was a sort of classic, and that the younger generation regards him as a representative of classicism.

Unfortunately it is hard to say without too much obscurity what classicism is.

Suppose that after a long sojourn in the country one enters one of those dreary provincial museums, one of those cemeteries abandoned to decay, where the silence and the musty smell denote the lapse of time; one immediately classifies the works exhibited into two groups: in one group the remains of the old collections of amateurs, and in the other the modern galleries, where the commissions given by the State have piled together the pitiful novelties bought in the annual salons according as studio intrigues or ministerial favour decides. It is in such circumstances that one becomes really and ingenuously sensitive to the contrast between ancient and modern art;

and that an old canvas by some Bolognese or from Lebrun's atelier, at once vigorous and synthetic in design, asserts its superiority to the dry analyses and thin coloured photographs of our gold–medallists!

Imagine, quite hypothetically, that a Cézanne is there. So we shall understand him better. First of all, we know we cannot place him in the modern galleries, so completely would he be out of key among the anecdotes and the fatuities. One must of sheer necessity place him among the old masters, to whom he is seen at a glance to be akin by his nobility of style. Gauguin used to say, thinking of Cézanne: 'Nothing is so much like a *croûte* [a daub] as a real masterpiece.' *Croûte* or masterpiece, one can only understand it in opposition to the mediocrity of modern painting. And already we grasp one of the certain characteristics of the classic, namely, *style*, that is to say synthetic order. In opposition to modern pictures, a Cézanne inspires by itself, by its qualities of unity in composition and colour, in short by its painting. The actualities, the illustrations to popular novels or historical events, with which the walls of our supposed museum are lined, seek to interest us only by means of the subject re-presented. Others perhaps establish the virtuosity of their authors. Good or bad, Cézanne's canvas is truly a *picture*.

Suppose now that for another experiment, and this time a less chimerical one, we put together three works of the same family, three *natures-mortes*, one by Manet, one by Gauguin, one by Cézanne. We shall distinguish at once the objectivity of Manet; that he imitates nature 'as seen through his temperament', that he translates an artistic sensation. Gauguin is more subjective. His is a decorative, even a hieratic interpretation of nature. Before the Cézanne we think only of the picture; neither the object represented nor the artist's personality holds our attention. We cannot decide so quickly whether it is an imitation or an interpretation of nature. We feel that such an art is nearer to Chardin than to Manet and Gauguin. And if at once we say: this is a picture and a classic picture, the word begins to take on a precise meaning, that, namely, of an equilibrium, a reconciliation of the objective and subjective.

In the Berlin Museum, for instance, the effect produced by Cézanne is significant. However much one admires Manet's *La Serre* or Renoir's *Enfants Bérard* or the admirable landscapes of Monet and Sisley, the presence of Cézanne makes one assimilate them (unjustly, it is true, but by the force of contrast) to the generality of modern productions: on the contrary the pictures of Cézanne seem like works of another period, no less refined but more robust than the most vigorous efforts of the Impressionists.

Thus we arrive at our first estimate of Cézanne as reacting against modern painting and against Impressionism.

* * *

Impressionism – and by that I mean much more the general movement, which has changed during the last twenty years the aspect of modern painting, than the special art of a Monet or a Renoir – Impressionism was synthetic in its tendencies, since its aim was to translate a sensation, to realize a mood; but its methods were analytic, since colour for it resulted from an infinity of contrasts. For it was by means of the decom-position of the prism that the Impressionists reconstituted light, divided colour and multiplied reflected lights and gradations; in fact, they substituted for varying greys as many different positive colours. Therein lies the fundamental error of Impressionism. The *Fifre* of Manet in four tones is necessarily more synthetic than the most delicious

Renoir, where the play of sunlight and shadow creates the widest range of varied half-tones. Now there is in a fine Cézanne as much simplicity, austerity and grandeur as in Manet, and the gradations retain the freshness and lustre which give their flower-like brilliance to the canvases of Renoir. Some months before his death Cézanne said: 'What I wanted was to make of Impressionism something solid and durable, like the art of the museums.' It was for this reason also that he so much admired the early Pissarros, and still more the early Monets. Monet was, indeed, the only one of his contemporaries for whom he expressed great admiration.

Thus at first guided by his Latin instinct and his natural inclination, and later with full consciousness of his purpose and his own nature, he set to work to create out of Impressionism a certain classic conception.

In constant reaction against the art of his time, his powerful individuality drew from it none the less the material and pretext for his researches in style; he drew from it the sustaining elements of his work. At a period when the artist's sensibility was considered almost universally to be the sole motive of a work of art, and when improvisation – 'the spiritual excitement provoked by exaltation of the senses' – tended to destroy at one blow both the superannuated conventions of the academies and the necessity for method, it happened that the art of Cézanne showed the way to substitute reflexion for empiricism without sacrificing the essential *rôle* of sensibility. Thus, for instance, instead of the chronometric notation of appearances, he was able to hold the emotion of the moment even while he elaborated almost to excess, in a calculated and intentional effort, his studies after nature. He *composed* his *natures-mortes*, varying intentionally the lines and the masses, disposing his draperies according to premeditated rhythms, avoiding the accidents of chance, seeking for plastic beauty; and all this without losing anything of the essential *motive* – that initial motive which is realized in its essentials in his sketches and water colours. I allude to the delicate symphony of juxtaposed gradations, which his eye discovered at once, but for which at the same moment his reason spontaneously demanded the logical support of composition, of plan and of architecture.

There was nothing less artificial, let us note, than this effort towards a just combination of style and sensibility. That which others have sought, and sometimes found, in the imitation of the old masters, the discipline that he himself in his earlier works sought from the great artists of his time or of the past, he discovered finally in himself. And this is the essential characteristic of Cézanne. His spiritual conformation, his *genius*, did not allow him to profit directly from the old masters: he finds himself in a situation towards them similar to that which he occupied towards his contemporaries. His originality grows in his contact with those whom he imitates or is impressed by; thence comes his persistent *gaucherie*, his happy *naïveté*, and thence also the incredible clumsiness into which his sincerity forced him. For him it is not a question of imposing style upon a study as, after all, Puvis de Chavannes did. He is so naturally a painter, so spontaneously classic. If I were to venture a comparison with another art, I should say that there is the same relation between Cézanne and Veronese as between Mallarmé of the 'Herodiade' and Racine of the 'Berenice'. With the same elements – new or at all events refreshed, without anything borrowed from the past, except the necessary forms (on the one hand the mould of the Alexandrine and of tragedy, on the other the traditional conception of the composed picture) – they find, both poet and painter, the language of the Masters. Both observed the same scrupulous conformity to the

necessities of their art; both refused to overstep its limits. Just as the writer determined
to owe the whole expression of his poem to what is, except for idea and subject, the
pure domain of literature – sonority of words, rhythm of phrase, elasticity of syntax –
the painter has been a painter before everything. Painting oscillates perpetually be-
tween invention and imitation: sometimes it copies and sometimes it imagines. These
are its variations. But whether it reproduces objective nature or translates more
specifically the artist's emotion, it is bound to be an art of concrete beauty, and our
senses must discover in the work of art itself – abstraction made of the subject
represented – an immediate satisfaction, a pure aesthetic pleasure. The painting of
Cézanne is literally the essential art, the definition of which is so refractory to criticism,
the realization of which seems impossible. It imitates objects without any exactitude
and without any accessory interest of sentiment or thought. When he imagines a sketch,
he assembles colours and forms without any literary preoccupation; his aim is nearer
to that of a Persian carpet weaver than of a Delacroix, transforming into coloured
harmony, but with dramatic or lyric intention, a scene of the Bible or of Shakespeare.
A negative effort, if you will, but one which declares an unheard of instinct for
painting.

He is the man who paints. Renoir said to me one day: 'How on earth does he do it?
He cannot put two touches of colour on to a canvas without its being already an
achievement.'

It is of little moment what the pretext is for this sampling of colour: nudes improb-
ably grouped in a non-existent landscape, apples in a plate placed awry upon
some commonplace material – there is always a beautiful line, a beautiful balance,
a sumptuous sequence of resounding harmonies. The gift of freshness, the sponta-
neity and novelty of his discoveries, add still more to the interest of his slightest
sketches.

'He is,' said Sérusier, 'the pure painter. His style is a pure style; his poetry is a
painter's poetry. The purpose, even the concept of the object represented, disappears
before the charm of his coloured forms. Of an apple by some commonplace painter one
says: I should like to eat it. Of an apple by Cézanne one says: How beautiful! One would
not peel it; one would like to copy it. It is in that that the spiritual power of Cézanne
consists. I purposely do not say idealism, because the ideal apple would be the one that
stimulated most the mucous membrane, and Cézanne's apple speaks to the spirit by
means of the eyes.'

'One thing must be noted,' Sérusier continues: 'that is the absence of subject. In
his first manner the subject was sometimes childish: after his evolution the subject
disappears, there is only the *motive*.' (It is the word that Cézanne was in the habit of
using.)

That is surely an important lesson. Have we not confused all the methods of art –
mixed together music, literature, painting? In this, too, Cézanne is in reaction. He is a
simple artisan, a primitive who returns to the sources of his art, respects its first
postulates and necessities, limits himself by its essential elements, by what constitutes
exclusively the art of painting. He determines to ignore everything else, both equivocal
refinements and deceptive methods. In front of the *motive* he rejects everything that
might distract him from painting, might compromise his *petite sensation* as he used to
say, making use of the phraseology of the aesthetic philosophy of his youth: he avoids at
once deceptive representation and literature.

II

The preceding reflections allow us to explain in what way Cézanne is related to Symbolism. Synthetism, which becomes, in contact with poetry, Symbolism, was not in its origin a mystic or idealist movement. It was inaugurated by landscape-painters, by painters of still-life, not at all by painters of the soul. Nevertheless it implied the belief in a correspondence between external forms and subjective states. Instead of evoking our moods by means of the subject represented, it was the work of art itself which was to transmit the initial sensation and perpetuate its emotions. Every work of art is a transposition, an emotional equivalent, a caricature of a sensation received, or, more generally, of a psychological fact.

'I wished to copy nature,' said Cézanne, 'I could not. But I was satisfied when I had discovered that the sun, for instance, could not be reproduced, but that it must be represented by something else . . . by colour.' There is the definition of Symbolism such as we understood it about 1890. The older artists of that day, Gauguin above all, had a boundless admiration for Cézanne. I must add that they had at the same time the greatest esteem for Odilon Redon. Odilon Redon also had searched outside of the reproduction of nature and of sensation for the plastic equivalents of his emotions and his dreams. He, too, tried to remain a *painter*, exclusively a painter, while he was translating the radiance and gloom of his imagination. [. . .]

It is a touching spectacle that a canvas of Cézanne presents; generally unfinished, scraped with a palette-knife, scored over with pentimenti in turpentine, many times repainted, with an *impasto* that approaches actual relief. In all this evidence of labour, one catches sight of the artist in his struggle for style and his passion for nature; of his acquiescence in certain classic formulæ and the revolt of an original sensibility; one sees reason at odds with inexperience, the need for harmony conflicting with the fever of original expression. Never does he subordinate his efforts to his technical means; 'for the desires of the flesh,' says St Paul, 'are contrary to those of the spirit, and those of the spirit are contrary to those of the flesh, they are opposed one to another in such wise that ye do not that which ye would.' It is the eternal struggle of reason with sensibility which makes the saint and the genius.

Let us admit that it gives rise sometimes, with Cézanne, to chaotic results. We have unearthed a classic spontaneity in his very sensations, but the realization is not reached without lapses. Constrained already by his need for synthesis to adopt disconcerting simplifications, he deforms his design still further by the necessity for expression and by his scrupulous sincerity. It is herein that we find the motives for the *gaucherie* with which Cézanne is so often reproached, and herein lies the explanation of that practice of naïveté and ungainliness common to his disciples and imitators. [. . .]

What astonishes us most in Cézanne's work is certainly his research for form, or, to be exact, for deformation. It is there that one discovers the most hesitation, the most *pentimenti* on the artist's part. The large picture of the Baigneuses, left unfinished in the studio at Aix, is from this point of view typical. Taken up again, numberless times during many years, it has varied but little in general appearance and colour, and even the disposition of the brush-strokes remains almost permanent. On the other hand the dimensions of the figures were often readjusted; sometimes they were life-size, some-times they were contracted to half; the arms, the torsos, the legs were enlarged and

diminished in unimaginable proportions. It is just there that lies the variable element in his work; his sentiment for form allowed neither of silhouette nor of fixed proportions. [...]

On the walls of Jas de Bouffan, covered up now with hangings, he has left improvisations, studies painted as the inspiration came, and which seem carried through at a sitting. They make one think, in spite of their fine pictorial quality, of the fanfaronnades of Claude in Zola's 'L'Œuvre', and of his declamations upon 'temperament'. The models of his choice at this period are engravings after the Spanish and Italian artists of the seventeenth century. When I asked him what had led him from this vehemence of execution to the patient technique of the separate brush-stroke, he replied, 'It is because I cannot render my sensation at once; hence I put on colour again, *I put it on as best I can.* But when I begin I endeavour always to paint with a full *impasto* like Manet, *giving the form with the brush.*'

'There is no such thing as line,' he said, 'no such thing as modelling, there are only contrasts. When colour attains its richness form attains its plenitude.'

Thus, in his essentially concrete perception of objects, form is not separated from colour; they condition one another, they are indissolubly united. And in consequence in his execution he wishes to realize them as he sees them, by a single brush-stroke. [...] All his faculty for abstraction – and we see how far the painter dominates the theorist – all his faculty for abstraction permits him to distinguish only among notable forms 'the sphere, the cone and the cylinder'. All forms are referred to those which he is alone capable of thinking. The multiplicity of his colour schemes varies them infinitely. But still he never reaches the conception of the circle, the triangle, the parallelogram; those are abstractions which his eye and brain refuse to admit. *Forms* are for him *volumes.*

Hence all objects were bound to tell for him according to their relief, and to be situated according to planes at different distances from the spectator within the supposed depth of the picture. A new antinomy, this, which threatens to render highly accidental 'that plane surface covered with colours arranged in a determined order'. Colorist before everything, as he was, Cézanne resolves this antinomy by chromatism – the transposition, that is, of values of black and white into values of colour.

'I want,' he told me, following the passage from light to shade on his closed fist – 'I want to do with colour what they do in black and white with the stump.' He replaces light by colour. This shadow is a colour, this light, this half-tone are colours. The white of this table-cloth is a blue, a green, a rose; they mingle in the shadows with the surrounding local tints; but the crudity in the light may be harmoniously translated by dissonant blue, green and rose. He substitutes, that is, contrasts of tint for contrasts of tone. He disentangles thus what he used to call 'the confusion of sensations'. In all this conversation, of which I here report scraps, he never once mentioned the word values. His system assuredly excludes relations of values in the sense accepted in the schools.

Volume finds, then, its expression in Cézanne in a gamut of tints, a series of touches; these touches follow one another by contrast or analogy according as the form is interrupted or continuous. This was what he was fond of calling *modulating* instead of modelling. We know the result of this system, at once shimmering and forcible; I will not attempt to describe the richness of harmony and the gaiety of illumination of his pictures. [...]

* * *

He is at once the climax of the classic tradition and the result of the great crisis of liberty and illumination which has rejuvenated modern art. He is the Poussin of Impressionism. He has the fine perception of a Parisian, and he is splendid and exuberant like an Italian decorator. He is orderly as a Frenchman and feverish as a Spaniard. He is a Chardin of the decadence and at times he surpasses Chardin. There is something of El Greco in him and often the healthfulness of Veronese. But such as he is he is so naturally, and all the scruples of his will, all the assiduity of his effort have only aided and exalted his natural gifts.

[...] The two operations, the *Aspect* and *Prospect*, as Poussin says, are no longer separate with Cézanne. To organize one's sensations was a discipline of the seventeenth century; it is the preconceived limitation of the artist's receptivity. But the true artist is like the true *savant*, 'a child-like and serious nature'. He accomplishes this miracle – to preserve amidst his efforts and his scruples all his freshness and naïveté.

9 Maurice Denis (1870–1943) 'From Gauguin and van Gogh to Neo-Classicism'

Denis here aims to reassert the importance of the Symbolist movement of the 1890s and to establish a revived classicism as its proper successor. His essay thus provides a bridge between the anti-naturalist tendencies of Symbolism and the 'call to order' of the post-war years. Originally published in *L'Occident*, Paris, May 1909; reprinted in Denis, *Théories 1890–1910*, Paris, 1912, pp. 113–23, from which the present version is translated.

The great hurricane that renewed French art around 1890 originated in the shop of Père Tanguy, colour-merchant, rue Clauzel, and in the Gloanec Inn at Pont-Aven. Gauguin gathered together at Pont-Aven a number of disciples: Chamaillard, Séguin, Filiger, Sérusier, the Dutchman de Hahn. This formed the 'weighty school of funda-mentals, in the midst of large pitchers of cider'. At Tanguy's – he was a former member of the Commune, a gentle anarchistic dreamer – there were spread out for the edification of the young, the revolutionary productions of van Gogh, Gauguin, Emile Bernard and their emulators. They hung in disarray next to canvases of the uncon-tested master, the initiator of the new movement, Paul Cézanne.

Bernard, van Gogh, Anquetin, Toulouse-Lautrec were the rebels of the Cormon studio: we were just ourselves. Bonnard, Ibels, Ranson, Denis, those around Sérusier, were the rebels of the Julien studio. Sympathetic to everything that seemed new and subversive, we were drawn to those who wiped the slate clean of both academic teaching, and of romantic or photographic naturalism, which had been universally asserted to be the only theory worth taking seriously in a scientific and democratic epoch. [...]

Those who witnessed the 1890 movement can no longer be shocked by anything; the most ludicrous and incomprehensible efforts of those who are now called the 'Fauves' can only stir memories of the extravagances of our generation. To know what excite-ment is, the vertigo of the unexpected, it is necessary to have seen the Volpini café during the exhibition of 1889. Tucked in a corner away from the Great Fair, far from the official art, and the masterpieces assembled for retrospectives, the first works by

Gauguin, Bernard, Anquetin, etc. hung quite pathetically, brought together for the first time. [...]

At this time, the critics reproached us for wanting to babble like children. Actually, we did return to childhood, we played the fool, and that was without doubt the most intelligent thing to do. Our art was an art of savages, of primitives. The movement of 1890 proceeded simultaneously from a state of extreme decadence and from the ferment of renewal. It was the moment when the diver touches bottom and resurfaces.

Without doubt, the hurricane of 1890 had been long prepared. These artists whose appearance caused a scandal, were the products of their time and place; it would be unjust to isolate them from their elders the Impressionists; in particular, it seems that the influence of Camille Pissarro on them was considerable. Moreover, they could not be reproached for having misunderstood their immediate precursors; and they showed from the outset the greatest esteem for those who launched them on their way; not only Camille Pissarro and Cézanne, and Degas, and Odilon Redon, but also Puvis de Chavannes whose official endorsement could have displeased their youthful intransigence.

It was therefore the necessary culmination – action and reaction together – of the great Impressionist movement. Everything has been said on this subject: the absence of any rule, the uselessness of academic teaching, the triumph of naturalism, the influence of Japan, all determined the joyous flourishing of an art apparently freed of all constraint. New motifs, the sun, and artificial lighting and all the vividness of modern life were allowed into the domain of art. Literature mixed with the vulgarities of Realism to put an end to the refined touches of Symbolism; the 'slice of life' was served ungarnished; at the same time the aristocratic love of the choice word, of the unadulterated state of the soul and of obscurity in poetry, provoked the lyricism of the young writers. That which we demanded of Cézanne, Gauguin and van Gogh, they found in the works of Verlaine, Mallarmé and Laforgue: in a manifesto article in the *Revue Encyclopédique* Albert Aurier wrote: 'Everywhere the right to dream is demanded, the right to fields of azure, the right to fly to the stars of absolute truth. The myopic copying of anecdotes from society, the stupid imitation of nature's blemishes, dull observation, trompe-l'oeil, the glory of being as true, as banally exact, as the photograph no longer satisfies any painter, any sculptor worthy of this name.' Musicians, less nihilistic than painters, but like them preoccupied with more individual liberty and more expressiveness, submitted at once to the influence of Wagnerian romanticism, of Russian picturesqueness, and of the pure music which was revealed to them by César Franck, Bach and the contrapuntilists of the sixteenth century.

Everything was in ferment. But finally it must be admitted that in the plastic arts, the idea of art as at first just restricted to the idea of the copy, relied on nothing more than Naturalist prejudice in both temperament and individual sensation. Critics said that that was how they saw things. We heightened the disgust with conventions, without any other goal than to destroy them: the right to do anything did not know any restriction. The excess of this anarchy brought about as a reaction the pursuit of the systematic and the taste for theory. [...]

Van Gogh and Gauguin resumed with vigour this epoch of confusion and of renaissance. Next to the scientific impressionism of Seurat, they represented barbarity, revolution and fever – and finally docility. Their efforts at the beginning escaped every

classification: and their theories were hard to differentiate from the older Impression-ism. For them, as for their predecessors, art was the rendering of sensation, it was the exaltation of individual sensibility. All the elements of excess and disorder derived from Impressionism exasperated them at first; it was only little by little that they became aware of their innovative role, and they perceived that their synthetism or their symbolism is precisely the antithesis of Impressionism.

Their work conquered its domain of influence by its brutal and paradoxical nature. We see the proof in the Northern countries, Russia, Scandinavia, Finland, where their influence preceded – and prepared – that of Cézanne. Without the destructive and contradictory anarchism of Gauguin and van Gogh, the example of Cézanne, with everything that it brings with it from tradition, measure and order, would not have been understood. The revolutionary elements of their works were the vehicle for the constructive elements. However, for the attentive observer, it has been easy to distin-guish since 1890, in the excessiveness of the works and the paradoxes of the theories, a classical reaction.

It suffices to remember that we have demanded since this distant era the title of 'Neo-Traditionalists'. But that is unimportant compared to what has happened since. The important fact is that since then an evolution has occurred towards order, and even amongst those who participated in the movement of 1890, or those who claimed to be attached to it. [...] In the midst of its elders, youth has become resolutely classical. One knows of the infatuation of the new generation for the seventeenth century, for Italy, for Ingres: Versailles is in fashion, Poussin applied to the nude; Bach always brings in a full house; Romanticism is ridiculed. In literature, in politics, young people have a passion for order. The return to tradition and to discipline is as unanimous as was the cult of the self and the spirit of revolt in our generation. In support of this, I note the fact that in the vocabularly of avant-garde critics, the word 'classical' is the supreme compliment, and consequently serves to designate the most 'advanced' trends. Hence-forth Impressionism will be considered an era of 'ignorance and frenzy' to which stands opposed 'a more noble art, more measured, more ordered, more cultivated' (consider the work of Braque).

Truly, the moment has come where it is necessary to choose, as Barrès has said, between traditionalism and the intellectual point of view. Trade unionists, or mon-archists of the Action Française, have equally come down to earth from their liberal or libertine clouds, and endeavour to remain within the logic of facts, to reason only with realities; but the monarchist theory, total nationalism, has amongst other advantages, that of keeping alive the successful experiences of the past. We, the other painters, have developed towards classicism because we have had the joy of posing the double aesthetic and psychological problem of art. We have substituted for the idea of 'nature viewed through a temperament' [Zola], the theory of equivalences or of the symbol. We affirm that the emotions or states of the soul provoked by some spectacle, create in the artistic imagination signs or plastic equivalents capable of reproducing these emotions or states of the soul without the need to create a *copy* of the initial spectacle; that each state of our sensibility must correspond to an objective harmony capable of being thus translated.

Art is no longer a purely visual sensation that we record, a photograph of nature, as sophisticated as possible. On the contrary, it is a creation of our spirit which nature provokes. Instead of 'working from vision, we search for the mysterious centre of

thought', as Gauguin said. The imagination becomes once again, as in Baudelaire, the queen of the faculties. Thus, we liberate our sensibility. Art, rather than a *copy*, becomes the *subjective transformation* of nature.

Objectively speaking, decorative, aesthetic and rational composition, which the Impressionists never considered because it ran contrary to their taste for improvisation, has become the counterpart, the necessary corrective to the theory of equivalents. In the cause of expressivity, this authorized all transpositions, even caricatures, any excesses of aspect: *objective transformation* has obliged each artist to transpose everything into beauty. In summary, the expressive synthesis, the symbol of a sensation has become an eloquent transcription of it, and simultaneously an object composed for visual pleasure.

Profoundly linked in Cézanne, these two trends developed to differing extents in van Gogh, Gauguin, Bernard, all of the old Synthetists. One can come to terms with their thinking, can basically summarize the essential element of their theories, as composed of two kinds of formal change. While decorative changes of form are the most common of Gauguin's preoccupations, it is by contrast subjective changes in form which give van Gogh's painting its character and lyricism. In the case of the former, one discovers beneath rustic or exotic surfaces, a rigorous logic and the artifices of composition, which, if one dare say it, preserves a little of the Italian rhetoric. The latter, by way of contrast, is an exasperated Romantic, who comes to us from the land of Rembrandt. The picturesque and the pathetic affect him more than plastic beauty and organization. Thus they represent an exceptional moment of the double movement, both Classical and Romantic. Let us look in these two painters of our youth for some concrete images to illustrate this abstract and perhaps obscure thesis.

In the spirited and abrupt style of van Gogh, in his search for radiance, and his violence of tone, I find everything that seduces the young *Tachistes*, and the reason why they content themselves with patches or streaks of pure colour. They admire his aggressive attitude in the face of nature, his abnormal, heightened, but truly lyrical vision of things; his impulse of conscience to say everything that he feels; the insistence with which he affirms the most capricious movements of his sensibility – and by what rudimentary means! – using a violent stroke, the bold relief of the thickening out of the paint. There is in his works an awkward way of attacking the canvas that the last of the Romantics took as a sign of genius; consider the heavy emphasis that Zola imposed on this type of painting in *l'Œuvre*. The pathetic and trivial influence of Naturalism had left its mark even on this mystic, this sophisticated man, this poet; I still see this in the new generation. The word temperament, with all its animalistic connotations, has retained its prestige. Van Gogh, finally, caused in the younger generation a reversion to Romanticism.

* * *

[...] Gauguin, who created so much disorder and incoherence in his life, did not tolerate any of this in his painting. He loved clarity, a sign of intelligence. The reconstruction of art, which Cézanne began with the materials of Impressionism, was continued by Gauguin with less sensibility and breadth, but with more theoretical rigour. He made the thoughts of Cézanne more explicit. In reimmersing them in the sources of art, in investigating the primary principles which he called the *eternal laws of the beautiful*, he gave them a greater force. 'Barbarity,' he wrote, 'is for me a return to

youth ... I have retreated far, further than the horses of the Parthenon ... right back to the dada of my childhood, the beloved wooden horse.'

We are indebted to the barbarians, to the primitives of 1890, for having highlighted some essential truths. We can no longer *reproduce* nature and life by more or less improvised trompe-l'oeil, but on the contrary, must reproduce our emotions and our dreams by *representing* them, using forms and harmonious colours. This is, I insist, a new position – at least for our times – on the problem of the nature of art. This concept is a fertile one.

I repeat, this concept is the fundamental one in art of all ages; there is no real art which is not Symbolist. [...]

* * *

If the youth of today manages to reject the negative systems which have disorganized art and aesthetics – and, simultaneously, French society and intelligence – they will find the truly contemporary elements of a classical restoration in our Synthetist or Symbolist views, in the rational interpretation of Cézanne and Gauguin. The theories of 1890 will have done more than just give a paradoxical twist to eternal verities. They will have made a new order rise up from anarchy. Our simple methods had at least the advantage of adapting themselves to new elements introduced by Impressionism, and of using them. Born of an attitude of decadence, they do not offer us an irresistible idea from the distant past, but organize the fresh resources of modern art, *our realities*, in such a way as to allow us to reconcile the example of the masters and the demands of our sensibility.

The history of art is nothing other than a perpetual beginning. The same principles of colour which make up the richness of a Gauguin or a van Gogh were applied by Tintoretto and Titian. The beauty of the curves, the style of the lines of a Degas or a Puvis de Chavannes can be found on the side of Greek vases, and of primitive frescoes.

We are aware of only a small number of positive truths; at least we can verify in the past glimpses of laws, certainties acquired by our own unfettered experience. Thus the idea of tradition, at first shapeless and rudimentary, has developed and enriched itself.

* * *

As the language of man, symbol of ideas, art can only be idealistic. Any confusion on this point has, hopefully, been definitively dispelled. We have once more given pride of place to intelligence, and highest of all, imagination, in the work of the artist. Whatever the impetus of a work towards nature, one must not forget that art does not have superior value unless it corresponds to the noblest and the most mysterious character-istics of the human soul. There is no example of a great artist who was not also a great poet, nor of a great work whose subject was purely pictorial. The most painterly of painters, Rembrandt, Rubens or Corot, were never content with being superb techni-cians: the works which immortalized them are, properly speaking, religious, no matter what their literary content may be.

The productions of modern art do not extend far beyond a small circle of initiates; these are small coteries which benefit from it. Every type of sensibility, every artist, incomplete though he may be, possesses a set of admirers, his public. Now the work of art must reach and move all people. The classical masterpieces have a character of universality, of the absolute, either because they express and epitomize an entire civilization, or because they give rise to a new culture. These masterpieces depict an order of the universe, a divine order, that the human intelligence can manifest in a way

that is fundamentally the same, though presented via a variety of individual formulations. These formulations only become classical to the extent that they express this order with greater eloquence and clarity. [...]

In this essay we have not tried to explain the enigma of genius. We circle around this miracle only to define various approaches and differing aspects. The evolution from Symbolism to Classicism that we have tried to make clear and to explain, does not diminish artistic spontaneity. If we hope that artistic freedom knows definite limits and that its sensibility submits itself to the judgment of reason, we also hope that these limits will increase its virtues, and that genius restrained by proper rules will acquire greater concentration, depth and force. It is true that we are tired of the individualist spirit, which rejects tradition, teaching and discipline and considers the artist as a kind of demi-god, whose caprice defies rules. It is true that this falsehood, initially our own, has become intolerable to us. However, we still maintain, from our Symbolist point of view, that the work of art is a general translation of individual emotions. The new order that we have discerned, born out of the experiences and the theories of 1890, born from anarchy itself, is based on a subordination of the faculties one to another. At the bottom level one always finds sensation; it proceeds from particular sensibility to general reason. One would not know how to look for the subject of a work of art except in individual perception, in the spontaneous perception of a relation, of an equivalence between certain states of the soul and certain plastic signs which they necessarily translate. The novelty consists in thinking that this type of symbolism, far from being incompatible with the classical method, can renew the effectiveness of that method and draw admirable developments from it. Not the least advantage of our system is the fact that the basis for a very objective art, a very general and plastic language, even a classical art, is the most subjective and the most subtle aspect of the human soul, the most mysterious spirit of our inner life.

10 Julius Meier-Graefe (1867–1935) 'The Mediums of Art, Past and Present'

Born in the Austro-Hungarian empire, Meier-Graefe studied in Germany, France and Switzerland. In 1895 he moved to Paris, where he became an advocate for Art Nouveau. He returned to Berlin in 1904. The present text is taken from the opening chapter of *Modern Art: Being a Contribution to a New System of Aesthetics*, originally published in German as *Entwickelungsgeschichte der modernen Kunst*, 1904. Meier-Graefe aimed to distinguish a specifically artistic element from social and material factors in the development of culture. His work helped decide the terms of reference in which the historical development of modern art was conceived by subsequent writers. We have used the translation by F. Simmonds and G. Chrystal, London and New York, 1908.

I

Our collective artistic culture was bound to suffer, when the collective forces of art were concentrated in a special domain, that of pictures and statues. The fact is not minimized by the consideration, that this development was the work of a glorious

history, originating in the most brilliant phases of modern culture. Nor can it be denied that the most splendid epochs of humanity achieved their great results without the omnipotence of pictures. [. . .]

* * *

In these days, the pure work of art has been brought into immediate contact with every-day life; an attempt has been made to transform it utterly, to make it the medium of the æsthetic aspirations of the house, whereas this function belongs properly to the house itself and the utilitarian objects in it. We have tried to popularize the highest expression of art, something only significant when applied to the loftiest purposes, something, the enjoyment of which without a certain solemnity is inconceivable, or, at least, only to be attained in moments of peculiar detachment. We have succeeded merely in vulgarizing it.

This is the source of the great error that retards our artistic culture. We revolve in vicious circles round the abstract work of art.

The painted or carved image is in its nature immovable. Not only because it was originally composed for a given space, but because the world of emotion to which it belongs lies wholly apart. This may be so powerful, that its association with the things of daily life cannot be effected without serious damage either to the one or the other.

The association of works of art with religious worship was therefore the most natural association possible. A heavenly illumination, itself possessed of all the attributes of divinity, art gave impetus to the soul in its aspirations towards the mystic, its flight from the sufferings of daily life, and offered the best medium possible for that materialization of the divine idea, which the primitive man demands in religion. The ancient Greek worship, with its natural, purely sensuous conceptions, was the happiest basis for the artist, for in Greece religion and art were one thing: beauty. The god was the ideal of beauty.

When the temple became a church, art lost its original purity, and became the handmaid of the hierarchy. But religion was so deeply implanted in the souls of the faithful, that both to executant and recipient the service never lost the mystic atmosphere, the common bond, and all hostile antagonism was avoided. It was the Reformation that first drove the image from the temple, and gave to worship a form, the austerity of which excluded any sensuous enjoyment.

This was one of the many contributory impulses that brought about the confusion of aesthetics. Art was so closely bound up with religion, that it almost seemed as if the enlightenment that shattered the one, must be dangerous to the other. The mysticism of art and that of religion had formerly mingled their currents. As a fact, the former was no less obscure than the latter – who can say even now, what the essence of art is? But the pious and sometimes beautiful fable of religion had to perish, to make way, not for Luther's compromise, but for something radically opposite, science, by which the raison d'être of art remained unaffected. Indeed, as science could not satisfy the mystic yearnings of the soul, the sphere of art was, if possible, extended, though it could no longer be restricted to conventional forms.

The emancipation of man from the dogmas of the church was an advance. In the domain of art, where it destroyed the fixed convention as to subject, it might have become beneficent. But as a fact, it entailed retrogression. Painting was not yet strong enough to stand alone, or perhaps it was already enervated; instead, now that it was free from all objective constraint, of rising to the heights of pure art, sustained by its own

convention alone, it gradually became vulgarized, and finally fell into perplexities from which it had been preserved in the early ages of culture.

A three-fold watchword inspired the political and social contests of the new age: Freedom, Truth, Equality. We think we have the first two; and our generation is warring for a verdict as to the third.

Art thought herself bound to take part in the contest. As on other battlefields, the three sections of the ideal were upheld simultaneously, and as in these again, the fight was sharpest and most decisive over the first two, Freedom and Truth.

Broadly speaking, the trilogy, taken absolutely, is Utopian, and even nonsensical; but in social matters, the ideal regulates itself in a rational manner. In art, where such was not the case, where the extravagance of the postulate was far in excess of its good sense, it worked most mischievously.

Art was to be free – but free from what? The innovators forgot, that freedom implies isolation. In her impulsive vehemence, art cast away the elements that made her indispensable to man. The vaster the wide ocean of unbounded aims before her, the more distant was the terra firma which had been her home. She lost her native land.

* * *

It was only in those earlier days, when proprietary rights were not associated with art, that the relation of the layman thereto approached the socialistic ideal. Art was for all, for it belonged to no one. It stood above individual greed, a highly communistic symbol in an age that in all else was far indeed from the socialism of our day. Now it has become the expression of our terrible class distinctions. It is only accessible to an aristocracy, whose domination is the more sinister, in that it is not based solely on rank and wealth, that is to say, on things by the division of which the ardent socialist hopes to re-establish the social equilibrium. There is nothing so unattainable, for the enjoyment of it presupposes an abnormal refinement of aesthetic perception, which has become as rare as genius itself. Nowadays, one must not only have a great deal of money to buy art, but one must be an exceptional creature, of peculiar gifts, to enjoy it. It exists only for the few, and these are far from being the most admirable or beneficent of mankind; they seem, indeed, to show all the characteristics of the degenerate. Loftiness of character, or of intelligence, are not essential to the comprehension of art. The greatest men of our age have notoriously known nothing about it, and what is more remarkable, artists themselves often understand it least of all. Artists have talked more nonsense about art than any other class of men. Modern artistic culture can scarcely be accounted an indispensable element of general culture any longer, for the simple reason that art has ceased to play a part in the general organism.

* * *

II

The incomprehensibility of painting and sculpture to the general public has been shrouded in a veil of pretentious exposition. The amount of talking and writing about art in our day exceeds that in all other epochs put together. The increase of sociability rising from increase of wealth made it necessary to invent suitable occupations for unproductive energies. Chatter about art became a highly popular form of such amusement; it requires no special preparation, no exertion, is independent of weather and seasons, and can be practised in drawing-rooms! Art has become like

caviare – everyone wants to have it, whether they like it or not. The immaterial elements of the former give a certain intellectual tone to the sport, which is lacking in a feast of caviare; it is therefore complacently opposed to such material enjoyments. [...]

Love of art, however, especially the kind of love that goes beyond platonic limits, becomes rarer as those who meddle with it multiply in every land. Purchase has become the touchstone of such affection; like marriage, it is a practical token of sentiment, and even to the artist, this evidence is generally more important than the impulse that inspired it.

It can hardly be otherwise now. If art is to be anything, it must not arouse merely that languid attention which people manifest when they politely approve something as 'very interesting.' It is not enough that it should inspire the pens of scribblers, and develop itself alone, and not others. In the form to which it is confined today – that of picture or statue, a marketable commodity – it could only exercise an influence by fulfilling the purpose of other marketable things: that of being purchased. But the popularization of art is rendered impossible by the extravagant prices commanded by recognized works of art and demanded for those that are not so recognized, by a frantic, absurd, and unhappily, thoroughly dishonest traffic. I can conceive of rich people who would refrain from the purchase of pictures out of sheer disgust at the trade, a desire to keep their hands clean. The purchasing amateur is a personality made up of the most obscure springs of action. The absolutely incalculable fluctuations in prices, the influence of fashion, nowhere so demented as in this connection, the desire to go on improving his collection, i.e., to bring it up to the fashionable standard of the moment, forces the collector to be always selling, to become the shamefaced dealer, who is, of course, the most shameless, and who introduces additional elements of disorder into a commerce already chaotic. The result is that there are, as a fact, no buyers, but only dealers, people who pile their pictures one above the other, deal exclusively, or almost exclusively, with each other, and have no connection with the real public. Statistics, showing how few are the hands to which the immense artistic wealth of the world is confined, would make a sensation. A great London dealer once told me that he had only three customers! Durand-Ruel, of Paris, has several times had certain famous Impressionist pictures in his possession at progressive prices, rising some 1000 per cent each time, and the purchasers have often been the same persons on several occasions.

Such conditions reduce the æsthetic usefulness of a work to a minimum. Pictures become securities, which can be kept locked up like papers. Even the individual, the owner, ceases to enjoy his possession. Nine-tenths of the most precious French pictures are kept for nine-tenths of the year in magnificent cases, to protect them from dust. Sales are effected as on the Bourse, and speculation plays an important part in the operations. The goods are scarcely seen, even at the sale. A typical, but by no means unique, example is afforded by the late Forbes collection. It consisted of I forget how many hundreds or thousands of pictures. To house them, the owner rented the upper storey of one of the largest London railway stations, vast storehouses, but all too circumscribed to allow of the hanging of the pictures. They stood in huge stacks against the walls, one behind the other: the Israels, Mauves, and Marises were to be counted by hundreds, the French masters of 1830 by dozens; there were exquisite examples of Millet, Corot, Daubigny, Courbet, &c., and Whistler. Although the stacks of pictures were held up by muscular servants, the enjoyment of these treasures was a

tremendously exhausting physical process. One walked between pictures; one felt capable of walking calmly over them! After five minutes in the musty atmosphere, goaded by the idiotic impulse to see as much as possible, and the irritating consciousness that it was impossible to grasp anything, every better instinct was stifled by an indifference that quenched all power of appreciation. The deathly calm one broke in upon, as one toiled sweating through these bare gigantic rooms where there was no space to turn, the whistling of the engines, the trembling of the floor as the trains ran in and out below, seemed to inspire a kind of strange fury, a silent longing to destroy the whole lot.

Who would be the loser if this were actually done? If anything could justify anarchism, it is the knowledge that the greatest artists toil in poverty, to enable a few dealers to grow rich after their deaths, and a few fanatics to hoard their works in warehouses. The most notorious vices are not so grotesquely irrational as this mania for hoarding, which, owing to its apparent innocuousness, has not yet been recognised as a malady. All the famous collectors of Paris, London, and America are more or less tainted with this disease. We enter their houses full of eager anticipation, and quit them with a sigh of relief, half suffocated by the pictures that cover every inch of wall-space, and wholly depressed, not by a feeling of envy, but by the thought that there are people who have voluntarily accepted the torture of spending their lives among all these things.

Even if a wiser economy should improve the conditions we have described, it will never be possible to induce a better appreciation of art by commercial means. Hence all the fine ideas of 'popular art' are doomed to remain mere dreams. It is materially impossible to produce pure works of art at prices that will bring them within the means of the masses. [...]

* * *

III

* * *

The dwelling-house of to-day has lost its formal relation to the age. Save for non-social, practical considerations, which express themselves in a certain comfort and in the employment of space to the best advantage, it shows a lack of cohesion with our lives. Contrary to the usage of former times, our sphere of action is now generally outside our houses. This action itself has changed, no less than its field; mental effort tends more and more to take the place of physical exertion. The men whose activity is most prolific in these days, that is, whose wills have the strongest influence upon production, use their limbs and muscles the least. The intellectual apparatus accordingly requires care and protection in its leisure.

The dwelling has become a place of recuperation, and this determines the character of the busy man's domicile.

As places of recuperation, our dwellings have, as a fact, become better adapted for artistic elements, and even for abstract works of art. We may for the moment set aside the dismal fact that the pure work of art is generally the only artistic thing in the house, and quite without relation to all the rest. Such conditions only make it the more essential, if man is not to renounce every loftier stimulus from without. But if the work in the house is to have any influence, in conditions so far removed from those of the earlier vehicles of art, it must be subordinated to these new conditions. It is not the

chief object that draws us to the place containing it, as in the case of a museum; we do not approach it with the devoutness of the soul athirst for mystic rapture, as formerly in a church. Comfort is the essential in this modern shrine, and a picture that disturbs our sense of well-being is clearly out of place in a house.

This sense of comfort is certainly not to be satisfied merely by artistic qualities. The very works that make the deepest impression upon us, are least adapted to domestic combination, because the sensuous value that might promote satisfaction, is present in them in forms unsuitable to our four walls or our hundred prepossessions. There are things one admires, and others one wishes to possess. That which decides between them is a whole world, and not a kind of hygiene, which teaches us to live with certain sensations, because they demand intellectual effort and sacrifice.

Art under such conditions ceases to be divine; she is no longer the enchantress who brings men to their knees before her, but rather a gentle little housewife, who surrounds us with tender attentions, and eagerly produces the sort of things that will distract tired people after a day's work.

Such a function is beneath the dignity of art. She could not accept it, if she was to remain what she had been in the past. It did not embrace her whole domain; it belongs by right to utilitarian art.

[...] If the uses of art change, art itself must change. If it cannot have the place it requires, it becomes meaningless. If it stands alone, it perishes. To restrict our artistic requirements to abstract painting and sculpture is a folly of the same order as that of the madman in the fable, who wished that everything he touched might turn to gold. Abstract art is a holiday delight. We are not a race of pleasure-seekers, and we are proud to say so. Our most rational idea is to divide, not wealth, but work, to see an era when there will be no drones, when every one will exert himself for the common good. In such a state the amateur will cease to exist.

IV

For what then do artists create, pending what is generally the posthumous consummation – that accumulation of their works described above?

Some for an unattainable object, every step towards which is marked by tears and blood, an ideal that can only be described in somewhat metaphysical rhetoric: the satisfaction of a conscience that has no relation to extrinsic things, of a supernal ambition, grandiose and dazzling in its conscious determination, in its consistent effort towards the elusive goal, amazing in the unconsciousness with which it achieves results that would seem only possible to the most strenuous toil. Creation for the sake of creation.

A far-seeing idealism sustains them, the hope that they will succeed in giving a new form of beauty. A blind optimism leads them, even when most neglected, to believe that they will be appreciated by some, that some will share the new joys they have discovered. And when the futility of such hopes is demonstrated, when they see their works passed over, or, worse still, bought by purchasers who have none of that intimate delight in their creations on which they had counted, they withdraw into themselves and do their greatest work.

Sometimes that which appears to them in their confident self-knowledge their greatest work, is recognized by the enlightened at last, and becomes an eternal

possession, a lasting element in after generations of artists, in whose works it lives in another form, completed by new achievement. It passes into the artistic heritage of the nation, and finally plays its part in national culture. Others fail; not that their self-knowledge is at fault, but that their talent or their intelligence falls short. Their numeric preponderance is so great, that they completely crowd out the few, and the limited demand of the public for pictures is supplied almost exclusively by them. I suppose that to every thousand painters of the one class, there is not more than one of the other. Imagine such a proportion in any other calling! The artist can mislead the public more easily than can a man of any other profession, for setting aside the affinity of the herd for all that is superficial, a sort of halo surrounds the painter; he profits by a number of institutions very favourable to mediocrity, which give a certain importance to the métier as such, and are readily turned to account by the adroit.

Foremost among these is the art-exhibition, an institution of a thoroughly bourgeois nature, due to the senseless immensity of the artistic output, and the consequent urgency of showing regularly what has been accomplished in the year. This institution may be considered the most important artistic medium of our age. [. . .]

Artists acquiesce in the system, because if they held aloof, their last means of expression would be denied them. They want, at least, to let their work be seen, and see it themselves, even among that of a thousand others, even for a few months, even under barbaric conditions. What becomes of it after the exhibition is indifferent to them. It is enough if the picture fulfils its purpose at the exhibition, attracts attention, is discussed by the critics, and, perhaps, even – this is the culminating distinction! – receives a medal.

To secure these results in competition with the thousands who are bent on the same ends, it is above all things necessary that a picture should have certain qualities that distinguish it from the rest. If the artist is bold enough, he makes it very large, or at all events very insistent, that it may strike the eye, even if badly hung.

It is obvious that under such conditions the purpose achieved by competition in other domains – that of promoting the selection of the best – can never be fulfilled. A variety of those base impulses, which always urge on the compact majority against the loftier individuality, play their part in the result. Rarely, indeed, has a genius been brought to light through these channels. The greater artists avoid these exchanges, and even the amateur does not frequent them, since quantity is not the only thing he craves.

The remnant of artistic sensibility that lingers in our age bids fair to be systematically crushed out by these exhibitions. If perchance any of the palatial barracks that house them should survive for posterity, they will be more damaging to us than any other relic. There will be persons who will go through these galleries in the spirit in which we visit ruined castles, and the rusty picture-hooks will be to them like gruesome instruments of torture.

Pictures once hung on these hooks . . .

This is the end of the history of pictures. We have, at least, the comfort of knowing that we can sink no lower. Once the symbol of the holiest, diffusing reverence in the church, and standing above mankind like the Divinity itself, the picture has become the diversion of an idle moment; the church is now a booth in a fair; the worshippers of old are frivolous chatterers.

11 Giorgio de Chirico (1888–1978) 'Mystery and Creation'

Although of an Italian family, de Chirico was Greek by birth and upbringing, with a conse-
quent familiarity with the classical heritage. He studied in Munich, where he was attracted to
the painting of Boecklin and Klinger and the philosophy of Schopenhauer and Nietzsche. In
Paris from 1911 to the outbreak of war he developed his 'Metaphysical painting': a self-
consciously enigmatic type of picture clearly inviting Freudian forms of interpretation. The
present text was written during this phase and before his return to Italy in 1915. It was first
published by André Breton in his *Surrealism and Painting*, Paris, 1928 (IVC5). The present
translation is taken from the *London Bulletin* (an organ of the Surrealist movement in
England), no. 6, October 1938, p. 14. (See also IIIA6.)

To become truly immortal a work of art must escape all human limits: logic and
common sense will only interfere. But once these barriers are broken it will enter the
regions of childhood vision and dream.

Profound statements must be drawn by the artist from the most secret recesses of his
being; there no murmuring torrent, no birdsong, no rustle of leaves can distract him.

What I hear is valueless; only what I see is living, and when I close my eyes my vision
is even more powerful.

It is most important that we should rid art of all that it has contained of *recognizable
material* to date, all familiar subject-matter, all traditional ideas, all popular symbols
must be banished forthwith. More important still, we must hold enormous faith
in ourselves: it is essential that the revelation we receive, the conception of an
image which embraces a certain thing, which has no sense in itself, which has no
subject, which means *absolutely nothing* from the logical point of view, I repeat, it is
essential that such a revelation or conception should speak so strongly in us, evoke such
agony or joy, that we feel compelled to paint, compelled by an impulse even more
urgent than the hungry desperation which drives a man to tearing at a piece of bread
like a savage beast.

I remember one vivid winter's day at Versailles. Silence and calm reigned supreme.
Everything gazed at me with mysterious, questioning eyes. And then I realized that
every corner of the palace, every column, every window possessed a spirit, an impene-
trable soul. I looked around at the marble heroes, motionless in the lucid air, beneath
the frozen rays of that winter sun which pours down on us *without love*, like perfect
song. A bird was warbling in a window cage. At that moment I grew aware of the
mystery which urges men to create certain strange forms. And the creation appeared
more extraordinary than the creators.

Perhaps the most amazing sensation passed on to us by prehistoric man is that of
presentiment. It will always continue. We might consider it as an eternal proof of the
irrationality of the universe. Original man must have wandered through a world full of
uncanny signs. He must have trembled at each step.

IB

Expression and the Primitive

1 August Endell (1871–1925) 'The Beauty of Form and Decorative Art'

Endell was an architect and designer associated with the Jugendstil tendency. In writings published in Munich at the begining of the century he advanced the idea of a new visual art, justified by analogy with music, which would be both abstract and expressive. The present essay was originally published in *Dekorative Kunst*, I, Munich, 1897–8, pp. 75–7, 119–25; the translation is taken from T. and C. Benton and D. Sharp (eds.), *Form and Function*, London, 1975.

In the ever more vehement yearning for a new style in architecture and applied art, and in the new, original and independent style of decoration, the dissonant warning voices of the cautious can be heard. From the dizzy heights of their experience, they smile down sympathetically upon the foolish exploits of their juniors and still remain ready to show to the general public the only path of truth. They teach us that there can be no new form, that all possibilities have been exhausted in the styles of the past, and that all art lies in an individually modified use of old forms. It even extends to selling the pitiful eclecticism of the last decades as the new style.

To those with understanding, this despondency is simply laughable. For they can clearly see, that we are not only at the beginning of a new stylistic phase, but at the same time on the threshold of the development of a completely new Art. An Art with forms which signify nothing, represent nothing and remind us of nothing, which arouse our souls as deeply and as strongly as music has always been able to do.

The barbarian finds our music distasteful; culture and education are necessary for its full appreciation. Appreciation of visual form is also something that must be acquired. We must learn to see it and really immerse ourselves in form. We must discover how to use our eyes. It may well be that man has for a long time delighted in form subconsciously. In the history of the fine arts this development can be clearly studied but it has not yet reached the point where it has finally taken root never to be forgotten. Painters have taught us a great deal, but their primary aim has always been colour, and where they were concerned with form, they mainly searched for the conceptual quality by the exact reproduction of the object, and not the aesthetic quality, which nature only rarely and by chance offers in the dimensions which the painter requires.

If we wish to understand and appreciate formal beauty we must learn to see in a detailed way. We must concentrate on the details, on the form of the root of a tree,

on the way in which a leaf is connected to its stalk, on the structure of the bark, on the lines made by the turbid spray on the shores of a lake. Also we must not just glance carelessly at the form. Our eye must trace, minutely, every curve, every twist, every thickening, every contraction, in short we must experience every nuance in the form. For there is only one point in our field of vision which we can see exactly, and it is only that which is clearly seen, which can hold some meaning for us. If we see in this way, an immensely rich new world is revealed to us, full of totally new experience. A thousand sensations are awakened within us. New feelings and shades of feeling, continual unexpected transformations. Nature seems to live and we begin to understand that there really are sorrowing trees and wicked treacherous branches, virginal grasses and terrible, gruesome flowers. Of course, not everything is going to affect us in this way, there are also things which are boring, meaningless and ineffectual, but the alert eye will everywhere observe forms of superb, soul-shattering magnificence.

This is the power of form upon the mind, a direct, immediate influence without any intermediary stage, by no means an anthropomorphic effect, but one of direct empathy. If we speak of a sorrowing tree, we do not at all think of the tree as a living being which sorrows, but mean only that it awakens the feeling of sorrow within us. Or when we say that the pine tree aspires upwards we do not animate the pine tree. It is just that the expression, of the act of aspiring, produces more easily in the mind of the listener a clearer image of verticality. We are employing nothing more than a verbal aid to make up for an inadequate vocabulary and to produce a living concept more quickly.

'How can the feelings aroused by form be explained?' is a question voiced most loudly by those who have never experienced them. I could answer, that there is no place for this here, that one can enjoy music without having to know why the chords can possibly move us so greatly. But in order to pacify those who doubt and to pave their way into the world of form, I should like to attempt to describe the emotive effect of the elements of form and their constituent parts, and also to at least outline the psychological explanation, so far as is possible without lengthy discussion ...

The straight line is not only mathematically but also aesthetically superior to all other lines. If we follow a straight line, for instance the vertical, with our eyes, this always retains the same direction in our field of vision. In contrast to this, a curved line, perhaps that of a round-headed archway for instance, alters its shape continually: first vertical, then slanting upwards, then horizontal, then slanting down and finally descending vertically. Whereas during the observation of curved lines there is always something new to grasp, the straight line always looks the same. As we look, our perception is quickened, and this is accelerated, the further the straight line extends, since every extra second of looking appears to add nothing to our perception. But since more familiar things are grasped more readily still, urging the eye on, the speed with which we perceive a straight line rises continuously.

Every quick motion gives us a certain feeling which we will call for the moment 'the feeling of speed'. The straight line awakes this feeling in us; it looks quick and the more so the longer it is. The width of the straight line, however – we are here speaking of real and not mathematical lines – has the effect of slowing it down. For a wide straight line requires more time for it to be appreciated than a narrow one, since it requires more

perception. The straight line therefore appears faster or slower depending on whether it is narrow or broad.

The effect of direction is of a completely different nature. The vertically descending straight line (i.e. the straight line which we follow from the top downwards) has a light and effortless effect. The horizontal has a quiet strength, and the vertically ascending line gives the effect of strong exertion. The slanting positions, slanting downwards or upwards, offer intermediary nuances, so that we have a continual table of characteristics stretching from a feeling of minimum effort to the strongest feeling of all. This emotional appeal is probably based on the fact that directing the eye upwards requires more effort than looking downwards. The reason for this is not quite clear. The mid-point of the eye is in front of the pivoting point, and probably of the centre of gravity. This in fact would mean that raising the eyeball requires effort but that lowering it does not. Besides this, certain assumptions about the processes in the retina enable us to give a second reason for the emotional effect which we are discussing. This however can only be developed in a more comprehensive description. [...]

Straightforwardness, sincerity, warmth, solemnity, profundity and sublimity all have a slow tempo in common, whereas frivolity, provocation, arrogance, harshness, violence and savagery are transmitted to us by speed and suddenness. In both cases, however, there is a step by step gradation of tension, effort, force, intensity or whatever one wishes to call it. An element of lightness and effortlessness is present in all simplicity and frivolity, whereas that which is savage or inspired calls forth within us extremes of effort. And just as with these extremes, there is a certain tempo for every emotion and a corresponding degree of exertion. We have attempted in the accompanying Table to organize the main nuances of emotion. In the horizontal rows, the effort rises from left to right whereas it is the tempo which rises in the vertical lines from bottom to top. The inner rectangle contains feelings of gaiety, those outside it are feelings of apathy. Apathy results in us from everything which is too weak or too strong, too slow or too fast for our endurance...

And because all sensations are only tempo and tension, form is able to awaken all shades of emotion within us. For we saw that the straight line always awoke within us not only these two kinds of sensation, but indeed every other possible variety. [...]

Quick								
	Malicious	Scornful	Haughty	Pathetic	Frigid	Pitiless	Cruel	Terrible
	Facetious	Frivolous	Provocative	Arrogant	Harsh	Violent	Savage	Hideous
	Coquettish	Chic	Ebullient	Daring	Reckless	Majestic	Awesome	Dreadful
T E M P O	Affected	Gracious	Elegant	Energetic	Vigorous	Firm	Brutal	Bestial
	Sweet	Dainty	Flexible	Fiery	Strong	Rugged	Powerful	Frightful
	Insipid	Delicate	Devoted	Generous	Distinguished	Mighty	Monstrous	Awful
	Vacuous	Straight-forward	Sincere	Warm	Solemn	Profound	Sublime	Gruesome
	Dim	Weak	Tired	Troubled	Sad	Melancholic	Sombre	Desperate

Slow Light ◄———————— EFFORT ————————► Heavy

[It is impossible, of course, to translate the German words precisely: this Table is intended to give the essence of Endell's idea.]

2 Albert Pinkham Ryder (1847–1917) 'Paragraphs from the Studio of a Recluse'

Ryder was born and brought up on the eastern seaboard of the United States, in the fishing and whaling community of New Bedford. At the outset of his career in the early 1870s, he had been influenced by the naturalism of the Barbizon painters and Corot. Between 1877 and 1896 Ryder made four trips to Europe, and in the 1880s his inclination to pastoral landscape began to be affected by the newly emergent ideas of Symbolism (see *Art in Theory 1815–1900*, Section VIC *passim*). He accordingly simplified the formal aspects of his pictures while intensifying their surface effects. During the 1880s he painted pictures based on literary themes culled from Shakespeare, Edgar Allen Poe, Wagner and others. But the works which had most impact on his successors, Jackson Pollock amongst them, were his evocative and heavily worked seascapes painted in the 1880s and '90s. The unorthodox media and paint application of these works have in many cases caused difficulties in conservation, due to colour instability and surface cracking. In the present text, while continuing to regard Nature as 'a teacher who never deceives', Ryder downplays imitation and emphasizes the importance of the artist's individual vision. Although Ryder painted less towards the end of his life, he was by then a prominent figure. Several of his works were included in the Armory Show of 1913, which is generally credited with introducing the modern movement to an American public. 'Paragraphs from the Studio of a Recluse' was originally published in the *Broadway Magazine*, XIV, New York, September 1905, pp. 10–11. Our text is taken from J. McCoubrey, *American Art 1700–1960*, Englewood Cliffs, NJ: Prentice-Hall, 1972, pp. 186–8.

The artist should fear to become the slave of detail. He should strive to express his thought and not the surface of it. What avails a storm cloud accurate in form and color if the storm is not therein? A daub of white will serve as a robe to Miranda if one feels the shrinking timidity of the young maiden as the heavens pour down upon her their vials of wrath.

It is the first vision that counts. The artist has only to remain true to his dream and it will possess his work in such a manner that it will resemble the work of no other man – for no two visions are alike, and those who reach the heights have all toiled up the steep mountains by a different route. To each has been revealed a different panorama.

Imitation is not inspiration, and inspiration only can give birth to a work of art. The least of a man's original emanation is better than the best of a borrowed thought. In pure perfection of technique, coloring and composition, the art that has already been achieved may be imitated, but never surpassed. Modern art must strike out from the old and assert its individual right to live through Twentieth Century impressionism and interpretation. The new is not revealed to those whose eyes are fastened in worship upon the old. The artist of today must work with his face turned toward the dawn, steadfastly believing that his dream will come true before the setting of the sun.

The canvas I began ten years ago I shall perhaps complete today or tomorrow. It has been ripening under the sunlight of the years that come and go. It is not that a canvas should be worked at. It is a wise artist who knows when to cry 'halt' in his composition, but it should be pondered over in his heart and worked out with prayer and fasting.

Art is long. The artist must buckle himself with infinite patience. His ears must be deaf to the clamor of his insistent friends who would quicken his pace. His eyes must

see naught but the vision beyond. He must await the season of fruitage without haste, without worldly ambitions, without vexation of spirit. An inspiration is no more than a seed that must be planted and nourished. It gives growth as it grows to the artist, only as he watches and waits with his highest effort.

* * *

Nature is a teacher who never deceives. When I grew weary with the futile struggle to imitate the canvases of the past, I went out into the fields, determined to serve nature as faithfully as I had served art. In my desire to be accurate I became lost in a maze of detail. Try as I would, my colors were not those of nature. My leaves were infinitely below the standard of a leaf, my finest strokes were coarse and crude. The old scene presented itself one day before my eyes framed in an opening between two trees. It stood out like a painted canvas – the deep blue of a midday sky – a solitary tree, brilliant with the green of early summer, a foundation of brown earth and gnarled roots. There was no detail to vex the eye. Three solid masses of form and color – sky, foliage and earth – the whole bathed in an atmosphere of golden luminosity. I threw my brushes aside; they were too small for the work in hand. I squeezed out big chunks of pure, moist color and taking my palette knife, I laid on blue, green, white and brown in great sweeping strokes. As I worked I saw that it was good and clean and strong. I saw nature springing into life upon my dead canvas. It was better than nature, for it was vibrating with the thrill of a new creation. Exultantly I painted until the sun sank below the horizon, then I raced around the fields like a colt let loose, and literally bellowed for joy.

3 André Derain (1880–1954) Letters to Vlaminck

The painters Derain and Vlaminck were both involved with the 'Fauve' tendency in France in the first decade of the century. In these letters, written in 1905 and 1909, Derain addresses the common ground of an interest in heightened pictorial colour, conceived as a strong form of response to naturalistic effects. Originally published in A. Derain, *Lettres à Vlaminck*, Paris, 1955, from which this translation has been made.

Estaque [undated, 1905]

[...] I sense that I am moving towards something better, where colourfulness counts for less than it did last year, so that more time can be spent on the issue of painting itself.

We are at a truly arduous stage of the problem. I am so lost that I ask myself in what words I can explain this to you ... If one does not attempt decorative art, all one can do is increasingly to purify the transposition of nature. We didn't do this on purpose, solely for the sake of colour. The design runs parallel. Many things are lacking in our idea of our art.

All in all, I can see no future except in composition, because in working from nature I am a slave to such stupid things that my emotions feel the repercussions of it. I don't see the future as corresponding to our trends; on the one hand, we are trying to disengage ourselves from objective things, and on the other hand, we retain them as both origin and final aim. No, honestly, if I stand back, I do not see in the least what I should do in order to be logical.

To compose visually, to amuse oneself in composing pictures like Denis, which are things one can see, is ultimately nothing but the transposition of a theatrical set. I think that the problem is rather to group forms in the light and to harmonize them simultaneously with the materials available. [...]

Collioure, 28 July 1905

I have so many things to tell you that I don't know which should be first. I am taking advantage of the rain to write to you, because usually there is a radiant sun which exasperates me by increasing the difficulties I have with synthesis, and also by complicating the acrobatics I attempt on the subject of light – so far as this concerns my experiments.

My trip has helped on two major points:

1 A new concept of light, which consists in the following: the negation of shadow. Here, the light is very strong, the shadows very clear. Shadows are a world of clarity and luminosity which is opposed to the sunlight: a world which one calls reflections.

Until now we have neglected both of these, and in the future, there will be a recovery of the expressive dimension of composition.

2 To know, in the company of Matisse, how to eradicate all division of tone. He continues; but I have completely abandoned it, and hardly use it any more. It's logical in a luminous and harmonious panel. But it damages things which draw their expressive power from deliberate dissonances.

It's ultimately a world which self-destructs when pushed to the absolute. I'm hurrying back to my work for the Independents, which is, all in all, the most logical from my point of view and which accords perfectly with my means of expression.

I would also like to resume my work in *oil*, because the events of each day only serve to give solid form to my first ideas. [...]

1909

[...] I'm piling up a lot of notes which may be of use to you. It's a shame that you can only spend eight days here. These landscape 'landscapes' are wonderful and would really please you. As for the atmosphere, it's fine, fine and colourful!...

Nevertheless, I'm going to do some landscapes, but against my will, almost. I don't feel the need for landscapes, nor for portraits, nor for still lifes. I've had wonderful feelings, whose grandeur can only be matched by a total possession of forms, which I use equally to create the grandeur. It's very difficult to possess a landscape.

But it's easier to create a harmonious shape, which in its very essence carries its own title, creating it through those affections one has felt in the physical world.

What Delacroix said is true: 'Nature is a dictionary; one draws words from it.' But more important than the dictionary is the will to write, the unity of our own thought; this is nothing other than the translation in spatial form of our virility, of our cowardice, of our sensitivity and of our intelligence. All of this, amalgamated, constitutes this personality which is realized in a shaped form.

Thus, for my painting for the *Independents*, must it have been better that it was? No, it would have spoken more absolutely in its intention, if it hadn't kept being so confident about the direction it was heading in.

I think it's a mistake to pretend we only have a good side; showing our faults and our incapacities is the best statement of absolute value to our neighbour.

So, while my canvas is not what is should have been, it's enough for another to understand that it is mine alone. It's already something!

... You are only good for decorative art! Good, that's perfectly all right. But my intelligence and my will create a reality, showing that they want to *exceed the gifts which have been given to me*.

Even if I don't create an absolute for myself, I at least give it my all, the equal to what I understand, and what I want.

It would take a long time to write to you about this. But this interests me beyond all measure. I want to talk to you about what interests me, the modern view of life. I think about it intensely here. It seems to me that everything converges on (or coincides with?) the search for happiness. Now, one can be disinterested, in an absolute way, living above and beyond joy or unhappiness; that does sometimes happen to great artistic emotions. But when you come back down to earth, you feel it all the more. To the maximum of joy corresponds the maximum of unhappiness.

Only one thing can save painting, and that's the joke. The joke shines through everything. The joke is all-powerful. With the joke one can pull through anything. Basically one is often very bored; but one manages to interest the spirit in the mask that one attaches to it. That's the most wonderful thing. But what ... to joke about something from frustration ... what happens afterwards is, you joke about your spirit itself.

From another point of view, greatness, great size is a stupid thing. What is a thing of great stature, of sentimental nobility, of great enthusiasm? If it wants to be thus, then it's stupid.

We are too uncertain of the progress of ideas in our era to desire a definite character. We have to submit to unconsciousness. As for the result, we cannot learn from our own lessons.

Similarly, it's ridiculous to want to adopt an attitude; it's necessary to follow life with kindness, drawing the maximum pleasure from that which surrounds you. When I say 'pleasure' I don't mean you have to be physically happy. I speak above all, of the assessment of this pleasure. [...]

4 Ernst Ludwig Kirchner (1880–1934) Programme of the Brücke

Die Brücke (the Bridge) was the name adopted by an avant-garde group founded in Dresden in 1905. The artists originally involved were Kirchner, K. Schmidt-Rottluff, E. Heckel and F. Bleyl. Together with the Munich-based Der Blaue Reiter (The Blue Rider), the Brücke represented the Expressionist tendency in German art. The programme was first published in 1906 as a woodcut broadsheet to accompany the Brücke exhibition at the Seifert factory, Dresden. The present text is translated from the woodcut.

With faith in progress and in a new generation of creators and spectators we call together all youth. As youth, we carry the future and want to create for ourselves freedom of life and of movement against the long-established older forces. Everyone who reproduces that which drives him to creation with directness and authenticity belongs to us.

5 Wilhelm Worringer (1881–1965) from *Abstraction and Empathy*

Subtitled 'A Contribution to the Psychology of Style', Worringer's essay was written as a doctoral thesis in 1906. It was published as *Abstraktion und Einfühlung* in Munich by Piper Verlag in 1908, and was to be continuously reprinted for over forty years. It was influential in countering what Worringer called the 'European-classical prejudice of our customary histor-ical conception and valuation of art'. It also furnished theoretical support for that widespread Modernist tendency in which enthusiasm for so-called primitive art was conjoined with interest in modern forms of abstraction. The present text is taken from the opening chapter, in the translation by Michael Bullock of the third – 1910 – edition, London and New York, 1953, pp. 3–5, 13–18, 23–5.

[...] Our investigations proceed from the presupposition that the work of art, as an autonomous organism, stands beside nature on equal terms and, in its deepest and innermost essence, devoid of any connection with it, in so far as by nature is under-stood the visible surface of things. Natural beauty is on no account to be regarded as a condition of the work of art, despite the fact that in the course of evolution it seems to have become a valuable element in the work of art, and to some extent indeed positively identical with it.

This presupposition includes within it the inference that the specific laws of art have, in principle, nothing to do with the aesthetics of natural beauty. It is therefore not a matter of, for example, analysing the conditions under which a landscape appears beautiful, but of an analysis of the conditions under which the representation of this landscape becomes a work of art.

Modern aesthetics, which has taken the decisive step from aesthetic objectivism to aesthetic subjectivism, i.e. which no longer takes the aesthetic as the starting-point of its investigations, but proceeds from the behaviour of the contemplating subject, culminates in a doctrine that may be characterised by the broad general name of the theory of empathy. This theory has been clearly and comprehensively formulated in the writings of Theodor Lipps. [...]

...the basic purpose of my essay is to show that this modern aesthetics, which proceeds from the concept of empathy, is inapplicable to wide tracts of art history. Its Archimedian point is situated at *one* pole of human artistic feeling alone. It will only assume the shape of a comprehensive aesthetic system when it has united with the lines that lead from the opposite pole.

We regard as this counter-pole an aesthetics which proceeds not from man's urge to empathy, but from his urge to abstraction. Just as the urge to empathy as a pre-assumption of aesthetic experience finds its gratification in the beauty of the organic, so the urge to abstraction finds its beauty in the life-denying inorganic, in the crystalline or, in general terms, in all abstract law and necessity.

We shall endeavour to cast light upon the antithetic relation of empathy and abstraction, by first characterizing the concept of empathy in a few broad strokes.

The simplest formula that expresses this kind of aesthetic experience runs: Aesthetic enjoyment is objectified self-enjoyment. To enjoy aesthetically means to enjoy myself in a sensuous object diverse from myself, to empathize myself into it. 'What I empathize into it is quite generally life. And life is energy, inner working, striving and accom-

plishing. In a word, life is activity. But activity is that in which I experience an expenditure of energy. By its nature, this activity is an activity of the will. It is endeavour or volition in motion.' [...]

The presupposition of the act of empathy is the general apperceptive activity. 'Every sensuous object, in so far as it exists for me, is always the product of two components, of that which is sensuously given and of my apperceptive activity.'

* * *

No psychology of the need for art – in the terms of our modern standpoint: of the need for style – has yet been written. It would be a history of the feeling about the world and, as such, would stand alongside the history of religion as its equal. By the feeling about the world I mean the psychic state in which, at any given time, mankind found itself in relation to the cosmos, in relation to the phenomena of the external world. This psychic state is disclosed in the quality of psychic needs, i.e. in the constitution of the absolute artistic volition, and bears outward fruit in the work of art, to be exact in the style of the latter, the specific nature of which is simply the specific nature of the psychic needs. Thus the various gradations of the feeling about the world can be gauged from the stylistic evolution of art, as well as from the theogony of the peoples.

Every style represented the maximum bestowal of happiness for the humanity that created it. This must become the supreme dogma of all objective consideration of the history of art. What appears from our standpoint the greatest distortion must have been at the time, for its creator, the highest beauty and the fulfilment of his artistic volition. Thus all valuations made from our standpoint, from the point of view of our modern aesthetics, which passes judgement exclusively in the sense of the Antique or the Renaissance, are from a higher standpoint absurdities and platitudes. [...]

The need for empathy can be looked upon as a presupposition of artistic volition only where this artistic volition inclines toward the truths of organic life, that is toward naturalism in the higher sense. The sensation of happiness that is released in us by the reproduction of organically beautiful vitality, what modern man designates beauty, is a gratification of that inner need for self-activation in which Lipps sees the presupposition of the process of empathy. In the forms of the work of art we enjoy ourselves. Aesthetic enjoyment is objectified self-enjoyment. The value of a line, of a form consists for us in the value of the life that it holds for us. It holds its beauty only through our own vital feeling, which, in some mysterious manner, we project into it.

Recollection of the lifeless form of a pyramid or of the suppression of life that is manifested, for instance, in Byzantine mosaics tells us at once that here the need for empathy, which for obvious reasons always tends toward the organic, cannot possibly have determined artistic volition. Indeed, the idea forces itself upon us that here we have an impulse directly opposed to the empathy impulse, which seeks to suppress precisely that in which the need for empathy finds its satisfaction.

This counter-pole to the need for empathy appears to us to be the urge to abstraction. [...]

The extent to which the urge to abstraction has determined artistic volition we can gather from actual works of art ... We shall then find that the artistic volition of savage peoples, in so far as they possess any at all, then the artistic volition of all primitive epochs of art and, finally, the artistic volition of certain culturally developed Oriental peoples, exhibit this abstract tendency. Thus the urge to abstraction stands at the beginning of every art and in the case of certain peoples at a high level of culture

remains the dominant tendency, whereas with the Greeks and other Occidental peoples, for example, it slowly recedes, making way for the urge to empathy. [...]

Now what are the psychic presuppositions for the urge to abstraction? We must seek them in these peoples' feeling about the world, in their psychic attitude toward the cosmos. Whereas the precondition for the urge to empathy is a happy pantheistic relationship of confidence between man and the phenomena of the external world, the urge to abstraction is the outcome of a great inner unrest inspired in man by the phenomena of the outside world; in a religious respect it corresponds to a strongly transcendental tinge to all notions. We might describe this state as an immense spiritual dread of space. [...]

Comparison with the physical dread of open places, a pathological condition to which certain people are prone, will perhaps better explain what we mean by this spiritual dread of space. In popular terms, this physical dread of open places may be explained as a residue from a normal phase of man's development, at which he was not yet able to trust entirely to visual impression as a means of becoming familiar with a space extended before him, but was still dependent upon the assurances of his sense of touch. As soon as man became a biped, and as such solely dependent upon his eyes, a slight feeling of insecurity was inevitably left behind. In the further course of his evolution, however, man freed himself from this primitive fear of extended space by habituation and intellectual reflection.

The situation is similar as regards the spiritual dread of space in relation to the extended, disconnected, bewildering world of phenomena. The rationalistic development of mankind pressed back this instinctive fear conditioned by man's feeling of being lost in the universe. The civilized peoples of the East, whose more profound world-instinct opposed development in a rationalistic direction and who saw in the world nothing but the shimmering veil of Maya, they alone remained conscious of the unfathomable entanglement of all the phenomena of life, and all the intellectual mastery of the world-picture could not deceive them as to this. Their spiritual dread of space, their instinct for the relativity of all that is, did not stand, as with primitive peoples, *before* cognition, but *above* cognition.

Tormented by the entangled inter-relationship and flux of the phenomena of the outer world, such peoples were dominated by an immense need for tranquillity. The happiness they sought from art did not consist in the possibility of projecting themselves into the things of the outer world, of enjoying themselves in them, but in the possibility of taking the individual thing of the external world out of its arbitrariness and seeming fortuitousness, of eternalizing it by approximation to abstract forms and, in this manner, of finding a point of tranquillity and a refuge from appearances. Their most powerful urge was, so to speak, to wrest the object of the external world out of its natural context, out of the unending flux of being, to purify it of all its dependence upon life, i.e. of everything about it that was arbitrary, to render it necessary and irrefragable, to approximate it to its *absolute* value. Where they were successful in this, they experienced that happiness and satisfaction which the beauty of organic-vital form affords *us*; indeed, they knew no other beauty, and therefore we may term it their beauty. [...]

If we accept this proposition...we are confronted by the following fact: The style most perfect in its regularity, the style of the highest abstraction, most strict in its exclusion of life, is peculiar to the peoples at their most primitive cultural level. A causal

connection must therefore exist between primitive culture and the highest, purest regular art-form. And the further proposition may be stated: The less mankind has succeeded, by virtue of its spiritual cognition, in entering into a relation of friendly confidence with the appearance of the outer world, the more forceful is the dynamic that leads to the striving after this highest abstract beauty.

Not that primitive man sought more urgently for regularity in nature, or experienced regularity in it more intensely; just the reverse: it is because he stands so lost and spiritually helpless amidst the things of the external world, because he experiences only obscurity and caprice in the inter-connection and flux of the phenomena of the external world, that the urge is so strong in him to divest the things of the external world of their caprice and obscurity in the world-picture and to impart to them a value of necessity and a value of regularity. To employ an audacious comparison: it is as though the instinct for the 'thing in itself' were most powerful in primitive man. Increasing spiritual mastery of the outside world and habituation to it mean a blunting and dimming of this instinct. Only after the human spirit has passed, in thousands of years of its evolution, along the whole course of rationalistic cognition, does the feeling for the 'thing in itself' re-awaken in it as the final resignation of knowledge. That which was previously instinct is now the ultimate product of cognition. Having slipped down from the pride of knowledge, man is now just as lost and helpless *vis-à-vis* the world-picture as primitive man, once he has recognized that 'this visible world in which we are is the work of Maya, brought forth by magic, a transitory and in itself unsubstantial semblance, comparable to the optical illusion and the dream, of which it is equally false and equally true to say that it is, as that it is not' (Schopenhauer, *Kritik der Kantischen Philosophie*).
* * *

In the urge to abstraction the intensity of the self-alienative impulse is . . . not characterized, as in the need for empathy, by an urge to alienate oneself from individual being, but as an urge to seek deliverance from the fortuitousness of humanity as a whole, from the seeming arbitrariness of organic existence in general, in the contemplation of something necessary and irrefragable. Life as such is felt to be a disturbance of aesthetic enjoyment. [. . .] Popular usage speaks with striking accuracy of 'losing oneself' in the contemplation of a work of art.

In this sense, therefore, it cannot appear over-bold to attribute all aesthetic enjoyment – and perhaps even every aspect of the human sensation of happiness – to the impulse of self-alienation as its most profound and ultimate essence. [. . .]

6 Henri Matisse (1869–1954) 'Notes of a Painter'

A major statement of Matisse's principles as a painter, composed soon after he was established as the leader of the 'Fauve' tendency in French painting. The artist took the opportunity to defend himself against criticism from the self-styled Sâr Péladan, a Symbolist painter and Rosicrucian (see *Art in Theory 1815–1900* VIC17). The 'Notes' provide an important reference for modern concepts of artistic expression. Originally published as 'Notes d'un peintre' in *La Grande Revue*, Paris, 25 December 1908. First English translation published in *Henri Matisse*, New York (Museum of Modern Art), 1931. The present translation is taken from J. D. Flam, *Matisse on Art*, London and New York, 1973, pp. 32–40. (See also IVA8.)

A painter who addresses the public not just in order to present his works, but to reveal some of his ideas on the art of painting, exposes himself to several dangers.

In the first place, knowing that many people like to think of painting as an appendage of literature and therefore want it to express not general ideas suited to pictorial means, but specifically literary ideas, I fear that one will look with astonishment upon the painter who ventures to invade the domain of the literary man. As a matter of fact, I am fully aware that a painter's best spokesman is his work.

However, such painters as Signac, Desvallières, Denis, Blanche, Guérin and Bernard have written on such matters and been well received by various periodicals. Personally, I shall simply try to state my feelings and aspirations as a painter without worrying about the writing.

But now I foresee the danger of appearing to contradict myself. I feel very strongly the tie between my earlier and my recent works, but I do not think exactly the way I thought yesterday. Or rather, my basic idea has not changed, but my thought has evolved, and my modes of expression have followed my thoughts. I do not repudiate any of my paintings but there is not one of them that I would not redo differently, if I had it to redo. My destination is always the same but I work out a different route to get there.

Finally, if I mention the name of this or that artist it will be to point out how our manners differ, and it may seem that I am belittling his work. Thus I risk being accused of injustice towards painters whose aims and results I best understand, or whose accomplishments I most appreciate, whereas I will have used them as examples, not to establish my superiority over them, but to show more clearly, through what they have done, what I am attempting to do. What I am after, above all, is expression. Sometimes it has been conceded that I have a certain technical ability but that all the same my ambition is limited, and does not go beyond the purely visual satisfaction such as can be obtained from looking at a picture. But the thought of a painter must not be considered as separate from his pictorial means, for the thought is worth no more than its expression by the means, which must be more complete (and by complete I do not mean complicated) the deeper is his thought. I am unable to distinguish between the feeling I have about life and my way of translating it.

Expression, for me, does not reside in passions glowing in a human face or manifested by violent movement. The entire arrangement of my picture is expressive: the place occupied by the figures, the empty spaces around them, the proportions, everything has its share. Composition is the art of arranging in a decorative manner the diverse elements at the painter's command to express his feelings. In a picture every part will be visible and will play its appointed role, whether it be principal or secondary. Everything that is not useful in the picture is, it follows, harmful. A work of art must be harmonious in its entirety: any superfluous detail would replace some other essential detail in the mind of the spectator.

Composition, the aim of which should be expression, is modified according to the surface to be covered. If I take a sheet of paper of a given size, my drawing will have a necessary relationship to its format. I would not repeat this drawing on another sheet of different proportions, for example, rectangular instead of square. Nor should I be satisfied with a mere enlargement, had I to transfer the drawing to a sheet the same shape, but ten times larger. A drawing must have an expansive force which gives life to the things around it. An artist who wants to transpose a composition from one canvas to

another larger one must conceive it anew in order to preserve its expression; he must alter its character and not just square it up onto the larger canvas.

Both harmonies and dissonances of colour can produce agreeable effects. Often when I start to work I record fresh and superficial sensations during the first session. A few years ago I was sometimes satisfied with the result. But today if I were satisfied with this, now that I think I can see further, my picture would have a vagueness in it: I should have recorded the fugitive sensations of a moment which could not completely define my feelings and which I should barely recognize the next day.

I want to reach that state of condensation of sensations which makes a painting. I might be satisfied with a work done at one sitting, but I would soon tire of it; therefore, I prefer to rework it so that later I may recognize it as representative of my state of mind. There was a time when I never left my paintings hanging on the wall because they reminded me of moments of over-excitement and I did not like to see them again when I was calm. Nowadays I try to put serenity into my pictures and re-work them as long as I have not succeeded.

Suppose I want to paint a woman's body: first of all I imbue it with grace and charm, but I know that I must give something more. I will condense the meaning of this body by seeking its essential lines. The charm will be less apparent at first glance, but it must eventually emerge from the new image which will have a broader meaning, one more fully human. The charm will be less striking since it will not be the sole quality of the painting, but it will not exist less for its being contained within the general conception of the figure.

Charm, lightness, freshness – such fleeting sensations. I have a canvas on which the colours are still fresh and I begin to work on it again. The tone will no doubt become duller. I will replace my original tone with one of greater density, an improvement, but less seductive to the eye.

The Impressionist painters, especially Monet and Sisley, had delicate sensations, quite close to each other: as a result their canvases all look alike. The word 'impression-ism' perfectly characterizes their style, for they register fleeting impressions. It is not an appropriate designation for certain more recent painters who avoid the first impres-sion, and consider it almost dishonest. A rapid rendering of a landscape represents only one moment of its existence [*durée*]. I prefer, by insisting upon its essential character, to risk losing charm in order to obtain greater stability.

Underlying this succession of moments which constitutes the superficial existence of beings and things, and which is continually modifying and transforming them, one can search for a truer, more essential character, which the artist will seize so that he may give to reality a more lasting interpretation. When we go into the seventeenth- and eighteenth-century sculpture rooms in the Louvre and look, for example, at a Puget, we can see that the expression is forced and exaggerated to the point of being disquieting. It is quite a different matter if we go to the Luxembourg; the attitude in which the sculptors catch their models is always the one in which the development of the members and tensions of the muscles will be shown to greatest advantage. And yet movement thus understood corresponds to nothing in nature: when we capture it by surprise in a snapshot, the resulting image reminds us of nothing that we have seen.

Movement seized while it is going on is meaningful to us only if we do not isolate the present sensation either from that which precedes it or that which follows it.

There are two ways of expressing things; one is to show them crudely, the other is to evoke them through art. By removing oneself from the literal *representation* of movement one attains greater beauty and grandeur. Look at an Egyptian statue: it looks rigid to us, yet we sense in it the image of a body capable of movement and which, despite its rigidity, is animated. The Greeks too are calm: a man hurling a discus will be caught at the moment in which he gathers his strength, or at least, if he is shown in the most strained and precarious position implied by his action, the sculptor will have epitomized and condensed it so that equilibrium is re-established, thereby suggesting the idea of duration. Movement is in itself unstable and is not suited to something durable like a statue, unless the artist is aware of the entire action of which he represents only a moment.

I must precisely define the character of the object or of the body that I wish to paint. To do so, I study my method very closely: If I put a black dot on a sheet of white paper, the dot will be visible no matter how far away I hold it: it is a clear notation. But beside this dot I place another one, and then a third, and already there is confusion. In order for the first dot to maintain its value I must enlarge it as I put other marks on the paper.

If upon a white canvas I set down some sensations of blue, of green, of red, each new stroke diminishes the importance of the preceding ones. Suppose I have to paint an interior: I have before me a cupboard; it gives me a sensation of vivid red, and I put down a red which satisfies me. A relation is established between this red and the white of the canvas. Let me put a green near the red, and make the floor yellow; and again there will be relationships between the green or yellow and the white of the canvas which will satisfy me. But these different tones mutually weaken one another. It is necessary that the various marks I use be balanced so that they do not destroy each other. To do this I must organize my ideas; the relationships between the tones must be such that it will sustain and not destroy them. A new combination of colours will succeed the first and render the totality of my representation. I am forced to transpose until finally my picture may seem completely changed when, after successive modifications, the red has succeeded the green as the dominant colour. I cannot copy nature in a servile way; I am forced to interpret nature and submit it to the spirit of the picture. From the relationship I have found in all the tones there must result a living harmony of colours, a harmony analogous to that of a musical composition.

For me all is in the conception. I must therefore have a clear vision of the whole from the beginning. I could mention a great sculptor who gives us some admirable pieces: but for him a composition is merely a grouping of fragments, which results in a confusion of expression. Look instead at one of Cézanne's pictures: all is so well arranged that no matter at what distance you stand or how many figures are represented you will always be able to distinguish each figure clearly and to know which limb belongs to which body. If there is order and clarity in the picture, it means that from the outset this same order and clarity existed in the mind of the painter, or that the painter was conscious of their necessity. Limbs may cross and intertwine, but in the eyes of the spectator they will nevertheless remain attached to and help to articulate the right body: all confusion has disappeared.

The chief function of colour should be to serve expression as well as possible. I put down my tones without a preconceived plan. If at first, and perhaps without my having been conscious of it, one tone has particularly seduced or caught me, more often than not once the picture is finished I will notice that I have respected this tone while I progressively altered and transformed all the others. The expressive aspect of colours imposes itself on me in a purely instinctive way. To paint an autumn landscape I will not try to remember what colours suit this season, I will be inspired only by the sensation that the season arouses in me: the icy purity of the sour blue sky will express the season just as well as the nuances of foliage. My sensation itself may vary, the autumn may be soft and warm like a continuation of summer, or quite cool with a cold sky and lemon-yellow trees that give a chilly impression and already announce winter.

My choice of colours does not rest on any scientific theory; it is based on observation, on sensitivity, on felt experiences. Inspired by certain pages of Delacroix, an artist like Signac is preoccupied with complementary colours, and the theoretical knowledge of them will lead him to use a certain tone in a certain place. But I simply try to put down colours which render my sensation. There is an impelling proportion of tones that may lead me to change the shape of a figure or to transform my composition. Until I have achieved this proportion in all the parts of the composition I strive towards it and keep on working. Then a moment comes when all the parts have found their definite relationships, and from then on it would be impossible for me to add a stroke to my picture without having to repaint it entirely.

In reality, I think that the very theory of complementary colours is not absolute. In studying the paintings of artists whose knowledge of colours depends upon instinct and feeling, and on a constant analogy with their sensations, one could define certain laws of colour and so broaden the limits of colour theory as it is now defined.

What interests me most is neither still life nor landscape, but the human figure. It is that which best permits me to express my almost religious awe towards life. I do not insist upon all the details of the face, on setting them down one-by-one with anatomical exactitude. If I have an Italian model who at first appearance suggests nothing but a purely animal existence, I nevertheless discover his essential qualities, I penetrate amid the lines of the face those which suggest the deep gravity which persists in every human being. A work of art must carry within itself its complete significance and impose that upon the beholder even before he recognizes the subject matter. When I see the Giotto frescoes at Padua I do not trouble myself to recognize which scene of the life of Christ I have before me, but I immediately understand the sentiment which emerges from it, for it is in the lines, the composition, the colour. The title will only serve to confirm my impression.

What I dream of is an art of balance, of purity and serenity, devoid of troubling or depressing subject-matter, an art which could be for every mental worker, for the businessman as well as the man of letters, for example, a soothing, calming influence on the mind, something like a good armchair which provides relaxation from physical fatigue.

Often a discussion arises as to the value of different processes, and their relationship to different temperaments. A distinction is made between painters who work directly from nature and those who work purely from imagination. Personally, I think neither of these methods must be preferred to the exclusion of the other. Both may be used in

turn by the same individual, either because he needs contact with objects in order to receive sensations that will excite his creative faculty, or his sensations are already organized. In either case he will be able to arrive at that totality which constitutes a picture. In any event I think that one can judge the vitality and power of an artist who, after having received impressions directly from the spectacle of nature, is able to organize his sensations to continue his work in the same frame of mind on different days, and to develop these sensations; this power proves he is sufficiently master of himself to subject himself to discipline.

The simplest means are those which best enable an artist to express himself. If he fears the banal he cannot avoid it by appearing strange, or going in for bizarre drawing and eccentric colour. His means of expression must derive almost of necessity from his temperament. He must have the humility of mind to believe that he has painted only what he has seen. I like Chardin's way of expressing it: 'I apply colour until there is a resemblance.' Or Cézanne's: 'I want to secure a likeness', or Rodin's: 'Copy nature!' Leonardo said: 'He who can copy can create.' Those who work in a preconceived style, deliberately turning their backs on nature, miss the truth. An artist must recognize, when he is reasoning, that his picture is an artifice; but when he is painting, he should feel that he has copied nature. And even when he departs from nature, he must do it with the conviction that it is only to interpret her more fully.

Some may say that other views on painting were expected from a painter, and that I have only come out with platitudes. To this I shall reply that there are no new truths. The role of the artist, like that of the scholar, consists of seizing current truths often repeated to him, but which will take on new meaning for him and which he will make his own when he has grasped their deepest significance. If aviators had to explain to us the research which led to their leaving earth and rising in the air, they would merely confirm very elementary principles of physics neglected by less successful inventors.

An artist always profits from information about himself, and I am glad to have learned what is my weak point. M. Péladan in the *Revue Hébdomadaire* reproaches a certain number of painters, amongst whom I think I should place myself, for calling themselves 'Fauves', and yet dressing like everyone else, so that they are no more noticeable than the floor-walkers in a department store. Does genius count for so little? If it were only a question of myself that would set M. Péladan's mind at ease, tomorrow I would call myself Sar and dress like a necromancer.

In the same article this excellent writer claims that I do not paint honestly, and I would be justifiably angry if he had not qualified his statement by saying, 'I mean honestly with respect to the ideal and the rules.' The trouble is that he does not mention where these rules are. I am willing to have them exist, but were it possible to learn them what sublime artists we would have!

Rules have no existence outside of individuals: otherwise a good professor would be as great a genius as Racine. Any one of us is capable of repeating fine maxims, but few can also penetrate their meaning. I am ready to admit that from a study of the works of Raphael or Titian a more complete set of rules can be drawn than from the works of Manet or Renoir, but the rules followed by Manet and Renoir were those which suited their temperaments and I prefer the most minor of their paintings to all the work of those who are content to imitate the *Venus of Urbino* or the *Madonna of the Goldfinch*. These latter are of no value to anyone, for whether we want to or not, we belong to our time and we share in its opinions, its feelings, even its delusions. All artists bear the

imprint of their time, but the great artists are those in whom this is most profoundly marked. Our epoch for instance is better represented by Courbet than by Flandrin, by Rodin better than by Frémiet. Whether we like it or not, however insistently we call ourselves exiles, between our period and ourselves an indissoluble bond is established, and M. Péladan himself cannot escape it. The aestheticians of the future may perhaps use his books as evidence if they get it in their heads to prove that no one of our time understood anything about the art of Leonardo da Vinci.

7 Roger Fry (1866–1934) 'An Essay in Aesthetics'

An important statement of Modernist aesthetic principles, providing a form of theoretical platform for Fry's two 'Post-Impressionist' exhibitions, held in London in 1910 and 1912. These exhibitions and Fry's own writings did much to establish the prevailing pattern of English and English-language interpretation of French modern art. First published in *New Quarterly*, London, 1909; reprinted in Fry's collected essays, *Vision and Design*, London, 1920, pp. 16–38, from which the present text is taken.

A certain painter, not without some reputation at the present day, once wrote a little book on the art he practises, in which he gave a definition of that art so succinct that I take it as a point of departure for this essay.

'The art of painting,' says that eminent authority, 'is the art of imitating solid objects upon a flat surface by means of pigments.' It is delightfully simple, but prompts the question – is that all? And, if so, what a deal of unnecessary fuss has been made about it. Now, it is useless to deny that our modern writer has some very respectable authorities behind him. Plato, indeed, gave a very similar account of the affair, and himself put the question – is it then worth while? And, being scrupulously and relentlessly logical, he decided that it was not worth while, and proceeded to turn the artists out of his ideal republic. For all that, the world has continued obstinately to consider that painting was worth while, and though, indeed, it has never quite made up its mind as to what, exactly, the graphic arts did for it, it has persisted in honouring and admiring its painters.

Can we arrive at any conclusions as to the nature of the graphic arts, which will at all explain our feelings about them, which will at least put them into some kind of relation with the other arts, and not leave us in the extreme perplexity, engendered by any theory of mere imitation? For, I suppose, it must be admitted that if imitation is the sole purpose of the graphic arts, it is surprising that the works of such arts are ever looked upon as more than curiosities, or ingenious toys, are ever taken seriously by grown-up people. Moreover, it will be surprising that they have any recognizable affinity with other arts, such as music or architecture, in which the imitation of actual objects is a negligible quantity.

To form such conclusions is the aim I have put before myself in this essay. Even if the results are not decisive, the inquiry may lead us to a view of the graphic arts that will not be altogether unfruitful.

I must begin with some elementary psychology, with a consideration of the nature of instincts. A great many objects in the world, when presented to our senses, put in motion a complex nervous machinery, which ends in some instinctive appropriate action. We see a wild bull in a field; quite without our conscious interference a nervous

process goes on, which, unless we interfere forcibly, ends in the appropriate reaction of flight. The nervous mechanism which results in flight causes a certain state of consciousness, which we call the emotion of fear. The whole of animal life, and a great part of human life, is made up of these instinctive reactions to sensible objects, and their accompanying emotions. But man has the peculiar faculty of calling up again in his mind the echo of past experiences of this kind, of going over it again, 'in imagination' as we say. He has, therefore, the possibility of a double life; one the actual life, the other the imaginative life. Between these two lives there is this great distinction, that in the actual life the processes of natural selection have brought it about that the instinctive reaction, such, for instance, as flight from danger, shall be the important part of the whole process, and it is towards this that the man bends his whole conscious endeavour. But in the imaginative life no such action is necessary, and, therefore, the whole consciousness may be focused upon the perceptive and the emotional aspects of the experience. In this way we get, in the imaginative life, a different set of values, and a different kind of perception.

* * *

That the graphic arts are the expression of the imaginative life rather than a copy of actual life might be guessed from observing children. Children, if left to themselves, never, I believe, copy what they see, never, as we say, 'draw from nature', but express, with a delightful freedom and sincerity, the mental images which make up their own imaginative lives.

Art, then, is an expression and a stimulus of this imaginative life, which is separated from actual life by the absence of responsive action. Now this responsive action implies in actual life moral responsibility. In art we have no such moral responsibility – it presents a life freed from the binding necessities of our actual existence.

What then is the justification for this life of the imagination which all human beings live more or less fully? To the pure moralist, who accepts nothing but ethical values, in order to be justified, it must be shown not only *not* to hinder but actually to forward right action, otherwise it is not only useless but, since it absorbs our energies, positively harmful. To such a one two views are possible, one the Puritanical view at its narrowest, which regards the life of the imagination as no better or worse than a life of sensual pleasure, and therefore entirely reprehensible. The other view is to argue that the imaginative life does subserve morality. And this is inevitably the view taken by moralists like Ruskin, to whom the imaginative life is yet an absolute necessity. It is a view which leads to some very hard special pleading, even to a self-deception which is in itself morally undesirable.

But here comes in the question of religion, for religion is also an affair of the imaginative life, and, though it claims to have a direct effect upon conduct, I do not suppose that the religious person if he were wise would justify religion entirely by its effect on morality, since that, historically speaking, has not been by any means uniformly advantageous. He would probably say that the religious experience was one which corresponded to certain spiritual capacities of human nature, the exercise of which is in itself good and desirable apart from their effect upon actual life. And so, too, I think the artist might if he chose take a mystical attitude, and declare that the fullness and completeness of the imaginative life he leads may correspond to an existence more real and more important than any that we know of in mortal life.

And in saying this, his appeal would find a sympathetic echo in most minds, for most people would, I think, say that the pleasures derived from art were of an altogether different character and more fundamental than merely sensual pleasures, that they did exercise some faculties which are felt to belong to whatever part of us there may be which is not entirely ephemeral and material.

It might even be that from this point of view we should rather justify actual life by its relation to the imaginative, justify nature by its likeness to art. I mean this, that since the imaginative life comes in the course of time to represent more or less what mankind feels to be the completest expression of its own nature, the freest use of its innate capacities, the actual life may be explained and justified by its approximation here and there, however partially and inadequately, to that freer and fuller life.

Before leaving this question of the justification of art, let me put it in another way. The imaginative life of a people has very different levels at different times, and these levels do not always correspond with the general level of the morality of actual life. Thus in the thirteenth century we read of barbarity and cruelty which would shock even us; we may, I think, admit that our moral level, our general humanity is decidedly higher today, but the level of our imaginative life is incomparably lower; we are satisfied there with a grossness, a sheer barbarity and squalor which would have shocked the thirteenth century profoundly. Let us admit the moral gain gladly, but do we not also feel a loss; do we not feel that the average businessman would be in every way a more admirable, more respectable being if his imaginative life were not so squalid and incoherent? And, if we admit any loss then, there is some function in human nature other than a purely ethical one, which is worthy of exercise.

Now the imaginative life has its own history both in the race and in the individual. In the individual life one of the first effects of freeing experience from the necessities of appropriate responsive action is to indulge recklessly the emotion of self-aggrandisement. The day-dreams of a child are filled with extravagant romances in which he is always the invincible hero. Music – which of all the arts supplies the strongest stimulus to the imaginative life and at the same time has the least power of controlling its direction – music, at certain stages of people's lives, has the effect merely of arousing in an almost absurd degree this egoistic elation . . . But with the teaching of experience and the growth of character the imaginative life comes to respond to other instincts and to satisfy other desires, until, indeed, it reflects the highest aspirations and the deepest aversions of which human nature is capable.

In dreams and when under the influence of drugs the imaginative life passes out of our own control, and in such cases its experiences may be highly undesirable, but whenever it remains under our own control it must always be on the whole a desirable life. That is not to say that it is always pleasant, for it is pretty clear that mankind is so constituted as to desire much besides pleasure, and we shall meet among the great artists, the great exponents, that is, of the imaginative life, many to whom the merely pleasant is very rarely a part of what is desirable. But this desirability of the imaginative life does distinguish it very sharply from actual life, and this is the direct result of that first fundamental difference, its freedom from necessary external conditions. Art, then, is, if I am right, the chief organ of the imaginative life; it is by art that it is stimulated and controlled within us, and, as we have seen, the imaginative life is distinguished by the greater clearness of its perception, and the greater purity and freedom of its emotion.

First with regard to the greater clearness of perception. The needs of our actual life are so imperative, that the sense of vision becomes highly specialized in their service. With an admirable economy we learn to see only so much as is needful for our purposes; but this is in fact very little, just enough to recognize and identify each object or person; that done, they go into an entry in our mental catalogue and are no more really seen. In actual life the normal person really only reads the labels as it were on the objects around him and troubles no further. Almost all the things which are useful in any way put on more or less this cap of invisibility. It is only when an object exists in our lives for no other purpose than to be seen that we really look at it, as for instance at a China ornament or a precious stone, and towards such even the most normal person adopts to some extent the artistic attitude of pure vision abstracted from necessity.

Now this specialization of vision goes so far that ordinary people have almost no idea of what things really look like, so that oddly enough the one standard that popular criticism applies to painting, namely, whether it is like nature or not, is one which most people are, by the whole tenor of their lives, prevented from applying properly. The only things they have ever really *looked* at being other pictures; the moment an artist who has looked at nature brings to them a clear report of something definitely seen by him, they are wildly indignant at its untruth to nature. This has happened so constantly in our own time that there is no need to prove it. One instance will suffice. Monet is an artist whose chief claim to recognition lies in the fact of his astonishing power of faithfully reproducing certain aspects of nature, but his really naïve innocence and sincerity were taken by the public to be the most audacious humbug, and it required the teaching of men like Bastien-Lepage, who cleverly compromised between the truth and an accepted convention of what things looked like, to bring the world gradually round to admitting truths which a single walk in the country with purely unbiased vision would have established beyond doubt.

But though this clarified sense perception which we discover in the imaginative life is of great interest, and although it plays a larger part in the graphic arts than in any other, it might perhaps be doubted whether, interesting, curious, fascinating as it is, this aspect of the imaginative life would ever by itself make art of profound importance to mankind. But it is different, I think, with the emotional aspect. We have admitted that the emotions of the imaginative are generally weaker than those of actual life. The picture of a saint being slowly flayed alive, revolting as it is, will not produce the same physical sensations of sickening disgust that a modern man would feel if he could assist at the actual event; but they have a compensating clearness of presentment to the consciousness. The more poignant emotions of actual life have, I think, a kind of numbing effect analogous to the paralysing influence of fear in some animals; but even if this experience be not generally admitted, all will admit that the need for responsive action hurries us along and prevents us from ever realizing fully what the emotion is that we feel, from coordinating it perfectly with other states. In short, the motives we actually experience are too close to us to enable us to feel them clearly. They are in a sense unintelligible. In the imaginative life, on the contrary, we can both feel the emotion and watch it. When we are really moved at the theatre we are always both on the stage and in the auditorium.

Yet another point about the emotions of the imaginative life – since they require no responsive action we can give them a new valuation. In real life we must to some extent

cultivate those emotions which lead to useful action, and we are bound to appraise emotions according to the resultant action. So that, for instance, the feelings of rivalry and emulation do get an encouragement which perhaps they scarcely deserve, whereas certain feelings which appear to have a high intrinsic value get almost no stimulus in actual life. For instance, those feelings to which the name of the cosmic emotion has been somewhat unhappily given find almost no place in life, but, since they seem to belong to certain very deep springs of our nature, do become of great importance in the arts.

Mortality, then, appreciates emotion by the standard of resultant action. Art appreciates emotion in and for itself.

This view of the essential importance in art of the expression of the emotions is the basis of Tolstoy's marvellously original and yet perverse and even exasperating book, *What is Art?*, and I willingly confess, while disagreeing with almost all his results, how much I owe to him.

He gives an example of what he means by calling art the means of communicating emotions. He says, let us suppose a boy to have been pursued in the forest by a bear. If he returns to the village and merely states that he was pursued by a bear and escaped, that is ordinary language, the means of communicating facts or ideas; but if he describes his state first of heedlessness, then of sudden alarm and terror as the bear appears, and finally of relief when he gets away, and describes this so that his hearers share his emotions, then his description is a work of art.

Now in so far as the boy does this in order to urge the villagers to go out and kill the bear, though he may be using artistic methods, his speech is not a pure work of art; but if of a winter evening the boy relates his experience for the sake of the enjoyment of his adventure in restrospect, or better still, if he makes up the whole story for the sake of the imagined emotions, then his speech becomes a pure work of art. But Tolstoy takes the other view, and values the emotions aroused by art entirely for their reaction upon actual life, a view which he courageously maintains even when it leads him to condemn the whole of Michelangelo, Raphael, and Titian, and most of Beethoven, not to mention nearly everything he himself has written, as bad or false art.

Such a view would, I think, give pause to any less heroic spirit. He would wonder whether mankind could have always been so radically wrong about a function that, whatever its value be, is almost universal. And in point of fact he will have to find some other word to denote what we now call art. Nor does Tolstoy's theory even carry him safely through his own book, since, in his examples of morally desirable and therefore good art, he has to admit that these are to be found, for the most part, among works of inferior quality. Here, then, is at once the tacit admission that another standard than morality is applicable. We must therefore give up the attempt to judge the work of art by its reaction on life, and consider it as an expression of emotions regarded as ends in themselves. And this brings us back to the idea we had already arrived at, of art as the expression of the imaginative life.

If, then, an object of any kind is created by man not for use, for its fitness to actual life, but as an object of art, an object subserving the imaginative life, what will its qualities be? It must in the first place be adapted to that disinterested intensity of contemplation, which we have found to be the effect of cutting off the responsive action. It must be suited to that heightened power of perception which we found to result therefrom.

And the first quality that we demand in our sensations will be order, without which our sensations will be troubled and perplexed, and the other quality will be variety, without which they will not be fully stimulated.

It may be objected that many things in nature, such as flowers, possess these two qualities of order and variety in a high degree, and these objects do undoubtedly stimulate and satisfy that clear disinterested contemplation which is characteristic of the aesthetic attitude. But in our reaction to a work of art there is something more – there is the consciousness of purpose, the consciousness of a peculiar relation of sympathy with the man who made this thing in order to arouse precisely the sensations we experience. And when we come to the higher works of art, where sensations are so arranged that they arouse in us deep emotions, this feeling of a special tie with the man who expressed them becomes very strong. We feel that he has expressed something which was latent in us all the time, but which we never realized, that he has revealed us to ourselves in revealing himself. And this recognition of purpose is, I believe, an essential part of the aesthetic judgement proper.

The perception of purposeful order and variety in an object gives us the feeling which we express by saying that it is beautiful, but when by means of sensations our emotions are aroused we demand purposeful order and variety in them also, and if this can only be brought about by the sacrifice of sensual beauty we willingly overlook its absence.

Thus, there is no excuse for a china pot being ugly, there is every reason why Rembrandt's and Degas' pictures should be, from the purely sensual point of view, supremely and magnificently ugly.

This, I think, will explain the apparent contradiction between two distinct uses of the word beauty, one for that which has sensuous charm, and one for the aesthetic approval of works of imaginative art where the objects presented to us are often of extreme ugliness. Beauty in the former sense belongs to works of art where only the perceptual aspect of the imaginative life is exercised, beauty in the second sense becomes as it were supersensual, and is concerned with the appropriateness and intensity of the emotions aroused. When these emotions are aroused in a way that satisfies fully the needs of the imaginative life we approve and delight in the sensations through which we enjoy that heightened experience because they possess purposeful order and variety in relation to those emotions.

One chief aspect of order in a work of art is unity; unity of some kind is necessary for our restful contemplation of the work of art as a whole, since if it lacks unity we cannot contemplate it in its entirety, but we shall pass outside it to other things necessary to complete its unity.

In a picture this unity is due to a balancing of the attractions of the eye about the central line of the picture. The result of this balance of attractions is that the eye rests willingly within the bounds of the picture. [...]

* * *

Let us now see how the artist passes from the stage of merely gratifying our demand for sensuous order and variety to that where he arouses our emotions. I will call the various methods by which this is effected the emotional elements of design.

The first element is that of the rhythm of the line with which the forms are delineated.

The drawn line is the record of a gesture, and that gesture is modified by the artist's feeling which is thus communciated to us directly.

The second element is mass. When an object is so represented that we recognize it as having inertia, we feel its power of resisting movement, or communicating its own movement to other bodies, and our imaginative reaction to such an image is governed by our experience of mass in actual life.

The third element is space. The same-sized square on two pieces of paper can be made by very simple means to appear to represent either a cube two or three inches high, or a cube of hundreds of feet, and our reaction to it is proportionately changed.

The fourth element is that of light and shade. Our feelings towards the same object become totally different according as we see it strongly illuminated against a black background or dark against light.

A fifth element is that of colour. That this has a direct emotional effect is evident from such words as gay, dull, melancholy in relation to colour.

I would suggest the possibility of another element, though perhaps it is only a compound of mass and space: it is that of the inclination to the eye of a plane, whether it is impending over or leaning away from us.

Now it will be noticed that nearly all these emotional elements of design are connected with essential conditions of our physical existence: rhythm appeals to all the sensations which accompany muscular activity; mass to all the infinite adaptations to the force of gravity which we are forced to make; the spatial judgement is equally profound and universal in its application to life; our feeling about inclined planes is connected with our necessary judgements about the conformation of the earth itself; light again, is so necessary a condition of our existence that we become intensely sensitive to changes in its intensity. Colour is the only one of our elements which is not of critical or universal importance to life, and its emotional effect is neither so deep nor so clearly determined as the others. It will be seen, then, that the graphic arts arouse emotions in us by playing upon what one may call the overtones of some of our primary physical needs. They have, indeed, this great advantage over poetry, that they can appeal more directly and immediately to the emotional accompaniments of our bare physical existence.

If we represent these various elements in simple diagrammatic terms, this effect upon the emotions is, it must be confessed, very weak. Rhythm of line, for instance, is incomparably weaker in its stimulus of the muscular sense than is rhythm addressed to the ear in music, and such diagrams can at best arouse only faint ghost-like echoes of emotions of differing qualities; but when these emotional elements are combined with the presentation of natural appearances, above all with the appearance of the human body, we find that this effect is indefinitely heightened.

When for instance, we look at Michelangelo's 'Jeremiah', and realize the irresistible momentum his movements would have, we experience powerful sentiments of reverence and awe. Or when we look at Michelangelo's 'Tondo' in the Uffizi, and find a group of figures so arranged that the planes have a sequence comparable in breadth and dignity to the mouldings of the earth mounting by clearly-felt gradations to an overtopping summit, innumerable instinctive reactions are brought into play.

At this point the adversary (as Leonardo da Vinci calls him) is likely to retort, 'You have abstracted from natural forms a number of so-called emotional elements which you yourself admit are very weak when stated with diagrammatic purity; you then put them back, with the help of Michelangelo, into the natural forms whence they were derived, and at once they have value, so that after all it appears that the natural forms

contain these emotional elements ready made up for us, and all that art need do is to imitate Nature.'

But, alas! Nature is heartlessly indifferent to the needs of the imaginative life; God causes His rain to fall upon the just and upon the unjust. The sun neglects to provide the appropriate limelight effect even upon a triumphant Napoleon or a dying Caesar. Assuredly we have no guarantee that in nature the emotional elements will be combined appropriately with the demands of the imaginative life, and it is, I think, the great occupation of the graphic arts to give us first of all order and variety in the sensuous plane, and then so to arrange the sensuous presentment of objects that the emotional elements are elicited with an order and appropriateness altogether beyond what Nature herself provides.

Let me sum up for a moment what I have said about the relation of art to Nature, which is, perhaps, the greatest stumbling-block to the understanding of the graphic arts.

I have admitted that there is beauty in Nature, that is to say, that certain objects constantly do, and perhaps any object may, compel us to regard it with that intense disinterested contemplation that belongs to the imaginative life, and which is impossible to the actual life of necessity and action; but that in objects created to arouse the aesthetic feeling we have an added conciousness of purpose on the part of the creator, that he made it on purpose not to be used but to be regarded and enjoyed; and that this feeling is characteristic of the aesthetic judgement proper.

When the artist passes from pure sensations to emotions aroused by means of sensations, he uses natural forms which, in themselves, are calculated to move our emotions, and he presents these in such a manner that the forms themselves generate in us emotional states, based upon the fundamental necessities of our physical and physiological nature. The artist's attitude to natural form is, therefore, infinitely various according to the emotions he wishes to arouse. He may require for his purpose the most complete representation of a figure, he may be intensely realistic, provided that his presentment, in spite of its closeness to natural appearance, disengages clearly for us the appropriate emotional elements. Or he may give us the merest suggestion of natural forms, and rely almost entirely upon the force and intensity of the emotional elements involved in his presentment.

We may, then, dispense once for all with the idea of likeness to Nature, of correctness or incorrectness as a test, and consider only whether the emotional elements inherent in natural form are adequately discovered, unless, indeed, the emotional idea depends at any point upon likeness, or completeness of representation.

8 Wassily Kandinsky (1866–1944) from *Concerning the Spiritual in Art*

Kandinsky was born in Moscow and trained in Munich, where he co-founded the group Der Blaue Reiter and where his major treatise was first published late in 1911 as *Über das Geistige in der Kunst* (Piper Verlag, dated 1912). His theories rest on a series of assumptions which were relatively widespread in modern artistic circles around the turn of the century: that there is a qualitative hierarchy in human experience (a belief central to the doctrine of Theosophy, to which both Kandinsky and Mondrian were attracted);

that works of art are united by their possession of an essential expressive or 'spiritual' value; and that this value is a function of art's autonomy with respect to naturalistic appearances. In this text Kandinsky develops a defence of art's 'essential' spiritual function into a programme for abstract painting conceived as an index of social and spiritual progress. First English translation 1914; the present version is taken from the translation of the second 1912 edition, in K. C. Lindsay and P. Vergo (eds. and trans.), *Kandinsky: Complete Writings on Art*, London, 1982, pp. 127–61. (See also IB9 and IIIC12.)

A General

I *Introduction*

Every work of art is the child of its time, often it is the mother of our emotions.

Thus, every period of culture produces its own art, which can never be repeated. Any attempt to give new life to the artistic principles of the past can at best only result in a work of art that resembles a stillborn child. For example, it is impossible for our inner lives, our feelings, to be like those of the ancient Greeks. Efforts, therefore, to apply Greek principles, e.g., to sculpture, can only produce forms similar to those employed by the Greeks, a work that remains soulless for all time. This sort of imitation resembles the mimicry of the ape. To all outward appearances, the movements of apes are exactly like those of human beings. The ape will sit holding a book in front of its nose, leafing through with a thoughtful expression on its face, but the inner meaning of these gestures is completely lacking.

There exists, however, another outward similarity of artistic forms that is rooted in a deeper necessity. The similarity of inner strivings within the whole spiritual-moral atmosphere – striving after goals that have already been pursued, but afterward forgotten – this similarity of the inner mood of an entire period can lead logically to the use of forms successfully employed to the same ends in an earlier period. Our sympathy, our understanding, our inner feeling for the primitives arose partly in this way. Just like us, those pure artists wanted to capture in their works the inner essence of things, which of itself brought about a rejection of the external, the accidental.

This important point of inner contact is, however, for all its importance, only a point. Our souls, which are only now beginning to awaken after the long reign of materialism, harbor seeds of desperation, unbelief, lack of purpose. The whole nightmare of the materialistic attitude, which has turned the life of the universe into an evil, purposeless game, is not yet over. The awakening soul is still deeply under the influence of this nightmare. Only a weak light glimmers, like a tiny point in an enormous circle of blackness. This weak light is no more than an intimation that the soul scarcely has the courage to perceive, doubtful whether this light might not itself be a dream, and the circle of blackness, reality. This doubt, and the still-oppressive suffering caused by a materialistic philosophy create a sharp distinction between our souls and those of the 'primitives.' Our souls, when one succeeds in touching them, give out a hollow ring, like a beautiful vase discovered cracked in the depths of the earth. For this reason the movement toward the primitive, which we are experiencing at this moment, can only be, with its present borrowed forms, of short duration.

These two similarities between modern art and the forms of bygone periods are, as can easily be seen, diametrically opposed. The first is external and thus has no future. The

second is internal and therefore conceals the seeds of the future within itself. After the period of materialistic trials to which the soul had apparently succumbed, yet which it rejected as an evil temptation, the soul emerges, refined by struggle and suffering. Coarser emotions such as terror, joy, sorrow, etc., which served as the content of art during this period of trial, will now hold little attraction for the artist. He will strive to awaken as yet nameless feelings of a finer nature. He himself leads a relatively refined and complex existence, and the work he produces will necessarily awaken finer emotions in the spectator who is capable of them, emotions that we cannot put into words.

* * *

II Movement

The spiritual life can be accurately represented by a diagram of a large acute triangle divided into unequal parts, with the most acute and smallest division at the top. The farther down one goes, the larger, broader, more extensive, and deeper become the divisions of the triangle.

The whole triangle moves slowly, barely perceptibly, forward and upward, so that where the highest point is 'today'; the next division is 'tomorrow,' i.e., what is today comprehensible only to the topmost segment of the triangle and to the rest of the triangle is gibberish, becomes tomorrow the sensible and emotional content of the life of the second segment.

At the apex of the topmost division there stands sometimes only a single man. His joyful vision is like an inner, immeasurable sorrow. Those who are closest to him do not understand him and in their indignation, call him deranged: a phoney or a candidate for the madhouse. [. . .]

In every division of the triangle one can find artists. Every one of them who is able to see beyond the frontiers of his own segment is the prophet of his environment, and helps the forward movement of the obstinate cartload of humanity. But if he does not possess the necessary sharp eye, or if he misuses or even closes it from unworthy motives or for unworthy purposes, then he is fully understood and celebrated by all his companions within his own segment. The bigger this segment is (and the lower down, therefore, it lies), the greater is the mass of people who find the artist's language comprehensible. It is obvious that every such segment hungers – consciously or (much more often) completely unconsciously – after its corresponding spiritual bread. This bread is given it by its artists, and tomorrow the next segment will reach for that same bread.

* * *

III Spiritual Turning-point

The spiritual triangle moves slowly forward and upward. Today, one of the largest of the lower divisions has grasped the elementary slogans of the materialistic 'credo.' As regards religion, its inhabitants bear various titles. They call themselves Jews, Catholics, Protestants, etc. In fact, they are atheists, a fact that a few of the most daring or most stupid openly admit. 'Heaven' is empty. 'God is dead.' Politically, these inhabitants are republicans or democrats. The fear, distaste, and hatred they felt yesterday for these political views are today directed at the term anarchy, about which they know

nothing save the terrifying name. Economically, these people are socialists. They sharpen the sword of justice to deal the fatal blow to the capitalist hydra and cut off the head of evil.

Since the inhabitants of this large division of the triangle have never managed to solve a problem for themselves and have always been pulled along in the cart of humanity by their self-sacrificing fellow men standing far above them, they know nothing of the effort of pulling, which they have never observed except from a great distance. For this reason, they imagine this effort to be very easy, believing in infallible remedies and prescriptions of universal application.

The next and lower division is dragged blindly upward by the one just described. But it hangs grimly onto its former position, struggling in fear of the unknown, of being deceived.

The higher divisions, religiously speaking, are not only blindly atheistic, but are able to justify their godlessness with the words of others (for example, Virchow's saying, unworthy of an educated man: 'I have dissected many corpses, but never yet discovered a soul'). Politically they are even more often republicans, are familiar with various parliamentary usages, and read the leading articles on politics in the newspapers. Economically, they are socialists of various shades, supporting their 'convictions' with a wealth of quotations (everything from Schweitzer's *Emma* to Lassalle's *Iron Law* and Marx's *Capital*, and much more).

In these higher divisions, other disciplines gradually emerge that were missing from those just described: science and art, to which belong also literature and music.

Scientifically, these people are positivists, recognizing only what can be weighed and measured. They regard anything else as potentially harmful nonsense, the same nonsense they yesterday called today's 'proven' theories.

In art they are naturalists, which permits them to recognize and even prize personality, individuality, and temperament in the artist, up to a certain limit designated by others and in which, for this very reason, they believe unswervingly.

In these higher compartments there exists, despite the visible order and certainty and infallible principles, a hidden fear, a confusion, a vacillation, an uncertainty – as in the heads of passengers aboard a great, steady ocean liner when black clouds gather over the sea, the dry land is hidden in mist, and the bleak wind heaps up the water into black mountains. And this is thanks to their education. For they know that the man who is today revered as intellectual, statesman, or artist was yesterday a ridiculed self-seeker, charlatan, or incompetent, unworthy of serious consideration.

And the higher one ascends the spiritual triangle, the more obvious becomes this sharp-edged fear, this insecurity. First, one finds here and there eyes capable of seeing for themselves, heads capable of putting two and two together. People with these gifts ask themselves, 'If this wisdom of the day before yesterday has been overthrown by that of yesterday, and the latter by that of today, then could it not also be somehow possible that the wisdom of today could be supplanted by that of tomorrow?' And the bravest of them reply, 'It is within the bounds of possibility.'

Second, one finds eyes capable of seeing what is 'not yet explained' by modern-day science. Such people ask themselves: 'Will science ever reach a solution to this problem if it continues along the same path it has been following until now? And if it reaches one, will we be able to rely on its answer?'

In these compartments can also be found professional intellectuals, who can remember how established facts, recognized by the academies, were first greeted by those same academies. Here, too, can be found art historians, who write books full of praise and deep sentiments – about an art that yesterday was regarded as senseless. By means of these books, they remove the hurdles over which art has long since jumped, and set up new ones, which this time are supposed to stay permanently and firmly in place. Engaged in this occupation, they fail to notice that they are building their barriers behind art rather than in front of it. If they notice it tomorrow, then they will quickly write more books in order to remove their barriers one stage further. And this occupation will continue unchanged until it is realized that the external principles of art can only be valid for the past and not for the future. No theory derived from these principles can account for the path ahead, which lies in the realm of the nonmaterial. One cannot crystallize in material form what does not yet exist in material form. The spirit that will lead us into the realms of tomorrow can only be recognized through feeling (to which the talent of the artist is the path). Theory is the lantern that illuminates the crystallized forms of yesterday and before.

And if we climb still higher, we see even greater confusion, as if in a great city, built solidly according to all architectural and mathematical rules, that is suddenly shaken by a mighty force. The people who live in this division indeed live in just such a spiritual city, where such forces are at work, and with which the spiritual architects and mathematicians have not reckoned. [...]

And higher still we find that there is no more fear. The work done here boldly shakes the pinnacles that men have set up. Here, too, we find professional intellectuals who examine matter over and over again and finally cast doubt upon matter itself, which yesterday was the basis of everything, and upon which the whole universe was supported. The electron theory – i.e., the theory of moving electricity, which is supposed completely to replace matter, has found lately many keen proponents, who from time to time overreach the limits of caution and thus perish in the conquest of this new stronghold of science, like heedless soldiers, sacrificing themselves for others at the desperate storming of some beleaguered fortress. But 'there is no fortress so strong that it cannot be taken.'

On the other hand, such facts as the science of yesterday greeted with the usual word 'swindle' are on the increase, or are merely becoming more generally known. Even the newspapers, those habitually most obedient servants of success and of the plebs, who base their business on 'giving the people what they want,' find themselves in many cases obliged to limit or even to suppress altogether the ironic tone of their articles about the latest 'miracles.' Various educated men, pure materialists among them, devote their powers of scientific investigation to those puzzling facts that can no longer be denied or kept quiet.

On the other hand, the number of people who set no store by the methods of materialistic science in matters concerning the 'nonmaterial', or matter that is not perceptible to our senses, is at last increasing. And just as art seeks help from the primitives, these people turn for help to half-forgotten times, with their half-forgotten methods. [...]

* * *

When religion, science, and morality are shaken (the last by the mighty hand of Nietzsche), when the external supports threaten to collapse, then man's gaze turns away from the external toward himself.

Literature, music, and art are the first and most sensitive realms where this spiritual change becomes noticeable in real form. These spheres immediately reflect the murky present; they provide an intimation of that greatness which first becomes noticeable only to a few, as just a tiny point, and which for the masses does not exist at all.

They reflect the great darkness that appeared with hardly any warning. They themselves become dark and murky. On the other hand, they turn away from the soulless content of modern life, toward materials and environments that give a free hand to the nonmaterial strivings and searchings of the thirsty soul.

* * *

IV The Pyramid

And so; gradually the different arts have set forth on the path of saying what they are best able to say, through means that are peculiar to each.

And in spite of, or thanks to, this differentiation, the arts as such have never in recent times been closer to one another than in this latest period of spiritual transformation.

In all that we have discussed above lie hidden the seeds of the struggle toward the nonnaturalistic, the abstract, toward inner nature. Consciously or unconsciously, they obey the words of Socrates: 'Know thyself!' Consciously or unconsciously, artists turn gradually toward an emphasis on their materials, examining them spiritually, weighing in the balance the inner worth of those elements out of which their art is best suited to create.

B Painting

V Effects of Color

Letting one's eyes wander over a palette laid out with colors has two main results:

1 There occurs a purely physical effect, i.e., the eye itself is charmed by the beauty and other qualities of the color. The spectator experiences a feeling of satisfaction, of pleasure, like a gourmet who has a tasty morsel in his mouth. Or the eye is titillated, as is one's palate by a highly spiced dish. It can also be calmed or cooled again, as one's finger can when it touches ice. These are all physical sensations and as such can only be of short duration. They are also superficial, leaving behind no lasting impression if the soul remains closed. Just as one can only experience a physical feeling of cold on touching ice (which one forgets after having warmed one's fingers again), so too the physical effect of color is forgotten when one's eyes are turned away. And as the physical sensation of the coldness of the ice, penetrating deeper, can give rise to other, deeper sensations and set off a whole chain of psychic experiences, so the superficial effect of color can also develop into a [deeper] form of experience.

Only familiar objects will have a wholly superficial effect upon a moderately sensitive person. Those, however, that we encounter for the first time immediately have a

spiritual effect upon us. A child, for whom every object is new, experiences the world in this way: it sees light, is attracted by it, wants to grasp it, burns its finger in the process, and thus learns fear and respect for the flame. And then it learns that light has not only an unfriendly, but also a friendly side: banishing darkness and prolonging the day, warming and cooking, delighting the eye. One becomes familiar with light by collecting these experiences and storing away this knowledge in the brain. The powerful, intense interest in light vanishes, and its attribute of delighting the eye is met with indifference. Gradually, in this way, the world loses its magic. One knows that trees provide shade, that horses gallop quickly, and that cars go even faster, that dogs bite, that the moon is far away, and that the man one sees in the mirror is not real.

The constantly growing awareness of the qualities of different objects and beings is only possible given a high level of development in the individual. With further development, these objects and beings take on an inner value, eventually an inner sound. So it is with color, which if one's spiritual sensitivity is at a low stage of development, can only create a superficial effect, an effect that soon disappears once the stimulus has ceased. Yet, even at this stage, this extremely simple effect can vary. The eye is more strongly attracted by the brighter colors, and still more by the brighter and warmer: vermilion attracts and pleases the eye as does flame, which men always regard covetously. Bright lemon yellow hurts the eye after a short time, as a high note on the trumpet hurts the ear. The eye becomes disturbed, cannot bear it any longer, and seeks depth and repose in blue or green.

At a higher level of development, however, there arises from this elementary impression a more profound effect, which occasions a deep emotional response. In this case we have:

2 The second main consequence of the contemplation of color, i.e., the psychological effect of color. The psychological power of color becomes apparent, calling forth a vibration from the soul. Its primary, elementary physical power becomes simply the path by which color reaches the soul.

Whether this second consequence is in fact a direct one, as might be supposed from these last few lines, or whether it is achieved by means of association, remains perhaps questionable. Since in general the soul is closely connected to the body, it is possible that one emotional response may conjure up another, corresponding form of emotion by means of association. For example, the color red may cause a spiritual vibration like flame, since red is the color of flame. A warm red has a stimulating effect and can increase in intensity until it induces a painful sensation, perhaps also because of its resemblance to flowing blood. This color can thus conjure up the memory of another physical agent, which necessarily exerts a painful effect upon the soul.

If this were the case, it would be easy to find an associative explanation for the other physical effects of color, i.e., its effects not only upon our sight, but also upon our other senses. One might assume that, e.g., bright yellow produces a sour effect by analogy with lemons.

It is, however, hardly possible to maintain this kind of explanation. As far as tasting colors is concerned, many examples are known where this explanation does not apply. A Dresden doctor tells how one of his patients, whom he describes as 'spiritually, unusually highly developed,' invariably found that a certain sauce had a 'blue' taste,

i.e., it affected him like the color blue. One might perhaps assume another similar, and yet different, explanation; that in the case of such highly developed people the paths leading to the soul are so direct, and the impressions it receives are so quickly produced, that an effect immediately communicated to the soul via the medium of taste sets up vibrations along the corresponding paths leading away from the soul to the other sensory organs (in this case, the eye). This effect would seem to be a sort of echo or resonance, as in the case of musical instruments, which without themselves being touched, vibrate in sympathy with another instrument being played. Such highly sensitive people are like good, much-played violins, which vibrate in all their parts and fibers at every touch of the bow.

If one accepts this explanation, then admittedly, sight must be related not only to taste, but also to all the other senses. Which is indeed the case. Many colors have an uneven, prickly appearance, while others feel smooth, like velvet, so that one wants to stroke them (dark ultramarine, chrome-oxide green, madder). Even the distinction between cold and warm tones depends upon this sensation. There are also colors that appear soft (madder), others that always strike one as hard (cobalt green, green-blue oxide), so that one might mistake them for already dry when freshly squeezed from the tube.

The expression 'the scent of colors' is common usage.

Finally, our hearing of colors is so precise that it would perhaps be impossible to find anyone who would try to represent his impression of bright yellow by means of the bottom register of the piano, or describe dark madder as being like a soprano voice.

This explanation (that is, in terms of association) is, however, insufficient in many instances that are for us of particular importance. Anyone who has heard of color therapy knows that colored light can have a particular effect upon the entire body. Various attempts to exploit this power of color and apply it to different nervous disorders have again noted that red light has an enlivening and stimulating effect upon the heart, while blue, on the other hand, can lead to temporary paralysis. If this sort of effect can also be observed in the case of animals, and even plants, then any explanation in terms of association completely falls down. These facts in any case prove that color contains within itself a little-studied but enormous power, which can influence the entire human body as a physical organism.

If association does not seem a sufficient explanation in this case, then it cannot satisfy us as regards the effect of color upon the psyche. In general, therefore, color is a means of exerting a direct influence upon the soul. Color is the keyboard. The eye is the hammer. The soul is the piano, with its many strings.

The artist is the hand that purposefully sets the soul vibrating by means of this or that key.

Thus it is clear that the harmony of colors can only be based upon the principle of purposefully touching the human soul.

This basic tenet we shall call the principle of internal necessity.

9 Wassily Kandinsky (1966–1944) The Cologne Lecture

Kandinsky here gives a summary account of his own work and of its development. He had been invited to lecture on his work at the opening of an exhibition in Cologne in 1914, and responded by sending a typescript text. A transcription of the original manuscript was

published in J. Eichner, *Kandinsky und Gabriele Münter, Von Ursprüngen Moderner Kunst*, Munich, 1957. The present version is taken from the translation in Lindsay and Vergo, op. cit., pp. 394–400. (See also IB8 and IIIC12.)

[...] I can in general characterize the three periods of my development...in the following manner:

I remember the first, or (as I called it) dilettante, period as the simultaneous effect of two different impulses. These two different impulses were, as my later development shows, fundamentally different.

1 Love of nature.
2 Indefinite stirrings of the urge to create.

This love of nature consisted principally of pure joy in an enthusiasm for the element of color. I was often so strongly possessed by a strongly sounding, perfumed patch of blue in the shadow of a bush that I would paint a whole landscape merely in order to fix this patch. Of course, such studies turned out badly, and I used to search after the kind of 'motifs' of which each constituent part would affect me equally strongly. Of course, I never found any. Then I would try to make more effective those parts of the canvas which produced a lesser effect. It was out of these exercises that my later ability developed...

At the same time I felt within myself incomprehensible stirrings, the urge to paint a *picture*. And I felt dimly that a picture can be something other than a beautiful landscape, an interesting and picturesque scene, or the portrayal of a person. Because I loved colors more than anything else, I thought even then, however confusedly, of color composition, and sought that objective element which could justify the [choice of] colors.

This was the transition to my time of study, and to the second period of my search.

...It soon appeared to me that past ages, having no longer any real existence, could provide me with freer pretexts for that use of color which I felt within myself. [...] I was far less free in my treatment of the 'laws of drawing.' E.g., I regarded it as necessary to keep people's heads more or less in a straight line, as one sees them on the street. [...]

Only very slowly did I come to free myself from this prejudice. In *Composition 2*, one can see the free use of color without regard for the demands of perspective. I always found it unpleasant, however, and often distasteful, to allow the figures to remain within the bounds of physiological laws and at the same time indulge in compositional distortions. It seemed to me that if one physical realm is destroyed for the sake of pictorial necessity, then the artist has the artistic right and the artistic duty to negate the other physical realms as well. I saw with displeasure in other people's pictures elongations that contradicted the structure of the body, or anatomical distortions, and knew well that this would not and could not be for me the solution to the question of representation. Thus, objects began gradually to dissolve more and more in my pictures. This can be seen in nearly all the pictures of 1910.

As yet, objects did not want to, and were not to, disappear altogether from my pictures. First, it is impossible to conjure up maturity artificially at any particular time. And nothing is more damaging and more sinful than to seek one's forms by force. One's inner impulse, i.e., the creating spirit, will inexorably create at the right moment

the form it finds necessary. One can philosophize about form; it can be analyzed, even calculated. It must, however, enter into the work of art of its own accord, and moreover, at that level of completeness which corresponds to the development of the creative spirit. Thus, I was obliged to wait patiently for the hour that would lead my hand to create abstract form.

Secondly (and this is closely bound up with my inner development), I did not want to banish objects completely. I have in many places spoken at length about the fact that objects, in themselves, have a particular spiritual sound, which can and does serve as the material for all realms of art. And I was still too strongly bound up with the wish to seek purely pictorial forms having *this* spiritual sound. Thus, I dissolved objects to a greater or lesser extent within the same picture, so that they might not all be recognized at once and so that these emotional overtones might thus be experienced gradually by the spectator, one after another. Here and there, purely abstract forms entered of their own accord, which therefore had to produce a purely pictorial effect without the above-mentioned coloration. In other words, I myself was not yet sufficiently mature to experience purely abstract form without bridging the gap by means of objects. If I had possessed this ability, I would already have created absolute pictures at that time.

In general, however, I already knew quite definitely at that time that I would conquer absolute painting. Experience bade me have the utmost patience. And yet, there were many times when it was infinitely difficult to follow this bidding.

[...] For a time I concentrated all my efforts upon the linear element, for I knew internally that this element still requires my attention. The colors, which I employed later, lie as if upon one and the same plane, while their inner weights are different. Thus, the collaboration of different spheres entered into my pictures of its own accord. By this means I also avoided the element of flatness in painting, which can easily lead and has already so often led to the ornamental. This difference between the inner planes gave my pictures a depth that more than compensated for the earlier, perspective depth. I distributed my weights so that they revealed no architectonic center. Often, heavy was at the top and light at the bottom. Often, I left the middle weak and strengthened the corners. I would put a crushing weight between parts that weighed little. I would let cold come to the fore and drive warm into the background. I would treat the individual color-tones likewise, cooling the warmer tones, warming the cold, so that even one single color was raised to the level of a composition. It is impossible, and relatively fruitless, to enumerate all the things that served me as means to an end. [...]

The summer of 1911, which was unusually hot for Germany, lasted desperately long. Every morning on waking, I saw from the window the incandescent blue sky. The thunderstorms came, let fall a few drops of rain, and passed on. I had the feeling as if someone seriously ill had to be made to sweat, but that no remedies were of any use: hardly had a few beads of sweat appeared than the tortured body would begin to burn all over again. One's skin cracked. One's breath failed. Suddenly, all nature seemed to me white; white (great silence – full of possibilities) displayed itself everywhere and expanded visibly. Later, I remembered this feeling when I observed that white played a special role and had been treated with particular attention in my pictures. Since that time, I know what undreamed-of possibilities this primordial color conceals within itself. I saw how wrongly I had hitherto conceived of this color, for I had regarded its presence in large masses as necessary merely to emphasize the linear element,

and had been afraid of the reckless quality of its inner strength. This discovery was of enormous importance for me. I felt, with an exactitude I had never yet experienced, that the principal tone, the innate, inner character of a color can be redefined *ad infinitum* by its different uses, that, e.g., the indifferent can become more expressive than what is thought of as the most highly expressive. This revelation turned the whole of painting upside-down and opened up before it a realm in which one had previously been unable to believe. I.e., the inner, thousandfold, unlimited values of one and the same quality, the possibility of obtaining and applying infinite series simply in combination with one single quality, tore open before me the gates of the realm of absolute art.

A spiritual-logical consequence of this experience was the impulse to make the external element of form even more concise, to clothe content in much cooler forms. To my way of thinking, which was at that time still completely unconscious, the highest tragedy clothed itself in the greatest coolness, that is to say, I saw that the greatest coolness is the highest tragedy. This is that cosmic tragedy in which the human element is only one sound, only a single voice, whose focus is transposed to within a sphere that approaches the divine. One must employ such expressions with care, and not play with them. Here, however, I use them consciously, and feel entitled to do so, for at this point I am speaking not about my own pictures, but about a kind of art that has never yet been personified and in its abstract being still waits for incarnation.

It was in this spirit, as far as I personally am concerned, that I painted many pictures (*Picture with Zig Zag, Composition 5* and *6*, etc.). I was, however, certain that if I lived long enough, I should enter into the realm I saw before my eyes. Just as one sees the summit of the mountain from below.

For the same reason, I became more and more strongly attracted by the unskilled. I abbreviated the expressive element by lack of expression. By the external position in which I placed it, I would emphasize an element that was in itself not very clear in its expression. I deprived my colors of their clarity of tone, dampening them on the surface and allowing their purity and true nature to glow forth, as if through frosted glass. *Improvisation 22* and *Composition 5* are painted in this way, as well as, for the most part, *Composition 6*. [...] *Composition 2* is painted without theme, and perhaps at that time I would have been nervous of taking a theme as my starting point. On the other hand, I calmly chose the Resurrection as the theme for *Composition 5*, and the Deluge for the sixth. One needs a certain daring if one is to take such outworn themes as the starting point for pure painting. It was for me a trial of strength, which in my opinion has turned out for the best.

The pictures painted since then have neither any theme as their point of departure, nor any forms of corporeal origin. This occurred without force, quite naturally, and of its own accord. In these latter years, forms that have arisen of their own accord right from the beginning have gained an ever-increasing foothold, and I immersed myself more and more in the manifold value of abstract elements. In this way, abstract forms gained the upper hand and softly but surely crowded out those forms that are of representational origin.

Thus, I circumnavigated and left behind me the three greatest dangers on the path I had foreseen. These were:

1 The danger of stylized form, which either comes into the world stillborn, or else, too weak to live, quickly dies.
2 The danger of ornamental form, the form belonging mainly to external beauty, which can be, and as a rule is outwardly expressive and inwardly expressionless.
3 The danger of experimental form, which comes into being by means of experimentation, i.e., completely without intuition, possessing, like *every* form, a certain inner sound, but one that deceitfully simulates internal necessity.

Inner maturity, upon which in general I have firmly relied, but which has afforded me nonetheless many a bitter hour of hopelessness, has of itself created the [necessary] formal element.

As has been said often enough, it is impossible to make clear the aim of a work of art by means of words. Despite a certain superficiality with which this assertion is leveled and in particular exploited, it is by and large correct, and remains so even at a time of the greatest education and knowledge of language and its material. And this assertion – I now abandon the realm of objective reasoning – is also correct because the artist himself can never either grasp or recognize fully his own goal.

And finally: the best of words are no use to him whose sensibilities have remained at an embryonic stage.

In conclusion, therefore, I shall embark upon the negative path and explain as clearly as possible what I do not want. Many assertions of present-day art criticism are refuted in the process, for such criticism has, alas, until now been often rebarbative and has shouted falsehoods into the ears of many who were inclined to hear.

I do not want to paint music.

I do not want to paint states of mind [*Seelenzustände*].

I do not want to paint coloristically or uncoloristically.

I do not want to alter, contest, or overthrow any single point in the harmony of the masterpieces of the past.

I do not want to show the future its true path.

Apart from my theoretical works, which until now from an objective, scientific point of view leave much to be desired, I only want to paint good, necessary, living pictures, which are experienced properly by at least a few viewers.

* * *

10 Franz Marc (1880–1916) 'The "Savages" of Germany' and 'Two Pictures'

Marc was co-editor with Kandinsky of the almanac *Der Blaue Reiter*, in which the present two texts were originally published in 1912. In his own paintings Marc purveyed a mystical approach to the natural and animal world, as a form of refusal of the urban and technical emphases of modern life. In these extracts Marc surveys the various groups composing the Expressionist avant-garde in Germany and justifies their evident unpopularity in terms of an epochal historical rupture. These translations are taken from K. Lankheit (ed.), *The Blaue Reiter Almanac*, English version, London, 1974, pp. 61, 64, 66–7, 68–9.

The 'Savages' of Germany

In this time of the great struggle for a new art we fight like disorganized 'savages' against an old, established power. The battle seems to be unequal, but spiritual matters are never decided by numbers, only by the power of ideas.

The dreaded weapons of the 'savages' are their *new ideas*. New ideas kill better than steel and destroy what was thought to be indestructible.

Who are these 'savages' in Germany?

For the most part they are both well known and widely disparaged: the Brücke in Dresden, the Neue Sezession in Berlin, and the Neue Vereinigung in Munich.

* * *

It is impossible to explain the recent works of these 'savages' as a formal development and new interpretation of impressionism ... The most beautiful prismatic colors and the celebrated cubism are now meaningless goals for these 'savages.'

Their thinking has a different aim: To create out of their work *symbols* for their own time, symbols that belong on the altars of a future spiritual religion, symbols behind which the technical heritage cannot be seen.

Scorn and stupidity will be like roses in their path.

Not all the official 'savages' in or out of Germany dream of this kind of art and of these high aims.

All the worse for them. After easy successes they will perish from their own superficiality despite all their programs, cubist and otherwise.

But we believe – at least we hope we are justified in believing – that apart from all these 'savage' groups in the forefront there are many quiet powers in Germany struggling with the same high, distant goals and that ideas are silently maturing unknown to the heralds of the battle.

In the dark, without knowing them, we give them our hand.

Two Pictures

It can be sensed that there is a new religion arising in the country, still without a prophet, recognized by no one.

Religions die slowly.

But the artistic style that was the inalienable possession of an earlier era collapsed catastrophically in the middle of the nineteenth century. There has been no style since. It is perishing all over the world as if seized by an epidemic. Since then, serious art has been the work of individual artists whose art has had nothing to do with 'style' because they were not in the least connected with the style or the needs of the masses. Their works arose rather in defiance of their times. They are characteristic, fiery signs of a new era that increase daily everywhere. This book will be their focus until dawn comes and with its natural light removes from these works the spectral appearance they now have. What appears spectral today will be natural tomorrow.

Where are such signs and works? How do we recognize the genuine ones?

Like everything genuine, its inner life guarantees its truth. All works of art created by truthful minds without regard for the work's conventional exterior remain genuine for all times.

* * *

The present isolation of the rare, genuine artist is absolutely unavoidable for the moment.
[...]
The reasons, we think, are these: nothing occurs accidentally and without organic reason – not even the loss of artistic style in the nineteenth century. This fact leads us to the idea that we are standing today at the turning point of two long epochs, similar to the state of the world fifteen hundred years ago, when there was also a transitional period without art and religion – a period in which great and traditional ideas died and new and unexpected ones took their place. Nature would not wantonly destroy the religion and art of the people without a great purpose. We are also convinced that we can already proclaim the first signs of the time.

The first works of a new era are tremendously difficult to define. Who can see clearly what their aim is and what is to come? But just the fact that they *do exist* and appear in many places today, sometimes independently of each other, and that they possess inner truth, makes us certain that they are the first signs of the coming new epoch – they are the signal fires for the pathfinders.

The hour is unique. Is it too daring to call attention to the small, unique signs of the time?

11 August Macke (1887–1914) 'Masks'

Macke was associated with Kandinsky and Marc in Munich in 1909–10 and joined with them in the formation of Der Blaue Reiter. Originally published in the *Blaue Reiter* almanac in 1912, the present text furnishes a typical case of the association of Modernism with the primitive, and of that diversification in the interests of art and art history which took place in Germany at the turn of the century. This translation from Lankheit, op. cit., pp. 85, 87–9.

[...] Is life not more precious than food and the body not more precious than clothing?

Incomprehensible ideas express themselves in comprehensible forms. Comprehensible through our senses as star, thunder, flower, as form.

Form is a mystery to us for it is the expression of mysterious powers. Only through it do we sense the secret powers, the 'invisible God.'

The senses are our bridge between the incomprehensible and the comprehensible.

To behold plants and animals is: to perceive their secret.

To hear the thunder is: to perceive its secret. To understand the language of forms means: to be closer to the secret, to live.

To create forms means: to live. Are not children more creative in drawing directly from the secret of their sensations than the imitator of Greek forms? Are not savages artists who have forms of their own powerful as the form of thunder?

Thunder, flower, any force expresses itself as form. So does man. He, too, is driven by something to find words for conceptions, to find clearness in obscurity, consciousness in the unconscious. This is his life, his creation.

As man changes, so do his forms change.

The relations that numerous forms bear to one another enable us to recognize the individual form. Blue first becomes visible against red, the greatness of the tree against the smallness of the butterfly, the youth of the child against the age of the old man. One

and two make three. The formless, the infinite, the zero remain incomprehensible. God remains incomprehensible.

Man expresses his life in forms. Each form of art is an expression of his inner life. The exterior of the form of art is its interior.

Each genuine form of art emerges from a living correlation of man to the real substance of the forms of nature, the forms of art. The scent of a flower, the joyful leaping of a dog, a dancer, the donning of jewelry, a temple, a painting, a style, the life of a nation, of an era.

The flower opens at sunrise. Seeing his prey, the panther crouches, and as a result of seeing it, his strength grows. And the tension of his strength shows in the length of his leap. The form of art, its style, is a result of tension.

* * *

In our complicated and confused era we have forms that absolutely enthrall everyone in exactly the same way as the fire dance enthralls the African or the mysterious drumming of the fakirs enthralls the Indian. As a soldier, the independent scholar stands beside the farmer's son. They both march in review similarly through the ranks, whether they like it or not. At the movies the professor marvels alongside the servant girl. In the vaudeville theater the butterfly-colored dancer enchants the most amorous couples as intensely as the solemn sound of the organ in a Gothic cathedral seizes both believer and unbeliever.

Forms are powerful expressions of powerful life. Differences in expression come from the material, word, color, sound, stone, wood, metal. One need not understand each form. One also need not read each language.

The contemptuous gesture with which connoisseurs and artists have to this day banished all artistic forms of primitive cultures to the fields of ethnology or applied art is amazing at the very least.

What we hang on the wall as a painting is basically similar to the carved and painted pillars in an African hut. The African considers his idol the comprehensible form for an incomprehensible idea, the personification of an abstract concept. For us the painting is the comprehensible form for the obscure, incomprehensible conception of a deceased person, of an animal, of a plant, of the whole magic of nature, of the rhythmical. [...]

Everywhere, forms speak in a sublime language right in the face of European aesthetics. Even in the games of children, in the hat of a cocotte, in the joy of a sunny day, invisible ideas materialize quietly.

The joys, the sorrows of man, of nations, lie behind the inscriptions, paintings, temples, cathedrals, and masks, behind the musical compositions, stage spectacles, and dances. If they are not there, if form becomes empty and groundless, then there is no art.

12 Emil Nolde (1867–1956) 'On Primitive Art'

The painter Nolde was a member of the Brücke from 1906 to 1908 (see IB4). His work is central to the characterization of a specifically German form of Expressionism. In the paintings by which he is best known, 'primitive' figure types are used to evoke emotional and religious themes. The present text was incorporated in Nolde's autobiographical *Jahre der Kämpfe* [*Years of Struggle*] *1912–1914*, Berlin, Rembrandt, 1934, pp. 172–8, with a note to the effect that it had been written in 1912 to introduce an intended book 'on the

artistic expressions of primitive peoples' on which Nolde was working at the time. The present translation is made from the 1934 edition.

1 'The most perfect art was Greek art. Raphael is the greatest of all masters in painting.' Such were the doctrines of every art teacher only twenty or thirty years ago.
2 Since then, much has changed. We do not care for Raphael, and are less enthusiastic about the statues of the so-called golden age of Greece. Our predecessors' ideals are not ours. Works signed by great names over the centuries appeal to us less. In the hurry and bustle of their times, worldly-wise artists created works for Popes and palaces. It is the ordinary people who laboured in their workshops and of whose lives scarcely anything is now known, whose very names have not come down to us, that we love and respect today in their plain, large-scale carvings in the cathedrals of Naumburg, Magdeburg and Bamberg.
3 Our museums are getting large and crammed and are growing rapidly. I am not keen on these vast collections, deadening by virtue of their sheer mass. A reaction against such excess must surely come soon.
4 Not long ago only a few artistic periods were thought suitable for museums. Then they were joined by exhibitions of Coptic and early Christian art, Greek terracottas and vases, Persian and Islamic art. But why is Indian, Chinese and Javanese art still classified under ethnology or anthropology? And why is the art of primitive peoples not considered art at all?
5 What is it about these primitive forms of expression that appeals so much to us artists?
6 In our own time, every earthenware vessel or piece of jewellery, every utensil or garment, has to be designed on paper before it is made. Primitive peoples, however, create their works with the material itself in the artist's hand, held in his fingers. They aspire to express delight in form and the love of creating it. Absolute originality, the intense and often grotesque expression of power and life in very simple forms – that may be why we like these works of native art.

13 Oskar Kokoschka (1886–1980) 'On the Nature of Visions'

Kokoschka's brief text condenses many of those themes which pervaded the Austro-German Expressionist avant-garde in the years before the First World War. Not yet inflected by politics, as Expressionism was to be by the war, Kokoschka's preoccupation is with that constant of German Idealism: the Spirit. He offers a vitalism in which the soul, notably the soul of the artist – free, untrammelled, and marked by a kind of fierce innocence – is in direct harmony with the forces of nature and the universe. Tellingly, his metaphors tend to the Biblical. Originally delivered as a lecture in Vienna, 26 January 1912, the text appeared in English translation by Heidi Medlinger and John Thwaites in Edith Hoffmann, *Kokoschka. Life and Work*, London, 1947, pp. 285–7, from which the present version is taken.

The state of awareness of visions is not one in which we are either remembering or perceiving. It is rather a level of consciousness at which we experience visions within ourselves.

This experience cannot be fixed; for the vision is moving, an impression growing and becoming visual, imparting a power to the mind. It can be evoked but never defined.

Yet the awareness of such imagery is a part of living. It is life selecting from the forms which flow towards it or refraining, at will.

A life which derives its power from within itself will focus the perception of such images. And yet this free visualizing in itself – whether it is complete or hardly yet perceptible, or undefined in either space or time – this has its own power running through. The effect is such that the visions seem actually to modify one's conscious-ness, at least in respect of everything which their own form proposes as their pattern and significance. This change in oneself, which follows on the vision's penetration of one's very soul, produces the state of awareness, of expectancy. At the same time there is an outpouring of feeling into the image which becomes, as it were, the soul's plastic embodiment. This state of alertness of the mind or consciousness has, then, a waiting, receptive quality. It is like an unborn child, as yet unfelt even by the mother, to whom nothing of the outside world slips through. And yet whatever affects his mother, all that impresses her down to the slightest birthmark on the skin, all is implanted in him. As though he could use her eyes, the unborn receives through her his visual impres-sions, even while he is himself unseen.

The life of the consciousness is boundless. It interpenetrates the world and is woven through all its imagery. Thus it shares those characteristics of living which our human existence can show. One tree left living in an arid land would carry in its seed the potency from whose roots all the forests of the earth might spring. So with ourselves; when we no longer inhabit our perceptions they do not go out of existence; they continue as though with a power of their own, awaiting the focus of another conscious-ness. There is no more room for death; for though the vision disintegrates and scatters, it does so only to reform in another mode.

Therefore we must harken closely to our inner voice. We must strive through the penumbra of words to the core within. 'The Word became flesh and dwelt among us.' And then the inner core breaks free – now feebly and now violently – from the words within which it dwells like a charm. 'It happened to me according to the Word.'

If we will surrender our closed personalities, so full of tension, we are in a position to accept this magical principle of living, whether in thought, intuition, or in our relationships. For in fact we see every day beings who are absorbed in one another, whether in living or in teaching, aimless or with direction. So it is with every created thing, everything we can communicate, every constant in the flux of living; each one has its own principle which shapes it, keeps life in it, and maintains it in our consciousness. Thus it is preserved, like a rare species, from extinction. We may identify it with 'me' or 'you' according to our estimate of its scale or its infinity. For we set aside the self and personal existence as being fused into a larger experience. All that is required of us is to RELEASE CONTROL. Some part of ourselves will bring us into the unison. The inquiring spirit rises from stage to stage, until it encompasses the whole of Nature. All laws are left behind. One's soul is a reverberation of the universe. Then too, as I believe, one's perception reaches out towards the Word, towards awareness of the vision.

As I said at first, this awareness of visions can never fully be described, its history can never be delimited, for it is a part of life itself. Its essence is a flowing and a taking form. It is love, delighting to lodge itself in the mind. This adding of something to ourselves – we may accept it or let it pass; but as soon as we are ready it will come to us by impulse,

from the very breathing of our life. An image will take shape for us suddenly, at the first look, as the first cry of a newborn child emerging from its mother's womb.

Whatever the orientation of a life, its significance will depend on this ability to conceive the vision. Whether the image has a material or an immaterial character depends simply on the angle from which the flow of psychic energy is viewed, whether at ebb or flood.

It is true that the consciousness is not exhaustively defined by these images moving, these impressions which grow and become visual, imparting a power to the mind which we can evoke at will. For of the forms which come into the consciousness some are chosen while others are excluded arbitrarily.

But this awareness of visions which I endeavor to describe is the viewpoint of all life as though it were seen from some high place; it is like a ship which was plunged into the seas and flashes again as a winged thing in the air.

Consciousness is the source of all things and of all conceptions. It is a sea ringed about with visions.

My mind is the tomb of all those things which have ceased to be the true Hereafter into which they enter. So that at last nothing remains; all that is essential of them is their image within myself. The life goes out of them into that image as in the lamp the oil is drawn up through the wick for nourishing the flame.

So each thing, as it communicates itself to me, loses its substance and passes into the HEREAFTER WHICH IS MY MIND. I incorporate its image which I can evoke without the intermediacy of dreams. 'Whenever two or three are gathered together in My name, I am in their midst' [Matt. 18:20]. And, as though it could go out to men, my vision is maintained, fed, as the lamp is by its oil, from the abundance of their living. If I am asked to make all this plain and natural the things themselves must answer for me, as it were, bearing their own witness. For I have represented them, I have taken their place and put on their semblance through my visions. It is the psyche which speaks.

I search, inquire, and guess. And with what sudden eagerness must the lamp wick seek its nourishment, for the flame leaps before my eyes as the oil feeds it. It is all my imagination, certainly, what I see there in the blaze. But if I have drawn something from the fire and you have missed it, well, I should like to hear from those whose eyes are still untouched. For is this not my vision? Without intent I draw from the outside world the semblance of things; but in this way I myself become part of the world's imaginings. Thus in everything imagination is simply that which is natural. It is nature, vision, life.

14 Alexander Shevchenko (1888–1948) 'Neo-Primitivism'

The painter Shevchenko was one of the several members of the Russian avant-garde who combined an interest in the artistic culture of the peasantry with an informed assimilation of French Cubism. He contributed to the 'Donkey's tail' group exhibition in March 1912, and his essay was published as a pamphlet in Moscow during the following year. Its full title is 'Neo-Primitivism: Its Theory, Its Potentials, Its Achievements'. The present translation is from the French version by Anne Duruflé, in T. Andersen, *Art et Poésies Russes 1900–1930. Textes choisis*, Paris: Centre Pompidou, 1979, pp. 71–3, 75–7. (A *lubok* is a form of vernacular Russian woodcut.)

We who hold Neo-Primitivism to be the artist's religion say:

Physical nature in the true sense no longer exists. It has become the foundation of apartment blocks, and the asphalt of pavements and streets. Physical nature is nothing but a memory, like a tale about something marvellous that has long since disappeared.

The Factory-Town dominates everything.

Perpetual movement, endless coming and going, nightmarish and confused visions of the city follow one after the other. In the daylight which is obscured by houses, in the light created by the electric suns of the night, life appears completely different to us, full of other new forms.

The world has been transformed into a monstrous, fantastic, perpetually moving machine; into an enormous automatic organism, inanimate, a gigantic whole constructed on a strict correspondence and balance of parts.

We and the entire world are parts of the whole.

Robot-like, we have become habituated to life – getting up, going to bed, eating and working to set times; and this sense of rhythm and mechanical harmony is reflected in our entire life, cannot but be reflected in our mode of thought, in our spiritual life, in art.

A simple, physical copy of nature can no longer satisfy us.

We are used to seeing surrounding nature modified, embellished by the hands of man the creator, and we can only demand the same of art.

Such is the creation of the century in which we live.

Naturalistic painting does not exist for us, just as nature does not exist without cleared, sanded or asphalted roads, without water-mains and artificial light, without telephone or tramway.

We are endeavouring to find new paths for our art, but we do not reject the old forms altogether, and of these we acknowledge above all primitive art, magic tales of the ancient Orient.

The simple and innocent beauty of the *lubok*, the austerity of primitive art, the mechanical precision of construction, the stylistic nobility and beautiful colours gathered together by the creative hand of the master artist, that is our watchword and slogan.

Life without movement is nothing, and that is why we always try not to restrict the form of objects to a single plane, but to communicate their movement by representing their intermediate forms.

Beauty only resides in the harmony of simple combinations of forms and colours. Mannered beauty borders on the illusory sophistication of the market, a product of the corruption of popular taste.

Primitives, icons, *lubki*, trays, signboards, fabrics of the Orient...these are the models of real value and of pictorial beauty.

The words 'Art' (that is to say fiction) and 'Nature' (that is to say reality), intersect to become 'the creative will of the painter', which takes its materials from divergent sources. That is why we do not aim for a naturalistic resemblance to nature in our paintings.

Nature is a raw material, which only excites in our souls this or that emotion at the moment when we carry out what we have conceived of within the plan of the painting.

One should copy neither art nor life, but instead observe them and study them both ceaselessly. In art, the observation and the study of nature must have as a point of departure a subject of art itself. We take as the starting-point of our art the *lubok*, primitive art, and the icon, for there we find a more precise, more direct perception of life and one which is, furthermore, purely pictorial.

Just like the primitivists and the painters of the East, we consider that the most valuable and productive work is that which is guided by direct perception. This opens up greater possibilities to the artist to reveal his own conception of the world, and does not distract attention with unnecessary details, which too often happens when one works from nature.

* * *

The word Neo-Primitivism itself is a word which both characterizes the evolution of pictorial realizations, their origin in primitive art, and likewise testifies that they belong to our era.

There are not and there cannot be phenomena arising from nothing.

Ideas are not born but reborn, and so everything that is normal is successive and develops from preceding forms.

Such is our school which, taking primitive art as its source, develops in the contemporary era.

Generally it is admissible to describe as primitive, not only the simplicity, the clumsiness of past artists, but also folk art, for which there is a specific name, the *lubok*. The word primitive directly reveals an Oriental origin, for today it reflects the entire spectrum of Oriental art – Japanese, Chinese, Korean, Indo-Persian art...

In our school, this notion reveals the character of painting (not of the subject), the manner of execution, the use of pictorial traditions of the Orient.

This initiation to the Orient is an inner and spiritual one. But this is not a simple imitation, of which one usually says 'it is in an Oriental style'; for example, Stelletski, whose works in no way speak of old Russia, of Byzantium, of icons, does not achieve this. This is nothing but historicism, the examining of lofty ideas in the manner of a dilettante, an imitation lacking perception, whereas the icons are completely suffused by the Orient and by Byzantium and at the same time remain completely original.

Neo-Primitivism is a profoundly national phenomenon.

Russia and the Orient have been indissolubly linked since the Tartar invasions, and the spirit of the Tartars, the spirit of the Orient, is embedded in our lives to such a degree that it is sometimes difficult to distinguish where the national character trait ends and where the influence of the Orient begins.

All human culture has in general come from Asia, not the other way round as certain people assert.

Our entire Asiatic culture and the foreign masters, the architects, weavers, artists, and all those from the Occident carrying within them a spark of European civilization, fell immediately in our barbarous country under the influence of the Tartar culture, of the Orient, of our more original, more passionate culture, and the Occidental civilization was reduced to dust before the Oriental culture.

Take our ancient Russian painting. It suffices to compare our grass writing with the tapestries of the Orient, our 'spiritual and moral painting' and its direct extension – the popular images and the *lubki* – with Indo-Persian painting, to discover quite clearly their common origin, their spiritual affinity.

In other countries, the influence of the Orient is no less evident, no less grandiose; the forms of Occidental art fashioned themselves entirely from Byzantine forms, which had been borrowed in their turn from the even older art of Georgia and Armenia.

Thus one comes full circle, a progression of the arts from us, the Orient, the Caucasus, towards Byzantium; then to Italy, borrowing from there techniques of oil painting and the easel; then returning to us.

Hence the epithets like 'Frenchified Painting' in which, if we take our investigation further, we find the splendour of our Barbary once again, the primitive art of the Orient, more so than the Occident with its simple, naturalistic, sometimes quite absurd imitation of nature.

All of this can in a sufficient measure justify our enthusiasm for the art of the Orient. It has become evident that there is no other reason to use the products of the Occident, which received them from the Orient, all the more so since after their long circular voyage they have had plenty of time to spoil and rot.

There is no longer any reason since we have daily and direct contact with Asia.

We are called Barbarians, Asiatics.

Yes, we are Asia and we are proud of it because 'Asia is the cradle of Nations', a good measure of Tartar blood flows in our veins and we salute the Orient which is to come, ultimate origin, cradle of culture, of all the arts.

Hence Neo-Primitivism which takes the Orient as its origin is not the repetition, the popularization of the Oriental which inevitably renders all art forms banal; no, it is entirely original. The Orient is reflected in Neo-Primitivism to a great extent, for instance in the interpretation, the traditions; yes, but our own national art plays a large role. (Just as when children create art.) This primitive art which is unique in its genre, is always profound and true, created where our Asiatic origin can be found in all its plenitude.

Nor is Neo-Primitivism a stranger to Occidental forms and we declare openly:

Asia has given us all the depth of its culture, its primitive nature, and Europe has in its turn added some traits of its own civilization.

Thus Neo-Primitivism is born of the fusion of Oriental traditions and the forms of the Occident. [. . .]

15 Benedetto Croce (1866–1952) 'What Is Art?'

The Italian philosopher Croce was an influential exponent of the view that art is to be identified with intuition, rather than with any physical object or range of objects. There are clear links between his aesthetic theory and the work of such Modernist critics as Roger Fry (IB7) and Clive Bell (IB16). Croce's *Guide to Aesthetics* was originally published as *Brevario di estetica* in 1913. The present extract is taken from the opening chapter in the translation by Patrick Romanell, Indianapolis, 1965.

[. . .] The question as to what art is – let me answer it immediately and in the simplest manner: art is *vision* or *intuition*. The artist produces an image or picture. The person who enjoys art turns his eyes in the direction which the artist has pointed out to him, peers through the hole which has been opened for him, and reproduces in himself the artist's image. 'Intuition,' 'vision,' 'contemplation,' 'imagination,' 'fancy,' 'invention,' 'representation,' and so forth, are words which continually reappear as almost synonymous in discussions on art. All of them give rise in our minds to the same concept or to the same set of concepts – a sign of universal consent.

But this answer of mine, that art is intuition, acquires significance as well as strength from all that it implicitly denies and from which art is distinguished. What are the negations it includes? I shall indicate the chief ones, or at least those most important for us at our present moment of culture.

The answer denies, above all, that art is a *physical* fact, as, for example, certain particular colors or combinations of colors, forms of the body, sounds or combinations of sounds, phenomena of heat or electricity – in brief, anything which goes under the name of 'physical.' [...]

* * *

...to overcome the strange and harsh sound of the truth in question or to become familiar with it, we should take into consideration that the proof of the unreality of the physical world has not only been established in an irrefutable way and is conceded by all philosophers (who are neither crass materialists nor involved in the strident contradictions of materialism), but that the proof itself is being acknowledged by the physicists themselves – as evident in the traces of philosophy which they mix in with their science – when they conceive physical phenomena as manifestations of principles which go beyond experience, such as the atoms or the ether, or as the manifestation of an Unknowable. Besides, the very Matter of the materialists is a supermaterial principle. Thus, physical facts, by their internal logic and by common consent, make themselves known not as something truly real, but as a *construction of our intellect for purposes of science*. Consequently, the question as to whether art is a physical fact should rationally assume another meaning, namely, whether art may *be constructed physically*.

This is certainly possible, and we actually do so whenever, on diverting our attention from the sense of a poem, or on giving up its enjoyment, we begin, say, to count the words of which the poem is composed and divide them into syllables and letters. Or whenever, on diverting our attention from the aesthetic effect of a statue, we measure it and weigh it. To do so is, no doubt, of the greatest utility to packers of statues, as to count words is useful to printers who have to 'compose' pages of poetry! But it is utterly useless to the contemplator or student of art, to whom it is not useful or permissible 'to divert his attention' from his proper object. Not even, therefore, in this second sense is art a physical fact, because when we undertake to penetrate its nature and its mode of operation, it is of no avail to make a physical thing out of it.

Another negation implicit in the definition of art as intuition is that if art is intuition, and if intuition signifies *theory* in the original sense of contemplation, then art cannot be a utilitarian act. For, inasmuch as a utilitarian act aims always at arriving at a pleasure and, hence, at removing a pain, art considered in terms of its own nature has nothing to do with the *useful*, or with *pleasure* and *pain*, as such.

It will be admitted in effect, without too much opposition, that a pleasure as pleasure, any pleasure whatever, is not in itself artistic. The pleasure from a drink of water which quenches our thirst is not artistic. Neither is a walk in the open air which stretches our limbs and makes our blood circulate more rapidly, nor is the attainment of a coveted post which results in lending security to our practical life, and so forth. Even in the relations which develop between ourselves and works of art, the difference between pleasure and art is self-evident. For the figure represented may be dear to us and awaken the most delightful memories, but the picture may be ugly, nevertheless. On the other hand, the picture may be beautiful, but the figure represented abominable

to our soul. Or the picture itself, which we approve as beautiful, may provoke later a fit of rage and envy, owing to its being a work of an enemy or a rival, to whom it will bring certain advantages and renewed vigor. Our practical interests, with their correlative pleasures and pains, are blended, become confused now and then, and disquiet our aesthetic interest, but never become *united* with it.

At most, to defend on more valid grounds the definition of art as the pleasurable, one might argue that art is not the pleasurable in general but a *special* form of it. However, this restriction is no longer a defense but rather an actual abandonment of that thesis. For assuming that art is a special form of the pleasurable, it follows that its distinctive character would not be supplied by the pleasurable as such, but by whatever distinguishes the artistic from other forms of the pleasurable. And it is to that distinctive element apart from the pleasurable, or different from it, to which it would be fitting to address the inquiry. [...]

A third negation effected with the help of the theory of art as intuition is the denial of art as a *moral act*. In other words, it denies that art is that form of practical activity which, though necessarily associated with the useful and with pleasure and pain, is not immediately utilitarian and hedonistic, operating as it does on a higher spiritual plane. Even so, as theoretical activity, intuition is against anything practical. In fact, as has been observed from time immemorial, art does not originate from an act of will. Good will, which constitutes the honest man, does not constitute the artist. Moreover, since art is not born from an act of will, it likewise is not subject to any moral evaluation, not because an exemption privilege is accorded to it, but simply because no way is available to apply moral distinctions to it. An artistic image can depict a morally praiseworthy or blameworthy action. But the image itself, as such, is neither praiseworthy nor blameworthy, morally. Not only is there no penal code which can condemn an image to prison or to death, but no moral judgment passed by a reasonable person could ever address itself to it as its object. Otherwise, to judge Dante's Francesca immoral or Shakespeare's Cordelia moral (these perform a mere artistic function, being like musical notes within Dante's and Shakespeare's souls) would be just as valid as to judge a square moral or a triangle immoral.

Furthermore, the moralistic theory of art is also represented in the history of aesthetic doctrines and is not altogether dead even today, although it is much discredited in current opinion. However, it is discredited not only for its internal defect, but, in addition, to some extent, on account of the moral shortcomings of some present tendencies which facilitate, thanks to psychological jargon, that refutation which should be made – and which we are here doing – solely on logical grounds. From the moralistic doctrine is derived art's pre-established goal to serve as a guide to the good, inspire the abhorrence of evil, correct and improve manners and morals. And from the same source comes the demand that artists contribute to the public education of the lower classes, the reinforcing of the national or warlike spirit of a people, the spreading of the ideals of a modest and industrious life, and so on.

All of which are things that art cannot do, any more than can geometry, which, notwithstanding, does not lose any of its respectability on this account; and in view of this, one does not see why art should lose any of its, either. [...]

[...] The moralistic doctrine has also its true side. For if art is beyond morals, the artist is not, since he is neither beyond nor this side of it, but under its dominion. Insofar as he is a man, the artist cannot shirk the duties of man and should consider art

itself – which is not and never will be morals – as a mission, to be practised like a priesthood.

Furthermore (and this is the last, and perhaps the most important, of the general negations which it suits my purposes to mention here), with the definition of art as intuition goes the denial that it has the character of *conceptual knowledge*. Conceptual knowledge in its pure form (which is that of the philosophical) is always oriented toward reality and aims to establish the real as distinguished from the unreal, or to diminish unreality in status by including it within reality as a subordinate part of itself. In contrast, intuition refers precisely to the lack of distinction between reality and unreality – to the image itself – with its purely ideal status as mere image.

The contrast being made here between intuitive or sensuous and conceptual or intellectual knowledge, between aesthetics and noetics, is aimed at restoring the autonomy of this simpler and elementary form of knowledge, which has been compared with the dream (dream, certainly not sleep) of the theoretical life, with respect to which philosophy would be the waking state. Accordingly, whoever before a work of art asks whether what the artist has expressed be metaphysically or historically true or false is asking a meaningless question, and falls into the error analogous to the one of the man who wants to bring before the tribunal of morality the ethereal images of fancy.

The question is meaningless because the distinction of true and false always concerns an assertion about reality, that is, a judgment, and thus is not applicable to the presentation of an image or to a mere subject – which is not the subject in a proposition, lacking as it does attribute or predicate. It is useless to object that the individual character of the image has no meaning without a reference to the universal, of which that image is its individuation. For here we certainly are not denying that the universal, like the spirit of God, is everywhere and animates everything from within itself. But we are denying that the universal is logically explicit or thought out in intuition as such. And likewise is it useless to appeal to the principle of the unity of the spirit, which is not weakened but rather strengthened by our precise distinction between fancy and thought, because only from distinction is opposition born, and concrete unity from opposition.

Ideality (as this property which distinguishes intuition from concept, art from philosophy and history, from assertion of the universal, and from perception or narration of events, has also been called) is the quintessence of art. As soon as reflection or judgment develops out of that state of ideality, art vanishes and dies. It dies in the artist, who changes from artist and becomes his own critic; it dies in the spectator or listener, who from rapt contemplator of art changes into a thoughtful observer of life.

* * *

In reality, intuition is production of an image. But it is not production of an incoherent accumulation of images obtained by reconjuring up ancient images, letting them succeed each other at will, or combining them in the same arbitrary fashion, such as joining the neck of a horse to the human head, as is done in a child's game. In order to express this distinction between intuition and fantasy, the olden poetics made use, especially, of the concept of *unity* and required that any artistic work produced be *simplex et unum*; or it utilized the allied concept of *unity in variety*, according to which the several images were to come to a focus and blend into a complex image. To meet the same need, the aesthetics of the nineteenth century worked out the distinction (which is found in not a few of its philosophers) between *fancy* (corresponding to the

artistic faculty proper) and *imagination* (corresponding to the extra-artistic faculty). To collect, select, divide, and combine images presupposes within the spirit the production and the possession of the single images themselves. Fancy is a producer, whereas imagination is a parasite, fit for incidental occasions but incapable of begetting organization and life. [. . .]

The artistic image (it has been said) is such, when it attaches an intelligible to a sensible, and represents an *idea*. Now 'intelligible' and 'idea' cannot have any other meaning (nor have they had any other for the defenders of this theory) than concept, even though it is the concrete concept or idea, which is peculiar to lofty philosophical speculation and differs from abstract concepts and from those representative of the sciences. But, in any case, the concept or idea unites the intelligible with the sensible in every instance, and not solely in art. For the new conception of the concept, inaugurated by Kant and immanent (so to speak) in all modern thought, heals the breach between the sensible and the intelligible worlds, conceiving as it does the concept as judgment, judgment as a priori synthesis, and a priori synthesis as the word which becomes flesh, as history. Thus, contrary to intention, that definition of art reduces fancy to logic, and art to philosophy. At best, it proves effective against the abstract conception of science, but not really as regards the problem of art. (Incidentally, Kant's *Critique of Judgment* – aesthetic and teleological – had precisely such historical function of correcting whatever of abstract still remained in the *Critique of Pure Reason*.) To require a sensible element for the concept, besides that one which it already possesses inherently as concrete concept, and besides the words by means of which it expresses itself, would be a superfluous thing. To be sure, if we insist on this requirement, we avoid the conception of art as philosophy or as history, but only to fall into the conception of art as *allegory*.

The insurmountable difficulties of allegory are well known; so is its barren and anti-artistic character known and universally felt. Allegory is the extrinsic union, or the conventional and arbitrary juxtaposition of two spiritual facts – a concept or thought and an image – whereby it is posited that *this* image must represent *that* concept. Moreover, not only does recourse to allegory fail to explain the integral character of the artistic image, but, what is more, it deliberately sets up a duality. For given the juxtaposition of thought and image, thought remains thought and image remains image, there being no relation between them. So much so that, whenever we contemplate the image, we forget the concept without any loss, but, on the contrary, to our gain; and whenever we think the concept, we dispel, likewise to our advantage, the superfluous and annoying image.

Allegory met with much favor in the Middle Ages, with its mixture of Germanic and Romanic elements, barbarism and culture, bold fancy and subtle reflection. However, this was owing to a theoretical prejudice, and not to the actual reality of medieval art itself, which, wherever it is art, ejects allegorism from itself or resolves it from within. This need to resolve allegoristic dualism leads, in fact, to refining the theory of intuition as allegory of the idea to the other theory, that of intuition as *symbol*. For in symbol the idea is no longer thinkable by itself, separable from the symbolizing representation, nor is the latter representable by itself effectively without the idea symbolized.

As Vischer the aesthetician (upon whom must fall the blame, if upon anybody, for a comparison so prosaic regarding a subject so poetic and metaphysical) used to declare,

the idea is all dissolved in the representation, just as a lump of sugar dissolved in a glass of water continues and functions in each molecule of water, yet is no longer recognizable as a lump of sugar. Only, the idea which has disappeared and has become all representation, the idea which it is not possible any longer to grasp as idea (except by extracting it, like sugar from sweetened water), is no longer idea. It is only the sign of the yet-to-be-discovered principle of the unity of the artistic image. Certainly, art is symbol, all symbol, that is, all significant. But symbol of what? Signifying what? Intuition is truly artistic, is truly intuition and not a chaotic accumulation of images, only when it has a vital principle which animates it and makes for its complete unity. [. . .]

16 Clive Bell (1881–1964) 'The Aesthetic Hypothesis'

Bell assisted Fry with the second of his 'Post-Impressionist' exhibitions in 1912, and the two critics were to be closely identified with the propagandizing of modern art in England for the next two decades. The present text is taken from the first chapter of *Art,* first published in London in 1914 and continuously reprinted for the next twenty years. Bell's ambitious aim was to provide 'a complete theory of visual art'. On the other hand his endeavour was clearly shaped by the specific effects of an enthusiasm for modern French painting. What he produced was a forceful and graspable manifesto for the broad aesthetic commitments of early twentieth-century Modernism.

The starting-point for all systems of aesthetics must be the personal experience of a peculiar emotion. The objects that provoke this emotion we call works of art. All sensitive people agree that there is a peculiar emotion provoked by works of art. I do not mean, of course, that all works provoke the same emotion. On the contrary, every work produces a different emotion. But all these emotions are recognizably the same in kind; so far, at any rate, the best opinion is on my side. That there is a particular kind of emotion provoked by works of visual art, and that this emotion is provoked by every kind of visual art, by pictures, sculptures, buildings, pots, carvings, textiles, &c., &c., &c., is not disputed, I think, by anyone capable of feeling it. This emotion is called the aesthetic emotion; and if we can discover some quality common and peculiar to all the objects that provoke it, we shall have solved what I take to be the central problem of aesthetics. We shall have discovered the essential quality in a work of art, the quality that distinguishes works of art from all other classes of objects.

For either all works of visual art have some common quality, or when we speak of 'works of art' we gibber. Everyone speaks of 'art', making a mental classification by which he distinguishes the class 'works of art' from all other classes. What is the justification of this classification? What is the quality common and peculiar to all members of this class? Whatever it be, no doubt it is often found in company with other qualities; but they are adventitious – it is essential. There must be some one quality without which a work of art cannot exist; possessing which, in the least degree, no work is altogether worthless. What is this quality? What quality is shared by all objects that provoke our aesthetic emotions? What quality is common to Sta. Sophia and the windows at Chartres, Mexican sculpture, a Persian bowl, Chinese carpets, Giotto's frescoes at Padua, and the masterpieces of Poussin, Piero della Francesca, and

Cézanne? Only one answer seems possible – significant form. In each, lines and colours combined in a particular way, certain forms and relations of forms, stir our aesthetic emotions. These relations and combinations of lines and colours, these aesthetically moving forms, I call 'Significant Form'; and 'Significant Form' is the one quality common to all works of visual art.

* * *

The hypothesis that significant form is the essential quality in a work of art has at least one merit denied to many more famous and more striking – it does help to explain things. We are all familiar with pictures that interest us and excite our admiration, but do not move us as works of art. To this class belongs what I call 'Descriptive Painting' – that is, painting in which forms are used not as objects of emotion, but as means of suggesting emotion or conveying information. Portraits of psychological and historical value, topographical works, pictures that tell stories and suggest situations, illustrations of all sorts, belong to this class. That we all recognize the distinction is clear, for who has not said that such and such a drawing was excellent as illustration, but as a work of art worthless? Of course many descriptive pictures possess, amongst other qualities, formal significance, and are therefore works of art: but many more do not. They interest us; they may move us too in a hundred different ways, but they do not move us aesthetically. According to my hypothesis they are not works of art. They leave untouched our aesthetic emotions because it is not their forms but the ideas or information suggested or conveyed by their forms that affect us. [. . .]

Most people who care much about art find that of the work that moves them most the greater part is what scholars call 'Primitive'. Of course there are bad primitives. [. . .] But such exceptions are rare. As a rule primitive art is good – and here again my hypothesis is helpful – for, as a rule, it is also free from descriptive qualities. In primitive art you will find no accurate representation; you will find only significant form. Yet no other art moves us so profoundly. Whether we consider Sumerian sculpture or pre-dynastic Egyptian art, or archaic Greek, or the Wei and T'ang masterpieces, or those early Japanese works of which I had the luck to see a few superb examples . . . at the Shepherd's Bush Exhibition in 1910, or whether, coming nearer home, we consider the primitive Byzantine art of the sixth century and its primitive developments amongst the Western barbarians, or, turning far afield, we consider that mysterious and majestic art that flourished in Central and South America before the coming of the white men, in every case we observe three common characteristics – absence of representation, absence of technical swagger, sublimely impressive form. Nor is it hard to discover the connection between these three. Formal significance loses itself in preoccupation with exact representation and ostentatious cunning.

Naturally, it is said that if there is little representation and less saltimbancery in primitive art, that is because the primitives were unable to catch a likeness or cut intellectual capers. The contention is beside the point. There is truth in it, no doubt, though, were I a critic whose reputation depended on a power of impressing the public with a semblance of knowledge, I should be more cautious about urging it than such people generally are. For to suppose that the Byzantine masters wanted skill, or could not have created an illusion had they wished to do so, seems to imply ignorance of the amazingly dexterous realism of the notoriously bad works of that age. Very often, I fear, the misrepresentation of the primitives must be attributed to what the critics call, 'wilful distortion'. Be that as it may, the point is that, either from want of skill or want

of will, primitives neither create illusions, nor make display of extravagant accomplishment, but concentrate their energies on the one thing needful – the creation of form. Thus have they created the finest works of art that we possess.

Let no one imagine that representation is bad in itself; a realistic form may be as significant, in its place as part of the design, as an abstract. But if a representative form has value, it is as form, not as representation. The representative element in a work of art may or may not be harmful; always it is irrelevant. For, to appreciate a work of art we need bring with us nothing from life, no knowledge of its ideas and affairs, no familiarity with its emotions. Art transports us from the world of man's activity to a world of aesthetic exaltation. For a moment we are shut off from human interests; our anticipations and memories are arrested; we are lifted above the stream of life. [...]

To appreciate a work of art we need bring with us nothing but a sense of form and colour and a knowledge of three-dimensional space. That bit of knowledge, I admit, is essential to the appreciation of many great works, since many of the most moving forms ever created are in three dimensions. To see a cube or a rhomboid as a flat pattern is to lower its significance, and a sense of three-dimensional space is essential to the full appreciation of most architectural forms. Pictures which would be insignificant if we saw them as flat patterns are profoundly moving because, in fact, we see them as related planes. If the representation of three-dimensional space is to be called 'representation', then I agree that there is one kind of representation which is not irrelevant. Also, I agree that along with our feeling for line and colour we must bring with us our knowledge of space if we are to make the most of every kind of form. Nevertheless, there are magnificent designs to an appreciation of which this knowledge is not necessary: so, though it is not irrelevant to the appreciation of some works of art it is not essential to the appreciation of all. What we must say is that the representation of three-dimensional space is neither irrelevant nor essential to all art, and that every other sort of representation is irrelevant.

That there is an irrelevant representative or descriptive element in many great works of art is not in the least surprising. ... Representation is not of necessity baneful, and highly realistic forms may be extremely significant. Very often, however, representation is a sign of weakness in an artist. A painter too feeble to create forms that provoke more than a little aesthetic emotion will try to eke that little out by suggesting the emotions of life. To evoke the emotions of life he must use representation. Thus a man will paint an execution, and, fearing to miss with his first barrel of significant form, will try to hit with his second by raising an emotion of fear or pity. But if in the artist an inclination to play upon the emotions of life is often the sign of a flickering inspiration, in the spectator a tendency to seek, behind form, the emotions of life is a sign of defective sensibility always. It means that his aesthetic emotions are weak or, at any rate, imperfect. Before a work of art people who feel little or no emotion for pure form find themselves at a loss. They are deaf men at a concert. They know that they are in the presence of something great, but they lack the power of apprehending it. They know that they ought to feel for it a tremendous emotion, but it happens that the particular kind of emotion it can raise is one that they can feel hardly or not at all. And so they read into the forms of the work those facts and ideas for which they are capable of feeling emotion, and feel for them the emotions that they can feel – the ordinary emotions of life. When confronted by a picture, instinctively they refer back its forms

to the world from which they came. They treat created form as though it were imitated form, a picture as though it were a photograph. Instead of going out on the stream of art into a new world of aesthetic experience, they turn a sharp corner and come straight home to the world of human interests. For them the significance of a work of art depends on what they bring to it; no new thing is added to their lives, only the old material is stirred. A good work of visual art carries a person who is capable of appreciating it out of life into ecstasy: to use art as a means to the emotions of life is to use a telescope for reading the news. You will notice that people who cannot feel pure aesthetic emotions remember pictures by their subjects; whereas people who can, as often as not, have no idea what the subject of a picture is. They have never noticed the representative element, and so when they discuss pictures they talk about the shapes of forms and the relations and quantities of colours. Often they can tell by the quality of a single line whether or no a man is a good artist. They are concerned only with lines and colours, their relations and quantities and qualities; but from these they win an emotion more profound and far more sublime than any that can be given by the description of facts and ideas. [...]

Significant form stands charged with the power to provoke aesthetic emotion in anyone capable of feeling it. The ideas of men go buzz and die like gnats; men change their institutions and their customs as they change their coats; the intellectual triumphs of one age are the follies of another; only great art remains stable and unobscure. Great art remains stable and unobscure because the feelings that it awakens are independent of time and place, because its kingdom is not of this world. To those who have and hold a sense of the significance of form what does it matter whether the forms that move them were created in Paris the day before yesterday or in Babylon fifty centuries ago? The forms of art are inexhaustible; but all lead by the same road of aesthetic emotion to the same world of aesthetic ecstasy.

17 Carl Einstein (1885–1940) 'Negro Sculpture'

Einstein studied philosophy, history, art history and classics at the University of Berlin. He met Picasso, Braque and Gris in 1907 and was interested in Cubism at an early stage. After the First World War he was involved in Wieland Herzfelde's Malik Verlag (see IVC7) and in 1928 he emigrated to Paris, where he became involved with the Surrealist movement. His essay was originally published as the introduction to a large selection of plates in *Neger-plastik*, Leipzig: Verlag der weissen Bücher, 1915. It engages both with the stylistic analysis of Heinrich Wölfflin, with whom Einstein had studied in Berlin (see *Art in Theory 1815–1900* VA8), and more particularly with the legacy of Adolf Hildebrand's *The Problem of Form in the Visual Arts* (1893, see *Art in Theory 1815–1900* VA6). Einstein follows Hildebrand in treating vision as active and art as a distinct cognitive practice, which should be analysed on its own terms. However, where Hildebrand proposed a kind of austere and dehistoricized neo-Classicism, Einstein conceived of Negro sculpture as a critical 'realism of form', its distance from naturalistic appearances rooted in a significant difference of experience and perception. He saw art's technical hermeticism not as a guarantee of its isolation from the social, but rather as the measure of its potential disruptiveness. The translation by Nicholas Walker for the present volume is taken from the second edition, Munich: Kurt Wolff, 1920, pp. v–xvi, xix–xx.

Remarks on Method

There is probably no art that the European approaches with more suspicion than the art of Africa. [...] The negro [...] is regarded from the outset as an inferior part of humanity that must be ruthlessly developed into something better, and what he has to offer is judged in advance as wanting. Entirely vague evolutionary hypotheses were hastily fashioned to account for him. For some he was pressed into service to provide a misguided concept of primitive man, while others garlanded this hapless object of research with demonstrably false phrases about a people of timeless prehistory. Some hoped to discover in the negro a kind of origin, a condition of life that will never escape its first beginnings. Many of the opinions entertained about African man are largely based on prejudices such as these, prejudices effectively developed to fit some comfortable theory or other. In passing judgement on the negro the European makes one assumption: that of an unqualified and almost fantastical superiority on his part.

In fact our lack of respect for the negro merely expresses an ignorance about him, and one that oppresses him quite unjustly.
[...]

Certain problems arising in connection with modern art, however, have encouraged a less superficial exploration of the art of the African peoples. Here too, as so often, we see how some current development in the world of art has led to the construction of a corresponding history, one in which the art of the African peoples has assumed a central place. What had appeared quite meaningless before now came to acquire special significance in the light of very recent endeavours in the visual arts. We suddenly came to realize that certain problems concerning space, and a certain form of artistic creation as such, were rarely to be found expressed with such purity as they are in negro art. As a result we grasped that our previous judgements concerning the negro and his art revealed far more about the judge than it ever did about the object in question. This new perspective was soon accompanied by a new enthusiasm. Negro art was now being collected precisely as art, and indeed with passion: one began actively and legitimately producing a freshly interpreted object from the old material.

[...] In general our knowledge of African art is scant and extremely vague. [...] Nonetheless we must begin from fact rather than some surreptitiously introduced substitute for fact. And I think there is one fact which imposes itself more reliably than any conceivable knowledge of an ethnographic or other kind, and that is the African sculptures themselves. We must ignore their 'objective' character, that is, we must ignore them as objects associated with a specific environment, and analyse them precisely as created forms [Gebilden]. We must try and see whether analysis of the formal character of these sculptures can lead us towards an overall conception of form commensurate with that found throughout the different forms of art in general. One thing will certainly have to be observed here, and one thing avoided: we must stay with the realm of perception [Anschauung], and proceed in accordance with its specific principles. We must never impose the structure of our own thoughts upon the realm of perception or the specific creativity we are attempting here to explore. We must refrain from hypothesizing comforting evolutionary trends or identifying intellectual processes of thought with the creative achievements of art. We must renounce the

prejudice that psychological processes can manifest themselves simply under reversed signs, that reflection upon art simply corresponds to the active creation of art. For such reflection is a generally distinct process, one that advances specifically beyond form and the world of form in order to locate the work of art within the realm of process [*Geschehen*] in general.

Describing sculpture in terms of created forms [*Gebilde*] proves much more fruitful than treating it in 'objectivist' terms. For any 'objectively' oriented description neces- sarily goes beyond the given created form, treats it as pointing to some kind of practice on a different level altogether rather than concentrating upon the created form itself. The proper analysis of forms, on the other hand, stays with what is immediately given as such. The only thing we must assume here are the specific forms in question. Yet these forms serve to facilitate our grasp of reality better than any individual things can do because, as forms, they simultaneously express something about the structures of seeing and the principles of perception, ineluctably leading us therefore precisely to a kind of knowledge that emphatically remains within the sphere of the given.

If it is possible to provide a formal analysis capable of identifying and circumscribing certain specific and unified features with regard to the articulation of space and the nature of vision, this already implicitly demonstrates that the created forms in question are indeed art. One might object here that this conclusion is already secretly dictated by a penchant for generalization and a predetermined intention on our part. This is quite wrong. For individual form [*Einzelform*] already harbours the required elements of spatial perception within itself, indeed explicitly presents these elements since it is only by means of form that they can be presented at all. The purely individual case [*Einzelfall*], on the other hand, fails to capture the specific character of the concept at issue. For the individual case and the general concept are related to one another in a purely dualistic manner. But it is precisely the essential congruence between the universal character of perception and its specific realization that defines the work of art. One should also remember that artistic creation is just as 'spontaneous' as is our inevitable urge to interpret and connect the specific forms of perception in terms of laws and principles. For in both cases we are successfully attempting to organize our own experience.

The Painterly Element

The typical European lack of understanding for African art is directly related to its stylistic power. For this art does indeed represent an exemplary case of sculptural vision.

One can certainly argue that the sculpture of our own continent has been profoundly influenced by surrogate and essentially painterly effects. Hildebrand's *Problem of Form* presents us with an ideal reconciliation of the painterly and the sculptural. But even the striking examples of French sculpture, up to and including Rodin, appear to be struggling towards a dissolution of the sculptural as such. Even the aspect of frontality, which is generally regarded as a rigorous and 'primitive' clarification of the cubic dimension [*des Kubischen*], must properly be interpreted as a painterly conception of the sculptural. For the three-dimensional character of sculpture is here summarized in terms of a few planes that effectively suppress the cubic aspect altogether. The parts closest to the viewer are emphasized and organized into planes,

while the more distant parts are presented as incidental modifications of the frontal plane whose own dynamic character is weakened as a result.

* * *

The viewer was drawn into the sculpture; he became in turn an inseparable function of it (as in perspectival sculpture for example); he related himself, through a predominantly psychological exercise of empathy, with the personality of the creator unless he felt forced explicitly to contradict or repudiate the latter. Sculpture thus became little more than a materially embodied conversation between two souls. A sculptor who worked this way was inevitably concerned above all to envisage the effect and the viewer in advance. In order to anticipate and to test the intended effect, he would then naturally try and transform himself into the viewer (as in Futurist sculpture). The resulting sculptures would then have to be defined essentially in terms of the effects they produced. The psychological and temporal aspect thereby completely overshadowed the determinate spatial articulation of the object. This identity between viewer and maker was posited precisely in order to facilitate what was, often even unconsciously, the end and aim of the creative effort. For this was the only way to ensure an unlimited artistic effect for the work.

It is entirely symptomatic that the effect exercised upon the viewer is generally interpreted as the direct inversion of the creative process, even if it is acknowledged to be less intense in character. The sculptor thus abandoned himself to the most relevant psychological processes and thereby transplanted himself into the position of the viewer. He would always assume a certain distance from the work corresponding to that of the prospective viewer and model the desired effect accordingly. He would place the emphasis upon the visual activity of the viewer, and add certain modelling 'touches' to ensure that it was the viewer alone who would effectively generate the authentic form of the object. The constructive configuration of space was sacrificed to the purely secondary, indeed essentially alien, means of material movement. Cubic space, the presupposition of all sculpture, was forgotten.

A few years ago, in France, we witnessed a crisis in art which has redefined our entire perspective. As a result of immense intellectual effort, we finally recognized the quite inappropriate and questionable character of the prevalent artistic procedures. Certain painters were strong enough to turn their backs upon a craft that was muddling along mechanically. Renouncing the prevailing methods, they investigated the fundamental elements involved in spatial perception [*Raumanschauung*], the elements which produce and determine the character of the latter. The results of all this crucial labour are now sufficiently familiar. It was inevitable that we should simultaneously discover negro sculpture and recognize that in isolation it had already learned to cultivate essentially pure sculptural forms.

The efforts of these painters are usually described in terms of 'abstraction', and it cannot be denied that a genuinely immediate understanding of space could only be approached on the basis of a devastating critique of misguided and entirely descriptive attempts to conceptualize it. This is an essential task, although in this connection we must emphatically distinguish negro sculpture from the art which was inspired by the latter and self-consciously developed its own identity in relation to it. What presents itself here as abstraction, presented itself there as immediately given nature. For we shall see that negro sculpture, in a formal sense, is also the most powerful kind of realism.

The artist of today is not working solely for the cause of pure form, for he is still registering it in terms of a certain opposition to his own earlier history, and his efforts remain entangled in an all too reactive attitude. This critical and necessary posture accentuates the analytical approach to art.

Religion and African Art

Negro art is above all determined and defined by religion. The crafted images are objects of worship, just as they are with any other ancient people. The maker produces his work as the embodiment and preservation of some divinity, and from the first maintains a certain distance from the work which either is the god or ensures the continuing presence of the god. The maker's labour is itself a kind of distanced adoration, and the work he fashions is a priori something which is independent of, and more powerful than, its maker – especially since he concentrates every fibre of his being upon the work and, as the weaker one in this relation, abandons himself entirely to it. His labour must be described in terms of religious dedication. The work itself, qua divinity, is something free that is independent of anything else that might bind it. The maker and the worshipper stand separated from it by an immeasurable distance. The god in the work does not intervene in the human realm, and even if it did, it would do so as the one that is mightier, and thus once again as the one that is essentially distanced and remote. The transcendent power of the work presupposes the religious dimension and is entirely grounded in it. The work is created in a state of adoration, of fearful awe, before the god, and that is similarly the effect produced by the work. The soul of the maker and the worshipper are attuned in advance, i.e. are constituted in an essentially identical manner. The resulting effect lies not in the work of art, but in the incontestably divine character that the work is assumed to possess. The artist himself would never presume to emulate or rival the effect produced by the god, an effect which is ineluctably exercised and whose character is already defined. The notion of the work of art as calculated to produce a certain effect is entirely meaningless in this context, especially when we consider that idols are actually often worshipped in the dark.

For here the artist labours over a work that is essentially independent, transcendent and detached. This transcendent character of the work corresponds to a perception of space which excludes any functional role for the viewer. The space in question must be presented definitively in a total, exhaustive and unfragmented manner. Spatial closure here is not a matter of abstraction, but one of immediate sensory experience. This closure can only be ensured when the cubic character of space, to which nothing further can possibly be added, is fully realized and acknowledged. The activity of the viewer does not come into it. [...]

Negro sculpture typically displays a vigorous independence as far as the parts of the work are concerned. This too is grounded in their religious character. The parts are defined in terms of themselves, not in terms of the viewer. They are experienced in relation to the compact mass of the object, not minimized by distance. This serves to accentuate the parts themselves and their defining contours.

There is also another striking feature to these works: most of them dispense with a base, or any similarly devised platform. This may seem surprising since the statues appear highly decorative in our eyes. But the god is never represented as anything other

than an independent being that itself requires no external support. He will not lack for faithful and adoring hands when he is borne in procession by his worshippers.

Art of this kind will seldom explicitly objectify the metaphysical dimension, for the latter is always presupposed as a matter of course. This dimension necessarily manifests itself entirely in the total form of the work where it is concentrated with astonishing intensity. Which is to say that the form is expressly articulated as a most sharply defined totality. This reveals a powerful realism in the formal sense. And this alone can activate the relevant impulses which do not need to assume form in an abstract or reactively polemical fashion because they are immediately identical with form itself. (The metaphysical dimension in the work of contemporary artists continues to betray their antecedent critique of the painterly and has invaded representation as an essential formal and objective principle: the unconditional character of both art and religion, their strictly demarcated but mutual correlation, has therefore been confusingly and destructively collapsed into one.) Formal realism, which is not to be understood as a mimetic naturalism, implies the moment of transcendence. For all thought of imitation or resemblance is excluded here: what human being is a god supposed to resemble, to what human being can a god ever be subjected? The result is thus a consistent realism of transcendent form. The work of art is not regarded as a deliberate or artificial creation of the artist, but rather as mythical reality which in power and strength exceeds all natural reality. The work is emphatically real by virtue of its closed form. Since it is intrinsically independent and exceedingly powerful in its own right, the sense of distance and remoteness involved necessarily inspires art of a tremendous intensity.

Amongst us Europeans the work of art is typically subjected to an emotional and even formal interpretation in so far as the viewer is expressly summoned to active optical participation. The character of the negro work of art, by contrast, is unequivocally defined, and this for more than purely formal reasons, namely religious ones as well. The work does not signify or symbolize anything. The work simply is the god who thus preserves his own self-contained mythical reality, one which draws the worshippers into itself, transforms them likewise into something mythical, and cancels the limits of their human existence.

The formal and the religious character of closure and self-containment correspond to one another. This is at once a formal and a religious realism. The European work of art has simply become a metaphor of the effect which encourages the viewer to respond as freely as he wishes. The Negro religious work of art is categorical and possesses a concentrated kind of being which precludes all limitation.

In order to ensure a clearly delineated and self-contained existence for the work of art, every temporal function must be suspended. In other words, there can be no question of gradually moving around or touching the work. The deity has no conditioning prehistory behind it, for that would contradict its emphatically binding existence. It must be presented directly in solid material without any recourse to modelling (*modélé*), something which would merely betray a personal, impious and interfering hand. The conception of space embodied in such a work of art must absorb cubic space entirely and express it in a rigorously unified manner. Any suggestion of perspective or accustomed frontality are precluded here and it would be impious to employ either. The work of art must present space as a uniform totality. For it can only appear as something timeless if it excludes any temporal approach grounded in notions of

movement. The work of art absorbs time by integrating what we normally experience as movement into its very form.

The Cubic Perception of Space

* * *

If we conceive of cubic space as form – and sculpture is properly concerned with this alone rather than with material mass – then we must first determine what cubic space really is. It is made up of parts that are not immediately perceptible at a glance. They must be perceptibly condensed into a single total form which demands a single act of vision on the part of the viewer and corresponds to a fixed three-dimensional spatial field. It is only in this way that the otherwise irrational character of cubic space can present itself as a perceptible configuration at all. The optical naturalism characteristic of western art is not in fact the imitation of external nature. The nature that is passively imitated here is based upon the perspective of the viewer. This is what accounts for the enormously relative and genetical character of most of our art. Our works of art are adapted to the perspective of the viewer (the idea of frontality, the distanced focus on the image), and responsibility for the final optical effect has been entrusted increasingly to the active participation of the viewer.

Form, like the processes of thought and imagination, represents a kind of equivalence [*Gleichung*]. This equivalence possesses an aesthetic character when it is apprehended unconditionally and without reference to anything external. For form is the total identity between spatial perception and individual realization where they coincide structurally and are not related as concept to individual case. The sphere of perception certainly encompasses many particular cases of active realization, but it possesses no superior qualitative reality in its own right. It is evident therefore that art represents a particular case of unconditional intensity and the quality in question must be recreated in it with undiminished power.

The task of sculpture is to produce an equivalence in which the naturally defined sensations of movement and thus of mass are entirely absorbed and in which their temporally articulated differences are transmuted into a formal structure. This equivalence accomplished in the work of art must be a total one if it is to be experienced differently from that produced by other human activities, if it is to be experienced as something unconditional, self-contained and essentially independent.

18 Hermann Bahr (1863–1934) from *Expressionism*

As one might expect from an account of Expressionism published in Munich, though Bahr broadens the field of reference of the term, his book shows the influence both of Worringer's ideas (see IB5) and of that concern for the spiritual functions of art which was associated with Der Blaue Reiter. It provides a vivid repository of themes and tendencies which were to remain implicit in much modern art theory and criticism for the next thirty years, to resurface in explicit form in the New York of the 1940s: recourse to sweeping anthropological generalization; belief in the superior philosophical wisdom of the East; disparagement of Impressionist painting for its supposed passivity as a form of representation; association of modernity with dehumanization; and consequent (neo-romantic) conviction that recovery

of a form of 'presocial' state is the precondition for recovery of critical virtue and authenti-
city. Written in 1914, and published as *Expressionismus*, Munich, 1916. English translation
by R. T. Gribble, London, 1920, pp. 35–7, 39–43, 45–6 and 83–8, from which the present
extracts are taken.

Without Precedent

The various sayings and proclamations of Expressionism only tell us that what the
Expressionist is looking for is without parallel in the past. A new form of Art is
dawning. And he who beholds an Expressionist picture by Matisse or Picasso, by
Pechstein or Kokoschka, by Kandinsky or Marc, or by Italian or Bohemian Futurists,
agrees; he finds them quite unprecedented. The newest school of painting consists of
small sects and groups that vituperate each other, yet one thing they all have in
common. They agree only on this point, that they all turn away from Impressionism,
turn even against it: hence I class all of them together under the name of Expression-
ists, although it is a name usually assumed only by one of the sects, while the others
protest at being classed in the same category. Whenever Impressionism tries to
simulate reality, striving for illusion, they all agree in despising this procedure. They
also share in common the passionate denial of every demand that we make of a picture
before we can accept it as a picture at all. Although we may not be able to understand a
single one of their pictures, of one thing we may be certain, they all do violence to the
sensible world. This is the true reason of the universal indignation they arouse; all that
has hitherto been the aim of painting, since painting first began, is now denied, and
something is striven for which has never yet been attempted. At least so the beholder is
likely to think, and the Expressionist will fully agree with him. Only the beholder
maintains that whatever nature does not sanction, but that on the contrary deliberately
goes against nature, can never be true Art, while the Expressionist insists that just this
is Art, is *his* Art. And if the beholder retorts vehemently that the painter should express
nothing but what he sees, the Expressionists assure him that they too paint only what
they see. And on this point there is a continual misunderstanding. Each of them when
he speaks of 'seeing' means something totally different. What is meant by 'seeing'?

Seeing

The history of painting is nothing but the history of vision – or seeing. Technique
changes only when the mode of seeing has changed; it only changes because the method
of seeing has changed. It changes so as to keep pace with changes of vision as they
occur. And the eye changes its method of seeing according to the relation man assumes
towards the world. A man views the world according to his attitude towards it. [...]
* * *

Two influences work on each other, an outer one and one from within us; each at
bottom equally unknown to us. Neither alone suffices. Experience is born from their
co-operation. They differ for each individual according as his own share is stronger
or weaker, the capacity of his eye more or less independent; according to the degree of
his attention, the extent of his experience, the power of his thought, the range of his
knowledge. As any one of these conditions changes, necessarily every appearance will
change with it. A man is usually unconscious of these various conditions. But it may

happen at times that he feels them strongly, and then it may also happen that he wishes to change them. As soon as he realizes that his seeing is always the result of some external influence, as well as of his own inner influence, it depends on whether he trusts the outer world more – or himself. Every human relation finally depends on this: once he has arrived at the stage where he can differentiate between himself and the rest of the world, when he can say 'I' and 'you', when he can separate outer from inner, he has no alternative but that of flight from the world into himself, or from himself into the world – or a third choice is possible, that of halting on the boundary line between the two. These are the three attitudes man can assume towards the phenomena of appearance.

When at the dawn of time man first awakened, he was startled by the world. To recover himself, to 'come to', he had to sever himself from nature; in his later memory this event is echoed and repeated in the impulse to break away from nature. He hates her; he fears her; she is stronger than he; he can only save himself from her by flight, or she will again seize and devour him. He escapes from her into himself. The fact of having the courage to separate from her, and to defy her, shows him that there must be a secret power in himself, and to this power he entrusts himself. From its depths he draws his own God and sets him up against nature. He requires a stronger power than himself, but stronger also than the world; enthroned above him, and above her, it can destroy him, but it can likewise protect him against her. Should his offering find favour, his God will banish the terrors of nature. And thus primeval man draws a magic circle of worship round himself and pricks it out with the signs of his God: Art begins, an attempt of man to break the grip of appearance by making his 'innermost' appear also; within the outer world, he has created another world which belongs to him and obeys him. If the former frightens him into mad flight, alarming and confusing all his senses – the eye, the ear, the groping hand, the moving foot – the latter pacifies and encourages him by its calm, by the rhythm and consonance of its rigid, unreal, and unceasing repetition of form. In primitive ornament change is conquered by rest, the appearance to the eye by the picture in the mind, the outer world by the inner man, and when the reality of nature perplexes and disturbs him because he can never fathom her depths, because she always extends further than he can reach, so that beyond the uttermost limit there stretches something beyond, and beyond this extends the threat of yet further vastness – Art frees him by drawing appearance from the depths and by flattening it out on a plane surface. Primeval man sees lines, circles, squares, and he sees them all flat, and he does so owing to the inner need of turning the threat of nature away from himself. His vision is in constant fear of being overpowered and so it is always on the defensive, it offers resistance, is ready to hit back. Every fresh outer stimulus alarms the inner perception, which is always armed and ready, never concedes entrance to nature, but out of the flux of experience he tears her bit by bit – banishing her from the depth to the surface – makes her unreal and human till her chaos has been conquered by his order.

It is not only primeval man who shows us this determined reaction of repulsion to every stimulus experienced. We recognize this attitude again in one of the highest phases of human development, in the East. There too man, now mature and civilized, has overcome nature. Appearance has been seen through and recognized as illusion, and should the deceiving eye try to entice him into this folly, he is taught by knowledge to withstand. In the East all beholding is tempered by an element of comprehending pity, and wherever the wise man gazes, he sees only that which he knows: the eye takes

in the outer stimulus, but only to unmask it instantly. All seeing, for him, is a looking away from nature. We, with our eyes, are still incapable even of imagining this state, for we still see everything, as far as the circle of our civilization reaches, with the eyes of the Greek.

The Greeks had turned man about: he stood against nature, they turned him towards her: he hid from her, they taught him to confide himself to her, to go with her, to be received by her, to become one with her. It must have been a great moment. [...]

* * *

In fact, the Impressionist is the consummation of classic development. The Impressionist, in visualizing, endeavours as much as possible to rule out every inner response to the outer stimulus. Impressionism is an attempt to leave nothing to man but his retina. One is apt to say of Impressionists that they do not 'carry out' a picture; it were better to say, they do not 'carry out' visualization. The Impressionist leaves out man's participation in appearance, for fear of falsifying it. [...]

Expressionism

This is the vital point – that man should find himself again. Schiller asks: 'Can man have been destined, for any purpose whatever, to lose himself?' It is the inhuman attempt of our time to force this loss upon him against his own nature. We would turn him into a mere instrument; he has become the tool of his own work, and he has no more sense, since he serves the machine. It has stolen him away from his soul. And now the soul demands his return. This is the vital point. All that we experience is but the strenuous battle between the soul and the machine for the possession of man. We no longer live, we are lived; we have no freedom left, we may not decide for ourselves, we are finished, man is unsouled, nature is unmanned. A moment ago we boasted of being her lords and masters and now she has opened her wide jaws and swallowed us up. Unless a miracle happens! That is the vital point – whether a miracle can still rescue this soulless, sunken, buried humanity. Never yet has any period been so shaken by horror, by such a fear of death. Never has the world been so silent, silent as the grave. Never has man been more insignificant. Never has he felt so nervous. Never was happiness so unattainable and freedom so dead. Distress cries aloud; man cries out for his soul; this whole pregnant time is one great cry of anguish. Art too joins in, into the great darkness she too calls for help, she cries to the spirit: this is Expressionism.

Never has any period found a clearer, a stronger mode of self-expression than did the period of bourgeois dominance in impressionistic Art. This bourgeois rule was incapable of producing original music or poetry; all the music or poetry of its day is invariably either a mere echoing of the past, or a presentiment of the future; but in Impressionistic painting it has made for itself such a perfect symbol of its nature, of its disorder, that perhaps some day when humanity is quite freed from its trammels and has atained the serene perspective of historic contemplation, it may be forgiven, because of these shining tokens. Impressionism is the falling away of man from spirit. Impressionism is man lowered to the position of a gramophone record of the outer world. Impressionists have been taken to task for not 'carrying out' their pictures; they do not even carry out their 'seeing', for man of the bourgeois period never 'carries out', never fulfils life. He halts, breaks off midway in the process of seeing, midway in the process of life at the very point where man's participation in life begins. Half-way in the

act of seeing these Impressionists stop, just where the eye, having been challenged, should make its reply: 'The ear is dumb, the mouth deaf,' says Goethe; 'but the eye both perceives and speaks.' The eye of the Impressionist only beholds, it does not speak; it hears the question, but makes no response. Instead of eyes, Impressionists have another set of ears, but no mouth, for a man of the bourgeois period is nothing but an ear, he listens to the world, but does not breathe upon it. He has no mouth, he is incapable of expressing himself, incapable of pronouncing judgment upon the world, of uttering the law of the spirit. The Expressionist, on the contrary, tears open the mouth of humanity; the time of its silence, the time of its listening is over – once more it seeks to give the spirit's reply.

Expressionism is as yet but a gesture. It is not a question of this or that Expressionist, much less of any particular work of his. Nietzsche says: 'The first and foremost duty of Art should be to beautify life ... Thereupon she must conceal or transmute all ugliness – and only after this gigantic task has been achieved can she turn to the special so-called Art of Art-production, which is but the appendage. A man who is conscious of possessing a superfluity of these beautifying and concealing and transmuting powers, will finally seek to disburden himself of this superabundance in works of Art; the same under special conditions applies to a whole nation. But at present we generally start at the wrong end of Art, we cling to her tail and reiterate the tag, that works of Art contain the whole of Art, and that by these we may repair and transform life ... simpletons that we are!' Under this bourgeois rule the whole of man has become an appendage. Impressionism makes a splendid tail! The Expressionist, however, does not throw out a peacock's wheel, he does not consider the single production, but seeks to restore man to his rightful position; only we have outgone Nietzsche – or, rather, we have retraced our steps and gone further back beyond him and have arrived at Goethe: Art is no longer only to 'beautify' life for us and to 'conceal or transmute ugliness', but Art must bring Life, produce Life from within, must fulfil the function of Life as man's most proper deed and action. Goethe says, 'Painting sets before us that which a man could and should see, and which usually he does not see.' If Expressionism at the moment behaves in an ungainly, violent manner, its excuse lies in the prevailing conditions it finds. These really are almost the conditions of crude and primitive humanity. People little know how near the truth they are when they jeer at these pictures and say they might be painted by savages. The bourgeois rule has turned us into savages. Barbarians, other than those feared by Rodbertus, threaten; we ourselves have to become barbarians to save the future of humanity from mankind as it now is. As primitive man, driven by fear of nature, sought refuge within himself, so we too have to adopt flight from a 'civilization' which is out to devour our souls. The Savage discovered in himself the courage to become greater than the threat of nature, and in honour of this mysterious inner redeeming power of his, which, through all the alarms and terrors of storm and of ravening beasts and of unknown dangers, never deserted him, never let him give in – in honour of this he drew a circle of guardian signs around him, signs of defiance against the threat of nature, obstinate signs of demarcation to protect his possessions against the intrusion of nature and to safeguard his belief in spirit. So, brought very near the edge of destruction by 'civilization', we discover in ourselves powers which cannot be destroyed. With the fear of death upon us, we muster these and use them as spells against 'civilization'. Expressionism is the symbol of the unknown in us in which we confide, hoping that it will save us. It is the token of

the imprisoned spirit that endeavours to break out of the dungeon – a tocsin of alarm given out by all panic-stricken souls. This is what Expressionism is.

19 Hans Prinzhorn (1886–1933) from *Artistry of the Mentally Ill*

Between the end of the First World War and the early 1920s, Prinzhorn worked as an assistant to Karl Willmans, the Director of the Heidelberg Psychiatric Clinic. He had originally trained in art history and philosophy in Vienna, before going on to study first music and then, in his late twenties, medicine. It was at this time that he developed the interest in psychiatry which flowered at the Heidelberg clinic after war service as an army surgeon. Willmans had already begun a collection of pictures by people suffering from mental illness. Prinzhorn scoured many psychiatric institutions not only in Germany but also in Austria, Switzerland, Holland and Italy, eventually amassing over 5,000 examples, all of which were made spontaneously by inmates of mental institutions, and not as a result of any 'art therapy'. Prinzhorn regarded the pictures and objects he collected as evidence of a natural urge to formal and symbolic expression which is repressed by the effects of modern civilization. Furthermore, he noted similarities between the visual imagery produced spontaneously by mentally ill people and the characteristic formal qualities of the art of the contemporary expressionist avant-garde. His conclusion was not that modern artists were mad, as conservatives tended to argue, but that there was an analogy between the schizophrenic's response to his illness and the artist's response to the troubled nature of his times. The art of the mentally ill thus joined the art of children and the art of indigenous peoples in a triad which formed the core of 'Primitivism': the avant-garde ideology which counterposed notions of truth, spontaneity and authenticity of expression, to the canons of academic art. In the following extracts, Prinzhorn explicitly addresses the relation between the artwork of the mentally ill and what he calls 'serious art'. They are taken from the closing sections of his book, where they follow extensive analysis of the examples themselves. *Bildnerei der Geisteskranken* was first published by Springer Verlag in Berlin in 1922. Despite its immediate success in Germany, no English translation was published until 1972. Our extracts are taken from the 1995 reprint of this translation, by Eric von Brockdorff, published as *Artistry of the Mentally Ill*, Springer Verlag New York, pp. 268–72. (Note that the translator has used the word 'configuration' for the key German concept 'Gestalt'. This is a complex concept which centres on ideas of 'form' and 'shape', connoting something which is intrinsic to the body in question rather than its mere outline. In German, the 'Gehalt'/'Gestalt' distinction conveys some of the English distinction between 'content' and 'form'.)

IV. Schizophrenic Configuration and Art

So far we have hardly discussed art. Now we can no longer escape the question: what has schizophrenia to do with serious art? [. . .]

Tradition and training play by far the major role in professional art. The truth of this assertion is shown most clearly by the fact that after even a short time the art of many individuals will always appear as the combined effort of a generation, although it may be grouped by races and countries. Art history accordingly speaks of schools and of the styles of certain periods, and gives prominence only to those personalities among the masses of artists who by the surpassing individuality of their personal styles themselves become pioneers. We can hardly cite a case in the whole history of art,

however, in which an untrained person, separated from the whole world and completely dependent on himself, suddenly reached for a pencil one day in order to produce pictures. The development of Rousseau, a customs official, is unique.

Formerly all inquiries into the origins of pictorial configuration [*Gestaltung*] began with a hypothetical beginner who was naturally thought of as a primitive. With this theoretical individual in mind we tried, by looking at the most ancient artistic artifacts, to understand the origins of art. We already pointed out the impossibility of a solution of the problem as long as it was approached chronologically. Some individuals assert dogmatically that one or a few principles explain the whole intricate process. These principles are based on common observations of the beginning and the development of pictorial configuration in children and on the drawing method observed in numerous primitives. But the creative process has never been investigated impartially and purely psychologically.

The persons who produced our pictures are distinguished by having worked more or less autonomously, without being nourished by the tradition and schooling to which we attributed the majority of the more customary works of art. Our patients are of course not independent of every traditional conception, but in beginning to compose spontaneously they create a gulf so wide from everything that may be learned about configuration, from all knowledge and skill, that today it cannot be equalled anywhere (except in other parts of the world). The configurative process, instinctive and free of purpose, breaks through in these people without any demonstrable external stimulus or direction – they know not what they do. Whatever may be said to limit the value of this insight, it is certain that nowhere else do we find the components of the configurative process, which are subconsciously present in every man, in such an unadulterated state.

If we succeeded in showing by means of our material that pictures which in many ways approached the quality of professional art grew out of these primarily subconscious components, these conclusions must follow: tradition and schooling can influence the configurative process only peripherally, by promoting, through praise and reproach, rules and systems. There is, however, a kind of intrinsic process; the preconditions for its development are present in every person. This assertion is supported by numerous experiences. We know today that most children possess an original configurative urge which develops freely in a suitable environment, but which disappears rapidly as the rationalism of schooling turns an instinctual, playful creature into a knowing and purposeful one. Experiences with primitives and with many dream experiences bear this out. As surely as configuration is an activity and itself has little to do with visions and fantasy, so does the ability to experience objective pictures in dreams and hypnotic hallucinations indicate an original configurative power. We observe repeatedly, especially in psychotherapy, that under the right circumstances almost every person is capable of experiencing his conflicts in an extremely pregnant symbolic disguise. We must therefore conclude that an original configurative instinct intrinsic to all men has been buried by the development of civilization. [. . .]

V. The Schizophrenic Outlook and Our Age

[. . .] Just as we refused to define the essence of schizophrenic configuration on the basis of superficial traits, so we decline to draw parallels between contemporary art and our pictures by comparing external characteristics. Such comparisons, not just by laymen but even by reputable psychiatrists, appear daily in the press and are vulgar and

sensational. Aside from the fact that even if the reported parallels were provable they would serve only to arm the philistines with fresh platitudes, such comparisons are based on a great psychological and logical error: it is superficial and wrong to infer an equality of the underlying psychic conditions from external similarities. The conclusion that a painter is mentally ill because he paints like a given mental patient is no more intelligent or convincing than another; viz., that Pechstein and Heckel are Africans from the Camerouns because they produce wooden figurines like those by Africans from the Camerouns. Anybody tending to such simpleminded conclusions does not deserve to be taken seriously. We used some examples to show that the pictures by our schizophrenics are reminiscent not only of primitive art but also of works from great cultures. Some of our works are so clearly artistic that many an average 'healthy' work is left far behind. External qualities will therefore not throw light on undeniable and deep relationships. It would seem much more rewarding to turn our attention to the related traits in the general emotional attitude evinced by the most recent serious art. There we find indeed as a basic trait a renunciation of the outside world as commonly understood, as well as a logical devaluation of its surface luster on which all Western art has heretofore depended, and finally a decisive turn inward upon the self. We have used the very same phrases in our efforts to describe the outlook of schizophrenics.

The astonishing fact that the schizophrenic outlook and that displayed in recent art can be described only by the same words immediately obliges us to state the differences as well. And that is not hard. For the schizophrenic there is the fateful experience. The alienation from the world of appearances is imposed on him as a gruesome, inescapable lot against which he often struggles for some time until he submits and slowly begins to feel at home in his autistic world, which is enriched by his delusions. For the contemporary artist alienation from the once familiar and courted reality may also result from an overpowering experience, but at least it involves conscious and rational decisions. It occurs because of painful self-analysis and because the surmounted relationships to society become repulsive, and it is therefore often mixed with doubts, a bad conscience, and resentments. On the other hand, it has a clear purpose, at least theoretically. By its nature the liberation from the compulsion of external appearances should be so complete that all configuration should deal only with pure psychic qualities. Its source should be a completely autonomous personality with ambitions of entering into a mystical union with the whole world.

The decline of the traditional outlook which gave rise to this extravagant, grandiose, often compulsively distorted attitude cannot be pursued here. In any case it is not simply a concern of expressionism, as shortsighted people still hope even today. On the contrary, expressionism is a symptom of the decline and an attempt to make the best of it. If we ignore the confusion of artistic programs and try to grasp the motivating idea which produces ever greater exaltations, we find the same longing for inspired creation reported in primitives and known from the greatest periods of culture. That brings us to the weakness of our time – its tragedy and grimness. What we seem to lack is just that primary experience which precedes all knowledge and which alone produces inspired art. Instead, after all our extravagant wishing, after all the determined triumphs over ancient errors, we finally end up with intellectual substitutes.

If we are correct, then the passionate emotions with which sensitive artists react to our pictures become completely understandable. These works really emerged from

autonomous personalities who carried out the mission of an anonymous force, who were independent of external reality, indebted to no one, and sufficient solely unto themselves. The inborn primeval process of configuration ran its course far from the outside world, without plan but by necessity, like all natural processes. Men who like Tolstoy, the most venerable among those who despair of our civilization, are given to anarchistic conceptions of artistic creation because of their mystical leanings, become easily intoxicated by the qualities of primeval configuration. We cannot refrain from pointing out that the most recent artistic styles cannot simply be dismissed as the private project of a few people hungry for publicity, a harmless and comfortable but still widely popular opinion. Cultural values and developments cannot be taught to anyone who has not experienced them. Given the great speed with which cultural forces become history today, the unperceptive person accepts as historic fact what until yesterday he believed he could safely ignore as the phantasmagoria of isolated enthusiasts. If we carefully observe the arts today we find a number of tendencies active in all of them, the fine arts as well as all branches of literature, to which only a genuine schizophrenic could do justice. Mind you, we are far from trying to prove the presence of symptoms of mental illness in these arts, but we do find an instinctive affinity for nuances which are familiar to us in schizophrenics. That affinity explains the similarities of our pictures to modern art and their attractiveness. What we said of the decline of the traditional outlook among creative artists applies to all professions. Just as common is a craving for direct intuitive experience combined with a mystical self-deification and the concern with metaphysics, from the genuine philosophical to the sectarian and theosophical in which magic powers are again at work. We are even tempted to invoke our formulation for the overall attitude of schizophrenic configuration and to see in the age something of the tense, ambivalent hesitation immediately preceding decisions. The tendencies toward a schizophrenic outlook are in the main those, however, which two decades ago sought relief from the overpowering rationalism of the last generations in the expressive modes and outlook of children and primitives. Those men who believe they are being stifled by it are not the worst.

Part II
The Idea of the Modern World

II
Introduction

The first decade of the twentieth century had witnessed an attempt to synthesize elements from a range of late nineteenth-century sources into a new art: an art that was *of* the new century yet could stand alongside the achievements of the classical tradition. One of the main supports of this new art had been the concept of 'expression'. Expression took on a variety of guises, but the one thing it needed was a notion of the 'self' of the artist, which could thus *be* expressed. In turn this Self had to have the attributes of authenticity. These were characteristically sought in hitherto marginalized and neglected places – from which the avant-garde artists drew a kind of 'natural' force. It remains a central paradox of the new art that it sought its authenticity in a remote Nature, but that this repeated incantation to Nature was made under urban circumstances. Nature cults, peasant decorations, primitive fetishes and so on signified what they did to people who lived in cities. It cannot be overstressed that the ideologies of the Universal, of transhistorical forms and transcultural sensibilities, of the directly expressive and the authentic, meant what they did to a relatively small group of urban sophisticates. The artists of the avant-garde were able to deploy these notions, and the artefacts they both drew upon and issued in, to justify their own critical distance from the values and priorities of their own industrialized, urbanized societies. The adequacy of art however, is predicated upon its avoidance of escapism. The expressive devices had to match the real experience. And as the passage into the new century deepened, so the modern condition bore down upon the avant-garde.

The impact of the modern condition was being felt across Europe. So too the avant-garde had become thoroughly internationalized by the time world war broke out. Undoubtedly Paris remained pre-eminent, and the development of Cubism ensured that this remained the case. None the less an avant-garde in the visual arts developed also in the German-speaking world in centres such as Berlin, Munich, Dresden and Vienna. Here it was possessed of a characteristic inflection towards the expressive subjective, linked in turn to concerns within a German philosophical and cultural tradition, which differentiated it from the more rationalist and classicizing tendencies that seem never to have been far below the surface of French art. A third emphasis is to be found in those urban centres which came relatively late to modernization in Italy and Russia, marked by attempt to embrace, in art, the distinctive rhythms of the modern as it shot through those hitherto relatively backward societies. Schematically, then, we may want to say that in the decade before the First World War, Cubism, Expressionism and Futurism mark different facets of a *European* avant-garde's reception of the modern into an established artistic tradition whose example was predominantly

French. Against the technical constraints obtaining within that tradition – a preoccupation with surface, and with the consequences of loosening colour and structure from depiction – there was room for the culturally relative experience to make its distinctive mark. In a sense, *that* is the underlying point: that the modern was not yet 'total' and as such could be measured, and its meaning assessed, against that which it was not. Across Europe, the sharply felt experience of the modern could still be silhouetted against a sense of tradition, of values rooted in the relatively unchanging conditions of a life lived by the soil and the seasons.

Convention distinguishes three related moments in the dynamic of the modern: modernization, modernity and Modernism. The first term denotes those processes of scientific and technological advance which caused the world to manifest itself differently than it had hitherto. In particular modernization refers to the growing impact of the machine, and not least in this period of the internal combustion engine, with all that its development implied in terms of the engineering and chemical industries. It is hard retrospectively to capture the extent of the transformation that was taking place. In developing societies in Europe at the turn into the twentieth century the new was ousting the old at a pace for which there was no historical precedent. Modernity refers to the social and cultural condition of these objective changes: the character of life under changed circumstances. Modernity was a form of experience, an awareness of change and of adaptation to change. But it was also a form of effect on the person: a character these changes and adaptations gave one. It was, so to speak, both a social and an inner experience. The condition of modernity exists in a shifting, symbiotic relationship with Modernism: the deliberate reflection upon and distillation of – in a word, the *representation* of – that inchoate experience of the new. The boundaries between these concepts are not easy to draw. There is a sense in which experience cannot be grasped until it is represented; though at the extreme it would be absurd to say that the modern condition could not be experienced without a modern art to read the experience against.

The response to the modern condition seems to have been experienced in two linked but ostensibly opposed registers. On the one hand, a profound pessimism at the growth of populations and their concentration in large cities was fuelled by the apparently increasing control of human life by the machine. For all that was being gained, there was a sense that life was losing a depth, a dimension of freedom, and that human beings were becoming imprisoned in what the German sociologist Max Weber saw as the 'iron cage' of modernity (see IIA1–2). Modernization was a Europe-wide phenomenon, and change was often experienced most sharply at its fringes, where the pace of that change had been at first delayed but was now dramatically accelerated by the need to catch up. It is as a change of this sort that we should hear the 'distant thunder' of the Russian poet Alexander Blok (IIA5).

On the other hand, these same changes, which brought about a mix of alienation and apocalypse in some, produced the opposite response in others: an almost hysterical exhilaration. The most emphatic reaction of this kind came from the Italian poet Marinetti, writing in the first instance from the European fringe. Like Blok, Marinetti was a successful Symbolist poet. Unlike him, however, Marinetti broke decisively with the legacy of Symbolism in order to formulate a new response to the age (IIA6). In the parable recounted in his founding Manifesto, he and his Symbolist friends descend from the aestheticized decadence of the studio to the street, where they commandeer

automobiles and career off through the night. Marinetti's car crashes, and he is pulled by workers from a factory's drainage ditch, but not before its evil waters have acted upon him like a baptism. Through the motor car and the factory, speed and machinery, Marinetti has been granted a compelling vision of the modern, and the task of the artist is simultaneously made plain. In the years immediately before the First World War the impulse captured by Marinetti in the prophetic term 'Futurism' was felt across the continent, from London to Moscow (see texts IIA7, 8, 10, 12, 13 and 14).

Marinetti was not the only source for this attempt to focus upon dynamism and change as the marks of the modern. Until the invention of the steam-engine, no one had travelled quicker than the fastest horse could run. Now people were racing motor cars across continents and taking to the air. As brute facts these must have been evident to all. But there were also philosophical attempts to map human consciousness in terms of flux, change and sensation. In a paradoxical move, the triumphs of technology and science fostered an idealist response to their significance. The principal voice of this response was Henri Bergson's (IIA4). The apparent pertinence of his ideas to common experience resulted in his suffering an uncommon fate for a philosopher: he became famous, and was much read – not least by the Futurist Umberto Boccioni (IIA7).

However different they may have been, the variant responses of depression and exhilaration are two sides of the same coin. At bottom both are responses to the *effects* of modernization. There is a third response, however, which is positioned adjacent to these two. Its principal concern is to seek the *cause* of the modern world's being as it is. Although during this period before the First World War its bearing on the development of art is slight, in the period which followed it was to become a dominant motif. Viewed from this third position, modernization is not, fundamentally, a technological fact, despite the visibility of machinery and architecture. It is a social fact, and is marked by the production of new social relations – relations between people, and more particularly between classes of people; not just relations between people and things. In the last resort we are talking about *capitalist* modernization. By this token the twin responses of depression and exhilaration remain within the register of terms in which, so to speak, the culture thought of itself. They are part, that is to say, of the ideology of modernization: the acute and contradictory forms of bourgeois response to bourgeois society. But a wholesale challenge to that social order was mounted in the name of the class which the bourgeoisie both feared and needed: which it simultaneously attempted to draw into the fold through ideologies of a shared nation, race or culture, yet largely excluded from the material (and indeed spiritual) wealth generated by the capitalist mode of production. This class was the working class, and its programme – or at least the programme advanced in its name – was socialism.

If we have seen from the one side a series of variant demands that art express modernity, within the socialist tradition there was a mounting demand that art be committed to the struggle to change that modernity. Building on Marx's comment that whereas philosophers had hitherto merely sought to understand the world intellectually the point was to change it practically, many voices on the Left articulated a role for art as the servant of an emancipatory social movement whose main force lay in the sphere of politics. Here then are the seeds of a century-long conflict (IIA3 and 9).

This conflict was heightened by the specific nature of the turn taken by avant-garde art in the years before the war. Expressionism and Futurism are both evidently forms of response to the circumstances of urban modernity: negative and positive undoubtedly,

but the modern world and its pressures remain legible in the work of artists as diverse as Kirchner and Boccioni. With Cubism, however, the situation is different. Particularly in its 'analytic' phase, Cubism is a hermetic art. The still life and the single portrait figure – the characteristic Cubist subject matter – give few clues to the storm of modernity blowing outside the studio. This apparent disregard is only emphasized by the submergence of even these subjects beneath a surface of shifting planes which assert themselves as the picture's primary object of attention. By a strange inversion, it seems as if the modern picture, rather than depicting the machines and buildings which made up the modern world, had internalized its modernity. The picture, it was easy to think, had become a thing in itself. Strictly speaking, it was not: it remained a signifier. But its signification was to remain largely unintelligible to those who failed to grasp the premises from which the new pictorial language was derived.

Notwithstanding this difficulty, Cubism rapidly established itself as the paradigm for subsequent avant-garde art. Cubism's achievement, by virtue of its unprecedented technical innovation, was that it succeeded in imbuing the form of the art with modernity. After that, it mattered less what particular subject an artist addressed. Some of the potency of this shift in technical priorities arises in regard to its consistency with a wider impulse which is traceable across many disciplines. It seems that the characteristic inflection of this modern impulse has been a fixing upon the materiality, the opacity, of the medium through which the world is represented. This marks a crucial change. For once this emphasis upon the means of representation is achieved, then whenever those means remain unchanged in a changing world, art will in its turn remain archaic – and as such be inadequate to the task of representing the modern – whatever subjects it chooses to depict. The perception that how one achieves the representation stands logically prior to what it represents, implies that the means of art require transformation in ways which parallel the changes modernization itself had wrought upon the world at large (see section IIB *passim*).

Cubism's technical innovations were rapidly assimilated by avant-garde artists. However, the question as to what Cubism meant, how it was to be thought of and understood, remained a focus for conflict. The autonomous decoration of a surface; penetration below surface appearance to the constants of 'true' reality; a modern Realism of 'conception', transforming the terms, but none the less retaining the critical interest, of a tradition derived from Courbet; a Kantian transcendental idealism in which the picture could achieve what language could not, namely representation of the *Ding an sich*; a Nietzschean imposition of a new beauty, moulding the masses to the artist's own Truth; a Bergsonian epistemology of flux. Each of these was canvassed within five years of the emergence of a recognizably new style around 1910 (see IIB1–10 *passim*).

Although no one account established itself definitively, some, such as Kahnweiler's Kantian approach (IIB10), appeared to be more serviceable than others. The reasons for this are complex and undoubtedly relate to the wider social circumstances in which avant-garde art came to function, both as a relatively autonomous specialized practice and as a kind of luxury commodity. Whatever the precise reasons may be, their cumulative effect was to prise apart the two aspects of Cubism which in retrospect seem most central to its critical force: its continued referentiality *and* its preoccupation with the autonomous picture surface. This had the effect of driving a wedge between a concern for art's realism in respect of wider social forms, and its own reality as a

signifying practice. The gulf thus opened, and sustained, it must be said, by the operation of more powerful ideological and political investments as the century has gone on, has rarely been bridged since.

Here, then, is set up a tension, a tension between poles which artists have sometimes striven to reconcile, while other artists at other times have hardened them into mutually exclusive alternatives. On the one side there is the impulse to an art whose first duty is to decode the modern world and perhaps even to participate in changing it. On the other is that art whose principal response to the modern condition has been the conclusion that art must transform itself. This problem of the relation of an 'autonomous' art to wider social change has remained constitutive of all ambitious art in the modern period. In this second section, debates over Cubism and the conditions of modernity can be seen both to replay aspects of the dialectic noted in the previous chapter between the theorists of 'modern life', Naturalism and Symbolism, and to anticipate the conflict over Modernism and Realism which played so prominent a role in later developments. In that sense these years, pre-eminently the years of Cubism, mark a turning-point, a hinge, as it were, between the modern art of the nineteenth century and what was to become the condition of modern art in the twentieth.

IIA
Modernity

1 Georg Simmel (1858–1918) 'The Metropolis and Mental Life'

Simmel, one of the founders of modern sociology, worked for most of his life at the University of Berlin. His writings ranged over philosophy, history and psychology, as well as sociology. Here he is particularly concerned with the effects of the impersonality and regimentation of the modern city on individual subjectivity. Originally published as 'Die Grossstädte und das Geistesleben', pp. 185–206 in *Die Grossstädte: Vorträge und Aufsätze zur Städteausstellung*, Jahrbuch der Gehe-Stiftung zu Dresden 9, Winter 1902–3. The present extract is taken from the translation by H. H. Gerth and C. Wright Mills in Kurt H. Wolff (ed.), *The Sociology of Georg Simmel*, Glencoe, IL, 1950, pp. 409–24.

The deepest problems of modern life derive from the claim of the individual to preserve the autonomy and individuality of his existence in the face of overwhelming social forces, of historical heritage, of external culture, and of the technique of life. The fight with nature which primitive man has to wage for his *bodily* existence attains in this modern form its latest transformation. The eighteenth century called upon man to free himself of all the historical bonds in the state and in religion, in morals and in economics. Man's nature, originally good and common to all, should develop unhampered. In addition to more liberty, the nineteenth century demanded the functional specialization of man and his work; this specialization makes one individual incomparable to another, and each of them indispensable to the highest possible extent. However, this specialization makes each man the more directly dependent upon the supplementary activities of all others. Nietzsche sees the full development of the individual conditioned by the most ruthless struggle of individuals; socialism believes in the suppression of all competition for the same reason. Be that as it may, in all these positions the same basic motive is at work: the person resists being leveled down and worn out by a social-technological mechanism. An inquiry into the inner meaning of specifically modern life and its products, into the soul of the cultural body, so to speak, must seek to solve the equation which structures like the metropolis set up between the individual and the super-individual contents of life. Such an inquiry must answer the question of how the personality accommodates itself in the adjustments to external forces.

The psychological basis of the metropolitan type of individuality consists in the *intensification of nervous stimulation* which results from the swift and uninterrupted change of outer and inner stimuli. Man is a differentiating creature. His mind is

stimulated by the difference between a momentary impression and the one which preceded it. Lasting impressions, impressions which differ only slightly from one another, impressions which take a regular and habitual course and show regular and habitual contrasts – all these use up, so to speak, less consciousness than does the rapid crowding of changing images, the sharp discontinuity in the grasp of a single glance, and the unexpectedness of onrushing impressions. These are the psychological conditions which the metropolis creates. With each crossing of the street, with the tempo and multiplicity of economic, occupational and social life, the city sets up a deep contrast with small-town and rural life with reference to the sensory foundations of psychic life. The metropolis exacts from man as a discriminating creature a different amount of consciousness than does rural life. Here the rhythm of life and sensory mental imagery flows more slowly, more habitually, and more evenly. Precisely in this connection the sophisticated character of metropolitan psychic life becomes understandable – as over against small-town life which rests more upon deeply felt and emotional relationships. [...]

[...] In the sphere of the economic psychology of the small group it is of importance that under primitive conditions production serves the customer who orders the good, so that the producer and the consumer are acquainted. The modern metropolis, however, is supplied almost entirely by production for the market, that is, for entirely unknown purchasers who never personally enter the producer's actual field of vision. Through this anonymity the interests of each party acquire an unmerciful matter-of-factness; and the intellectually calculating economic egoisms of both parties need not fear any deflection because of the imponderables of personal relationships. [...]

In certain seemingly insignificant traits, which lie upon the surface of life, the same psychic currents characteristically unite. Modern mind has become more and more calculating. The calculative exactness of practical life which the money economy has brought about corresponds to the ideal of natural science: to transform the world into an arithmetic problem, to fix every part of the world by mathematical formulas. [...] The technique of metropolitan life is unimaginable without the most punctual integration of all activities and mutual relations into a stable and impersonal time schedule. Here again the general conclusions of this entire task of reflection become obvious, namely, that from each point on the surface of existence – however closely attached to the surface alone – one may drop a sounding into the depth of the psyche so that all the most banal externalities of life finally are connected with the ultimate decisions concerning the meaning and style of life. Punctuality, calculability, exactness are forced upon life by the complexity and extension of metropolitan existence and are not only most intimately connected with its money economy and intellectualistic character. These traits must also color the contents of life and favor the exclusion of those irrational, instinctive, sovereign traits and impulses which aim at determining the mode of life from within, instead of receiving the general and precisely schematized form of life from without [...]

The same factors which have thus coalesced into the exactness and minute precision of the form of life have coalesced into a structure of the highest impersonality; on the other hand, they have promoted a highly personal subjectivity. There is perhaps no psychic phenomenon which has been so unconditionally reserved to the metropolis as has the blasé attitude. The blasé attitude results first from the rapidly changing and closely compressed contrasting stimulations of the nerves. From this, the enhancement

of metropolitan intellectuality, also, seems originally to stem. Therefore, stupid people who are not intellectually alive in the first place usually are not exactly blasé. A life in boundless pursuit of pleasure makes one blasé because it agitates the nerves to their strongest reactivity for such a long time that they finally cease to react at all. [...]

This physiological source of the metropolitan blasé attitude is joined by another source which flows from the money economy. The essence of the blasé attitude consists in the blunting of discrimination. This does not mean that the objects are not perceived, as is the case with the half-wit, but rather that the meaning and differing values of things, and thereby the things themselves, are experienced as insubstantial. They appear to the blasé person in an evenly flat and gray tone; no one object deserves preference over any other. This mood is the faithful subjective reflection of the completely internalized money economy. [...]

Whereas the subject of this form of existence has to come to terms with it entirely for himself, his self-preservation in the face of the large city demands from him a no less negative behavior of a social nature. This mental attitude of metropolitans toward one another we may designate, from a formal point of view, as reserve. If so many inner reactions were responses to the continuous external contacts with innumerable people as are those in the small town, where one knows almost everybody one meets and where one has a positive relation to almost everyone, one would be completely atomized internally and come to an unimaginable psychic state. Partly this psychological fact, partly the right to distrust which men have in the face of the touch-and-go elements of metropolitan life, necessitates our reserve. As a result of this reserve we frequently do not even know by sight those who have been our neighbors for years. And it is this reserve which in the eyes of the small-town people makes us appear to be cold and heartless. Indeed, if I do not deceive myself, the inner aspect of this outer reserve is not only indifference but, more often than we are aware, it is a slight aversion, a mutual strangeness and repulsion, which will break into hatred and fight at the moment of a closer contact, however caused. The whole inner organization of such an extensive communicative life rests upon an extremely varied hierarchy of sympathies, indifferences, and aversions of the briefest as well as of the most permanent nature. The sphere of indifference in this hierarchy is not as large as might appear on the surface. Our psychic activity still responds to almost every impression of somebody else with a somewhat distinct feeling. The unconscious, fluid and changing character of this impression seems to result in a state of indifference. Actually this indifference would be just as unnatural as the diffusion of indiscriminate mutual suggestion would be unbearable. From both these typical dangers of the metropolis, indifference and indiscriminate suggestibility, antipathy protects us. A latent antipathy and the preparatory stage of practical antagonism effect the distances and aversions without which this mode of life could not at all be led. The extent and the mixture of this style of life, the rhythm of its emergence and disappearance, the forms in which it is satisfied – all these, with the unifying motives in the narrower sense, form the inseparable whole of the metropolitan style of life. What appears in the metropolitan style of life directly as dissociation is in reality only one of its elemental forms of socialization.

This reserve with its overtone of hidden aversion appears in turn as the form or the cloak of a more general mental phenomenon of the metropolis: it grants to the individual a kind and an amount of personal freedom which has no analogy whatsoever under other conditions. [...]

[. . .] Today metropolitan man is 'free' in a spiritualized and refined sense, in contrast to the pettiness and prejudices which hem in the small-town man. For the reciprocal reserve and indifference and the intellectual life conditions of large circles are never felt more strongly by the individual in their impact upon his independence than in the thickest crowd of the big city. This is because the bodily proximity and narrowness of space makes the mental distance only the more visible. It is obviously only the observe of this freedom if, under certain circumstances, one nowhere feels as lonely and lost as in the metropolitan crowd. For here as elsewhere it is by no means necessary that the freedom of man be reflected in his emotional life as comfort.

It is not only the immediate size of the area and the number of persons which, because of the universal historical correlation between the enlargement of the circle and the personal inner and outer freedom, has made the metropolis the locale of freedom. It is rather in transcending this visible expanse that any given city becomes the seat of cosmopolitanism. The horizon of the city expands in a manner comparable to the way in which wealth develops; a certain amount of property increases in a quasi-automatical way in ever more rapid progression. As soon as a certain limit has been passed, the economic, personal, and intellectual relations of the citizenry, the sphere of intellectual predominance of the city over its hinterland, grow as in geometrical progression. Every gain in dynamic extension becomes a step, not for an equal, but for a new and larger extension. From every thread spinning out of the city, ever new threads grow as if by themselves, just as within the city the unearned increment of ground rent, through the mere increase in communication, brings the owner automatically increasing profits. At this point, the quantitative aspect of life is transformed directly into qualitative traits of character. [. . .]

[. . .] In the measure of its expansion, the city offers more and more the decisive conditions of the division of labor. It offers a circle which through its size can absorb a highly diverse variety of services. At the same time, the concentration of individuals and their struggle for customers compel the individual to specialize in a function from which he cannot be readily displaced by another. It is decisive that city life has transformed the struggle with nature for livelihood into an inter-human struggle for gain, which here is not granted by nature but by other men. For specialization does not flow only from the competition for gain but also from the underlying fact that the seller must always seek to call forth new and differentiated needs of the lured customer. In order to find a source of income which is not yet exhausted, and to find a function which cannot readily be displaced, it is necessary to specialize in one's services. This process promotes differentiation, refinement, and the enrichment of the public's needs, which obviously must lead to growing personal differences within this public.

All this forms the transition to the individualization of mental and psychic traits which the city occasions in proportion to its size. [. . .]

The most profound reason, however, why the metropolis conduces to the urge for the most individual personal existence – no matter whether justified and successful – appears to me to be the following: the development of modern culture is characterized by the preponderance of what one may call the 'objective spirit' over the 'subjective spirit.' This is to say, in language as well as in law, in the technique of production as well as in art, in science as well as in the objects of the domestic environment, there is embodied a sum of spirit. The individual in his intellectual development follows the growth of this spirit very imperfectly and at an ever increasing distance. If, for instance,

we view the immense culture which for the last hundred years has been embodied in things and in knowledge, in institutions and in comforts, and if we compare all this with the cultural progress of the individual during the same period – at least in high status groups – a frightful disproportion in growth between the two becomes evident. Indeed, at some points we notice a retrogression in the culture of the individual with reference to spirituality, delicacy, and idealism. This discrepancy results essentially from the growing division of labor. For the division of labor demands from the individual an ever more one-sided accomplishment, and the greatest advance in a one-sided pursuit only too frequently means dearth to the personality of the individual. In any case, he can cope less and less with the overgrowth of objective culture. The individual is reduced to a negligible quantity, perhaps less in his consciousness than in his practice and in the totality of his obscure emotional states that are derived from this practice. The individual has become a mere cog in an enormous organization of things and powers which tear from his hands all progress, spirituality, and value in order to transform them from their subjective form into the form of a purely objective life. It needs merely to be pointed out that the metropolis is the genuine arena of this culture which outgrows all personal life. Here in buildings and educational institutions, in the wonders and comforts of space-conquering technology, in the formations of community life, and in the visible institutions of the state, is offered such an overwhelming fullness of crystallized and impersonalized spirit that the personality, so to speak, cannot maintain itself under its impact. On the one hand, life is made infinitely easy for the personality in that stimulations, interests, uses of time and consciousness are offered to it from all sides. They carry the person as if in a stream, and one needs hardly to swim for oneself. On the other hand, however, life is composed more and more of these impersonal contents and offerings which tend to displace the genuine personal colorations and incomparabilities. This results in the individual's summoning the utmost in uniqueness and particularization, in order to preserve his most personal core. He has to exaggerate this personal element in order to remain audible even to himself. The atrophy of individual culture through the hypertrophy of objective culture is one reason for the bitter hatred which the preachers of the most extreme individualism, above all Nietzsche, harbor against the metropolis. But it is, indeed, also a reason why these preachers are so passionately loved in the metropolis and why they appear to the metropolitan man as the prophets and saviors of his most unsatisfied yearnings.

* * *

2 Max Weber (1864–1920) 'Asceticism and the Spirit of Capitalism'

From *The Protestant Ethic and the Spirit of Capitalism*. Weber's pioneering study examined the effects of an ideological formation (Protestant religion) on the constitution of an economic order (modern capitalism). The present text addresses the constraining effects on modern culture of the heritage of puritanism, striking a profoundly pessimistic note in its appraisal of modernity. Originally published in the *Archiv für Sozialwissenschaft und Sozialpolitik*, XX and XXI, 1904–5, pp. 155–83. First English translation by the American sociolo-

gist Talcott Parsons, London and New York, 1930, from which the present extract is taken (pp. 180–2).

One of the fundamental elements of the spirit of modern capitalism, and not only of that but of all modern culture: rational conduct on the basis of the idea of the calling, was born ... from the spirit of Christian asceticism. [...] The idea that modern labour has an ascetic character is of course not new. Limitation to specialized work, with a renunciation of the Faustian universality of man which it involves, is a condition of any valuable work in the modern world; hence deeds and renunciation inevitably condition each other today. This fundamentally ascetic trait of middle-class life, if it attempts to be a way of life at all, and not simply the absence of any, was what Goethe wanted to teach, at the height of his wisdom, in the *Wanderjahren*, and in the end which he gave to the life of his *Faust*. For him the realization meant a renunciation, a departure from an age of full and beautiful humanity, which can no more be repeated in the course of our cultural development than can the flower of the Athenian culture of antiquity.

The Puritan wanted to work in a calling; we are forced to do so. For when asceticism was carried out of monastic cells into everyday life, and began to dominate worldly morality, it did its part in building the tremendous cosmos of the modern economic order. This order is now bound to the technical and economic conditions of machine production which to-day determine the lives of all the individuals who are born into this mechanism, not only those directly concerned with economic acquisition, with irresistible force. Perhaps it will so determine them until the last ton of fossilized coal is burnt. In Baxter's view the care for external goods should only lie on the shoulders of the 'saint like a light cloak, which can be thrown aside at any moment'. But fate decreed that the cloak should become an iron cage.

Since asceticism undertook to remodel the world and to work out its ideals in the world, material goods have gained an increasing and finally an inexorable power over the lives of men as at no previous period in history. To-day the spirit of religious asceticism – whether finally, who knows? – has escaped from the cage. But victorious capitalism, since it rests on mechanical foundations, needs its support no longer. The rosy blush of its laughing heir, the Enlightenment, seems also to be irretrievably fading, and the idea of duty in one's calling prowls about in our lives like the ghost of dead religious beliefs. Where the fulfilment of the calling cannot directly be related to the highest spiritual and cultural values, or when, on the other hand, it need not be felt simply as economic compulsion, the individual generally abandons the attempt to justify it at all. In the field of its highest development, in the United States, the pursuit of wealth, stripped of its religious and ethical meaning, tends to become associated with purely mundane passions, which often actually give it the character of sport.

No one knows who will live in this cage in the future, or whether at the end of this tremendous development entirely new prophets will arise, or there will be a great rebirth of old ideas and ideals, or, if neither, mechanized petrification, embellished with a sort of convulsive self-importance. For of the last stage of this cultural development, it might well be truly said: 'Specialists without spirit, sensualists without heart; this nullity imagines that it has attained a level of civilization never before achieved.'

3 Vladimir Ilyich Lenin (1870–1924) 'Party Organization and Party Literature'

In the changed circumstances after the Russian revolution of 1905 Lenin addressed the issue of the autonomy of art and literature, insisting instead on its implication in modern life in the class struggle between bourgeoisie and proletariat (see IIA9). Although he is speaking in the first instance solely about 'party' literature, hostile critics have seen the argument as paving the way for totalitarian control of the arts (see IVB11 and 15). Frequently reprinted, the essay was originally published in *Novaya Zhizn*, no. 12, Moscow, 13 November 1905. The present translation is taken from *Lenin on Literature and Art*, Moscow, 1967, pp. 24–9.

The new conditions for Social-Democratic work in Russia which have arisen since the October Revolution have brought the question of party literature to the fore. The distinction between the illegal and the legal press, that melancholy heritage of the epoch of feudal, autocratic Russia, is beginning to disappear. [...]

So long as there was a distinction between the illegal and the legal press, the question of the party and non-party press was decided extremely simply and in an extremely false and abnormal way. The entire illegal press was a party press, being published by organizations and run by groups which in one way or another were linked with groups of practical party workers. The entire legal press was non-party – since parties were banned – but it 'gravitated' towards one party or another. Unnatural alliances, strange 'bed-fellows' and false cover-devices were inevitable. The forced reserve of those who wished to express party views merged with the immature thinking or mental cowardice of those who had not risen to these views and who were not, in effect, party people.

An accursed period of Aesopian language, literary bondage, slavish speech, and ideological serfdom! The proletariat has put an end to this foul atmosphere which stifled everything living and fresh in Russia. But so far the proletariat has won only half freedom for Russia.

The revolution is not yet completed. While tsarism is *no longer* strong enough to defeat the revolution, the revolution is *not yet* strong enough to defeat tsarism. And we are living in times when everywhere and in everything there operates this unnatural combination of open, forthright, direct and consistent party spirit with an underground, covert, 'diplomatic' and dodgy 'legality'. This unnatural combination makes itself felt even in our newspaper ...

Be that as it may, the half-way revolution compels all of us to set to work at once organizing the whole thing on new lines. Today literature, even that published 'legally', can be nine-tenths party literature. It must become party literature. In contradistinction to bourgeois customs, to the profitmaking, commercialized bourgeois press, to bourgeois literary careerism and individualism, 'aristocratic anarchism' and drive for profit, the socialist proletariat must put forward the principle of *party literature*, must develop this principle and put it into practice as fully and completely as possible.

What is this principle of party literature? It is not simply that, for the socialist proletariat, literature cannot be a means of enriching individuals or groups; it cannot, in fact, be an individual undertaking, independent of the common cause of the proletariat. Down with non-partisan writers! Down with literary supermen! Literature must become *part* of the common cause of the proletariat, 'a cog and a screw' of one single

great Social-Democratic mechanism set in motion by the entire politically-conscious vanguard of the entire working class. Literature must become a component of organized, planned and integrated Social-Democratic Party work.

'All comparisons are lame,' says a German proverb. So is my comparison of literature with a cog, of a living movement with a mechanism. And I daresay there will even be hysterical intellectuals to raise a howl about such a comparison, which degrades, deadens, 'bureaucratizes' the free battle of ideas, freedom of criticism, freedom of literary creation, etc., etc. Such outcries, in point of fact, would be nothing more than an expression of bourgeois-intellectual individualism. There is no question that literature is least of all subject to mechanical adjustment or levelling, to the rule of the majority over the minority. There is no question, either, that in this field greater scope must undoubtedly be allowed for personal initiative, individual inclination, thought and fantasy, form and content. All this is undeniable; but all this simply shows that the literary side of the proletarian party cause cannot be mechanically identified with its other sides. This, however, does not in the least refute the proposition, alien and strange to the bourgeoisie and bourgeois democracy, that literature must by all means and necessarily become an element of Social-Democratic Party work, inseparably bound up with the other elements. Newspapers must become the organs of the various party organizations, and their writers must by all means become members of these organizations. Publishing and distributing centres, bookshops and reading-rooms, libraries and similar establishments – must all be under Party control. The organized socialist proletariat must keep an eye on all this work, supervise it in its entirety, and, from beginning to end, without any exception, infuse into it the life-stream of the living proletarian cause, thereby cutting the ground from under the old, semi-Oblomov, semi-shopkeeper Russian principle: the writer does the writing, the reader does the reading.

We are not suggesting, of course, that this transformation of literary work, which has been defiled by the Asiatic censorship and the European bourgeoisie, can be accomplished all at once. Far be it from us to advocate any kind of standardized system, or a solution by means of a few decrees. Cut-and-dried schemes are least of all applicable here. What is needed is that the whole of our Party, and the entire politically-conscious Social-Democratic proletariat throughout Russia, should become aware of this new problem, specify it clearly and everywhere set about solving it. Emerging from the captivity of the feudal censorship, we have no desire to become, and shall not become, prisoners of bourgeois-shopkeeper literary relations. We want to establish, and we shall establish, a free press, free not simply from the police, but also from capital, from careerism, and what is more, free from bourgeois-anarchist individualism.

These last words may sound paradoxical, or an affront to the reader. What! some intellectual, an ardent champion of liberty, may shout. What, you want to impose collective control on such a delicate, individual matter as literary work! You want workmen to decide questions of science, philosophy, or aesthetics by a majority of votes! You deny the absolute freedom of absolutely individual ideological work!

Calm yourselves, gentlemen! First of all, we are discussing party literature and its subordination to party control. Everyone is free to write and say whatever he likes, without any restrictions. But every voluntary association (including the party) is also free to expel members who use the name of the party to advocate anti-party views. Freedom of speech and the press must be complete. But then freedom of association

must be complete too. I am bound to accord you, in the name of free speech, the full right to shout, lie and write to your heart's content. But you are bound to grant me, in the name of freedom of association, the right to enter into, or withdraw from, association with people advocating this or that view. The party is a voluntary association, which would inevitably break up, first ideologically and then physically, if it did not cleanse itself of people advocating anti-party views. And to define the border-line between party and anti-party there is the party programme, the party's resolutions on tactics and its rules and, lastly, the entire experience of international Social-Democracy, the voluntary international associations of the proletariat, which has constantly brought into its parties individual elements and trends not fully consistent, not completely Marxist and not altogether correct and which, on the other hand, has constantly conducted periodical 'cleansings' of its ranks. So it will be with us too, supporters of bourgeois 'freedom of criticism', *within* the Party. We are now becoming a mass party all at once, changing abruptly to an open organization, and it is inevitable that we shall be joined by many who are inconsistent (from the Marxist standpoint), perhaps we shall be joined even by some Christian elements, and even by some mystics. We have sound stomachs and we are rock-like Marxists. We shall digest those inconsistent elements. Freedom of thought and freedom of criticism within the Party will never make us forget about the freedom of organizing people into those voluntary associations known as parties.

Secondly, we must say to you bourgeois individualists that your talk about absolute freedom is sheer hypocrisy. There can be no real and effective 'freedom' in a society based on the power of money, in a society in which the masses of working people live in poverty and the handful of rich live like parasites. Are you free in relation to your bourgeois publisher, Mr Writer, in relation to your bourgeois public, which demands that you provide it with pornography in frames and paintings, and prostitution as a 'supplement' to 'sacred' scenic art? This absolute freedom is a bourgeois or an anarchist phrase (since, as a world outlook, anarchism is bourgeois philosophy turned inside out). One cannot live in society and be free from society. The freedom of the bourgeois writer, artist or actress is simply masked (or hypocritically masked) dependence on the money-bag, on corruption, on prostitution.

And we socialists expose this hypocrisy and rip off the false labels, not in order to arrive at a non-class literature and art (that will be possible only in a socialist extra-class society), but to contrast this hypocritically free literature, which is in reality linked to the bourgeoisie, with a really free one that will be *openly* linked to the proletariat.

It will be a free literature, because the idea of socialism and sympathy with the working people, and not greed or careerism, will bring ever new forces to its ranks. It will be a free literature, because it will serve, not some satiated heroine, not the bored 'upper ten thousand' suffering from fatty degeneration, but the millions and tens of millions of working people – the flower of the country, its strength and its future. It will be a free literature, enriching the last word in the revolutionary thought of mankind with the experience and living work of the socialist proletariat, bringing about permanent interaction between the experience of the past (scientific socialism, the completion of the development of socialism from its primitive, utopian forms) and the experience of the present (the present struggle of the worker comrades).

To work, then, comrades! We are faced with a new and difficult task. But it is a noble and grateful one – to organize a broad, multiform and varied literature inseparably

linked with the Social-Democratic working-class movement. All Social-Democratic literature must become Party literature. Every newspaper, journal, publishing house, etc., must immediately set about reorganizing its work, leading up to a situation in which it will, in one form or another, be integrated into one Party organization or another. Only then will 'Social-Democratic' literature really become worthy of that name, only then will it be able to fulfil its duty and, even within the framework of bourgeois society, break out of bourgeois slavery and merge with the movement of the really advanced and thoroughly revolutionary class.

4 Henri Bergson (1859–1941) from *Creative Evolution*

Bergson achieved an extensive intellectual influence, particularly in France, in the years preceding the First World War. In particular, his ideas on memory, the *élan vital*, and the subjective construction of reality, pervaded the avant-garde, having an impact on Cubism and, more explicitly, Futurism. *L'Evolution créatrice*, was originally published in Paris in 1907; an authorized English translation by Arthur Mitchell was published in London in 1911. The present extracts are taken from pp. 171–3, 194–6 and 296–9.

... Fabricating consists in carving out the form of an object in matter. What is the most important is the form to be obtained. As to the matter, we choose that which is most convenient; but, in order to choose it, that is to say, in order to go and seek it among many others, we must have tried, in imagination at least, to endow every kind of matter with the form of the object conceived. In other words, an intelligence which aims at fabricating is an intelligence which never stops at the actual form of things nor regards it as final, but, on the contrary, looks upon all matter as if it were carvable at will. Plato compares the good dialectician to the skilful cook who carves the animal without breaking its bones, by following the articulations marked out by nature. An intelligence which always proceeded thus would really be an intelligence turned toward speculation. But action, and in particular fabrication, requires the opposite mental tendency: it makes us consider every actual form of things, even the form of natural things, as artificial and provisional; it makes our thought efface from the object perceived, even though organized and living, the lines that outwardly mark its inward structure; in short, it makes us regard its matter as indifferent to its form. The whole of matter is made to appear to our thought as an immense piece of cloth in which we can cut out what we will and sew it together again as we please. Let us note, in passing, that it is this power that we affirm when we say that there is a *space*, that is to say, a homogeneous and empty medium, infinite and infinitely divisible, lending itself indifferently to any mode of decomposition whatsoever. A medium of this kind is never perceived; it is only conceived. What is perceived is extension coloured, resistant, divided according to the lines which mark out the boundaries of real bodies or of their real elements. But when we think of our power over this matter, that is to say, of our faculty of decomposing and recomposing it as we please, we project the whole of these possible decompositions and recompositions behind real extension in the form of a homogeneous space, empty and indifferent, which is supposed to underlie it. This space is therefore, pre-eminently, the plan of our possible action on things, although, indeed, things have a natural tendency, as we shall explain further on, to enter into a frame of

this kind. It is a view taken by mind. The animal has probably no idea of it, even when, like us, it perceives extended things. It is an idea that symbolizes the tendency of the human intellect to fabrication. [...] Suffice it to say that *the intellect is characterized by the unlimited power of decomposing according to any law and of recomposing into any system.*

* * *

Instinct is sympathy. If this sympathy could extend its object and also reflect upon itself, it would give us the key to vital operations – just as intelligence, developed and disciplined, guides us into matter. For – we cannot too often repeat it – intelligence and instinct are turned in opposite directions, the former towards inert matter, the latter towards life. Intelligence, by means of science, which is its work, will deliver up to us more and more completely the secret of physical operations; of life it brings us, and moreover only claims to bring us, a translation in terms of inertia. It goes all round life, taking from outside the greatest possible number of views of it, drawing it into itself instead of entering into it. But it is to the very inwardness of life that *intuition* leads us, – by intuition I mean instinct that has become disinterested, self-conscious, capable of reflecting upon its object and of enlarging it indefinitely.

That an effort of this kind is not impossible, is proved by the existence in man of an aesthetic faculty along with normal perception. Our eye perceives the features of the living being, merely as assembled, not as mutually organized. The intention of life, the simple movement that runs through the lines, that binds them together and gives them significance, escapes it. This intention is just what the artist tries to regain, in placing himself back within the object by a kind of sympathy, in breaking down, by an effort of intuition, the barrier that space puts up between him and his model. It is true that this aesthetic intuition, like external perception, only attains the individual. But we can conceive an inquiry turned in the same direction as art, which would take life *in general* for its object, just as physical science, in following to the end the direction pointed out by external perception, prolongs the individual facts into general laws. No doubt this philosophy will never obtain a knowledge of its object comparable to that which science has of its own. Intelligence remains the luminous nucleus around which instinct, even enlarged and purified into intuition, forms only a vague nebulosity. But, in default of knowledge properly so called, reserved to pure intelligence, intuition may enable us to grasp what it is that intelligence fails to give us, and indicate the means of supplementing it. On the one hand, it will utilize the mechanism of intelligence itself to show how intellectual moulds cease to be strictly applicable; and on the other hand, by its own work, it will suggest to us the vague feeling, if nothing more, of what must take the place of intellectual moulds. Thus, intuition may bring the intellect to recognize that life does not quite go into the category of the many nor yet into that of the one; that neither mechanical causality nor finality can give a sufficient interpretation of the vital process. Then, by the sympathetic communication which it establishes between us and the rest of the living, by the expansion of our consciousness which it brings about, it introduces us into life's own domain, which is reciprocal interpenetration, endlessly continued creation. But, though it thereby transcends intelligence, it is from intelligence that has come the push that has made it rise to the point it has reached. Without intelligence, it would have remained in the form of instinct, riveted to the special object of its practical interest, and turned outward by it into movements of locomotion.

How theory of knowledge must take account of these two faculties, intellect and intuition, and how also, for want of establishing a sufficiently clear distinction between

them, it becomes involved in inextricable difficulties, creating phantoms of ideas to which there cling phantoms of problems, we shall endeavour to show a little further on. We shall see that the problem of knowledge, from this point of view, is one with the metaphysical problem, and that both one and the other depend upon experience. On the one hand, indeed, if intelligence is charged with matter and instinct with life, we must squeeze them both in order to get the double essence from them; metaphysics is therefore dependent upon theory of knowledge. But, on the other hand, if consciousness has thus split up into intuition and intelligence, it is because of the need it had to apply itself to matter at the same time as it had to follow the stream of life. The double form of consciousness is then due to the double form of the real, and theory of knowledge must be dependent upon metaphysics. In fact, each of these two lines of thought leads to the other; they form a circle, and there can be no other centre to the circle but the empirical study of evolution. It is only in seeing consciousness run through matter, lose itself there and find itself there again, divide and reconstitute itself, that we shall form an idea of the mutual opposition of the two terms, as also, perhaps, of their common origin. [. . .]

* * *

Matter or mind, reality has appeared to us as a perpetual becoming. It makes itself or it unmakes itself, but it is never something made. Such is the intuition that we have of mind when we draw aside the veil which is interposed between our consciousness and ourselves. This, also, is what our intellect and senses themselves would show us of matter, if they could obtain a direct and disinterested idea of it. But, preoccupied before everything with the necessities of action, the intellect, like the senses, is limited to taking, at intervals, views that are instantaneous and by that very fact immobile of the becoming of matter. Consciousness, being in its turn formed on the intellect, sees clearly of the inner life what is already made, and only feels confusedly the making. Thus, we pluck out of duration those moments that interest us, and that we have gathered along its course. These alone we retain. And we are right in so doing, while action only is in question. But when, in *speculating* on the *nature* of the real, we go on regarding it as our practical interest requires us to regard it, we become unable to perceive the true evolution, the radical becoming. Of becoming we perceive only states, of duration only instants, and even when we speak of duration and of becoming, it is of another thing that we are thinking. Such is the most striking of the two illusions we wish to examine. It consists in supposing that we can think the unstable by means of the stable, the moving by means of the immobile.

The other illusion is near akin to the first. It has the same origin, being also due to the fact that we import into speculation a procedure made for practice. All action aims at getting something that we feel the want of, or at creating something that does not yet exist. In this very special sense, it fills a void, and goes from the empty to the full, from an absence to a presence, from the unreal to the real. Now the unreality which is here in question is purely relative to the direction in which our attention is engaged, for we are immersed in realities and cannot pass out of them; only, if the present reality is not the one we are seeking, we speak of the *absence* of this sought-for reality wherever we find the *presence* of another. We thus express what we have as a function of what we want. This is quite legitimate in the sphere of action. But, whether we will or no, we keep to this way of speaking, and also of thinking, when we speculate on the nature of things independently of the interest they have for us. Thus arises the second of the two

illusions. [...] It is due, like the other, to the static habits that our intellect contracts when it prepares our action on things. Just as we pass through the immobile to go to the moving, so we make use of the void in order to think the full.

We have met with this illusion already in dealing with the fundamental problem of knowledge. The question, we then said, is to know why there is order, and not disorder, in things. But the question has meaning only if we suppose that disorder, understood as an absence of order, is possible, or imaginable, or conceivable. Now, it is only order that is real; but, as order can take two forms, and as the presence of the one may be said to consist in the absence of the other, we speak of disorder whenever we have before us that one of the two orders for which we are not looking. The idea of disorder is then entirely practical. It corresponds to the disappointment of a certain expectation, and it does not denote the absence of all order, but only the presence of that order which does not offer us actual interest. So that whenever we try to deny order completely, absolutely, we find that we are leaping from one kind of order to the other indefinitely, and that the supposed suppression of the one and the other implies the presence of the two. [...]

5 Alexander Blok (1880–1921) 'Nature and Culture'

Blok was the leading Russian Symbolist poet. In his mystical apprehension of 'the distant thunder', and the contradiction between the age-old world of the soil and the modern world of the city and technology, he prefigured the upheavals of the First World War and the Russian Revolution. 'Nature and Culture' uses the eruption of Mount Etna in Sicily as a metaphor for this social cataclysm. It was read as a paper to the Religious-Philosophical Society in St Petersburg on 30 December 1908. The present translation by I. Freiman is taken from Alexander Blok, *The Spirit of Music*, London, 1946, pp. 50–2 and 55. (See also IIIB7.)

The telegraph hammers all over Europe, but it tells hardly a word of the glory that once was Messina. The vulgar words of the news-telegrams acquire the force of ancient Italian chronicles; but from Etna columns of yellow smoke are escaping. Sicily continues to tremble, and we cannot appease her tremors.

Is it really necessary to be optimistic in the face of these facts? And is it really necessary to be a pessimist or a superstitious person in order to point out that the flag of culture can always be lowered whenever the distant thunder of approaching storm is heard.

The earth has been shaken by underground ferments more than once. And more than once have we celebrated our infirmity before the plague, before hunger and rebellion, before the coward. What sort of frightful vindictiveness has been accumulated in us down the centuries? Human nature becomes more and more rigid, mechanized, more and more resembles a gigantic laboratory in which the vengeance of the elements is prepared. Science flourishes in order to subjugate the earth; art flourishes in order – like a winged day-dream, a mysterious aeroplane – to fly away from the earth; industry flourishes in order that people may part company with the earth.

Every promoter of culture is a demon, cursing the earth and devising wings in order to fly away from it. The heart of the advocate of progress breathes vengeance on the earth, on the elements; on the earth's crust not yet sufficiently hardened; vengeance for

all its difficult times and endless spaces, for the rusty onerous chain of cause and effect, for the injustice of life and the injustice of death. Persons of culture, advocates of progress, choice intellectuals, foaming at the mouth, construct machines, move science forward in secret spite, trying to forget and not to hear the rumbling of the elements, subterranean and terrestrial, which are stirring, now here now there. Only sometimes they awake and look around them and see the same earth – cursed, yet with its tranquil moments – and look upon it as upon some theatrical performance, some absurd, attractive tale.

There are others for whom the earth is not a tale but a wonderful and enduring fact, who know the elements and know themselves as having come forth from them. They are 'elemental people'. They are tranquil, like the earth, but for a while their activity is similar to the first faint rumblings of subterranean jolts. They know that 'to everything there is a season and a time to every purpose under the sun: a time to be born and a time to die; a time to plant and a time to pluck up that which is planted; a time to kill and a time to heal; a time to break down and a time to build up.' (Ecclesiastes.)

Some practical profession is more necessary and appropriate to them than industry and culture.

They also live in a dream. But their dream is unlike our dreams, in the same way as the fields of Russia are unlike the brilliant bustling of the Nevsky avenue. We see in our dreams and we dream in reality, how we may fly away from the earth in a plane, how, with the help of radium, we may explore the bowels of the earth, and of our body, how we may reach the north pole, and, through the last synthetic energy of our intellect, how we may subordinate the universe to a single, supreme law.

They, the elemental people, dream and create legends about the earth. They dream of temples, dispersed over the earth's face; of monasteries, where stands, behind a curtain, unseen by anyone, the statue of Nikolay, the worker of miracles; of the wind which sways the rye in the night – 'she who dances through the rye'; of the planks which rise to the surface from the bottom of a deep pond – fragments of foreign ships, because the pond is 'a ventilator of the ocean'. The earth is one with them and they are one with the earth, indistinguishable from it. It seems now and then that the hill is animate, and the tree is animate, and the church is animate, as the peasant himself is animate. Only, everything in this plain still sleeps but, when it stirs – everything as it stands will go: the peasants will go, the groves and the churches will go, and the incarnate Mothers of God will go forth from the hills, and the lakes will overflow the banks, and the rivers will flow backwards, and the whole earth will go.

* * *

[...] Between the two fires of infuriated vengeance, between two camps, we are living. Therefore it is so frightful. What kind of fire is it which breaks out into the light from under the 'crusted lava'? Is it such as devastated Calabria, or is this – a purifying fire?

Whichever it is, we are living through a terrible crisis. We still do not know exactly what events await us, but, in our hearts, the needle of the seismograph is already deflected. Already we see ourselves, as if against the background of a glow, flying in a light, rickety aeroplane, high above the earth; but beneath us is a rumbling and fire-spitting mountain, and down its sides, behind clouds of ashes, roll streams of red-hot lava.

6 Filippo Tommaso Marinetti (1876–1944) 'The Foundation and Manifesto of Futurism'

Marinetti was an established Symbolist poet, founder and editor of the journal *Poesia* (1905), before rejecting Symbolism in favour of new ideas about the defining characteristics of modern life: simultaneity, dynamism and speed. These became the stylistic preoccupations of a Futurist movement. Futurism also represented a conscious attempt to place Italian art in the forefront of the European avant-garde. Politically Marinetti's nationalism led him into a lifelong relationship with Mussolini's Fascism. The 'Founding Manifesto' was first published in the newspaper *Le Figaro* in Paris on 20 February 1909. It received its first English translation in 1912 in conjunction with the Futurist exhibition at the Sackville Gallery, London. The present translation, by R. W. Flint, is taken from his *Marinetti's Selected Writings*, London, 1971, pp. 39–44. (The ellipses are integral.)

We had stayed up all night, my friends and I, under hanging mosque lamps with domes of filigreed brass, domes starred like our spirits, shining like them with the prisoned radiance of electric hearts. For hours we had trampled our atavistic ennui into rich oriental rugs, arguing up to the last confines of logic and blackening many reams of paper with our frenzied scribbling.

An immense pride was buoying us up, because we felt ourselves alone at that hour, alone, awake, and on our feet, like proud beacons or forward sentries against an army of hostile stars glaring down at us from their celestial encampments. Alone with stokers feeding the hellish fires of great ships, alone with the black spectres who grope in the red-hot bellies of locomotives launched down their crazy courses, alone with drunkards reeling like wounded birds along the city walls.

Suddenly we jumped, hearing the mighty noise of the huge double-decker trams that rumbled by outside, ablaze with coloured lights, like villages on holiday suddenly struck and uprooted by the flooding Po and dragged over falls and through gorges to the sea.

Then the silence deepened. But, as we listened to the old canal muttering its feeble prayers and the creaking bones of sickly palaces above their damp green beards, under the windows we suddenly heard the famished roar of automobiles.

'Let's go!' I said. 'Friends, away! Let's go! Mythology and the Mystic Ideal are defeated at last. We're about to see the Centaur's birth and, soon after, the first flight of Angels! . . . We must shake the gates of life, test the bolts and hinges. Let's go! Look there, on the earth, the very first dawn! There's nothing to match the splendour of the sun's red sword, slashing for the first time through our millennial gloom!'

We went up to the three snorting beasts, to lay amorous hands on their torrid breasts. I stretched out on my car like a corpse on its bier, but revived at once under the steering wheel, a guillotine blade that threatened my stomach.

The raging broom of madness swept us out of ourselves and drove us through streets as rough and deep as the beds of torrents. Here and there, sick lamplight through window glass taught us to distrust the deceitful mathematics of our perishing eyes.

I cried, 'The scent, the scent alone is enough for our beasts.'

And like young lions we ran after Death, its dark pelt blotched with pale crosses as it escaped down the vast violet living and throbbing sky.

But we had no ideal Mistress raising her divine form to the clouds, nor any cruel Queen to whom to offer our bodies, twisted like Byzantine rings! There was nothing to make us wish for death, unless the wish to be free at last from the weight of our courage!

And on we raced, hurling watchdogs against doorsteps, curling them under our burning tyres like collars under a flatiron. Death, domesticated, met me at every turn, gracefully holding out a paw, or once in a while hunkering down, making velvety caressing eyes at me from every puddle.

'Let's break out of the horrible shell of wisdom and throw ourselves like pride-ripened fruit into the wide, contorted mouth of the wind! Let's give ourselves utterly to the Unknown, not in desperation but only to replenish the deep wells of the Absurd!'

The words were scarcely out of my mouth when I spun my car around with the frenzy of a dog trying to bite its tail, and there, suddenly, were two cyclists coming towards me, shaking their fists, wobbling like two equally convincing but nevertheless contradictory arguments. Their stupid dilemma was blocking my way – Damn! Ouch!...I stopped short and to my disgust rolled over into a ditch with my wheels in the air....

O maternal ditch, almost full of muddy water! Fair factory drain! I gulped down your nourishing sludge; and I remembered the blessed black breast of my Sudanese nurse....When I came up – torn, filthy, and stinking – from under the capsized car, I felt the white-hot iron of joy deliciously pass through my heart!

A crowd of fishermen with handlines and gouty naturalists were already swarming around the prodigy. With patient, loving care those people rigged a tall derrick and iron grapnels to fish out my car, like a big beached shark. Up it came from the ditch, slowly, leaving in the bottom, like scales, its heavy framework of good sense and its soft upholstery of comfort.

They thought it was dead, my beautiful shark, but a caress from me was enough to revive it; and there it was, alive again, running on its powerful fins!

And so, faces smeared with good factory muck – plastered with metallic waste, with senseless sweat, with celestial soot – we, bruised, our arms in slings, but unafraid, declared our high intentions to all the *living* of the earth:

Manifesto of Futurism

1 We intend to sing the love of danger, the habit of energy and fearlessness.
2 Courage, audacity, and revolt will be essential elements of our poetry.
3 Up to now literature has exalted a pensive immobility, ecstasy, and sleep. We intend to exalt aggressive action, a feverish insomnia, the racer's stride, the mortal leap, the punch and the slap.
4 We affirm that the world's magnificence has been enriched by a new beauty: the beauty of speed. A racing car whose hood is adorned with great pipes, like serpents of explosive breath – a roaring car that seems to ride on grapeshot is more beautiful than the *Victory of Samothrace*.
5 We want to hymn the man at the wheel, who hurls the lance of his spirit across the Earth, along the circle of its orbit.

6 The poet must spend himself with ardour, splendour, and generosity, to swell the enthusiastic fervour of the primordial elements.

7 Except in struggle, there is no more beauty. No work without an aggressive character can be a masterpiece. Poetry must be conceived as a violent attack on unknown forces, to reduce and prostrate them before man.

8 We stand on the last promontory of the centuries! . . . Why should we look back, when what we want is to break down the mysterious doors of the Impossible? Time and Space died yesterday. We already live in the absolute, because we have created eternal, omnipresent speed.

9 We will glorify war – the world's only hygiene – militarism, patriotism, the destructive gesture of freedom-bringers, beautiful ideas worth dying for, and scorn for woman.

10 We will destroy the museums, libraries, academies of every kind, will fight moralism, feminism, every opportunistic or utilitarian cowardice.

11 We will sing of great crowds excited by work, by pleasure, and by riot; we will sing of the multicoloured, polyphonic tides of revolution in the modern capitals; we will sing of the vibrant nightly fervour of arsenals and shipyards blazing with violent electric moons; greedy railway stations that devour smoke-plumed serpents; factories hung on clouds by the crooked lines of their smoke; bridges that stride the rivers like giant gymnasts, flashing in the sun with a glitter of knives; adventurous steamers that sniff the horizon; deep-chested locomotives whose wheels paw the tracks like the hooves of enormous steel horses bridled by tubing; and the sleek flight of planes whose propellers chatter in the wind like banners and seem to cheer like an enthusiastic crowd.

It is from Italy that we launch through the world this violently upsetting incendiary manifesto of ours. With it, today, we establish *Futurism*, because we want to free this land from its smelly gangrene of professors, archaeologists, *ciceroni* and antiquarians. For too long has Italy been a dealer in second-hand clothes. We mean to free her from the numberless museums that cover her like so many graveyards.

Museums: cemeteries! . . . Identical, surely, in the sinister promiscuity of so many bodies unknown to one another. Museums: public dormitories where one lies forever beside hated or unknown beings. Museums: absurd abattoirs of painters and sculptors ferociously slaughtering each other with colour-blows and line-blows, the length of the fought-over walls!

That one should make an annual pilgrimage, just as one goes to the graveyard on All Souls' Day – that I grant. That once a year one should leave a floral tribute beneath the *Gioconda*, I grant you that . . . But I don't admit that our sorrows, our fragile courage, our morbid restlessness should be given a daily conducted tour through the museums. Why poison ourselves? Why rot?

And what is there to see in an old picture except the laborious contortions of an artist throwing himself against the barriers that thwart his desire to express his dream completely? . . . Admiring an old picture is the same as pouring our sensibility into a funerary urn instead of hurling it far off, in violent spasms of action and creation.

Do you, then, wish to waste all your best powers in this eternal and futile worship of the past, from which you emerge fatally exhausted, shrunken, beaten down?

In truth I tell you that daily visits to museums, libraries, and academies (cemeteries of empty exertion, Calvaries of crucified dreams, registries of aborted beginnings!) are, for artists, as damaging as the prolonged supervision by parents of certain young people drunk with their talent and their ambitious wills. When the future is barred to them, the admirable past may be a solace for the ills of the moribund, the sickly, the prisoner.... But we want no part of it, the past, we the young and strong *Futurists*!

So let them come, the gay incendiaries with charred fingers! Here they are! Here they are!... Come on! set fire to the library shelves! Turn aside the canals to flood the museums!... Oh, the joy of seeing the glorious old canvases bobbing adrift on those waters, discoloured and shredded!... Take up your pickaxes, your axes and hammers and wreck, wreck the venerable cities, pitilessly!

The oldest of us is thirty: so we have at least a decade for finishing our work. When we are forty, other younger and stronger men will probably throw us in the wastebasket like useless manuscripts – we want it to happen!

They will come against us, our successors, will come from far away, from every quarter, dancing to the winged cadence of their first songs, flexing the hooked claws of predators, sniffing doglike at the academy doors the strong odour of our decaying minds, which will already have been promised to the literary catacombs.

But we won't be there.... At last they'll find us – one winter's night – in open country, beneath a sad roof drummed by a monotonous rain. They'll see us crouched beside our trembling aeroplanes in the act of warming our hands at the poor little blaze that our books of today will give out when they take fire from the flight of our images.

They'll storm around us, panting with scorn and anguish, and all of them, exasperated by our proud daring, will hurtle to kill us, driven by a hatred the more implacable the more their hearts will be drunk with love and admiration for us.

Injustice, strong and sane, will break out radiantly in their eyes.

Art, in fact, can be nothing but violence, cruelty, and injustice.

The oldest of us is thirty: even so we have already scattered treasures, a thousand treasures, of force, love, courage, astuteness, and raw will-power; have thrown them impatiently away, with fury, carelessly, unhesitatingly, breathless, and unresting... Look at us! We are still untired! Our hearts know no weariness because they are fed with fire, hatred, and speed!... Does that amaze you? It should, because you can never remember having lived! Erect on the summit of the world, once again we hurl our defiance at the stars!

You have objections? – Enough! Enough! We know them.... We've understood! ... Our fine deceitful intelligence tells us that we are the revival and extension of our ancestors – Perhaps!... If only it were so! – But who cares? We don't want to understand!... Woe to anyone who says those infamous words to us again!

Lift up your heads!

Erect on the summit of the world, once again we hurl defiance to the stars!

7 Umberto Boccioni (1882–1916) et al. 'Futurist Painting: Technical Manifesto'

The leader of the group of young artists collected around Marinetti, the painter/sculptor Boccioni was primarily responsible for this attempt to apply Marinetti's example to the visual arts. Influenced by Bergson (see IIA4), the Manifesto also betrays an involvement with Divisionism preceding the Futurist's encounter with Parisian Cubism. Originally published as a leaflet by *Poesia* in Milan, 11 April 1910 and also signed by Carlo Carrà, Luigi Russolo, Giacomo Balla and Gino Severini. The present translation is taken from the Sackville Gallery catalogue of 1912.

On the 18th of March, 1910, in the limelight of the Chiarella Theatre of Turin, we launched our first manifesto to a public of three thousand people – artists, men of letters, students and others; it was a violent and cynical cry which displayed our sense of rebellion, our deep-rooted disgust, our haughty contempt for vulgarity, for academic and pedantic mediocrity, for the fanatical worship of all that is old and worm-eaten.

We bound ourselves there and then to the movement of Futurist Poetry which was initiated a year earlier by F. T. Marinetti in the columns of the *Figaro*.

The battle of Turin has remained legendary. We exchanged almost as many knocks as we did ideas, in order to protect from certain death the genius of Italian Art.

And now during a temporary pause in this formidable struggle we come out of the crowd in order to expound with technical precision our programme for the renovation of painting, of which our Futurist Salon at Milan was a dazzling manifestation.

Our growing need of truth is no longer satisfied with Form and Colour as they have been understood hitherto.

The gesture which we would reproduce on canvas shall no longer be a fixed *moment* in universal dynamism. It shall simply be the *dynamic sensation* itself.

Indeed, all things move, all things run, all things are rapidly changing. A profile is never motionless before our eyes, but it constantly appears and disappears. On account of the persistency of an image upon the retina, moving objects constantly multiply themselves; their form changes like rapid vibrations, in their mad career. Thus a running horse has not four legs, but twenty, and their movements are triangular.

All is conventional in art. Nothing is absolute in painting. What was truth for the painters of yesterday is but a falsehood today. We declare, for instance, that a portrait must not be like the sitter, and that the painter carries in himself the landscapes which he would fix upon his canvas.

To paint a human figure you must not paint it; you must render the whole of its surrounding atmosphere.

Space no longer exists: the street pavement, soaked by rain beneath the glare of electric lamps, becomes immensely deep and gapes to the very centre of the earth. Thousands of miles divide us from the sun; yet the house in front of us fits into the solar disk.

Who can still believe in the opacity of bodies, since our sharpened and multiplied sensitiveness has already penetrated the obscure manifestations of the medium? Why should we forget in our creations the doubled power of our sight, capable of giving results analogous to those of the X-rays?

It will be sufficient to cite a few examples, chosen amongst thousands, to prove the truth of our arguments.

The sixteen people around you in a rolling motor bus are in turn and at the same time one, ten, four, three; they are motionless and they change places; they come and go, bound into the street, are suddenly swallowed up by the sunshine, then come back and sit before you, like persistent symbols of universal vibration.

How often have we not seen upon the cheek of the person with whom we are talking the horse which passes at the end of the street.

Our bodies penetrate the sofas upon which we sit, and the sofas penetrate our bodies. The motor bus rushes into the houses which it passes, and in their turn the houses throw themselves upon the motor bus and are blended with it.

The construction of pictures has hitherto been foolishly traditional. Painters have shown us the objects and the people placed before us. We shall henceforward put the spectator in the centre of the picture.

As in every realm of the human mind, clear-sighted individual research has swept away the unchanging obscurities of dogma, so must the vivifying current of science soon deliver painting from academism.

We would at any price re-enter into life. Victorious science has nowadays disowned its past in order the better to serve the material needs of our time; we would that art, disowning its past, were able to serve at last the intellectual needs which are within us.

Our renovated consciousness does not permit us to look upon man as the centre of universal life. The suffering of a man is of the same interest to us as the suffering of an electric lamp, which, with spasmodic starts, shrieks out the most heartrending expressions of colour. The harmony of the lines and folds of modern dress works upon our sensitiveness with the same emotional and symbolical power as did the nude upon the sensitiveness of the old masters.

In order to conceive and understand the novel beauties of a Futurist picture, the soul must be purified; the eye must be freed from its veil of atavism and culture, so that it may at last look upon Nature and not upon the museum as the one and only standard.

As soon as ever this result has been obtained, it will be readily admitted that brown tints have never coursed beneath our skin; it will be discovered that yellow shines forth in our flesh, that red blazes, and that green, blue and violet dance upon it with untold charms, voluptuous and caressing.

How is it possible still to see the human face pink, now that our life, redoubled by noctambulism, has multiplied our perceptions as colourists? The human face is yellow, red, green, blue, violet. The pallor of a woman gazing in a jeweller's window is more intensely iridescent than the prismatic fires of the jewels that fascinate her like a lark.

The time has passed for our sensations in painting to be whispered. We wish them in future to sing and re-echo upon our canvases in deafening and triumphant flourishes.

Your eyes, accustomed to semi-darkness, will soon open to more radiant visions of light. The shadows which we shall paint shall be more luminous than the high-lights of our predecessors, and our pictures, next to those of the museums, will shine like blinding daylight compared with deepest night.

We conclude that painting cannot exist today without Divisionism. This is no process that can be learned and applied at will. Divisionism, for the modern painter, must be an *innate complementariness* which we declare to be essential and necessary.

Our art will probably be accused of tormented and decadent cerebralism. But we shall merely answer that we are, on the contrary, the primitives of a new sensitiveness, multiplied hundredfold, and that our art is intoxicated with spontaneity and power.

WE DECLARE:

1 That all forms of imitation must be despised, all forms of originality glorified.
2 That it is essential to rebel against the tyranny of the terms 'harmony' and 'good taste' as being too elastic expressions, by the help of which it is easy to demolish the works of Rembrandt, of Goya and of Rodin.
3 That the art critics are useless or harmful.
4 That all subjects previously used must be swept aside in order to express our whirling life of steel, of pride, of fever and of speed.
5 That the name of 'madman' with which it is attempted to gag all innovators should be looked upon as a title of honour.
6 That innate complementariness is an absolute necessity in painting, just as free metre in poetry or polyphony in music.
7 That universal dynamism must be rendered in painting as a dynamic sensation.
8 That in the manner of rendering Nature the first essential is sincerity and purity.
9 That movement and light destroy the materiality of bodies.

WE FIGHT:

1 Against the bituminous tints by which it is attempted to obtain the patina of time upon modern pictures.
2 Against the superficial and elementary archaism founded upon flat tints, and which, by imitating the linear technique of the Egyptians, reduces painting to a powerless synthesis, both childish and grotesque.
3 Against the false claims to belong to the future put forward by the secessionists and the independents, who have installed new academies no less trite and attached to routine than the preceding ones.
4 Against the nude in painting, as nauseous and as tedious as adultery in literature.

We wish to explain this last point. Nothing is *immoral* in our eyes; it is the monotony of the nude against which we fight. We are told that the subject is nothing and that everything lies in the manner of treating it. That is agreed; we too, admit that. But this truism, unimpeachable and absolute fifty years ago, is no longer so today with regard to the nude, since artists obsessed with the desire to expose the bodies of their mistresses have transformed the Salons into arrays of unwholesome flesh!

We demand, for ten years, the total suppression of the nude in painting.

8 Robert Delaunay (1885–1941) 'On the Construction of Reality in Pure Painting'

Delaunay was associated with the 'public' group of Cubists (including Léger, Gleizes and Metzinger), who addressed themes related to modern life more explicitly than either

Braque or Picasso. He went on to develop a virtually abstract, colour-based art, derived from his Cubism. For this he was credited by the critic Guillaume Apollinaire with having originated the *sui generis* movement of 'Orphism'. This 'aesthetic declaration' by Delaunay was published in full by Apollinaire in the course of his own article, 'Reality, Pure Painting', in *Der Sturm*, Berlin, December 1912. The present translation, by Susan Suleiman, is taken from Leroy C. Breunig (ed.), *Apollinaire on Art*, London, 1972, pp. 262–5.

Realism is the eternal quality in art; without it there can be no permanent beauty, because it is the very essence of beauty.

Let us seek purity of means in painting, the clearest expression of beauty.

In impressionism – and I include in that term all the tendencies that reacted to it: neo-impressionism, precubism, cubism, neocubism, in other words, everything that represents technique and scientific procedure – we find ourselves face to face with nature, far from all the correctness of 'styles', whether Italian, Gothic, African, or any other.

From this point of view, impressionism is undeniably a victory, but an incomplete one. The first stammer of souls brimming over in the face of nature, and still somewhat stunned by this great reality. Their enthusiasm has done away with all the false ideas and archaic procedures of traditional painting (draftsmanship, geometry, perspective) and has dealt a deathblow to the neo-classical, pseudo-intellectual, and moribund Academy.

This movement of liberation began with the impressionists. They had had precursors: El Greco, a few English painters, and our own revolutionary Delacroix. It was a great period of preparation in the search for the only reality: 'light,' which finally brought all these experiments and reactions together in impressionism.

One of the major problems of modern painting today is still the way in which the light that is necessary to all vital expressions of beauty functions. It was Seurat who discovered the 'contrast of complementaries' in light.

Seurat was the first theoretician of light. Contrast became a means of expression. His premature death broke the continuity of his discoveries. Among the impressionists, he may be considered the one who attained the ultimate in means of expression.

His creation remains the discovery of the contrast of complementary colors. (Optical blending by means of dots, used by Seurat and his associates, was only a technique; it did not yet have the importance of contrasts used as a means of construction in order to arrive at pure expression.)

He used this first means to arrive at a specific representation of nature. His paintings are kinds of fleeting images.

Simultaneous contrast was not discovered, that is to say, achieved, by the most daring impressionists; yet it is the only basis of pure expression in painting today.

Simultaneous contrast ensures the dynamism of colors and their construction in the painting; it is the most powerful means to express reality.

Means of expression must not be personal; on the contrary, they must be within the comprehension of every intuition of the beautiful, and an artist's *métier* must be of the same nature as his creative conception.

The simultaneity of colors through simultaneous contrasts and through all the (uneven) quantities that emanate from the colors, in accordance with the way they are expressed in the movement represented – that is the only reality one can construct through painting.

We are no longer dealing here either with effects (neo-impressionism within impressionism), or with objects (cubism within impressionism), or with images (the physics of cubism within impressionism).

We are attaining a purely expressive art, one that excludes all the styles of the past (archaic, geometric) and is becoming a plastic art with only one purpose: to inspire human nature toward beauty. Light is not a method, it slides toward us, it is communicated to us by our sensibility. Without the perception of light – the eye – there can be no movement. In fact, it is our eyes that transmit the sensations perceived in nature to our soul. Our eyes are the receptacles of the present and, therefore, of our sensibility. Without sensibility, that is, without light, we can do nothing. Consequently, our soul finds its most perfect sensation of life in harmony, and this harmony results only from the simultaneity with which the quantities and conditions of light reach the soul (the supreme sense) by the intermediary of the eyes.

And the soul judges the forms of the image of nature by comparison with nature itself – a pure criticism – and it governs the creator. The creator takes note of everything that exists in the universe through entity, succession, imagination, and simultaneity.

Nature, therefore, engenders the science of painting.

The first paintings were simply a line encircling the shadow of a man made by the sun on the surface of the earth.

But how far removed we are, with our contemporary means, from these effigies – we who possess light (light colors, dark colors, their complementaries, their intervals, and their simultaneity) and all the quantities of colors emanating from the intellect to create harmony.

Harmony is sensibility ordered by the creator, who must try to render the greatest degree of realistic expression, or what might be called the subject; the subject is harmonic proportion, and this proportion is composed of various simultaneous elements in a single action. The subject is eternal in the work of art, and it must be apparent to the initiated in all its order, all its science.

Without the subject, there are no possibilities. This does not, however, mean a literary and, therefore, anecdotic subject; the subject of painting is exclusively plastic, and it results from vision. It must be the pure expression of human nature.

The eternal subject is to be found in nature itself; the inspiration and clear vision characteristic of the wise man, who discovers the most beautiful and powerful boundaries. [. . .]

9 Georgy Valentinovich Plekhanov (1856–1918) from *Art and Social Life*

Plekhanov became a revolutionary while studying in St Petersburg in the early 1870s. Initially wedded to the ideals of the *narodnik* movement, which was orientated towards the peasantry, Plekhanov soon turned to Marxism. His perception that the way to socialism lay not through the peasantry but through the nascent urban proletariat, and his articulation of this position during the 1880s, led to his being regarded as the 'father of Russian Marxism'. For almost forty years Plekhanov's work was conducted in émigré circles, mostly in Switzerland, along with other Russian revolutionaries, including Lenin. After working with Lenin to found the

Russian Social Democratic Workers' Party in 1898, he was involved in the split between the Menshevik and Bolshevik factions in 1903, ultimately siding with the former. Along with many other revolutionary exiles, Plekhanov was a deeply cultured man and sought to extend Marxist theory to cover the arts. Typically, however, his regard for the arts as a civilizing and educational tool led him to disparage the experimentation of the avant-garde. In his view, the modern movement's concentration on formal innovation rather than widely accessible subject-matter, as well as its emphasis on individualism and subjectivity, rendered it client to the bourgeoisie in its phase of crisis, rather than making it a potential ally of progressive political forces. *Art and Social Life* was a worked-up version of lectures originally given in Liège and Paris in 1912. It was published in parts in the journal *Sovremennik* in November and December 1912 and January 1913. The text is mostly concerned with literature. Only towards the end does Plekhanov turn to the visual arts, where he rounds on Cubism as the latest and most extreme manifestation of philosophical idealism and bourgeois decadence, charges which were to be often repeated by theoretical representatives of the communist movement during the twentieth century. The present extracts are taken from *Art and Social Life*, translated by A. Fineberg, London: Lawrence and Wishart, n.d., pp. 57–62 and 67–8.

Let us turn to painting.

Complete indifference to the idea content of their works was already displayed by the impressionists. One of them very aptly expressed the conviction of them all when he said: 'The chief dramatis persona in a picture is light.' But the sensation of light is only a sensation – that is, it is not *yet* emotion, and not *yet* thought. An artist who confines his attention to the realm of sensations is indifferent to emotion and thought. He may paint a good landscape. And the impressionists did, in fact, paint many excellent landscapes. But landscape is not the whole of painting. Let us recall Leonardo da Vinci's *Last Supper* and ask, is light the chief dramatis persona in this famous fresco? We know that its subject is that highly dramatic moment in the relationship of Jesus to his disciples when he says: 'One of you shall betray me.' Leonardo da Vinci's task was to portray the state of mind of Jesus himself, who was deeply grieved by his dreadful discovery, and of his disciples, who could not believe there could be a traitor in their small company. If the artist had believed that the chief dramatis persona in a picture is light, he would not have thought of depicting this drama. And if he had painted the fresco nevertheless, its chief artistic interest would have been centred not on what was going on in the hearts of Jesus and his disciples, but on what was happening on the walls of the chamber in which they were assembled, on the table at which they were seated, and on their own skins – that is, on the various light effects. We should then have had not a terrific spiritual drama, but a series of excellently painted patches of light: one, say, on a wall of the chamber, another on the table-cloth, a third on Judas' hooked nose, a fourth on Jesus' cheek, and so on and so forth. But because of this the impression caused by the fresco would be infinitely weaker, and the specific importance of Leonardo da Vinci's production would be infinitely less. Some French critics have compared impressionism with realism in literature. And there is some basis for the comparison. But if the impressionists were realists, it must be admitted that their realism was quite superficial, that it did not go deeper than the 'husk of appearances'. And when this realism acquired a firm position in modern art – as it undoubtedly did – artists trained under its influence had only one of two alternatives: either to exercise their ingenuity over the 'husk of appearances' and devise ever more astonishing and ever more artificial light effects; or to attempt to penetrate

beneath the 'husk of appearances', having realised the mistake of the impressionists and grasped that the chief dramatis persona in a picture is not light, but man and his highly diversified emotional experiences. And we do indeed find both these trends in modern art. Concentration of interest on the 'husk of appearances' accounts for those paradoxical canvases before which even the most indulgent critic shrugs his shoulders in perplexity and confesses that modern painting is passing through a 'crisis of ugliness'. Recognition, on the other hand, that it is impossible to stop at the 'husk of appearances' impels artists to seek for idea content, that is, to worship what they had only recently burned. But to impart idea content to a production is not so easy as it may seem. Idea is not something that exists independently of the real world. A man's stock of ideas is determined and enriched by his relations with that world. And he whose relations with that world are such that he considers his ego the 'only reality', inevitably becomes an out-and-out pauper in the matter of ideas. Not only is he bereft of ideas, but – and this is the chief point – he is not in a position to conceive any. And just as people, when they have no bread, eat dockweed, so when they have no clear ideas they content themselves with vague hints at ideas, with surrogates borrowed from mysticism, symbolism and the similar 'isms' characteristic of the period of decadence. In brief, we find in painting a repetition of what we have seen in literature: realism decays because of its inherent vacuity and idealistic reaction triumphs.

Subjective idealism was always anchored in the idea that there is no reality save our ego. But it required the boundless individualism of the era of bourgeois decadence to make this idea not only an egotistical rule defining the relations between people each of whom 'loves himself as God' – the bourgeoisie was never distinguished by excessive altruism – but also the theoretical foundation of a new esthetics.

The reader has of course heard of the so-called cubists. And if he has had occasion to see some of their productions, I do not run much risk of being mistaken if I assume that he was not at all delighted with them. In me, at any rate, they do not evoke anything resembling esthetic enjoyment. 'Nonsense cubed!' are the words that suggest themselves at the sight of these ostensibly artistic exercises. But cubism, after all, has its cause. Calling it nonsense raised to the third degree is not explaining its origin. This, of course, is not the place to attempt such an explanation. But even here one may indicate the direction in which it is to be sought. Before me lies an interesting book: *Du cubisme*, by Albert Gleizes and Jean Metzinger. Both authors are painters, and both belong to the cubist school. Let us obey the rule audiatur et altera pars [Let the other side be heard], and let us hear what they have to say. How do they justify their bewildering creative methods?

'There is nothing real outside of us,' they say. – '. . . It does not occur to us to doubt the existence of the objects which act upon our senses: but reasonable certainty is possible only in respect to the images which they evoke in our mind.'

From this the authors conclude that we do not know what forms objects have in themselves. And since these forms are unknown, they consider they are entitled to portray them at their own will and pleasure. They make the noteworthy reservation that they do not find it desirable to confine themselves, as the impressionists do, to the realm of sensation. 'We seek the essential,' they assure us, 'but we seek it in our personality not in an eternity laboriously fashioned by mathematicians and philosophers.'

In these arguments, as the reader will see, we meet, first of all, the already well-known idea that our ego is the 'only reality'. True, we meet it here in less rigid guise. Gleizes and Metzinger affirm that nothing is farther from their thought than to doubt the existence of external objects. But having granted the existence of the external world, our authors right there and then declare it to be unknowable. And this means that, for them too, there is nothing real except their ego.

If images of objects arise in us because the latter act upon our external senses, then it surely cannot be said that the outer world is unknowable: we obtain knowledge of it precisely because of this action. Gleizes and Metzinger are mistaken. Their argument about forms-in-themselves is also very lame. They cannot seriously be blamed for their mistakes: similar mistakes have been made by men infinitely more adept in philosophy than they. But one thing cannot be passed over, namely, that from the supposed unknowableness of the outer world, our authors infer that the essential must be sought in 'our personality'. This inference may be understood in two ways: first, by 'personality' may be meant the whole human race in general; secondly, it may mean each personality separately. In the first case, we arrive at the transcendental idealism of Kant; in the second, at the sophistical recognition that each separate person is the measure of all things. Our authors incline towards the sophistical interpretation of their inference.

And once its sophistical interpretation is accepted, one may permit oneself anything one likes in painting and in everything else. If instead of the 'Woman in Blue' (La femme en bleu – a painting exhibited by Fernand Léger at last autumn's Salon), I depict several stereometric figures, who has the right to say I have painted a bad picture? Women are part of the outer world around me. The outer world is unknowable. To portray a woman, I have to appeal to my own 'personality', and my 'personality' lends the woman the form of several haphazardly arranged cubes, or, rather, parallelepipeds. These cubes cause a smile in everybody who visits the Salon. But that's all right. The 'crowd' laughs only because it does not understand the language of the artist. The artist must under no circumstances give way to the crowd. 'Making no concessions, explaining nothing and telling nothing, the artist accumulates internal energy which illuminates everything around him.' And until such energy is accumulated, there is nothing for it but to draw stereometric figures.

We thus get an amusing parody on Pushkin's 'To The Poet':

> Exacting artist, are you pleased with your creation?
> You are? Then let the mob abuse your name
> And on the altar spit where burns your flame.
> And shake your tripod in its childlike animation.

The amusing thing about the parody is that in this case the 'exacting artist' is content with the most obvious nonsense. Incidentally, the appearance of such parodies shows that the inherent dialectics of social life have now led the theory of art for art's sake to the point of utter absurdity.

It is not good that man should be alone. The present 'innovators' in art are not satisfied with what their predecessors created. There is nothing wrong in this. On the contrary, the urge for something new is very often a source of progress. But not everybody who searches for something new, really finds it. One must know how to

look for it. He who is blind to the new teachings of social life, he to whom there is no reality save his own ego, will find in his search for something 'new' nothing but a new absurdity. It is not good that man should be alone.

It appears, then, that in present-day social conditions the fruits of art for art's sake are far from delectable. The extreme individualism of the era of bourgeois decay cuts off artists from all sources of true inspiration. It makes them completely blind to what is going on in social life, and condemns them to sterile preoccupation with personal emotional experiences that are entirely without significance and with the phantasies of a morbid imagination. The end product of their preoccupation is something that not only has no relation to beauty of any kind, but which moreover represents an obvious absurdity that can only be defended with the help of sophistical distortions of the idealist theory of knowledge.

* * *

I try, as the saying goes, not to weep or to laugh, but to understand. I do not say that modern artists '*must*' take inspiration from the emancipatory aspirations of the proletariat. No, if the apple-tree *must* bear apples, and the pear-tree *must* produce pears, artists who adhere to the standpoint of the bourgeoisie *must* revolt against the foresaid aspirations. *In decadent times art 'must'* be decadent. This is inevitable. And there is no point in being 'indignant' about it. But, as the *Communist Manifesto* rightly says, 'in times when the class struggle nears the decisive hour, the process of dissolution going on within the ruling class, in fact within the whole range of old society, assumes such a violent, glaring character, that a small section of the ruling class cuts itself adrift, and joins the revolutionary class, the class that holds the future in its hands. Just as, therefore, at an earlier period, a section of the nobility went over to the bourgeoisie, so now a portion of the bourgeoisie goes over to the proletariat, and in particular, a portion of the bourgeois ideologists, who have raised themselves to the level of comprehending theoretically the historical movement as a whole.'

Among the bourgeois ideologists who go over to the proletariat, we find very few artists. The reason probably is that it is only people who think that can 'raise themselves to the level of comprehending theoretically the historical movement as a whole', and modern artists, in contradiction to the great masters of the Renaissance, do extremely little thinking. But however that may be, it can be said with certainty that every more or less gifted artist will increase his power substantially if he absorbs the great emancipatory ideas of our time. Only these ideas must become part of his flesh and blood, and he must express them precisely as an artist. He must be able, moreover, to form a correct opinion of the artistic modernism of the present-day ideologists of the bourgeoisie. The ruling class has now reached a position where, for it, going forward means sinking downward. And this sad fate is shared by all its ideologists. The most advanced of them are precisely those who have sunk lower than all their predecessors.

10 Franz Marc (1880–1916) 'Foreword' to the planned second volume of *Der Blaue Reiter*

Though a second edition of the original almanac was published in 1914, the planned second volume was aborted because of the war. In Marc's proposed editorial statement, written in February 1914, the assertive primitivism of the pre-war years takes a darker cast from

contemporary events. Marc was killed in action at Verdun in 1916. The present translation is taken from K. Lankheit (ed.), *Blaue Reiter Almanac*, London, 1974, p. 260.

Once more and *many times more* we are trying to divert the attention of ardent men from the nice and pretty illusion inherited from the olden days toward existence, horrible and resounding.

Whenever the leaders of the crowds turn right, we turn left; when they point to a goal, we turn our backs; whatever they warn us against we hurry toward.

The world is crammed to suffocation. On every stone man has put the brand of his cleverness. Every word is leased or invested. What can man do for salvation but give up everything and flee? What but draw a dividing line between yesterday and today?

This is the great task of our time – the only one worth living and dying for. Not the slightest contempt for the great past is involved in this. We want something else. We do not want to live as carefree heirs or to live on the past. Even if we wanted to live like that, we could not. The inheritance is used up, and substitutes are making the world base.

Therefore we venture forth into new fields, and we are shocked to find that everything is still untrodden, unspoken, uncultivated, unexplored. The world lies virginal before us; our steps are shaky. If we dare to walk, we must cut the umbilical cord that ties us to our maternal past.

The world is giving birth to a new time; there is only one question: has the time now come to separate ourselves from the old world? Are we ready for the *vita nuova?* This is the terrifying question of our age. It is the question that will dominate this book. Everything in this volume is related to this question and to nothing else. By it alone should we measure its form and its value.

11 Fernand Léger (1881–1955) 'Contemporary Achievements in Painting'

Léger's Cubism was oriented towards modern life and the achievement of a modern form of painting adequate to the experience of such a life. Paradoxically, it was the freeing of painting from the necessity to *depict* modernity that was seen to underwrite the promise of modernity's being properly *represented*. First published in the journal *Soirées de Paris* in 1914. The present translation, by Alexander Anderson, is taken from F. Léger, *The Function of Painting*, New York, 1973, pp. 11–12, 13–15, 16–17.

Contemporary achievements in painting are the result of the modern mentality and are closely bound up with the visual aspect of external things that are creative and necessary for the painter.

Before tackling the purely technical questions, I am going to try to explain why contemporary painting is representative, in the modern sense of the word, of the new visual state imposed by the evolution of the new means of production.

A work of art must be significant in its own time, like any other intellectual manifestation. Because painting is visual, it is necessarily the reflection of external

rather than psychological conditions. Every pictorial work must possess this moment-ary and eternal value that enables it to endure beyond the epoch of its creation.

If pictorial expression has changed, it is because modern life has necessitated it. The existence of modern creative people is much more intense and more complex than that of people in earlier centuries. The thing that is imagined is less fixed, the object exposes itself less than it did formerly. When one crosses a landscape by automobile or express train, it becomes fragmented; it loses in descriptive value but gains in synthetic value. The view through the door of the railroad car or the automobile windshield, in combination with the speed, has altered the habitual look of things. A modern man registers a hundred times more sensory impressions than an eighteenth-century artist; so much so that our language, for example, is full of diminutives and abbreviations. The compression of the modern picture, its variety, its breaking up of forms, are the result of all this. It is certain that the evolution of the means of locomotion and their speed have a great deal to do with the new way of seeing. Many superficial people raise the cry 'anarchy' in front of these pictures because they cannot follow the whole evolution of contemporary life that painting records. They believe that painting has abruptly broken the chain of continuity, when, on the contrary, it has never been so truly realistic, so firmly attached to its own period as it is today. A kind of painting that is realistic in the highest sense is beginning to appear, and it is here to stay.

A new criterion has appeared in response to a new state of things. Innumerable examples of rupture and change crop up unexpectedly in our visual awareness. I will choose the most striking examples. The advertising billboard, dictated by modern commercial needs, that brutally cuts across a landscape is one of the things that has most infuriated so-called men of . . . good taste. [. . .]

* * *

In spite of this resistance, the old-fashioned costume of the towns has had to evolve with everything else. The black suit, which contrasts with the bright feminine outfits at fashionable gatherings, is a clear manifestation of an evolution in taste. Black and white resound and clash, and the visual effect of present-day fashionable parties is the exact opposite of the effect that similar social gatherings in the eighteenth century, for example, would have produced. The dress of that period was all in the same tones, the whole aspect was more decorative, less strongly contrasted, and more uniform.

Evolution notwithstanding, the average bourgeois has retained his ideas of tone on tone, the decorative concept. The red parlor, the yellow bedroom, will, especially in the provinces, continue to be the last word in good form for a long time. Contrast has always frightened peaceful and satisfied people; they eliminate it from their lives as much as possible, and as they are disagreeably startled by the dissonances of some billboard or other, so their lives are organized to avoid all such uncouth contact. This milieu is the last one an artist should frequent; truth is shrouded and feared; all that remains is manners, from which an artist can seek in vain to learn some-thing.

In earlier periods, the utilization of contrasts could never be fully exploited for several reasons. First, the necessity for strict subservience to a subject that had to have a sentimental value.

Never, until the impressionists, had painting been able to shake off the spell of literature. Consequently, the utilization of plastic contrasts had to be diluted by the need to tell a story, which painters have now recognized as completely unnecessary.

From the day the impressionists liberated painting, the modern picture set out at once to structure itself on contrasts; instead of submitting to a subject, the painter makes an insertion and uses a subject in the service of purely plastic means. All the artists who have shocked public opinion in the last few years have always sacrificed the subject to the pictorial effect. [. . .]

This liberation enables the contemporary painter to use these means in dealing with the new visual state that I have just described. He must prepare himself in order to confer a maximum of plastic effect on means that have not yet been so used. He must not become an imitator of the new visual objectivity, but be a sensibility completely subject to the new state of things.

He will not be original just because he will have broken up an object or placed a red or yellow square in the middle of his canvas; he will be original by virtue of the fact that he has caught the creative spirit of these external manifestations.

As soon as one admits that only realism in conception is capable of realizing, in the most plastic sense of the word, these new effects of contrast, one must abandon visual realism and concentrate all the plastic means toward a specific goal.

Composition takes precedence over all else; to obtain their maximum expressiveness, lines, forms, and colors must be employed with the utmost possible logic. It is the logical spirit that will achieve the greatest result, and by the logical spirit in art, I mean the power to order one's sensibility and to concentrate one's means in order to yield the maximum effect in the result.

It is true that if I look at objects in their surroundings, in the real atmosphere, I do not perceive any line bounding the zones of color, of course; but this belongs to the realm of visual realism and not to the wholly modern one of realism in conception. To try deliberately to eliminate specific means of expression such as outlines and forms except for their significance in terms of color is childish and retrograde. The modern picture can have lasting value and escape death not by excluding some means of expression because of a prejudice for one alone but, on the contrary, by concentrating all the possible means of plastic expression on a specific goal. Modern painters have understood that; before them, a drawing had one special value, and a painting had another. From now on, everything is brought together, in order to attain essential variety along with maximum realism. A painter who calls himself modern, and who rightly considers perspective and sentimental value to be negative methods, must be able to replace them in his pictures with something other than, for instance, an unending harmony of pure tones.

* * *

By employing all the pictorial means of expression, composition through multiplicative contrast not only allows a greater range of realistic experience, but also ensures variety; in fact, instead of opposing two means of expression in an immediate cumulative relationship, you compose a picture so that groups of similar forms are opposed by other contrary groupings. If you distribute your color in the same way, that is, by adding similar tones, coloring each of these groupings of forms in contrast with the tones of an equivalent addition, you obtain collective sources of tones, lines, and colors acting against other contrary and dissonant sources. Contrast = dissonance, and hence a maximum expressive effect. I will take as an example a commonplace subject: the visual effect of curled and round puffs of smoke rising between houses. You want to convey their plastic value. Here you have the best example on which to apply research

into multiplicative intensities. Concentrate your curves with the greatest possible variety without breaking up their mass; frame them by means of the hard, dry relationship of the surfaces of the houses, dead surfaces that will acquire movement by being colored in contrast to the central mass and being opposed by live forms; you will obtain a maximum effect.

This theory is not an abstraction but is formulated according to observations of natural effects that are verified every day. I purposely did not take a so-called modern subject because I do not know what is an ancient or modern subject; all I know is what is a new interpretation. But locomotives, automobiles, if you insist, advertising billboards, are all good for the application of a form of movements; all this research comes, as I have said, from the modern environment. But you can advantageously substitute the most banal, worn-out subject, like a nude in a studio and a thousand others, for locomotives and other modern engines that are difficult to pose in one's studio. All that is method; the only interesting thing is how it is used.

12 Percy Wyndham Lewis (1882–1957) 'Our Vortex'

Wyndham Lewis led the radical, 'Vorticist' wing of the English avant-garde before the First World War, in opposition to the more traditionally oriented Bloomsbury group around Roger Fry and Clive Bell (see IB7 and 16). He was the co-founder and editor of *Blast*, the journal of the Vorticist group, published both in emulation of and in competition with Futurist manifestations. The present text was originally published in the first issue of *Blast*, London, June 1914.

I Our vortex is not afraid of the Past: it has forgotten its existence.

Our vortex regards the Future as as sentimental as the Past.

The Future is distant, like the Past, and therefore sentimental.

The mere element 'Past' must be retained to sponge up and absorb our melancholy.

Everything absent, remote, requiring projection in the veiled weakness of the mind, is sentimental.

The Present can be intensely sentimental – especially if you exclude the mere element 'Past'.

Our vortex does not deal in reactive Action only, nor identify the Present with numbing displays of vitality.

The new vortex plunges to the heart of the Present.

The chemistry of the Present is different to that of the Past. With this different chemistry we produce a New Living Abstraction.

The Rembrandt Vortex swamped the Netherlands with a flood of dreaming.

The Turner Vortex rushed at Europe with a wave of light.

We wish the Past and Future with us, the Past to mop up our melancholy, the Future to absorb our troublesome optimism.

With our Vortex the Present is the only active thing.

Life is the Past and the Future.

The Present is Art.

II Our Vortex insists on water-tight compartments.

There is no Present – there is Past and Future, and there is Art.

Any moment not weakly relaxed and slipped back, or, on the other hand, dreaming optimistically, is Art.

'Just Life' or *soi-disant* 'Reality' is a fourth quantity, made up of the Past, the Future and Art.

This impure Present our Vortex despises and ignores.

For our Vortex is uncompromising.

We must have the Past and the Future, Life simple, that is, to discharge ourselves in, and keep us pure for non-life, that is Art.

The Past and Future are the prostitutes Nature has provided.

Art is periodic escapes from this Brothel.

Artists put as much vitality and delight into this saintliness, and escape out, as most men do their escapes into similar places from respectable existence.

The Vorticist is at his maximum point of energy when stillest.

The Vorticist is not the Slave of Commotion, but its Master.

The Vorticist does not suck up to Life.

He lets Life know its place in a Vorticist Universe!

III In a Vorticist Universe we don't get excited at what we have invented.

If we did it would look as though it had been a fluke.

It is not a fluke.

We have no Verbotens.

There is one Truth, ourselves, and everything is permitted.

But we are not Templars.

We are proud, handsome and predatory.

We hunt machines, they are our favourite game.

We invent them and then hunt them down.

This is a great Vorticist age, a great still age of artists.

IV As to the lean belated Impressionism at present attempting to eke out a little life in these islands:

Our Vortex is fed up with your dispersals, reasonable chicken-men.

Our Vortex is proud of its polished sides.

Our Vortex will not hear of anything but its disastrous polished dance.

Our Vortex desires the immobile rhythm of its swiftness.

Our Vortex rushes out like an angry dog at your Impressionistic fuss.

Our Vortex is white and abstract with its red-hot swiftness.

13 Henri Gaudier-Brzeska (1891–1915) 'Gaudier-Brzeska Vortex' and 'Vortex Gaudier-Brzeska (Written from the Trenches)'

French by birth, Gaudier lived in England from the end of 1910, first being peripherally associated with the journal *Rhythm*, and then with the Vorticist group around Wyndham Lewis. Both texts reprinted here are marked by a rejection of the Greek/classical tradition in favour of a primitivist directness of expression. Intellectually both are marked by Bergson

and Nietzsche. The first essay was published in *Blast* in June 1914, before the outbreak of war; the second, in effect a letter from the Front, was published in *Blast 2* in autumn 1915, after Gaudier-Brzeska's death in action.

Gaudier-Brzeska Vortex

Sculptural energy is the mountain.

Sculptural feeling is the appreciation of masses in relation.

Sculptural ability is the defining of these masses by planes.

The PALEOLITHIC VORTEX resulted in the decoration of the Dordogne caverns.

Early stone-age man disputed the earth with animals.

His livelihood depended on the hazards of the hunt – his greatest victory the domestication of a few species.

Out of the minds primordially preoccupied with animals Fonts-de-Gaume gained its procession of horses carved in the rock. The driving power was life in the absolute – the plastic expression the fruitful sphere.

The sphere is thrown through space, it is the soul and object of the vortex –

The intensity of existence had revealed to man a truth of form – his manhood was strained to the highest potential – his energy brutal – HIS OPULENT MATURITY WAS CONVEX.

The acute fight subsided at the birth of the three primary civilizations. It always retained more intensity East.

The HAMITE VORTEX of Egypt, the land of plenty –

Man succeeded in his far reaching speculations – Honour to the divinity!

Religion pushed him to the use of the VERTICAL which inspires awe. His gods were self made, he built them in his image, and RETAINED AS MUCH OF THE SPHERE AS COULD ROUND THE SHARPNESS OF THE PARALLELOGRAM.

He preferred the pyramid to the mastaba.

The fair Greek felt this influence across the middle sea.

The fair Greek saw himself only. HE petrified his own semblance.

HIS SCULPTURE WAS DERIVATIVE his feeling for form secondary. The absence of direct energy lasted for a thousand years.

The Indians felt the hamitic influence through Greek spectacles. Their extreme temperament inclined towards asceticism, admiration of non-desire as a balance against abuse produced a kind of sculpture without new form perception – and which is the result of the peculiar.

Vortex of Blackness and Silence

PLASTIC SOUL IS INTENSITY OF LIFE BURSTING THE PLANE.

The Germanic barbarians were verily whirled by the mysterious need of acquiring new arable lands. They moved restlessly, like strong oxen stampeding.

The SEMITIC VORTEX was the lust of war. The men of Elam, of Assur, of Bebel and the Kheta, the men of Armenia and those of Canaan had to slay each other cruelly for the possession of fertile valleys. Their gods sent them the vertical direction, the earth, the SPHERE.

They elevated the sphere in a splendid squatness and created the HORIZON-TAL.

From Sargon to Amir-nasir-pal men built man-headed bulls in horizontal flight-walk. Men flayed their captives alive and erected howling lions: THE ELONGATED HORIZONTAL SPHERE BUTTRESSED ON FOUR COLUMNS, and their king-doms disappeared.

Christ flourished and perished in Yudah.

Christianity gained Africa, and from the seaports of the Mediterranean it won the Roman Empire.

The stampeding Franks came into violent contact with it as well as the Greco-Roman tradition.

They were swamped by the remote reflections of the two vortices of the West.

Gothic sculpture was but a faint echo of the HAMITO-SEMITIC energies through Roman traditions, and it lasted half a thousand years, and it wilfully divagated again into the Greek derivation from the land of Amen-Ra.

VORTEX OF A VORTEX!!

VORTEX IS THE POINT ONE AND INDIVISIBLE!

VORTEX IS ENERGY! and it gave forth SOLID EXCREMENTS in the quattro e cinque cento, LIQUID until the seventeenth century, GASES whistle till now. THIS is the history of form value in the West until the FALL OF IMPRESSIONISM.

The black-haired men who wandered through the pass of Khotan into the valley of the YELLOW RIVER lived peacefully tilling their lands, and they grew prosperous.

Their paleolithic feeling was intensified. As gods they had themselves in the persons of their human ancestors – and of the spirits of the horse and of the land and the grain.

THE SPHERE SWAYED.

THE VORTEX WAS ABSOLUTE.

The Shang and Chow dynasties produced the convex bronze vases.

The features of Tao-t'ie were inscribed inside of the square with the rounded corners – the centuple spherical frog presided over the inverted truncated cone that is the bronze war drum.

THE VORTEX WAS INTENSE MATURITY. Maturity is fecundity – they grew numerous and it lasted for six thousand years.

The force relapsed and they accumulated wealth, forsook their work, and after losing their form-understanding through the Han and T'ang dynasties, they founded the Ming and found artistic ruin and sterility.

THE SPHERE LOST SIGNIFICANCE AND THEY ADMIRED THEM-SELVES.

During their great period off-shoots from their race had landed on another contin-ent. After many wanderings some tribes settled on the highlands of Yukatan and Mexico.

When the Ming were losing their conception, these neo-Mongols had a flourishing state. Through the strain of warfare they submitted the Chinese sphere to horizontal treatment much as the Semites had done. Their cruel nature and temperament supplied them with a stimulant: THE VORTEX OF DESTRUCTION.

Besides these highly developed peoples there lived on the world other races inhabit-ing Africa and the Ocean islands.

When we first knew them they were very near the paleolithic stage. Though they were not so much dependent upon animals their expenditure of energy was wide, for they began to till the land and practice crafts rationally, and they fell into contemplation before their sex: the site of their great energy: THEIR CONVEX MATURITY.

They pulled the sphere lengthways and made the cylinder, this is the VORTEX OF FECUNDITY, and it has left us the masterpieces that are known as love charms.

The soil was hard, material difficult to win from nature, storms frequent, as also fevers and other epidemics. They got frightened: This is the VORTEX OF FEAR, its mass is the POINTED CONE, its masterpieces the fetishes.

And WE the moderns: Epstein, Brancusi, Archipenko, Dunikowski, Modigliani, and myself, through the incessant struggle in the complex city, have likewise to spend much energy.

The knowledge of our civilization embraces the world, we have mastered the elements.

We have been influenced by what we liked most, each according to his own individuality, we have crystallized the sphere into the cube, we have made a combination of all the possible shaped masses – concentrating them to express our abstract thoughts of conscious superiority.

Will and consciousness are our

<p style="text-align:center">VORTEX.</p>

Vortex Gaudier-Brzeska
(WRITTEN FROM THE TRENCHES)

I HAVE BEEN FIGHTING FOR TWO MONTHS and I can now gauge the intensity of life.

HUMAN MASSES teem and move, are destroyed and crop up again.

HORSES are worn out in three weeks, die by the roadside.

DOGS wander, are destroyed, and others come along.

WITH ALL THE DESTRUCTION that works around us NOTHING IS CHANGED, EVEN SUPERFICIALLY. *LIFE IS THE SAME STRENGTH*, THE MOVING AGENT THAT PERMITS THE SMALL INDIVIDUAL TO ASSERT HIMSELF.

THE BURSTING SHELLS, the volleys, wire entanglements, projectors, motors, the chaos of battle DO NOT ALTER IN THE LEAST the outlines of the hill we are besieging. A company of PARTRIDGES scuttle along before our very trench.

IT WOULD BE FOLLY TO SEEK ARTISTIC EMOTIONS AMID THESE LITTLE WORKS OF OURS.

THIS PALTRY MECHANISM, WHICH SERVES AS A PURGE TO OVER-NUMEROUS HUMANITY.

THIS WAR IS A GREAT REMEDY.

IN THE INDIVIDUAL IT KILLS ARROGANCE, SELF-ESTEEM, PRIDE.

IT TAKES AWAY FROM THE MASSES NUMBERS UPON NUMBERS OF UNIMPORTANT UNITS, WHOSE ECONOMIC ACTIVITIES BECOME NOXIOUS AS THE RECENT TRADES CRISES HAVE SHOWN US.

MY VIEWS ON SCULPTURE REMAIN ABSOLUTELY *THE SAME*.

IT IS THE *VORTEX* OF WILL, OF DECISION, THAT BEGINS.

I SHALL DERIVE MY EMOTIONS SOLELY FROM THE ARRANGEMENT OF SURFACES, I shall present my emotions by the ARRANGEMENT OF MY SURFACES, THE PLANES AND LINES BY WHICH THEY ARE DEFINED.

Just as this hill where the Germans are solidly entrenched, gives me a nasty feeling, solely because its gentle slopes are broken up by earth-works, which throw long shadows at sunset. Just so shall I get feeling, of whatsoever definition, from a statue ACCORDING TO ITS SLOPES, varied to infinity.

I have made an experiment. Two days ago I pinched from an enemy a mauser rifle. Its heavy unwieldy shape swamped me with a powerful IMAGE of brutality.

I was in doubt for a long time whether it pleased or displeased me.

I found that I did not like it.

I broke the butt off and with my knife I carved in it a design, through which I tried to express a gentler order of feeling, which I preferred.

BUT I WILL EMPHASIZE that MY DESIGN *got its effect* (just as the gun had) FROM A VERY SIMPLE COMPOSITION OF LINES AND PLANES.

14 Ludwig Meidner (1884–1966) 'Instructions for Painting Pictures of the Metropolis'

Meidner's long career was deeply marked by the vicissitudes of German political history. Born into a Jewish family in the late nineteenth century, he maintained a lifelong commitment to a humanitarian socialism, and in art to a series of variations on a basis of expressive realism. After the First World War he was active in the Novembergruppe and the Arbeitsrat für Kunst (see IIIB8–10). During the Weimar period he became a college lecturer, a post he lost after Hitler came to power. He lived to see his work pilloried in the Nazi *Degenerate Art* exhibition (see IVB20). After surviving the regime throughout the 1930s he finally sought asylum in Britain, only to be interned as an enemy alien for the duration of the Second World War. He eventually returned to the new German Federal Republic in 1953. The present text dates from the period of Meidner's attraction to an expressionistic variant of Futurism, *c*.1912–16. It is marked by the then widely felt need to address the contemporary condition of modernity, most particularly the *Grossstadt*, the big city, the metropolis – of which Berlin was the pre-eminent example in fact, and New York becoming so in myth. This was a perspective which in those years exerted its influence on German artists as dissimilar as Ernst Ludwig Kirchner and George Grosz. Meidner argues both against what he sees as the vagueness and imprecision of Impressionist representations of the city, and no less forcefully against the other component of expressionist ideology, namely an attraction to the 'primitive'. To him, the imperative is clear: to paint the modern city in a modern style – not Impressionist, not Divisionist, not Primitivist, not decorative or ornamental, but Cubist. This is a version of Cubism which aligns with both the geometric aspects of city planning and the hard-headed, scientific attitude of modern urban life. And yet, although Meidner's invocation of the engineer anticipates to some extent the Taylorist-influenced rhetoric of the post-war avant-garde, the apocalyptic tone of his text betrays a continuing identification with pre-war expressionism. 'Instructions for Painting Pictures of the Metropolis' originally appeared in the journal *Kunst und Kunstler*, XII, 6, Berlin 1914, pp. 312–14. The present translation by Nicholas Walker is made from Dieter Schmidt (ed.), *Schriften deutscher Kunstler des*

zwanzigsten Jahrhunderts, Band 1, Manifeste 1905–1933, Dresden: Verlag der Kunst, 1964, pp. 84–9.

We must at last begin to paint the home where we live, the metropolis that we love without reserve. With feverish scrawling hands we must cover canvases without number, and large as frescoes, with everything that is strange and splendid, everything that is monstrous and striking, about our great avenues and railway stations, our towers and factories.

Of course we can all remember those paintings from the eighteen-seventies and eighties that also depicted the streets and alleys of the metropolis. Like those of Pissarro and Monet, lyrical artists both, who had started out by painting bushes, trees and meadows. These were landscape artists who carried the sweet haziness of their bucolic work over into their paintings of the city. But can one really paint the teeming confusion of houses and boulevards in the same transparent stippling style, as if they were brooks and flower-beds?

It is impossible to tackle our problems with the techniques of Impressionism. We must forget all these earlier knacks and methods, and develop entirely new modes of expression for ourselves.

The first task is this: that we learn to see, to see more intensely and more precisely than our predecessors have done. The hazy vagueness of the Impressionists is useless to us here. Traditional perspective has also lost its significance for us and merely impedes our creative impulse. Notions like 'tonality', 'plays of coloured light', 'iridescent shadow', 'dissolution of contour', 'complementary colours', and whatever else may be invoked here, have degenerated into academic concepts. In the second place – and this is no less crucial – we must become emphatically creative in our art. We cannot simply carry our easels out into the bustling streets and then try, blinking as we do so, to reproduce the 'tonal values' they present. A street is not made up of tonal values, but is something which bombards us with sizzling rows of windows and humming beams of light dancing amidst vehicles of all kinds, a thousand undulating globes, the shreds and fragments of individuals, the signboards, the roaring tumult of amorphous masses of colour.

The idea of painting in the open air is utterly mistaken. We cannot transfer the contingent and disorganized character of our motifs straight onto canvas and thereby produce a picture. On the contrary, we must boldly and deliberately transform the optical impressions we have thoroughly absorbed from the external world into a composition.

It should be said at once: there is no question of filling up the painted surface in the purely decorative or ornamental manner of Kandinsky or Matisse. We are concerned rather with the fullness of life itself: with space, with brightness and darkness, with weight and lightness, with the very movement of things – in short with a deeper and more thorough exploration of reality.

There are essentially three elements which we must employ in the production of the picture: 1 light, 2 focal point and 3 angularity of line.

Our initial problem is a problem of light, although not exclusively so since, unlike the Impressionists, we do not experience light as a ubiquitous presence. They saw light everywhere. They shed brightness over the entire surface of their pictures, even their shadows are bright and transparent. Cézanne had already advanced far beyond them in this respect. There is a kind of swaying strength and power in his work which lends great truth to his paintings.

For we do not actually perceive light everywhere in nature. Often enough we are presented right in the foreground with great planes which appear rigid and unilluminated. Here and there we can feel the weight, the obscurity, the motionlessness of matter. The light seems to flow in rivers. It cuts up the things it falls upon. We have a distinct feeling for strips, lines and bundles of light. Entire complexes of objects sway in the light and appear in turn as transparent – but once again, we come upon intervening rigidity, upon broad masses of opacity. We are blinded by a tumult of light and dark amidst the towering rows of houses. Strips of light are broadly spread across the walls. A rocket of light explodes amidst a turmoil of human heads. A sudden patch of light appears between the moving vehicles. The sky pours in upon us like a waterfall and its abundant illumination instantly dissolves the darkness below. Sharp contours waver in the glare. A host of lines radiates outwards in dizzying rhythms.

Light brings everything that occupies space into movement. The towers, the houses, the lamps all seem to swim, to hang suspended up above.

The light may be white, or silvery, or violet or blue or whatever. But preferably take a white as pure as possible. Lay it down with broad strokes of the brush – with some deep blue, or some ebony black, alongside it. Do not hesitate, but cover your canvas, this way and that, with the boldest of white. Take your blue – the thick, warm Paris blue or the cool but strong ultramarine – take umber and plenty of ochre, and scrawl away with speed and nervous excitement. You should be brutal and shameless, just as your motifs themselves are brutal and shameless. It is not enough to have the proper rhythm in your fingertips, you must turn and twist between madness and laughter!

The question of focal point is also important for the act of composition. For this is the most intense part of the picture and the central focus of the entire composition. You can situate it anywhere, whether in the centre, or right or left of the centre, but for compositional reasons it is good to place it somewhat beneath the centre of the picture. It is also important to ensure that everything at this point is clear, sharply distinguished, with not a trace of mysticism. In the central focus of the picture the straight lines appear in perpendicular. The further we move from the central focus the more the lines begin to bend. If we stand, for example, looking straight ahead into the middle of the street, then the houses are all seen in perpendicular, and their rows of windows seem to accord with standard perspective in so far as they taper away towards the horizon. But the houses immediately next to us – whose presence we only sense with half an eye as it were – appear to sway and collapse. For here the lines which in reality run parallel with one another suddenly shoot up and intersect with one another. The gables, the chimneys, the windows have now become obscure and chaotic masses, fantastically foreshortened and essentially ambiguous.

You should use a small brush for the central focus and make your lines short and vigorously felt just as they make their immediate appearance. And make sure you paint here in an extremely nervous fashion. But as you move towards the edges of the picture, you can afford to become broader and more indefinite in your approach.

In the past people used to say: there are no straight lines in nature, and open nature itself is not mathematical. No one loved angular lines, and even Whistler resolved them into a multitude of tiny sections. Ever since the days of Ruisdael the angular line has been utterly condemned in landscape painting, and artists have always taken great pains not to include buildings, new churches or castles, into their pictures. They preferred

picturesque objects precisely because they were so irregular and abundantly shaped: ruins, derelict houses, luxuriously foliated trees.

But we who live today, we contemporaries of the engineer, we know how to experience the beauty of angular lines, the beauty of geometrical forms. We may remark in passing that the modern movement of Cubism also displays an enormous sympathy for geometrical forms, that such forms indeed possess an even greater significance here than they do for us.

The angular lines of which we are speaking – principally applied as they are in graphic art – should not be confused with the lines traced upon a building plan with the aid of a mason's triangle. Never believe that the straight line is something cold and rigid! You must simply draw it with enough excitement and properly observe its flow. It should be now thin, now thick, trembling gently with nervous excitement.

When we look upon our cities, what do we see but battles of mathematics? See what triangles and circles and polygons assault us in the street. Rulers are flying off in all directions. We are pierced on every side by angularities. Even the moving people and animals appear like geometrical constructions.

Take up a broad brush and draw your own angular lines with force upon the paper. If you can use real art to organize such tumult, it will appear more vital and vivid than all the pretentious brushwork of our academic teachers.

There is little that needs to be said about colour. Employ all the colours on your palette – but if you should undertake to paint Berlin, be sure simply to use black and white, just a little ochre and ultramarine, and plenty of deep brown. Do not worry about 'cold' or 'warm' tones, about 'complementary colours' or any of that nonsense – you are not 'Divisionists'! Express yourself spontaneously in a liberated and uninhibited way. What matters is simply for hundreds of young painters to plunge into this new field with unfettered enthusiasm as soon as possible. Here I have merely provided some useful hints and suggestions in this direction. There may well be other, perhaps better and more convincing ways of doing what I propose. But the metropolis must nonetheless be painted!

The manifestos of the Futurists – though not their actual foolish creations – have shown us where the problems are, while Robert Delaunay inaugurated our movement only three years ago with his grand conception of the Eiffel Tower. In this very year I have myself provided a practical example, in certain paintings and successful drawings, of the theoretical views defended here. All younger artists of ability should now set about the work without delay and flood our exhibitions with depictions of the city.

Unfortunately minds today are still confused with all manner of regressive ideas. The stammering art of primitive peoples also fascinates some of our younger German artists and nothing seems more important than Bushman painting and Aztec sculpture. And the self-important clamour of sterile Frenchmen on behalf of the 'image', of 'absolute painting' and suchlike things has also had a considerable effect amongst us. But let us be honest! Let us simply confess that we are not Negroes, that we are not Christians of the early Middle Ages! That we are inhabitants of Berlin, in the year 1913, that we sit and argue in coffee-shops, that we read a great deal and are highly knowledgeable about the history of art, that we have all been mightily influenced by Impressionism! Why on earth should we imitate the manners and outlooks of earlier ages, or champion artistic incapacity as the proper path to follow? Are the crude and

meanly depicted figures which are now to be seen in every exhibition an appropriate expression for the complexities of our own soul?

Let us paint what is right in front of us, our own world of cities! – their tumultuous streets, the elegance of their iron suspension bridges, the gasometers hanging in mountains of whitish cloud, the roaring colours of the buses and the railway trains, the surging telephone wires (do they not sing too?), the buffoonery of advertising columns, and the night ... The night of the metropolis ...

And would not the drama of a well-painted factory chimney then move us more deeply than any *Fire in the Borgo* or *Battle of Constantine*, more than any number of Raphaels?

15 Karl Kraus (1874–1936) from 'In These Great Times'

Kraus lived and worked in Vienna. He was an author and playwright, but is best known for the journal *Die Fackel* (*The Torch*) which he published virtually single-handed from 1899 to 1936, the time of the Anschluss. His linguistic facility and obsessive attention to detail were legendary, as were his sustained attacks on the hypocrisy of the institutions of Austrian life. On the outbreak of the First World War Kraus fell silent, feeling that a hasty response would be subject to misunderstanding in the charged atmosphere of the time. His silence was broken by the address 'In dieser grossen Zeit', read on 19 November 1914 in Vienna and published in *Die Fackel* the following month. The present extract is taken from the opening section of the translation in H. Zohn (ed.), *In These Great Times: A Karl Kraus Reader*, Manchester, 1976/84. (The 'manifesto' to which Kraus refers was the proclamation of war, 'To My Peoples', delivered by the Emperor Franz Josef in August 1914.)

In these great times which I knew when they were this small; which will become small again, provided they have time left for it; and which, because in the realm of organic growth no such transformation is possible, we had better call fat times and, truly, hard times as well; in these times in which things are happening that could not be imagined and in which what can no longer be *imagined* must *happen*, for if one could imagine it, it would not happen; in these serious times which have died laughing at the thought that they might become serious; which, surprised by their own tragedy, are reaching for diversion and, catching themselves redhanded, are groping for words; in these loud times which boom with the horrible symphony of actions which produce reports and of reports which cause actions: in these times you should not expect any words of my own from me – none but these words which barely manage to prevent silence from being misinterpreted. Respect for the immutability, the subordination of language before this misfortune is too deeply rooted in me. In the realm of poverty of imagination where people die of spiritual famine without feeling spiritual hunger, where pens are dipped in blood and swords in ink, that which is not thought must be done, but that which is only thought is unutterable. Expect no words of my own from me. Nor would I be able to say anything new, for in the room in which one writes there is such noise, and at this time one should not determine whether it comes from animals, from children, or merely from mortars. He who encourages deeds with words desecrates words and deeds and is doubly despicable. This occupation is not extinct. Those

who now have nothing to say because actions are speaking continue to talk. Let him who has something to say come forward and be silent! Nor may I bring out old words as long as deeds are committed that are new to us and spectators say that they were not to be expected of them. My words were able to drown out rotary presses, and if these were not brought to a standstill, this is no reflection on my words. Even the greater machine has not managed to do it, and an ear that hears the trumpets of the day. All that blood has not made the muck of life congeal in fright, nor has it made printer's ink blanch. The maw, rather, swallowed up the many swords, and we looked only at the maw and measured greatness only by the maw. And 'gold for iron' fell from the altar into the operetta, bombing was a music-hall song, and fifteen thousand prisoners were put in a special edition of the newspaper which a soubrette read from the stage so that a librettist might take a curtain call. For me (the insatiable one who does not have sacrifices enough), the line commanded by fate has not been reached. For me it is war only if only those who are unfit are sent off to it. Otherwise my peace has no peace; I secretly prepare for the great times and think thoughts that I can tell only to the Good Lord and not to the good state which now does not permit me to tell it that it is too tolerant. For if the state does not now have the idea of choking off the so-called freedom of the press, which does not notice a few white spots, then it never will; and if I were to put this into its head, the state would do violence to the idea, and my text would be the only victim. So I shall have to wait, though I am the only Austrian who cannot wait but would like to see the end of the world replaced by a simple auto-da-fé. The idea which I should like to put into the heads of the actual holders of nominal power is only an *idée fixe* of mine. But an unstable state of ownership, that of a state and of a civilized world, is saved by such fixed ideas. A general is not believed when he talks about the importance of swamps – until one day Europe is viewed only as the surroundings of swamps. Of a terrain I see only the swamps, of their depth I see only the surface, of a situation I see only its manifestations, of these I see only a reflection, and even of that I see only the outlines. And sometimes an intonation or even a hallucination suffices me. Do me the favor, just for fun, of following me to the surface of this problem-deep world which was not created until it became cultured, which revolves around its own axis and wishes the sun revolved around it.

Above that exalted manifesto, that prose poem which initiated a time full of action, the only poem this time has produced till now, above the most humane poster which the street was able to offer our eyes there hangs the head of a vaudeville comedian, larger than life. Next to it a manufacturer of rubber heels desecrates the mystery of creation by saying of a kicking infant that this is the only way a human being ought to come into the world, using this particular brand. If I am of the opinion that, things being the way they are, it would be better if people did not come into the world at all, I am an eccentric. But if I maintain that under such circumstances no one will come into the world in the future and that at a later date boot-heels may come into the world but without the persons to go with them, because they were not able to keep pace with their own development and stayed behind as the last obstacle to their progress – if I maintain this sort of thing, I am a fool who deduces the whole condition from a symptom, the plague from a bubo. If I were not a fool but an educated man, I would draw such bold conclusions from a bacillus and not from a bubo, and people would believe me. How foolish to say that one should confiscate the bubo to rid oneself of the plague! But I am

truly of the opinion that in this time, however we may call it or evaluate it, whether it is out of joint or already set right, whether it is accumulating murder and rottenness before the eyes of a Hamlet or is already becoming ripe for the arm of a Fortinbras – that in its condition the root lies at the surface. This sort of thing can be made clear by a great confusion, and what was once paradoxical is now confirmed by the great times. Since I am neither a politician nor his half-brother, an esthete, I would not dream of denying the necessity of anything that is happening or of complaining that mankind does not know how to die in beauty. [...] Mankind consists of customers. Behind flags and flames, heroes and helpers, behind all fatherlands an altar has been erected at which pious science wrings its hands: God created the consumer! Yet God did not create the consumer that he might prosper on earth, for the consumer was created naked and becomes a dealer only when he sells clothes. The necessity to eat in order to live cannot be disputed philosophically, though the public nature of this function evidences an ineradicable lack of modesty. Culture is the tacit agreement to let the means of subsistence disappear behind the purpose of existence. Civilization is the subordination of the latter to the former. [...]

16 Kasimir Malevich (1878–1935) *From Cubism and Futurism to Suprematism: The New Realism in Painting*

Malevich rapidly assimilated Western European avant-garde art in the decade before the First World War: Impressionism, Primitivism, Cubism, Futurism. After the severing of links to the West by the outbreak of war in the autumn of 1914, Malevich launched Suprematism at '0.10 The Last Futurist Exhibition' in Petrograd in December 1915. A pamphlet to accompany the exhibition was published there, with the title *From Cubism to Suprematism in Art, to New Realism in Painting, to Absolute Creation*. It was republished in expanded form as *From Cubism and Futurism to Suprematism: The New Realism in Painting* in Moscow in 1916. The present translation is taken from T. Anderson (ed.), *K. S. Malevich: Essays on Art* 1915–1933, vol. 1, Copenhagen, 1969, pp. 19–21, 23–5, 26–36 and 38–41. (See also IIIC8, 9 and IVD1.)

Only with the disappearance of a habit of mind which sees in pictures little corners of nature, madonnas and shameless *Venuses, shall we witness a work of pure, living art.*

I have transformed myself *in the zero of form* and dragged myself out of the *rubbish-filled pool of Academic art.*

I have destroyed the ring of the horizon and escaped from the circle of things, from the horizon-ring which confines the artist and the forms of nature.

This accursed ring, which opens up newer and newer prospects, leads the artist away from the *target of destruction.*

And only a cowardly consciousness and meagre creative powers in an artist are deceived by this fraud and base *their art on the forms of nature*, afraid of losing the foundation on which the savage and the academy have based their art.

To reproduce beloved objects and little corners of nature is just like a thief being enraptured by his legs in irons.

Only dull and impotent artists screen their work with *sincerity*.
In art there is a need for *truth*, not *sincerity*.

Things have disappeared like smoke; to gain the new artistic culture, art approaches creation as an end in itself and domination over the forms of nature.

The Art of the Savage and its Principles

The savage was the first to found the principle of naturalism: fashioning his drawings out of a dot and five little sticks, he tried to recreate his own image.

This first attempt laid the basis for conscious imitation of the forms of nature.

From this arose the aim of approaching the face of nature as closely as possible.

And all the artists' efforts were directed towards the representation of her creative forms.

Collective art, or the art of copying, had its origin in the tracing of the savage's first primitive image.

Collective, because the real man with his subtle range of feelings, psychology and anatomy had not yet been discovered.

The savage saw neither his external image, nor his inner condition.

His consciousness could only see the shape of a man, animal, etc.

And as his consciousness developed, so the scheme by which he depicted nature grew more complicated.

The further his consciousness embraced nature, the more complicated his work became and the more his knowledge and ability increased.

His consciousness developed only on one side, the side of nature's creation, and not on the side of new forms of art.

Therefore his primitive pictures cannot be considered as creative work.

The deformities in his pictures are the result of weakness on the technical side.

Technique, like consciousness, was only on the path of its development.
– And his pictures must not be considered as Art.

For inability is not art.

He merely pointed the way to art.

Consequently, the original scheme was a framework, on which the generations hung newer and newer discoveries made in nature.

And the scheme grew more complicated and achieved its flowering in the Ancient World and the Renaissance of art.

The masters of these two epochs portrayed man in his complete form, both inner and outer.

Man was assembled and his inner condition was expressed.

But despite their colossal mastery, they did not complete the savage's idea:

The reflection, as in a mirror, of nature on canvas.

And it is a mistake to believe that their age was the brightest flowering in art, and that the younger generation must at all costs strive towards this ideal.

Such a concept is false.

It diverts young forces from the contemporary stream of life, thereby demoralizing them.

Their bodies fly in aeroplanes, but art and life are covered with the old robes of Neros and Titians.

Thus they are unable to see the new beauty of our modern life.

For they live by the beauty of past ages.

So the Realists, Impressionists, Cubism, Futurism and Suprematism were not understood.

These last-mentioned artists cast off the robes of the past and came out into contemporary life to find a new beauty.

And I say:

That no torture-chamber of the Academies can withstand the passage of time.

Forms move and are born, and we make newer and newer discoveries.

And what I reveal to you, do not conceal.

And it is absurd to force *our* age into the old forms of time past.

* * *

In copying or tracing the forms of nature we have fed our consciousness with a false understanding of art.

The work of the Primitives has been taken for creation.

That of the Classics – also creation. [...]

The transferring of real objects onto canvas is the art of skilful reproduction, and only that.

And between the art of creating and the art of copying there is a great difference. [...]

The artist can be a creator only when the forms in his picture have nothing in common with nature.

For art is the ability to construct, not on the interrelation of form and colour, and not on an aesthetic basis of beauty in composition, *but on the basis of weight, speed and the direction of movement*.

Forms must be given life and the right to individual existence. [...]

An artist is under the obligation to be a free creator, but not a freebooter.

An artist is given talent in order that he may give to life his share of creation and increase the flow of life. Only in absolute creation will he acquire his right.

And this is possible when we free all our art from vulgar subject-matter and teach our consciousness to see everything in nature not as real forms and objects, but as material masses from which forms must be made, which have nothing in common with nature.

Thus the habit of seeing Madonnas and Venuses in pictures, with fat, playful cupids, will disappear.

Colour and texture in painting are ends in themselves. They are the essence of painting, but this essence has always been destroyed by the subject.

And if the masters of the Renaissance had discovered the surface of painting, it would have been much more exalted and valuable than any Madonna or Gioconda.

And any carved-out pentagon or hexagon would have been a greater work of sculpture than the Venus de Milo or David.

* * *

Academic realists – they are the last descendants of the savage.

It is they who go about in the worn-out robes of the past.

And again, as before, some have thrown off this greasy robe.

And given the rag-merchant from the Academy a slap in the face with their declaration of Futurism.

They began with a mighty movement to beat on the consciousness, like nails in a stone wall.

To pull you out of the catacombs into the speed of our time.

I affirm that whoever has not trod the path of Futurism as the exponent of modern life, is condemned to crawl for ever among the ancient graves and feed on the crusts of the past.

Futurism opened the 'new' in modern life: the beauty of speed.

And through speed we move more swiftly.

And we who only yesterday were Futurists, arrived through speed at new forms, at new relationships with nature and things.

We arrived at Suprematism, leaving Futurism as a loop-hole through which those left behind will pass.

We have abandoned Futurism; and we, the most daring, *have spat on the altar of its art*.

But can cowards spit on their idols.

Like we did yesterday!!!

I tell you, you will not see the new beauty and the truth, until you make up your minds to spit. [. . .]

We did not renounce Futurism because it was languishing, and its end was approaching. No. The beauty of speed which it discovered is eternal and the new will still be revealed to many.

As we run to our goal through the speed of Futurism, thought moves more swiftly, and whoever finds himself in Futurism is nearer to this aim and further from the past.

And your lack of understanding is quite natural. How can a man who always rides in a gig understand the experiences and impressions of one who travels in an express, or flies through the air?

The Academy is a mouldy vault, in which art flagellates itself.

Huge wars, great inventions, conquest of the air, speed of travel, telephones, telegraphs, dreadnoughts – the realm of electricity.

But our young artists paint Neros and half-naked Roman warriors.

All honour to the Futurists, who forbade the painting of female hams, the painting of portraits and guitars in moonlight.

They took an enormous step forward, they gave up meat and glorified the machine.
But meat and the machine are the muscles of life.
Both are the bodies in which life moves.

Here two worlds have collided.
The world of meat and the world of iron.
Both forms are the organs of utilitarian reason.
And the relationship of the artist to the forms which things take in life has to be explained.
Until now the artist always pursued the thing.
Thus the new Futurism pursues the machine of to-day's speed.
These are both kinds of art: the old and the new, Futurism, are behind the running forms.
And the question arises: will this aim in painting justify its existence?
No!
Because in pursuing the form of aeroplanes or automobiles, we shall always be anticipating new cast-off forms of technical life . . .
And secondly:
In pursuing the form of things, we cannot discover painting as an end in itself, the way to direct creation.
Painting will remain the means of reproducing this or that condition of the forms of life.

But the Futurists forbade the depiction of nakedness not for the sake of giving freedom to painting or words to act as ends in themselves. But because of the change in the technical side of life.
The new life of iron and the machine, the roar of automobiles, the glitter of electric lights, the whirring of propellers, have awoken the soul, which was stifling in the catacombs of ancient reason and has emerged on the roads woven between earth and sky.
If all artists could see the crossroads of these celestial paths, if they could comprehend these monstrous runways and the weaving of our bodies with the clouds in the sky, then they would not paint chrysanthemums.

The dynamic of movement has directed thought to produce the dynamic of plastic painting.
But the efforts of the Futurists to produce purely plastic painting as such, were not crowned with success.
They could not abandon subject-matter, which would have made their task easier.
When they had driven reason halfway off the surface of the picture (the old callous of habit that sees everything naturalistically), they were able to make a picture of the new life, of new things, but only this.

In the depiction of movement, the wholeness of things *vanished* as their flashing particles hid themselves among other running bodies.
And in constructing the parts of the running objects, they tried to depict only the impression of movement.

But in order to depict the movement of modern life, one must operate with its forms. Which made the arrival of painting at its goal more difficult.

But however it was done, consciously or unconsciously, for the sake of movement, or for the sake of depicting impressions, the wholeness of things was violated.

And in this breaking-up and violation of wholeness lay the hidden meaning which the naturalistic aim had concealed.

The aim underlying this destruction was not primarily that of depicting the movement of things, but that of their destruction for the sake of the pure essence of painting; that is, towards an approach to non-objective creation. [...]

Having overthrown reason, the Futurists proclaimed intuition as the subconscious.

However, they created their pictures not from the subconscious forms of intuition, but employed the forms of utilitarian reason. [...]

The intuitive, it seems to me, should reveal itself in forms which are unconscious and without response.

I consider that it was necessary to understand the intuitive in art as the aim of our selective feeling towards objects. And it followed a purely conscious path, decisively forcing its way through the artist.

It appears as two levels of consciousness fighting between themselves.

But the consciousness, accustomed to the training of utilitarian reason, could not accord with the sense which led to the destruction of the world of objects.

The artist did not understand this aim, and, submitting to this sense, betrayed reason and disfigured the form.

Creation by utilitarian reason has a specific purpose.

But intuitive creation has no utilitarian purpose. Until now we have had no such manifestation of Intuition in art.

In art all pictures emerge from creative forms of a utilitarian order. All the naturalists' pictures have the same form as in nature.

The intuitive form should emerge from nothing.

In the same way that Reason, which creates things for everyday life, takes them from nothing and perfects them. [...]

The artist should now know what, and why, things happen in his pictures.

Formerly he lived by some kind of mood. He awaited the rising of the moon, twilight, put green shades on his lamps, and this all attuned his mood like a violin.

But when asked why this face was crooked, or green, he could not give an exact answer.

'I want it so, I like it like that...'

In the end this desire was ascribed to intuitive will.

Consequently the intuitive feeling did not speak clearly. And in that case, its condition was not only subconscious, but totally unconscious.

Paintings were a tangle of these concepts. The picture was half real, half deformed.

Being a painter, I ought to say why in pictures people's faces are painted green and red.

The picture – paint, colour – lies within our organism. Its outbursts are great and demanding.

My nervous system is coloured by them.

My brain burns with their colours.

But colour was oppressed by common-sense, was enslaved by it. And the spirit of colour weakened and died out.

But when it conquered common-sense, then the colours flowed onto the detested form of real things.

The colours matured, but their form did not mature in the consciousness.

This is why faces and bodies were red, green and blue.

But this was the portent leading to the creation of forms in painting which were ends in themselves.

Now it is necessary to give the body shape and lend it a living form in real life.

And this will be when forms emerge from the mass of the painting; that is, they will arise in the same way that utilitarian forms arose.

Such forms will not be copies of living things in life, but will themselves be a living thing.

A painted surface is a real, living form.

Intuitive feeling is now becoming conscious, not longer is it subconscious.

Or even, rather, the other way round – it was always conscious, only the artist was unable to interpret its demands.

The forms of Suprematism, the new realism in painting, are already proof of the construction of forms from nothing, discovered by Intuitive Reason.

In Cubism, the attempt to disfigure the forms of reality and the breaking-up of objects represent the striving of the will towards the independent life of the forms which it has created.

Futurist Painting

[. . .] The Futurists hold the dynamic of three-dimensional form to be of prime importance in painting.

But in failing to destroy the world of objects, they achieve only the dynamic of things.

Therefore Futurist paintings and all those of by-gone artists can be reduced from twenty colours to one, and not lose their impression.

Repin's picture, Ivan the Terrible, could be devoid of colour and still give us the same impressions of horror as in colour.

The subject will always kill colour and we shall not notice it.

Then, when the faces painted green and red to a certain extent kill the subject, the colour is more noticeable. And colour is that by which a painting lives: which means it is the most important.

And here I have arrived at pure colour forms.

And Suprematism is the pure art of painting, whose independence cannot be reduced to a single colour.

The gallop of a horse can be depicted with a pencil of one colour.

But it is impossible to depict the movement of red, green or blue masses with a pencil.

Painters should abandon subject and objects if they wish to be pure painters.

This demand for the dynamic of plastic painting indicates the need for the mass in painting to emerge from the object and arrive at the domination of form as an end in itself over content and things, at non-objective Suprematism – at the new realism in art, at absolute creation.

Futurism approaches the dynamism of painting through the academism of form.

And the path of both forces leads to Suprematism in painting.

If we examine the art of Cubism, and ask what energy in objects roused the intuitive feeling to activity, we shall see that the energy in painting was secondary.

The very object itself, together with its essence, purpose, sense, or the fullness of its presentation, the Cubists thought, were also unnecessary.

Until now it seemed that the beauty of objects was preserved when they were transferred whole into the picture, their essence being revealed especially in the crudeness of the line, or in its simplification.

But it transpired that one more situation of objects was discovered, which reveals to us the new beauty.

Namely: intuitive feeling discovered in objects the energy from the dissonance obtained in the collision of two opposed forms.

Objects embody a mass of moments in time. Their forms are various, and consequently their depictions are various.

All these aspects of time in things and their anatomy – the rings of a tree – have become more important than their essence and meaning.

And these new situations were adopted by the Cubists as a means of constructing pictures.

At the same time these means were so constructed that the unexpected collision of two forms would provide a dissonance of the greatest force of tension.

And the scale of each form is arbitrary.

Which justifies the appearance of parts of real objects in positions not relating to nature.

In achieving this new beauty, or simply energy, we have freed ourselves from the impression of the wholeness of objects.

The millstone round the neck of painting is beginning to crack.

An object painted according to the principle of Cubism can be considered finished when its dissonances are exhausted.

Nevertheless, all forms which repeat themselves should be omitted by the artist as copies.

But if the artist finds little tension in the picture, he is free to take them from another object.

Consequently in Cubism the principle of the transference of objects falls down. A picture is made, but the object is not transferred.

Whence this conclusion:

If for thousands of years past the artist has tried to approach the depiction of an object as closely as possible, to present its essence and meaning, then in our era of Cubism the artist has destroyed objects together with their meaning, essence and purpose.

The new picture has sprung from their fragments.

Objects have vanished like smoke, for the sake of the new culture of art.

* * *

There is no more love of little corners, there is no more love for which the truth of art was betrayed.

The square is not a subconscious form. It is the creation of intuitive reason.

It is the face of the new art.

The square is a living, royal infant.

It is the first step of pure creation in art. Before it, there were naive deformities and copies of nature.

Our world of art has become new, non-objective, pure.

Everything has vanished, there remains a mass of material, from which the new forms will be built.

In the art of Suprematism forms will live, like all living forms of nature.

These forms announce that man has gained his equilibrium by arriving from a state of single reasoning at one of double reasoning.

Utilitarian reasoning and intuitive reasoning.

The new realism in painting is very much realism in painting, for it contains no realism of mountains, sky, water ...

Until now there was realism of objects, but not of painted units of colour, which are constructed so that they depend neither on form, nor on colour, nor on their position relative to each other.

Each form is free and individual.

Each form is a world.

Any painting surface is more alive than any face from which a pair of eyes and a grin jut out.

A face painted in a picture gives a pitiful parody of life, and this allusion is only a reminder of the living.

But a surface lives, it has been born. The grave reminds us of a dead person, a picture of a living one.

Or on the contrary, a living face, a landscape in nature, reminds us of a picture, i.e. of something dead.

This is why it is strange to look at a red or black painted surface.

This is why they snigger and spit at the exhibitions of new movements.

Art and its new aims were always a spittoon.

But cats grow accustomed to a place and it is difficult to train them to a new one.

For such people art is absolutely unnecessary. As long as there are pictures of their grandmother and their favourite little corners of lilac groves.

Everything runs from the past to the future, but everything should live by the present, for in the future the apple-trees will shed their blossom.

Tomorrow will wipe out the trace of the present, and you will not catch up with the pace of life.

The mire of the past, like a millstone, will drag you into the slough.

This is why I hate all those who supply you with monuments to the dead.

The Academy and the critics are this millstone. Round your neck are the old realism and the movement which strives towards the reproduction of living nature.

They act in the same way as in the times of the Grand Inquisition.

Their aims are laughable, because they want at all costs to force what they take from nature to live on the canvas.

At the same time as everything is running and breathing, there are their frozen poses in pictures. And this torture is worse than breaking on the wheel. Sculptured statues, inspired (which means living), stand in their tracks, posed in movement.

Is this not torture?

Setting the soul in marble and then mocking the living.

But your pride is an artist who knows how to torture.

You put birds in a cage also for pleasure.

And for the sake of knowledge you keep animals in zoological gardens.

I am fortunate to have broken out of that torture-chamber of the Inquisition which is academism.

I have arrived at the surface and can take the dimension of a living body.

But I shall use the dimension from which I shall create the new.

I have released all the birds from the eternal cage, and opened the gates to the animals in zoological gardens.

May they tear to pieces and devour the remains of your art.

And may the freed bear bathe his body in the ice of the frozen north and not languish in the aquarium of boiled water in the academic garden.

You may delight in the composition of a painting, but surely composition is the sentence of death to a figure condemned by the artist to an eternal pose.

Your delight is the confirmation of this sentence.

The Group of Suprematists: K. Malevich, I. Puni, M. Men'kov, I. Klyun, K. Boguslavskaya, and Rozanova, has led the struggle for the freedom of objects from the obligations of art.

And calls upon the Academy to renounce the inquisition of nature.

The instrument of torture is idealism and the demands of aesthetic feeling.

The idealisation of the form of man is the mortification of much living sinew.

Aestheticism is the garbage of intuitive feeling.

You want to see pieces of living nature on the hooks of your walls.

Just as Nero admired the torn bodies of people and animals from the zoological garden.

I say to all: reject love, reject aestheticism, reject the trunks of wisdom, for in the new culture your wisdom is laughable and insignificant.

I have united the knots of wisdom and set free the consciousness of colour!

Remove from yourselves quickly the hardened skin of centuries, so that you may catch us up the more easily.

I have overcome the impossible and formed gulfs with my breathing.

You are in the nets of the horizon, like fish!

We, Suprematists, throw open the way to you.

Hurry!

– For tomorrow you will not recognize us.

IIB
Cubism

1 Jean Metzinger (1883–1957) 'Note on Painting'

The author was a Cubist painter, one of the principal organizers of the public launch of Cubism at the Salon des Indépendants in the spring of 1911. His brief essay establishing Cubism as the decisive modern movement, and in particular Picasso and Braque as its leaders, had appeared in Paris the previous autumn in *Pan*, October–November 1910, pp. 649–51. The present translation is taken from Edward Fry (ed.), *Cubism*, New York and London, 1966, pp. 59–60.

Is there any of the most modern works in painting and sculpture that does not secretly obey the Greek rhythm?

Nothing, from the Primitives to Cézanne, breaks decisively with the chain of variations contained in the Hellenic theme. I see today the rebels of yesterday mechanically prostrating themselves before the bas-relief at Eleusis. Gothics, Romantics, Impressionists, the old measure has triumphed over your praiseworthy departures from rhythm; and yet your labours have not been in vain – they have established in us the foreknowledge of a new and different rhythm.

For us the Greeks invented the human form; we must reinvent it for others.

We are not concerned, here, with a partial 'movement' dealing in accepted freedoms (those of interpretation, transposition, etc.: half-measures!), but with a fundamental liberation.

Already there are arising men of courage who know what they are doing – here are painters: Picasso, Braque, Delaunay, Le Fauconnier. Wholly and only painters, they do not illuminate concepts in the manner of the 'neo-primitives'; they are too enlightened to believe in the stability of any system, even one called classical art, and at the same time they recognize in the most novel of their own creations the triumph of desires that are centuries old. Their reason holds the balance between the pursuit of the transient and the mania for the eternal. While condemning the absurdity of the theoreticians of 'emotion', they take good care not to drag painting towards purely decorative speculation. When, in order to defeat the deceptiveness of vision, they momentarily impose their domination on the external world, their understanding remains untouched by Hegelian superstition.

It is useless to paint where it is possible to describe.

Fortified with this thought, Picasso unveils to us the very face of painting.

Rejecting every ornamental, anecdotal or symbolic intention, he achieves a painterly purity hitherto unknown. I am aware of no paintings from the past, even the finest, that belong to painting as clearly as his.

Picasso does not deny the object, he illuminates it with his intelligence and feeling. With visual perceptions he combines tactile perceptions. He tests, understands, organizes: the picture is not to be a transposition or a diagram, in it we are to contemplate the sensible and living equivalent of an idea, the total image. Thesis, antithesis, synthesis – the old formula undergoes an energetic inter-inversion of its first two terms: Picasso confesses himself a realist. Cézanne showed us forms living in the reality of light, Picasso brings us a material account of their real life in the mind – he lays out a free, mobile perspective, from which that ingenious mathematician Maurice Princet has deduced a whole geometry.

The fine shades neutralize one another round ardent constructions. Picasso disdains the often brutal technique of the so-called colourists, and brings the seven colours back to the primordial unity of white.

The abandonment of the burdensome inheritance of dogma; the displacing, again and again, of the poles of habit; the lyrical negation of axioms; the clever mixing, again and again, of the successive and the simultaneous: Georges Braque knows thoroughly the great natural laws that warrant these liberties.

Whether it be a face or a fruit he is painting, the total image radiates in time; the picture is no longer a dead portion of space. A main volume is physiologically born of concurrent masses. And this miraculous dynamic process has a fluid counterpoint in a colour-scheme dependent on the ineluctable two-fold principle of warm and cold tones.

Braque, joyfully fashioning new plastic signs, commits not a single fault of taste. Let us not be misled by the word 'new'; without detracting from this painter's boldness in innovation, I can compare him to Chardin and Lancret: I can link the daring grace of his art with the genius of our race...

2 Guillaume Apollinaire (1880–1918) 'The Cubists'

The poet and essayist Apollinaire was one of the most influential figures in the Parisian avant-garde in the first two decades of the twentieth century. He was rapidly established both as a leading intellectual influence on, and impresario of, Cubism. This essay, which distinguishes Cubism from the Impressionist-Fauvist tradition in terms of its formal and monumental qualities, appeared as part of his review of the Salon d'Automne of 1911. It was originally published in Paris in *L'Intransigeant*, 10 October 1911. The present translation is taken from Leroy C. Breunig (ed.), *Apollinaire on Art*, London, 1972, p. 183.

In a tiny room, Room 8, are the works of a few painters known by the name of cubists. Cubism is not, as is generally thought, the art of painting everything in the form of cubes.

In 1908, Picasso showed a few paintings in which there were some simply and firmly drawn houses that gave the public the illusion of these cubes, whence the name of our youngest school of painting. This school has already aroused passionate discussion. Cubism can in no way be considered a systematic doctrine; it does, however, constitute a school, and the painters who make up this school want to transform their art by

returning to first principles with regard to line and inspiration, just as the fauves – and many of the cubists were at one time fauves – returned to first principles with regard to color and composition.

However, the public, accustomed as it is to the brilliant but practically formless daubs of the impressionists, refused to recognize at first glance the greatness of the formal conceptions of our cubists. People were shocked to see contrasts between dark forms and lighted segments, because they were used to seeing only paintings without shadows. In the monumental appearance of compositions that go beyond the frivolities of contemporary art, the public has refused to see what is really there: a noble and restrained art ready to undertake the vast subjects for which impressionism had left painters totally unprepared. Cubism is a necessary reaction that will give rise to great works, whether people like it or not. For is it possible, can anyone believe for an instant, that the undeniable efforts of these young artists will remain sterile? I will even go further, and without underestimating the talents of all sorts that are manifest at the Salon d'Automne, I will say that cubism is the most noble undertaking in French art today. [. . .]

3 Guillaume Apollinaire (1880–1918) 'On the Subject in Modern Painting'

In this essay Apollinaire defines Cubism as an austere, pure art, offering a pleasure of its own as distinct from the pleasure to be derived either from nature or from depictions of it. He appears to view it as a step on the way to a potentially abstract art. Originally published in *Les Soirées de Paris*, February 1912. The present translation is taken from Breunig, op. cit., pp. 197–8.

The new painters paint works that do not have a real subject, and from now on, the titles in catalogues will be like names that identify a man without describing him.

Just as there are some very skinny people named Portly and some very dark-haired people named Fair. I have seen paintings entitled *Solitude* that show several figures.

Painters sometimes still condescend to use vaguely explanatory words such as *portrait*, *landscape*, or *still-life*; but many young painters simply employ the general term *painting*.

If painters still observe nature, they no longer imitate it, and they carefully avoid the representation of natural scenes observed directly or reconstituted through study. Modern art rejects all the means of pleasing that were employed by the greatest artists of the past: the perfect representation of the human figure, voluptuous nudes, carefully finished details, etc. . . . Today's art is austere, and even the most prudish senator could find nothing to criticize in it.

Indeed, it is well known that one of the reasons cubism has enjoyed such success in elegant society is precisely this austerity.

Verisimilitude no longer has any importance, for the artist sacrifices everything to the composition of his picture. The subject no longer counts, or if it counts, it counts for very little.

If the aim of painting has remained what it always was – namely, to give pleasure to the eye – the works of the new painters require the viewer to find in them a different kind of pleasure from the one he can just as easily find in the spectacle of nature.

An entirely new art is thus being evolved, an art that will be to painting, as painting has hitherto been envisaged, what music is to literature.

It will be pure painting, just as music is pure literature.

In listening to a concert, the music-lover experiences a joy qualitatively different from that he experiences in listening to natural sounds, such as the murmur of a stream, the rushing of a torrent, the whistling of the wind in the forest, or to the harmonies of a human language founded on reason and not on aesthetics.

Similarly, the new painters provide their admirers with artistic sensations due exclusively to the harmony of lights and shades and independent of the subject depicted in the picture.

We all know the story of Apelles and Protogenes, as it is told by Pliny.

It provides an excellent illustration of aesthetic pleasure independent of the subject treated by the artist and resulting solely from the contrasts I have just mentioned.

Apelles arrived one day on the island of Rhodes to see the works of Protogenes, who lived there. Protogenes was not in his studio when Apelles arrived. Only an old woman was there, keeping watch over a large canvas ready to be painted. Instead of leaving his name, Apelles drew on the canvas a line so fine that one could hardly imagine anything more perfect.

On his return, Protogenes noticed the line and, recognizing the hand of Apelles, drew on top of it another line in a different color, even more subtle than the first, thus making it appear as if there were three lines on the canvas.

Apelles returned the next day, and the subtlety of the line he drew then made Protogenes despair. That work was for a long time admired by connoisseurs, who contemplated it with as much pleasure as if, instead of some barely visible lines, it had contained representations of gods and goddesses.

The young painters of the avant-garde schools, then, wish to do pure painting. Theirs is an entirely new plastic art. It is only at its beginnings, and is not yet as abstract as it would like to be. The new painters are in a sense mathematicians without knowing it, but they have not yet abandoned nature, and they examine it patiently.

A Picasso studies an object the way a surgeon dissects a corpse.

If this art of pure painting succeeds in disengaging itself entirely from the traditional way of painting, the latter will not necessarily disappear. The development of music, after all, did not cause the disappearance of the various literary genres, nor did the acrid taste of tobacco replace the savor of food.

4 Guillaume Apollinaire (1880–1918) 'The New Painting: Art Notes'

Here Apollinaire discusses the depiction of space in Cubist painting, claiming (problematically) that it embodies contemporary ideas of a 'fourth dimension'. These were related to

the development of non-Euclidean geometries in the late nineteenth century, as well as to Einstein's theory of relativity. This latter, though doubtless little understood, was an object of contemporary fascination, particularly to the avant-garde, in the years before the First World War. Apollinaire first developed this connection in a lecture delivered to accompany a Cubist exhibition in November 1911. Originally published in *Les Soirées de Paris*, April–May 1912. The present translation is taken from Breunig, op. cit., pp. 222–3.

The new painters have been sharply criticized for their preoccupation with geometry. And yet, geometric figures are the essence of draftsmanship. Geometry, the science that deals with space, its measurement and relationships, has always been the most basic rule of painting.

Until now, the three dimensions of Euclidean geometry sufficed to still the anxiety provoked in the souls of great artists by a sense of the infinite – anxiety that cannot be called scientific, since art and science are two separate domains.

The new painters do not intend to become geometricians, any more than their predecessors did. But it may be said that geometry is to the plastic arts what grammar is to the art of writing. Now today's scientists have gone beyond the three dimensions of Euclidean geometry. Painters have, therefore, very naturally been led to a preoccupation with those new dimensions of space that are collectively designated, in the language of modern studios, by the term *fourth dimension*.

Without entering into mathematical explanations pertaining to another field, and confining myself to plastic representation as I see it, I would say that in the plastic arts the fourth dimension is generated by the three known dimensions: it represents the immensity of space eternalized in all directions at a given moment. It is space itself, or the dimension of infinity; it is what gives objects plasticity. It gives them their just proportion in a given work, whereas in Greek art, for example, a kind of mechanical rhythm is constantly destroying proportion.

Greek art had a purely human conception of beauty. It took man as the measure of perfection. The art of the new painters takes the infinite universe as its ideal, and it is to the fourth dimension alone that we owe this new measure of perfection that allows the artist to give objects the proportions appropriate to the degree of plasticity he wishes them to attain. [...]

Wishing to attain the proportions of the ideal and not limiting themselves to humanity, the young painters offer us works that are more cerebral than sensual. They are moving further and further away from the old art of optical illusions and literal proportions, in order to express the grandeur of metaphysical forms. [...]

5 Guillaume Apollinaire (1880–1918) from *The Cubist Painters* (Chapter VII)

Apollinaire's book, for which his own principal title was *Méditations esthétiques*, comprised a miscellaneous collection of writings, some dating back to 1905. In Chapter VII he strives, somewhat misleadingly, to disentangle four distinct tendencies within Cubism. He also speaks of an inner or essential reality, whose dictates Cubism obeys; and links the new movement to the tradition of Courbet as well as of Cézanne. Originally published Paris, 1912. The present extract is taken from Edward Fry, op. cit., pp. 116–18.

Cubism differs from the old schools of painting in that it is not an art of imitation, but an art of conception which tends towards creation.

In representing conceptualized reality or creative reality, the painter can give the effect of three dimensions. He can to a certain extent cube. But not by simply rendering reality as seen, unless he indulges in *trompe-l'œil*, in foreshortening, or in perspective, thus distorting the quality of the forms conceived or created.

I can discriminate four tendencies in cubism. Of these, two are parallel and pure.

Scientific cubism is one of the pure tendencies. It is the art of painting new structures out of elements borrowed not from the reality of sight, but from the reality of insight. All men have a sense of this interior reality. A man does not have to be cultivated in order to conceive, for example, of a round form.

The geometrical aspect, which made such an impression on those who saw the first canvases of the scientific cubists, came from the fact that the essential reality was rendered with great purity, while visual accidents and anecdotes had been eliminated. The painters who follow this tendency are: Picasso, whose luminous art also belongs to the other pure tendency of cubism, Georges Braque, Albert Gleizes, Marie Laurencin and Juan Gris.

Physical cubism is the art of painting new structures with elements borrowed, for the most part, from visual reality. This art, however, belongs in the cubist movement because of its constructive discipline. It has a great future as historical painting. Its social role is very clear, but it is not a pure art. It confuses what is properly the subject with images. The painter-physicist who created this trend is Le Fauconnier.

Orphic cubism is the other important trend of the new school. It is the art of painting new structures with elements which have not been borrowed from the visual sphere, but have been created entirely by the artist himself, and been endowed by him with fullness of reality. The works of the orphic artist must simultaneously give a pure aesthetic pleasure; a structure which is self-evident; and a sublime meaning, that is, a subject. This is pure art. The light in Picasso's paintings is based on this conception, which Robert Delaunay is also in the process of discovering and towards which Fernand Léger, Francis Picabia, and Marcel Duchamp are also directing their energies.

Instinctive cubism is the art of painting new structures with elements which are not borrowed from visual reality, but are suggested to the artist by instinct and intuition; it has long tended towards orphism. The instinctive artist lacks lucidity and an aesthetic doctrine; instinctive cubism includes a large number of artists. Born of French impressionism, this movement has now spread all over Europe.

Cézanne's last paintings and his watercolours belong to cubism, but Courbet is the father of the new painters; and André Derain, whom I propose to discuss some other time, was the eldest of his beloved sons, for we find him at the beginning of the fauvist movement, which was a kind of introduction to cubism, and also at the beginning of this great subjective movement; but it would be too difficult today to write discerningly of a man who so wilfully stands apart from everyone and everything.

The modern school of painting seems to me the most audacious that has ever appeared. It has posed the question of what is beautiful in itself.

It wants to visualize beauty disengaged from whatever charm man has for man, and until now, no European artist has dared attempt this. The new artists demand an ideal beauty, which will be, not merely the proud expression of the species, but the expression of the universe, in so far as it has been humanized by light.

The new art clothes its creations with a magnificence which surpasses anything else conceived by the artists of our time. Ardent in its search for beauty, it is noble and energetic, and the reality it brings us is marvellously clear. I love the art of today because above all else I love the light; for man loves the light more than anything; it was he who invented fire.

6 Jacques Rivière (1886–1925) 'Present Tendencies in Painting'

The author, a well-known critic, offered an extended and critical discussion of various technical aspects of Cubist representation: again underpinned by philosophical idealization of a profound or true reality distinct from mere appearance. Ironically he concludes the essay by praising more conservative Cubists while criticizing the more thoroughgoing practitioners for pushing their new principles too far. Originally published in the *Revue d'Europe et d'Amérique*, Paris, March 1912, pp. 384–406. The present extract is taken from Fry, op. cit., pp. 75–80. (Ellipses are integral to the English version.)

One must, I think, guard against misinterpreting the uneasiness and the hesitant conviction shown by the cubists. I do not see it as a sign that their vocation is arbitrary, nor do I conclude from it that their inner torments are all in vain. On the contrary, their perplexity makes me believe that there is in their enterprise something greater than themselves, an overwhelmingly powerful necessity in the evolution of painting, a truth greater than they can see at first sight. They are the precursors – clumsy, like all precursors – of a new art which is henceforth inevitable ...

My intention is to give the cubists a little more freedom and assurance by supplying them with the deep reasons for what they are doing. True, this will not be possible without showing them how badly they have done it so far.

I The Present Needs of Painting

... The true purpose of painting is to represent objects as they really are; that is to say, differently from the way we see them. It tends always to give us their sensible *essence*, their presence, this is why the image it forms does not resemble their *appearance* ...

Let us now try to determine more precisely what sorts of transformation the painter must impose on objects as he sees them in order to express them as they are. These transformations are both negative and positive: he must eliminate lighting and perspective, and he must replace them with other and more truly plastic values.

Why lighting must be eliminated

... It is the sign of a particular instant ... If, therefore, the plastic image is to reveal the essence and permanence of beings, it must be free of lighting effects ...

Lighting is not only a superficial mark; it has the effect of profoundly altering the forms themselves ... It can therefore be said that lighting prevents things from *appearing as they are* ... Contrary to what is usually thought, sight is a successive

sense; we have to combine many of its perceptions before we can know a single object well. But the painted image is fixed...

What must be put in place of lighting

He [the cubist] has renounced lighting – that is to say, the direction of the light – but not light itself... It is enough for him to replace a crude and unjust distribution of light and shade with a more subtle and more equal distribution; it is enough for him to divide up between all the surfaces the shade that formerly accumulated on some; he will use the small portion of shading allotted to each one by placing it against the nearest edge of some other lit surface, in order to mark the respective inclination and divergence of the parts of the object.

In this way he will be able to model the object without having recourse to contrasts, simply by means of summits and declivities. This procedure will have the advantage of marking not only the separation but also the join of the planes; instead of a succession of bright salients and black cavities, we shall see slopes supported on one another in a gentle solidarity. As they will be both separate and united, the exigencies of multiplicity and those of unity will be satisfied at one and the same time.

In short the painter, instead of showing the object *as he sees it* – that is to say, dismembered into bright and dark surfaces – will construct it *as it is* – that is to say, in the form of a geometrical volume, set free from lighting effects. In place of its relief he will put its volume.

Why perspective must be eliminated

...Perspective is as accidental a thing as lighting. It is the sign, not of a particular moment in time, but of a particular position in space. It indicates not the situation of the objects, but the situation of a spectator... Hence, in the final analysis, perspective is also the sign of an instant, of the instant when a certain man is at a certain point.

What is more, like lighting, it alters them – it dissimulates their true form. In fact, it is a law of optics – that is, a physical law...

Certainly reality shows us these objects mutilated in this way. But in reality we can change position: a step to the right and a step to the left complete our vision. The knowledge we have of an object is, as I said before, a complex sum of perceptions. The plastic image does not move: it must be complete at first sight; therefore it must renounce perspective.

What must be put in place of perspective

...The elimination of perspective leads quite naturally to this simple rule: the object must always be presented from the most revealing angle...

It may even sometimes involve more than one viewpoint: sometimes it will display itself as it is impossible for us to see it, with one side more than we would ever discover in it if we stayed still...

An object can be represented in a profound and perfect way by one only of its parts, *provided this part is the node of all the others*... A house, if one looks at the point where

two roof-planes and two walls meet, is more completely known than if one saw the whole façade and nothing else...

Perspective is not the only way of expressing depth; nor, perhaps, is it the best way. It does not express depth in itself, directly and explicity; it can only suggest it by outlining profiles...

Fortunately depth is not pure emptiness; one can attribute a certain consistency to it, since it too is occupied – by air. The painter will therefore be able to express it otherwise than by perspective – by giving it a body; not by suggesting it, but by painting it as if it were a material thing. To this end he will make all the edges of the object into starting-points for gentle planes of shadow that will recede towards the more distant objects. Where one object is in front of others, this fact will be shown by the fringes of shadow with which its contour will be edged; its form will detach itself from the others not as a simple profile on a screen, but because the strokes delimiting it will be flanges, and because from them shadows will flow towards the background, as the waters of a river fall regularly from a dam. The depth will make its appearance as a subtle but visible recession accompanying the objects; they will hardly appear to lie on the same plane, for between them there will insinuate itself a positive distancing and separation produced by these small dark slopes. They will be distinguished from each other without needing to alter their real appearance, simply and solely by the sensible presence, between their images, of the intervals which separate them in nature. By embodying itself in shadows, space, which maintains their discreteness in nature, will continue to do so in the picture as well.

This procedure will have the advantage over perspective of marking the connection as well as the distinction between objects; for the planes which keep them apart will also form a transition between them. These planes will at one and the same time repel and bring closer the more distant objects.

II The Mistakes of the Cubists

In spite of appearances, painting has not yet emerged from impressionism. All art is impressionist that aims at representing, instead of the things themselves, the sensation we have of them; instead of reality, the image by which we become aware of it; instead of the object, the intermediary that brings us into relation with it...

The cubists are destined to take up the greater part of the lesson of Cézanne; they are going to give back to painting its true aim, which is to reproduce, with asperity and with respect, objects as they are...

First mistake of the cubists

From the truth that the painter must always show enough faces of an object to suggest its volume, they conclude that he must show all its faces. From the truth that sometimes it is necessary to add to the visible faces another, which could not be seen except by changing one's position a little, they conclude that it is necessary to add all the faces one could see by moving right round the object and looking at it from above and below.

The absurdity of such an inference does not need any long demonstration. Let us simply remark that the procedure, as understood by the cubists, arrives at a result that is the direct opposite of its purpose. If the painter sometimes shows more faces of an object than one can really see at once, this is in order to give its volume. But every volume is closed and implies the joining of the planes to each other; it consists in a certain relationship of all the faces to a centre. By putting all its faces side by side, the cubists give the object the appearance of an unfolded map and destroy its volume...

Second mistake of the cubists

From the truth that lighting and perspective, which act to subordinate the parts to the object and the objects to the picture, have to be eliminated, they conclude that all subordination must be renounced... They understand *eliminating perspective and lighting* to mean *sacrificing nothing as secondary*; they take these two ideas as equivalent, as interchangeable. They thus condemn themselves never again to select anything from reality; and since there can be no subordination without selection, the elements in their pictures relapse into anarchy and form a mad cacophony which makes us laugh...

Third and perhaps last mistake of the cubists

From the truth that depth must be expressed in genuinely plastic terms – by supposing it to have its own consistency – they conclude that it must be represented with as much solidity as the objects themselves and by the same means.

To each object they add the distance which separates it from neighbouring objects, in the form of planes as resistant as its own; and in this way they show it prolonged in all directions and armed with incomprehensible fins. The intervals between forms – all the empty parts of the picture, all the places in it occupied by nothing but air, find themselves filled up by a system of walls and fortifications. These are new, entirely imaginary objects, thrusting in between the first ones as though to wedge them tight.

Here again the procedure renders itself useless and automatically does away with the effects it aims at producing. The purpose of the painter's efforts to express depth is only to distinguish objects one from another, only to mark their independence in the third dimension. But if he gives to what separates them the same appearance as he gives to each of them, he ceases to represent their separation and tends, on the contrary, to confuse them, to weld them into an inexplicable continuum.

In short, the cubists behave as if they were parodying themselves. By carrying their newly-found principles to the point of absurdity, they deprive them of meaning. They do away with the volume of the object by their unwillingness to leave out any of its elements. They do away with the individual integrity of the objects in the picture by trying to keep them intact. They do away with depth (whose function it is to distinguish one object from another) by trying to represent it solidly...

It is, indeed, impossible not to discern already in the work of some young artists a more intelligent and penetrating understanding of cubism. I have directed my criticisms here principally at Picasso, at Braque and at the group formed by Metzinger, Gleizes, Delaunay, Léger, Herbin, Marcel Duchamp. Le Fauconnier, who was a member of

it, seems to be freeing himself from it. He may become a fine painter. But it is chiefly towards Derain and Dufy on the one hand, and on the other towards La Fresnaye, de Segonzac and Fontenay, that my best hopes have tended, ever since Picasso, who for a moment seemed near to possessing genius, strayed into occult researches where it is impossible to follow him. Lastly, I shall set apart André Lhote, whose recent works appear to me to announce, with admirable simplicity, the decisive arrival of the new painting.

7 Albert Gleizes (1881–1953) and Jean Metzinger (1883–1957) from *Cubism*

Both authors were Cubist painters involved in the public launch of Cubism at the Salon des Indépendants in 1911. The present essay was written during the build-up to the large Section d'Or exhibition in October 1912. Once again 'profound' and 'superficial' realisms are distinguished, and a link is traced to Courbet. The view of Cubism advanced here takes on a marked Nietzschean inflection in its closing passages. Originally published as *Du Cubisme*, Paris, 1912; translated into English in 1913. The present extracts are taken from R. L. Herbert, *Modern Artists on Art*, New York, 1964, pp. 2–18.

I

To evaluate the importance of Cubism, we must go back to Gustave Courbet.

This master – after David and Ingres had magnificently brought to an end a secular idealism – instead of wasting himself in servile repetitions like Delaroche and the Devérias, inaugurated a yearning for realism which is felt in all modern work. However, he remained a slave to the worst visual conventions. Unaware that in order to discover one true relationship it is necessary to sacrifice a thousand surface appearances, he accepted without the slightest intellectual control everything his retina communicated. He did not suspect that the visible world only becomes the real world by the operation of thought, and that the objects which strike us with the greatest force are not always those whose existence is richest in plastic truths.

Reality is deeper than academic recipes, and more complex also. Courbet was like one who contemplates the Ocean for the first time and who, diverted by the play of the waves, does not think of the depths; we can hardly blame him, because it is to him that we owe our present joys, so subtle and so powerful.

Edouard Manet marks a higher stage. All the same, his realism is still below Ingres' idealism, and his *Olympia* is heavy next to the *Odalisque*. We love him for having transgressed the decayed rules of composition and for having diminished the value of anecdote to the extent of painting 'no matter what.' In that we recognize a precursor, we for whom the beauty of a work resides expressly in the work, and not in what is only its pretext. Despite many things, we call Manet a realist less because he represented everyday events than because he endowed with a radiant reality many potential qualities enclosed in the most ordinary objects.

After him there was a cleavage. The yearning for realism was split into superficial realism and profound realism. The former belongs to the Impressionists: Monet, Sisley, etc.; the latter to Cézanne.

The art of the Impressionists involves an absurdity: by diversity of color it tries to create life, yet its drawing is feeble and worthless. A dress shimmers, marvelous; forms disappear, atrophied. Here, even more than with Courbet, the retina predominates over the brain; they were aware of this and, to justify themselves, gave credit to the incompatibility of the intellectual faculties and artistic feeling.

However, no energy can thwart the general impulse from which it stems. We will stop short of considering Impressionism a false start. Imitation is the only error possible in art; it attacks the law of time, which is Law. Merely by the freedom with which they let the technique appear, or showed the constituent elements of a hue, Monet and his disciples helped widen the horizon. They never tried to make Painting decorative, symbolic, moral, etc. If they were not great painters, they were painters, and that is enough for us to venerate them.

People have tried to make Cézanne into a sort of genius *manqué*: they say that he knew admirable things but that he stuttered instead of singing out. The truth is that he was in bad company. Cézanne is one of the greatest of those who orient history, and it is inappropriate to compare him to Van Gogh or Gauguin. He recalls Rembrandt. Like the author of the *Pilgrims of Emmaus*, disregarding idle chatter, he plumbed reality with a stubborn eye and, if he did not himself reach those regions where profound realism merges insensibly into luminous spirituality, at least he dedicated himself to whoever really wants to attain a simple, yet prodigious method.

He teaches us how to dominate universal dynamism. He reveals to us the modifications that supposedly inanimate objects impose on one another. From him we learn that to change a body's coloration is to corrupt its structure. He prophesies that the study of primordial volumes will open up unheard-of horizons. His work, an homogeneous block, stirs under our glance; it contracts, withdraws, melts, or illuminates itself and proves beyond all doubt that painting is not – or is no longer – the art of imitating an object by means of lines and colors, but the art of giving to our instinct a plastic consciousness.

He who understands Cézanne, is close to Cubism. From now on we are justified in saying that between this school and the previous manifestations there is only a difference of intensity, and that in order to assure ourselves of the fact we need only attentively regard the process of this realism which, departing from Courbet's superficial realism, plunges with Cézanne into profound reality, growing luminous as it forces the unknowable to retreat.

* * *

At this point we should like to destroy a widespread misapprehension to which we have already made allusion. Many consider that decorative preoccupations must govern the spirit of the new painters. Undoubtedly they are ignorant of the most obvious signs which make decorative work the antithesis of the picture. The decorative work of art exists only by virtue of its *destination*; it is animated only by the relations established between it and the given objects. Essentially dependent, necessarily incomplete, it must in the first place satisfy the mind so as not to distract it from the display which justifies and completes it. It is an organ.

A painting carries within itself its *raison d'être*. You may take it with impunity from a church to a drawing-room, from a museum to a study. Essentially independent, necessarily complete, it need not immediately satisfy the mind: on the contrary, it should lead it, little by little, toward the imaginative depths where burns the light of

organization. It does not harmonize with this or that ensemble, it harmonizes with the totality of things, with the universe: it is an organism.

* * *

II

Dissociating, for convenience, things that we know to be indissolubly united, let us study, by means of form and color, the integration of the plastic consciousness.

To discern a form implies, besides the visual function and the faculty of moving oneself, a certain development of the mind; to the eyes of most people the external world is amorphous.

To discern a form is to verify it by a pre-existing idea, an act that no one, save the man we call an artist, can accomplish without external assistance.

Before a natural spectacle, the child, in order to coordinate his sensations and to subject them to mental control, compares them with his picture-book; culture intervening, the adult refers himself to works of art.

The artist, having discerned a form which presents a certain intensity of analogy with his pre-existing idea, prefers it to other forms, and consequently – for we like to force our preferences on others – he endeavors to enclose the quality of this form (the unmeasurable sum of the affinities perceived between the visible manifestation and the tendency of his mind) in a symbol likely to affect others. When he succeeds he forces the crowd, confronted by his integrated plastic consciousness, to adopt the same relationship he established with nature. But while the painter, eager to create, rejects the natural image as soon as he has made use of it, the crowd long remains the slave of the painted image, and persists in seeing the world only through the adopted sign. That is why any new form seems monstrous, and why the most slavish imitations are admired.

* * *

To whom shall we impute the misapprehension? To the painters who disregard their rights. When from any spectacle they have separated the features which summarize it, they believe themselves constrained to observe an accuracy which is truly superfluous. Let us remind them that we visit an exhibition to contemplate painting and to enjoy it, not to enlarge our knowledge of geography, anatomy, etc.

Let the picture imitate nothing and let it present nakedly its *raison d'être!* Then we should indeed be ungrateful were we to deplore the absence of all those things – flowers, or landscape, or faces – whose mere reflection it might have been. Nevertheless, let us admit that the reminiscence of natural forms cannot be absolutely banished; as yet, at all events. An art cannot be raised all at once to the level of a pure effusion.

This is understood by the Cubist painters, who tirelessly study pictorial form and the space which it engenders.

This space we have negligently confused with pure visual space or with Euclidean space.

Euclid, in one of his postulates, speaks of the indeformability of figures in movement, so we need not insist upon this point.

If we wished to tie the painter's space to a particular geometry, we should have to refer it to the non-Euclidean scientists; we should have to study, at some length, certain of Riemann's theorems.

As for visual space, we know that it results from the harmony of the sensations of convergence and accommodation of the eye.

For the picture, a flat surface, the accommodation is negative. Therefore the convergence which perspective teaches us to simulate cannot evoke the idea of depth. Moreover, we know that the most serious infractions of the rules of perspective will by no means compromise the spatiality of a painting. Do not the Chinese painters evoke space, despite their strong partiality for *divergence*?

To establish pictorial space, we must have recourse to tactile and motor sensations, indeed to all our faculties. It is our whole personality which, contracting or expanding, transforms the plane of the picture. As it reacts, this plane reflects the personality back upon the understanding of the spectator, and thus pictorial space is defined: a sensitive passage between two subjective spaces.

The forms which are situated within this space spring from a dynamism which we profess to dominate. In order that our intelligence may possess it, let us first exercise our sensitivity. There are only *nuances*. Form appears endowed with properties identical to those of color. It is tempered or augmented by contact with another form, it is destroyed or it flowers, it is multiplied or it disappears. An ellipse may change its circumference because it is inscribed in a polygon. A form more emphatic than those which surround it may govern the whole picture, may imprint its own effigy upon everything. Those picture-makers who minutely imitate one or two leaves in order that all the leaves of a tree may seem to be painted, show in a clumsy fashion that they suspect this truth. An illusion, perhaps, but we must take it into account. The eye quickly interests the mind in its errors. These analogies and contrasts are capable of all good and all evil; the masters felt this when they strove to compose with pyramids, crosses, circles, semicircles, etc.

To compose, to construct, to design, reduces itself to this: to determine by our own activity the dynamism of form.

Some, and they are not the least intelligent, see the aim of our technique in the exclusive study of volumes. If they were to add that because surfaces are the limits of volumes, and lines those of surfaces, it suffices to imitate a contour in order to represent a volume, we might agree with them; but they are thinking only of the *sensation of relief*, which we consider insufficient. We are neither geometers nor sculptors; for us, lines, surfaces, and volumes are only nuances of the notion of fullness. To imitate only volumes would be to deny these nuances for the benefit of a monotonous intensity. We might as well renounce at once our vow of variety.

Between sculpturally bold reliefs, let us throw slender shafts which do not define, but which suggest. Certain forms must remain implicit, so that the mind of the spectator is the chosen place of their concrete birth.

Let us also contrive to cut by large restful surfaces any area where activity is exaggerated by excessive contiguities.

In short, the science of design consists in instituting relations between straight lines and curves. A picture which contained only straight lines or curves would not express existence.

It would be the same with a painting in which curves and straight lines exactly compensated one another, for exact equivalence is equal to zero.

The diversity of the relations of line to line must be indefinite; on this condition it incorporates quality, the unmeasurable sum of the affinities perceived between that

which we discern and that which already existed within us; on this condition a work of art moves us.

What the curve is to the straight line, the cold tone is to the warm in the domain of color.

III

After the Impressionists had burned up the last Romantic bitumens, some believed in a renaissance, or at least the advent of a new art: the art of color. Some were delirious. They would have given the Louvre and all the museums of the world for a scrap of cardboard spotted with hazy pink and apple-green. We are not jesting. To these excesses we owe the experience of a bold and necessary experiment.

Seurat and Signac thought of schematizing the palette and, boldly breaking with an age-long habit of the eye, established optical mixture.

Noble works of art, by Seurat as well as by Signac, Cross, and certain others, testify to the fertility of the Neo-Impressionist method; but it appears contestable as soon as we cease to regard it on the plane of superficial realism.

Endeavoring to assimilate the colors of the palette with those of the prism, it is based on the exclusive use of pure elements. Now the colors of the prism are homogeneous, while those of the palette, being heterogeneous, can furnish pure elements only insofar as we accept the idea of a *relative purity*.

Suppose this were possible. A thousand little touches of pure color break down white light, and the resultant synthesis should take place in the eye of the spectator. They are so disposed that they are not reciprocally annihilated by the optical fusion of the complementaries; for, outside the prism, whether we form an optical mixture or a mixture on the palette, the result of the sum of complementaries is a troubled grey, not a luminous white. [. . .]

* * *

It was then that the Cubists taught a new way of imagining light.

According to them, to illuminate is to reveal; to color is to specify the mode of revelation. They call luminous that which strikes the mind, and dark that which the mind has to penetrate.

We do not automatically associate the sensation of white with the idea of light, any more than black with the idea of darkness. We admit that a black jewel, even if of a matte black, may be more luminous than the white or pink satin of its case. Loving light, we refuse to measure it, and we avoid the geometric ideas of focus and ray, which imply the repetition – contrary to the principle of variety which guides us – of light planes and dark intervals in a given direction. Loving color, we refuse to limit it, and sober or dazzling, fresh or muddy, we accept all the possibilities contained between the two extreme points of the spectrum, between the cold and the warm tone.

Here are a thousand tints which escape from the prism, and hasten to range themselves in the lucid region forbidden to those who are blinded by the immediate.

IV

If we consider only the bare fact of painting, we attain a common ground of understanding.

Who will deny that this fact consists in dividing the surface of the canvas and investing each part with a quality which must not be excluded by the nature of the whole?

Taste immediately dictates a rule: we must paint so that no two portions of the same extent ever meet in the picture. Common sense approves and explains: let one portion repeat another, and the whole becomes measurable. The art which ceases to be a fixation of our personality (unmeasurable, in which nothing is ever repeated), fails to do what we expect of it.

The inequality of parts being granted as a prime condition, there are two methods of regarding the division of the canvas. According to the first, all the parts are connected by a rhythmic artifice which is determined by one of them. This one – its position on the canvas matters little – gives the painting a center from which or toward which the gradations of color tend, according as the maximum or minimum of intensity resides there.

According to the second, in order that the spectator ready to establish unity himself may apprehend all the elements in the order assigned to them by creative intuition, the properties of each portion must be left independent, and the plastic continuity must be broken into a thousand surprises of light and shade.

Hence we have two methods apparently inimical.

However little we know of the history of art, we can readily find names which illustrate each. The interesting point is to reconcile them.

The Cubist painters endeavour to do so, and whether they partially interrupt the ties demanded by the first method or confine one of those forces which the second insists should be freely allowed to flash out, they achieve that superior disequilibrium without which we cannot conceive lyricism.

Both methods are based on the kinship of color and form.

Although of a hundred thousand living painters only four or five appear to perceive it, a law here asserts itself which is to be neither discussed nor interpreted, but rigorously followed:

Every inflection of form is accompanied by a modification of color, and every modification of color gives birth to a form.

There are tints which refuse to wed certain lines; there are surfaces which cannot support certain colors, repelling them to a distance or sinking under them as under too heavy a weight.

To simple forms the fundamental hues of the spectrum are allied, and fragmentary forms should assume sparkling colors.

* * *

There is nothing real outside ourselves, there is nothing real except the coincidence of a sensation and an individual mental direction. Far from us any thought of doubting the existence of the objects which strike our senses; but, being reasonable, we can only have certitude with regard to the images which they make blossom in our mind.

It therefore amazes us that well-meaning critics explain the remarkable difference between the forms attributed to nature and those of modern painting, by a desire to represent things not as they appear, but as they are. And how are they? According to them, the object possesses an absolute form, an essential form, and, in order to uncover it, we should suppress chiaroscuro and traditional perspective. What naïveté! An object

has not one absolute form, it has several; it has as many as there are planes in the domain of meaning. The one which these writers point to is miraculously adapted to geometric form. Geometry is a science, painting is an art. The geometer measures, the painter savors. The absolute of the one is necessarily the relative of the other; if logic is alarmed at this, so much the worse! Will it ever prevent a wine from being different in the retort of the chemist and in the glass of the drinker?

We are frankly amused to think that many a novice may perhaps pay for his too literal comprehension of Cubist theory, and his faith in absolute truth, by arduously juxtaposing the six faces of a cube or the two ears of a model seen in profile.

Does it ensue from this that we should follow the example of the Impressionists and rely upon the senses alone? By no means. We seek the essential, but we seek it in our personality, and not in a sort of eternity, laboriously fitted out by mathematicians and philosophers.

* * *

[...] We reject not only synchronistic and primary images, but also fanciful occult-ism, an easy way out; if we condemn the exclusive use of common signs it is not at all because we think of replacing them by cabalistic ones. We will even willingly confess that it is impossible to write without using clichés, and to paint while disregarding familiar signs completely. It is up to each one to decide whether he should disseminate them throughout his work, mix them intimately with personal signs, or boldly plaster them, magical dissonances, tatters of the great collective lie, on a single point of the plane of higher reality which he sets aside for his art. A true painter takes into account all the elements which experience reveals to him, even if they are neutral or vulgar. A simple question of tact.

But objective or conventional reality, this world intermediate between another's consciousness and our own, never ceases to fluctuate according to the will of race, religion, scientific theory, etc., although humanity has labored from time immemorial to hold it fast. Into the occasional gaps in the cycle, we can insert our personal discoveries and contribute surprising exceptions to the norm.

* * *

V

To carry out a work of art it is not enough to know the relations of color and form and to apply the laws that govern them; the artist must also contrive to free himself from the servitude inherent in such a task. Any painter of healthy sensitivity and sufficient intelligence can provide us with well-painted pictures; but only he can awaken beauty who is designated by Taste. We call thus the faculty thanks to which we become conscious of Quality, and we reject the notions of good taste and bad taste which correspond with nothing positive: a faculty is neither good nor bad, it is simply more or less developed.

We attribute a rudimentary taste to the savage who is delighted by glass beads, but we might with infinitely greater justice consider as a savage the so-called civilized man who, for example, can appreciate nothing but Italian painting or Louis XV furniture. Taste is valued according to the number of qualities it allows us to perceive; yet when this number exceeds a certain figure it diminishes in intensity and evaporates into eclecticism. Taste is innate; but like sensitivity, which enhances it, it is tributary to the

will. Many deny this. What is more obvious, however, than the influence of the will on our senses? [...]

* * *

The will exerted on taste with a view to a qualitative possession of the world derives its merit from the subjugation of every conquest to the nature of the chosen material.

Without using any allegorical or symbolic literary artifice, but with only inflections of lines and colors, a painter can show in the same picture both a Chinese and a French city, together with the mountains, oceans, flora and fauna, peoples with their histories and their desires, everything which in exterior reality separates them. Distance or time, concrete thing or pure conception, nothing refuses to be said in the painter's tongue, any more than in that of the poet, the musician, or the scientist.

* * *

That the ultimate end of painting is to reach the masses, we have agreed; it is, however, not in the language of the masses that painting should address the masses, but in its own, in order to move, to dominate, to direct, and not in order to be understood. It is the same with religions and philosophies. The artist who abstains from any concessions, who does not explain himself and who tells nothing, builds up an internal strength whose radiance shines all around.

It is in consummating ourselves within ourselves that we shall purify humanity, it is by increasing our own riches that we shall enrich others, it is by setting fire to the heart of the star for our intimate joy that we shall exalt the universe.

To sum up, Cubism, which has been accused of being a system, condemns all systems.

The technical simplifications which have provoked such accusations denote a legitimate anxiety to eliminate everything that does not exactly correspond to the conditions of the plastic material, a noble vow of purity. Let us grant that it is a method, but let us not permit the confusion of method with system.

For the partial liberties conquered by Courbet, Manet, Cézanne, and the Impressionists, Cubism substitutes an indefinite liberty.

Henceforth objective knowledge at last regarded as chimerical, and all that the crowd understands by natural form proven to be convention, the painter will know no other laws than those of Taste.

From then on, by the study of all the manifestations of physical and mental life, he will learn to apply them. But if all the same he ventures into metaphysics, cosmogony, or mathematics, let him be content with obtaining their savor, and abstain from demanding of them certitudes which they do not possess. In their depths one finds nothing but love and desire.

A realist, he will fashion the real in the image of his mind, for there is only one truth, ours, when we impose it on everyone. And it is the faith in Beauty which provides the necessary strength.

8 Fernand Léger (1881–1955) 'The Origins of Painting and its Representational Value'

Léger formulates a claim that Cubism embodies a 'realism of conception' in respect of the relations and contrasts drawn between pictorial elements themselves. In its specialization

and internal fragmentation such an art will be an expression of modern life. Originally published in *Montjoie*, Paris, 1913. The present extract is taken from Léger, op. cit., pp. 3–10. (For further texts by Léger see IIA11 and IVC19.)

Without claiming to explain the aim or the means of an art that is already at a fairly advanced stage of development, I am going to attempt, as far as it is possible, to answer one of the questions most often asked about modern pictures. I put this question in its simplest form: 'What does that represent?' I will concentrate on this simple question and, with a brief explanation, will try to prove its utter inanity.

If, in the field of painting, imitation of an object had value in itself, any picture by anyone at all that had any imitative character would have pictorial value. As I do not think it is necessary to insist upon this point or to discuss such an example, I now assert something that has been said before but that needs to be said again here: the *realistic* value of a work of art is completely independent of any imitative character.

This truth should be accepted as dogma and made axiomatic in the general understanding of painting.

I am using the word 'realistic' intentionally in its most literal sense, *for the quality of a pictorial work is in direct proportion to its quantity of realism*.

In painting, what constitutes what we call realism?

Definitions are always dangerous, for in order to capture a complete concept in a few words, it is necessary to make a concession, which often sacrifices clarity or is too simplistic.

In spite of everything I will risk a definition and say that, in my view, pictorial realism is the simultaneous ordering of three great plastic components: Lines, Forms, and Colors.

No work can lay claim to pure classicism, that is, to a lasting quality independent of the period of its creation, if one of those components is completely sacrificed to the detriment of the other two. [. . .]

I repeat: every epoch has produced such works, which, despite all the talent they involve, remain simply period pieces. They become dated; they may astonish or intrigue present generations, but since they do not have the components needed to attain to pure realism, they must finally disappear. For most of the painters who preceded the impressionists, the three indispensable components that I mentioned earlier were closely linked to the imitation of a subject that contained an absolute value in itself. [. . .]

The impressionists were the first to reject the *absolute value of the subject and to consider its value to be merely relative*.

That is the tie that links and explains the entire modern evolution. The impressionists are the great originators of the present movement; they are its primitives in the sense that, wishing to free themselves from the imitative aspect, they considered painting for its color only, neglecting all form and all line almost entirely.

The admirable work resulting from this conception necessitates comprehension of a new kind of color. Their quest for real atmosphere even then treated the subject as relative: trees, houses merge and are closely interconnected, enveloped in a colored dynamism that their methods did not yet allow them to develop.

The imitation of the subject that their work still involves is thus, even then, no more than a pretext for variety, a theme and nothing more. For the impressionists a green

apple on a red rug is no longer the relationship between two objects, but the relationship between two tones, a green and a red.

When this truth became formulated in living works, the present movement was inevitable. I particularly stress this epoch of French painting, for I think it is at this precise moment that the two great pictorial concepts, *visual realism* and *realism of conception*, meet – the first completing its ascent, which includes all traditional painting down to the impressionists, and the second, realism of conception, beginning with them.

The first, as I have said, demands an object, a subject, devices of perspective that are now considered negative and antirealistic.

The second, dispensing with all this cumbersome baggage, has already been achieved in many contemporary pictures.

One painter among the impressionists, Cézanne, understood everything that was incomplete in traditional painting. He felt the necessity for a new form and draftsmanship closely linked to the new color. All his life and all his work were spent in this search.

* * *

In the history of modern painting Cézanne will occupy the place that Manet held some years before him. Both were transitional painters.

Manet, through his investigations and his own sensibility, gradually abandoned the methods of his predecessors to arrive at impressionism, and he is unquestionably its great creator.

The more one examines the work of these two painters, the more one is struck by the historical analogy between them.

Manet was inspired by the Spanish, by Velásquez, by Goya, by the most luminous works, to arrive at new forms.

Cézanne finds a color and, unlike Manet, struggles in the pursuit of a structure and form that Manet has *destroyed* and that he feels is absolutely necessary to express the great reality.

All the great movements in painting, whatever their direction, have always proceeded by revolution, by reaction, and not by evolution.

* * *

The relationships among volumes, lines, and colors will prove to be the springboard for all the work of recent years and for all the influence exerted on artistic circles both in France and abroad.

From now on, everything can converge toward an intense realism obtained by purely dynamic means.

Pictorial contrasts used in their purest sense (complementary colors, lines, and forms) are henceforth the structural basis of modern pictures.

* * *

Many people are patiently awaiting the end of what they call *a phase* in the history of art; they are waiting for *something else*, and they think that modern painting is passing through a stage, a necessary one perhaps, but that it will return to what is commonly called 'painting for everyone.'

This is a very great mistake. When an art like this is in possession of all its means, which enable it to achieve absolutely complete works, it is bound to be dominant for a very long time.

I am convinced that we are approaching a conception of art as comprehensive as those of the greatest epochs of the past: the same tendency to large scale, the same collective effort. [. . .]

* * *

For painters, living like everyone else in an age neither more nor less intellectual than preceding ones, merely different, in order to impose a similar way of seeing and to destroy everything that perspective and sentimentalism had helped to erect, it was necessary to have something else besides their audacity and their individual conception.

If the age had not lent itself to this – I repeat, if their art had not had an affinity with its own time and had not been an evolution deriving from past epochs – it would not have been able to survive.

Present-day life, more fragmented and faster moving than life in previous eras, has had to accept as its means of expression an art of dynamic divisionism; and the sentimental side, the expression of the subject (in the sense of popular expression), has reached a critical moment that must be clearly defined.

In order to find a comparable period, I will go back to the fifteenth century, the time of the culmination and decline of the Gothic style. During this entire period, architecture was the great means of popular expression: the basic structure of cathedrals had been embellished with every lifelike ornament that the French imagination could discover and invent.

But the invention of printing was bound to revolutionize and change totally these means of expression. [. . .]

Without attempting to compare the present evolution, with its scientific inventions, to the revolution brought about at the end of the Middle Ages by Gutenberg's invention, in the realm of humanity's means of expression, I maintain that modern mechanical achievements such as color photography, the motion-picture camera, the profusion of more or less popular novels, and the popularization of the theaters have effectively replaced and henceforth rendered superfluous the development of visual, sentimental, representational, and popular subject matter in pictorial art.

I earnestly ask myself how all those more or less historical or dramatic pictures shown in the French Salon can compete with the screen of any cinema. Visual realism has never before been so intensely captured.

Several years ago one could still argue that at least moving pictures lacked color, but color photography has been invented. 'Subject' paintings no longer have even this advantage; their popular side, their only reason for existence, has disappeared, and the few workers who used to be seen in museums, planted in front of a cavalry charge by M. Detaille or a historical scene by M. J.-P. Laurens, are no longer there: they are at the cinema.

The average bourgeois also – the small merchant who fifty years ago enabled these minor local and provincial masters to make a living – now has completely dispensed with their services.

Photography requires fewer sittings than portrait painting, captures a likeness more faithfully, and costs less. The portrait painter is dying out, and the genre and historical painters will die out too – not by a natural death but killed off by their period.

This will have killed that.

Since the means of expression have multiplied, plastic art must logically limit itself to its own purpose: *realism of conception*. (This was born with Manet, developed by the

impressionists and Cézanne, and is achieving wide acceptance among contemporary painters.)

Architecture itself, stripped of all its representational trimmings, is approaching a modern and utilitarian conception after several centuries of false traditionalism.

Architectural art is confining itself to its own means – the relationship between lines and the balance of large masses; the decorative element itself is becoming plastic and architectural.

Each art is isolating itself and limiting itself to its own domain.

Specialization is a modern characteristic, and pictorial art, like all other manifestations of human genius, must submit to its law; it is logical, for by limiting each discipline to its own purpose, it enables achievements to be intensified.

In this way pictorial art gains in realism. The modern conception is not simply a passing abstraction, valid only for a few initiates; it is the total expression of a new generation whose needs it shares and whose aspirations it answers.

9 Olga Rozanova (1886–1916) 'The Bases of the New Creation and the Reasons Why it is Misunderstood'

Rozanova was one of a number of women artists prominent in the Russian avant-garde (see also IIID3 and 6), and was active in a succession of groups from 1911 onwards. The present essay, her major statement on the new art, was published in the third issue of the journal of the Union of Youth group in St Petersburg in 1913. The present extract is taken from John Bowlt, *Russian Art of the Avant Garde*, London, 1976 and 1988, pp. 103–6, 107–9.

The art of Painting is the decomposition of nature's ready-made images into the distinctive properties of the common material found within them and the creation of different images by means of the interrelation of these properties; this interrelation is established by the Creator's individual attitude. The artist determines these properties by his visual faculty. The world is a piece of raw material – for the unreceptive soul it is the back of a mirror, but for reflective souls it is a mirror of images appearing continually.

How does the world reveal itself to us? How does our soul reflect the world? In order to reflect, it is necessary to perceive. In order to perceive, it is necessary to touch, to see. Only the Intuitive Principle introduces us to the World.

And only the Abstract Principle – Calculation – as the consequence of the active aspiration to express the world, can build a Picture.

This establishes the following order in the process of creation:

1 Intuitive Principle
2 Individual transformation of the visible
3 Abstract creation

The fascination of the visible, the charm of the spectacle, arrests the eye, and the artist's primary aspiration to create arises from this confrontation with nature. The desire to penetrate the World and, in reflecting it, to reflect oneself is an intuitive

impulse that selects the Subject – this word being understood in its purely painterly meaning.

In this way, nature is a 'Subject' as much as any subject set for painting *in abstracto* and is the point of departure, the seed, from which a Work of Art develops; the intuitive impulse in the process of creation is the first psychological stage in this development. How does the artist use the phenomena of nature, and how does he transform the visible World on the basis of his relationship with it?

A rearing horse, motionless cliffs, a delicate flower, are equally beautiful if they can express themselves in equal degree.

But what can the artist express if he repeats them?

At best, an unconscious plagiarism of nature, for which the artist, not knowing his own objectives, could be forgiven; at worst, a plagiarism in the literal sense of the word, when people would refuse to reject it merely out of creative impotence.

– Because the artist must be not a passive imitator of nature, but an active spokesman of his relationship with her. Hence the question arises: to what extent and to what degree should nature's influence on the artist be expressed?

A servile repetition of nature's models can never express all her fullness.

It is time, at long last, to acknowledge this and to declare frankly, once and for all, that other ways, other methods of expressing the World are needed.

The photographer and the servile artist, in depicting nature's images, will repeat them.

The artist of artistic individuality, in depicting them, will reflect himself.

He will reveal the properties of the World and erect from them a New World – the World of the Picture, and by renouncing repetition of the visible, he will inevitably create different images; in turning to their practical realization on the canvas, he will be forced to reckon with them.

The Intuitive Principle, as an extrinsic stimulus to creation, and individual trans-formation – the second stage in the creative process – have played their role in advancing the meaning of the abstract.

The abstract embraces the conception of creative Calculation, and of expedient relations to the painterly task. It has played an essential role in the New Art by indissolubly combining the conception of artistic means and the conception of artistic ends. Modern art is no longer a copy of concrete objects; it has set itself on a different plane, it has upturned completely the conception of Art that existed hitherto.

The artist of the Past, riveted to nature, forgot about the picture as an important phenomenon, and as a result, it became merely a pale reminder of what he saw, a boring assemblage of ready-made, indivisible images of nature, the fruit of logic with its immutable, nonaesthetic characteristics. Nature enslaved the artist.

And if in olden times, the individual transformation of nature found occasional expression when the artist changed it according to his individual conception (the works of archaic eras, of infant nations, the primitives), it was, nevertheless, an example of an unrealized property, attempts at free speech, and more often than not, the ready-made images triumphed as a result.

Only now does the artist create a Picture quite consciously not only by not copying nature, but also by subordinating the primitive conception of it to conceptions

complicated by all the psychology of modern creative thought: what the artist sees + what he knows + what he remembers, etc. In putting paint onto canvas, he further subjects the result of this consciousness to a constructive processing that, strictly speaking, is the most important thing in Art – and the very conception of the Picture and of its self-sufficient value can arise only on this condition.

In an ideal state of affairs the artist passes spontaneously from one creative state to another, and the Principles – the Intuitive, the Individual, the Abstract – are united organically, not mechanically. I do not intend to analyze the individual trends of modern art but wish merely to determine the general character of the New creative World View. I shall touch on these trends only to the extent that they are the consequence of this New creative psychology and evoke this or that attitude in the public and critics nurtured on the psychology of the old conception of art. To begin with, the art of our time will be fatally incomprehensible to such people unless they make the effort to accept the required viewpoint.

For the majority of the public nurtured by pseudo artists on copies of nature, the conception of beauty rests on the terms 'Familiar' and 'Intelligible.' So when an art created on new principles forces the public to awaken from its stagnant, sleepy attitudes crystallized once and for all, the transition to a different state incites protest and hostility since the public is unprepared for it.

* * *

Every new epoch in art differs from the preceding one in that it introduces many new artistic theses into its previously cultivated experience, and in following the path of this development, it works out a new code of artistic formulas. But in the course of time, creative energy begins inevitably to slacken.

New formulas cannot be cultivated – on the contrary, those cultivated previously develop artistic technique to an extraordinary level of refinement and reduce it to prestidigitation of the paintbrush; the extreme expression of this is a crystallization into the conditioned repetition of ready-made forms. And in this soil the putrid flowers of imitation thrive. Without going into the depths of art history, we can cite examples of imitation from the not too distant past (it, too, has grown obsolete), namely, the exhibitions of the 'World of Art' and especially the 'Union of Russian Artists' as they now stand: they give nothing to the treasure house of art and essentially are merely the epigones of the Wanderers. The only difference is that the servile imitation of nature with a smattering of Social-Populist ideology (the Wanderers) is replaced in this case by the imitation of an intimate aristocratic life with its cult of antiquity and sentimentality of individual experience (the cozy art of the 'World of Art' exhibitions and their like).

I pointed out above that all previous art had touched on problems of a purely painterly nature only by allusion and that it had confined itself generally to the repetition of the visible; we can say therefore that only the nineteenth century, thanks to the school of the impressionists, advanced theses that had been unknown previously: the stipulation of a locale of air and light in the picture and color analysis.

Then followed Van Gogh, who hinted at the principle of dynamism, and Cézanne, who advanced the questions of construction, planar and surface dimension.

But Van Gogh and Cézanne are only the estuaries of those broad and impetuous currents that are most well defined in our time: futurism and cubism.

Proceeding from the possibilities to which I alluded (dynamism, planar and surface dimension), each of these currents has enriched art with a series of independent theses.

Moreover, although initially they were diametrically opposed to each other (Dynamics, Statics), they were enriched subsequently with a series of common theses. These have lent a common tone to all modern trends in painting.

Only modern Art has advocated the full and serious importance of such principles as pictorial dynamism, volume and equilibrium, weight and weightlessness, linear and plane displacement, rhythm as a legitimate division of space, design, planar and surface dimension, texture, color correlation, and others. Suffice it to enumerate these principles that distinguish the New Art from the Old to be convinced that they are the Qualitative – and not just the quantitative – New Basis that proves the 'self-sufficient' significance of the New Art. They are principles hitherto unknown that signify the rise of a new era in creation – an era of purely artistic achievements.

– The era of the final, absolute liberation of the Great Art of Painting from the alien traits of Literature, Society, and everyday life. Our age is to be credited with the cultivation of this valuable world view – an age that is not affected by the question of how quickly the individual trends it has created flash past.

After elucidating the essential values of the New Art, one cannot help noting the extraordinary rise in the whole creative life of our day, the unprecedented diversity and quantity of artistic trends.

10 Daniel-Henry Kahnweiler (1884–1976) from *The Rise of Cubism*

Kahnweiler was the leading dealer in Cubist art at the moment of its foundation. His contact, indeed his friendship, with Picasso and Braque enabled them to work relatively unhindered by the demands of public exhibition. Declared an enemy alien on the outbreak of war in 1914, when his collection was sequestrated, Kahnweiler retired to Switzerland. There, influenced by his readings in philosophy, particularly an interest in Kant, he composed a theoretical work *Der Gegenstand der Ästhetik*, which included his pioneering study of Cubism. This appeared separately, first in Zurich in 1916 and subsequently in book form as *Der Weg zum Kubismus* in Munich in 1920. The present translation is taken from Robert Motherwell (ed.), *Documents of Modern Art*, New York, 1949, pp. 1, 6–8 and 9–14.

1

[. . .] painting in our time has become lyric, its stimulus the pure intense delight in the beauty of things. Lyric painting celebrates this beauty without epic or dramatic overtones. It strives to capture this beauty in the unity of the work of art. The nature of the new painting is clearly characterized as representational as well as structural: representational in that it tries to reproduce the formal beauty of things: structural in its attempt to grasp the meaning of this formal beauty in the painting.

Representation and structure conflict. Their reconciliation by the new painting, and the stages along the road to this goal, are the subject of this work.

* * *

3

[...] In the year 1906, Braque, Derain, Matisse and many others were still striving for expression through color, using only pleasant arabesques, and completely dissolving the form of the object. Cézanne's great example was still not understood. Painting threatened to debase itself to the level of ornamentation; it sought to be 'decorative,' to 'adorn' the wall.

Picasso had remained indifferent to the temptation of color. He had pursued another path, never abandoning his concern for the object. The literary 'expression' which had existed in his earlier work now vanished. A lyricism of form retaining fidelity to nature began to take shape. [...]

Toward the end of 1906, ... the soft round contours in Picasso's paintings gave way to hard angular forms; instead of delicate rose, pale yellow and light green, the massive forms were weighted with leaden white, gray and black.

Early in 1907 Picasso began a strange large painting [*Les Demoiselles d'Avignon*] depicting women, fruit and drapery, which he left unfinished. It cannot be called other than unfinished, even though it represents a long period of work. Begun in the spirit of the works of 1906, it contains in one section the endeavors of 1907 and thus never constitutes a unified whole.

The nudes, with large, quiet eyes, stand rigid, like mannequins. Their stiff, round bodies are flesh-colored, black and white. That is the style of 1906.

In the foreground, however, alien to the style of the rest of the painting, appear a crouching figure and a bowl of fruit. These forms are drawn angularly, not roundly modeled in chiaroscuro. The colors are luscious blue, strident yellow, next to pure black and white. This is the beginning of Cubism, the first upsurge, a desperate titanic clash with all of the problems at once.

These problems were the basic tasks of painting: to represent three dimensions and color on a flat surface, and to comprehend them in the unity of that surface. 'Representation,' however, and 'comprehension' in the strictest and highest sense. Not the simulation of form by chiaroscuro, but the depiction of the three-dimensional through drawing on a flat surface. No pleasant 'composition' but uncompromising, organically articulated structure. In addition, there was the problem of color, and finally, the most difficult of all, that of the amalgamation, the reconciliation of the whole.

Rashly, Picasso attacked all the problems at once. He placed sharp-edged images on the canvas, heads and nudes mostly, in the brightest colors: yellow, red, blue and black. He applied the colors in thread-like fashion to serve as lines of direction, and to build up, in conjunction with the drawing, the plastic effect. But, after months of the most laborious searching, Picasso realized that complete solution of the problem did not lie in this direction. [...]

In the spring of 1908 he resumed his quest, this time solving one by one the problems that arose. He had to begin with the most important thing, and that seemed to be the explanation of form, the representation of the three-dimensional and its position in space on a two-dimensional surface. [...]

Thus Picasso painted figures resembling Congo sculptures, and still lifes of the simplest form. His perspective in these works is similar to that of Cézanne. Light is

never more than a means to create form – through chiaroscuro, since he did not at this time repeat the unsuccessful attempt of 1907 to create form through drawing. Of these paintings one can no longer say, 'The light comes from this or that side,' because light has become completely a means. The pictures are almost monochromatic; brick red and red brown, often with a gray or gray green ground, since the color is meant only to be chiaroscuro.

While Picasso was painting in Paris, and in the summer, at La Rue-des-Bois (near Creil, Oise), Braque, at the other end of France, in l'Estaque (near Marseilles) was painting the series of landscapes we have already mentioned. No connection existed between the two artists. This venture was a completely new one, totally different from Picasso's work of 1907; by an entirely different route Braque arrived at the same point as Picasso. If, in the whole history of art, there were not already sufficient proof that the appearance of the aesthetic product is conditioned in its particularity by the spirit of the time, that even the most powerful artists unconsciously execute its will, then this would be proof. Separated by distance, and working independently, the two artists devoted their most intense effort to paintings which share an extraordinary resemblance. This relationship between their paintings continued but ceased to be astonishing because the friendship between the two artists, begun in the winter of that year, brought about a constant exchange of ideas.

Picasso and Braque had to begin with objects of the simplest sort: in landscape, with cylindrical tree trunks and rectangular houses; in still life, with plates, symmetrical vessels, round fruits and one or two nude figures. They sought to make these objects as plastic as possible, and to define their position in space. Here we touch upon the indirect advantage of lyric painting. It has made us aware of the beauty of form in the simplest objects, where we had carelessly overlooked it before. These objects have now become eternally vivid in the reflected splendor of the beauty which the artist has abstracted from them. [...]

4

In the winter of 1908, the two friends began to work along common and parallel paths. The subjects of their still life painting became more complex, the representation of nudes more detailed. The relation of objects to one another underwent further differentiation, and structure, heretofore relatively uncomplicated . . . took on more intricacy and variety. Color, as the expression of light, or chiaroscuro, continued to be used as a means of shaping form. Distortion of form, the usual consequence of the conflict between representation and structure, was strongly evident.

Among the new subjects introduced at this time were musical instruments, which Braque was the first to paint, and which continued to play such an important role in cubist still life painting. Other new motifs were fruit bowls, bottles and glasses.

During the summer of 1909 which Picasso spent at Horta (near Tolosa, Spain) and Braque at La Roche Guyon (on the Seine, near Mantes) the new language of form was further augmented and enriched, but left essentially unchanged.

Several times during the spring of 1910 Picasso attempted to endow the forms of his pictures with color. That is, he tried to use color not only as an expression of light, or chiaroscuro, for the creation of form, but rather as an equally important end in itself. Each time he was obliged to paint over the color he had thus introduced . . .

At the same time Braque made an important discovery. In one of his pictures he painted a completely naturalistic nail casting its shadow on a wall. The usefulness of this innovation will be discussed later. The difficulty lay in the incorporation of this 'real' object into the unity of the painting. From then on, both artists consistently limited the space in the background of the picture. In a landscape, for instance, instead of painting an illusionistic distant horizon in which the eye lost itself, the artists closed the three-dimensional space with a mountain. In still life or nude painting, the wall of a room served the same purpose. This method of limiting space had already been used frequently by Cézanne.

During the summer, again spent in l'Estaque, Braque took a further step in the introduction of 'real objects,' that is, of realistically painted things introduced, undistorted in form and color, into the picture. We find lettering for the first time in a *Guitar Player* of the period. Here again, lyrical painting uncovered a new world of beauty – this time in posters, display windows and commercial signs which play so important a role in our visual impressions.

Much more important, however, was the decisive advance which set Cubism free from the language previously used by painting. This occurred in Cadaqués (in Spain, on the Mediterranean near the French border) where Picasso spent his summer. Little satisfied, even after weeks of arduous labor, he returned to Paris in the fall with his unfinished works. But he had taken the great step; he had pierced the closed form. A new tool had been forged for the achievement of the new purpose.

Years of research had proved that closed form did not permit an expression sufficient for the two artists' aims. Closed form accepts objects as contained by their own surfaces, viz., the skin; it then endeavours to represent this closed body, and, since no object is visible without light, to paint this 'skin' as the contact point between the body and light where both merge into color. This chiaroscuro can provide only an illusion of the form of objects. In the actual three dimensional world the object is there to be touched even after light is eliminated. Memory images of tactile perceptions can also be verified on visible bodies. The different accommodations of the retina of the eye enable us, as it were, to 'touch' three-dimensional objects from a distance. Two-dimensional painting is not concerned with all this. Thus the painters of the Renaissance, using the closed form method, endeavored to give the illusion of form by painting light as color on the surface of objects. It was never more than 'illusion.'

Since it was the mission of color to create the form as chiaroscuro, or light that had become perceivable, there was no possibility of rendering local color or color itself. It could only be painted as objectivated light.

In addition, Braque and Picasso were disturbed by the unavoidable distortion of form which worried many spectators initially. [...] Comparison between the real object as articulated by the rhythm of forms in the painting and the same object as it exists in the spectator's memory inevitably results in 'distortions' as long as even the slightest verisimilitude in the work of art creates this conflict in the spectator. Through the combined discoveries of Braque and Picasso during the summer of 1910 it became possible to avoid these difficulties by a new way of painting.

On the one hand, Picasso's new method made it possible to 'represent' the form of objects and their position in space instead of attempting to imitate them through illusionistic means. With the representation of solid objects this could be effected by a process of representation that has a certain resemblance to geometrical drawing. This

is a matter of course since the aim of both is to render the three-dimensional object on a two-dimensional plane. In addition, the painter no longer has to limit himself to depicting the object as it would appear from one given viewpoint, but wherever necessary for fuller comprehension, can show it from several sides, and from above and below.

Representation of the position of objects in space is done as follows: instead of beginning from a supposed foreground and going on from there to give an illusion of depth by means of perspective, the painter begins from a definite and clearly defined background. Starting from this background the painter now works toward the front by a sort of scheme of forms in which each object's position is clearly indicated, both in relation to the definite background and to other objects. Such an arrangement thus gives a clear and plastic view. But, if only this scheme of forms were to exist it would be impossible to see in the painting the 'representation' of things from the outer world. One would only see an arrangement of planes, cylinders, quadrangles, etc.

At this point Braque's introduction of undistorted real objects into the painting takes on its full significance. When 'real details' are thus introduced the result is a stimulus which carries with it memory images. Combining the 'real' stimulus and the scheme of forms, these images construct the finished object in the mind. Thus the desired physical representation comes into being in the spectator's mind.

Now the rhythmization necessary for the coordination of the individual parts into the unity of the work of art can take place without producing disturbing distortions, since the object in effect is no longer 'present' in the painting, that is, since it does not yet have the least resemblance to actuality. Therefore, the stimulus cannot come into conflict with the product of the assimilation. In other words, there exist in the painting the scheme of forms and small real details as stimuli integrated into the unity of the work of art; there exists, as well, but only in the mind of the spectator, the finished product of the assimilation, the human head, for instance. There is no possibility of a conflict here, and yet the object once 'recognized' in the painting is now 'seen' with a perspicacity of which no illusionistic art is capable.

As to color, its utilization as chiaroscuro had been abolished. Thus, it could be freely employed, as color, within the unity of the work of art. For the representation of local color, its application on a small scale is sufficient to effect its incorporation into the finished representation in the mind of the spectator.

In the words of Locke, these painters distinguish between primary and secondary qualities. They endeavor to represent the primary, or most important qualities, as exactly as possible. In painting these are: the object's form, and its position in space. They merely suggest the secondary characteristics such as color and tactile quality, leaving their incorporation into the object to the mind of the spectator.

This new language has given painting an unprecedented freedom. It is no longer bound to the more or less verisimilar optic image which describes the object from a single viewpoint. It can, in order to give a thorough representation of the object's primary characteristics, depict them as stereometric drawing on the plane, or, through several representations of the same object, can provide an analytical study of that object which the spectator then fuses into one again in his mind. The representation does not necessarily have to be in the closed manner of the stereometric drawing; colored planes, through their direction and relative position, can bring together the formal scheme without uniting in closed forms. This was the great advance made at Cadaqués. Instead

of an analytical description, the painter can, if he prefers, also create in this way a synthesis of the object, or in the words of Kant, 'put together the various conceptions and comprehend their variety in one perception.' [...]

[...] Here we must make a sharp distinction between the impression made upon the spectator and the lines of the painting itself. The name 'Cubism' and the designation 'Geometric Art' grew out of the impression of early spectators who 'saw' geometric forms in the paintings. This impression is unjustified, since the visual conception desired by the painter by no means resides in the geometric forms, but rather in the representation of the reproduced objects.

How does such a sensory illusion come about? It occurs only with observers whom lack of habit has prevented from making the associations which lead to objective perception. Man is possessed by an urge to objectivate; he wants to 'see something' in the work of art which should – and he is sure of this – represent something. His imagination forcefully calls up memory images, but the only ones which present themselves, the only ones which seem to fit the straight lines and uniform curves are geometric images. Experience has shown that this 'geometric impression' disappears completely as soon as the spectator familiarizes himself with the new method of expression and gains in perception.

If we disregard representation, however, and limit ourselves to the 'actual' individual lines in the painting, there is no disputing the fact that they are very often straight lines and uniform curves. Furthermore, the forms which they serve to delineate are often similar to the circle and rectangle, or even to stereometric representations of cubes, spheres and cylinders. But, such straight lines and uniform curves are present in all styles of the plastic arts which do not have as their goal the illusionistic imitation of nature. Architecture, which is a plastic art, but at the same time non–representational, uses these lines extensively. The same is true of applied art. Man creates no building, no product which does not have regular lines. In architecture and applied art, cubes, spheres and cylinders are the permanent basic forms. They do not exist in the natural world, nor do straight lines. But they are deeply rooted in man; they are the necessary condition for all objective perception.

Our remarks until now about visual perception have concerned its content alone, the two dimensional 'seen' and the three dimensional 'known' visual images. Now we are concerned with the form of these images, the form of our perception of the physical world. The geometric forms we have just mentioned provide us with the solid structure; on this structure we build the products of our imagination which are composed of stimuli on the retina and memory images. They are our categories of vision. When we direct our view on the outer world, we always demand those forms but they are never given to us in all their purity. The flat picture which we 'see' bases itself mainly on the straight horizontal and vertical, and secondly on the circle. We test the 'seen' lines of the physical world for their greater or lesser relationship to these basic lines. Where no actual line exists, we supply the 'basic' line ourselves. For example, a water horizon which is limited on both sides appears horizontal to us; one which is unlimited on both sides appears curved. Furthermore, only our knowledge of simple stereometric forms enables us to add the third dimension to the flat picture which our eye perceives. Without the cube, we would have no feeling of the three dimensionality of objects, and without the sphere and cylinder, no feeling of the varieties of this three dimensionality. Our a priori knowledge of these forms is the necessary condition, without which there

would be no seeing, no world of objects. Architecture and applied art realize in space these basic forms which we always demand in vain of the natural world; the sculpture of periods which have turned away from nature approaches these forms insofar as its representational goal permits, and the two-dimensional painting of such periods gives expression to the same longing in its use of 'basic lines.' Humanity is possessed not only by the longing for these lines and forms, but also by the ability to create them. This ability shows itself clearly in those civilizations in which no 'representational' plastic art has produced other lines and forms.

In its works Cubism, in accordance with its role as both constructive and representational art, brings the forms of the physical world as close as possible to their underlying basic forms. Through connection with these basic forms, upon which all visual and tactile perception is based, Cubism provides the clearest elucidation and foundation of all forms. The unconscious effort which we have to make with each object of the physical world before we can perceive its form is lessened by cubist painting through its demonstration of the relation between these objects and basic forms. Like a skeletal frame these basic forms underlie the impression of the represented object in the final visual result of the painting; they are no longer 'seen' but are the basis of the 'seen' form. [...]

11 Georges Braque (1882–1963) 'Thoughts on Painting'

Braque's aphorisms, purportedly jotted down in the margins of his drawings, emphasize both the autonomy of Cubism, the 'constitution of a pictorial fact', *and* its status as a form of representation. They were first collected and published by Pierre Reverdy in his journal *Nord–Sud*, Paris, December 1917. The present translation is taken from Edward Fry, op. cit., pp. 147–8.

1 In art progress consists not in extension but in the knowledge of its limits.
2 The limits of the means employed determine the style, engender the new form and impel to creation.
3 The charm and the force of children's paintings often stem from the limited means employed. Conversely the art of decadence is a product of extension.
4 New means, new subjects.
5 The subject is not the object; it is the new unity, the lyricism which stems entirely from the means employed.
6 The painter thinks in forms and colours.
7 The aim is not to *reconstitute* an anecdotal fact but to *constitute* a pictorial fact.
8 Painting is a mode of representation.
9 One must not imitate what one wishes to create.
10 One does not imitate the appearance; the appearance is the result.
11 To be pure imitation, painting must make an abstraction of appearances.
12 To work from nature is to improvise. One must beware of an *all-purpose* formula, suitable for interpreting the other arts as well as reality, and which, instead of creating, would produce only a style or rather a stylization.
13 The arts that make their effect by their purity have never been all-purpose arts. Greek sculpture and its decadence, among others, teach us this.

14 The senses deform, the mind forms. Work to perfect the mind. There is no certainty except in what the mind conceives.

15 A painter trying to make a circle would only make a ring. Possibly the look of it may satisfy him but he will have doubts. The compass will restore his certainty. The *papiers collés* in my drawings have also given me a kind of certainty.

16 *Trompe-l'œil* is due to an *anecdotal* accident that makes its effect through the simplicity of the facts.

17 The *papiers collés*, the imitation wood – and other elements of the same nature – which I have used in certain drawings, also make their effect through the simplicity of the facts, and it is this that has led people to confuse them with *trompe-l'œil*, of which they are precisely the opposite. They too are simple facts, but *created by the mind* and such that they are one of the justifications of a new figuration in space.

18 Nobility comes from contained emotion.

19 Emotion must not be rendered by an emotional trembling. It is not something that is added, or that is imitated. It is the germ, the work is the flowering.

20 I love the rule which corrects emotion.

12 Pablo Picasso (1881–1973) 'Picasso Speaks'

Picasso's comments on Cubism were given in an interview with Marius de Zayas, an American critic, in 1923. They are sceptical of attempts to intellectualize Cubism, representing it instead as an art like any other whose success or failure is determined by results rather than intentions. De Zayas had lived in Paris before the First World War, moving in Apollinaire's circles. He was involved in mounting the first exhibition of Picasso's work in America in 1911 and had published two books on the new art in 1913 and 1915, the latter on the influence of African art. He became director of the Modern Gallery in New York in 1915, exhibiting Picasso and Braque among others. The present interview, in a translation approved by Picasso, was originally published as 'Picasso Speaks' in *The Arts*, New York, May 1923, pp. 315–26. (For further texts by Picasso see IVD2 and VC5 and 6.)

I can hardly understand the importance given to the word *research* in connection with modern painting. In my opinion to search means nothing in painting. To find, is the thing. Nobody is interested in following a man who, with his eyes fixed on the ground, spends his life looking for the pocketbook that fortune should put in his path. The one who finds something no matter what it might be, even if his intention were not to search for it, at least arouses our curiosity, if not our admiration.

Among the several sins that I have been accused of committing, none is more false than the one that I have, as the principal objective in my work, the spirit of research. When I paint my object is to show what I have found and not what I am looking for. In art intentions are not sufficient and, as we say in Spanish: love must be proved by facts and not by reasons. What one does is what counts and not what one had the intention of doing.

We all know that Art is not truth. Art is a lie that makes us realize truth, at least the truth that is given us to understand. The artist must know the manner whereby to convince others of the truthfulness of his lies. If he only shows in his work that he has

searched, and re-searched, for the way to put over lies, he would never accomplish anything.

The idea of research has often made painting go astray, and made the artist lose himself in mental lucubrations. Perhaps this has been the principal fault of modern art. The spirit of research has poisoned those who have not fully understood all the positive and conclusive elements in modern art and has made them attempt to paint the invisible and, therefore, the unpaintable.

They speak of naturalism in opposition to modern painting. I would like to know if anyone has ever seen a natural work of art. Nature and art, being two different things, cannot be the same thing. Through art we express our conception of what nature is not.

Velasquez left us his idea of the people of his epoch. Undoubtedly they were different from what he painted them, but we cannot conceive a Philip IV in any other way than the one Velasquez painted. Rubens also made a portrait of the same king and in Rubens's portrait he seems to be quite another person. We believe in the one painted by Velasquez, for he convinces us by his right of might.

From the painters of the origins, the primitives, whose work is obviously different from nature, down to those artists who, like David, Ingres, and even Bouguereau, believed in painting nature as it is, art has always been art and not nature. And from the point of view of art there are no concrete or abstract forms, but only forms which are more or less convincing lies. That those lies are necessary to our mental selves is beyond any doubt, as it is through them that we form our aesthetic point of view of life.

Cubism is no different from any other school of painting. The same principles and the same elements are common to all. The fact that for a long time Cubism has not been understood and that even today there are people who cannot see anything in it, means nothing. I do not read English, an English book is a blank book to me. This does not mean that the English language does not exist, and why should I blame anybody else but myself if I cannot understand what I know nothing about?

I also often hear the word evolution. Repeatedly I am asked to explain how my painting evolved. To me there is no past or future in art. If a work of art cannot live always in the present it must not be considered at all. The art of the Greeks, of the Egyptians, of the great painters who lived in other times, is not an art of the past; perhaps it is more alive today than it ever was. Art does not evolve by itself, the ideas of people change and with them their mode of expression. When I hear people speak of the evolution of an artist, it seems to me that they are considering him standing between two mirrors that face each other and reproduce his image an infinite number of times, and that they contemplate the successive images of one mirror as his past, and the images of the other mirror as his future, while his real image is taken as his present. They do not consider that they all are the same images in different planes.

Variation does not mean evolution. If an artist varies his mode of expression this only means that he has changed his manner of thinking, and in changing, it might be for the better or it might be for the worse.

The several manners I have used in my art must not be considered as an evolution, or as steps toward an unknown ideal of painting. All I have ever made was made for the present and with the hope that it will always remain in the present. I have never taken into consideration the spirit of research. When I have found something to express, I have done it without thinking of the past or of the future. I do not believe I have used radically different elements in the different manners I have used in painting. If the

subjects I have wanted to express have suggested different ways of expression I have never hesitated to adopt them. I have never made trials nor experiments. Whenever I had something to say, I have said it in the manner in which I have felt it ought to be said. Different motives inevitably require different methods of expression. This does not imply either evolution or progress, but an adaptation of the idea one wants to express and the means to express that idea.

Arts of transition do not exist. In the chronological history of art there are periods which are more positive, more complete than others. This means that there are periods in which there are better artists than in others. If the history of art could be graphically represented, as in a chart used by a nurse to mark the changes of temperature of her patient, the same silhouettes of mountains would be shown, proving that in art there is no ascendant progress, but that it follows certain ups and downs that might occur at any time. The same occurs with the work of an individual artist.

Many think that Cubism is an art of transition, an experiment which is to bring ulterior results. Those who think that way have not understood it. Cubism is not either a seed or a foetus, but an art dealing primarily with forms, and when a form is realized it is there to live its own life. A mineral substance, having geometric formation, is not made so for transitory purposes, it is to remain what it is and will always have its own form. But if we are to apply the law of evolution and transformation to art, then we have to admit that all art is transitory. On the contrary, art does not enter into these philosophic absolutisms. If Cubism is an art of transition I am sure that the only thing that will come out of it is another form of Cubism.

Mathematics, trigonometry, chemistry, psychoanalysis, music, and whatnot, have been related to Cubism to give it an easier interpretation. All this has been pure literature, not to say nonsense, which brought bad results, blinding people with theories.

Cubism has kept itself within the limits and limitations of painting, never pretending to go beyond it. Drawing, design, and color are understood and practiced in Cubism in the spirit and manner that they are understood and practiced in all other schools. Our subjects might be different, as we have introduced into painting objects and forms that were formerly ignored. We have kept our eyes open to our surroundings, and also our brains.

We give to form and color all their individual significance, as far as we can see it; in our subjects, we keep the joy of discovery, the pleasure of the unexpected; our subject itself must be a source of interest. But of what use is it to say what we do when everybody can see it if he wants to?

Part III
Rationalization and Transformation

III
Introduction

By the outbreak of the First World War the channels of the avant-garde were open. Those channels mostly ran to Paris, from cities as diverse as Oslo and Milan, Moscow, Vienna and Barcelona. But sometimes the current ran the other way too, and on occasion scarcely touched Paris at all: a Russian-German axis grew strong, signalled by Kandinsky's presence in Munich. August 1914, however, put a stop to this mutual fertilization, and gave xenophobia a foothold in the avant-garde which it has never quite lost. The effect of the war was not simply a matter of travel ceasing. Willingly or unwillingly, artists were drawn into the conflict. Many were wounded, died or suffered mental collapse. Others – or in some cases the same – became disenchanted with their societies to the extent of allying themselves with wider social forces devoted to their overthrow. As war was joined on the social agenda by revolution, the artistic avant-garde acquired a more forceful political dimension than hitherto. These years were apocalyptic. The Hapsburg, Hohenzollern, Ottoman and Romanov dynasties, repositories of power for centuries rather than mere decades, were overthrown. Mass political movements came to occupy the historical stage, Fascism and Communism foremost among them. Technology advanced, military technology furthest of all, taking with it the apparatus of social control. Death and devastation occurred on a scale unseen in Europe since the plagues. To regard a form of art as modern was to require of it that it respond in aesthetic kind to the demands imposed by the modern condition. It is scarcely to be wondered at, then, that the war years and their aftermath should have proved a traumatic period for the artistic avant-garde.

Two different and opposed responses are discernible among the various groups of artists, related to the different wartime circumstances of specific countries and cities. On the one side there was the belief that the war had been the result of a breakdown, particularly of a breakdown in shared values and social cohesion, of which the pre-war avant-garde was itself a symptom. In this light the war came to be viewed as a cleansing process, the 'great test', in Le Corbusier's phrase: a sacrifice required for the re-establishment of a civilized order (see IIIA *passim*). On the other stood a perception of the war as the quite specific outcome of that order's concealed barbarism: a perception that the war represented a heightened version of bourgeois society, or a limited version of its broader priorities. In order to ensure that such a catastrophe never happened again, far from that order being re-established, what was required was that the social forces whose order in the last instance it was, be themselves swept away (see IIIB *passim*).

Paris had been the focal point of an international avant-garde. But the war led to a wave of nationalism in French culture which victory only intensified. French tradition was perceived as the legitimate descendant of the Renaissance and Classical tradition, and its re-establishment became the common coin of debate (IIIA2, 5, 7 and 9). This voice had in fact been heard before the war (see IA8 and 9). The difference now was that agreement came from broader sections of the avant-garde, which hitherto had in general tended to be identified by the distance it took from dominant values. The meaning of Cubism became a particular site of controversy. Cubism mattered because its status was incontestable as the paradigmatic modern movement. Its effect on the practice of art had been such that it could not now be ignored by those wishing to orientate art to the new circumstances. What was at issue was what Cubism meant. Pre-war Cubism had had bohemian, even anarchistic affiliations, not least in respect of the Spaniard Picasso: a far cry from the invocation of a national, classical tradition now being made by those such as Denis who occupied the right of the avant-garde spectrum. But the war had the effect of shifting this emphasis within avant-garde thought from its somewhat paradoxical and conservative margin to the centre. Cubism came to be redefined in terms consonant with the *rappel à l'ordre* (see IIIA1 and 5).

The classicizing tendency was not restricted to France. Italy, also on the winning side in the war, had been host to the most aggressively anti-classical pre-war avant-garde in the form of the Futurist movement. But the realities of the war – the reality at bottom of pitting men against machines – had disabled that rhetoric as effectively as it had maimed many of the flesh-and-blood individuals who had assented to it. There ensued a turn to the classical tradition with all that it was supposed to embody in terms of eternal, unchanging values (see IIIA4 and 6). In England, the pre-war Vorticist avant-garde had suffered a similar depletion and diversion of its energies. In 1921 Wyndham Lewis added an English voice to the endemic post-war call for reconnection to tradition (IIIA10).

There is a sense, then – or perhaps better a sector – in which the avant-garde stopped in its tracks. In a closely related but ultimately different sense, however, the avant-garde was also redefined: in terms which removed it from any oppositional locale, and established it as the modernized bearer of tradition, and as such as a candidate for a plausible culture of the modern bourgeoisie (see IIIA7).

Yet for some this was always going to be insufficient, if not indeed tantamount to a betrayal of the avant-garde's raison d'être. The alternative reading of the war as the fault of bourgeois society rather than of its opponents, involved an alternative and complementary reading of Cubism. Not accidentally these forces were initially focused in Zurich, that is to say in neutral Switzerland, surrounded by the warring capitalist powers – and as such both a whirlpool of intrigue and a refuge for opponents of the war. Seen from this perspective, the avant-garde was far from appearing as a body which needed only to be smartened up to play its part in social restoration; rather, it appeared to be already complicit in the culture of the international bourgeoisie; it followed that it deserved to be finished off along with its sponsors (see IIIB1 and 3). Among its other targets, Dada mounted an onslaught on the sense which had been made of art. Marcel Duchamp had already left for America before the war, and was thus himself removed from the reach of the European conflict. But with his Ready-mades he essayed perhaps the most extreme refutation of the claim that there is some essential, or classical, property that is shared by all great art (see IIIB2).

Duchamp's was not a political critique in any strict sense, and by the same token neither was Picabia's (see IIIB14). Zurich Dada, and perhaps even more so its descendants in Paris, Barcelona and New York, were cultural gestures with a broader ideological rather than a more narrowly political impact. It is in the light of this that Dada is commonly perceived as anti-art and irrationalist. It was both those things. But it was the Dada position that bourgeois art, bourgeois order and bourgeois rationalism had been implicated in the deaths of millions; that bourgeois culture was no more than a mask of civilization laid over a deeper barbarism. Cubism, as art, was no more worth saving than any of the other -isms. But before it went under, Cubism had hit upon a device whose potential transcended the circumscribed circle of an artistic avant-garde, tied ultimately to its haut-bourgeois sponsors. This was collage. Developed into photomontage, it became the main weapon in the critical artist's armoury against convention. Nowhere was this transition from a more or less hermetic art, through cultural contestation, to an explicitly politically motivated intervention, more evident than in the inflection given to Dada, late in the war, in Berlin (see IIIB4–6).

From the foregoing it may at first appear that there is a direct correlation to be made between artistic form and political standpoint. It may seem, that is to say, that a search for underlying principles, let alone a reinstatement of figuration, signifies a conservative politics; whereas a technically radical practice grounded in devices for the scrambling of sense – be they verbal or pictorial – automatically implies a politically radical stance. There is indeed some truth in this. But it does not hold for all instances, let alone in all places. This issue of place is important, for much here concerns the question of context. Before the First World War ended it had brought in its train an event which, put simply, changed the context for the art of succeeding decades, until the Second World War, and beyond. The Russian Revolution of October 1917 set an agenda for both art and politics which only at the very end of the century could perhaps be seen to have receded into history. Then, at the moment of its occurrence, its effect was electrifying. The socialist revolution against the entire bourgeois order rendered the field of problems and possibilities significantly different. In Europe there was no area of human endeavour which escaped its influence. Art was no exception.

The problem may be put like this. The *rappel à l'ordre* was fundamentally restorative, as its name implies. It was not necessarily altogether reactionary. For example, it did not characteristically result in calls for the restoration of the monarchies. But what it did set out to restore, in fact to stimulate anew, was the order of bourgeois capitalism organized around the form of the nation-state. It was this which culture in general and art in particular was called upon to support. By contrast Dadaism in its various forms was an oppositional force committed to the overthrow of that damaged but resilient status quo. The point which arises here, it goes almost without saying, is that what in fact the Dadaists could not do, the Bolsheviks did. The rules of the game were effectively changed by the success of the Communist revolution in what was to become the Soviet Union. For the prospect of positive participation in the building of a new life rapidly came onto the agenda of radical art practice. Intervention in daily life was no longer opposition to an entrenched status quo. Equally rapidly, the types of attitude and practice evolved to cope with that situation fed back to influence radical artists in the West, who were hopeful of achieving similar successes against their own restored forms of bourgeois capitalism (IIID2 and 4). In this situation there is no direct equivalence between art and politics, nothing to say that a conservatively formed

poem or painting may not be fuelled by Bolshevik political desire (see IIIB13); nothing either to say that the technically radical artwork may not be predicated upon an idealist cosmology to which socialism, or even democracy, is anathema (see IIIC12). And the uniquely expressive 'I', at one moment the cutting-edge of the avant-garde and scourge of bourgeois conformity, could at the next stand for petty-bourgeois reaction and self-indulgence, in its refusal of the collectivity required to defend the revolution and build the new world (see IIIB11 and 12).

These currents are vividly represented in Germany in the wake of the revolution of November 1918, not least in that alliance of Expressionists and Dadaists which was the Novembergruppe (see IIIB8). But this fragile avant-garde coalition was pulled apart by the failure of the German revolution and the setting up of the bourgeois Weimar Republic. The turn to a 'new objectivity' was the somewhat paradoxical outcome for many of those who had been most closely identified with Berlin Dada (IIIA12). The move to figuration was underwritten for artists like Grosz, Heartfield and Schlichter by membership of the newly formed German Communist Party (see IIIB9 and 13). The tendency among left-wing artists to turn again to objective forms of figuration is dealt with more fully in the next section (see IVB *passim*). What pertains here is to note the diversity of aims underlying the technically not dissimilar practices of Carrà, de Chirico and Derain, and of Grosz and other members of the Novembergruppe Left opposition.

There was another kind of order emergent in the post-war West European avant-garde which had relations of a different kind with the art practice evolving in the Soviet Union. Dadaists and artists of the new objectivity shared a broad political perspective with the post-revolutionary avant-garde, but little in the way of techniques. Others, however, while sharing relatively little in terms of political sympathies, seemed to employ very nearly identical technical procedures.

The war years saw the achievement of a vision which had possessed the avant-garde since the turn of the century: an abstract art. Although often credited with having painted the first abstract picture as early as 1910, Kandinsky was in fact still doubtful as to the feasibility of an abstract art in 1914 (see IB9). In the conditions of relative isolation imposed by the war two remarkably similar forms of geometric abstraction were achieved almost simultaneously at opposite ends of the continent. Close scrutiny either of the paintings themselves or of the theories underlying them would have revealed clear distinctions. None the less, in the long view there are obvious similarities between the painting of Mondrian, advanced under the rubric of the 'new plastic' in Holland, and the painting of Malevich, who called his work 'Suprematism', in Russia (see IIIC6–8). While no less idiosyncratic than Kandinsky, Malevich and Mondrian had both passed through Cubism, and thus shared a technical resource which both marked their art off from his, and offered a greater promise of development to other artists. Cubism was always at bottom a representational art, but in its autonomization of the picture surface and in its animation of that surface as a series of shifting planes, it seems to have offered the technical device which enabled theories of abstraction to be realized in practice. It is moreover a key feature of this abstract art that it was advanced as a relevant response to social as well as to aesthetic demands. In Holland, Mondrian joined with Van Doesburg and others in the De Stijl group to advertise abstract art as the spiritual precursor of a utopian social harmony (see IIIC3 and 4). In Weimar Germany the establishment of the Bauhaus served to bring together a number of artists and designers variously committed to the advance-

ment of a similar ideal (IIIC13–15). In Russia the revolution led Malevich to transform his Suprematism into the collective UNOVIS – Supporters of the New Art – the more effectively to propagandize abstraction as the revolutionary art appropriate to the new revolutionary society (see IIIC9 and 11).

Malevich's approach remained idealist in tendency. In response to the Marxist materialism of the Bolsheviks however, other Russian artists developed an austere form of technical inquiry, a so-called 'laboratory art', under the overall name of Constructivism (see IIID2, 3, 5, 6 and 7). That there are clear overlaps between developments in Holland, Germany and Russia has often been taken as justifying claims for the existence of an 'international constructive tendency'. Russian Construct-ivism however, remains distinct, politically and theoretically, if not always technically and formally; distinguished by its post-revolutionary situation from comparable prac-tices in the bourgeois societies of Western Europe. 'Utilitarian' constructivism in Russia stood at the high-water mark of a frequently voiced avant-garde aspiration: the ultimate dissolution of art into life. In their social dimension, Western forms of constructive abstraction proceeded by a similar route to the opposite destination: the aestheticization of life itself. If their hopes were fulfilled, art as it was currently practised would cease, not because it had been subsumed into life but because the whole of life would have been rendered artistic.

The former claim proceeds from Marxist historical materialism, and it committed those making it to the construction of a new life here and now within the real history of the revolution. For the latter, historical reality, let alone the contingencies of political organization, seems at times to have been viewed as impeding a utopian vision. The materialism of the one was as much opposed to the idealism of the other as any Dadaist would have been to demands to reinstate the classical.

There are, then, moments of unusual proximity as well as deep divergence across the spectrum of the European avant-garde in the years after the First World War, years given their peculiar and lasting character by the impact of the Russian Revolution and the response it drew from artists. No one template or pattern will do to describe these relations, as technical and contextual factors form first into one constellation only to dissolve into another. There is an elusive but significant distinction to be made between one sense of order which is predicated on a reinstatement of the classical tradition, and another which aspires to a kind of modernization of the universal, a geometric Modernist utopianism. This latter in its turn, though, must be distinguished from yet a third kind of order built upon a sense of historical contingency and rupture, rather than any conviction of eternal verities and forms of continuity. We may speak of three tendencies in Classicism, Rationalism and Constructivism. These are at the same time *both* responses to war and revolution, *and* responses to previous avant-garde work. None of the three tendencies is fully explicable in isolation. The impulse to a kind of avant-garde *dis*order, which also infuses the period, similarly exists in symbiosis with its apparent opposites (IIIC19). What is being contested, culturally and technically, is a social space. The kinds of society which might emerge, and the kinds of art which might therefore be possible, seemed uniquely open in the approximate decade 1916/17 to 1926/27. The old world had gone down like Atlantis in the maelstrom of world war, and the shape of the new one had not yet been defined.

IIIA
Neo-Classicism and the Call to Order

1 Amédée Ozenfant (1886–1966) 'Notes on Cubism'

The author was a Cubist painter as well as a prolific writer (see also IIIA7 and IVA2). This essay is an early statement of the desire, in the changed circumstances of the war and its aftermath, to clean up Cubism: to 'rationalize' and 'purify' it. Not least, this involved separating it from any supposed German associations and explicitly formulating a relation to the French classical tradition. Originally published as 'Notes sur le Cubisme' in *L'Elan*, no. 10, Paris, December 1916, from which the present translation is made. (This was the final edition of a journal founded by Ozenfant in April 1915.)

The campaign of *Elan* has shown that Cubism owes nothing to the Germans: since the insults about this issue were killed off in Paris, they have become rare in the provinces.

But none the less Cubism is widely discussed.

The literary world shows us that intelligent amateurs of art are interested in our pursuits, and most of this world shows a certain good will and an understanding of Cubism; nevertheless, an important part of this same public continues to look down on Cubists and feel that the Cubists do the same to them. The public happily scoffs at that which is beyond its understanding. Moreover, certain artists have been led to adopt an abstruse and disdainful attitude to the public, judging them to be fools.

For many, Cubism has remained an art of the clique or coterie: it is useless to harp on the dangers art runs when it shuts itself in an ivory tower.

Certain Cubists, mimicking Picasso, have thought it possible to rebuild the pretentious and trivial ivory tower of the Romantics and to top it off with a cap brought down from Montmartre.

Others, neither artists nor intellectuals but true ignoramuses, have worn out the public with a pseudo-scientific pathos, discrediting the works of the true Cubists.

This interest in Cubism is quite evident today, so that from now on it will be possible to speak of it reasonably, of its truth and of its errors.

Cubism is assured a genuine importance in the history of the plastic arts, because it has already partly realized its purist plan of cleansing the language of the plastic arts of parasitic expressions, just as Mallarmé tried to do in verbal language.

Cubism is a Movement of Purism

Following the experiments of Ingres, Cézanne, Seurat, Matisse on the essential properties of visible matter, Cubism has pointed out that optical effects count formally, beyond all description or representation, by the power of their harmonies and dissonances.

Cubism was to fuse the regeneration of contemporary art with the great tradition of the formalists: Assyrians, Greeks, Chinese and the admirable anonymous 'Negro' artists.

Eliminating all literal representation, the Picassos, Braques and Archipenkos showed once again the essential elements in the works of a Claude Lorrain or a Negro painter: *the optical relations of matter*. Despite the interest of its experiments, Cubism went through a crisis. This was the fault of certain major artists who, tempted by the commodity that Cubism had made from itself, turned in upon themselves and lapsed into the automatic use of the same forms over and over. This threatened to ossify Cubism into a formula of angles, the repetition of handles, spouts, to stand for pitchers and so on.

This was a crisis because true Cubists, renouncing the charm of living curves, used the line and the square in a Socratic manner; whereas the mediocrities (having successively abandoned pointillism, then Matisse-ism, as old hat), decided that Cubism was the last fashionable bandwagon. Their latest delight is to impose parts of a square on women's faces; this is to turn Cubism into a machine-tool.

A crisis, because some ignoramuses, contrary to all reason, banished the third dimension as out of date, and replaced it by a new fourth dimension. As this fourth dimension is purely hypothetical (the formal sense of man remains conditioned by his perceptions, which are purely three-dimensional) what do they do? They suppress the third dimension. So in effect they reduce to just two dimensions, forgetting that it is ludicrous to pretend, *with the help of the two dimensions, to create from them a fourth*.

The third dimension (depth) is never absent from any plastic work, even in a simple drawing, since this drawing *suggests on one plane the limits of different planes*. It is never absent, even in a canvas covered with patches of colour, since formally the diverse colours appear to be on different planes.

The only painting in two dimensions would be *a surface plane painted in a single colour*.

If in a plastic work the third dimension is *necessarily perspectival*, one can argue, as a necessary corollary, that there are no plastic works *which lack perspective*.

However, there are Cubists who declare they have depicted the fourth dimension and abolished the third, in the process supplanting perspective. As if you could play around with perspective, and the volume of substantial objects, just on the basis of fashion or some decree!

This just proves that formalists, being architects of matter and working with the properties of this matter in space, should in the interests of both Cubism and Art, know as much as possible about the laws that govern them, to avoid making free with these same laws.

The artist has a right to unlimited poetic licence if his sensibility guides him, but such a licence can only ever serve to confirm the existence of these laws.

There is also a crisis because the *faux naifs*, followers of Rousseau, believe in the indispensability of the trivial. They are accompanied by a group of poets, pale imitations of Max Jacob, and of grotesque musicians who prattle, whistle and tinkle. There is a crisis, finally, because certain artists, enamoured of strength, forget that strength without flexibility is brutality; a manifestation of weakness, certainly a form of sickliness.

One of the most highly prized achievements in Cubism is, first, to have succeeded in introducing into art new harmonies of matter, form and tone. Second, to have shown, as it seems to me, that everything is beautiful from a certain angle.

Cubism knew how to change accepted angles.

Contributing a new way of attuning our eyes (though sometimes perversely), it revealed new beauties to the eye, thereby diminishing ugliness by getting us used to its artistic taste.

Finally, it seems that Cubism too often forgets that its value does not depend on the absence of representation, but on the beauty of harmony. If it is true that the interest of a form is independent of meaningfulness, the opposite is true; that meaning takes nothing from formal beauty.

If it seems just to class Braque amongst the great formal artists, this is not because his art is non-representational. If it seems certain that Segonzac is a great formal artist, this is not because his art is representational.

However, it seems probable that the representationality of forms, far from damaging their shape, may be a source of formal strength (because the emotion of plastic art is not solely an optical phenomenon). The intellect reacts to the optical sensation, and enriches or deforms it, according to whether one has used it appropriately or not.

Remember that this intervention by the intelligence would allow one to make use of the resources of natural association: and thus Cubism would avoid the danger of ossifying its forms into 'decorative' formulae. (This is something that the Persians, the Cretans, the Arabs, etc. did not avoid when they organized the interplay of form beyond all representation.)

We will indulge those followers who constitute a school because in spite of everything, they have use of the forms of the masters; they can exaggerate them, quickly make them unbearable, set free the liberty that their genius holds in chains.

2 Guillaume Apollinaire (1880–1918) 'The New Spirit and the Poets'

Apollinaire stresses the return to discipline and to order demanded of the post-war avant-garde. This involved a rejection of romanticism, which is seen as tainted by German associations, and the invocation of classicism, rooted in a sense of the nation. Originally published as 'L'Esprit Nouveau et les Poètes', *Mercure de France*, Paris, 1 December 1918. The present extract is taken from R. Shattuck (ed.), *Selected Writings of Guillaume Apollinaire*, New York, 1971, pp. 227–30. (For previous texts by Apollinaire see IIB2–5.)

The new spirit which will dominate the poetry of the entire world has nowhere come to light as it has in France. The strong intellectual discipline which the French have

always imposed on themselves permits them, as well as their spiritual kin, to have a conception of life, of the arts and of letters, which, without being simply the recollection of antiquity, is also not the counterpart of romantic prettiness.

The new spirit which is making itself heard strives above all to inherit from the classics a sound good sense, a sure critical spirit, perspectives on the universe and on the soul of man, and the sense of duty which lays bare our feelings and limits or rather contains their manifestations.

It strives further to inherit from the romantics a curiosity which will incite it to explore all the domains suitable for furnishing literary subject matter which will permit life to be exalted in whatever form it occurs.

To explore truth, to search for it, as much in the ethnic domain, for example, as in that of the imagination – those are the principal characteristics of the new spirit.

This tendency, moreover, has always had its bold proponents, although they were unaware of it; for a long time it has been taking shape and making progress.

However, this is the first time that it has appeared fully conscious of itself. [...]
* * *

It would have been strange if in an epoch when the popular art *par excellence*, the cinema, is a book of pictures, the poets had not tried to compose pictures for meditative and refined minds which are not content with the crude imaginings of the makers of films. These last will become more perceptive, and one can predict the day when, the photograph and the cinema having become the only form of publication in use, the poet will have a freedom heretofore unknown.

One should not be astonished if, with only the means they have now at their disposal, they set themselves to preparing this new art (vaster than the plain art of words) in which, like conductors of an orchestra of unbelievable scope, they will have at their disposition the entire world, its noises and its appearances, the thought and language of man, song, dance, all the arts and all the artifices, still more mirages than Morgane could summon up on the hill of Gibel, with which to compose the visible and unfolded book of the future.

But generally you will not find in France the 'words at liberty' which have been reached by the excesses of the Italian and Russian futurists, the extravagant offspring of the new spirit, for France abhors disorder. She readily questions fundamentals, but she has a horror of chaos.
* * *

Do not believe that this new spirit is complicated, slack, artificial, and frozen. In keeping with the very order of nature, the poet puts aside any high-flown purpose. There is no longer any Wagnerianism in us, and the young authors have cast far away all the enchanted clothing of the mighty romanticism of Germany and Wagner, just as they have rejected the rustic tinsel of our early evaluations of Jean-Jacques Rousseau.

I do not believe that social developments will ever go so far that one will not be able to speak of national literature. On the contrary, however far one advances on the path of new freedoms, they will only reinforce most of the ancient disciplines and bring out new ones which will not be less demanding than the old. This is why I think that, whatever happens, art increasingly has a country. Furthermore, poets must always express a milieu, a nation; and artists, just as poets, just as philosophers, form a social estate which belongs doubtless to all humanity, but as the expression of a race, of one given environment.

Art will only cease being national the day that the whole universe, living in the same climate, in houses built in the same style, speaks the same language with the same accent – that is to say never. From ethnic and national differences are born the variety of literary expressions, and it is that very variety which must be preserved.

A cosmopolitan lyric expression would only yield shapeless works without character or individual structure, which would have the value of the commonplaces of international parliamentary rhetoric. And notice that the cinema, which is the perfect cosmopolitan art, already shows ethnic differences immediately apparent to everyone, and film enthusiasts immediately distinguish between an American and an Italian film. Likewise the new spirit, which has the ambition of manifesting a universal spirit and which does not intend to limit its activity, is none the less, and claims to respect the fact, a particular and lyric expression of the French nation, just as the classic spirit is, *par excellence*, a sublime expression of the same nation.

It must not be forgotten that it is perhaps more dangerous for a nation to allow itself to be conquered intellectually than by arms. That is why the new spirit asserts above all an order and a duty which are the great classic qualities manifested by French genius; and to them it adds liberty. This liberty and this order, which combine in the new spirit, are its characteristic and its strength.

3 Oswald Spengler (1880–1936) from *The Decline of the West*

Spengler's massive work became a benchmark of the conservative response to the modern world in general and the upheaval wrought by the First World War in particular. Although its cultural pessimism had an effect on Nazism, the work also had an influence upon figures as diverse as El Lissitsky, Ludwig Wittgenstein and, much later, Clement Greenberg. In this extract Spengler charts the decline of Western art from the Renaissance to Expressionism. Originally published as *Der Untergang des Abendlandes, Gestalt und Wirklichkeit*, Munich, 1918. English translation by C. F. Atkinson, London, 1926. The present extract is taken from Chapter VIII, 'Music and Plastic (2) Act and Portrait', pp. 291–4.

[...]

The sign of all living art, the pure harmony of 'will', 'must' and 'can', the self-evidence of the aim, the un-self-consciousness of the execution, the unity of the art and the Culture – all that is past and gone. In Corot and Tiepolo, Mozart and Cimarosa, there is still a real mastery of the mother-tongue. After them, the process of mutilation begins, but no one is conscious of it because no one now can speak it fluently. Once upon a time, Freedom and Necessity were identical; but now what is understood by freedom is in fact indiscipline. In the time of Rembrandt or Bach the 'failures' that we know only too well were quite unthinkable. The Destiny of the form lay in the race or the school, not in the private tendencies of the individual. Under the spell of a great tradition full achievement is possible even to a minor artist, because the living art brings him in touch with his task and the task with him. To-day, these artists can no longer perform what they intend, for intellectual operations are a poor substitute for the trained instinct that has died out. [...]

Between Wagner and Manet there is a deep relationship, which is not, indeed, obvious to everyone but which Baudelaire with his unerring flair for the decadent detected at once. For the Impressionists, the end and the culmination of art was the conjuring up of a world in space out of strokes and patches of colour, and this was just

what Wagner achieved with three bars. A whole world of soul could crowd into these three bars. Colours of starry midnight, of sweeping clouds, of autumn, of the day dawning in fear and sorrow, sudden glimpses of sunlit distances, world-fear, impending doom, despair and its fierce effort, hopeless hope – all these impressions which no composer before him had thought it possible to catch, he could paint with entire distinctness in the few tones of a motive. Here the contrast of Western music with Greek plastic has reached its maximum. Everything merges in bodiless infinity, no longer even does a linear melody wrestle itself clear of the vague tone-masses that in strange surgings challenge an imaginary space. The motive comes up out of dark terrible deeps. It is flooded for an instant by a flash of hard bright sun. Then, suddenly, it is so close upon us that we shrink. It laughs, it coaxes, it threatens, and anon it vanishes into the domain of the strings, only to return again out of endless distances, faintly modified and in the voice of a single oboe, to pour out a fresh cornucopia of spiritual colours. Whatever this is, it is neither painting nor music, in any sense of these words that attaches to previous work in the strict style. [. . .]

All that Nietzsche says of Wagner is applicable, also, to Manet. Ostensibly a return to the elemental, to Nature, as against contemplation-painting (Inhaltsmalerei) and abstract music, their art really signifies a concession to the barbarism of the Megalopolis, the beginning of dissolution sensibly manifested in a mixture of brutality and refinement. As a step, it is necessarily the last step. An artificial art has no further organic future, it is the mark of the end.

And the bitter conclusion is that it is all irretrievably over with the arts of form of the West. The crisis of the 19th Century was the death-struggle. Like the Apollinian, the Egyptian and every other, the Faustian art dies of senility, having actualized its inward possibilities and fulfilled its mission within the course of its Culture.

What is practised as art to-day – be it music after Wagner or painting after Cézanne, Leibl and Menzel – is impotence and falsehood. Look where one will, can one find the great personalities that would justify the claim that there is still an art of determinate necessity? Look where one will, can one find the *self-evidently necessary* task that awaits such an artist? We go through all the exhibitions, the concerts, the theatres, and find only industrious cobblers and noisy fools, who delight to produce something for the market, something that will 'catch on' with a public for whom art and music and drama have long ceased to be spiritual necessities. At what a level of inward and outward dignity stand to-day that which is called art and those who are called artists! In the shareholders' meeting of any limited company, or in the technical staff of any first-rate engineering works there is more intelligence, taste, character and capacity than in the whole music and painting of present-day Europe. There have always been, for one great artist, a hundred superfluities who practised art, but so long as a great tradition (and *therefore* great art) endured even these achieved something worthy. We can forgive this hundred for existing, for in the ensemble of the tradition they were the footing for the individual great man. But to-day we have only these superfluities, and ten thousand of them, working art 'for a living' (as if that were a justification!). One thing is quite certain, that to-day every single art-school could be shut down without art being affected in the slightest. We can learn all we wish to know about the art-clamour which a megalopolis sets up in order to forget that its art is dead from the Alexandria of the year 200. There, as here in our world-cities, we find a pursuit of illusions of artistic progress, of personal peculiarity, of 'the new style', of 'unsuspected possibilities', theoretical babble, pretentious fashionable artists, weight-

lifters with cardboard dumb-bells – the 'Literary Man' in the Poet's place, the unabashed farce of Expressionism which the art-trade has organized as a 'phase of art-history', thinking and feeling and forming as industrial art. Alexandria, too, had problem-dramatists and box-office artists whom it preferred to Sophocles, and painters who invented new tendencies and successfully bluffed their public. What do we possess to-day as 'art'? A faked music, filled with artificial noisiness of massed instruments; a faked painting, full of idiotic, exotic and showcard effects, that every ten years or so concocts out of the form-wealth of millennia some new 'style' which is in fact no style at all since everyone does as he pleases; a lying plastic that steals from Assyria, Egypt and Mexico indifferently. Yet this and only this, the taste of the 'man of the world', can be accepted as the expression and sign of the age. [...]

4 Carlo Carrà (1881–1966) 'Our Antiquity'

Originally a Futurist painter, Carrà came to reject the avant-garde vehemently, embracing instead a notion of the persistence of eternal values embodied in the classical tradition in art. After a meeting with de Chirico in 1917 he was involved in the promotion of a 'Metaphysical School' of Italian painters. Composed between 1916 and 1918, this essay was originally published in Carrà's *Pittura metafisica*, Florence, 1919. The present translation by C. Tisdall is taken from M. Carrà, *Metaphysical Art*, New York, 1971, pp. 33–8 and 41–3.

Whatever else will our contemporaries find to reproach us with! And yet, if we too had forgotten our origins we would certainly be praised, but we would no longer be fit to carry out works of uncontaminated will.

Our ancient character is firmly rooted in severe law, almost as if to vegetate more comfortably in modern reality without destroying it.

Admittedly, it would at times be pleasant to leave this state of inebriation in which we live, were it not for the magic link which holds us bound to our poor 'savage gods'.

The hot winds of history arouse this spiritual disposition for new and profound things. They hint of calm music. The game becomes serious, my friends, and to sing this music too freely could also be dangerous.

We never knew 'indifference', but now our spasmodic passions have ceased to preach. We prefer to conceal ourselves from the eyes of the profane. We are alone in the profundity of our epoch, alone with our sin, and with our study.

By a strange anarchical paradox we have returned, almost without wishing to do so, to pure classicism.

What was it that breathed in our ears the sound of so many things we believed to be dead?

The truth is that we know of no greater happiness than that of listening to ourselves.

What is this feeling that provokes in us the jealousy that a thought of ours may tomorrow belong to many men, a jealousy greater than that provoked by the thought that our woman may cease to be ours?

If we too had reduced the spirit of art to a convenient calculation of algebra and daily bread, we would perhaps feel more secure, but also more mortified than we do. The enjoyments of easily-conquered paradises always leave us indifferent.

We too have sung the praise of the western orgies; then we felt it permissible to receive our brothers' indecision with the tenderness befitting our democratic habits.

But now we have become more cautious, and no longer tolerate the riots which ambitious and disturbed people denominate 'artistic movements'. These villains always ensnare incautious youth, which, eager to make itself felt, fails to realize that its youthful adventurousness is prone to malevolence and ungrateful obduracy.

From this it can be discerned that we no longer wish to see ourselves confronted with uncertain premises. If it is not a sin of pride to do so, let us claim to have thrown overboard a good part of our corruptibility, or at least of our own belief in lying prophecies.

We have become aware of the truths that are said to be serious, and we do not accept that the veils have been lifted for the delight of the unworthy. It is an illusion that one can force this on those who do not wish it, and he who tries to do so, demonstrates such candour that he is pardonable because the need to give vent to the passions that torment him is manifest. He is unlike us, for with experience we have lost this candour and believe most firmly that that which is particular to the individual can never belong to a generation.

* * *

The chameleon-like reproduction of visible reality is another ugly thing that has been imported from outside. In places where painters were not used to condensation of the elements of the body, they could now surrender, with deceitful ardour, as if it were a liberation, to theories that were born and resolved without being completed. And it was thus that the painting of so-called effects of light (which really concern only highly-strung stage electricians) came to be accepted.

What was needed was a return to the Italian idea of the original solidity of things, so that men would recognize the well-disguised deceit of the astute philosophies which are put into circulation with all the publicity necessary for the triumph of an industrial product.

But now that the inevitable intoxication has been slept off, matters are returning to a more determined state. In this way, linear delights will no longer be disrupted by ecstatic rotations of colour and we will no longer be pushed towards trivial and trembling mobility and tumultuous surfaces.

The appearance of even the smallest bodies is no longer changed by ephemeral distractions, our ends are no longer resolved in light which cannot celebrate weight.

The aims will change and by means of a second, richer, more diffuse and conscious transposition, reality will again be conceived with an inextinguishable spiritual ardour which will comply more persuasively with form. After this, colour, and the picture.

Combinations of the module will return in valiant opposition, and with them, the golden section, giving a more ample spatial breath.

Tonal matter will be assembled homogeneously in all its immanent weight.

Internal discipline brings us to a more fulfilled significance, to a cubature pregnant with poetry.

And this is how we initiated the second period of our artistic development after having confronted the public in the Italian theatres, and brawled in the squares, for the advent of a new art.

* * *

Much water has flowed under the bridges of art, but the proprieties that preside over painting are yet to be clarified. They can be summarized in the following impulses of the spirit:

a) line (straight and curved in contrast) in proportional arrangements of individual forces,
b) the local tone of aspects of reality (simultaneous relationship of chiaroscuro and chromatic colour),
c) the first stage of the form having been attained, to find the balance of the volumes; that is, the synthesis which constitutes the definitive order within the painting. Let us not forget that art cannot be only the immediate reflection of a sensation; neither must forms remain as merely raw external expressions of the reality that surrounds us, or be limited to arresting the shadows of vibratory movement.

* * *

Let us have creation, not the imitation of phenomena. Certain slight nervous stimuli make us smile; we can no longer mistake them for real spiritual joy.

The mislaid necessities of style are returning, or rather are reborn; and the artist, with greater purity than before, proclaims them irrefutably present.

Never has this problem been felt to be so important as it is today by those who are exponents of the collective spirit. It is the law of realization that presides over artistic representation. And so, say what you will, to reduce painting to a realistic recognition of human and natural appearances is almost equivalent to a disregard of the superior aims of art.

Artistic creation involves a watchful, diligent and attentive will, and demands a continued effort to prevent the 'apparitions' from being overlooked. Artistic creation, which is satisfaction of the imagination and intellect, is destined to stimulate in the beholder a particular meaning and a repetition of that satisfaction felt by the artist.

* * *

Let it not be thought, however, that we wish to isolate the problem of national art from the finality of European – universal – order, on which every artistic problem is directly dependent. We will dwell in detail on the task that the young are called to perform, a grave responsibility for anyone conscious of the situation in which Italian art, for various reasons, finds itself. To try to analyse these reasons could be to fall into the error of a man dissecting the human body in the hope of discovering not only the law of life but also that of human emotion.

On the other hand, to run joyously towards certain intoxications, shouting 'long live' or 'down with' according to one's sympathies or antipathies, is to lose contact with the concreteness of things. It therefore follows, if one cannot reasonably isolate the examination of a single part without considering the idea imparted by the parts, that one cannot form a general idea without considering its particular effects. Whether one proceeds from the general to the particular, or vice versa, whether one proceeds by synthesis or analysis, every artistic problem must be seen as connected in all its parts and with its necessary unity.

But we know that in the sum of experiences there arise so many new and unforeseen elements that unity either cannot be attained, or makes itself manifest in unexpected ways.

In aesthetic activity more than in any other human activity, one never attains the end one sets out to reach. But in days of great aesthetic disorganization, any support is good. Today, for men of imagination, tendencies of equal falsity contend for supremacy at the crossroads of obscure directions.

Light as a fountain, spiritualization slowly comes; but those who wish to understand are not intimidated by adverse forces.

We are no longer constrained by physical illuminations to play at blind man's buff with our thoughts. This is the theory of the card players who when they want spades and see clubs turn up, change their tactics.

It is easy to throw hurried accents into a mess of hypotheses of doubtful taste, or to outline improvised figures without clarity, precision or control. But even if there are infinite ways of erring, there is only one way to work correctly.

* * *

We are not concerned with an intimate and objective examination of a definitive form, because nothing is definitive, but with a form of art as yet scarcely sketched in, simple and elementary. And rather than a norm we set out to provide a suggestion in generic terms.

Nevertheless, the choice of new criteria and postulates is already a guarantee of seriousness and probity, if not yet a demonstration of new constructions of forms hitherto sought and imagined and invoked in vain.

But one could already demonstrate with readily accessible facts that metaphysical painting is nothing but an intuitive development of that which preceded it, and in actual fact it perhaps represents the first, imprecise, ideal projection; the first steps on intractable soil; an uncontrollable desire to go beyond purely sensory and materialistic forms, however superfluous it may seem to us to claim the roots of this form of art in the Italian tradition. We do not wish to base any claim on the future, because art, like history, passes through successive stages, though this does not alter its profound essence, and it carries the future within it.

As can be seen, we do not rest our case on originality, but rather on the discovery of origins which will lead to the achievement of rigorous and immutable forms.

* * *

[...] Perhaps this word [originality] constitutes the greatest and most disquieting misunderstanding to emerge from the workshops of the artistic peasantry in these recent years.

It is bitter for the sensitive man to see how arrogance, ostentation, frivolity, vacuity, wantonness and every excess nowadays are the most positive characteristics of today's artists.

From this arises the reciprocal concern shown by today's painters for surpassing each other in the incessant invention of new styles, supposing that they can capture the admiration of the public by such artifice, and neglecting the improvement of their real creative faculty; their output is consequently closer to bizarre eccentricity than to the real imagination which neither tires the mind nor diverts the attention from the substantial aims of art.

And it is precisely this pitiful mania for seeming original that prevents contemporary painters from realizing the varied graces of linear relationships, so essential in the production of that magic enchantment which used to be familiar to the painter.

So it happens that, while on the one hand we consider irksome the closed orders, the arthritic systems and the dead forms which the good old Academy's rules seek to put back into circulation, on the other we must rebuke the young painters who are neglecting the most elementary awareness and absolutely every necessity of study to follow their own fatuous whims; because in the last resort we should never forget that

he who refrains from study of the great masters through fear of losing his native sensibility, will only succeed in creating a form of art without roots and without real excellence.

It would be as if someone claimed that it is possible to become a great poet without having any appreciation at all of language.

Even the earth would produce only wild plants, if the farmer's care and toil did not put it in condition to receive the seeds and participate in the nourishment of delicate produce.

This is what happens to the painter as long as he ignores the precious contribution made by the great masters over the centuries. He who fears to lose his native poetic sense should not devote himself to art or poetry, since these presuppose a knowledge of historical development and of the informative laws of expression.

5 Léonce Rosenberg (1881–1947) 'Tradition and Cubism'

Rosenberg replaced Kahnweiler as the principal dealer involved in Cubism. He particularly supported the 'rationalized' developments of the Parisian avant-garde in the post-war period through his gallery, the Galerie de l'Effort Moderne, and the accompanying publication, the *Bulletin de l'Effort Moderne*. The present text was originally published in the organ of the Metaphysical School, *Valori Plastici*, Rome, February–March 1919. This translation is from E. Fry (ed.), *Cubism*, New York and London, 1966, p. 150.

Taking no account of accident, pushing aside anecdote, neglecting the particular, the 'cubist' artists tend towards the constant and the absolute. Instead of reconstituting an aspect of nature, they seek to construct the plastic equivalents of natural objects, and the pictorial fact so constituted becomes an aspect created by the mind. The construction realised in this way has not a comparative value but a strictly intrinsic value, or, to use a Platonic phrase, is 'beautiful in itself'. There is nothing arbitrary in its architecture; on the contrary, everything in it is the consequence of a feeling, and is subject to the eternal laws of equilibrium.

To make a picture, the artist begins by choosing and grouping certain elements from external reality; in other words by synthesis he draws from some object the *elements* – forms and colours – necessary to the assembling of his subject. The transition from object to subject constitutes his aesthetic, which is governed by the mind. After this, to pass from the subject to the work, he employs a variety of *means* proper to the expression of his subject; this process constitutes his technique, and it is inspired by emotion. This effort defies analysis; it carries within itself all the mystery of Art. The final result is the *picture*, whose emanation is Beauty.

6 Giorgio de Chirico (1888–1978) 'The Return to the Craft'

De Chirico suffered a breakdown during the war. After a one-man show in Rome in 1919 he became increasingly preoccupied with the technical methods of earlier Italian painting. This essay, concluding with an affirmation in Latin of his status as a classical painter, was first published as 'Il ritorno al mestiere' in *Valori Plastici*, Rome, November–December 1919. The

present extract is taken from the translation in Carrà, op. cit., pp. 141–6. (For a previous text by de Chinico see IA11.)

By now it is quite apparent: the painters who have been agitating for half a century, who have been racking their brains to invent schools and systems, who have sweated with the continual effort of seeming original, of presenting their personalities, now hide like rabbits behind the banner of multifarious fancy-work, and press ahead the latest defence of their ignorance and impotence: the pretence of spirituality. (This is an uncontrollable phenomenon, but only for the majority, including the writers on art; a few intelligent men, whom you and I know, are capable of understanding of what this spirituality consists and of esteeming it for what it is worth.) These painters, then, are returning prudently, with outstretched hands like men walking in the dark, towards an art less obstructed by fancy-work, towards clearer and more concrete forms, and towards surfaces that can testify without too many equivocations, just what one knows and what one can do. In my opinion this is a good sign. Such a turn of events was inevitable.

It is curious to note how this return came about. It was effectuated with prudence, or to be plain, with fear. It seems that the painters feared that in going back, they would stumble and fall into the same snares and traps that they themselves had laid during the previous advance. Such fear is justified by the fact that they are unarmed, vulnerable and weak. While returning it is necessary, too, that they grasp hold of a few of those same fancy tricks: that they make use of the shields they used during the advance. And so the great problem that terrifies them most in this return is that of the human figure.

Man who with his canons rises again like a spectre in front of man.

The neglect of anthropomorphic representation, and the deformation of it, encouraged entire legions of painters to turn out stupid and facile reproductions. With its return the problem of animal-man looms larger and more terrible than ever, since, this time, the right weapons to confront it are lacking, or rather they are in existence, but they are blunt, and many have forgotten how to use them.

These painters can no longer hide behind the excuse of primitive artifice.

The case of the penitent painter of today is tragic, but amidst such puerile confusion there is also a comic side to it that encourages an ironic smile from beneath the observer's moustache.

* * *

To return to the craft! This will not be easy and will demand time and toil. The schools and the masters are deficient, or rather they are vilified by the colouristic riot that has invaded Europe in this half-century. The academies exist, full of methods and systems, but, alas, what results they produce! What on earth would the weakest student of 1600 say if he could see a masterpiece by a *professore* of an Italian academy, or by a *cher maître* of the Ecole des Beaux-Arts of Paris? [...]

* * *

[...] This is the point we have reached. This is the state of confusion, ignorance and overwhelming stupidity in the midst of which the very few painters whose brains are clear and whose eyes are clean are preparing to return to pictorial science following the principles and teachings of our old masters. Their first lesson was drawing; drawing, the divine art, the foundation of every plastic construction, skeleton of every good work, eternal law that every artifice must follow. Drawing, ignored, neglected and

deformed by all modern painters (I say all, including the decorators of parliamentary halls and the various professors of the realm), drawing, I say, will return not as a *fashion* as those who talk of artistic events are accustomed to say, but as an inevitable necessity, as a condition *sine qua non* of good creation. '*Un tableau bien dessiné est toujours assez bien peint*,' said Jean Dominique Ingres, and I think he knew more about it than all the modern painters. Just as in elections voters are exhorted to go to the polls, we, who were the first to set a good example in painting, summon those painters who have been or can be redeemed to *go to the statues*. Yes, to the statues to learn the nobility and the religion of drawing, to the statues to dehumanize you a little, you who in spite of all your puerile devilries were still *too human*. If you lack the time and the means to go and copy in the sculpture museums, if the academies have not yet adopted the system of shutting the future painter up for at least five years in a room in which there is nothing but marble and plaster statues, if the dawn of laws and canons has not yet arisen, have patience; and meanwhile, so as not to lose time, buy a plaster copy – though it need not be a reproduction of an antique masterpiece. Buy your plaster copy, and then in the silence of your room copy it ten, twenty, a hundred times. Copy it until you manage to produce a satisfying work, to draw a hand or a foot in such a way that if they were to come alive miraculously, the bones, muscles, nerves and tendons would all be correct.

To return to the craft, our painters must be extremely diligent in the perfection of their means: canvas, colours, brushes, oils and varnishes must be of the highest quality. Colours, unfortunately, are of very poor quality nowadays because the roguery and immorality of the manufacturers and the modern painters' mania for speed have encouraged the distribution of very poor products, since no painter was likely to protest. It would be a good thing if painters again took up the habit of making their own canvas and colours. Rather more patience and effort is necessary: but, when the painter has understood once and for all that the execution of a painting is not a thing to be carried out in the shortest possible time, a thing merely to be exhibited or sold to a dealer; when he has understood that the same painting should be worked on for months, even years, until it is completely smooth and polished; and until the painter's conscience is completely clear; when he has understood this he will not find it difficult to sacrifice a few hours a day to the preparation of his own canvases and colours. He will do it with care and with love, it will cost him less, and will provide him with safer and more consistent colours.

When this transformation comes about, the finest painters, who will be considered the *masters*, will be able to exert control and act as judges and inspectors for the minor painters. It would be wise to adopt the discipline current in the era of the great Flemish painters who, united in societies, used to elect a president who had the power to inflict punishments, to impose fines and even to expel from the society a painter who was guilty of negligence or who had used inferior materials.

When Ingres painted, he had within reach one hundred paintbrushes of the finest quality, perfectly washed and dried and ready for use the moment the artist needed them. Today our avant-garde boasts of using a couple of rough decorator's brushes, clogged with dried paint, hard and never washed. [. . .]

As far as material and craft are concerned, futurism dealt the final blow to Italian painting. Even before the advent of futurism it was navigating murky waters, but the futurist revels made the bucket overflow.

Now night falls on everything. We have reached the second half of the parabola. Hysteria and roguery are condemned. I think that by now we are all satiated with roguery, whether it be political, literary, or painterly. With the sunset of hysteria more than one painter will return to the craft, and those who have already done so can work with freer hands, and their work will be more adequately recognized and recompensed.

As for me, I am calm, and I decorate myself with three words that I wish to be the seal of all my work: *Pictor classicus sum*.

7 Charles Edouard Jeanneret (Le Corbusier) (1887–1965) and Amédée Ozenfant (1886–1966) 'Purism'

The authors met in late 1917, whereupon Jeanneret, trained as an architect and draughtsman, also took up painting. In November 1918 they jointly published *After Cubism (Après le Cubisme)*, developing the ideas broached in Ozenfant's 'Notes on Cubism' of 1916 (III A1). In 1920 they founded the review *L'Esprit Nouveau* to promote a return, within the avant-garde, to principles of classical order. 'Purism', a comprehensive statement of these principles, was published in the fourth issue of 1920, pp. 369–86. The present extracts are taken from the first English translation in R. L. Herbert, *Modern Artists on Art*, New York, 1964, pp. 58–61, 63–5, 73.

Introduction

Logic, born of human constants and without which nothing is human, is an instrument of control and, for he who is inventive, a guide toward discovery; it controls and corrects the sometimes capricious march of intuition and permits one to go ahead with certainty.

It is the guide that sometimes precedes and sometimes follows the explorer; but without intuition it is a sterile device; nourished by intuition, it allows one 'to dance in his fetters.'

Nothing is worthwhile which is not general, nothing is worthwhile which is not transmittable. We have attempted to establish an esthetic that is rational, and therefore human. [...]

The Work of Art

The work of art is an artificial object which permits the creator to place the spectator in the state he wishes; later we will study the means the creator has at his disposal to attain this result.

With regard to man, esthetic sensations are not all of the same degree of intensity or quality; we might say that there is a hierarchy.

The highest level of this hierarchy seems to us to be that special state of a mathematical sort to which we are raised, for example, by the clear perception of a great general law (the state of mathematical lyricism, one might say); it is superior to the brute pleasure of the senses; the senses are involved, however, because every being in this state is as if in a state of beatitude.

The goal of art is not simple pleasure, rather it partakes of *the nature of happiness.*

It is true that plastic art has to address itself more directly to the senses than pure mathematics which only acts by symbols, these symbols sufficing to trigger in the mind consequences of a superior order; in plastic art, the senses should be strongly moved in order to predispose the mind to the release into play of subjective reactions without which there is no work of art. But there is no art worth having without this excitement of an intellectual order, of a mathematical order; architecture is the art which up until now has most strongly induced the states of this category. The reason is that everything in architecture is expressed by order and economy.

The means of executing a work of art is a transmittable and universal language.

One of the highest delights of the human mind is to perceive the order of nature and to measure its own participation in the scheme of things; the work of art seems to us to be a labor of putting into order, a masterpiece of human order.

Now the world only appears to man from the human vantage point, that is, the world seems to obey the laws man has been able to assign to it; when man creates a work of art, he has the feeling of acting as a 'god.'

Now a law is nothing other than the verification of an order.

In summary, a work of art should induce a sensation of a mathematical order, and the means of inducing this mathematical order should be sought among universal means.

System

* * *

Man and organized beings are products of *natural selection.* In every evolution on earth, the organs of beings are more and more adapted and purified, and the entire forward march of evolution is a function of purification. The human body seems to be the highest product of natural selection.

When examining these selected forms, one finds a tendency toward certain identical aspects, corresponding to constant functions, functions which are of maximum efficiency, maximum strength, maximum capacity, etc., that is, maximum economy. ECONOMY is the law of natural selection.

It is easy to calculate that it is also the great law which governs what we will call 'mechanical selection.'

Mechanical selection began with the earliest times and from those times provided objects whose general laws have endured; only the means of making them changed, the rules endured.

In all ages and with all people, man has created for his use objects of prime necessity which responded to his imperative needs; these objects were associated with his organism and helped complete it. In all ages, for example, man has created containers: vases, glasses, bottles, plates, which were built to suit the needs of maximum capacity, maximum strength, maximum economy of materials, maximum economy of effort. In all ages, man has created objects of transport: boats, cars; objects of defense: arms; objects of pleasure: musical instruments, etc., all of which have always obeyed the law of selection: economy.

One discovers that all these objects are true extensions of human limbs and are, for this reason, of human scale, harmonizing both among themselves and with man.

The machine was born in the last century. The problem of selection was posed more imperatively than ever (commercial rivalry, cost price); one might say that the machine has led fatally to the strictest respect for, and application of, the laws of economy. [...]

Modern mechanization would appear to have created objects decidedly remote from what man had hitherto known and practiced. It was believed that he had thus retreated from natural products and entered into an arbitrary order; our epoch decries the misdeeds of mechanization. We must not be mistaken, this is a complete error: the machine has applied with a rigor greater than ever the physical laws of the world's structure. [...]

From all this comes a fundamental conclusion: that respect for the laws of physics and of economy has in every age created highly selected objects; that these objects contain analogous mathematical curves with deep resonances; that these artificial objects obey the same laws as the products of natural selection and that, consequently, there thus reigns a total harmony, bringing together the only two things that interest the human being: himself and what he makes.

Both natural selection and mechanical selection are manifestations of purification.

From this it would be easy to conclude that the artist will again find elitist themes in the objects of natural and mechanical selection. As it happens, artists of our period have taken pleasure in ornamental art and have chosen ornamented objects.

A work of art is an association, a symphony of consonant and architectured forms, in architecture and sculpture as well as in painting.

To use as theme anything other than the objects of selection, for example, objects of decorative art, is to introduce a second symphony into the first; it would be redundant, surcharged, it would diminish the intensity and adulterate the quality of the emotion.

Of all recent schools of painting, only Cubism foresaw the advantages of choosing selected objects, and of their inevitable associations. But, by a paradoxical error, instead of sifting out the general laws of these objects, Cubism only showed their accidental aspects, to such an extent that on the basis of this erroneous idea it even re-created arbitrary and fantastic forms. Cubism made square pipes to associate with matchboxes, and triangular bottles to associate with conical glasses.

From this critique and all the foregoing analyses, one comes logically to the necessity of a reform, the necessity of a logical choice of themes, and the necessity of their association not by deformation, but *by formation*.

If the Cubists were mistaken, it is because they did not seek out the invariable constitutents of their chosen themes, which could have formed a universal, transmittable language.

* * *

Purism

The highest delectation of the human mind is the perception of order, and the greatest human satisfaction is the feeling of collaboration or participation in this order. The

work of art is an artificial object which lets the spectator be placed in the state desired by the creator. The sensation of order is of a mathematical quality. The creation of a work of art should utilize means for specified results. Here is how we have tried to create a language possessing these means:

Primary forms and colors have standard properties (universal properties which permit the creation of a transmittable plastic language). But the utilization of primary forms does not suffice to place the spectator in the sought-for state of mathematical order. For that one must bring to bear the associations of natural or artificial forms, and the criterion for their choice is the degree of selection at which certain elements have arrived (natural selection and mechanical selection). The Purist element issued from the purification of standard forms is not a copy, but a creation whose end is to materialize the object in all its generality and its invariability. Purist elements are thus comparable to words of carefully defined meaning; Purist syntax is the application of constructive and modular means; it is the application of the laws which control pictorial space. A painting is a whole (unity); a painting is an artificial formation which, by appropriate means, should lead to the objectification of an entire 'world.' One could make an art of allusions, an art of fashion, based upon surprise and the conventions of the initiated. Purism strives for an art free of conventions which will utilize plastic constants and address itself above all to the universal properties of the senses and the mind.

8 Albert Gleizes (1881–1953) 'The Dada Case'

The author's pre-war Cubism (see IIB7) was affected by the post-war 'call to order'. He represents here a response to the criticism mounted by Dada of classical principles and of the bourgeois social order from which they were held to derive. Notably, however, his response is made as a defence, not of that social order, but of eternal principles. To its adherents it was 'l'esprit nouveau' that was progressive, Dada a manifestation of the decay of bourgeois society. Originally published in *Action*, no. 3, Paris, April 1920. The present translation by Ralph Mannheim is taken from R. Motherwell (ed.), *The Dada Painters and Poets*, New York, 1951, pp. 298–303.

[...] It cannot for one moment be denied that we are now at a great turning-point in the history of mankind. In every country a hierarchy, the hierarchy of bourgeois capitalism, is crumbling, powerless to recapture the reins of power. Events have proved stronger than men, and men are being tossed this way and that, with very little idea of what is happening. The political parties from the extreme right to the extreme left continue to accuse one another of every crime. They cannot get it into their heads that responsibility is an idle word when applied to man, and that superior forces which scientific investigations have not succeeded in fathoming act upon the species far more strongly than any supposed individual will. This bourgeois hierarchy which has organized the economic system on a material plane sees nothing but its threatened class interests. It has reached such a degree of impotence that it can no longer conceive of a system which might provide a safety valve for the ever-mounting pressure in the lower parts of its organism. On the contrary, it constantly increases the pressure, having lost all conception of a possible breaking-point.

On the material plane this bourgeois hierarchy is already dead; what we see now is the decomposition of its corpse. The movement with which it still seems to be endowed is merely the wriggling of the worms that are devouring it, and the glow which prevents the night from being complete is the phosphorescence that we know as the will-o'-the-wisp.

Here let it be understood that 'bourgeois hierarchy' is not meant in any demagogic sense. The mania for classification has created certain distinctions whose reality is purely an appearance, and our demagogues use them as a basis for telling the lower classes that they have nothing in common with the upper classes. If they do this for reasons of strategy, it is understandable, but if they are simple-minded enough to believe what they say, it's too bad for them. The bourgeoisie is the expression of a human leaning towards the bestial enjoyment of material realities. And as the division of wealth – an economic conception – is based on money, it is to the power of money that the goods of this world belong. In the human struggle, those who have this power are on top, those who do not possess it but who have the same desire to possess it for the same ends, are on the bottom. Consequently the bourgeois spirit is not peculiar to any special class, but is common to the whole of society. The last scavenger of cigarette butts has the same impulses as the financier who makes peace or war, all that separates them is a simple matter of realization.

The collapse of the money-base and the increasing shortage of goods – these are the factors that are undermining the whole social organism. The cataclysm seems inevitable. There will be nothing ideological about it. From the point of view of the human consciousness, it will be quite simply a rebellion of the stomach and an exasperation of the desire to enjoy life. And indeed, every class of our decomposing society is characterized by an urge toward the satisfaction of every physical desire, and by a total lack of constructiveness or organization.

This engulfing materialism, which is so typical of our bourgeois society, quite naturally prevents us from paying serious attention to the disintegration on the spiritual plane, since spiritual values are what count least in a regime of this sort and the word spiritual has taken on an air of waggish insignificance, living on services rendered and on jokes.

However, it is by juxtaposing the rot on the material plane with the rot on the spiritual plane that we shall gain an accurate understanding of the Dada movement. I am even prepared to say that it is easier to follow the course of this movement than that of the material crisis. Its organism is simpler than the complex of material forces.

The decomposing material body of the bourgeois hierarchy has its counterpart in the decomposition of its spiritual values. The material body returns to dust, the spirit returns to the void. The Dada movement is not the voluntary work of individuals; it is the fatal product of a state of affairs.

* * *

At the source of the Dada spirit, we find an adroit utilization of spiritual values once combatted, but now grown fashionable. Then various new impulses brought a sudden revelation. The need to be first became a dogmatic tenet, bringing with it further madness. And to these diverse psychological states correspond a series of pathological states. The abuse of pleasures of all sorts brings the search for artificial stimulation of the senses, to the lashing of the nervous system with liquor and drugs. Result: the total loss of control over the physical organism.

Prior to this stage, what does the individual offer? An intellectual suppleness, yes, but no extraordinary sensibility; a certain *savoir-faire* but nothing to suggest any latent constructive temperament. During this stage and after, he has the illusion of being liberated from the physical laws that govern us. This is a familiar adjunct of the hypnosis induced by drugs, but it is more serious when the illusion is prolonged past the crisis. It is at this moment that the domain of Dada opens. The impossibility of constructing, of organizing anything whatsoever, the absence of even the most confused notion of any such construction, has led Dada to decree that there is no such thing and that the only solution is to do anything, no matter what, under the guise of instinct.

* * *

Their only certainties derive from an exasperation of the bourgeois conception of art, essentially individualistic and hence reserved for a few of the initiate. Carrying this principle to its absurd conclusion, they shut themselves up in themselves. The presentation of the Dada work is always full of taste, the paintings reveal charming colors, all very fashionable, the books and magazines are always delightfully made up and rather recall the catalogues of perfume manufacturers. There is nothing in the outward aspect of these productions to offend anyone at all; all is correctness, good form, delicate shading, etc. . . .

The forms in their art work are likewise inoffensive, the *graffiti* they draw are quite proper. The texts are so impenetrable that there can be no possible ground for indignation. Sometimes a choice of words creates a lively and felicitous image. What they call instinct is anything that passes through their heads, and from time to time something quite nice passes through their heads. This is no more surprising than to find a certain suggestion of organization in accidental cloud formations.

But very soon we become aware of the dominants, the *leit-motivs* which recur in their artistic and literary works. And then the pathological case becomes brutally evident. Their minds are forever haunted by a sexual delirium and a scatalogical frenzy. Their morbid fantasy runs riot around the genital apparatus of either sex. There is real joy in their discovery of their own sex and the feminine sex. Though they deny everything *a priori*, we must, in spite of that denial, which strikes me as somewhat premature, recognize that they are full of conviction when it comes to those ornaments with which babies are made and which they so love to toy with. They are obsessed with the organs of reproduction to such a degree that those of their works which may possibly reveal genius are inevitably of a genital character. Moreover, by lingering in these domains, they have found, perhaps without seeking it, another source of instinctive inspiration. They have discovered the anus and the by-products of intestinal activity. And their joy, already great, was further augmented. Progressing from one discovery to another, they announce their triumph to all comers. They make marbles with fecal matter, they gallop over it, they run probing fingers through it. This is a phenomenon well known to psychiatrists. They confuse excrement with the products of the mind. They use the same word to designate two different things.

* * *

Dada claims to discredit art by its agitation. But one can no more discredit art, which is the manifestation of an imperious impulsion of the instinct, than one can discredit human society, which also springs from an imperious impulsion of the instinct. One can no more discredit art by systematically destroying its values, than one can discredit society by a fraudulent international bankruptcy. What Dada destroys, without assum-

ing responsibility for its acts, is certain notions of servitude which would vanish very nicely without its help; since what is destroying the bourgeois hierarchy on the material plane is its false conception of the distribution of social wealth. And that is why Dada, in the last analysis, represents merely the ultimate decomposition of the spiritual values of that decomposed bourgeois hierarchy. [...]

9 André Derain (1880–1954) 'On Raphael'

Though Derain had been a leading member of the pre-war avant-garde (see IB3), like many other artists he turned increasingly to classicism during and after the war. His affirmation of this conservative commitment appears in a statement originally published as 'Sur Raphaël' in *L'Esprit Nouveau*, no. 3, Paris, December 1920, from which the present translation is made.

Raphael is the most widely misunderstood of artists! Raphael is not a master for the young: he cannot be the founder of a school made up of beginners. The only way to approach Raphael is after many disappointments. If one departs from him, it is a disaster; he is a genius capable of spoiling the greatest. There are distressing examples of this. Besides, his influence was non–existent for more than a century; we are just emerging from a period in which one only sought direction from masters of the Dutch school. The recent reorganization of the Louvre is the happy proof that this time is past. Raphael is above da Vinci, who is a sound test of worth, and far from being divine has a taste for corruption. Raphael alone is divine!

10 Percy Wyndham Lewis (1882–1957) 'The Children of the New Epoch'

The author perceives that the war has put an end to 'blasting and bombardiering', to Vorticism (see IIA12), indeed to the apparent anarchy of the pre-war avant-garde *tout court*. In its place he alludes to 'robustness', 'hygiene' and 'authority': terms which were to become familiar in conservative rhetoric, not least in the 'call to order' so influential in sections of the avant-garde. Originally published in *The Tyro*, no. 1, London, 1921.

We are at the beginning of a new epoch, fresh to it, the first babes of a new, and certainly a better, day. The advocates of the order that we supersede are still in a great majority. The obsequies of the dead period will be protracted, and wastefully expensive. But it is nevertheless nailed down, cold, but with none of the calm and dignity of death. The post-mortem has shown it to be suffering from every conceivable malady.

No time has ever been more carefully demarcated from the one it succeeds than the time we have entered on has been by the Great War of 1914–18. It is built solidly behind us. All the conflicts and changes of the last ten years, intellectual and other, are terribly symbolized by it. To us, in its immense meaningless shadow, it appears like a mountain range that has suddenly risen as a barrier, which should be interpreted as an indication of our path. There is no passage back across that to the lands of yesterday.

Those for whom that yesterday means anything, whose interests and credentials are on the other side of that barrier, exhort us dully or frantically to scale that obstacle (largely built by their blunders and egotisms) and return to the Past. On the other hand, those *whose interests lie all ahead*, whose credentials are in the future, move in this abrupt shadow with satisfaction, forward, and away from the sealed and obstructed past.

So we, then, are the creatures of a new state of human life, as different from nineteenth-century England, say, as the Renaissance was from the Middle Ages. We are, however, weak in numbers as yet, and to some extent, uncertain and untried. What steps are being taken for our welfare, how are we provided for? Are the next few generations going to produce a rickety crop of Newcomers, or is the new epoch to have a robust and hygienic start-off?

A phenomenon we meet, and are bound to meet for some time, is the existence of a sort of No Man's Land atmosphere. The dead never rise up, and men will not return to the Past, whatever else they may do. But as yet there is Nothing, or rather the corpse of the past age, and the sprinkling of children of the new. There is no mature authority, outside of creative and active individual men, to support the new and delicate forces bursting forth everywhere today.

So we have sometimes to entrench ourselves; but we do it with rage: and it is our desire to press constantly on to realization of what is, after all, our destined life.

11 Juan Gris (1887–1927) Reply to a Questionnaire

A leading member of the pre-war Cubist avant-garde, Gris here stresses the rational bases of his art and its continuity with the classical tradition enshrined in the Louvre. These typically post-war claims were made in response to a questionnaire circulated by the editors of *L'Esprit Nouveau*, Jeanneret and Ozenfant. Originally published in *L'Esprit Nouveau*, no. 5, Paris, February 1921, pp. 533–4.

His aesthetic system: 'I work with elements of the spirit, with the imagination. I try to concretize that which is abstract. I go from the general to the particular; that is to say, I depart from an abstraction to arrive at a real fact. My art is an art of synthesis, a deductive art, as Raynal says.'

'I want to attain a new description. I want to be able to create special individuals by departing from a general type.'

'I consider that the architectural side of painting is mathematical, the abstract side; I want to humanize it. Cézanne created a cylinder from a bottle; for my part, I depart from the cylinder to create a special type of individual; I create a bottle from a cylinder, a certain bottle. Cézanne heads towards architecture, whereas I depart from it. It's for this reason that I compose with abstractions (colours) and I determine when these colours have become objects; for example, I compose with black and white and I determine when the white has become a paper and the black a shadow; I mean that I fix the white so that it becomes a paper, and the black to turn it into a shadow. This type of painting is to the other type what poetry is to prose.'

His method: 'If in the *system* I distance myself from all idealist and naturalist art, in method I do not want to escape from the Louvre. My method is the perennial method, that which the masters used; these are the *means*, they are constant.'

12 Gustav Friedrich Hartlaub (1884–1963) 'Reply to a Questionnaire'

G. F. Hartlaub, art historian and Director of the Mannheim Kunsthalle, is generally credited with the first usage of the term 'Neue Sachlichkeit' to refer to the new figurative tendencies which emerged in German art after the First World War (see IIIB9 and 13, IVB5 and 6). In 1923 he published in the journal *Kunstblatt* an open letter inviting contributions to 'a medium-sized exhibition of paintings and graphic art which might perhaps have the title "Die Neue Sachlichkeit"'. He continued, 'I am interested in bringing together representative works by those artists who over the last ten years have been neither Impressionistically vague nor Expressionistically abstract, neither sensuously superficial nor constructivistically introverted. I want to show those artists who have remained – or who have once more become – avowedly faithful to positive, tangible reality.' The exhibition took longer to organize than expected, and eventually took place between June and September 1925. The ideas involved had achieved currency some time before, however. The editor of *Kunstblatt*, Paul Westheim, had reviewed Italian figurative tendencies in 1919, and 'Pittura Metafisica' paintings were shown in Berlin in 1920 (see IIIA4 and 6). In 1922 Westheim sent out a questionnaire under the title 'A new Naturalism?' and printed the replies in a special issue of the magazine. Hartlaub's response gained considerable currency as a key statement of the new outlook. First, he drew a line under Expressionism. Then he proceeded to divide the new figurative tendency into distinct right and left wings, which he associated respectively with an interest in classicism, and a more documentary focus on the contemporary. The text was originally published in *Das Kunstblatt*, VI, 9, Berlin, September 1922, pp. 389–93. The present translation, by Nicholas Walker, is taken from that source.

In 1918 I wrote in my book *Art and Religion*: 'It is essential for Expressionism to remain faithful to itself.' The artistic will [*Kunstwollen*] that informs the most abstract principles of formal calculation, in Cubism, as well as the freest kind of emotional expression, in Kandinsky, shared a single point of departure in the recognition that 'there is also a universe within.' This artistic will, albeit in the most diverse of ways, had attempted with passionate intensity to make this universe visible in its own right over against the external reality of the world of things. To this extent 'Expressionism' was a most remarkable symptom of a restored metaphysical and, in the broadest sense of the word, *religious will to renewal* in the minds of whole generations. As soon as this common will began to ebb, this daring intervention within the midst of a materialist social order and a materialist view of the world inevitably came to seem deluded, and thus to be *fragmented* or even *renounced entirely*.

And this is indeed what has happened. The second and third generations of 'youthful art' have *failed* in their intent, most of them having lost their faith once again, infinitely disappointed and exhausted as they were by war, revolution and the post-war situation. In part they have simply contented themselves with schematizing the new formal possibilities, with employing them, more or less easily, for purely decorative purposes. And in part they have effectively *squandered* the achievements of abstraction in carefully calculated experiments of artistic titillation that have so far been confined to very restricted circles. Many have also compromised the 'proto-religious will' with an unforgivable insincerity. Others have been more honest. Where the divine breath had once pervaded and illumined the phenomena of this world and gathered its

immaterial forms into purer and more spiritual shapes, these artists have increasingly abandoned themselves to a black satanic magic. They have not illuminated the world, but merely shattered it into imaginary fragments. And instead of transmuting the latter into a higher organic kind of life, they have pursued a cynical futurism, producing nothing but artful mechanisms, mechanical golems, malignant images of our own perverse age. There are very few artists still inspired by that deep mystical urge of romanticism which the moderns of the late nineteenth century had incorporated into the impressionist view of the world. These few artists are like very lonely 'specialists' in today's world. It is impossible to found a school on the work of a Paul Klee.

It was thus inevitable that *reaction* should set in, just as reaction and resignation now rule in the political sphere after the powerful utopian visions of 1918. The overall direction of this backlash was clear from the beginning. To encapsulate the new approach in the slogan *Return to Nature!* may not represent the deepest analysis in purely theoretical terms, but this is surely the most evident feature of the recent trend.

I can distinguish a *right* and a *left* wing here. The former, conservative to the point of classicism in its emphasis on timeless values, seeks now, after the experience of so much extremity and chaos, to sanctify everything sound and healthy, the bodily-sculptural reality that is faithfully drawn from nature, while perhaps enhancing the earthier and more ample dimension here. Michelangelo, Ingres, Genelli, even the Nazarenes, are championed as the relevant models in this respect. The left wing, on the other hand, stridently contemporary, evincing far less faith in art, spawned rather by the very denial of art, seeks with primitivist exactitude and obsessive self-exposure to unveil the reality of chaos as the true countenance of our time.

Since Expressionism has failed to remain true to its own original and comprehensive creative impulse, the present solution may perhaps be the only one that still remains, the best and the most salutary in the circumstances. All we can do is to *affirm* it, especially since it seems strong enough to nourish new forces of the creative will. What is decisive here is this: even though both these trends profess to be as unromantic as it is possible to be, they have not entirely relinquished the most precious achievements of the spiritual will of earlier generations. For certain profound levels of consciousness, tapped once before, continue to communicate their rejuvenating powers even now. A certain longing for the elementary and the childlike has remained with us, and has even on occasion found fulfilment. Certain expressive potentialities of the soul, once dis-covered, are no longer forgotten (like that 'interior recollection' [*Verinnerlichung*] which has rarely been traced back beyond the purely neurological domain). The extremely rigorous formal discipline and the new constructive possibilities exemplified in Cubism, for example, can above all no longer be forgotten, and likewise the bold exploration of the emotional symbolism of *colour*. The recent naturalism no longer has anything in common with that of a Corinth or a Zille. And even the new 'classicism' – if we may so describe it – would distance itself from that of Canova and Adolf Hildebrand.

We must therefore declare ourselves, though with some painful resignation, for this recent *Return to Nature*. We cannot ignore the clamour and affectation, and the often purely decorative tendencies, of these new 'purists', of these classicists with rather 'negroid' sympathies (as Hausenstein describes them); nor can we ignore the political anger and the cynicism that narrow the horizons of the opposing party and lend such an unyielding and convulsive character to their strident intersecting images. But despite

all this we must still hope that tomorrow, or some day soon, both of these currents may successfully unite and create a broader path on which to advance. We await the future appearance of another, and redeemed, Max Beckmann.

Nor should we forget that there are also a number of modern painters for whom the struggles and problems we have discussed have never presented themselves at all, and who have proved more felicitous heirs of Cézanne than the Cubists have been. André Derain still lives.

IIIB
Dissent and Disorder

1 Hugo Ball (1886–1927) 'Dada Fragments'

Together with Emmy Hennings, Ball founded the Cabaret Voltaire in Zurich on 5 February 1916. The aim, as he later declared, was 'to remind the world that there are independent men "beyond war and Nationalism" who live for other ideals'. These 'Fragments' and diary entries from 1916–17 were originally published in Ball's book *Flucht aus der Zeit* (*Flight from Time*), Munich/Leipzig, 1927. The present translation, by Eugene Jolas, is taken from Motherwell, *The Dada Painters and Poets*, New York, 1951, pp. 57–4. (The ellipses are integral.)

March 12, 1916 – Introduce symmetries and rhythms instead of principles. Contradict the existing world orders...

What we are celebrating is at once a buffoonery and a requiem mass...

June 12, 1916 – What we call Dada is a harlequinade made of nothingness in which all higher questions are involved, a gladiator's gesture, a play with shabby debris, an execution of postured morality and plenitude...

The Dadaist loves the extraordinary, the absurd, even. He knows that life asserts itself in contradictions, and that his age, more than any preceding it, aims at the destruction of all generous impulses. Every kind of mask is therefore welcome to him, every play at hide and seek in which there is an inherent power of deception. The direct and the primitive appear to him in the midst of this huge anti-nature, as being the supernatural itself...

The bankruptcy of ideas having destroyed the concept of humanity to its very innermost strata, the instincts and hereditary backgrounds are now emerging pathologically. Since no art, politics or religious faith seems adequate to dam this torrent, there remain only the *blague* and the bleeding pose...

The Dadaist trusts more in the sincerity of events than in the wit of persons. To him persons may be had cheaply, his own person not excepted. He no longer believes in the comprehension of things from *one* point of departure, but is nevertheless convinced of the union of all things, of totality, to such an extent that he suffers from dissonances to the point of self-dissolution...

The Dadaist fights against the death-throes and death-drunkenness of his time. Averse to every clever reticence, he cultivates the curiosity of one who experiences delight even in the most questionable forms of insubordination. He knows that this world of systems has gone to pieces, and that the age which demanded cash has organized a bargain sale of godless philosophies. Where bad conscience begins for the market-booth owners, mild laughter and mild kindliness begin for the Dadaist ...

June 13, 1916 – The image differentiates us. Through the image we comprehend. Whatever it may be – it is night – we hold the print of it in our hands ...

The word and the image are one. Painting and composing poetry belong together. Christ is image and word. The word and the image are crucified ...

June 18, 1916 – We have developed the plasticity of the word to a point which can hardly be surpassed. This result was achieved at the price of the logically constructed, rational sentence, and therefore, also, by renouncing the document (which is only possible by means of a time-robbing grouping of sentences in a logically ordered syntax). We were assisted in our efforts by the special circumstances of our age, which does not allow a real talent either to rest or ripen, forcing it to a premature test of its capacities, as well as by the emphatic élan of our group, whose members sought to surpass each other by an even greater intensification and accentuation of their platform. People may smile, if they want to; language will thank us for our zeal, even if there should not be any directly visible results. We have charged the word with forces and energies which made it possible for us to rediscover the evangelical concept of the 'word' (logos) as a magical complex of images ...

* * *

November 21, 1916 – Note about a criticism of individualism: The accentuated 'I' has constant interests, whether they be greedy, dictatorial, vain or lazy. It always follows appetites, so long as it does not become absorbed in society. Whoever renounces his interests, renounces his 'I'. The 'I' and the interests are identical. Therefore, the individualistic-egoistic ideal of the Renaissance ripened to the general union of the mechanized appetites which we now see before us, bleeding and disintegrating.

* * *

March 30, 1917 – The new art is sympathetic because in an age of total disruption it has conserved the will-to-the-image; because it is inclined to force the image, even though the means and parts be antagonistic. Convention triumphs in the moralistic evaluation of the parts and details; art cannot be concerned with this. It drives toward the in-dwelling, all-connecting life nerve; it is indifferent to external resistance. One might also say: morals are withdrawn from convention, and utilized for the sole purpose of sharpening the senses of measure and weight ...

* * *

April 18, 1917 – Perhaps the art which we are seeking is the key to every former art: a salomonic key that will open all mysteries.

May 23, 1917 – Dadaism – a mask play, a burst of laughter? And behind it, a synthesis of the romantic, dandyistic and – daemonistic theories of the 19th century.

2 Marcel Duchamp (1887–1968) 'The Richard Mutt Case'

Duchamp, having abandoned painting and emigrated to America, began to produce 'Ready-mades', works calculated to reveal, among their other effects, the workings of the art institution as inseparable from the attribution of artistic value. In 1917, under the pseudonym 'R. Mutt', he submitted a urinal to the open exhibition of the Society of Independent Artists in New York, with the title 'Fountain'. The piece was refused entry (as he no doubt intended). Accompanied by a photo taken by Alfred Stieglitz, the present text was originally published in the second and last issue of *The Blind Man*, New York, May 1917. Duchamp was unquestionably responsible for its publication, though he never acknowledged authorship of the text itself. It is reproduced here from Lucy Lippard (ed.), *Dadas on Art*, Englewood Cliffs, NJ, 1971, p. 143.

They say any artist paying six dollars may exhibit.

Mr Richard Mutt sent in a fountain. Without discussion this article disappeared and never was exhibited.

What were the grounds for refusing Mr Mutt's fountain: –

1 Some contended it was immoral, vulgar.
2 Others, it was plagiarism, a plain piece of plumbing.

Now Mr Mutt's fountain is not immoral, that is absurd, no more than a bathtub is immoral. It is a fixture that you see every day in plumbers' show windows.

Whether Mr Mutt with his own hands made the fountain or not has no importance. He CHOSE it. He took an ordinary article of life, placed it so that its useful significance disappeared under the new title and point of view – created a new thought for that object.

As for plumbing, that is absurd. The only works of art America has given are her plumbing and her bridges.

3 Tristan Tzara (1896–1963) 'Dada Manifesto 1918'

Romanian by birth, Tzara arrived in Zurich in 1915 where he participated in the Cabaret Voltaire, which opened early in the following year. He later edited *Dada*, the most important of the French Dada reviews. The 'Manifesto 1918' was originally read in Zurich on 23 March 1918. It was first published in *Dada*, no. 3, 1918 and reprinted in *Sept Manifestes Dada*, Paris, 1924. The present extracts, translated by Ralph Mannheim, are taken from Motherwell, op. cit., pp. 76–82.

The magic of a word – Dada – which has brought journalists to the gates of a world unforeseen, is of no importance to us.

To put out a manifesto you must want: ABC
to fulminate against 1, 2, 3,
to fly into a rage and sharpen your wings to conquer and disseminate little abcs and big abcs, to sign, shout, swear, to organize prose into a form of absolute and irrefutable

evidence, to prove your non plus ultra and maintain that novelty resembles life just as the latest-appearance of some whore proves the essence of God. His existence was previously proved by the accordion, the landscape, the wheedling word. To impose your ABC is a natural thing – hence deporable. Everybody does it in the form of crystalbluffmadonna, monetary system, pharmaceutical product, or a bare leg advertising the ardent sterile spring. The love of novelty is the cross of sympathy, demonstrates a naive je m'enfoutisme, it is a transitory, positive sign without a cause.

But this need itself is obsolete. In documenting art on the basis of the supreme simplicity: novelty, we are human and true for the sake of amusement, impulsive, vibrant to crucify boredom. At the crossroads of the lights, alert, attentively awaiting the years, in the forest. I write a manifesto and I want nothing, yet I say certain things, and in principle I am against manifestoes, as I am also against principles (half-pints to measure the moral value of every phrase too too convenient; approximation was invented by the impressionists). I write this manifesto to show that people can perform contrary actions together while taking one fresh gulp of air; I am against action; for continuous contradiction, for affirmation too, I am neither for nor against and I do not explain because I hate common sense. [...]

Dada Means Nothing

If you find it futile and don't want to waste your time on a word that means nothing... The first thought that comes to these people is bacteriological in character: to find its etymological, or at least its historical or psychological origin. We see by the papers that the Kru Negroes call the tail of a holy cow Dada. The cube and the mother in a certain district of Italy are called: Dada. A hobby horse, a nurse both in Russian and Rumanian: Dada. Some learned journalists regard it as an art for babies, other holy jesusescallingthelittlechildren of our day, as a relapse into a dry and noisy, noisy and monotonous primitivism. Sensibility is not constructed on the basis of a word; all constructions converge on perfection which is boring, the stagnant idea of a gilded swamp, a relative human product. A work of art should not be beauty in itself, for beauty is dead; it should be neither gay nor sad, neither light nor dark to rejoice or torture the individual by serving him the cakes of sacred aureoles or the sweets of a vaulted race through the atmospheres. A work of art is never beautiful by decree, objectively and for all. Hence criticism is useless, it exists only subjectively, for each man separately, without the slightest character of universality. Does anyone think he has found a psychic base common to all mankind? The attempt of Jesus and the Bible covers with their broad benevolent wings: shit, animals, days. How can one expect to put order into the chaos that constitutes that infinite and shapeless variation: man? The principle: 'love thy neighbor' is a hypocrisy. 'Know thyself' is utopian but more acceptable, for it embraces wickedness. No pity. After the carnage we still retain the hope of a purified mankind. I speak only of myself since I do not wish to convince, I have no right to drag others into my river, I oblige no one to follow me and everybody practices his art in his own way, if he knows the joy that rises like arrows to the astral layers, or that other joy that goes down into the mines of corpse-flowers and fertile spasms. Stalactites: seek them everywhere, in managers magnified by pain, eyes white as the hares of the angels.

And so Dada was born of a need for independence, of a distrust toward unity. Those who are with us preserve their freedom. We recognize no theory. We have enough cubist and futurist academies: laboratories of formal ideas. Is the aim of art to make money and cajole the nice nice bourgeois? Rhymes ring with the assonance of the currencies and the inflexion slips along the line of the belly in profile. All groups of artists have arrived at this trust company after riding their steeds on various comets. While the door remains open to the possibility of wallowing in cushions and good things to eat. [. . .]

Cubism was born out of the simple way of looking at an object: Cézanne painted a cup 20 centimeters below his eyes, the cubists look at it from above, others complicate appearance by making a perpendicular section and arranging it conscientiously on the side. (I do not forget the creative artists and the profound laws of matter which they established once and for all.) The futurist sees the same cup in movement, a succession of objects one beside the other, and maliciously adds a few force lines. This does not prevent the canvas from being a good or bad painting suitable for the investment of intellectual capital.

The new painter creates a world, the elements of which are also its implements, a sober, definite work without argument. The new artist protests: he no longer paints (symbolic and illusionist reproduction) but creates – directly in stone, wood, iron, tin, boulders – locomotive organisms capable of being turned in all directions by the limpid wind of momentary sensation. All pictorial or plastic work is useless: let it then be a monstrosity that frightens servile minds, and not sweetening to decorate the refectories of animals in human costume, illustrating the sad fable of mankind. –

* * *

Philosophy is the question: from which side shall we look at life, God, the idea or other phenomena. Everything one looks at is false. I do not consider the relative result more important than the choice between cake and cherries after dinner. The system of quickly looking at the other side of a thing in order to impose your opinion indirectly is called dialectics, in other words, haggling over the spirit of fried potatoes while dancing method around it.

If I cry out:

> *Ideal, ideal, ideal,*
> *Knowledge, knowledge, knowledge,*
> *Boomboom, boomboom, boomboom,*

I have given a pretty faithful version of progress, law, morality and all other fine qualities that various highly intelligent men have discussed in so many books, only to conclude that after all everyone dances to his own personal boomboom, and that the writer is entitled to his boomboom: the satisfaction of pathological curiosity; a private bell for inexplicable needs; a bath; pecuniary difficulties; a stomach with repercussions in life; the authority of the mystic wand formulated as the bouquet of a phantom orchestra made up of silent fiddle bows greased with philtres made of chicken manure. With the blue eye-glasses of an angel they have excavated the inner life for a dime's worth of unanimous gratitude. If all of them are right and if all pills are Pink Pills, let us try for once not to be right. Some people think they can explain rationally, by thought, what they think. But that is extremely relative. Psychoanalysis is a dangerous disease, it

puts to sleep the anti-objective impulses of man and systematizes the bourgeoisie. There is no ultimate Truth. The dialectic is an amusing mechanism which guides us / in a banal kind of way / to the opinions we had in the first place. Does anyone think that, by a minute refinement of logic, he had demonstrated the truth and established the correctness of these opinions? Logic imprisoned by the senses is an organic disease. To this element philosophers always like to add: the power of observation. But actually this magnificent quality of the mind is the proof of its impotence. We observe, we regard from one or more points of view, we choose them among the millions that exist. Experience is also a product of chance and individual faculties. Science disgusts me as soon as it becomes a speculative system, loses its character of utility – that is so useless but is at least individual. I detest greasy objectivity, and harmony, the science that finds everything in order. Carry on, my children, humanity... Science says we are the servants of nature: everything is in order, make love and bash your brains in. Carry on, my children, humanity, kind bourgeois and journalist virgins... I am against systems, the most acceptable system is on principle to have none. To complete oneself, to perfect oneself in one's own littleness, to fill the vessel with one's individuality, to have the courage to fight for and against thought, the mystery of bread, the sudden burst of an infernal propeller into economic lilies [...]

Active Simplicity

Inability to distinguish between degrees of clarity: to lick the penumbra and float in the big mouth filled with honey and excrement. Measured by the scale of eternity, all activity is vain – (if we allow thought to engage in an adventure the result of which would be infinitely grotesque and add significantly to our knowledge of human impotence). But supposing life to be a poor farce, without aim or initial parturition, and because we think it our duty to extricate ourselves as fresh and clean as washed chrysanthemums, we have proclaimed as the sole basis for agreement: art. It is not as important as we, mercenaries of the spirit, have been proclaiming for centuries. Art afflicts no one and those who manage to take an interest in it will harvest caresses and a fine opportunity to populate the country with their conversation. Art is a private affair, the artist produces it for himself; an intelligible work is the product of a journalist, and because at this moment it strikes my fancy to combine this monstrosity with oil paints: a paper tube simulating the metal that is automatically pressed and poured hatred cowardice villainy. The artist, the poet rejoice at the venom of the masses condensed into a section chief of this industry, he is happy to be insulted: it is a proof of his immutability. When a writer or artist is praised by the newspapers, it is a proof of the intelligibility of his work: wretched lining of a coat for public use; tatters covering brutality, piss contributing to the warmth of an animal brooding vile instincts. Flabby, insipid flesh reproducing with the help of typographical microbes.

We have thrown out the cry-baby in us. Any infiltration of this kind is candied diarrhea. To encourage this act is to digest it. What we need is works that are strong straight precise and forever beyond understanding. Logic is a complication. Logic is always wrong. It draws the threads of notions, words, in their formal exterior, toward illusory ends and centers. Its chains kill, it is an enormous centipede stifling independence. Married to logic, art would live in incest, swallowing, engulfing its own tail, still part of its own body, fornicating within itself, and passion would become a nightmare

tarred with protestantism, a monument, a heap of ponderous gray entrails. But the suppleness, enthusiasm, even the joy of injustice, this little truth which we practise innocently and which makes us beautiful: we are subtle and our fingers are malleable and slippery as the branches of that sinuous, almost liquid plant; it defines our soul, say the cynics. That too is a point of view; but all flowers are not sacred, fortunately, and the divine thing in us is our call to anti-human action. I am speaking of a paper flower for the buttonholes of the gentlemen who frequent the ball of masked life, the kitchen of grace, white cousins lithe or fat. They traffic with whatever we have selected. The contradiction and unity of poles in a single toss can be the truth. If one absolutely insists on uttering this platitude, the appendix of a libidinous, malodorous morality. Morality creates atrophy like every plague produced by intelligence. The control of morality and logic has inflicted us with impassivity in the presence of policemen – who are the cause of slavery, putrid rats infecting the bowels of the bourgeoisie which have infected the only luminous clean corridors of glass that remained open to artists.

Let each man proclaim: there is a great negative work of destruction to be accomplished. We must sweep and clean. Affirm the cleanliness of the individual after the state of madness, aggressive complete madness of a world abandoned to the hands of bandits, who rend one another and destroy the centuries. Without aim or design, without organization: indomitable madness, decomposition. Those who are strong in words or force will survive, for they are quick in defense, the agility of limbs and sentiments flames on their faceted flanks.

Morality has determined charity and pity, two balls of fat that have grown like elephants, like planets, and are called good. There is nothing good about them. Goodness is lucid, clear and decided, pitiless toward compromise and politics. Morality is an injection of chocolate into the veins of all men. This task is not ordered by a supernatural force but by the trust of idea brokers and grasping academicians. Sentimentality: at the sight of a group of men quarreling and bored, they invented the calendar and the medicament wisdom. With a sticking of labels the battle of the philosophers was set off (mercantilism, scales, meticulous and petty measures) and for the second time it was understood that pity is a sentiment like diarrhea in relation to the disgust that destroys health, a foul attempt by carrion corpses to compromise the sun. I proclaim the opposition of all cosmic faculties to this gonorrhea of a putrid sun issued from the factories of philosophical thought, I proclaim bitter struggle with all the weapons of –

Dadaist Disgust

Every product of disgust capable of becoming a negation of the family is Dada; a protest with the fists of its whole being engaged in destructive action: *Dada; knowledge of all the means rejected up until now by the shamefaced sex of comfortable compromise and good manners: Dada; abolition of logic, which is the dance of those impotent to create: Dada; of every social hierarchy and equation set up for the sake of values by our valets: Dada; every object, all objects, sentiments, obscurities, apparitions and the precise clash of parallel lines are weapons for the fight: Dada; abolition of memory: Dada; abolition of archaeology: Dada; abolition of prophets: Dada; abolition of the future: Dada; absolute and unquestionable faith in every god that is the immediate product of spontaneity:* Dada; elegant and unprejudiced leap from a harmony to the other sphere; trajectory of a word tossed like a

screeching phonograph record; to respect all individuals in their folly of the moment: whether it be serious, fearful, timid, ardent, vigorous, determined, enthusiastic; to divest one's church of every useless cumbersome accessory; to spit out disagreeable or amorous ideas like a luminous waterfall, or coddle them – with the extreme satisfaction that it doesn't matter in the least – with the same intensity in the thicket of one's soul – pure of insects for blood well-born, and gilded with bodies of archangels. Freedom: Dada Dada Dada, a roaring of tense colors, and interlacing of opposites and of all contradictions, grotesques, inconsistencies:

LIFE

4 Richard Huelsenbeck (1892–1974) 'First German Dada Manifesto' ('Collective Dada Manifesto')

Having been active in Zurich Dada, Huelsenbeck returned to Germany in January 1917. Berlin Dada became the most explicitly political part of the movement, associated with German Bolshevism. This first manifesto nevertheless remains largely oriented to artistic struggles, simultaneously mounting an attack on the failure of Expressionism, and allying Dada with 'the new medium', viz. collage and montage. It was delivered at the I. B. Neumann gallery in Berlin in February 1918, and originally published in *Der Zweemann*, Hanover, *c*.1919; reprinted in Huelsenbeck (ed.), *Dada Almanach*, Berlin, 1920. It was then reissued in 1920 as 'Collective Dada Manifesto' signed by: Huelsenbeck, Tristan Tzara, Franz Jung, George Grosz, Marcel Janco, Raoul Hausmann, Hugo Ball, Pierre Albert-Birot, Hans Arp et al. The present translation by Ralph Mannheim is taken from Motherwell, op. cit., pp. 242–6.

Art in its execution and direction is dependent on the time in which it lives, and artists are creatures of their epoch. The highest art will be that which in its conscious content presents the thousandfold problems of the day, the art which has been visibly shattered by the explosions of last week, which is forever trying to collect its limbs after yesterday's crash. The best and most extraordinary artists will be those who every hour snatch the tatters of their bodies out of the frenzied cataract of life, who, with bleeding hands and hearts, hold fast to the intelligence of their time. Has expressionism fulfilled our expectations of such an art, which should be an expression of our most vital concerns?

No! No! No!

Have the expressionists fulfilled our expectations of an art that burns the essence of life into our flesh?

No! No! No!

Under the pretext of turning inward, the expressionists in literature and painting have banded together into a generation which is already looking forward to honorable mention in the histories of literature and art and aspiring to the most respectable civic distinctions. On pretext of carrying on propaganda for the soul, they have, in their struggle with naturalism, found their way back to the abstract, pathetic gestures which

presuppose a comfortable life free from content or strife. The stages are filling up with kings, poets and Faustian characters of all sorts; the theory of a melioristic philosophy, the psychological naiveté of which is highly significant for a critical understanding of expressionism, runs ghostlike through the minds of men who never act. Hatred of the press, hatred of advertising, hatred of sensations are typical of people who prefer their armchair to the noise of the street, and who even make it a point of pride to be swindled by every smalltime profiteer. That sentimental resistance to the times, which are neither better nor worse, neither more reactionary nor more revolutionary than other times, that weak-kneed resistance, flirting with prayers and incense when it does not prefer to load its cardboard cannon with Attic iambics – is the quality of a youth which never knew how to be young. Expressionism, discovered abroad, and in Germany, true to style, transformed into an opulent idyll and the expectation of a good pension, has nothing in common with the efforts of active men. The signers of this manifesto have, under the battle cry:

Dada!!!!!

gathered together to put forward a new art, from which they expect the realization of new ideals. What then is DADAISM?

The word Dada symbolizes the most primitive relation to the reality of the environment; with Dadaism a new reality comes into its own. Life appears as a simultaneous muddle of noises, colors and spiritual rhythms, which is taken unmodified into Dadaist art, with all the sensational screams and fevers of its reckless everyday psyche and with all its brutal reality. This is the sharp dividing line separating Dadaism from all artistic directions up until now and particularly from FUTURISM which not long ago some puddingheads took to be a new version of impressionist realization. Dadaism for the first time has ceased to take an aesthetic attitude toward life, and this it accomplishes by tearing all the slogans of ethics, culture and inwardness, which are merely cloaks for weak muscles, into their components.

The Bruitist poem

represents a streetcar as it is, the essence of the streetcar with the yawning of Schulze the coupon clipper and the screeching of the brakes.

The Simultaneist poem

teaches a sense of the merrygoround of all things; while Herr Schulze reads his paper, the Balkan Express crosses the bridge at Nish, a pig squeals in Butcher Nuttke's cellar.

The Static poem

makes words into individuals, out of the letters spelling woods, steps the woods with its treetops, liveried foresters and wild sows, maybe a boarding house steps out too, and maybe it's called Bellevue or Bella Vista. Dadaism leads to amazing new possibilities and forms of expression in all the arts. It made cubism a dance on the stage, it disseminated the BRUITIST music of the futurists (whose purely Italian concerns it

has no desire to generalize) in every country in Europe. The word Dada in itself indicates the internationalism of the movement which is bound to no frontiers, religions or professions. Dada is the international expression of our times, the great rebellion of artistic movements, the artistic reflex of all these offensives, peace congresses, riots in the vegetable market, midnight suppers at the Esplanade, etc., etc. Dada champions the use of the

new medium in painting.

Dada is a CLUB, founded in Berlin, which you can join without commitments. In this club every man is chairman and every man can have his say in artistic matters. Dada is not a pretext for the ambition of a few literary men (as our enemies would have you believe), Dada is a state of mind that can be revealed in any conversation whatever, so that you are compelled to say: this man is a DADAIST – that man is not; the Dada Club consequently has members all over the world, in Honolulu as well as New Orleans and Meseritz. Under certain circumstances to be a Dadaist may mean to be more a businessman, more a political partisan than an artist – to be an artist only by accident – to be a Dadaist means to let oneself be thrown by things, to oppose all sedimentation; to sit in a chair for a single moment is to risk one's life (Mr Wengs pulled his revolver out of his pants pocket). A fabric tears under your hand, you say yes to a life that strives upward by negation. Affirmation – negation: the gigantic hocuspocus of existence fires the nerves of the true Dadaist – and there he is, reclining, hunting, cycling – half Pantagruel, half St Francis, laughing and laughing. Blast the aesthetic-ethical attitude! Blast the bloodless abstraction of expressionism! Blast the literary hollowheads and their theories for improving the world! For Dadaism in word and image, for all the Dada things that go on in the world! To be against this manifesto is to be a Dadaist!

5 Richard Huelsenbeck (1892–1974) and Raoul Hausmann (1886–1971) 'What is Dadaism and what does it want in Germany?'

The First German Dada Manifesto emphasized 'movement' and 'struggle'. The remaining requirement for a 'program of action' was fulfilled by the present manifesto. Its utopian character is evident. Some erstwhile Dadaists such as Grosz and Heartfield rapidly took the more practical step of joining the German Communist Party (KPD) at its foundation in January 1919. The manifesto appeared in *Der Dada*, no. 1, 1919, where it was co-signed by Jefim Golyscheff, and was reprinted in Huelsenbeck's *En Avant Dada*, Hanover, 1920. The present translation by Ralph Mannheim is from Motherwell, op. cit., pp. 41–2.

1 Dadaism demands:

1) The international revolutionary union of all creative and intellectual men and women on the basis of radical Communism;
2) The introduction of progressive unemployment through comprehensive mechanization of every field of activity. Only by unemployment does it become possible for the individual to achieve certainty as to the truth of life and finally become accustomed to experience;
3) The immediate expropriation of property (socialization) and the communal feeding of all; further, the erection of cities of light, and gardens which will belong to society as a whole and prepare man for a state of freedom.

2 *The Central Council demands:*

a) Daily meals at public expense for all creative and intellectual men and women on the Potsdamer Platz (Berlin);

b) Compulsory adherence of all clergymen and teachers to the Dadaist articles of faith;

c) The most brutal struggle against all directions of so-called 'workers of the spirit' (Hiller, Adler), against their concealed bourgeoisism, against expressionism and post-classical education as advocated by the Sturm group;

d) The immediate erection of a state art center, elimination of concepts of property in the new art (expressionism); the concept of property is entirely excluded from the super-individual movement of Dadaism which liberates all mankind;

e) Introduction of the simultaneist poem as a Communist state prayer;

f) Requisition of churches for the performance of bruitism, simultaneist and Dadaist poems;

g) Establishment of a Dadaist advisory council for the remodelling of life in every city of over 50,000 inhabitants;

h) Immediate organization of a large scale Dadaist propaganda campaign with 150 circuses for the enlightenment of the proletariat;

i) Submission of all laws and decrees to the Dadaist central council for approval;

j) Immediate regulation of all sexual relations according to the views of international Dadaism through establishment of a Dadaist sexual center.

The Dadaist revolutionary central council.
German group: Hausmann, Huelsenbeck
Business Office: Charlottenburg, Kantstrasse 118.
Applications for membership taken at business office.

6 Richard Huelsenbeck (1892–1974) from *En Avant Dada*

Huelsenbeck wrote a major article surveying the history of the Dada movement from its inception in Zurich to its virtual dissolution by 1920. The closing passages, reprinted here, repeat the alignment of Dada to Bolshevism while reserving to it a wider programme than mere economic amelioration. The article is also suspicious of the widespread ethos of (re-) construction, and maintains a hostile attitude to both German and French national traditions in culture. Originally published as *En Avant Dada: Eine Geschichte des Dadaismus*, Hanover, 1920. This extract is taken from the translation by Ralph Mannheim in Motherwell, op. cit., pp. 42–5.

[. . .] In an article on expressionism Kornfeld makes the distinction between the ethical man and the psychological man. The ethical man has the child-like piety and faith which permit him to kneel at some altar and recognize some God, who has the power to lead men from their misery to some paradise. The psychological man has journeyed vainly through the infinite, has recognized the limits of his spiritual possibilities, he knows that every 'system' is a seduction with all the consequences of seduction and every God an opportunity for financiers.

The Dadaist, as the psychological man, has brought back his gaze from the distance and considers it important to have shoes that fit and a suit without holes in it. The Dadaist is an atheist by instinct. He is no longer a metaphysician in the sense of finding a rule for the conduct of life in any theoretical principles, for him there is no longer a 'thou shalt'; for him the cigarette-butt and the umbrella are as exalted and as timeless as the 'thing in itself.' Consequently, the good is for the Dadaist no 'better' than the bad – there is only a simultaneity, in values as in everything else. This simultaneity applied to the economy of facts is communism, a communism, to be sure, which has abandoned the principle of 'making things better' and above all sees its goal in the destruction of everything that has gone bourgeois. Thus the Dadaist is opposed to the idea of paradise in every form, and one of the ideas farthest from his mind is that 'the spirit is the sum of all means for the improvement of human existence.' The word 'improvement' is in every form unintelligible to the Dadaist, since behind it he sees a hammering and sawing on this life which, though useless, aimless and vile, represents as such a thoroughly spiritual phenomenon, requiring no improvement in a metaphysical sense. To mention spirit and improvement in the same breath is for the Dadaist a blasphemy. 'Evil' has a profound meaning, the polarity of events finds in it a limit, and though the real political thinker (such as Lenin seems to be) creates a movement, i.e., he dissolves individualities with the help of a theory, he changes nothing. And that, as paradoxical as it may seem, is the import of the Communist movement.

The Dadaist exploits the psychological possibilities inherent in his faculty for flinging out his own personality as one flings a lasso or lets a cloak flutter in the wind. He is not the same man today as tomorrow, the day after tomorrow he will perhaps be 'nothing at all,' and then he may become everything. He is entirely devoted to the movement of life, he accepts its angularity – but he never loses his distance to phenomena, because at the same time he preserves his creative indifference, as Friedlaender-Mynona calls it. It seems scarcely credible that anyone could be at the same time active and at rest, that he should be devoted, yet maintain an attitude of rejection; and yet it is in this very anomaly that life itself consists, naive, obvious life, with its indifference toward happiness and death, joy and misery. The Dadaist is naive. The thing he is after is obvious, undifferentiated, unintellectual life. For him a table is not a mouse-trap and an umbrella is definitely not to pick your teeth with. In such a life art is no more and no less than a psychological problem. In relation to the masses, it is a phenomenon of public morality.

The Dadaist considers it necessary to come out against art, because he has seen through its fraud as a moral safety valve. Perhaps this militant attitude is a last gesture of inculcated honesty, perhaps it merely amuses the Dadaist, perhaps it means nothing at all. But in any case, art (including culture, spirit, athletic club), regarded from a serious point of view, is a large-scale swindle. And this . . . most especially in Germany, where the most absurd idolatry of all sorts of divinities is beaten into the child in order that the grown man and taxpayer should automatically fall on his knees when, in the interest of the state or some smaller gang of thieves, he receives the order to worship some 'great spirit.' I maintain again and again: the whole spirit business is a vulgar utilitarian swindle. In this war the Germans (especially in Saxony where the most infamous hypocrites reside) strove to justify themselves at home and abroad with Goethe and Schiller. Culture can be designated solemnly and with complete naivety as the national spirit become form, but also it can be characterized as a compensatory phenomenon, an obeisance to an invisible judge, as veronal for the conscience. The

Germans are masters of dissembling, they are unquestionably the magicians (in the vaudeville sense) among nations, in every moment of their life they conjure up a culture, a spirit, a superiority which they can hold as a shield in front of their endangered bellies. It is this hypocrisy that has always seemed utterly foreign and incomprehensible to the French, a sign of diabolical malice. The German is unnaive, he is twofold and has a double base.

Here we have no intention of standing up for any nation. The French have the least right of anyone to be praised as a *grande nation*, now that they have brought the chauvinism of our times to its greatest possible height. The German has all the qualities and drawbacks of the idealist. You can look at it whichever way you like. You can construe the idealism that distorts things and makes them function as an absolute (the discipline of corpses) whether it be vegetarianism, the rights of man or the monarchy, as a pathological deformation, or you can call it ecstatically 'the bridge to eternity,' 'the goal of life,' or more such platitudes. The expressionists have done quite a bit in that direction. The Dadaist is instinctively opposed to all this. He is a man of reality who loves wine, women and advertising, his culture is above all of the body. *Instinctively he sees his mission in smashing the cultural ideology of the Germans.* I have no desire to justify the Dadaist. He acts instinctively, just as a man might say he was a thief out of 'passion,' or a stamp-collector by preference. The 'ideal' has shifted: the abstract artist has become (if you insist, dear reader) a wicked materialist, with the abstruse characteristic of considering the care of his stomach and stock jobbing more honorable than philosophy. 'But that's nothing new,' those people will shout who can never tear themselves away from the 'old.' But it is something startlingly new, since for the first time in history the consequence has been drawn from the question: What is German culture? (Answer: Shit), and this culture is attacked with all the instruments of satire, bluff, irony and finally, violence. And in a great common action.

Dada is German Bolshevism. The bourgeois must be deprived of the opportunity to 'buy up art for his justification.' Art should altogether get a sound thrashing, and Dada stands for the thrashing with all the vehemence of its limited nature. The technical aspect of the Dadaist campaign against German culture was considered at great length. Our best instrument consisted of big demonstrations at which, in return for a suitable admission fee, everything connected with spirit, culture and inwardness was symbolically massacred. It is ridiculous and a sign of idiocy exceeding the legal limit to say that Dada (whose actual achievements and immense success cannot be denied) is 'only of negative value.' Today you can hardly fool first-graders with the old saw about positive and negative.

The gentlemen who demand the 'constructive' are among the most suspicious types of a caste that has long been bankrupt. It has become sufficiently apparent in our time that law, order and the constructive, the 'understanding for an organic development,' are only symbols, curtains and pretexts for fat behinds and treachery. If the Dadaist movement is nihilism, then nihilism is a part of life, a truth which would be confirmed by any professor of zoology. Relativism, Dadaism, Nihilism, Action, Revolution, Gramophone. It makes one sick at heart to hear all that together, and as such (insofar as it becomes visible in the form of a theory), it all seems very stupid and antiquated. Dada does not take a dogmatic attitude. If Knatschke proves today that Dada is old stuff, Dada doesn't care. A tree is old stuff too, and people eat dinner day after day without experiencing any particular disgust. This whole physiological attitude toward

the world, that goes so far as to make – as Nietzsche the great philologist did – all culture depend on dry or liquid nutriment, is of course to be taken with a grain of salt. It is just as true and just as silly as the opposite. But we are after all human and commit ourselves by the mere fact of drinking coffee today and tea tomorrow. Dada foresees its end and laughs. Death is a thoroughly Dadaist business, in that it signifies nothing at all. Dada has the right to dissolve itself and will exert this right when the time comes. With a businesslike gesture, freshly pressed pants, a shave and a haircut, it will go down into the grave, after having made suitable arrangements with the Thanatos Funeral Home. The time is not far distant. We have very sensitive fingertips and a larynx of glazed paper. The mediocrities and the gentry in search of 'something mad' are beginning to conquer Dada. At every corner of our dear German fatherland, literary cliques, with Dada as a background, are endeavoring to assume a heroic pose. A movement must have sufficient talent to make its decline interesting and pleasant. In the end it is immaterial whether the Germans keep on with their cultural humbug or not. Let them achieve immortality with it. But if Dada dies here, it will some day appear on another planet with rattles and kettledrums, pot covers and simultaneous poems, and remind the old God that there are still people who are very well aware of the complete idiocy of the world.

7 Alexander Blok (1880–1921) 'The Decline of Humanism'

Almost alone in his milieu Blok allied himself with the Bolshevik revolution of October 1917. His poem 'The Twelve' of January 1918 celebrates the struggle of a group of Red Guards through a blinding snowstorm; they are being led, the poem's conclusion discloses, by the figure of Jesus Christ carrying a red banner. This contemporaneous lecture was delivered on 9 April 1918. After it, Blok reportedly said, 'For me, it [the revolution] is not just a fundamental change in all our outward life but something much more. First of all, it is the birth of a new kind of man such has never been seen on earth before.' The present extract is taken from the translation by I. Frieman in Alexander Blok, *The Spirit of Music*, London, 1946, pp. 68–70. (See also IIA5.)

Every movement has its birth in the spirit of music, through which it acts, but after a lapse of time it degenerates and begins to lose the musical, the primal element out of which it was born and, as a result, perishes. It ceases to be culture and becomes civilization. Thus it was in the ancient world – thus it is with us.

The guardian of the spirit of music becomes just those elements to which music always reverts (*revertitur in terram suam unde erat*): namely the people or the barbaric masses. Those masses who have never had anything but the spirit to call their own remain, therefore, the guardians of culture in those epochs in which a limping and no longer resounding civilization has become the enemy of culture – and this in spite of the fact that civilization governs all the factors of progress such as science and technique and the rest. This is no paradox. A civilization dies and a new one, similar to the perishing movement, rises out of the same musical elements.

The culture of the future was not being nourished by the discordant efforts of civilization to remedy that which cannot be improved, not by resuscitating the dead, or by trying to unify Humanism anew, but by those synthesized, revolutionary exertions,

by those musical and will-stressed floods and forces to which Wagner, in particular, has given expression. The entire complicated system of poetic and musical rhythms (especially towards the end of the nineteenth century) against which the Philistines of Humanism took up a more and more hostile and stubborn attitude, was nothing but the musical preparation of a new cultural movement, a reflection of those elemental rhythms of nature out of which emerged the overture of the present epoch.

Music followed its accustomed ways. It floated like a shimmering cloud above the last of the Humanists and then, darkened, descended as rain or enveloped mankind of the nineteenth century in a shroud of mist through which those errant beings who had lost their way, called out trying to find each other.

In Europe's most important lyrics of those times the musical sounds perceived through rain and mist resounded. Under the sodden earth there trembled a musical rustling and roaring as the elemental voices of the barbaric masses and the utterances of the great artists of the century rose. That new flood, which had been flowing underground for a century, swelled more and more, breached the surface of civilization now here, now there, until with irresistible force it broke through, intoxicated and saturated with the spirit of music.

The civilized ear apprehended that music as a wild choir of discordant voices. For a great many the music of that time was intolerable, and I do not exaggerate by any means when I maintain that many of us, overwhelmed by it, broke down under its stridency. It was destructive of all those achievements of civilization which were considered unassailable. It ran counter to all our established melodies of 'Truth, Goodness and Beauty' and it confronted, almost with hostility, the education and cultural development which Humanist Europe had inherited from the preceding century.

It is an established fact that a new movement, hostile to the civilized world, extended itself, a movement which disrupted civilization and so shook the continent that at the very outset it resembled a group of scattered islands in danger of being swept away by the all-destroying flood. The most important things which civilization had produced, from the Humanistic viewpoint of ethics, aesthetics and justice, were menaced. As civilized Humanists we can never submit to the new movement's persuasion. But if we cannot submit, if we must cling rather to the values which the Humanistic civilization had proclaimed as indestructible, shall we not then soon be isolated from that culture and that world which perceives in the broken flood the rustling and roaring of the elemental music of the masses?

Man is animal; man is plant and flower; in him slumbers the beast, in him lives mimosa-like softness. Both are transitory appearances, sometimes masks. This flight of appearances involves a change of methods; *man's entire being is in revolt; he has risen from a century-long stupor of civilization. Spirit, soul and body have been caught up by the storm and, in the turmoil of the spiritual, political and social revolutions which have their causes in the cosmos, there takes place a transformation – the birth of the new man.*

I have attempted to determine the climacteric in the past of Humanism's decline. The artists who remained faithful to the spirit of music I look upon as witnesses of that decline because they participated in it. It is time to order and revalue that crisis according to these characteristics: according to its artistic sensibility and to the degree of perfection with which its rhythms mirrored the world's life. All other characteristics,

national characteristics not expected, are, to my mind, of secondary or of no consideration at all.

We Russians have no historical memories, but in us lives the elemental, and is sufficiently strong; it is still reserved for our immeasurable country to realize the significant. We have not heard of Petrarch or Hutten – only of the wind which courses across the steppes and the musical notes of our own wild nature which resound in the ears of Gogol, Tolstoy and Dostoyevsky.

I sum up and draw the conclusion that there can be no shadow of doubt as to the final outcome of the struggle and that a new movement, born out of the spirit of music, has taken the place of the old human civilization. So far, it still resembles a runaway stream which carries with it the debris of civilization. But already in this movement a metamorphosis out of which the new personality is to emerge is taking shape: not the ethical, political or humanist, being but, in the words of Wagner, the creative being, the artistic person, who alone will be capable of living life in the epoch of storms and whirlwinds into which mankind unwittingly has jettisoned itself.

8 Novembergruppe: Draft Manifesto 1918 and 'Guidelines' 1919

The Novembergruppe was an organization of artists formed on 3 December 1918 in response to the German revolution of November 1918. Leading figures included Max Pechstein and Cesar Klein. Others involved were Rudolf Belling, Heinrich Campendonk and Otto Müller. After the defeat of the Revolution, and the establishment of the bourgeois Weimar Republic, differences of opinion emerged about the group's role and commitments. These early statements mark the utopian moment of the group's enthusiastic foundation. The present translations are taken from V. H. Miesel (ed.), *Voices of German Expressionism*, Englewood Cliffs, NJ, 1970, pp. 169–70, 171.

Manifesto

We are standing on the fertile soil of the revolution.

Our slogan is: *Freedom, Equality, and Fraternity!*

We are uniting because we have human and artistic convictions in common.

We believe that our first duty is to dedicate all our energies to the moral regeneration of a young and free Germany.

We plead for excellence in all things and we shall support this plea with all the means at our disposal.

We insist upon an unlimited freedom of expression as well as public acknowledgement of it.

We believe it is our special duty to gather together all significant artistic talent and dedicate it to the collective well-being of the nation.

We belong to no party, no class. We are human beings, human beings who work tirelessly at the task appointed us by nature. It is a task, like any other if it is to benefit the whole *Volk*, which must take into consideration the general public good and requires the appreciation and recognition of that general public.

We respect every achievement in every sphere and we are of the opinion that the most competent men will assume the heaviest duties, submitting themselves to such duties for the sake and benefit of the whole *Volk*.

Our goal – each at his place in hard, tireless, collective, creative work.

We feel young, free, and pure.

Our spotless love belongs to a young, free Germany and we shall fight against all backwardness and reaction, bravely, without reserve, and with all the power at our command.

We send our fondest greetings to all those who have heard the call and feel responsible – Cubists, Futurists, and Expressionists. Join us!

Guidelines

I. *The November Group* is the (German) alliance of radical artists.

II. The *November Group* is not a union for the defence of economic interests, nor is it (merely) an association for exhibition purposes.

III. The *November Group* wishes to exercise a decisive influence upon all artistic matters by merging into a general alliance all like-minded creative forces.

IV. We demand a voice and an active role in:

1. All architectural projects as a matter of public concern: city planning, new settlements, the public buildings of government, industry and the social services, private building projects, the preservation of monuments, the suppression of artistically worthless architectural monuments.

2. The reorganization of art schools and their curricula: the suspension of authoritarian supervision, the election of teachers by artists' associations and students, the elimination of scholarships, the unification of architecture, sculpture, painting, and design schools, the establishment of studios for work and experimentation.

3. The transformation of museums: the suppression of biased collecting policies, the elimination of an overemphasis upon the acquiring of objects having only scholarly value; their transformation into people's art centres, unprejudiced centres of timeless principles.

4. The allotment of exhibition halls: the elimination of special privileges and capitalistic influences.

5. Legislation on artistic matters: giving artists equal rights as spiritual creators, the protection of artistic property, the elimination of all duties and taxes on works of art.

V. The *November Group* will demonstrate their solidarity and their achievement by continuous public announcements and by an annual exhibition in November. The central committee will supervise these continuing announcements and exhibitions. All members are entitled to equal exhibition space and will not be judged by any jury. The central committee will also arrange all special exhibits.

9 Novembergruppe Opposition: 'Open Letter to the Novembergruppe'

A Left Opposition to the Novembergruppe leadership coalesced as the group appeared to vacillate over its commitments to the Revolution. In artistic terms the Opposition was opposed to the individualism associated with Expressionism and sought to develop instead either a 'new objectivity' or a 'non-objective art'. Its 'Open Letter' was originally published in *Der Gegner*, II, nos. 8–9, June, 1921. The present translation was made by Elizabeth Lane-Thussu for the Open University, 1983.

> The present leaders of the November Group are continually insisting that the November Group is no more than a purely aesthetic-revolutionary organization, founded also for economic reasons. They are lying. The first circular, which called for its setting up, expressly stressed the 'revolutionary' artists' commitment to the Revolution. The first statement of aims begins with the sentences: 'At last our call to arms has been taken up. The Revolution has come down on our side. The Revolution demands that we painters, sculptors and architects of the new spirit join together!' [. . .]

The November Group was founded ostensibly by artists who wanted *to realize a revolutionary desire for a new ideal community and for cooperation with the working people*, free from the machinations of elitist art clubs and dealers' speculations. That is why young and proletarian-oriented artists joined up with the November Group. In innumerable meetings and statements they stressed that the November Group should only exclude the Right and in no way the Left. Not for a moment did any of the leading members seriously confront the problem of hierarchy common to all other bourgeois artists' groups, even with the awareness afforded them by the proletarian revolution – all they did was to confuse the issue with their slippery rhetoric, so that they could foster their own egos in the old sordid way of artists, by having the largest possible membership, a despised herd they looked down upon from the heights of their fame. [. . .]

Those at the top realized that *among the younger members there was a certain number who believed in the proletarian revolution, and felt the necessity of integrating artists into the body of the workers*; and that a certain section of the membership did not wish to be artists in the bourgeois-cultural sense, *because they saw the way to fulfil themselves not in promoting an apparently revolutionary aesthetic*, but instead sought the justification of the artist's existence as the instrument of the people's latent desires for a new, untainted way of life, and because they did not want to appear to be superior, conceited experts, dismissing in a high-handed way any attempts for a better way of working, condemning them on the basis of values borrowed from a bourgeois aesthetic. All the hopes and wishes of this section of the membership were squashed by these leaders, who used all kinds of dodges and misleading references to the 'well-known lack of unity among artists' on the one hand, and a brutal exploitation of their powers, on the other. [. . .]

What was the use of the revolutionary members demanding a clear-cut stand against the authorities over the pressures and difficulties they made with the November

Group's participation in the Great Berlin Art Exhibition at the Lehrter Bahnhof? None, because these leaders had their reputations and sinecures to protect despite the views of the group's vital forces. The Ministry had threatened not to open the November Group section if, as last year, works were exhibited which did not correspond with the authorities' ideas about art. So they submitted; the President of the Great Berlin Exhibition committee, Schlichting, mobilized a completely false moral campaign *against two pictures by Rudolf Schlichter and Otto Dix that didn't find favour with him*, threatened them with the Public Prosecutor, and even the Group, it appeared, had to submit; Reichspräsident Ebert sauntered through the galleries at the opening, showing the futility of the exercise. And these sycophants of artists were happy – their egos could bask in the presence of their 'rulers' – those lackeys of exploitation and supporters of courts martial.

These leading lights have received a box on the ears for their lack of principle, but we, who feel responsible for promoting an ideal society, have never had nor ever will have anything in common with them. Our love is for the proletariat, because only the proletariat will bring about, through communism, equality for all people and forms of work, and freedom from slavery and exploitation. We have not become artists in order to have a comfortable and irresponsible life, living off the exploiters' demand for luxury. *We feel solidarity with the proletariat's struggle* for the realization of a humane society, in which there is no oppression, in which we will not, as we do now, have the contradiction of working in opposition to society only to exist by its permission, like parasites.

We feel bound by the task laid on us by the world's proletariat in their struggle for a new existence inspired by a new spirit. We are aware of our duty to work together with the masses towards the achievement of this society. And so we say this to those prominent figures: *Our goal must be seen to be the overthrow of this aesthetic-formalistic pedantry, either by a new objectivity, born of a disgust with exploitative, bourgeois society; or by the explorative preliminary attempts of a non-objective art form* which is equally seeking a victory over individualism in rejecting this aesthetic and this society, to benefit a new kind of person. There is neither understanding nor room for these ideas in the November Group as it is presently constituted; the leaders dismiss such demands as *nonsensical rubbish* and on the contrary emphasize their own position, which comes close to being a *dictatorship of 'fashionable' people and businessmen* over the energetic, progressive members. The November Group should not let its name become a term for fellow-travellers, a label which could hang on for years, and we must resist this dictatorship, we must shake off these leaders and by our secession force other individuals to that decision. The actions of the leading figures who neither have ideas nor have ever been capable of leading, who suppress us out of pure self-interest, have resulted in the most deplorable compromises such as submitting to the orders of the Ministry of Culture and the Berlin Artists' Association; their actions have also led to the November Group being totally unaware of the public, although their sufferance of the efforts of the proletarian-minded artists has served to lend the group a revolutionary image; but they have stamped on all the progressive spirits in so far as there were any, instead of extending a friendly hand to them. But a group that is not capable these days of recognizing and adopting the strivings and goals of these independent spirits has no justification for its existence.

This is the decisive hour: *expressing the will of the people, carrying out productive work for a new, emerging community* demands relentless rejection of the trade in compromises. We call on those members who grasp *that today Art means protest against the sleep-walking bourgeoisie, against continual exploitation and philistinism, to join in our opposition* and help to carry out the necessary purge.

We know that we have to be the expression of the revolutionary forces, the instrument of the needs of the age and the people, and we reject any connection with the aesthetic profiteers and pedants from tomorrow onwards. We must bear witness to the revolution, to the new society, and this must be no mere lip-service, and so we want to put our explicit aims into effect, to co-operate in establishing the new humane society, the community of workers!

The November Group Opposition:
Otto Dix, Max Dungert, George Grosz, Raoul Hausmann, Hanna Höch, Ernst Krantz, Mutzenbecher, Thomas Ring, Rudolf Schlichter, Georg Scholz, Willy Zierath.

10 Walter Gropius (1883–1969) Reply to Arbeitsrat für Kunst Questionnaire

In early 1919 a questionnaire was circulated by the Arbeitsrat für Kunst (Workers' Council for Art), an artists' organization, like the Novembergruppe generated by the November Revolution. Thirteen questions addressed issues ranging from art education and public housing to the best ways for modern art to 'harmonize' with the people. Gropius, founder and director of the Bauhaus (see IIIC15), was at this time a member of the Arbeitsrat, and succeeded Bruno Taut as Chairman in March 1919. His answers to questions V and VI concerned the position of the artist in a socialist state and the nature and role of art exhibitions. Originally published in *Yes! Voices of the Workers' Council for Art*, Berlin, 1919. The present translation is taken from Miesel, op. cit., pp. 173–4.

V. Art and state are irreconcilable concepts. They are by their very nature opposed. The creative spirit, vital and dynamic, unique and unpredictable, refuses to be limited by the laws of the state or by the straitjacket of bourgeois values. And if the state uses force to interfere with the free development of such 'abnormal' creators it is actually cutting its own life's blood supply. Thus our age is suffocated by a world of shopkeepers, is trapped in a quagmire of materialism. The real task of socialism is to destroy the evil demon of commercialism in order that the creative spirit of the *Volk* might once more flourish. The mentality of our nation has already been profoundly shaken by the recent disaster and after the total collapse of the old life it has been made so sensitive that it might make Germany more receptive to the new spirit than any of the other European nations. For war, hunger, and pestilence have jarred us out of our obstinacy, they have aroused us out of our inertia and self-satisfaction, they have finally awakened our sleepy and lazy hearts. Through pain we have been taught once again to feel. Feeling is, after all, the source of inspiration, feeling leads to finding, to that creative power which organizes and structures, in short – in the broadest sense – to a passion for building. And this passion for building, for structure – *this architectural*

spirit – is the natural antithesis to the world of shopkeepers, to the spirit of disintegration and destruction which is the deadly enemy of all art.

VI. Art exhibitions are the misbegotten creatures of an art-starved Europe. Since art is dead in the actual life of civilized nations it has been relegated to these grotesque morgues and there prostituted. Today a work of art no longer occupies a well-defined and hallowed place in the midst of the *Volk*, it is free as a bird and has become merely a luxury object in the salons of the bourgeoisie. An art exhibition is its warehouse and market. The *Volk* leaves empty-handed and has no conception of a living art. Therefore, in place of the old salon art exhibition, let us have *traveling art shows* in temporary, brightly painted huts or even tents, shows featuring not only paintings and sculptures but also architectural models, large and small or stereo and cinematic presentations of architecture. The task of future art exhibitions is to show painting and sculpture in the context of architecture, to show how they function in buildings and thus to make art once again living and vital.

11 Max Beckmann (1884–1950) 'Creative Credo'

The author was invalided out of the German Army in 1915. His 'Credo' was composed in 1918 at the moment of the Empire's defeat and the subsequent revolution of November 1918, but before the defeat of the revolution and the establishment of the Weimar Republic, which took place in 1919. Originally published in Kasimir Edschmid (ed.), *Schöpferische Konfession, Tribüne der Kunst und Zeit*, XIII, Berlin, 1920. The present translation is taken from Miesel, op. cit., pp. 107–9.

I paint and I'm satisfied to let it go at that since I'm by nature tongue-tied and only a terrific interest in something can squeeze a few words out of me.

Nowadays whenever I listen to painters who have a way with words, frequently with real astonishment, I become a little uneasy about whether I can find language beautiful and spirited enough to convey my enthusiasm and passion for the objects of the visible world. However, I've finally calmed myself about this. I'm now satisfied to tell myself: 'You are a painter, do your job and let those who can, talk.' I believe that essentially I love painting so much because it forces me to be objective. There is nothing I hate more than sentimentality. The stronger my determination grows to grasp the unutterable things of this world, the deeper and more powerful the emotion burning inside me about our existence, the tighter I keep my mouth shut and the harder I try to capture the terrible, thrilling monster of life's vitality and to confine it, to beat it down and to strangle it with crystal-clear, razor-sharp lines and planes.

I don't cry. I hate tears, they are a sign of slavery. I keep my mind on my business – on a leg, on an arm, on the penetration of the surface thanks to the wonderful effects of foreshortening, on the partitioning of space, on the relationship of straight and curved lines, on the interesting placement of small, variously and curiously shaped round forms next to straight and flat surfaces, walls, tabletops, wooden crosses, or house façades. Most important for me is volume, trapped in height and width; volume on the plane, depth without losing the awareness of the plane, the architecture of the picture.

Piety? God? Oh beautiful, much misused words. I'm both when I have done my work in such a way that I can finally die. A painted or drawn hand, a grinning or

weeping face, that is my confession of faith; if I have felt anything at all about life it can be found there.

The war has now dragged to a miserable end. But it hasn't changed my ideas about life in the least, it has only confirmed them. We are on our way to very difficult times. But right now, perhaps more than before the war, I need to be with people. In the city. That is just where we belong these days. We must be a part of all the misery which is coming. We have to surrender our heart and our nerves, we must abandon ourselves to the horrible cries of pain of a poor deluded people. Right now we have to get as close to the people as possible. It's the only course of action which might give some purpose to our superfluous and selfish existence – that we give people a picture of their fate. And we can only do that if we love humanity.

Actually it's stupid to love mankind, nothing but a heap of egoism (and we are a part of it too). But I love it anyway. I love its meanness, its banality, its dullness, its cheap contentment, and its oh-so-very-rare heroism. But in spite of this, every single person is a unique event, as if he had just fallen from a star. And isn't the city the best place to experience this? They say that the air in the country is cleaner and that there are fewer temptations. But I believe that dirt is the same wherever you are. Cleanliness is a matter of the will. Farmers and landscapes are all very beautiful and occasionally even refreshing. But the great orchestra of humanity is still in the city.

What was really unhealthy and disgusting before the war was that business interests and a mania for success and influence had infected all of us in one form or another. Well, we have had four years of staring straight into the stupid face of horror. Perhaps a few people were really impressed. Assuming, of course, anyone had the slightest inclination to be impressed.

Complete withdrawal in order to achieve that famous purity people talk about as well as the loss of self in God, right now all that is too bloodless and also loveless for me. You don't dare do that kind of thing until your work is finished and our work is painting.

I certainly hope we are finished with much of the past. Finished with the mindless imitation of visible reality; finished with feeble, archaistic, and empty decoration, and finished with that false, sentimental, and swooning mysticism! I hope we will achieve a transcendental objectivity out of a deep love for nature and mankind. The sort of thing you can see in the art of Mälesskircher, Grünewald, Breughel, Cézanne, and Van Gogh.

Perhaps with the decline of business, perhaps (something I hardly dare hope) with the development of communism, the love of objects for their own sake will become stronger. I believe this is the only possibility open to us for achieving a great universal style.

That is my crazy hope which I can't give up, which in spite of everything is stronger in me than ever before. And someday I want to make buildings along with my pictures. To build a tower in which mankind can shriek out its rage and despair and all their poor hopes and joys and wild yearning. A new church. Perhaps this age may help me.

12 Max Pechstein (1881–1955) 'Creative Credo'

An Expressionist painter since the formation of the Brücke group in Dresden in 1905 (see IB4), Pechstein here offers a singularly expressionist 'Credo'. His individualism would at

this date (1920) have sat in a somewhat strained relationship with the more overtly left-wing elements of the post-war German avant-garde. Originally published in Edschmid, op. cit. The present translation is taken from Miesel, op. cit., pp. 180–1.

Work!
Ecstasy! Smash your brains! Chew, stuff your self, gulp it down, mix it around! The bliss of giving birth! The crack of the brush, best of all as it stabs the canvas. Tubes of color squeezed dry. And the body?
 It doesn't matter.
 Health?
 Make yourself healthy!
 Sickness doesn't exist! Only work and I'll say that again – only blessed work! Paint! Dive into colors, roll around in tones! in the slush of chaos! Chew the broken-off mouthpiece of your pipe, press your naked feet into the earth. Crayon and pen pierce sharply into the brain, they stab into every corner, furiously they press into the whiteness. Black laughs like the devil on paper, grins in bizarre lines, comforts in velvety planes, excites and caresses. The storm roars – sand blows about – the sun shatters to pieces – and nevertheless, the gentle curve of the horizon quietly embraces everything.
 Beaten down, exhausted, just a worm, collapse into your bed. A deep sleep will make you forget your defeat. A new day! A new struggle! Ecstasy again! One day after the other, a sparkling, constantly changing chain of days. One experience after the other. That damned brain! What is it that churns and twitches and jumps in there? Hah! Tear your head off, or grab it with both hands, turn it around, twist it off. Then we'll scrape it out and scratch it out. Get rid of every last little bit. Sand! Water! Scrub it clean. There now!! Almost as good as new! an unused skull. Night! Night! No stars, pitch black. Without desire!
 Tomorrow is another day.

13 George Grosz (1893–1959) 'My New Pictures'

Grosz had made a series of transitions, from an amalgam of Futurism and Expressionism, to Berlin Dada, and to membership of the German Communist Party on its foundation in January 1919. By 1920 he had virtually abandoned painting and had produced several portfolios of prints attacking bourgeois society. These were published by the Communist-oriented press Malik Verlag. The 'new pictures' to which he refers in this text of 1920 mark a resumption of painting in a style influenced on the one hand, ideologically, by the demands for a socialist objectivity, and on the other, technically, by the more traditional forms of pictorial space paradoxically exemplified in the concurrent work of conservatives like Carrà (IIIA4). Originally published in *Das Kunstblatt*, V, no. 1, Berlin, 1921. The present translation is taken from Miesel, op. cit., pp. 185–8. (For further texts by Grosz see IVB8 and IVC7.).

Today art is absolutely a secondary affair. Anyone able to see beyond their studio walls will admit this. Just the same, art is something which demands a clearcut decision from artists. You can't be indifferent about your position in this trade, about your attitude toward the problem of the masses, a problem which is no problem if you can see

straight. Are you on the side of the exploiters or on the side of the masses who are giving these exploiters a good tanning?

You can't avoid this issue with the old rigmarole about the sublimity and holiness and transcendental character of art. These days an artist is bought by the best-paying jobber or Maecenas – this business of commissions is called in a bourgeois state the advancement of culture. But today's painters and poets don't want to know anything at all about the masses. How else can you explain the fact that virtually nothing is exhibited which in any way reflects the ideals and efforts, the will of the aspiring masses.

The artistic revolutions of painters and poets are certainly interesting and aesthetically valuable – but still, in the last analysis, they are studio problems and many artists who earnestly torment themselves about such matters end up by succumbing to skepticism and bourgeois nihilism. This happens because persisting in their individualistic artistic eccentricities they never learn to understand revolutionary issues with any clarity; in fact, they rarely bother with such things. Why, there are even art-revolutionary painters who haven't freed themselves from painting Christ and the apostles; now, at the very time when it is their revolutionary duty to double their efforts at propaganda in order to purify the world of supernatural forces, God and His angels, and thereby sharpen mankind's awareness of its true relationship to the world. Those symbols, long since exhausted, and the mystical raptures of that stupid saint hocus-pocus, today's painting is full of that stuff and what can it possibly mean to us? All this painted nonsense certainly can't stand up to reality. Life is much too strong for it.

What should you do to give content to your paintings?

Go to a proletarian meeting; look and listen how people there, people just like you, discuss some small improvement of their lot.

And understand – these masses are the ones who are reorganizing the world. Not you! But you can work with them. You could help them if you wanted to! And that way you could learn to give your art a content which was supported by the revolutionary ideals of the workers.

As for my works in this issue, I want to say the following: I am again trying to give an absolutely realistic picture of the world. I want every man to understand me – without that profundity fashionable these days, without those depths which demand a veritable diving outfit stuffed with cabalistic and metaphysical hocus-pocus. In my efforts to develop a clear and simple style I can't help drawing closer to Carrà. Nevertheless, everything which is metaphysical and bourgeois about Carrà's work repels me. My work should be interpreted as training, as a hard workout, without any vision into eternity! I am trying in my so-called works of art to construct something with a completely realistic foundation. Man is no longer an individual to be examined in subtle psychological terms, but a collective, almost mechanical concept. Individual destiny no longer matters. Just as the ancient Greeks, I would like to create absolutely simple sport symbols which would be so easily understood that no commentary would be necessary.

I am suppressing colour. Lines are used in an impersonal, photographic way to construct volumes. Once more stability, construction, and practical purpose – e.g., sport, engineer, and machine but devoid of Futurist romantic dynamism.

Once more to establish control over line and form – it's no longer a question of conjuring up on canvas brightly coloured Expressionistic soul-tapestries – the object-

ivity and clarity of an engineer's drawing is preferable to the uncontrolled twaddle of the cabala, metaphysics, and ecstatic saints.

It isn't possible to be absolutely precise when you write about your own work, especially if you're always in training – then each day brings new discoveries and a new orientation. But I would like to say one thing more: I see the future development of painting taking place in workshops, in pure craftsmanship, not in any holy temple of the arts. Painting is manual labor, no different from any other; it can be done well or poorly. Today we have a star system, so do the other arts – but that will disappear.

Photography will play an important role: nowadays a photographer can give you a better and cheaper picture of yourself than a painter. Besides, modern artists prefer to distort things after their own fashion – and they have a peculiar aversion to a good likeness. The anarchism of Expressionism must stop! Today painters are forced into this situation because they are unenlightened and have no links with working people. But a time will come when artists – instead of being scrubby bohemian anarchists – will be clean, healthy workers in a collectivistic community. Until this goal is realized by the working class the intellectual will remain cynical, skeptical, and confused. Not until then will art be able to break out of its narrow and shallow confines where it flows anaemically through the life of the 'upper ten-thousand', not until then will it become a great stream capable of nourishing all of working humanity. Then capitalism's mono- poly of spiritual things will be ended. –

And here also communism will lead to a truly classless society, to an enrichment and further development of humanity.

14 Francis Picabia (1879–1953) 'Thank you, Francis!'

The author passed through a succession of avant-garde styles before becoming a leading figure in international Dada, moving between Paris and New York. He founded the Dada review *391* in 1917 and edited it until 1924. The present text, which includes a refusal of the then ascendant classicism, was originally published as 'Francis Merci!' in *Littérature*, new series no. 8, Paris, January 1923. The present translation is taken from Lippard, 1971, op. cit. pp. 171–2.

One must become acquainted with everybody except oneself; one must not know which sex one belongs to; I do not care whether I am male or female, I do not admire men more than I do women. Having no virtues, I am assured of not suffering from them. Many people seek the road which can lead them to their ideal: I have no ideal; the person who parades his ideal is only an arriviste. Undoubtedly, I am also an arriviste, but my lack of scruples is an invention for myself, a subjectivity. Objectively it would consist of awarding myself the légion d'honneur, of wishing to become a minister or of plotting to get into the Institute! Well, for me, all that is shit!

What I like is to invent, to imagine, to make myself a new man every moment, then forget him, forget everything. We should be equipped with a special eraser, gradually effacing our works and the memory of them. Our brain should be nothing but a blackboard, or white, or, better, a mirror in which we would see ourselves for a moment, only to turn our backs on it two minutes later. My ambition is to be a man sterile for others; the man who sets himself up as a school disgusts me, he gives his

gonorrhea to artists for nothing and sells it as dearly as possible to amateurs. Actually, writers, painters, and other idiots have passed on the word to fight against the 'monsters,' monsters who, naturally, do not exist, who are pure inventions of man.

Artists are afraid; they whisper in each other's ears about a bogey man which might well prevent them from playing their dirty little tricks! No age, I believe, has been more imbecilic than ours. These gentlemen would have us believe that nothing is happening anymore; the train reversing its engines, it seems, is very pretty to look at, cows are no longer enough! The travelers to this backward Decanville are named: Matisse, Morandi, Braque, Picasso, Léger, de Segonzac, etc., etc. . . . What is funniest of all is that they accept, as stationmaster, Louis Vauxcelles, whose great black napkin contains only a foetus!

Since the war, a ponderous and half-witted sentiment of morality rules the entire world. The moralists never discern the moral facts of appearances, the Church for them is a morality like the morality of drinking water, or of not daring to wash one's ass in front of a parrot! All that is arbitrary; people with morals are badly informed, and those who are informed know that the others will not inform themselves.

There is no such thing as a moral problem; morality like modesty is one of the greatest stupidities. The asshole of morality should take the form of a chamber-pot, that's all the objectivity I ask of it.

This contagious disease called morality has succeeded in contaminating all of the so-called artistic milieux; writers and painters become serious people, and soon we shall have a minister of painting and literature; I don't doubt that there will be still more frightful asininities. The poets no longer know what to say, so some are becoming Catholics, others believers; these men manufacture their little scribblings as Félix Potin does his cold chicken preserves; people say that Dada is the end of romanticism, that I am a clown, and they cry long live classicism which will save the pure souls and their ambitions, the simple souls so dear to those afflicted by dreams of grandeur!

However, I do not abandon the hope that nothing is finished yet, I am here, and so are several friends who have a love of life, a life we do not know and which interests us for that very reason.

IIIC
Abstraction and Form

1 Hans Arp (1887–1966) Introduction to a Catalogue

Arp was born in Strasbourg to a German father and a French mother. Between 1900 and 1909 he studied art in Strasbourg, Weimar and Paris. His first experiments with abstraction were made in Switzerland soon afterwards. He was a founder-member of the Moderne Bund in Lucerne and a contributor to the *Blaue Reiter* almanac (see IB9, 10 and IIA10). The present catalogue introduction was written for an exhibition of the work of Arp, Otto van Rees and A. C. van Rees-Dutilh at the Galerie Tannert in Zurich in 1915. By this time Arp was familiar with the work of the Cubists and was making abstract collages of paper and fabric. His meeting with Sophie Tauber during the course of the exhibition encouraged his interest in abstract work and led to collaborative work on collages and embroideries. Both were to be associated with the Zurich Dada group, which formed among those associated with the Cabaret Voltaire after its foundation in February 1916 (see IIIB1). Our source for the text is the version printed in Stefanie Poley, *Hans Arp: Die Formensprache im plastischen Werk*, Stuttgart: Gerd Hatje, 1978, p. 109. It was translated for the present volume by Nicholas Walker.

The works presented here are constructions [*Bauten*] of lines, planes, forms, colours. They seek to approach the ineffable truth concerning mankind and the eternal. They turn away from everything egotistical in man. They express hatred for all shameless human limitations, hatred for pictures, for paintings.

The illusionistic images produced by the Greeks, and the illusionistic painting of the Renaissance, have led human beings to overestimate their own kind, have led to division and discord. We have proved incapable of employing the hands of our brothers as if they were our own, and they have become our enemies instead. Anonymity has been usurped by celebrity, by technical bravura. Wisdom has perished.

Wisdom was the feeling for what is high, great, broad, sharp, even, heavy, bright, light, colourful. And instead of displaying such feeling simply and directly, it has been replaced by and derived from subject-matter and a thousand other things, has been suffocated by quotidian trivialities and personal platitudes. Wisdom was the feeling for an essentially shared reality, for the mystical, for the indeterminate indeterminable, for the greatest determinacy of all. Representation is imitation, spectacle, rope-dancing. No one denies there are rope-dancers of varying degrees of ability. But art is reality, and the reality we share must assert itself beyond all particularity. The 'new art' is as new as the oldest pots and vessels, the oldest cities and laws, and has long been

practised by the oldest peoples of Asia, America, Africa, and most recently during the Gothic Age.

2 Man Ray (1890–1977) Statement

American by birth, though involved for most of his career with the European avant-garde centred in Paris, Man Ray is normally associated with his development of photographic techniques in the orbit first of Dada, and later of Surrealism. In this early statement he articulates a more orthodox formalist point of view. The 'Statement' was originally printed in 'The Forum Exhibition of Modern American Painters', Anderson Galleries, New York, March 1916. It is reproduced here from Lippard, 1971, op. cit., p. 156.

Throughout time painting has alternately been put to the service of the church, the state, arms, individual patronage, nature appreciation, scientific phenomena, anecdote and decoration.

But all the marvelous works that have been painted, whatever the sources of inspiration, still live for us because of absolute qualities they possess in common.

The creative force and the expressiveness of painting reside materially in the color and texture of pigment, in the possibilities of form invention and organization, and in the flat plane on which these elements are brought to play.

The artist is concerned solely with linking these absolute qualities directly to his wit, imagination, and experience, without the go-between of a 'subject.' Working on a single plane as the instantaneously visualizing factor, he realizes his mind motives and physical sensations in a permanent and universal language of color, texture, and form organization. He uncovers the pure plane of expression that has so long been hidden by the glazings of nature imitation, anecdote, and the other popular subjects.

Accordingly the artist's work is to be measured by the vitality, the invention, and the definiteness and conviction of purpose within its own medium.

3 Viktor Shklovsky (1893–1984) from 'Art as Technique'

The author was a participant in the Russian school of formalist linguistics which addressed crucial problems about the technical nature of art and literature in the years around the Revolution. Taking as his stalking-horse a Symbolist literary theory, Shklovsky outlines an opposing view of the nature of art. According to this, the purpose of art is 'de-familiarization'. As Shklovsky wrote elsewhere: 'A new form appears not in order to express a new content, but in order to replace an old form, which has already lost its artistic value.' Originally published as 'Iskusstvo kak priyom' in *Sborniki*, II, Petrograd, 1917. These excerpts are drawn from the English translation ('Art as Technique', or 'Art as Device') in L. T. Lemon and M. J. Reis (eds.), *Russian Formalist Criticism*, Lincoln, NE, 1965, pp. 5–24.

'Art is thinking in images.' This maxim, which even high school students parrot, is nevertheless the starting point for the erudite philologist who is beginning to put together some kind of systematic literary theory. The idea, originated in part by

Potebnya, has spread. 'Without imagery there is no art, and in particular no poetry,' Potebnya writes. And elsewhere, 'Poetry, as well as prose, is first and foremost a special way of thinking and knowing.'

Poetry is a special way of thinking; it is, precisely, a way of thinking in images, a way which permits what is generally called 'economy of mental effort,' a way which makes for 'a sensation of the relative ease of the process.' Aesthetic feeling is the reaction to this economy. This is how the academician Ovsyaniko-Kulikovsky, who undoubtedly read the works of Potebnya attentively, almost certainly understood and faithfully summarized the ideas of his teacher. Potebnya and his numerous disciples consider poetry a special kind of thinking – thinking by means of images; they feel that the purpose of imagery is to help channel various objects and activities into groups and to clarify the unknown by means of the known. [...]

'Without imagery there is no art' – 'Art is thinking in images.' These maxims have led to far-fetched interpretations of individual works of art. Attempts have been made to evaluate even music, architecture, and lyric poetry as imagistic thought. After a quarter of a century of such attempts Ovsyaniko-Kulikovsky finally had to assign lyric poetry, architecture, and music to a special category of imageless art and to define them as lyric arts appealing directly to the emotions. And thus he admitted an enormous area of art which is not a mode of thought. A part of this area, lyric poetry (narrowly considered), is quite like the visual arts; it is also verbal. But, much more important, visual art passes quite imperceptibly into nonvisual art; yet our perceptions of both are similar.

Nevertheless, the definition 'Art is thinking in images,' which means (I omit the usual middle terms of the argument) that art is the making of symbols, has survived the downfall of the theory which supported it. It survives chiefly in the wake of Symbolism, especially among the theorists of the Symbolist movement.

* * *

Potebnya's conclusion, which can be formulated 'poetry equals imagery,' gave rise to the whole theory that 'imagery equals symbolism,' that the image may serve as the invariable predicate of various subjects. [...] The conclusion stems partly from the fact that Potebnya did not distinguish between the language of poetry and the language of prose. Consequently, he ignored the fact that there are two aspects of imagery: imagery as a practical means of thinking, as a means of placing objects within categories; and imagery as poetic, as a means of reinforcing an impression. I shall clarify with an example. I want to attract the attention of a young child who is eating bread and butter and getting the butter on her fingers. I call, 'Hey, butterfingers!' This is a figure of speech, a clearly prosaic trope. Now a different example. The child is playing with my glasses and drops them. I call, 'Hey, butterfingers!' This figure of speech is a poetic trope. (In the first example, 'butterfingers' is metonymic; in the second, metaphoric – but this is not what I want to stress.)

Poetic imagery is a means of creating the strongest possible impression. As a method it is, depending upon its purpose, neither more nor less effective than other poetic techniques; it is neither more nor less effective than ordinary or negative parallelism, comparison, repetition, balanced structure, hyperbole, the commonly accepted rhetorical figures, and all those methods which emphasize the emotional effect of an expression (including words or even articulated sounds). But poetic imagery only externally resembles either the stock imagery of fables and ballads or thinking in images [...]

The law of the economy of creative effort is also generally accepted. [Herbert] Spencer wrote:

> On seeking for some clue to the law underlying these current maxims, we may see shadowed forth in many of them, the importance of economizing the reader's or the hearer's attention. To so present ideas that they may be apprehended with the least possible mental effort, is the desideratum towards which most of the rules above quoted point.... Hence, carrying out the metaphor that language is the vehicle of thought, there seems reason to think that in all cases the friction and inertia of the vehicle deduct from its efficiency; and that in composition, the chief, if not the sole thing to be done, is to reduce this friction and inertia to the smallest possible amount.

* * *

These ideas about the economy of energy, as well as about the law and aim of creativity, are perhaps true in their application to 'practical' language; they were, however, extended to poetic language. Hence they do not distinguish properly between the laws of practical language and the laws of poetic language. The fact that Japanese poetry has sounds not found in conversational Japanese was hardly the first factual indication of the differences between poetic and everyday language. Leo Jakubinsky has observed that the law of the dissimilation of liquid sounds does not apply to poetic language. This suggested to him that poetic language tolerated the admission of hard-to-pronounce conglomerations of similar sounds. In his article, one of the first examples of scientific criticism, he indicates inductively the contrast... between the laws of poetic language and the laws of practical language.

We must, then, speak about the laws of expenditure and economy in poetic language not on the basis of an analogy with prose, but on the basis of the laws of poetic language.

If we start to examine the general laws of perception, we see that as perception becomes habitual, it becomes automatic. Thus, for example, all of our habits retreat into the area of the unconsciously automatic; if one remembers the sensations of holding a pen or of speaking in a foreign language for the first time and compares that with his feeling at performing the action for the ten thousandth time, he will agree with us. Such habituation explains the principles by which, in ordinary speech, we leave phrases unfinished and words half expressed. [...]

[...] By this 'algebraic' method of thought we apprehend objects only as shapes with imprecise extensions; we do not see them in their entirety but rather recognize them by their main characteristics. We see the object as though it were enveloped in a sack. We know what it is by its configuration, but we see only its silhouette. The object, perceived thus in the manner of prose perception, fades and does not leave even a first impression; ultimately even the essence of what it was is forgotten. Such perception explains why we fail to hear the prose word in its entirety... and, hence, why (along with other slips of the tongue) we fail to pronounce it. The process of 'algebrization,' the over-automatization of an object, permits the greatest economy of perceptive effort. [...]

[...] Habitualization devours works, clothes, furniture, one's wife, and the fear of war. 'If the whole complex lives of many people go on unconsciously, then such lives are as if they had never been.' And art exists that one may recover the sensation of life; it exists to make one feel things, to make the stone *stony*. The purpose of art is to impart

the sensation of things as they are perceived and not as they are known. The technique of art is to make objects 'unfamiliar,' to make forms difficult, to increase the difficulty and length of perception because the process of perception is an aesthetic end in itself and must be prolonged. *Art is a way of experiencing the artfulness of an object; the object is not important.*

[...] Art removes objects from the automatism of perception in several ways.

* * *

[...] I personally feel that defamiliarization is found almost everywhere form is found. In other words, the difference between Potebnya's point of view and ours is this: An image is not a permanent referent for those mutable complexities of life which are revealed through it; its purpose is not to make us perceive meaning, but to create a special perception of the object – *it creates a 'vision' of the object instead of serving as a means for knowing it.*

* * *

In studying poetic speech in its phonetic and lexical structure as well as in its characteristic distribution of words and in the characteristic thought structures compounded from the words, we find everywhere the artistic trademark – that is, we find material obviously created to remove the automatism of perception; the author's purpose is to create the vision which results from that deautomatized perception. A work is created 'artistically' so that its perception is impeded and the greatest possible effect is produced through the slowness of the perception. [...] Leo Jakubinsky has demonstrated the principle of phonetic 'roughening' of poetic language in the particular case of the repetition of identical sounds. The language of poetry is, then, a difficult, roughened, impeded language. In a few special instances the language of poetry approximates the language of prose, but this does not violate the principle of 'roughened' form.

> Her sister was called Tatyana.
> For the first time we shall
> Wilfully brighten the delicate
> Pages of a novel with such a name.

wrote Pushkin. The usual poetic language for Pushkin's contemporaries was the elegant style of Derzhavin; but Pushkin's style, because it seemed trivial then, was unexpectedly difficult for them. We should remember the consternation of Pushkin's contemporaries over the vulgarity of his expressions. He used the popular language as a special device for prolonging attention, just as his contemporaries generally used Russian words in their usually French speech (see Tolstoy's examples in *War and Peace*).

Just now a still more characteristic phenomenon is under way. Russian literary language, which was originally foreign to Russia, has so permeated the language of the people that it has blended with their conversation. On the other hand, literature has now begun to show a tendency towards the use of dialects (Remizov, Klyuyev, Essenin, and others, so unequal in talent and so alike in language, are intentionally provincial) and of barbarisms (which gave rise to the Severyanin group). And currently Maxim Gorky is changing his diction from the old literary language to the new literary colloquialism of Leskov. Ordinary speech and literary language have thereby changed places (see the work of Vyacheslav Ivanov and many others). And finally, a strong

tendency, led by Khlebnikov, to create a new and properly poetic language has emerged. In the light of these developments we can define poetry as *attenuated, tortuous* speech. Poetic speech is *formed speech*. Prose is ordinary speech [...]

4 De Stijl: 'Manifesto 1'

The De Stijl group was founded in Holland in 1917, dedicated to a synthesis of art, design and architecture. Its leading figure was Theo van Doesburg. Other members included Gerrit Rietveld and J. J. P. Oud, both architect-designers, and the painters Georges Vantongerloo and Piet Mondrian. Links were established with the Bauhaus in Weimar Germany, and with similar projects in Russia, particularly through contacts with El Lissitsky. The 'Manifesto', principally the work of van Doesburg, was composed in 1918. It was published in the group's journal *De Stijl*, V, no. 4, Amsterdam, 1922. The present translation by Nicholas Bullock is taken from Stephen Bann (ed.), *The Tradition of Constructivism*, London, 1974, p. 65.

1 There is an old and a new consciousness of time.
The old is connected with the individual.
The new is connected with the universal.
The struggle of the individual against the universal is revealing itself in the world war as well as in the art of the present day.
2 The war is destroying the old world and its contents: individual domination in every state.
3 The new art has brought forward what the new consciousness of time contains: a balance between the universal and the individual.
4 The new consciousness is prepared to realize the internal life as well as the external life.
5 Traditions, dogmas, and the domination of the individual are opposed to this realization.
6 The founders of the new plastic art, therefore, call upon all who believe in the reformation of art and culture to eradicate these obstacles to development, as in the new plastic art (by excluding natural form) they have eradicated that which blocks pure artistic expression, the ultimate consequence of all concepts of art.
7 The artists of today have been driven the whole world over by the same consciousness, and therefore have taken part from an intellectual point of view in this war against the domination of individual despotism. They therefore sympathize with all who work to establish international unity in life, art, culture, either intellectually or materially. [...]

5 Theo van Doesburg (1883–1931) from *Principles of Neo-Plastic Art*

This was van Doesburg's main statement of the principles of De Stijl. It was begun as early as 1915, first published in Dutch in 1919, and subsequently issued in Germany by the Bauhaus, as *Grundbegriffe der Neuen Gestalden Kunst*, Bauhausbuch, vol. 6, Munich, 1925. The present extract is taken from the English translation by Janet Seligman, London, 1969.

XX If an object of experience as such enters visibly into the work this object is an auxiliary means within the expressional means. The mode of expression will in this event be inexact.

XXI When the aesthetic experience is expressed directly through the creative means of the branch of art in question, the mode of expression will be exact.[1]

Example 5

When we look at old paintings, e.g., one by someone like Nicolas Poussin, we are struck by the fact that the human figures are portrayed in physical attitudes which we are unaccustomed to see in daily life, yet their corporeality is convincingly reproduced; the landscape too has clearly been improved. The leaves on the trees, the grass on the ground, the hills, the sky, all are true to life and yet the painter did not intend all this to be so. The attitudes and gestures of these people, the exact spot on which the individual figures stand and the relationship of the groups of figures to the surrounding space and the areas of space in between are far from being fortuitous or natural. Stress has clearly been laid upon attitudes and relationships. Everything has obviously been carefully pondered. Everything is governed by fixed *laws*. Even the light, uniformly strong over the whole canvas, differs from natural light.

Such a painting is in a high degree true to life and yet, as a result of definite intentions on the part of the painter, it differs from nature. Why? Because the artist was working according to artistic and aesthetic laws (constructively organizing) and not purely from the point of view of natural objective legibility. The painter was more concerned about aesthetic purposes than about natural forms.

Instead of allowing the picturesque fortuitousness and diversity of nature to pre-dominate, he seeks to achieve expression of a universal idea by purposeful organization of the figures and subordination of the details. Thus he appears to neglect the laws of nature in favour of those of artistic creation. He uses natural forms only as a means of attaining his artistic aim.[2]

The aim is: to create a harmonious whole in which the equilibrium of the whole, an aesthetic unity, is achieved by means of multiple exchanges and by cancelling out the positions and postures of the figures, the areas of space and masses and lines of movement in the picture (by relationships).

Indeed up to a point this artistic harmony is achieved. Up to a point, because the artistic aim is not sought directly through the artistic means, but only indirectly, obscured behind natural forms. Neither colour nor form appears in its pure state as colour and form. Rather colour and form are used to assist in producing an illusion of some other thing, e.g., leaves, glass, limbs, silk, stone, etc.

Such a work of art is the artistic idea expressed by naturalistic means.

It is an aesthetic-naturalistic work of art.

It deviates from external nature in so far as it is aesthetic (more inward); it deviates from the aesthetic idea in so far as it is naturalistic. It is, so to speak, split and is thus not an *unambiguously and exactly* formative work.

The aim of the formative artist is simply this: to give form to his aesthetic experience of reality or, one might also say, his creative experience of the fundamental essence of things. The visual artist can leave the repetition of stories, fairy-tales, etc., to poets and writers. The only way in which visual art can be developed and deployed is by

revaluing and purifying the formative means. Arms, legs, trees, and landscapes are not unequivocally painterly means. Painterly means are: colours, forms, lines, and planes.

Taking the development of visual art as a whole, we can, in fact, see the means becoming increasingly clearly defined and providing the possibility of purely formative expression for the artistic experience. Since these formative means have made their appearance as the principal visible factor, everything in painting, sculpture, and, to some extent, in architecture which has no immediate place among the purely expressional means has been relegated to the background.

It is unnecessary to record every stage in the development of their importance in the evolution towards an exact artistic expression. We may summarize all these various currents, whether or not they belong to systems as: the conquest of an exact expressional form of the aesthetic experience of reality.

The essence of the formative idea (of aesthetics) is expressed by the term *cancellation*.

One element cancels out another.

This cancelling out of one element by another is expressed in nature as well as in art. In nature, more or less concealed behind the accidents of the particular case, in art (at least in the exact, formative kind), clearly revealed.

Although we cannot grasp the perfect harmony, the absolute equilibrium of the universe, each and everything in the universe (every motif) is nevertheless subordinated to the laws of this harmony, this equilibrium. It is the artist's business to discover and give form to this concealed harmony, this universal equilibrium of things, to demonstrate its conformity to its own laws, etc.

The (truly exact) work of art is a metaphor of the universe obtained with artistic means.

We saw in example 5 that artistic equilibrium was achieved in the work of art of an earlier age by the repeated cancelling out of one figural position by another, one dimension by another, etc.; by, therefore, a reciprocal cancelling out of *means borrowed from nature*.

The great step forward made by the exact formative work of art consists in the fact that it achieves aesthetic equilibrium by pure artistic means and by these alone.

In the exact, formative work of art the formative idea is given direct and actual expression by continual cancelling out of the expressional means: thus a horizontal position is cancelled out by a vertical one, similarly dimension (large by small) and proportion (broad by narrow). One plane is cancelled out by another which circumscribes it or one which is related to it, etc., the same applies to colour: one colour is cancelled out by another (e.g., yellow by blue, white by black), one group of colours by another group of colours and all coloured planes are cancelled out by non-coloured planes and vice versa.[3] In this way (according to Piet Mondrian: 'Neue Gestaltung' in the *Bauhausbücher*, Vol. 5), by means of a constant cancelling out of position, dimension, proportion and colour, a harmonious overall relationship, artistic equilibrium, is achieved and with it, in the most exact manner, the aim of the artist: to create a formative harmony, *to give truth in the way of beauty*. The artist no longer embodies his idea by indirect representation: symbols, slices of life, genre scenes, etc.; he gives form to his idea directly and purely by the artistic means available for the purpose.

The work of art becomes an independent, *artistically alive* (plastic) organism in which everything counterbalances everything else.

1 The artist is, of course, entirely free to make use of any science (e.g., mathematics), any technique (e.g., printing-press, machine, etc.) and any material whatever, to achieve this exactitude.

2 What the decadents of Cubism with their 'superrealism' are now almost without exception aiming at is exactly the same thing: a classical, painterly harmony achieved by means borrowed from nature. That in this process the natural forms are not intended as such but are to be regarded only as objective phenomena, makes, from the artistic point of view, no fundamental difference. One might label this movement Neo-Baroque.

3 In Impressionism this cancelling out was expressed intuitively. In order to achieve a harmonious impression one colour was cancelled out by another. Hence the expression: colour-relationship.

6 Piet Mondrian (1872–1944) 'Dialogue on the New Plastic'

Mondrian absorbed the lessons of Cubism during a stay in Paris before the First World War. He returned to Holland in 1914. There he developed both the practice of a new abstract art and the theoretical principles underlying it. One of the most extensive early attempts to explain the principles of his new art took the form of a dialogue with a doubting critic. By the device of identifying this critic as a singer, Mondrian was enabled to use musical analogies in his explanations. The essay was originally published as 'Dialoog over de Nieuwe Beelding' in two issues of *De Stijl*, Leiden, February and March 1919. (It should be noted that the Dutch term *beelding* carries connotations of forming and making which are absent from the more basically material sense of 'plastic'.) The present extract is taken from the English translation in Harry Holzman and Martin S. James (eds. and trans.), *The New Art – The New Life: The Collected Writings of Piet Mondrian*, Boston, 1986, pp. 75–81. (For a later text by Mondrian see IVA10.)

A: A Singer

B: A Painter

A: I admire your earlier work. Because it means so much to me, I would like better to understand your present way of painting. I see nothing in these rectangles. What are you aiming at?

B: My new paintings have the same aim as the previous ones. Both have the *same* aim, but my latest work brings it out more clearly.

A: And what is that?

B: To express *relationships* plastically through oppositions of color and line.

A: But didn't your earlier work represent *nature*?

B: I expressed myself *by means* of nature. But if you carefully observe the sequence of my work, you will see that it progressively abandoned the naturalistic appearance of things and increasingly emphasized the plastic expression of relationships.

A: Do you find, then, that natural appearance interferes with the plastic expression of relationships?

B: You must agree that if two words are sung with the same strength, with the same emphasis, each weakens the other. One cannot express both natural appearance as we see it and plastic relationships with the same determinateness. In naturalistic form, in naturalistic color, and in naturalistic line, plastic relationships are veiled. To be expressed plastically in a determinate way, relationships must be represented only through color and line. In the capriciousness of nature, form and color are weakened by *curvature* and by the *corporeality* of things. To give the means of expression of

painting their full value in my earlier work, I increasingly allowed color and line to speak for themselves.

A: But how can color and line as such, without the form we perceive in nature, express anything determinately?

B: To express plastically color and line means to establish *opposition* through color and line; and this opposition expresses plastic *relationship*. *Relationship* is what I have always sought, and that is what all painting seeks to express.

A: But painting always used nature for plastic expression and through the beauty of nature was elevated to the ideal.

B: Yes, it rose to the ideal *through the beauty* of nature; but in *plastic expression* the ideal is something other than the mere representation of natural appearance.

A: But doesn't the ideal exist only in us?

B: It exists in us and *outside* of us. The ancients said that the ideal is everywhere and in everything. In any case, the ideal is manifested aesthetically as beauty. But what did you mean a moment ago by 'the beauty of nature'?

A: I had in mind, for example, an ancient work, an image said to contain all the beauty of the human form.

B: Well, think for a moment of masterpieces of the so-called realistic schools, which show none of this ideal beauty and nevertheless express *beauty*. Comparing these two types of art, you will already see that not only the beauty of nature but also its so-called ugliness can move us or, as you say, elevate us toward the ideal. Neither subject matter, the representation, nor nature itself creates the beauty of painting. They merely establish the *type* of beauty by determining *the composition, the color, and the form*.

A: But that is not how a layman thinks of it, although what you say seems plausible. Nevertheless, I cannot imagine relationships expressed otherwise than by means of some subject matter or representation and not just through a composition of color and line *alone*; just as I can't appreciate sounds *without* melody – a sound composition by one of our modern composers means *nothing* to me.

B: In painting you must first try to see *composition, color, and line* and not the representation *as representation*. Then you will finally come to feel the subject matter a hindrance.

A: When I recall your transitional work, where color that was not true to nature to some extent destroyed the subject matter, I do see more clearly that beauty can be created, even far more forcefully created, without verisimilitude. For those paintings gave me a far stronger aesthetic sensation than purely naturalistic painting. But surely the color must have *form*?

B: Form or the illusion of form; anyway, color must be *clearly delimited* if it is to represent anything plastically. In what you call my transitional work, you rightly saw that the subject matter was neutralized by a free expression of color. But you must also see that its plastic expression was determined by form that still remained largely true to nature. To harmonize color and form, the subject matter of the painting, and therefore the *form*, was carefully selected. If I aimed, for instance, to express *vastness and extension*, the subject was *chosen* with this in mind. The plastic idea took on various expressions, according to whether it was a dune landscape or the sea or a church that formed the subject. You remember my flowers; they too were carefully

'chosen' from the many varieties there are. Didn't you find that they had yet 'another' expression than my seascapes, dunes, and churches?

A: Indeed! To me the flowers conveyed something more intimate, as it were; while the sea, dunes, and churches spoke more directly of 'space.'

B: So you see the importance of form. A closed form, such as a flower, says something other than an open curved line as in the dunes, and something else again than the straight line of a church or the radiating petals of some other flowers, for example. By comparing, you see that a particular form makes a particular impression, that line has *plastic* power and that the most tensed line most purely expresses immutability, strength, and vastness.

A: But I still don't understand why you favor the *straight line* and have come *entirely* to exclude the curved.

B: The search for the expression of vastness led to the search for the *greatest* tension: the straight line; because all curvature resolves into the straight, no place remains for the curved.

A: Did you come to this conclusion suddenly?

B: No, very gradually. First I abstracted the capricious, then the freely curved, and finally the mathematically curved.

A: So it was through this abstracting that you came to exclude all naturalistic representation and subject matter?

B: That's right, *through the work itself*. The theories I just mentioned concerning these exclusions came afterward. Consistent abstracting led me to exclude the visible-concrete completely from my plastic expression. In painting a tree I progressively abstracted the curves: you can understand that very little 'tree' remained.

A: But can't a tree be represented with straight lines?

B: Perfectly true. Now I see something is lacking in my explanation: *abstraction alone* is not enough to eliminate the naturalistic from painting. Line and color must *be composed otherwise* than in nature.

A: Then what the painter calls composition also changes too?

B: Yes, an entirely different composition, more mathematical but not symmetrical, is needed in order to achieve pure plastic expression of equilibrated relationship. Merely to express the natural with straight lines still remains *naturalistic* reproduction even though the effect is already much stronger.

A: But won't such abstracting and transformed composition make everything look *alike*?

B: That is a necessity rather than a hindrance, if we wish to express plastically what all things have in common instead of what sets them apart. Thus the *particular*, which diverts us from what is essential, disappears; only the universal remains. The depiction of objects gives way to pure plastic expression of relationship.

A: Our talk yesterday showed me that Abstract Painting grew out of naturalistic painting. It became clear to me mainly because I know your earlier work. Then Abstract Painting is not just *intellectual* but also the product of *feeling*?

B: Of both: deeper feeling and deeper intellect. When feeling is deepened, in many eyes it is destroyed. That is why the deeper emotion of the New Plastic is so little understood. But one must *learn* to *see* Abstract-Real painting, just as the painter had to *learn to create* in an abstract-real way. It represents the *process of life* that is

reflected in the plastic expression of art. People too often view the work of art as a *luxury*, something merely *pleasant*, even as a decoration, as something that lies *outside* life. Yet art and life are *one*; art and life are both expressions of truth. If, for instance, we see that equilibrated relationships in society signify what is *just*, then one realizes that in art too the demands of life press forward when the spirit of the time is ripe.

A: I am very sympathetic to the unity of art and life, yet *life* is the main thing!

B: All expressions of life – religion, social life, art, etc. – always have a common *basis*. We should go into that further; there is so much to say. Some have felt this strongly and it led one of us to found *De Stijl*.

A: I have looked at *De Stijl*, but it was not very easy for me to understand.

B: I recommend repeated reading. But the ideas that *De Stijl* expounds can give you no more than a *conception* of the *essence* of the New Plastic and its connection with life: the content of the New Plastic can be *seen* only in the *work itself*. Only through intuitive feeling, through long contemplation and comparison, can one come to complete appreciation of the new.

A: Perhaps so, but I still feel that art will be much impoverished if the natural is eliminated.

B: How can its expression be impoverished if it conveys more clearly what is important and essential to the work of art?

A: But the *straight* line alone can say so little.

B: The straight line tells the truth; and the *significance* you want it to have is of no value for painting; such significance is literary, preconceived. Painting has to be purely *plastic*, and in order to achieve this it must use plastic means that do not signify the individual. This also justifies the use of rectangular color planes.

A: Does this hold for classical painting, in fact for all previous painting, which always represented appearance?

B: Indeed, if you really understand that all pure painting aimed to be purely *plastic*, then the consequent application of this idea not only justifies *universal* plastic means but *demands* it. Unintentionally, naturalistic painting gives too much prominence to the particular. The *universal* is what all art seeks to express: therefore, the New Plastic is justified relative to all painting.

A: But is the New Plastic justified in relation to *nature?*

B: If you understood that the New Plastic expresses the *essential* of everything, you would not ask that question. Besides, art is a duality of *nature-and-man* and not nature *alone.* Man transforms nature according to his own image; when man expresses his deepest being, thus manifesting his *inwardness*, he must necessarily *interiorize* natural appearance.

A: Then you don't despise nature?

B: On the contrary. For the New Plastic, too, nature is that great manifestation through which our deepest being is revealed and assumes concrete appearance.

A: Nevertheless, to *follow* nature seems to me the true path.

B: The appearance of nature is far stronger and much more beautiful than any *imitation* of it can ever be; if we wish to reflect nature, fully, we are *compelled* to find *another* plastic. Precisely for the sake of nature, of reality, we avoid its natural appearance.

A: But nature manifests itself in an indefinite variety of forms; do you show nothing of this?

B: I see reality as a *unity*; what is manifested in all its appearances is *one and the same*: the *immutable*. We try to express this plastically as purely as possible.

A: It seems reasonable to take the immutable as the basis: the *changeable* provides nothing solid. But what do you call *immutable*?

B: *The plastic expression of immutable relationship: the relationship of two straight lines perpendicular to each other.*

A: Is there no danger of *monotony* in so consistently expressing the immutable?

B: The danger exists, but the *artist*, not the *plastic method*, would create it. The New Plastic has its *oppositions*, its *rhythm*, its *technique*, its *composition*, and these not only give scope for the plastic expression of life, of movement, but they still contain so much of the *changeable* that it is still difficult for the artist to find pure plastic expression of the *immutable*.

A: Nevertheless, in what little I have seen of the New Plastic, I noticed just this monotony; I failed to experience the inspiration, the deep emotion that more naturalistic painting gives me. It is what I fail to hear in the compositions of modern music; as I said earlier, the recent tone combinations without melody fail to stir me as music with melody does.

B: But surely an equilibrated composition of *pure* tone relationships should be able to stir one even more deeply.

A: How can you say that, not being a musician!

B: I can say it because, fundamentally, all art is one. Painting has shown me that the equilibrated composition of color relationships ultimately surpasses naturalistic composition and naturalistic plastic – when the aim is to express equilibrium, harmony, *as purely as possible*.

A: I agree that the essential of art is the creation of *harmony*, but . . .

B: But harmony does not mean the same thing to everyone and does not speak to everyone *in the same way*. That is why it is so easy to understand that there are differences in the modes of plastic expression.

A: Then this leaves room for naturalistic painting and melody in music. But do you mean they will be outgrown in the future?

B: The more purely we perceive harmony, the more purely we will plastically express relationships of color and of sound; this seems logical to me.

A: So the New Plastic is the end of painting?

B: Insofar as there can be no purer plastic expression of equilibrated relationships – in art. The New Plastic was born only yesterday and has yet to reach its culmination.

A: Then it could become completely different?

B: Not completely. But in any case, the New Plastic could not return to naturalistic or form expression, for it grew out of these. It is bound to the fixed law of art, which as I said, is the *unity of man and nature*. If in this duality the New Plastic is to create *pure* relationships and therefore unity, it cannot allow the natural to predominate; therefore, it must remain abstract.

A: I now see more and more that I thought of painting as representation of the visible, whereas it is possible in painting to express beauty in quite another way. Perhaps one day I will come to love the New Plastic as you do, but so far . . .

B: If you see both naturalistic painting and the New Plastic from a *purely plastic* point of view, that is, distinct from subject matter or the expressive means, then you will

see but one thing in both: the plastic expression of relationship. If from *the point of view of painting* you can thus see beauty in one mode of expression, you will also see it in the other. [. . .]

7 Piet Mondrian (1872–1944) *Neo-Plasticism: The General Principle of Plastic Equivalence*

Mondrian returned to Paris in 1919. The present essay was written in 1920 and marked the first exposition of his ideas in French. Mondrian himself considered it definitive, claiming in 1932 to have done 'nothing further' in writing. Mondrian was included by Léonce Rosenberg in his exhibition 'Masters of Cubism' of 1921, and the essay was published as a pamphlet, *Le Néo-Plasticisme: Principe général de l'équivalence plastique,* by Rosenberg's Galerie de l'Effort Moderne in Paris, January 1921. The present extracts are taken from Holzman and James, op. cit., pp. 132–47.

Although art is the plastic expression of *our* aesthetic emotion, we cannot therefore conclude that art is only 'the aesthetic expression of our subjective sensations.' Logic demands that art be the *plastic expression of our whole being*: therefore, it must be equally the plastic appearance of the *nonindividual*, the absolute and annihilating opposition of subjective sensations. That is, it must also be the *direct expression of the universal in us* – which is the *exact appearance of the universal outside us.*

The universal thus understood is that which *is* and *remains constant*: the more or less *unconscious* in us, as opposed to the more or less *conscious* – the *individual*, which is repeated and renewed.

Our whole being is as much the one as the other: *the unconscious and the conscious, the immutable and the mutable, emerging and changing form through their reciprocal action.*

This action contains all the misery and all the happiness of life: misery is caused by *continual separation*, happiness by perpetual rebirth of *the changeable.* The immutable is beyond all misery and all happiness: it is *equilibrium.*

Through the immutable in us, we are united with all things; the mutable destroys our equilibrium, limits us, and separates us from all that is other than us. It is from this equilibrium, from *the unconscious,* from *the immutable* that art comes. It attains its *plastic expression* through *the conscious.* In this way, *the appearance of art* is plastic expression of *the unconscious and of the conscious.* It shows *the relationship* of each to the other: its appearance changes, but *art* remains immutable.

In 'the totality of our being' the individual or the universal may dominate, or equilibrium between the two may be approached. [. . .] In all the arts objective fought against subjective, universal against individual: *pure plastic expression* against *descriptive expression.* Thus art tended toward *equilibrated plastic.*

Disequilibrium between individual and universal creates the *tragic* and is expressed as *tragic plastic.* In whatever exists as form or corporeality, the natural dominates: this creates the tragic . . .

The tragic in life leads to artistic creation: *art,* because it is abstract and in opposition to the natural concrete, can anticipate the gradual disappearance of the tragic. The more the tragic diminishes, the more art gains in purity.

The new spirit can manifest itself only in the midst of the tragic. It finds only the old form, for the new plastic is yet to be created. Born in the environment of the past, it can be expressed only in the *vital reality of the abstract....*

Because it is part of the whole, the new spirit cannot free itself entirely from the tragic. The *New Plastic*, expressing the vital *reality of the abstract*, has not entirely freed itself from the tragic but it has ceased to be dominated by it.

In contrast, in the old plastic the tragic dominates. It cannot dispense with the tragic and tragic plastic.

So long as the individual dominates, tragic plastic is necessary, for that is what creates its emotion. But as soon as a period of greater maturity is reached, tragic plastic becomes insupportable.

* * *

For let us not forget that we are at a turning point of culture, *at the end of everything ancient: the separation between the two is absolute and definite.* Whether it is recognized or not, one can logically foresee that the future will no longer understand tragic plastic, just like an adult who cannot understand the soul of the child.

At the same time as it suppresses the dominating tragic, the new spirit suppresses *description* in art. Because the obstacle of form has been destroyed, the new art affirms itself as *pure plastic*. The new spirit has found its *plastic expression*. In its maturity, the one and the other are neutralized, and they are coupled into unity. Confusion in the apparent unity of interior and exterior has been resolved into an *equivalent duality forming absolute unity*. The individual and the universal are *in more equilibrated opposition*. Because they are merged in unity, description becomes superfluous: *the one is known through the other*. They are plastically expressed without use of form: *their relationship alone (through direct plastic means) creates the plastic*.

It is in *painting* that the New Plastic achieved complete expression for the first time. This plastic could be formulated because its principle was solidly established, and it continues to perfect itself unceasingly.

Neo-Plasticism has its roots in Cubism. It can equally be called *Abstract-Real painting* because the *abstract* (just like the mathematical sciences but without attaining the absolute, as they do) can be expressed by plastic reality. In fact, this is the essential characteristic of the New Plastic in painting. It is a composition of rectangular color planes that expresses the most profound reality. It achieves this by *plastic expression of relationships* and not by natural appearance. It realizes what all painting has always sought but could express only in a veiled manner. The colored planes, as much by position and dimension as by the greater value given to color, plastically express only *relationships* and not forms.

The New Plastic brings its relationships into *aesthetic equilibrium* and thereby expresses *the new harmony*.

The future of the New Plastic and its true realization in painting lies in *chromoplastic in architecture...* It governs the interior as well as the exterior of the building and includes everything that plastically expresses relationships through color. No more than the 'New Plastic-as-painting,' which prepares the way for it, can chromoplastic be regarded as 'decoration.' It is *entirely new painting* in which all painting is resolved, pictorial as well as decorative. It unites the *objective* character of decorative art (but much more strongly) with the *subjective* character of pictorial art (but much more

profoundly). At this moment, for material and technical reasons, it is very difficult to foresee its exact image.

At present each art strives to express itself more directly through its *plastic means* and seeks to *free* its means as much as possible.

Music tends toward the liberation of *sound, literature* toward the liberation of *word.* Thus, by purifying their plastic means, they achieve the *pure plastic of relationships.* The degree and mode of purification vary with the art and the epoch in which they can be attained.

In fact, the new spirit is revealed by the plastic means: it is *expressed* through *composition.* Composition must express *equilibrated plastic as a function of the individual and of the universal.* Dominating tragic must be abolished by composition and plastic means together: for if plastic appearance is not composed *in constant and neutralizing opposition,* the plastic means would return to the expression of 'form' and would be veiled anew by the descriptive.

tension

Thus *Neo-Plasticism* in art is not simply a question of 'technique.' In the New Plastic, and *through it,* technique changes. The touchstone of the new spirit, next to composition, is precisely what is so often lightly called '*technique.*'

'It is by *appearance* that one judges whether a work of art is really pure plastic expression of the universal'....

Because sculpture and painting have been able to reduce their primitive plastic means to *universal plastic means,* they can find effective plastic expression *in exactness and in the abstract.* Architecture by its very nature already has at its disposal a plastic means free of the capricious form of natural appearance.

In the New Plastic, painting no longer expresses itself through the *corporeality* of appearance that gives it a naturalistic expression. To the contrary, painting is expressed plastically by *plane within plane.* By reducing three-dimensional corporeality to a single plane, *it expresses pure relationship.*

* * *

... *The new spirit* must be manifested *in all the arts without exception.* That there are differences between the arts is no reason that one should be valued less than the other; that can lead to *another* appearance but not to an *opposed* appearance. As soon as one art becomes plastic expression of the abstract, the others can no longer remain plastic expressions of the natural. The two do not go together: from this comes their mutual hostility down to the present. The New Plastic abolishes this antagonism: *it creates the unity of all the arts.* [...]

Sculpture and architecture, until the present, destroy space *as space* by dividing it. The new sculpture and architecture must destroy *the work of art as an object or thing.*

Each art possesses its own *specific* expression, its *particular nature.* 'Although the content of all art is one, the possibilities of plastic expression are different for each art. Each art discovers these possibilities within its own domain and must remain limited by its bounds. Each art possesses its own *means of expression:* the *transformation* of its plastic means has to be discovered independently by each art and must remain limited by its own bounds. Therefore the potentialities of one art cannot be judged according to the potentialities of another, but must be considered independently and only with regard to the art concerned...'.

'With the advancing culture of the spirit, all the arts, regardless of differences in their expressive means, in one way or another become more and more the plastic creation of determinate, equilibrated relationship: for equilibrated relationship must purely express the universal, the harmony, the unity that are proper to the spirit.'

* * *

... Through the new spirit, man himself creates a new beauty, whereas in the past he only painted and described the beauty of nature. This new beauty has become indispensable to the new man, for in it he expresses *his own image in equivalent opposition with nature*. THE NEW ART IS BORN.

8 Kasimir Malevich (1878–1935) 'Non-Objective Art and Suprematism'

Malevich claimed that Suprematism began in 1913. Its first exposition took place, however, in December 1915; the works of 1913 to which he refers were set designs (involving squares) for the Futurist opera *Victory over the Sun*, which he saw as significant in the genesis of Suprematism. The *Black Square* of 1915 had served as a zero point from which Malevich could develop a vocabulary of coloured forms, mostly rectangular and often giving the appearance of 'flying' in pictorial space. By 1919 he believed he had burst through colour into white, the 'colour' of infinity. This text was originally published in the catalogue to the 10th State Exhibition, Moscow 1919, at which Malevich exhibited his 'White on White' canvases. The present translation is taken from Larissa Zhadova, *Malevich: Suprematism and Revolution in Russian Art 1910–1920*, London, 1982, pp. 282–3. (For other texts by Malerich, see IIA16, IIIC9 and IVD1.)

The plane which formed a square was the progenitor of Suprematism, the new colour realism, as non-objective art (see the pamphlet *Cubism, Futurism and Suprematism*, 1st, 2nd and 3rd editions, 1915 and 1916). [See IIA16.]

Suprematism arose in Moscow in 1913 and the first works which appeared at an exhibition of painting in Petrograd aroused indignation among 'papers that were then in good standing' and critics, as well as among professionals – the leading painters.

In referring to non-objectivity, I merely wished to make it plain that Suprematism is not concerned with things, objects, etc., and more: non-objectivity in general has nothing to do with it. Suprematism is a definite system in accordance with which colour has developed throughout the long course of its culture.

Painting arose from the mixing of colours and – at moments when aesthetic warmth brought about a flowering – turned colour into a chaotic mix, so that it was objects as such which served as the pictorial framework for the great painters. I found that the closer one came to the culture of painting, the more the frameworks (i.e. objects) lost their systematic nature and broke up, thus establishing a different order governed by painting.

It became clear to me that new frameworks of pure colour must be created, based on what colour demanded and also that colour, in its turn, must pass out of the pictorial mix into an independent unity, a structure in which it would be at once individual in a collective environment and individually independent.

The system is constructed in time and space, independently of any aesthetic considerations of beauty, experience or mood, but rather as a philosophical colour system, the realization of new trends in my thinking – as a matter of knowledge.

At the present moment man's path lies across space. Suprematism is the semaphore of light in its infinite abyss.

The blue colour of the sky has been overcome by the Suprematist system, it has been broken through and has entered into white, which is the true actual representation of infinity and therefore freed from the colour background of the sky.

A hard, cold system, unsmilingly set in motion by philosophical thought. Indeed, its real power may already be in motion within this system.

All the daubings produced by utilitarian intentions are insignificant and limited in scope. Their point is merely a matter of application and the past, and it arises from recognition and deduction by philosophical thought at the level at which we see the cosy nooks that cater for commonplace taste, or create a new one.

In one of its phases, Suprematism has a purely philosophical impetus, cognitive by means of colour: in another, it is a form capable of application by making available a new style of Suprematist decoration.

But it may manifest itself in objects as a transformation or embodiment of space within them, thereby removing their singularity from the mind.

It has become clear as a result of Suprematist philosophical colour thinking that the will is able to develop an artistic system when the object has been annulled in the artist's mind as a pictorial framework and a vehicle, and that, as long as objects remain a framework and a vehicle, his will must go on gyrating within a compositional circle and among objective forms.

Everything that we see arose from the colour mass transformed into plane and volume. Every machine, house, person and table, all are pictorial volume systems intended for particular purposes.

The artist too must transform the colour masses and create an artistic system, but he must not paint little pictures of fragrant roses since all this would be dead representation pointing back to life.

And even if his construction is non–objective, but is based on the inter-relation of colours, his will cannot but be confined between the walls of aesthetic planes, instead of achieving philosophical penetration.

I am only free when my will, basing itself critically and philosophically on that which exists, is able to formulate a basis for new phenomena.

I have ripped through the blue lampshade of the constraints of colour. I have come out into the white. Follow me, comrade aviators. Swim into the abyss. I have set up the semaphores of Suprematism.

I have overcome the lining of the coloured sky, torn it down and into the bag thus formed, put colour, tying it up with a knot. Swim in the white free abyss, infinity is before you.

9 Kasimir Malevich (1878–1935) *The Question of Imitative Art*

Malevich has been frequently represented as an other-worldly mystic, and after the Revolution in Russia he was indeed criticized for Idealism by artists and commentators whose own

orientation was more explicitly political. Despite his idiosyncrasies, however, the present text demonstrates Malevich's cognizance of contemporary events and his determination to relate Suprematism to them while refusing the claims of previous styles of art adequately to represent the new life. Originally published in Smolensk, 1920. The present translation is taken from T. Andersen (ed.), *K. S. Malevich: Essays on Art 1915–1933*, vol. 1, Copenhagen, 1969, pp. 167–71, 173 and 176–80. (The 'constituent assembly', it should be noted, was the political body of the Provisional Government under Kerensky set up following the February Revolution of 1917, and dissolved by the Bolsheviks in the name of the Soviets – workers' councils – in October of that year.)

[. . .] After long centuries marking the destruction of the bearers of youth the day has come for the clash between youth and age. Today a desperate struggle is being carried on with the old man who is trying to stifle youth. Today we are witnessing one of the usual mistakes of the old, which does not comprehend the movements of new life; today the old men are striving to ensure that there may never be another spring: but there will be, for in it lies the birth of a new universal step. Today the avant-gardes of economics and politics are fighting to gain territory, in order to prepare a place for the foundations of the new world: all the young forces are collecting on it and will create a world in their new image. Today the man has awoken who shouts for all the world to hear and calls all humanity to unity. Our unity is essential for his being: not to obtain rights and liberty or to build an economic, utilitarian life, but in order that, by the safeguarding of our bodily needs, our being may advance to the single unity and wholeness on the path of universal movement, as our main and, indeed, only goal. The unity of all humanity is essential, for a new single man of action is needed. We wish to form ourselves according to a new pattern, plan and system; we wish to build in such a way that all the elements of nature will unite with man and create a single, all-powerful image. With this aim the economic principle leads us along its path and collects all the lives that have been scattered in the chaos of nature, separate and isolated, uniting them in his path: thus every personality, every individual, formerly isolated, is now incorporated in the system of united action.

This is why nowadays no individual personality is allowed to have the freedom of isolation or to live as it pleases, arranging a personal economic programme for its own vegetable-garden, since it must be included in the system of sharing and of common freedom and rights; hence the individual has no rights, for the rights are common to all, and the individual personality itself is simply a fragment from a united being, all of whose fragments must be joined together in one, since they originated from one. Thus all the many lives in nature, with all their various advantages, have become incorporated in man and have brought him their entire will and wisdom; now only he – man – as a centre can turn nature into another new image, which will be nothing less than man himself: a completed step on the eternal path. Our new society should occupy itself in this way, but in order to begin building we need a plan of action and a system. We already know that every aspect of our life is based on the economics of subsistence and of movement in general, whence stem politics, rights and liberty. Of these the most important is economics, which is the measure of our contemporary life: this is how we measure it, and anything that does not come under this measure is not contemporary. We should, accordingly, apply this measure absolutely, to all forms of our expression, in order to be in accordance with the general plan for the contemporary development of

an organism. Thanks to the economic system, every individual is subject to it, whilst it can no longer produce anything apart from the system of sharing. The communist town is not arising from the chaos of private buildings, but according to a general plan: the form of each building will stem from this plan and not from the whim of individual personalities.

Freedom of the individual can only be in accordance with the common freedom; hence no personality has any private property, for all its forms are a phenomenon of the general economic movement. Hence arises the collective – a group of personalities linked by the agreement of collective individualism on the basis of common economic action, and forming a unit of the general unity. The joining together of all the collectives is the unity towards which contemporary life is moving. [...] None of the forms of economic development and of human consciousness that were found in the old world can exist any longer, for a new meaning has appeared. No form of the old can exist, for revolutionary perfection is ceaselessly bearing its being further and further by means of our consciousness, broadening and deepening space by energic economic reasoning. If, on the other hand, we leave the old form, we are serving counter-revolutionary perfection. Each day, in economic and political life, brings purification from what is old – this is where perfection lies. But in art everything is the other way round: the older a work the more it is considered valuable, beautiful, artistic and skilful, just as in the wine trade old wine is the most prized. They always try to show the people that old art is valuable and beautiful, at the same time stifling, muffling and slandering everything modern. Today, when Revolutionary Perfection is bringing a new, youthful world of forms as the body of being, reactionary elements dig up and bring out into the street the remains of past perfection, showing them to the masses. It is not shown to aid understanding of the development of form, as an example of old life; no, they strive to prove and convince that the world of art they have dug up is beautiful, that its beauty is the greatest of all, and that it is lofty and difficult; they say that to repeat it one would have to possess talent, to be highly skilful and study a great deal, whilst modern art is very simple: any fool can draw a square, but no one can repeat Raphael or Rubens. But these reactionaries forget that perfection demands instantaneous action. Any boy can light a match and get fire in an instant. No one remembers the original primitive method of getting fire by rubbing wood together, and no one would advocate the old method. They are striving to inculcate the new meaning of revolutionary movement into old art. Life threw the icon out of people's houses, but now they are showing it dressed up in a new meaning.

* * *

The movement of the new world is divided in two: on the one hand the fighting, destructive avant-garde with the banner of economics, politics, rights and freedom, and, on the other hand, the creative army which appears after it, creating form for the whole utilitarian and spiritual world of things. Creativity is the essence of man, as the highest being in nature, and everyone should take up this activity. Creativity changes in the same way as the party's revolutionary attitude. People who were formerly considered revolutionaries have now turned out to be counter-revolutionaries: the same thing happens in art. In academism people saw creativity, painting and form, but with the arrival of new trends it turned out to contain neither creativity nor painting nor form. Many people think that anything except communism is beneficial to the people;

the same sort of people think that only academism can produce real art: both are cases of blindness to their own real perfection.

Just as up to now many people have been unable to conceive clearly the form of the commune, so many have failed to see form in new art; but those that have seen it have also seen a new world for their life. For no better reason than that they could see neither form nor art in new art, attacks and persecutions were carried out, just as they were in political affairs. Formerly art rested on artistic beauty, but now we must embark on the purely creative path of economic movement. This is the only road of development for all humanity and from it stem all the forms which are international: the car, aeroplane, telephone, machine, etc. The spreading of this conception amongst the people and its introduction to the channel of creative inventions will place it in world-wide unity. Economy in movement is the same for everyone, whilst, on the other hand, everyone has different aesthetic tastes, and therefore move towards not unity but division and separation; contemporary life leaves this by means of communism.

It is necessary to consciously place creativity as the aim of life, as the perfection of oneself, and therefore current views on art must be changed: art is not a picture of pleasures, decoration, mood, experience or the conveyance of beautiful nature. This type of art no longer exists; nor do jesters, dancers and other miscellaneous theatrical grimacers (these monkeyish grimaces have also come to an end). There has appeared a silent, dynamic creation of new art's edifice in the red image of the world. [...]

[...] How we must study and what we must stand on is an important question, for your deed depends upon the stand you take. What is comprehended is also realized; this takes place in my consciousness and passing through experimental action is fixed in real existence; hence I appear to be divided into two parts: on the one hand, the experimental consciousness of a laboratory model fact, and, on the other, the real, utilitarian, living action. Studios should naturally be divided in this way. This is the chief basis from which the different types of comprehension may stem. And so the new construction studios will pass from the artistic culture of aesthetic beauties to the action of natural investigation, losing all the quirks of imitative studios: a plan of unity is needed for all technical constructions. Every phenomenon of form is the result of our energic movement, directed along the path of economy, which results in this or that form of a thing. Each artistic trend is a form of this type, a striving to convey by the briefest possible movement this or that state of a thing, as a question that has arisen externally. But all the trends, basing themselves on the aestheticism of art's beauty, have forgotten the important thing: the economy of movement. It was only in Cubism that this basis began to come more clearly to the fore, pouring itself out in the bright form of the Suprematist trend. New art is no longer organized under the flag of aesthetic taste, but is passing over to party organization. UNOVIS is now a party which has put economy as its basis. Thus art becomes closely linked with the communism of humanity's economic wellbeing. [...]

[...] Academism as art, as philosophical comprehension, and as a psychological phenomenon is already a definite form which has closed the ring of the horizon around imitative art. The new creation can no longer remain within this horizon, any more than the economic, political, civil life of rights and liberty can.

The form of academism as representation, as agitation, as a means for propaganda, is essentially temporary in the same way as grocers' shop signs are. Literacy will do away with the representation of objects on signs, whereas the expression of power sensations

can only be made through the abstract forms of the red moving against the white. Just as one cannot convey the power movements of a machine by portraying a man, so, likewise, one cannot convey the actual force of red, by portraying a worker in a red apron. At the essence of the new arts lies not representation but creative construction: raising ourselves by means of constructions we achieve the highest natural development in all humanity. We are moving towards a world where everyone will create, rather than repeating and mechanizing a form that an inventor has rejected. We must set creativity's path in such a way that all the masses will take part in the development of every creative thought that appears, without turning it into mechanized production or cliché. [...] Humanity contains the idea of unity, and this is its being; but it is so blocked up that it can only be reached with great difficulty. Our contemporary communist principle leads to it, but thanks to the fact that the path is blocked by chaotic forms one cannot get through except by war, although great achievements are to be made by the creative building of life's forms. If the masses were freed from the limitations of national and every other kind of patriotism and property which have been wound around their being by false leaders, the whole people would be fused into one and would naturally be drawn into general fusion, a unity of all forces in one form. As it is, it is destroyed by nationalism, and, preserving the latter, cannot be united as a result of which it produces a multitude of forms for its national, self-centered construction.

The contemporary being of modern man strives for a unity that will break up the boundaries between national vegetable gardens, summoning all the nations to a single pole, that in unity they might create the image of all humanity. There is only one path to this unification and unity – the economic path. This is the carrot that man chases in order to complete the form of pure action. This is the path of the economic and political avant-garde which is preparing territory for the pure action of creative work. Here lies the supremacy of contemporaneity. Imitative art has always been dependent on the various peculiarities of nationalism. It has developed in exact accordance with every phenomenon of economic, political, moral, religious, anecdotal, historical and everyday life; it has also had people waking up and shouting about the pure unity of pictorial action. But these people belonged not to imitative art but to creative construction, as a result of which many of them were banished by the state and ridiculed by society and the shameful critical press. They were subjected to cold and hunger, but their youthfulness kept them warm, and thanks to this they are still alive despite all these hardships. And thus we have lived to see a great revolution in imitative art. 1910 marked the conflagration, the clash between the revolutionary creative construction of Cubism and imitative art.

This civil war between new and old art is still going on. The academism of art's arrière-garde has been waging a desperate struggle with the innovators by means of the press and the censorship, but the October Revolution, having smashed the foundations of the old state, has partly recognized the innovators in art also. The innovators have been recognized and even given a place in the arrière-garde's college, but this is not enough to satisfy us: imitative art must be destroyed like the imperialist army. We innovators protest against a constituent assembly in art, for agreement is ridiculous when it means uniting two opposing trends which form some third monster – this is what constituent imitative art means. Today, as yesterday, engaged in ceaseless struggle we are moving towards a new path for art's innovators, which we shall make the method and system for establishing the utilitarian world of things, as a tender to the

moving being. We shall make for creative work which will be not merely personal but belong to the united masses. Our imitative art studios represent a constituent assembly, for they accommodate all the trends and even some individual personalities not belonging to any of the trends – the apolitical.

* * *

A strip of the new world has today been formed on Russian territory and the entire old world has arisen against it. The leaders of the economic-political armies are engaged in a struggle for rights and liberty.

Just as in the old days the West, East and South oppressed us economically, so it was in art. Now we have an army, faithful towards a new principle in economic life, and the vanguard of art. The economic life of the new world has produced the commune. The creative construction of the new art has produced the Suprematism of the square. [...]

10 Naum Gabo (1890–1977) and Anton Pevsner (1886–1962) 'The Realistic Manifesto'

The artists, who were brothers, had become familiar with avant-garde art in the west before the First World War, but by the time of the Revolution were back in Russia working at the Free Art Studios in Moscow. They issued their manifesto both as an affirmation of the value of formal 'constructive' aims in avant-garde art, and as a refusal of the more physical and ultimately utilitarian tendency which was beginning to be associated with Tatlin. Originally issued as a poster in Moscow, 5 August 1920, to accompany the artists' joint open-air exhibition with Gustav Klucis on Tverskoie Boulevard. The present translation, by Gabo himself, is taken from H. Read, *Gabo*, London, 1957, pp. 151–2. (The internal ellipses in this text are integral and do not indicate editorial excisions.)

Above the tempests of our weekdays,
 Across the ashes and cindered homes of the past,
 Before the gates of the vacant future,
 We proclaim today to you artists, painters, sculptors, musicians, actors, poets ... to you people to whom Art is no mere ground for conversation but the source of real exaltation, our word and deed.

The impasse into which Art has come in the last twenty years must be broken.

The growth of human knowledge with its powerful penetration into the mysterious laws of the world which started at the dawn of this century,

The blossoming of a new culture and a new civilization with their unprecedented-in-history surge of the masses towards the possession of the riches of Nature, a surge which binds the people into one union, and last, not least, the war and the revolution (those purifying torrents of the coming epoch), have made us face the fact of new forms of life, already born and active.

What does Art carry into this unfolding epoch of human history?

Does it possess the means necessary for the construction of the new Great Style?

Or does it suppose that the new epoch may not have a new style?

Or does it suppose that the new life can accept a new creation which is constructed on the foundations of the old?

In spite of the demand of the renascent spirit of our time, Art is still nourished by impression, external appearance, and wanders helplessly back and forth from Naturalism to Symbolism, from Romanticism to Mysticism.

The attempts of the Cubists and the Futurists to lift the visual arts from the bogs of the past have led only to new delusions.

* * *

Neither Futurism nor Cubism has brought us what our time has expected of them.

Besides those two artistic schools our recent past has had nothing of importance or deserving attention.

But Life does not wait and the growth of generations does not stop and we who go to relieve those who have passed into history, having in our hands the results of their experiments, with their mistakes and their achievements, after years of experience equal to centuries ... we say ...

No new artistic system will withstand the pressure of a growing new culture until the very foundation of Art will be erected on the real laws of Life.

Until all artists will say with us ...

All is a fiction ... only life and its laws are authentic and in life only the active is beautiful and wise and strong and right, for life does not know beauty as an aesthetic measure ... efficacious existence is the highest beauty.

Life knows neither good nor bad nor justice as a measure of morals ... need is the highest and most just of all morals.

Life does not know rationally abstracted truths as a measure of cognizance, deed is the highest and surest of truths.

Those are the laws of life. Can art withstand these laws if it is built on abstraction, on mirage, and fiction?

We say ...

Space and time are re-born to us today.

Space and time are the only forms on which life is built and hence art must be constructed.

States, political and economic systems perish, ideas crumble, under the strain of ages ... but life is strong and grows and time goes on in its real continuity.

Who will show us forms more efficacious than this ... who is the great one who will give us foundations stronger than this?

Who is the genius who will tell us a legend more ravishing than this prosaic tale which is called life?

The realization of our perceptions of the world in the forms of space and time is the only aim of our pictorial and plastic art.

In them we do not measure our works with the yardstick of beauty, we do not weigh them with pounds of tenderness and sentiments.

The plumb-line in our hand, eyes as precise as a ruler, in a spirit as taut as a compass ... we construct our work as the universe constructs its own, as the engineer constructs his bridges, as the mathematician his formula of the orbits.

We know that everything has its own essential image; chair, table, lamp, telephone, book, house, man ... they are all entire worlds with their own rhythms, their own orbits.

That is why we in creating things take away from them the labels of their owners ... all accidental and local, leaving only the reality of the constant rhythm of the forces in them.

1. *Thence in painting we renounce colour as a pictorial element, colour is the idealized optical surface of objects; an exterior and superficial impression of them; colour is accidental and it has nothing in common with the innermost essence of a thing.*

We affirm *that the tone of a substance,* i.e. *its light-absorbing material body is its only pictorial reality.*

2. We renounce *in a line, its descriptive value; in real life there are no descriptive lines, description is an accidental trace of a man on things, it is not bound up with the essential life and constant structure of the body. Descriptiveness is an element of graphic illustration and decoration.*

We affirm *the line only as a direction of the static forces and their rhythm in objects.*

3. We renounce *volume as a pictorial and plastic form of space; one cannot measure space in volumes as one cannot measure liquid in yards: look at our space . . . what is it if not one continuous depth?*

We affirm *depth as the only pictorial and plastic form of space.*

4. We renounce *in sculpture, the mass as a sculptural element.*

It is known to every engineer that the static forces of a solid body and its material strength do not depend on the quantity of the mass . . . example a rail, a T-beam, etc.

But you sculptors of all shades and directions, you still adhere to the age-old prejudice that you cannot free the volume of mass. Here (in this exhibition) we take four planes and we construct with them the same volume as of four tons of mass.

Thus we bring back to sculpture the line as a direction and in it we affirm depth as the one form of space.

5. We renounce *the thousand-year-old delusion in art that held the static rhythms as the only elements of the plastic and pictorial arts.*

We affirm *in these arts a new element the kinetic rhythms as the basic forms of our perception of real time.*

These are the five fundamental principles of our work and our constructive technique. [. . .]

11 UNOVIS: 'Programme of a United Audience in Painting of the Vitebsk State Free Workshops'

Malevich began teaching in Vitebsk in 1919, shortly ousting the incumbent Chagall and introducing his own course based on Suprematism. The same year, or in 1920, inspired partly no doubt by the contemporary fashion for collectivity, he organized UNOVIS, the 'Union of the New Art' or the 'Affirmers of the New Art'. This included, *inter alia*, Lissitsky, Puni, Klucis, Ermolaeva, Suetin and Chasnik. Members of the group travelled with Malevich to Petrograd in 1922 where the name continued to be used to designate the products of Malevich and his circle until at least the late 1920s. The present text outlines the educational programme organized under the auspices of UNOVIS in the Academy at Vitebsk in 1920. The translation is from Zhadova, op. cit., pp. 311, 314–16.

[. . .] Those studying in the art workshops in Vitebsk have mustered with the leaders of the UNOVIS collective as a united audience for problems of painting without shutting

themselves off from problems of architecture the philosophy of the new art the theatre etc. The work of UNOVIS proceeds multilaterally: painting is in the course, decorative art, the applied modelling of useful objects and sculpture. A special week is appointed for each problem. It has proved possible to unite five workshops except for the academic workshop. When the need to devise a method for the workshops has been understood we will be able to create a new utilitarian world of objects and direct the rest of the overall conception of the existing art trends to the actual life of that which is new. The atomization of shuttered personalities within workshops is not in accordance with the times and is counter-revolutionary in terms of general direction. These also are landlords and owners of their personal programmes and systems which were set aside by the new economic system for the sake of the common good. The new economic trend in art must take this new road and enlist the individual in the united programme of action at school and in life. Creating thereby a method for the new trends in art we shall achieve a definite programme corresponding to or fulfilling the movement of present times. Every step forward in economic life comes about because a new form of life is structured in the depths of the new awareness. New arts create a method and it is this method that we apply in UNOVIS and it has yielded positive results. In devising the programme we are also mindful of educational guidance as a contribution to the creation of a modern system of teaching.

Basic themes:
1 general orientation of the workshop – Cubism, Futurism and Suprematism as the new colour pictorial world formulation. Basic trends take shape as the themes of all other tendencies develop.
2 systematization, articulation of structures in painting, balance of formal structures in painting, paint and painting, material.

Section 1
Group 1 Abstraction of objects. Knowledge of pictorial and sculptural form, volume, plane, as an introduction to Cubism. Painting – colour. Painting – materials. Elements of structuring. Acquaintance with system and construction of structure on canvas and in space.

Section 2
Group 2 Cubism.
1 Cézanne and his pictorial outlook as executed in pictorial images.
2 Theory of Cubism and system of form construction by means of pictorial texture and materials.
3 Space and the form of the Cubist distribution of elements.
4 Construction of nature, displacement of construction and elaboration of a new Cubist one.
5 Ordering of elements in purely pictorial form.
6 Cubism and nature. Static and mobile state.

Section 3
Group 1
1 Futurism as a theory of velocity.

2 Van Gogh as an exponent of dynamics, the realization of his outlook.
3 Futurism and nature, town and village as objects affecting the structure of an instant's velocity.
4 Theory of Futurism.
5 Construction of the velocity of objects. The academic approach.

Section 4
1 Pure dynamics of colour. System of construction. Economy. Decoration. Ornament. Theatre.
2 Uncoloured Suprematist motion.
3 Theory of movement of colour energy.
4 Architecture. Three-dimensional Suprematism of the structure.
5 The square – its economical development.
6 The philosophy of Suprematism. Science – the refutation of science. The inner development of natural science constructions.
7 Personality and unity. The collective as a way to unity.

Decorative workshops
1 Theatre.
2 Dynamism.
3 Statics.
4 The making of objects, their form.
5 Wall painting and the plane. Decorative composition

12 Wassily Kandinsky (1866–1944) 'Plan for the Physico-psychological Department of the Russian Academy of Artistic Sciences'

Kandinsky had returned from Germany to Russia after the outbreak of the First World War. After the Revolution he briefly became a leading figure in the reorganization of art education. However, his mystical inclinations and his continued insistence on intuition and subjectivity resulted in hostility to his proposals. He left again for Western Europe and took up an appointment at the Bauhaus in 1922. The present text of a plan for the Academy of Artistic Sciences, submitted in June 1921, is an abbreviation of the much longer 'Programme' which he developed for the Institute of Artistic Culture (Inkhuk) in Moscow in 1920. It was the rejection of this latter which led him to reformulate his proposal for the Academy; the rejection of that in turn which led him to emigrate. The 'Plan' was originally published in the *Journal of the Russian Academy of Artistic Science*, no. 1, Moscow, Summer 1923, pp. 415–16. The present translation is taken from John Bowlt, *Russian Art of the Avant Garde*, London, 1976 and 1988, pp. 197–8. (For earlier texts by Kandinsky see IB8 and 9.)

The department sets as its task to disclose the inner, positive laws on the basis of which aesthetic works are formed within every sphere of art and, in connection with the results obtained, to establish the principles of synthetic artistic expression. This task can be reduced to a number of concrete objectives: (1) the study of artistic elements as

the material from which a work of art is formed, (2) the study of construction in creation as a principle whereby the artistic purpose is embodied, (3) the study of composition in art as a principle whereby the idea of a work of art is constructed.

The work of the department must be carried out in two directions: (a) a series of lectures based on the established program and (b) experimental research. We have not managed to pursue this experimental research owing to a lack of funds essential for the organization of laboratories.

The series of lectures 'Elements of Art' has been given, and now certain of their materials, observations, and ideas are being processed. The series of lectures on construction in nature, art, and technology is being developed. The series 'Composition' is being prepared.

In accordance with these aims and tasks, the department's scientific plan for 1922–3 consists of the following:

I The completion of a session of preliminary research work concerning the problem of construction in art. To this end, the following lectures on the problem of construction should be given at plenary meetings: (a) construction in extraaesthetic creation (utilitarian-productional construction), (b) architecture, (c) sculpture, (d) painting, (e) printing industry, (f) music, (g) plastic rhythm, (h) literature, (i) theater, (j) productional art.

II Research into primitive art and into all the aesthetic concepts that give primitive art its style. In this respect a number of specific tasks have been formulated: (1) Research into the laws of the statics and dynamics of primitive art: (a) in an individual or typical/group context; (b) in the evolution of one form from another. (2) Methods: (a) a formal, positive, art historians' approach, inasmuch as the research is connected with the formal and descriptive study of art objects; (b) a psychological approach, inasmuch as the research will concern the psychology of artistic creation and perception. (3) Materials: children's art, the art of primitive and backward peoples, primordial art, the primitives of early Christian and medieval art; primitivism in modern art; aesthetic concepts that characterize primitive art found, for the most part, in the art of the ancient East. (4) The materials can be developed with regard to (a) specific branches of art and (b) artistic groupings organically interconnected, and (c) they can be directed toward a synthetic summary of general inferences.

The research plan concerning the problem of primitive art and the aesthetic concepts that give art its style in the sphere of the spatial (visual) arts and vis-à-vis the material mentioned and outlined above can be defined thus: (1) Art that develops a plane or surface (so-called painting): (a) color, (b) line, (c) spatial expression, (d) material, (e) means of processing the surface, (f) laws of construction, (g) concept. (2) Art that organizes volumes (so-called sculpture): (a) material, (b) mass, (c) volume, (d) chiaroscuro, (e) color, (f) line, (g) surface, (h) laws of construction, (i) concept. (3) Art that organizes actual three-dimensional space (so-called architecture): (a) architectural mass, (b) space, (c) light and shade, (d) line, (e) surface, (f) color, (g) construction, (h) concept. (4) Types and phases of development of the general artistic concept in primitive art, their positive and aesthetic bases. (5) The psychology of aesthetic expression and perception (within the framework of primitive art).

13 Johnannes Itten (1888–1967) 'Analyses of the Old Masters'

Born and trained in Switzerland, Itten made his first abstract works in 1916. The same year he moved to Vienna, where he established a private art school. In his work and teaching he combined experience of Cubist and Expressionist painting with elements drawn from progressive educational theory, from contemporary theories of musical composition, and from the life-system proposed in Mazdaznan, one of several contemporary cults which claimed to transmit an ancient and universal wisdom. In 1919 he was invited, on the recommendation of Alma Mahler, to join the staff of the Bauhaus at Weimar, where he took control of the workshops in carpentry, metal-work, carving, stained glass and (with Schlemmer) mural painting. The reputation of the Bauhaus rests largely on its early promulgation of integrated modern design principles with a view to their industrial implementation. The school's origins, however, were in the confused conditions of the end of a world war, the eruption and failure of a revolution, and the establishment of bourgeois democracy in the Weimar Republic. A utopianism inseparable from this moment coexisted in tension with more orthodox and rationalistic elements, particularly in early Bauhaus pronouncements. Itten's significant contribution to the school and to its legacy was made in the design of the Vorkurs, a mandatory six-month process of induction, designed to liberate the creative energies of students and to sensitize them to the properties and potential of different materials and techniques. His analysis of the art of the Old Masters was integral to the course. Itten was on common ground with such modernist theorists as Clive Bell in his tendency to reduce compositions to formal 'essentials', and to question whether the basic principles of form are really teachable (see IB16). Yet in its emphasis on the need for first-hand practical experience, and in its utopian proposal that high art should be dissolved into social life through the medium of applied design, the Vorkurs was not incompatible with the contemporary ideals of Russian Constructivism. In the event, however, the spread of a Mazdaznan 'anti-materialism' among Itten's adherents effectively divided the Bauhaus. His position proved irreconcilable with that of the director Walter Gropius (see IIIC15) and in October 1922 he gave in his notice, leaving the following spring. Itten's text was originally published as 'Analysen alter Meister', in Bruno Adler (ed.), *Utopia: Dokumente der Wirklichkeit*, Weimar: Utopia-Verlag, 1921, pp. 29–49. This translation by Nicholas Walker is taken from pp. 29–37.

To experience [*erleben*] a work of art is to re-experience it, to rouse the essential and living character that rests within its form as one's own personal life. The work of art is born anew in us.

We claim that to experience a work of art is to re-create this work of art. This is because, from the spiritual perspective, there is no great difference between the human being who experiences a work of art and the human being who presents an experienced form externally in terms of the work. Every human being can be trained to draw a circular line, but not everyone possesses the inner power to experience that line. I can release this internal power, but I cannot give it to anyone else. Since the act of experience is dependent upon the spiritual resonance [*Schwingungskraft*] of the soul, and since we cannot grasp the nature of the soul or the spirit, we must say that this is a gift of God, inborn within those who have been made in his image, a path through which He may communicate the divine breath to the human soul.

Something that is vividly represented is always a thing experienced, and something experienced is always vividly represented. Nothing dead can ever appear vivid or alive, and nothing vivid or alive can ever appear dead.

Our capacity for external representation is dependent upon the material composition and physical constitution of a human body, of the fingers, hands, arms, feet, legs, of the torso, of the inner organs, like the heart, lungs, and stomach, of the organs of the senses, and of the brain. In short it depends upon the composition of all the materials and organs of the body.

The act of experience is a spiritual capacity of the soul. With respect to the more crudely material phenomena, it is the physical senses that generate experience, whereas with respect to the subtler and more spiritual phenomena, it is the spiritual senses which do so.

To perceive form is to be moved, and to be moved is to give form. Even the slightest stirring of feeling is a form which irradiates movement. All living things reveal themselves to us by means of movement. Everything is marked by movement, and nothing is dead. For otherwise it could not exist at all.

Everything that exists is distinguished with respect to the quantity and quality of movement, is distinguished with respect to space and time. All form is similarly distinguished, just as movement is. [...]

Without movement there is no perception, without perception there is no form, without form there is no material. Material is form. Form = movement in space and time. Therefore material = movement in space and time.

We have already claimed that all materials are the means of representation. But now we have seen that all materials are forms. Thus form itself is the means of representation. If this is indeed the case, and the essential nature of form is ultimately grounded in its spiritual origin in the soul, which itself can never be comprehended, then the conclusion which easily and inevitably follows is this:

It is just as impossible to teach the means of representation as it is to teach form. For teaching and learning mean having understood and coming to understand. Only an undeveloped mind, therefore, could ever entertain the notion that form is teachable.

This raises the question: are teaching and understanding ever really possible at all? We never rationally fathom the ultimate ground of a thing. Ultimately we are unable to teach or comprehend material, form or movement. We can only perceive perception.

Only modesty and great humility before Him, the incomprehensible One, can help us to endure this insight.

I can perceive perception. I can perceive the process of movement, but I can never perceive movement as such, only the actual motility of something. All teaching and learning, therefore, is nothing but the perception of such motility in the teacher, in the learner. Motility generates motility. Anyone who ponders this carefully will be able to draw a multitude of conclusions for himself. All that we are interested in now are the consequences for the practitioner of the visual arts if the above claims are accepted.

Movement gives birth to form. Form gives birth to movement. Every point, every line, every surface, every body, every shadow, every ray of light and every colour are forms that are born of movement and which themselves generate movement. Grief and joy, hate and love, distaste and fondness, these are all forms of psyche and born of movement.

If I wish to experience a line, I must also move my own hand, tracing its course, or I must follow it with my senses, and thus be moved psychologically, moved in my own soul. And if at last I can inwardly represent a line to myself, and behold it spiritually, then I am moved in my own spirit.

The three distinct levels of motility are the following. If I draw the line physically by hand, then I am physically moved – the first physical grade of motility. If I follow a line with my senses, then we have the second psychological grade of motility. If I inwardly represent the line to myself in spirit, then I find myself in the third spiritual grade of motility. The physical grade is an outer motility, the spiritual grade is an inner motility, the psychological grade is a motility that is both inner and outer, a compound of both forms. Viewed from the perspective of the highest form we must say that clarity and brightness correspond to inner spiritual motility, while darkness and obscurity correspond to outer physical motility. The third grade illumines the first and wrests it from the dark, just as the sun illumines the moon. [. . .]

14 Oskar Schlemmer (1888–1943) Diary Extracts

Schlemmer was born in Stuttgart, where, like Itten and Paul Klee, he studied under Adolf Hölzel. In 1920 both he and Klee were appointed to the teaching staff of the Bauhaus. The central motif of Schlemmer's mature work – deployed in paintings, reliefs, sculptures and even in his *Triadic Ballet* of 1922 – was the human figure, reduced to a simplified formal component in otherwise non-figurative or schematically architectural settings. The following notes were written during a period of preparation for the first public exhibition of Bauhaus work. Schlemmer was given responsibility for the decoration of the vestibule in the main building and for the overall concept of the exhibition. The first section of the notes refers to the plan for the vestibule, shelved in the event due to conservative opposition from its other users. The section dated July–August 1923 refers to murals executed during that year in the Weimar Workshop Building, designed by Henry van de Velde. (These were destroyed seven years later.) Following publication in the journal *Das Kunstblatt*, this latter section of the notes was widely taken as representative of Bauhaus views on the integration of art and architecture. As a whole, the notes testify to Schlemmer's awareness of a crisis facing easel-painting, and of the danger to mural painting where it was used as architectural decoration. His response was to treat the human figure as a kind of guarantor of symbolic content in otherwise abstract work. The notes are translated from Tut Schlemmer (ed.), *Oskar Schlemmer, Briefe und Tagebücher*, Stuttgart: Verlag Gerd Hatje, 1977, pp. 62–3, 63–4, 68. The entry for July–August 1923 was first published in slightly expanded form as 'Gestaltungsprinzipien bei der malerisch-plastischen Ausgestaltung des Staatliches Bauhauses', in *Das Kunstblatt*, vol. IV, nos. 11–12, 1923, pp. 340–3. The translation in the present volume was made by Nicholas Walker.

November 1922

For the coming exhibition the vestibule of the Bauhaus will serve specifically to display the general tendencies within the Bauhaus with respect to the building itself. Given the necessary austerity of the intended building, it will naturally be impossible to do full justice to them. There will not be much room for the painters to do anything, in regard to murals, and even less room for the sculptors. Mural painting, and especially sculpture, will therefore represent the problematic faculties of the Bauhaus, at least until they come to exercise greater influence in the outside world: the temple of the future, the dome of democracy, the cathedral of socialism, these will all have to wait their time. At the moment we merely have the plain building itself and must accept the

representative tendencies more or less as we find them. The vestibule cries out for further development. It could become the effective symbol of the Bauhaus if we use it, even in van de Velde's present layout, to display mural painting and sculpture together and present them in a way that is otherwise generally impossible. And we must present them in this way if we are ever to have any hope of receiving such, and better, commissions in the future.

Mural painting, rightly praised as a genre that is capable of accomplishing an emphatic relationship to space and architecture, in contrast to the autonomous character of easel-painting and the associated danger of *l'art pour l'art*, must find an appropriate site and solution here at the Bauhaus. Mural art must be justified in ethical terms, and the central idea it presents must be a universal one, or at least it must harbour those values that will allow it to become such. The proper function of mural painting is to give appropriate form to some important theme. It still has this task even today, indeed more so now than ever before. And the will to pursue it has made itself felt especially today, and indeed especially in German painting.

Disturbed by developments in the Romance countries which propagate a new kind of naturalism or end up by denying art itself, we would seem to hold the fate of art in our own hands, defending it as we must from the forces of conservatism and anarchism alike. This is how I interpret Kandinsky's highly suggestive remarks about the coming exhibition as a 'world event'. And it is appropriate to pursue the middle course here, although this is otherwise generally contemptible, precisely because it promises that synthesis of architecture, painting and sculpture which is so much desired.

* * *

Mid-November 1922

Some reflections upon art, upon what is most specific to myself, that which I have always striven and taken great pains to accomplish, and which is therefore inimitable.

I emphatically do not want an applied art [*Kunstgewerbe*], one that is merely a dilution of abbreviated ideas.

I emphatically do not want to paint up houses.

I emphatically do not want to build houses, except for an ideal one derived from my own pictures in so far as they have expressly anticipated it.

I emphatically do not want to produce what industrial manufacture already does better, what engineers do better. What remains is the metaphysical element: art itself.

* * *

November 1922

The Bauhaus and me:

What is it I want to achieve? To create a style of painting that affirms a necessity over and beyond fashion or aesthetic form, a necessity that asserts its rights alongside the instrumental necessity that belongs to machines and to all objects of use.

This style is necessarily therefore ethical in character. It represents a style of living for the purpose of 'raising self-awareness'.

I want to realize it in self-contained works which naturally require an appropriate environment – pre-eminently an architectural one.

I do not believe in handicraft. We are not attempting to restore medieval handicraft, any more than medieval art, not even in a qualified and relevant modern sense. Such handicraft has been rendered obsolete by modern development as a whole. In the age of technology and the machine decorative craft of this kind simply becomes a commodity for the rich, for it lacks the broad-based character it formerly enjoyed and possesses no genuine popular roots. The role once played by handicraft has already been taken over today by industrial manufacture, or soon will be in line with the general trend towards the production of typified and reliable objects of use that are manufactured from genuinely appropriate materials.

It is just the same with architecture. Audacity and innovation here derive from contemporary technical achievements. A majestic example: the country house of Frank Lloyd Wright. These developments have taken their natural course in accordance with the spirit of objectivity [*Sachlichkeit*], without displaying any major artistic ambitions.

I do not believe that handicraft, as practised at the Bauhaus, is capable of fulfilling any deeper social aims over and beyond the aesthetic dimension. This is not accomplished simply by establishing a 'rapport with industry'. It would be necessary to permeate this domain, to be dissolved in it. That cannot be our task; we should have to turn our backs on the Bauhaus.

* * *

July/August 1923

Design principles [*Gestaltungsprinzipien*] for the overall pictorial and sculptural layout of the workshop at the national Bauhaus in Weimar:

The spatial layout was already provided by van de Velde. The already plainly whitewashed walls were at least walls, as fervently demanded by a new young generation of painters who hoped thereby to liberate themselves from the fruitless thrall of easel-painting.

It must certainly be said that in this disenchanted world of ours any art that would take great themes for its subject, as monumental painting and sculpture do, seems particularly isolated and neglected. The foundations upon which such art was formerly built have been shattered or entirely lost: the consciousness of the people, ethics, religion. The new is still afflicted with birth pangs, and is contested, unrecognized. But one great theme still abides, immemorially old but everlastingly new, the depicted object and creative subject of all times: humanity, the human figure itself. Man has been described as the measure of all things. Indeed! Architecture is the noblest art of measurement: then join your forces with one another!

It must be said that the measure we bear within ourselves, if creatively expressed, is capable of being ever new and of shaping what is new. Of course, we have geometry, the golden section, the theory of proportions. But these are dead and sterile unless they are properly felt, sensed and experienced [*erlebt*]. We must allow ourselves to be astonished by the marvel of proportion, by the splendour of arithmetical ratios and numerical correspondences, and construct the principles we need from the results of such enquiries. A counterpoint of painting will never be discovered, or if so, will merely prove a lifeless schema in comparison to the true counterpoint of music. This implies that the creative process in these two arts is entirely different. Following

spontaneously along this hallowed path, our labours in the workshop building revealed how the figures of 3, 5 and 7 kept recurring in the most various guises and relations. Feeling acted first, and reason registered the result. And as with form, so too with colour. The triad of fundamental colours red–blue–yellow, the further extension to five through the non-colours black and white, and the resulting numerical series of possible combinations, have their counterpart in the elementary and fundamental forms of surface and plastic volume, although they only provide the rudimentary framework for the incalculable resonance that is sought.

The type is the elementary principle in the figurative sphere. And its creation is the ultimate and supreme task, one that it may well seem impudent even to approach when fate casts such a shadow over the possibilities of its execution. The potential variations of the figural subject can be realized in sculpture (relief), colour and line. As abstractions the figural proportions are correspondingly intensified, presented as much larger or much smaller than the human body; but the latter should still define the general centre and measure of things.

The technically required use of opaque (non-chemical) earthen colours produces a colour scale with its own intrinsic harmony. As primary colours: English red – ultramarine – ochre (with white and black for priming). As secondary colours: caput mortuum, burnt umber, indigo. To these we must add the metallic colours: gold, silver, copper, blue-silver, purple-silver.

15 Walter Gropius (1883–1969) 'The Theory and Organization of the Bauhaus'

The author was the founder and first Director of the Bauhaus, established in Weimar in 1919. Though Gropius shared Itten's commitment to 'release the creative powers of the student', he always had the well-designed building as an end in view, and he was increasingly concerned that the work of the school should be assured of a productive outcome through contacts with industry. Originally published as *Idee und Aufbau des Staatlichen Bauhaus Weimar* by the Bauhaus Press (Bauhausverlag), Munich, 1923. The present extracts are taken from the translation in Herbert Bayer, Walter Gropius and Ise Gropius (eds.), *Bauhaus 1919–1928*, New York (Museum of Modern Art), 1938, pp. 22–31.

The dominant spirit of our epoch is already recognizable although its form is not yet clearly defined. The old dualistic world-concept which envisaged the ego in opposition to the universe is rapidly losing ground. In its place is rising the idea of a universal unity in which all opposing forces exist in a state of absolute balance. This dawning recognition of the essential oneness of all things and their appearances endows creative effort with a fundamental inner meaning. No longer can anything exist in isolation. We perceive every form as the embodiment of an idea, every piece of work as a manifestation of our innermost selves. Only work which is the product of inner compulsion can have spiritual meaning. Mechanized work is lifeless, proper only to the lifeless machine. So long, however, as machine-economy remains an end in itself rather than a means of freeing the intellect from the burden of mechanical labor, the individual will remain enslaved and society will remain disordered. The solution depends on a change in the individual's attitude toward his work, not on the betterment of his outward

circumstances, and the acceptance of this new principle is of decisive importance for new creative work.

* * *

The 'academy'

The tool of the spirit of yesterday was the 'academy.' It shut off the artist from the world of industry and handicraft, and thus brought about his complete isolation from the community. In vital epochs, on the other hand, the artist enriched all the arts and crafts of a community because he had a part in its vocational life, and because he acquired through actual practice as much adeptness and understanding as any other worker who began at the bottom and worked his way up. But lately the artist has been misled by the fatal and arrogant fallacy, fostered by the state, that art is a profession which can be mastered by study. Schooling alone can never produce art! Whether the finished product is an exercise in ingenuity or a work of art depends on the talent of the individual who creates it. This quality cannot be taught and cannot be learned. On the other hand, manual dexterity and the thorough knowledge which is a necessary foundation for all creative effort, whether the workman's or the artist's, can be taught and learned.

Isolation of the artist

Academic training, however, brought about the development of a great art-proletariat destined to social misery. For this art-proletariat, lulled into a dream of genius and enmeshed in artistic conceit, was being prepared for the 'profession' of architecture, painting, sculpture or graphic art, without being given the equipment of a real education – which alone could have assured it of economic and esthetic independence. Its abilities, in the final analysis, were confined to a sort of drawing-painting that had no relation to the realities of materials, techniques or economics. Lack of all vital connection with the life of the community led inevitably to barren esthetic speculation. The fundamental pedagogic mistake of the academy arose from its preoccupation with the idea of the individual genius and its discounting the value of commendable achievement on a less exalted level. Since the academy trained a myriad of minor talents in drawing and painting, of whom scarcely one in a thousand became a genuine architect or painter, the great mass of these individuals, fed upon false hopes and trained as one-sided academicians, was condemned to a life of fruitless artistic activity. Unequipped to function successfully in the struggle for existence, they found themselves numbered among the social drones, useless, by virtue of their schooling, in the productive life of the nation.

With the development of the academies genuine folk art died away. What remained was a drawing-room art detached from life. In the 19th century this dwindled to the production of individual paintings totally divorced from any relation to an architectural entity. The second half of the 19th century saw the beginning of a protest against the devitalizing influence of the academies. Ruskin and Morris in England, van de Velde in Belgium, Olbrich, Behrens and others in Germany, and, finally, the Deutsche Werkbund, all sought, and in the end discovered, the basis of a reunion between creative artists and the industrial world. In Germany, arts and crafts (Kunstgewerbe) schools

were founded for the purpose of developing, in a new generation, talented individuals trained in industry and handicraft. But the academy was too firmly established: practical training never advanced beyond dilettantism, and draughted and rendered 'design' remained in the foreground. The foundations of this attempt were laid neither wide enough nor deep enough to avail much against the old *l'art pour l'art* attitude, so alien to, and so far removed from life. [...]

Analysis of the designing process

The objective of all creative effort in the visual arts is to give form to space.... But what is space, how can it be understood and given a form?

... Although we may achieve an awareness of the infinite we can give form to space only with finite means. We become aware of space through our undivided Ego, through the simultaneous activity of soul, mind and body. A like concentration of all our forces is necessary to give it form. Through his intuition, through his metaphysical powers, man discovers the immaterial space of inward vision and inspiration. This conception of space demands realization in the material world, a realization which is accomplished by the brain and the hands.

The brain conceives of *mathematical space* in terms of numbers and dimensions.... *The hand masters matter* through the crafts, and with the help of tools and machinery.

Conception and visualization are always simultaneous. Only the individual's capacity to feel, to know and to execute varies in degree and in speed. True creative work can be done only by the man whose knowledge and mastery of the physical laws of statics, dynamics, optics, acoustics equip him to give life and shape to his inner vision. In a work of art the laws of the physical world, the intellectual world and the world of the spirit function and are expressed simultaneously.

The Bauhaus at Weimar

Every factor that must be considered in an educational system which is to produce actively creative human beings is implicit in such an analysis of the creative process. At the 'State Bauhaus at Weimar' the attempt was made for the first time to incorporate all these factors in a consistent program.

[...] The theoretical curriculum of an art academy combined with the practical curriculum of an arts and crafts school was to constitute the basis of a comprehensive system for gifted students. Its credo was: 'The Bauhaus strives to coordinate all creative effort, to achieve, in a new architecture, *the unification of all training in art and design*. The ultimate, if distant, goal of the Bauhaus is the *collective work of art* – the Building – in which no barriers exist between the structural and the decorative arts.'

The guiding principle of the Bauhaus was therefore the idea of creating a new unity through the welding together of many 'arts' and movements: a unity having its basis in Man himself and significant only as a living organism.

Human achievement depends on the proper coordination of all the creative faculties. It is not enough to school one or another of them separately: they must all be thoroughly trained at the same time. The character and scope of the Bauhaus teachings derive from the realization of this.

The Curriculum

The course of instruction at the Bauhaus is divided into:
* * *

The Preliminary Course (Vorlehre)

Practical and theoretical studies are carried on simultaneously in order to release the creative powers of the student, to help him grasp the physical nature of materials and the basic laws of design. Concentration on any particular stylistic movement is studiously avoided. Observation and representation – with the intention of showing the desired identity of Form and Content – define the limits of the preliminary course. Its chief function is to liberate the individual by breaking down conventional patterns of thought in order to make way for personal experiences and discoveries which will enable him to see his own potentialities and limitations. For this reason collective work is not essential in the preliminary course. Both subjective and objective observation will be cultivated: both the system of abstract laws and the interpretation of objective matter.

Above all else, the discovery and proper valuation of the individual's means of expression shall be sought out. The creative possibilities of individuals vary. One finds his elementary expressions in rhythm, another in light and shade, a third in color, a fourth in materials, a fifth in sound, a sixth in proportion, a seventh in volumes or abstract space, an eighth in the relations between one and another, or between the two to a third or fourth.

All the work produced in the preliminary course is done under the influence of instructors. It possesses artistic quality only in so far as any direct and logically developed expression of an individual which serves to lay the foundations of creative discipline can be called art.

Instruction in form problems

Intellectual education runs parallel to manual training. The apprentice is acquainted with his future stock-in-trade – the elements of form and color and the laws to which they are subject. Instead of studying the arbitrary individualistic and stylized formulae current at the academies, he is given the mental equipment with which to shape his own ideas of form. This training opens the way for the creative powers of the individual, establishing a basis on which different individuals can cooperate without losing their artistic independence. Collective architectural work becomes possible only when every individual, prepared by proper schooling, is capable of understanding the idea of the whole, and thus has the means harmoniously to coordinate his independent, even if limited, activity with the collective work. Instruction in the theory of form is carried on in close contact with manual training. Drawing and planning, thus losing their purely academic character, gain new significance as auxiliary means of expression. We must know both vocabulary and grammar in order to speak a language; only then can we communicate our thoughts. Man, who creates and constructs, must learn the

specific language of construction in order to make others understand his idea. Its vocabulary consists of the elements of form and color and their structural laws. The mind must know them and control the hand if a creative idea is to be made visible. The musician who wants to make audible a musical idea needs for its rendering not only a musical instrument but also a knowledge of theory. Without this knowledge, his idea will never emerge from chaos.

A corresponding knowledge of theory – which existed in a more vigorous era – must again be established as a basis for practice in the visual arts. The academies, whose task it might have been to cultivate and develop such a theory, completely failed to do so, having lost contact with reality. Theory is not a recipe for the manufacturing of works of art, but the most essential element of collective construction; it provides the common basis on which many individuals are able to create together a superior unit of work; theory is not the achievement of individuals but of generations.

The Bauhaus is consciously formulating a new coordination of the means of construction and expression. Without this, its ultimate aim would be impossible. For collaboration in a group is not to be obtained solely by correlating the abilities and talents of various individuals. Only an apparent unity can be achieved if many helpers carry out the designs of a single person. In fact, the individual's labor within the group should exist as his own independent accomplishment. Real unity can be achieved only by coherent restatement of the formal theme, by repetition of its integral proportions in all parts of the work. Thus everyone engaged in the work must understand the meaning and origin of the principal theme.

Forms and colors gain meaning only as they are related to our inner selves. Used separately or in relation to one another they are the means of expressing different emotions and movements: they have no importance of their own. Red, for instance, evokes in us other emotions than does blue or yellow; round forms speak differently to us than do pointed or jagged forms. The elements which constitute the 'grammar' of creation are its rules of rhythm, of proportion, of light values and full or empty space. Vocabulary and grammar can be learned, but the most important factor of all, the organic life of the created work, originates in the creative powers of the individual.

The practical training which accompanies the studies in form is founded as much on observation, on the exact representation or reproduction of nature, as it is on the creation of individual compositions. These two activities are profoundly different. The academies ceased to discriminate between them, confusing nature and art – though by their very origin they are antithetical. Art wants to triumph over Nature and to resolve the opposition in a new unity, and this process is consummated in the fight of the spirit against the material world. The spirit creates for itself a new life other than the life of nature.

Each of these departments in the course on the theory of form functions in close association with the workshops, an association which prevents their wandering off into academicism.

The goal of the Bauhaus curriculum

... the culminating point of the Bauhaus teaching is a demand for a new and powerful working correlation of all the processes of creation. The gifted student must regain a

feeling for the interwoven strands of practical and formal work. The joy of building, in the broadest meaning of that word, must replace the paper work of design. Architecture unites in a collective task all creative workers, from the simple artisan to the supreme artist.

For this reason, the basis of collective education must be sufficiently broad to permit the development of every kind of talent. Since a universally applicable method for the discovery of talent does not exist, the individual in the course of his development must find for himself the field of activity best suited to him within the circle of the community. The majority become interested in production; the few extraordinarily gifted ones will suffer no limits to their activity. After they have completed the course of practical and formal instruction, they undertake independent research and experiment.

Modern painting, breaking through old conventions, has released countless suggestions which are still waiting to be used by the practical world. But when, in the future, artists who sense new creative values have had practical training in the industrial world, they will themselves possess the means for realizing those values immediately. They will compel industry to serve their idea and industry will seek out and utilize their comprehensive training.

16 Theo van Doesburg (1883–1931), El Lissitsky (1890–1947), Hans Richter (1888–1976) 'Declaration of the International Fraction of Constructivists of the First International Congress of Progressive Artists'

The relations between Soviet Constructivism and similar avant-garde tendencies in the West are obscure and tangled. Evidence of Russian work began to be available in Berlin from around the end of the civil war in 1921. El Lissitsky, who arrived in Berlin at the end of that year, reputedly had with him a copy of the Programme of the First Working Group of Constructivists (which was not published until 1922; see IIID6). Lissitsky, along with Ilya Ehrenburg, also published the tri-lingual journal *Veshch/Gegenstand/Objet* in Berlin in 1922 (see IIID8). Also in 1922, the first official exhibition of post-war Russian art took place. Despite these contacts, however, Western responses to Russian art generally entailed a degree of depoliticization. In the Soviet situation 'constructivism' was part of a broader project to participate in the building of a new society. In the West it was a tendency of abstract art and design. This is the context for the 'Congress of the International Union of Progressive Artists' held in Düsseldorf in May 1922. The proposed Union has been referred to as a half-way house between a 'meta-Novembergruppe' (see IIIB8) and a 'proto-Abstraction-Création' (see IVA6). A more radically minded grouping dissented from this stance, however. The Russian Unovis artist El Lissitsky (see IIIC11 and 12) joined forces with Theo van Doesburg of the Dutch De Stijl group (see IIIC4 and 5), and the German Dadaist painter and film-maker Hans Richter, to publish a 'Declaration' on 30 May, in which the authors counterposed their own more militant programme to the idealistic stance of the Union. The text was subsequently published in *De Stijl*, V, no. 4, Scheveningen, 1923, pp. 61–4, from which the present translation has been made by Nicholas Walker.

We came to Düsseldorf with the firm intention of establishing an International Society. The consequences are as follows:

The Union:
I. The inaugural proclamation of the Union declares a 'warm and productive international interaction between minds' as its organizing principle.
Ourselves:
I. *Good will is not a programme* and cannot therefore serve as the basis of an organization, especially if the good will *fails* at the moment when it should have translated itself into a distinct reality at the Congress over against the opposing party.

The Union:
II. Total lack of clarity about the proper purpose of the Union – about whether it should serve as a kind of trade union in order to defend its own economic interests, or whether it should constitute an economic forum for pursuing and realizing specific cultural interests.
Ourselves:
II. For us it is quite clear that *a specific outlook concerning the problems of art must be established first*, and that the relevant economic questions can only play a role once this is done.

The Union:
III. No definition of 'progressive artists' is provided. When considering the agenda of the congress questions of this kind were *excluded* on the grounds that the particular individual's approach to the problems of art is an entirely personal matter.
Ourselves:
III. We define the progressive artists as those who *deny and contest the priority of the subjective in art*, who construct their works not on the basis of lyrical caprice, but in accordance with the new formative principle: the systematic organization of means in the service of *universally comprehensible expression*.

The Union:
IV. It is obvious from the founding manifesto that the Union envisages a series of initiatives *aimed principally at furthering the international business of art exhibitions*. The Union is thus effectively planning *to pursue an entrepreneurial politics of colonization*.
Ourselves:
IV. *We repudiate the art exhibitions of today as warehouses for the commercial exchange of things that are simply ranged alongside one another in an intrinsically unrelated manner.* We stand today between a society which does not need us and a society that does not yet exist. That is why the only exhibitions acceptable to us are those which *demonstrate* what we still wish to accomplish (projects, plans, models) or what we have already accomplished.

For all these reasons it is clear that an International Society of progressive artists can only properly be established on the following basis:
a) Art, just like science and technology, is a method of organizing our *shared life in general*.
b) We must recognize that art has *ceased to be a dream world* that opposes itself to the world of reality, that it has *ceased to be a means for unveiling cosmic mysteries*. *Art is a universal and real expression of the creative energy which organizes the progress of humanity*. That is to say: art is a tool of the universal process of labour.

c) *We must struggle if we are to transform this view into reality. And we must be organized in order to enter on this struggle.* This is the only way that collective human energy can be liberated. Considerations of principle and economic considerations are thereby unified. *The proceedings of the congress have demonstrated, through the priority still ascribed to the individual perspective on art, that an International Society in the progressive spirit of solidarity cannot be constructed from the elements of this congress.*
Düsseldorf, 30 May 1922

<div align="right">

Theo van Doesburg
El Lissitsky
Hans Richter

</div>

17 Wladyslaw Strzeminski (1893–1952) 'What is legitimately called the New Art...'

Born in Minsk, Strzeminski served as an engineer in the Tsarist army during the First World War. He was wounded in 1917 and convalesced in Moscow, where he turned to art and studied at the post-revolutionary Vkhutemas and Inkhuk (see IIID5 and 6). In the early twenties he was influenced by Malevich and became associated with the Unovis group (see IIIC11). In 1922, after the Civil War, Strzeminski left the Soviet Union for Poland together with his wife, the sculptor Katarzyna Kobro. He became a prominent member of the Polish avant-garde, helping to found the Block group in 1924 with Mieczyslaw Szczuka. The present text was published in the group's journal in 1924. It reflects a tension between Strzeminski's concern with the investigation of plastic form, and the more utilitarian turn advocated by Szczuka. In response to this clash, Strzeminski left Block in early 1925, and elaborated his own theory of 'Unism'. He subsequently remained in Poland, but became part of an international current of 'constructive' abstraction (see IVA5). He later returned to figuration, but remained beyond the pale of Socialist Realism, and after the Second World War was effectively prevented from earning his living as an artist. 'What is legitimately called the New Art...' was first published in *Blok*, no. 2, Warsaw, April 1924. It is reprinted here in full in the translation published in the catalogue *Constructivism in Poland 1923–1936*, Museum Folkwang, Essen and Rijksmuseum Kröller-Müller, Otterlo, 1973, pp. 75–6.

1. What is legitimately called New Art, pursues the perfection of the plastic form.
2. To analyse the domain of the plastic arts we cannot use the universal method of research, blurring the difference that exists between this and the other domains.
3. The perfection of a work of art must be its content – rather than a blueprint and a narrative about another content, experienced elsewhere and then finding its vestige and imitation in the form of a work of art.
 Nota bene:
 Also, a work of art should not be a narrative about the content of the present day. Let its actuality be measured by the standard of its perfection, possible to be attained only today.
4. Classic art has achieved a certain level of perfection. Its further development has been impeded by: literary exploits; the principle of symmetry; the so-called 'noble sinuosity' of shapes.

5. A work of art must be built according to laws which are its own. It can have no model, neither in the exactitude of photography, nor in the samples of industrial products, nor in any other thing whatsoever.

6. A work of plastic art does not express itself. A work of art is not a sign of anything. It is (exists) all by itself.

7. A work of art is the Organicity of a spatial phenomenon.

8. Dynamism is spatio-temporal action, and thus it does not belong to the plastic arts.

9. The present day has surpassed the directions of the so-called new art: cubism, futurism, suprematism, grounded on the dynamic element.

10. Cubism, starting from a uniform system of contrasts, invented and introduced the difference in texturing and the difference of shapes.

11. Formerly, the organicity of a work of art used to be pursued by imitating the organic shapes of nature or by imitating the hiero-mathematics of Pythagoras (in ornamental works – the principle of symmetry, the triangle of Leonardo da Vinci, the diagonal of Tintoretto). This could not be done. The laws of art cannot be reduced to the laws of nature. Either the logic of art, or the logic of things. Also the creatively impotent schemes of Pythagoras, violently pressed into art rather then inherent in it, have fallen bankrupt ever since the time of Raphael's frescoes. It is since that date that the agony of the principles of symmetry has begun.

12. Deriving a work of art from the image of contemporary technology, an artist is a little closer to his objective, for both one and the other is a product of human hands. But here the old literary and naturalistic superstition is still lingering ('a picture tells a story', 'a picture expresses', 'a picture reproduces'), whereas it neither tells, nor expresses or reproduces anything; it simply is, exists. The difference in the aims, and thus in the system of construction, has been blurred. A machine is an organic whole, and its aim is the perfection of its output. As a whole, it can be beautiful, though it does not attempt it. A work of art is a visual organic whole and as a whole it can be beautiful, though it does not attempt to be it.

18 El Lissitsky (1890–1947) 'A. and Pangeometry'

Lissitsky was strongly affected by Malevich's Suprematism while working at Vitebsk in 1919. He in particular was responsible for the development of Suprematism as a graphic – and hence reproducible – means of building support for the Revolution. In the early and mid-1920s he was influential in establishing contacts between Russian revolutionary art and those with similar concerns in Western Europe (see IIIC16 and IIID8). The present essay (in which Lissitsky employs two abbreviations: A. = Art; F. = Form) was originally published in German in Carl Einstein and Paul Westheim (eds.), *Europa Almanach*, Potsdam, 1925. The present translation by Eric Dluhosch is taken from El Lissitsky, *Russia: An Architecture for World Revolution*, London, 1970, pp. 142–9.

[...] The term A. resembles a chemist's graduated glass. Each age contributes its own quantity: for example, 5 drams of the perfume 'Coty' to tickle the nostrils of the fine gentry. Or another example, 10 cc of sulfuric acid to be thrown into the face of the

ruling classes. Or, 15 cc of some kind of metallic solution that later changes into a new source of light. Thus, A. is an invention of the mind, i.e., a complex, where rationality is fused with imagination, the physical with the mathematical, the $\sqrt{1}$ with $\sqrt{-1}$. The series of analogies I shall present below are not offered as proof – my work serves that purpose much better – but in order to clarify my views. Parallels between A. and mathematics must be drawn very carefully, for any overlap is fatal for A.

Planimetric Space

Plastic F. – like mathematics – begins with counting. Its space is made up of physical, two-dimensional, flat surfaces. Its rhythm, the elementary harmony of the natural numerical series 1, 2, 3, 4 . . .

The newly created object . . . let's say a relief, is compared with real objects in nature. For example, if the relief shows the front part of an animal hiding part of another animal behind, this then does not mean that the latter, the hidden part, has ceased to exist; it simply means that a certain distance exists between the two objects – a space. As a consequence, through experience the knowledge is gained that distance exists between objects and that objects exist *in space*.

Thus, the two-dimensional plane ceases to be merely a surface. The plane begins to include space, and the mathematical series 1, $1\frac{1}{2}$, 2, $2\frac{1}{2}$. . . is created.

Perspective Space

The simple flat surface perceived by the eye stretches and extends into vivid space, evolving into a new system. The perspective mode finds its expression within this system. It is commonly assumed that perspective representation of space is objective, unequivocal, and obvious. People say, 'The camera too sees the world in terms of perspective,' but this ignores the fact that, contrary to common practice in the West, the Chinese have built a camera with concave rather than convex lenses, thereby producing an equally objective image of the world in the mechanical sense, but obviously quite different in all other respects. Perspective representation of space is based on a rigid three-dimensional view of the world based on the laws of Euclidean geometry. The world is put into a cubic box and transformed within the picture plane into something resembling a pyramidal form. [. . .] Here, the apex of the visual cone has its location either in our eye, i.e., in front of the object, or is projected to the horizon, i.e., behind the object. The former approach has been taken by the East, the latter by the West.

Perspective limits space; it has made it finite, closed. However, despite all of this, the 'sum total' (here 'sum total' means the aggregate of all possible numbers that may be geometrically expressed by a straight line – 'the fixed line') of A. has been enriched in the sense that each point, even one infinitely close, can be represented by a number. Planimetric space has produced the arithmetic series. In it, objects are perceived according to the relationship 1, 2, 3, 4, 5 . . . Perspective space resembles a geometric series, and objects are perceived according to the relationship 1, 2, 4, 8, 16, 32 . . . Until our time the 'sum total' of A. has not experienced any new extensions. However, a fundamental reorientation has taken place in science. The geocentric cosmic order of Ptolemy has been replaced by the heliocentric order of Copernicus. Rigid Euclidean

space has been destroyed by Lobachevski, Gauss, and Riemann. The impressionists were the first artists who began to explode traditional perspective space. The methods of the cubists were even more radical. They pulled the space-confining horizon into the foreground and identified it with the surface of the painting. They built up the solid surface of the canvas by means of psychological devices (pasted-on wall tapestries, etc.) and by elementary destruction of form. They built from the plane of the picture forward into space. The ultimate results of this process: Picasso's reliefs and the contrereliefs of Tatlin. [...]

The establishment of the □ by K. Malevich (Petersburg 1913) was the first manifestation of the extension of the 'sum total' of A. (Mondrian accomplished the ultimate solution in the development of Western painting. He reduces surface to its primeval state, namely surface *only*, in the sense that there is no longer any spatial in or out of a given surface. Whenever Mondrian's principle is transposed by fashionable A.'s onto the three surfaces of a room, it turns into decoration.)

Our numerical system, being a positional system, has been making use of 0 for a long time, but only in the sixteenth century did 0 first cease to be regarded as 'nothing,' and become a numeral (Cordano, Tartaglia), i.e., a real number. And only now, in the twentieth century, has the □ been recognized as a plastic quantity, i.e., the 0 of the total body of A. This fully chromatic, fully color-saturated □ on a white surface has begotten a new conception of space.

New optical experience has taught us that two surfaces of different intensity must be conceived as having a varying distance relationship between them, even though they may lie in the same plane.

Irrational Space

Strictly speaking, distances in this space are measured only by the intensity and the position of rigidly defined color planes. Such space is structured within a framework of the most unequivocal directions: vertically, horizontally, or diagonally. It is a positional system. These distances cannot be measured with a finite scale, as for instance objects in planimetric or perspective space. Here distances are irrational and cannot be represented as a finite relationship of two whole numbers.

An example of such irrationality is the relationship of the diagonal of a square to its side, i.e., $= \sqrt{2} = 1.4$, or more precisely, 1.41, or still more precisely, 1.414, etc., becoming increasingly more accurate, *ad infinitum*.

Suprematism has extended the apex of the finite visual cone of perspective into infinity.

It has broken through the 'blue lampshade of the heavens.' The color of space is no longer assumed to be a single *blue* ray of the color spectrum, but the whole spectrum – *white*. Suprematist space can be formed in front of the surface as well as in depth. If one assigns the value 0 to the picture surface, then one may call the depth direction – (negative), and the frontal direction + (positive), or vice versa. Thus, suprematism has swept away the illusion of three-dimensional space on a plane, replacing it by the ultimate illusion of *irrational* space with attributes of infinite extensibility in depth and foreground.

This brings us to an A. complex that can be brought into juxtaposition with the mathematical analogy of an uninterrupted straight line, containing the whole natural

numerical series which embraces: whole, decimal, negative, positive, and irrational numbers, including 0.

However, that is not all. Mathematics has created a 'new thing': imaginary (imaginary = not real, assumed) numbers. These include numbers which, when multiplied by themselves, result in negative values. The square root of the negative of 1 is an imaginary thing called i ($\sqrt{-1} = i$). We now enter a realm that cannot be directly registered by the senses, that cannot be demonstrated, that follows from a purely logical construction and therefore represents an elementary crystallization of human thought. What does this have to do with sense perception, or simple vividness in A.? In their vital quest for the enlargement of F. in A., a number of modern artists – including some of my friends – believe that they can build up multidimensional real spaces that may be entered without an umbrella, where space and time have been combined into a mutually interchangeable single whole. Concurrently with this, they relate their theories with an altogether much too agile superficiality to the most advanced scientific theories, without having a genuinely deep understanding of these theories (viz., multidimensional space, theory of relativity, Minkowski's universe, etc.). Now the productive artist should certainly be allowed to expound any theory he wishes, provided his work remains positive. In our field, only the direction of expansion has been positive up to now, but because of incorrect interpretations of seductive scientific theories the works themselves remain inadequate. [...] mathematically existing multidimensional spaces really cannot be visualized, neither can they be represented; in short, it is impossible to give them material form. We can only change the form of our physical space but not its structure, i.e., its three-dimensionality. We cannot change the degree of curvature of our space in a real way, i.e., the square or the cube cannot be transformed into any other stable form. Only a mirage may be capable of giving us such an illusion. The theory of relativity has provided evidence that quantities of time and space are dependent on the motion of each respective system. According to this theory, a man may die even before he was born. However, insofar as actual pragmatic sense-experience teaches us, things move the other way, forcing us to follow our own physical laws and building up A. F.'s which must needs affect us through the medium of our five physical senses.

* * *

Time is only indirectly comprehended by our senses. The change of position of an object in space indicates the passage of time. When the speed of these changes approached the accelerated rate of our modern rhythms, artists thought it necessary to register these phenomena. The Italian futurists have caught the vibrations of quickly moving bodies flitting back and forth in space. However, bodies are brought into motion by means of forces. Suprematism created the dynamic tension of forces. The accomplishment of the futurists and the suprematists is represented by static surfaces characterized by dynamism. These are irrationally transposed and concretized oscillograms of speed and dynamism. Such an approach is quite unsatisfactory. [...]

We are now at the beginning of a period in which A. is, on the one hand, degenerating into making pasticci of museum monuments, while, on the other hand, struggling for the creation of a new conception of space. I have demonstrated above that space and objects form a mutually functional relationship. This creates the problem of creating *imaginary* space by means of material objects.

Imaginary Space

Our capacity for visual perception is limited in the apprehension of motion and of the total condition of an object in general: for example, a recurring motion having a frequency of less than $\frac{1}{30}$ sec. gives the impression of constant motion. The motion picture is based on this principle. [...] However, the cinema depends on dematerialized surface projection using merely a single facet of our visual faculties. Of course it is well known that a material point in motion is capable of forming a line; for example: a glowing piece of coal in motion gives the impression of a luminous line, while the motion of a material line gives the impression of a surface or a volume. That is only one indication of how elementary solids can be used to construct an object that forms a whole in three-dimensional space while in a state of rest; yet when brought into motion it becomes an entirely new object, i.e., a new space impression that will exist only during the duration of the motion, and is therefore imaginary. [...]

The infinitely variegated effects that may be achieved by the F. of imaginary space can already be sensed to a limited extent even today. The whole range of all of our visual capacities may thus be brought into play. To name a few: stereoscopic effects of motion by passage through colored media; color impressions produced by superimposition of chromatic clusters of light rays as the result of polarization, etc.; the transformation of acoustic phenomena into visual form. We can safely predict that everyday life will borrow widely from these A. achievements. However, as far as we are concerned, the most important aspect of this development is the fact that this A.-F. will be accompanied by the destruction of the old A. notion of monumentality. Even today the opinion still prevails that A. must be something created for eternity: indestructible, heavy, massive, carved in granite or cast in bronze – the Cheops Pyramid. The Eiffel Tower is not monumental, for it was not built for eternity but as an attraction for a world fair; no solid masses, but a pierced space needle. We are now producing work which in its overall effect is essentially intangible. For we do not consider a work monumental in the sense that it may last for a year, a century, or a millennium, but rather on the basis of continual expansion of human performance.

In the preceding I have traced the variability of our space conceptions and the subsequent F.'s of A., thus arriving at *nonmaterial materialism*. This sounds like a paradox. However, experience proves that *progress consists of our being compelled to accept and, indeed, to regard as self-evident and essential, views that our forefathers considered incomprehensible and were in fact incapable of comprehending.*

19 Hannah Höch (1889–1978) 'The painter'

Born in Gotha, Hannah Höch studied in Berlin. Through her relationship with Raoul Hausmann she came into contact with the Dadaist circle there in 1918, the year in which the Club Dada was established in the city (see IIIB5). In the course of the same year the two artists developed the technique of photomontage. Berlin Dada was more explicitly associated with the politics of the left than any of the other Dada groupings, and in the hands of Hausmann, Höch and John Heartfield the new medium was to be put to use in satirical comment on that contemporary culture from which its component images were drawn (see

also IVC15 for a Russian text on photomontage). Höch's *Cut with the Dada Kitchen Knife through the Last Era of the Weimar Beer-belly Culture* was exhibited at the First International Dada Fair in 1920. 'The painter' was probably written at this time. In its account of the male genius at work it conjoins a proto-feminist irony with scepticism about claims for meaning in abstract art. The original text is printed in *Hannah Höch: Eine Lebens-Collage*, Berlin: Archiv-Edition, 1989, vol. 1, pp. 747–9. Our version is taken from the translation by Anne Halley in Maud Lavin, *Cut with the Kitchen Knife: the Weimar Photomontages of Hannah Höch*, New Haven and London: Yale University Press, 1993, pp. 216–18.

Once upon a time there was a painter. He wasn't called Dribble, or anything like that, as he might have been in earlier times. It was around 1920 – the painter was a modern painter – so his name was Heavenlykingdom. Unlike the real painters of earlier times, he was not asked to work only with brush and palette. This was his wife's fault: she thwarted the boundless flight of his genius. At least four times in four years, he was forced to wash dishes – the kitchen dishes. The first time, actually, there had been a pressing reason. She was giving birth to the baby Heavenlykingdom. The other three times had not seemed absolutely necessary to Heavenlykingdom, Sr. But he wanted to keep the peace – because after all God had created the male to do just that – and so had no choice but to obey her Xanthippian demand. Yet the matter continued to weigh on him. He felt degraded as a man and as a painter under its dark shadow. On the days of crisis he would suffer nightmares. He kept seeing Michelangelo washing up the cups. He knew enough about psychoanalysis to confront the woman with the truth that such demands always arise out of the desire to dominate, no matter what other reasons there might be. As a modern person he felt that in theory he had to agree with the equality of the sexes – still, if one looked closely at the situation one could not – and then, especially in your own house – her demand seemed to him comparable to an enslavement of his soul . . .

Now one day he began to paint a picture. A dark force moved him, because he was full of dark forces. He wanted to represent, to cube really, the essential likeness between the nature of chives and the female soul. In theory the whole problem was solved. He saw the emptiness that fills both these objects precisely and with total intellectual clarity. There is more to genius than intellect, however, and, when he connected the herb's snake-like form with the previously mentioned soul, his unusually developed instinct gave him mystical knowledge. No genius would deny a certain complement of mysticism.

Our Heavenlykingdom was deeply wounded by something he had also heard about from his fellow men: although these little women are often really tiny, they can still not be shaped and modeled into the form one needs for physical and psychic comfort. Had he been a writer, he would have been compelled to enrich literature with a ponderous work on the theme, 'When you go to Woman, do not forget the whip.' But under the circumstances that you know about now, his painting was to be called, 'The Chive and the Female Soul: A Comparison.' I think it was already announced for exhibition, while the canvas still shone blankly, spotlessly receptive. One has to do everything in good time. Gotthold – that was Heavenlykingdom's first name – suffered under the female soul in the totality of his manhood. And we all need to confront what makes us suffer. No wonder, then, that Heavenlykingdom (secretly) began to think of himself as on a level with a redeemer – let's admit it, with Christ – because of the likeness he has discovered.

But you have to imagine the painting properly – as it were, a scientifically dissected representation – the female soul, totally clear in a segmented cubist painting – so that everyone able to adopt an abstract point of view could read, there she is, that's her innermost being. And next to that the analogy and parallel: chives. Wouldn't everyone see it as clear as day? We also know that when we recognize what ails us, we are cured. So what perspectives would open up with the creation of this painting? Wouldn't the most burning question of our time be solved? Yet we have had to admit too often that theory and practice don't coincide. He had worked on his picture for two years and two days already. He labored and labored mightily, unable to advance beyond the chives. In the first place, the painting remained green. As soon as he used a different color, the disturbance that resulted was so great that he covered it with green again. For a while he thought that the treacherous female soul (treachery no doubt its most important element alongside emptiness) could appear as a cubist lemon-yellow spiral among the green – a shape more or less like one of those sofa-springs that winds crookedly upward. But alas, painting is color as well as form. The yellow refused to meld with the massive green of his chive allegory. He had no choice but to remove the winding spiral. A painter must remain enough of an aesthete to refuse to paint badly for the sake of his idea. The same thing happened with the composition. He tried and tried, even falling into trances, but nothing beyond the dull repetitive up-and-down of the chive motif would develop. Over and over again he hoped to fix the damnable female soul in a fluted doughnut-shape. But his eye remained objective and told him the truth without pity: this fretwork muddies the powerful melody of the chive movement. His most intimate friend, looking at the painting, remarked that it had the kind of power that liberated itself in an overwhelming sense of bore...No, that's not what he said. He said, liberates itself in sameness. Then he decided with a heavy heart to abandon the female soul and to devote himself only to chives from now on.

A month later, and the President, who has just opened the exhibition, is propelling his presidential belly around the myriad chambers that display the works of all the painters of the realm. Suddenly he stops. His face displays emotion. His entourage observes closely. He begins to speak. 'A masterpiece,' he stammers. 'Has my administration ever produced anything better?' He questioned everyone around him. All that green – what can it remind me of? His adjutant (unless an assistant goes by another name in a Republic) suggested helpfully, 'Of the revolution? Of the revolution, my President?'

'Absolutely right. The revolution.'

They say the State bought the painting for the National Gallery. They say that when its creator was asked for the title, he omitted mention of the chives and proudly called it 'The Female Soul.' They say Gotthold Heavenlykingdom will be the next candidate for a Nobel Prize.

20 José Ortega y Gasset (1883–1955) from 'The Dehumanization of Art'

Numbered among the most influential Spanish philosophers of the twentieth century, Ortega y Gasset was educated at universities in Madrid and in Germany, and was appointed

professor of metaphysics at Madrid in 1910. He remained in this post until 1936 when, with the outbreak of civil war, he left Spain for voluntary exile in Europe and Argentina. His commitment to humanist individualism and fear of mass society is reflected in the title of his best-known work *The Revolt of the Masses* (Madrid, 1929). Ortega returned to Spain after the Second World War, founding the Institute of Humanities in Madrid in 1948. His extended reflection on modern art, 'La Deshumanización del arte' was first published in Madrid in 1925. Ortega sets out, in his own words, 'to study art from a sociological point of view'. He concludes that the unpopularity of modern art is structural, rather than accidental, because of its gradual withdrawal from the representation of easily recoverable human content. For Ortega however, this is not a conservative argument against the modern movement but an assertion of its appropriateness to the scientific temper of the modern age. For Ortega, art as art, rather than masquerading as a key to the human soul, is an art appropriate to a secular, modern intelligentsia and not to backward masses seeking compensation in sentiment. The present extracts are taken from *The Dehumanization of Art and other Essays on Art, Culture, and Literature*, translated by Helene Weyl, Princeton, NJ: Princeton University Press, 1948/1968, pp. 3–54.

Unpopularity of the New Art

All modern art is unpopular, and it is so not accidentally and by chance, but essentially and by fate.

It might be said that every newcomer among styles passes through a stage of quarantine. The battle of *Hernani* comes to mind, and all the other skirmishes connected with the advent of Romanticism. However, the unpopularity of present-day art is of a different kind. A distinction must be made between what is not popular and what is unpopular. A new style takes some time in winning popularity; it is not popular, but it is not unpopular either. The break-through of Romanticism, although a frequently cited example, is, as a sociological phenomenon, exactly the opposite of the present situation of art. Romanticism was very quick in winning 'the people' to whom the old classical art had never appealed. The enemy with whom Romanticism had to fight it out was precisely a select minority irretrievably sold to the classical forms of the '*ancien régime*' in poetry. The works of the romanticists were the first, after the invention of printing, to enjoy large editions. Romanticism was the prototype of a popular style. First-born of democracy, it was coddled by the masses.

Modern art, on the other hand, will always have the masses against it. It is essentially unpopular; moreover, it is antipopular. Any of its works automatically produces a curious effect on the general public. It divides the public into two groups: one very small, formed by those who are favorably inclined towards it; another very large – the hostile majority. (Let us ignore that ambiguous fauna – the snobs.) Thus the work of art acts like a social agent which segregates from the shapeless mass of the many two different castes of men.

Which is the differentiating principle that creates these two antagonistic groups? Every work of art arouses differences of opinion. Some like it, some don't; some like it more, some like it less. Such disagreements have no organic character, they are not a matter of principles. A person's chance disposition determines on which side he will fall. But in the case of the new art the split occurs in a deeper layer than that on which differences of personal taste reside. It is not that the majority does not *like* the art of the young and the minority likes it, but that the majority, the

masses, do not *understand* it. The old bigwigs who were present at the performance of *Hernani* understood Victor Hugo's play very well; precisely because they understood it they disliked it. Faithfully adhering to definite aesthetic norms, they were disgusted at the new artistic values which this piece of art proposed to them.

'From a sociological point of view' the characteristic feature of the new art is, in my judgment, that it divides the public into the two classes of those who understand it and those who do not. This implies that one group possesses an organ of comprehension denied to the other – that they are two different varieties of the human species. The new art obviously addresses itself not to everybody, as did Romanticism, but to a specially gifted minority. Hence the indignation it arouses in the masses. When a man dislikes a work of art, but understands it, he feels superior to it; and there is no reason for indignation. But when his dislike is due to his failure to understand, he feels vaguely humiliated and this rankling sense of inferiority must be counterbalanced by indignant self-assertion. Through its mere presence, the art of the young compels the average citizen to realize that he is just this – the average citizen, a creature incapable of receiving the sacrament of art, blind and deaf to pure beauty. But such a thing cannot be done after a hundred years of adulation of the masses and apotheosis of the people. Accustomed to ruling supreme, the masses feel that the new art, which is the art of a privileged aristocracy of finer senses, endangers their rights as men. Whenever the new Muses present themselves, the masses bristle.

For a century and a half the masses have claimed to be the whole of society. Stravinski's music or Pirandello's drama have the sociological effect of compelling the people to recognize itself for what it is: a component among others of the social structure, inert matter of the historical process, a secondary factor in the cosmos of spiritual life. On the other hand, the new art also helps the elite to recognize themselves and one another in the drab mass of society and to learn their mission which consists in being few and holding their own against the many. [...]

Artistic Art

If the new art is not accessible to every man this implies that its impulses are not of a generically human kind. It is an art not for men in general but for a special class of men who may not be better but who evidently are different.

One point must be clarified before we go on. What is it the majority of people call aesthetic pleasure? What happens in their minds when they 'like' a work of art; for instance, a theatrical performance? The answer is easy. A man likes a play when he has become interested in the human destinies presented to him, when the love and hatred, the joys and sorrows of the personages so move his heart that he participates in it all as though it were happening in real life. And he calls a work 'good' if it succeeds in creating the illusion necessary to make the imaginary personages appear like living persons. In poetry he seeks the passion and pain of the man behind the poet. Paintings attract him if he finds on them figures of men or women whom it would be interesting to meet. A landscape is pronounced 'pretty' if the country it represents deserves for its loveliness or its grandeur to be visited on a trip.

It thus appears that to the majority of people aesthetic pleasure means a state of mind which is essentially undistinguishable from their ordinary behavior. It differs merely in accidental qualities, being perhaps less utilitarian, more intense, and free from painful

consequences. But the object towards which their attention and, consequently, all their other mental activities are directed is the same as in daily life: people and passions. By art they understand a means through which they are brought in contact with interesting human affairs. Artistic forms proper – figments, fantasy – are tolerated only if they do not interfere with the perception of human forms and fates. As soon as purely aesthetic elements predominate and the story of John and Mary grows elusive, most people feel out of their depth and are at a loss what to make of the scene, the book, or the painting. As they have never practiced any other attitude but the practical one in which a man's feelings are aroused and he is emotionally involved, a work that does not invite sentimental intervention leaves them without a cue.

Now, this is a point which has to be made perfectly clear. Not only is grieving and rejoicing at such human destinies as a work of art presents or narrates a very different thing from true artistic pleasure, but preoccupation with the human content of the work is in principle incompatible with aesthetic enjoyment proper. [. . .]

A work of art vanishes from sight for a beholder who seeks in it nothing but the moving fate of John and Mary or Tristan and Isolde and adjusts his vision to this. Tristan's sorrows are sorrows and can evoke compassion only in so far as they are taken as real. But an object of art is artistic only in so far as it is not real. In order to enjoy Titian's portrait of Charles the Fifth on horseback we must forget that this is Charles the Fifth in person and see instead a portrait – that is, an image, a fiction. The portrayed person and his portrait are two entirely different things; we are interested in either one or the other. In the first case we 'live' with Charles the Fifth, in the second we look at an object of art.

But not many people are capable of adjusting their perceptive apparatus to the pane and the transparency that is the work of art. Instead they look right through it and revel in the human reality with which the work deals. When they are invited to let go of this prey and to direct their attention to the work of art itself they will say that they cannot see such a thing, which indeed they cannot, because it is all artistic transparency and without substance.

During the nineteenth century artists proceeded in all too impure a fashion. They reduced the strictly aesthetic elements to a minimum and let the work consist almost entirely in a fiction of human realities. In this sense all normal art of the last century must be called realistic. Beethoven and Wagner were realistic, and so was Chateaubriand as well as Zola. Seen from the vantage-point of our day Romanticism and Naturalism draw closer together and reveal their common realistic root.

Works of this kind are only partially works of art, or artistic objects. Their enjoyment does not depend upon our power to focus on transparencies and images, a power characteristic of the artistic sensibility; all they require is human sensibility and willingness to sympathize with our neighbor's joys and worries. No wonder that nineteenth century art has been so popular; it is made for the masses inasmuch as it is not art but an extract from life. Let us remember that in epochs with two different types of art, one for minorities and one for the majority, the latter has always been realistic.

I will not now discuss whether pure art is possible. Perhaps it is not; but . . . even though pure art may be impossible there doubtless can prevail a tendency toward a purification of art. Such a tendency would effect a progressive elimination of the human, all too human, elements predominant in romantic and naturalistic production.

And in this process a point can be reached in which the human content has grown so thin that it is negligible. We then have an art which can be comprehended only by people possessed of the peculiar gift of artistic sensibility – an art for artists and not for the masses, for 'quality' and not for hoi polloi.

That is why modern art divides the public into two classes, those who understand it and those who do not understand it – that is to say, those who are artists and those who are not. The new art is an artistic art.

I do not propose to extol the new way in art or to condemn the old. My purpose is to characterize them as the zoologist characterizes two contrasting species. The new art is a world-wide fact. For about twenty years now the most alert young people of two successive generations – in Berlin, Paris, London, New York, Rome, Madrid – have found themselves faced with the undeniable fact that they have no use for traditional art; moreover, that they detest it. With these young people one can do one of two things: shoot them, or try to understand them. As soon as one decides in favor of the latter it appears that they are endowed with a perfectly clear, coherent, and rational sense of art. Far from being a whim, their way of feeling represents the inevitable and fruitful result of all previous artistic achievement. Whimsical, arbitrary, and consequently unprofitable it would be to set oneself against the new style and obstinately remain shut up in old forms that are exhausted and the worse for wear. In art, as in morals, what ought to be done does not depend on our personal judgment; we have to accept the imperative imposed by the time. Obedience to the order of the day is the most hopeful choice open to the individual. Even so he may achieve nothing; but he is much more likely to fail if he insists on composing another Wagnerian opera, another naturalistic novel.

In art repetition is nothing. Each historical style can engender a certain number of different forms within a generic type. But there always comes a day when the magnificent mine is worked out. Such, for instance, has been the fate of the romantico-naturalistic novel and theater. It is a naïve error to believe that the present infecundity of these two genres is due to lack of talent. What happens is that the possible combinations within these literary forms are exhausted. It must be deemed fortunate that this situation coincides with the emergence of a new artistic sensibility capable of detecting other untouched veins.

When we analyze the new style we find that it contains certain closely connected tendencies. It tends (1) to dehumanize art, (2) to avoid living forms, (3) to see to it that the work of art is nothing but a work of art, (4) to consider art as play and nothing else, (5) to be essentially ironical, (6) to beware of sham and hence to aspire to scrupulous realization, (7) to regard art as a thing of no transcending consequence.

* * *

First Installment on the Dehumanization of Art

With amazing swiftness modern art has split up into a multitude of divergent directions. Nothing is easier than to stress the differences. But such an emphasis on the distinguishing and specific features would be pointless without a previous account of the common fund that in a varying and sometimes contradictory manner asserts itself throughout modern art. [...]

The important thing is that there unquestionably exists in the world a new artistic sensibility. Over against the multiplicity of special directions and individual works, the new sensibility represents the generic fact and the source, as it were, from which the former spring. This sensibility it is worth while to define. And when we seek to ascertain the most general and most characteristic feature of modern artistic production we come upon the tendency to dehumanize art.

* * *

More about the Dehumanization of Art

[...] Seeing requires distance. Each art operates a magic lantern that removes and transfigures its objects. On its screen they stand aloof, inmates of an inaccessible world, in an absolute distance. When this derealization is lacking, an awkward perplexity arises: we do not know whether to 'live' the things or to observe them.

Madame Tussaud's comes to mind and the peculiar uneasiness aroused by dummies. The origin of this uneasiness lies in the provoking ambiguity with which wax figures defeat any attempt at adopting a clear and consistent attitude toward them. Treat them as living beings, and they will sniggeringly reveal their waxen secret. Take them for dolls, and they seem to breathe in irritated protest. They will not be reduced to mere objects. Looking at them we suddenly feel a misgiving: should it not be they who are looking at us? Till in the end we are sick and tired of those hired corpses. Wax figures are melodrama at its purest.

The new sensibility, it seems to me, is dominated by a distaste for human elements in art very similar to the feelings cultured people have always experienced at Madame Tussaud's, while the mob has always been delighted by that gruesome waxen hoax. In passing we may here ask ourselves a few impertinent questions which we have no intention to answer now. What is behind this disgust at seeing art mixed up with life? Could it be disgust for the human sphere as such, for reality, for life? Or is it rather the opposite: respect for life and unwillingness to confuse it with art, so inferior a thing as art? But what do we mean by calling art an inferior function – divine art, glory of civilization, *fine fleur* of culture, and so forth? . . . these questions are impertinent; let us dismiss them.

* * *

Iconoclasm

It is not an exaggeration to assert that modern paintings and sculptures betray a real loathing of living forms or forms of living beings. The phenomenon becomes particularly clear if the art of these last years is compared with that sublime hour when painting and sculpture emerge from Gothic discipline as from a nightmare and bring forth the abundant, world-wide harvest of the Renaissance. Brush and chisel delight in rendering the exuberant forms of the model – man, animal, or plant. All bodies are welcome, if only life with its dynamic power is felt to throb in them. And from paintings and sculptures organic form flows over into ornament. It is the epoch of the cornucopias whose torrential fecundity threatens to flood all space with round, ripe fruits.

Why is it that the round and soft forms of living bodies are repulsive to the present-day artist? Why does he replace them with geometric patterns? For with all the

blunders and all the sleights of hand of cubism, the fact remains that for some time we have been well pleased with a language of pure Euclidean patterns.

The phenomenon becomes more complex when we remember that crazes of this kind have periodically recurred in history. Even in the evolution of prehistoric art we observe that artistic sensibility begins with seeking the living form and then drops it, as though affrighted and nauseated, and resorts to abstract signs, the last residues of cosmic or animal forms. The serpent is stylized into the meander, the sun into the swastica. At times, this disgust at living forms flares up and produces public conflicts. The revolt against the images of Oriental Christianism, the Semitic law forbidding representation of animals – an attitude opposite to the instinct of those people who decorated the cave of Altamira – doubtless originate not only in a religious feeling but also in an aesthetic sensibility whose subsequent influence on Byzantine art is clearly discernible.

A thorough investigation of such eruptions of iconoclasm in religion and art would be of high interest. Modern art is obviously actuated by one of these curious iconoclastic urges.

Negative Influence of the Past

[. . .] It is in art and pure science, precisely because they are the freest activities and least dependent on social conditions, that the first signs of any changes of collective sensibility become noticeable. A fundamental revision of man's attitude towards life is apt to find its first expression in artistic creation and scientific theory. The fine texture of both these matters renders them susceptible to the slightest breeze of the spiritual trade-winds. As in the country, opening the window of a morning, we examine the smoke rising from the chimney-stacks in order to determine the wind that will rule the day, thus we can, with a similar meteorologic purpose, study the art and science of the young generation.

The first step has been to describe the new phenomenon. Only now that this is done can we proceed to ask of which new general style of life modern art is the symptom and the harbinger. The answer requires an analysis of the causes that have effected this strange about-face in art. Why this desire to dehumanize? Why this disgust at living forms? Like all historical phenomena this too will have grown from a multitude of entangled roots which only a fine flair is capable of detecting. An investigation of this kind would be too serious a task to be attacked here. However, what other causes may exist, there is one which, though perhaps not decisive, is certainly very clear.

We can hardly put too much stress on the influence which at all times the past of art exerts on the future of art. In the mind of the artist a sort of chemical reaction is set going by the clash between his individual sensibility and already existing art. He does not find himself all alone with the world before him; in his relations with the world there always intervenes, like an interpreter, the artistic tradition. What will the reaction of creative originality upon the beauty of previous works be like? It may be positive or negative. Either the artist is in conformity with the past and regards it as his heritage which he feels called upon to perfect; or he discovers that he has a spontaneous indefinable aversion against established and generally acclaimed art. And as in the first case he will be pleased to settle down in the customary forms and repeat some of

their sacred patterns, thus he will, in the second, not only deviate from established tradition but be equally pleased to give to his work an explicit note of protest against the time-honored norms.

The latter is apt to be overlooked when one speaks of the influence of the past on the present. That a work of a certain period may be modeled after works of another previous period has always been easily recognized. But to notice the negative influence of the past and to realize that a new style has not infrequently grown out of a conscious and relished antagonism to traditional styles seems to require somewhat of an effort.

As it is, the development of art from Romanticism to this day cannot be understood unless this negative mood of mocking aggressiveness is taken into account as a factor of aesthetic pleasure. Baudelaire praises the black Venus precisely because the classical is white. From then on the successive styles contain an ever increasing dose of derision and disparagement until in our day the new art consists almost exclusively of protests against the old. The reason is not far to seek. When an art looks back on many centuries of continuous evolution without major hiatuses or historical catastrophes its products keep on accumulating, and the weight of tradition increasingly encumbers the inspiration of the hour. Or to put it differently, an ever growing mass of traditional styles hampers the direct and original communication between the nascent artist and the world around him. In this case one of two things may happen. Either tradition stifles all creative power – as in Egypt, Byzantium, and the Orient in general – or the effect of the past on the present changes its sign and a long epoch appears in which the new art, step by step, breaks free of the old which threatened to smother it. The latter is typical of Europe whose futuristic instinct, predominant throughout its history, stands in marked contrast to the irremediable traditionalism of the Orient.

A good deal of what I have called dehumanization and disgust for living forms is inspired by just such an aversion against the traditional interpretation of realities. The vigor of the assault stands in inverse proportion to the distance. Keenest contempt is felt for nineteenth-century procedures although they contain already a noticeable dose of opposition to older styles. On the other hand, the new sensibility exhibits a somewhat suspicious enthusiasm for art that is most remote in time and space, for prehistoric or savage primitivism. In point of fact, what attracts the modern artist in those primordial works is not so much their artistic quality as their candor; that is, the absence of tradition.

If we now briefly consider the question: What type of life reveals itself in this attack on past art? we come upon a strange and stirring fact. To assail all previous art, what else can it mean than to turn against Art itself? For what is art, concretely speaking, if not such art as has been made up to now?

Should that enthusiasm for pure art be but a mask which conceals surfeit with art and hatred of it? But, how can such a thing come about? Hatred of art is unlikely to develop as an isolated phenomenon; it goes hand in hand with hatred of science, hatred of State, hatred, in sum, of civilization as a whole. Is it conceivable that modern Western man bears a rankling grudge against his own historical essence? Does he feel something akin to the *odium professionis* of medieval monks – that aversion, after long years of monastic discipline, against the very rules that had shaped their lives? [. . .]

Doomed to Irony

When we discovered that the new style taken in its most general aspect is characterized by a tendency to eliminate all that is human and to preserve only the purely artistic elements, this seemed to betray a great enthusiasm for art. But when we then walked around the phenomenon and looked at it from another angle we came upon an unexpected grimace of surfeit or disdain. The contradiction is obvious and must be strongly stressed. It definitely indicates that modern art is of an ambiguous nature which, as a matter of fact, does not surprise us; for ambiguous have been all important issues of these current years. A brief analysis of the political development in Europe would reveal the same intrinsic ambiguity.

However, in the case of art, the contradiction between love and hatred for one and the same thing will appear somewhat mitigated after a closer inspection of present-day artistic production.

The first consequence of the retreat of art upon itself is a ban on all pathos. Art laden with 'humanity' had become as weighty as life itself. It was an extremely serious affair, almost sacred. At times – in Schopenhauer and Wagner – it aspired to nothing less than to save mankind. Whereas the modern inspiration – and this is a strange fact indeed – is invariably waggish. The waggery may be more or less refined, it may run the whole gamut from open clownery to a slight ironical twinkle, but it is always there. And it is not that the content of the work is comical – that would mean a relapse into a mode or species of the 'human' style – but that, whatever the content, the art itself is jesting. To look for fiction as fiction – which, we have said, modern art does – is a proposition that cannot be executed except with one's tongue in one's cheek. Art is appreciated precisely because it is recognized as a farce. It is this trait more than any other that makes the works of the young so incomprehensible to serious people of less progressive taste. To them modern painting and music are sheer 'farce' – in the bad sense of the word – and they will not be convinced that to be a farce may be precisely the mission and the virtue of art. A 'farce' in the bad sense of the word it would be if the modern artist pretended to equal status with the 'serious' artists of the past, and a cubist painting expected to be extolled as solemnly and all but religiously as a statue by Michelangelo. But all he does is to invite us to look at a piece of art that is a joke and that essentially makes fun of itself. For this is what the facetious quality of the modern inspiration comes down to. Instead of deriding other persons or things – without a victim no comedy – the new art ridicules art itself.

And why be scandalized at this? Art has never shown more clearly its magic gift than in this flout at itself. Thanks to this suicidal gesture art continues to be art, its self-negation miraculously bringing about its preservation and triumph.

I much doubt that any young person of our time can be impressed by a poem, a painting, or a piece of music that is not flavored with a dash of irony.

Nor is this ironical reflection of art upon itself entirely new as an idea and a theory. In the beginning of the last century a group of German romanticists, under the leadership of the two brothers Schlegel, pronounced irony the foremost aesthetic category, their reasons being much the same as those of our young artists. Art has no right to exist if, content to reproduce reality, it uselessly duplicates it. Its mission is to

conjure up imaginary worlds. That can be done only if the artist repudiates reality and by this act places himself above it. Being an artist means ceasing to take seriously that very serious person we are when we are not an artist.

This inevitable dash of irony, it is true, imparts to modern art a monotony which must exasperate patience herself. But be that as it may, the contradiction between surfeit and enthusiasm now appears resolved. The first is aroused by art as a serious affair, the second is felt for art that triumphs as a farce, laughing off everything, itself included – much as in a system of mirrors which indefinitely reflect one another no shape is ultimate, all are eventually ridiculed and revealed as pure images. [...]

Art a Thing of no Consequence

[...] All peculiarities of modern art can be summed up in this one feature of its renouncing its importance – a feature which, in its turn, signifies nothing less than that art has changed its position in the hierarchy of human activities and interests. These activities and interests may be represented by a series of concentric circles whose radii measure the dynamic distances from the axis of life where the supreme desires are operating. All human matters – vital and cultural – revolve in their several orbits about the throbbing heart of the system. Art which – like science and politics – used to be very near the axis of enthusiasm, that backbone of our person, has moved toward the outer rings. It has lost none of its attributes, but it has become a minor issue.

The trend toward pure art betrays not arrogance, as is often thought, but modesty. Art that has rid itself of human pathos is a thing without consequence – just art with no other pretenses.

IIID
Utility and Construction

1 KOMFUT: 'Programme Declaration'

In a transitional phase between their pre-revolutionary and hence relatively apolitical art, and the post-revolutionary turn to utilitarian constructivism, Russian avant-garde artists organized KOMFUT: an acronym for Communism and Futurism. The title was also intended to differentiate Russian avant-garde artists, conventionally dubbed 'Futurists', from the Italian group, who were being increasingly identified with Fascism. The 'Declaration' was originally published in *Iskusstvo kommuny* (*Art of the Commune*), no. 8, Petrograd, 26 January 1919, p. 3. The present translation is taken from Bowlt, op. cit., pp. 165–6.

A Communist regime demands a Communist consciousness. All forms of life, morality, philosophy, and art must be re-created according to Communist principles. Without this, the subsequent development of the Communist Revolution is impossible.

In their activities the cultural-educational organs of the Soviet government show a complete misunderstanding of the revolutionary task entrusted to them. The social-democratic ideology so hastily knocked together is incapable of resisting the century-old experience of the bourgeois ideologists, who, in their own interests, are exploiting the proletarian cultural-educational organs.

Under the guise of immutable truths, the masses are being presented with the pseudo teachings of the gentry.

Under the guise of universal truth – the morality of the exploiters.

Under the guise of the eternal laws of beauty – the depraved taste of the oppressors.

It is essential to start creating our own Communist ideology.

It is essential to wage merciless war against all the false ideologies of the bourgeois past.

It is essential to subordinate the Soviet cultural-educational organs to the guidance of a new cultural Communist ideology – an ideology that is only now being formulated.

It is essential – in all cultural fields, as well as in art – to reject emphatically all the democratic illusions that pervade the vestiges and prejudices of the bourgeoisie.

It is essential to summon the masses to creative activity.

2 Vladimir Tatlin (1885–1953) 'The Initiative Individual in the Creativity of the Collective'

Tatlin passed through a variety of avant-garde styles, from primitivism to Cubism, in the years before the First World War. From about 1915 onwards he became increasingly identified as the leader of a trend in the Russian avant-garde opposed to Malevich's Suprematism. This emphasized 'the culture of materials', and formed the basis of the move to utilitarian constructivism and 'art into production' after the Revolution. Tatlin frequently wrote in the condensed epigrammatic style of contemporary political slogans (e.g., 'Organized material is a utilitarian form' (1922); 'Not to the left, not to the right, but to the necessary. Not the old, not the new, but the necessary' (1923)). The present comparatively extended text was composed in 1919 for the first issue of the journal *International Iskusstvo (International Art)*. It remained unpublished. The present translation is taken from Larissa Zhadova (ed.), *Tatlin*, London, 1988, pp. 237–8. (See also IIID12.)

Theses

1 The initiative individual is the collector of the *energy* of the collective, directed towards knowledge and invention.
2 The initiative individual serves as a contact between the invention and the creativity of the collective.
3 The viability of the collective is confirmed by the number of initiative units distinguished by it.
4 The initiative individual is the refraction point of the collective's creativity and brings realization to the idea.
5 Art, always being connected with life at the moment of change in the political system (change of the Collective-consumer), and being cut off from the collective in the person of the artist, goes through an acute revolution. A revolution strengthens the impulse of invention. That is why there is a flourishing of art following a revolution, when the inter-relationship between the initiative individual and the collective is clearly defined.
6 Invention is always the working out of impulses and desires of the collective and not of the individual.
7 The world of numbers, as the nearest to the architectonics of art, gives us: 1) confirmation of the existence of the inventor; 2) a complete organic connection of the individual with the collective numeral. There is no error in Khlebnikov's example. 1) 'In a series of natural numbers, prime numbers, indivisible and non-recurring, are scattered. Each of these numbers carries with it its new numerical world. From this it follows that among numbers too there are inventors.' 2) 'If we take the principle of addition, and add one more to a thousand individuals, the arrival and departure of this individual will be unnoticed. If we take the principle of multiplication, then a positive singular multiplied by a thousand makes the entire thousand positive. A negative singular multiplied by a thousand makes the whole thousand negative. From this it follows that there exists a complete organic connection between the individual and the collective numeral.'

3 Lyubov Popova (1889–1924) Statement in catalogue of 'Tenth State Exhibition'

Popova was one of a notable generation of women artists in the Russian avant-garde in the years immediately preceding and succeeding the Revolution of 1917. She had become familiar with Cubism in Paris before the First World War. Her statement seems to distinguish autonomous work on painting from the problems of depicting a world outside art; though such apparently 'autonomous' art became increasingly dubbed 'laboratory research' in order to validate it in terms of the general need to participate in building the new, post-revolutionary life. The 'Statement' was originally published in the catalogue to the 'Tenth State Exhibition: Non-objective Creation and Suprematism', Moscow, April 1919. The present translation is taken from Bowlt, op. cit., pp. 146–8.

(+) Painting	(−) Not painting but the depiction of reality
I. *Architectonics*	
(a) Painterly space (cubism)	I. *Aconstructiveness*
(b) Line	(a) Illusionism
(c) Color (suprematism)	(b) Literariness
(d) Energetics (futurism)	(c) Emotions
(e) Texture	(d) Recognition
II. The necessity for transformation by means of the omission of parts of form (began in cubism)	

Construction in painting = the sum of the energy of its parts.

Surface is fixed but forms are volumetrical.

Line as color and as the vestige of a transverse plane participates in, and directs the forces of, construction.

Color participates in energetics by its weight.

Energetics = direction of volumes + planes and lines or their vestiges + all colors.

Texture is the content of painterly surfaces.

Form is not of equal value throughout its whole sequence. The artistic consciousness must select those elements indispensable to a painterly context, in which case all that is superfluous and of no artistic value must be omitted.

Hence depiction of the concrete – artistically neither deformed nor transformed – cannot be a subject of painting.

Images of 'painterly,' and not 'figurative,' values are the aim of the present painting.

4 Nikolai Punin (1888–1953) 'The Monument to the Third International'

The author was an art historian and critic who was active after the Russian revolution in the Fine Art department (IZO) of the Commissariat of Enlightenment (Narkompros) in Petrograd. Through his work on Lenin's plan for 'Monumental Propaganda' he became involved with Tatlin's projected 'Monument to the Third International', the organization which the Bolsheviks had set up to coordinate the international socialist revolution. The essay was originally published as a pamphlet by IZO – Narkompros, Petrograd, 1920. The present translation was made by Christina Lodder for the Open University, 1983.

In 1919 the Department of Fine Arts within the People's Commissariat for Enlightenment commissioned the artist V. E. Tatlin to develop a design for a monument to the Third International. The artist Tatlin immediately set to work and produced a design. The artists V. E. Tatlin, I. A. Meerzon, M. P. Vinogradov and T. M. Shapiro formed a 'Creative Collective', then developed the design in detail and constructed a model.

The main idea of the monument is based on an organic synthesis of the principles of architecture, sculpture and painting and was intended to produce a new type of monumental structure, uniting in itself a purely creative form with a utilitarian form. In accordance with this idea, the design of the monument consists of three large glass structures, erected by means of a complex system of vertical struts and spirals. These structures are arranged one above the other and are contained within different, harmoniously related forms. A special type of mechanism would enable them to move at different speeds. The lower structure (A), in the form of a cube, moves on its axis at the speed of one revolution a year and is intended for legislative purposes. Here may be held conferences of the International, meetings of international congresses and other broadly legislative meetings. . . . The next structure (B), in the form of a pyramid, rotates on its axis at the speed of one full revolution a month and is intended for executive functions (the Executive Committee of the International, the secretariat and other administrative and executive bodies). Finally, the upper cylinder (C), rotating at a speed of one revolution a day, is intended to be a resource centre for the following facilities: an information office; a newspaper; the publication of proclamations, brochures and manifestoes – in a word, all the various means of broadly informing the international proletariat, and in particular a telegraph, projectors for a large screen located on the axes of a spherical segment ($a_1 - B_3$), and a radio station, the masts of which rise above the monument. There is no need to point out the enormous possibilities for equipping and organizing these structures. The details of the design have not yet been specified, they

can be discussed and worked out during subsequent elaboration of the monument's interior. It is necessary to explain that according to the artist Tatlin's conception, the glass structures should have vacuum walls (a thermos) which will make it easy to maintain a constant temperature within the edifice. The separate parts of the monument will be connected to one another and to the ground by means exclusively of complexly structured electrical elevators, adjusted to the differing rotation speeds of the structures. Such are the technical bases of the project.

The artistic significance of the project

A social revolution by itself does not change artistic forms, but it does provide a basis for their gradual transformation. The idea of monumental propaganda has not changed sculpture or sculptors, but it has struck at the very principle of plastic appearance which prevails in the bourgeois world. Renaissance traditions in the plastic arts appear modern only while the feudal and bourgeois roots of capitalist states remain undestroyed. The Renaissance burned out, but only now is the charred ruin of Europe being purged.

It is true that Communist governments for a certain time will use, as a means of monumental propaganda, figurative monuments in the style of Greek and Italian classicism, but this is only because these governments are forced to use them in the same way as they are compelled to use specialists of the pre-revolutionary school. Figurative monuments (Greek and Italian) are at variance with contemporary reality in two respects. They cultivate individual heroism and conflict with history: torsos and heads of heroes (and gods) do not correspond to the modern interpretation of history. Their forms are too private for places where there are ten versts of proletarians in rows. At best they express the character, feelings and thoughts of the hero, but who expresses the tension of the emotions and the thoughts of the collective thousand? A type? But a type concretizes, limits and levels the mass. The mass is richer, more alive, more complicated and more organic.

But even if a type is portrayed, figurative monuments contradict actuality even more through the limitation of their expressive means, their static quality. The agitational action of such monuments is extraordinarily weak amidst the noise, movement and dimensions of the streets. Thinkers on granite plinths perhaps see many, but few see them. They are constrained by the form which evolved when sailing ships, transport by mule and stone cannon balls flourished. A wartime telephone wire hits the hero's nose, a tram stop is more of an obelisk; townspeople recall Lassalle more times each day through book covers and newspaper headlines in libraries, than through passing by, beneath his proud head. Lassalle stands unseen and unneeded ever since the end of the unveiling ceremony. . . .

A monument must live the social and political life of the city and the city must live in it. It must be necessary and dynamic, then it will be modern. The forms of contemporary, agitational plastic arts lie beyond the depiction of man as an individual. They are found by the artist who is not crippled by the feudal and bourgeois traditions of the Renaissance, but who has laboured like a worker on the three unities of contemporary plastic consciousness: material, construction, volume. Working on material, construction and volume, Tatlin has produced a form which is new in the world of monumental creation. Such a form is the monument to the Third International.

The best artist in the Russia of the Workers and Peasants (his life proving his knowledge of the working masses), was commissioned a year ago to develop a design for a monument to the Third International. The project which has been designed is not only completely remarkable as a manifestation of contemporary artistic life, but it can also be interpreted as a profound break in the deadening circle of the over-ripe and decadent art of our time. Art is embracing the twentieth century, delineating areas of development in all aspects of creative activity. Regarding myself, to some extent, competent in artistic matters, I consider that this project is an international event in the art world.

One of the most complex cultural problems is solved before our very eyes: a utilitarian form appears as a purely creative form. Once again a new classicism becomes possible, not as a renaissance but as an invention. The theorists of the international workers' movement have long sought a classical content for socialist culture. Here it is. We maintain that the present project is the first revolutionary artistic work, and one which we can send to Europe.

Form in the project is placed along two axes (aa_1 and bb_3), which are in a constant state of conflict. The line a to a_1 develops into a movement upwards which is broken at each point by the movement of the spirals from b, b_1, b_2, b_3, to the line aa_1. The collision of these two movements (by their very nature mutually contradictory) must produce a break – such as characterized 'cubism' (long since left behind), and entail the destruction of the utilitarian idea. But the converging spirals, adopting the movement of aa_1 (and bb_3), carry these lines above and beyond the movement of the main support (girder aa_1) to the same point, producing a dynamic image, imbued with the powerful tension of endlessly disturbed and clashing axes. The whole form oscillates like a steel snake, constrained and organized by the one general movement of all the parts, to raise itself above the earth. The form wants to overcome the material and the force of gravity, the strength of the resistance is enormous and massive: straining every muscle, the form finds an outlet through the most elastic and rapid lines which the world knows, through spirals. They are full of movement, aspiration, and speed: they are taut like the creative will and like a muscle tensed with a hammer.

The application of the spiral and its organization into a modern form is, by itself, an enrichment of the composition. In the same way as the equilibrium of the parts in a triangle makes it the best expression of the Renaissance, so the best expression of our spirit is the spiral. The interaction of weight and support is the most pure (classical) form of stasis; the classical form of dynamism is the spiral. Societies divided by class fought to own the earth, the line of their movement is horizontal. The spiral is the movement of liberated humanity. The spiral is the ideal expression of liberation: with its base set in the earth, it flees from the ground and becomes a symbol of the suspension of all animal, earthly and grovelling interests.

Bourgeois societies love to develop the animal life on top of the earth, working its surface: they build shops, arcades, banks. Bourgeois life, based on the urban squares, was played out in full view and for show. Creative humanity disappears with its animal life into the earth, where the co-operatives' work is not visible. The square is a place for agitation, games and for festivals. Emancipated life rises above the earth, above grey and earthly materials. As living accommodation and social space carried to a level above the earth, the building is an expression of modernity and the content of contemporary life. At the same time, it comprises the content of a great artistic form.

The content of any form can be taken and condensed by utility, because the utility of a form is nothing other than the organization of its content. Forms devoid of practical significance (the majority of artistic forms which have existed up to now), are simply forms which are not organized. And perhaps the principle of organization has for the first time actually been realized in art. The monument is calculated on the concentration of legislative (Structure A), executive (Structure B) and informative (Structure C) initiatives; furthermore, in accordance with the stated principle of expressing modernity, these structures are raised into a higher level of space. In this way, and through the material (glass), the purity of the initiatives, their liberation from material constraints and their ideal qualities are stressed. An art devoid of creative idealism which is the content of intuition, is an art of impure rhythm. Up to now no one has succeeded in breaking rhythms down into the elements of material culture which define the growth and conditions of existence. But life itself consists of rhythms. Intuition flows in accordance with these rhythms. The purity and the intensity of the rhythms define the degree of talent, but I know of no more pure or intense rhythms than those in Tatlin's work. He possesses an eye of the greatest sensitivity with respect to material and it is precisely the juxtaposition of materials which defines the limits of the rhythmic waves. We accept, as a basis, that the unit of a rhythm is the section of a wave, enclosed between the qualities of the glass and the qualities of the iron. Just as the production of a number of oscillations along a wave is a spatial measure of sound, so the relationship of glass to iron is a measure of material rhythm. There is a stern and incandescent simplicity hidden in the juxtaposition of these two most elementary materials, both in a similar way brought into existence by fire. These materials are the elements of modern art. The form, defined by their juxtaposition, produces a rhythm of such broad and powerful oscillation that it seems like the birth of an ocean.

To translate this form into reality means to realize a dynamism of the same unsurpassed greatness as that embodied in the stasis of the pyramid. We maintain that only the full power of the multi-million strong proletarian consciousness could bring into the world the idea of this monument and its forms. The monument must be realized by the muscles of this power, because we have an ideal, living and classical expression in the pure and creative form of the international union of the workers of the whole world.

5 Alexander Rodchenko (1891–1956) 'Slogans' and 'Organizational Programme' of the Workshop for the Study of Painting in State Art Colleges

After being involved in the avant-garde group around Tatlin, Rodchenko became the leading representative, first of 'laboratory research' and then of the movement from 'art into production' in the years after the Revolution. He was involved in drawing up courses for the Vkhutemas, the State Higher Artistic and Technical Studios, where he taught from 1920 to 1930. From the mid-1920s he turned mainly to photography. Both the 'Slogans' and the 'Organizational Programme', drawn up in 1920–1, were first published in *Khudozhestvenno–konstructorskoe obrazovanie (Artistic–Constructive Education)*, no. 4, Moscow, 1973, pp. 203–6. The present translation is taken from S.-O. Khan Magomedov, *Rodchenko: The Complete Work*, London, 1986, p. 291.

Slogans

(The discipline of construction, chief director Rodchenko)

Construction = organization of elements.

Construction is a modern concept.

Art is a branch of mathematics, like all sciences.

Construction is the modern requirement for organization and utilitarian use of material.

Constructivist life is the art of the future.

Art which does not enter into life will be put under a No. of the archaeological museum of *antiquity*.

It is time that art entered into life in an organized fashion.

Life organized along Constructivist lines is superior to the delirious magic art of the sorcerers.

The future will not construct monasteries for the priests, prophets and minstrels of art.

Down with art as a beautiful patch on the squalid life of the rich.

Down with art as a precious stone in the midst of the dismal and dirty life of the poor.

Down with art as a means of escaping from a life that is not worth living.

Conscious and organized life, that knows how to see and build, is contemporary art.

The man who has organized his life, his work and himself is a genuine artist.

Work for life and not for palaces, cathedrals, cemeteries and museums.

Work in the midst of everything and with everybody; down with monasteries, institutes, studios, ateliers and islands. Awareness, experience, purpose, construction, technique and mathematics, these are the companions of contemporary art.

Organizational programme of the workshop for the study of painting in State Art Colleges

1 The workshop for the study of painting has an educational and an experimental function.
 a The scientific duties of the workshop are the analysis and elaboration of problems in art and in pictorial technique. In order to carry out this part of its work the workshop will conduct experiments:
 1 in the field of colour
 2 in the field of form
 3 following the laws of construction
 4 studying the treatment of the surface layer of materials, i.e. their preparation.
 b The educational aims of the workshop involve giving students a technical and scientific preparation and practice in the various techniques of painting, independently of creative individualism.
2 The workshop is divided up into special sections for analysis of the separate elements of painting:
 1 colour
 2 form

3 construction
4 *faktura*
5 materials.

The study breaks down into:

a elaboration of the elements taken individually
 1 analysis of the fundamental characteristics of each element (on the practical and the theoretical plane)
 2 observation of examples of the treatment of elements in works of art from different periods
 3 analysis of elements in objects
 4 practical handling of special problems in the elaboration of individual elements
b comparison of elements
 1 study of the interrelationship of different elements
 2 observation of the way elements are combined in works of art
 3 study of the combination of elements in objects
 4 practical handling of problems concerned with the combination of elements.

<div align="right">

Rodchenko
12 December 1920

</div>

6 Alexander Rodchenko (1891–1956) and Varvara Stepanova (1894–1958) 'Programme of the First Working Group of Constructivists'

Although the term has been widely applied to the Russian avant-garde in general, indeed to a later school of abstract art in the West in the shape of an 'international constructive tendency' (see IVA9), 'Constructivism' in a strict sense came into being in Russia in 1921 as part of moves to realign avant-garde art to the productive demands of building up the new, post-revolutionary society. It was intimately bound up with practical, theoretical and educational work taking place at Vkhutemas and Inkhuk. In addition to Rodchenko and Stepanova (who were married), leading members were Alexei Gan, Konstantin Medunetsky and the brothers Vladimir and Georgii Stenberg. Originally published in *Ermitazh*, no. 13, Moscow, August 1922, pp. 3–4. Other versions of the Programme exist in translation. This version was the only one printed in Russian during the 1920s. Translated by Christina Lodder for the Open University, 1983.

The Group of Constructivists has set itself the task of finding *the communistic expression of material structures*.

In approaching its task the group insists on the need to synthesize the ideological aspect with the formal for the real transference of laboratory work on to the rails of practical activity.

Therefore, at the time of its establishment, the group's programme in its ideological aspect pointed out that:

1 Our sole ideology is scientific communism based on the theory of historical materialism.
2 The theoretical interpretation and assimilation of the experience of Soviet construction must impel the group to turn away from experimenal activity 'removed from life' towards real experimentation.
3 In order to master the creation of practical structures in a really scientific and disciplined way the Constructivists have established three disciplines: *Tectonics, Faktura and Construction.*
 A Tectonics or the tectonic style is tempered and formed on the one hand from the properties of communism and on the other from the expedient use of industrial material.
 B *Faktura* is the organic state of the worked material or the resulting new state of its organism. Therefore, the group considers that *faktura* is material consciously worked and expediently used, without hampering the construction or restricting the tectonics.
 C Construction should be understood as the organizational function of Constructivism.

If tectonics comprises the relationship between the ideological and the formal which gives unity to the practical design, and *faktura* is the material, the construction reveals the very process of that structuring.

In this way the third discipline is the realization of the design through the use of the worked material.

The Material. The material as substance or matter. Its investigation and industrial application, properties and significance. Futhermore, time, space, volume, plane, colour, line and light are also material for the Constructivists, without which they cannot construct material structures.

The Immediate Tasks Of The Group

1 In the ideological sphere:

To prove theoretically and practically the incompatibility of aesthetic activity with the functions of intellectual and material production.

The real participation of intellectual and material production as an equal element in the creation of communist culture.

2 In the practical sphere:

To publish a statement.

To publish a weekly paper, VIP [*Vestnik Intellektual'nogo Proizvodstva; The Herald of Intellectual Production*].

To print brochures and leaflets on questions relating to the activities of the group.

To construct designs.

To organize exhibitions.

To establish links with all the Production Boards and Centres of that unified Soviet machine which in fact practically shapes and produces the emergent forms of the communist way of life.

3 In the agitational sphere:

 i The Group declares uncompromising war on art.

ii It asserts that the artistic culture of the past is unacceptable for the communistic forms of Constructivist structures.

7 Alexei Gan (1889–1942) from *Constructivism*

The author was a designer as well as an artist and theorist active in Inkhuk and the First Working Group of Constructivists. Gan's book is the most extensive exposition of the principles of Constructivism, but is marked by an extremity of formulation which caused disagreement even within the group. The book itself embodied Constructivist typographical and design principles. The brief extract reproduced here discusses the key triad of Constructivist concepts: 'tectonics', 'faktura' and 'construction'. 'Faktura' essentially concerns the properties of materials and the processes of their working; 'construction' ways of combining and organizing them; and 'tectonics' the vague, but from a constructivist perspective none the less essential, area of these principles' relation to the theory of Communism. Originally published as *Konstruktivizm*, Tver, 1922. The present translation is taken from Camilla Gray, *The Great Experiment*, London, 1962, pp. 284–7, reprinted as *The Russian Experiment in Art 1863–1922*, London, 1971.

Tectonic emerges and forms itself based on the one hand on the characteristics of Communism, and on the other on the expedient use of industrial materials. The word tectonic is taken from geology where it is used to define eruption from the earth's centre.

Tectonic is a synonym for the organic, for the explosion from an inner being.

The tectonic as a discipline should lead the Constructivist in practice to a synthesis of the new content and the new form. He must be a Marxist educated man who has once and for all outlived art and really advanced on industrial material. The tectonic is his guiding star, the brain of experimental and practical activity.

Factura is the whole process of the working of material. The working of material as a whole and not the working of one side.

Here the material is understood in its raw state. The expedient use of material means its selection and working over, but the character of this working over [of the material] in its integrity is factura: the organic condition of the worked over material or the new condition of its organism.

The material is the body, the matter. The transformation of this raw material into one form or another continues to remind us of its primary form and conveys to us the next possibility in its transformation.

In so far as we transform and work over [materials], we are engaged in factura. Proceeding from this, the second discipline one can formulate thus: Factura is to consciously select material and use it expediently without halting the movement of the construction or limiting its tectonic.

Construction. Construction must be understood as the co-ordinating function of Constructivism.

If the tectonic unites the ideological and formal, and as a result gives a unity of conception, and the factura is the condition of the material, then the construction discovers the actual process of putting together.

Thus we have the third discipline, the discipline of the formation of conception through the use of worked material.

All hail to the Communist expression of material building! [. . .]

The end has come to pure and applied [art]. A time of social expediency has begun. An object of only utilitarian significance will be introduced in a form acceptable to all.

Nothing by chance, uncalculated, nothing from blind taste and aesthetic arbitrariness. Everything must be technically and functionally directed.

Once and for all the idea of a final solution and eternal truths must be invalidated.

The roots of art were always in material-formal substances, in production . . .

From the speculative activity of art to socially directed artistic work . . .

The technical system of society, the ordering of its wealth, creates the ordering of human relationships. . . .

In the field of cultural organization, the only valid criterion is that which is indissolubly connected with the general tasks of the revolution . . . Art is dead! There is no room for it in the human work apparatus. Work, technique and organization!

Let us tear ourselves away from our speculative activity [art] and find the way to real work, applying our knowledge and skills to real, live and expedient work. Intellectual-material production sets up working mutual relations and a production basis with science and technique, replacing art which by its very nature cannot be disentangled from religion and philosophy and is not capable of pulling itself out of the closed circle of abstract, speculative activity . . .

Tectonic, factura, construction. Retaining the lasting material and formal basis of art such as colour, line, surface, volume and movement, artistic work materialistically directed will become, in conditions of expedient activity and intellectual-material production, capable of opening new means of artistic *expression*.

Not to reflect, not to represent and not to interpret reality, but to really build and express the systematic tasks of the new class, the proletariat. The master of colour and line, the builder of space-volume forms and the organizer of mass productions must all become constructors in the general work of the arming and moving of the many-millioned human masses. . . .

Our Constructivism has declared unconditional war on art, for the means and qualities of art are not able to systematize the feelings of a revolutionary environment.
[. . .]

8 El Lissitsky (1890–1947) and Ilya Ehrenburg (1891–1967) Statement by the Editors of *Veshch*

Lissitsky and the writer Ehrenburg collaborated in 1922 to produce a short-lived trilingual journal under the name *Veshch/Gegenstand/Objet*, intended to relate developments in post-revolutionary Soviet art and design to similar movements in the West. Typically the cover of the third issue drew together Malevich's *Black Square* and a locomotive in a dramatic montage. The journal occupied a mid-point between Suprematism and utilitarian Constructivism. The statement reproduced here was delivered by Lissitsky to a congress of 'progressive artists' in Düsseldorf in 1922 and was instrumental in the organization of an 'International Fraction of Constructivists' at that Congress. The *Veshch* statement was published in *De Stijl*, V, no. 4, Amsterdam, 1922. The present translation, by Nicholas Bullock, is taken from S. Bann (ed.), *The Tradition of Constructivism*, London and New York, 1974, pp. 63–4.

1 I come here as representative of the magazine *Veshch/ Gegenstand/ Objet*, which stands for a new way of thinking and unites the leaders of the new art in nearly all countries.

2 Our thinking is characterized by the attempt to turn away from the old subjective, mystical conception of the world and to create an attitude of universality – clarity – reality.

3 That this way of thinking is truly international may be seen from the fact that during a seven-year period of complete isolation from the outside world, we were attacking the same problems in Russia as our friends here in the West, but without any knowledge of the others. In Russia we have fought a hard but fruitful struggle to realize the new art on a broad social and political front.

4 In doing so we have learned that progress in art is possible only in a society that has already completely changed its social structure.

5 By progress we mean here the freeing of art from its role as ornament and decoration, from the need to satisfy the emotions of the few. Progress means proving and explaining that everybody has the right to create. We have nothing to do with those who minister to art like priests in a cloister.

6 The new art is founded not on a subjective, but on an objective basis. This, like science, can be described with precision and is by nature constructive. It unites not only pure art, but all those who stand at the frontier of the new culture. The artist is companion to the scholar, the engineer, and the worker.

7 As yet the new art is not always understood; it is not only society that misunderstands it, but more dangerously, it is misunderstood by those who call themselves progressive artists.

8 To combat this situation we must join ranks so that we really can fight back. It is essentially this fight that unites us. If our aim were only to defend the material interests of a group of people called artists, we would not need another union, because there are already international unions for painters, decorators, and varnishers, and professionally we belong to these.

9 WE REGARD THE FOUNDING OF AN INTERNATIONAL OF PROGRESSIVE ARTISTS AS THE BANDING TOGETHER OF FIGHTERS FOR THE NEW CULTURE. Once again art will return to its former role. Once again we shall find a collective way of relating the work of the artist to the universal.

9 *LEF*: 'Whom is *LEF* Alerting?'

Vladimir Mayakovsky, the leading revolutionary poet, organized the group 'Left Front of the Arts' around the journal *LEF* in 1923. During the years of the civil war, 'leftist' art had been hegemonic. In the changed conditions of the New Economic Policy more technically conservative trends in art and literature re-emerged, claiming to serve the Revolution under the banners of 'realism' and 'popularity'. Mayakovsky's aim was to regroup the Left and re-establish its claims to be the true art of the Revolution. This manifesto–editorial appeared in the first issue of *LEF*, Moscow, 1923, pp. 10–11. The present translation, by Richard Sherwood, is taken from *Form*, Brighton, no. 10, October 1969, pp. 32–3 (reprinted in *Screen*, London, vol. 12, no. 4, Winter 1971–2, pp. 35–7).

This is addressed to us. *Comrades in Lef!*

We know that we, the 'left' master-craftsmen, are the best workers in today's art. Up to the Revolution we piled up highly correct draft-plans, clever theorems and cunning formulae, for the forms of the new art.

One thing is clear: the slippery, globular belly of the bourgeoisie was a bad site for building.

During the Revolution we amassed a great many truths, we studied life, we received the task of building a very real structure for the centuries ahead.

A world shaken by the booming of war and revolution is difficult soil for grandiose constructions.

We temporarily filed away our formulae, while helping to consolidate the days of revolution.

Now the globe of the bourgeois paunch exists no longer. Sweeping away the old with the revolution we cleared the field for the new structures of art at the same time. The earthquake is over. Cemented by spilt blood the USSR stands firmly.

It is time to start *big things. The seriousness of our attitude to ourselves is the one solid foundation for our work.*

Futurists!

Your services to art are great; but don't dream of living on the dividend of yesterday's revolutionary spirit. Show by your work today that your outburst is not the desperate wailing of the wounded intelligentsia, but a struggle, labouring shoulder to shoulder with all those who are straining towards the victory of the commune.

Constructivists!

Be on your guard against becoming just another aesthetic school. Constructivism in art alone is nothing. It is a question of the very existence of art. Constructivism must become the supreme formal engineering of the whole of life. Constructivism in a performance of shepherd pastorals is nonsense. Our ideas must be developed on the basis of present-day things.

Production artists!

Be on your guard against becoming applied-artist handicraftsmen.

In teaching the workers learn from the worker. In dictating aesthetic orders to the factory from your studios you become simply customers.

Your school is the factory floor.

Formalists!

The formal method is the key to the study of art. Every flea of a rhyme must be accounted for. But avoid catching fleas in a vacuum. Only together with the sociological study of art will your work become not only interesting, but necessary.

Students!

Avoid giving out the chance distortions of the dilettante striving for innovation, for the 'dernier cri' of art. The innovation of the dilettante is a steamship on the legs of a chicken.

Only in craftsmanship have you the right to throw out the old.

Everyone together!

As you go from theory to practice remember your craftsmanship, your technical skill.

Hackwork on the part of the young who have the strength for colossal things, is even more repulsive than the hackwork of the flabby little academics.

Master and students of 'Lef'!

The question of our very existence is being decided. The very greatest idea will perish if we do not mould it skilfully.

The most skilful forms will remain black threads in blackest night, will evoke merely the annoyance and irritation of those who stumble over them if we do not apply them to the shaping of the present day, the day of revolution.

Lef is on guard.

Lef is the defender for all inventors.

Lef is on guard.

Lef will throw off all the old fuddy-duddies, all the ultra-aesthetes, *all the copiers.*

10 Osip Brik (1888–1945) 'The So-called "Formal Method"'

The author was a critic and theorist, closely associated with Rodchenko and Mayakovsky, and hence with Constructivism and the Left Front of the Arts. He had also been involved with the 'Opoyaz' group of formalist linguists. Linguistic Formalism had come under attack from more orthodox Marxists, as indeed had the Constructivism which emerged from the preceding, essentially formalist, avant-garde art. Here Brik seeks to establish the revolutionary credentials of such practices, turning the tables on his opponents by claiming that it is these which are truly Materialist and the more orthodox forms which are reliant upon Idealism. Originally published in *LEF*, vol. 1, Moscow 1923, pp. 213–25. The present translation is by Richard Sherwood (loc. cit.), pp. 42–4. (For other texts by Brik see IIID11 and IVC8.)

'Opoyaz' and its so-called 'formal method' has become a bugbear to the literary pontiffs and priestling dabblers in literature. This impudent attempt to approach the poetic icons from a scientific point of view evoked a storm of indignation. A 'league of resistance to the formal method' was formed, or, to be more exact, a 'league of resistance to the removal of poetic values'.

This would not be worth mentioning, were there not several Marxists, albeit motheaten ones, among the 'resisters'. This calls for an explanation.

'Opoyaz' maintains that *there are no poets and writers – there are just poetry and writing.* Everything that a poet writes is meaningful as a part of his general work, and is totally worthless as an expression of his 'I'. If a poetic work can be comprehended as a 'human document', like an entry in a diary, it is interesting to the author, to his wife, relatives, friends and maniacs of the type who passionately seek the answer to the riddle 'was Pushkin a smoker?' – and to no one else.

The poet is an expert in his own business. And that is all. But to be a good expert you must know the needs of those for whom you are working, you must live one life with them. Otherwise your work won't come off and will be useless. The social role of the poet cannot be understood from an analysis of his individual qualities and habits. *A mass study of the devices of the poetic craft is necessary*, these devices to be distinguished from the estimative areas of human labour; also the laws of their historical development. Pushkin was not the founder of a school, but simply its leader. If Pushkin had never existed 'Eugene Onegin' would still have been written. And America would have been discovered without Columbus. We have no history of literature yet. There is just

a history of the 'generals' of literature; 'Opoyaz' will make possible the writing of this history. The poet is an expert of the word, a word-creator, serving his own class, his own social group. What to write about is intimated to him by the consumer. *Poets do not invent themes, they take them from their surrounding milieu.* The work of the poet starts with the processing of the theme, with finding a corresponding linguistic form for it.

Studying poetry means studying the laws of this linguistic processing. *The history of poetry is the history of the development of the devices of linguistic fashioning.* Why poets have taken this or that actual theme, and not others, is explained by their belonging to this or that social group, and has no connection with their poetic work. This is important for the poet's biography, but the history of poetry is not a book of 'Lives of the Saints', and must not be like one.

Why poets used certain devices, and not others, in the processing of themes, what causes the appearance of a new device, how an old one dies off – this is the subject for the most thorough research of scientific poetics. 'Opoyaz' marks off its work from the work of adjacent scientific disciplines not in order to go 'out of this world' but in order to establish and expand a series of the most vital problems of man's literary activity in the neatest way possible.

'Opoyaz' studies the laws of poetic production. Who will dare prevent it doing so?

What does 'Opoyaz' contribute to the proletarian construction of culture?

1 A scientific system instead of a chaotic accumulation of facts and personal opinions.
2 A social evaluation of creative people instead of an idolatrous interpretation of the 'language of the gods'.
3 A knowledge of the laws of production instead of a 'mystical' penetration into the 'secrets' of creation.

'Opoyaz' is the best educator for the young proletarian writers.

The 'prolet-poets' are still afflicted with the thirst for 'self-revelation'. They constantly tear themselves away from their class. They do not want to be simply 'prolet-poets'. They look for 'cosmic', 'planetary' or 'deep' themes. They think that in his theme the poet must leap out of his milieu, that only then will he reveal himself and create – the 'eternal'.

'Opoyaz' will show them that everything great has been created in answer to questions of the day, that the 'eternal' today was then a topic of the time, and that the great poet does not reveal himself, but simply carries out the social command.

'Opoyaz' will help its comrade prolet-poets to overcome the traditions of bourgeois literature, by scientifically proving its moribundity and counter-revolutionism.

'Opoyaz' will come to the aid of proletarian creation not with hazy little chats about the 'proletarian spirit' and 'communist consciousness', but with the exact technical meanings of the devices of contemporary poetic creation. *'Opoyaz' is the grave-digger of poetic idealistics.* It is useless to fight it. And all the more so for Marxists.

11 Osip Brik (1888–1945) 'From Picture to Calico-Print'

Brik embraced the ethos of 'art into production'. He accordingly condemned easel-art as archaic and moreover irrevocably marked by bourgeois individualism. In its place he

advocated photography, photomontage, and the use of reproducible screen (i.e. 'calico') printing. To this extent Brik's essay in particular, and indeed the Constructivist–Productivist avant-garde in general, stand as precursors of the later preconceptions of Walter Benjamin in his seminal essay 'The Work of Art in the Age of Mechanical Reproduction' (1936) (see IVD6). Originally published in *LEF*, no. 6, Moscow, 1924, pp. 30–1, 34. The present translation is by Richard Sherwood (loc. cit.), pp. 48–51.

The propaganda of production art is now crowned with success.

It is becoming obvious that art culture is not totally covered by objects for exhibitions and museums, that, in particular, painting is not 'pictures', but the entire aggregate of the pictorial designing of life.

The calico-print is just the same sort of product of art culture as the picture, and there is no foundation for drawing any sort of dividing line between the two.

Moreover, the belief is growing that the picture is dying, that it is inextricably bound to the forms of the capitalist system, to its cultural ideology, and that the calico-print is now moving into the centre of creative attention, – that calico, and work on it, are now the peaks of art work.

This is a fact. Our cultural creative work is now entirely purpose-orientated. We do not think up for ourselves any cultural work that does not pursue some definite practical aim. The concepts of 'pure science', 'pure art', and 'self-valuable truths and beauties' are foreign to us. We are practicians, – and in this lies the distinguishing feature of our cultural consciousness.

The easel-art picture can find no place in such a consciousness. For its strength and significance lie in its non-utilitarianism, in the fact that it serves no other purpose than that of pleasing, of 'delighting the eye'.

All attempts to turn an easel-painting into an agit-picture are fruitless. Not because no talented artist could be found to do it, but because it is unthinkable in its very essence.

The easel painting is intended for a prolonged existence, to last for years and even centuries. But what agit-theme could last for such a time? What agit-picture would not be obsolete within a month? And if the theme of the agit-picture were obsolete, what would there be left in it?

A theme of short-lived effect must not be dealt with by devices intended for a lengthy existence. A one-day object must not be built to last centuries.

This is why the agit-picture cannot bear comparison with the agit-poster, this is why there are no good agit-pictures.

The 'pure' easel-artists have exercised good judgement in refusing to work on agit-themes. They realize that this way the easel-painting will perish, that it loses its basic values – its 'timeless', 'non-utilitarian' significance, and that the poster will outdo it. They are therefore making desperate attacks to save it by another method: – to impress on one and all that the easel-painting is, in its purely formal sense, a huge cultural fact, that without it any art culture is unthinkable.

They maintain that if no easel-paintings are made, then art culture will perish, that the creative 'freedom' which is apparent in the making of these easel-paintings must not be extinguished for a single second otherwise art will end.

Let the theme of the picture be trivial, let there be an abstract 'free' play of the pictorial forms, – this is unimportant; what is important is that this non-temporal, non-

utilitarian, 'purely aesthetic' value will continue to exist, that one will be able to glance at it, be imbued with it – and art culture will be saved.

This is how monks reason. Their righteous life outside the world saves the world.

And yet the easel-artists are right. If the painting can be saved it is only in this way.

If it is true that the easel-painting is necessary for the existence of art culture, that without it art culture will perish, then, of course, we must take every step to encourage its development and well-being.

But it is not true. The easel-painting is not only unnecessary to our present day art culture, but is one of the most powerful brakes to its development. And this is why.

Of course, the chief evil is not in the monkish reasonings of the 'pure' easel-artists. These can easily be dispelled by the light of anti-religious, anti-aesthetic propaganda. What is bad is that these monkish dogmas are turned into productional and pedagogical principles.

The nub of the matter is that the easel-artists do not deny the importance and necessity of other forms of art culture. They fully allow the existence of agit-posters, sketches for calico-printing, and book covers; they simply maintain that without easel-painting all these 'secondary' aspects are unthinkable, that easel-painting is the creative base on which all the culture of painting is constructed.

Hence the conclusion that if you want to make good calico-prints, learn how to paint landscapes.

The easel-artists argue thus: the artist, wherever he works, whatever he does, must be master of an art culture, must be artistically educated. This art culture, this art education, is given to him by easel-painting.

Having mastered the 'secrets' of easel-painting, he thereby masters the 'secrets' of every sort of painting work, be it calico, the book-cover, the poster, or theatre decoration.

And this is where the easel-artists are cruelly wrong.

The painting is the product of a certain aspect of artistic work. To make a painting one must expend a certain quantity of technical devices and skills, namely those devices and skills with which a picture can be made. Why does it follow that these devices and skills are universal? Why does it suddenly turn out that the devices and skills suitable for one craft are right for any other?

Let us admit that partial coincidences are also possible, that part of the devices may be universally used; but why should one craft be basic in relation to another? Why should the making of a still-life be more basic than the making of a calico-print? Why should one first learn to make still-life pictures, and then proceed to calico-prints, and not the other way round?

The easel-artists like to compare pure easel-painting with pure mathematics. They say that both of them give general principles, general propositions, which can then be applied in practice.

But the easel-artists forget that a picture is not science, but practical work, and cannot establish any 'general' propositions. The experience of the easel-painter is not the experience of the artist in general, but merely the experience of one particular case of pictorial work.

The easel-artists want to vindicate their right of existence.

If easel-art died, as a socially necessary aspect of artistic craft, then, they say, let it come back to life as a universal artistic method, as the highest school of all artistic practical work.

This is how the zealots of classical antiquity tried to vindicate the need for Greek and Latin in secondary schools.

But the pedagogic universality of easel-art can be disproved not only by theoretical arguments, but also by everyday practical experience.

The sad fate of artists who have passed through the easel-art school, and then try to apply their knowledge and skills in production, is well known. Nothing comes of it.

However, the easel-artist, by and large, doesn't care a thing about production. The acknowledgment of production art is an empty phrase in his mouth.

If work in production were always to remain art of the lowest sort it would be all the same to him. This is why it is not the easel-artists who will find methods for this type of work, and it will not be from easel-art that the solution of the problems of production art will come.

Only those artists who have broken once and for all with easel-artistry, who have in fact recognised production work as not only an equally legitimate aspect of art work, but as the only one possible, – only these artists can undertake the solving of the problems of present-day art culture productively and successfully.

Among these artists, as yet still few in number, are the members of INKHUK: – Rodchenko, Lavinsky, Vesnin, Stepanova, Johanson, Senkin, Klutsis and the late Lyubov Popova.

There is one very serious objection that the easel-artists make against the production artists. They say: *Your works are no different from the most primitive sort of applied art; you are doing just what applied artists have always done, 'applying' easel drawings to factory-produced objects. But what will you do if there are to be no easel-works? What will you 'apply'?*

It is true that art work, and factory or workshop work, are still separate. The artist is still an alien in the factory. People react suspiciously to him, they do not let him get close. They do not trust him. They cannot understand why he must know the technical processes, why he should have information of a purely industrial nature. His business is to draw, to make drawings – and it is the business of the factory to choose suitable ones from among them and stick them on ready-made manufactures.

The basic idea of production art, that the external appearance of a thing is determined by its economic purpose and not by abstract, aesthetic considerations, is still insufficiently apprehended by our industrialists, and it seems to them that the artist, in seeking to delve into the 'economic secret' of the object, is poking his nose into other people's business.

Hence the inevitable applied art, – a result of the alienation of the artist from production. As he does not receive the necessary economic directives he involuntarily falls back on aesthetic stereotypes.

What conclusion can be drawn from this?

Forward! – to the overcoming of this alienation.

Forward! – to the union of artist and factory.

And never: backwards – to pure easel work, or backwards – to little pictures.

Leading artists have already set out on the road from picture to calico-print, and of course they will not turn back. But this is only the beginning. The entire mass of young

artists must understand that this road is the only true one, that it is along this road that the development of art culture will proceed.

It is necessary for our industrialists to understand their role in this matter, since on this depends the acceleration of this historical process.

The initiative of the director of the first cotton-printing factory in Moscow (formerly the Tsindel), comrade Arkhangelsky, and of Professor Viktorov, who invited the artists Stepanova and Popova to work there, is worthy of great attention and praise.

And if it is still too early to speak about the results of this first experiment, then it is essential to mention its huge cultural value.

The art culture of the future is being made in the factories and workshops, and not in attic studios.

Let young artists remember this, if they want to avoid falling prematurely into the archives, together with the haughty easel-artists.

12 Vladimir Tatlin (1885–1953) 'Report of the Section for Material Culture's Research Work for 1924'

Tatlin had been involved in an organizational capacity within the Petrograd Museum of Artistic Culture (Ginkhuk) since 1921. From November 1923, though in practice earlier, he was head of the Section for Material Culture. He resigned in 1925, after a conflict with his old adversary Malevich, though this was perhaps symptomatic of wider pressures being exerted on Constructivists by the mid-1920s. The Section's original title referred to 'Research on the Construction of the Object'. It investigated the processing of materials, such as paint surfaces, and colours, and initiated projects in practical design work, the best-known of which were for a suit of clothes, an overcoat and a stove. The basic principle was the creating of new forms for the new 'everyday life'. Originally submitted internally within Ginkhuk in 1924. The present translation is taken from Zhadova, op. cit., pp. 256–7. (For an earlier text by Tatlin see IIID2.)

Taking into account that the industrial and domestic production inherited from the old world, including painting, as well as our experience in both town and country in all its manifestations, is in a state of anarchy: production is splintered into chance productive units, experience is abnormally individualized and without unity of form. Recognizing also that the shaping principle of culture, production and experience is material, the Section for Material Culture sets itself the task of:

1 Research into material as the shaping principle of culture.
2 Research into everyday life as a certain form of material culture.
3 The synthetic forming of material and, as a result of such formation, the construction of standards for new experience.

To realize these tasks the Section carried out the following work:

I Experimental research into coating materials. The work was carried out in the direction of broadening the use of coating materials, determining new means of preparing surfaces. The Section showed a number of colour selections which, thanks

to their particular colour qualities, could find an application in production; moreover, the Section found for certain coating materials normal methods of preparation (colour-norms), thanks to which materials of this kind can be widely used in our everyday life. In connection with the demonstration of new standards two lectures were given by the director of this work:

1 Colour as coating material (against Impressionism and other 'isms'.)
2 Specific colour fields in various cultural epochs.

II Experimental research into the properties of material. Work was done and developed on the shaping of material in space; to this purpose research was undertaken into the construction of reliefs and counter-reliefs, our experience in analysing a fully material volume was broadened, and finally the significance of material as an unlimited element which uniquely shapes culture was confirmed. At the synoptic exhibition patterns of reliefs and counter-reliefs of classical construction were shown, in connection with which two lectures were given:

a form as a result of material volume;
b the development of spatial perceptions from recent tendencies in art to the counter-relief.

The shaping of materials in the conditions of contemporary everyday life. In this division the Section worked out two patterns in several variants of clothing-norms and a fireplace-norm. Patterns of clothing-norms were designed in a number of sketches and drawings, of which 1) A man's overcoat; 2) A jacket; 3) A smock; 4) Trousers, one set for workers and citizens of the USSR (townspeople), were realized by the Department of Material Culture jointly with the factories of Leningrad Clothing Manufacturers' Trust.

The design of a fireplace-norm for workers' apartments was developed in three variants: model of a complex stove-range with all the means for preparing and preserving food, the model of a simplified stove, and the model of an economical stove. The demonstration of new models was accompanied by lectures.

Material culture, contemporary everyday life and production.

Besides this, a number of conversations were held with specialist workers, workers who were students of institutes of higher education; evaluation forms were collected.

At the synoptic yearly exhibition all the designs were shown and accompanied by necessary explanations.

The Section's staff:

The scientific staff: Khapaev, Kobelev, Kholodov, Nekrasov, Geintse.

Specialist workers: Nikolaev, Sokovich.

The Section has an accessory and assembly shop, in which work was carried out on the assembly and preparing of necessary parts for developing demonstration patterns.

Director of the Section for Material Culture, V. Tatlin
Leningrad, 10 November 1924

Part IV
Freedom, Responsibility and Power

IV

Introduction

During the period between the wars, contributors to the theoretical discourses of modern art tended to orient themselves by reference to three dominant and problematic concepts: abstraction, Realism and, after the mid-1920s, Surrealism, the adopted name of the principal avant-garde movement of the period (see IVC2). There was no serious debate about art which did not implicate at least one of these, and little that did not explicitly or implicitly propose some ordering of the relations between them. (The apparent exceptions help prove the rule. The work of Henri Matisse and Pierre Bonnard evades incorporation under any of our three headings. But for all the considerable merit of their work, there was no substantial criticism or theory for which that work served as a focus during the period in question.)

Just how any one of these terms was understood depended both upon the range of examples in view and upon the commitments and investments in respect of the other two which were at issue in any given context. To those for whom Piet Mondrian was the type of the abstract artist, for example, abstraction and Surrealism appeared irreconcilable. But the abstractions of Paul Klee and Joan Miró were among the forms of painting claimed on behalf of the Surrealist movement by that movement's principal theorist, André Breton. The form of Realism proposed by George Grosz and Wieland Herzfelde in 1925 was openly hostile to an abstract art they perceived as idealistic (IVC7; see also IIIC19). Yet ten years later Herbert Read could claim that it was the abstract artists who were the true revolutionaries, at the same time deprecating the Surrealists for their 'negativity' (IVD3).

These were not simply squabbles over the demarcation of stylistic territories. As Read's text makes clear, arguments about the meaning and value of artistic commitments were affected, often unwittingly, by the gravitational force exercised by larger allegiances, which were political in character. The principal forms of these were Communism, Fascism and a third which consisted of that familiar if not uncomplicated blend of liberal principles with capitalist economics which remains the dominant form of life in the industrialized nations of the West. If this third allegiance lacked a clear and named identity in artistic debate, that was because it tended to coincide with the position from which such debate was generally conducted in the West, even by those attracted to Communism or to Fascism. It was, as it were, the widely assumed state of human nature from which the other allegiances were perceived as attractive or invidious forms of political culture.

In sketching these two triads – abstraction, Realism and Surrealism on the one hand, and Communism, Fascism and liberal-capitalism on the other – we do not mean to

suggest that systematic and exclusive forms of connection can be drawn from the one set to the other. On the contrary. For example, while there were certainly many Communists who were committed to forms of Realism in the 1920s, and while the identification of Realism with Communism became a cliché of art-critical discourse on both the Left and the Right during the 1930s, the same period furnishes evidence of the dedication of abstract art to the task of building socialism (both in Russia and, as a less plausible enterprise, in the abortive Weimar Republic), while the fact that it has been possible for art historians to speak of 'Nazi Realism' indicates a persistent difficulty in analysis of Realism as a practical concept. In turn, the association of Modernism with an ideal and autonomous form of abstract art might seem to connect with that tendency to 'spiritualize' social and economic values which Marx noted in capitalism. But to insist on this connection would be both to minimize the significance of utopian socialism in the thinking of the artists concerned, and to ignore their concerted opposition to capitalism in its Fascist form (see IVA4). The evidence may show how important it was believed to be by many artists, critics and ideologues that connections should be made between artistic forms and political allegiances. But it also shows that attempts to make such connections *systematic* were doomed to failure then as now.

There can be no adequate understanding of the issues at stake in the artistic theory of the 1920s and 1930s without allowing for the effects of the Russian Revolution, both as its aftermath was experienced in subsequent Russian history, and as its implications were perceived in the imagination of Western artists and writers. Following the death of Lenin in 1924, Stalin's promulgation of the doctrine of 'Socialism in one country' signalled the rejection of the internationalism of the revolution. With the benefit of hindsight it can be said that it also signified the bureaucratic establishment of an iron pragmatism, to be implemented in the later 1920s through the adoption of the Five Year Plan and the collectivization of agriculture. The exiling of Trotsky at the end of the decade marked not just the ending of a revolutionary phase, but the entrenchment of a counter-revolutionary régime.

But the mechanisms of repression are not easily distinguished from the hard necessities which might be encountered in the building of a new socialist society. Even for those directly touched by the events and processes in question there can have been no clear point at which unjustifiable disloyalty to the revolution was transformed into justified dissent at its betrayal. Georg Lukács's '"Tendency" or Partisanship?' is revealing of the complex problems and perceptions of its moment (IVB10). Written in 1932, the year in which Russian literary and artistic organizations came under central control (IVB11), it opposes the ultra-Left tendentiousness of the Proletcult and argues for the identification of partisanship with humanism; in the process it prepares some positive theoretical ground for the doctrine of Socialist Realism, which was to be given the stamp of official policy by Stalin's spokesman two years later (see IVB15). The idea of a specifically Socialist Realism had been waiting in the wings for some time, both as a form of affirmation of new social orders in Russia (IVB2 and 3) and Mexico (IVB4), and as a voice of Left opposition to forms of abstract art (IVC7). But even in Stalinist Russia, the practical and conceptual relations between Realism and abstraction could be highly complex. In the same year that Lukács's text was written we find Kasimir Malevich, the consistent proponent of an extreme abstraction and the butt of official criticism in the late 1920s, arguing the need to establish pictorial identities for new social types (IVD1). During the 1930s, the

question of the relations between an intentionally popular Realism and an avant-garde abstraction or 'Expressionism' was one which came to preoccupy artists and intellectuals on the Left, not simply in Russia but throughout the industrialized world (see, for example, IVB12, 13 and 16–19, IVC15, 18 and 19, IVD4, 8 and 11).

Informed contributors to this debate were in a small minority, however. If the true historical conditions of criticism and theory were hard to diagnose in Russia itself, spectators in the West generally understood the effects of revolution either in terms of echoes and whispers, or by listening to propaganda. The majority of those drawn to the Communist Parties of the West tended to believe Stalinist propaganda, supporting this where appropriate by extrapolations from Marxist theory, in order to support a roseate view of Russian social and cultural achievements. For the majority of this group abstract art and Surrealism alike were suspect by virtue of their unpopularity – their implication in what was seen as an elite social order. The conservatives, on the other hand, tended to believe the propaganda of their own governments, threatened in imagination if not in fact, according to which Bolshevik demons were engaged in the levelling of all culture down to the lowest common denominator. For the majority of this second group modern art was also unspeakable, so that it came easily to them to identify modern art with revolutionary politics in general and with bolshevism in particular.

Kulturbolschewismus – cultural bolshevism – was a blanket term of condemnation used by the Nazis to refer to forms of Expressionist and abstract art. By the early 1930s the practice of modern art, like the pursuit of left-wing politics, had become dangerous in Germany. By the mid-1930s the Parisian art world was substantially populated with exiles and emigrants from both Russia and Germany, many of them Jews. Joining those already attracted to Paris as the supposed metropolitan centre of artistic Modernism, they helped to form a varied, homeless and cosmopolitan avant-garde. The publication of *Circle* in London in 1937 both marked the establishment of close English contacts with this community, and advertised London as a possible point of further migration (see IVA9–11).

If the effects of the Russian Revolution were influential, directly or indirectly, upon the cultural policies and theories of the West, the rise of Fascism was clearly as pressing a consideration in the minds of those who perceived its significance and its dangers. 1935 marked a point of convergence of these two historical vectors. Following the Seventh World Congress of the Comintern in July of that year, Moscow issued a directive to the cohorts in the West both to redirect their energies and to extend the political base of their organizations. These were to form Popular Fronts against Fascism, thus broadening their platform and their appeal in such a way as to conscript liberal opinion and establish common cause with other anti-Fascist organizations. It was to one of many such bodies that the German Jewish intellectual Walter Benjamin had delivered his paper 'The Author as Producer' (IVC17). Benjamin's complex argument takes account of the mixed complexion of the typical audience for critical debate on the Left – part Stalinists committed to a form of Social Realism, part liberal intellectuals persuaded of the autonomy of aesthetic value – though his conclusion conformed to the expectations of neither. In 1936 the apparent case for a Popular Front was strengthened by the overthrow of a legitimate republican government by Fascist forces in Spain. The ensuing civil war effected further polarization of Left and Right allegiances in the rest of Europe. An event from this war, the bombing of Guernica

by the German Luftwaffe acting in alliance with the Spanish Fascists, was the subject of a commemorative mural by Picasso. Widely exhibited between 1937 and 1939, this monumental work provided a specific and dramatic focus for the conjunction of artistic with political considerations.

It should be said that, if the policy of the Popular Front provided platforms for anti-Fascist sentiment among artists and their supporters, this was not because many of them were practical revolutionaries. On the contrary, it was because that policy happened to coincide with a wider tendency within the Modern Movement to transfer the concept of revolution from the sphere of practical politics to the sphere of art, and to associate both with an absolute freedom of thought and imagination. Conjoining the ideas of Marx with those of Freud, the Surrealists saw themselves as working for what Salvador Dali called 'a revolution in consciousness' (IVC14; see also IVC16). In their turn the abstract artists proposed a 'universal freedom' predicated on 'freedom of ideas' (IVA11). Although the technical strategies were very different, both assumed a possible 'imaginative freedom' which their works were intended to exemplify or to encourage. Pursuit of freedom in these terms became the common ethical platform of modern artists in the face of the political conditions of the time. By the mid-1930s the valuation of art as 'revolutionary' had come to fulfil much the same function in the discourses of modern art as the discovery of formal significance by the criticism of the previous two decades: it was the principal seal of approval for which the respective advocates and supporters of abstract art, of Realism and of Surrealism competed on behalf of one tendency or the other.

We have noted the importance of Communism and Fascism as conditions of the artistic theory of the period between the wars, even where they are not acknowledged as such. We also suggested earlier that a third form of allegiance coincided with the ground from which the majority of this theory issued. In conclusion we would propose that the most significant critical debate of the later 1920s and 1930s was one which had as its central preoccupation the need to survey the ground of the third form of allegiance: the assumed natural order. What was required was a self-conscious and sceptical representation of modern Western culture itself and of its constitutive values; an analysis made as it were from within, but by reference to concepts drawn from outside – the 'outside' being that imagined world of modern political alternatives for which Communism and Fascism defined opposing poles, the one possibly positive, the other decidely negative. The methodological instruments for this analysis were largely found within the Marxist intellectual tradition. This was the task variously addressed, at one time or another, by André Breton in France (IVC5 and 6), by Siegfried Kracauer, Walter Benjamin, Theodor Adorno and Ernst Bloch in exile from Germany (IVC10 and 17, IVD6–8), and by Meyer Schapiro, Clement Greenberg and Harold Rosenberg in America (IVD4, 11 and 12). (It is a measure of Britain's relative disengagement from this debate, and of the price that was paid for this disengagement, that Herbert Read's was the strongest native contribution.) What distinguished these various writers was their common engagement with a pressing and difficult question: what was to be revealed about the political and ethical character of modern culture through the diagnosis of its artistic forms?

The question was both urgent and complex. Its urgency was revealed by the prevalence of 'revolutionary' as a valuation for art, and by a sense of the imminence and unpredictability of change; its complexity in the lack of systematic connection

between the two triads mentioned earlier. The critics who addressed these conditions to best effect were those equipped to see through a Realism which was generally not realistic to a Communism which was generally not communistic. Prompted on occasion by the voice of the exiled Trotsky (IVD9), they deduced the common totalitarian character of Stalinism and Fascism from the stylistic and ethical character of the sponsored art. They diagnosed a failure of modernity, and they drew surprising conclusions: that Modernism and Realism were not each other's stylistic opposites but rather each other's necessary cultural and ethical conditions: that, whatever their respective stylistic forms might be, Modernism, in effect, *was* Realism, and vice versa.

IVA
The Modern as Ideal

1 Paul Klee (1879–1940) from On Modern Art

Swiss by birth, Klee spent most of his working life in Germany, latterly at the Bauhaus, until forced into exile by the victory of the Nazis in 1933. For much of this time he was involved in a creative dialogue with Kandinsky. 'On Modern Art' was first delivered as a lecture to the Jena Kunstverein in 1924. It was first published, as *Paul Klee: Über die moderne Kunst*, by the Verlag Benteli, Bern-Bumpliz, in 1945. The present extracts are taken from the translation by Paul Findlay in Herbert Read (intro.), *Paul Klee: On Modern Art*, London, 1948, pp. 13–15, 19–25, 29–33, 37–47 and 53–5.

May I use a simile, the simile of the tree? The artist has studied this world of variety and has, we may suppose, unobtrusively found his way in it. His sense of direction has brought order into the passing stream of image and experience.

This sense of direction in nature and life, this branching and spreading array, I shall compare with the root of the tree.

From the root the sap flows to the artist, flows through him, flows to his eye.

Thus he stands as the trunk of the tree.

Battered and stirred by the strength of the flow, he molds his vision into his work.

As, in full view of the world, the crown of the tree unfolds and spreads in time and in space, so with his work.

Nobody would affirm that the tree grows its crown in the image of its root. Between above and below can be no mirrored reflection. It is obvious that different functions expanding in different elements must produce vital divergences.

But it is just the artist who at times is denied those departures from nature which his art demands. He has even been charged with incompetence and deliberate distortion.

And yet, standing at his appointed place, the trunk of the tree, he does nothing other than gather and pass on what comes to him from the depths. He neither serves nor rules – he transmits.

His position is humble. And the beauty at the crown is not his own. He is merely a channel.

* * *

The creation of a work of art – the growth of the crown of the tree – must of necessity, as a result of entering into the specific dimensions of pictorial art, be accompanied by distortion of the natural form. For, therein is nature reborn.

What, then, are these specific dimensions?

First, there are the more or less limited, formal factors, such as line, tone value, and color.

Of these, line is the most limited, being solely a matter of simple Measure. Its properties are length (long or short), angles (obtuse or acute), length of radius and focal distance. All are quantities subject to measurement.

Measure is the characteristic of this element. Where the possibility of measurement is in doubt, line cannot have been handled with absolute purity.

Of a quite different nature is tone value, or, as it is also called, chiaroscuro – the many degrees of shading between black and white. This second element can be characterized by Weight. One stage may be more or less rich in white energy, another more or less weighted toward the black. The various stages can be weighed against one another. Further, the blacks can be related to a white norm (on a white background) and the whites to a black norm (on a blackboard). Or both together can be referred to a medium grey norm.

Thirdly, color, which clearly has quite different characteristics. For it can be neither weighed nor measured. Neither with scales nor with ruler can any difference be detected between two surfaces, one a pure yellow and the other a pure red, of similar area and similar brilliance. And yet, an essential difference remains, which we, in words, label yellow and red.

In the same way, salt and sugar can be compared, in their saltiness and sweetness.

Hence, color may be defined as Quality.

We now have three formal means at our disposal – Measure, Weight, and Quality, which in spite of fundamental differences, have a definite interrelationship.

The form of this relationship will be shown by the following short analysis.

Color is primarily Quality. Secondly, it is also Weight, for it has not only color value but also brilliance. Thirdly, it is Measure, for besides Quality and Weight, it has its limits, its area, and its extent, all of which may be measured.

Tone value is primarily Weight, but in its extent and its boundaries, it is also Measure.

Line, however, is solely Measure.

Thus, we have found three quantities which all intersect in the region of pure color, two only in the region of pure contrast, and only one extends to the region of pure line.

These three quantities impart character, each according to its individual contribution – three interlocked compartments. The largest compartment contains three quantities, the medium two, and the smallest only one [. . .]

This shows a remarkable intermixture of our quantities and it is only logical that the same high order should be shown in the clarity with which they are used. It is possible to produce quite enough combinations as it is.

Vagueness in one's work is therefore only permissible when there is a real inner need. A need which could explain the use of colored or very pale lines, or the application of further vagueness such as the shades of grey ranging from yellow to blue.
* * *

Leaving this subject of formal elements I now come to the first construction using the three categories of elements which have just been enumerated.

This is the climax of our conscious creative effort.
This is the essence of our craft.
This is critical.

From this point, given mastery of the medium, the structure can be assured foundations of such strength that it is able to reach out into dimensions far removed from conscious endeavor.

This phase of formation has the same critical importance in the negative sense. It is the point where one can miss the greatest and most important aspects of content and thus fail, although possibly possessing the most exquisite talent. For one may simply lose one's bearings on the formal plane. Speaking from my own experience, it depends on the mood of the artist at the time which of the many elements are brought out of their general order, out of their appointed array, to be raised together to a new order and form an image which is normally called the subject.

This choice of formal elements and the form of their mutual relationship is, within narrow limits, analogous to the idea of motif and theme in musical thought.

With the gradual growth of such an image before the eyes an association of ideas gradually insinuates itself which may tempt one to a material interpretation. For any image of complex structure can, with some effort of imagination, be compared with familiar pictures from nature.

These associative properties of the structure, once exposed and labelled, no longer correspond wholly to the direct will of the artist (at least not to his most intensive will)

and just these associative properties have been the source of passionate misunderstandings between artist and layman.

While the artist is still exerting all his efforts to group the formal elements purely and logically so that each in its place is right and none clashes with the other, a layman, watching from behind, pronounces the devastating words 'But that isn't a bit like uncle.'

The artist, if his nerve is disciplined, thinks to himself, 'To hell with uncle! I must get on with my building.... This new brick is a little too heavy and to my mind puts too much weight on the left; I must add a good-sized counterweight on the right to restore the equilibrium.'

And he adds this side and that until finally the scales show a balance.

And he is relieved if, in the end, the shaking which he has perforce had to give his original pure structure of good elements, has only gone so far as to provide that opposition which exists as contrast in a living picture.

But sooner or later, the association of ideas may of itself occur to him, without the intervention of a layman. Nothing need then prevent him from accepting it, provided that it introduces itself under its proper title.

Acceptance of this material association may suggest additions which, once the subject is formulated, clearly stand in essential relationship to it. If the artist is fortunate, these natural forms may fit into a slight gap in the formal composition, as though they had always belonged there.

The argument is therefore concerned less with the question of the existence of an object, than with its appearance at any given moment – with its nature.

I only hope that the layman who, in a picture, always looks for his favorite subject, will, as far as I am concerned, gradually die out and remain to me nothing but a ghost which cannot help its failings. [. . .]
* * *

Certain proportions of line, the combination of certain tones from the scale of tone values, certain harmonies of color, carry with them at the time quite distinctive and outstanding modes of expression.

The linear proportions can, for example, refer to angles: movements which are angular and zigzag – as opposed to smooth and horizontal – strike resonances of expression which are similarly contrasting.

In the same way a conception of contrast can be given by two forms of linear construction, the one consisting of a firmly jointed structure and the other of lines loosely scattered.

Contrasting modes of expression in the region of tone value are given by:

The wide use of all tones from black to white, implying full-bodied strength.

Or the limited use of the upper light half or the lower dark half of the scale.

Or medium shades around the grey which imply weakness through too much or too little light.

Or timid shadows from the middle. These, again, show great contrasts in meaning.

And what tremendous possibilities for the variation of meaning are offered by the combination of colors.

Color as tone value: e.g. red in red, i.e. the entire range from a deficiency to an excess of red, either widely extended, or limited in range. Then the same in yellow (something quite different). The same in blue – what contrasts!

Or colors diametrically opposed – i.e. changes from red to green, from yellow to purple, from blue to orange.

Tremendous fragments of meaning.

Or changes of color in the direction of chords, not touching the grey center, but meeting in a region of warmer or cooler grey.

What subtleties of shading compared with the former contrasts.

Or: color changes in the direction of arcs of the circle, from yellow through orange to red or from red through violet to blue, or far flung over the whole circumference.

What tremendous variations from the smallest shading to the glowing symphony of color. What perspectives in the dimension of meaning!

Or finally, journeys through the whole field of color, including the grey center, and even touching the scale from black to white.

Only on a new dimension can one go beyond these last possibilities. We could now consider what is the proper place for the assorted colors, for each assortment clearly possesses its possibilities of combination.

And each formation, each combination will have its own particular constructive expression, each figure its face – its features.

* * *

I would like now to examine the dimensions of the object in a new light and so try to show how it is that the artist frequently arrives at what appears to be such an arbitrary 'deformation' of natural forms.

First, he does not attach such intense importance to natural form as do so many realist critics, because, for him, these final forms are not the real stuff of the process of natural creation. For he places more value on the powers which do the forming than on the final forms themselves.

He is, perhaps unintentionally, a philosopher, and if he does not, with the optimists, hold this world to be the best of all possible worlds, nor to be so bad that it is unfit to serve as a model, yet he says:

'In its present shape it is not the only possible world.'

Thus he surveys with penetrating eye the finished forms which nature places before him.

The deeper he looks, the more readily he can extend his view from the present to the past, the more deeply he is impressed by the one essential image of creation itself, as Genesis, rather than by the image of nature, the finished product.

Then he permits himself the thought that the process of creation can today hardly be complete and he sees the act of world creation stretching from the past to the future. Genesis eternal!

He goes still further!

He says to himself, thinking of life around him: this world at one time looked different and, in the future, will look different again.

Then, flying off to the infinite, he thinks: it is very probable that, on other stars, creation has produced a completely different result.

Such mobility of thought on the process of natural creation is good training for creative work.

It has the power to move the artist fundamentally, and since he is himself mobile, he may be relied upon to maintain freedom of development of his own creative methods.

This being so, the artist must be forgiven if he regards the present state of outward appearances in his own particular world as accidentally fixed in time and space. And as altogether inadequate compared with his penetrating vision and intense depth of feeling.

* * *

These unsettled times have brought chaos and confusion (or so it seems, if we are not too near to judge).

But among artists, even among the youngest of them, one urge seems to be gradually gaining ground:

The urge to the culture of these creative means, to their pure cultivation, to their pure use.

The legend of the childishness of my drawing must have originated from those linear compositions of mine in which I tried to combine a concrete image, say that of a man, with the pure representation of the linear element.

Had I wished to present the man 'as he is,' then I should have had to use such a bewildering confusion of line that pure elementary representation would have been out of the question. The result would have been vagueness beyond recognition.

And anyway, I do not wish to represent the man as he is, but only as he might be.

And thus I could arrive at a happy association between my vision of life [*Weltanschauung*] and pure artistic craftsmanship.

And so it is over the whole field of use of the formal means: in all things, even in colors, must all trace of vagueness be avoided.

This then is what is called the untrue coloring in modern art.

As you can see from this example of 'childishness' I concern myself with work on the partial processes of art. I am also a draughtsman.

I have tried pure drawing, I have tried painting in pure tone values. In color, I have tried all partial methods to which I have been led by my sense of direction in the color circle. As a result, I have worked out methods of painting in colored tone values, in complementary colors, in multicolors and methods of total color painting.

Always combined with the more subconscious dimensions of the picture.

Then I tried all possible syntheses of two methods. Combining and again combining, but, of course, always preserving the culture of the pure element.

Sometimes I dream of a work of really great breadth, ranging through the whole region of element, object, meaning, and style.

This, I fear, will remain a dream, but it is a good thing even now to bear the possibility occasionally in mind.

Nothing can be rushed. It must grow, it should grow of itself, and if the time ever comes for that work – then so much the better!

We must go on seeking it!

We have found parts, but not the whole!
We still lack the ultimate power, for:
the people are not with us.

But we seek a people. We began over there in the Bauhaus. We began there with a community to which each one of us gave what he had.
More we cannot do.

2 Amédée Ozenfant (1886–1966) from *Foundations of Modern Art*

Ozenfant's close collaboration with Jeanneret/Le Corbusier (see IIIA7) had ended in 1925 with the final issue of *L'Esprit Nouveau*. Thereafter he took a less exclusive position, worked with Léger, visited the Bauhaus, and opened his own academy in Paris. His *Foundations of Modern Art* is a characteristic statement of European Modernism: focusing on the autonomy of art and the innateness of our feelings for it, yet universalizing its supposedly underlying principles to the point of claiming their identity with the principles of nature itself. Originally published in Paris, 1928, and widely translated and reprinted. First English translation by John Rodker, New York, 1931, from pp. 278, 281, 284–5 of which these extracts are taken. (For an earlier text by Ozenfant see IIIA1.)

To succeed in assuaging reality a work of art should:

1 Respect the profound and innate sense in us of nature's fundamental reactions, and not too much outrage them: for then we are led to compare the work with its subject, which brings us back to the literal reality (as a monster reminds us of the normal creature).
2 Yet remain, nevertheless, at such a distance from nature's aspects that the disturbance introduced into habitual aspects may deprive us momentarily of our rationalizing facilities. Thus some illogical woman's argument, falling suddenly into a closely reasoned discussion, unhorses the arguers and makes us ponder.

Being no longer controlled by the powerful impulses of 'common sense', and the 'normal,' the valves of our unconscious open, and permit the fusion of our slumbering, suppressed, or unwitted potentialities. Thus a world of new sensations and awareness comes into being. Faustian joys!

The problem is how to create a form of hallucination that will be a substitute for the simple perception of the work of art as an object (poem, music, painting, or architecture). [. . .]

The work should convey a feeling that it conforms profoundly to the dictates of nature (which does not mean to say that it must keep to habitual aspects of it). In order to make this rather vague formula clearer, an example will suffice: paint the statue of some Pharaoh violet or green, and the effect will be ridiculous, a fine organic thing ruined; yet every day we see these same faults, which add a certain piquancy to certain kinds of painting, but not for long.

So when we admire some natural object, it is merely because the harmony of form and colour affects us? No, it is because, above all, we have an instinct in us, and at times

an awareness, more or less conscious, of the ordering of the universe: and the object we admire answers to that order, and reveals to us the measure of its adaptation. [. . .]

The sea moves. In that infinite monotony nothing catches the eye. Suddenly a wave unfurls its perfect spirals. The sea is performing a precise act. It is as though the whole ocean were compact in that perfect wave. Sometimes nature seems to have attained the creation of a perfect type: that is, has objectified a conception clearly formulated. A law has been adhered to closely. Thus we are enabled to read one of nature's metrical verses. It fits in well with our geometry.

Bees construct their cells to an obvious geometry: solutions crystallize out in constant forms: waves are propagated according to curves that can be formulated and reduced to equations: capitals curl on themselves like Ionic shells. Joy for the senses and the mind. The geometer, the analyst, at the same moment light on concordances that seem miraculous to us. Is the world geometric? Is geometry the thread that man has seized which links all things? Or is it that the laws which guide the brain are geometric, and so it is able to perceive only what fits into its warp and woof? The fact remains that seekers discover either algebraic or geometric relations. The abundance of concordances has caused the wisest critics to affirm, that if a particular hypothesis be justifiable, the others certainly are not. I believe, rather, that in such multiple concordances the proof should be seen that everything depends on the laws of our intelligences, and that the diverse modalities of geometric or algebraic analysis, since they are but diverse forms of our thinking, must inevitably harmonize with each other. They but render, in various languages, the same phenomena.

Everything appears to develop according to mathematical 'forms,' which happen in fact to be elementary forms of the language of art: of all the arts. It is inspiring, but the contrary would be incomprehensible to us: yet what is most astonishing is that we are astonished by it. How could geometry and algebra, abstract transfers of the concrete universe, not reveal systematic concordances between us and the universe?

Mathematical constants adapt themselves equally well to Egyptian or Greek art. They apply also to those natural objects we call beautiful. Does that mean that artists were conscious of nature's norms, and used them in their art? Or does it mean only that every effort of creation, to be truly great, must submit to certain constant laws? We cannot say. Yet it is true that the Egyptians, Arabs, Persians, and certain men of the Renaissance like Piero della Francesca and Leonardo, were mad on mathematics, and applied certain arithmetical or geometrical principles to their art. On the other hand, we can assert, that although certain moderns ignore such principles, there are many who pay great attention to them. What is important is to be able, even remotely, to intuit or feel certain constants. It matters little whether they be arithmetical, geometrical, logarithmical, or appertain to some other system: the important thing is that they should be present. If they are, even though too uncertain to constitute a precise technic, yet they will be certain enough to fecundate a trend, a spirit, an ethic, an aesthetic.

That is why art, in the highest sense, cannot be free. For a work to be great a certain harmony between man and nature must come into being. Fine naturally beautiful things are the product of instinctive art. Nature, instinct, intellect, sometimes converge, blending into forms that inspire us. When the artist succeeds in creating some such miracle, it may be he is unveiling the abscissa and coordinates of the perceptible universe: or alternatively, those of our deepest depths: which comes to the *same* thing.

I suggest that it is possible that forms are the consequence of a sort of call from space! Matter, by which I mean the densest waves, would appear to infiltrate itself, as into a mould, into such space as offers least resistance to it: it then becomes perceptible to us.

How much more beautiful and moving is the universe when conceived as ethereal palpitation of those waves which make up all things, and yet are nothing if universal laws have not moulded them into structures perceptible to our senses and intellect, which themselves are adapted to the universal structure, and to us. Out of chaos we make a world, a consequence of art, which in return reveals our proper structure to us.

Structures are all we can perceive. Thus it is that the universe is only 'structure,' and that the Artist is the God of man. [...]

3 Hans Hofmann (1880–1966) 'On The Aims of Art'

The author, German by birth, was active in the early twentieth-century European avant-garde before emigrating to America. In New York in the 1930s he ran a school of painting which was influential on those who were to constitute the post-war American avant-garde, particularly the critic Clement Greenberg. The present essay anticipates many of the emphases of Greenberg's writings, particularly in its stress on the medium, the picture plane, and the unity of the work. Written in Bad Toelz, Germany, in late 1931, the essay was translated into English at a time when Hofmann was teaching occasional courses in California. It was originally published in *The Fortnightly*, Campbell, CA, vol. 1, no. 13, 26 February 1932, pp. 7–11, from which the present extracts are taken.

[...] The medium which is used in creating becomes the work of art if the principles and meaning, the essential nature of the medium are mastered and if the artist is intuitive in spirit. For artistic intuition emanates from the cosmos and embraces the whole world. The vaulting, creative mind recognizes no boundaries to its realm, the mind has ever brought new spheres under control. Artistic intuition is the basis for confidence of the spirit. Art is always spiritual, a result of introspection, finding expression through the natural entity of the medium. Every medium of expression has its own laws; founded on these laws it can be made to resonate and vibrate when stimulated by the impulses coming directly from the natural world, when the artist is equipped with finely balanced sense and mentality, conscious feeling and memory. The artist intensifies his concepts, condenses his experience into a spiritual reality complete in itself and thus creates a new reality in terms of the medium. Thus is the work of art a world in itself but reflecting the sensorial and emotional world for the artist. [...]

* * *

The artist must follow his inner leading independent of fads and fashions, therefore art education should take this individual inner direction more seriously than is done at present. Art teaching is not soap manufacture. The value in the artist is apt to be that of differences rather than that of likeness.

It would be nonsense to graft an education foreign to this inner direction onto an introspective personality – a character able to pursue deep study. Should the lark sing like the nightingale? There are inward-looking personalities, introverts, and outward-looking, extroverts. The character seeking purely the external values never possesses

the true inner greatness unless the external expression is but a final stage of deep inner development, of introspection. Just so, the purely external estimates of a work of art, for instance the measures of the format – the size of the painting – are of no importance whatsoever in judging its real value. An etching may be greater than acres of murals. A violin solo may be greater than a symphony, when judged as pure art. Scope of influence is not a measure of artistic quality. The only values which make a work of art great are emotional and sensory. Life-content. Expressed experience. Sensory raw material blended to a spiritual unity through legitimate use of the medium is art. In this sense the small picture format might be much more living, much more leavening, stirring, awakening than square yards of wall space.

This 'inner greatness' pictorially, is determined and limited by the degree to which depth in effect and illusion serve the artistic purpose. The width of a line may present the idea of infinity. The sensitive artist may develop the spatial meaning of any sized format indefinitely. An epigram may contain the world and the universe of life. And from the depth-sensation, movement develops. There are movements into space and movements forward, out of space, both in form and in color. The product of movement and counter-movement is tension. When tension – working strength – is expressed it endows the work of art with the living effect of co-ordinated, though opposing forces. Tension and movement, or movement and counter-movement, lawfully ordered within unity, paralleling the artist's life-experience and his artistic and human discipline, endow the work with the power to stir the observer rhythmically to a response to living, spiritual totality. The picture swings, oscillates, vibrates with form-rhythms integrated to the purpose of spatial (and volumnar) unity and it resonates with color rhythms balanced, focussed and so ordered as to produce the richest intensity of light contrast. It is not the contrast of two or three, but the contrasted balance of many contributing factors, which produces the paradox of life within unity. Largeness of format in accepted absolute measures has little if any relation to the power of the greatest possible variety within the most perfect, unified balance. [...]

In painting we distinguish two kinds of creations; (1) the *symphonic* animation of the picture plane, as in the so-called art of easel painting (or print making, etching, engraving, and other forms of drawing which may connote color) and (2) the *decorative* animation of the picture plane, as in so-called mural painting. The purposes here are alike in one respect and different in another. Truly considered, however, the names 'easel picture' and 'mural picture' express purely external differences. In philosophic reality every work which possesses intrinsic greatness is at once decorative and symphonically focussed and integrated. The symphonic creation intends the highest enrichment of the given format through sensory and emotional differentiation on an enormous scale (yet indifferent to actual size measurement) and therefore monumental. (But again monumental qualities are not to be confused with mere standard, partial size measurements. They are an affair of relativity.) The truly monumental can only come about by means of the most exact and refined relation between parts. The truly monumental is tuned to the finest degree, and so becomes great – monumental. The picture swings and resounds to the rhythm of color, increased through integration to the highest light-intensity and richness. By, with and from color, form is intensified in subordination to spatial and spiritual unity, in large presentation-areas of light and form (form complexes and light complexes – the plasticity as known through the hands, and the pattern as known through the eyes), by means of rhythmic animation.

In symphonic painting color is the real building medium. 'When the color has the greatest fullness, the form contains the greatest richness.' This declaration of Cézanne's is the guide for this branch of art. (Symphonic painting).

Swinging and pulsating form and its answer resonating space, originates in color intervals differentiated, (each color-plane standing in the greatest contrast possible to its neighbor within the balance of the whole) but this differentiation is dominated by that simplification coming only through great order. (Great design is produced by the ability to simplify essentials and the organization, in a simple order, of ever-present life essentials.) Here one finds the reason that the art of painting is so overwhelming for despite the highest condensation, it is always decorative in the highest degree. [...] In decorative painting the emotional and intellectually considered effort focusses on the greatest simplification, which in the case of mural painting, must be in conformation with the architectural surroundings, and so becomes a harmonious part of the environment.

Painting as a whole, however, possesses fundamental laws. The highest law of painting is: The entity of the picture plane must be preserved. This entity is its essential two-dimensionality. This high principle of painting is: The picture plane must be preserved. Then comes the second principle: The essence of the picture is its two-dimensionality. This law connotes at once: the picture plane must achieve a three-dimensional effect (as distinguished from illusion) by means of the creative process. These two lawful principles apply both to color and to form.

A third principle must be recognized regarding symphonic painting. In the process of coloring (painting) the surface of the canvas (the picture plane) should receive the greatest possible richness in light-emanation-effect, and at the same time, it should retain the transparency of the jewel. (Which stands as the prototype of exactly ordered form.) The light and form should control illusory oscillation into space and out of space. (Renoir, Rembrandt) A painting not subscribing to this principle, no matter what its kind, has only [an] uncertain relation – perhaps none at all – to art in its highest sense. Such a painting must, in the main be only a collection of fragments and details without relation and underlying unity. Even the completest mastery of representing objective forms does not change the matter. Form must be balanced by means of space. We differentiate the animated form and the space pervaded by energy. Form exists because of space and space exists because of form. [...]

We must discriminate between the word 'decorative' in a pictorial sense and decorative in a naturalistic sense. The pictorially decorative effect is achieved through musical contrasts and rhythmic relations conditioned by space. This leads to abstraction, through which objective values are by no means necessarily eliminated, but on the contrary are made more effective by rhythmic relation. Color and form then function symbolically.

The word 'decorative' used in a naturalistic sense implies only the representation of objects in a further developed objective arrangement directed by fanciful and arbitrary taste and subordinated to some literary meaning foreign to the art of painting for itself. For the valuation of a painting however, all literary or journalistic considerations should be abandoned entirely. Burdening the canvas with propaganda or history does not make the painting a better work of art. Such burdening, in the majority of cases, decreases the quality of the work and with it the living, vivid relations and swinging, vibrating space proper to a work of visual art. [...] The spiritual and mental content of the work of art is again, only found in the quality of the painting and not in the allegory or in the symbolic meaning presented through the objects in the painting. The aim of

art, so far as one can speak in art of an aim at all, has always been the same; the melting together of material gained in experience in life with the natural qualities of the medium. The medium swings and resonates as one strikes its strings and as one masters its registers and stops. For every medium possesses its own rhythmic laws and thus its strict limitations through which it is distinguished as the specific way of expression that it is. The limitation of the medium is an essential condition for the quality in a work of art, for the boundlessness of the spirit can only find material expression within the lawful limits of a medium. [...]

4 Abstraction-Création: Editorial Statements to *Cahiers* nos. 1, 1932 and 2, 1933

The Association Abstraction-Création was founded in Paris in February 1931 to organize 'manifestations' of non-figurative art. The organizing committee included Hans Arp, Albert Gleizes, Jean Hélion, Auguste Herbin, František Kupka and Georges Vantongerloo. It had an international membership, not least amongst the community of exiles who were beginning to congregate in Paris as the totalitarian regimes in Stalinist Russia and Nazi Germany increasingly proscribed abstract work. One of the Association's hallmarks was the equation of 'abstraction' with 'freedom'. Five *Cahiers* or yearbooks were published between 1932 and 1936. The present editorial statements are translated from the first and second. For a response to the questionnaire printed in no. 2, see IVA5.

1

abstraction
creation
non-figurative art

we have chosen these words as names for our group and for our activities, because we have not found any others which are less obscure or less controversial. the collection of reproductions in this book can serve as a definition of these terms. we are not particularly committed to them in other respects.

non-figuration, that's to say a purely plastic culture which excludes every element of explication, anecdote, literature, naturalism, etc. ...

abstraction, because certain artists have come to the concept of non-figuration by the progressive abstraction of forms from nature.

creation, because other artists have attained non-figuration direct, purely via geometry, or by the exclusive use of elements commonly called abstract such as circles, planes, bars, lines, etc. ...

we do not judge, we do not compare, we do not distinguish works constructed by progressive abstraction or by direct creation. we are trying to compose a document of non-figurative art.

selection, the responsibility of the committee of the association of abstraction-creation, is based on the criterion of non-figuration: however, only those artists are invited to participate in the group who definitively consider themselves to be non-figurative artists. artists who at the same time produce works containing more or less obvious forms of living things or objects are not invited, nor are those who produce works without commitments of this kind, no matter what the value of the latter.

we think that the assembly in this book of very different works, which are none the less harmonized by the common idea of non-figuration, will enable the public to grasp the possibilities and the scope of purely plastic art.

each artist has been invited to express in an article the reasons which he feels essentially motivate his point of view. these articles, whether written by himself or by a specially chosen writer, are the responsibility of the artist concerned: they involve him alone.

the committee has asked different writers and different personalities interested in non-figurative art to reply to some questions concerning the place of this art in contemporary society and culture. the following artists are considered qualified according to the criteria stated to participate in the association, and have also been invited: kandinski, neugeboren, fernandez, carlsund.

considered unable to join: lissitski, mallevich, tatline.

some declined the invitation; the reproductions of the works of others were not available for inclusion at the time of publication.

the association abstraction-creation is totally independent of all other groups, commercial firms, and publicity interests.

2

The journal *Abstraction-Création* no. 2 appears at a moment when free thought is being fiercely contested, in many ways, on all levels, in some countries more successfully than in others, but everywhere.

Like the previous issue, this journal presents works and declarations of independent artists, who endeavour, each in their own way, to respond to the cultural demands of the era. They have come together around the general idea of Non-Figuration. They do not agree on all points, but think that all tendencies should be followed through in the direction in which they point.

No one can determine in advance the course of subsequent art. Any attempt to limit artistic efforts according to considerations of race, ideology or nationality is intolerable.

We commit this second journal to total opposition to all oppression, of whatever kind.

The Committee

The Committee of the Association 'Abstraction-Création' asked its adherents the following questions:

1 Why do you not paint nudes?
2 What do you think of the influence of trees on your works?
3 Is a locomotive a work of art? Why? Why not?
4 Does the fact that a work has the appearance of a machine or of a technical creation, detract or add to its artistic effectiveness?
5 Does the fact that a work has an animal appearance detract or add to its artistic effectiveness?

The replies, like the other articles contained in the journal, following the pattern adopted in the first journal, are the sole responsibility of the signatory and involve him alone.

The Association 'Abstraction-Création' is totally independent of all groups, of commercial firms, and publicity interests.

5 Wladyslaw Strzeminski (1893–1952) Statements

Strzeminski was a participant in the Polish Constructivist avant-garde of the 1920s. Having been a founder member of the group *Block*, he left in 1925 over the issue of utilitarianism, aligning himself instead with the investigation of plastic form in painting (see IIIC17). During the later 1920s he elaborated the concept of 'Unism', implementing it in his abstract art between *c*.1925 and 1935. The outcome was an art of rigorous medium-specificity which, in common with much abstract work of the period, was envisaged both as strictly autonomous *and* as possessed of a utopian social dimension. It was assumed, that is, that art could stand as a model. These two statements were published in the yearbooks of the group 'Abstraction-Création', nos. 1 and 2, Paris, 1932 and 1933, from which the present translations are made. (The second takes the form of a reply to a questionnaire circulated by the editors of *Abstraction-Création*, reproduced in IVA4.)

1

there, where there is a division, the painting is cut into parts, what should their relation be?

line. if there is only one, we then see its relation to the border of the painting, if there are many, we see the relations between the lines and between each line and the border of the painting.

line has always created divisions of the painting, where we have divisions, what should their reciprocal relation be? we link the divided parts in a rhythm of mutual connections, one dimension with another, there exists then a rhythm like the essential aesthetic emotions of the painting. this rhythm is formed from the opposition of directions and dimensions.

what is the law of unity of rhythm? the unity of rhythm is achieved by subordinating the dimensional relations to the same mathematical formula. this mathematical formula determines the relation between the height and breadth of the painting. all the fractions and forms are maintained in this mathematical relationship. in this way we achieve an absolute rhythmic unity of all the forms, the largest of which is the painting itself.

however, where we have a line, we will have a division and instead of a single painting, we will have separated parts. line divides – the aim must not be the division of the painting, but its unity, presented in a direct way: optically.

in consequence it is necessary to renounce line. it is necessary to renounce rhythm, because it only exists in the relations between independent parts. it is necessary to renounce opposites and contrasts. because only separated forms can create oppositions and contrasts. it is necessary to renounce division, because it gives concentration and the greatest intensity to forms in proximity to outline – and cuts the painting into sections, containing concentrated forms and weak forms.

after having studied in my paintings the problem of structural rhythm, i am now considering the idea of the unity of a painting – these paintings being photographically unreproducible, i am presenting reproductions of older paintings.

2

1 When painting the nude one is also obliged to paint the background. In any case, when we paint an object, we find in the painting the object and the background, therefore two things in the one painting. Sometimes even several objects and the background, therefore several visual experiences in the one painting.

2 Trees have demonstrated to me what a work of art is not. The form of a tree results from: a) the symmetry (in the form and distribution of leaves). This symmetry is the result of the division of the cells of a plant. The painting does not grow, its cells are not subject to division and that is why symmetry has no place there, b) a fluid curve of the branches and trunk, resulting from the pressure of the wind, from the direction of the sun (of light), from the vaporization of sap in a plant. We do not find these forces in a painting, therefore its form is different.

3 The aim of a locomotive is to produce energy, which is necessary to start the train moving. When we project its form, we take into consideration this aim, that is to say the best means of producing energy. Independently of this, it may be that the locomotive, in its entirety, or in part (by chance), are beautiful.

The aim of a work of art is unity of composition. The greater this unity, the more we approach the aim. Independently of this, a work of art and its fragments can be beautiful. But this is only a question of chance, this is not the aim of art.

The accidental beauty of a locomotive, of an animal, or of a painting, do not determine the realisation of artistic aims, since the only admissible criterion is the extent to which the aim of making something has been attained.

A machine only exists to produce certain objects or the energy necessary for their construction.

The animal world only exists to eat, to live in a world of sensations and to be eaten by man.

A work of art aims at a higher degree of unity of composition. The more focused its homogeneity, the closer we draw to the aim.

6 Carl Gustav Jung (1875–1961) On the concept of the 'archetype'

Psychoanalytic theory has had an incalculable influence on the modern movement in art, particularly where notions of the 'unconscious' are concerned. Freud's ideas were undoubtedly the most influential, initially upon the Surrealists but also, much later, on feminist work in the 1970s and after, when they tended to be mediated through Lacan's re-interpretations (see, *inter alia*, IA3, IVC2, 3 and 6, VIID10 and VIIIB6). However, Freud's great rival, C. G. Jung, also had an impact, particularly on American artists in the 1940s. The defining feature of the latter's psychoanalytic theory was his insistence on the *collective*, rather than the solely individual nature of the unconscious. Jung conceived of the unconscious as shaped by the accumulated experience of humanity, which settled down as sediment in the form of 'archetypes'. These are not, so to speak, primitive 'figures' but innate *dispositions* to respond to certain basic kinds of experience, such as desire and loss. Thus for Jung the archetypes affected the creation of symbols, myths, legends etc. For artists persuaded by these ideas, the evocation of archetypes could potentially have profound effects upon viewers of their work (see VA2–9 for traces of such thinking). Jung was born in Switzerland and studied at the universities of Basel and Zurich. He became established as a psychiatrist through his work at the Burghölzli Asylum in Zurich. For five years Jung and Freud were close, but in 1912 they broke apart after disagreeing about the nature of the unconscious. Jung was interested in religion and alchemy, and such cultural issues occupy a prominent place in his collected works. The present extracts are taken from papers published in 1934 and 1938. The first, 'Archetypes of the Collective Unconscious', was published in the *Eranos–Jahrbuch*, 1934. The second, 'On the Concept of the Archetype', formed the first part of a longer study of the 'Psychological Aspects of the Mother Archetype', which appeared in the same publication in 1938. Our extracts are taken from the translation by R. F. C. Hull in *The Collected Works of C. G. Jung*, vol. 9, part I, edited by Herbert Read, Michael Fordham and Gerhard Adler, London, 1968, pp. 3–5 and 78–80.

Archetypes of the Collective Unconscious

The hypothesis of a collective unconscious belongs to the class of ideas that people at first find strange but soon come to possess and use as familiar conceptions. This has been the case with the concept of the unconscious in general. After the philosophical idea of the unconscious, in the form presented chiefly by Carus and von Hartmann, had gone down under the overwhelming wave of materialism and empiricism, leaving hardly a ripple behind it, it gradually reappeared in the scientific domain of medical psychology.

At first the concept of the unconscious was limited to denoting the state of repressed or forgotten contents. Even with Freud, who makes the unconscious – at least metaphorically – take the stage as the acting subject, it is really nothing but the

gathering place of forgotten and repressed contents, and has a functional significance thanks only to these. For Freud, accordingly, the unconscious is of an exclusively personal nature, although he was aware of its archaic and mythological thought-forms.

A more or less superficial layer of the unconscious is undoubtedly personal. I call it the *personal unconscious*. But this personal unconscious rests upon a deeper layer, which does not derive from personal experience and is not a personal acquisition but is inborn. This deeper layer I call the *collective unconscious*. I have chosen the term 'collective' because this part of the unconscious is not individual but universal; in contrast to the personal psyche, it has contents and modes of behaviour that are more or less the same everywhere and in all individuals. It is, in other words, identical in all men and thus constitutes a common psychic substrate of a suprapersonal nature which is present in every one of us.

Psychic existence can be recognized only by the presence of contents that are *capable of consciousness*. We can therefore speak of an unconscious only in so far as we are able to demonstrate its contents. The contents of the personal unconscious are chiefly the *feeling-toned complexes*, as they are called; they constitute the personal and private side of psychic life. The contents of the collective unconscious, on the other hand, are known as *archetypes*.

The term 'archetype' occurs as early as Philo Judaeus, with reference to the *Imago Dei* (God-image) in man. It can also be found in Irenaeus, who says: 'The creator of the world did not fashion these things directly from himself but copied them from archetypes outside himself.' In the *Corpus Hermeticum*, God is called τὸ ἀρχέτυπον φῶς (archetypal light). The term occurs several times in Dionysius the Areopagite, as for instance in *De caelesti hierarchia*, II, 4: 'immaterial Archetypes,' and in *De divinis nominibus*, I, 6: 'Archetypal stone.' The term 'archetype' is not found in St. Augustine, but the idea of it is. Thus in *De diversis quaestionibus LXXXIII* he speaks of '*ideae principales*, "which are themselves not formed . . . but are contained in the divine understanding."' 'Archetype' is an explanatory paraphrase of the Platonic εἶδος. For our purposes this term is apposite and helpful, because it tells us that so far as the collective unconscious contents are concerned we are dealing with archaic or – I would say – primordial types, that is, with universal images that have existed since the remotest times. The term 'représentations collectives,' used by Lévy-Bruhl to denote the symbolic figures in the primitive view of the world, could easily be applied to unconscious contents as well, since it means practically the same thing. Primitive tribal lore is concerned with archetypes that have been modified in a special way. They are no longer contents of the unconscious, but have already been changed into conscious formulae taught according to tradition, generally in the form of esoteric teaching. This last is a typical means of expression for the transmission of collective contents originally derived from the unconscious.

Another well-known expression of the archetypes is myth and fairytale. But here too we are dealing with forms that have received a specific stamp and have been handed down through long periods of time. The term 'archetype' thus applies only indirectly to the 'représentations collectives,' since it designates only those psychic contents which have not yet been submitted to conscious elaboration and are therefore an immediate datum of psychic experience. In this sense there is a considerable difference between the archetype and the historical formula that has evolved. Especially on the higher levels of esoteric teaching the archetypes appear in a form that reveals quite unmistakably the critical and evaluating influence of conscious elaboration. Their

immediate manifestation, as we encounter it in dreams and visions, is much more individual, less understandable, and more naïve than in myths, for example. The archetype is essentially an unconscious content that is altered by becoming conscious and by being perceived, and it takes its colour from the individual consciousness in which it happens to appear.

* * *

On the Concept of the Archetype

[...] Nowadays we have to start with the hypothesis that, so far as predisposition is concerned, there is no essential difference between man and all other creatures. Like every animal, he possesses a preformed psyche which breeds true to his species and which, on closer examination, reveals distinct features traceable to family antecedents. We have not the slightest reason to suppose that there are certain human activities or functions that could be exempted from this rule. We are unable to form any idea of what those dispositions or aptitudes are which make instinctive actions in animals possible. And it is just as impossible for us to know the nature of the preconscious psychic disposition that enables a child to react in a human manner. We can only suppose that his behaviour results from patterns of functioning, which I have described as *images*. The term 'image' is intended to express not only the form of the activity taking place, but the typical situation in which the activity is released. These images are 'primordial' images in so far as they are peculiar to whole species, and if they ever 'originated' their origin must have coincided at least with the beginning of the species. They are the 'human quality' of the human being, the specifically human form his activities take. This specific form is hereditary and is already present in the germ-plasm. The idea that it is not inherited but comes into being in every child anew would be just as preposterous as the primitive belief that the sun which rises in the morning is a different sun from that which set the evening before.

Since everything psychic is preformed, this must also be true of the individual functions, especially those which derive directly from the unconscious predisposition. The most important of these is creative fantasy. In the products of fantasy the primordial images are made visible, and it is here that the concept of the archetype finds its specific application. I do not claim to have been the first to point out this fact. The honour belongs to Plato. The first investigator in the field of ethnology to draw attention to the widespread occurrence of certain 'elementary ideas' was Adolf Bastian. Two later investigators, Hubert and Mauss, followers of Durkheim, speak of 'categories' of the imagination. And it was no less an authority than Hermann Usener who first recognized unconscious preformation under the guise of 'unconscious thinking.' If I have any share in these discoveries, it consists in my having shown that archetypes are not disseminated only by tradition, language, and migration, but that they can rearise spontaneously, at any time, at any place, and without any outside influence.

The far-reaching implications of this statement must not be overlooked. For it means that there are present in every psyche forms which are unconscious but nonetheless active – living dispositions, ideas in the Platonic sense, that preform and continually influence our thoughts and feelings and actions.

Again and again I encounter the mistaken notion that an archetype is determined in regard to its content, in other words that it is a kind of unconscious idea (if such an

expression be admissible). It is necessary to point out once more that archetypes are not determined as regards their content, but only as regards their form and then only to a very limited degree. A primordial image is determined as to its content only when it has become conscious and is therefore filled out with the material of conscious experience. Its form, however, as I have explained elsewhere, might perhaps be compared to the axial system of a crystal, which, as it were, preforms the crystalline structure in the mother liquid, although it has no material existence of its own. This first appears according to the specific way in which the ions and molecules aggregate. The archetype in itself is empty and purely formal, nothing but a *facultas praeformandi*, a possibility of representation which is given *a priori*. The representations themselves are not inherited, only the forms, and in that respect they correspond in every way to the instincts, which are also determined in form only. The existence of the instincts can no more be proved than the existence of the archetypes, so long as they do not manifest themselves concretely. With regard to the definiteness of the form, our comparison with the crystal is illuminating inasmuch as the axial system determines only the sterometric structure but not the concrete form of the individual crystal. This may be either large or small, and it may vary endlessly by reason of the different size of its planes or by the growing together of two crystals. The only thing that remains constant is the axial system, or rather, the invariable geometric proportions underlying it. The same is true of the archetype. In principle, it can be named and has an invariable nucleus of meaning – but always only in principle, never as regards its concrete manifestation.

7 Alfred H. Barr Jr (1902–1981) from *Cubism and Abstract Art*

The author was the first Director of the Museum of Modern Art in New York. Barr's innovations in many ways set the terms in which modern art has continued to be viewed, both as regards the physical display of works of art and the scholarly apparatus – notably the exhibition catalogue – which surrounds them. To accompany the exhibition 'Cubism and Abstract Art' of 1936 Barr produced for the catalogue a complex diagram to illustrate the dominance of two trends in modern art: one 'fantastic' in purport and largely curvilinear or biomorphic in execution; the other rationalist and principally rectilinear. Though Barr's perspective was thus fundamentally formalist, he was not altogether heedless of social and political circumstances. For Barr, abstract and near-abstract avant-garde art expressed a freedom denied to art, and *a fortiori* to society, by regimes which enforced particular artistic forms (regimes which he had experienced at first hand on visits to Stalinist Russia and Nazi Germany). Originally published by the Museum of Modern Art, New York, 1936. The present extracts are taken from pp. 11, 13, 19.

The early twentieth century

Sometimes in the history of art it is possible to describe a period or a generation of artists as having been obsessed by a particular problem. The artists of the early fifteenth century for instance were moved by a passion for imitating nature. In the North the Flemings mastered appearances by the meticulous observation of external detail. In Italy the Florentines employed a profounder science to discover the laws of perspective, of foreshortening, anatomy, movement and relief.

In the early twentieth century the dominant interest was almost exactly opposite. The pictorial conquest of the external visual world had been completed and refined many times and in different ways during the previous half millennium. The more adventurous and original artists had grown bored with painting facts. By a common and powerful impulse they were driven to abandon the imitation of natural appearance.

'Abstract'

'Abstract' is the term most frequently used to describe the more extreme effects of this impulse away from 'nature.' It is customary to apologize for the word 'abstract,' but words to describe art movements or works of art are often inexact: we no longer apologize for applying the ethnological word 'Gothic' to French thirteenth-century art and the Portuguese word for an irregular pearl, 'Baroque,' to European art of the seventeenth century. Substitutes for 'abstract' such as 'non-objective' and 'non-figurative' have been advocated as superior. But the image of a square is as much an 'object' or a 'figure' as the image of a face or a landscape; in fact 'figure' is the very prefix used by geometers in naming A or B the abstractions with which they deal.

This is not to deny that the adjective 'abstract' is confusing and even paradoxical. For an 'abstract' painting is really a most positively concrete painting since it confines the attention to its immediate, sensuous, physical surface far more than does the canvas of a sunset or a portrait. The adjective is confusing, too, because it has the implications of both a verb and a noun. The verb *to abstract* means *to draw out of* or *away from*. But the noun *abstraction* is something already drawn out of or away from – so much so that like a geometrical figure or an amorphous silhouette it may have no apparent relation to concrete reality. 'Abstract' is therefore an adjective which may be applied to works of art with a certain latitude. [. . .]

The ambiguity of the word abstract as applied to works of art is really useful for it reveals the ambiguity and confusion which is inseparable from the subject.[. . .]
* * *

Dialectic of abstract art

Abstract art today needs no defense. It has become one of the many ways to paint or carve or model. But it is not yet a kind of art which people like without some study and some sacrifice of prejudice. Prejudice can sometimes be met with argument, and for this purpose the dialectic of abstract painting and sculpture is superficially simple enough. It is based upon the assumption that a work of art, a painting for example, is worth looking at primarily because it presents a composition or organization of color, line, light and shade. Resemblance to natural objects, while it does not necessarily destroy these esthetic values, may easily adulterate their purity. Therefore, since resemblance to nature is at best superfluous and at worst distracting, it might as well be eliminated. [. . .]

Such an attitude of course involves a great impoverishment of painting, an elimination of a wide range of values, such as the connotations of subject matter, sentimental, documentary, political, sexual, religious; the pleasures of easy recognition; and the

enjoyment of technical dexterity in the imitation of material forms and surfaces. But in his art the abstract artist prefers impoverishment to adulteration. [...]

* * *

Two main traditions of Abstract Art

At the risk of grave oversimplification the impulse towards abstract art during the past fifty years may be divided historically into two main currents, both of which emerged from Impressionism. The first and more important current finds its sources in the art and theories of Cézanne and Seurat, passes through the widening stream of Cubism and finds its delta in the various geometrical and Constructivist movements which developed in Russia and Holland during the War and have since spread throughout the World. This current may be described as intellectual, structural, architectonic, geometrical, rectilinear and classical in its austerity and dependence upon logic and calculation. The second – and, until recently, secondary – current has its principal source in the art and theories of Gauguin and his circle, flows through the *Fauvisme* of Matisse to the Abstract Expressionism of the pre-War paintings of Kandinsky. After running under ground for a few years it reappears vigorously among the masters of abstract art associated with Surrealism. This tradition, by contrast with the first, is intuitional and emotional rather than intellectual; organic or biomorphic rather than geometrical in its forms; curvilinear rather than rectilinear, decorative rather than structural, and romantic rather than classical in its exaltation of the mystical, the spontaneous and the irrational. Apollo, Pythagoras and Descartes watch over the Cézanne-Cubist-geometrical tradition; Dionysus (an Asiatic god), Plotinus and Rousseau over the Gauguin-Expressionist-non-geometrical line.

Often, of course, these two currents intermingle and they may both appear in one man. At their purest the two tendencies may be illustrated by paintings of twenty years ago: a Suprematist composition by Malevich and an *Improvisation* by Kandinsky. The geometrical strain is represented today by the painter Mondrian and the Constructivists Pevsner and Gabo; the non-geometrical by the painter Miro and the sculptor Arp. The shape of the square confronts the silhouette of the amoeba.

8 Henri Matisse (1869–1954) Statements to Tériade

For most of the 1920s and 1930s Matisse had worked in the south of France. His works of this period have a relationship to hedonism and luxury which has often provoked concern even among supporters such as Clement Greenberg; though it should be said that these doubts have tended to be resolved in Matisse's favour. In the mid-1930s Matisse seems to have experienced similar doubts and to have conceived the need to return to the basic principles of his art, to reinforce his 'purity of means'. E. Tériade was a critic and friend who had published previous statements by Matisse in 1929–30 and 1933. Entitled 'Constance de Fauvisme', the present statements were published, somewhat paradoxically, in the Surrealist journal *Minotaure*, II, no. 9, 15 October 1936, p. 3, under Tériade's editorship. (The parenthetical passages are from an alternative version of the statements published by Raymond Escholier in 1937.) The present translation is taken from J. D. Flam, *Matisse on Art*, London and New York, 1973, p. 74. (For an earlier text by Matisse see IB6.)

When the means of expression have become so refined, so attenuated that their power of expression wears thin, it is necessary to return to the essential principles which made human language. They are, after all, the principles which 'go back to the source', which relive, which give us life. Pictures which have become refinements, subtle gradations, dissolutions without energy, call for beautiful blues, reds, yellows – matter to stir the sensual depths in men. This is the starting point of Fauvism: the courage to return to the purity of the means.

Our senses have an age of development which does not come from the immediate surroundings, but from a moment in civilization. We are born with the sensibility of a given period of civilization. And that counts far more than all we can learn about a period. The arts have a development which comes not only from the individual, but also from an accumulated strength, the civilization which precedes us. One can't do just anything. A talented artist cannot do just as he likes. If he used only his talents, he would not exist. We are not the masters of what we produce. It is imposed on us.

In my latest paintings, I have united the acquisitions of the last twenty years to my essential core, to my very essence.

The reaction of each stage is as important as the subject. For this reaction comes from me and not from the subject. It is from the basis of my interpretation that I continually react until my work comes into harmony with me. Like someone writing a sentence, rewrites it, makes new discoveries... At each stage, I reach a balance, a conclusion. At the next sitting, if I find a weakness in the whole, I find my way back into the picture by means of the weakness – I re-enter through the breach – and reconceive the whole. Thus everything becomes fluid again and as each element is only one of the component forces (as in an orchestration), the whole can be changed in appearance but the feeling still remains the same. A black could very well replace a blue, since basically the expression derives from the relationships. [A kilogram of green is greener than half a kilo. Gauguin attributes this saying to Cézanne in a visitor's book at the house of Marie Gloanec at Pont-Aven.] One is not bound to a blue, to a green or to a red. You can change the relationships by modifying the quantity of the components without changing their nature. That is, the painting will still be composed of blue, yellow and green, in altered quantities. Or you can retain the relationships which form the expression of a picture, replacing a blue with a black, as in an orchestra a trumpet may be replaced by an oboe. [It all depends on the feeling you're after.]

... At the final stage the painter finds himself freed and his emotion exists complete in his work. He himself, in any case, is relieved of it.

9 Naum Gabo (1890–1977) 'The Constructive Idea in Art'

Gabo had emigrated to Western Europe after the end of the civil war in the Soviet Union in 1921. One result of the successful career he then pursued was that the term 'Constructivism' lost the specific connotations it had had among artists in the early Soviet Union. There it had been identified with a move out of art into production (see IIID). In the West the term became identified with a school of abstract sculpture and, to a lesser extent, painting. By the 1930s it could be claimed with some justification that there existed an 'international constructive tendency' with its own principles, catalogue of works, and relevant publications. Gabo's

essay was originally published as the lead article in the major survey of this tendency which he helped edit in 1937: L. Martin, B. Nicholson and N. Gabo (eds.), *Circle – International Survey of Constructive Art*, London, 1937, pp. 1–10. (For an earlier text by Gabo see IIIC10.)

Our century appears in history under the sign of revolutions and disintegration. The revolutions have spared nothing in the edifice of culture which had been built up by the past ages. They had already begun at the end of the last century and proceeded in ours with unusual speed until there was no stable point left in either the material or the ideal structure of our life. The war was only a natural consequence of a disintegration which started long ago in the depths of the previous civilization. It is innocent to hope that this process of disintegration will stop at the time and in the place where we want it to. Historical processes of this kind generally go their own way. They are more like floods, which do not depend on the strokes of the oarsmen floating on the waters. But, however long and however deep this process may go in its material destruction, it cannot deprive us any more of our optimism about the final outcome, since we see that in the realm of ideas we are now entering on the period of reconstruction.

* * *

 The immediate source from which the Constructive idea derives is Cubism, although it had almost the character of a repulsion rather than an attraction. The Cubistic school was the summit of a revolutionary process in Art which was already started by the Impressionists at the end of the last century. One may estimate the value of particular Cubistic works as one likes, but it is incontestable that the influence of the Cubistic ideology on the spirits of the artists at the beginning of this century has no parallel in the history of Art for violence and intrepidity. The revolution which this school produced in the minds of artists is only comparable to that which happened at approximately the same time in the world of physics. [. . .]

 [. . .] The basis of the Constructive idea in Art lies in an entirely new approach to the nature of Art and its functions in life. In it lies a complete reconstruction of the means in the different domains of Art, in the relations between them, in their methods and in their aims. It embraces those two fundamental elements on which Art is built up, namely, the Content and the Form. These two elements are from the Constructive point of view one and the same thing. It does not separate Content from Form – on the contrary, it does not see as possible their separated and independent existence. The thought that Form could have one designation and Content another cannot be incorporated in the concept of the Constructive idea. In a work of art they have to live and act as a unit, proceed in the same direction and produce the same effect. I say 'have to' because never before in Art have they acted in such a way in spite of the obvious necessity of this condition. It has always been so in Art that either one or the other predominated, conditioning and predetermining the other.

 This was because in all our previous Art concepts of the world a work of art could not have been conceived without the representation of the external aspect of the world. [. . .]

 [. . .] This was the main obstacle to the rejuvenation of Art, and it was at this point that the Constructive idea laid the cornerstone of its foundation. It has revealed a universal law that the elements of a visual art such as lines, colours, shapes, possess their own forces of expression independent of any association with the external aspects of the world; that their life and their action are self-conditioned psychological phenomena rooted in human nature; that those elements are not chosen by convention for

any utilitarian or other reason as words and figures are, they are not merely abstract signs, but they are immediately and organically bound up with human emotions. The relation of this fundamental law has opened up a vast new field in art giving the possibility of expression to those human impulses and emotions which have been neglected. Heretofore these elements have been abused by being used to express all sorts of associative images which might have been expressed otherwise, for instance, in literature and poetry.

But this point was only one link in the ideological chain of the constructive concept, being bound up with the new conception of Art as a whole and of its functions in life. The Constructive idea sees and values Art only as a creative act. By a creative act it means every material or spiritual work which is destined to stimulate or perfect the substance of material or spiritual life. Thus the creative genius of Mankind obtains the most important and singular place. In the light of the Constructive idea the creative mind of Man has the last and decisive word in the definite construction of the whole of our culture. To be sure, the creative genius of Man is only a part of Nature, but from this part alone derives all the energy necessary to construct his spiritual and material edifice. Being a result of Nature it has every right to be considered as a further cause of its growth. Obedient to Nature, it intends to become its master; attentive to the laws of Nature it intends to make its own laws, following the forms of Nature it re-forms them. We do not need to look for the origin of this activity, it is enough for us to state it and to feel its reality continually acting on us. Life without creative effort is unthinkable, and the whole course of human culture is one continuous effort of the creative will of Man. Without the presence and the control of the creative genius, Science by itself would never emerge from the state of wonder and contemplation from which it is derived and would never have achieved substantial results. Without the creative desire Science would go astray in its own schemes, losing its aim in its reasoning. [...]

[...] The Constructive idea does not see that the function of Art is to represent the world. It does not impose on Art the function of Science. Art and Science are two different streams which rise from the same creative source and flow into the same ocean of the common culture, but the currents of these two streams flow in different beds. Science teaches, Art asserts; Science persuades, Art acts; Science explores and apprehends, informs and proves. It does not undertake anything without first being in accord with the laws of Nature. Science cannot deal otherwise because its task is knowledge. Knowledge is bound up with things which are and things which are, are heterogeneous, changeable and contradictory. Therefore the way to the ultimate truth is so long and difficult for Science.

The force of Science lies in its authoritative reason. The force of Art lies in its immediate influence on human psychology and in its active contagiousness. Being a creation of Man it re-creates Man. Art has no need of philosophical arguments, it does not follow the signposts of philosophical systems; Art, like life, dictates systems to philosophy. It is not concerned with the meditation about what is and how it came to be. That is a task for Knowledge. Knowledge is born of the desire to know, Art derives from the necessity to communicate and to announce. The stimulus of Science is the deficiency of our knowledge. The stimulus of Art is the abundance of our emotions and our latent desires. Science is the vehicle of facts – it is indifferent, or at best tolerant, to the ideas which lie behind facts. Art is the vehicle of ideas and its attitude to facts is strictly partial. Science looks and observes, Art sees and foresees. Every great scientist

has experienced a moment when the artist in him saved the scientist. 'We are poets,' said Pythagoras, and in the sense that a mathematician is a creator he was right.

In the light of the Constructive idea the purely philosophical wondering about real and unreal is idle. Even more idle is the intention to divide the real into super-real and sub-real, into conscious reality and sub-conscious reality. The Constructive idea knows only one reality. Nothing is unreal in Art. Whatever is touched by Art becomes reality, and we do not need to undertake remote and distant navigations in the sub-conscious in order to reveal a world which lies in our immediate vicinity. [...]

There is and there can be only one reality – existence. For the Constructive idea it is more important to know and to use the main fact that Art possesses in its own domain the means to influence the course of this existence enriching its content and stimulating its energy.

This does not mean that this idea consequently compels Art to an immediate construction of material values in life; it is sufficient when Art prepares a state of mind which will be able only to construct, co-ordinate and perfect instead of to destroy, disintegrate and deteriorate. Material values will be the inevitable result of such a state. For the same reason the Constructive idea does not expect from Art the performance of critical functions even when they are directed against the negative sides of life. What is the use of showing us what is bad without revealing what is good? The Constructive idea prefers that Art perform positive works which lead us towards the best. The measure of this perfection will not be so difficult to define when we realize that it does not lie outside us but is bound up in our desire and in our will to it. The creative human genius, which never errs and never mistakes, defines this measure. Since the beginning of Time man has been occupied with nothing else but the perfecting of his world.

To find the means for the accomplishment of this task the artist need not search in the external world of Nature; he is able to express his impulses in the language of those absolute forms which are in the substantial possession of his Art. This is the task which we constructive artists have set ourselves, which we are doing and which we hope will be continued by the future generation.

10 Piet Mondrian (1872–1944) 'Plastic Art and Pure Plastic Art'

Mondrian published this restatement of his theoretical principles at a moment when there appeared the prospect of an international movement grounded in similar precepts. He again distinguishes 'universal' from 'individual', 'subjective' from 'objective', but points out that the balance between them must be sought in practice, not merely in theory. He is also more concerned than hitherto to relate these fundamental principles of 'dynamic equilibrium' to the world at large, to what he calls 'world disorder'. The text thus furnishes another assertion from within the European avant-garde of the paradoxical 'utility of pure abstract art'. Originally published in Martin, Nicholson and Gabo, op. cit., pp. 41–56. (For earlier texts by Mondrian see IIIC6 and 7.)

Part I

Although art is fundamentally everywhere and always the same, nevertheless two main human inclinations, diametrically opposed to each other, appear in its many and varied

expressions. One aims at the *direct creation of universal beauty*, the other at the *aesthetic expression of oneself*, in other words, of that which one thinks and experiences. The first aims at representing reality objectively, the second subjectively. Thus we see in every work of figurative art the desire, objectively to represent beauty, solely through form and colour, in mutually balanced relations, and, at the same time, an attempt to express that which these forms, colours and relations arouse in us. This latter attempt must of necessity result in an individual expression which veils the pure representation of beauty. Nevertheless, both the two opposing elements (universal – individual) are indispensable if the work is to arouse emotion. Art had to find the right solution. In spite of the dual nature of the creative inclinations, figurative art has produced a harmony through a certain co-ordination between objective and subjective expression. For the spectator, however, who demands a pure representation of beauty, the individual expression is too predominant. For the artist the search for a unified expression through the balance of two opposites has been, and always will be, a continual struggle.

Throughout the history of culture, art has demonstrated that universal beauty does not arise from the particular character of the form, but from the dynamic rhythm of its inherent relationships, or – in a composition – from the mutual relations of forms. Art has shown that it is a question of determining the relations. It has revealed that the forms exist only for the creation of new relationships: that forms create relations and that relations create forms. In this duality of forms and their relations neither takes precedence.

The only problem in art is to achieve a balance between the subjective and the objective. But it is of the utmost importance that this problem should be solved, in the realm of plastic art – technically, as it were – and not in the realm of thought. The work of art must be 'produced', 'constructed'. One must create as objective as possible a representation of forms and relations. Such work can never be empty because the opposition of its constructive elements and its execution arouse emotion.

If some have failed to take into account the inherent character of the form and have forgotten that this – untransformed – predominates, others have overlooked the fact that an individual expression does not become a universal expression through figurative representation, which is based on our conception of feeling, be it classical, romantic, religious, surrealist. Art has shown that universal expression can only be created by a *real equation of the universal and the individual*.

Gradually art is purifying its plastic means and thus bringing out the relationships between them. Thus, in our day two main tendencies appear: the one maintains the figuration, the other eliminates it. While the former employs more or less complicated and particular forms, the latter uses simple and neutral forms, or, ultimately, the free line and the pure colour. It is evident that the latter (non-figurative art) can more easily and thoroughly free itself from the domination of the subjective than can the figurative tendency; particular forms and colours (figurative art) are more easily exploited than neutral forms. It is, however, necessary to point out, that the definitions 'figurative' and 'non-figurative' are only approximate and relative. For every form, even every line, represents a figure, no form is absolutely neutral. Clearly, everything must be relative, but, since we need words to make our concepts understandable, we must keep to these terms.

Among the different forms we may consider those as being neutral which have neither the complexity nor the particularities possessed by the natural forms or abstract

forms in general. We may call those neutral which do not evoke individual feelings or ideas. Geometrical forms being so profound an abstraction of form may be regarded as neutral; and on account of their tension and the purity of their outlines they may even be preferred to other neutral forms.

If, as a conception, non-figurative art has been created by the mutual interaction of the human duality, this art has been *realized* by the mutual interaction of *constructive elements and their inherent relations*. This process consists in mutual purification; purified constructive elements set up pure relationships, and these in their turn demand pure constructive elements. Figurative art of today is the outcome of figurative art of the past, and non-figurative art is the outcome of the figurative art of today. Thus the unity of art is maintained.

If non-figurative art is born of figurative art, it is obvious that the two factors of human duality have not only changed, but have also approached one another towards a mutual balance; towards unity. One can rightly speak of an *evolution in plastic art*. It is of the greatest importance to note this fact, for it reveals the true way of art; the only path along which we can advance. Moreover, the evolution of the plastic arts shows that the dualism which has manifested itself in art is only relative and temporal. Both science and art are discovering and making us aware of the fact that *time is a process of intensification*, an evolution from the individual towards the universal, of the subjective towards the objective; towards the essence of things and of ourselves.

A careful observation of art since its origin shows that artistic expression seen from the outside is *not a process of extending but of intensifying one and the same thing*, universal beauty; and that seen from the inside *it is a growth*. Extension results in a continual repetition of nature; it is not human and art cannot follow it. So many of these repetitions which parade as 'art' clearly cannot arouse emotions.

Through intensification one creates successively on more profound planes; extension remains always on the same plane. Intensification, be it noted, is diametrically opposed to extension; they are at right angles to each other as are length and depth. This fact shows clearly the temporal opposition of non-figurative and figurative art.

But if throughout its history art has meant a *continuous and gradual change in the expression of one and the same thing*, the opposition of the two trends – in our time so clear-cut – is actually an unreal one. It is illogical that the two principal tendencies in art, figurative and non-figurative (objective and subjective) should be so hostile. Since art is in essence universal, its expression cannot rest on a subjective view. Our human capacities do not allow of a perfectly objective view, but that does not imply that the plastic expression of art is based on subjective conception. Our subjectivity realizes but does not create the work. [. . .]

Art is not made for anybody and is, at the same time, for everybody. It is a mistake to try to go too fast. The complexity of art is due to the fact that different degrees of its evolution are present at one and the same time. The present carries with it the past and the future. But we need not try to foresee the future; we need only take our place in the development of human culture, a development which has made non-figurative art supreme. It has always been only one struggle, of only one real art; to create universal beauty. This points the way for both present and future. We need only continue and develop what already exists. [. . .]

* * *

Art makes us realize that there are *fixed laws which govern and point to the use of the constructive elements of the composition and of the inherent inter-relationships between them.* These laws may be regarded as subsidiary laws to the *fundamental* law of equivalence which creates *dynamic equilibrium and reveals the true content of reality.*

Part II

* * *

In spite of world disorder, instinct and intuition are carrying humanity to a real equilibrium, but how much misery has been and is still being caused by primitive animal instinct. How many errors have been and are being committed through vague and confused intuition? Art certainly shows this clearly. But art shows also that in the course of progress, intuition becomes more and more conscious and instinct more and more purified. Art and life illuminate each other more and more; they reveal more and more their laws according to which a real and living balance is created.

Intuition enlightens and so links up with pure thought. They together become an intelligence which is not simply of the brain, which does not calculate, but which feels and thinks. Which is creative both in art and in life. From this intelligence there must arise non-figurative art in which instinct no longer plays a dominating part. Those who do not understand this intelligence regard non-figurative art as a purely intellectual product.

Although all dogma, all preconceived ideas, must be harmful to art, the artist can nevertheless be guided and helped in his intuitive researches by reasoning apart from his work. If such reasoning can be useful to the artist and can accelerate his progress, it is indispensable that such reasoning should accompany the observations of the critics who talk about art and who wish to guide mankind. Such reasoning, however, cannot be individual, which it usually is; it cannot arise out of a body of knowledge outside plastic art. If one is not an artist oneself one must at least know *the laws and culture of plastic art.* If the public is to be well informed and if mankind is to progress it is essential that the confusion which is everywhere present should be removed. For enlightenment, a clear demonstration of the *succession of artistic tendencies is necessary.* Hitherto, a study of the different styles of plastic art in their progressive succession has been difficult since the expression of the essence of art has been veiled. In our time, which is reproached for not having a style of its own, the content of art has become clear and the different tendencies reveal more clearly the progressive succession of artistic expression. Non-figurative art brings to an end the ancient culture of art; at present therefore, one can review and judge more surely *the whole culture of art.* We are not at the turning-point of this culture; *the culture of particular form is approaching its end. The culture of determined relations has begun.*

It is not enough to explain the value of a work of art in itself; it is above all necessary to show *the place which a work occupies on the scale of the evolution of plastic art.* Thus in speaking of art, it is not permissible to say 'this is how I see it' or 'this is my idea'. True art like true life takes a *single road.*

The laws which in the culture of art have become more and more determinate are *the great hidden laws of nature which art establishes in its own fashion.* It is necessary to stress the fact that these laws are more or less hidden behind the superficial aspect of nature. Abstract art is therefore opposed to a natural representation of things. But it *is not*

opposed to nature as is generally thought. It is opposed to the raw primitive animal nature of man, but it is one with true human nature. It is opposed to the conventional laws created during the culture of the particular form but it is one with the laws of the culture of pure relationships.

* * *

In pure plastic art the significance of different forms and lines is very important; it is precisely this fact which makes it pure.

In order that art may be really abstract, in other words, that it should not represent relations with the natural aspect of things, the law of the *denaturalization of matter* is of fundamental importance. In painting, the primary colour that is as pure as possible realizes this abstraction of natural colour. But colour is, in the present state of technique, also the best means for denaturalizing matter in the realm of abstract constructions in three dimensions; technical means are as a rule insufficient.

All art has achieved a certain measure of abstraction. This abstraction has become more and more accentuated until in pure plastic art not only a transformation of form but also of matter – be it through technical means or through colour – a more or less neutral expression is attained. [. . .]

Non-figurative art is created by establishing *a dynamic rhythm of determinate mutual relations* which *excludes the formation of any particular form*. We note thus, that to destroy particular form is only to do more consistently what all art has done.

The dynamic rhythm which is essential in all art is also the essential element of a non-figurative work. In figurative art this rhythm is veiled.

Yet we all pay homage to clarity.

The fact that people generally prefer figurative art (which creates and finds its continuation in abstract art) can be explained by the dominating force of the individual inclination in human nature. *From this inclination arises all the opposition to art which is purely abstract.*

* * *

In removing completely from the work all objects, 'the world is not separated from the spirit', but is on the contrary, *put into a balanced opposition* with the spirit, since the one and the other are purified. This creates a perfect unity between the two opposites. There are, however, many who imagine that they are too fond of life, particular reality, to be able to suppress figuration, and for that reason they still use in their work the object or figurative fragments which indicate its character. Nevertheless, one is well aware of the fact that in art one cannot hope to represent in the image things as they are, nor even as they manifest themselves in all their living brilliance. The impressionists, divisionists, and pointillistes have already recognized that. There are some today who, recognizing the weakness and limitation of the image, attempt to create a work of art through the objects themselves, often by composing them in a more or less transformed manner. This clearly can not lead to an expression of their content nor of their true character. One can more or less remove the conventional appearance of things (surrealism), but they continue nevertheless to show their particular character and to arouse in us individual emotions. To love things in reality is to love them profoundly; it is to see them as a microcosmos in the macrocosmos. *Only in this way can one achieve a universal expression of reality.* Precisely on account of its profound love for things, non-figurative art does not aim at rendering them in their particular appearance.

Precisely by its existence non-figurative art shows that 'art' *continues always on its true road*. It shows that 'art' is *not the expression of the appearance of reality such as we see it, nor of the life which we live, but that it is the expression of true reality and true life...indefinable but realizable in plastics*.

* * *

[...] Execution and technique play an important part in the aim of establishing a more or less objective vision which the essence of the non-figurative work demands. The less obvious the artist's hand is the more objective will the work be. This fact leads to a preference for a more or less mechanical execution or to the employment of materials produced by industry. Hitherto, of course, these materials have been imperfect from the point of view of art. If these materials and their colours were more perfect and if a technique existed by which the artist could easily cut them up in order to compose his work as he conceives it, an art more real and more objective in relation to life than painting would arise. All these reflections evoke questions which have already been asked many years ago, mainly: is art still necessary and useful for humanity? Is it not even harmful to progress? Certainly the art of the past is superfluous to the new spirit and harmful to its progress: just because of its beauty it holds many people back from the new conception. The new art is, however, still very necessary to life. In a clear manner it establishes the laws according to which a real balance is reached. Moreover, it must create among us a profoundly human and rich beauty realized not only by the best qualities of the new architecture, but also by all that the constructive art in painting and sculpture makes possible.

But although the new art is necessary, the mass is conservative. Hence these cinemas, these radios, these bad pictures which overwhelm the few works which are really of our era.

It is a great pity that those who are concerned with the social life in general do not realize the utility of pure abstract art. Wrongly influenced by the art of the past, the true essence of which escapes them, and of which they only see that which is superfluous, they make no effort to know pure abstract art. Through another conception of the word 'abstract', they have a certain horror of it. They are vehemently opposed to abstract art because they regard it as something ideal and unreal. In general they use art as propaganda for collective or personal ideas, thus as literature. They are both in favour of the progress of the mass and against the progress of the elite, thus against the logical march of human evolution. Is it really to be believed that the evolution of the mass and that of the elite are incompatible? The elite rises from the mass; is it not therefore its highest expression?

* * *

It would be illogical to suppose that non-figurative art will remain stationary, for this art contains *a culture* of the use of new plastic means and their determinate relations. Because the field is new there is all the more to be done. What is certain is that no escape is possible for the non-figurative artist; he *must stay within his field and march towards the consequence of his art*.

This consequence brings us, in a future perhaps remote, towards the end of *art as a thing separated from our surrounding environment, which is the actual plastic reality*. But this end is at the same time a new beginning. Art will not only continue but will realize itself more and more. By the unification of architecture, sculpture and painting, a new plastic reality will be created. Painting and sculpture will not manifest themselves as

separate objects, nor as 'mural art' which destroys architecture itself, nor as 'applied' art, but *being purely constructive* will aid the creation of an atmosphere not merely utilitarian or rational but also pure and complete in its beauty.

11 Barbara Hepworth (1903–1975) 'Sculpture'

Hepworth had been invited to join the Association Abstraction-Création together with Ben Nicholson in 1932. She developed an individual form of 'pure' carved sculpture in the mid-1930s. Examples were included in the international exhibition 'Abstract and Concrete' shown in London and elsewhere in 1936. Her concern in this statement is with the 'universality' of the experience of art, and hence with a relationship between the art's abstraction – or 'purity' – and its socially progressive potential. Originally published in Martin, Nicholson and Gabo, op. cit., pp. 113–16.

I

Full sculptural expression is spatial – it is the three-dimensional realization of an idea, either by mass or by space construction. The materials for sculpture are unlimited in their variety of quality, tenseness and aliveness. But for the imaginative idea to be fully and freely projected into stone, wood or any plastic substance, a complete sensibility to material – an understanding of its inherent quality and character – is required. There must be a perfect unity between the idea, the substance and the dimension: this unity gives scale. The idea – the imaginative concept – actually *is* the giving of life and vitality to material; but when we come to define these qualities we find that they have very little to do with the physical aspect of the sculpture. When we say that a great sculpture has vision, power, vitality, scale, poise, form or beauty, we are not speaking of physical attributes. Vitality is not a physical, organic attribute of sculpture – it is a spiritual inner life. Power is not man power or physical capacity – it is an inner force and energy. Form realization is not just any three-dimensional mass – it is the chosen perfected form, of perfect size and shape, for the sculptural embodiment of the idea. Vision is not sight – it is the perception of the mind. It is the discernment of the reality of life, a piercing of the superficial surfaces of material existence, that gives a work of art its own life and purpose and significant power.

One of the most profound qualities of sculpture is scale – it can only be perceived intuitively because it is entirely a quality of thought and vision. Sculpture does not gain or lose spiritual significance by having more or less of physical attributes. A vital work has perfect co-ordination between conception and realization; but actual physical contours do not limit a perfected idea.

It does not matter whether a sculpture is asymmetrical or symmetrical – it does not lose or gain by being either: for instance, it can be said that an asymmetrical sculpture has more points of view. But this is only one aspect of the sculptural entity – asymmetry can be found in the tension, balance, inner vital impact with space and in the scale.

The fact that a plastic projection of thought can only live by its inner power and not by physical content, means that the range for its choice of form is free and unlimited –

the range of many forms to one form, surprising depths and juxtapositions to the most subtle, very small to very large. All are equal, and capable of the maximum of life according to the intensity of the vision.

Scale is not physical size, because a very small thing can have good scale or a very large thing poor scale – though often large sculptures achieve good scale because the artist approaches their conception with a greater seriousness and thought. Size can be emphasized by the juxtaposition of the very large to the very small; but this is only one side of sculptural relationships. There is the sculpture which has magnificent scale because of its precise and exact relationship between dimension and idea – it creates space for itself by its own vitality. There are two main sculptural identities – one which comes within the embrace of our hands and arms, and the other which stands free and unrelated to our sense of touch. Both have their distinct and individual quality of scale which makes an expansion and spaciousness in everything surrounding them. Scale is connected with our whole life – perhaps it is even our whole intuitive capacity to feel life.

II

The most difficult and complicated form relationships do not necessarily give a sculpture the fullest spiritual content. Very often, as the thought becomes more free the line is purified, and as principles – the laws which contain lesser laws – are comprehended, the forms become simplified and strengthened. In the physical world we can discover in the endless variations of the same form, the one particular form which demonstrates the power and robustness of the simplified structure – the form is clear and every part of it in precise unity with the whole. It is not the accidental or casual, but the regular irregularity, the perfect sequence which gives the maximum expression of individual life. In the three-dimensional realization there is always this exact form, or sequence of form – which can most fully and freely convey the idea. But there is no formula that can reveal the sequence; the premise is individual and the logical sequence purely intuitive – the result of equilibrium between thought and medium.

The perception of these differences, imperfections and perfections helps us to understand the language the sculptor uses to convey the whole feeling and thought of his experience. It is the sculptor's work fully to comprehend the world of space and form, to project his individual understanding of his own life and time as it is related universally in this particular plastic extension of thought, and to keep alive this special side of existence. A clear social solution can only be achieved when there is a full consciousness in the realm of thought and when every section constitutes an inherent part of the whole.

The sculptural elements have long been neglected and unconsidered, the form consciousness of people has become atrophied; but now much is being done by a more balanced and free education – a greater co-ordination between hand and head – that will keep alive the intuitive form perceptions of the child. A world without form consciousness would scarcely be alive at all. The consciousness and understanding of volume and mass, laws of gravity, contour of the earth under our feet, thrusts and stresses of internal structure, space displacement and space volume, the relation of man to a mountain and man's eye to the horizon, and all laws of movement and equilibrium

– these are surely the very essence of life, the principles and laws which are the vitalization of our experience, and sculpture a vehicle for projecting our sensibility to the whole of existence.

III

The whole life force is in the vision which includes all phantasy, all intuitive imagination, and all conscious selection from experience. Ideas are born through a perfect balance of our conscious and unconscious life and they are realized through this same fusion and equilibrium. The choice of one idea from several, and the capacity to relate the whole of our past experience to the present idea is our conscious mind: our sensitivity to the unfolding of the idea in substance, in relation to the very act of breathing, is our unconscious intuition.

'Abstract' is a word which is now most frequently used to express only the type of the outer form of a work of art; this makes it difficult to use it in relation to the spiritual vitality or inner life which is the real sculpture. Abstract sculptural qualities are found in good sculpture of all time, but it is significant that contemporary sculpture and painting have become abstract in thought and concept. As the sculptural idea is in itself unfettered and unlimited and can choose its own forms, the vital concept selects the form and substance of its expression quite unconsciously.

Contemporary constructive work does not lose by not having particular human interest, drama, fear or religious emotion. It moves us profoundly because it represents the whole of artist's experience and vision, his whole sensibility to enduring ideas, his whole desire for a realization of these ideas in life and a complete rejection of the transitory and local forces of destruction. It is an absolute belief in man, in landscape and in the universal relationship of constructive ideas. The abstract forms of his work are now unconscious and intuitive – his individual manner of expression. His conscious life is bent on discovering a solution to human difficulties by solving his own thought permanently, and in relation to his medium. If we had lived at a time when animals, fire worship, myth or religion were the deepest emotional aspects of life, sculpture would have taken the form, unconsciously, of a recognizable god; and the formal abstract relationships in the representation would have been the conscious way of vitalizing these ideas; but now, these formal relationships have become our thought, our faith, waking or sleeping – they can be the solution to life and to living. This is no escapism, no ivory tower, no isolated pleasure in proportion and space – it is an unconscious manner of expressing our belief in a possible life. The language of colour and form is universal and not one for a special class (though this may have been in the past) – it is a thought which gives the same life, the same expansion, the same universal freedom to everyone.

The artist rebels against the world as he finds it because his sensibility reveals to him the vision of a world that could be possible – a world idealistic, but practical – idealistic, inclusive of all vitality and serenity, harmony and dynamic movement – a concept of a freedom of ideas which is all-inclusive except to that which causes death to ideas. In his rebellion he can take either of two courses – he can give way to despair and wildly try to overthrow all those things which seem to stand between the world as it appears to be and the world as it could be – or he can passionately affirm and re-affirm and demonstrate in his plastic medium his faith that this world of ideas does exist. He

can demonstrate constructively, believing that the plastic embodiment of a free idea – a universal truth of spiritual power – can do more, say more and be more vividly potent, because it puts no pressure on anything.

A constructive work is an embodiment of freedom itself and is unconsciously perceived even by those who are consciously against it. The desire to live is the strongest universal emotion, it springs from the depths of our unconscious sensibility – and the desire to give life is our most potent, constructive, conscious expression of this intuition.

12 American Abstract Artists: Editorial Statement 1938

The American Abstract Artists group was founded in 1936, and published Yearbooks in 1938, 1939 and 1946. The group's principal indebtedness was to European abstract art, as it was then being buttressed by the formation of Paris-based organizations such as Abstraction-Création and Cercle et Carré (founded in 1930). It was strongly opposed to the various schools of realistic art then claiming attention in America, arguing instead for art's essential distinction from life and for its universality. The AAA Yearbooks were published in facsimile in the Arno Series of Contemporary Art, no. 23, Arno Press, New York, 1969.

By the fact of their active existence and production, the American Abstract Artists express the authenticity and autonomy of the modern movement in the United States. The word abstract is incorporated in our title as a provisional gesture, so that we can be identified as a particular group in our effort to clarify growing and actively significant concepts of art.

Abstract, like so many other words, is too often used as an idiosyncratic suggestion, rather than as a concept which defines particular values. To understand abstract art is, in reality, no more a problem than understanding any and all art. And this depends upon the ability of the individual to perceive essentials, to perceive that which is called universally significant, and to evaluate the unity and relationship that is contained in any work.

As the first and only comprehensive organization of its type in the United States, we are faced with the familiar problem of a largely unsympathetic and biased criticism, a criticism which merely negates, condemns, or ridicules. There is, however, a more encouraging response to our exhibitions and lectures, a response that could be especially experienced only by the form and action of a representative and authentic organization. Individuals working and studying against the odds of isolation can now be articulate and related to others working in similar directions.

The membership of this group is homogeneous to the extent of its recognition of mutual problems and limitations, and in its willingness to cooperate in the presentation and solution of these problems. We are, as in any group, heterogeneous and diverse in our concepts.

To place artistic, or any cultural effort on the level of a competition is to negate the method and meaning of knowledge. American Abstract Artists dedicates itself to the problems of the artist and the student, presented in the terms of method and activity that define the artist; and limits itself accordingly for the purpose of clarification. As to the question of which aspects of life affect the artist in his effort, this is demonstrated by the

character and efficacy of his activity and production; for this we present the individual artist.

No educated intelligence can draw the so-called 'line of national culture' as an ambition and objective, without discerning its ambiguity. Beside being impossible, such a misconception is a negation of the very essence of cultural effort; the general heightening and application of knowledge. To make this negation may be politically expedient but it serves only to preserve and sway ignorance. While knowledge belongs to no nationality, particular nations do exist, and each nation has, and is, a peculiar and limited cultural development.

Considering the tempo of present political history and the importance of the various fields of knowledge in relationship to it, we can do nothing better than emphasize that the contemporary must respect the interpenetration and concatenation of all culture. True culture is recognizable when established from the standpoint of scientific thought and effort. For us it is established through the freedom to develop facilities and to maintain their proportional distribution, as civilized achievements, toward the enlivenment of existence – an unequivocal application toward the physical and psychic benefit of all humanity.

For these reasons, American Abstract Artists was formed in November of 1936. It has now attained a national scope and is more active in 1938.

– The Editors

13 Ibram Lassaw (1913–2004) 'On Inventing Our Own Art'

The author was a member of the American Abstract Artists group. In this short statement he reproduces in highly condensed form the central credos of inter-war abstract art: its status as its own reality rather than the secondary depiction of an external reality, its power to express emotion directly, and the need to behave as though re-inventing art from first principles. Originally published in the *American Abstract Artists' Yearbook*, 1938, reprinted by Arno Press, 1969.

The contemporary artist who works in the various plastic media is becoming aware of the unlimited and hitherto undreamed of possibilities in art. In order to penetrate this vast new world we must abandon most of the traditional experiences. The significant art expression of the various cultures in the history of man is greatly appreciated by the artist and interested layman; nevertheless the present day artist must, in a sense, work as though the art of the past has never existed; as though we invented art.

The crystallized concepts of the terms 'sculpture' and 'painting' are dissolving. It has always been considered a function of these plastic arts to describe appearances of people, houses, historical and religious events and subjects, and almost all scenes occurring in the life of man. Up till now narration has also been considered a necessary and integral part of art expression.

Until the invention of printing on a mass scale, and the development of photography, painting and sculpture were the only means of conveying ideas (outside of speech) to the millions of people who were completely illiterate. Now photography and the cinema have been brought to such a high state of perfection that painting cannot hope to compete with

them in either description or story telling. Stripped of these superimposed tasks, the underlying structure of art becomes clear. Colors and forms alone have a greater power to move man emotionally and psychologically. It becomes more and more apparent that art has something more and something much greater to offer.

In view of these developments, artists are beginning to realize the limitations of time-honored laws of art, so-called, and even the various media. It seems that each of the many cultures of the past had grown and developed an art expression peculiar to itself. Our own age, in some ways so completely different from all past times and at the same time so eclectic of our heritage, is now forming a new viewpoint of art.

Many people are now learning that we cannot produce an art of our own by continuing to borrow styles and ways of working that came from such different physical, philosophical and psychological world environments as the past shows. It is like trying to transplant a tree after tearing it out of the soil without its roots.

Certain artists have abandoned traditional pigment painting and solid, static sculpture. They feel that the important thing for art is to be alive, to be full of suggestion and possibilities, to enlarge our sensibility and to intensify experience. They are experimenting in the great fields opened up by the growth of modern physics, electricity and machinery and are influenced by the recent discoveries in psychology and psychoanalysis. In these searches our baggage of traditional values is a hindrance. 'Facts long amassed, patiently juxtaposed, avariciously preserved, are suspect. They bear the stigma of prudence, of conformism, of constancy, of slowness,' writes Gaston Bachelard.

The new attitude that is being formed as a result of these searches is concerned with the invention of objects affecting man psychologically by means of physical phenomena. It is a new form of magic. The artist no longer feels that he is 'representing reality', he is actually making reality. Direct sensual experience is more real than living in the midst of symbols, slogans, worn-out plots, clichés – more real than political-oratorical art. Reality is something stranger and greater than merely photographic rendering can show. Jean Cocteau has very aptly said in his film *Le Sang d'un Poète*: 'A plaster cast is exactly like the original except in everything.' We must make originals. All aesthetic phenomena produced by artists belong to the field of art, whether they fit into the former concepts and definitions or not. A work of art must work.

14 Ben Nicholson (1894–1982) 'Notes on Abstract Art'

Nicholson was the foremost English abstract painter of the inter-war years and a leading figure in attempts to establish the English Modern Movement on an international footing. He showed abstract all-white reliefs in an exhibition at the Lefevre Gallery, London, in 1935. The following year he was represented in the exhibition 'Abstract and Concrete', and in 1937 acted as co-editor of *Circle* with Gabo and the architect Leslie Martin. His 'Notes on Abstract Art' were originally published in *Horizon* (London), October 1941, and in slightly revised form in Herbert Read (intro.), *Ben Nicholson, Paintings, Reliefs, Drawings*, London, 1948, from pp. 23–6 of which the present text is taken.

About 'abstract' art: I have not yet seen it pointed out that this liberation of form and colour is closely linked with all the other liberations one hears about. I think it ought, perhaps, to come into one of our lists of war-aims. After all, every movement of human life is affected by form and colour, everything we see, touch, think and feel is linked up with it, so that when an artist can use these elements freely and creatively it can be a tremendously potent influence in our lives. The power, for instance, to create space (not 'literary' space but actual space) is surely invaluable. I think, too, that so far from 'abstract' art being the withdrawal of the artist from reality (into an 'ivory tower') it has brought art once again into common every-day life – there is evidence of this in its common spirit with and influence on many things like contemporary architecture, aeroplanes, cars, refrigerators, typography, publicity, electric torches, lipstick holders, etc. But like all the more profound religious, poetic, scientific, musical or artistic ideas its deepest meaning is only understood by a few and the process seems to be that these interpret it to a few more who pass it on to the rest of the world who unconsciously incorporate it in their lives. A Raphael is not a painting in the National Gallery – it is an active force in our lives.

It was interesting that during an exhibition of abstract work which I held in London several people in different professions wrote saying that they felt a common bond between their job and mine: a yacht designer, for instance, wrote that it was a hair's breadth in design which decided the pace or lack of pace in a yacht and that it seemed to be this same hair's breadth in design which decided the power or lack of power in a relief. These people were getting at the roots of the matter far more than those critics who were concerned as to whether they were works of art and if so why (at first sight) they were so unlike the work of Tintoretto. One can say that the problems dealt with in 'abstract' art are related to the interplay of forces and, therefore, that any solution reached has a bearing on all interplay between forces: it is related to Arsenal v. Tottenham Hotspur quite as much as to the stars in their courses. I think the recent liberation of the powerful forces of form and colour is an important event, and when critics announce or foretell the death of abstract art they show the same misunderstanding of the freedom of form and colour as the dictators do of the freedom of the individual: putting an end to the liberty of either is, however, a hopeless job, right from the start, as there is only one way of doing so – by putting an end not only to the human race but to every other form of life.

Many people expect one kind of art to exclude all others, but I don't see why all the different forms can't proceed at the same time: there is a place for abstract art, for surrealist art or indeed for an art based more directly on representation, though since abstract art is painting and sculptural expression free and undiluted it must have a special potency of its own.

A great deal of painting and sculpture to-day is concerned with the imitation of life, with the imitation of a man, a tree or a flower instead of using colour and form to create its *equivalent*; no one will ask what a tree is supposed to represent and yet, with the most innocent expression in the world, they will ask what a painting or a sculpture or a construction in space is supposed to represent. This equivalent must be conceived within the terms of the medium, it must be pure painting and sculptural expression, since the introduction of anything extraneous means that the conception is adulterated and therefore that it can no longer have a complete application to other forms of life. [. . .]

In painting a 'still-life' one takes the simple every-day forms of a bottle – mug – jug – plate-on-table as the basis for the expression of an idea: the forms are not entirely free though they are free to the extent that each object can be seen from as many viewpoints as you wish at one and the same time but the colours are free: bottle-colour for plate, plate-colour for table, or just as you wish and working in this way you have in time not a still-life of objects but an equivalent of something much more like deer passing through a winter forest, over foothills and mountains, through sunlight and shadows in Arizona, Cornwall or Provence and so, inevitably, you eventually at some point discard altogether the forms of even the simplest objects as a basis and work out your idea, not only in free colour but also in free form. To most people this development may sound easy but, for example, although I made my first 'abstract' painting in 1923 it wasn't till 1933 that I was able to establish this development. At first the circles were freely drawn and the structure loose with accidental textures, later I valued more the direct contact that could be obtained by flat planes of colour made and controlled to an exact pitch and the greater tension obtainable by the use of true circles and rectangles – the super-ficial appeal became less, but the impact of the idea more direct and therefore more powerful. The geometrical forms often used by abstract artists do not indicate, as has been thought, a conscious and intellectual mathematical approach – a square or a circle in art are nothing in themselves and are alive only in the instinctive and inspir-ational use an artist can make of them in expressing a poetic idea. If you take a large ultramarine blue and a small cadmium red square and place them on a cool white surface along with a pencilled circle, you can create a most exciting tension between these forces, and if at any time this tension becomes too exciting you can easily, by the smallest mark made by a compass in its centre, transfix the circle like any butter-fly! [...]

About space-construction: I can explain one aspect of this by an early painting I made of a shop-window in Dieppe though, at the time, this was not made with any conscious idea of space but merely using the shop-window as a theme on which to base an imaginative idea. The name of the shop was 'Au Chat Botté', and this set going a train of thought connected with the fairy tales of my childhood and, being in French, and my French being a little mysterious, the words themselves had also an abstract quality – but what was important was that this name was printed in very lovely red lettering on the glass window – *giving one plane* – and in this window were reflections of what was behind me as I looked in – *giving a second plane* – while through the window objects on a table were performing a kind of ballet and forming the 'eye' or life-point of the painting – *giving a third plane*. These three planes and all their subsidiary planes were interchangeable so that you could not tell which was real and which unreal, what was reflected and what unreflected, and this created, as I see now, some kind of space or an imaginative world in which one could live.

The same process takes place in making an abstract painting or relief, where, for instance, as the simplest example – you can take a rectangular surface and cut a section of it one plane lower and then in the higher plane cut a circle deeper than, but without touching, the lower plane. *One is immediately conscious that this circle has pierced the lower plane without having touched it* – even a dog or a cat will realize this instantly – and this creates space. The awareness of this is felt subconsciously and it is useless to approach it intellectually as this, so far from helping, only acts as a barrier. This language is comprehensible to anyone who doesn't set up barriers – the dog and cat set

up no barriers and their eyes, whiskers and tails are alive, without restriction, but the whiskers of an intellectual do not give off the necessary spark and contact cannot be made.

I think that so far from being a limited expression, understood by a few, abstract art is a powerful, unlimited and universal language.

IVB
Realism as Figuration

1 Vladimir Ilyich Lenin (1870–1924) 'On Proletarian Culture'

Shortly after the Revolution Lenin became involved in a dispute over the issue of 'proletarian culture'. To the supporters of this idea, just as the Revolution had resulted in the overthrow of the old political and economic forms of society, so the existing bourgeois culture should now be replaced by a culture of the working class. It was Lenin's view, on the other hand, that the Revolution had to proceed on the basis of existing bourgeois standards (see also Plekhanov, IIA9). Moreover the *idea* of 'proletarian culture' was advanced by an organization, Proletcult, which Lenin perceived as a threat to the authority of the Party itself. The hostile resolution was submitted to the Proletcult conference on 8 October 1920. It was originally published after Lenin's death in *Krasnaya Nov*, no. 3, 1926. The present translation is taken from *Lenin on Literature and Art*, Moscow, 1967, pp. 188–9. (For an earlier text by Lenin, see IIA3.)

DRAFT RESOLUTION

1 All educational work in the Soviet Republic of workers and peasants, in the field of political education in general and in the field of art in particular, should be imbued with the spirit of the class struggle being waged by the proletariat for the successful achievement of the aims of its dictatorship, i.e., the overthrow of the bourgeoisie, the abolition of classes, and the elimination of all forms of exploitation of man by man.

2 Hence, the proletariat, both through its vanguard – the Communist Party – and through the many types of proletarian organizations in general, should display the utmost activity and play the leading part in all the work of public education.

3 All the experience of modern history and, particularly, the more than half-century-old revolutionary struggle of the proletariat of all countries since the appearance of the *Communist Manifesto* has unquestionably demonstrated that the Marxist world outlook is the only true expression of the interests, the viewpoint, and the culture of the revolutionary proletariat.

4 Marxism has won its historic significance as the ideology of the revolutionary proletariat because, far from rejecting the most valuable achievements of the bourgeois epoch, it has, on the contrary, assimilated and refashioned everything of value in the more than two thousand years of the development of human thought and culture. Only further work on this basis and in this direction, inspired by the practical experience of the proletarian dictatorship as the final stage in the struggle against every form of exploitation, can be recognized as the development of a genuine proletarian culture.

5 Adhering unswervingly to this stand of principle, the All-Russia Proletcult Congress rejects in the most resolute manner, as theoretically unsound and practically harmful, all attempts to invent one's own particular brand of culture, to remain isolated in self-contained organizations, to draw a line dividing the field of work of the People's Commissariat for Education and the Proletcult, or to set up a Proletcult 'autonomy' within establishments under the People's Commissariat for Education and so forth. On the contrary, the Congress enjoins all Proletcult organizations to fully consider themselves in duty bound to act as auxiliary bodies of the network of establishments under the People's Commissariat for Education, and to accomplish their tasks under the general guidance of the Soviet authorities (specifically, of the People's Commissariat for Education) and of the Russian Communist Party, as part of the tasks of the proletarian dictatorship.

2 AKhRR: 'Declaration'

The Association of Artists of Revolutionary Russia was the main 'Realist' group which arose after the end of the civil war under the New Economic Policy. It was violently opposed to the avant-garde, representing it as a remnant of the bourgeois order, and as such unfit to claim the mantle of 'revolutionary art'. AKhRR's approved method involved a technique rooted in the mastery of traditional academic skills. The inaugural Declaration was published in the catalogue to their 'Exhibition of Studies, Sketches, Drawings and Graphics from the Life and Customs of the Workers' and Peasants' Red Army', Moscow, June–July 1922. It was reprinted in Ivan Matsa et al. (eds.), *Sovetskoie Isskusstvo za 15 let*, Moscow and Leningrad, 1933. The present translation is taken from John Bowlt, *Russian Art of the Avant Garde*, London, 1976 and 1988, pp. 266–7.

The Great October Revolution, in liberating the creative forces of the people, has aroused the consciousness of the masses and the artists – the spokesmen of the people's spiritual life.

Our civic duty before mankind is to set down, artistically and documentarily, the revolutionary impulse of this great moment of history.

We will depict the present day: the life of the Red Army, the workers, the peasants, the revolutionaries, and the heroes of labor.

We will provide a true picture of events and not abstract concoctions discrediting our Revolution in the face of the international proletariat.

The old art groups existing before the Revolution have lost their meaning, the boundaries between them have been erased in regard to both ideology and form – and they continue to exist merely as circles of people linked together by personal connections but devoid of any ideological basis or content.

It is this content in art that we consider a sign of truth in a work of art, and the desire to express this content induces us, the artists of Revolutionary Russia, to join forces; the tasks before us are strictly defined.

The day of revolution, the moment of revolution, is the day of heroism, the moment of heroism – and now we must reveal our artistic experiences in the monumental forms of the style of heroic realism.

By acknowledging continuity in art and by basing ourselves on the contemporary world view, we create this style of heroic realism and lay the foundation of the universal building of future art, the art of a classless society.

3 AKhRR: 'The Immediate Tasks of AKhRR'

This text took the form of a circular to all branches of AKhRR in May 1924. It followed the exhibition 'Revolution, Life and Labour' of February 1924. The circular expands on AKhRR's criticism of the Western avant-garde and of its assimilation by Russian 'leftist' avant-garde groups. By contrast it situates itself in a 'Realist' tradition headed in French art by Courbet and in Russia by the nineteenth-century Realist group the Wanderers. The circular was reprinted in Matsa, op. cit. The present translation is taken from Bowlt, op. cit., pp. 268–71.

The presidium of AKhRR and its Russian Communist Party (Bolsheviks) faction consider it essential – on the second anniversary of the Association of Artists of Revolutionary Russia (May 1, 1924) – to sum up its artistic and social activities and to define its ideological policy in its subsequent practical work, once the immediate tasks facing AKhRR have been solved.

From the very beginning of AKhRR's existence, when it proclaimed in its declaration the need for a creative response to the October Revolution and for a new reality in visual art, it has been quite clear that AKhRR should take the organization of the new elements of social art organically linked to our revolutionary epoch as the basis of its artistic work, and that it should do this by regenerating art on the foundation of a high and authentic level of painterly skill.

The creation of the elements of a social art in the Russian school acted, by the very fact of its existence, as a logical balance to the development of, and enthusiasm for, the extreme, so-called leftist trends in art; it displayed their petty-bourgeois, pre-Revolutionary, decadent substance, which was expressed in their attempt to transfer the fractured forms of Western art – mainly French (Cézanne, Derain, Picasso) – to a soil alien both economically and psychologically.

In no way does this signify that we should ignore all the formal achievements of French art in the second half of the nineteenth century and to a certain extent in the first quarter of the twentieth within the general treasury of world art (the careful, serious study and assimilation of the painterly and formal achievements of modern art is an essential obligation of every serious artist who aspires to become a master). AKhRR objects only to the aspiration to reduce the whole development of art to the imitation and repetition of models of the French school, a school that is nurtured, in turn, on the sources of old traditions in art.

After their two years of work in factories and plants, after the many exhibitions they organized – which laid the foundation for the Museum of the All-Union Central Council of Trade Unions and for the Red Army and Navy Museum – the main group of AKhRR members felt convinced that subject matter, thematic method in the study and conversion of reality, was the main element in organizing form.

It became clear to the AKhRR artists that the factory, the plant, the production worker, electrification, the heroes of labor, the leaders of the Revolution, the new life of the peasants, the Red Army, the Komsomol and Pioneers, the death and funeral of the

Revolution's leader – all this contained a new color of unprecedented power and severe fascination, a new interpretation of synthetic form, a new compositional structure; in a word, contained the aggregate of those conditions whose execution would regenerate easel and monumental painting.

For the expression of these new forms created by the Revolution, the frayed, lost forms and lacerated color hired from the masters of the French school are absolutely useless.

For the expression of these new forms created by the Revolution a new style is essential, a strong, precise, invigorating style that organizes thought and feeling, the style that in our short declaration is called heroic realism.

The difficulty of solving and realizing the above tasks lies in the fact that, while aspiring toward content in art, it is very easy to lapse into feeble, simple imitation of a host of outdated art schools and trends.

Those artists, those young artists who wish first and foremost to be sincere, who wish to shake off the yoke of vacuous philosophizing and inversion of the bases of visual art decomposed through the process of analysis, fully realize the necessity to regenerate the unity of form and content in art; and they direct all their strength, all their creative potential, to the ceaseless scientific and completely professional study of the new model, giving it the acutely realistic treatment that our epoch dictates.

The so-called indifference to politics of certain contemporary groups of artists is a well or badly concealed aversion to the Revolution and a longing for a political and moral restoration.

The harsh material conditions that surround the present-day artist on the one hand deprive the artist of the protection of his professional interests and the safeguarding of his work and on the other hand determine his view of art as a weapon for the ideological struggle and clearly aggravate the difficulty of this path; but if the Revolution has triumphed, in spite of the innumerable obstacles, then the will to express the Revolution creatively will help the contemporary realist artist to overcome all the difficulties he encounters on his path.

It is essential to remember that a creative artistic expression of the Revolution is not a fruitless and driveling sentimentality toward it but a real service, because the creation of a revolutionary art is first and foremost the creation of an art that will have the honor of shaping and organizing the psychology of the generations to come.

Only now, after two years of AKhRR, after the already evident collapse of the so-called leftist tendencies in art, is it becoming clear that the artist of today must be both a master of the brush and a revolutionary fighting for the better future of mankind. Let the tragic figure of Courbet serve as the best prototype and reminder of the aims and tasks that contemporary art is called on to resolve.

The reproaches of formal weakness and dilettantism that were cast at the Wanderers by other art groups can by rights be repaid to those who made them, for if we remember the formal achievements of the best Wanderers (Perov, Surikov, Repin), we can see how much more profound, sincere, and serious they were than their descendants poisoned by the vacuous decorativism, retrospectivism, and brittle decadence of the prerevolutionary era.

Kramskoi's prediction that the ideas of a social art would triumph under a different political regime is beginning to be brilliantly justified; it is confirmed by the mass withdrawal from all positions of the so-called leftist front observable in contemporary art.

Give particular attention to the young artists, organize them, turn all your efforts to giving polish to those natural artists from among the workers and peasants who are beginning to prove their worth in wall newspapers; and the hour is not far off when, perhaps, the Soviet art school will be destined to become the most original and most important factor in the renaissance of world art.

Ceaseless artistic self-discipline, ceaseless artistic self-perfection, unremitting effort in the preparations for the next AKhRR exhibition – this is the only path that will lead to the creation of a genuine, new art on whose heights form will fuse with content. And the presidium of AKhRR and its Russian Communist Party (Bolsheviks) faction appeal to all artists who hold near and dear the behests and aims set before AKhRR to rally around the association in a powerful, united, artistic, and revolutionary organization.

4 David A. Siqueiros (1896–1974) et al. 'A Declaration of Social, Political and Aesthetic Principles'

Siqueiros was active in the Mexican mural art movement in the years following the Mexican revolution. His commitment to Communism later led him into conflict with the other leading muralist, Diego Rivera, when in the 1930s the latter became allied with Trotsky (see IVB13 and IVD9). During Trotsky's exile in Mexico, Siqueiros was in fact implicated in an assassination attempt against him. The Declaration denigrates the tradition of easel art for its alleged privacy and elitism, and instead advocates a monumental public art. Drawn up by Siqueiros in 1922, it was signed by all the members of the Syndicate of Technical Workers, Painters and Sculptors. The present translation, by Sylvia Calles, is taken from David A. Siqueiros, *Art and Revolution*, London, 1975, pp. 24–5. (For further texts by Siqueiros see IVB16 and VC20.)

The Syndicate of Technical Workers, Painters and Sculptors directs itself to the native races humiliated for centuries; to the soldiers made into hangmen by their officers; to the workers and peasants scourged by the rich; and to the intellectuals who do not flatter the bourgeoisie.

We side with those who demand the disappearance of an ancient, cruel system in which the farm worker produces food for the loud-mouthed politicians and bosses, while he starves; in which the industrial workers in the factories weave cloth and by the work of their hands make life comfortable for the pimps and prostitutes, while they crawl and freeze; in which the Indian soldier heroically leaves the land he has tilled and eternally sacrifices his life in a vain attempt to destroy the misery which has lain on his face for centuries.

The noble work of our race, down to its most insignificant spiritual and physical expressions, is native (and essentially Indian) in origin. With their admirable and extraordinary *talent to create beauty, peculiar to themselves, the art of the Mexican people is the most wholesome spiritual expression in the world* and this tradition is our greatest treasure. Great because it belongs collectively to the people and this is why our fundamental aesthetic goal must be to socialize artistic expression and wipe out bourgeois individualism.

We *repudiate* so-called easel painting and every kind of art favoured by ultra-intellectual circles, because it is aristocratic, and we praise monumental art in all its forms, because it is public property.

We *proclaim* that at this time of social change from a decrepit order to a new one, the creators of beauty must use their best efforts to produce ideological works of art for the people; art must no longer be the expression of individual satisfaction which it is today, but should aim to become a fighting, educative art for all.

5 Red Group: 'Manifesto'

The Red Group arose out of the old Novembergruppe Opposition (see IIIB8 and 9), as an organization of artists active in the Communist Party (KPD) in Weimar Germany. Most of its adherents had previously been involved in Berlin Dada, and tended now to be involved in the Neue Sachlichkeit movement, which basically entailed an 'objective' approach to painting and photography (see IIIA12). As they understood it, 'objectivity' involved no conflict with partisanship in terms of the class struggle and its attendant political alignments. First published in *Die Rote Fahne* (*The Red Flag*), 57, Berlin, 1924. The present translation is taken from M. Kay Flavell, *George Grosz: A Biography*, New Haven, CT, 1988, p. 309.

Communist Artists' Group

Artists organized and active in the Communist Party have combined to form a Communist Artists' Group. The members of this group, known as 'The Red Group of the Union of Communist Artists', share the conviction that a good Communist is first of all a Communist, and only secondarily a technician, artist, and so on. They believe that all knowledge and skills are tools placed in the service of the class struggle.

In close conjunction with the local central organs of the Communist Party they have undertaken to realize the following programme, briefly outlined below, in order to increase the effectiveness of communist propaganda in the fields of literature, drama and the visual arts. The mode of production of communist artists, hitherto much too anarchistic, must now be replaced by a planned form of cooperation:

1 Organization of ideologically unified propaganda evenings.
2 Practical support in all revolutionary meetings.
3 Opposition to the Free German ideological survivals in proletarian meetings (patriotic romanticism).
4 Artistic training organized within each district; sample copies of wall newspapers; guidance in preparing posters and placards for demonstrations, etc.; support of the efforts (far too dilettantish at present) of party members to proclaim the revolution by word and image.
5 Organization of travelling exhibitions.
6 Ideological and practical education among the revolutionary artists themselves.
7 Public opposition to counter-revolutionary cultural manifestations.
8 Disruption and neutralization of work by bourgeois artists.
9 Exploitation of bourgeois art exhibitions for propaganda purposes.
10 Contact with pupils in art establishments and institutions, in order to revolution-ize them.

We regard the 'Red Group' as the core of an ever-expanding organization of all proletarian revolutionary artists in Germany.

Already several writers, along with our drama comrade Erwin Piscator, have joined the Communist Artists' Group. We now appeal to further artists and writers to join our ranks and work in practical terms with us on the basis of our working plan. All correspondence to be sent to Rudolf Schlichter, Neue Winterfeldstr. 17, Berlin. 13 June 1924.

Union of Communist Artists. Chairman: George Grosz. Deputy Chairman: Karl Witte, writer. Secretary: John Heartfield.

6 Otto Dix (1891–1969) 'The Object Is Primary'

During and immediately after the First World War Dix produced Expressionist-oriented work on themes of war, corruption and social decay. As the 1920s progressed, his technique became deliberately 'objective', based on research into the methods of the Old Masters, while the range of his subjects remained basically the same. Dix was not a member of the Communist Party, and tended to give his themes 'human', even religious inflections in preference to militantly class-based viewpoints. This did not protect him from being condemned as 'un-German' by the Nazis in the 1930s. The present statement was written at a time when Dix was working on his *City* triptych, and was originally published in *Berliner Nachtausgabe*, Berlin, 3 December 1927. It is reprinted in U. M. Schneede (ed.), *Die Zwanziger Jahre, Manifeste und Dokumente deutscher Künstler*, Cologne, 1979, from which text the present translation is made. The argument depends upon an identification of 'object' with 'subject' which is difficult to render into English. Dix's point is that novelty of expression is not feasible as an aim in itself, but follows from attention to that (object) which is the painting's subject.

In recent years, one catchphrase has motivated the present generation of creative artists. It urges them to 'Find new forms of expression!' I very much doubt, however, whether such a thing is possible. Anyone who looks at the paintings of the Old Masters, or immerses himself in the study of their works, will surely agree with me.

As I see it, at any rate, the new element in painting lies in the extension of its subject area, an enhancement of those forms of expression already present in essence in the Old Masters. For me, the object is primary and determines the form. I have therefore always felt it vital to get as close as possible to the thing I see. 'What' matters more to me than 'How'. Indeed, 'How' arises from 'What'.

7 ARBKD (Asso): 'Manifesto' and 'Statutes'

The German Association of Revolutionary Visual Artists (Association Revolutionärer Bildender Künstler Deutschlands), colloquially known as the 'Asso', was formed in Berlin in 1928, following the example of AKhRR in Russia (IVB2 and 3), and with a programme modelled on that of the Red Group. Its formation cannot be disentangled from political events, most notably the inception of the ultra-Left 'Third Period' in Russia. This invoked a heightened phase of class struggle which, as far as culture was concerned, led to the formation of new and militant Communist art organizations, and a reinvigoration of the idea of a 'proletarian

culture'. This in its turn resulted in demands for positive images of working-class life and labour: a demand which the Asso set out to fulfil. Its membership of several hundred included John Heartfield, Otto Nagel, Laszlo Peri and Arthur Segal. The Manifesto and Statutes were issued in 1928. They are reprinted in Schneede, op. cit., from which text the present translation is made.

Art is a weapon, the artist a warrior in the people's struggle for freedom from a bankrupt system!

'Social being determines consciousness'
Karl Marx

In all cultural epochs of the past economic circumstances have determined the development of art as a whole and left a distinct mark on it.

The rise of the money economy and trade in the fifteenth century created the conditions for individual artistic activity.

The rising middle class needed art, as one of the most effective methods of demonstrating its power and dominance to the rest of the world. Moreover, the accumulation of money in individual hands offered an opportunity of investing it in treasures of all kinds, and in works of art.

Only thus can the vast luxury and magnificence of the Renaissance be explained, and only on these economic foundations was it possible for art to rise in so spectacular a way.

In the epoch of fully established industrial capitalism, however, matters are different. Even at the height of its development, industrial capitalism did not require the aid of art to boost its power by glorifying it. It had very different and much more efficacious methods at its disposal. The expansion of production, investment of capital in stocks and shares, and ownership of all society's consumer goods allowed the bourgeoisie to display their power and safeguard their dominant position by creating a strong bourgeois state, with all its attendant means of enforcing its power.

Profit is the first principle of the capitalist system! Only thus can the fact that the same criterion was applied to art be explained. As a result, the art trade came into being and works of art became *market commodities*, although only those which fetched high prices from the point of view of profit.

What, in these circumstances, is the *situation of the majority of artists?* We need only quote the proverb which says that 'Art goes a-begging' to indicate the situation of artists in a capitalist society clearly enough. Unable to make a bare living, lacking any kind of social protection, the artist is given no chance to develop.

These are the real facts concerning *the place of art and culture* in the capitalist society. Where expensive colleges and academies are still maintained today, it is only to make the ruling classes appear to patronize art and culture. By comparison with the many millions spent annually on armaments and the apparatus of power (the police, the judiciary, etc.), the expenditure of the *Länder* and local government authorities on the encouragement of freelance artists is ridiculously low.

This system, which could not have succeeded without the cruel exploitation of millions of working people, is now approaching its end. Shaken by economic crises, threatened in its very existence by the struggle for liberty of the revolutionary proletariat, the bourgeoisie sees only one means of delaying its fall: Fascism! But Fascism means the *ruthless*

dictatorship of capitalism to suppress any kind of progress in cultural life. Fascism means a further drop in the standard of living of all working people, and wholesale cuts to all funding for cultural purposes, which is already low enough.

This fact, clearly recognized by Marxist-minded artists, must be brought home to all destitute artists, dispelling the hopes and illusions still placed by some of them on the 'strong man' [Hitler]. The devastating influence of the system will not be countered by the dictatorship of the bourgeoisie in the form of Fascism. Only the fall of the capitalist system and the establishment of a socialist order of society can free mankind from the fetters of want and oppression.

Only in a socialist society, where the entire means of production are in the hands of the working people, will all workers have equal rights and be able to enjoy the benefits of all social and cultural achievements.

Only the revolutionary proletariat as the creator of all social assets (the fruits of which it could not gather under the capitalist system) is competent, acting with all the oppressed, to do away with the old system root and branch. When the material situation of millions of working people in the socialist system has been improved, there will be a great new hunger for knowledge and culture. New forces are stirring and need room to develop.

Look at Soviet Russia!

While the army of the unemployed is growing to vast proportions throughout the capitalist world, while the material and cultural level of great strata of society there has sunk to a minimum, and art and artists seem doomed to perish, the USSR has not hands enough to satisfy all its new needs. The most distinguished scientists, architects and city planners of today are already at work in the Soviet Union, the first state of workers and peasants in the world, where they receive an enthusiastic welcome and find an unparalleled field in which to operate.

'Revolutions are the locomotives of world history!'

It is an historical fact that revolutionary upheavals always bring a great stimulus to all areas of life, but whereas the radical changes of the past and their achievements benefited only a ruling minority, today's social revolution serves the liberation and higher development of all mankind.

The *'Association of Revolutionary Visual Artists of Germany'* (ARBKD) has been formed because of the understanding of these facts by revolutionary artists, as described above.

Visual artists! All of you suffer from the present terrible circumstances, when you are forced to live and work amidst dreadful privations and humiliations! Recognize the cause of your misery! Your wretchedness is rooted in the same causes as that of the proletariat!

Your place, therefore, is at the side of the fighting proletariat. Like the workers, the artists have 'nothing to lose but their chains, but a whole world to gain!'

Join us!

Statutes of The ARBKD

1 The 'Association of Revolutionary Visual Artists of Germany' is a sister organization of the Association of Artists of Revolutionary Russia, and is known as the ARBKD.

2 The ARBKD aims to unite all revolutionary visual artists who support the proletarian class struggle. Through this union, the ARBKD will bring together the scattered forces supporting the class struggle into a centralized organization with a single purpose.

3 Unlike those associations of artists that are based only on stylistic movements and the principle of 'art for art's sake', the ARBKD aims to promote the class struggle, in a manner suited in both style and content to the needs of the working classes.

4 Besides a regular membership fee the ARBKD will receive from its members a certain percentage of the fees for all work it has procured for them.

5 The ARBKD will be run not by an executive board but by a committee of five, who will collectively make decisions about all the affairs of the ARBKD. One member of this committee will be responsible for its business management. The committee will be chosen by the full assembly. It may be removed at any time by a majority decision of the assembly.

6 The members of the ARBKD will meet at least once a month.

7 The committee will decide on the admission of a member. Admissions must be confirmed by the membership.

8 George Grosz (1893–1959) from 'My Life'

In the later 1920s Grosz produced more 'objective' work in accordance with the tendency of Die Neue Sachlichkeit. At the same time, owing to the increasingly ultra-Left turn by the Communist International, a demand was made on left-wing artists to produce unmistakably optimistic, even propagandistic, imagery. This Grosz baulked at, for all his political commitment to the cause of the working class. His statement in response to Communist criticism was first published in *Prozektor*, 14, Moscow, 1928. The present translation, by Eileen Martin, is taken from the catalogue *Prints and Drawings of the Weimar Republic*, Stuttgart, 1985, p. 61. (For further texts by Grosz see IIIB13 and IVC7.)

[...] Often comrades who think they are particularly clever object to my depictions of workers on the grounds that my proletarians are not, in their view, real proletarians, they are artifical figures, the product of the petty bourgeois, as the anarchistic artist Grosz sees them. What they mean is that since the working class is growing one should show the growing proletariat as a 'positive idea'. But I don't think it is necessary to meet the requirements of a 'Hurrah–Bolshevism', that sees the proletariat as always neatly brushed and combed in the old hero's dress. I at least cannot imagine the proletariat any other way than the way I draw it. I still see them as oppressed, at the bottom of the social scale, badly dressed, badly paid, in dark, stinking housing and very often dominated by the bourgeois desire to 'get to the top'. Apart from that I very definitely don't believe that one can only serve by following a one-sided and false idealization of the propaganda, singing praises. There are other ways of showing the worker than with his sleeves rolled up showing a strong biceps, in the style of the agit posters. You can't proceed from so sentimental an idea and say that my image is false from the standpoint of the propaganda . . . You have to remember that the mass of the German proletariat has not yet become so aware of his strength as the worker in the Soviet Union. To help the workers to understand their oppression and suffering, force them to admit openly to themselves that they are

wretched and enslaved, awaken their self-confidence and stir them to the class war, that is
the task for art, and it is the task I serve.

9 Alfred Rosenberg (1893–1946) from *The Myth of the Twentieth Century*

The author was one of the Nazis' leading spokesmen on art and culture. In 1929 he formed
the Combat League for German Culture (Kampfbund für Deutsche Kultur). He extended the
concept of 'cultural bolshevism' (Kulturbolschewismus), initially broached by Hitler in *Mein
Kampf* in 1924. According to this claim all modern art was the product of a Communist-
Jewish conspiracy to undermine the 'beauty-ideal' of the Aryan race. In this belief Rosenberg
came to be involved in a conflict with Goebbels who, in his youth, had himself been the
author of an Expressionist play, and who tended to favour Expressionism as an appropri-
ately 'German' art. The conflict was resolved in Rosenberg's favour on the intervention of
Hitler. As a result, all manifestations of modern art were deemed '*entartet*' (degenerate; see
IVB20). This extract is from Rosenberg's *Der Mythus des 20. Jahrhunderts*, 1930, trans-
lated in Robert Pois (ed.), *Alfred Rosenberg, Selected Writings*, London, 1970, pp. 149–52.
(For evidence of the intellectual pedigree of notions of Aryanism and degeneracy respect-
ively, see Gobineau's 'Essay on the Inequality of the Human Races' and Nordau's 'Degener-
ation', in *Art in Theory 1815–1900*, IIIA6 and VB17.)

[. . .] The metropolis began its race-annihilating work. The coffee-houses of the asphalt
men became studios; theoretical bastardized dialectics became laws for ever-new
'directions'. A race-chaos of Germans, Jews and anti-natural street races was abroad.
The result was mongrel 'art'.

[. . .] Mongrelism claimed that its bastardized progeny, nurtured by spiritual syphilis
and artistic infantilism, was able to represent 'expressions of the soul'. One should gaze
long and hard upon something like Kokoschka's *Self Portrait*, in order to gain a halfway
understanding of the monstrous inner-nature of this idiot-art. In a novel, Hanns Heinz
Ewers tells of a child who was talented in so unnatural a manner as to derive a special
satisfaction from the illness of elephantiasis. Our contemporary 'European intelligent-
sia' finds itself in a similar position today; an intelligentsia which, through Jewish pens,
worships the Kokoschkas, Chagalls, Pechsteins and so on as the leaders of future art.
Wherever this form goes it bears the features of degeneration, as in the case of
Schwalback, who already has dared to represent Jesus as flat-footed and bow-legged.
Lovis Corinth displayed a certain robustness, yet even this butcher of the brush pales
in comparison with the clay-corpse-coloured bastardizations of Syrian Berlin.

Impressionism, which originally was borne by strong, talented artists, became a
battle-cry of decomposing intellectualism. An atomistic world-view atomized even the
colours; the dull level of understanding of natural science achieved its apogee in the
practitioners and theoreticians of Impressionism. A mythless world procreated a
mythless sensuousness. Men who desired inwardly to break free from this were broken.
Van Gogh is a tragic example of one who longed and went mad. Gauguin is another
example of the attempt to break free from intellectualism. Only the Paul Signacs
painted on, uninhibited, unconcernedly, gluing their bits of colour next to one another.
[. . .]

The complete tragedy of a mythless age also revealed [...] itself in the following decades. Men no longer wanted intellectualism; they began to hate the endless dissection of colour and to despise the brown gallery-colours and copies of Titian. With correct feeling, they began to search for redemption, expression and strength. And the result of this powerful tension was – the abortion of Expressionism. A whole race had cried for expression and now had nothing that it could express. It called for beauty and no longer had an ideal of beauty. It wanted to search for life in a revived spirit of creativity and it had lost every true ability to create form. Thus, Expressionism became a style: instead of nurturing a new style-constructing strength, it continued the process of atomization. Internally unprincipled they [the Expressionists] devoured 'primitive art', over-reached themselves in praise of Japan and China, and began in all seriousness to direct European-Nordic art back to Asia... Thus, a bar-room mystique alternated with cerebralism and cubist linear chaos, until men became completely satiated and are today again searching, and in vain, with what they call 'New Realism' [i.e. Die Neue Sachlichkeit].

The essence of this completely chaotic development lies, among other places, in the loss of that beauty-ideal which, while in many forms and costumes, still has remained the underlying support for all European creative art. Democratic, race-corrupting precepts and the *Volk*-annihilating metropolis combined with the carefully planned decomposing activities of the Jews. The result was not only the shattering of *Weltanschauung* and state thought, but also of the art of the Nordic West.

10 Georg Lukács (1885–1971) ' "Tendency" or Partisanship?'

One of the twentieth century's leading Marxist thinkers on art, Lukács offered intellectual support for Socialist Realism. Hungarian by birth, he was active in Germany around 1930 after a period in the Soviet Union, and prior to returning there after the Nazi assumption of power in 1933. The present text was an intervention in the dispute between a tendentious, self-professedly 'proletarian' art, often, if somewhat paradoxically, with roots in avant-garde experimentation, and a more sober art with its heritage in bourgeois tradition. The claim made for the latter was that it was the medium of a more generalized 'realism'. As such it could be linked to the policy of 'Socialist Realism', though Lukács's treatment is characteristically more nuanced than Socialist Realism as an official doctrine ever was. Originally published in *Die Linkskurve*, vol. 4, no. 6, Berlin, 1932, pp. 13–21. The present extracts are taken from the translation by David Fernbach in Rodney Livingstone (ed.), *Georg Lukács: Essays on Realism*, London, 1980, pp. 37–42. (For a later text by Lukács see VC21.)

It is understandable, indeed obvious, that the first proletarian literature should have linked up with the 'tendency' literature of what little was left of the literature of the progressive bourgeoisie, and thus took over both the theory and practice of 'tendency'. It did so all the more, in that right from the start it was forced to adopt, in intensified form, the positions held by this progressive bourgeois literature at the time. 'Tendency', in other words, is something very relative. In bourgeois literary theory, as recognized today even officially, a text is seen as displaying 'tendency' if its class basis and aim are hostile (in class terms) to the prevailing orientation; one's own 'tendency', therefore, is not a tendency at all, but only that of one's opponent. The positions of

struggle that the various literary factions of the bourgeoisie took up against one another, in which connection, of course, it was generally the more politically and socially progressive trend that was particularly reproached for its 'tendency', rather than the reactionary trend, were assumed with doubled vigour against the first beginnings of proletarian literature. Any depiction of society, whether the society of the proletariat or that of the bourgeoisie, and no matter whether this was presented from the class standpoint of the proletariat itself, or simply from one close to it, was viewed as 'tendentious', and every possible argument as to its 'inartistic' and 'hostile-to-art' character was marshalled against it. At the same time, bourgeois 'pure art' became ever poorer in content and further removed from reality, while simultaneously growing ever more tendentious, so that the prejudice about proletarian 'tendency' art became increasingly hypocritical. Under such conditions, it is only too readily understandable that the young proletarian literature should have taken up the term of abuse applied to it by the class enemy and worn it as a badge of honour, just like the Dutch '*Geusen*' (beggars) in the sixteenth and seventeenth centuries, or the '*sans-culottes*' of the French revolution. For a long time, therefore, we referred to our literature with pride as a 'tendency literature'.

Yet however understandable it was to take up this theoretical position, this in no way means it is theoretically correct. On the contrary. It takes over unseen, together with the bourgeois formulation of the problem and the bourgeois terminology, the entire bourgeois eclecticism involved in the very terms of the problem itself, its bourgeois-eclectic contradictions, which are not superseded, but rather in part glossed over, and in part rigidly polarized. What we particularly have in mind here is the antithesis between 'pure art' and 'tendency'. On this basis, only two answers are possible. Either, on the one hand, we express contempt for 'pure art' and its perfection of form; literature has a social function in the class struggle, which determines its content; we fulfil this function consciously, and do not worry about the decaying bourgeoisie's questions of form. (This is to restrict literature to everyday agitation, the standpoint of mechanical materialism in literary theory.) Or else, on the other hand, we acknowledge an 'aesthetic' and attempt to reconcile with it a 'tendency' that is taken from the realm of the 'social' or 'political', i.e. a realm that is 'foreign to art'. In this way, the insoluble task of introducing into the work of art a component that is 'foreign to art' is raised in a haphazard manner. On the one hand, therefore, aesthetic immanence is (tacitly) recognized, i.e. the 'pure' autonomy of the work of art, or the domination of form over content; while on the other hand it is demanded that a content which in this view lies outside the artistic ('tendency') should prevail. The result is an eclectic idealism.

These untranscended (and on this basis untranscendable) contradictions are what account for Franz Mehring's lack of sureness on this question. It is well known that Mehring also viewed the Kantian aesthetic that was decisive for the artistic theory of the declining bourgeoisie as a necessary theoretical foundation. The basic conception expressed in this, of 'purposefulness without purpose', and the exclusion of all 'interestedness' from the consideration of art, is evidently a theory of 'pure art'. [...]

[...] The limitation of this conception is shown by the way that the question of 'tendency' is made into a question of the relationship between art and morality, so that the subjective idealist character of 'tendency' clearly emerges: 'tendency' is a demand, an 'ought', an ideal, which the writer counterposes to reality; it is not a tendency of

social development itself, which is simply made conscious by the poet (in Marx's sense), but rather a (subjectively devised) commandment, which reality is requested to fulfil. Behind this line of thought lies first of all the rigid and formalized separation of the various spheres of human activity from one another. That is to say, we are confronted by the ideological reflection of the capitalist division of labour. However, instead of thinking of this reflection as the consequence of the division of labour, and subjecting it to Marxist analysis and criticism, it is conceived in purely ideological terms as an 'eternal' law that separates 'essences' and is then made into the starting-point of all further analyses in a quite unhistorical manner. Second, human activity, practice, is conceived not in its real, objective or material production, and as applied to changing society, but rather in its distorted and upside-down ideological reflection (as 'morality'), so that in a similarly ahistorical way, the distorted ideological result has to be made the theoretical starting-point. Third, this counterposing of art and morality contains an uncritical and ideological illusion of the human individual as an 'atom' of society (cf. on this illusion *The Holy Family*), as well as the fetishized conception of society as something 'thing-like', surrounding human beings as an 'alien' reality (the environment theory), rather than being simply the sum and the system, the result of human activity (even if under capitalism this result is not conscious or intended). Fourth, corresponding to this rigid and mechanical counterposing of (individual) man and society, which underlies the entire bourgeois conception of 'morality', we find that the work of art is isolated from social practice, from material production and the class struggle, and the task of art is thought to be that of realizing an 'aesthetic ideal'. And fifth, on this view art and morality are not results of the same social practice, but rather realizations of different, divergent and rigidly counterposed ideals (in Kant's case, 'interest' and 'disinterest'). We can therefore apply to their relationship, and to the solution of the problem of literature and 'tendency' ('morality'), what Hegel wrote about the undialectical conception of body and soul: 'If we take them to be absolutely antithetical and absolutely independent, they are as impenetrable to each other as one piece of matter to another.'

* * *

Here we already have in embryo the literary theory of Trotskyism. For it is clear that when Trotsky writes that 'the dictatorship of the proletariat is not the culturally productive organization of a new society, but rather a revolutionary means of struggle to achieve this', later going on to counterpose rigidly to one another socialism and class struggle, culture accordingly assumes for him, corresponding to the intensification of class struggle and the concretization of all problems in it, the same position that (Kantian) 'pure art' did for Mehring. 'Revolutionary literature must be permeated with the spirit of social hatred . . . (thus it is simply a "tendency art": G.L.). Under socialism the foundation of society is solidarity (so that a "pure art", a "genuine culture" is possible: G.L.).' It is no accident, then, that the uncritical acceptance of Mehring's writings in our literary and cultural theory has given a boost to Trotskyism. In the same way, any mechanistic reduction of our literary goals, whether conscious and intentional or not, must necessarily end up taking a Trotskyist turn.

It cannot be our task here to analyse in detail all the errors of this conception; this has already been done to a large extent, moreover, in the struggle against Trotskyism. Here we need only indicate the mistake that is decisive for our present question: the false and undialectical view of the subjective factor. Marx and Engels repeatedly gave the

dialectic of subjective and objective factors in social development a correct dialectical formulation, in a quite unmistakable fashion. [. . .]

. . . It is precisely a knowledge of social necessity that determines the correct (and important) place of the subjective factor in the development, contrary to both the mechanistic and the idealist conceptions. Yet it does so for the proletariat in a different fashion than for other classes. The thesis that the working class 'have no ideals to realize' applies only to the proletariat. For other classes, including the revolutionary period of the bourgeoisie, what Engels wrote still holds: 'Ideology is a process accomplished by the so-called thinker consciously, it is true, but with a false consciousness' (letter to Mehring, 14 July 1893). This 'false consciousness' has the subsequent result that conscious human activity in the historical process either has no active significance at all, or else is allotted an inflated independence or leading role, as is also shown in the way that the subjective factor appears in the form of 'morality', its goals taking the form of the 'ideal'. Even those bourgeois writers and thinkers who have penetrated relatively deeply into the dialectic of history, still either get lost in foggy mysticism or remain trapped in contradictions they are unable to resolve. [. . .]

The proletariat, however, does not face this ideological barrier. Its social being allows it (and thus also proletarian revolutionary writers) to transcend this barrier and clearly see the class relationships, the development of the class struggle, that lies behind the fetishized forms of capitalist society. Clarity about these connections and their laws of development also means clarity as to the role of the subjective factor in this development: both the determination of this subjective factor by the objective economic and historical development, and the active function of this subjective factor in the transformation of objective conditions. This knowledge is in no way a mechanical and immediate product of social being. It has rather to be produced. The process of its production, however, is both a product of the internal (material and ideological) disposition of the proletariat, as well as a factor promoting the development of the proletariat from a 'class in itself' to a 'class for itself', i.e. promoting its internal organization for the fulfilment of its world-historical task (the rise of trade unions and the party, their further development, etc.).

If the subjective factor in history is viewed in this way – and this is how it must be viewed by a proletarian revolutionary writer with a command of dialectical materialism – then all the problems we have discussed above in connection with 'tendency' simply cease to be problems at all. Such a writer can reject the dilemma between 'pure' art and 'tendency' art. For in his depiction, a depiction of objective reality with its real driving forces and real developmental tendencies, there is no space for an 'ideal', whether moral or aesthetic. He does not introduce any demands on the portrayal of reality 'from without', for since they are the integral moments of objective reality, from which they emerge and which they help to mould in their turn, any demands that grow concretely out of the class struggle are necessarily an inherent part of the writer's portrayal of reality. This is the necessary result, if the writer seeks to depict reality correctly, i.e. dialectically. He can also reject, therefore, the other dilemma of the 'tendentious' introduction of 'tendency' into the portrayal, the nakedly immediate counterposing of 'tendency' and depiction of reality. He does not need to distort the reality, to adjust it or 'tendentiously' touch it up, for his depiction, if it is correct and dialectical, is precisely built up on a knowledge of those tendencies (in the proper, Marxian sense of

the term) that prevail in the objective development. And no 'tendency' can or need be counterposed to this objective reality as a 'demand', for the demands that the writer represents are integral parts of the self-movement of this reality itself, at the same time the results and premisses of this self-movement.

It clearly emerges from all this that the rejection of 'tendency' in no way means any 'higher watchtower' of the writer's, in Freiligrath's sense, that would be above 'the battlements of party' (a view which Mehring, for all his eclectic defence of 'tendency', inclines towards despite his dislike of it). On the contrary, a correct dialectical depiction and literary portrayal of reality presupposes the partisanship of the writer. Naturally, again not some kind of 'partisanship in general' as defended by Herwegh, something abstract, subjectivist and arbitrary, but rather partisanship for the class that is the bearer of historical progress in our period: for the proletariat, and specifically for that 'section of the working-class party', the Communists, who are distinguished from other proletarians because 'in the national struggles of the proletarians of the different countries, they point out and bring to the front the common interests of the entire proletariat, independently of nationality', while 'in the various stages of development which the struggle of the working class against the bourgeoisie has to pass through, they always and everywhere represent the interests of the movement as a whole' [*Communist Manifesto*].

A partisanship of this kind, unlike 'tendency' or 'tendentious' presentation, does not stand in contradiction to objectivity in the reproduction and portrayal of reality. It is on the contrary the pre-condition for a true – dialectical – objectivity. In contrast to 'tendency', where a position taken for some cause amounts to an idealistic glorification, and a position against something means simply tearing it to pieces, in contrast also to an 'above party' attitude, whose motto (never kept to in practice) is 'to understand all is to forgive all' – an attitude that contains an unconscious and hence almost always mendacious standpoint – this partisanship champions precisely the position that makes possible knowledge and portrayal of the overall process as a synthetically grasped totality of its true driving forces, as the constant and heightened reproduction of the dialectical contradictions that underlie it. This objectivity, however, depends on a correct – dialectical – definition of the relationship between subjectivity and objectivity, the subjective factor and objective development, and the dialectical unity of theory and practice. [...]

11 Central Committee of the All-Union Communist Party: 'Decree on the Reconstruction of Literary and Artistic Organizations'

The 1920s had seen fierce debates in the Soviet Union between advocates of a radical art committed to direct intervention in society, and a more technically conservative art which saw its major role as one of reinforcement of social and political developments. Relatively speaking, the state had abstained from all this. By the 1930s this was changing, as the increasingly totalitarian state under Stalin sought to intervene in all walks of life. A Decree passed on 23 April 1932 dissolved all existing art groups and replaced them with a single, national, Artists' Union. The Decree was reproduced in Matsa, op. cit. This translation is drawn from Bowlt, op. cit., pp. 288–90.

The Central Committee states that over recent years literature and art have made considerable advances, both quantitative and qualitative, on the basis of the significant progress of Socialist construction.

A few years ago the influence of alien elements, especially those revived by the first years of NEP, was still apparent and marked. At this time, when the cadres of proletarian literature were still weak, the Party helped in every possible way to create and consolidate special proletarian organs in the field of literature and art in order to maintain the position of proletarian writers and art workers.

At the present time the cadres of proletarian literature and art have managed to expand, new writers and artists have come forward from the factories, plants, and collective farms, but the confines of the existing proletarian literature and art organizations (VOAPP, RAPP, RAPM, etc.) are becoming too narrow and are hampering the serious development of artistic creation. This factor creates a danger: these organizations might change from being an instrument for the maximum mobilization of Soviet writers and artists for the tasks of Socialist construction to being an instrument for cultivating elitist withdrawal and loss of contact with the political tasks of contemporaneity and with the important groups of writers and artists who sympathize with Socialist construction.

Hence the need for the appropriate reconstruction of literary and artistic organizations and the extension of the basis of their activity.

Following from this, the Central Committee of the All-Union Communist Party (Bolsheviks) decrees:

1 Liquidation of the Association of Proletarian Writers (VOAPP, RAPP).
2 Integration of all writers who support the platform of the Soviet government and who aspire to participate in Socialist construction in a single union of Soviet writers with a Communist faction therein.
3 Execution of analogous changes with regard to the other arts.
4 Charging of the Organizational Bureau with working out practical measures for the fulfilment of this resolution.

12 John Reed Club of New York: 'Draft Manifesto'

John Reed was the American journalist who wrote *Ten Days That Shook The World*, an eyewitness account of the Bolshevik Revolution of 1917. A network of left-wing art groups with a broadly 'proletarian' ideology emerged in the United States at the end of the 1920s. They allied themselves with the programme of the conference of the International Union of Writers and Artists held at Kharkov in the Soviet Union in 1930. These groups, named in honour of Reed, existed until the change in international communist cultural policy to the Popular Front in 1935. The New York group produced a Draft Manifesto for the national organization, to be submitted to its conference in May 1932. Originally published in *New Masses*, June 1932, p. 14.

Mankind is passing through the most profound crisis in its history. An old world is dying; a new one is being born. Capitalist civilization, which has dominated the economic, political, and cultural life of continents, is in the process of decay. It received

a deadly blow during the imperialist war which it engendered. It is now breeding new and more devastating wars. At this very moment the Far East seethes with military conflicts and preparations which will have far-reaching consequences for the whole of humanity.

Meantime, the prevailing economic crisis is placing greater and greater burdens upon the mass of the world's population, upon those who work with hand or brain. In the cities of five-sixths of the globe, millions of workers are tramping the streets looking for jobs in vain. In the rural districts, millions of farmers are bankrupt. The colonial countries reverberate with the revolutionary struggles of oppressed peoples against imperialist exploitation; in the capitalist countries the class struggle grows sharper from day to day.

The present crisis has stripped capitalism naked. It stands more revealed than ever as a system of robbery and fraud, unemployment and terror, starvation and war.

The general crisis of capitalism is reflected in its culture. The economic and political machinery of the bourgeoisie is in decay, its philosophy, its literature, and its art are bankrupt. Sections of the bourgeoisie are beginning to lose faith in its early progressive ideas. The bourgeoisie is no longer a progressive class, and its ideas are no longer progressive ideas. On the contrary: as the bourgeois world moves toward the abyss, it reverts to the mysticism of the middle ages. Fascism in politics is accompanied by neo-catholicism in thinking. Capitalism cannot give the mass of mankind bread. It is equally unable to evolve creative ideas.

This crisis in every aspect of life holds America, like the other capitalist countries, in its iron grip. Here there is unemployment, starvation, terror, and preparation for war. Here the government, national, state and local, is dropping the hypocritical mask of democracy, and openly flaunts a fascist face. The demand of the unemployed for work or bread is answered with machine-gun bullets. Strike areas are closed to investigators; strike leaders are murdered in cold blood. And as the pretense of constitutionalism is dropped, as brute force is used against workers fighting for better living conditions, investigations reveal the utmost corruption and graft in government, and the closest cooperation of the capitalist political parties and organized crime.

In America, too, bourgeois culture writhes in a blind alley. Since the imperialist war, the best talents in bourgeois literature and art, philosophy and science, those who have the finest imaginations and the richest craftsmanship, have revealed from year to year the sterility, the utter impotence of bourgeois culture to advance mankind to higher levels. They have made it clear that although the bourgeoisie has a monopoly of the instruments of culture, its culture is in decay. Most of the American writers who have developed in the past fifteen years betray the cynicism and despair of capitalist values. The movies are a vast corrupt commercial enterprise, turning out infantile entertainment or crude propaganda for the profit of stockholders. Philosophy has become mystical and idealist. Science goes in for godseeking. Painting loses itself in abstractions or trivialities.

In the past two years, however, a marked change has come over the American intelligentsia. The class struggle in culture has assumed sharp forms. Recently we have witnessed two major movements among American intellectuals: the Humanist movement, frankly reactionary in its ideas; and a movement to the left among certain types of liberal intellectuals.

The reasons for the swing to the left are not hard to find. The best of the younger American writers have come, by and large, from the middle classes. During the boom which followed the war these classes increased their income. They played the stock-market with profit. They were beneficiaries of the New Era. The crash in the autumn of 1929 fell on their heads like a thunderbolt. They found themselves the victims of the greatest expropriation in the history of the country. The articulate members of the middle classes – the writers and artists, the members of the learned professions – lost that faith in capitalism which during the twenties trapped them into dreaming on the decadent shores of post-war European culture. These intellectuals suddenly awoke to the fact that we live in the era of imperialism and revolution; that two civilizations are in mortal combat and that they must take sides.

A number of factors intensified their consciousness of the true state of affairs. The crisis has affected the intellectual's mind because it has affected his income. Thousands of school-teachers, engineers, chemists, newspapermen and members of other profes-sions are unemployed. The publishing business has suffered acutely from the economic crisis. Middle-class patrons are no longer able to buy paintings as they did formerly. The movies and theaters are discharging writers, actors and artists. And in the midst of this economic crisis, the middle-class intelligentsia, nauseated by the last war, sees another one, more barbarous still, on the horizon. They see the civilization in whose tenets they were nurtured going to pieces.

In contrast, they see a new civilization rising in the Soviet Union. They see a land of 160,000,000 people, occupying one-sixth of the globe, where workers rule in alliance with farmers. In this vast country there is no unemployment. Amidst the decay of capitalist economy, Soviet industry and agriculture rise to higher and higher levels of production every year. In contrast to capitalist anarchy, they see planned Socialist economy. They see a system with private profit and the parasitic classes which it nourishes abolished; they see a world in which the land, the factories, the mines, the rivers, and the hands and brains of the people produce wealth not for a handful of capitalists but for the nation as a whole. In contrast to the imperialist oppression of the colonies, to the lynching of Negroes, to Scottsboro cases, they see 132 races and nationalities in full social and political equality cooperating in the building of a Socialist society. Above all, they see a cultural revolution unprecedented in history, unparalleled in the contemporary world. They see the destruction of the monopoly of culture. They see knowledge, art, and science made more accessible to the mass of workers and peasants. They see workers and peasants themselves creating literature and art, them-selves participating in science and invention. And seeing this, they realize that the Soviet Union is the vanguard of the new Communist society which is to replace the old.

Some of the intellectuals who have thought seriously about the world crisis, the coming war and the achievements of the Soviet Union, have taken the next logical step. They have begun to realize that in every capitalist country the revolutionary working class struggles for the abolition of the outworn and barbarous system of capitalism. Some of them, aligning themselves with the American workers, have gone to strike areas in Kentucky and Pennsylvania and have given their talents to the cause of the working class.

Such allies from the disillusioned middle-class intelligentsia are to be welcomed. But of primary importance at this stage is the development of the revolutionary culture of the working class itself. The proletarian revolution has its own philosophy developed

by Marx, Engels and Lenin. It has developed its own revolutionary schools, news-papers, and magazines; it has its worker-correspondents, its own literature and art. In the past two decades there have developed writers, artists and critics who have approached the American scene from the viewpoint of the revolutionary workers.

To give this movement in arts and letters greater scope and force, to bring it closer to the daily struggle of the workers, the John Reed Club was formed in the fall of 1929. In the past two and a half years, the influence of this organization has spread to many cities. Today there are thirteen John Reed Clubs throughout the country. These organizations are open to writers and artists, whatever their social origin, who subscribe to the fundamental program adopted by the international conference of revolutionary writers and artists which met at Kharkov, in November, 1930. The program contains six points upon which all honest intellectuals, regardless of their background may unite in the common struggle against capitalism. They are:

1 Fight against imperialist war, defend the Soviet Union against capitalist aggres-sion;
2 Fight against fascism, whether open or concealed, like social-fascism;
3 Fight for the development and strengthening of the revolutionary labor movement;
4 Fight against white chauvinism (against all forms of Negro discrimination or persecution) and against the persecution of the foreign-born;
5 Fight against the influence of middle-class ideas in the work of revolutionary writers and artists;
6 Fight against the imprisonment of revolutionary writers and artists, as well as other class-war prisoners throughout the world.

On the basis of this minimum program, we call upon all honest intellectuals, all honest writers and artists, to abandon decisively the treacherous illusion that art can exist for art's sake, or that the artist can remain remote from the historic conflicts in which all men must take sides. We call upon them to break with bourgeois ideas which seek to conceal the violence and fraud, the corruption and decay of capitalist society. We call upon them to align themselves with the working class in its struggle against capitalist oppression and exploitation, against unemployment and terror, against fas-cism and war. We urge them to join with the literary and artistic movement of the working class in forging a new art that shall be a weapon in the battle for a new and superior world.

13 Diego Rivera (1886–1957) 'The Revolutionary Spirit in Modern Art'

After working in the Parisian avant-garde during the second decade of the century, Rivera returned to his native Mexico to participate in, indeed to help formulate, the country's mural art programme. The idea of such an art was conceived as a counter to the tradition of easel art, and was stimulated by debates on the social role of art following the Russian Revolution. A committed Communist, Rivera none the less became critical of Stalinism and its policy in the arts, and for most of the 1930s was allied with Trotsky (see IVD9). The present essay was written while Rivera was engaged on commissions in the United States. Originally

published in *Modern Quarterly*, New York, vol. 6, no. 3, Autumn 1932, pp. 51–7. ('Super-Realism' is Rivera's name for Surrealism.)

ART is a social creation. It manifests a division in accordance with the division of social classes. There is a bourgeois art, there is a revolutionary art, there is a peasant art, but there is not, properly speaking, a proletarian art. The proletariat produces art of struggle but no class can produce a class art until it has reached the highest point of its development. The bourgeoisie reached its zenith in the French Revolution and thereafter created art expressive of itself. When the proletariat in its turn really begins to produce its art, it will be after the proletarian dictatorship has fulfilled its mission, has liquidated all class differences and produced a classless society. The art of the future, therefore, will not be proletarian but Communist. During the course of its development, however, and even after it has come into power, the proletariat must not refuse to use the best technical devices of bourgeois art, just as it uses bourgeois technical equipment in the form of cannon, machine guns, and steam turbines. [. . .]

 . . . The man who is truly a thinker, or the painter who is truly an artist, cannot, at a given historical moment, take any but a position in accordance with the revolutionary development of his own time. The social struggle is the richest, the most intense and the most plastic subject which an artist can choose. Therefore, one who is born to be an artist can certainly not be insensible to such developments. When I say born to be an artist, I refer to the constitution or make-up of his eyes, of his nervous system, of his sensibility, and of his brains. The artist is a direct product of life. He is an apparatus born to be the receptor, the condenser, the transmitter and the reflector of the aspirations, the desires, and the hopes of his age. At times, the artist serves to condense and transmit the desires of millions of proletarians; at times, he serves as the condenser and transmitter only for small strata of the intellectuals or small layers of the bourgeoisie. We can establish it as a basic fact that the importance of an artist can be measured directly by the size of the multitudes whose aspirations and whose life he serves to condense and translate.

 The typical theory of nineteenth-century bourgeois esthetic criticism, namely 'art for art's sake,' is an indirect affirmation of the fact which I have just stressed. According to this theory, the best art is the so-called 'art for art's sake,' or 'pure' art. One of its characteristics is that it can be appreciated only by a very limited number of superior persons. It is implied thereby that only those few superior persons are capable of appreciating that art; and since it is a superior function it necessarily implies the fact that there are very few superior persons in society. This artistic theory which pretends to be a-political has really an enormous political content – the implication of the superiority of the few. Further, this theory serves to discredit the use of art as a revolutionary weapon and serves to affirm that all art which has a theme, a social content, is bad art. It serves, moreover, to limit the possessors of art, to make art into a kind of stock exchange commodity manufactured by the artist, bought and sold on the stock exchange, subject to the speculative rise and fall which any commercialized thing is subject to in stock exchange manipulations. At the same time, this theory creates a legend which envelops art, the legend of its intangible, sacrosanct, and mysterious character which makes art aloof and inaccessible to the masses. [. . .]

 [. . .] Since the proletariat has need of art, it is necessary that the proletariat take possession of art to serve as a weapon in the class struggle. To take possession or

control of art, it is necessary that the proletariat carry on the struggle on two fronts. On one front is a struggle against the production of bourgeois art, – and when I say struggle I mean struggle in every sense – and on the other is a struggle to develop the ability of the proletariat to produce its own art. It is necessary for the proletariat to learn to make use of beauty in order to live better. It ought to develop its sensibilities, and learn to enjoy and make use of the works of art which the bourgeoisie, because of special advantages of training, has produced. Nor should the proletariat wait for some painter of good will or good intentions to come to them from the bourgeoisie; it is time that the proletariat develop artists from their own midst. By the collaboration of the artists who have come out of the proletariat and those who sympathize and are in alliance with the proletariat, there should be created an art which is definitely and in every way superior to the art which is produced by the artists of the bourgeoisie.

Such a task is the program of the Soviet Union today. [...]

[...] [Russian avant-garde artists] carried on a truly heroic struggle to make that art accessible to the Russian masses. They worked under conditions of famine, the strain of revolution and counter revolution, and all the material and economic difficulties imaginable, yet they failed completely in their attempts to persuade the masses to accept Cubism, or Futurism, or Constructivism as the art of the proletariat. Extended discussions of the whole problem arose in Russia. Those discussions and the confusion resulting from the rejection of modern art gave an opportunity to the bad painters to take advantage of the situation. The academic painters, the worst painters who had survived from the old regime in Russia, soon provided competition on a grand scale. Pictures inspired by the new tendencies of the most advanced European schools were exhibited side by side with the works of the worst academic schools of Russia. Unfortunately, those that won the applause of the public were not the new painters and the new European schools but the old and bad academic painters. Strangely enough, it seems to me, it was not the modernistic painters but the masses of the Russian people who were correct in the controversy. Their vote showed not that they considered the academic painters as the painters of the proletariat, but that the art of the proletariat must not be a hermetic art, an art inaccessible except to those who have developed and undergone an elaborate esthetic preparation. The art of the proletariat has to be an art that is warm and clear and strong. It was not that the proletariat of Russia was telling these artists: 'You are too modern for us.' What it said was: 'You are not modern enough to be artists of the proletarian revolution.' The revolution and its theory, dialectical materialism, have no use for art of the ivory tower variety. They have need of an art which is as full of content as the proletarian revolution itself, as clear and forthright as the theory of the proletarian revolution.

In Russia there exists the art of the people, namely peasant art. It is an art rooted in the soil. In its colors, its materials, and its force it is perfectly adapted to the environment out of which it is born. It represents the production of art with the simplest resources and in the least costly form. For these reasons it will be of great utility to the proletariat in developing its own art. The better Russian painters working directly after the Revolution should have recognized this and then built upon it, for the proletariat, so closely akin to the peasant in many ways, would have been able to understand this art. Instead of this the academic artists, intrinsically reactionary, were able to get control of the situation. Reaction in art is not merely a matter of theme. A painter who conserves and uses the worst technique of bourgeois art is a reactionary artist, even

though he may use this technique to paint such a subject as the death of Lenin or the red flag on the barricades. [...]

Mural art is the most significant art for the proletariat. In Russia mural paintings are projected on the walls of clubs, of union headquarters, and even on the walls of the factories. [...] But the easel picture is an object of luxury, quite beyond the means of the proletariat.

* * *

Bourgeois art will cease to develop when the bourgeoisie as a class is destroyed. Great paintings, however, will not cease to give aesthetic pleasure though they have no political meaning for the proletariat. One can enjoy the Crucifixion by Mantegna and be moved by it aesthetically without being a Christian. It is my personal opinion that there is in Soviet Russia today too great a veneration of the past. To me, art is always alive and vital, as it was in the Middle Ages when a new mural was painted every time a new political or social event required one. Because I conceive of art as a living and not a dead thing, I see the profound necessity for a revolution in questions of culture, even in the Soviet Union.

Of the recent movements in art, the most significant to the revolutionary movement is that of Super-Realism. Many of its adherents are members of the Communist Party. Some of their recent work is perfectly accessible to the masses. Their maxim is 'Super-Realism at the service of the Revolution.' Technically they represent the development of the best technique of the bourgeoisie. In ideology, however, they are not fully Communist. And no painting can reach its highest development or be truly revolution-ary unless it be truly Communist.

And now we come to the question of propaganda. (All painters have been propa-gandists or else they have not been painters. Giotto was a propagandist of the spirit of Christian charity, the weapon of the Franciscan monks of his time against feudal oppression. Breughel was a propagandist of the struggle of the Dutch artisan petty bourgeoisie against feudal oppression. Every artist who has been worth anything in art has been such a propagandist.) The familiar accusation that propaganda ruins art finds its source in bourgeois prejudice. Naturally enough the bourgeoisie does not want art employed for the sake of revolution. It does not want ideals in art because its own ideals cannot any longer serve as artistic inspiration. It does not want feelings because its own feelings cannot any longer serve as artistic inspiration. Art and thought and feeling must be hostile to the bourgeoisie today. Every strong artist has a head and a heart. Every strong artist has been a propagandist. I want to be a propagandist and I want to be nothing else. I want to be a propagandist of Communism and I want to be it in all that I can think, in all that I can speak, in all that I can write, and in all that I can paint. I want to use my art as a weapon. [...]

14 Mario Sironi (1885–1961) 'Manifesto of Mural Painting'

After war service, the erstwhile Futurist Sironi became committed to Fascism. After the Fascists took power in Italy in 1922 he became a leading member of the Novecento group in Milan, organized by Mussolini's mistress Margherita Sarfatti. He turned increasingly to classical themes in order to bolster Fascist values through an implied equation with Ancient Rome. This led to an affirmation of mural painting as the art form most appropriate to

Fascism, in virtue of its scale and public accessibility. The 'Manifesto della pittura murale' was also signed by Achille Funi, Massimo Campigli and Carlo Carrà. Originally published in *Colonna*, no. 1, Milan, December 1933. Reproduced in *Les Réalismes 1919–1939*, Paris: Centre Pompidou, 1980, from which the present translation is made.

Fascism is a style of life: it is life itself for Italians. No formula will ever succeed in completely expressing it, let alone defining it. Similarly, no formula will ever succeed in expressing, let alone defining, what is understood as Fascist art, that is to say, an art which is the plastic expression of the Fascist spirit.

Fascist art will be created little by little and will be the result of the slow labour of the best people. That which can and must be done straight away is to free artists from the numerous doubts which linger on.

In the Fascist state art acquires a social function: an educative function. It must translate the ethic of our times. It must give a unity of style and grandeur of contour to common life. Thus art will once again become what it was in the greatest of times and at the heart of the greatest civilizations: a perfect instrument of spiritual direction.

The individualist conception of 'art for art's sake' is dead. As a result of this there is a deep incompatibility between the goals that Fascist art assigns itself and all the forms of art born of the arbitrary, of individualization, of the particular aesthetic of a group, of a coterie, an academy. The great disquiet which troubles all European art is the product of a time of spiritual decomposition. Modern painting, for years and years technical exercises and minute analyses of natural phenomena of Nordic origin, today feels the need for a superior spiritual synthesis.

Fascist art rejects experiments or investigations, the endeavours which the current century has indulged in. It rejects above all the 'consequences' of these investigations, which have unfortunately been prolonged into the present. Although seeming varied and often diverse, these investigations all derive from the vulgar materialist view of life which was characteristic of the past century and which is not only alien to us, but eventually became intolerable.

Mural painting is social painting par excellence. It acts on the popular imagination more directly than any other form of painting, and inspires lesser arts more directly.

The renaissance of mural painting, above all of the fresco, allows the formulation of the problem of Fascist art. The answer is the practical purpose of mural painting (public buildings, public places with a civic function). They are governed by laws; it is the supremacy of the stylistic element over the emotional, it is its intimate association with architecture which forbids the artist from giving way to improvization and simple virtuosity. On the contrary, they oblige the artist to control himself by a decisive and virile technical execution of his task. The technique of mural painting obliges the artist to develop his own imagination and to organize it completely. There is no form of painting in which order and rigour of composition predominate, no form of 'genre' painting, which stands up to these tests set by the technical demands and large dimensions of the mural painting technique.

From mural painting will arise the 'Fascist style' with which the new civilization will be able to identify. The educative function of painting is above all a question of style. The artist will succeed in making an impression on popular consciousness by the style, by the suggestion of climate, rather than by the subject-matter (as the Communists think).

Questions of 'subject' are too simplistic to be essential to the solution. Mere political orthodoxy of 'subject' does not suffice: it is a convenient expedient, erroneously used by the 'advocates of content'. To be in harmony with the spirit of revolution, the style of Fascist painting will have to be antique as well as very new: it will have to resolutely dispense with the hitherto predominant trend of a narrow and monotonous art, based on an alleged, fundamentally false, 'good sense' which reflects neither a 'modern' nor a 'traditional' attitude. It will have to combat all the false returns which bolster an elementary aestheticism and constitute an obvious outrage to any true sense of tradition.

A moral question arises for every artist. The artist must renounce this egocentricity which from now on can only sterilize his spirit, and become a 'militant' artist who serves a moral ideal, subordinating his own individuality to collective work.

We do not intend to advocate practical anonymity, which is repugnant to the Italian temperament, but rather an intimate sense of devotion to collective work. We firmly believe that the artist will become a *man amongst men* as was the case in the most prestigious eras of our civilization.

We do not want to advocate hypothetical agreement on a single artistic formula – which would be practically impossible – but a precise and express artistic will to free art from subjective and arbitrary elements, such as that specious originality, which is desired and sustained only by our vanity.

We believe that the voluntary establishment of a work-discipline is necessary to create true and authentic talent. Our great traditions, principally decorative in character, mural and stylistic, strongly favour the birth of a Fascist style. No elective affinities with the great epochs of our past can be understood without a profound understanding of our time. The spirituality of the beginnings of the Renaissance is closer to us than the splendour of the great Venetians. The art of pagan and Christian Rome is closer to us than Greek art. We have recently come to mural painting by virtue of aesthetic principles which have developed in the Italian spirit since the war. It is not by chance, but by insight into our times that the most audacious experiments of Italian painters have already focused, for years, on mural techniques and stylistic problems. The way forward is indicated by these endeavours, until the necessary unity can be achieved.

15 Andrei Zhdanov (1896–1948) 'Speech to the Congress of Soviet Writers'

After the dissolution of 'competing' art groups in 1932, the principal event determining future Soviet cultural policy was the first Congress of Soviet Writers held in Moscow in August–September 1934. The Congress approved the doctrine of Socialist Realism as the only art appropriate to the 'building of Communism'. Although the Congress was devoted to literature, the doctrine applied across the arts. The keynote address, enunciating the policy of Socialist Realism, was given by Andrei Zhdanov, then Secretary of the Communist Party and Stalin's chief cultural commissar. An English translation of Congress speeches appeared as H. G. Scott (ed.), *Problems of Soviet Literature*, London, 1935. This was reprinted as *The Soviet Writers Congress 1934*, London, 1977. The extracts are taken from pp. 17–18, 19, 20–3. (For a later defence of Socialist Realism see VC9.)

The key to the success of Soviet literature is to be sought for in the success of socialist construction. Its growth is an expression of the successes and achievements of our socialist system. Our literature is the youngest of all literatures of all peoples and countries. And at the same time it is the richest in ideas, the most advanced and the most revolutionary literature. Never before has there been a literature which has organized the toilers and oppressed for the struggle to abolish once and for all every kind of exploitation and the yoke of wage slavery. Never before has there been a literature which has based the subject-matter of its works on the life of the working class and peasantry and their fight for socialism. Nowhere, in no country in the world, has there been a literature which has defended and upheld the principle of equal rights for the toilers of all nations, the principle of equal rights for women. There is not, there cannot be in bourgeois countries a literature which consistently smashes every kind of obscurantism, every kind of mysticism, priest-hood and superstition, as our literature is doing.

* * *

The present state of bourgeois literature is such that it is no longer able to create great works of art. The decadence and disintegration of bourgeois literature, resulting from the collapse and decay of the capitalist system, represent a characteristic trait, a characteristic peculiarity of the state of bourgeois culture and bourgeois literature at the present time. Gone never to return are the times when bourgeois literature, reflecting the victory of the bourgeois system over feudalism, was able to create great works of the period when capitalism was flourishing. Everything now is growing stunted – themes, talents, authors, heroes.

* * *

[...] Those representatives of bourgeois literature who feel the state of things more acutely are absorbed in pessimism, doubt in the morrow, eulogy of darkness, extolment of pessimism as the theory and practice of art. [...]

* * *

That is how matters stand in capitalist countries. Not so with us. Our Soviet writer derives the material for his works of art, his subject-matter, images, artistic language and speech, from the life and experience of the men and women of Dnieprostroy, of Magnitostroy. Our writer draws his material from the heroic epic of the Chelyuskin expedition, from the experience of our collective farms, from the creative action that is seething in all corners of our country.

In our country the main heroes of works of literature are the active builders of a new life – working men and women, men and women collective farmers, Party members, business managers, engineers, members of the Young Communist League, Pioneers. Such are the chief types and the chief heroes of our Soviet literature. Our literature is impregnated with enthusiasm and the spirit of heroic deeds. It is optimistic, but not optimistic in accordance with any 'inward,' animal instinct. It is optimistic in essence, because it is the literature of the rising class of the proletariat, the only progressive and advanced class. Our Soviet literature is strong by virtue of the fact that it is serving a new cause – the cause of socialist construction.

Comrade Stalin has called our writers engineers of human souls. What does this mean? What duties does the title confer upon you?

In the first place, it means knowing life so as to be able to depict it truthfully in works of art, not to depict it in a dead, scholastic way, not simply as 'objective reality,' but to depict reality in its revolutionary development.

In addition to this, the truthfulness and historical concreteness of the artistic portrayal should be combined with the ideological remoulding and education of the toiling people in the spirit of socialism. This method in *belles lettres* and literary criticism is what we call the method of socialist realism.

Our Soviet literature is not afraid of the charge of being 'tendentious.' Yes, Soviet literature is tendentious, for in an epoch of class struggle there is not and cannot be a literature which is not class literature, not tendentious, allegedly non-political.

And I think that every one of our Soviet writers can say to any dull-witted bourgeois, to any philistine, to any bourgeois writer who may talk about our literature being tendentious: 'Yes, our Soviet literature is tendentious, and we are proud of this fact, because the aim of our tendency is to liberate the toilers, to free all mankind from the yoke of capitalist slavery.'

To be an engineer of human souls means standing with both feet firmly planted on the basis of real life. And this in its turn denotes a rupture with romanticism of the old type, which depicted a non-existent life and non-existent heroes, leading the reader away from the antagonisms and oppression of real life into a world of the impossible, into a world of utopian dreams. Our literature, which stands with both feet firmly planted on a materialist basis, cannot be hostile to romanticism, but it must be a romanticism of a new type, revolutionary romanticism. We say that socialist realism is the basic method of Soviet *belles lettres* and literary criticism, and this presupposes that revolutionary romanticism should enter into literary creation as a component part, for the whole life of our Party, the whole life of the working class and its struggle consist in a combination of the most stern and sober practical work with a supreme spirit of heroic deeds and magnificent future prospects. Our Party has always been strong by virtue of the fact that it has united and continues to unite a thoroughly business-like and practical spirit with broad vision, with a constant urge forward, with a struggle for the building of communist society. Soviet literature should be able to portray our heroes; it should be able to glimpse our tomorrow. This will be no utopian dream, for our tomorrow is already being prepared for today by dint of conscious planned work.

One cannot be an engineer of human souls without knowing the technique of literary work, and it must be noted that the technique of the writer's work possesses a large number of specific peculiarities.

You have many different types of weapons. Soviet literature has every opportunity of employing these types of weapons (genres, styles, forms and methods of literary creation) in their diversity and fullness, selecting all the best that has been created in this sphere by all previous epochs. From this point of view, the mastery of the technique of writing, the critical assimiliation of the literary heritage of all epochs, represents a task which you must fulfil without fail, if you wish to become engineers of human souls.

Comrades, the proletariat, just as in other provinces of material and spiritual culture, is the sole heir of all that is best in the treasury of world literature. The bourgeoisie has squandered its literary heritage; it is our duty to gather it up carefully, to study it and, having critically assimilated it, to advance further.

To be engineers of human souls means to fight actively for the culture of language, for quality of production. Our literature does not as yet come up to the requirements of our era. The weaknesses of our literature are a reflection of the fact that people's

consciousness lags behind economic life – a defect from which even our writers are not, of course, free. That is why untiring work directed towards self-education and towards improving their ideological equipment in the spirit of socialism represents an indispensable condition without which Soviet writers cannot remould the mentality of their readers and thereby become engineers of human souls.

16 David A. Siqueiros (1896–1974) 'Towards a Transformation of the Plastic Arts'

Like his fellow Mexican muralists Rivera and Orozco, Siqueiros undertook commissions in the United States in the 1930s. The current essay was written in New York in 1934. It forms an expansion of his earlier 'Declaration' of 1922 (IVB4), developing the theme of the necessity of a public mural art. Notably, however, as well as attacks on the avant-garde, the essay contains severe, albeit veiled, criticism of Rivera, both for the style of his murals and for the Trotskyist politics underlying them. The present translation, by Sylvia Calles, is taken from Siqueiros, op. cit., pp. 45–8. (For a later text by Siqueiros see VC20.)

Painters, sculptors, engravers, newspaper illustrators, photographers, architects (Mexicans, South Americans, North Americans, Europeans), we have decided to *foment* an international movement to transform the *plastic arts*.

Our movement is based on critical analysis of the two great contemporary art experiences: the Paris movement and the modern Mexican movement usually known as the Mexican Renaissance. *Both these movements are disintegrating today.*

One of our valuable antecedents is the mechanical techniques used by Siqueiros in the groups he formed in Los Angeles and Buenos Aires; the *Mural Painters Group of Los Angeles* and the *Polygraphic team of Buenos Aires*.

What do we want?

We want to produce an art which will be *physically* capable of serving the *public* through its *material form*. True art forms which will reach far and wide. This art must be commercialized according to the possibilities of each country, in order to avoid the *bourgeois élitism* of European art and the *tourist-oriented bureaucracy* of Mexican art. We must rid ourselves of the European Utopia of *art for art's sake*, and also of Mexican *demagogic opportunism*. We must put an end to superficial *folk art*, of the type called '*Mexican Curious*' which predominates in Mexico today, and substitute for it an art which is internationally valid though based on local antecedents and functional elements.

We must coordinate our abilities and experiences and work together as a technical team. We must put an end to the *egocentrism* of modern European art and the false *collectivism* of official Mexican art, with its 'socialism'. We shall both learn and teach our new art in the *course of producing it: theory and practice will go together*. We shall put an end to sterile *verbal didactic* teaching, which has produced nothing of value in the last four hundred years of academism, and which even today is still the only method of teaching art both in Mexico and all over the world.

We must make use of all the *modern tools and materials* which serve the purpose of our art, and put an end to the incredible technical anachronism to be found in Mexico and Europe. Instead, we shall establish the fundamental premise that *art movements should always develop in accordance with the technical possibilities of their age.* Modern technique and mechanics have made such enormous progress that they can enrich our creative capacity beyond our wildest imagination. Unfortunately artists today seem to know nothing of the science and technology from which their materials evolve, and their knowledge is restricted to knowing in which shop to buy them. Modern industry has made revolutionary changes in the chemistry of pigments which modern artists know nothing whatever about.

We must develop a *polygraphic art* which will combine both plastic and graphic art and provide a greater potential for artistic expression. Art must no longer be separated into units, either pure painting or pure sculpture, it must find a new, more powerful, more modern language which will give it much greater repercussion and validity as an art expression.

We must use *new, dialectic* forms, rather than *dead, scholarly, mechanical* ones. We must evolve a *dynamic graphic art* in tune with the *dynamism of the world today*, and we must rid ourselves of *mysticism*, of *snobbish 'archaeologism'*, and the other defects of modern art in both Europe and Mexico.

Our art must have a *real scientific basis*. We must get rid of the *empiricism*, and *emotivism* which have characterized the art movements of the world until today. For the first time in history, we shall find *scientific* truths which can be proved, either physically, chemically, or psychologically. In this way we will be able to forge a strong connection between art and science.

We must foment the teaching of *exterior mural painting*, public painting, in the street, in the sunlight, on the sides of tall buildings instead of the advertisements you see there now, in strategic positions where the people can see them, mechanically produced and materially adapted to the realities of modern construction. We must put an end to tourist-inspired *Mexican muralism* with its archaic technique, and bureaucracy; murals painted in out of the way places and which only emerge from hiding in select monographs published for foreign amateurs. We will be preparing ourselves for the society of the future, in which our type of art will be preferred to all others, because it is the effective daily expression of art for the masses.

We shall, *of course*, conserve all the absolute values of the other art movements, because we feel that tradition is an accumulation of experiences on which our work must be based. This is even more important since our movement is a *classical* movement, in as much as it responds to the social and technical realities of the moment in which it exists.

We shall give practical form to our theories by creating *workshop schools of plastic and graphic art*, from which we shall exclude archaic, livid monocopy forms and procedures, such as easel painting; we shall exclude everything which cannot be reproduced, we shall exclude exhibitions in 'distinguished' galleries for the benefit of amateurs and critics, expensive limited editions, in fact everything which can be considered art for the private collector and for a privileged élite. In this way we shall be consequential with our own period of history, and we shall be anticipating the art forms of the future. In this way we shall provide an immediate and evident service to the great masses and to all humanity.

In our workshop schools we will develop *polychromed engraving* (both the traditional and, more especially the modern), *polychromed lithography* (traditional and modern); *large editions of polychromed posters* (mechanically printed); *photo-engraving* (by experimental methods); *scenography; applied painting* (on standards, flags, posters, curtains and commercial art); *reproducible polychromed sculpture* (made of cement, plaster cement and all other modern materials); *photo-genic painting* (all our artwork must be able to be photographically reproduced); *photo-montage, cliché montage* (applicable to all kinds of graphic reproduction); *documentary photography and cinema*; manual and mechanical printing (the problem of printing is fundamental to all popular art); *modern mural painting* (on cement, with silicates, using a spray gun and other applicable tools or mechanical means such as electro-ceramics, etc.); *the chemical theory and practice of pigments and all other art materials* (to prove the great superiority of modern materials over traditional ones); *descriptive geometry and industrial drawing*; the *social history of the arts* (rather than anecdotism).

As for publicity, we shall have *simultaneous exhibitions* (in private buildings belonging to organizations and in public places; at home and abroad); *co-ordinated exhibitions* (of multiple painting and photogenic art); we will publish *popular monographs* (at prices accessible to the people); we shall set up *permanent sales posts* (in towns and villages, in factories, etc.); we will try to make *direct sales of personal work* (in order to help our collaborators, etc.). Our workshop schools will have a publicity section which will take charge of this commercial programme and invent new sales methods, because we feel that our economic development depends on our finding a way to commercialize our products in accordance with the possibilities of the masses.

17 Stuart Davis (1894–1964) and Clarence Weinstock (1910–1964) 'Abstract Painting in America', 'Contradictions in Abstractions' and 'A Medium of 2 Dimensions'

This exchange offers a revealing insight into left-wing artistic debates in the 1930s in the United States. Davis was a painter whose work tended towards abstraction. He did not embrace an art-for-art's-sake position, however, at least not as usually characterized by the Left. To the contrary, he addressed the economic condition of American artists during the Depression, and was prominent in the Artists' Union. The first extract is taken from Davis's Introduction to the catalogue of an exhibition at the Whitney Museum of American Art, New York, February–March 1935. In brief, it is a defence of abstract art. This essay was countered in the pages of *Art Front* by the magazine's editor, Clarence Weinstock (vol. 1, no. 4, New York, April 1935). Weinstock opposes Davis from a fundamentally Social Realist position, claiming that a figurative art alone can adequately address the conflicts of the modern world. Davis's response, published in *Art Front*, May 1935, is to claim that abstract art is itself revolutionary with respect to the bourgeois figurative tradition, and materialist with respect to the very means from which it is made. This latter, he claims, may be to the ultimate advantage of the abstract artist in reacting to the problems of contemporary life. The Davis extracts are reprinted in D. Kelder, *Stuart Davis*, New York, 1971, pp. 112–16. The Weinstock text is reproduced from *Art Front*. Passages included in quotation marks at the end of Davis's second text were among sections omitted from the printed version of his first.

[...] I begin very, very broadly by saying that the American artist became conscious of abstract art by the impact of the Armory Show in 1913. [...] There was no American artist who saw this show but was forced to revalue his artistic concepts. The final charge was touched off in the foundations of the autocracy of the Academy in a blast which destroyed its strangle hold on critical art values forever. Henceforth the American artist realized his right to free expression and exercised that right. [...]

[...] What is abstract art? The question will be answered differently by each artist to whom the question is put. This is so because the generative idea of abstract art is alive. It changes, moves and grows like any other living organism. However, from the various individual answers some basic concordance could doubtless be abstracted. This basic concordance of opinion would be very elementary and would probably run something like this. Art is not and never was a mirror reflection of nature. All efforts at imitation of nature are foredoomed to failure. Art is an understanding and interpretation of nature in various media. Therefore in our efforts to express our understanding of nature we will always bear in mind the limitations of our medium of expression. Our pictures will be expressions which are parallel to nature and parallel lines never meet. We will never try to copy the uncopyable but will seek to establish a material tangibility in our medium which will be a permanent record of an idea or emotion inspired by nature. This being so, we will never again ask the question of painting, 'Is it a good likeness, does it look like the thing it is supposed to represent?' Instead we will ask the question, 'Does this painting which is a defined two-dimensional surface convey to me a direct emotional or ideological stimulus?' Since we forego all efforts to reflect optical illusions and concentrate on the reality of our canvas, we will now study the material reality of our medium, paint on canvas or whatever it may be. The approach has become scientifically experimental. A painting for example is a two-dimensional plane surface and the process of making a painting is the act of defining two-dimensional space on that surface. Any analogy which is drawn from our two-dimensional expression to three-dimensional nature will only be forceful in the degree to which our painting has achieved a two-dimensional clarity and logic.

The above is my idea of the basic implications in the abstract concept and I think it is implicit in all the various explanations and viewpoints which have been advanced about abstract art. The American artists who from various angles have oriented themselves about the abstract idea have not in all cases been as wholeheartedly scientific as the above considerations would seem to call for. However, I believe that even in those cases where the artistic approach has been almost entirely emotional, the concept of the autonomous existence of the canvas as a reality which is parallel to nature has been recognized. [...] [DAVIS]

Any painting may be considered abstract at a certain stage of analysis, that stage in which only the colour-form categories are being studied. The rankest illustration has that privilege. On the other hand the most abstract painting may be looked at as though it were the most concrete representation of imagined objects, simple or complex, in arbitrary space relations.

Mr Davis says a painting is a 'two-dimensional plane surface, and the process of making a painting is the act of defining two-dimensional space on that surface'. This seems an extremely mechanical definition in that it is confined only to the physical description of a canvas, and to the act of composition. It is like the behaviourist descrip-

tion of a thought as covert mouth muscle moving. It is also an anti-dialectical definition, in that the emergence of quality is in no way suggested, not even by the next statement, which is 'Any analogy which is drawn from our two-dimensional expression to three-dimensional nature will only be forceful in the degree to which our painting has achieved a two-dimensional clarity and logic.' But how can an analogy arise between the merely parallel systems of art and nature? As to two-dimensional clarity and logic, the poet fulfils the same demand when he objectifies his similes and metaphors, makes them stand on their own legs as things in their own right. But just as the poet's metaphors could not exist unless there were some element in common between the things to which they apply and themselves, so this two-dimensional clarity and logic could never produce analogies to three-dimensional nature unless the systems of art and nature were not parallel but continuous, unless there were a dynamic relation between the experience of events and aesthetic experience. Meaning is the element in terms of which nature and art are united, and just meaning is omitted from this abstract conception of painting. Thus, abstract art is produced by an intention founded on a limited definition of painting in general. Its pursuit demands of the artist a fiery passion for form, in fact one might say it can be justified only when this passion exists. But this passion is too confined, it burns only in one corner of the eye. Form becomes like so much monopoly capital to which the society of art is sacrificed.

The absence of meaning, that is, of an apprehension of objects in much more than their visual character, determines the fatal contradiction of abstract art. It makes this art like the intellectualist philosophy of scholasticism, based on a faith in God. Here all the clarity and logic are based on faith in the spectator, on a naive hope that he will make the same interpretation of the colour forms that the artist did. That this hope is not valid is proven by the frequent question of simple people and workers, 'What does it mean?' They are not prepared to take the liberties with an artist's work at which no lorgnetted art lover hesitates.

No meaning is the equivalent of *any* meaning. Thus an abstract painting is at the mercy of whatever physical associations the spectator has in mind which may make alterations of planes and masses running directly counter to the intention of the artist . . .

An art in which emotion and ideology are so random must lose out amidst modern conflict. It can exist only in relatively undisturbed societies, or where an artificial stability has been temporarily built by a small section of society, rich patrons and dependent creators. This breakwater, leaky at all times, is now washed away. [. . .]

With this world in advancing motion before him, with men breaking through cruelty, hunger, imperialism, fascism, war, to a consciousness of them, for power over them, can the modern artist deny the claim of all meaningful experience to be subject for him? He can, but not very lightly. [WEINSTOCK]

Mr. Weinstock finds contradictions in abstract art in his comments on the 'Abstract Painting in America' exhibition at the Whitney Museum. There is nothing surprising in this as Mr Weinstock is supposedly an advocate of the general theory of dialectical materialism, in which nature and society are perceived to be in a constant state of revolutionary movement through the struggle of the contradictions or opposites present in all unities.

I think that in searching for the contradictions he has overlooked some very apparent affirmations. One, that abstract painting actually does exist. Two, that a number of abstract paintings of the last twenty-five years clearly come within the field of first-rate art. Three, the revolutionary history of abstract painting.

[...] In his desire to affirm the approaching revolutionary art of the international labor movement he is undialectical in his tendency to deny the reality of bourgeois origins and concomitants. For example, in the recent exhibitions of painting and sculpture at the Artists' Union, there were quite a few exhibits well within the category of abstract art, and no one could say that they were among the worst of the exhibits. True, these abstractions were not in general the expression of that class consciousness which a more lengthy participation in any union activities tends to produce. But these, and all abstractions, were the result of a revolutionary struggle relative to the bourgeois academic traditions of the immediate past and even the present. In the materialism of abstract art in general, is implicit a negation of many ideals dear to the bourgeois heart. Abstract art will in turn be negated along with its bourgeois associations, but in our awareness of this let us see the situation realistically and admit that abstract art is still in the picture. Does Mr Weinstock pretend that the abstract tendencies in painting and the Fascist tendencies of the American Scene school of Benton, etc.. are both alike because they are both within the bourgeois scheme? Such a view would not seem to be realistic.

In regard to Mr Weinstock's criticism of my introduction to the catalogue of the Abstract Show at the Whitney Museum, I can well imagine that the introduction is open to criticism. However, I am not sure that the points selected by Mr Weinstock are the weakest. My description of a painting as a two-dimensional space definition which is parallel to nature, and which is forceful to the degree of its logical clarity, he finds inadequate and undialectical. Perhaps it is, to one not too familiar with the subject, but with this theory I have gotten results which are admitted to be good relative to the time and place. The definition assumed that the artist was already in possession of an idea which was the result of his contact with nature, which idea was qualitatively different [from] the sum of the sources of its generation. Add conditioning by the mind material and the emergence of a new quality by its transference to a medium of two dimensions, the canvas. Maybe the use of the phrase 'parallel to nature' is incorrect from the standpoint of philosophical usage. But the definition was meant to be a description of the material quality of a painting and did not by intention imply that because the painting was a quality distinct from its sources, it had no connection with them. Further, it did not by intention imply that the two-dimensional space definition was an act undirected by social purpose.

[...] 'The adherents of this school argue that abstract art was divorced from reality, that it had no contact with the people. While admitting its technical contributions they deny it any cultural validity. Because fundamentally the concern of the abstract artist had been his own canvas and a select group of those interested in art. The abstract artist did not concern himself with the life problems of the people around him. Therefore, says the social-content school, he has betrayed his place of trust as cultural leader. He has not been realistic.'

'But the abstract artist was realistic at least with regard to his materials.'

'If the historical process is forcing the artist to relinquish his individualistic isolation and come into the arena of life problems, it may be the abstract artist who is best

equipped to give vital artistic expression to such problems – because he has already learned to abandon the ivory tower in his objective approach to his materials.'

[DAVIS]

18 Grant Wood (1892–1942) from *Revolt Against the City*

The author was a prominent Regionalist, a representative of 'American Scene' painting in the 1930s. Whereas the other major school of contemporary figurative painting, Social Realism, was associated with urban conditions and the political Left, Regionalism tended to espouse conservative values as embodied in the American agricultural heartland. Both were suspicious of the avant-garde. Wood's pamphlet was originally issued by the independent publisher Frank Luther Mott in Iowa City, 1935. It is reprinted as an Appendix to James M. Dennis, *Grant Wood: A Study in American Art and Culture*, New York, 1975, from which the present extracts are taken. (PWA refers to the Public Works of Art Project, later the Federal Arts Project, under which American artists were given employment between 1933 and 1943, many of them on the decoration of public buildings.)

... Painting has declared its independence from Europe, and is retreating from the cities to the more American village and country life. Paris is no longer the Mecca of the American artist. The American public, which used to be interested solely in foreign and imitative work, has readily acquired a strong interest in the distinctly indigenous art of its own land; and our buyers of paintings and patrons of art have naturally and honestly fallen in with the movement away from Paris and the American pseudo-Parisians. It all constitutes not so much a revolt against French technique as against the adoption of the French mental attitude and the use of French subject matter in favour of an American way of looking at things, and a utilization of the materials of our own American scene.

This is no mere chauvinism. If it is patriotic, it is so because a feeling for one's own milieu and for the validity of one's own life and its surroundings is patriotic. Certainly I prefer to think of it, not in terms of sentiment at all, but rather as a common-sense utilization for art of native materials – an honest reliance by the artist upon subject matter which he can best interpret because he knows it best.

Because of this new emphasis upon native materials, the artist no longer finds it necessary to migrate even to New York, or to seek any great metropolis. No longer is it necessary for him to suffer the confusing cosmopolitanism, the noise, the too intimate gregariousness of the large city. True, he may travel, he may observe, he may study in various environments, in order to develop his personality and achieve backgrounds and a perspective; but this need be little more than incidental to an educative process that centers in his own home region.

* * *

Let me try to state the basic idea of the regional movement. Each section has a personality of its own, in physiography, industry, psychology. Thinking painters and writers who have passed their formative years in these regions, will, by care-taking analysis, work out and interpret in their productions these varying personalities. When the different regions develop characteristics of their own, they will come into competition with each other; and out of this competition a rich American culture will grow. It

was in some such manner that Gothic architecture grew out of competition between different French towns as to which could build the largest and finest cathedrals. And indeed the French Government has sponsored a somewhat similar kind of competition ever since Napoleon's time.

The germ of such a system for the United States is to be found in the art work recently conducted under the PWA. This was set up by geographical divisions, and it produced remarkable results in the brief space of time in which it was in operation. I should like to see such encouragement to art work continued and expanded. The Federal Government should establish regional schools for art instruction to specially gifted students in connection with universities or other centers of culture in various sections.

In suggesting that these schools should be allied with the universities, I do not mean to commit them to pedantic or even strictly academic requirements. But I do believe that the general liberal arts culture is highly desirable in a painter's training. The artist must know more today than he had to know in former years. My own art students, for example, get a general course in natural science – not with any idea of their specializing in biology or physics, but because they need to know what is going on in the modern world. The main thing is to teach students to think, and if they can to feel. Technical expression, though important, is secondary; it will follow in due time, according to the needs of each student. Because of this necessity of training in the liberal arts, the Government art schools should be placed at educational centers.

The annual exhibits of the work of schools of this character would arouse general interest and greatly enlarge our American art public. A local pride would be excited that might rival that which even hard-headed business men feel for home football teams and such enterprises. There is nothing ridiculous about such support; it would be only a by-product of a form of public art education which, when extended over a long period of time would make us a great art-loving nation.

Mural painting is obviously well adapted to Government projects, and it is also highly suitable for regional expression. It enables students to work in groups, to develop original ideas under proper guidance, and to work with a very definite purpose. I am far from commending all the painting that has gone onto walls in the past year or two, for I realize there has not been much success in finding a style well suited to the steel-construction building; but these things will come, and there is sure to be a wonderful development in mural painting within the next few years. In it I hope that art students working with Government aid may play a large part. My students at the State University of Iowa hope to decorate the entire University Theater, when the building is finished, in true fresco; and there is to be regional competition for the murals and sculpture in three new Iowa post offices . . .

I am willing to go so far as to say that I believe the hope of a native American art lies in the development of regional art centers and the competition between them. It seems the one way to the building up of an honestly art-conscious America. [. . .]

But whatever may be the future course of regional competitions, the fact of the revolt against the city is undeniable. Perhaps but few would concur with Thomas Jefferson's characterization of cities as 'ulcers on the body politic'; but, for the moment at least, much of their lure is gone. Is this only a passing phase of abnormal times? Having at heart a deep desire for a widely diffused love for art among our whole people, I can only hope that the next few years may see a growth of non-urban and regional activity in the arts and letters.

19 Francis Klingender (1907–1955) 'Content and Form in Art'

Originally trained as an economist and historian, Klingender none the less conceived art as possessed of a significant social role, as what he called 'one of the great value-forming agencies in the social structure'. An orthodox Marxist, he was during the 1930s a member of the executive committee of the London-based Artists' International Association. The present text was originally written as one of five contributions to an AIA symposium on the subject of 'Revolutionary Art'. This resulted in the publication *Five on Revolutionary Art*, ed. Betty Rea, London, 1935, from pp. 27–8 and 41–4 of which the present extract is taken. (For a later text by Klingender see VC2.)

Like all other forms of social consciousness art is an expression of social existence, an ideological reflection of the everchanging forms which the struggle between social man and nature assumes in the process of human development. If we are to analyse art, we must thus commence by analysing the social group whose art it is. The character of any given phase of social reality is objectively determined first by its technical equipment for the struggle with nature, by its productive resources, and secondly by the specific manner in which its individual members co-operate with one another in applying their technique to the tasks of production. In all phases of social development intermediary between the classless communities of the early hunting tribes and the classless society of Communism the latter criterion is expressed in the class structure of the given social unit.

Art, however, is more than a mere reflection of social reality. It is at the same time, and even primarily, a revolutionary agent for the transformation of that reality. Untrammelled by the rigid fetters of transcendental dogma, without, on the other hand, having to resort to the lengthy processes of logical deduction and experimental verification, art is the most spontaneous form of social consciousness. As such it immediately reacts to any change in the basic factors of existence, it immediately senses the resulting discrepancy between the new conditions of life and the old forms of consciousness, which it at once sets about to transform. In continually changing the consciousness of man, art is one of the most powerful and indispensable allies of all forces of advance.

Viewed in this light, the problem of content assumes an entirely new significance. Content is not, what it necessarily appears to be if art is approached as an independent entity, if the study of art is divorced from the study of social reality, the mere 'literary' subject-matter of art, its history is not mere iconography. The content of art is an expression of the peculiar emotional and intellectual response of a given social group to the material conditions of its existence, a response that is given an immediately convincing, because emotionally heightened, *form* in art. Form without content, form torn from its vital source of social existence must necessarily be sterile. The negation of content leaves art a lifeless abstraction doomed to decay. Form is the language by which content is communicated, to remain convincing it must change with every change of the content it is destined to express. Content and form are thus the inseparable poles of a greater unity, the unity of style that has its roots in the mother soil of social reality.

* * *

The conquest of nature was the great historical mission of capitalism. By training the former small-scale producers in the discipline of collective work, by equipping that new working class with the tools of modern science and industry and thus raising the productivity of man at a hitherto unheard of rate, capitalism produced the material conditions required for the successful establishment of a free, classless, society. This progressive role of the bourgeoisie was embodied in the mechanical materialism of 19th century science and in the objective realism culminating in the art of Courbet.

Once the technical revolution was achieved, as it was in the France of the 1870s, the continued existence of capitalist accumulation with its symptoms of permanent poverty for the great mass of the population and of the rapid enrichment of a small minority (symptoms indispensable for its specific task of rapidly increasing the productivity of human labour) ceased to be a historical necessity. The capitalist class joined the forces of reaction, the proletariat took its place as the vanguard of human progress.

The historical task of the proletariat is the solution of the problem of human relations in society: the abolition of class exploitation and the transfer of the means of production to society that alone enables the new mastery over nature to be applied for increasing the welfare of all. Thus the next step in the *content* sphere of art is the step from the objective interpretation of nature to the active transformation of social reality (a step corresponding to the replacement of mechanical by dialectic, historical, materialism). The defeat of the Commune and the social ostracism of the progressive bourgeois artists who had dared openly to support it (the campaign of deliberate calumny of which Courbet was the victim, a campaign persisting even in recent art historical literature, has its equal only in the heresy hunts of the mediæval inquisition), for a long time delayed this step.

The development of modern art from impressionism to abstract form has, I submit, the following two-fold significance: in the first place it embodies the ever more frantic flight from content, i.e. from social reality, from all reality whatever, of the retrogressive capitalist class. Even during the imperialist era, however, the scientific and technical conquest of nature continued to proceed at a rapid rate, although its fruits could not increase the welfare of man, were in fact applied to the more efficient destruction of man, as long as it remained fettered to the interests of monopoly capitalism. In the same way the progressive energies of the artists, barred as they were by their service to the bourgeoisie from the vital sphere of content, found an escape in the revolutionary transformation of the technique of perception, of artistic communication, of form, a transformation embodying all the optical, acoustic, mechanical achievements of modern science (the conquest of light and colour, photography, the film, steel and concrete construction, etc.). It is only necessary to look at any ordinary news reel in order to realize how greatly our most elementary responsiveness to shape and sound has been enlarged by the technical discoveries of modern art. Nevertheless, as long as this technical revolution remains fettered to the escape from content of a decaying class, to the extent that it submits to the negation of content, modern art inevitably sinks to the level of pure experimentation for the discovery of new facts concerning the psycho-physical response of the human organism at the present time to different types of shape and colour patterns: to the level, in fact, of the kaleidoscope and of the Montessori bricks. Far from achieving the emancipation of art, the destruction of content necessarily leads to the destruction also of form – a climax epically symbolized in the white square painted on a white canvass of square

shape by the suprematist Malevitch. In its final decay the capitalist class destroys its art, as it destroys its science.

Impoverished, reduced to the income level of the skilled factory hand, or un-employed, the scientist, the technician, the artist increasingly comes to see in the working class of today the standard bearer of all human progress. Transfused with the vital energy of the new social content the technical achievements of modern art will at last lead to an undreamed of enrichment of human experience.

20 Adolf Hitler (1889–1945) Speech Inaugurating the 'Great Exhibition of German Art'

The exhibition of 'Degenerate Art' ('*Entartete Kunst*') was held in Munich in the summer of 1937. Representative works of avant-garde art were presented as evidence of corruption, madness and 'cultural bolshevism': the work, as Hitler put it in 1935, of 'fools, liars, or criminals who belong in insane asylums or prisons'. Concurrently the Nazis mounted an exhibition of 'true German art' in the Haus der Deutschen Kunst, also in Munich. Hitler's inaugural speech was originally published as 'Der Führer eröffnet die Grosse Deutsche Kunstausstellung 1937' in *Die Kunst im Dritten Reich*, I, nos. 7–8, Munich, July–August 1937, pp. 47–61. The present extracts are taken from the English translation by Ilse Falk published in H. B. Chipp (ed.), *Theories of Modern Art*, Berkeley, CA, and London, 1968, pp. 474–83. (See also IVB9.)

[...] That flood of slime and ordure which the year 1918 belched forth into our lives was not a product of the lost war, but was only freed in its rush to the surface by that calamity. Through the defeat, an already thoroughly diseased body experienced the total impact of its inner decomposition. Now, after the collapse of the social, economic, and cultural patterns which continued to function in appearance only, the baseness already underlying them for a long time, triumphed, and indeed this was so in all strata of our life.

[...] On (these) cultural grounds, more than on any others, Judaism had taken possession of those means and institutions of communication which form, and thus finally rule over public opinion. Judaism was very clever indeed, especially in employing its position in the press with the help of so-called art criticism and succeeding not only in confusing the natural concepts about the nature and scope of art as well as its goals, but above all in undermining and destroying the general wholesome feeling in this domain....

Art, on the one hand, was defined as nothing but an international communal experience, thus killing altogether any understanding of its integral relationship with an ethnic group. On the other hand its relationship to time was stressed, that is: There was no longer any art of peoples or even of races, but only an art of the times. [...]

According to such a theory, as a matter of fact, art and art activities are lumped together with the handiwork of our modern tailor shops and fashion industries. And to be sure, following the maxim: Every year something new. One day Impressionism, then Futurism, Cubism, maybe even Dadaism, etc. A further result is that even for the most insane and inane monstrosities thousands of catchwords to label them will have to be found, and have indeed been found. If it weren't so sad in one sense, it would almost be

a lot of fun to list all the slogans and clichés with which the so-called 'art initiates' have described and explained their wretched products in recent years. . . .

Until the moment when National-Socialism took power, there existed in Germany a so-called 'modern art,' that is, to be sure, almost every year another one, as the very meaning of this word indicates. National-Socialist Germany, however, wants again a 'German Art,' and this art shall and will be of eternal value, as are all truly creative values of a people. Should this art, however, again lack this eternal value for our people, then indeed it will mean that it also has no higher value today.

When, therefore, the cornerstone of this building was laid, it was with the intention of constructing a temple, not for a so-called modern art, but for a true and everlasting German art, that is, better still, a House for the art of the German people, and not for any international art of the year 1937, '40, '50 or '60. For art is not founded on time, but only on peoples. It is therefore imperative for the artist to erect a monument, not so much to a period, but to his people. For time is changeable, years come and go. Anything born of and thriving on a certain epoch alone, would perish with it. And not only all which had been created before us would fall victim to this mortality, but also what is being created today or will be created in the future.

But we National-Socialists know only one mortality, and that is the mortality of the people itself. Its causes are known to us. As long as a people exists, however, it is the fixed pole in the flight of fleeting appearances. It is the being and the lasting permanence. And, indeed, for this reason, art as an expression of the essence of this being, is an eternal monument. . . .

* * *

Art can in no way be a fashion. As little as the character and the blood of our people will change, so much will art have to lose its mortal character and replace it with worthy images expressing the life-course of our people in the steadily unfolding growth of its creations. Cubism, Dadaism, Futurism, Impressionism, etc., have nothing to do with our German people. For these concepts are neither old nor modern, but are only the artifactitious stammerings of men to whom God has denied the grace of a truly artistic talent, and in its place has awarded them the gift of jabbering or deception. I will therefore confess now, in this very hour, that I have come to the final inalterable decision to clean house, just as I have done in the domain of political confusion, and from now on rid the German art life of its phrase-mongering.

'Works of art' which cannot be understood in themselves but, for the justification of their existence, need those bombastic instructions for their use, finally reaching that intimidated soul, who is patiently willing to accept such stupid or impertinent nonsense – these works of art from now on will no longer find their way to the German people.

All those catchwords: 'inner experience,' 'strong state of mind,' 'forceful will,' 'emotions pregnant with the future,' 'heroic attitude,' 'meaningful empathy,' 'experienced order of the times,' 'original primitivism,' etc. – all these dumb, mendacious excuses, this claptrap or jabbering will no longer be accepted as excuses or even recommendations for worthless, integrally unskilled products. [. . .]

I have observed among the pictures submitted here, quite a few paintings which make one actually come to the conclusion that the eye shows things differently to certain human beings than the way they really are, that is, that there really are men who see the present population of our nation only as rotten cretins; who, on principle, see meadows blue, skies green, clouds sulphur yellow, and so on, or, as they say, experience them as such. I do not want to enter into an argument here about the question of

whether the persons concerned really do or do not see or feel in such a way; but, in the name of the German people, I want to forbid these pitiful misfortunates who quite obviously suffer from an eye disease, to try vehemently to foist these products of their misinterpretation upon the age we live in, or even to wish to present them as 'Art.'

No, here there are only two possibilities: Either these so-called 'artists' really see things this way and therefore believe in what they depict; then we would have to examine their eyesight-deformation to see if it is the product of a mechanical failure or of inheritance. In the first case, these unfortunates can only be pitied; in the second case, they would be the object of great interest to the Ministry of Interior of the Reich which would then have to take up the question of whether further inheritance of such gruesome malfunctioning of the eyes cannot at least be checked. If, on the other hand, they themselves do not believe in the reality of such impressions but try to harass the nation with this humbug for other reasons, then such an attempt falls within the jurisdiction of the penal law.

This House, in any case, has neither been planned, nor was it built for the works of this kind of incompetent or art criminal....

[...] No, I say. The diligence of the builder of this House and the diligence of his collaborators must be equaled by the diligence of those who want to be represented in this House. Beyond this, I am not the least bit interested in whether or not these 'also-rans' of the art world will cackle among themselves about the eggs they have laid, thereby giving to each other their expert opinion.

For the artist does not create for the artist, but just like every one else he creates for the people.

And we will see to it that from now on the people will once again be called upon to be the judges of their own art....

I do not want anybody to have false illusions: National-Socialism has made it its primary task to rid the German Reich, and thus, the German people and its life of all those influences which are fatal and ruinous to its existence. And although this purge cannot be accomplished in one day, I do not want to leave the shadow of a doubt as to the fact that sooner or later the hour of liquidation will strike for those phenomena which have participated in this corruption.

But with the opening of this exhibition the end of German art foolishness and the end of the destruction of its culture will have begun.

From now on we will wage an unrelenting war of purification against the last elements of putrefaction in our culture. [...]

* * *

IVC
Realism as Critique

1 Leon Trotsky (1879–1940) from *Literature and Revolution*

Trotsky's book is the most sustained contribution by a leading Bolshevik politician to the debate on art initiated by the Russian Revolution. In contrast to later, official interventions, it is marked by a comparative openness to the avant-garde, and by a general assertion of the relative autonomy of art. These extracts are mainly concerned with the Soviet avant-garde and with a critical conception of realism in art. The 'Lef' mentioned at the outset refers to the group 'Left Front of the Arts' organized in 1923 by the poet Mayakovsky around the journal of the same name (see IIID9 and IVC9). Written during the summers of 1922 and 1923, Trotsky's book was originally published in Moscow in 1924. The English translation of 1925, by Rose Strunsky, is used here. Extracts are from the reprint by RedWords, London, 1991, pp. 166–70, 188–90, 198–200, 261–5. (For a later text by Trotsky see IVD9.)

The error of the 'Lef', at least of some of its theorists, appears to us in its most generalized form, when they make an ultimatum for the fusion of art with life. It is not to be argued that the separation of art from other aspects of social life was the result of the class structure of society, that the self-sufficient character of art is merely the reverse side of the fact that art became the property of the privileged classes, and that the evolution of art in the future will follow the path of a growing fusion with life, that is, with production, with popular holidays and with the collective group life. It is good that the 'Lef' understands this and explains it. But it is not good when they present a short-time ultimatum on the basis of the present-day art, when they say: leave your 'lathe' and fuse with life. In other words, the poets, the painters, the sculptors, the actors must cease to reflect, to depict, to write poems, to paint pictures, to carve sculptures, to speak before the footlights, but they must carry their art directly into life. But how, and where, and through what gates? Of course, one may hail every attempt to carry as much rhythm and sound and colour as is possible into popular holidays and meetings and processions. But one must have a little historical vision, at least, to understand that between our present-day economic and cultural poverty and the time of the fusion of art with life, that is, between the time when life will reach such proportions that it will be entirely formed by art, more than one generation will have come and gone. Whether for good or for bad, the 'lathe-like' art will remain for many years more, and will be the instrument of the artistic and social development of the masses and their aesthetic enjoyment, and this is true not only of the art of painting, but of lyrics, novels, comedies,

tragedies, sculpture and symphony. To reject art as a means of picturing and imaging knowledge because of one's opposition to the contemplative and impressionisitic bourgeois art of the last few decades, is to strike from the hands of the class which is building a new society its most important weapon. Art, it is said, is not a mirror, but a hammer: it does not reflect, it shapes. But at present even the handling of a hammer is taught with the help of a mirror, a sensitive film which records all the movements. Photography and motion-picture photography, owing to their passive accuracy of depiction, are becoming important educational instruments in the field of labour. If one cannot get along without a mirror, even in shaving oneself, how can one recon-struct oneself or one's life, without seeing oneself in the 'mirror' of literature? Of course no one speaks about an exact mirror. No one even thinks of asking the new literature to have a mirror-like impassivity. The deeper literature is, and the more it is imbued with the desire to shape life, the more significantly and dynamically it will be able to 'picture' life.

What does it mean to 'deny experiences', that is, deny individual psychology in literature and on the stage? This is a late and long outlived protest of the left wing of the intelligentsia against the passive realism of the Chekhov school and against dreamy symbolism. [. . .] In what way, on what grounds, and in the name of what, can art turn its back to the inner life of present-day man who is building a new external world, and thereby rebuilding himself? If art will not help this new man to educate himself, to strengthen and refine himself, then what is it for? And how can it organize the inner life, if it does not penetrate it and reproduce it? Here Futurism merely repeats its own ABCs which are now quite behind the times.

The same may be said about institutional life. Futurism arose as a protest against the art of petty realists who sponged on life. Literature suffocated and became stupid in the stagnant little world of the lawyer, the student, the amorous lady, the district civil servant, and of all their feelings, their joys and their sorrows. But should one carry one's protest against sponging on life to the extent of separating literature from the conditions and forms of human life? If the Futurist protest against a shallow realism had its historical justification, it was only because it made room for a new artistic re-creating of life, for destruction and reconstruction on new pivots. [. . .]

In reply to criticisms against the 'Lef', which are often more insulting than convin-cing, the point is emphasized that the 'Lef' is still constantly seeking. Undoubtedly the 'Lef' seeks more than it has found. But this is not a sufficient reason why the party cannot do that which is persistently recommended, and canonize the 'Lef' or even a definite wing of it, as 'Communist Art'. It is as impossible to canonize seekings as it is impossible to arm an army with an unrealized invention.

But does this mean that the 'Lef' stands absolutely on a false road, and that we can have nothing to do with it? No, it does not mean this. The situation is not that the party has definite and fixed ideas on the question of art in the future, and that a certain group is sabotaging them. This is not the case at all. The party has not, and cannot have, ready-made decisions on versification, on the evolution of the theatre, on the renova-tion of the literary language, on architectural style, etc., just as in another field the party has not and cannot have ready-made decisions on the best kind of fertilization, on the most correct organization of transport, and on the most perfect machine guns. But as regards machine guns and transportation and fertilization, the practical decisions are needed immediately. What does the party do then? It assigns certain party workers to

the task of considering and mastering these problems, and it checks up these party workers by the practical results of their achievements. In the field of art the question is both simpler and more complex. As far as the political use of art is concerned, or the impossibility of allowing such use by our enemies, the party has sufficient experience, insight, decision and resource. But the actual development of art, and its struggle for new forms, are not part of the party's tasks, nor is it its concern. The party does not delegate anyone for such work. [. . .]

* * *

When one breaks a hand or a leg, the bones, the tendons, the muscles, the arteries, the nerves and the skin do not break and tear in one line, nor afterwards do they grow together and heal at the same time. So, in a revolutionary break in the life of society, there is no simultaneity and no symmetry of processes either in the ideology of society, or in its economic structure. The ideological premises which are needed for the revolution are formed before the revolution, and the most important ideological deductions from the revolution appear only much later. It would be extremely flippant to establish by analogies and comparisons the identity of Futurism and Communism, and so form the deduction that Futurism is the art of the proletariat. Such pretensions must be rejected. But this does not signify a contemptuous attitude towards the work of the Futurists. In our opinion they are the necessary links in the forming of a new and great literature. But they will prove to be only a significant episode in its evolution. To prove this, one has to approach the question more concretely and historically. The Futurists in their way are right when, in answer to the reproach that their works are above the heads of the masses, they say that Marx's *Capital* is also above their heads. Of course the masses are culturally and aesthetically unprepared, and will rise only slowly. But this is only one of the causes of it being above their heads. There is another cause. In its methods and in its forms, Futurism carries within itself clear traces of that world, or rather, of that little world in which it was born, and which – psychologically and not logically – it has not left to this very day. It is just as difficult to strip Futurism of the robe of the intelligentsia as it is to separate form from content. And when this happens, Futurism will undergo such a profound qualitative change that it will cease to be Futurism. This is going to happen, but not tomorrow. But even today one can say with certainty that much in Futurism will be useful and will serve to elevate and to revive art, if Futurism will learn to stand on its own legs, without any attempt to have itself decreed official by the government, as happened in the beginning of the Revolution. The new forms must find for themselves, and independently, an access into the consciousness of the advanced elements of the working class as the latter develop culturally. Art cannot live and cannot develop without a flexible atmosphere of sympathy around it. On this road, and on no other, does the process of complex interrelation lie ahead. The cultural growth of the working class will help and influence those innovators who really hold something in their bosom. The mannerisms which inevitably crop out in all small groups will fall away, and from the vital sprouts will come fresh forms for the solution of new artistic tasks. This process implies, first of all, an accumulation of material culture, a growth of prosperity and a development of technique. There is no other road. It is impossible to think seriously that history will simply conserve the works of the Futurists, and will serve them up to the masses after many years, when the masses will have become ripe for them. This, of course, would be *passéism* of the purest kind. When that time, which is not immediate, will come, and the

cultural and aesthetic education of the working masses will destroy the wide chasm between the creative intelligentsia and the people, art will have a different aspect from what it has today. In the evolution of that art, Futurism will prove to have been a necessary link. And is this so very little?

* * *

Our Marxist conception of the objective social dependence and social utility of art, when translated into the language of politics, does not at all mean a desire to dominate art by means of decrees and orders. It is not true that we regard only that art as new and revolutionary which speaks of the worker, and it is nonsense to say that we demand that the poets should describe inevitably a factory chimney, or the uprising against capital! Of course the new art cannot but place the struggle of the proletariat in the centre of its attention. But the plough of the new art is not limited to numbered strips. On the contrary, it must plough the entire field in all directions. Personal lyrics of the very smallest scope have an absolute right to exist within the new art. [...] No one is going to prescribe themes to a poet or intends to prescribe them. Please write about anything you can think of! But allow the new class which considers itself, and with reason, called upon to build a new world, to say to you in any given case: It does not make new poets of you to translate the philosophy of life of the Seventeenth Century into the language of the Acméists. The form of art is, to a certain and very large degree, independent, but the artist who creates this form, and the spectator who is enjoying it, are not empty machines, one for creating form and the other for appreciating it. They are living people, with a crystallized psychology representing a certain unity, even if not entirely harmonious. This psychology is the result of social conditions. The creation and perception of art forms is one of the functions of this psychology. And no matter how wise the Formalists try to be, their whole conception is simply based upon the fact that they ignore the psychological unity of the social man, who creates and who consumes what has been created.

The proletariat has to have in art the expression of the new spiritual point of view which is just beginning to be formulated within him, and to which art must help him give form. This is not a state order, but an historical demand. Its strength lies in the objectivity of historical necessity. You cannot pass this by, nor escape its force.

* * *

Can we christen revolutionary art with any of the names that we have? Osinsky somewhere called it realistic. The thought here is true and significant, but there ought to be an agreement on a definition of this concept to prevent falling into a misunderstanding.

The most perfect realism in art is coincident in our history with the 'golden age' of literature, that is, with the classical literature of the noblemen.

The period of tendentious themes, when a work was judged primarily by the social ideals of the author, coincides with the period when the awakening intelligentsia sought an outlet to public activity, and tried to make a union with the 'people' against the old regime.

The Decadent school and Symbolism, which appeared in opposition to the 'realism' which ruled before them, correspond to the period when the intelligentsia tried to separate itself from the people and began to worship its own moods and experiences. Though, in fact, it submitted itself to the bourgeoisie, it tried not to dissolve itself into

the bourgeoisie psychologically or scientifically. In this cause Symbolism invoked the aid of heaven.

Pre-war Futurism was an attempt of the intelligentsia to rise out of the wreck of Symbolism, while still holding on to individualism, to find a personal pivot in the impersonal conquests of material culture.

Such is the rough logic of the succession of the large periods in the development of Russian literature. Each one of these tendencies contained a definite social and group attitude towards the world which laid its impress upon the themes of the works, upon their content, upon the selection of environment, of the dramatic characters, etc. The idea of content does not refer to subject matter, in the ordinary sense of the term, but to social purpose. A lyric without a theme can express an epoch or a class or its point of view as well as a social novel.

Then there comes the question of form. Within certain limits, this develops in accord with its own laws, like any other technology. Each new literary school – if it is really a school and not an arbitrary grafting – is the result of a preceding development, of the craftsmanship of word and colour already in existence, and only pulls away from the shores of what has been attained in order to conquer the elements anew.

Evolution is dialectical in this case, too. The new tendency in art negates the preceding one, and why? Evidently there are sentiments and thoughts which feel crowded within the framework of the old methods. But at the same time, the new moods find in the already old and fossilized art some elements which when further developed can give them adequate expression. The banner of revolt is raised against the 'old' as a whole, in the name of the elements which can be developed. Each literary school is contained potentially in the past and each one develops by pulling away hostilely from the past. The relation between form and content (the latter is to be understood not simply as a 'theme' but as a living complex of moods and ideas which seek artistic expression) is determined by the fact that a new form is discovered, proclaimed and developed under the pressure of an inner need, of a collective psychological demand, which, like all human psychology, has its roots in society.

This explains the dualism of every literary tendency; on the one hand, it adds something to the technique of art, heightening (or lowering) the general level of craftsmanship; on the other hand, in its concrete historical form, it expresses definite demands which, in the final analysis, have a class character. We say class, but this also means individual, because a class speaks through an individual. It also means national, because the spirit of a nation is determined by the class which rules it and which subjects literature to itself. [...]

What are we to understand under the term realism? At various periods, and by various methods, realism gave expression to the feelings and needs of different social groups. Each one of these realistic schools is subject to a separate and social literary definition, and a separate formal and literary estimation. What have they in common? A definite and important feeling for the world. It consists in a feeling for life as it is, in an artistic acceptance of reality, and not in a shrinking from it, in an active interest in the concrete stability and mobility of life. It is a striving either to picture life as it is or to idealize it, either to justify or to condemn it, either to photograph it or generalize and symbolize it. But it is always a preoccupation with our life of three dimensions as a sufficient and invaluable theme for art. In this large philosophical sense and not in the

narrow sense of a literary school, one may say with certainty that the new art will be realistic. [. . .]

This means a realistic monism, in the sense of a philosophy of life, and not a 'realism' in the sense of the traditional arsenal of literary schools. On the contrary, the new artist will need all the methods and processes evolved in the past, as well as a few supplementary ones, in order to grasp the new life. And this is not going to be artistic eclecticism, because the unity of art is created by an active world-attitude and active life-attitude. [. . .]

2 André Breton (1896–1966) from the First Manifesto of Surrealism

Breton was introduced to Freudian analysis [see IA3] while serving in a medical capacity in the First World War. After the apparent exhaustion of Dada, Breton assumed the leadership of the left wing of the avant-garde, opposing the irrational and the work of the subconscious to the nationalism and technicism of the Esprit Nouveau group (see IIIA7). To this end he articulated the definitive formulation of the concept of Surrealism. The term had been coined by Apollinaire, who had also promoted the idea of a 'new spirit' (see IIIA2). Breton's first Manifesto of Surrealism was originally published in Paris in 1924. The present extracts are taken from the translation by R. Seaver and H. R. Lane in André Breton, *Manifestoes of Surrealism*, Ann Arbor, MI, 1969, pp. 3–47.

[. . .] Beloved imagination, what I most like in you is your unsparing quality.

The mere word 'freedom' is the only one that still excites me. I deem it capable of indefinitely sustaining the old human fanaticism. It doubtless satisfies my only legitimate aspiration. Among all the many misfortunes to which we are heir, it is only fair to admit that we are allowed the greatest degree of freedom of thought. It is up to us not to misuse it. To reduce the imagination to a state of slavery – even though it would mean the elimination of what is commonly called happiness – is to betray all sense of absolute justice within oneself. Imagination alone offers me some intimation of what *can be*, and this is enough to remove to some slight degree the terrible injunction; enough, too, to allow me to devote myself to it without fear of making a mistake (as though it were possible to make a bigger mistake). Where does it begin to turn bad, and where does the mind's stability cease? For the mind, is the possibility of erring not rather the contingency of good?

There remains madness, 'the madness that one locks up,' as it has aptly been described. That madness or another. . . . We all know, in fact, that the insane owe their incarceration to a tiny number of legally reprehensible acts and that, were it not for these acts their freedom (or what we see as their freedom) would not be threatened. I am willing to admit that they are, to some degree, victims of their imagination, in that it induces them not to pay attention to certain rules – outside of which the species feels itself threatened – which we are all supposed to know and respect. But their profound indifference to the way in which we judge them, and even to the various punishments meted out to them, allows us to suppose that they derive a great deal of comfort and consolation from their imagination, that they enjoy their madness sufficiently to endure

the thought that its validity does not extend beyond themselves. And, indeed, hallucinations, illusions, etc., are not a source of trifling pleasure. [...]

The case against the realistic attitude demands to be examined, following the case against the materialistic attitude. The latter, more poetic in fact than the former, admittedly implies on the part of man a kind of monstrous pride which, admittedly, is monstrous, but not a new and more complete decay. It should above all be viewed as a welcome reaction against certain ridiculous tendencies of spiritualism. Finally, it is not incompatible with a certain nobility of thought.

By contrast, the realistic attitude, inspired by positivism, from Saint Thomas Aquinas to Anatole France, clearly seems to me to be hostile to any intellectual or moral advancement. I loathe it, for it is made up of mediocrity, hate, and dull conceit. It is this attitude which today gives birth to these ridiculous books, these insulting plays. It constantly feeds on and derives strength from the newspapers and stultifies both science and art by assiduously flattering the lowest of tastes; clarity bordering on stupidity, a dog's life. The activity of the best minds feels the effects of it; the law of the lowest common denominator finally prevails upon them as it does upon the others. [...]

* * *

We are still living under the reign of logic...But in this day and age logical methods are applicable only to solving problems of secondary interest. The absolute rationalism that is still in vogue allows us to consider only facts relating directly to our experience. Logical ends, on the contrary, escape us. It is pointless to add that experience itself has found itself increasingly circumscribed. It paces back and forth in a cage from which it is more and more difficult to make it emerge. It too leans for support on what is most immediately expedient, and it is protected by the sentinels of common sense. Under the pretense of civilization and progress, we have managed to banish from the mind everything that may rightly or wrongly be termed superstition, or fancy; forbidden is any kind of search for truth which is not in conformance with accepted practices. It was, apparently, by pure chance that a part of our mental world which we pretended not to be concerned with any longer – and, in my opinion by far the most important part – has been brought back to light. For this we must give thanks to the discoveries of Sigmund Freud. On the basis of these discoveries a current of opinion is finally forming by means of which the human explorer will be able to carry his investigations much further, authorized as he will henceforth be not to confine himself solely to the most summary realities. The imagination is perhaps on the point of reasserting itself, of reclaiming its rights. If the depths of our mind contain within it strange forces capable of augmenting those on the surface, or of waging a victorious battle against them, there is every reason to seize them – first to seize them, then, if need be, to submit them to the control of our reason. The analysts themselves have everything to gain by it. But it is worth noting that no means has been designated a priori for carrying out this undertaking, that until further notice it can be constructed to be the province of poets as well as scholars, and that its success is not dependent upon the more or less capricious paths that will be followed.

Freud very rightly brought his critical faculties to bear upon the dream. It is, in fact, inadmissible that this considerable portion of psychic activity (since, at least from man's birth until his death, thought offers no solution of continuity, the sum of the

moments of dream, from the point of view of time, and taking into consideration only the time of pure dreaming, that is the dreams of sleep, is not inferior to the sum of the moments of reality, or, to be more precisely limiting, the moments of waking) has still today been so grossly neglected. I have always been amazed at the way an ordinary observer lends so much more credence and attaches so much more importance to waking events than to those occurring in dreams. It is because man, when he ceases to sleep, is above all the plaything of his memory, and in its normal state memory takes pleasure in weakly retracing for him the circumstances of the dream, in stripping it of any real importance, and in dismissing the only *determinant* from the point where he thinks he has left it a few hours before: this firm hope, this concern. He is under the impression of continuing something that is worthwhile. Thus the dream finds itself reduced to a mere parenthesis, as is the night. And, like the night, dreams generally contribute little to furthering our understanding. This curious state of affairs seems to me to call for certain reflections:

1 Within the limits where they operate (or are thought to operate) dreams give every evidence of being continuous and show signs of organization. Memory alone arrogates to itself the right to excerpt from dreams, to ignore the transitions, and to depict for us rather a series of dreams than the *dream itself*. By the same token, at any given moment we have only a distinct notion of realities, the coordination of which is a question of will. What is worth noting is that nothing allows us to presuppose a greater dissipation of the elements of which the dream is constituted. I am sorry to have to speak about it according to a formula which in principle excludes the dream. When will we have sleeping logicians, sleeping philosophers? I would like to sleep, in order to surrender myself to the dreamers, the way I surrender myself to those who read me with eyes wide open; in order to stop imposing, in this realm, the conscious rhythm of my thought. Perhaps my dream last night follows that of the night before, and will be continued the next night, with an exemplary strictness. *It's quite possible*, as the saying goes. And since it has not been proved in the slightest that, in doing so, the 'reality' with which I am kept busy continues to exist in the state of dream, that it does not sink back down into the immemorial, why should I not grant to dreams what I occasionally refuse reality, that is, this value of certainty in itself which, in its own time, is not open to my repudiation? Why should I not expect from the sign of the dream more than I expect from a degree of consciousness which is daily more acute? Can't the dream also be used in solving the fundamental questions of life? Are these questions the same in one case as in the other and, in the dream, do these questions already exist? Is the dream any less restrictive or punitive than the rest? I am growing old and, more than that reality to which I believe I subject myself, it is perhaps the dream, the difference with which I treat the dream, which makes me grow old.

2 Let me come back again to the waking state. I have no choice but to consider it a phenomenon of interference. Not only does the mind display, in this state, a strange tendency to lose its bearings (as evidenced by the slips and mistakes the secrets of which are just beginning to be revealed to us), but, what is more, it does not appear that, when the mind is functioning normally, it really responds to anything but the suggestions which come to it from the depths of that dark night to which I commend it. However conditioned it may be, its balance is relative. It scarcely dares express itself

and, if it does, it confines itself to verifying that such and such an idea, or such and such a woman, has made an impression on it. What impression it would be hard pressed to say, by which it reveals the degree of its subjectivity, and nothing more. This idea, this woman, disturb it, they tend to make it less severe. What they do is isolate the mind for a second from its solvent and spirit it to heaven, as the beautiful precipitate it can be, that it is. When all else fails, it then calls upon chance, a divinity even more obscure than the others to whom it ascribes all its aberrations. Who can say to me that the angle by which that idea which affects it is offered, that what it likes in the eye of that woman is not precisely what links it to its dream, binds it to those fundamental facts which, through its own fault, it has lost? And if things were different, what might it be capable of? I would like to provide it with the key to this corridor.

3 The mind of the man who dreams is fully satisfied by what happens to him. The agonizing question of possibility is no longer pertinent. Kill, fly faster, love to your heart's content. And if you should die, are you not certain of reawaking among the dead? Let yourself be carried along, events will not tolerate your interference. You are nameless. The ease of everything is priceless.

What reason, I ask, a reason so much vaster than the other, makes dreams seem so natural and allows me to welcome unreservedly a welter of episodes so strange that they would confound me now as I write? And yet I can believe my eyes, my ears; this great day has arrived, this beast has spoken.

If man's awaking is harder, if it breaks the spell too abruptly, it is because he has been led to make for himself too impoverished a notion of atonement.

4 From the moment when it is subjected to a methodical examination, when, by means yet to be determined, we succeed in recording the contents of dreams in their entirety (and that presupposes a discipline of memory spanning generations; but let us nonetheless begin by noting the most salient facts), when its graph will expand with unparalleled volume and regularity, we may hope that the mysteries which really are not will give way to the great Mystery. I believe in the future resolution of these two states, dream and reality, which are seemingly so contradictory, into a kind of absolute reality, a *surreality*, if one may so speak. It is in quest of this surreality that I am going, certain not to find it but too unmindful of my death not to calculate to some slight degree the joys of its possession.

A story is told according to which Saint-Pol-Roux, in times gone by, used to have a notice posted on the door of his manor house in Camaret, every evening before he went to sleep, which read: THE POET IS WORKING.

A great deal more could be said, but in passing I merely wanted to touch upon a subject which in itself would require a very long and much more detailed discussion ...At this juncture, my intention was merely to mark a point by noting the *hate of the marvelous* which rages in certain men, this absurdity beneath which they try to bury it. Let us not mince words: the marvelous is always beautiful, anything marvelous is beautiful, in fact only the marvelous is beautiful.

* * *

One evening...before I fell asleep, I perceived, so clearly articulated that it was impossible to change a word, but nonetheless removed from the sound of any voice, a rather strange phrase which came to me without any apparent relationship to the events in which, my consciousness agrees, I was then involved, a phrase which seemed to me insistent, a phrase, if I may be so bold, *which was knocking at the window*. I took

cursory note of it and prepared to move on when its organic character caught my attention. Actually, this phrase astonished me: unfortunately I cannot remember it exactly, but it was something like: 'There is a man cut in two by the window,' but there could be no question of ambiguity, accompanied as it was by the faint visual image of a man walking cut half way up by a window perpendicular to the axis of his body. Beyond the slightest shadow of a doubt, what I saw was the simple reconstruction in space of a man leaning out a window. But this window having shifted with the man, I realized that I was dealing with an image of a fairly rare sort, and all I could think of was to incorporate it into my material for poetic construction. No sooner had I granted it this capacity than it was in fact succeeded by a whole series of phrases, with only brief pauses between them, which surprised me only slightly less and left me with the impression of their being so gratuitous that the control I had then exercised upon myself seemed to me illusory and all I could think of was putting an end to the interminable quarrel raging within me.

Completely occupied as I still was with Freud at that time, and familiar as I was with his methods of examination which I had had some slight occasion to use on some patients during the war, I resolved to obtain from myself what we were trying to obtain from them, namely, a monologue spoken as rapidly as possible without any intervention on the part of the critical faculties, a monologue consequently unencumbered by the slightest inhibition and which was, as closely as possible, akin to *spoken thought*. It had seemed to me, and still does – the way in which the phrase about the man cut in two had come to me is an indication of it – that the speed of thought is no greater than the speed of speech, and that thought does not necessarily defy language, nor even the fast-moving pen. It was in this frame of mind that Philippe Soupault – to whom I had confided these initial conclusions – and I decided to blacken some paper, with a praiseworthy disdain for what might result from a literary point of view. The ease of execution did the rest. By the end of the first day we were able to read to ourselves some fifty or so pages obtained in this manner, and begin to compare our results. All in all, Soupault's pages and mine proved to be remarkably similar: the same overconstruction, shortcomings of a similar nature, but also, on both our parts, the illusion of an extraordinary verve, a great deal of emotion, a considerable choice of images of a quality such that we would not have been capable of preparing a single one in longhand, a very special picturesque quality and, here and there, a strong comical effect. The only difference between our two texts seemed to me to derive essentially from our respective tempers, Soupault's being less static than mine, and, if he does not mind my offering this one slight criticism, from the fact that he had made the error of putting a few words by way of titles at the top of certain pages, I suppose in a spirit of mystification. On the other hand, I must give credit where credit is due and say that he constantly and vigorously opposed any effort to retouch or correct, however slightly, any passage of this kind which seemed to me unfortunate. In this he was, to be sure, absolutely right. It is, in fact, difficult to appreciate fairly the various elements present; one may even go so far as to say that it is impossible to appreciate them at a first reading. To you who write, these elements are, on the surface, *as strange to you as they are to anyone else*, and naturally you are wary of them. Poetically speaking, what strikes you about them above all is their *extreme degree of immediate absurdity*, the quality of this absurdity, upon closer scrutiny, being to give way to everything admissible, everything legitimate in the

world: the disclosure of a certain number of properties and of facts no less objective, in the final analysis, than the others.

In homage to Guillaume Apollinaire, who had just died and who, on several occasions, seemed to us to have followed a discipline of this kind, without however having sacrificed to it any mediocre literary means, Soupault and I baptized the new mode of pure expression which we had at our disposal and which we wished to pass on to our friends, by the name of SURREALISM [. . .]

Those who might dispute our right to employ the term SURREALISM in the very special sense that we understand it are being extremely dishonest, for there can be no doubt that this word had no currency before we came along. Therefore, I am defining it once and for all:

SURREALISM, *n*. Psychic automatism in its pure state, by which one proposes to express – verbally, by means of the written word, or in any other manner – the actual functioning of thought. Dictated by thought, in the absence of any control exercised by reason, exempt from any aesthetic or moral concern.

ENCYCLOPEDIA. *Philosophy*. Surrealism is based on the belief in the superior reality of certain forms of previously neglected associations, in the omnipotence of dream, in the disinterested play of thought. It tends to ruin once and for all all other psychic mechanisms and to substitute itself for them in solving all the principal problems of life. [. . .]

* * *

. . . The mind which plunges into Surrealism relives with glowing excitement the best part of its childhood. For such a mind, it is similar to the certainty with which a person who is drowning reviews once more, in the space of less than a second, all the insurmountable moments of his life. Some may say to me that the parallel is not very encouraging. But I have no intention of encouraging those who tell me that. From childhood memories, and from a few others, there emanates a sentiment of being unintegrated, and then later of *having gone astray*, which I hold to be the most fertile that exists. It is perhaps childhood that comes closest to one's 'real life'; childhood beyond which man has at his disposal, aside from his laissez-passer, only a few complimentary tickets; childhood where everything nevertheless conspires to bring about the effective, risk-free possession of oneself. Thanks to Surrealism, it seems that opportunity knocks a second time. It is as though we were still running toward our salvation, or our perdition. In the shadow we again see a precious terror. Thank God, it's still only Purgatory. With a shudder, we cross what the occultists call *dangerous territory*. In my wake I raise up monsters that are lying in wait; they are not yet too ill-disposed toward me, and I am not lost, since I fear them. [. . .]

* * *

Surrealism, such as I conceive of it, asserts our complete *nonconformism* clearly enough so that there can be no question of translating it, at the trial of the real world, as evidence for the defense. It could, on the contrary, only serve to justify the complete state of distraction which we hope to achieve here below. Kant's absentmindedness regarding women, Pasteur's absentmindedness about 'grapes,' Curie's absentminded-

ness with respect to vehicles, are in this regard profoundly symptomatic. This world is only very relatively in tune with thought, and incidents of this kind are only the most obvious episodes of a war in which I am proud to be participating. Surrealism is the 'invisible ray' which will one day enable us to win out over our opponents. 'You are no longer trembling, carcass.' This summer the roses are blue; the wood is of glass. The earth, draped in its verdant cloak, makes as little impression upon me as a ghost. It is living and ceasing to live that are imaginary solutions. Existence is elsewhere.

3 Louis Aragon (1897–1982) from *Paris Peasant*

After initially studying medicine, Aragon turned to literature towards the end of the First World War. He was a close friend of André Breton, and together also with Philippe Soupault founded the review *Littérature* in 1919. Under the joint impact of the nineteenth-century writer Isidore Ducasse, Comte de Lautréamont (author of the conceit, 'as beautiful as the chance meeting of an umbrella and a sewing machine on a dissecting table'), and of contemporary Dada, particularly the collages of Max Ernst, the three developed the method of 'psychic automatism' as a device for freeing the unconscious. Breton later recalled strolls through Paris with Aragon: 'The localities that we passed through, even the most colourless ones, were positively transformed by a spellbinding romantic inventiveness that never altered, and that needed only a street-turning or a shop window to inspire a fresh outpouring.' In the body of his novel, *Le Paysan de Paris*, Aragon wrote descriptively, along the lines of these 'outpourings' to Breton, but he deliberately began with an introduction containing, in his words, 'abstract formulations'. Here we reprint that introduction ('Preface to a Modern Mythology'), and the opening paragraphs of the book's first section, 'The Passage de l'Opéra'. These were first published in the *Revue Européenne* in four instalments between June and September of 1924. The second chapter, 'A Feeling for Nature at the Buttes-Chaumont' appeared in the same review in 1925, and a final part, 'The Peasant's Dream', was added in 1926. The entire text was published in book form by Gallimard in that year. The present extracts are taken from the translation by Simon Watson Taylor, published as *Paris Peasant*, London: Jonathan Cape, 1971, pp. 19–29.

Preface to a Modern Mythology

Every idea, these days, seems to have passed its critical phase. It is a generally accepted fact that abstract notions about mankind have all been eroded imperceptibly by the investigation they have undergone, that human light has infiltrated its rays everywhere and that as a result nothing has escaped this universal process which is subject, at the most, to revision. So we have the spectacle of the world's philosophers incapable of tackling the smallest problem without first going through the routine of recapitulating and then refuting everything their predecessors have had to say on the subject. And by that very fact their every thought is inevitably the function of some previous error, based upon it and inheriting some of its features. A curious and strangely contrary method: seemingly afraid of genius, in the one domain where the sole imperative must be genius itself, pure invention, revelation. The impression persists that those who have made thought their province are fleetingly aware that dialectical means are

inadequate and provide ineffectual guidance on the road to certainty of any kind. But this awareness has simply led them to argue about dialectical means, not about dialectics itself and still less about its objective, truth. Or if truth has by some miracle claimed their attention, they have always considered it as an end and not as a concept. Everyone wanted to join in the quarrel about the objectivity of certainty: no one dreamed of questioning the reality of certainty itself.

The characteristics of certainty vary according to the philosopher's chosen system, ranging from gross certainty to the ideal scepticism of those who are certain of nothing but their uncertainty. But however reduced may be its scope – to the consciousness of being, for example – certainty is envisaged by all these searching minds as possessing peculiar and definable characteristics which allow it to be distinguished from error. Certainty is not reality. From this fundamental belief proceeds the success of the famous Cartesian doctrine of evidence.

We are still discovering the full extent of the havoc this illusion has worked. Of all the stumbling blocks confronting the onward movement of the mind and imagination none, surely, has been more difficult to avoid than this sophism about evidence, a sophism which flattered one of mankind's most prevalent ways of thought. It is to be encountered at the roots of all logic. It is the ultimate justification for every proof which man claims of a proposition he has stated. Man invokes its authority in making deductions, and comes to conclusions on the same basis. In this way he has elaborated a changing and always evident truth, and asks himself vainly why it never seems to satisfy him.

But there exists a black kingdom which the eyes of man avoid because its landscape fails signally to flatter them. This darkness, which he imagines he can dispense with in describing the light, is error with its unknown characteristics, error which demands that a person contemplate it for its own sake before rewarding him with the evidence about fugitive reality that it alone could give. Surely it must be realized that the face of error and the face of truth cannot fail to have identical features? Error is certainty's constant companion. Error is the corollary of evidence. And anything said about truth may equally well be said about error: the delusion will be no greater. Without this idea of evidence, error would not exist. Without evidence no one would even pause to think about error.

* * *

My habits of thought have been so conditioned by innumerable tortuous processes that today I find myself unable to place complete confidence in any notion I may have of the universe without first subjecting that notion to an abstract examination. This spirit of analysis, this spirit and this need, have been transmitted to me. And like a man tearing himself away from sleep, it costs me a painful effort to tear myself away from this mental habit, so as to think simply, naturally, in terms of what I see and touch. And yet, can the knowledge deriving from reason even begin to compare with know-ledge perceptible by sense? No doubt the number of people crass enough to rely exclusively on the former and scorn the latter are sufficient in themselves to explain the disfavour into which everything deriving from the senses has gradually fallen. But when the most scholarly of men have taught me that light is a vibration, or have calculated its wavelengths for me, or offered me any other fruits of their labours of reasoning, they will still not have rendered me an account of what is important to me about light, of what my eyes have begun to teach me about it, of what makes me

different from a blind man – things which are the stuff of miracles, not subject matter for reasoning.

Humanity's stupid rationalism contains an unimaginably large element of materialism. This fear of error which everything recalls to me at every moment of the flight of my ideas, this mania for control, makes man prefer reason's imagination to the imagination of the senses. And yet it is always the imagination alone which is at work. Nothing, neither strict logic nor overwhelming impression, can convince me about reality, can convince me that I am not basing reality on a delirium of interpretation. But in the case of the senses, man, after absorbing the teachings of various traditional schools, has begun to have doubts about himself; one can imagine by what play of mirrors this has been at the expense of the opposite thought process, reasoning. And there we have man a prey to mathematics. In trying to free himself from matter he has become the prisoner of the properties of matter.

Frankly, I am beginning to be convinced that, short of some conjuring trick, neither the senses nor reason can be apprehended separately from each other, and that doubtless they only exist functionally. Beyond its discoveries, surprises and improbabilities, reason's greatest triumph derives from the confirmation it provides of popular error. Its greatest glory is that it can give a precise sense to those instinctual utterances that pedants have always despised. Light is meaningful only in relation to darkness, and truth presupposes error. It is these mingled opposites which people our life, which make it pungent, intoxicating. We only exist in terms of this conflict, in the zone where black and white clash. And what do I care about white and black? Their realm is death.

I no longer wish to refrain from the errors of my fingers, the errors of my eyes. I know now that these errors are not just booby traps but curious paths leading towards a destination that they alone can reveal to me. There are strange flowers of reason to match each error of the senses. Admirable gardens of absurd beliefs, forebodings, obsessions and frenzies. Unknown, ever-changing gods take shape there. I shall contemplate these leaden faces, these hemp-seeds of the imagination. How beautiful you are in your sand-castles, you columns of smoke! New myths spring up beneath each step we take. Legend begins where man has lived, where he lives. All that I intend to think about from now on is these despised transformations. Each day the modern sense of existence becomes subtly altered. A mythology ravels and unravels. It is a knowledge, a science of life open only to those who have no training in it. It is a living science which begets itself and makes away with itself. I am already twenty-six years old, am I still privileged to take part in this miracle? How long shall I retain this sense of the marvellous suffusing everyday existence? I see it fade away in every man who advances into his own life as though along an always smoother road, who advances into the world's habits with an increasing ease, who rids himself progressively of the taste and texture of the unwonted, the unthought of. To my great despair, this is what I shall never know.

The Passage de l'Opéra

Man no longer worships the gods on their heights. Solomon's temple has slid into a world of metaphor where it harbours swallows' nests and corpse-white lizards. The spirit of religions, coming down to dwell in the dust, has abandoned the sacred places. But there are other places which flourish among mankind, places where men go calmly

about their mysterious lives and in which a profound religion is very gradually taking shape. These sites are not yet inhabited by a divinity. It is forming there, a new godhead precipitating in these re-creations of Ephesus like acid-gnawed metal at the bottom of a glass.

Life itself has summoned into being this poetic deity which thousands will pass blindly by, but which suddenly becomes palpable and terribly haunting for those who have at last caught a confused glimpse of it. It is you, metaphysical entity of places, who lull children to sleep, it is you who people their dreams. These shores of the unknown, sands shivering with anguish or anticipation, are fringed by the very substance of our minds. A single step into the past is enough for me to rediscover this sensation of strangeness which filled me when I was still a creature of pure wonder, in a setting where I first became aware of the presence of a coherence for which I could not account but which sent its roots into my heart.

The whole fauna of human fantasies, their marine vegetation, drifts and luxuriates in the dimly lit zones of human activity, as though plaiting thick tresses of darkness. Here, too, appear the great lighthouses of the mind, with their outward resemblance to less pure symbols. The gateway to mystery swings open at the touch of human weakness and we have entered the realms of darkness. One false step, one slurred syllable together reveal a man's thoughts. The disquieting atmosphere of places contains similar locks which cannot be bolted fast against infinity. Wherever the living pursue particularly ambiguous activities, the inanimate may sometimes assume the reflection of their most secret motives: and thus our cities are peopled with unrecognized sphinxes which will never stop the passing dreamer and ask him mortal questions unless he first projects his meditation, his absence of mind, towards them. But if this wise man has the power to guess their secret, and interrogates them in his turn, all that these faceless monsters will grant is that he shall once again plumb his own depths. Henceforth, it is the modern light radiating from the unusual that will rivet his attention.

How oddly this light suffuses the covered arcades which abound in Paris in the vicinity of the main boulevards and which are rather disturbingly named *passages*, as though no one had the right to linger for more than an instant in those sunless corridors. A glaucous gleam, seemingly filtered through deep water, with the special quality of pale brilliance of a leg suddenly revealed under a lifted skirt. The great American passion for city planning, imported into Paris by a prefect of police during the Second Empire and now being applied to the task of redrawing the map of our capital in straight lines, will soon spell the doom of these human aquariums. Although the life that originally quickened them has drained away, they deserve, nevertheless, to be regarded as the secret repositories of several modern myths: it is only today, when the pickaxe menaces them, that they have at last become the true sanctuaries of a cult of the ephemeral, the ghostly landscape of damnable pleasures and professions. Places that were incomprehensible yesterday, and that tomorrow will never know.

4 Louis Aragon (1897–1982) et al. 'Declaration of the Bureau de Recherches Surréalistes'

By the beginning of 1925 the first two issues of the journal *La Révolution Surréaliste* were available, and Aragon's Surrealist 'novel' *Paysan de Paris (Paris Peasant)* had been published

in the *Revue Européenne*. Works by Naville, Artaud, Eluard and others had also appeared. The intention of Surrealism was not, however, to be a mere literary movement, but a revolutionary cultural *practice*. To this end, later in 1925 the Surrealists took common cause with the Communist journal *Clarté*. This attempt to transcend the limits of a merely artistic practice is prefigured by the 'Declaration' issued under the imprimatur of the Bureau de Recherches Surréalistes on 27 January 1925. The Declaration had twenty-six signatories in addition to Aragon, including Breton, Eluard, Naville, Soupault, Artaud, Ernst and Masson. The present translation, by Richard Howard, is taken from Maurice Nadeau, *The History of Surrealism*, New York, 1965, pp. 262–3.

With regard to a false interpretation of our enterprise, stupidly circulated among the public,

We declare as follows to the entire braying literary, dramatic, philosophical, exegetical and even theological body of contemporary criticism:

1 We have nothing to do with literature;

But we are quite capable, when necessary, of making use of it like anyone else.

2 *Surrealism* is not a new means of expression, or an easier one, nor even a metaphysic of poetry.

It is a means of total liberation of the mind *and of all that resembles it.*

3 We are determined to make a Revolution.

4 We have joined the word *surrealism* to the word *revolution* solely to show the disinterested, detached, and even entirely desperate character of this revolution.

5 We make no claim to change the *mores* of mankind, but we intend to show the fragility of thought, and on what shifting foundations, what caverns we have built our trembling houses.

6 We hurl this formal warning to Society: Beware of your deviations and *faux-pas*, we shall not miss a single one.

7 At each turn of its thought, Society will find us waiting.

8 We are specialists in Revolt.

There is no means of action which we are not capable, when necessary, of employing.

9 We say in particular to the Western world: *surrealism* exists. And what is this new ism that is fastened to us? Surrealism is not a poetic form. It is a cry of the mind turning back on itself, and it is determined to break apart its fetters, even if it must be by material hammers!

Bureau de Recherches Surréalistes,
15, Rue de Grenelle

5 André Breton (1896–1966) *Surrealism and Painting*

Surrealism originated as a literary movement and rapidly took on a revolutionary politico-cultural role. The question of its relationship to painting remained unclear, a difficulty little clarified by art histories which focus merely on the aspect of dream imagery seen as an idiosyncratic modern art 'style'. The gist of Breton's argument is that vision is the most powerful of the senses, and so the ability to fix visual images means that Surrealism does have an interest in painting. The problem was that art had hitherto concentrated on the outer world, but as such it could never compete with reality itself. However, by turning to focus on inner reality, painting could indeed be fruitful terrain for Surrealist work. Breton's model for

this was Picasso. It is worth noting, though, that he maintained a mordant hostility to the conventional business of art criticism, as well as to other supposedly leading avant-gardists such as Matisse, Derain, and to a lesser extent even Picasso's original collaborator, Braque; not to mention those who had turned Cubism into a school. Early Surrealist visual work (the first exhibition of which took place in November 1925) experimented with collective author- ship and automatic techniques adapted from literary production. Overall, as in other areas of Surrealist work, the aim was to produce a crisis in bourgeois consciousness, to use painting, in Breton's words, as an 'expedient' in the service of revolution. Breton's *Surrealism and Painting* was first published in full as a pamphlet in 1928, having previously appeared in episodes in *La Révolution Surréaliste*. The present extracts are taken from the translation by David Gascoyne, London, 1936.

The eye exists in its primitive state. The marvels of the earth a hundred feet high, the marvels of the sea a hundred feet deep, have for their witness only the wild eye that when in need of colours refers simply to the rainbow. It is present at the conventional exchange of signals that the navigation of the mind would appear to demand. But who is to draw up the scale of vision? There are those things that I have already seen many a time, and that others tell me they have likewise seen, things that I believe I should be able to remember, whether I cared about them or not, such, for instance, as the façade of the Paris Opera House, or a horse, or the horizon; there are those things that I have seen only very seldom, and that I have not always chosen to forget, or not to forget, as the case may be; there are those things that having looked at in vain I never dare to see, which are all the things I love (in their presence I no longer see anything else); there are those things that others have seen, and that by means of suggestion they are able or unable to make me see also; there are also those things that I see differently from other people, and those things that I begin to see and that *are not visible*. And that is not all. [. . .]

The need of fixing visual images, whether these images exist before their fixation or not, stands out from all time and has led to the creation of a veritable language, which does not seem to me more artificial than any other, over the origins of which I do not feel it necessary to linger here. The most I can do is to consider the present state of this language from the same angle as that from which I should consider the present state of poetic language. It seems to me that I can demand a great deal from a faculty which, above almost all others, gives me advantage over the real, over what is vulgarly understood by *the real*. Why is it that I am so much at the mercy of a few lines, a few coloured patches? The object, the strange object itself draws from these things the greatest amount of its force of provocation, and God knows whether this is a great provocation, for *I* cannot understand whither it is tending. What does it matter to me whether trees are green, whether a piano is at this moment 'nearer' to me than a state- coach, whether a ball is cylindrical or round? That is how things are, nevertheless, if I am to believe my eyes, that is to say up to a certain point. In such a domain I dispose of a power of illusion whose limits, if I am not careful, I cease to perceive. If at this moment I turn to some illustration or other in a book, there is nothing to prevent the world around me from ceasing to exist. In place of what was surrounding me there is now something else, since, for example, I can without difficulty take part in quite another ceremony. . . . The corner formed by the ceiling and two walls in the picture can easily be substituted for the corner of this ceiling and these two walls. I turn over a few pages and, in spite of the almost uncomfortable heat, I do not in the least refuse to consent to this winter landscape. I can play with these winged children. 'He saw before

him an illuminated cavern,' says a caption, and I can actually see it too. I see it in a way in which I do not at this moment see you for whom I am writing, yet all the same I am writing so as to be able to see you one day, just as truly as I have lived a second for this Christmas tree, this illuminated cavern or these angels. It does not matter whether there is a perceptible difference between beings thus invoked and real beings, for this difference can at any moment be made light of. So that it is impossible for me to consider a picture as anything but a window, in which my first interest is to know what it *looks out on*, or, in other words, whether, from where I am, there is a 'beautiful view', for there is nothing I love so much as that which stretches away before me and *out of sight*. Within the frame of an *unnamed figure, land- or seascape*, I can enjoy an enormous spectacle. [. . .]

Now I declare I have passed like a madman through the slippery-floored halls of museums; and I am not the only one. In spite of a few marvellous glances I have received from women just like those of today, I have never for an instant been the dupe of the unknown that those subterranean and immovable walls had to offer me. I left adorable supplicants behind without remorse. There were too many scenes all at once; I had not the heart to speculate upon them. As I passed by in front of all those religious compositions and pastoral allegories, I could not help losing the sense of the part I was playing. The enchantments that the street outside had to offer me were a thousand times more real. It is not my fault if I cannot help feeling a profound lassitude when confronted by the interminable march past of the entries for this gigantic prix de Rome in which nothing, neither the subjects nor the manner of treating them, has been left optional.

I do not necessarily mean that no emotion can be aroused by a painting of 'Leda', or that no heart-rending sun can set behind a scene of 'Roman palaces', nor even that it would be impossible to give some semblance of eternal morality to the illustration of a fable as ridiculous as *Death and the Woodcutter*. I simply mean that genius has nothing to gain by following these beaten tracks and roundabout paths. There is nothing with which it is so dangerous to take liberties as liberty.

But all question of emotion for emotion's sake apart, let us not forget that in this epoch it is reality itself that is in question. How can anyone expect us to be satisfied with the passing disquiet that such and such a work of art brings us? There is no work of art that can hold its own before our essential *primitivism* in this respect. When I know how the grim struggle between the actual and the possible will end, when I have lost all hope of enlarging the field of the real, until now strictly limited, to truly stupefying proportions, when my imagination, recoiling upon itself, can no longer do more than coincide with my memory, I will willingly accord myself, like the others, a few relative satisfactions. I shall then number myself among the 'embroiderers', whom I shall have had to forgive. But not before.

The very narrow conception of imitation which art has been given as its aim is at the bottom of the serious misunderstanding that we see continuing right up to the present. In the belief that they are only capable of reproducing more or less fortunately the image of that which moves them, painters have been far too easy-going in their choice of models. The mistake lies in thinking that the model can only be taken from the exterior world, or even simply that it can be taken at all. Certainly human sensibility can confer a quite unforeseen distinction upon even the most vulgar-looking object; none the less, to make the magic power of figuration which certain men possess

serve the purpose of preserving and reinforcing that which would exist without them anyway, is to make wretched use of it. There lies the inexcusable abdication. It is in any case impossible, under the present conditions of thought, when above all the exterior world appears more and more suspect, still to consent to such a sacrifice. The plastic work of art, in order to respond to the undisputed necessity of thoroughly revising all real values, will either refer to a *purely interior model* or cease to exist.

It remains to us to determine what is meant by the term *interior model*, and at this point it becomes a question of tackling the great problem raised in recent years by the attitude of those few men who have truly rediscovered a reason to paint – a problem that a miserable system of art-criticism is forced desperately to evade. In the domain of poetry, Lautréamont, Rimbaud and Mallarmé were the first to endow the human mind with what it lacked so much: I mean a truly *insolent* grace, which has enabled the mind, on finding itself withdrawn from all ideals, to begin to occupy itself with its own life, in which the attained and the desired no longer mutually exclude one another, and thereupon to attempt to submit to a permanent and most rigorous censorship whatever has constrained it heretofore. After their appearance, the idea of what is forbidden and what is allowed adopted its present elasticity, to such a point that the words family, fatherland, society, for instance, seem to us now to be so many macabre jests. It was they who really caused us to make up our minds to rely for our redemption here below upon ourselves alone, so that we have desperately to pursue their footsteps, animated by that feverish desire for conquest, total conquest, that will never leave us; so that our eyes, our precious eyes, have to reflect that which, while not existing, is yet as intense as that which does exist, and which has once more to consist of visual images, fully compensating us for what we have left behind. The mysterious path on which fear dogs our every step and our desire to turn back is only overcome by the fallacious hope of being accompanied, has for the past fifteen years been swept by a powerful searchlight. It is now fifteen years since Picasso began to explore this path, bearing rays of light with him as he went. No one had had the courage to see anything there before he came. Poets used to talk of a country they had discovered, where in the most natural way in the world a drawing-room appeared 'at the bottom of a lake', but this image was only a virtual one for us. What miracle has enabled this man, whom it is my astonishment and good fortune to know, to body forth all that remained, up till his appearance, in the highest domain of fantasy? What a revolution must have taken place within him for it to have been possible for this to happen! [...] In order to be able to break suddenly away from sensible things, or with more reason from the *easiness* of their customary appearance, one has to be aware of their treason to such a high degree that one cannot escape recognizing the fact of Picasso's immense responsibility. A single failure of will-power on his part would be sufficient for everything we are concerned with to be at least put back, if not wholly lost. His admirable perseverance is such a valuable guarantee that it dispenses with all need for us to appeal to any other authority. Shall we ever know what awaits us at the end of this agonizing journey? All that matters is that the exploration be continued, and that the objective rallying signs take place without any possibility of equivocation and follow one another uninterrupt-edly. [...]

One would have to have formed no idea of Picasso's exceptional predestination to dare to fear or hope for a partial renunciation on his part. Nothing seems to me more amusing or more just than that, in order to discourage insupportable followers or to

draw a sigh of relief from the beast of reaction, he has only from time to time to offer for their admiration the things he has scrapped. From the laboratory open to the sky there will continue to escape, at nightfall, divinely unwonted beings, dancers dragging fragments of marble mantelpieces behind them, adorably laden tables, beside which yours are mere turning-tables, and all that remains clinging to the immemorial newspaper: *Le Four....* It has been said that there could be no such thing as surrealist painting. Painting, literature – what are they to us, O Picasso, you who have carried the spirit, no longer of contradiction, but of evasion, to its furthest point! From each one of your pictures you have let down a rope-ladder, or rather a ladder made of the sheets of your bed, and we, and probably you with us, desire only to climb up into your sleep and down from it again. And they come and talk to us of painting, they come and remind us of that lamentable expedient which is painting!

When we were children we had toys that would make us weep with pity and anger today. One day, perhaps, we shall see the toys of our whole life, like those of our childhood, once more. It was Picasso who gave me this idea. [...] We grow up until a certain age, it seems, and our playthings grow up with us. Playing a part in the drama whose only theatre is the mind, Picasso, creator of tragic toys for adults, has caused man to grow up and, sometimes under the guise of exasperating him, has put an end to his puerile fidgeting.

On account of these many considerations, we emphatically claim him as one of us, even while it is impossible and would be impudent to subject his methods to the rigorous system of criticism which we propose to institute. If surrealism has assigned to itself a line of conduct, it has only to submit to it in the way that Picasso has submitted to it and will continue to submit; I hope by saying this to prove myself very exacting. I shall always oppose the absurdly restrictive character of that which any kind of discipline[1] would impose on the activity of the man from whom we persist in expecting more than from anyone else. The 'cubist' discipline made this mistake long ago. Such restrictions may be suitable for others, but it seems to me urgently desirable that Picasso and Braque should be exempted.

I believe that men will long continue to feel the need of following to its source the magical river flowing from their eyes, bathing with the same hallucinatory light and shade both the things that are and the things that are not. Not always quite knowing to what the disturbing discovery is due, they will place one of these springs high above the summit of any mountain. The region where the charming vapours of the as yet unknown, with which they are to fall in love, condense, will appear to them in a lightning-flash. Perhaps even there they will set up their wretched booths, will multiply and exterminate one another, and have no other desire than to return *to earth* after having plundered! If there then remains in the world, amidst the disorder of vanity and darkness, a single appearance of perfect resolution, of ideal reduction to a point, of all those things that swayed us during the distant epoch of our lives, I ask for nothing better than that this may be the twenty or thirty pictures that we made our thought's happy shores – happy without knowing it, happy that after all shores should exist. [...]

We shall see the Revolution, concerning the definition of which there can today be no more misunderstanding, and it will provide a reason for our scruples. It is only before the Revolution that I consider it to be efficacious to summon the best men that I know. The responsibility of painters, as of all those to whom it falls due in no small measure to prevent, in whatever form of expression is theirs, the survival of the sign for

the thing signified, seems to me at present to be both a heavy and an ill-supported one. Yet that is the price of eternity. The mind slips up on this apparently fortuitous circumstance as on a piece of banana-skin. Those who prefer to take no account of the moment when they expect the least to happen seem to me to lack that mysterious aid which to my mind is the only aid of any importance. The revolutionary content of a work, or merely its content, could not depend upon the choice of the elements which this work brings into play. This accounts for the difficulty of obtaining a strict and objective scale of plastic values at a time when a total revision of all values is about to be undertaken, and when clairvoyance obliges us to recognize only those values which are likely to hasten this revision.

Confronted by the utter bankruptcy of art-criticism, a bankruptcy that is really quite comic, it is not for us to complain that the articles of a Raynal, a Vauxcelles or a Fels surpass the limits of imbecility. The continued scandal of Cézannism, of neo-academism, or of machinism, is incapable of compromising the issue that is our real interest. Whether Utrillo is still or already a good 'seller', whether Chagall happens to be considered a surrealist or not, are matters for grocers' assistants. Undoubtedly the study of conventions, to which I will content myself with making a passing allusion, could be profoundly edifying if it were properly conducted, but it would be a waste of time for me to attempt it here, inasmuch as these conventions are in perfect accord with all those things which, in a more general domain, are now being denounced. From an intellectual point of view, it is simply a question of finding out to what causes can be attributed the incontestable failure of certain artists, which, in two or three cases, goes so far as to appear to us as resulting from the loss of a *state of grace*.

Now that Picasso, absolved by his genius from all merely moral obligations, he who unceasingly deceives appearances with reality, going so far as to defy, to a sometimes alarming extent, that which, as we see it, is forever unforgiving – now that Picasso, finally escaping from all compromise, remains master of a situation that except for him we should have considered desperate, it does in fact seem that the majority of his early companions are travelling a road that is the furthest apart from ours and his own. Those who, with such particularly prophetic intuition, called themselves 'les Fauves', no longer do anything now except pace ridiculously up and down behind the bars of time, and from their final pounces, so little to be feared, the least dealer, or tamer, can defend himself with a chair. These discouraged and discouraging old lions are Matisse and Derain. They do not even retain their nostalgia for the forest and the desert; they have passed into a tiny arena: their gratitude to those who mate them and keep them alive. A *Nude* by Derain, a new *Window* by Matisse – what surer testimony could there be to the truth of the contention that 'not all the water in the sea would suffice to wash out one drop of intellectual blood'?[2] So will these men never rise again? Should they now desire to make honourable amends to the mind, they would find themselves forever lost, both they and the others. The air once so limpid, the journey that will not be made, the uncrossed distance that separates the place where one left an object from the place where one finds it again on waking, the inseparable eternities of this hour and of this place, are all at the mercy of our first act of submission. I should like to discuss so total a loss at greater length. But what is to be done? It is too late.

I cannot help being moved by the destiny of Georges Braque. This man has taken infinite precautions. Between his head and his hands I seem to see a great hour-glass

whose sand appears to be in no greater a hurry than the motes that dance in a ray of sunlight. Sometimes this hour-glass goes down on the horizon and then the sand flows no more. That is because Braque '*loves the rule that corrects emotion*', while I myself do nothing but violently deny this rule. Where did he get it from? There must be some idea of God behind it.[3] *It's very nice* to paint, and *it's very nice* not to paint. One can even paint 'well', and not paint well. In short . . . Braque is at present a great refugee. I am afraid that in a year or two's time I shall no longer be able to mention his name. But that is being a little hasty.

Apollinaire turned against him after 1918. When he himself was beginning to turn out so badly that death was about to stop him, he could hardly find strong enough terms – and he chose other pretexts – to attack those who were offering to give in. Braque already appeared to be one of them. I have not the same reasons for attacking him, and never shall have, and I shall not forget that for many years he followed on his own account the road on which he and Picasso stood alone. [. . .]

But one day Braque took pity on reality. I cannot too often repeat that for every object to be in its place, every one of us must put something of ourselves there. Think of those interminable seconds of posing which last our whole lives long. Without fear of consequences, one can indefinitely repeat the gesture of offering a bouquet. But it is a lot to ask of the bouquet that it should reveal the hand which offers it and which is trembling. Braque's hand has trembled.

[1] Even were that the 'surrealist' discipline.
[2] Isidore Ducasse.
[3] To speak of God, to think of God is in every respect to give him his due, and when I say that, it is very certain that I do not make this idea mine, even in order to combat it. *I have always wagered against God*, and I regard the little that *I have won* in this world as simply the outcome of this bet. The stake (my life) has been so ridiculous that I am conscious of having won to the full. Everything that is doddering, squint-eyed, infamous, sullying and grotesque is contained for me in this single word: God. [. . .]

6 André Breton (1896–1966) from the Second Manifesto of Surrealism

Surrealism had maintained a tense relationship with the Communist Party since 1925. Ever since Breton had insisted, against Pierre Naville, on the necessity for remaining independent of the Party, the danger had existed of becoming merely an artistic vanguard. In 1929 Breton purged the by now successful group and issued a second Manifesto, explicitly embracing Marxism and taking up a position allied to Trotsky, against orthodox, Stalinist Communism. The Second Manifesto was published as the final (12th) edition of *La Révolution Surréaliste* on 15 December 1929. This journal was itself replaced by the new, more austere *Le Surréalisme au Service de la Révolution*, which ran until 1933. Extracts from the Second Manifesto are taken from the English translation by Seaver and Lane in *Manifestoes of Surrealism*, op. cit., pp. 123–87.

Surrealism, although a special part of its function is to examine with a critical eye the notions of reality and unreality, reason and irrationality, reflection and impulse, knowledge and 'fatal' ignorance, usefulness and uselessness, is analogous at least in one respect with historical materialism in that it too tends to take as its point of departure the 'colossal abortion' of the Hegelian system. It seems impossible to me

to assign any limitations – economic limitations, for instance – to the exercise of a thought finally made tractable to negation, and to the negation of negation. How can one accept the fact that the dialectical method can only be validly applied to the solution of social problems? The entire aim of Surrealism is to supply it with practical possibilities in no way competitive in the most immediate realm of consciousness. I really fail to see – some narrow-minded revolutionaries notwithstanding – why we should refrain from supporting the Revolution, provided we view the problems of love, dreams, madness, art, and religion from the same angle they do. Now, I have no hesitation in saying that, prior to Surrealism, nothing systematic has been done in this direction, and at the point where we found it *the dialectical method, in its Hegelian form, was inapplicable for us too*. There was, for us too, the necessity to put an end to idealism properly speaking, the creation of the word 'Surrealism' would testify to this [...]

We also intend to place ourselves at a point of departure such that for us philosophy is 'outclassed.' It is, I think, the fate of all those for whom reality is not only important theoretically but for whom it is also a matter of life or death to make an impassioned appeal, as Feuerbach desired, to that reality: our fate to give as we do, *completely*, without any reservations, our allegiance to the principle of historical materialism. [...]

Our allegiance to the principle of historical materialism ... there is no way to play on these words. So long as that depends solely on us – I mean provided that communism does not look upon us merely as so many strange animals intended to be exhibited strolling about and gaping suspiciously in its ranks – we shall prove ourselves fully capable of doing our duty as revolutionaries. [...]

[...] In September 1928, ... these two questions ... were asked me:

1. Do you believe that literary and artistic output is a purely individual phenomenon? Don't you think that it can or must be the reflection of the main currents which determine the economic and social evolution of humanity?

2. Do you believe in a literature and an art which express the aspirations of the working class? Who, in your opinion, are the principal representatives of this literature and this art?

My answers were as follows:

1. Most certainly, the same goes for literary or artistic output as for any intellectual phenomenon, in that the only question one can rightly raise concerning it is that of the *sovereignty of thought*. That is, it is impossible to answer your question affirmatively or negatively, and all one can say is that the only observable philosophical attitude in such a case consists in playing up 'the contradiction (which does exist) between the nature of human thought which we take to be absolute and the reality of that thought in a crowd of individuals of limited thought'. [Engels] [...] This thought, in the area where you ask me to consider such and such a specific expression in relation to it, can only oscillate between the awareness of its inviolate autonomy and that of its utter dependence. In our own time, artistic and literary production appears to me to be wholly sacrificed to the need that this drama, after a century of truly harrowing poetry and philosophy (Hegel, Feuerbach, Marx, Lautréamont, Rimbaud, Jarry, Freud, Chaplin,

Trotsky), has to work itself out. Under these circumstances, to say that this output can or must reflect the main currents which determine the economic and social evolution of humanity would be offering a rather unrefined judgment, implying the purely circumstantial awareness of thought and giving little credit to its fundamental nature: both unconditioned and conditioned, utopian and realistic, finding its end in itself and aspiring only to serve, etc.

2. I do not believe in the present possibility of an art or literature which expresses the aspirations of the working class. If I refuse to believe in such a possibility, it is because, in any prerevolutionary period the writer or artist, who of necessity is a product of the bourgeoisie, is by definition incapable of translating these aspirations. I do not deny that he can get some idea of these aspirations and that, in rather exceptional moral circumstances, he may be capable of conceiving of the relativity of any cause in terms of the proletarian cause. I consider it to be a matter of sensitivity and integrity for him. This does not mean, however, that he will elude the remarkable doubt, inherent in the means of expression which are his, which forces him to consider from a very special angle, within himself and for himself alone, the work he intends to do. In order to be viable, this work demands to be *situated* in relationship to certain other already existing works and must, in its turn, open up new paths. Making all due allowances, it would, for example, be just as pointless to protest against the assertion of a poetic determinism, whose laws cannot be promulgated, as against that of dialectical materialism. Speaking personally, I am convinced that the two kinds of evolution are strictly similar and, moreover, that they have at least this much in common: *they are both unsparing.* Just as Marx's forecasts and predictions – as far as almost all the external events which have transpired since his death are concerned – have proved to be accurate, I can see nothing which would invalidate a single word of Lautréamont's with respect to events of interest only to the mind. By comparison, any attempt to explain social phenomena other than by Marx is to my mind as erroneous as any effort to defend or illustrate a so-called 'proletarian' literature and art at a time in history when no one can fairly claim any real kinship with the proletarian culture, for the very excellent reason that this culture does not yet exist, even under proletarian regimes. [...]

* * *

It is incumbent on us...to try to see more and more clearly what is transpiring unbeknownst to man in the depths of his mind, even if he should begin to hold his own vortex against us. We are, in all this, a far cry from wanting to reduce the portion of what can be untangled, and nothing could be farther from our minds than being sent back to the scientific study of 'complexes.' To be sure, Surrealism, which as we have seen deliberately opted for the Marxist doctrine in the realm of social problems, has no intention of minimizing Freudian doctrine as it applies to the evaluation of ideas: on the contrary, Surrealism believes Freudian criticism to be the first and only one with a really solid basis. While it is impossible for Surrealism to remain indifferent to the debate which, in its presence, pits qualified practitioners of various psychoanalytical tendencies against one another – just as it is obliged to consider daily and with impassioned interest the struggle taking place within the leadership of the International – it need not interfere in a controversy which, it would seem, cannot long pursue a useful course except among practitioners. This is not the area in which Surrealism intends to point up the result of its personal experiments. But since by their very

nature those individuals who are drawn to Surrealism are especially interested in the Freudian concept which affects the greater part of their deep concerns as men – the concern to create, to destroy artistically – I mean the definition of the phenomenon known as 'sublimation,' Surrealism basically asks these people to bring to the accomplishment of their mission a new *awareness*, to perform an act of self-observation, which in their case is of very exceptional value, to compensate for what is insufficient about the penetration of so-called 'artistic' states of mind by men who for the most part are not artists but doctors. Moreover, Surrealism demands that, by taking a path opposite from the one we have just seen them follow, those who possess, in the Freudian sense, the 'precious faculty' we are referring to, bend their efforts toward studying in this light the most complex mechanism of all, 'inspiration,' and, from the moment they cease thinking of it as something sacred, Surrealism demands that, however confident they are of its extraordinary virtue they dream only of making it shed its final ties, or even – something no one had ever dared conceive of – of making it submit to them. There is no point in resorting to subtleties on this point; we all know well enough what inspiration is. There is no way of mistaking it; it is what has provided for the supreme needs of expression in every time and clime. It is commonly said that it is either present or it is not, and if it is absent, nothing of what, by way of comparison, is suggested by the human cleverness that interest, discursive intelligence, and the talent acquired by dint of hard work obliterate, can make up for it. We can easily recognize it by that total possession of our mind which, at rare intervals, prevents our being, for every problem posed, the plaything of one rational solution rather than some other equally rational solution, by that sort of short circuit it creates between a given idea and a respondent idea (written, for example). Just as in the physical world, a short circuit occurs when the two 'poles' of a machine are joined by a conductor of little or no resistance. In poetry and in painting, Surrealism has done everything it can and more to increase these short circuits. It believes, and it will never believe in anything more wholeheartedly, in reproducing artificially this ideal moment when man, in the grip of a particular emotion, is suddenly seized by this something 'stronger than himself' which projects him, in self-defense, into immortality. If he were lucid, awake, he would be terrified as he wriggled out of this tight situation. The whole point for him is not to be free of it, for him to go on talking the entire time this mysterious ringing lasts: it is, in fact, the point at which he ceases to belong to himself that he belongs to us. These products of psychic activity, as far removed as possible from the desire to make sense, as free as possible of any ideas of responsibility which are always prone to act as brakes, as independent as possible of everything which is not 'the passive life of the intelligence' – these products which automatic writing and the description of dreams represent offer at one and the same time the advantage of being unique in providing elements of appreciation of great style to a body of criticism which, in the realm of art, reveals itself to be strangely helpless, of permitting a general reclassification of lyrical values, and of proposing a key capable of opening indefinitely that box of many bottoms called man, a key that dissuades him from turning back, for reasons of self-preservation, when in the darkness he bumps into doors, locked from the outside, of the 'beyond,' of reality, of reason, of genius, and of love. A day will come when we will no longer allow ourselves to use it in such cavalier fashion, as we have done, with its palpable proofs of an existence other than the one we think we are living. We

will then be surprised to realize that, having come so close to seizing *the truth*, most of us have been careful to provide ourselves with an alibi, be it literary or any other, rather than throwing ourselves, without knowing how to swim, into the water, and without believing in the phoenix, plunging into the fire to reach this truth. [...]

7 George Grosz (1893–1959) and Wieland Herzfelde (1896–1988) 'Art is in Danger'

Herzfelde had founded the left-wing publishing house Malik Verlag in 1917, publishing, *inter alia*, Grosz's satirical graphic portfolios such as *Face of the Ruling Class* and *Ecce Homo*. By the mid-1920s Grosz had resumed painting, and his art had generally become more sober under the impact of Neue Sachlichkeit (see IIIA12). However, both authors remained convinced of the implication of art in social conflict, and therefore militantly opposed to any notion of a 'pure' art. On the other hand this did not amount to a prescription for the orthodox figuration then being adopted by many left-wing artists. The essay was originally published as 'Die Kunst ist in Gefahr: ein Orientierungsversuch' by Malik Verlag, Berlin, 1925. The present extracts are taken from the translation by Gabriele Bennet in Lucy Lippard (ed.), *Dadas on Art*, Princeton, NJ, 1971, pp. 80–5. (For earlier texts by Grosz see IIIB13 and IVB8.)

JESUS IN THE TRENCHES

The German Dada movement was rooted in the realization, which came simultaneously to several of my comrades and myself, that it was complete insanity to believe that 'spirit' [Geist] or people of 'spirit' ruled the world. Goethe under bombardment, Nietzsche in rucksack, Jesus in the trenches – there were still people who continued to believe in the autonomous power of spirit and art.

Dada was the first significant art movement in Germany in decades. Don't laugh – through this movement all the 'isms' of art became yesterday's inconsequential studio affairs. Dada was not a 'made' movement, but an organic product, originating in reaction to the head-in-the-clouds tendency of so-called holy art, whose disciples brooded over cubes and Gothic art while the generals were painting in blood. Dada forced the devotees of art to show their colors.

DADA AS EXTERMINATOR

What did the Dadas do? They said it's all the same, whether one just blusters – or gives forth with a sonnet from Petrarch, Shakespeare, or Rilke; whether one gilds boot-heels or carves Madonnas: the shooting goes on, profiteering goes on, hunger goes on, lying goes on; why all that art? Wasn't it the height of fraud to pretend art created spiritual values? Wasn't it unbelievably ridiculous that art was taken seriously by itself and no one else? 'Hands off holy art!' screamed the foes of Dada. 'Art is in danger!' 'Spirit is being dishonoured!' This prattle about the spirit, when the only spirit was the dishonoured one of the press, which wrote: Buy war bonds! – What prattle about art, as they finally arrived at the task of overpainting with beauty and interesting features the face of Anno 13, which daily unmasked itself more and more.

AGAINST WINDMILLS

Today I know, together with all the other founders of Dada, that our only mistake was to have been seriously engaged at all with so-called art. Dada was the breakthrough, taking place with bawling and scornful laughter; it came out of a narrow, overbearing, and overrated milieu, and floating in the air between the classes, knew no responsibility to the general public. We saw then the insane end products of the ruling order of society and burst into laughter. We had not yet seen the system behind this insanity.

IT DAWNS

The pending revolution brought gradual understanding of this system. There were no more laughing matters, there were more important problems than those of art; if art was still to have a meaning, it had to submit to those problems. In the void in which we found ourselves after overcoming art phraseology, some of us dadas got lost, mainly those in Switzerland and France, who had experienced the cultural shocks of the last decade more from the newspaper perspective. The rest of us saw the great new task: Tendency Art in the service of the revolutionary cause.

GALLOP THROUGH ART HISTORY

The demand for Tendency irritates the art world, today perhaps more than ever, to enraged and disdainful opposition. Admittedly all times have had important works of tendentious character, although such works are not appreciated for their tendentiousness, but rather for their formal, "purely artistic" qualities. These circles completely fail to recognize that at all times all art has a tendency, that only the character and clarity of this tendency have changed. [...]

WANDERERS INTO THE VOID

However, there are still artists who consciously and emphatically attempt to avoid tendency of any kind by renouncing completely the representational, even the problematical. Often they believe they can work instinctively and aimlessly, like Nature, which, without visible purpose, gives form and color to crystals, plants, stones – everything that exists. They give their paintings obscure names, or just numbers. Evidently this method is based upon the attempt to produce pure stimulus, as in music, through intentional elimination of all other effectual possibilities. The painter is to be nothing but a creator of form and color. Whether these artists believe their work has no 'deeper meaning,' or whether they impart to it an emotional or metaphysical meaning hardly perceptible to the spectator, the fact remains that they intentionally renounce all the artist's possibilities of ideological influence (in the areas of eroticism, religion, politics, aesthetics, morality, etc.), standing silent and indifferent, that is, irresponsibly, in relation to social occurrence, or – in cases where that is not the intention – they work in vain through ignorance and ineptitude.

NO ANSWER IS ALSO AN ANSWER

When such artists enter the service of industry and applied art, there can be as little objection raised as when a politician engages himself as a craftsman. A matter of talent.

When this art of literary attraction is pursued for its own sake, decidedly blasé indifference and irresponsible individualistic feelings are propagated.

SKILL DOES NO HARM

Obviously, the artist's relationship to the world is always expressed in his work and that relationship inevitably gives it its tendency. Thus it is only justifiable to blame an artist for his tendency when that tendency contradicts the artist's broad view, as unintentionally revealed in his style; or when an artist tries to compensate for ineptitude by adding a tendentious motif or title. Someone might use inadequate means in support of a tendency of which he is completely convinced; there too, one cannot object to the tendency because of his inadequate ability to express it.

But one has never heard of Grützner being reproached with his propaganda for German beer or for the monastic joys of manhood, or of Grünewald being reproached with his Christian belief. When artlovers attempt to dismiss a work because of its tendency, as a principle or as a vehicle of sensation, they do not approach the artist's work critically, but are hostile to the idea for which he stands.

WHOSE BREAD I EAT, HIS PRAISE I SING

The artist, whether he likes it or not, lives in continual correlation to the public, to society, and he cannot withdraw from its laws of evolution, even when, as today, they include class conflict. Anyone maintaining a sophisticated stance above or outside of things is also taking sides, for such indifference and aloofness is automatically a support of the class currently in power – in Germany, the Middle Class. Moreover, a great number of artists quite consciously support the bourgeois system, since it is within that system that their work sells.

WHAT WILL I THINK TOMORROW?

In November, 1918, as the tide seemed to be turning – the most sheltered simpleton suddenly discovered his sympathy for the working people, and for several months mass-produced red and reddish allegories and pamphlets did well in the art market. Soon afterward, however, quiet and order returned; would you believe it, our artists returned with the greatest possible silence to the higher regions: 'What do you mean? We remained revolutionary – but the workers, don't even mention them. They are all bourgeois. In this country one cannot make a revolution.' And so they brood again in their studios over 'really' revolutionary problems of form, color, and style.

THE YOUNG MAN DIGESTS EVERYTHING

Formal revolution lost its shock effect a long time ago. The modern citizen digests everything; only the money chests are vulnerable. Today's young merchant is not like

his counterpart in Gustav Freytag's times: ice-cold, aloof, he hangs the most radical things in his apartment.... Rash and unhesitating acceptance so as not to be 'born yesterday' is the password. Automobile – the newest, most sporty model. Nothing said about professional mission, obligations of wealth; cool, objective to the point of dullness, sceptical, without illusions, avaricious, he understands only his merchandise, for everything else – including the fields of philosophy, ethics, art – for all culture, there are specialists who determine the fashion, which is then accepted at face value. Even the formal revolutionaries and 'wanderers into the void' do fairly well, for, underneath, they are related to those gentlemen, and have, despite all their apparent discrepancies, the same indifferent, arrogant view of life.

PAINT USEFULLY

Anyone to whom the workers' revolutionary cause is not just a phrase or 'a beautiful idea, but impossible to realize,' cannot be content to work harmlessly along dealing with formal problems. He must try to express the workers' battle idea and measure the value of his work by its social usefulness and effectiveness, rather than by uncontrollable individual artistic principles or public success.

LAST ROUND

Let us summarize: the meaning, nature, and history of art are directly related to the meaning, nature, and history of society. The prerequisite for the perception and evaluation of contemporary art is an intellect directed at the knowledge of facts and of correlations with real life and all its convulsions and tensions. For a hundred years, man has been seizing the earth's means of production. At the same time, the fight among men for possession of these means assumes ever more extensive forms, drawing all men into its vortex. There are workers, employees, civil servants, commercial travelers, and stock-holders, contractors, merchants, men of finance. Everyone else represents stages of these two fronts. The struggle for existence of a mankind divided into the exploited and the exploiters is, in its sharpest and final form: class warfare.

Yes, art is in danger:

Today's artist, if he does not want to run down and become an antiquated dud, has the choice between technology and class warfare propaganda. In both cases he must give up 'pure art.' Either he enrolls as an architect, engineer, or advertising artist in the army (unfortunately very feudalistically organized) which develops industrial powers and exploits the world; or, as a reporter and critic reflecting the face of our times, a propagandist and defender of the revolutionary idea and its partisans, he finds a place in the army of the suppressed who fight for their just share of the world, for a significant social organization of life.

8 Osip Brik (1888–1945) 'Photography versus Painting'

In Russia by the mid-1920s, lessening of opportunities for practical intervention in social construction had led many Constructivists, notably Rodchenko, to develop an interest in

photography. The concept of 'factography' represented the linking of photography to reportage. Brik argues that photography, far from being a mere craft, is in a position to eclipse painting as a means of representing reality. His essay thus constitutes both an attack on revivals of figurative painting, and a recommendation to develop the theory and practice of photography itself as the most appropriate contemporary mode of Realism. Originally published in *Sovetskoie Foto*, no. 2, 1926. The present translation is taken from David Elliott (ed.), *Rodchenko*, Oxford, 1979, pp. 90–1. (For earlier texts by Brik see IIID10 and 11.)

Photography pushes painting aside. Painting resists and is determined not to capitulate. This is how the battle must be interpreted which started a hundred years ago when the camera was invented and which will only end when photography has finally pushed painting out of the place it held in daily life. The photographers' motto was: precision, speed, cheapness. These were their advantages. Here they could compete with painters. Particularly in the case of portraits. Even the most gifted painter cannot achieve the degree of faithful reproduction of which the camera is capable. Even the quickest painter cannot supply a portrait within minutes. The cheapest painting is more expensive than the most expensive photograph. After portraits landscapes were tackled, reproductions, genre pictures. And all had the same advertisement: precision, speed, cheapness. The painters recognised the danger. The success of photography was enormous. Immediate steps had to be taken. A stronger counter-attack mounted.

Cheapness and speed could hardly be fought. The camera works more cheaply and quickly. Precision can be disputed. So this was where the attack was centred.

Photography is not coloured. Painting is. This means that painting reproduces an object more faithfully and is without rival in this respect.

This is how the painters argue. And the consumer had to be convinced of this. But the painters were wrong and many are still wrong today.

It is true that in life we do see objects in colour. And a painting reproduces these objects by means of colours. But these are different from nature, not identical with her. Painting cannot transpose real colours, it can only copy – more or less approximately – a tint we see in nature. And the problem is not how talented a painter is, but is basic to the very nature of his or her work. The colour media with which a painter works (oil, watercolour, size) have a different effect on our eyes than the rays of light which give diverse colours to objects. However much the painter tries s/he cannot go beyond the narrow limits of the palette. S/he cannot give a picture those colours – either in quality or in quantity – which objects possess in reality.

Photography does not yet reproduce exact colouring, but at least it does not falsify an object by giving it the wrong colours. And this is an advantage not to be underestimated.

The most sensitive and progressive painters have long since grasped that precision of colour reproduction is not at all easy and that the principles of painterly colouring are not identical with those of reality. So they declared: 'Precision is not the ultimate aim.'

The painter's task certainly does not consist in showing an object as it is but rather in recreating it in a painting according to different, purely painterly laws. What do we care for how an object looks? Let observers and photographers deal with that, we – the painters – make pictures in which nature is not the subject but merely an initial

impetus for ideas. The painter not only has the right to change reality, it is virtually his duty to do so; otherwise he is not a painter but a bad copyist – a photographer.

Life cannot be represented in a painting, it would be senseless to imitate it; that means it must be recreated on canvas in a separate, painterly way. This is the idea behind the theories and schools of painting which have emerged since the middle of the 19th century under the names of Impressionism, Cubism, Suprematism and many others. The painters' repudiation of the idea of reproducing nature marked a decisive divide between photography and painting. They had separate tasks which could not be compared. Each fulfills its own task. The photographer captures life and the painter makes pictures. A photograph transmits no colours at all; a painting gives a consciously different, non-real colour to an object. The situation seems clear. But here, in Soviet Russia, an interesting artistic phenomenon can be observed, namely the attempt by the painters to regain lost positions and to strive for the reproduction of reality in line with photography. This is reflected in the activities of the AKhRR (Association of the Visual Artists of Revolutionary Russia). The social roots of this phenomenon are quite obvious: Firstly an immense need for a visual record of the new life. Secondly a lot of painters who abandoned their style because nobody wanted to buy their pictures, and thirdly far less artistically cultured buyers who do not distinguish between an exact reproduction of an object and an approximation. The attempt by the AKhRR to resurrect the so-called painterly realism is completely hopeless. One of the representatives of the AKhRR said in a discussion: 'As long as photography is not sufficiently advanced in this country realistic painting is necessary.' This 'as long as' shows up in a nutshell what the work of the AKhRR means. As long as we do not have enough automobiles we will have to go by horse-drawn carts. But sooner or later we shall go in automobiles.

The photographer captures life and events more cheaply, quickly and precisely than the painter. Herein lies his strength, his enormous social importance. And he is not frightened by any outdated daub.

But the photographers themselves do not realise their social importance. They know they are doing a necessary, important task, but they think they are only artisans, humble workers far removed from artists and painters. The photographer is enormously impressed by the fact that the painter does not work to commission but for himself, that paintings are presented in large exhibitions with varnishing days, catalogues, music, buffet food and speeches, that long essays giving an exact analysis of composition, structure, brushwork and colour scale are written on every picture, every painter, and that such exhibitions are regarded as cultural events. All this confirms him in the idea that painting is true art, photography merely an insignificant craft.

This explains every photographer's dream to achieve a painterly effect in his photographs. It also explains the attempts to take artistic photographs and to work on them 'so that they look like reproductions of paintings.'

The photographer does not understand that this chasing after painterly attitudes and the slavish imitation of painting destroys his craft and takes away the forcefulness on which its social importance is based. He moves away from faithful reproduction of nature and submits to aesthetic laws which distort this very nature. The photographer wants to attain the social recognition which the painter enjoys. This is a perfectly normal wish. But it is not fulfilled by the photographer following the painter, but rather by his opposing his own art to that of the painter. If the photographer follows the

main principle of his craft, which is the ability to capture nature faithfully, he will as a matter of course create things which will have just as strong an effect on the spectator as the painting of an artist, whoever he may be.

The photographer must show that it is not just life ordered according to aesthetic laws which is impressive, but also vivid, everyday life itself as it is transfixed in a technically perfect photograph.

By battling against the aesthetic distortion of nature the photographer acquires his right to social recognition, and not by painfully and uselessly striving to imitate models alien to photography.

This is not an easy path, but it is the only true one. It is not easy because neither here nor in the West is there even the beginning of a theory of the art of photography, the art of how to make highly accomplished photographs. All that is being written or said on the subject is reduced either to a series of technical tips and prescriptions or to hints on how to achieve painterly effects, how to make a photograph not look like a photograph.

And yet some artists and painters do exist who have abandoned painting in favour of photography; people who understand that photography has its mission, its aims, its own development; there are some among them who have already achieved certain results in this field.

What is needed is that these people somehow exchange their views, tell each other of their experiences, unite their powers in a common effort, a common battle against the painterly element in photography and towards a new theory of the art of photography which is independent of the laws of painting. The experiences of those people who have previously been painters are particularly interesting in this context.

Former popes and monks make the most convinced campaigners against religion. Nobody knows the mysteries of churches and monasteries better than they. The best fighters against painterly aestheticism are former painters. Nobody knows the secrets of artistic creation better. Nobody can expose the falseness of artistic reproduction of reality better. They have consciously moved away from painting, they will consciously fight for photography. One of them is A. M. Rodchenko, once a brilliant painter, today a committed photographer. His photographic works are little known by the general public because they are mainly experimental. The public wants definitely finished products, but for the professional photographers, for those who take an interest in the development of a photographic art, an acquaintance with Rodchenko's results is indispensable.

His main task is to move away from the principles of painterly composition of photographs and to find other, specifically photographic laws for their making and composition. And this must after all interest everybody who does not see photography as a pitiable craft but as a subject of enormous social relevance, called upon to silence painting's chatter about representing life artistically.

9 Sergei Tretyakov (1892–1939) 'We Are Searching' and 'We Raise the Alarm'

Tretyakov edited *Novy Lef* (*New Lef*), the journal which Mayakovsky restarted in 1927, the original *LEF* (see IIID9) having folded early in 1925. In these short texts he advocates 'factography' as a progressive alternative to a revived academicism in art and literature,

with an emphasis on photography and documentary film. Official hostility to these trends did not decline, however, and *Novy Lef* ceased publication in 1928. By the early 1930s attempts to develop a critical Realist practice on the base of innovatory forms had foundered on the imposition of 'Socialist Realism' (see IVB11 and 15). These essays were originally published in *Novy Lef*, no. 11/12, 1927. They were translated by Ben Brewster in *Screen*, London, vol. 12, no. 4, Winter 1971–2, from which the present extracts are taken.

We Are Searching

From the outset Lef has worked on the problem of the social function of things produced by workers in art. The task is to set aside all the vague and often ostentatious motivations and get at the real social purpose of an art work, at the effect it produces, then to establish the means and conditions, which will enable the artist to achieve this effect most fully and with the utmost economy of force and devices. [...]

To the easel painting, which supposedly functions as 'a mirror of reality' Lef opposes the photograph – a more accurate, rapid and objective means of fixing fact.

To the easel painting – claimed to be a permanent source of agit – Lef opposes the placard, which is topical, designed and adapted for the street, the newspaper and the demonstration, and which hits the emotions with the sureness of artillery fire.

In literature to *belles-lettres* and the related claim to 'reflection' Lef opposes reportage – literature of fact – which breaks with literary art traditions and moves entirely into the field of 'factography' to serve the newspaper and the journal. This is what is meant by Lef prose which we are disseminating through various newspaper articles and publishing in exemplary extracts in the journal *New Lef*.

On the other hand, Lef continues to promote poetry which it places within a definite agit function, assigns clear tasks in journalism and coordinates with other newspaper material.

These are the two fields from which the Lef formula of art is developing. If fact is needed – old art is no use. Old art deforms fact – to grasp fact use new methods.

If stimulus and agit are needed – assemble all the appropriate material available, but bear in mind that agit divorced from a concrete aim to which it is directed, agit transformed into agit in general, a play on nerves, stimulation for its own sake, is agit aesthetics and operates in society like drugs or dangerous drink. [...]

The fixing of fact and agit represent two basic functions. In considering these we must also consider the devices through which these functions can be realized.

The art product operates (chiefly) as either intellectualization or emotionalization. In fact these may well represent two functional axes in relation to which the old concepts 'epic' and 'lyric' are now crystallizing. We consider that with increased precision of work in art, the former will gain ground at the expense of the latter. We are moving towards a time when the intellectual content of facts will give them agit effect far surpassing that of any emotionalized pressuring.

It can be assumed that the schema appropriate to the fine arts will apply equally to the cinema. [...]

When Lef theorists analyse formal and material distinctions between the 'play' film and the 'unplayed' film, Tretyakov proceeds from the film material. Shklovsky from the narrative structure of the scenario. Zhemchuzhny from the shooting arrangements, and so on, hence the apparent variations.

But when the question is the social function of these two categories, then Lef's orientation emerges immediately and clearly: on the one hand towards the cinema of fact – the news-reel in the widest sense of the term – and on the other hand to the pragmatically orientated, topical, actuality agit-film. [...]

We Raise the Alarm

The Civil War was also a period of fierce struggle on the art front. The revolutionary Futurists and Com-Futs were not just a detachment of anti-traditionalists rushing in to conquer the tastes of the period. They flung art into the thick of revolutionary activity. They set the tone and held the hegemony in the field of aesthetic forms. Their innovations and projects, while not always fully realized, were always significant and grandiose. Tatlin's Tower, Mayakovsky's *Mystery Bouffe*, the Rosta Posters and the RSFSR productions and in common ideas of the epoch as important and inspiring as those that give rise to the worker's army and communist Saturday labour. The greatest achievement of left art in that period was the establishment of the principle of production art, whereby the former entertainer/joker/clown/conjurer/hanger-on of society's entertainment world switched categorically to the ranks of the workers, exchanging an aesthetic fantasy for the creation of things that were useful and needed by the proletariat.

Lef was the form which the activities of revolutionary Futurism took in the conditions of the New Economic Policy – an association of workers in left art. Lef means Left front, and Left front implies opposition to any other front. The novelty of the Lef position as against the position of Com-Fut lay in the fact that the principles established in the preceding period now had to be realised in conditions of competitive production with other group suppliers of aesthetic products. 'Whose side are you on?' proved to be an urgent question in the field of art too. The whole of academy art ranged itself against Lef. Academy art was economically powerful for it had once again found its old, well-tried consumer. It demanded a licence to trade and this was obligingly granted in the shape of the formula about 'assuming the cultural heritage.'

'Whose side are you on?' – a frenetic rag fair had broken out in the marketplace of aesthetic products where talent, charlatanry and all kinds of fine imitations elbowed each other furiously. Their guidelines were the box office takings and production costs, their aims, to satisfy the tastes of the consumer. They lost no time in disassociating themselves from 'Lefism' even while appropriating Lef formal devices for their own constructivist nicknacks. But Lef proved to have staying power and vitality. Wherever artistic initiative was needed, Lef emerged and acted; to each piece of expediency on the part of academism, Lef raised its own utilitarian-based objection. But since Lef considered that an aggressive stance was vital, it had at all costs to maintain a distance between itself and its enemies: failing this it would have found itself thrust into the general melee where it would have had its arms pinned and been paralysed. As it was, the roach that crept up from the right wing of art did in fact paralyse Lef to a significant extent by taking over all its inventions, terminology, techniques, constructivist devices, parading itself in Lef colours to the point where the inexperienced eye would have been hard put to distinguish where a wooden construction was a construction and where a postcard with an inscription, where verse was a controlled organisation of language, and where simply musty lyricism.

'Whose side are you on?' was transformed into 'anything goes, with anyone, and anywhere', and embraces all-round. Instead of a struggle there came the sermon which preached inter-departmental agreement in the bosom of a single 'Soviet' art. Ideological differences in art were annulled – everything was reduced to a question of formal and technical differences. A band of all-embracing associations arose, flying the 'red' 'Revolutionary', 'Soviet', banner.

New Lef had not come into existence by chance, and the bearers of the innovatory initiative could not accept this 'peace and good-will to all departments' as appropriate soil for the blossoming of a Soviet art which would 'strike awe in the hearts of our enemies in the remaining five sixths of the world', as certain admirable and responsible comrades like to put it.

Drawing the teeth of natural enemies in the art field can lead to only one thing – they all end up toothless. The greatest sin for a worker in the art field now is not lack of talent or inventiveness, but on the contrary, principles. [...]

The first fact against which Lef must take a stand is this replacement of intergroup wars of principles by a levelling of all the conflicting tendencies within the protection of a corporative-type union.

The battle for form has been reduced to a battle for the stylistic sign. New inventions in the field of form are no longer weapons for cultural advance, but merely a new ornament, a new embellishing device, a new addition to the assortment of aesthetic embroideries and rattles offered to the public. [...] The subjection of material to inappropriate formal means can only lead to the distortion of the splendid material offered by Soviet reality.

Soviet reality fixed by the lens of a Soviet camera (even in the form of a painted photograph if the preservation of a colour impression is called for) which finds a place in the pages of an illustrated journal is as important and essential as daily bread. But the same material hanging on the walls of an AKhRR exhibition in the form of an easel painting – which for all its sympathies in this direction the AKhRR hasn't an idea where to put or how to use – is material fixed by the outworn devices of a transplant art and therefore material ruined.

'Red' icon painting devices lend themselves to this kind of distortion of material (proud, fiery-eyed leaders, selfless marching pioneers, peasant Ivans with their heraldic sickles): All of this is a feature of the agit-poster, against which if I am not mistaken, the AKhRR is waging a battle, but whose devices they seem to be attempting to adapt to their own needs. [...]

[...] It is a fact that once the concern with form lessened, what remained was the line of least resistance, the reactivation of already worn-out formal models and the rejection of innovations in form. The persistent cry of the 'saviours of art' against so-called stunts and conjuring tricks has led to a situation where they are now credited with the defence of either the crudely talentless, or of the good old stereotype.

The first mistake of these 'saviours' was their endorsement of the formula form/content, 'what'/'how' (rather than Lef's proposed 'material-purpose-form/thing') and in the activation of each part separately. The second mistake, the forced peddling of the 'primacy of content' (i.e. of a completely indeterminate and undifferentiated phenomenon) was in fact realized in a deterioration in form. The 'how' flew up the chimney. Surely 'how' has its own noun – 'quality'... and the struggle for how/quality is the struggle for form. The struggle for quality in art has now been replaced by a struggle

for the reinstatement of the pre-war stereotype, what has happened is a flight back-wards into the wilderness. [. . .]

[. . .] Material in raw forms – this is the vanguard of contemporary art. But raw forms can only serve an informational purpose and this is the tragedy of the situation – as soon as the question of the use of material on levels other than that of pure information arises, say in agit – pre-war formal devices immediately appear on the scene and thanks to them the material is either deformed as we have seen, or is immediately subjected to the aims of aesthetic diversion from reality and its task of construction.

But the pre-war norm has its defenders.

Why should art be concerned with raising quality and seeking new forms when the basic mass of consumers of aesthetic products swallow them in the pre-war models and even praise them. Down with innovation; down with experiment; long live the aesthetic inertia of the masses.

There is only one context in which the public can honestly be fed the pre-war aesthetic norm: when what is intended is the pre-war norm's corresponding social purpose – to draw the consciousness and emotions of the consumer away from the essential tasks of reality. And this is the point we have reached. The pre-war norm in form has drawn after it the pre-war norm in ideology: art as relaxation, art as pleasant stimulus, art as diversion . . . is this not a variation on the old 'art as dream, day-dream, fantasy'? [. . .]

[. . .] A full stop has been reached. The pre-war norm has been achieved. The altar of art has resurged out of the tedious abysses of our 'depressing, grey, everyday reality' to provide citizens with a legalised daily escape route into the kingdom of dream/stereotypes. Topical raw material still survives, but never mind. . . . The specialists will invent a means of getting imaginative exoticism from Party history material, or treat it in say, ancient Roman or Babylonian tones, or even in the Sergievo-suburbs-iconpainting style and everyone will feel that art is serving revolutionary construction (well of course, look at the themes, incidents, characters) while in reality art will be serving a philistine escapism from the revolution.

These are the four dangers:

- levelling
- lowering of form
- pre-war stereotypes
- art as a drug

Lef is aware and will fight responsibly
for an aggressive, class-active art
for innovation appropriate to the tasks of socialist construction
for art/lifebuilding, art/activisor, art/agit
for the culture of form

10 Siegfried Kracauer (1889–1966) from 'The Mass Ornament'

Originally trained in architecture and philosophy, the author was a critical theorist and cultural commentator in Weimar Germany, working for much of the time on the *Frankfurter*

Zeitung. He particularly sought out overlooked and marginal areas of life as keys to the characteristics of modernity, on the paradoxical grounds that it was the critical scrutiny of the surfaces of life that led one to comprehend the underlying determinations of reality. In this respect his work resonated with that of other critical Marxists in Weimar such as Adorno and Benjamin. Kracauer went into exile after the rise of the Nazis, initially to Paris and then to America. The present essay was published in *Frankfurter Zeitung*, 9–10 June 1927. This text is drawn from the two opening sections, in the translation by Barbara Corell and Jack Zipes in *New German Critique*, 5, Spring 1975, pp. 67–70.

I

An analysis of the simple surface manifestations of an epoch can contribute more to determining its place in the historical process than judgments of the epoch about itself. As expressions of the tendencies of a given time, these judgments cannot be considered valid testimonies about its overall situation. On the other hand the very unconscious nature of surface manifestations allow for direct access to the underlying meaning of existing conditions. Conversely, the interpretation of such manifestations is tied to an understanding of these conditions. The underlying meaning of an epoch and its less obvious pulsations illuminate one another reciprocally.

II

A change in taste has been taking place quietly in the field of physical culture, always a popular subject in illustrated newspapers. It began with the *Tiller Girls*. These products of American 'distraction factories' are no longer individual girls, but indissoluble female units whose movements are mathematical demonstrations. Even as they crystallize into patterns in the revues of Berlin, performances of the same geometrical exactitude are occurring in similarly packed stadiums in Australia and India, not to mention America. Through weekly newsreels in movie houses they have managed to reach even the tiniest villages. One glance at the screen reveals that the ornaments consist of thousands of bodies, sexless bodies in bathing suits. The regularity of their patterns is acclaimed by the masses, who themselves are arranged in row upon ordered row.

These spectacular pageants, which are brought into existence not only by the Girls and the spectators at the stadium, have long since taken on an established form. They have achieved an *international* stature and have attracted aesthetic interest.

The bearers of the ornaments are the *masses*. This is not the same as the people, for whenever the people form patterns, these patterns do not hover in mid-air but emerge from community. A current of organic life flows from these communal groups, whose shared destiny connects them with their ornaments. These ornaments appear as a magic force so laden with meaning that they cannot be reduced to a purely linear structure. [...] The patterns seen in the stadiums and cabarets...are composed of elements which are mere building blocks, nothing more. The construction of an edifice depends on the size of the stones and their number. It is the mass which makes the impact. Only as parts of a mass, not as individuals who believe themselves to be formed from within, are human beings components of a pattern.

The ornament is an *end in itself*. In its early stages the ballet also yielded ornaments which moved kaleidoscopically. But even after they had discarded their ritual meaning,

they remained still the plastic formation of the erotic life which gave rise to them and determined their traits. In contrast, the synchronized movement of the Girls is devoid of any such connections; it is a linear system which no longer has erotic meaning but at best points to the place where the erotic resides. Nor do the living constellations in the stadiums have the meaning of military demonstrations. No matter how orderly the latter appeared, that order was considered a means to an end; the parade march evolved out of patriotic feelings and in turn aroused them in soldiers and loyal subjects. The constellations of Girls, however, have no meaning outside of themselves, and the masses are not a moral unit like a company of soldiers. The patterns cannot even be described as ornamental accessories for gymnastic discipline. The training of the units of Girls is intended instead to produce an immense number of parallel lines, and the desired effect is to train the greatest number of people in order to create a pattern of unimaginable dimensions. In the end there is the closed ornament, whose life components have been drained of their substance.

Even though the masses bring it about, they do not participate in conceiving the ornament. And as linear as it may seem, no line juts out of the small segments to determine the whole of the mass pattern. In this it resembles the *aerial photographs* of landscapes and cities for it does not emerge from the interior of a given reality, but rather appears above it. Similarly, actors are not aware of stage setting in its totality; yet, they consciously take part in its formation, and in the case of ballet dancers, the pattern is still open to the influence of its performers. The more its composition is reduced to linear design, the further it is removed from the immanent consciousness of those forming it. Yet this does not mean that it is observed by a more critical eye. The fact is that nobody would notice the pattern if the crowd of spectators, who have an aesthetic relation to it and do not represent anyone, were not sitting in front of it.

The ornament, detached from its bearers, must be understood *rationally*. It consists of degrees and circles like those found in textbooks of Euclidean geometry. Waves and spirals, the elementary structures of physics, are also included; discarded are the proliferations of organic forms and the radiations of spiritual life. Hereafter, the *Tiller Girls* can no longer be reassembled as human beings. Their mass gymnastics are never performed by whole, autonomous bodies whose contortions would deny rational understanding. Arms, thighs and other segments are the smallest components of the composition.

The structure of the mass ornament reflects that of the general contemporary situation. Since the principle of the *capitalist production process* does not stem purely from nature, it must destroy the natural organisms which it regards either as a means or as a force of resistance. Personality and national community (*Volksgemeinschaft*) perish when calculability is demanded; only as a tiny particle of the mass can the individual human being effortlessly clamber up charts and service machines. A system which is indifferent to variations of form leads necessarily to the obliteration of national characteristics and to the fabrication of masses of workers who can be employed and used uniformly throughout the world. – Like the mass ornament, the capitalist production process is an end in itself. The commodities which it creates are not actually produced to be possessed but to make unlimited profits. Its growth is bound up with that of the factory. The producer does not work for private gains of which he can only make limited use – the surplus profits in America are transferred to cultural accumulation centers such as libraries, universities, etc., in which intellectuals are groomed

who through their later activity reimburse with interest the capital advanced to them. The producer works for the expansion of the business; values are not produced for values' sake. Though such work may once have concerned itself with the production and consumption of values, these have now become side effects which serve the production process. The activities which have been invested in the process have divested themselves of their substantial meaning. – The production process runs its course publicly in secret. Everyone goes through the necessary motions at the conveyor belt, performs a partial function without knowing the entirety. Similar to the pattern in the stadium, the organization hovers above the masses as a monstrous figure whose originator withdraws it from the eyes of its bearers, and who himself hardly reflects upon it. – It is conceived according to rational principles which the Taylor system only takes to its final conclusion. The hands in the factory correspond to the legs of the *Tiller Girls*. Psycho-technical aptitude tests seek to compute emotional dispositions above and beyond manual abilities. The mass ornament is the aesthetic reflex of the rationality aspired to by the prevailing economic system.

 Certain intellectuals have taken offense at the emergence of the *Tiller Girls* and the image created by the stadium pageants. Whatever amuses the masses, they judge as a diversion of the masses. Contrary to such opinion, I would argue that the *aesthetic* pleasure gained from the ornamental mass movements is *legitimate*. They belong in fact to the isolated configurations of the time, configurations which imbue a given material with form. The masses which are arranged in them are taken from offices and factories. The structural principle upon which they are modeled determines them in reality as well. When great amounts of reality-content are no longer visible in our world, art must make do with what is left, for an aesthetic presentation is all the more real the less it dispenses with the reality outside the aesthetic sphere. No matter how low one rates the value of the mass ornament, its level of reality is still above that of artistic productions which cultivate obsolete noble sentiments in withered forms – even when they have no further significance.

* * *

11 October (Association of Artistic Labour): 'Declaration'

The group October was formed in Russia in 1928. It constituted a kind of umbrella organiza-
tion for those artists who had earlier been associated with the avant-garde, who were
committed to the production of new forms of art as part of the construction of a new
socialist society, but who were simultaneously aligned against what was fast becoming the
actually dominant trend in post-revolutionary art: namely the figurative realism of the AKhRR,
in effect the forerunner of Socialist Realism (see IVB2 and 3). The notable feature of the
Declaration is its mobilization of the term 'realism' precisely against what it sees not as an
adequate form of realism at all but as a conservative harking back to the past. Yet on the
other side, while declaring in favour of rational and constructive approaches, the group
renounce the abstract industrialism and technicism into which some among the avant-garde
had fallen. Rodchenko, Stepanova, Lissitsky, Klucis and Deineka were all represented in the
October group's only exhibition, held in Moscow in June 1930. Other members included
the film director Eisenstein; the architect-designers Gan, Ginsburg, the Vesnin brothers, and
the German Hannes Meyer, who was expelled from the Bauhaus in 1929; and the Mexican

muralist Diego Rivera, who became a member during his time in Russia in 1928. The group was disbanded in 1932 after the government decree on the reconstitution of competing artistic groups into a single Artists Union (see IVB11). The Declaration was originally published in *Sovremennya arkhitektura* (Contemporary Architecture) no. 3, March 1928, pp. 73–4. It is translated in Bowlt, *Russian Art of the Avant Garde* (op. cit.), from which source the present version is taken (pp. 274–9).

At the present time all art forms must define their positions at the front of the Socialist cultural revolution.

We are profoundly convinced that the spatial arts (architecture, painting, sculpture, graphics, the industrial arts, photography, cinematography, etc.) can escape their current crisis only when they are subordinated to the task of serving the concrete needs of the proletariat, the leaders of the peasantry, and the backward national groups.

In participating consciously in the proletariat's ideological class struggle against hostile forces and in supporting the rapprochement of the peasantry and the nationalities with the proletariat, the spatial arts must serve the proletariat and the working masses in two interconnected fields:

in the field of ideological propaganda (by means of pictures, frescoes, printing, sculpture, photography, cinematography, etc.);

in the field of production and direct organization of the collective way of life (by means of architecture, the industrial arts, the designing of mass festivals, etc.).

For those artists who are fully aware of these principles, the following immediate tasks await:

1. The artist who belongs to the epoch of the proletarian dictatorship regards himself not as an isolated figure passively reflecting reality, but as an active fighter at the ideological front of the Proletarian Revolution; this is the front that, by its actions, is organizing mass psychology and is helping to design the new way of life. This orientation compels the proletarian artist to take stock of himself continually in order to stand with the revolutionary proletarian avant-garde at the same high ideological level.

2. He must submit to critical examination all formal and technical artistic achievements of the past. Of especial value to proletarian art are the achievements of the last decades, when the methods of the rational and constructive approaches to artistic creation, which had been lost by the artists of the petty bourgeoisie, were restored and developed considerably. It was at this time that artists began to penetrate the creation of dialectical and materialist methodology, of which artists had not been aware previously, and of the methods of mechanical and laboratory scientific technology; this has provided a great deal that can and must serve as material for the development of proletarian art. However, the fundamental task of the proletarian artist is not to make an eclectic collection of old devices for their own sake, but with their aid, and on new technological ground, to create new types and a new style of the spatial arts.

3. The ultimate orientation of the artist who would express the cultural interests of the revolutionary proletariat should be to propagate the world view of dialectical materialism by the maximum means of expression within the spatial arts, and to design materially the mass, collective forms of the new life. In the light of this, we reject the philistine realism of epigones; the realism of a stagnant, individualistic way of life; passively contemplative, static, naturalistic realism with its fruitless copying of reality,

embellishing and canonizing the old way of life, sapping the energy and enervating the will of the culturally underdeveloped proletariat.

We recognize and will build proletarian realism that expresses the will of the active revolutionary class; a dynamic realism that reveals life in movement and in action and that discloses systematically the potentials of life; a realism that makes things, that rebuilds rationally the old way of life and that, in the very thick of the mass struggle and construction, exerts its influence through all its artistic means. But we simultaneously reject aesthetic, abstract industrialism and unadulterated technicism that passes itself off as revolutionary art. For art to affect life creatively, we emphasize that all means of expression and design must be utilized in order to organize the consciousness, will, and emotions of the proletariat and of the working masses with maximum force. To this end, the organic cooperation of all spatial art forms must be established.

* * *

In issuing the present declaration, we disassociate ourselves from all existing art groups active in the field of the spatial arts. We are prepared to join forces with some of them as long as they acknowledge the basic principles of our platform in practical terms. We greet the idea of a federation of art societies and will support any serious organizational steps in this direction.

We are embarking at a time of transition for the development of the spatial arts in the USSR. With regard to the basic forces active in modern Soviet art, the natural process of artistic and ideological self-determination is being hampered by a number of unhealthy phenomena. We consider it our duty to declare that we reject the system of personal and group patronage and protection for individual artistic trends and individual artists. We support wholly the unrestricted, healthy competition of artistic directions and schools within the areas of technical competence, higher quality of artistic and ideological production and stylistic researches. But we reject unhealthy competition between artistic groups for commissions and patronage of influential individuals and institutions. We reject any claim by any one association of artists to ideological monopoly or exclusive representation of the artistic interests of the working and peasant masses. We reject the system that can allow an artificially created and privileged position (moral and material) for any one artistic group at the expense of other associations or groups; this is a radical contradiction of the Party's and the government's artistic policy. We reject speculation on 'social commissions,' which occurs beneath the mask of revolutionary theme and everyday realism, and which replaces any serious effort to formulate a revolutionary world view and world perception with a simplified interpretation of a hurriedly invented revolutionary subject. We are against the dictatorship of philistine elements in the Soviet spatial arts and for the cultural maturity, artistic craftsmanship, and ideological consistence of the new proletarian artists, who are quickly gaining strength and advancing to the fore. [...]

12 Georges Bataille (1892–1962) from 'Critical Dictionary'

Bataille became *de facto* leader of a dissident Surrealist group after the expulsions of 1930 and Breton's explicit inscription of Marxism into Surrealism's perspective. To Breton's

'historical materialism' Bataille opposed a more basic materialism *per se*: a materialism of matter, of sheer stuff, devoid of form, but a materialism which also acknowledges the actual diversity and untidiness of social and psychological experience. Hence his fundamental category of the 'Informe'. The present short texts, 'Esthète', 'Informe' and 'Matérialisme', are taken from Bataille's 'Critical Dictionary', published in various issues of the journal *Documents*, Paris, 1929–30. Reprinted in G. Bataille, *Documents*, Paris, 1968, from which the present translations are made.

Aesthete

It being well understood that no one accepts such a title, it must, however, be understood that this word has been devalued to the same extent and in the same way as *artist* or *poet*. ('This man is an Artist' or 'I esteem Poets' and, above all, 'the pleasant exactness that Aesthetes give their character'...) When it comes down to it, these words have the power to disturb and to nauseate: after fifteen years, one finds the shoe of a dead woman at the bottom of a cupboard; one throws it in the rubbish bin. There is a cynical pleasure in considering words which take something of us with them to the dustbin.

Moreover, the automatic protest against an obsolete character type is by now a more or less transparent dodge. The unfortunate who says that art no longer works, because that way one remains disengaged from the 'dangers of action', says something deserving of the same attention as the dead woman's shoe. Although it may be quite disgusting to look at, a cliché is as much subject to conditions of obsolescence as an internal combustion engine. Everything in the emotional order which responds to an allowable need is condemned to a process of improvement, which, from another viewpoint, one is obliged to regard with the same disquieted (or cynical) curiosity which some Chinese torture might attract.

The Formless

A dictionary should begin from the point when it is no longer concerned with the meaning but only with the use of words. Thus *formless* is not only an adjective with a certain meaning, but a term serving to deprecate, implying the general demand that everything should have a form. That which it designates has no rights to any sense, and is everywhere crushed under foot like a spider or a worm. For the satisfaction of academics, the universe must take shape. The entirety of philosophy has no other end in view: it puts a frock-coat on that which is, a frock-coat of mathematics. To affirm on the other hand that the universe does not resemble anything and is nothing but *formless* amounts to the claim that the universe is something like a spider or a gob of spittle.

Materialism

Most materialists, although they want to eliminate all spiritual things, have ended up describing an order of being which, in so far as it involves hierarchical relations, is characterized as specifically idealistic. They have located dead matter at the summit of a conventional hierarchy of facts of diverse orders, without noticing that they have thereby succumbed to the obsession with an *ideal* form of matter, with a form more

approximate than any other to that which matter *should be*. Dead matter, the pure idea, and God each respond in the same way, which is to say perfectly, unremarkably, like a docile student, answering a question that can only be put by idealist philosophers: the question of the essence of things, the exact *idea* by which things become intelligible. The classical materialists have not even really substituted the cause for *modal necessity* (the *quare* for *quamobrem*, that is, determinism for fatalism, the past for the future). In the role that they have unwittingly assigned to the idea of science, in order to supply their need for external authority, all expectation has in effect been placed on the concept of *modal necessity*. If the principle of order that they have defined is precisely the stable element which has permitted science to attain its apparently unassailable position, a real divine eternity, the choice of this principle can hardly be attributed to chance. The conformity of dead matter to the idea of science is substituted by most materialists for a religious relation, established earlier in history, between the divine maker and its creations, the one being the *idea* of the others.

Materialism will be considered as a senile form of idealism to the extent that it fails to ground itself directly on psychological or social facts, rather than on abstractions such as artificially isolated physical phenomena. Thus it is from Freud, among others – rather than from physicists, long since dead, whose concepts are today beyond consideration – that it is necessary to take a representation of matter. We shall not be concerned that the fear of psychological ramifications (fear which testifies solely to intellectual debility) leads timid spirits to view this standpoint as an evasion, or as a return to spiritual values. It is time, when the concept of materialism is involved, to refer to the direct interpretation of raw phenomena, *excluding all idealism*; and not to some system based on fragmentary elements of an ideological analysis, developed in the name of a religious analogy.

13 Georges Bataille (1892–1962) 'The *Lugubrious Game*'

This text takes its title from a painting of 1929 by Salvador Dali, which Bataille interpreted diagrammatically (on the grounds that Dali had refused permission for its reproduction). Originally published as 'Le "Jeu lugubre"' in *Documents*, Paris, no. 7, December 1929, from which this translation is made.

Intellectual despair culminates neither in cowardice nor in dreaming, but in violence. Thus there is no question of abandoning certain investigations. It is simply a matter of knowing how to give vent to rage; that's all that's required for thrashing around in prisons like madmen – or for overthrowing them.

Against the half-measures, the evasions, the ravings, which betray great poetic powerlessness, one can oppose nothing but a black rage and an unspeakable bestiality. There is no other way to act than like a pig, guzzling in the dung and the mud, rooting with its snout, its repugnant voracity unstoppable.

If the forms brought together by a painter on a canvas were without repercussions, if, for example – since we are speaking of voracity (even in the intellectual realm), of horrible shadows which affront the mind – jaws with hideous teeth did not protrude from Picasso's skull to frighten those who still have the impudence to think respectable thoughts, then painting would serve well to distract people from their rage, as bars and

American films do. But why hesitate to say that when Picasso paints, the dislocation of forms leads to the dislocation of thought. The immediate process of thought, which in other cases culminates in an idea, aborts. We cannot ignore the fact that flowers are aphrodisiacs, that a single outburst of laughter can penetrate and excite a crowd, consequently that an outburst of screaming constitutes an equally obstinate form of miscarriage, susceptible to the reverberations of a *non serviam* opposed by brute humanity to the idea. This idea has the same degrading power over man that a harness has over a horse: I can snort and rail; I cannot go left or right; the head is bridled and held fast by the idea which forces all men to walk in a straight line. They walk under the symbol, amongst others, of papers printed with the coat of arms of the State. By trickery almost, human life is made always to conform to the image of the soldier commanded to act. Sudden cataclysms, great popular outbursts, demonstrations, monstrous revolutionary killings, are the measures of the inevitable compensations.

I am trying to say, almost without preamble, that the paintings of Picasso are hideous, that those of Dali are of a terrible ugliness. To assure oneself otherwise is to be a victim of the intractability of words, or even of an evil somehow relevant to the practices of black magic. To measure the extent of the evil all that's required is bluntly to imagine a small girl, with a charming look, whose soul will be the abominable mirror of Dali. The language of this small girl is not a language but a pestilence. And if she still appears admirably beautiful, it is, as one says, as black blood is beautiful, running over the coat of a cow or the neck of a woman. (If violence can save a being from profound boredom, it is because they can reach, by some obscure error, a terrible but satisfying ugliness. It has to be said, moreover, that ugliness can be horrible without redress, and thus, unfortunately, that nothing is more common than ambiguous ugliness provocatively offering the illusion of its opposite. As for irrevocable ugliness, it is just as detestable as certain forms of beauty: beauty which does not disguise anything, which is nothing but the mask of lost immodesty, which never fails and remains eternally at attention like a coward.)

Little by little the contradictory signs of servitude and revolt reveal themselves in all things. The great constructions of the intelligence are by definition prisons: that is why they are persistently overthrown. The dreams and illusory darknesses remain within reach of diehard irresolutes whose unconscious calculation is not after all so clumsy, since they innocently put revolt within the shelter of the law. How can one not admire loss of will, blind attraction, uncertainty adrift, going from voluntary distraction to attention? It is true that I speak here of that which is already forgotten as Dali's razors slice from our faces the grimaces of horror, which probably risk making us spew up like drunks this servile nobility, this idiotic idealism which leaves us under the charm of some comical slavemaster.

Strangely sick dogs have for so long licked the fingers of their masters howling at death in the country in the middle of the night. To these frightful howlings there respond, as a thunderbolt responds to the fracas of the rain, such cries as are difficult to speak of without excitement.

A few days before July 1789, the Marquis de Sade, doomed to rage in his dungeon in the Bastille, drew a crowd around his prison by uttering an insane scream through the drain which served to empty his dirty water, in doubtless the most consequential noise ever produced by human larynx. This cry had historic consequences, for it went:

'People of Paris, they are killing the prisoners.' It was like the cry of an old pensioner having his throat cut at night in a suburb. It is known that Governor Launay, alarmed at the gathering uproar, had the prisoner transferred to another prison, which did not prevent his own head from going, a few hours later, to terrify the city from the top of a stake.

But if one wants to account explicitly for the excessive character of the cry, it is necessary to turn to the deposition of Rose Keller, who accused de Sade of having used her for his services. This deposition, recently discovered by Mr Maurice Heine, is categorical. The young woman recounts that after having been tortured with a whip, she tried to move him by her tears and by her pleadings, he being a man at once so prepossessing and so evil. As she invoked all manner of things saintly and touching, Sade suddenly halted, and deaf to everything, gave forth with dreadful and absolutely sickening cries.

It is understood that a chronic disquiet over a course of years may signify nothing other than the feeling that something is lacking in existence. It is hardly worth making the point that what is lacking are the cries themselves, whether uttered or heard; that everywhere the disturbed have apparently lost their heads, consigning human life to ennui and disgust, but pretending at the same moment to conserve it, even to defend it, and sometimes heroically, against the defilements which appeared to them ignoble.

This is said without critical intent of any kind; for it is evident that violence is often quite brutally hilarious, to exhaust the questioner's patience. Here alone I take my stand. I have no choice – thus pursuing this bestial hilarity to its extreme – but to lift my heart to Dali, and to grunt like a pig before his canvases.

14 Salvador Dali (1904–1989) 'The Stinking Ass'

Born in Spain, Dali contacted the Surrealist movement in Paris in 1929, and was welcomed to the cause by Breton at a time when the authority of the latter's theorizations was subject to challenge from the 'materialist' position of Bataille. Dali had already worked with Luis Buñuel on the film *Un Chien Andalou* (*An Andalusian Dog*). The 'stinking ass' refers to one of the film's typically surreal and disturbing images. The 'Modern Style' refers to the Art Nouveau architecture vividly exemplified in the work of Dali's compatriot Gaudi, which he takes as an 'automatistic' counter to the rationalism of the Modern Movement. The essay stakes an avant-garde claim for Dali's own basically conservative technique. His case is that the unusual juxtaposition and 'doubling' of minutely figurative images is causally connected to the mental processes of paranoia. The resulting images are possessed of a critical and emancipatory potential, he asserts, in so far as they reveal what is normally concealed by the mechanisms of repression. Dali was expelled from the movement in 1934, though he continued to exhibit as a Surrealist until the end of the decade. This essay was first published in *La Femme Visible*, Editions Surréalistes, Paris, 1930. Translated by J. Bronowski in *This Quarter*, vol. 5, no. 1, September 1932, pp. 49–54; reprinted in L. Lippard, *Surrealists on Art*, Princeton, NJ, 1970, pp. 97–100, from which the present text is taken.

TO GALA ELUARD

It is possible for an activity having a moral bent to originate in a violently paranoiac will to systematize confusion.

The very fact of paranoia, and particularly consideration of its mechanism as a force and power, brings us to the possibility of a mental attack which may be of the order of, but in any case is at the opposite pole to, the attack to which we are brought by the fact of hallucination.

I believe the moment is at hand when, by a paranoiac and active advance of the mind, it will be possible (simultaneously with automatism and other passive states) to systematize confusion and thus to help to discredit completely the world of reality.

The new images which paranoiac thought may suddenly release will not merely spring from the unconscious; the force of their paranoiac power will itself be at the service of the unconscious.

These new and menacing images will act skilfully and corrosively, with the clarity of daily physical appearances; while its particular self-embarrassment will make us yearn for the old metaphysical mechanism having about it something we shall readily confuse with the very essence of nature, which, according to Heraclitus, delights in hiding itself.

Standing altogether apart from the influence of the sensory phenomena with which hallucination may be considered more or less connected, the paranoiac activity always employs materials admitting of control and recognition. It is enough that the delirium of interpretation should have linked together the implications of the images of the different pictures covering a wall for the real existence of this link to be no longer deniable. Paranoia uses the external world in order to assert its dominating idea and has the disturbing characteristic of making others accept this idea's reality. The reality of the external world is used for illustration and proof, and so comes to serve the reality of our mind.

Doctors agree that the mental processes of paranoiacs are often inconceivably swift and subtle, and that, availing themselves of associations and facts so refined as to escape normal people, paranoiacs often reach conclusions which cannot be contradicted or rejected and in any case nearly always defy psychological analysis.

The way in which it has been possible to obtain a double image is clearly paranoiac. By a double image is meant such a representation of an object that it is also, without the slightest physical or anatomical change, the representation of another entirely different object, the second representation being equally devoid of any deformation or abnormality betraying arrangement.

Such a double image is obtained in virtue of the violence of the paranoiac thought which has cunningly and skilfully used the requisite quantity of pretexts, coincidences, &c., and so taken advantage of them as to exhibit the second image, which then replaces the dominant idea.

The double image (an example of which is the image of a horse which is at the same time the image of a woman) may be extended, continuing the paranoiac advance, and then the presence of another dominant idea is enough to make a third image appear (for example, the image of a lion), and so on, until there is a number of images limited only by the mind's degree of paranoiac capacity.

I challenge materialists to examine the kind of mental attack which such an image may produce. I challenge them to inquire into the more complex problem, which of

these images has the highest probability of existence if the intervention of desire is taken into account; and also into the problem, even graver and more general, whether the series of these representations has a limit, or whether, as we have every reason to think, such a limit does not exist, or exists merely as a function of each individual's paranoiac capacity.

All this (assuming no other general causes intervene) is certainly enough for me to contend that our images of reality themselves depend upon the degree of our paranoiac faculty, and yet that theoretically a man sufficiently endowed with this faculty may at will see the form of any real object change, exactly as in voluntary hallucination, but with this (destructively) important difference, that the various forms assumed by the object in question are universally open to control and recognition as soon as the paranoiac has merely indicated them.

The paranoiac mechanism whereby the multiple image is released is what supplies the understanding with the key to the birth and origin of all images, the intensity of these dominating the aspect which hides the many appearances of the concrete. It is precisely thanks to the intensity and traumatic nature of images, as opposed to reality, and to the complete absence of interpenetration between reality and images, that we are convinced of the (poetic) impossibility of any kind of *comparison*. It would be possible to compare two things only if they admitted of no sort of mutual relation, conscious or unconscious. If such a comparison could be made tangible, it would clearly illustrate our notion of the arbitrary.

It is by their failure to harmonize with reality, and owing also to the arbitrary element in their presence, that images so easily assume the forms of reality and that the latter in turn adapts itself so readily to the violences of images, which materialist thought idiotically confuses with the violences of reality.[1]

Nothing can prevent me from recognizing the frequent presence of images in the example of the multiple image, even when one of its forms has the appearance of a stinking ass and, more, that ass is actually and horribly putrefied, covered with thousands of flies and ants; and, since in this case no meaning is attachable to the distinct forms of the image apart from the notion of time, nothing can convince me that this foul putrefaction of the ass is other than the hard and blinding flash of new gems.

Nor can we tell if the three great images – excrement, blood and putrefaction – are not precisely concealing the *wished for* 'Treasure Island.'

Being connoisseurs of images, we have long since learned to recognize the image of desire in images of terror, and even the new dawn of the 'Golden Age' in the shameful scatologous images.

In accepting images the appearance of which reality strives painfully to imitate, we are brought to *desire ideal* objects.

Perhaps no image has produced effects to which the word *ideal* can more properly be applied than the tremendous image which is the staggering ornamental architecture called the 'Modern Style.' No collective effort has produced a dream world so pure and so disturbing as the 'Modern Style' buildings, these being, apart from architecture, the true realization in themselves of desires grown solid. Their most violent and cruel automatism pitifully betrays a hatred of reality and a need for seeking refuge in an ideal world, just as happens in infantile neurosis.

This, then, is something we can still like, the imposing mass of these cold and intoxicating buildings scattered over Europe and despised and neglected by anthologies and scholarship. This is enough to confound our swinish contemporary aestheticians, the champions of the execrable 'modern art,' and enough too to confound the whole history of art.

It has to be said once for all to art critics, artists, &c., that they need expect nothing from the new surrealist images but disappointment, distaste and repulsion. Quite apart from plastic investigation and other buncombe, the new images of surrealism must come more and more to take the forms and colours of demoralization and confusion. The day is not far off when a picture will have the value, and only the value, of a simple moral act, and yet this will be the value of a simple *unmotivated act*.

As a functional form of the mind, the new images will come to follow the free bent of desire at the same time as they are vigorously repressed. The desperate activity of these new images may also contribute, simultaneously with other surrealist activities, to the destruction of reality, and so benefit everything which, through infamous and abominable ideals of all kinds, aesthetic, humanitarian, philosophical, &c., brings us back to the clear springs of masturbation, exhibitionism, crime, and love.

We shall be idealists subscribing to no ideal. The ideal images of surrealism will serve the imminent crisis of consciousness; they will serve Revolution.

[1] What I have in mind here are, in particular, the materialist ideas of Georges Bataille, but also, in general, all the old materialism which this gentleman dodderingly claims to rejuvenate when he bolsters it up with modern psychology.

15 Gustav Klucis (1895–1944) 'Photomontage as a New Problem in Agit Art'

Born in Latvia, Klucis studied in Riga and St Petersburg. He designed posters and decorations for the May Day celebrations in 1918 and in the same year entered the Free Art Studios in Moscow, where he studied with Malevich and Antoine Pevsner, exhibiting two years later with Pevsner and Naum Gabo on Tverskoie Boulevard (see IIIC10). During the early 1920s he produced a number of designs for agitprop stands, based on geometrical constructions in wood and paper, and in 1925 was involved in the organization of the Soviet section at the International Exhibition of Modern Decorative and Industrial Arts in Paris. His interest in photomontage dates from the later 1920s, when he worked extensively on the design of posters. Klucis remained loyal to the Communist Party and to the aims of the Revolution. His claim for photomontage rests on its potential for political effectiveness and for realism. By the time this text was written, however, his modernism rendered him suspect in the eyes of a regime growing increasingly hostile to the avant-garde tradition. We have included an editorial comment added to the text on the occasion of its original publication, which notes both the artist's implication in the October group (see IVC11) and his apparently 'formalist' sympathies. Klucis was arrested during the Second World War and died in Siberia. The text was first published in *Literatura i iskusstvo*, 9/10, Moscow, 1931, pp. 86–95. Our version is translated from the German text in *Gustav Klucis: Retrospective*, ed. Roland Nachtigäller, Kassel, Museum Friedericianum, March–May 1991, Stuttgart: Verlag Gerd

Hatje, pp. 312–20. The following extracts, translated by Nicholas Walker, are taken from pp. 315–16 and 320.

* * *

A photomontage is a complex of elements organized according to a specific method, the so-called montage method. These elements are 1) the political slogan – a quotation, a caption, etc.; 2) the photograph of some social act or event as the pictorial element (including documentary photographs); 3) colour for activation; 4) graphic elements; 5) the planar and perspectival design for the synthetic execution of photomontage and graphic representation.

The method of photomontage is divided into two organically related processes: 1) preparation of the individual elements (the photomechanical processes); 2) the process of montage itself (combination and organization of the elements).

To ensure the utmost activation of the materials photomontage employs the following principles for the organization of its materials (montage): a) use of different scales (with the aim of heightening the impact of the work and replacing the traditional and restrictive use of perspective) which itself offers very significant compositional possibilities; b) use of highly contrasting colours and forms; c) activation through liberated placement of elements (cutting them out from the passive background and actively colouring them; employing extreme contrasts of chromatic and achromatic colour).

The production of a poster proceeds in the following sequence of steps: 1) IzoGIZ commission; 2) development of the theme (the content of the poster); 3) development of the overall structure (construction of the poster); 4) taking the relevant photographs in the factories and plants; 5) process of montage (organization). The principal task as far as organization of the materials is concerned is to manifest the class significance of the issue (the significance of the political slogan involved). One of the great merits of photomontage is precisely the way in which it has facilitated a new method for producing essentially activist posters. It is a characteristic feature of the latter that the poster surface is articulated and defined by the political content of the presented materials rather than by aesthetic principles. The old system for the composition of posters, based on the aesthetic principle, must be liquidated (by eliminating the framing border within the poster). The new principle is based upon the combination (montage) of topical materials (political slogans, documentary photographs, quotations, colour, graphic elements, etc.) that present a consistent political line and take account of the concrete position of the viewer precisely in order to achieve the maximum expressive impact, political clarity and effective influence. This is the reason for the political significance and formal specificity of this principle. This also clarifies the fundamental difference between photomontage on the one hand, as a synthetic art that presents a number of essentially interdependent elements, and photography as a technical category on the other.

The photograph fixes a static moment, an isolated shot. Photomontage visualizes the dialectical unfolding of a theme of the given subject, the dialectical unity between political slogan and representation. Photography and the photograph are technical means for creating a representational form, they constitute documentary material but they are not ends in themselves. Like any other art, photomontage solves the problem of so-called pictoriality by presenting the manifold and interrelated character of reality,

by revealing the concrete manifestations of the constructive socialist project precisely through the combination of elements (the method of photomontage).

* * *

Photomontage is not a form but a method – a method that does not start from form, but from the conditions that determine all form: the task specific to the individual poster (or book, etc.), the broad mass for whom the individual work is intended, the relevant location (square, street, window display, department store), the processes of mass production (printing techniques).

Each work is treated in a different manner in accordance with the specific conditions of the individual concrete case. By its very essence, the technique of photomontage resists canonization and excludes the clichés of aesthetic convention. Its fundamental aim is to foreground the given phenomena in a dialectical manner, i.e. in their relationship to other forms and according to their significance for further development.

The Section Office of the Spatial Arts of the LIJa [Institute of Literature, Art and Language] in the Communist Academy believes that comrade Klucis's extended discussion of the problems of photomontage, strongly emphasizing the importance of this visual art, was extremely timely and is generally correct. But we should add that the Section Office considers some of the hypotheses advanced in the discussion paper as incorrect and regards them as unreflective remnants of the artistic principles of the 'October' group to which Klucis earlier belonged: i.e. the analysis of the specific character of photomontage, which strongly smells of 'functionalism', the obvious overvaluation of photomontage, which the author singles out as the most important art at the expense of all the others, and, finally, an insufficiently critical attitude towards the early, perceptibly formalist products of photomontage in particular.

16 Max Ernst (1891–1976) 'What is Surrealism?'

Educated in philosophy, psychiatry and art history, but self-taught as a painter, Ernst served in the German army from 1914 to 1918 and was thereafter involved in the activities of the Dada group in Cologne. An exhibition of his collages was staged by the Dada group in Paris in 1921, and he moved to the French capital the following year, staying with Paul and Gala Eluard. His early paintings reveal an interest in the theories of Freud (see IA3), and in imagery associated with dreams and neuroses. He acquired a copy of Prinzhorn's *Artistry of the Mentally Ill* on its publication in 1922 (see IB19). Following publication of Breton's first 'Manifesto of Surrealism' in 1924 (see IVC2), Ernst claimed the technique of *frottage* as a form of pictorial automatism compatible with the 'automatic writing' practised by the literary Surrealists. The first works produced by this technique were the 34 drawings of his *Histoire naturelle*, exhibited and published in 1926. Ernst's central role in the Surrealist movement was acknowledged in numerous exhibitions and publications during the later 1920s and 1930s, though he broke with Breton in 1938. After internment as an enemy alien during the Second World War, he escaped to New York in 1941. The following text was originally published as 'Was ist Surrealismus?' in the catalogue of an exhibition of the same title held at the Kunsthaus, Zurich, in October–November 1934, pp. 3–7. Our translation (by Nicholas Walker) is made from the text reprinted in *Max Ernst: Gemälde. Plastiken. Collagen. Frottagen. Bücher*, Stuttgart: Württembergischer Kunstverein, January–March 1979, pp. 49–51.

'Le mot délit n'a, en géneral, pas être compris'
Paul Eluard

The fairy-tale of artistic creativity, this pitiful relic of the myth of divine creation, has remained the last delusion of Western culture. One of the most crucial revolutionary acts of Surrealism was passionately to have attacked this myth on well-considered grounds, and thus to have dispatched it once and for all. It did so by insisting emphatically upon the purely passive role of the 'author' as far as the mechanism of poetic inspiration is concerned, by unmasking the notion of 'active control' through reason, morality or aesthetic deliberation as inimical to inspiration. As a viewer like anyone else, the 'author' can witness the emergence of the work, can follow the unfolding phases of its development with indifference or passion. Just as the poet listens to the automatic processes of thought and jots down their results, so too the painter projects what his optical inspiration suggests to him directly onto paper and canvas.

The old idea of 'talent' must of course be abandoned here, along with hero worship and the legend – so beloved of those prone to such admiration – of the creative 'fecundity' of the artist who lays three eggs today, one tomorrow, and none on Sunday. As we all know, every 'normal' person, and not just the artist, possesses an inexhaustible store of buried images within the unconscious. All that is required is courage and a liberating method (like *écriture automatique* ['automatic writing']), a voyage of discovery into the unconscious that will unearth found objects ('images') in an unfalsified state (uncontaminated by conscious control). The concatenation of these objects can be interpreted as a kind of irrational knowledge or poetic objectivity in accordance with Paul Eluard's definition: 'Poetic objectivity is nothing but the concatenation of all subjective elements of which the poet is temporarily the slave, and not the master.' It follows from this that the 'artist' simply falsifies matters.

At first painters and sculptors found it very difficult to find methods, comparable to that of *écriture automatique*, which are adequate for their own techniques of potential expression and can ensure the required poetic objectivity, i.e. the exclusion of reason, taste, and conscious intention from the productive process of the work of art. Theoretical analyses could not assist them here, but only practical experiments and the results thereby produced. 'The accidental encounter between a sewing machine and an umbrella on a dissecting table' (Lautréamont) is now a celebrated, even classical, example of the phenomenon discovered by the Surrealists: the conjunction of two (or more) allegedly quite incompatible elements in an incompatible context sparks off the most powerful poetical insights. Any number of individual and collective experiments (those known as *Cadavre exquis* ['Exquisite corpse'] for example) have proved the feasibility of this approach. It transpired that the more arbitrary the conjunction of elements was, the more surely and ineluctably the ensuing spark of poetic inspiration was capable of effecting a partial or total transformation of things. The delight we feel in every such successful metamorphosis derives not from the wretched aesthetic desire for distraction, but from an ancient and vital need of the intellect: for liberation from the tedious and deceiving paradise of hardened memories and for the exploration of a new and infinitely broader realm of experience. This is a realm in which the boundary between the so-called inner and outer world (as defined by traditional philosophy) becomes progressively blurred and will probably one day disappear entirely (once more precise methods than *écriture automatique* have been discovered). This is why, without pretensions, I was

justified in giving the title *Histoire naturelle* ['Natural History'] to a sequence of plates on which I had transcribed, with maximum precision, a series of optical hallucinations. The revolutionary significance of this depiction of nature, absurd as it may seem at first, will perhaps appear more clearly if we consider the analogous results obtained in the modern field of micro-physics. P. Jordan presents the results of analysing a self-propelled electron and its precise location: 'This experimental refutation of the idea that there are factual circumstances in the external world which possess objective reality quite independent of the process of observation eliminates one of the principal arguments for the distinction between the inner and the outer world.'

If the Surrealists are widely described as painters of a constantly mutating dream-world, this should not imply that they reproduce their dreams in painting (this would simply be a descriptive and naive realism), or that each artist uses the elements of dreams to construct a little private world in which to play out some benevolent or malevolent role (this would simply be a 'flight from the time'). It means rather that these artists move freely, boldly and confidently at the borderline between the inner and the outer world, a borderline that is physically and psychologically entirely real ('surreal') even if it has not yet been adequately defined and determined, that they undertake to register precisely what they see and experience there, and that they intervene wherever their revolutionary instincts suggest they should.[1]

The fundamental distinction and opposition between action and meditation (as defined by traditional philosophy) thereby collapses along with the fundamental distinction and opposition between the inner and the outer world. It is the universal significance of Surrealism that with this discovery no dimension of life is closed off to us.

* * *

What is Surrealism? Any attempt to answer this question with a definition will inevitably be disappointed until such time as the movement has come to a decisive end. My brief remarks here were merely intended to clarify the increasing and in part already strongly prevailing conceptual confusion concerning the surrealist movement. All I can do now is refer the reader to A. Breton's 'Surrealist Manifestos' and 'Les Vases communicants'. The fact that contradictions appear, and continue to reappear, within the changing positions successively adopted by the Surrealists proves only that the movement is properly in flux. By overthrowing the established relationships between what counted as 'realities', Surrealism has thus inevitably played its part in accelerating the general crisis in the consciousness and conscience of our time.

[1] As opposed to abstractionism which deliberately restricts its possibilities to the purely aesthetic interaction between colours, planes, volumes, lines and space – all apparently in the hope of resuscitating the old myth of creation, as is revealed by the name of the group *Abstraction-Création* [see IVA4].

17 Walter Benjamin (1892–1940) 'The Author as Producer'

Benjamin was born in Berlin into a Jewish family. At his death by suicide, fleeing from the Nazis in 1940, he was virtually unknown outside a coterie of Marxist critical philosophers in the orbit of the Frankfurt School. Posthumously he has become accepted as one of the century's most original Marxist thinkers. The present text was delivered as a lecture on 27

April 1934 to the Institute for the Study of Fascism, an organization based in Paris where Benjamin, like many of his audience no doubt, was in exile from the Nazis. The essay is inherently difficult, trying as it does to bring about a rapprochement between aesthetic quality and political correctness in the work of art. Its argument is at least initially inextricable from the context of its delivery. As an organization of the sort assimilated into the Popular Front, the Institute would have favoured a form of Social Realism, an art in which content is assumed to be all. By linking political correctness to quality, which he in turn identified with technical innovation, Benjamin was standing this assumption on its head. At least a part of his text's manifold inference is that it was in the experimental, critical avant-garde that political virtue was to be found. The present version is taken from the translation by Anna Bostock in Walter Benjamin, *Understanding Brecht*, London, 1983, pp. 85–103. The passage quoted from a 'perceptive critic' [p. 497] is Benjamin's own. (See also IVD6.)

You will remember how Plato, in his project for a Republic, deals with writers. In the interests of the community, he denies them the right to dwell therein. Plato had a high opinion of the power of literature. But he thought it harmful and superfluous – in a *perfect* community, be it understood. Since Plato, the question of the writer's right to exist has not often been raised with the same emphasis; today, however, it arises once more. Of course it only seldom arises in this *form*. But all of you are more or less conversant with it in a different form, that of the question of the writer's autonomy: his freedom to write just what he pleases. *You* are not inclined to grant him this autonomy. You believe that the present social situation forces him to decide in whose service he wishes to place his activity. The bourgeois author of entertainment literature does not acknowledge this choice. You prove to him that, without admitting it, he is working in the service of certain class interests. A progressive type of writer does acknowledge this choice. His decision is made upon the basis of the class struggle: he places himself on the side of the proletariat. And that's the end of his autonomy. He directs his activity towards what will be useful to the proletariat in the class struggle. This is usually called pursuing a tendency, or 'commitment'.

Here you have the key word around which a debate has been going on for a long time. You are familiar with it, and so you know how unfruitful this debate has been. For the fact is that this debate has never got beyond a boring 'on-the-one-hand', 'on-the-other-hand': *on the one hand* one must demand the right tendency (or commitment) from a writer's work, *on the other hand* one is entitled to expect his work to be of a high quality. This formula is, of course, unsatisfactory so long as we have not understood the precise nature of the relationship which exists between the two factors, commitment and quality. One can declare that a work which exhibits the right tendency need show no further quality. Or one can decree that a work which exhibits the right tendency must, of necessity, show every other quality as well.

This second formulation is not without interest; more, it is correct. I make it my own. But in doing so I refuse to decree it. This assertion must be *proved*. And it is for my attempt to prove it that I now ask for your attention. – You may object that this is a rather special, indeed a far-fetched subject. You may ask whether I hope to advance the study of fascism with such a demonstration. – That is indeed my intention. For I hope to be able to show you that the concept of commitment, in the perfunctory form in which it generally occurs in the debate I have just mentioned, is a totally inadequate instrument of political literary criticism. I should like to demonstrate to you that the tendency of a work of literature can be politically correct only if it is also correct in the

literary sense. That means that the tendency which is politically correct includes a literary tendency. And let me add at once: this literary tendency, which is implicitly or explicitly included in every correct political tendency, this and nothing else makes up the quality of a work. It is because of this that the correct political tendency of a work extends also to its literary quality: because a political tendency which is correct comprises a literary tendency which is correct.

[...] Social relations, as we know, are determined by production relations. And when materialist criticism approached a work, it used to ask what was the position of that work *vis-à-vis* the social production relations of its time. That is an important question. But also a very difficult one. The answer to it is not always unequivocal. And I should now like to propose a more immediate question for your consideration. A question which is somewhat more modest, which goes less far, but which, it seems to me, stands a better chance of being answered. Instead of asking: what is the position of a work *vis-à-vis* the productive relations of its time, does it underwrite these relations, is it reactionary, or does it aspire to overthrow them, is it revolutionary? – instead of this question, or at any rate before this question, I should like to propose a different one. Before I ask: what is a work's position *vis-à-vis* the production relations of its time, I should like to ask: what is its position *within* them? This question concerns the function of a work within the literary production relations of its time. In other words, it is directly concerned with literary *technique*.

By mentioning technique I have named the concept which makes literary products accessible to immediate social, and therefore materialist, analysis. At the same time, the concept of technique represents the dialectical starting-point from which the sterile dichotomy of form and content can be surmounted. And furthermore this concept of technique contains within itself an indication of the right way to determine the relationship between tendency and quality, which was the object of our original inquiry. If, then, we were entitled earlier on to say that the correct political tendency of a work includes its literary quality because it includes its literary tendency, we can now affirm more precisely that this literary tendency may consist in a progressive development of literary technique, or in a regressive one.

* * *

[...] One of the decisive developments in Germany during the last ten years was that many of her productive minds, under the pressure of economic circumstances, underwent a revolutionary development in terms of their *mentality* – without at the same time being able to think through in a really revolutionary way the question of their own work, its relationship to the means of production and its technique. As you see, I am speaking of the so-called left intelligentsia and in so doing I propose to confine myself to the bourgeois left intelligentsia which, in Germany, has been at the centre of the important literary-political movements of the last decade. I wish to single out two of these movements, Activism and New Objectivity (*Neue Sachlichkeit*), in order to show by their example that political commitment, however revolutionary it may seem, functions in a counter-revolutionary way so long as the writer experiences his solidarity with the proletariat only *in the mind* and not as a producer.

* * *

Brecht has coined the phrase 'functional transformation' (*Umfunktionierung*) to describe the transformation of forms and instruments of production by a progressive intelligentsia – an intelligentsia interested in liberating the means of production and

hence active in the class struggle. He was the first to address to the intellectuals the far-reaching demand that they should not supply the production apparatus without, at the same time, within the limits of the possible, changing that apparatus in the direction of Socialism. 'The publication of the *Versuche*,' we read in the author's introduction to the series of texts published under that title, 'marks a point at which certain works are not so much intended to represent individual experiences (i.e. to have the character of finished works) as they are aimed at using (transforming) certain existing institutes and institutions.' It is not spiritual renewal, as the fascists proclaim it, that is desirable; what is proposed is technical innovation. I shall return to this subject later. Here I should like to confine myself to pointing out the decisive difference between merely supplying a production apparatus and changing it. I should like to preface my remarks on the New Objectivity with the proposition that to supply a production apparatus without trying, within the limits of the possible, to change it, is a highly disputable activity even when the material supplied appears to be of a revolutionary nature. For we are confronted with the fact – of which there has been no shortage of proof in Germany over the last decade – that the bourgeois apparatus of production and publication is capable of assimilating, indeed of propagating, an astonishing amount of revolutionary themes without ever seriously putting into question its own continued existence or that of the class which owns it. In any case this remains true so long as it is supplied by hacks, albeit revolutionary hacks. And I define a hack as a man who refuses as a matter of principle to improve the production apparatus and so prise it away from the ruling class for the benefit of Socialism. I further maintain that an appreciable part of so-called left-wing literature had no other social function than that of continually extracting new effects or sensations from this situation for the public's entertainment. Which brings me to the New Objectivity. It launched the fashion for reportage. Let us ask ourselves whose interests were advanced by this technique.

For greater clarity let me concentrate on photographic reportage. Whatever applies to it is transferable to the literary form. Both owe their extraordinary development to publication techniques – radio and the illustrated press. Let us think back to Dadaism. The revolutionary strength of Dadaism lay in testing art for its authenticity. You made still-lifes out of tickets, spools of cotton, cigarette stubs, and mixed them with pictorial elements. You put a frame round the whole thing. And in this way you said to the public: look, your picture frame destroys time; the smallest authentic fragment of everyday life says more than painting. Just as a murderer's bloody fingerprint on a page says more than the words printed on it. Much of this revolutionary attitude passed into photomontage. You need only think of the works of John Heartfield, whose technique made the book jacket into a political instrument. But now let us follow the subsequent development of photography. What do we see? It has become more and more subtle, more and more modern, and the result is that it is now incapable of photographing a tenement or a rubbish-heap without transfiguring it. Not to mention a river dam or an electric cable factory: in front of these, photography can now only say, 'How beautiful.' *The World Is Beautiful* – that is the title of the well-known picture book by Renger-Patzsch in which we see New Objectivity photography at its peak. It has succeeded in turning abject poverty itself, by handling it in a modish, technically perfect way, into an object of enjoyment. For if it is an economic function of photography to supply the masses, by modish processing, with matter which previously eluded mass consumption – Spring, famous people, foreign countries – then one of

its political functions is to renovate the world as it is from the inside, i.e. by modish techniques.

Here we have an extreme example of what it means to supply a production apparatus without changing it. Changing it would have meant bringing down one of the barriers, surmounting one of the contradictions which inhabit the productive capacity of the intelligentsia. What we must demand from the photographer is the ability to put such a caption beneath his picture as will rescue it from the ravages of modishness and confer upon it a revolutionary use value. And we shall lend greater emphasis to this demand if we, as writers, start taking photographs ourselves. Here again, therefore, technical progress is, for the author as producer, the basis of his political progress. In other words, intellectual production cannot become politically useful until the separate spheres of competence to which according to the bourgeois view, the process of intellectual production owes its order, have been surmounted; more precisely, the barriers of competence must be broken down by each of the productive forces they were created to separate, acting in concert. By experiencing his solidarity with the proletariat, the author as producer experiences, directly and simultaneously, his solidarity with certain other producers who, until then, meant little to him.

* * *

I have spoken of the way in which certain modish photographers proceed in order to make human misery an object of consumption. Turning to the New Objectivity as a literary movement, I must go a step further and say that it has turned *the struggle against misery* into an object of consumption. In many cases, indeed, its political significance has been limited to converting revolutionary reflexes, in so far as these occurred within the bourgeoisie, into themes of entertainment and amusement which can be fitted without much difficulty into the cabaret life of a large city. The characteristic feature of this literature is the way it transforms political struggle so that it ceases to be a compelling motive for decision and becomes an object of comfortable contemplation; it ceases to be a means of production and becomes an article of consumption. A perceptive critic has commented on this phenomenon, using Erich Kästner as an example, in the following terms: 'This left-radical intelligentsia has nothing to do with the working-class movement. It is a phenomenon of bourgeois decadence and as such the counterpart of that mimicry of feudalism which, in the Kaiser's time, was admired in a reserve lieutenant. Left-radical journalists of Kästner's, Tucholsky's or Mehring's type are a mimicry of the proletarian for decadent strata of the bourgeoisie. Their function, viewed politically, is to bring forth not parties but cliques; viewed from the literary angle, not schools but fashions; viewed economically, not producers but agents. Agents or hacks who make a great display of their poverty and turn the gaping void into a feast. One couldn't be more comfortable in an uncomfortable situation.'

This school, as I said, made a great display of its poverty. By so doing it evaded the most urgent task of the writer of today: that of recognizing how poor he is and how poor he must be in order to be able to begin again at the beginning. For that is the point at issue. True, the Soviet State does not, like Plato's Republic, propose to expel its writers, but it does – and this is why I mentioned Plato at the beginning – propose to assign to them tasks which will make it impossible for them to parade the richness of the creative personality, which has long been a myth and a fake, in new masterpieces. To expect a renovation – in the sense of more personalities and more works of this kind – is a privilege of fascism, which, in this context, produces such foolish formulations as the one with

which Günther Gründel rounds off the literary section of *The Mission of the Young Generation*: 'We cannot close this...review of the present and outlook into the future...in a better way than by saying that the *Wilhelm Meister*, the *Grüne Heinrich* of our generation have not yet been written.' Nothing will be further from the mind of an author who has carefully thought about the conditions of production today than to expect or even to want such works to be written. He will never be concerned with products alone, but always, at the same time, with the means of production. In other words, his products must possess an organizing function besides and before their character as finished works. And their organizational usefulness must on no account be confined to propagandistic use. Commitment alone will not do it. The excellent Lichtenberg said: 'It is not what a man is convinced of that matters, but what his convictions make of him.' Of course opinions matter quite a lot, but the best opinion is of no use if it does not make something useful of those who hold it. The best 'tendency' is wrong if it does not prescribe the attitude with which it ought to be pursued. And the writer can only prescribe such an attitude in the place where he is active, that is to say in his writing. Commitment is a necessary, but never a sufficient, condition for a writer's work acquiring an organizing function. For this to happen it is also necessary for the writer to have a teacher's attitude. And today this is more than ever an essential demand. *A writer who does not teach other writers teaches nobody.* The crucial point, therefore, is that a writer's production must have the character of a model: it must be able to instruct other writers in their production and, secondly, it must be able to place an improved apparatus at their disposal. This apparatus will be the better, the more consumers it brings in contact with the production process – in short, the more readers or spectators it turns into collaborators. We already possess a model of this kind, of which, however, I cannot speak here in any detail. It is Brecht's epic theatre.

* * *

You may have noticed that the reflections whose conclusions we are now nearing make only one demand on the writer: the demand to *think*, to reflect upon his position in the production process. We can be sure that such thinking, *in the writers who matter –* that is to say the best technicians in their particular branches of the trade – will sooner or later lead them to confirm very soberly their solidarity with the proletariat. [...]

* * *

[...] Aragon was therefore perfectly right when, in another context, he said: 'The revolutionary intellectual appears first of all and above everything else as a traitor to his class of origin.' In a writer this betrayal consists in an attitude which transforms him, from a supplier of the production apparatus, into an engineer who sees his task in adapting that apparatus to the ends of the proletarian revolution. That is a mediating effectiveness, but it nevertheless frees the intellectual from the purely destructive task to which Maublanc, and many comrades with him, believe he has to be consigned. Will he succeed in furthering the unification of the means of intellectual production? Does he see ways of organizing the intellectual workers within their actual production process? Has he suggestions for changing the function of the novel, of drama, of poetry? The more completely he can address himself to these tasks, the more correct his thinking will be and, necessarily, the higher will be the technical quality of his work. And conversely: the more precisely he thus understands his own position within the production process, the less it will occur to him to pass himself off as a 'man of mind'. The mind, the spirit that makes itself heard in the name of fascism, *must* disappear. The mind which believes only

in its own magic strength *will* disappear. For the revolutionary struggle is not fought between capitalism and mind. It is fought between capitalism and the proletariat.

18 Bertolt Brecht (1898–1956) 'Popularity and Realism'

One of the principal emphases in the extensive cultural debates which took place between Marxist intellectuals in the 1930s was a focus on the question of Realism in art. The leading proponent of the concept of Socialist Realism, and hence the most articulate critic of the Modern Movement, was Georg Lukács (see IVB10). It fell to Brecht to develop a response: a hybrid art which critically addressed the realities of its time but did so not on the basis of outmoded traditional forms but of avant-garde technical innovation. Principally this work was in the theatre, but it was accompanied by theoretical reflections on the question as a whole. Written in 1938, these were intended for publication in the exile periodical *Das Wort* but, for reasons which remain unclear, were never printed in Brecht's lifetime. The present version is taken from the translation by Stuart Hood in Theodor Adorno et al., *Aesthetics and Politics*, London, 1977, pp. 79–85.

Whoever looks for slogans to apply to contemporary German literature, must bear in mind that anything that aspires to be called literature is printed exclusively abroad and can almost exclusively be read only abroad. The term *popular* as applied to literature thus acquires a curious connotation. The writer in this case is supposed to write for a people among whom he does not live. Yet if one considers the matter more closely, the gap between the writer and the people is not as great as one might think. Today it is not quite as great as it seems, and formerly it was not as small as it seemed. The prevailing aesthetic, the price of books and the police have always ensured that there is a considerable distance between writer and people. Nevertheless it would be wrong, that is to say unrealistic, to view the widening of this distance as a purely 'external' one. Undoubtedly special efforts have to be made today in order to be able to write in a popular style. On the other hand, it has become easier; easier and more urgent. The people have split away more clearly from their upper layers; their oppressors and exploiters have stepped out and joined a bloody battle with them of vast dimensions. It has become easier to take sides. An open battle has so to speak broken out among the 'public'.

The demand for a realistic style of writing can also no longer be so easily dismissed today. It has acquired a certain inevitability. The ruling classes use lies oftener than before – and bigger ones. To tell the truth is clearly an ever more urgent task. Suffering has increased and with it the number of sufferers. In view of the immense suffering of the masses, concern with little difficulties or with difficulties of little groups has come to be felt as ridiculous, contemptible.

There is only one ally against growing barbarism – the people, who suffer so greatly from it. It is only from them that one can expect anything. Therefore it is obvious that one must turn to the people, and now more necessary than ever to speak their language. Thus the terms *popular art* and *realism* become natural allies. It is in the interest of the people, of the broad working masses, to receive a faithful image of life from literature, and faithful images of life are actually of service only to the people, the broad working masses, and must therefore be absolutely comprehensible and profitable to them – in

other words, popular. Nevertheless these concepts must first be thoroughly cleansed before propositions are constructed in which they are employed and merged. It would be a mistake to think that these concepts are completely transparent, without history, uncompromised or unequivocal. ('We all know what they mean – don't let's split hairs.') The concept of *popularity* itself is not particularly popular. It is not realistic to believe that it is. There is a whole series of abstract nouns ending in 'ity' which must be viewed with caution. Think of *utility, sovereignty, sanctity*; and we know that the concept of *nationality* has a quite particular, sacramental, pompous and suspicious connotation, which we dare not overlook. We must not ignore this connotation, just because we so urgently need the concept *popular*.

It is precisely in the so-called poetical forms that 'the people' are represented in a superstitious fashion or, better, in a fashion that encourages superstition. They endow the people with unchanging characteristics, hallowed traditions, art forms, habits and customs, religiosity, hereditary enemies, invincible power and so on. A remarkable unity appears between tormenters and tormented, exploiters and exploited, deceivers and deceived; it is by no means a question of the masses of 'little' working people in opposition to those above them.

The history of the many deceptions which have been practised with this concept of the people is a long and complicated one – a history of class struggles. We do not intend to go into it here – we only wish to keep the fact of the deception in sight, when we say that we need popular art and mean thereby art for the broad masses, for the many who are oppressed by the few, 'the people themselves', the mass of producers who were for so long the object of politics and must now become the subject of politics. Let us recall that the people were for long held back from any full development by powerful institutions, artificially and forcefully gagged by conventions, and that the concept *popular* was given an ahistorical, static, undevelopmental stamp. We are not concerned with the concept in this form – or rather, we have to combat it.

Our concept of what is popular refers to a people who not only play a full part in historical development but actively usurp it, force its pace, determine its direction. We have a people in mind who make history, change the world and themselves. We have in mind a fighting people and therefore an aggressive concept of what is *popular*.

Popular means: intelligible to the broad masses, adopting and enriching their forms of expression / assuming their standpoint, confirming and correcting it / representing the most progressive section of the people so that it can assume leadership, and therefore intelligible to other sections of the people as well / relating to traditions and developing them / communicating to that portion of the people which strives for leadership the achievements of the section that at present rules the nation.

Now we come to the concept of *realism*. This concept, too, must first be cleansed before use, for it is an old concept, much used by many people and for many ends. This is necessary because the people can only take over their cultural heritage by an act of expropriation. Literary works cannot be taken over like factories; literary forms of expression cannot be taken over like patents. Even the realistic mode of writing, of which literature provides many very different examples, bears the stamp of the way it was employed, when and by which class, down to its smallest details. With the people struggling and changing reality before our eyes, we must not cling to 'tried' rules of narrative, venerable literary models, eternal aesthetic laws. We must not derive realism as such from particular existing works, but we shall use every means, old and new, tried

and untried, derived from art and derived from other sources, to render reality to men in a form they can master. We shall take care not to describe one particular, historical form of novel of a particular epoch as realistic – say that of Balzac or Tolstoy – and thereby erect merely formal, literary criteria for realism. We shall not speak of a realistic manner of writing only when, for example, we can smell, taste and feel everything, when there is 'atmosphere' and when plots are so contrived that they lead to psychological analysis of character. Our concept of realism must be wide and political, sovereign over all conventions.

Realistic means: discovering the causal complexes of society / unmasking the prevailing view of things as the view of those who are in power / writing from the standpoint of the class which offers the broadest solutions for the pressing difficulties in which human society is caught up / emphasizing the element of development / making possible the concrete, and making possible abstraction from it.

These are vast precepts and they can be extended. Moreover we shall allow the artist to employ his fantasy, his originality, his humour, his invention, in following them. We shall not stick to too detailed literary models; we shall not bind the artist to too rigidly defined modes of narrative.

We shall establish that the so-called sensuous mode of writing – where one can smell, taste and feel everything – is not automatically to be identified with a realistic mode of writing; we shall acknowledge that there are works which are sensuously written and which are not realistic, and realistic works which are not written in a sensuous style. We shall have to examine carefully the question whether we really develop a plot best when our ultimate objective is to reveal the spiritual life of the characters. Our readers will perhaps find that they have not been given the key to the meaning of the events if, led astray by various artistic devices, they experience only the spiritual agitation of the heroes. By adopting the forms of Balzac and Tolstoy without testing them thoroughly, we might weary our readers – the people – as much as these writers often do themselves. Realism is not a mere question of form. Were we to copy the style of these realists, we would no longer be realists.

For time flows on, and if it did not, it would be a bad prospect for those who do not sit at golden tables. Methods become exhausted; stimuli no longer work. New problems appear and demand new methods. Reality changes; in order to represent it, modes of representation must also change. Nothing comes from nothing; the new comes from the old, but that is why it is new.

The oppressors do not work in the same way in every epoch. They cannot be defined in the same fashion at all times. There are so many means for them to avoid being spotted. They call their military roads motor-ways; their tanks are painted so that they look like MacDuff's woods. Their agents show blisters on their hands, as if they were workers. No: to turn the hunter into the quarry is something that demands invention. What was popular yesterday is not today, for the people today are not what they were yesterday.

Anyone who is not a victim of formalistic prejudices knows that the truth can be suppressed in many ways and must be expressed in many ways. [...]

I am speaking from experience when I say that one need not be afraid to produce daring, unusual things for the proletariat so long as they deal with its real situation. There will always be people of culture, connoisseurs of art, who will interject: 'Ordinary people do not understand that.' But the people will push these persons impatiently aside and come to a direct understanding with artists. There is high-flown stuff, made

for cliques, and intended to create new cliques – the two-thousandth reblocking of an old felt hat, the spicing of old, rotting meat: this the proletariat rejects ('What a state they must be in!') with an incredulous, yet tolerant shake of the head. It was not the pepper that was rejected, but the decaying meat: not the two-thousandth blocking, but the old felt. When they themselves wrote and produced for the stage they were wonderfully original. So-called agitprop art, at which people, not always the best people, turned up their noses, was a mine of new artistic methods and modes of expression. From it there emerged magnificent, long-forgotten elements from ages of genuine popular art, boldly modified for new social aims: breathtaking contractions and compressions, beautiful simplifications, in which there was often an astonishing elegance and power and a fearless eye for the complex. Much of it might be primitive, but not in that sense in which the spiritual landscapes of bourgeois art, apparently so subtle, are primitive. It is a mistake to reject a style of representation because of a few unsuccessful compositions – a style which strives, frequently with success, to dig down to the essentials and to make abstraction possible. [...]

The criteria for popular art and realism must therefore be chosen both generously and carefully, and not drawn merely from existing realistic works and existing popular works, as often happens; by so doing, one would arrive at formalistic criteria, and at popular art and realism in form only.

Whether a work is realistic or not cannot be determined merely by checking whether or not it is like existing works which are said to be realistic, or were realistic in their time. In each case, one must compare the depiction of life in a work of art with the life itself that is being depicted, instead of comparing it with another depiction. Where popularity is concerned, there is one extremely formalistic procedure of which one must beware. The intelligibility of a literary work is not guaranteed merely if it is written exactly like other works which were understood in their time. These other works which were understood in their time were also not always written like the works before them. Steps had been taken to make them intelligible. In the same way, we must do something for the intelligibility of new works today. There is not only such a thing as *being popular*, there is also the process of *becoming popular*.

If we wish to have a living and combative literature, which is fully engaged with reality and fully grasps reality, a truly popular literature, we must keep step with the rapid development of reality. The great working masses are already on the move. The industry and brutality of their enemies is proof of it.

19 Fernand Léger (1881–1955) 'The New Realism Goes On'

The question of Realism, a major preoccupation of German intellectuals, was debated also on the French Left. Louis Aragon, who had withdrawn from the Surrealist group in favour of the more orthodox Communism which he then maintained for the rest of his life, was the leading figure in the Maison de la Culture, an institution supported by the Communist Party in Paris. A series of discussions on questions of Realism took place there in the mid-1930s. These involved perspectives as divergent as those of Aragon himself and the architect Le Corbusier. The painter Léger's intervention called for a 'New Realism': a *modern* art which would consciously sustain an address to the modern world. His lecture was published in *Querelle du Réalisme*, Paris, 1936, and in English translation by the American left-wing

journal *Art Front*, New York, vol. 3, no. 1, February 1937, pp. 7–8. The present extracts are taken from that translation by Samuel Putnam, as reprinted in Fernand Léger, *The Function of Painting*, New York, 1973, pp. 114–18. (For earlier texts by Léger see IIA11 and IIB8.)

Each art era has its own realism: it invents it, more or less, in relation to preceding epochs. Sometimes this is a reaction, at other times a continuation of the same line.

* * *

Realisms vary by reason of the fact that the artist finds himself always living in a different era, in a new environment, and amid a general trend of thought, dominating and influencing his mind.

For a half-century now, we have been living in an extremely rapid age, one rich in scientific, philosophical and social evolutions. This speed has, I think, rendered possible the precipitation and the realization of the new realism, which is quite different from the plastic conceptions that have gone before.

It was the Impressionists who 'broke the line,' Cézanne in particular. The moderns have followed by accentuating this liberation. We have freed color and geometric form. They have conquered the world. This new realism wholly rules the last fifty years, in the easel picture as well as in the decorative art of street and interior.

As for those pictures which made possible this evolution, the common reproach is that they have been snatched up by the dealers and the big collectors and that the people have no access to them. Whose fault is it? That of the present social order. If our works have not made their way among the people, the fault, I repeat, is that of the social order; it is not due to any lack of human quality on the part of the works in question. Under such a pretext as the latter, they would have us burn our bridges, coolly pass sentence of death upon that painting which brought us our freedom – a freedom so hard won – and turn our steps backward, God knows where. The names of Rembrandt and Rubens are evoked.

Under the pretext that we are to attempt to win at once the wholly admirable masses, whose instinct is so sure, and who are merely waiting to grasp the new verity – under such a pretext, they would have us start those same masses backward from century to century, traveling at first by rail and, later on, by horse and buggy and by cart, until they end up 'going in for the antique' on foot. This is an insult to these men of a new world, who ask nothing better than to understand and to go forward. It is officially to pronounce them incapable of rising to the level of that new realism which is their age – the age in which they live, in which they work, and which they have fashioned with their own hands. They are told that *le moderne* is not for us; it is for the rich, a specialized art, a bourgeois art, an art that is false from the bottom up.

It *is* possible for us to create and to realize a new collective social art: we are merely waiting for social evolution to permit it.

Our tastes, our traditions incline to the primitive and popular artists of before the Renaissance. It is from this same Renaissance that individualism in painting dates; and I do not believe there is any use in looking in this direction, if we desire to bring into being a fresh mural art, one that shall be at once popular, collective and contemporary. Our age is sufficiently rich in plastic materials to furnish us with the elements. But unfortunately, until new social conditions shall have been brought about, the people will fail to benefit from those elements.

I should like to say a word as to leisure – the creation and organization of leisure for workers. That, I take it, is the cardinal point of this discussion. *Everything depends on it.*

At no period in the history of the world have workers had access to plastic beauty, for the reason that they have never had the necessary time and freedom of mind. Free the masses of the people, give them the possibility of thinking, of seeing, of self-cultivation – that is all we ask; they will then be in a position to enjoy to the utmost the plastic novelties which modern art has to offer. The people themselves every day create manufactured objects that are pure in tonal quality, finished in form, exact in their proportions; they have already visualized the real and the potential plastic elements. Hanging on the wall in the popular bals-musettes, you will find *aeroplane propellers.* They strike everyone as being objects of beauty, and they are very close to certain modern sculptures.

It would require no great effort for the masses to be brought to feel and to understand the new realism, which has its origins in modern life itself, the continuing phenomena of life, under the influence of manufactured and geometrical objects, transposed to a realm where the imagination and the real meet and interlace, a realm from which all literary and descriptive sentimentality has been banished, all dramatization such as comes from other poetic or bookish tendencies. [. . .]

The working class has a right to all this. It has a right, on its walls, to mural paintings signed by the best modern artists. Give it time and leisure, and it will make itself at home with such paintings, will learn to live with and to love them.

What kind of representational art, may I ask, would you impose upon the masses, to compete with the daily allurements of the movies, the radio, large-scale photography and advertising? How enter into competition with the tremendous resources of modern mechanics, which provide an art popularized to a very high degree?

An art popular in character but inferior in quality – based upon the excuse that they will never understand anything about art, anyway – would be unworthy of them. On the contrary, quality is the thing to be sought, in an art that is interior and easy to live with. [. . .]

[. . .] In this domain, where it is a question of manifesting life's intensity under all its aspects, there are some wholly new possibilities – scenic, musical, in the way of color, movement, light, and chant – that have not as yet been grouped and orchestrated to their fullest extent. The man of the people comes into the world with a feeling for beauty. The ditch-digger who prefers a blue belt to a red one for holding up his trousers is making an act of choice. His instinctive judgment passed upon manufactured objects is esthetic in character. He will say 'the pretty bicycle,' 'the nice car,' before he knows whether or not it will function. This in itself indicates an acceptance of a fact: the new realism. Seductive shop windows where the isolated object causes the prospective purchaser to halt: the new realism.

All men, even the most stunted, have in them a potentiality of meeting the beautiful half way. But in the presence of the art work, the picture or the poem, if their leisure – I must insist upon it – does not permit them to cultivate this potentiality, they will go on, all their lives, forming their judgments by comparison. They will prefer Bouguereau to Ingres, for the reason that Bouguereau is the better imitator. Judgment by comparison is not valid; every art work calls for an individual appraisal, it is an independent whole; and if men are given assistance, they will succeed in making such an appraisal. The

human masses, demanding their place in the sun, the man of the people – let us not forget that they are poetry's last great refuge.

The man of the people it is who invents that mobile and ever new form: popular speech. He lives in an atmosphere of incessant verbal invention. While his hand is tightening a bolt, his imagination runs ahead, inventing new words, new poetic forms. All down the ages, the people have gone on inventing their language, which is their own form of realism. This language is unbelievably rich in substance. *Slang* is the finest and most vital poetry that there is. Popular actors, popular singers make use of it in the neighborhood theaters. They are the masterly inventors of it. This verbal form represents an alliance of realism and imaginative transposition; it is a new realism, perpetually in movement.

And is this class of mankind to be excluded, then, from those joys and satisfactions which the modern art work can give? Are the people to be refused 'their chance' of rising to a higher plastic level, when they themselves every day are inventing a new language that is wholly new? That is inexcusable. They have the right to demand that the time's revolution be carried out, and that they in their turn be permitted to enter the domain of the beautiful, which has always been closed to them up to now.

IVD
Modernism as Critique

1 Kasimir Malevich (1878–1935) Letter to Meyerhold

Malevich had worked with the experimental theatre director Vsevolod Meyerhold in 1918, designing the sets for a production of Mayakovsky's *Mystery Bouffe*. The present letter of 8 April 1932 both refers back to the revolutionary period and suggests reasons for Malevich's return to a form of figuration in the late 1920s, at a time when his work was subject to increasing official disfavour. His argument is that if post-revolutionary culture is to be protected from collapse either into utilitarianism or into conservatism, its social content must be transformed into artistic values. This he continues to associate with the specificity and limitations of the medium. But he now associates this 'non-objective' tendency with a re-emergent need to acknowledge the object: specifically the 'new object' which he believed had appeared as a result of the proletarian revolution. First published in this translation by Willem Langeveldt in *Kunst & Museumjournaal*, Amsterdam, vol. 1, no. 6, 1990, pp. 9–10. (For earlier texts by Malevich see IIA16, IIIC8 and 9.)

We have not managed to meet over the last year. Our conversations on the stairs of the Romanov House of Culture have not clarified anything particular about the question of the new theatre.

You said to me then that my time was coming. Your confidence started me thinking about the fact that your artistic ideas are beginning to develop in the direction of looking for new forms of theatre. That you are beginning to bring to an end that whole Constructivist course of yours, and moving towards a new phase.

But listen to what I heard when I was in Moscow last April: you are planning to build a new theatre with the stage in the middle. If this is true, it suggests to me that your ideas are still stuck in that same Constructivist wheel that is rolling down the path leading to the destruction of theatre. In this way the art of theatre is developing along the same path as the art of painting, the path of Impressionism, Cézannism, Cubism, Futurism and *non-objective Suprematism*.

Theatre did not of course go the same logical way, and the art of theatre did not have non-objective form or painters or directors. At the time of Futurism all hope lay with the painting and literature of Kruchenykh, Khlebnikov, Kamenski and Burlyuk, and I hoped that Meyerhold would stand at the head of the theatrical movement and lead it towards non-objective form, as in painting and literature. But apparently theatre could not go all the way down this path, and got no further than inviting new artists to perform in old forms. [...] But sooner or later they will end up on that path. Once people come to understand that art is non-objective, they will be able to present

new and interesting theatre. But at the moment, in this phase of building socialism in which all the arts must participate, art must return to backward areas and become figurative.

Painting has turned back from the non-objective way to the object, and the development of painting has returned to the figurative part of the way that had led to the destruction of the object. But on the way back, painting came across a new object that the proletarian revolution had brought to the fore and which had to be given form, which means that it had to be raised to the level of a work of art. Enriched by a new painting spectrum, by form and composition, the new arts must give this object shape on an artistic level, that is to say they must elevate every thematic subject into a painting, and that painting is the plane on which a two-dimensional and frontal development of the content takes place before the spectator. After returning to the figurative way and the way of the painting, art will end up at the frame, within which, after all, the picture comes into being.

If you destroyed the footlights, and I cooperated in that in Mayakovski's *Mystery Bouffe*, then we must now stop doing that, reinstall the footlights and place objects or content before them in an artistic form. From now on the artistic sense will take first place. The main task of the Soviet artist will be to create great artistic paintings. This is why I am utterly convinced that if you keep to the way of Constructivism, where you are now firmly stuck, which raises not one artistic issue except for pure utilitarianism and in theatre simple agitation, which may be one hundred per cent consistent ideologically but is completely castrated as regards artistic problems, and forfeits half of its value; if you go on as you are (keep this letter so that you can check up later), then Stanislavski will emerge as the winner in the theatre and the old forms will survive. And as to architecture, if the architects do not produce artistic architecture, the Greco-Roman style of Zyeltovski will prevail, together with the Repin style in painting. The culture of the arts must not disappear, and they are all artists. So found your theatre as an artistic creation, don't build it on the lines of a circus but in the same footlights as those in which the new artistic painting will stand. But if you demolish the footlights, if your elements leap out of the painting, performers who run into the auditorium or appear from it, it will amount to nothing. These are my thoughts in brief. This question could be gone into much more deeply in a discussion.

2 Pablo Picasso (1881–1973) 'Conversation with Picasso'

The present text derives from a conversation which took place at Boisgeloup in 1935. Picasso's remarks were transcribed immediately afterwards by his interlocutor Christian Zervos, editor of *Cahiers d'Art*, a journal in which the artist's work was regularly reproduced. The resulting notes were informally approved by Picasso prior to their publication. Besides a large number of sculptures, his representative works of the mid-1930s include still lifes and lyrical figure subjects painted in a decorative and brightly coloured late-Cubist style. First published as 'Conversation avec Picasso' in *Cahiers d'Art*, X, 7–10, Paris, 1935, pp. 173–8. English translation published in A. H. Barr Jr, *Picasso: Fifty Years of his Art*, New York, 1946, pp. 272–4, from which the present version is taken. (For further texts by Picasso see IIB12 and VC5 and 6.)

[...] It is my misfortune – and probably my delight – to use things as my passions tell me. What a miserable fate for a painter who adores blondes to have to stop himself putting them into a picture because they don't go with the basket of fruit! How awful for a painter who loathes apples to have to use them all the time because they go so well with the cloth. I put all the things I like into my pictures. The things – so much the worse for them; they just have to put up with it.

In the old days pictures went forward toward completion by stages. Every day brought something new. A picture used to be a sum of additions. In my case a picture is a sum of destructions. I do a picture – then I destroy it. In the end, though, nothing is lost; the red I took away from one place turns up somewhere else.

It would be very interesting to preserve photographically, not the stages, but the metamorphoses of a picture. Possibly one might then discover the path followed by the brain in materializing a dream. But there is one very odd thing – to notice that basically a picture doesn't change, that the first 'vision' remains almost intact, in spite of appearances. I often ponder on a light and a dark when I have put them into a picture; I try hard to break them up by interpolating a color that will create a different effect. When the work is photographed, I note that what I put in to correct my first vision has disappeared, and that, after all, the photographic image corresponds with my first vision before the transformation I insisted on.

A picture is not thought out and settled beforehand. While it is being done it changes as one's thoughts change. And when it is finished, it still goes on changing, according to the state of mind of whoever is looking at it. A picture lives a life like a living creature, undergoing the changes imposed on us by our life from day to day. This is natural enough, as the picture lives only through the man who is looking at it. [...]

When you begin a picture, you often make some pretty discoveries. You must be on guard against these. Destroy the thing, do it over several times. In each destroying of a beautiful discovery, the artist does not really suppress it, but rather transforms it, condenses it, makes it more substantial. What comes out in the end is the result of discarded finds. Otherwise, you become your own connoisseur. I sell myself nothing.

Actually, you work with few colors. But they seem like a lot more when each one is in the right place.

Abstract art is only painting. What about drama?

There is no abstract art. You must always start with something. Afterward you can remove all traces of reality. There's no danger then, anyway, because the idea of the object will have left an indelible mark. It is what started the artist off, excited his ideas, and stirred up his emotions. Ideas and emotions will in the end be prisoners in his work. Whatever they do, they can't escape from the picture. They form an integral part of it, even when their presence is no longer discernible. Whether he likes it or not, man is the instrument of nature. It forces on him its character and appearance. [...] One cannot go against nature. It is stronger than the strongest man. It is pretty much to our interest to be on good terms with it! We may allow ourselves certain liberties, but only in details.

Nor is there any 'figurative' and 'nonfigurative' art. Everything appears to us in the guise of a 'figure.' Even in metaphysics ideas are expressed by means of symbolic 'figures.' See how ridiculous it is then to think of painting without 'figuration.' A person, an object, a circle are all 'figures'; they react on us more or less intensely. Some are nearer our sensations and produce emotions that touch our affective faculties;

others appeal more directly to the intellect. They all should be allowed a place because I find my spirit has quite as much need of emotion as my senses. Do you think it concerns me that a particular picture of mine represents two people? Though these two people once existed for me, they exist no longer. The 'vision' of them gave me a preliminary emotion; then little by little their actual presences became blurred; they developed into a fiction and then disappeared altogether, or rather they were transformed into all kinds of problems. They are no longer two people, you see, but forms and colors: forms and colors that have taken on, meanwhile, the idea of two people and preserve the vibration of their life.

I deal with painting as I deal with things, I paint a window just as I look out of a window. If an open window looks wrong in a picture, I draw the curtain and shut it, just as I would in my own room. In painting, as in life, you must act directly. Certainly, painting has its conventions, and it is essential to reckon with them. Indeed, you can't do anything else. And so you always ought to keep an eye on real life.

The artist is a receptacle for emotions that come from all over the place: from the sky, from the earth, from a scrap of paper, from a passing shape, from a spider's web. That is why we must not discriminate between things. Where things are concerned there are no class distinctions. We must pick out what is good for us where we can find it – except from our own works. I have a horror of copying myself. [...]

[...] The painter goes through states of fullness and evaluation. That is the whole secret of art, I go for a walk in the forest of Fontainebleau. I get 'green' indigestion. I must get rid of this sensation into a picture. Green rules it. A painter paints to unload himself of feelings and visions. People seize on painting to cover up their nakedness. They get what they can wherever they can. In the end I can't believe they get anything at all. They've simply cut a coat to the measure of their own ignorance. They make everything, from God to a picture, in their own image. That is why the picture-hook is the ruination of a painting – a painting which has always a certain significance, at least as much as the man who did it. As soon as it is brought and hung on a wall, it takes on quite a different kind of significance, and the painting is done for.

Academic training in beauty is a sham. We have been deceived, but so well deceived that we can scarcely get back even a shadow of the truth. The beauties of the Parthenon, Venuses, Nymphs, Narcissuses are so many lies. Art is not the application of a canon of beauty but what the instinct and the brain can conceive beyond any canon. When we love a woman we don't start measuring her limbs. We love with our desires – although everything has been done to try and apply a canon even to love. The Parthenon is really only a farmyard over which someone put a roof; colonnades and sculptures were added because there were people in Athens who happened to be working, and wanted to express themselves. It's not what the artist *does* that counts, but what he *is*. Cézanne would never have interested me a bit if he had lived and thought like Jacques Emile Blanche, even if the apple he painted had been ten times as beautiful. What forces our interest is Cézanne's anxiety – that's Cézanne's lesson; the torments of Van Gogh – that is the actual drama of the man. The rest is a sham.

Everyone wants to understand art. Why not try to understand the songs of a bird? Why does one love the night, flowers, everything around one, without trying to understand them? But in the case of a painting people have to *understand*. If only they would realize above all that an artist works of necessity, that he himself is only a

trifling bit of the world, and that no more importance should be attached to him than to plenty of other things which please us in the world, though we can't explain them. People who try to explain pictures are usually barking up the wrong tree. Gertrude Stein joyfully announced to me the other day that she had at last understood what my picture of the three musicians was meant to be. It was a still life!

How can you expect an onlooker to live a picture of mine as I lived it? A picture comes to me from miles away: who is to say from how far away I sensed it, saw it, painted it; and yet the next day I can't see what I've done myself. How can anyone enter into my dreams, my instincts, my desires, my thoughts, which have taken a long time to mature and to come out into the daylight, and above all grasp from them what I have been about – perhaps against my own will?

With the exception of a few painters who are opening new horizons to painting, young painters today don't know which way to go. Instead of taking up our researches in order to react clearly against us, they are absorbed with bringing the past back to life – when truly the whole world is open before us, everything waiting to be done, not just redone. Why cling desperately to everything that has already fulfilled its promise? There are miles of painting 'in the manner of'; but it is rare to find a young man working in his own way.

Does he wish to believe that man can't repeat himself? To repeat is to run counter to spiritual laws; essentially escapism.

I'm no pessimist, I don't loathe art, because I couldn't live without devoting all my time to it. I love it as the only end of my life. Everything I do connected with it gives me intense pleasure. But still, I don't see why the whole world should be taken up with art, demand its credentials, and on that subject give free rein to its own stupidity. Museums are just a lot of lies, and the people who make art their business are mostly imposters. I can't understand why revolutionary countries should have more prejudices about art than out-of-date countries! We have infected the pictures in museums with all our stupidities, all our mistakes, all our poverty of spirit. We have turned them into petty and ridiculous things. We have been tied up to a fiction, instead of trying to sense what inner life there was in the men who painted them. There ought to be an absolute dictatorship . . . a dictatorship of painters . . . a dictatorship of one painter . . . to suppress all those who have betrayed us, to suppress the cheaters, to suppress the tricks, to suppress mannerisms, to suppress charms, to suppress history, to suppress a heap of other things. But common sense always gets away with it. Above all, let's have a revolution against that! The true dictator will always be conquered by the dictatorship of common sense . . . and maybe not!

3 Herbert Read (1893–1968) 'What Is Revolutionary Art?'

Written as one of five contributions to the symposium on 'Revolutionary Art' staged by the Artists' International Association (formerly the Artists' International) in London in 1935 (see also IVB19). Read was the most informed and sympathetic supporter of the Modern Movement in England in the 1930s, and a close friend of Henry Moore. His essay testifies on the one hand to the character and persistence of current arguments for a revolutionary function in culture, and on the other to the separation of the small English avant-garde into factions which variously reflected the major tendencies of European art at the time: Social

Realism, Surrealism and Abstraction. First published in B. Rea (ed.), *Five on Revolutionary Art*, London, 1935, from pp. 12–17 and 18–27 of which the present version is taken.

[...] Revolutionary art should be revolutionary. That surely is a simple statement from which we can begin the discussion. We can at once dismiss the feeble interpretation of such a statement as an injunction to paint pictures of red flags, hammers and sickles, factories and machines, or revolutionary subjects in general... But such a feeble interpretation does actually persist among Communists, and was in fact responsible for the failure of the first exhibition organized by the Artists' International. It is responsible for the partisan adulation of a competent but essentially second-rate artist like Diego Rivera.

We can best approach the question from the angle of an abstract art like architecture. [...] Architecture is a necessary art, and it is intimately bound up with the social reconstruction which must take place under a Communist régime. How do we, as Englishmen, conceive a Communist architecture? As a reversion to Tudor rusticity, or Georgian stateliness, or the bourgeois pomp of the neo-classical style? Surely none of these styles can for a moment be considered in relation to the city of the future. Must we not rather confidently look forward to a development of the new architecture of which Walter Gropius is the foremost exponent; of that architecture which, in his own words, 'bodies itself forth, not in stylistic imitation or ornamental frippery, but in those simple and sharply modelled designs in which every part merges naturally into the comprehensive volume of the whole.' Only in this manner, by following the path clearly indicated by Gropius in his work and writings, can we find 'a concrete expression of the life of our epoch'. [...]

But corresponding to the new architecture, to a large extent arising from the same fertile ground of the Bauhaus experiment founded and directed by Gropius, is the art generally known as 'abstract'. The name is admittedly a makeshift, and between an abstract artist like Mondrian or Ben Nicholson at one end of the scale, and an equally so-called 'abstract' artist like Miró or Henry Moore, there is only a remote connection. But for the moment these differences do not matter. Such names represent the modern school in painting and sculpture in its widest and most typical aspect, and these artists, I wish to claim, are the true revolutionary artists, whom every Communist should learn to respect and encourage.

Such an opinion will be met by a formidable opposition, precisely among Communists who are interested in art. Communist artists from Germany will tell you that they have 'been through all that'; that abstract art is dead, and that in any case it is incomprehensible to the proletariat and of no use to the revolutionary movement. Like the simple bourgeois of another generation, they ask for something they can understand, a 'realistic' art above all, something they can use as propaganda.

Actually, I believe that such artists are confessing their failure – as artists. The abstract movement in art is not dead, and not likely to be for many years to come. That it will gradually be transformed not only the dialectical conception of history, but the slightest acquaintance with the history of art, compels us to admit. But how it will be transformed is more than we can tell. The facts we have to recognize are: that all the artists of any intellectual force belong to this movement; that this movement is contemporary and revolutionary; and that only the apparent independence and isolation of the abstract artist – his refusal to toe the line and become an emotional

propagandist – only this fact hinders the Communist from accepting the abstract movement in art as the contemporary revolutionary movement in art.

To describe this attitude in the abstract artist as formalistic, as mere decorative dilettantism, not only betrays a lack of æsthetic sensibility, but an ignorance of the actual ideals and personalities of the artists themselves. Most of the artists in question are more or less openly in sympathy with the Communist movement. Why, then, do they adopt in all its integrity what is called the formalist attitude?

The question cannot be answered without a short digression on the nature of art. Any considerable work of art has two distinct elements: a formal element appealing to our sensibility for reasons which cannot be stated with any clarity, but which are certainly psychological in origin; and an arbitrary or accidental element of more complex appeal which is the outer clothing given to these underlying forms. It is at least arguable that the purely formal element in art does not change; that the same canons of harmony and proportion are present in primitive art, in Greek art, in Gothic art, in Renaissance art and in the art of the present day. Such forms, we may say, are archetypal; due to the physical structure of the world and the psychological structure of man. And it is for this reason that the artist, with some show of reason, can take up an attitude of detachment. It is his sense of the importance of the archetypal which makes him relatively indifferent to the phenomenal. The recognition of such universal formal qualities in art is consistently materialistic. It no more contradicts the materialistic interpretation of the history of art than does a recognition of the relative permanency of the human form, or of the forms of crystals in geology. Certain factors in life are constant; but to that extent they are not a part of history. History is concerned with that part of life which is subject to change; and the Marxian dialectic is an interpretation of history, not a theory of the structure or morphology of life.

Another consideration which mitigates the objection to the formalistic attitude is that, granted the existence of permanent and unchanging elements in art, there is, admittedly, at various periods, a different valuation of such elements. In fact, what is the difference between classical and romantic epochs but a difference in the emphasis given to the formal basis of works of art? [...] It is merely, we might say, a difference of accent. But it is in precisely such a way that a reasonable Marxian would expect art to be inflected. We can, therefore, in any broad historical generalisations, dismiss the underlying formal structure of art, to concentrate on style and mannerism. For it is in style and mannerism that the prevailing ideology of a period is expressed.

If we admit so much, it follows that it is a mere illusion for the artist to imagine that he can for ever maintain an attitude of detachment. I can only see one logical exception – the artist who can so deprive his work of temporary and accidental qualities that what he achieves is in effect *pure form*. And significantly enough that is the claim of one extreme of the abstract movement, an extreme which includes some of the most talented artists now living. Having no sympathy with any existing ideology, they attempt to escape into a world without ideologies. They shut themselves within the Ivory Tower, and it is just possible that, *for the time being* (the very special time in which we live) their tactics may be of some advantage to the art of the future. Their position will become clearer as we proceed.

Apart from such a desperate retreat, we have to admit that the artist cannot in any effective way avoid the economic conditions of his time; he cannot ignore them, for they will not ignore him. Reality, in one guise or another, forces the artist along a determined course, and if the artist does not realise this, it is only because he is in the middle of the stream, where the water is deep and the current strong.

* * *

[...] Excluding the great mass of academic bourgeois art, and within the general category of revolutionary art, we have two distinct movements, both professing to be modern, both *intentionally* revolutionary.

The first of these has no very descriptive label, but it is essentially formalist, in the sense already mentioned. It is sometimes called abstract, sometimes non-figurative, sometimes constructivist, sometimes geometric. It is most typically represented by painters like Mondrian, Hélion, Ben Nicholson, Moholy-Nagy; and by sculptors like Brancusi, Gabo and Barbara Hepworth.

The second movement has a distinctive name – Surréalisme or Superrealism, and is represented by painters like Max Ernst, Salvador Dali, Miró, Tanguy, and by a sculptor like Arp.

The first movement is plastic, objective and ostensibly non-political.

The second group is literary (even in paint), subjective, and actively Communist.

Those distinctions are obvious, on the surface. But I want to suggest that we cannot be satisfied with such superficial distinctions. We cannot accept the surréalistes at their own valuation, and welcome them as the only true revolutionary artists. Nevertheless, they are performing a very important revolutionary function, and it must be said on their behalf that they realize the importance of their function with far more clarity than the official Marxians, who have shown them no favour. For official Marxians, concentrating on their economic problems, do not see the relevance of the cultural problem, more particularly the artistic problem. The mind of the artist, they complacently assume, that too will, in Trotsky's phrase, limp after the reality they are creating.

But everywhere the greatest obstacle to the creation of this new social reality is the existence of the cultural heritage of the past – the religion, the philosophy, the literature and the art which makes up the whole complex ideology of the bourgeois mind. The logic of the facts – the economic facts: war, poverty amidst plenty, social injustice – that logic cannot be denied. But so long as the bourgeois mind has its bourgeois ideology, it will deny the facts; it will construct an elaborate rationalization which effectively ignores them.

The superrealists, who possess very forceful expositors of their point of view – writers like André Breton – realize this very clearly, and the object of their movement is therefore to discredit the bourgeois ideology in art, to destroy the academic conception of art. Their whole tendency is negative and destructive. The particular method they adopt, in so far as they have a common method, consists in breaking down the barriers between the conscious reality of life and the unconscious reality of the dream-world – to so mingle fact and fancy that the normal concept of reality no longer has existence [...]

We can see, therefore, the place of surréalisme in the revolutionary movement. What of this other kind of modern art – the art of pure form immured in its Ivory Tower?

That art too, I wish to contend, has its revolutionary function, and in the end it is the most important function of all. Superrealism is a negative art, as I have said, a destructive art; it follows that it has only a temporary rôle; it is the art of a transitional period. It may lead to a new romanticism, especially in literature, but that lies beyond its immediate function.

But abstract art has a positive function. It keeps inviolate, until such time as society will once more be ready to make use of them, the universal qualities of art – those elements which survive all changes and revolutions. It may be said that as such it is merely art in pickle – an activity divorced from reality, of no immediate interest to the revolutionary. But that, I maintain, is a very short view of the situation. And actually such art is not so much in pickle as might be supposed. For in one sphere, in architecture and to some extent in industrial arts, it is already in social action. There we find the essential link between the abstract movement in modern painting and the most advanced movement in modern architecture – the architecture of Gropius, Markelius, Le Corbusier. ... It is not merely a similarity of form and intention, but an actual and intimate association of personalities.

This single link points the way to the art of the future – the art of the new classless society. It is impossible to predict all the forms of this art, and it will be many years before it reaches its maturity. But you cannot build a new society – and you must *build* such a society, with bricks and mortar, steel and glass – you cannot build such a society without artists. The artists are waiting for their opportunity: abstract artists who are, in this time of transition, perfecting their formal sensibility, and who will be ready, when the time comes, to apply their talents to the great work of reconstruction. That is not a work for romanticists and literary sentimentalists. Communism is realist, scientific, essentially classical. But let us realize that we have romanticists in our midst – tender-minded idealists who would like to blur the precise outlines of our vision with democratic ideals of egalitarianism, Tolstoyan simplicity and naivety, community-singing and boy-scoutism. Such people imagine that revolutionary art is a kind of folk-art, peasant pottery, madrigals and ballads. Surely that is not a conception of art worthy of the true Communist. We want something tougher, something more intellectual and 'difficult', something that we can without falsity and self-deception put beside the great epochs of art in the past.

REVOLUTIONARY ART IS CONSTRUCTIVE
REVOLUTIONARY ART IS INTERNATIONAL
REVOLUTIONARY ART IS REVOLUTIONARY

4　Meyer Schapiro (1904–1996) 'The Social Bases of Art'

Schapiro was of the few art historians writing in the English language in the 1930s who applied the resources of the Marxist intellectual tradition to the problems of analysis of modern art and its development. In this paper he brings a social-historical form of explanation to bear on the current conditions of artistic practice. Originally delivered as a contribution to the First American Artists' Congress in New York in 1936, and first published in the proceedings of the Congress. Reprinted in D. Shapiro (ed.), *Social Realism – Art as a*

Weapon: Critical Studies in American Art, New York, 1973, from pp. 120–7 of which the present version is taken.

[...] If modern art seems to have no social necessity, it is because the social has been narrowly identified with the collective as the anti-individual, and with repressive institutions and beliefs, like the church or the state or morality, to which most individuals submit. But even those activities in which the individual seems to be unconstrained and purely egoistic depend upon socially organized relationships. Private property, individual competitive business enterprise or sexual freedom, far from constituting non-social relationships, presuppose specific, historically developed forms of society. Nearer to art there are many unregistered practices which seem to involve no official institutions, yet depend on recently acquired social interests and on definite stages of material development. A promenade, for example (as distinguished from a religious procession or a parade), would be impossible without a particular growth of urban life and secular forms of recreation. The necessary means – the streets and the roads – are also social and economic in origin, beyond or prior to any individual; yet each man enjoys his walk by himself without any sense of constraint or institutional purpose.

In the same way, the apparent isolation of the modern artist from practical activities, the discrepancy between his archaic, individual handicraft and the collective, mechanical character of most modern production, do not necessarily mean that he is outside society or that his work is unaffected by social and economic changes. The social aspect of his art has been further obscured by two things, the insistently personal character of the modern painter's work and his preoccupation with formal problems alone. The first leads him to think of himself in opposition to society as an organized repressive power, hostile to individual freedom; the second seems to confirm this in stripping his work of any purpose other than a purely 'aesthetic'.

But if we examine attentively the objects a modern artist paints and the psychological attitudes evident in the choice of these objects and their forms, we will see how intimately his art is tied to the life of modern society.

Although painters will say again and again that content doesn't matter, they are curiously selective in their subjects. They paint only certain themes and only in a certain aspect. The content of the great body of art today, which appears to be unconcerned with content, may be described as follows. First, there are natural spectacles, landscapes or city-scenes, regarded from the viewpoint of a relaxed spectator, a vacationist or sportsman, who values the landscape chiefly as a source of agreeable sensations or mood; artificial spectacles and entertainments – the theatre, the circus, the horse-race, the athletic field, the music-hall – or even works of painting, sculpture, architecture and technology, experienced as spectacles or objects of art; the artist himself and individuals associated with him; his studio and his intimate objects, his model posing, the fruit and flowers on his table, his window and the view from it; symbols of the artist's activity, individuals practising other arts, rehearsing, or in their privacy; instruments of art, especially of music, which suggest an abstract art and improvisation; isolated intimate fields, like a table covered with private instruments of idle sensation, drinking glasses, a pipe, playing cards, books, all objects of manipulation, referring to an exclusive, private world in which the individual is immobile, but

free to enjoy his own moods and self stimulation. And finally, there are pictures in which the elements of professional artistic discrimination, present to some degree in all painting – the lines, spots of color, areas, textures, modelling – are disengaged from things and juxtaposed as 'pure' aesthetic objects.

Thus elements drawn from the professional surroundings and activity of the artist; situations in which we are consumers and spectators; objects which we confront intimately, but passively or accidentally, or manipulate idly and in isolation – these are typical subjects of modern painting. They recur with surprising regularity in contemporary art.

Modern artists have not only eliminated the world of action from their pictures, but they have interpreted past art as if the elements of experience in it, the represented objects, were incidental things, pretexts of design or imposed subjects, in spite of which, or in opposition to which, the artist realized his supposedly pure aesthetic impulse. They are therefore unaware of their own objects or regard them as merely incidental pretexts for form. But a little observation will show that each school of modern artists has its characteristic objects and that these derive from a context of experience which also operates in their formal fantasy. The picture is not a rendering of external objects – that is not even strictly true of realistic art – but the objects assembled in the picture come from an experience and interests which affect the formal character. An abstract art built up out of other objects, that is, out of other interests and experience, would have another formal character.

* * *

A modern work, considered formally, is no more artistic than an older work. The preponderance of objects drawn from a personal and artistic world does not mean that pictures are now more pure than in the past, more completely works of art. It means simply that the personal and aesthetic contexts of secular life now condition the formal character of art, just as religious beliefs and practices in the past conditioned the formal character of religious art. The conception of art as purely aesthetic and individual can exist only where culture has been detached from practical and collective interests and is supported by individuals alone. But the mode of life of these individuals, their place in society, determine in many ways this individual art. In its most advanced form, this conception of art is typical of the *rentier* leisure class in modern capitalist society, and is most intensely developed in centers, like Paris, which have a large *rentier* group and considerable luxury industries. Here the individual is no longer engaged in a struggle to attain wealth; he has no direct relation to work, machinery, competition; he is simply a consumer, not a producer. He belongs to a class which recognizes no higher group or authority. The older stable forms of family life and sexual morality have been destroyed; there is no royal court or church to impose a regulating pattern on his activity. For this individual the world is a spectacle, a source of novel pleasant sensations, or a field in which he may realize his 'individuality,' through art, through sexual intrigue and the most varied, but non–productive, mobility [. . .]

[. . .] It is the situation of painting in such a society, and the resulting condition of the artist, which confer on the artist to-day certain common tendencies and attitudes. Even the artist of lower middle-class or working-class origin comes to create pictures congenial to the members of this upper class, without having to identify himself directly with it. He builds, to begin with, on the art of the last generation and is influenced by the success of recent painters. The general purpose of art being aesthetic,

he is already predisposed to interests and attitudes, imaginatively related to those of the leisure class, which values its pleasures as aesthetically refined, individual pursuits. He competes in an open market and therefore is conscious of the novelty or uniqueness of his work as a value. He creates out of his own head (having no subject-matter imposed by a commission), works entirely by himself, and is therefore concerned with his powers of fantasy, his touch, his improvised forms. His sketches are sometimes more successful than his finished pictures, and the latter often acquire the qualities of a sketch.

Cut off from the middle class at the very beginning of his career by poverty and insecurity and by the non-practical character of his work, the artist often repudiates its moral standards and responsibilities. He forms on the margin of this inferior philistine world a free community of artists in which art, personalities and pleasure are the obsessing interests. The individual and the aesthetic are idealized as things completely justified in themselves and worth the highest sacrifices. The practical is despised except insofar as it produces attractive mechanical spectacles and new means of enjoyment, or insofar as it is referred abstractly to a process of inventive design, analogous to the painter's art. His frequently asserted antagonism to organized society does not bring him into conflict with his patrons, since they share his contempt for the 'public' and are indifferent to practical social life. Besides, since he attributes his difficulties, not to particular historical conditions, but to society and human nature as such, he has only a vague idea that things might be different than they are; his antagonism suggests to him no effective action, and he shuns the common slogans of reform or revolution as possible halters on his personal freedom.

Yet helpless as he is to act on the world, he shows in his art an astonishing ingenuity and joy in transforming the shapes of familiar things. This plastic freedom should not be considered in itself an evidence of the artist's positive will to change society or a reflection of real transforming movements in the every-day world. For it is essential in this anti-naturalistic art that just those relations of visual experience which are most important for action are destroyed by the modern artist. As in the fantasy of a passive spectator, colors and shapes are disengaged from objects and can no longer serve as a means in knowing them. The space within pictures becomes intraversable; its planes are shuffled and disarrayed, and the whole is re-ordered in a fantastically intricate manner. Where the human figure is preserved, it is a piece of picturesque still-life, a richly pigmented, lumpy mass, individual, irritable and sensitive; or an accidental plastic thing among others, subject to sunlight and the drastic distortions of a design. If the modern artist values the body, it is no longer in the Renaissance sense of a firm, clearly articulated, energetic structure, but as temperamental and vehement flesh.

The passivity of the modern artist with regard to the human world is evident in a peculiar relation of his form and content. In his effort to create a thoroughly animated, yet rigorous whole, he considers the interaction of color upon color, line upon line, mass upon mass. Such pervasive interaction is for most modern painters the very essence of artistic reality. Yet in his choice of subjects he rarely, if ever, seizes upon corresponding aspects in social life. He has no interest in, no awareness of, such interaction in the every-day world. On the contrary, he has a special fondness for those objects which exist side by side without affecting each other, and for situations in which the movements involve no real interactions. The red of an apple may oppose the green of another apple, but the apples do not oppose each other. The typical human

situations are those in which figures look at each other or at a landscape or are plunged in a revery or simulate some kind of absorption. And where numerous complicated things are brought together in apparent meaningful connection, this connection is cryptic, bizarre, something we must solve as a conceit of the artist's mind.

The social origins of such forms of modern art do not in themselves permit one to judge this art as good or bad; they simply throw light upon some aspects of their character and enable us to see more clearly that the ideas of modern artists, far from describing eternal and necessary conditions of art, are simply the results of recent history. In recognizing the dependence of his situation and attitudes on the character of modern society, the artist acquires the courage to change things, to act on his society and for himself in an effective manner.

He acquires at the same time new artistic conceptions. Artists who are concerned with the world around them in its action and conflict, who ask the same questions that are asked by the impoverished masses and oppressed minorities – these artists cannot permanently devote themselves to a painting committed to the aesthetic moments of life, to spectacles designed for passive, detached individuals, or to an art of the studio.

There are artists and writers for whom the apparent anarchy of modern culture – as an individual affair in which each person seeks his own pleasure – is historically progressive, since it makes possible for the first time the conception of the human individual with his own needs and goals. But it is a conception restricted to small groups who are able to achieve such freedom only because of the oppression and misery of the masses. The artists who create under these conditions are insecure and often wretched. Further, this freedom of a few individuals is identified largely with consumption and enjoyment; it detaches man from nature, history and society, and although, in doing so, it discovers new qualities and possibilities of feeling and imagination, unknown to older culture, it cannot realize those possibilities of individual development which depend on common productive tasks, on responsibilities, on intelligence and cooperation in dealing with the urgent social issues of the moment. The individual is identified with the private (that is, the privation of other beings and the world), with the passive rather than active, the fantastic rather than the intelligent. Such an art cannot really be called free, because it is so exclusive and private; there are too many things we value that it cannot embrace or even confront. An individual art in a society where human beings do not feel themselves to be most individual when they are inert, dreaming, passive, tormented or uncontrolled, would be very different from modern art. And in a society where all men can be free individuals, individuality must lose its exclusiveness and its ruthless and perverse character.

5 Jan Mukařovský (1891–1975) from *Aesthetic Function*

Mukařovský was a member of the distinguished Prague School of linguists. His book *Aesthetic Function: Norm and Value as Social Facts* was originally published in Prague in 1934 or 1936. In arguing for the importance of aesthetic value in art, Mukařovský makes an important distinction between the 'disinterestedness' normally claimed for art within the Modernist critical tradition and art's necessary self-sufficiency. He is then able to claim that it is by virtue of its autonomy that art exerts a bearing upon reality. The present brief extract is taken from the translation by Mark E. Suino, Ann Arbor, MI, 1970, pp. 86–90.

[. . .] We have arrived at a point from which it is possible to survey the mutual relationship between aesthetic value and the other values contained in a work of art, and to explain the true nature of that relationship. Previously we confined ourselves to the assertion that aesthetic value dominates all other values in a work of art. This assertion follows with logical necessity from the basis of art – that privileged region of aesthetic phenomena – which is, due to the dominance of the aesthetic function and aesthetic value, distinct from the countless number of other phenomena in which the aesthetic function is facultative and subordinate to some other function. [. . .] If we assert that aesthetic function and value in a work of art dominate over other functions and values, we are not offering a postulate for a practical relation to art (in which, even today, for some individuals and collectives, some other function is dominant). We are simply drawing a theoretical conclusion from the position which art occupies in the entire realm of aesthetic phenomena, assuming that differentiation of functions has been accomplished.

Even these avowedly theoretical formulations have been criticized, due to a misunderstanding, as espousing 'formalism' and art-for-art's-sake. The self-sufficiency of the work of art, an aspect of the dominant position of aesthetic function and value, is mistakenly confused with the Kantian 'disinterestedness' of art. In order to correct this error it is necessary to look at the position and character of aesthetic value in art from within artistic structure. That is, we must proceed from extra-aesthetic values – distributed among individual elements of a work – toward aesthetic value which binds the work into a unity. In so doing we discover something which is unique and unexpected. We said earlier that all elements of a work of art, in form and content, possess extra-aesthetic values which, within the work, enter into mutual relationships. The work of art appears, in the final analysis, as an actual collection of extra-aesthetic values and nothing else. The material components of the artistic artifact, and the manner in which they are used as artistic means, assume the role of mere conductors of energies introduced by extra-aesthetic values. If we ask ourselves at this point what has happened to aesthetic value, it appears that it has dissolved into individual extra-aesthetic values, and is really nothing but a general term for the dynamic totality of their mutual interrelationships. The distinction between 'form' and 'content' as used in the investigation of an art work is thus incorrect. The formalism of the Russian school of aesthetic and literary theory was correct in maintaining that all elements of a work are, without distinction, components of form. It must be added that all components are equally the bearers of meaning and extra-aesthetic values, and thus components of content. The analysis of 'form' must not be narrowed to a mere formal analysis. On the other hand, however, it must be made clear that only the *entire* construction of the work, and not just the part called 'content,' enters into an active relation with the system of life values which govern human affairs.

The dominance of aesthetic value above all other values, a distinguishing feature of art, is thus something other than a mere external superiority. The influence of aesthetic value is not that it swallows up and represses all remaining values, but that it releases every one of them from direct contact with a corresponding life-value. It brings an entire assembly of values contained in the work as a dynamic whole into contact with a total system of those values which form the motive power of the life practice of the perceiving collective. What is the nature and goal of this contact? Above all it must be borne in mind, as we have already demonstrated, that this contact is rarely idyllically

tranquil. As a rule the values contained in the art work are somewhat different, both in their mutual relationships and in the quality of individual values, from the complex system of values which is valid for the collective. There thus arises a mutual tension, and herein lies the particular meaning and effect of art. The constant necessity for practical application of values determines the free movement of the totality of values governing the life practice of the collective. The displacement of individual members of the hierarchy (re-valuation of values) is very difficult here, and is accompanied by strong shocks to the entire life practice of the given collective (slowing of development, uncertainty of values, disintegration of the system, even revolutionary eruptions). On the other hand, values in the art work – of which each by itself is free of actual dependency, but whose totality has potential validity – can, without harm, regroup and transform themselves. They can experimentally crystallize into a new configuration and dissolve an old one, can adapt to the development of the social situation and to new creative facts of reality, or at least seek the possibility of such adaptation.

Viewed in this light, the autonomy of the art work and the dominance of the aesthetic function and value within it appear not as destroyers of all contact between the work and reality – natural and social – but as constant stimuli of such contact. Art is a vital agent of great importance, even in periods of development and forms which stress self-orientation in art plus dominance of aesthetic function and value. Sometimes it is during just such stages which combine development and self-orientation that art may exert considerable influence on the relation of man to reality.

6 Walter Benjamin (1892–1940) 'The Work of Art in the Age of Mechanical Reproduction'

Benjamin's major work during the years of his Parisian exile was the unfinished *Arcades* project (the *Passagenwerk*), a study of the roots of modernity in Haussmannization, and of Baudelaire's response to it. This embodied a wider interest in new cultural forms, which Benjamin shared with other Weimar intellectuals. Albeit with roots in the nineteenth century, the typical and central new forms of the twentieth century emerged through technologies of mass reproduction: printing, in the first instance, but especially photography and cinema. In the present essay Benjamin argues that the 'aura' of the original, unique work of art is lost to reproducibility; but that this, far from being something to mourn, opens up progressive possibilities. Originally published in the Frankfurt Institute journal (by then operating in exile in the United States), *Zeitschrift für Sozialforschung*, V, no. 1, New York, 1936. The present version is taken from the English translation by Harry Zohn in H. Arendt (ed.), Walter Benjamin, *Illuminations*, London, 1973, pp. 219–53. (See also IVC17.)

I

[. . .] Around 1900 technical reproduction had reached a standard that not only permitted it to reproduce all transmitted works of art and thus to cause the most profound change in their impact upon the public; it also had captured a place of its own among the artistic processes. For the study of this standard nothing is more revealing than the nature of the repercussions that these two different manifestations – the reproduction of works of art and the art of the film – have had on art in its traditional form.

II

Even the most perfect reproduction of a work of art is lacking in one element: its presence in time and space, its unique existence at the place where it happens to be. This unique existence of the work of art determined the history to which it was subject throughout the time of its existence. This includes the changes which it may have suffered in physical condition over the years as well as the various changes in its ownership. The traces of the first can be revealed only by chemical or physical analyses which it is impossible to perform on a reproduction; changes of ownership are subject to a tradition which must be traced from the situation of the original.

The presence of the original is the prerequisite to the concept of authenticity. Chemical analyses of the patina of a bronze can help to establish this, as does the proof that a given manuscript of the Middle Ages stems from an archive of the fifteenth century. The whole sphere of authenticity is outside technical – and, of course, not only technical – reproducibility. Confronted with its manual reproduction, which was usually branded as a forgery, the original preserved all its authority; not so *vis à vis* technical reproduction. The reason is twofold. First, process reproduction is more independent of the original than manual reproduction. [...] Secondly, technical reproduction can put the copy of the original into situations which would be out of reach for the original itself. Above all, it enables the original to meet the beholder halfway, be it in the form of a photograph or a phonograph record. [...]

The situations into which the product of mechanical reproduction can be brought may not touch the actual work of art, yet the quality of its presence is always depreciated. This holds not only for the art work but also, for instance, for a landscape which passes in review before the spectator in a movie. In the case of the art object, a most sensitive nucleus – namely, its authenticity – is interfered with whereas no natural object is vulnerable on that score. The authenticity of a thing is the essence of all that is transmissible from its beginning, ranging from its substantive duration to its testimony to the history which it has experienced. Since the historical testimony rests on the authenticity, the former, too, is jeopardized by reproduction when substantive duration ceases to matter. And what is really jeopardized when the historical testimony is affected is the authority of the object.

One might subsume the eliminated element in the term 'aura' and go on to say: that which withers in the age of mechanical reproduction is the aura of the work of art. This is a symptomatic process whose significance points beyond the realm of art. One might generalize by saying: the technique of reproduction detaches the reproduced object from the domain of tradition. By making many reproductions it substitutes a plurality of copies for a unique existence. And in permitting the reproduction to meet the beholder or listener in his own particular situation, it reactivates the object reproduced. These two processes lead to a tremendous shattering of tradition which is the obverse of the contemporary crisis and renewal of mankind. Both processes are intimately connected with the contemporary mass movements. Their most powerful agent is the film. Its social significance, particularly in its most positive form, is inconceivable without its destructive, cathartic aspect, that is, the liquidation of the traditional value of the cultural heritage. [...]

* * *

IV

The uniqueness of a work of art is inseparable from its being imbedded in the fabric of tradition. [...] Originally the contextual integration of art in tradition found its expression in the cult. We know that the earliest art works originated in the service of a ritual – first the magical, then the religious kind. It is significant that the existence of the work of art with reference to its aura is never entirely separated from its ritual function. In other words, the unique value of the 'authentic' work of art has its basis in ritual, the location of its original use value. This ritualistic basis, however remote, is still recognizable as secularized ritual even in the most profane forms of the cult of beauty. The secular cult of beauty, developed during the Renaissance and prevailing for three centuries, clearly showed that ritualistic basis in its decline and the first deep crisis which befell it. With the advent of the first truly revolutionary means of reproduction, photography, simultaneously with the rise of socialism, art sensed the approaching crisis which has become evident a century later. At the time, art reacted with the doctrine of *l'art pour l'art*, that is, with a theology of art. This gave rise to what might be called a negative theology in the form of the idea of 'pure' art, which not only denied any social function of art but also any categorizing by subject matter. . . .

An analysis of art in the age of mechanical reproduction must do justice to these relationships, for they lead us to an all-important insight: for the first time in world history, mechanical reproduction emancipates the work of art from its parasitical dependence on ritual. To an ever greater degree the work of art reproduced becomes the work of art designed for reproducibility. From a photographic negative, for example, one can make any number of prints; to ask for the 'authentic' print makes no sense. But the instant the criterion of authenticity ceases to be applicable to artistic production, the total function of art is reversed. Instead of being based on ritual, it begins to be based on another practice – politics.

* * *

VII

The nineteenth-century dispute as to the artistic value of painting versus photography today seems devious and confused. This does not diminish its importance, however; if anything, it underlines it. The dispute was in fact the symptom of a historical transformation the universal impact of which was not realized by either of the rivals. When the age of mechanical reproduction separated art from its basis in cult, the semblance of its autonomy disappeared forever. The resulting change in the function of art transcended the perspective of the century; for a long time it even escaped that of the twentieth century, which experienced the development of the film.

* * *

XI

The shooting of a film, especially of a sound film, affords a spectacle unimaginable anywhere at any time before this. [...] In the theater one is well aware of the place from

which the play cannot immediately be detected as illusionary. There is no such place for the movie scene that is being shot. Its illusionary nature is that of the second degree, the result of cutting. That is to say, in the studio the mechanical equipment has penetrated so deeply into reality that its pure aspect freed from the foreign substance of equipment is the result of a special procedure, namely, the shooting by the specially adjusted camera and the mounting of the shot together with other similar ones. The equipment-free aspect of reality here has become the height of artifice; the sight of immediate reality has become an orchid in the land of technology.

Even more revealing is the comparison of these circumstances, which differ so much from those of the theater, with the situation in painting. Here the question is: How does the cameraman compare with the painter? To answer this we take recourse to an analogy with a surgical operation. The surgeon represents the polar opposite of the magician. The magician heals a sick person by the laying on of hands; the surgeon cuts into the patient's body. The magician maintains the natural distance between the patient and himself; though he reduces it very slightly by the laying on of hands, he greatly increases it by virtue of his authority. The surgeon does exactly the reverse; he greatly diminishes the distance between himself and the patient by penetrating into the patient's body, and increases it but little by the caution with which his hand moves among the organs. In short, in contrast to the magician – who is still hidden in the medical practitioner – the surgeon at the decisive moment abstains from facing the patient man to man; rather, it is through the operation that he penetrates into him.

Magician and surgeon compare to painter and cameraman. The painter maintains in his work a natural distance from reality, the cameraman penetrates deeply into its web. There is a tremendous difference between the pictures they obtain. That of the painter is a total one, that of the cameraman consists of multiple fragments which are assembled under a new law. Thus, for contemporary man the representation of reality by the film is incomparably more significant than that of the painter, since it offers, precisely because of the thoroughgoing permeation of reality with mechanical equipment, an aspect of reality which is free of all equipment. And that is what one is entitled to ask from a work of art.

XII

Mechanical reproduction of art changes the reaction of the masses toward art. The reactionary attitude toward a Picasso painting changes into the progressive reaction toward a Chaplin movie. The progressive reaction is characterized by the direct, intimate fusion of visual and emotional enjoyment with the orientation of the expert. Such fusion is of great social significance. The greater the decrease in the social significance of an art form, the sharper the distinction between criticism and enjoyment by the public. The conventional is uncritically enjoyed, and the truly new is criticized with aversion. With regard to the screen, the critical and the receptive attitudes of the public coincide. The decisive reason for this is that individual reactions are predetermined by the mass audience response they are about to produce, and this is nowhere more pronounced than in the film. The moment these responses become manifest they control each other. Again, the comparison with painting is fruitful. A painting has always had an excellent chance to be viewed by one person or by a few. The simultaneous contemplation of paintings by a large public, such as developed in the nineteenth

century, is an early symptom of the crisis of painting, a crisis which was by no means occasioned exclusively by photography but rather in a relatively independent manner by the appeal of art works to the masses.

Painting simply is in no position to present an object for simultaneous collective experience, as it was possible for architecture at all times, for the epic poem in the past, and for the movie today. Although this circumstance in itself should not lead one to conclusions about the social role of painting, it does constitute a serious threat as soon as painting, under special conditions and, as it were, against its nature, is confronted directly by the masses. In the churches and monasteries of the Middle Ages and at the princely courts up to the end of the eighteenth century, a collective reception of paintings did not occur simultaneously, but by graduated and hierarchized mediation. The change that has come about is an expression of the particular conflict in which painting was implicated by the mechanical reproducibility of paintings. Although paintings began to be publicly exhibited in galleries and salons, there was no way for the masses to organize and control themselves in their reception. Thus the same public which responds in a progressive manner toward a grotesque film is bound to respond in a reactionary manner to surrealism.

* * *

XIV

One of the foremost tasks of art has always been the creation of a demand which could be fully satisfied only later. The history of every art form shows critical epochs in which a certain art form aspires to effects which could be fully obtained only with a changed technical standard, that is to say, in a new art form. The extravagances and crudities of art which thus appear, particularly in the so-called decadent epochs, actually arise from the nucleus of its richest historical energies. In recent years, such barbarisms were abundant in Dadaism. It is only now that its impulse becomes discernible: Dadaism attempted to create by pictorial – and literary – means the effects which the public today seeks in the film.

Every fundamentally new, pioneering creation of demands will carry beyond its goal. Dadaism did so to the extent that it sacrificed the market values which are so characteristic of the film in favor of higher ambitions – though of course it was not conscious of such intentions as here described. The Dadaists attached much less importance to the sales value of their work than to its uselessness for contemplative immersion. The studied degradation of their material was not the least of their means to achieve this uselessness. Their poems are 'word salad' containing obscenities and every imaginable waste product of language. The same is true of their paintings, on which they mounted buttons and tickets. What they intended and achieved was a relentless destruction of the aura of their creations, which they branded as reproductions with the very means of production. Before a painting of Arp's or a poem by August Stramm it is impossible to take time for contemplation and evaluation as one would before a canvas of Derain's or a poem by Rilke. In the decline of middle-class society, contemplation became a school for asocial behaviour; it was countered by distraction as a variant of social conduct. Dadaistic activities actually assured a rather vehement distraction by making works of art the center of scandal. One requirement was foremost: to outrage the public.

From an alluring appearance or persuasive structure of sound the work of art of the Dadaists became an instrument of ballistics. It hit the spectator like a bullet, it happened to him, thus acquiring a tactile quality. It promoted a demand for the film, the distracting element of which is also primarily tactile, being based on changes of place and focus which periodically assail the spectator. Let us compare the screen on which a film unfolds with the canvas of a painting. The painting invites the spectator to contemplation; before it the spectator can abandon himself to his associations. Before the movie frame he cannot do so. No sooner has his eye grasped a scene than it is already changed. It cannot be arrested. Duhamel, who detests the film and knows nothing of its significance, though something of its structure, notes this circumstance as follows: 'I can no longer think what I want to think. My thoughts have been replaced by moving images.' The spectator's process of association in view of these images is indeed interrupted by their constant, sudden change. This constitutes the shock effect of the film, which, like all shocks, should be cushioned by heightened presence of mind. By means of its technical structure, the film has taken the physical shock effect out of the wrappers in which Dadaism had, as it were, kept it inside the moral shock effect.

XV

The mass is a matrix from which all traditional behavior toward works of art issues today in a new form. Quantity has been transmuted into quality. The greatly increased mass of participants has produced a change in the mode of participation. The fact that the new mode of participation first appeared in a disreputable form must not confuse the spectator. Yet some people have launched spirited attacks against precisely this superficial aspect. Among these, Duhamel has expressed himself in the most radical manner. What he objects to most is the kind of participation which the movie elicits from the masses. Duhamel calls the movie 'a pastime for helots, a diversion for uneducated, wretched, worn-out creatures who are consumed by their worries . . ., a spectacle which requires no concentration and presupposes no intelligence . . ., which kindles no light in the heart and awakens no hope other than the ridiculous one of someday becoming a "star" in Los Angeles.' Clearly, this is at bottom the same ancient lament that the masses seek distraction whereas art demands concentration from the spectator. That is a commonplace. The question remains whether it provides a platform for the analysis of the film. A closer look is needed here. Distraction and concentration form polar opposites which may be stated as follows: A man who concentrates before a work of art is absorbed by it. He enters into this work of art the way legend tells of the Chinese painter when he viewed his finished painting. In contrast, the distracted mass absorbs the work of art. This is most obvious with regard to buildings. Architecture has always represented the prototype of a work of art the reception of which is consummated by a collectivity in a state of distraction. The laws of its reception are most instructive.

Buildings have been man's companions since primeval times. Many art forms have developed and perished. Tragedy begins with the Greeks, is extinguished with them, and after centuries its 'rules' only are revived. The epic poem, which had its origin in the youth of nations, expires in Europe at the end of the Renaissance. Panel painting is a creation of the Middle Ages, and nothing guarantees its uninterrupted

existence. But the human need for shelter is lasting. Architecture has never been idle. Its history is more ancient than that of any other art, and its claim to being a living force has significance in every attempt to comprehend the relationship of the masses to art. Buildings are appropriated in a twofold manner: by use and by perception – or rather, by touch and sight. Such appropriation cannot be understood in terms of the attentive concentration of a tourist before a famous building. On the tactile side there is no counterpart to contemplation on the optical side. Tactile appropriation is accomplished not so much by attention as by habit. As regards architecture, habit determines to a large extent even optical reception. The latter, too, occurs much less through rapt attention than by noticing the object in incidental fashion. This mode of appropriation, developed with reference to architecture, in certain circumstances acquires canonical value. For the tasks which face the human apparatus of perception at the turning points of history cannot be solved by optical means, that is, by contemplation, alone. They are mastered gradually by habit, under the guidance of tactile appropriation.

The distracted person, too, can form habits. More, the ability to master certain tasks in a state of distraction proves that their solution has become a matter of habit. Distraction as provided by art presents a covert control of the extent to which new tasks have become soluble by apperception. Since, moreover, individuals are tempted to avoid such tasks, art will tackle the most difficult and most important ones where it is able to mobilize the masses. Today it does so in the film. Reception in a state of distraction, which is increasing noticeably in all fields of art and is symptomatic of profound changes in apperception, finds in the film its true means of exercise. The film with its shock effect meets this mode of reception halfway. The film makes the cult value recede into the background not only by putting the public in the position of the critic, but also by the fact that at the movies this position requires no attention. The public is an examiner, but an absent-minded one.

EPILOGUE

The growing proletarianization of modern man and the increasing formation of masses are two aspects of the same process. Fascism attempts to organize the newly created proletarian masses without affecting the property structure which the masses strive to eliminate. Fascism sees its salvation in giving these masses not their right, but instead a chance to express themselves. The masses have a right to change property relations; Fascism seeks to give them an expression while preserving property. The logical result of Fascism is the introduction of aesthetics into political life. The violation of the masses, whom Fascism, with its *Führer* cult, forces to their knees, has its counterpart in the violation of an apparatus which is pressed into the production of ritual values.

All efforts to render politics aesthetic culminate in one thing: war. War and war only can set a goal for mass movements on the largest scale while respecting the traditional property system. This is the political formula for the situation. The technological formula may be stated as follows: Only war makes it possible to mobilize all of today's technical resources while maintaining the property system. [. . .]

[. . .] The destructiveness of war furnishes proof that society has not been mature enough to incorporate technology as its organ, that technology has not been sufficiently developed to cope with the elemental forces of society. The horrible features of

imperialistic warfare are attributable to the discrepancy between the tremendous means of production and their inadequate utilization in the process of production – in other words, to unemployment and the lack of markets. Imperialistic war is a rebellion of technology which collects, in the form of 'human material,' the claims to which society has denied its natural material. Instead of draining rivers, society directs a human stream into a bed of trenches; instead of dropping seeds from airplanes, it drops incendiary bombs over cities; and through gas warfare the aura is abolished in a new way.

'*Fiat ars – pereat mundus*,' says Fascism, and as Marinetti admits, expects war to supply the artistic gratification of a sense perception that has been changed by technology. This is evidently the consummation of '*l'art pour l'art*.' Mankind, which in Homer's time was an object of contemplation for the Olympian gods, now is one for itself. Its self-alienation has reached such a degree that it can experience its own destruction as an aesthetic pleasure of the first order. This is the situation of politics which Fascism is rendering aesthetic. Communism responds by politicizing art.

7 Theodor Adorno (1903–1969) Letter to Benjamin

Music critic, sociologist and philosopher, Adorno, like Benjamin, was associated with the 'Frankfurt School' (the Institute for Social Research, originally affiliated to the University of Frankfurt in 1923), though he was not to become a permanent member until 1938, when he followed the school into exile in New York. In this letter he comments on a draft of Benjamin's 'The Work of Art in the Age of Mechanical Reproduction', on the one hand defending the critical function of the autonomous work of art, on the other questioning whether technical change was really likely to result in a progressive popular art. The letter was written in March 1936 and was first published in *Über Walter Benjamin*, Frankfurt, 1970. The present translation, by Harry Zohn, is taken from Theodor Adorno et al., *Aesthetics and Politics*, London, 1977, pp. 120–6. (For later texts by Adorno see VC14 and VIB6.)

London, 18 March 1936

Dear Herr Benjamin:

If today I prepare to convey to you some notes on your extraordinary study I certainly have no intention of offering you criticism or even an adequate reponse. [...]

Let me therefore confine myself to one main theme. My ardent interest and my complete approval attach to that aspect of your study which appears to me to carry out your original intention – the dialectical construction of the relationship between myth and history – within the intellectual field of the materialistic dialectic: namely, the dialectical self-dissolution of myth, which is here viewed as the disenchantment of art. [...]

It is this accord which for me constitutes the criterion for the differences that I must now state, with no other aim than to serve our 'general line', which is now so clearly discernible. In doing so, perhaps I can start out by following our old method of immanent criticism. In your earlier writings, of which your present essay is a continuation, you differentiated the idea of the work of art as a structure from the symbol of theology and from the taboo of magic. I now find it disquieting – and here I see a

sublimated remnant of certain Brechtian motifs – that you now casually transfer the concept of magical aura to the 'autonomous work of art' and flatly assign to the latter a counter-revolutionary function. I need not assure you that I am fully aware of the magical element in the bourgeois work of art (particularly since I constantly attempt to expose the bourgeois philosophy of idealism, which is associated with the concept of aesthetic autonomy, as mythical in the fullest sense). However, it seems to me that the centre of the autonomous work of art does not itself belong on the side of myth – excuse my topic parlance – but is inherently dialectical; within itself it juxtaposes the magical and the mark of freedom. If I remember correctly, you once said something similar in connection with Mallarmé, and I cannot express to you my feeling about your entire essay more clearly than by telling you that I constantly found myself wishing for a study of Mallarmé as a counterpoint to your essay, a study which, in my estimation, you owe us as an important contribution to our knowledge. Dialectical though your essay may be, it is not so in the case of the autonomous work of art itself; it disregards an elementary experience which becomes more evident to me every day in my own musical experience – that precisely the uttermost consistency in the pursuit of the technical laws of autonomous art changes this art and instead of rendering it into a taboo or fetish, brings it close to the state of freedom, of something that can be consciously produced and made. I know of no better materialistic programme than that statement by Mallarmé in which he defines works of literature as something not inspired but made out of words; and the greatest figures of reaction, such as Valéry and Borchardt (the latter with his essay about villas which, despite an unspeakable comment about workers, could be taken over in a materialistic sense in its entirety), have this explosive power in their innermost cells. If you defend the *kitsch* film against the 'quality' film, no one can be more in agreement with you than I am; but *l'art pour l'art* is just as much in need of a defence, and the united front which exists against it and which to my knowledge extends from Brecht to the Youth Movement, would be encouragement enough to undertake a rescue.

[...] And at this point, to be sure, the debate turns political quickly enough. For if you render rightly technicization and alienation dialectical, but not in equal measure the world of objectified subjectivity, the political effect is to credit the proletariat (as the cinema's subject) directly with an achievement which, according to Lenin, it can realize only through a theory introduced by intellectuals as dialectical subjects, who themselves belong to the sphere of works of art which you have consigned to Hell.

Understand me correctly. I would not want to claim the autonomy of the work of art as a prerogative, and I agree with you that the aural element of the work of art is declining – not only because of its technical reproducibility, incidentally, but above all because of the fulfilment of its own 'autonomous' formal laws . . . But the autonomy of the work of art, and therefore its material form, is not identical with the magical element in it. The reification of a great work of art is not just loss, any more than the reification of the cinema is all loss. It would be bourgeois reaction to negate the reification of the cinema in the name of the ego, and it would border on anarchism to revoke the reification of a great work of art in the spirit of immediate use-values. '*Les extrèmes me touchent*' [Gide], just as they touch you – but only if the dialectic of the lowest has the same value as the dialectic of the highest, rather than the latter simply decaying. Both bear the stigmata of capitalism, both contain elements of change (but

never, of course, the middle-term between Schönberg and the American film). Both are torn halves of an integral freedom, to which however they do not add up. It would be romantic to sacrifice one to the other, either as the bourgeois romanticism of the conservation of personality and all that stuff, or as the anarchistic romanticism of blind confidence in the spontaneous power of the proletariat in the historical process – a proletariat which is itself a product of bourgeois society.

To a certain extent I must accuse your essay of this second romanticism. You have swept art out of the corners of its taboos – but it is as though you feared a consequent inrush of barbarism (who could share your fear more than I?) and protected yourself by raising what you fear to a kind of inverse taboo. [...]

[...] Accordingly, what I would postulate is *more* dialectics. On the one hand, dialectical penetration of the 'autonomous' work of art which is transcended by its own technology into a planned work; on the other, an even stronger dialecticization of utilitarian art in its negativity, which you certainly do not fail to note but which you designate by relatively abstract categories like 'film capital', without tracking it down to its ultimate lair as immanent irrationality. When I spent a day in the studios of Neubabelsberg two years ago, what impressed me most was how *little* montage and all the advanced techniques that you emphasize are actually used; rather, reality is everywhere *constructed* with an infantile mimetism and then 'photographed'. You under-estimate the technicality of autonomous art and over-estimate that of dependent art; this, in plain terms, would be my main objection. But this objection could only be given effect as a dialectic between extremes which you tear apart. In my estimation, this would involve nothing less than the complete liquidation of the Brechtian motifs which have already undergone an extensive transformation in your study – above all, the liquidation of any appeal to the immediacy of interconnected aesthetic effects, however fashioned, and to the actual consciousness of actual workers who have absolutely no advantage over the bourgeois except their interest in the revolution, but otherwise bear all the marks of mutilation of the typical bourgeois character. This prescribes our function for us clearly enough – which I certainly do not mean in the sense of an activist conception of 'intellectuals'. But it cannot mean either that we may only escape the old taboos by entering into new ones – 'tests', so to speak. The goal of the revolution is the abolition of fear. Therefore we need have no fear of it, nor need we ontologize our fear. It is not bourgeois idealism if, in full knowledge and without mental prohibitions, we maintain our solidarity with the proletariat instead of making of our own necessity a virtue of the proletariat, as we are always tempted to do – the proletariat which itself experiences the same necessity and needs us for knowledge as much as we need the proletariat to make the revolution. I am convinced that the further development of the aesthetic debate which you have so magnificently inaugurated, depends essentially on a true accounting of the relationship of the intellectuals to the working-class.

* * *

I feel that our theoretical disagreement is not really a discord between us but rather, that it is my task to hold your arm steady until the sun of Brecht has once more sunk into exotic waters. Please understand my criticisms only in this spirit.

Your old friend,
Teddie Wiesengrund

8 Ernst Bloch (1885–1977) 'Discussing Expressionism'

As a German intellectual in exile during the later 1930s, Bloch was engaged in dispute with Lukács over the nature of Expressionism, which at the time was seen as virtually synonymous with artistic avant-gardism. Here he defends Expressionism against the views expressed by Lukács in 'The Greatness and Decline of Expressionism', published in *International Literature* in 1934. (The 'USPD', to which reference is made, was the Independent Social-Democratic Party, formed in 1916 as an anti-war secession from the German Social Democratic Party.) Bloch's essay was originally published in Moscow in 1938 in the expatriate German-language journal *Das Wort* (*The Word*). It was read by Clement Greenberg, and was one of the triggers for his influential essay 'Avant-Garde and Kitsch' (IVD11). 'Discussing Expressionism' was reprinted in *Erbschaft dieser Zeit* (*Legacy of Today*), Frankfurt, 1962, when Bloch added the passage included here between square brackets. The present translation, by Rodney Livingstone, is taken from Adorno et al., op. cit., pp. 18–27.

What material does Lukács . . . use to expound his view of the Expressionists? He takes prefaces or postscripts to anthologies, 'introductions' . . . newspaper articles . . . and other items of the same sort. So he does not get to the core of the matter, the imaginative works which make a concrete impression in time and space, a reality which the observer may re-experience for himself. His material is second-hand from the outset; it is literature on Expressionism, which he then proceeds to use as a basis for literary, theoretical and critical judgements. No doubt Lukács's purpose is to explore 'the social base of the movement and the ideological premises arising from that base'. But it thereby suffers from the methodological limitation that it produces only a concept of concepts, an essay on essays and even lesser pieces. [. . .]

[. . .] None of this even touches the actual *creative* works of Expressionism, which alone are of interest to us. [. . .] there is surely no need to labour the point that in the emotional outbursts of the art of the period, with their semi-archaic, semi-utopian hypostases, which remain today as enigmatic as they were then, there is to be found far more than the 'USPD ideology' to which Lukács would like to reduce Expressionism. No doubt these emotional outbursts were even more dubious than enigmatic when they had no object outside themselves. But to describe them as the expression of 'the forlorn perplexity of the petty-bourgeois' is scarcely adequate. Their substance was different; it was composed partly of archaic images, but partly too of revolutionary fantasies which were critical and often quite specific. Anyone who had ears to hear could hardly have missed the revolutionary element their cries contained, even if it was undisciplined and uncontrolled, and 'dissipated' a considerable amount of the 'classical heritage' – or what was then more accurately 'classical lumber'. Permanent Neo-classicism, or the conviction that anything produced since Homer and Goethe is not worth considering unless it is produced in their image or as an abstraction from them, is no vantage-point from which to keep one's eye on the last avant-garde movement but one, or to pass judgement on it.

Given such an attitude, what recent artistic experiments can possibly avoid being censured? They must all be summarily condemned as aspects of the decay of capitalism – not just in part, which might not be unreasonable, but wholesale, one hundred per cent. The result is that there can be no such thing as an avant-garde within late

capitalist society; anticipatory movements in the superstructure are disqualified from possessing any truth. That is the logic of an approach which paints everything in black and white – one hardly likely to do justice to reality, indeed even to answer the needs of propaganda. Almost all forms of opposition to the ruling class which are not communist from the outset are lumped together with the ruling class itself. This holds good even when, as Lukács illogically concedes in the case of Expressionism, the opposition was subjectively well-intentioned and its adherents felt, painted and wrote as adversaries of the Fascism that was to come. In the age of the Popular Front, to cling to such a black-and-white approach seems less appropriate than ever; it is mechanical, not dialectical. All these recriminations and condemnations have their source in the idea that ever since the philosophical line that descends from Hegel through Feuerbach to Marx came to an end, the bourgeoisie has nothing more to teach us, except in technology and perhaps the natural sciences; everything else is at best of 'sociological' interest. It is this conception which convicts such a singular and unprecedented phenomenon as Expressionism of being pseudo-revolutionary from the very beginning. It allows, indeed forces, the Expressionists to figure as forerunners of the Nazis. [. . .]

[. . .] This is not the occasion for a detailed discussion of an issue so crucial that only the most thorough analysis can do it justice: for it involves all the problems of the dialectical-materialist theory of reflection (*Abbildlehre*). I will make only one point. Lukács's thought takes for granted a closed and integrated reality that does indeed exclude the subjectivity of idealism, but not the seamless 'totality' which has always thriven best in idealist systems, including those of classical German philosophy. Whether such a totality in fact constitutes reality, is open to question. If it does, then Expressionist experiments with disruptive and interpolative techniques are but an empty *jeu d'esprit*, as are the more recent experiments with montage and other devices of discontinuity. But what if Lukács's reality – a coherent, infinitely mediated totality – is not so objective after all? What if his conception of reality has failed to liberate itself completely from Classical systems? What if authentic reality is also discontinuity? Since Lukács operates with a closed, objectivistic conception of reality, when he comes to examine Expressionism he resolutely rejects any attempt on the part of artists to shatter any image of the world, even that of capitalism. Any art which strives to exploit the *real* fissures in surface inter-relations and to discover the new in their crevices, appears in his eyes merely as a wilful act of destruction. He thereby equates experiment in demolition with a condition of decadence.

At this point, even his ingenuity finally flags. It is undoubtedly the case that the Expressionists utilized, and even exacerbated, the decadence of late bourgeois civilization. Lukács resents their 'collusion in the ideological decay of the imperialist bourgeoisie, without offering either criticism or resistance, acting indeed on occasion as its vanguard'. But in the first place there is very little truth in the crude idea of 'collusion'; Lukács himself acknowledges that Expressionism 'was ideologically a not insignificant component of the anti-war movement'. Secondly, so far as 'collusion' in an active sense goes, the actual furtherance of cultural decline, one must ask: are there not dialectical links between growth and decay? Are confusion, immaturity and incomprehensibility always and in every case to be categorized as bourgeois decadence? Might they not equally – in contrast with this simplistic and surely unrevolutionary view – be part of the transition from the old world to the new? Or at least be part of the struggle leading to that transition? This is an issue which can only be resolved by concrete examination

of the works themselves; it cannot be settled by omniscient *parti-pris* judgements. So the Expressionists were the 'vanguard' of decadence. Should they instead have aspired to play doctor at the sick-bed of capitalism? Should they have tried to plaster over the surface of reality, in the spirit, say, of the Neo-classicists or the representatives of Neo-objectivity [*Neue Sachlichkeit*], instead of persisting in their efforts of demolition? [...]

[...] No-one maintains that Expressionism should be taken as a model or regarded as a 'precursor'. But neither is there any justification for refurbishing interest in Neo-classicism by renewing outmoded battles with an Expressionism long since devalued. Even if an artistic movement is not a 'precursor' of anything, it may for that very reason seem closer to young artists than [a third-hand classicism which calls itself 'socialist realism' and is administered as such. Superimposed on the architecture, painting and writing of the Revolution, it is stifling them.] [...]

[...] There is surely no denying that formalism was the least of the defects of Expressionist art (which must not be confused with Cubism). On the contrary, it suffered far more from a neglect of form, from a plethora of expressions crudely, wildly or chaotically ejaculated; its stigma was amorphousness. It more than made up for this, however, by its closeness to the people, its use of folklore. [...] It is enough, of course, that fake art [*kitsch*] is itself popular, in the bad sense. The countryman in the 19th century exchanged his painted wardrobe for a factory-made display cabinet, his old, brightly-painted glass for a coloured print and thought himself at the height of fashion. But it is unlikely that anyone will be misled into confusing these poisoned fruits of capitalism with genuine expressions of the people; they can be shown to have flowered in a very different soil, one with which they will disappear.

Neo-classicism is, however, by no means such a sure antidote to kitsch; nor does it contain an authentically popular element. It is itself much too 'highbrow' and the pedestal on which it stands renders it far too artificial. By contrast, as we have already noted, the Expressionists really did go back to popular art, loved and respected folklore – indeed, so far as painting was concerned, were the first to discover it. [...] The heritage of Expressionism has not yet ceased to exist, because we have not yet even started to consider it.

9 André Breton (1896–1966), Diego Rivera (1886–1957) and Leon Trotsky (1879–1940) 'Towards a Free Revolutionary Art'

In 1936 the Moscow show trials served to dramatize Stalin's treatment of political opponents and independent intellectuals. Two years later Breton visited Mexico on a lecture tour. While there he was introduced to the exiled Trotsky by the painter Diego Rivera. The present text was a product of this meeting, and of a shared perception of the repressive nature of both Fascism and Stalinism. Although the effective authors were Breton and Trotsky, it was considered expedient by Trotsky that Rivera's name should be substituted for his own. Nothing came of the Independent Federation which the manifesto announced. Within two years Paris had fallen to the Nazis and Trotsky had been assassinated by a Stalinist agent. The present translation by Dwight MacDonald was first published in *Partisan Review*, New York, IV, no. 1, Fall 1938, pp. 49–53, and immediately after in the *London Bulletin*, December 1938–January 1939.

We can say without exaggeration that never has civilization been menaced so seriously as today. The Vandals, with instruments which were barbarous, and so comparatively ineffective, blotted out the culture of antiquity in one corner of Europe. But today we see world civilization, united in its historic destiny, reeling under the blows of reactionary forces armed with the entire arsenal of modern technology. We are by no means thinking only of the world war that draws near. Even in times of 'peace' the position of art and science has become absolutely intolerable.

Insofar as it originates with an individual, insofar as it brings into play subjective talents to create something which brings about an objective enriching of culture, any philosophical, sociological, scientific or artistic discovery seems to be the fruit of a precious *chance*, that is to say, the manifestation, more or less spontaneous, of *necessity*. Such creations cannot be slighted, whether from the standpoint of general knowledge (which interprets the existing world), or of revolutionary knowledge (which, the better to change the world, requires an exact analysis of the laws which govern its movement). Specifically, we cannot remain indifferent to the intellectual conditions under which creative activity takes place, nor should we fail to pay all respect to those particular laws which govern intellectual creation.

In the contemporary world we must recognize the ever more widespread destruction of those conditions under which intellectual creation is possible. From this follows of necessity an increasingly manifest degradation not only of the work of art but also of the specifically 'artistic' personality. The regime of Hitler, now that it has rid Germany of all those artists whose work expressed the slightest sympathy for liberty, however superficial, has reduced those who still consent to take up pen or brush to the status of domestic servants of the regime, whose task it is to glorify it on order, according to the worst possible aesthetic conventions. If reports may be believed, it is the same in the Soviet Union, where Thermidorian reaction is now reaching its climax.

It goes without saying that we do not identify ourselves with the currently fashionable catchword: 'Neither fascism nor communism!' a shibboleth which suits the temperament of the philistine, conservative and frightened, clinging to the tattered remnants of the 'democratic' past. True art, which is not content to play variations on ready-made models but rather insists on expressing the inner needs of man and of mankind in its time – true art is unable *not* to be revolutionary, *not* to aspire to a complete and radical reconstruction of society. This it must do, were it only to deliver intellectual creation from the chains which bind it, and to allow all mankind to raise itself to those heights which only isolated geniuses have achieved in the past. We recognize that only the social revolution can sweep clean the path for a new culture. If, however, we reject all solidarity with the bureaucracy now in control of the Soviet Union, it is precisely because, in our eyes, it represents, not communism, but its most treacherous and dangerous enemy.

The totalitarian regime of the USSR, working through the so-called cultural organizations it controls in other countries, has spread over the entire world a deep twilight hostile to every sort of spiritual value. A twilight of filth and blood in which, disguised as intellectuals and artists, those men steep themselves who have made of servility a career, of lying for pay a custom, and of the palliation of crime a source of pleasure. The official art of Stalinism mirrors with a blatancy unexampled in history their efforts to put a good face on their mercenary profession.

The repugnance which this shameful negation of principles of art inspires in the artistic world – a negation which even slave states have never dared to carry so far – should give rise to an active, uncompromising condemnation. The *opposition* of writers and artists is one of the forces which can usefully contribute to the discrediting and overthrow of regimes which are destroying, along with the right of the proletarian to aspire to a better world, every sentiment of nobility and even of human dignity.

The communist revolution is not afraid of art. It realizes that the role of the artist in a decadent capitalist society is determined by the conflict between the individual and various social forms which are hostile to him. This fact alone, insofar as he is conscious of it, makes the artist the natural ally of revolution. The process of *sublimation*, which here comes into play and which psychoanalysis has analyzed, tries to restore the broken equilibrium between the integral 'ego' and the outside elements it rejects. This restoration works to the advantage of the 'ideal of self,' which marshals against the unbearable present reality all those powers of the interior world, of the 'self,' which are *common to all men* and which are constantly flowering and developing. The need for emancipation felt by the individual spirit has only to follow its natural course to be led to mingle its stream with this primeval necessity – the need for the emancipation of man.

The conception of the writer's function which the young Marx worked out is worth recalling. 'The writer,' he declared, 'naturally must make money in order to live and write, but he should not under any circumstances live and write in order to make money.... The writer by no means looks on his work as a *means*. It is *an end in itself* and so little a means in the eyes of himself and of others that if necessary he sacrifices his existence to the existence of his work.... *The first condition of the freedom of the press is that it is not a business activity.*' It is more than ever fitting to use this statement against those who would regiment intellectual activity in the direction of ends foreign to itself, and prescribe, in the guise of so-called reasons of state, the themes of art. The free choice of these themes and the absence of all restrictions on the range of his exploitations – these are possessions which the artist has a right to claim as inalienable. In the realm of artistic creation, the imagination must escape from all constraint and must under no pretext allow itself to be placed under bonds. To those who urge us, whether for today or for tomorrow, to consent that art should submit to a discipline which we hold to be radically incompatible with its nature, we give a flat refusal and we repeat our deliberate intention of standing by the formula *complete freedom for art*.

We recognize, of course, that the revolutionary state has the right to defend itself against the counterattack of the bourgeoisie, even when this drapes itself in the flag of science or art. But there is an abyss between these enforced and temporary measures of revolutionary self-defense and the pretension to lay commands on intellectual creation. If, for the better development of the forces of material production, the revolution must build a *socialist* regime with centralized control, to develop intellectual creation an *anarchist* regime of individual liberty should from the first be established. No authority, no dictation, not the least trace of orders from above! Only on a base of friendly cooperation, without constraint from outside, will it be possible for scholars and artists to carry out their tasks, which will be more far-reaching than ever before in history.

It should be clear by now that in defending freedom of thought we have no intention of justifying political indifference, and that it is far from our wish to revive a so-called pure art which generally serves the extremely impure ends of reaction. No, our

conception of the role of art is too high to refuse it an influence on the fate of society. We believe that the supreme task of art in our epoch is to take part actively and consciously in the preparation of the revolution. But the artist cannot serve the struggle for freedom unless he subjectively assimilates its social content, unless he feels in his very nerves its meaning and drama and freely seeks to give his own inner world incarnation in his art.

In the present period of the death agony of capitalism, democratic as well as fascist, the artist sees himself threatened with the loss of his right to live and continue working. He sees all avenues of communication choked with the debris of capitalist collapse. Only naturally, he turns to the Stalinist organizations which hold out the possibility of escaping from his isolation. But if he is to avoid complete demoralization, he cannot remain there, because of the impossibility of delivering his own message and the degrading servility which these organizations exact from him in exchange for certain material advantages. He must understand that his place is elsewhere, not among those who betray the cause of the revolution and mankind, but among those who with unshaken fidelity bear witness to the revolution, among those who, for this reason, are alone able to bring it to fruition, and along with it the ultimate free expression of all forms of human genius.

The aim of this appeal is to find a common ground on which may be reunited all revolutionary writers and artists, the better to serve the revolution by their art and to defend the liberty of that art itself against the usurpers of the revolution. We believe that aesthetic, philosophical and political tendencies of the most varied sort can find here a common ground. Marxists can march here hand in hand with anarchists, provided both parties uncompromisingly reject the reactionary police patrol spirit represented by Joseph Stalin and by his henchman Garcia Oliver.

We know very well that thousands on thousands of isolated thinkers and artists are today scattered throughout the world, their voices drowned out by the loud choruses of well-disciplined liars. Hundreds of small local magazines are trying to gather youthful forces about them, seeking new paths and not subsidies. Every progressive tendency in art is destroyed by fascism as 'degenerate.' Every free creation is called 'fascist' by the Stalinists. Independent revolutionary art must now gather its forces for the struggle against reactionary persecution. It must proclaim aloud the right to exist. Such a union of forces is the aim of the *International Federation of Independent Revolutionary Art* which we believe it is now necessary to form.

We by no means insist on every idea put forth in this manifesto, which we ourselves consider only a first step in the new direction. We urge every friend and defender of art, who cannot but realize the necessity for this appeal, to make himself heard at once. We address the same appeal to all those publications of the left wing which are ready to participate in the creation of the International Federation and to consider its task and its methods of action.

When a preliminary international contact has been established through the press and by correspondence, we will proceed to the organization of local and national congresses on a modest scale. The final step will be the assembly of a world congress which will officially mark the foundation of the International Federation.

Our aims:

The independence of art – for the revolution.

The revolution – for the complete liberation of art!

10 R. G. Collingwood (1889–1943) 'Good Art and Bad Art'

Collingwood was born in Cumbria and studied at the University of Oxford, where he was made Professor of Philosophy in 1934. Best known for his work in philosophical aesthetics, he was also an authority on the archaeology of Roman Britain. He published *Outlines of a Philosophy of Art* in 1925, developing and reworking the material in *The Principles of Art*, first published in 1938 (Oxford: Oxford University Press). In his Preface to the latter, Collingwood welcomed what he saw as 'an important revival in the arts', accompanied by 'a growth of aesthetic theory and criticism, written mostly not by academic philosophers or amateurs of art, but by poets, dramatists, painters, and sculptors themselves'. The thesis of *The Principles of Art* follows Benedetto Croce in identifying art with intuitive response and with emotion rendered conscious through linguistic forms of expression (see IB15). Where Clive Bell had identified aesthetic emotion with response to significant form, and had seen art as an automatic means to good (IB16), Collingwood identified the production of art with critical imaginative activity and associated 'good art' with the inculcation of a kind of realism in the face of history and culture. In the final section of *The Principles of Art* Collingwood presents a strong case in favour of T. S. Eliot's poem *The Waste Land*. His notable conclusion is that 'Art is community's medicine for that worst disease of the mind, the corruption of consciousness.' The idea that the life of the artist is waged as a war against the corruption of consciousness finds a later echo in Michael Fried's association of modernist painting with 'life lived . . . in a state of continuous moral and intellectual alertness' (see VIB9). 'Good Art and Bad Art' is the third and final subsection in a chapter on 'Art as Language', pp. 280–5 in the Oxford University Press paperback edition, 1958.

The definition of any given kind of thing is also the definition of a good thing of that kind: for a thing that is good in its kind is only a thing which possesses the attributes of that kind. To call things good and bad is to imply success and failure. When we call things good or bad not in themselves but relatively to us, as when we speak of a good harvest or a bad thunderstorm, the success or failure implied is our own; we mean that these things enable us to realize our purposes, or prevent us from doing so. When we call things good or bad in themselves, the success or failure implied is theirs. We are implying that they acquire the attributes of their kind by an effort on their own part, and that this effort may be either more or less successful.

I am not raising the question whether it is true, as the Greeks thought, that there are natural kinds, and that what we call a dog is something that is trying to be a dog. For all my present argument is concerned, either that view may be true (in which case dogs can be good or bad in themselves), or the alternative view may be true, that the idea of a dog is only a way in which we choose to classify the things we come across, in which case dogs can be good or bad only in relation to us. I am only concerned with good and bad works of art. Now, a work of art is an activity of a certain kind; the agent is trying to do something definite, and in that attempt he may succeed or he may fail. It is, moreover, a conscious activity; the agent is not only trying to do something definite, he also knows what it is that he is trying to do; though knowing here does not necessarily imply being able to describe, since to describe is to generalize, and generalizing is the function of the intellect, and consciousness does not, as such, involve intellect.

A work of art, therefore, may be either a good one or a bad one. And because the agent is necessarily a conscious agent, he necessarily knows which it is. Or rather, he necessarily knows this so far as his consciousness in respect of this work of art is uncorrupted; for we have seen that there is such a thing as untruthful or corrupt consciousness.

Any theory of art should be required to show, if it wishes to be taken seriously, how an artist, in pursuing his artistic labour, is able to tell whether he is pursuing it successfully or unsuccessfully: how, for example, it is possible for him to say, 'I am not satisfied with that line; let us try it this way...and this way...and this way...there! that will do.' A theory which pushes the artistic experience too far down the scale, to a point below the region where experience has the character of knowledge, is unable to meet this demand. It can only evade it by pretending that the artist in such cases is acting not as an artist, but as a critic and even (if criticism of art is identified with philosophy of art) as a philosopher. But this pretence should deceive nobody. The watching of his own work with a vigilant and discriminating eye, which decides at every moment of the process whether it is being successful or not, is not a critical activity subsequent to, and reflective upon, the artistic work, it is an integral part of that work itself. A person who can doubt this, if he has any grounds at all for his doubt, is presumably confusing the way an artist works with the way an incompetent student in an art-school works; painting blindly, and waiting for the master to show him what it is that he has been doing. In point of fact, what a student learns in an art-school is not so much to paint as to watch himself painting: to raise the psycho–physical activity of painting to the level of art by becoming conscious of it, and so converting it from a psychical experience into an imaginative one.

What the artist is trying to do is to express a given emotion. To express it, and to express it well, are the same thing. To express it badly is not one way of expressing it (not, for example, expressing it, but not *selon les règles*), it is failing to express it. A bad work of art is an activity in which the agent tries to express a given emotion, but fails. This is the difference between bad art and art falsely so called. In art falsely so called there is no failure to express, because there is no attempt at expression; there is only an attempt (whether successful or not) to do something else.

But expressing an emotion is the same thing as becoming conscious of it. A bad work of art is the unsuccessful attempt to become conscious of a given emotion: it is what Spinoza calls an inadequate idea of an affection. Now, a consciousness which thus fails to grasp its own emotions is a corrupt or untruthful consciousness. For its failure (like any other failure) is not a mere blankness; it is not a doing nothing; it is a misdoing something; it is activity, but blundering or frustrated activity. A person who tries to become conscious of a given emotion, and fails, is no longer in a state of sheer unconsciousness or innocence about that emotion; he has done something about it, but that something is not to express it. What he has done is either to shirk it or dodge it: to disguise it from himself by pretending either that the emotion he feels is not that one but a different one, or that the person who feels it is not himself, but some one else: two alternatives which are so far from being mutually exclusive that in fact they are always concurrent and correlative.

If we ask whether this pretence is conscious or unconscious, the answer is, neither. It is a process which occurs not in the region below consciousness (where it could not, of course, take place, since consciousness is involved in the process itself), nor yet in the

region of consciousness (where equally it could not take place, because a man cannot literally tell himself a lie; in so far as he is conscious of the truth he cannot literally deceive himself about it); it occurs on the threshold that divides the psychical level of experience from the conscious level. It is the malperformance of the act which converts what is merely psychic (impression) into what is conscious (idea).

The corruption of consciousness in virtue of which a man fails to express a given emotion makes him at the same time unable to know whether he has expressed it or not. He is, therefore, for one and the same reason, a bad artist and a bad judge of his own art. A person who is capable of producing bad art cannot, so far as he is capable of producing it, recognize it for what it is. He cannot, on the other hand, really think it good art; he cannot think that he has expressed himself when he has not. To mistake bad art for good art would imply having in one's mind an idea of what good art is, and one has such an idea only so far as one knows what it is to have an uncorrupt consciousness; but no one can know this except a person who possesses one. An insincere mind, so far as it is insincere, has no conception of sincerity.

But nobody's consciousness can be wholly corrupt. If it were, he would be in a condition as much worse than the most complete insanity we can discover or imagine, as that is worse than the most complete sanity we can conceive. He would suffer simultaneously every possible kind of mental derangement, and every bodily disease that such derangements can bring in their train. Corruptions of consciousness are always partial and temporary lapses in an activity which, on the whole, is successful in doing what it tries to do. A person who on one occasion fails to express himself is a person quite accustomed to express himself successfully on other occasions, and to know that he is doing it. Through comparison of this occasion with his memory of these others, therefore, he ought to be able to see that he has failed, this time, to express himself. And this is precisely what every artist is doing when he says, 'This line won't do.' He remembers what the experience of expressing himself is like, and in the light of that memory he realizes that the attempt embodied in this particular line has been a failure. Corruption of consciousness is not a recondite sin or a remote calamity which overcomes only an unfortunate or accursed few; it is a constant experience in the life of every artist, and his life is a constant and, on the whole, a successful warfare against it. But this warfare always involves a very present possibility of defeat; and then a certain corruption becomes inveterate.

What we recognize as definite kinds of bad art are such inveterate corruptions of consciousness. Bad art is never the result of expressing what is in itself evil, or what is innocent perhaps in itself, but in a given society a thing inexpedient to be publicly said. Every one of us feels emotions which, if his neighbours became aware of them, would make them shrink from him with horror: emotions which, if he became aware of them, would make him horrified at himself. It is not the expression of these emotions that is bad art. Nor is it the expression of the horror they excite. On the contrary, bad art arises when instead of expressing these emotions we disown them, wishing to think ourselves innocent of the emotions that horrify us, or wishing to think ourselves too broad-minded to be horrified by them.

Art is not a luxury, and bad art not a thing we can afford to tolerate. To know ourselves is the foundation of all life that develops beyond the merely psychical level of experience. Unless consciousness does its work successfully, the facts which it offers to intellect, the only things upon which intellect can built its fabric of thought, are false

from the beginning. A truthful consciousness gives intellect a firm foundation upon which to build; a corrupt consciousness forces intellect to build on a quicksand. The falsehoods which an untruthful consciousness imposes on the intellect are falsehoods which intellect can never correct for itself. In so far as consciousness is corrupted, the very wells of truth are poisoned. Intellect can build nothing firm. Moral ideals are castles in the air. Political and economic systems are mere cobwebs. Even common sanity and bodily health are no longer secure. But corruption of consciousness is the same thing as bad art.

I do not speak of these grave issues in order to magnify the office of any small section in our communities which arrogates to itself the name of artists. That would be absurd. Just as the life of a community depends for its very existence on honest dealing between man and man, the guardianship of this honesty being vested not in any one class or section, but in all and sundry, so the effort towards expression of emotions, the effort to overcome corruption of consciousness, is an effort that has to be made not by specialists only but by every one who uses language, whenever he uses it. Every utterance and every gesture that each one of us makes is a work of art. It is important to each one of us that in making them, however much he deceives others, he should not deceive himself. If he deceives himself in this matter, he has sown in himself a seed which, unless he roots it up again, may grow into any kind of wickedness, any kind of mental disease, any kind of stupidity and folly and insanity. Bad art, the corrupt consciousness, is the true *radix malorum*.

11 Clement Greenberg (1909–1995) 'Avant-Garde and Kitsch'

With this essay Greenberg imported some specific concerns of the German intellectual Left into the American forum of the then Trotskyist *Partisan Review*, where a debate about the political role of art and literature had been going on for the previous three years. (In particular, Greenberg's text shows signs of acquaintance with Bloch's 'Discussing Expressionism'; see IVD8) His analysis of the avant-garde unites a social-historical form of explanation with an interest in the qualitative distinctness of advanced art. In Greenberg's 1939 formulation, the avant-garde is that historical agency which functions to keep culture alive in the face of capitalism. (In a 1972 reprint of the article Greenberg corrected his mistaken identification of Repin as a painter of pseudo-realistic battle scenes.) First published in *Partisan Review*, New York, VI, no. 5, Fall 1939, pp. 34–49. (For later texts by Greenberg see VA1 and 10, VIB5 and 8.)

One and the same civilization produces simultaneously two such different things as a poem by T. S. Eliot and a Tin Pan Alley song, or a painting by Braque and a *Saturday Evening Post* cover. All four are on the order of culture, and ostensibly, parts of the same culture and products of the same society. Here, however, their connection seems to end. A poem by Eliot and a poem by Eddie Guest – what perspective of culture is large enough to enable us to situate them in an enlightening relation to each other? Does the fact that a disparity such as this within the frame of a single cultural tradition, which is and has been taken for granted – does this fact indicate that the disparity is a part of the natural order of things? Or is it something entirely new, and particular to our age?

The answer involves more than an investigation in aesthetics. It appears to me that it is necessary to examine more closely and with more originality than hitherto the relationship between aesthetic experience as met by the specific – not the generalized – individual, and the social and historical contexts in which that experience takes place. What is brought to light will answer, in addition to the question posed above, other and perhaps more important questions.

I

A society, as it becomes less and less able, in the course of its development, to justify the inevitability of its particular forms, breaks up the accepted notions upon which artists and writers must depend in large part for communication with their audiences. It becomes difficult to assume anything. All the verities involved by religion, authority, tradition, style, are thrown into question, and the writer or artist is no longer able to estimate the response of his audience to the symbols and references with which he works. In the past such a state of affairs has usually resolved itself into a motionless Alexandrianism, an academicism in which the really important issues are left un-touched because they involve controversy, and in which creative activity dwindles to virtuosity in the small details of form, all larger questions being decided by the precedent of the old masters. The same themes are mechanically varied in a hundred different works, and yet nothing new is produced: Statius, mandarin verse, Roman sculpture, Beaux-Arts painting, neo–republican architecture.

It is among the hopeful signs in the midst of the decay of our present society that we – some of us – have been unwilling to accept this last phase for our own culture. In seeking to go beyond Alexandrianism, a part of Western bourgeois society has pro-duced something unheard of heretofore: – avant-garde culture. A superior conscious-ness of history – more precisely, the appearance of a new kind of criticism of society, an historical criticism – made this possible. This criticism has not confronted our present society with timeless utopias, but has soberly examined in the terms of history and of cause and effect the antecedents, justifications and functions of the forms that lie at the heart of every society. Thus our present bourgeois social order was shown to be, not an eternal, 'natural' condition of life, but simply the latest term in a succession of social orders. New perspectives of this kind, becoming a part of the advanced intellectual conscience of the fifth and sixth decades of the nineteenth century, soon were absorbed by artists and poets, even if unconsciously for the most part. It was no accident, therefore that the birth of the avant-garde coincided chronologically – and geographic-ally, too – with the first bold development of scientific revolutionary thought in Europe.

True, the first settlers of bohemia – which was then identical with the avant-garde – turned out soon to be demonstratively uninterested in politics. Nevertheless, without the circulation of revolutionary ideas in the air about them, they would never have been able to isolate their concept of the 'bourgeois' in order to define what they were *not*. Nor, without the moral aid of revolutionary political attitudes would they have had the courage to assert themselves as aggressively as they did against the prevailing standards of society. Courage indeed was needed for this, because the avant-garde's emigration from bourgeois society to bohemia meant also an emigration from the markets of capitalism, upon which artists and writers had been thrown by the falling away of

aristocratic patronage. (Ostensibly, at least, it meant this – meant starving in a garret – although, as we will be shown later, the avant-garde remained attached to bourgeois society precisely because it needed its money.)

Yet it is true that once the avant-garde had succeeded in 'detaching' itself from society, it proceeded to turn around and repudiate revolutionary as well as bourgeois politics. The revolution was left inside society, a part of that welter of ideological struggle which art and poetry find so unpropitious as soon as it begins to involve those 'precious' axiomatic beliefs upon which culture thus far has had to rest. Hence it developed that the true and most important function of the avant-garde was not to 'experiment,' but to find a path along which it would be possible to keep culture *moving* in the midst of ideological confusion and violence. Retiring from public altogether, the avant-garde poet or artist sought to maintain the high level of his art by both narrowing and raising it to the expression of an absolute in which all relativities and contradictions would be either resolved or beside the point. 'Art for art's sake' and 'pure poetry' appear, and subject matter or content becomes something to be avoided like a plague.

It has been in search of the absolute that the avant-garde has arrived at 'abstract' or 'nonobjective' art – and poetry, too. The avant-garde poet or artist tries in effect to imitate God by creating something valid solely on its own terms, in the way nature itself is valid, in the way a landscape – not its picture – is aesthetically valid; something *given*, increate, independent of meanings, similars or originals. Content is to be dissolved so completely into form that the work of art or literature cannot be reduced in whole or in part to anything not itself.

But the absolute is absolute, and the poet or artist, being what he is, cherishes certain relative values more than others. The very values in the name of which he invokes the absolute are relative values, the values of aesthetics. And so he turns out to be imitating, not God – and here I use 'imitate' in its Aristotelian sense – but the disciplines and processes of art and literature themselves. This is the genesis of the 'abstract.' In turning his attention away from subject matter of common experience, the poet or artist turns it in upon the medium of his own craft. The nonrepresentational or 'abstract,' if it is to have aesthetic validity, cannot be arbitrary and accidental, but must stem from obedience to some worthy constraint or original. This constraint, once the world of common, extroverted experience has been renounced, can only be found in the very processes or disciplines by which art and literature have already imitated the former. These themselves become the subject matter of art and literature. If, to continue with Aristotle, all art and literature are imitation, then what we have here is the imitation of imitating. To quote Yeats:

> Nor is there singing school but studying
> Monuments of its own magnificence.

Picasso, Braque, Mondrian, Miró, Kandinsky, Brancusi, even Klee, Matisse and Cézanne derive their chief inspiration from the medium they work in.[1] The excitement of their art seems to lie most of all in its pure preoccupation with the invention and arrangement of spaces, surfaces, shapes, colors, etc., to the exclusion of whatever is not necessarily implicated in these factors. The attention of poets like Rimbaud, Mallarmé, Valéry, Éluard, Pound, Hart Crane, Stevens, even Rilke and

Yeats, appears to be centered on the effort to create poetry and on the 'moments' themselves of poetic conversion, rather than on experience to be converted into poetry. Of course, this cannot exclude other preoccupations in their work, for poetry must deal with words, and words must communicate. Certain poets, such as Mallarmé and Valéry, are more radical in this respect than others – leaving aside those poets who have tried to compose poetry in pure sound alone. However, if it were easier to define poetry, modern poetry would be much more 'pure' and 'abstract.' As for the other fields of literature – the definition of avant-garde aesthetics advanced here is no Procrustean bed. But aside from the fact that most of our best contemporary novelists have gone to school with the avant-garde, it is significant that Gide's most ambitious book is a novel about the writing of a novel, and that Joyce's *Ulysses* and *Finnegans Wake* seem to be, above all, as one French critic says, the reduction of experience to expression for the sake of expression, the expression mattering more than what is being expressed.

That avant-garde culture is the imitation of imitating – the fact itself – calls for neither approval nor disapproval. It is true that this culture contains within itself some of the very Alexandrianism it seeks to overcome. The lines quoted from Yeats referred to Byzantium, which is very close to Alexandria; and in a sense this imitation of imitating is a superior sort of Alexandrianism. But there is one most important difference: the avant-garde moves, while Alexandrianism stands still. And this, precisely, is what justifies the avant-garde's methods and makes them necessary. The necessity lies in the fact that by no other means is it possible today to create art and literature of a high order. To quarrel with necessity by throwing about terms like 'formalism,' 'purism,' 'ivory tower' and so forth is either dull or dishonest. This is not to say, however, that it is to the *social* advantage of the avant-garde that it is what it is. Quite the opposite.

The avant-garde's specialization of itself, the fact that its best artists are artists' artists, its best poets, poets' poets, has estranged a great many of those who were capable formerly of enjoying and appreciating ambitious art and literature, but who are now unwilling or unable to acquire an initiation into their craft secrets. The masses have always remained more or less indifferent to culture in the process of development. But today such culture is being abandoned by those to whom it actually belongs – our ruling class. For it is to the latter that the avant-garde belongs. No culture can develop without a social basis, without a source of stable income. And in the case of the avant-garde, this was provided by an elite among the ruling class of that society from which it assumed itself to be cut off, but to which it has always remained attached by an umbilical cord of gold. The paradox is real. And now this elite is rapidly shrinking. Since the avant-garde forms the only living culture we now have, the survival in the near future of culture in general is thus threatened.

We must not be deceived by superficial phenomena and local successes. Picasso's shows still draw crowds, and T. S. Eliot is taught in the universities; the dealers in modernist art are still in business, and the publishers still publish some 'difficult' poetry. But the avant-garde itself, already sensing the danger, is becoming more and more timid every day that passes. Academicism and commercialism are appearing in the strangest places. This can mean only one thing: that the avant-garde is becoming unsure of the audience it depends on – the rich and the cultivated.

Is it the nature itself of avant-garde culture that is alone responsible for the danger it finds itself in? Or is that only a dangerous liability? Are there other, and perhaps more important, factors involved?

II

Where there is an avant-garde, generally we also find a rearguard. True enough – simultaneously with the entrance of the avant-garde, a second new cultural phenomenon appeared in the industrial West: that thing to which the Germans give the wonderful name of *Kitsch*: popular, commercial art and literature with their chromeotypes, magazine covers, illustrations, ads, slick and pulp fiction, comics, Tin Pan Alley music, tap dancing, Hollywood movies, etc., etc. For some reason this gigantic apparition has always been taken for granted. It is time we looked into its whys and wherefores.

Kitsch is a product of the industrial revolution which urbanized the masses of Western Europe and America and established what is called universal literacy.

Prior to this the only market for formal culture, as distinguished from folk culture, had been among those who, in addition to being able to read and write, could command the leisure and comfort that always goes hand in hand with cultivation of some sort. This until then had been inextricably associated with literacy. But with the introduction of universal literacy, the ability to read and write became almost a minor skill like driving a car, and it no longer served to distinguish an individual's cultural inclinations, since it was no longer the exclusive concomitant of refined tastes.

The peasants who settled in the cities as proletariat and petty bourgeois learned to read and write for the sake of efficiency, but they did not win the leisure and comfort necessary for the enjoyment of the city's traditional culture. Losing, nevertheless, their taste for the folk culture whose background was the countryside, and discovering a new capacity for boredom at the same time, the new urban masses set up a pressure on society to provide them with a kind of culture fit for their own consumption. To fill the demand of the new market, a new commodity was devised: ersatz culture, kitsch, destined for those who, insensible to the values of genuine culture, are hungry nevertheless for the diversion that only culture of some sort can provide.

Kitsch, using for raw material the debased and academicized simulacra of genuine culture, welcomes and cultivates this insensibility. It is the source of its profits. Kitsch is mechanical and operates by formulas. Kitsch is vicarious experience and faked sensations. Kitsch changes according to style, but remains always the same. Kitsch is the epitome of all that is spurious in the life of our times. Kitsch pretends to demand nothing of its customers except their money – not even their time.

The precondition for kitsch, a condition without which kitsch would be impossible, is the availability close at hand of a fully matured cultural tradition, whose discoveries, acquisitions, and perfected self-consciousness kitsch can take advantage of for its own ends. It borrows from it devices, tricks, stratagems, rules of thumb, themes, converts them into a system, and discards the rest. It draws its life blood, so to speak, from this reservoir of accumulated experience. This is what is really meant when it is said that the popular art and literature of today were once the daring, esoteric art and literature of yesterday. Of course, no such thing is true. What is meant is that when enough time

has elapsed the new is looted for new 'twists,' which are then watered down and served up as kitsch. Self-evidently, all kitsch is academic; and conversely, all that's academic is kitsch. For what is called the academic as such no longer has an independent existence, but has become the stuffed–shirt 'front' for kitsch. The methods of industrialism displace the handicrafts.

Because it can be turned out mechanically, kitsch has become an integral part of our productive system in a way in which true culture could never be, except accidentally. It has been capitalized at a tremendous investment which must show commensurate returns; it is compelled to extend as well as to keep its markets. While it is essentially its own salesman, a great sales apparatus has nevertheless been created for it, which brings pressure to bear on every member of society. Traps are laid even in those areas, so to speak, that are the preserves of genuine culture. It is not enough today, in a country like ours, to have an inclination towards the latter; one must have a true passion for it that will give him the power to resist the faked article that surrounds and presses in on him from the moment he is old enough to look at the funny papers. Kitsch is deceptive. It has many different levels, and some of them are high enough to be dangerous to the naive seeker of true light. A magazine like the *New Yorker*, which is fundamentally high-class kitsch for the luxury trade, converts and waters down a great deal of avant-garde material for its own uses. Nor is every single item of kitsch altogether worthless. Now and then it produces something of merit, something that has an authentic folk flavor; and these accidental and isolated instances have fooled people who should know better.

Kitsch's enormous profits are a source of temptation to the avant-garde itself, and its members have not always resisted this temptation. Ambitious writers and artists will modify their work under the pressure of kitsch, if they do not succumb to it entirely. And then those puzzling borderline cases appear, such as the popular novelist, Simenon, in France, and Steinbeck in this country. The net result is always to the detriment of true culture in any case.

Kitsch has not been confined to the cities in which it was born, but has flowed out over the countryside, wiping out folk culture. Nor has it shown any regard for geographical and national-cultural boundaries. Another mass product of Western industrialism, it has gone on a triumphal tour of the world, crowding out and defacing native cultures in one colonial country after another, so that it is now by way of becoming a universal culture, the first universal culture ever beheld. Today the native of China, no less than the South American Indian, the Hindu, no less than the Polynesian, have come to prefer to the products of their native art, magazine covers, rotogravure sections and calendar girls. How is this virulence of kitsch, this irresistible attractiveness, to be explained? Naturally, machine-made kitsch can undersell the native handmade article, and the prestige of the West also helps; but why is kitsch a so much more profitable export article than Rembrandt? One, after all, can be reproduced as cheaply as the other.

In his last article on the Soviet cinema in the *Partisan Review*, Dwight Macdonald points out that kitsch has in the last ten years become the dominant culture in Soviet Russia. For this he blames the political regime – not only for the fact that kitsch is the official culture, but also that it is actually the dominant, most popular culture, and he quotes the following from Kurt London's *The Seven Soviet Arts*: '...the attitude of the masses both to the old and new art styles probably remains essentially dependent

on the nature of the education afforded them by their respective states.' Macdonald goes on to say: 'Why after all should ignorant peasants prefer Repin (a leading exponent of Russian academic kitsch in painting) to Picasso, whose abstract technique is at least as relevant to their own primitive folk art as is the former's realistic style? No, if the masses crowd into the Tretyakov (Moscow's museum of contemporary Russian art: kitsch), it is largely because they have been conditioned to shun "formalism" and to admire "socialist realism."'

In the first place it is not a question of a choice between merely the old and merely the new, as London seems to think – but of a choice between the bad, up-to-date old and the genuinely new. The alternative to Picasso is not Michelangelo, but kitsch. In the second place, neither in backward Russia nor in the advanced West do the masses prefer kitsch simply because their governments condition them toward it. Where state educational systems take the trouble to mention art, we are told to respect the old masters, not kitsch; and yet we go and hang Maxfield Parrish or his equivalent on our walls, instead of Rembrandt and Michelangelo. Moreover, as Macdonald himself points out, around 1925 when the Soviet regime was encouraging avant-garde cinema, the Russian masses continued to prefer Hollywood movies. No, 'conditioning' does not explain the potency of kitsch.

All values are human values, relative values, in art as well as elsewhere. Yet there does seem to have been more or less of a general agreement among the cultivated of mankind over the ages as to what is good art and what bad. Taste has varied, but not beyond certain limits; contemporary connoisseurs agree with the eighteenth-century Japanese that Hokusai was one of the greatest artists of his time; we even agree with the ancient Egyptians that Third and Fourth Dynasty art was the most worthy of being selected as their paragon by those who came after. We may have come to prefer Giotto to Raphael, but we still do not deny that Raphael was one of the best painters of his time. There has been an agreement then, and this agreement rests, I believe, on a fairly constant distinction made between those values only to be found in art and the values which can be found elsewhere. Kitsch, by virtue of a rationalized technique that draws on science and industry, has erased this distinction in practice.

Let us see, for example, what happens when an ignorant Russian peasant such as Macdonald mentions stands with hypothetical freedom of choice before two paintings, one by Picasso, the other by Repin. In the first he sees, let us say, a play of lines, colors and spaces that represent a woman. The abstract technique – to accept Macdonald's supposition, which I am inclined to doubt – reminds him somewhat of the icons he has left behind him in the village, and he feels the attraction of the familiar. We will even suppose that he faintly surmises some of the great art values the cultivated find in Picasso. He turns next to Repin's picture and sees a battle scene. The technique is not so familiar – as technique. But that weighs very little with the peasant, for he suddenly discovers values in Repin's picture that seem far superior to the values he has been accustomed to find in icon art; and the unfamiliar itself is one of the sources of those values: the values of the vividly recognizable, the miraculous and the sympathetic. In Repin's picture the peasant recognizes and sees things in the way in which he recognizes and sees things outside of pictures – there is no discontinuity between art and life, no need to accept a convention and say to oneself, that icon represents Jesus because it intends to represent Jesus, even if it does not remind me very much of a man. That Repin can paint so realistically that identifications are self-evident immediately

and without any effort on the part of the spectator – that is miraculous. The peasant is also pleased by the wealth of self-evident meanings which he finds in the picture: 'it tells a story.' Picasso and the icons are so austere and barren in comparison. What is more, Repin heightens reality and makes it dramatic: sunset, exploding shells, running and falling men. There is no longer any question of Picasso or icons. Repin is what the peasant wants, and nothing else but Repin. It is lucky, however, for Repin that the peasant is protected from the products of American capitalism, for he would not stand a chance next to a *Saturday Evening Post* cover by Norman Rockwell.

Ultimately, it can be said that the cultivated spectator derives the same values from Picasso that the peasant gets from Repin, since what the latter enjoys in Repin is somehow art too, on however low a scale, and he is sent to look at pictures by the same instincts that send the cultivated spectator. But the ultimate values which the cultivated spectator derives from Picasso are derived at a second remove, as the result of reflection upon the immediate impression left by the plastic values. It is only then that the recognizable, the miraculous and the sympathetic enter. They are not immediately or externally present in Picasso's painting, but must be projected into it by the spectator sensitive enough to react sufficiently to plastic qualities. They belong to the 'reflected' effect. In Repin, on the other hand, the 'reflected' effect has already been included in the picture, ready for the spectator's unreflective enjoyment. Where Picasso paints *cause*, Repin paints *effect*. Repin predigests art for the spectator and spares him effort, provides him with a short cut to the pleasure of art that detours what is necessarily difficult in genuine art. Repin, or kitsch, is synthetic art.

The same point can be made with respect to kitsch literature: it provides vicarious experience for the insensitive with far greater immediacy than serious fiction can hope to do. And Eddie Guest and the *Indian Love Lyrics* are more poetic than T. S. Eliot and Shakespeare.

III

If the avant-garde imitates the processes of art, kitsch, we now see, imitates its effects. The neatness of this antithesis is more than contrived; it corresponds to and defines the tremendous interval that separates from each other two such simultaneous cultural phenomena as the avant-garde and kitsch. This interval, too great to be closed by all the infinite gradations of popularized 'modernism' and 'modernistic' kitsch, corresponds in turn to a social interval, a social interval that has always existed in formal culture, as elsewhere in civilized society, and whose two termini converge and diverge in fixed relation to the increasing or decreasing stability of the given society. There has always been on one side the minority of the powerful – and therefore the cultivated – and on the other the great mass of the exploited and poor – and therefore the ignorant. Formal culture has always belonged to the first, while the last have had to content themselves with folk or rudimentary culture, or kitsch.

In a stable society that functions well enough to hold in solution the contradictions between its classes, the cultural dichotomy becomes somewhat blurred. The axioms of the few are shared by the many; the latter believe superstitiously what the former believe soberly. And at such moments in history the masses are able to feel wonder and admiration for the culture, on no matter how high a plane, of its masters. This applies at least to plastic culture, which is accessible to all.

In the Middle Ages the plastic artist paid lip service at least to the lowest common denominators of experience. This even remained true to some extent until the seventeenth century. There was available for imitation a universally valid conceptual reality, whose order the artist could not tamper with. The subject matter of art was prescribed by those who commissioned works of art, which were not created, as in bourgeois society, on speculation. Precisely because his content was determined in advance, the artist was free to concentrate on his medium. He needed not to be philosopher, or visionary, but simply artificer. As long as there was general agreement as to what were the worthiest subjects for art, the artist was relieved of the necessity to be original and inventive in his 'matter' and could devote all his energy to formal problems. For him the medium became, privately, professionally, the content of his art, even as his medium is today the public content of the abstract painter's art – with that difference, however, that the medieval artist had to suppress his professional preoccupation in public – had always to suppress and subordinate the personal and professional in the finished, official work of art. If, as an ordinary member of the Christian community, he felt some personal emotion about his subject matter, this only contributed to the enrichment of the work's public meaning. Only with the Renaissance do the inflections of the personal become legitimate, still to be kept, however, within the limits of the simply and universally recognizable. And only with Rembrandt do 'lonely' artists begin to appear, lonely in their art.

But even during the Renaissance, and as long as Western art was endeavoring to perfect its technique, victories in this realm could only be signalized by success in realistic imitation, since there was no other objective criterion at hand. Thus the masses could still find in the art of their masters objects of admiration and wonder. Even the bird that pecked at the fruit in Zeuxis' picture could applaud.

It is a platitude that art becomes caviar to the general when the reality it imitates no longer corresponds even roughly to the reality recognized by the general. Even then, however, the resentment the common man may feel is silenced by the awe in which he stands of the patrons of this art. Only when he becomes dissatisfied with the social order they administer does he begin to criticize their culture. Then the plebian finds courage for the first time to voice his opinions openly. Every man, from the Tammany alderman to the Austrian house-painter, finds that he is entitled to his opinion. Most often this resentment toward culture is to be found where the dissatisfaction with society is a reactionary dissatisfaction which expresses itself in revivalism and puritanism, and latest of all, in fascism. Here revolvers and torches begin to be mentioned in the same breath as culture. In the name of godliness or the blood's health, in the name of simple ways and solid virtues, the statue-smashing commences.

IV

Returning to our Russian peasant for the moment, let us suppose that after he has chosen Repin in preference to Picasso, the state's educational apparatus comes along and tells him that he is wrong, that he should have chosen Picasso – and shows him why. It is quite possible for the Soviet state to do this. But things being as they are in Russia – and everywhere else – the peasant soon finds the necessity of working hard all day for his living and the rude, uncomfortable circumstances in which he lives do not allow him enough leisure, energy and comfort to train for the enjoyment of Picasso.

This needs, after all, a considerable amount of 'conditioning.' Superior culture is one of the most artificial of all human creations, and the peasant finds no 'natural' urgency within himself that will drive him toward Picasso in spite of all difficulties. In the end the peasant will go back to kitsch when he feels like looking at pictures, for he can enjoy kitsch without effort. The state is helpless in this matter and remains so as long as the problems of production have not been solved in a socialist sense. The same holds true, of course, for capitalist countries and makes all talk of art for the masses there nothing but demagogy.[2]

Where today a political regime establishes an official cultural policy, it is for the sake of demagogy. If kitsch is the official tendency of culture in Germany, Italy and Russia, it is not because their respective governments are controlled by philistines, but because kitsch is the culture of the masses in these countries, as it is everywhere else. The encouragement of kitsch is merely another of the inexpensive ways in which totalitarian regimes seek to ingratiate themselves with their subjects. Since these regimes cannot raise the cultural level of the masses – even if they wanted to – by anything short of a surrender to international socialism, they will flatter the masses by bringing all culture down to their level. It is for this reason that the avant-garde is outlawed, and not so much because a superior culture is inherently a more critical culture. (Whether or not the avant-garde could possibly flourish under a totalitarian regime is not pertinent to the question at this point.) As a matter of fact, the main trouble with avant-garde art and literature, from the point of view of fascists and Stalinists, is not that they are too critical, but that they are too 'innocent,' that it is too difficult to inject effective propaganda into them, that kitsch is more pliable to this end. Kitsch keeps a dictator in closer contact with the 'soul' of the people. Should the official culture be one superior to the general mass-level, there would be a danger of isolation.

Nevertheless, if the masses were conceivably to ask for avant-garde art and literature, Hitler, Mussolini and Stalin would not hesitate long in attempting to satisfy such a demand. Hitler is a bitter enemy of the avant-garde, both on doctrinal and personal grounds, yet this did not prevent Goebbels in 1932–1933 from strenuously courting avant-garde artists and writers. When Gottfried Benn, an Expressionist poet, came over to the Nazis he was welcomed with a great fanfare, although at that very moment Hitler was denouncing Expressionism as *Kulturbolschewismus*. This was at a time when the Nazis felt that the prestige which the avant-garde enjoyed among the cultivated German public could be of advantage to them, and practical considerations of this nature, the Nazis being skillful politicians, have always taken precedence over Hitler's personal inclinations. Later the Nazis realized that it was more practical to accede to the wishes of the masses in matters of culture than to those of their paymasters; the latter, when it came to a question of preserving power, were as willing to sacrifice their culture as they were their moral principles; while the former, precisely because power was being withheld from them, had to be cozened in every other way possible. It was necessary to promote on a much more grandiose style than in the democracies the illusion that the masses actually rule. The literature and art they enjoy and understand were to be proclaimed the only true art and literature and any other kind was to be suppressed. Under these circumstances people like Gottfried Benn, no matter how ardently they support Hitler, become a liability; and we hear no more of them in Nazi Germany.

We can see then that although from one point of view the personal philistinism of Hitler and Stalin is not accidental to the roles they play, from another point of view it is

only an incidentally contributory factor in determining the cultural policies of their respective regimes. Their personal philistinism simply adds brutality and double-darkness to policies they would be forced to support anyhow by the pressure of all their other policies – even were they, personally, devotees of avant-garde culture. What the acceptance of the isolation of the Russian Revolution forces Stalin to do, Hitler is compelled to do by his acceptance of the contradictions of capitalism and his efforts to freeze them. As for Mussolini – his case is a perfect example of the *disponibilité* of a realist in these matters. For years he bent a benevolent eye on the Futurists and built modern-istic railroad stations and government-owned apartment houses. One can still see in the suburbs of Rome more modernistic apartments than almost anywhere else in the world. Perhaps Fascism wanted to show its up-to-dateness, to conceal the fact that it was a retrogression; perhaps it wanted to conform to the tastes of the wealthy elite it served. At any rate Mussolini seems to have realized lately that it would be more useful to him to please the cultural tastes of the Italian masses than those of their masters. The masses must be provided with objects of admiration and wonder; the latter can dispense with them. And so we find Mussolini announcing a 'new Imperial style.' Marinetti, Chirico, *et al.*, are sent into the outer darkness, and the new railroad station in Rome will not be modernistic. That Mussolini was late in coming to this only illustrates again the relative hesitance with which Italian Fascism has drawn the necessary implications of its role.

Capitalism in decline finds that whatever of quality it is still capable of producing becomes almost invariably a threat to its own existence. Advances in culture, no less than advances in science and industry, corrode the very society under whose aegis they are made possible. Here, as in every other question today, it becomes necessary to quote Marx word for word. Today we no longer look toward socialism for a new culture – as inevitably as one will appear, once we do have socialism. Today we look to socialism *simply* for the preservation of whatever living culture we have right now.

1 I owe this formulation to a remark made by Hans Hofmann, the art teacher, in one of his lectures. From the point of view of this formulation, Surrealism in plastic art is a reactionary tendency which is attempting to restore 'outside' subject matter. The chief concern of a painter like Dali is to represent the processes and concepts of his consciousness, not the processes of his medium.

2 It will be objected that such art for the masses as folk art was developed under rudimentary conditions of production – and that a good deal of folk art is on a high level. Yes it is – but folk art is not Athene, and it's Athene whom we want: formal culture with its infinity of aspects, its luxuriance, its large compre-hension. Besides, we are now told that most of what we consider good in folk culture is the static survival of dead formal, aristocratic, cultures. Our old English ballads, for instance, were not created by the 'folk,' but by the post-feudal squirearchy of the English countryside, to survive in the mouths of the folk long after those for whom the ballads were composed had gone on to other forms of literature. Unfortunately, until the machine age, culture was the exclusive prerogative of a society that lived by the labor of serfs or slaves. They were the real symbols of culture. For one man to spend time and energy creating or listening to poetry meant that another man had to produce enough to keep himself alive and the former in comfort. In Africa today we find that the culture of slave-owning tribes is generally much superior to that of the tribes that possess no slaves.

12 Harold Rosenberg (1906–1978) 'The Fall of Paris'

Poet and art critic, Rosenberg here celebrates the international character of Modernism and of Paris as its early twentieth-century capital. He is also concerned, however, to point to the

manifest vulnerability of a merely cultural Modernism in face of the actual political divisions of the modern world. His conclusion anticipates the establishment of New York as the new metropolitan centre of Modernist culture during the 1940s. First published in *Partisan Review* in 1940. Slightly revised text printed in Harold Rosenberg, *Tradition of the New*, London and New York, 1962, pp. 209–20, from which the present version is taken. (See also VA16.)

The Style of Today

The laboratory of the twentieth century has been shut down. Let us admit, though, the rapping of the soldier's fist did not interrupt the creation of fresh wonders. For more than a decade there had been a steady deflation of that intellectual exuberance which had sent out over the earth the waves of cubism, futurism, vorticism – and later, dadaism, the Russian Ballet, surrealism. Yet up to the day of the occupation, Paris had been the Holy Place of our time. The only one. Not because of its affirmative genius alone, but perhaps, on the contrary, through its passivity, which allowed it to be possessed by the searchers of every nation. By Picasso and Juan Gris, Spaniards; by Modigliani, Boccioni and Severini, Italians; by Brancusi, Roumanian; by Joyce, Irishman; by Mondrian, Dutchman; by Lipchitz, Polish Lithuanian; by Archipenko, Kandinsky, Diaghilev, Larionov, Russians; by Calder, Pound, Gertrude Stein, Man Ray, Americans; by Kupka, Czechoslovak; Lehmbruck and Max Ernst, Germans; by Wyndham Lewis and T. E. Hulme, Englishmen . . . by all artists, students, refugees.

The hospitality of this cultural Klondike might be explained as the result of a tense balance of historical forces, preventing any one class from imposing upon the city its own restricted forms and aims. Here life seemed to be forever straining towards a new quality. Since it might be the sign of what was to come, each fresh gesture took on an immediate importance. Twentieth-century Paris was to the intellectual pioneer what nineteenth-century America had been to the economic one. Here, the world beat a pathway to the door of the inventor – not of mouse traps but of perspectives.

Thus Paris was the only spot where necessary blendings could be made and mellowed, where it was possible to shake up such 'modern' doses as Viennese psychology, African sculpture, American detective stories, Russian music, neo-Catholicism, German technique, Italian desperation.

Paris represented the International of culture. To it, the city contributed something of its own physiognomy, a pleasant gift of sidewalk cafés, evening streets, shop signs, postmen's uniforms, argot, discursive female janitors. But despite this surface local color, twentieth-century art in Paris was not Parisian; in many ways it was more suited to New York or Shanghai than to this city of eighteenth-century parks and alleys. What was done in Paris demonstrated clearly and for all time that such a thing as international culture could exist. Moreover, that this culture had a definite style: the *Modern*.

A whole epoch in the history of art had come into being without regard to national values. The significance of this fact is just now becoming apparent. Ten years ago, no one would have questioned the possibility of a communication above the national, nor consequently, of the presence of above-national elements even in the most national of art forms. Today, however, 'sanity movements' everywhere are striving to line up art at the chauvinist soup kitchens. And to accomplish this, they attack the value and even the reality of Modernism and 'the Paris style.' National life alone is put forward as the

source of all inspiration. But the Modern in literature, painting, architecture, drama, design, remains, in defiance of government bureaus or patriotic streetcleaners, as solid evidence that a creative communion sweeping across all boundaries is not out of the reach of our time.

In all his acts contemporary man seems narrow and poor. Yet there are moments when he seems to leap towards the marvellous in ways more varied and whole-hearted than any of the generations of the past. In the 'School of Paris,' belonging to no one country, but world-wide and world-timed and pertinent everywhere, the mind of the twentieth century projected itself into possibilities that will occupy mankind during many cycles of social adventure to come. Released in this aged and bottomless metropolis from national folklore, national politics, national careers; detached from the family and the corporate taste; the lone individual, stripped, yet supported on every side by the vitality of other outcasts with whom it was necessary to form no permanent ties, could experiment with everything that man today has within him of health or monstrousness: with pure intellect, revelling in the tension of a perfectly adjusted line; with the ferocious trance of the unmotivated act; with the quiverings of mood and memory left by unmixed paints; with arbitrary disciplines and the catharsis they produce; with the nonsense of the street and the classics; with the moody pulps and absolute lyrics of paranoiac dreams. [...]

True, the Paris Modern did not represent all the claims of present-day life. Any more than its 'Internationalism' meant the actual getting together of the peoples of different countries. It was an inverted mental image, this Modern, with all the transitoriness and freedom from necessity of imagined things. A dream living-in-the-present and a dream world citizenship – resting not upon a real triumph, but upon a willingness to go as far as was necessary into nothingness in order to shake off what was dead in the real. A negation of the negative.

Perhaps the wrenching of Western culture that had produced this style had been too severe, resulting in a kind of 'Leftism' in the field of thought, an over-defiance of the powers of the past. Science and philosophy had crossed national boundaries in earlier centuries; abstract ideas had shown that they could drop from the skies without regard to time or place; but life itself, manners, ways of speaking, of acting, of composing images, of planning the future, had always been imprisoned by the gravitation of the community site, where the grip of the dead was most unrelaxing....

Then, suddenly, almost in the span of a single generation, everything buried underground had been brought to the surface. The perspective of the immediate had been established – or rather, a multiple perspective, in which time no longer reared up like a gravestone or flourished like a tree but threw up a shower of wonders at the will of the onlooker.

The urge toward a free life, in a society that every year tangled him deeper and deeper in the web of the systematic, had carried the individual too far.

So the Modern became, not a progressive historical movement, striving to bury the dead deeper, but a new sentiment of eternity and of eternal life. The cultures of the jungle, the cave, the northern ice fields, of Egypt, primitive Greece, antique China, medieval Europe, industrial America – all were given equal due.

Strange vision of an eternity that consists of sheets of time and space picked from history like cards from a pack and constantly shuffled, arranged, scattered, regrouped, rubbed smooth, re-faced, spread in design, brushed off to the floor. An absolute of the relative, to be re-created in compositions of bits of newspaper, horse-hair, classic prints, the buttocks of a South Sea Islander, petroglyphs, arbitrary shapes suggested by the intoxication of the moment.

Thus the Paris Modern, resting on the deeply felt assumption that history could be entirely controlled by the mind, produced a No-Time, and the Paris 'International' a No-Place. And this is as far as mankind has gone toward freeing itself from its past. [. . .]

But note: processes less spectacular than those of the Paris studios had also been steadily loosening the cultural reefs of the past. Paris has been synonymous with Modernism in the sense of the special style and tempo of our consciousness. But it is a mistake to see this city also as central to the modern in the larger sense, the sense in which we think of the contemporary as beginning in 1789. This larger and more fundamental span has not belonged to Paris alone. It has embraced equally the United States, South America, industrial and revolutionary China, Japan, Russia, the whole of Europe, every spot in the world touched by contemporary civilization. Despite the fall of Paris, the social, economic, and cultural workings which define the modern epoch are active everywhere. Even the style has not vanished with the elimination of its capital: having been driven from the realm of art, it now reappears in new military and propaganda techniques. If there is a break between our lives and the kind of life existing before 1789, the current debasement of the Paris of the past 150 years does not imply a break of similar magnitude with the future. The world takes its shape from the modern, with consciousness or without it.

The Intellectual Form of Defeat

The cultural International had a capital: Paris. In the 1920s the political International, too, had a capital: Moscow. It is a tragic irony of our epoch that these world centers were not brought together until the signing of the Franco-Soviet pact, when both were already dead. Then the two cadavers of hope embraced farcically, with mutual suspicion and under the mutually exclusive provincial slogans: DEFENSE OF THE USSR and FRANCE FOR FRENCHMEN.

The intellectuals turned out in full dress – the 'proletarians,' of course, with red rosettes and suggestive smirks – to the wedding of their pair of radical ghosts. And offered themselves as anxious godfathers to its earthly issue, the Popular Front. From that time on it became bad luck even to recall the graves of international culture and international socialism.

* * *

A few courageous men – Gide, Breton, Victor Serge, a few others – strove to uphold the tradition of French criticism. But what 'higher need' had paralyzed the conscience of non-conformist Paris?

The higher need was Antifascism. [. . .]

[. . .] Wearing armbands supplied by Moscow, the Paris Left adopted the style of the conventional, the sententious, the undaring, the morally lax – in the name of social duty and the 'Defense of Culture.' Feasible Fronts were formed in which all the participants

were forced to give up their power of action – perhaps a profound desire for this renunciation was the main reason for the coalitions.

Antifascist unity became everything; programs, insight, spirit, truth, nothing. [...]

[...] To defend Paris, men and slogans long discredited were restored to power. The Communists claimed the 'Marseillaise' as their own and former surrealist poets acclaimed Romain Rolland.

In this milieu, inquiry soon became not merely a matter of taste but of bad taste. Another blow by Fascist radicalism and it became treachery.

Meanwhile, modern formulae perfected both by Paris and Moscow in the hour of their inspiration, and now discarded, had been eagerly seized upon by Germany and adapted to its peculiar aims. In that country politics became a 'pure (i.e., inhuman)' art, independent of everything but the laws of its medium. The subject matter of this 'avant-garde' politics was, like that of earlier art movements of Paris, the weakness, meanness, incoherence and intoxication of modern man. Against this advanced technique, which in itself has nothing to do with revolutionary change, the Paris of Popular Front compromise was helpless.

* * *

So that, at last, when the crisis is ripe, a fast-moving explosive force finds nothing in its path but a pile of decomposed scrapings.

The Academy had failed to halt modern art, and Fascism was not to be stopped by clichés.

In the Fascist political and military adventures, modernist mysticism, dreaming of an absolute power to rearrange life according to any pattern of its choice, submits itself to trial. Against this experiment is opposed, not conservation, but other forms of contemporary consciousness, another Modernism.

No one can predict the center of this new phase. For it is not by its own genius alone that a capital of culture arises. Current flowing throughout the world lifted Paris above the countryside that surrounds it and kept it suspended like a magic island. And its decline, too, was the result not of some inner weakness – not of 'sensuality' or 'softness,' as its former friends and present enemies declare – but of a general ebb. For a decade, the whole of civilization has been sinking down, lowering Paris steadily towards the soil of France. Until its restoration as the capital of a nation was completed by the tanks of the Germans.

Part V
The Individual and the Social

V

Introduction

The Third Reich was intended to last for a thousand years. The fact that it failed to achieve that goal was the result of massive collective effort and sacrifice. Forces were unleashed which even a few decades previously would have been beyond the powers of imagination. The capacity for human cruelty has doubtless remained relatively constant. But its exercise on an industrial scale has been a twentieth-century prerogative. When we talk of art being required to express, or represent, the modern condition, we do well to remember what is being asked of it.

One direct consequence of the gathering of those forces which precipitated a Second World War was the destruction of the greater part of the avant-garde's social basis in Western Europe. Refugees from the dictatorships had made their way to Paris in the 1930s. Some had proceeded to London. Now, with the fall of Paris, for many radical artists and intellectuals that journey continued across the Atlantic. The physical presence of so many major avant-garde artists in New York was a contributory factor in the emergence of an indigenous American artistic avant-garde. To say that this new avant-garde transcended European precedent is not of course to say that it did not depart from European examples. It is, however, to say that something significantly new and un-European was made of them. Some aspects of the European constellation were built upon, while others were discarded. For reasons which were undoubtedly connected to the wider exercise of American power, American artists seem to have been emboldened to take what they needed in order to make an adequately modern art which they felt appropriate to their own conditions (VA10). And yet as the American experience itself became quintessentially 'modern', the art that resulted had few of the trappings of the narrowly national and was able to aspire, with some success and some legitimacy, to international standing. The relations of the provincial and the cosmopolitan are clearly fraught, and their resolution will be bound up with social and political priorities, not least in respect of the implication of the aesthetic *in* the social. An understanding along these lines seems certainly to have animated the ambition of the artists themselves (see VA3 and 14).

From the perspective of the Americans, the least useful aspect of the European avant-garde seems to have been its commitment to utopian rationalism. Americans appear to have had little time for that European idealism which had proved so singularly inadequate to the challenge of Fascism, or for the geometric abstraction in which such rationalism characteristically issued. They remained interested in the Cubism from which that art was technically descended; but principally, it seems, as a constraint which needed to be loosened. The problem of how to achieve this was more

than a simply technical matter. In so far as modern painting had a form of *philosophical* credibility, it was largely secured by Cubism.

In the prevailing conditions, the upshot was that once again Expressionism beckoned. The impulse to expression seems to have become muted, or even conventionalized, in the European avant-garde, at least since the defeat of the German revolution. It subsided as it were into the middle ground of the Modern Movement, while the leading edge of avant-garde practice was formed by abstraction on the one hand and on the other by the Surrealist preoccupation with the automatic transcription of the unconscious. Yet as the events of history had once again become so overwhelming, and the force of state control so total (due to the prosecution of the war in the democracies as well as in the dictatorships), avant-garde artists appear once again to have been thrust back into themselves. At its most basic, this internal exile was a way of avoiding subservience to, and of maintaining some independence from, the dominant culture. An additional factor here was that the avenue of collective redress, that is to say, the socialist tradition, was also widely identified as a form of closure, in both its major political *and* artistic forms – respectively Soviet Communism and Socialist Realism. It appeared that sceptical artists had few places left to go. On their own testimony they were driven into themselves (see VA5 and 11).

On this trek out of an unbearable history, the artist's companion was myth (see VA2 and 8). In fact the inner and the mythical were made to coincide as expressive resources with which to face a modern world otherwise beyond description. As they had to a previous generation overwhelmed by the force of the modern world, the archaic and the unconscious offered themselves as lifeboats for the avant-garde. Within the European tradition Surrealism furnished the principal reference for both. Breton had articulated Freud's theories of dreams and the unconscious to Marx's programme of collective social emancipation. American artists seem to have been less concerned to change history than to survive it. Perhaps for this reason it was Jung's theory of the unconscious (IVA6), with its emphasis on the primitive and on shared archetypes deeply embedded in the human psyche, that proved most congenial to Pollock and other artists.

In their drive towards this supposed bedrock of experience American artists forced through an emphatic conjunction between expression and abstraction. Abstraction was definitively prised apart from its association with a dubious social utopianism and rendered newly vigorous through its connection to a robust and hard-won sense of self (VA14). Art, as Clyfford Still put it, became 'an unqualified act' (VA15 and 17). Without exception, those American artists who attempted to articulate their project at this time spoke of myth and transcendence, the roots of art in the unconscious, and of art itself as a solitary act; in the same breath they would characteristically speak of the hostility of the age, and the traps of any sense of community and security. Something else they shared, something subsequently often overlooked in attacks upon American Modernism, was a refusal of the journalistic distinction between representational and abstract art. For them, their archetypal, myth-based abstraction stood or fell according to its content. They saw their work as representative of a true response, in an age so hostile as to disqualify conventional depiction. The works themselves were held to embody moods and emotions, and through the achievement of independence from traditional constraints of depiction, to have acceded to something very like human character. There is of course no small irony in the fact that the

most adventurous art produced by artists living in the most technically sophisticated nation on earth should consist in a kind of homage to primitive people and a refusal of the operations of the conscious mind. Nonetheless, in Gottlieb's words, such work was the only valid response to 'the neurosis which is our reality'. As such, it was not abstraction at all, but 'the realism of our time' (VA7; see also VA12).

The experience of 'neurosis' in the face of the Holocaust and the atom bomb was not of course peculiar to Americans. In fact whereas American artists had at least been physically protected from the effects of Nazism, Paris, hitherto the centre of avant-garde culture, had been an occupied city. After the war, belief in human goodness was no doubt subject to at least as great a strain there as it was in New York (VB1).

Art in Paris accordingly shares many properties with the work of the new American avant-garde, particularly in respect of an informal, 'expressive' paint application and an evocation of the primitive. It is hard, however, to escape a sense that it remains more circumscribed by tradition than its transatlantic counterpart. Two main factors qualify the post-war European experience. First, the European Left was strong, especially the Communist Party, its prestige enhanced by the leading role it had played in the Resistance (VC4, 5 and 13). There was no comparable pole of attraction in Cold War America. Second, whereas America was now rich, richer by far than in the Depression years of the 1930s, Europe was devastated.

One result of this combination of circumstances was that whereas in America individualism rapidly tended towards a form of depoliticization, in Europe it remained part of a determinedly anti-bourgeois stance. The angst which was for so long a feature of the European post-war condition had less to breed on in the United States. The complex interface between this anti-bourgeois individualism on the one hand and Communism on the other was largely absent in America, the more so following the systematic delegitimization of the Left during the McCarthy years. Before the war, sections of the emergent avant-garde had been informed by left-wing anti-Stalinism in its anarchist or Trotskyist form. As the Cold War was launched in the post-war world it proved a small step from anti-Stalinism to a generalized anti-Communism in which the distinct features of former positions were lost to view. No doubt American avant-garde artists remained individually distanced from the dominant values of an increasingly consumer-oriented capitalism. That, in a way, was the point: individualism was the ideology of that culture. In Europe, individualism retained a philosophical and political thrust which rendered it still largely oppositional: to bourgeois values on the one side and no less to the dogma of Socialist Realism on the other; but also, in addition to these, to the increasing pace of Americanization. The Marshall Plan brought more than food, machines and money to Europe: it also brought values. And while these proved enormously attractive in terms of popular culture, there was apprehension in the avant-garde, and particularly in left-wing circles, over what was perceived as the philistinism and conformity of American life.

Jean-Paul Sartre made an ambitious attempt to open a dialogue between Existentialism, predicated upon the individual exercise of free will, and the Communist Party ideology of 'humanism' (VB2). Yet for all his efforts the Communists' somewhat manufactured optimism stood in stark contrast to a mood of uncertainty and despair (see VB5, 7 and 10). The characteristic avant-garde emphasis upon the primitive, the direct and the unschooled was given sharp focus in the French situation by Dubuffet's 'Art Brut'. This was initially a form of celebration of the vitality and truth to be found

in graffiti and in the art of children and of the insane. In turn, Dubuffet and others pursued this vitality and authenticity in their own art. The implication of this work was that the human and the civilized were at opposite poles – a conclusion which must have seemed to be supported by the experience of the war.

The legacy of Surrealism retained in Europe a diversity not so apparent in America. Antonin Artaud mingled his Surrealist origins with the signs of his own instability in a form of single-handed resistance to a world perceived as insane (VB5). The psycho-analyst Jacques Lacan mediated the Freudian theory of the unconscious through his pre-war involvement with the Surrealist group to produce an account of the develop-ment of the human individual which considerably privileged the act of looking (VB8): few ideas have proved more fruitful for later representations of human subjectivity than his 'mirror phase'. The political aspect of Surrealism survived in the group Cobra, not least as a form of left-wing resistance to orthodox Communism and to its rigid doctrine of Realism in the arts (see VB9 and VC12 and 13).

Whatever happened in the United States, much European art still remained provin-cial with respect to France. In some places the mood of isolation and loss persisted well after the overcoming of those socio-economic conditions which had initially fuelled it (VB13 and 14). Post-war angst, it seems, was capable of hardening into a rhetoric of the human condition *per se*. Whereas for Sartre, Existentialism led to the Left, for many others the prospect of a Left dominated by Soviet Communism led to the rejection of all explicitly political alignment (see VB11). For Europeans as for American Abstract Expressionists, however, such resolute individualism proved susceptible to manipula-tion by Cold War strategists. Individualism was made to signify more powerfully as a pawn in the ideological struggle with 'totalitarianism' than in terms of the freedom of the individual within the emergent post-war commodity-capitalisms of the West. As a result much of its libertarian force was weakened, and the organized Left remained suspicious of many of the forms taken by avant-garde art.

In brief, individualism *was* a social ideology. This is not to say that certain freedoms were not real. But at the same time, whose freedom, and in what it was held to consist, let alone where its limits lay, were questions which the broader ideological conflicts of the time often simply subsumed. Predictably, the practice of art provided a sphere where these alternatives could clash. Equally predictably, these clashes were for the most part conducted from behind the ramparts of ideological certitude. The division of the world into two competing superpower blocs produced a mutually hostile political rhetoric between the two leaderships. It was a telling irony that they shared the same conservative tastes in art (VC9 and 15). In the debate about the social place of art, the possibility of complexity lay elsewhere.

The centre ground was appropriated by liberal democracy. On the one side distinct from conservatism, on the other from a conveniently over-simplified 'totalitarianism', liberalism set the characteristic tone (see VC16–19). More tensioned positions were possible, however. As remarked above, there remained islands of the anti-Stalinist Left (see VC11 and 12); a position which was not entirely snuffed out even in America (VA16 and VC10). In somewhat more orthodox but ultimately no more secure vein, both Picasso and Léger joined the ranks of the French Communist Party. There were no more authoritative figures in the avant-garde tradition, but from the point of view of the Party their work remained a scandalous deviation from the 'Realism' which it was held to be the business of Communists to propagate (see VC5, 6 and 13). In Italy an

intense debate took place on the social responsibility of the artist, one of the leading advocates of a committed realism being the communist painter Renato Guttuso (VC4). In the mid-1950s David Siqueiros used his prestige – the prestige of a Communist artist of long standing who had even been implicated in an assassination attempt upon Trotsky – to warn Soviet artists of the ossification of Socialist Realism (VC20). One of the most powerful criticisms of Modernism in the arts was made by the philosopher-critic Georg Lukács. He also steered a course away from dogmatic Socialist Realism, in an argument tellingly framed at the moment when Hungary attempted to break from Russian domination (VC21).

Artistic debate was many-sided in the decade or so after the end of the Second World War. Among those who encountered the new American art in Europe in the 1950s few doubted that it had established the paradigm for ambitious work in the immediate future. On the other hand, its aesthetic prominence appeared to have been bought at a high cost: the cost of abandoning many of the commitments which had made the European avant-garde a powerful social force since its inception in the nineteenth century. Many have lamented that the European and American avant-gardes – which they see as far from distinct, technically or philosophically – were not brought into dialogue, so that the more complex political radicalism of the former might have come to fertilize the latter. The challenging, even disturbing possibility, however, is that it was its very refusal to become embroiled in the morass of post-war European debate that enabled American art to achieve what it did, and to achieve it as art.

VA
The American Avant-Garde

1 Clement Greenberg (1909–1994) 'Towards a Newer Laocoon'

The title refers both to Gotthold Lessing's *Laocoön: An Essay upon the Limits of Poetry and Painting*, of 1766 (see *Art in Theory 1648–1815*, IIIA10), and to Irving Babbitt's *The New Laokoön: An Essay on the Confusion of the Arts*, of 1910. Greenberg thus clearly signals his concern with a long-standing question in aesthetics: is the existence of limits serving to distinguish *between* the various arts also a condition of the possibility of value *within* them? According to Greenberg's argument, it is a historical characteristic of the modern arts that each has had to define itself in terms of the limitations of its proper medium. At a time when vociferous claims were being made for the 'Realism' of various forms of figurative art, his aim was at one and the same time to establish the quality of certain abstract art and to justify abstraction as the fulfilment of an inexorable historical tendency. (The issues raised here by Greenberg were to be revived and reformulated twenty-seven years later by Michael Fried in his 'Art and Objecthood', VIIA7.) Originally published in *Partisan Review*, New York, VII, no. 4, July–August 1940, pp. 296–310.

The dogmatism and intransigence of the 'non-objective' or 'abstract' purists of painting today cannot be dismissed as symptoms merely of a cultist attitude towards art. Purists make extravagant claims for art, because usually they value it much more than any one else does. For the same reason they are much more solicitous about it. A great deal of purism is the translation of an extreme solicitude, an anxiousness as to the fate of art, a concern for its identity. We must respect this. When the purist insists upon excluding 'literature' and subject matter from plastic art, now and in the future, the most we can charge him with off-hand is an unhistorical attitude. It is quite easy to show that abstract art like every other cultural phenomenon reflects the social and other circum-stances of the age in which its creators live, and that there is nothing inside art itself, disconnected from history, which compels it to go in one direction or another. But it is not so easy to reject the purist's assertion that the best of contemporary plastic art is abstract. Here the purist does not have to support his position with metaphysical pretensions. And when he insists on doing so, those of us who admit the merits of abstract art without accepting its claims in full must offer our own explanation for its present supremacy.

Discussion as to purity in art and, bound up with it, the attempts to establish the differences between the various arts are not idle. There has been, is, and will be, such a thing as a confusion of the arts. From the point of view of the artist engrossed in

the problems of his medium and indifferent to the efforts of theorists to explain abstract art *completely*, purism is the terminus of a salutary reaction against the mistakes of painting and sculpture in the past several centuries which were due to such a confusion.

I

There can be, I believe, such a thing as a dominant art form; this was what literature had become in Europe by the 17th century. [...]

Now, when it happens that a single art is given the dominant role, it becomes the prototype of all art: the others try to shed their proper characters and imitate its effects. The dominant art in turn tries itself to absorb the functions of the others. A confusion of the arts results, by which the subservient ones are perverted and distorted; they are forced to deny their own nature in an effort to attain the effects of the dominant art. However, the subservient arts can only be mishandled in this way when they have reached such a degree of technical facility as to enable them to pretend to conceal their *mediums*. In other words, the artist must have gained such power over his material as to annihilate it seemingly in favor of *illusion*. Music was saved from the fate of the pictorial arts in the 17th and 18th centuries by its comparatively rudimentary technique and the relative shortness of its development as a formal art. Aside from the fact that in its nature it is the art furthest removed from imitation, the possibilities of music had not been explored sufficiently to enable it to strive for illusionist effects.

But painting and sculpture, the arts of illusion par excellence, had by that time achieved such facility as to make them infinitely susceptible to the temptation to emulate the effects, not only of illusion, but of other arts. Not only could painting imitate sculpture, and sculpture, painting, but both could attempt to reproduce the effects of literature. And it was for the effects of literature that 17th and 18th century painting strained most of all. Literature, for a number of reasons, had won the upper hand, and the plastic arts – especially in the form of easel painting and statuary – tried to win admission to its domain. Although this does not account completely for the decline of those arts during this period, it seems to have been the form of that decline. Decline it was, compared to what had taken place in Italy, Flanders, Spain and Germany the century before. Good artists, it is true, continue to appear – I do not have to exaggerate the depression to make my point – but not good *schools* of art, not good followers. The circumstances surrounding the appearance of the individual great artists seem to make them almost all exceptions; we think of them as great artists 'in spite of.' There is a scarcity of distinguished small talents. And the very level of greatness sinks by comparison to the work of the past.

In general, painting and sculpture in the hands of the lesser talents – and this is what tells the story – become nothing more than ghosts and 'stooges' of literature. All emphasis is taken away from the medium and transferred to subject matter. It is no longer a question even of realistic imitation, since that is taken for granted, but of the artist's ability to interpret subject matter for poetic effects and so forth.

* * *

III

Romanticism was the last great tendency following *directly* from bourgeois society that was able to inspire and stimulate the profoundly responsible artist – the artist conscious of certain inflexible obligations to the standards of his craft. By 1848 Romanticism had exhausted itself. After that the impulse, although indeed it had to originate in bourgeois society, could only come in the guise of a denial of that society, as a turning away from it. It was not to be an about-face towards a new society, but an emigration to a Bohemia which was to be art's sanctuary from capitalism. It was to be the task of the avant-garde to perform in opposition to bourgeois society the function of finding new and adequate cultural forms for the expression of that same society, without at the same time succumbing to its ideological divisions and its refusal to permit the arts to be their own justification. The avant-garde, both child and negation of Romanticism, becomes the embodiment of art's instinct of self-preservation. It is interested in, and feels itself responsible to, only the values of art; and, given society as it is, has an organic sense of what is good and what is bad for art.

As the first and most important item upon its agenda, the avant-garde saw the necessity of an escape from ideas, which were infecting the arts with the ideological struggles of society. Ideas came to mean subject matter in general. (Subject matter as distinguished from content: in the sense that every work of art must have content, but that subject matter is something the artist does or does not have in mind when he is actually at work.) This meant a new and greater emphasis upon form, and it also involved the assertion of the arts as independent vocations, disciplines and crafts, absolutely autonomous, and entitled to respect for their own sakes, and not merely as vessels of communication. It was the signal for a revolt against the dominance of literature, which was subject matter at its most oppressive.

[...] The campaign for redemption of painting was to be one of comparatively slow attrition at first. Nineteenth century painting made its first break with literature when in the person of the Communard, Courbet, it fled from spirit to matter. Courbet, the first real avant-garde painter, tried to reduce his art to immediate sense data by painting only what the eye could see as a machine unaided by the mind. He took for his subject matter prosaic contemporary life. As avant-gardists so often do, he tried to demolish official bourgeois art by turning it inside out. By driving something as far as it will go you often get back to where it started. A new flatness begins to appear in Courbet's painting, and an equally new attention to every inch of the canvas, regardless of its relation to the 'centers of interest.' [...]

Impressionism, reasoning beyond Courbet in its pursuit of materialist objectivity, abandoned common sense experience and sought to emulate the detachment of science, imagining that thereby it would get at the very essence of painting as well as of visual experience. It was becoming important to determine the essential elements of each of the arts. Impressionist painting becomes more an exercise in color vibrations than representation of nature. Manet meanwhile, closer to Courbet, was attacking subject matter on its own terrain by including it in his pictures and exterminating it then and there. His insolent indifference to his subject, which in itself was often striking, and his flat color-modelling were as revolutionary as Impressionist technique proper. Like the

Impressionists he saw the problems of painting as first and foremost problems of the medium, and he called the spectator's attention to this.

IV

The second variant of the avant-garde's development is concurrent in time with the first. It is easy to recognize this variant, but rather difficult to expose its motivation. Tendencies go in opposite directions, and cross-purposes meet. But tying everything together is the fact that in the end cross-purposes indeed do meet. There is a common effort in each of the arts to expand the expressive resources of the medium, not in order to express ideas and notions, but to express with greater immediacy sensations, the irreducible elements of experience. Along this path it seemed as though the avant-garde in its attempt to escape from 'literature' had set out to treble the confusion of the arts by having them imitate every other art except literature. (By this time literature had had its opprobrious sense expanded to include everything the avant-garde objected to in official bourgeois culture.) Each art would demonstrate its powers by capturing the effects of its sister arts or by taking a sister art for its subject. Since art was the only validity left, what better subject was there for each art than the procedures and effects of some other art? Impressionist painting, with its progressions and rhythmic suffusions of color, with its moods and atmospheres, was arriving at effects to which the Impressionists themselves gave the terms of Romantic music. [. . .]

Aside from what was going on inside music, music as an art in itself began at this time to occupy a very important position in relation to the other arts. Because of its 'absolute' nature, its remoteness from imitation, its almost complete absorption in the very physical quality of its medium, as well as because of its resources of suggestion, music had come to replace poetry as the paragon art. It was the art which the other avant-garde arts envied most, and whose effects they tried hardest to imitate. [. . .]

But only when the avant-garde's interest in music led it to consider music as a *method* of art rather than as a kind of effect did the avant-garde find what it was looking for. It was when it was discovered that the advantage of music lay chiefly in the fact that it was an 'abstract' art, an art of 'pure form.' It was such because it was incapable, objectively, of communicating anything else than a sensation, and because this sensation could not be conceived in any other terms than those of the sense through which it entered the consciousness. An imitative painting can be described in terms of non-visual identities, a piece of music cannot, whether it attempts to imitate or not. The effects of music are the effects, essentially, of pure form; those of painting and poetry are too often accidental to the formal natures of these arts. Only by accepting the example of music and defining each of the other arts solely in the terms of the sense or faculty which perceived its effect and by excluding from each art whatever is intelligible in the terms of any other sense or faculty would the non-musical arts attain the 'purity' and self-sufficiency which they desired; which they desired, that is, in so far as they were avant-garde arts. The emphasis, therefore, was to be on the physical, the sensorial. 'Literature's' corrupting influence is only felt when the senses are neglected. The latest confusion of the arts was the result of a mistaken conception of music as the only immediately sensuous art. But the other arts can also be sensuous, if only they will look to music, not to ape its effects but to borrow its principles as a 'pure' art, as an art which is abstract because it is almost nothing else except sensuous.

V

Guiding themselves, whether consciously or unconsciously, by a notion of purity derived from the example of music, the avant-garde arts have in the last fifty years achieved a purity and a radical delimitation of their fields of activity for which there is no previous example in the history of culture. The arts lie safe now, each within its 'legitimate' boundaries, and free trade has been replaced by autarchy. Purity in art consists in the acceptance, willing acceptance, of the limitations of the medium of the specific art. To prove that their concept of purity is something more than a bias in taste, painters point to Oriental, primitive and children's art as instances of the universality and naturalness and objectivity of their ideal of purity. [...] The issue is, of course, focused most sharply in the plastic arts, for they, in their non-decorative function, have been the most closely associated with imitation, and it is in their case that the ideal of the pure and the abstract has met the most resistance.

The arts, then, have been hunted back to their mediums, and there they have been isolated, concentrated and defined. It is by virtue of its medium that each art is unique and strictly itself. To restore the identity of an art the opacity of its medium must be emphasized. For the visual arts the medium is discovered to be physical; hence pure painting and pure sculpture seek above all else to affect the spectator physically. [...]

[...] The purely plastic or abstract qualities of the work of art are the only ones that count. Emphasize the medium and its difficulties, and at once the purely plastic, the proper, values of visual art come to the fore. Overpower the medium to the point where all sense of its resistance disappears, and the adventitious uses of art become more important.

The history of avant-garde painting is that of a progressive surrender to the resistance of its medium; which resistance consists chiefly in the flat picture plane's denial of efforts to 'hole through' it for realistic perspectival space. In making this surrender, painting not only got rid of imitation – and with it, 'literature' – but also of realistic imitation's corollary confusion between painting and sculpture. (Sculpture, on its side, emphasizes the resistance of its material to the efforts of the artist to ply it into shapes uncharacteristic of stone, metal, wood, etc.) Painting abandons chiaroscuro and shaded modelling. Brush strokes are often defined for their own sake. The motto of the Renaissance artist, *Ars est artem celare*, is exchanged for *Ars est artem demonstrare*. Primary colors, the 'instinctive,' easy colors, replace tones and tonality. Line, which is one of the most abstract elements in painting since it is never found in nature as the definition of contour, returns to oil painting as the third color between two other color areas. Under the influence of the square shape of the canvas, forms tend to become geometrical – and simplified, because simplification is also a part of the instinctive accommodation to the medium. But most important of all, the picture plane itself grows shallower and shallower, flattening out and pressing together the fictive planes of depth until they meet as one upon the real and material plane which is the actual surface of the canvas; where they lie side by side or interlocked or transparently imposed upon each other. Where the painter still tries to indicate real objects their shapes flatten and spread in the dense, two-dimensional atmosphere. A vibrating tension is set up as the objects struggle to maintain their volume against the tendency of the real picture plane to re-assert its material flatness and crush them to silhouettes.

In a further stage realistic space cracks and splinters into flat planes which come forward, parallel to the plane surface. [...]

The destruction of realistic pictorial space, and with it, that of the object, was accomplished by means of the travesty that was cubism. The cubist painter eliminated color because, consciously or unconsciously, he was parodying, in order to destroy, the academic methods of achieving volume and depth, which are shading and perspective, and as such have little to do with color in the common sense of the word. The cubist used these same methods to break the canvas into a multiplicity of subtle recessive planes, which seem to shift and fade into infinite depths and yet insist on returning to the surface of the canvas. As we gaze at a cubist painting of the last phase we witness the birth and death of three-dimensional pictorial space.

And as in painting the pristine flatness of the stretched canvas constantly struggles to overcome every other element, so in sculpture the stone figure appears to be on the point of relapsing into the original monolith, and the cast seems to narrow and smooth itself back to the original molten stream from which it was poured, or tries to remember the texture and plasticity of the clay in which it was first worked out.

Sculpture hovers finally on the verge of 'pure' architecture, and painting, having been pushed up from fictive depths, is forced through the surface of the canvas to emerge on the other side in the form of paper, cloth, cement and actual objects of wood and other materials pasted, glued or nailed to what was originally the transparent picture plane, which the painter no longer dares to puncture – or if he does, it is only to dare. Artists like Hans Arp, who begin as painters, escape eventually from the prison of the single plane by painting on wood or plaster and using molds or carpentry to raise and lower planes. They go, in other words, from painting to colored bas-relief, and finally – so far must they fly in order to return to three-dimensionality without at the same time risking the illusion – they become sculptors and create objects in the round, through which they can free their feelings for movement and direction from the increasing ascetic geometry of pure painting. (Except in the case of Arp and one or two others, the sculpture of most of these metamorphosed painters is rather unsculptural, stemming as it does from the discipline of painting. It uses color, fragile and intricate shapes and a variety of materials. It is construction, fabrication.) [...]

VI

I find that I have offered no other explanation for the present superiority of abstract art than its historical justification. So what I have written has turned out to be an historical apology for abstract art. To argue from any other basis would require more space than is at my disposal, and would involve an entrance into the politics of taste – to use Venturi's phrase – from which there is no exit – on paper. My own experience of art has forced me to accept most of the standards of taste from which abstract art has derived, but I do not maintain that they are the only valid standards through eternity. I find them simply the most valid ones at this given moment. I have no doubt that they will be replaced in the future by other standards, which will be perhaps more inclusive than any possible now. And even now they do not exclude all other possible criteria. I am still able to enjoy a Rembrandt more for its expressive qualities than for its achievement of abstract values – as rich as it may be in them.

It suffices to say that there is nothing in the nature of abstract art which compels it to be so. The imperative comes from history, from the age in conjunction with a particular moment reached in a particular tradition of art. This conjunction holds the artist in a vise from which at the present moment he can escape only by surrendering his ambition and returning to a stale past. This is the difficulty for those who are dissatisfied with abstract art, feeling that it is too decorative or too arid and 'inhuman,' and who desire a return to representation and literature in plastic art. Abstract art cannot be disposed of by a simple-minded evasion. Or by negation. We can only dispose of abstract art by assimilating it, by fighting our way through it. Where to? I do not know. Yet it seems to me that the wish to return to the imitation of nature in art has been given no more justification than the desire of certain partisans of abstract art to legislate it into permanency.

2 Adolph Gottlieb (1903–1974) and Mark Rothko (1903–1970) with Barnett Newman (1905–1970) Statement

In a review of the Federation of Modern Painters and Sculptors' exhibition in New York in June 1943 the critic Edward Alden Jewell expressed his 'befuddlement' at paintings by Gottlieb and Rothko, offering the hospitality of his column should the artists be willing to explain their work. Though the resulting statement was signed by Gottlieb and Rothko, Newman assisted in its composition. The statement stands as a virtual manifesto for the form of American painting which these three jointly represented in the early to mid-1940s, and in particular for their neo-Expressionist interest in the intrinsic significance of persistent themes and myths. Originally published in Jewell's column in the *New York Times*, 13 June 1943.

To the artist the workings of the critical mind is one of life's mysteries. That is why, we suppose, the artist's complaint that he is misunderstood, especially by the critic, has become a noisy commonplace. It is therefore an event when the worm turns and the critic quietly, yet publicly, confesses his 'befuddlement,' that he is 'nonplused' before our pictures at the federation show. We salute this honest, we might say cordial, reaction toward our 'obscure' paintings, for in other critical quarters we seem to have created a bedlam of hysteria. And we appreciate the gracious opportunity that is being offered us to present our views.

We do not intend to defend our pictures. They make their own defense. We consider them clear statements. Your failure to dismiss or disparage them is *prima facie* evidence that they carry some communicative power. We refuse to defend them not because we cannot. It is an easy matter to explain to the befuddled that *The Rape of Persephone* is a poetic expression of the essence of the myth; the presentation of the concept of seed and its earth with all the brutal implications; the impact of elemental truth. Would you have us present this abstract concept, with all its complicated feelings, by means of a boy and girl lightly tripping?

It is just as easy to explain *The Syrian Bull* as a new interpretation of an archaic image, involving unprecedented distortions. Since art is timeless, the significant rendition of a symbol, no matter how archaic, has as full validity today as the archaic symbol had then. Or is the one 3000 years old truer? ... easy program notes can help only the simple-minded.

No possible set of notes can explain our paintings. Their explanation must come out of a consummated experience between picture and onlooker. The point at issue, it seems to us, is not an 'explanation' of the paintings, but whether the intrinsic ideas carried within the frames of these pictures have significance. We feel that our pictures demonstrate our aesthetic beliefs, some of which we, therefore, list:

1 To us art is an adventure into an unknown world, which can be explored only by those willing to take the risks.
2 This world of the imagination is fancy-free and violently opposed to common sense.
3 It is our function as artists to make the spectator see the world our way – not his way.
4 We favor the simple expression of the complex thought. We are for the large shape because it has the impact of the unequivocal. We wish to reassert the picture plane. We are for flat forms because they destroy illusion and reveal truth.
5 It is a widely accepted notion among painters that it does not matter what one paints as long as it is well painted. This is the essence of academism. There is no such thing as good painting about nothing. We assert that the subject is crucial and only that subject-matter is valid which is tragic and timeless. That is why we profess spiritual kinship with primitive and archaic art.

Consequently, if our work embodies these beliefs it must insult any one who is spiritually attuned to interior decoration; pictures for the home; pictures for over the mantel; pictures of the American scene; social pictures; purity in art; prize-winning potboilers; the National Academy, the Whitney Academy, the Corn Belt Academy; buckeyes; trite tripe, etc.

3 Jackson Pollock (1912–1956) Answers to a Questionnaire

Pollock's first one-man exhibition was held in November 1943 at the Art of This Century Gallery in New York, where many of the European Surrealists were shown during the war. In this statement, published three months later, he establishes a position for himself in relation to his American origins on the one hand and the concerns of the European avant-garde on the other. The questions were written by Pollock himself with assitance from a representative of the gallery. Originally printed in *Arts and Architecture*, New York, LXI, February 1944.

Where were you born?
JP: Cody, Wyoming, in January, 1912. My ancestors were Scotch and Irish.
Have you traveled any?
JP: I've knocked around some in California, some in Arizona. Never been to Europe.
Would you like to go abroad?
JP: No. I don't see why the problems of modern painting can't be solved as well here as elsewhere.
Where did you study?
JP: At the Art Students' League, here in New York. I began when I was seventeen. Studied with Benton, at the League, for two years.

How did your study with Thomas Benton affect your work, which differs so radically from his?

JP: My work with Benton was important as something against which to react very strongly, later on; in this, it was better to have worked with him than with a less resistant personality who would have provided a much less strong opposition. At the same time, Benton introduced me to Renaissance art.

Why do you prefer living here in New York to your native West?

JP: Living is keener, more demanding, more intense and expansive in New York than in the West; the stimulating influences are more numerous and rewarding. At the same time, I have a definite feeling for the West: the vast horizontality of the land, for instance; here only the Atlantic Ocean gives you that.

Has being a Westerner affected your work?

JP: I have always been very impressed with the plastic qualities of American Indian art. The Indians have the true painter's approach in their capacity to get hold of appropriate images, and in their understanding of what constitutes painterly subject matter. Their color is essentially Western, their vision has the basic universality of all real art. Some people find references to American Indian art and calligraphy in parts of my pictures. That wasn't intentional; probably was the result of early memories and enthusiasms.

Do you consider technique to be important in art?

JP: Yes and no. Craftsmanship is essential to the artist. He needs it just as he needs brushes, pigments, and a surface to paint on.

Do you find it important that many famous modern European artists are living in this country?

JP: Yes. I accept the fact that the important painting of the last hundred years was done in France. American painters have generally missed the point of modern painting from beginning to end. (The only American master who interests me is Ryder.) Thus the fact that good European moderns are now here is very important, for they bring with them an understanding of the problems of modern painting. I am particularly impressed with their concept of the source of art being the unconscious. This idea interests me more than these specific painters do, for the two artists I admire most, Picasso and Miró, are still abroad.

Do you think there can be a purely American art?

JP: The idea of an isolated American painting, so popular in this country during the thirties, seems absurd to me, just as the idea of creating a purely American mathematics or physics would seem absurd. . . . And in another sense, the problem doesn't exist at all; or, if it did, would solve itself: An American is an American and his painting would naturally be qualified by that fact, whether he wills it or not. But the basic problems of contemporary painting are independent of any one country.

4 Jackson Pollock (1912–1956) Two Statements

In 1947, Pollock made an application for a Guggenheim Fellowship. The first of the two statements printed below was written as part of this application. The 'large painting for Miss Peggy Guggenheim' was the work of 1943 known as *Mural*, now in the collection of the University of Iowa. The second statement was written for the first and only edition of

Possibilities, edited by Robert Motherwell and Harold Rosenberg and published in New York in the winter of 1947/8. The final paragraph formed part of Pollock's draft, but was omitted in the statement as originally published. Our source for both statements is Francis V. O'Connor, *Jackson Pollock*, New York: The Museum of Modern Art, 1967, pp. 39–40.

I

I intend to paint large movable pictures which will function between the easel and mural. I have set a precedent in this genre in a large painting for Miss Peggy Guggenheim which was installed in her house and was later shown in the 'Large Scale Paintings' show at the Museum of Modern Art. It is at present on loan at Yale University.

I believe the easel picture to be a dying form, and the tendency of modern feeling is towards the wall picture or mural. I believe the time is not yet ripe for a *full* transition from easel to mural. The pictures I contemplate painting would constitute a halfway state, and an attempt to point out the direction of the future, without arriving there completely.

II

My painting does not come from the easel. I hardly ever stretch my canvas before painting. I prefer to tack the unstretched canvas to the hard wall or the floor. I need the resistance of a hard surface. On the floor I am more at ease. I feel nearer, more a part of the painting, since this way I can walk around it, work from the four sides and literally be *in* the painting. This is akin to the method of the Indian sand painters of the West.

I continue to get further away from the usual painter's tools such as easel, palette, brushes, etc. I prefer sticks, trowels, knives and dripping fluid paint or a heavy impasto with sand, broken glass and other foreign matter added.

When I am *in* my painting, I'm not aware of what I'm doing. It is only after a sort of 'get acquainted' period that I see what I have been about. I have no fears about making changes, destroying the image, etc., because the painting has a life of its own. I try to let it come through. It is only when I lose contact with the painting that the result is a mess. Otherwise there is pure harmony, an easy give and take, and the painting comes out well.

The source of my painting is the unconscious. I approach painting the same way I approach drawing. That is direct – with no preliminary studies. The drawings I do are relative to my painting but not for it.

5 Mark Rothko (1903–1970) 'The Romantics were Prompted...'

Rothko here offers a modern revision of Romanticism, conceiving art as a form of transcendent experience in face of the ordinariness and hostility of the everyday world. Originally published in *Possibilities*, New York, 1, 1947, p. 84.

The romantics were prompted to seek exotic subjects and to travel to far off places. They failed to realize that, though the transcendental must involve the strange and unfamiliar, not everything strange or unfamiliar is transcendental.

The unfriendliness of society to his activity is difficult for the artist to accept. Yet this very hostility can act as a lever for true liberation. Freed from a false sense of security and community, the artist can abandon his plastic bank-book, just as he has abandoned other forms of security. Both the sense of community and of security depend on the familiar. Free of them, transcendental experiences become possible.

I think of my pictures as dramas; the shapes in the pictures are the performers. They have been created from the need for a group of actors who are able to move dramatically without embarrassment and execute gestures without shame.

Neither the action nor the actors can be anticipated, or described in advance. They begin as an unknown adventure in an unknown space. It is at the moment of completion that in a flash of recognition, they are seen to have the quantity and function which was intended. Ideas and plans that existed in the mind at the start were simply the doorway through which one left the world in which they occur.

The great cubist pictures thus transcend and belie the implications of the cubist program.

The most important tool the artist fashions through constant practice is faith in his ability to produce miracles when they are needed. Pictures must be miraculous: the instant one is completed, the intimacy between the creation and the creator is ended. He is an outsider. The picture must be for him, as for anyone experiencing it later, a revelation, an unexpected and unprecedented resolution of an eternally familiar need.

On shapes:

- They are unique elements in a unique situation.
- They are organisms with volition and a passion for self-assertion.
- They move with internal freedom, and without need to conform with or to violate what is probable in the familiar world.
- They have no direct association with any particular visible experience, but in them one recognizes the principle and passion of organisms.

The presentation of this drama in the familiar world was never possible, unless everyday acts belonged to a ritual accepted as referring to a transcendent realm.

Even the archaic artist, who had an uncanny virtuosity, found it necessary to create a group of intermediaries, monsters, hybrids, gods, and demigods. The difference is that, since the archaic artist was living in a more practical society than ours, the urgency for transcendent experience was understood, and given an official status. As a consequence, the human figure and other elements from the familiar world could be combined with, or participate as a whole in the enactment of the excesses which characterize this improbable hierarchy. With us the disguise must be complete. The familiar identity of things has to be pulverized in order to destroy the finite associations with which our society increasingly enshrouds every aspect of our environment.

Without monsters and gods, art cannot enact our drama: art's most profound moments express this frustration. When they were abandoned as untenable superstitions, art sank into melancholy. It became fond of the dark, and enveloped its objects in the nostalgic intimations of a half-lit world. For me the great achievements of the centuries in which the artist accepted the probable and familiar as his subjects were the pictures of the single human figure – alone in a moment of utter immobility.

But the solitary figure could not raise its limbs in a single gesture that might indicate its concern with the fact of mortality and an insatiable appetite for ubiquitous experi- ence in face of this fact. Nor could the solitude be overcome. It could gather on beaches and streets and in parks only through coincidence, and, with its companions, form a *tableau vivant* of human incommunicability.

I do not believe that there was ever a question of being abstract or representational. It is really a matter of ending this silence and solitude, of breathing and stretching one's arms again.

6 Mark Rothko (1903–1970) Statement

It was a common assumption among the American avant-garde painters of the 1940s and 1950s that a painting could be a kind of equivalent for an individual person, at least in the sense that it invited the spectator into a form of one-to-one relationship. First published in *Tiger's Eye*, New York, vol. 1, no. 2, December 1947, p. 44.

A picture lives by companionship, expanding and quickening in the eyes of the sensitive observer. It dies by the same token. It is therefore a risky and unfeeling act to send it out into the world. How often it must be permanently impaired by the eyes of the vulgar and the cruelty of the impotent who would extend their affliction universally!

7 Adolph Gottlieb (1903–1974) Statement

In similar vein to Rothko, Gottlieb here offers what was to become a widespread justification for the abstraction of the New York School: that the artist was effectively forced out of traditional forms of pictorial realism by the unsocial nature of the times. Originally published in the short-lived avant-garde periodical *Tiger's Eye*, New York, vol. 1, no. 2, December 1947, p. 43.

Certain people always say we should go back to nature. I notice they never say we should go forward to nature. It seems to me they are more concerned that we should go back, than about nature.

If the models we use are the apparitions seen in a dream, or the recollection of our pre-historic past, is this less part of nature or realism, than a cow in a field? I think not.

The role of the artist, of course, has always been that of image-maker. Different times require different images. Today when our aspirations have been reduced to a desperate attempt to escape from evil, and times are out of joint, our obsessive, subterranean and pictographic images are the expression of the neurosis which is our reality. To my mind certain so-called abstraction is not abstraction at all. On the contrary, it is the realism of our time.

8 Barnett Newman (1905–1970) 'The Ideographic Picture'

Written for the catalogue of an exhibition of the same title at the Betty Parsons Gallery, New York, 20 January–8 February, 1947. Besides Newman, exhibitors were Hans Hofmann,

Pietro Lazzari, Boris Margo, Ad Reinhardt, Mark Rothko, Theodoros Stamos and Clyfford Still. Newman aims to distance his own work and that of his fellow exhibitors from the prevailing assumption that to be an abstract painter is to be uninterested in ideas. He deploys the concept of the 'ideograph' to this end. In the following year he was to be associated with Rothko, William Baziotes and Robert Motherwell in the founding of a school under the name 'Subjects of the Artist'.

> Ideograph – A character, symbol, or figure which suggests the idea without expressing its name.
>
> Ideographic – Representing ideas directly and not through the medium of their names; applies specifically to that mode of writing which by means of symbols, figures, or hieroglyphics suggests the idea of an object without expressing its name.
>
> – *The Century Dictionary*
>
> Ideograph – A symbol or character painted, written, or inscribed, representing ideas.
>
> – *The Encyclopaedia Britannica*

The Kwakiutl artist painting on a hide did not concern himself with the inconsequentials that made up the opulent social rivalries of the Northwest Coast Indian scene, nor did he, in the name of a higher purity, renounce the living world for the meaningless materialism of design. The abstract shape he used, his entire plastic language, was directed by a ritualistic will towards metaphysical understanding. The everyday realities he left to the toymakers; the pleasant play of non-objective pattern to the women basket weavers. To him a shape was a living thing, a vehicle for an abstract thought-complex, a carrier of the awesome feelings he felt before the terror of the unknowable. The abstract shape was, therefore, real rather than a formal 'abstraction' of a visual fact, with its overtone of an already-known nature. Nor was it a purist illusion with its overload of pseudo-scientific truths.

The basis of an aesthetic act is the pure idea. But the pure idea is, of necessity, an aesthetic act. Here then is the epistemological paradox that is the artist's problem. Not space cutting nor space building, not construction nor fauvist destruction; not the pure line, straight and narrow, nor the tortured line, distorted and humiliating; not the accurate eye, all fingers, nor the wild eye of dream, winking; but the idea-complex that makes contact with mystery – of life, of men, of nature, of the hard, black chaos that is death, or the grayer, softer chaos that is tragedy. For it is only the pure idea that has meaning. Everything else has everything else.

Spontaneous, and emerging from several points, there has arisen during the war years a new force in American painting that is the modern counterpart of the primitive art impulse. As early as 1942, Mr Edward Alden Jewell was the first publicly to report it. Since then, various critics and dealers have tried to label it, to describe it. It is now time for the artist himself, by showing the dictionary, to make clear the community of intention that motivates him and his colleagues. For here is a group of artists who are not abstract painters, although working in what is known as the abstract style. [...]

9 Barnett Newman (1905–1970) 'The First Man Was an Artist'

In asserting the priority of the aesthetic over the social, Newman echoes both the primitivism of the earlier Expressionists and the disdain in which scientific and utilitarian thought was

characteristically held by the Surrealists. His contemporary paintings betray the same preoccupation with the concept and mythology of creation that characterizes this essay. Originally published in *Tiger's Eye* (of which Newman was associate editor), vol. 1, no. 1, October 1947, pp. 57–60.

A scientist has just caught the tail of another metaphor. Out of the Chinese dragon's teeth, piled high in harvest on the shelves of Shanghai's drugstores and deep in the Java mud, a half million years old, he has constructed Meganthropus palaeojavanicus, 'man the great,' the giant, who, the paleontologists now tell us, was our human ancestor. And for many, he has become more real than Cyclops, than the Giant of the Beanstalk. Those unconvinced by the poetic dream, who reject the child's fable, are now sure of a truth found today 500,000 years old. Shall we artists quarrel with those who need to wait for the weights of scientific proof to believe in poetry? Or shall we let them enjoy their high adventure laid out in mud and in drugstore teeth? For truth is for them at last the Truth.

Quarrel we must, for there is the implication in this paleontological find of another attempt to claim possession of the poetic gesture; that the scientist rather than the artist discovered the Giant. It is not enough for the artist to announce with arrogance his invincible position: that the job of the artist is not to discover truth, but to fashion it, that the artist's work was done long ago. This position, superior as it may be, separates the artist from everyone else, declares his role against that of all. The quarrel here must include a critique of paleontology, an examination of the new sciences.

In the last sixty years, we have seen mushroom a vast cloud of 'sciences' in the fields of culture, history, philosophy, psychology, economics, politics, aesthetics, in an ambitious attempt to claim the non-material world. Why the invasion? Is it out of fear that its materialistic interpretation of physical phenomena, its narrow realm of physics and chemistry, may give science a minor historical position if, in the larger attempt to resolve the metaphysical mysteries, the physical world may take only a small place? Has science, in its attempt to dominate all realms of thought, been driven willy nilly to act politically so that, by denying any place to the metaphysical world, it could give its own base of operations a sense of security? Like any state or church, science found the drive to conquer necessary to protect the security of its own state of physics. To accomplish this expansion, the scientist abandoned the revolutionary scientific act for a theological way of life.

The domination of science over the mind of modern man has been accomplished by the simple tactic of ignoring the prime scientific quest; the concern with its original question *what*? When it was found that the use of this question to explore all knowledge was utopian, the scientist switched from an insistence on it to a roving position of using any question. It was easy for him to do so because he could thrive on the grip mathematical discipline had, as a romantic symbol of purity and perfection, on the mind of man. So intense is the reverence for this symbol, scientific method, that it has become the new theology. And the mechanics of this theology, so brilliant is the rhythm of its logic-rite, its identification of truth with proof, that it has overwhelmed the original ecstacy of scientific quest, scientific inquiry.

For there is a difference between method and inquiry. Scientific inquiry, from its beginnings, has perpetually asked a single and specific question, *what*? What is the rainbow, what is an atom, what a star? In the pursuit of this question, the physical sciences have built a realm of thought that has validity because the question is basic for

the attainment of descriptive knowledge and permits a proper integration between its quest, the question *what* constantly maintained, and its tool, mathematics or logic, for the discovery of its answer. Scientific method, however, is free of the question. It can function on any question, or, as in mathematics, without a question. But the choice of quest, the kind of question, is the basis of the scientific act. That is why it is so pathetic to watch the scientist, so proud of his critical acumen, delude himself by the splendor of the ritual of method which, concerned only with its own relentless ceremonial dance, casts its spell not only over the lay observer but also over the participating scientist, with its incessant drumbeat of proof.

Original man, what does it matter who he was, giant or pygmy? What was he? That is the question for a science of paleontology that would have meaning for us today. For if we knew what original man was, we could declare what today's man is not. Paleontology, by building a sentimental science around the question *who* (who was your great-grandfather), cannot be excused for substituting this question for the real one, because, according to the articles of faith that make up scientific method, there is not nor can there ever be sufficient proof for positive answer. After all, paleontology, like the other non-material sciences, has entered a realm where the only questions worth discussing are the questions that cannot be proved. We cannot excuse the abdication of its primal scientific responsibility because paleontology substituted the sentimental question *who* for the scientific *what*. Who cares who he was? What was the first man, was he a hunter, a toolmaker, a farmer, a worker, a priest, or a politician? Undoubtedly the first man was an artist.

A science of paleontology that sets forth this proposition can be written if it builds on the postulate that the aesthetic act always precedes the social one. The totemic act of wonder in front of the tiger-ancestor came before the act of murder. It is important to keep in mind that the necessity for dream is stronger than any utilitarian need. In the language of science, the necessity for understanding the unknowable comes before any desire to discover the unknown.

Man's first expression, like his first dream, was an aesthetic one. Speech was a poetic outcry rather than a demand for communication. Original man, shouting his consonants, did so in yells of awe and anger at his tragic state, at his own self-awareness and at his own helplessness before the void. Philologists and semioticians are beginning to accept the concept that, if language is to be defined as the ability to communicate by means of signs, be they sounds or gestures, then language is an animal power. Anyone who has watched the common pigeon circle his female knows that she knows what he wants.

The human in language is literature, not communication. Man's first cry was a song. Man's first address to a neighbor was a cry of power and solemn weakness, not a request for a drink of water. Even the animal makes a futile attempt at poetry. Ornithologists explain the cock's crow as an ecstatic outburst of his power. The loon gliding lonesome over the lake, with whom is he communicating? The dog, alone, howls at the moon. Are we to say that the first man called the sun and the stars *God* as an act of communication and only after he had finished his day's labor? The myth came before the hunt. The purpose of man's first speech was an address to the unknowable. His behavior had its origin in his artistic nature.

Just as man's first speech was poetic before it became utilitarian, so man first built an idol of mud before he fashioned an axe. Man's hand traced the stick through the mud

to make a line before he learned to throw the stick as a javelin. Archeologists tell us that the ax-head suggested the ax-head idol. Both are found in the same strata so they must have been contemporaneous. True, perhaps, that the ax-head idol of stone could not have been carved without axe instruments, but this is a division in metier, not in time, since the mud figure anticipated both the stone figure and the axe. (A figure can be made out of mud but an axe cannot.) The God image, not pottery, was the first manual act. It is the materialistic corruption of present-day anthropology that has tried to make men believe that original man fashioned pottery before he made sculpture. Pottery is the product of civilization. The artistic act is man's personal birthright.

The earliest written history of human desires proves that the meaning of the world cannot be found in the social act. An examination of the first chapter of Genesis offers a better key to the human dream. It was inconceivable to the archaic writer that original man, that Adam, was put on earth to be a toiler, to be a social animal. The writer's creative impulses told him that man's origin was that of an artist and he set him up in a Garden of Eden close to the Tree of Knowledge, of right and wrong, in the highest sense of divine revelation. The fall of man was understood by the writer and his audience not as a fall from Utopia to struggle, as the sociologicians would have it, nor, as the religionists would have us believe, as a fall from Grace to Sin, but rather that Adam, by eating from the Tree of Knowledge, sought the creative life to be, like God, 'a creator of worlds,' to use Rashi's phrase, and was reduced to the life of toil only as a result of a jealous punishment.

In our inability to live the life of a creator can be found the meaning of the fall of man. It was a fall from the good, rather than from the abundant, life. And it is precisely here that the artist today is striving for a closer approach to the truth concerning original man than can be claimed by the paleontologist, for it is the poet and the artist who are concerned with the function of original man and who are trying to arrive at his creative state. What is the *raison d'être*, what is the explanation of the seemingly insane drive of man to be painter and poet if it is not an act of defiance against man's fall and an assertion that he return to the Adam of the Garden of Eden? For the artists are the first men.

10 Clement Greenberg (1909–1994) 'The Decline of Cubism'

From the perspective of America in the 1940s, the Second World War was symptomatic of a modern decline in the vitality and authority of European culture. In his post-war deliberations on the School of Paris, Greenberg associates this decline on the one hand with loss of faith in the notion of social and scientific progress and on the other with a moment of opportunity in American artistic culture. Originally published in *Partisan Review*, New York, March 1948, pp. 366–9. (For other texts by Greenberg see IVD11, VA1, VIB5 and 8.)

As more and more of the recent work of the masters of the School of Paris reaches this country after the six years' interruption between 1939 and 1945, any remaining doubt vanishes as to the continuing fact of the decline of art that set in in Paris in the early thirties. [...]

The problem for criticism is to explain why the cubist generation and its immediate successors have, contrary to artists' precedent, fallen off in middle and old age, and why

belated impressionists like Bonnard and Vuillard could maintain a higher consistency of performance during the last fifteen years; why even the German expressionist, Max Beckmann, so inferior to Picasso in native gifts, should paint better today than he does. And why, finally, Matisse, with his magnificent but transitional style, which does not compare with cubism for historical importance, is able to rest so securely in his position as the greatest master of the twentieth century, a position Picasso is further than ever from threatening.

At first glance we realize that we are faced with the debacle of the age of 'experiment,' of the Apollinairian and cubist mission and its hope, coincident with that of Marxism and the whole matured tradition of Enlightenment, of humanizing the world. In the plastic arts cubism, and nothing else, is the age of 'experiment.' Whatever feats fauvism in the hands of Matisse, and late impressionism in those of Bonnard and Vuillard, have been capable of, cubism remains the great phenomenon, the epoch-making feat of twentieth-century art, a style that has changed and determined the complexion of Western art as radically as Renaissance naturalism once did. And the main factor in the recent decline of art in Europe is the disorientation of cubist style, which is involved in a crisis that – by a seeming quirk – spares the surviving members of the generation of artists preceding it in point of historical development.

Yet it does not matter who is exempted from this crisis, so long as cubism is not. For cubism is still the only vital style of our time, the one best able to convey contemporary feeling, and the only one capable of supporting a tradition which will survive into the future and form new artists. The surviving masters of impressionism, fauvism, and expressionism can still deliver splendid performances, and they can influence young artists fruitfully – but they cannot *form* them. Cubism is now the only school. But why, then, if cubism is the only style adequate to contemporary feeling, should it have shown itself, in the persons of its masters, less able to withstand the tests of the last twenty years? The answer is subtle but not far-fetched.

The great art style of any period is that which relates itself to the true insights of its time. But an age may repudiate its real insights, retreat to the insights of the past – which, though not its own, seem safer to act upon – and accept only an art that corresponds to this repudiation; in which case the age will go without great art, to which truth of feeling is essential. In a time of disasters the less radical artists, like the less radical politicians, will perform better since, being familiar with the expected consequences of what they do, they need less nerve to keep to their course. But the more radical artists, like the more radical politicians, become demoralized because they need so much more nerve than the conservatives in order to keep to a course that, guided by the real insights of the age, leads into unknown territory. Yet if the radical artist's loss of nerve becomes permanent, then art declines as a whole, for the conservative artist rides only on momentum and eventually loses touch with the insights of his time – by which all genuine artists are nourished. Or else society may refuse to have any new insights, refuse to make new responses – but in that case it would be better not to talk about art at all.

Cubism originated not only from the art that preceded it, but also from a complex of attitudes that embodied the optimism, boldness, and self-confidence of the highest stage of industrial capitalism, of a period in which the scientific outlook had at last won a confirmation that only some literary men quarreled with seriously, and in which society seemed to have demonstrated its complete capacity to solve its most serious internal as

well as environmental problems. Cubism . . . expressed the positivist or empirical state of mind with its refusal to refer to anything outside the concrete experience of the particular discipline, field, or medium in which one worked; and it also expressed the empiricist's faith in the supreme reality of concrete experience. Along with this . . . went an all-pervasive conviction that the world would inevitably go on improving, so that no matter what chances one took with the new, the unknown, or the unforeseeable, there was no risk of getting anything inferior or more dangerous than what one already had.

Cubism reached its height during the First World War and, though the optimism on which it unconsciously floated was draining away fast, during the twenties it was still capable, not only of masterpieces from the hands of Picasso, Braque, Léger, but also of sending forth such bold innovators as Arp, Mondrian, and Giacometti, not to mention Miró. But in the early thirties, by which time both Picasso's and Braque's art had entered upon a crisis from which neither artist has since shown any signs of recovering, the social, emotional, and intellectual substructure of cubism began crumbling fast. Even Klee fell off after 1930. Surrealism and neo-romanticism, with their rejuvenated academicism, sprang up to compete for attention, and Bonnard, painting better and better within a discipline and frame of mind established as long ago as 1905 and for that reason, apparently, more impervious to the prevalent malaise, began to be talked about as the greatest French painter of his time, notwithstanding the presence of Matisse to whom Bonnard himself owed so much.

After 1939 the cubist heritage entered what would seem the final stage of its decline in Europe. True, Dubuffet, a cubist at heart, has appeared since then, and the best of the younger generation of French artists – Tal Coat, Kermadec, Manessier, Le Moal, Pignon, Tailleux, etc., etc. – work within cubism; but so far they have added nothing but refinements. None of them, except Dubuffet, is truly original. It is no wonder that the death of abstract art, which, even in its Kandinsky and Klee variants, is still essentially cubist, has been announced so often during the last ten years. In a world filled with nostalgia and too profoundly frightened by what has just happened to dare hope that the future contains anything better than the past, how can art be expected to hold on to advanced positions? The masters of cubism, formed by the insights of a more progressive age, had advanced too far, and when history began going backwards they had to retreat, in confusion, from positions that were more exposed because they were more advanced. The metaphor, I feel, is exact.

Obviously, the present situation of art contains many paradoxes and contradictions that only time will resolve. Prominent among them is the situation of art in this country. If artists as great as Picasso, Braque, and Léger have declined so grievously, it can only be because the general social premises that used to guarantee their functioning have disappeared in Europe. And when one sees, on the other hand, how much the level of American Art has risen in the last five years, with the emergence of new talents so full of energy and content as Arshile Gorky, Jackson Pollock, David Smith – and also when one realizes how consistently John Marin has maintained a high standard, whatever the narrowness of his art – then the conclusion forces itself, much to our own surprise, that the main premises of Western art have at last migrated to the United States, along with the center of gravity of industrial production and political power.

Not all the premises have reached this shore – not by a long shot; but enough of them are here and enough of them have abandoned Paris to permit us to abandon our

chronic, and hitherto justified, pessimism about the prospects of American art, and hope for much more than we dared hope for in the past. It is not beyond possibility that the cubist tradition may enjoy a new efflorescence in this country. Meanwhile the fact remains that it is in decline at the moment.

11 Barnett Newman (1905–1970) 'The Sublime is Now'

Newman here echoes the conclusion of the previous text. His essay is symptomatic of the American painters' desire to distinguish their work from European forms of abstract art. For all their apparent social marginality, the American avant-garde artists saw themselves as historically and geographically situated in such a manner that the initiative for the development of modern art now lay with them. Originally published in *Tiger's Eye*, vol. 1, no. 6, December 1948, pp. 51–3.

The invention of beauty by the Greeks, that is, their postulate of beauty as an ideal, has been the bugbear of European art and European aesthetic philosophies. Man's natural desire in the arts to express his relation to the Absolute became identified and confused with the absolutisms of perfect creations – with the fetish of quality – so that the European artist has been continually involved in the moral struggle between notions of beauty and the desire for sublimity.

The confusion can be seen sharply in Longinus, who despite his knowledge of non-Grecian art, could not extricate himself from his platonic attitudes concerning beauty, from the problem of value, so that to him the feeling of exaltation became synonymous with the perfect statement – an objective rhetoric. But the confusion continued on in Kant, with his theory of transcendent perception, that the phenomenon is *more* than phenomenon; and with Hegel, who built a theory of beauty, in which the sublime is at the bottom of a structure of *kinds of beauty*, thus creating a range of hierarchies in a set of relationships to reality that is completely formal. (Only Edmund Burke insisted on a separation. Even though it is an unsophisticated and primitive one, it is a clear one and it would be interesting to know how closely the Surrealists were influenced by it. To me Burke reads like a Surrealist manual.)

The confusion in philosophy is but the reflection of the struggle that makes up the history of the plastic arts. To us today there is no doubt that Greek art is an insistence that the sense of exaltation is to be found in perfect form, that exaltation is the same as ideal sensibility, in contrast, for example, with the Gothic or Baroque, in which the sublime consists of a desire to destroy form; where form can be formless.

The climax in this struggle between beauty and the sublime can best be examined inside the Renaissance and the reaction later against the Renaissance that is known as modern art. In the Renaissance the revival of the ideals of Greek beauty set the artists the task of rephrasing an accepted Christ legend in terms of absolute beauty as against the original Gothic ecstacy over the legend's evocation of the Absolute. And the Renaissance artists dressed up the traditional ecstacy in an even older tradition – that of eloquent nudity or rich velvet. It was no idle quip that moved Michelangelo to call himself a sculptor rather than a painter, for he knew that only in his sculpture could the desire for the grand statement of Christian sublimity be reached. He could despise with good reason the beauty-cults who felt the Christ drama on a stage of rich velvets and

brocades and beautifully textured flesh tints. Michelangelo knew that the meaning of the Greek humanities for his time involved making Christ – the man, into Christ – who is God; that his plastic problem was neither the medieval one, to make a cathedral, nor the Greek one, to make a man like a god, but to make a cathedral out of man. In doing so he set a standard for sublimity that the painting of his time could not reach. Instead, painting continued on its merry quest for a voluptuous art until in modern times, the Impressionists, disgusted with its inadequacy, began the movement to destroy the established rhetoric of beauty by the Impressionist insistence on a surface of ugly strokes.

The impulse of modern art was this desire to destroy beauty. However, in discarding Renaissance notions of beauty, and without an adequate substitute for a sublime message, the Impressionists were compelled to preoccupy themselves, in their struggle, with the culture values of their plastic history so that instead of evoking a new way of experiencing life they were able only to make a transfer of values. By glorifying their own way of living, they were caught in the problem of what is really beautiful and could only make a restatement of their position on the general question of beauty; just as later the Cubists, by their Dada gestures of substituting a sheet of newspaper and sandpaper for both the velvet surfaces of the Renaissance and the Impressionists, made a similar transfer of values instead of creating a new vision, and succeeded only in elevating the sheet of paper. So strong is the grip of the *rhetoric* of exaltation as an attitude in the large context of the European culture pattern that the elements of sublimity in the revolution we know as modern art, exist in its effort and energy to escape the pattern rather than in the realization of a new experience. Picasso's effort may be sublime but there is no doubt that his work is a preoccupation with the question of what is the nature of beauty. Even Mondrian, in his attempt to destroy the Renaissance picture by his insistence on pure subject matter, succeeded only in raising the white plane and the right angle into a realm of sublimity, where the sublime paradoxically becomes an absolute of perfect sensations. The geometry (perfection) swallowed up his metaphysics (his exaltation).

The failure of European art to achieve the sublime is due to this blind desire to exist inside the reality of sensation (the objective world, whether distorted or pure) and to build an art within a framework of pure plasticity (the Greek ideal of beauty, whether that plasticity be a romantic active surface, or a classic stable one). In other words, modern art, caught without a sublime content, was incapable of creating a new sublime image, and unable to move away from the Renaissance imagery of figures and objects except by distortion or by denying it completely for an empty world of geometric formalisms – a *pure* rhetoric of abstract mathematical relationships, became enmeshed in a struggle over the nature of beauty; whether beauty was in nature or could be found without nature.

I believe that here in America, some of us, free from the weight of European culture, are finding the answer, by completely denying that art has any concern with the problem of beauty and where to find it. The question that now arises is how, if we are living in a time without a legend or mythos that can be called sublime, if we refuse to admit any exaltation in pure relations, if we refuse to live in the abstract, how can we be creating a sublime art?

We are reasserting man's natural desire for the exalted, for a concern with our relationship to the absolute emotions. We do not need the obsolete props of an

outmoded and antiquated legend. We are creating images whose reality is self-evident and which are devoid of the props and crutches that evoke associations with outmoded images, both sublime and beautiful. We are freeing ourselves of the impediments of memory, association, nostalgia, legend, myth, or what have you, that have been the devices of Western European painting. Instead of making *cathedrals* out of Christ, man, or 'life,' we are making it out of ourselves, out of our own feelings. The image we produce is the self-evident one of revelation, real and concrete, that can be understood by anyone who will look at it without the nostalgic glasses of history.

12 Willem de Kooning (1904–1997) 'A Desperate View'

De Kooning's work of the thirties and early forties was dominated by figure compositions influenced by the technical legacy of the European avant-garde, notably Picasso and Miró. But during the years between the end of the Second World War and 1950, his work was marked by a series of gestural, all-over, apparently abstract compositions, many of which tended to monochrome. Ten such works were shown in De Kooning's first one-man exhibition in New York in April 1948. Press coverage and other solo and group exhibitions rapidly followed. De Kooning's work of the period is generally regarded as culminating in *Attic* of 1949, and *Excavation*, completed in June 1950, and shown in the Venice Biennale of that year. The starkness of colour, the turbulent brushwork, and the vestigial traces of parts of figures led to an existentialist type of interpretation, in line with pervasive ideas of an 'age of anxiety'. It was during this time, in 1949, that De Kooning delivered a talk entitled 'A Desperate View' at the 'Subjects of the Artist' school in Greenwich Village, New York. This was an independent school organized by Rothko, Motherwell, Clyfford Still (briefly) and Barnett Newman. It opened in October 1948, continued in the spring term of 1949, and closed in April 1950. In addition to De Kooning's talk, others were given by Rothko, Gottlieb and Reinhardt. Joseph Cornell showed films, Huelsenbeck spoke on Dada, and John Cage on Indian sand painting. De Kooning's talk, reprinted here in full, is taken from *The Collected Writings of Willem de Kooning*, Madras and New York: Hanuman Books, 1988, pp. 9–14.

My interest in desperation lies only in that sometimes I find myself having become desperate. Very seldom do I start out that way. I can see of course that, in the abstract, thinking and all activity is rather desperate. When an idea is given, one is struck with it. You cannot help seeing it and even using it as a possibility. In Genesis, it is said that in the beginning was the void and God acted upon it. For an artist that is clear enough. It is so mysterious that it takes away all doubt. One is utterly lost in space forever. You can float in it, fly in it, suspend in it and today, it seems, to tremble in it is maybe best or anyhow very fashionable. The idea of being integrated with it is a desperate idea. In art, one idea is as good as another. If one takes the idea of trembling, for instance, all of a sudden most of art starts to tremble. Michelangelo starts to tremble. El Greco starts to tremble. All the impressionists start to tremble. The Egyptians are trembling invisibly and so do Vermeer and Giacometti and all of a sudden, for the time being, Raphael is languid and nasty; Cezanne was always trembling but very precisely.

 The only certainty today is that one must be self-conscious. The idea of order can only come from above. Order, to me, is to be ordered about and that is a limitation.

An artist is forced by others to paint out of his own free will. If you take the attitude that it is not possible to do something, you have to prove it by doing it.

Art should *not* have to be a certain way. It is no use worrying about being related to something it is impossible not to be related to. Style is a fraud. I always felt that the Greeks were hiding behind their columns. It was a horrible idea of van Doesburg and Mondrian to try to force a style. The reactionary strength of power is that it keeps style and things going.

It is impossible to find out how a style began. I think it is the most bourgeois idea to think one can make a style before hand. To desire to make a style is an apology for one's anxiety. Anyhow, I think innovators come at the end of a period. Cezanne gave the finishing touches to Impressionism before he came face to face with his 'little sensation'.

Whatever an artist's personal feelings are, as soon as an artist fills a certain area on the canvas or circumscribes it, he becomes historical. He acts from or upon other artists.

An artist is someone who makes art too. He did not invent it. How it started – 'to hell with it.' It is obvious that it has no progress. The idea of space is given him to change if he can. The subject matter in the abstract is *space*. He fills it with an attitude. The attitude never comes from himself alone.

You are with a group or movement because you cannot help it.

13 Jackson Pollock (1912–1956) Interview with William Wright

Taped in the summer of 1950 by William Wright for the Sag Harbor radio station, but not broadcast. Pollock's most successful show of all-over abstract paintings was held later in the same year. Transcript published in F. V. O'Connor, *Jackson Pollock*, New York: The Museum of Modern Art, 1967, pp. 79–81.

Mr Pollock, in your opinion, what is the meaning of modern art?

JP: Modern art to me is nothing more than the expression of contemporary aims of the age that we're living in.

Did the classical artists have any means of expressing their age?

JP: Yes, they did it very well. All cultures have had means and techniques of expressing their immediate aims – the Chinese, the Renaissance, all cultures. The thing that interests me is that today painters do not have to go to a subject matter outside of themselves. Most modern painters work from a different source. They work from within.

Would you say that the modern artist has more or less isolated the quality which made the classical works of art valuable, that he's isolated it and uses it in a purer form?

JP: Ah – the good ones have, yes.

Mr Pollock, there's been a good deal of controversy and a great many comments have been made regarding your method of painting. Is there something you'd like to tell us about that?

JP: My opinion is that new needs need new techniques. And the modern artists have found new ways and new means of making their statements. It seems to me that the modern painter cannot express this age, the airplane, the atom bomb, the radio, in

the old forms of the Renaissance or of any other past culture. Each age finds its own technique.

Which would also mean that the layman and the critic would have to develop their ability to interpret the new techniques.

JP: Yes – that always somehow follows. I mean, the strangeness will wear off and I think we will discover the deeper meanings in modern art.

I suppose every time you are approached by a layman they ask you how they should look at a Pollock painting, or any other modern painting – what they look for – how do they learn to appreciate modern art?

JP: I think they should not look for, but look passively – and try to receive what the painting has to offer and not bring a subject matter or preconceived idea of what they are to be looking for.

Would it be true to say that the artist is painting from the unconscious, and the – canvas must act as the unconscious of the person who views it?

JP: The unconscious is a very important side of modern art and I think the unconscious drives do mean a lot in looking at paintings.

Then deliberately looking for any known meaning or object in an abstract painting would distract you immediately from ever appreciating it as you should?

JP: I think it should be enjoyed just as music is enjoyed – after a while you may like it or you may not. But – it doesn't seem to be too serious. I like some flowers and others, other flowers I don't like. I think at least it gives – I think at least give it a chance.

Well, I think you have to give anything that sort of chance. A person isn't born to like good music, they have to listen to it and gradually develop an understanding of it or liking for it. If modern painting works the same way – a person would have to subject himself to it over a period of time in order to be able to appreciate it.

JP: I think that might help, certainly.

Mr Pollock, the classical artists had a world to express and they did so by representing the objects in that world. Why doesn't the modern artist do the same thing?

JP: H'm – the modern artist is living in a mechanical age and we have a mechanical means of representing objects in nature such as the camera and photograph. The modern artist, it seems to me, is working and expressing an inner world – in other words – expressing the energy, the motion, and other inner forces.

Would it be possible to say that the classical artist expressed his world by representing the objects, whereas the modern artist expresses his world by representing the effects the objects have upon him?

JP: Yes, the modern artist is working with space and time, and expressing his feelings rather than illustrating.

Well, Mr Pollock, can you tell us how modern art came into being?

JP: It didn't drop out of the blue; it's a part of a long tradition dating back with Cézanne, up through the cubists, the post-cubists, to the painting being done today.

Then, it's definitely a product of evolution?

JP: Yes.

Shall we go back to this method question that so many people today think is important? Can you tell us how you developed your method of painting, and why you paint as you do?

JP: Well, method is, it seems to me, a natural growth out of a need, and from a need the modern artist has found new ways of expressing the world about him. I happen

to find ways that are different from the usual techniques of painting, which seems a little strange at the moment, but I don't think there's anything very different about it. I paint on the floor and this isn't unusual – the Orientals did that.

How do you go about getting the paint on the canvas? I understand you don't use brushes or anything of that sort, do you?

JP: Most of the paint I use is a liquid, flowing kind of paint. The brushes I use are used more as sticks rather than brushes – the brush doesn't touch the surface of the canvas, it's just above.

Would it be possible for you to explain the advantage of using a stick with paint – liquid paint rather than a brush on canvas?

JP: Well, I'm able to be more free and to have greater freedom and move about the canvas, with greater ease.

Well, isn't it more difficult to control than a brush? I mean, isn't there more a possibility of getting too much paint or splattering or any number of things? Using a brush, you put the paint right where you want it and you know exactly what it's going to look like.

JP: No, I don't think so. I don't – ah – with experience – it seems to be possible to control the flow of the paint, to a great extent, and I don't use – I don't use the accident – cause I deny the accident.

I believe it was Freud who said there's no such thing as an accident. Is that what you mean?

JP: I suppose that's generally what I mean.

Then, you don't actually have a preconceived image of a canvas in your mind?

JP: Well, not exactly – no – because it hasn't been created, you see. Something new – it's quite different from working, say, from a still life where you set up objects and work directly from them. I do have a general notion of what I'm about and what the results will be.

That does away, entirely, with all preliminary sketches?

JP: Yes, I approach painting in the same sense as one approaches drawing; that is, it's direct. I don't work from drawings, I don't make sketches and drawings and color sketches into a final painting. Painting, I think today – the more immediate, the more direct – the greater the possibilities of making a direct – of making a statement.

Well, actually every one of your paintings, your finished canvases, is an absolute original.

JP: Well – yes – they're all direct painting. There is only one.

Well, now, Mr Pollock, would you care to comment on modern painting as a whole? What is your feeling about your contemporaries?

JP: Well, painting today certainly seems very vibrant, very alive, very exciting. Five or six of my contemporaries around New York are doing very vital work, and the direction that painting seems to be taking here – is – away from the easel – into some sort, some kind of wall – wall painting.

I believe some of your canvases are of very unusual dimensions, isn't that true?

JP: Well, yes, they're an impractical size – 9 × 18 feet. But I enjoy working big and – whenever I have a chance, I do it whether it's practical or not.

Can you explain why you enjoy working on a large canvas more than on a small one?

JP: Well, not really. I'm just more at ease in a big area than I am on something 2 × 2; I feel more at home in a big area.

You say 'in a big area.' Are you actually on the canvas while you're painting?

JP: Very little. I do step into the canvas occasionally – that is, working from the four sides I don't have to get into the canvas too much.

I notice over in the corner you have something done on plate glass. Can you tell us something about that?

JP: Well, that's something new for me. That's the first thing I've done on glass and I find it very exciting. I think the possibilities of using painting on glass in modern architecture – in modern construction – terrific.

Well, does the one on glass differ in any other way from your usual technique?

JP: It's pretty generally the same. In this particular piece I've used colored glass sheets and plaster slabs and beach stones and odds and ends of that sort. Generally it's pretty much the same as all of my paintings.

Well, in the event that you do more of these for modern buildings, would you continue to use various objects?

JP: I think so, yes. The possibilities, it seems to me are endless, what one can do with glass. It seems to me a medium that's very much related to contemporary painting.

Mr Pollock, isn't it true that your method of painting, your technique, is important and interesting only because of what you accomplish by it?

JP: I hope so. Naturally, the result is the thing – and – it doesn't make much difference how the paint is put on as long as something has been said. Technique is just a means of arriving at a statement.

14 David Smith (1906–1965) 'Aesthetics, the Artist and the Audience'

Smith was the foremost American sculptor of his generation. He made his first welded-iron work in 1933 and continued to pursue open and constructed forms of sculpture until his death. Like his contemporaries among the painters, he expresses a marked confidence in the vitality of modern American art. This is the text of a speech given at Deerfield, Massachusetts, on 24 September 1952. Printed in Garnett McCoy (ed.), *David Smith*, New York and London, 1973, pp. 88–107. (For a later text by Smith see VIB2.)

I wish to present my conclusions first and start my presentation backward.

Time is a new dimension in sculpture, and since I don't accent bulkmass and prefer open delineation and transparent form – so that the front views through to the back – the same method by statement may work as well.

To the creative artist, in the making of art it is doubtful whether aesthetics have any value to him.

The truly creative artist deals with vulgarity.

Nobody understands art but the artist.

Affection for art is the sole property of the artist. The majority approach art with hostility.

The artist deserves to be belligerent to the majority.

The artist is a product of his time, and his belligerence is a defense and not a preference.

There is no such thing as a layman. The layman is either an art lover or an art rejector.

The viewer of art, the art lover, has the privilege of accepting or rejecting. But there is no such thing as a layman. He is either a pretender or the verbalizer.

Masterpieces are made today.

Aesthetics are written conclusions or directives. The creative artist should not be impressed by verbal directives. His aesthetics are primarily unconscious and of a visual recording. No words or summations are involved. The artist does not deny aesthetics or the history of art. The myth in art, the history of art, are both enjoyed and used, but they are utilized by the memory of vision which is the only language in which the artist who made the work of art intended it to be understood.

I have spoken of the artist's use of the vulgar. But this term I use because, to the professional aesthetician, it is a vulgarity in his code of beauty, because he has not recognized it as yet or made rules for its acceptance. To the creative artist it is his beauty, but to the audience, who will wait for the aesthetician's explanation, it is too new and has not yet hammered its way into acceptance. It will not conform to the past, it is beyond the pale. Art aestheticians can only make conclusions or discourse after the work of art is made. The birth of the idea, the concept, is the important act in the work of art.

Nobody understands art but the artist because nobody is as interested in art, its pursuit, its making, as the artist. This need eliminate no one from enjoying any art – if they do not limit it with preconceived notions of what art should be or demand confinement in which it should stay. The true way to understand the work of art is to travel the path by visual response, similar to the method the artist used in arriving at the work.

Does the onlooker realize the amount of affection which goes into a work of art – the intense affection – belligerent vitality – and total conviction? To the artist it must be total to provide satisfaction. Does the critic, the audience, the philosopher even possess the intensity of affection for the work which its creator possessed? Can they project or understand this belligerent vitality and affection which contemporary art possesses? Or do they deal in the quality at all? Is this emotion too highly keyed – is it outside their lives? Or are they too skeptical? Or do they need written confirmation and general acceptance before they will let their own natural response be admitted to themselves?

All the artists I know find survival and the right to work by means other than the sale of their work. Their work speaks solely by their own conviction. They are not beholden to tradition or directives other than their own. Any artist must meet the world with his work. When he meets the world, what is his aim? Is there a need for aim, if the inner convictions and drive are so great that he will not settle for anything short of the fact that being an artist – and to exercise his mode of expression – is the most important pursuit in the world?

Since the artist cannot exist outside his time, certain social pressure has affected him, certain critical opinion has directed him. He feels the majority rejection, so for whom does he make art? For himself first, for the opinion of other artists next, and specifically those artists in his own mores and in his own aesthetic realm. But his world and his realm is the same world that all others inhabit. He has no secret code or key, no special foresight, environment, brilliance, erudition. He exercises the right of vision – projection – by his own choice. His preference is to be a working and recognized member of his culture, and to have his work accepted. [...]

Yes, masterpieces are made today. Masterpieces are only works of art that people especially like. The twentieth century has produced very many. Present-day, contemporary America is producing masterpieces – a virile, aggressive, increasing number of painters and sculptors not before produced here. [. . .]

The aesthetics of contemporary American art have not been written. The forward movement does not have a name. Its heritage is certainly post-Fauvist, post-Cubist, post-Expressionist, post-purist, post-Constructivist. But there are certain outstanding elements involved. One of the forces is freedom, and a belligerent freedom, to reject the established tradition of the verbal aestheticians, philosophers, and critics; instead to express emotionally and directly with the artist himself as subject, without concession to the classic routine, still life, sex, mono-object and the other historic forms. Possibly this is too free, too defiant, to accept that the soul of man's total belief can be the subject of art. No subject is taboo in art. Why cannot the nature of man himself be the subject? There is no order but the order of man. Yet this is great order. There is not even form, as we traditionally know it. There is no chiaroscuro of solid bodies; now space becomes solid, and solids become transparent. Why should we worry that sculpture isn't chiaroscurally solid? Concept is more important than chiaroscuro. Nothing is really unsolid. Mass is energy, space is energy, space is mass. Whether such things are scientific facts is very, very unimportant. Art is poetic. It is poetically irrational. The irrational is the major force in man's nature. And as such the artist still deals with nature. Neither artist nor audience can deal with concepts that are not nature.

15 Clyfford Still (1904–1980) Statement

Still worked and taught in California from 1946 to 1950 and moved to New York in 1951. This statement was written to accompany the work included in an exhibition at the Museum of Modern Art, New York, the following year. As the tenor of Still's writing indicates, there are connections to be made between the concerns of the American avant-garde and the contemporary concerns of European Existentialism (VB2 and 11). Published in Dorothy C. Miller (ed.), *15 Americans*, New York, 1952, pp. 21–2.

That pigment on canvas has a way of initiating conventional reactions for most people needs no reminder. Behind these reactions is a body of history matured into dogma, authority, tradition. The totalitarian hegemony of this tradition I despise, its presumptions I reject. Its security is an illusion, banal, and without courage. Its substance is but dust and filing cabinets. The homage paid to it is a celebration of death. We all bear the burden of this tradition on our backs but I cannot hold it a privilege to be a pallbearer of my spirit in its name.

From the most ancient times the artist has been expected to perpetuate the values of his contemporaries. The record is mainly one of frustration, sadism, superstition, and the will to power. What greatness of life crept into the story came from sources not yet fully understood, and the temples of art which burden the landscape of nearly every city are a tribute to the attempt to seize this elusive quality and stamp it out.

The anxious men find comfort in the confusion of those artists who would walk beside them. The values involved, however, permit no peace, and mutual resentment is deep when it is discovered that salvation cannot be bought.

We are now committed to an unqualified act, not illustrating outworn myths or contemporary alibis. One must accept total responsibility for what he executes. And the measure of his greatness will be in the depth of his insight and his courage in realizing his own vision.

Demands for communication are both presumptuous and irrelevant. The observer usually will see what his fears and hopes and learning teach him to see. But if he can escape these demands that hold up a mirror to himself, then perhaps some of the implications of the work may be felt. But whatever is seen or felt it should be remembered that for me these paintings had to be something else. It is the price one has to pay for clarity when one's means are honoured only as an instrument of seduction or assault.

16 Harold Rosenberg (1906–1978) from 'The American Action Painters'

In the critical representation of Abstract Expressionism, Rosenberg and Greenberg were responsible for the two dominant modes, the former emphasizing existential drama and commitment where the latter concentrated upon formal and technical innovation. 'Action Painting' was the designation under which the new informal abstract art of the 1940s and 1950s first became widely known in English-language criticism, to be gradually supplanted by the now more widespread 'Abstract Expressionism' – a term which tends specifically to identify the work of American painters rather than their comparable European contemporaries. In fact Rosenberg may originally have intended his title to carry a connotation of political commitment which has largely been ignored (i.e. to read as 'American-Action Painters' rather than as 'American Action-Painters'). Echoing a theme from his earlier 'Fall of Paris' (IVD12), he identifies America as the new locus of the 'International of Culture', and 'Action Painting' as the advanced form of that culture, in which the possibility of revolution is kept alive at least in imagination. Originally published in *Art News*, New York, LI, December 1952, pp. 22ff. Reprinted in Rosenberg, *The Tradition of the New*, New York, 1959, pp. 23–39. The present extract is taken from the first half of the essay.

Getting Inside the Canvas

At a certain moment the canvas began to appear to one American painter after another as an arena in which to act – rather than as a space in which to reproduce, redesign, analyse or 'express' an object, actual or imagined. What was to go on the canvas was not a picture but an event.

The painter no longer approached his easel with an image in his mind; he went up to it with material in his hand to do something to that other piece of material in front of him. The image would be the result of this encounter.

* * *

Call this painting 'abstract' or 'Expressionist' or 'Abstract-Expressionist', what counts is its special motive for extinguishing the object, which is not the same as in other abstract or Expressionist phases of modern art.

The new American painting is not 'pure' art, since the extrusion of the object was not for the sake of the aesthetic. The apples weren't brushed off the table in order to

make room for perfect relations of space and colour. They had to go so that nothing would get in the way of the act of painting. In this gesturing with materials the aesthetic, too, has been subordinated. Form, colour, composition, drawing, are auxiliaries, any one of which – or practically all, as has been attempted logically, with unpainted canvases – can be dispensed with. What matters always is the revelation contained in the act. It is to be taken for granted that in the final effect, the image, whatever be or be not in it, will be a *tension*.

Dramas Of As If

A painting that is an act is inseparable from the biography of the artist. The painting itself is a 'moment' in the adulterated mixture of his life – whether 'moment' means the actual minutes taken up with spotting the canvas or the entire duration of a lucid drama conducted in sign language. The act-painting is of the same metaphysical substance as the artist's existence. The new painting has broken down every distinction between art and life.

It follows that anything is relevant to it. Anything that has to do with action – psychology, philosophy, history, mythology, hero worship. Anything but art criticism. The painter gets away from art through his act of painting; the critic can't get away from it. The critic who goes on judging in terms of schools, styles, form – as if the painter were still concerned with producing a certain kind of object (the work of art), instead of living on the canvas – is bound to seem a stranger. [...]

Art – relation of the painting to the works of the past, rightness of colour, texture, balance, etc. – comes back into painting by way of psychology. As Stevens says of poetry, 'it is a process of the personality of the poet.' But the psychology is the psychology of creation. Not that of the so-called psychological criticism that wants to 'read' a painting for clues to the artist's sexual preferences or debilities. The work, the act, translates the psychologically given into the intentional, into a 'world' – and thus transcends it.

With traditional aesthetic references discarded as irrelevant, what gives the canvas its meaning is not psychological data but *role*, the way the artist organizes his emotional and intellectual energy as if he were in a living situation. The interest lies in the kind of act taking place in the four-sided arena, a dramatic interest.

Criticism must begin by recognizing in the painting the assumptions inherent in its mode of creation. Since the painter has become an actor, the spectator has to think in a vocabulary of action: its inception, duration, direction – psychic state, concentration and relaxation of the will, passivity, alert waiting. He must become a connoisseur of the gradations between the automatic, the spontaneous, the evoked.

'It's Not That, It's Not That, It's Not That'

With a few important exceptions, most of the artists of this vanguard found their way to their present work by being cut in two. Their type is not a young painter but a re-born one. The man may be over forty, the painter around seven. The diagonal of a grand crisis separates him from his personal and artistic past.

Many of the painters were 'Marxists' (WPA unions, artists' congresses); they had been trying to paint Society. Others had been trying to paint Art (Cubism, Post-Impressionism) – it amounts to the same thing.

The big moment came when it was decided to paint . . . just TO PAINT. The gesture on the canvas was a gesture of liberation, from Value – political, aesthetic, moral.

If the war and the decline of radicalism in America had anything to do with this sudden impatience, there is no evidence of it. About the effects of large issues upon their emotions, Americans tend to be either reticent or unconscious. The French artist thinks of himself as a battleground of history; here one hears only of private Dark Nights. Yet it is strange how many segregated individuals came to a dead stop within the past ten years and abandoned, even physically destroyed, the work they had been doing. A far-off watcher unable to realize that these events were taking place in silence might have assumed they were being directed by a single voice.

At its centre the movement was away from, rather than towards. The Great Works of the Past and the Good Life of the Future became equally nil.

The refusal of values did not take the form of condemnation or defiance of society, as it did after the First World War. It was diffident. The lone artist did not want the world to be different, he wanted his canvas to be a world. Liberation from the object meant liberation from the 'nature', society and art already there. It was a movement to leave behind the self that wished to choose his future and to nullify its promissory notes to the past.

With the American, heir of the pioneer and the immigrant, the foundering of Art and Society was not experienced as a loss. On the contrary, the end of Art marked the beginning of an optimism regarding himself as an artist.

The American vanguard painter took to the white expanse of the canvas as Melville's Ishmael took to the sea.

On the one hand, a desperate recognition of moral and intellectual exhaustion; on the other, the exhilaration of an adventure over depths in which he might find reflected the true image of his identity.

Painting could now be reduced to that equipment which the artist needed for an activity that would be an alternative to both utility and idleness. Guided by visual and somatic memories of paintings he had seen or made – memories which he did his best to keep from intruding into his consciousness – he gesticulated upon the canvas and watched for what each novelty would declare him and his art to be.

Based on the phenomenon of conversion the new movement is, with the majority of the painters, essentially a religious movement. In almost every case, however, the conversion has been experienced in secular terms. The result has been the creation of private myths.

The tension of the private myth is the content of every painting of this vanguard. The act on the canvas springs from an attempt to resurrect the saving moment in his 'story' when the painter first felt himself released from Value – myth of past self-recognition. Or it attempts to initiate a new moment in which the painter will realize his total personality – myth of future self-recognition.

Some formulate their myth verbally and connect individual works with its episodes. With others, usually deeper, the painting itself is the exclusive formulation, a Sign.

The revolution against the given, in the self and in the world, which since Hegel has provided European vanguard art with theories of a New Reality, has re-entered America in the form of personal revolts. Art as action rests on the enormous

assumption that the artist accepts as real only that which he is in the process of creating. 'Except the soul has divested itself of the love of created things…' The artist works in a condition of open possibility, risking, to follow Kierkegaard, the anguish of the aesthetic, which accompanies possibility lacking in reality. To maintain the force to refrain from settling anything, he must exercise in himself a constant No. [...]

17 Clyfford Still (1904–1980) Letter to Gordon Smith

Written for the catalogue of a collection of Still's work held at the Buffalo Fine Arts Academy, Albright-Knox Art Gallery, of which Smith was director. The collection was exhibited from 5 November to 13 December 1959, and the catalogue *Paintings by Clyfford Still* was published on that occasion. The letter is dated 1 January, 1959.

Your suggestion that I write a few notes for the catalog of this collection of paintings raises the same interest and the same qualifications that were present when the exhibition itself was first considered. The paradox manifest by the appearance of this work in an institution whose meaning and function must point in a direction opposite to that implied in the paintings – and my own life – was accepted. I believe it will not be resolved, but instead will be sharpened and clarified. For it was never a problem of aesthetics, or public or private acceptance, that determined my responsibility to the completed work. Rather, it was the hope to make clear its conceptual germination of idea and vision, without which all art becomes but an exercise in conformity with shifting fashions or tribal ethics. Perhaps a brief review is in order –.

In the few directions we were able to look during the 1920s, whether to past cultures or the scientific, aesthetic, and social myths of our own, it was amply evident that in them lay few answers valid for insight or imagination.

The fog had been thickened, not lifted, by those who, out of weakness or for positions of power, looked back to the Old World for means to extend their authority in this newer land. Already mired by moralists and utilitarians in the swamps of folkways and synthetic traditions, we were especially vulnerable to the mechanistic interpretations of motive and meaning. There followed a deluge of total confusion.

Self-appointed spokesmen and self-styled intellectuals with the lust of immaturity for leadership invoked all the gods of Apology and hung them around our necks with compulsive and sadistic fervor. Hegel, Kierkegaard, Cézanne, Freud, Picasso, Kandinsky, Plato, Marx, Aquinas, Spengler, Einstein, Bell, Croce, Monet – the list grows monotonous. But that ultimate in irony – the Armory Show of 1913 – had dumped upon us the combined and sterile conclusions of Western European decadence. For nearly a quarter of a century we groped and stumbled through the nightmare of its labyrinthine evasions. And even yet its banalities and trivia are welcomed and exploited by many who find the aura of death more reassuring than their impotence or fears. No one was permitted to escape its fatalistic rituals – yet I, for one, refused to accept its ultimatums.

To add to the body of reference or 'sensibility' which indulges homage or acquiescence to the collectivist rationale of our culture, I must equate with intellectual suicide.

The omnivorousness of the totalitarian mind, however, demands a rigor of purpose and subtlety of insight from anyone who would escape incorporation.

Semantically and ethically the corruption is complete. Preoccupation with luminous devices is equated with spiritual enlightenment. The laws of Euclid are publicly damned to promote work illustrating an authoritarian dialectic. Witless parodies are displayed as evidence of social artistic commitment; and qualitative arrangements are presented as evidence of access to supernal mysteries. The rush to betray, in the name of aesthetics or 'painting', an imagery born in repudiation of socio-psychological fallacies becomes a popular, but sinister, measure of its power.

Unknown are the crimes not covered by the skirts of that ubiquitous old harridan called Art. Even the whimperings and insolence of the venal are treasured in her name – and for their reassurance – by the arrogant and contemptuous. Indeed, among ambitious esthetes, artists, architects, and writers, the burden of our heritage is borne lightly but mainly by hatred or cyncism. The impudence and sterility which so hypnotically fascinate the indifferent, perform a sordid substitute for responsibility and truth.

I held it imperative to evolve an instrument of thought which would aid in cutting through all cultural opiates, past and present, so that a direct, immediate, and truly free vision could be achieved, and an idea be revealed with clarity.

To acquire such an instrument, however – one that would transcend the powers of conventional technics and symbols, yet be as an aid and instant critic of thought – demanded full resolution of the past, and present, through it. No shouting about individualism, no capering before an expanse of canvas, no manipulation of academic conceits or technical fetishes can truly liberate. These only make repetition inevitable and compound deceit.

Thus it was necessary to reject the superficial value of material – its qualities, its tensions, and its concomitant ethic. Especially it became necessary not to remain trapped in the banal concepts of space and time, nor yield to the morbidity of 'the objective position'; nor to permit one's courage to be perverted by authoritarian devices for social control.

It was as a journey that one must make, walking straight and alone. No respite or short-cuts were permitted. And one's will had to hold against every challenge of triumph, or failure, or the praise of Vanity Fair. Until one had crossed the darkened and wasted valleys and come at last into clear air and could stand on a high and limitless plain. Imagination, no longer fettered by the laws of fear, became as one with Vision. And the Act, intrinsic and absolute, was its meaning, and the bearer of its passion.

The work itself, whether thought of as image of Idea, as revelation, or as a manifest of meaning, could not have existed without a profound concern to achieve a purpose beyond vanity, ambition, or remembrance, for a man's term of life. Yet, while one looks at this work, a warning should be given, lest one forget, among the multitude of issues, the relation I bear to those with 'eyes'. Although the reference is in a different context and for another purpose, a metaphor is pertinent as William Blake set it down:

> The Vision of Christ that thou dost see
> Is my Vision's Greatest Enemy:
> Thine is the friend of All Mankind,
> Mine speaks in parables to the Blind:

Therefore, let no man under-value the implications of this work or its power for life:– or for death, if it is misused.

Although several large and significant areas of the work can not be exhibited, I believe what will be shown will justify the interest and effort you have so courageously given.

VB
Individualism in Europe

1 Wols (Alfred Otto Wolfgang Schulze, 1913–1951) Aphorisms

After displaying a precocious musical ability during adolescence, Schulze began to dabble in photography, and at the age of nineteen attended the Bauhaus in Berlin, where it had recently moved from Dessau. Moholy-Nagy advised him to move to Paris, where he duly arrived in 1933. He became acquainted with the Surrealists, and for the rest of the thirties pursued a career as a photographer, adopting the pseudonym Wols. His Surrealist-inspired photographic work appeared in various fashion magazines, and he won a contract to photograph the fashion pavilion at the International Exhibition in 1937. However, the outbreak of war in 1939 led to his temporary internment as an enemy alien. With a career in photography now ruled out, Wols lived precariously in the south of France, developing the ink drawings and poems he had worked on privately in the thirties. When he returned to Paris after the Liberation, these drawings made an immediate impact on the Existentialist circle around Sartre (see VB6). Wols' first exhibition took place at the Galerie René Drouin in December 1945. At this time he was living in extreme poverty in cheap hotels on the Left Bank, financially supported by Sartre and others. Drouin provided him with painting materials, and the resulting pictures were exhibited, again at Drouin's, in 1947. In 1949 he took part there in the exhibition *Huit oeuvres nouvelles*, in the company of Dubuffet, Fautrier, Mathieu and Michaux. Michel Tapié took his work to be exemplary of a new aesthetic, which he dubbed 'un art autre', publishing a book of the same title in 1952 (see VB12). In his final years Wols suffered from illness and from the alcoholism to which he had succumbed during the war. He died of food poisoning at the age of thirty-eight. The aphorisms in which Wols set down his world-view were composed throughout the 1940s and are unnumbered and, with one exception, undated. The present selection is made from the translation by Peter Inch and Annie Fatet, published as *Wols. Aphorisms and Pictures*, Gillingham: Arc Press, 1971.

> The universe is a unity
> making itself manifest
> through an infinite number
> of relative phenomena
> in part accessible to our senses
> (in their relativity).
> Only through things
> do we sense the unity.
>
> Unity is not the blend of what we
> see or think, it *is*. From itself

it lets perishable details be seen
or glimpsed or sensed, forms, objects etc. –
which go back (their span completed) into
universal nothingness where neither misery nor happiness
is individual.

If the world could
have had the chance
of not existing,
existence could have existed.

Man is no more interesting
than other temporary manifestations.
Since god is in everything
it is superfluous
to personify him,
to name God
or to learn
anything by heart.
Keeping to what is simple is implied and normal.
When one sees one must not worry
at what one could do with what one can see
but see what is there.

It is likely that God prefers
flies to men.
Anthropods are technically superior
to man.
The day a butterfly has been beautiful
it has done its task.
It is doubtful if man
can reach the level of wasps.

Man looks at everything in terms of human interest:
to such an extent
that he does not comprehend things for themselves;
to nature he is useless;
he uses it, without being able
to render it the least service.

One who mistakes what he sees for truth is wrong.
The conception a dog has
(with nearly the same organs as man)
can already be sensibly different
and no more wrong, nor more true.

One is born – one dies
one comes from the great nothing and one goes back there
it is laughable
before one is neutral

after one is neutral
without people
there it is
one does not understand (the mediocre outcome).

A priori, if a man
is really interested in himself
he must formulate his answer to the question
am I a vessel
a funnel
a fountain?
or nothing?

Of all the things one finds on earth
man is the most inconvenient.

Chance, seeing that it is not
chance, is a great master;
chance only exists in our eyes
it is an agent for the master 'universe'.

Eyes shut, I often watch
what I see;
everything is there, beautiful, tiring.

People with waking dreams get to
know of a thousand things
which escape those who only
dream in sleep.

Seeing is shutting one's eyes.

Seeing to the bottom of things
is merely seeing a solitary single thing.
Seeing deeply
is seeing a thing that is unique.

If you could see to the bottom of a thing.
you would realise it is one and the same as that
in your own me.
But is it possible to see right down there?
To feel it, to love it.

Eyes open
eyes shut
we find
even in disgust
in the abyss and in boredom
we find.

Whatever we do, we do

because we are incapable of not doing it;
the less we do, the less we are misled;
records – superlative efforts –
detract from perfection;
the nil position
is the only true position,
and the hardest to achieve.

Only by being nothing is perfect concentration
possible. The maximum concentration man can possibly realise
is obtained lying down, eyes shut. At the least outside manifestation
dispersal, diffusion begin. Standing,
legs take away part of the vigour. Eyes open,
concentration is cut down. External visible
effects grow in relative *proportion* to the remoteness
of the perfect state. Obviously the most beautiful
works are the least patent. Big illustrious works
(on view everywhere) are cheap, demand external
efforts, give relief, but are not worth the trouble.

To believe in nature, including everything
seeming to be material, is enough.

The Image can be in rapport with nature
like the Bach fugue with Christ;
such a case is not a re-copy
but an analogous creation.

The christian's mistake is
to appeal without prayers
to a kind of important person;
one must appeal to nobody
or to the void.

Whether God is represented
by circles or a straight line
is all the same to me.
But he cannot be represented
by people.

At Cassis, the pebbles, fish,
rocks under a magnifying glass
the salt of the sea and the sky
made me forget about human pretensions
invited me to turn my back
on the chaos of our goings-on
showed me eternity
in the little harbour waves
which repeat themselves
without repeating themselves.
Nothing is explicable

we only know appearances.
All loves lead to one love.
Beyond personal loves
there is the nameless love
the great mystery
the absolute
X
Tao
God
Cosmos
Holy Ghost
One
Infinity.
The abstract that penetrates everything
is ungraspable;
in each moment
in each thing
eternity is there. (Dieulefit, 1944)

We kill what is best,
and on first insane acquaintance.
The committed have the honour of being killed
by society, quicker than cattle:
Ch. Baudelaire, E. Poe, Rimbaud, Lautréamont,
Roger le Comte, Van Gogh, Modigliani, Wols,
Artaud, Novalis, Mozart, Shelley . . .

The desperate case is preferable, lying in an
old bag under the tree
a bottle in his hand
looking up
a long . . . long time.

One tells one's little terrestial tales
across little bits of paper.

Wols says 'leave plasticity to sculptors'. He has
never violated his little bits of paper with any
false plasticity.
Klee propelled dreaming and human thought
as far as the most amazing beauty. Wols on the
other hand performs his gymnastics on a slope where
our small (and where good taste lets reason
capsize) personal dramas hardly count
and where ugliness and beauty become one.

Words are chameleons
music's right is to be abstract
experiencing that everything is inexplicable leads to the dream
no explaining music
no explaining dreams.

The ungraspable penetrates everything
we ought to know that everything rhymes.
Painting or not painting
Wols doesn't care.
But it is strange that he may be wandering like
E. Poe's man of the
crowd, and might sometimes
cadge a drink
while the culprits
comfortably breathe literature
and beefsteak.

2 Jean-Paul Sartre (1905–1980) from *Existentialism and Humanism*

'Humanism' was a term adopted by the Communist Parties to describe their philosophical world-view, particularly during the period of struggle against Fascism. Such orthodox Marxism tended to be determinist. By contrast, Sartre had developed the philosophy of Existentialism during the 1930s, laying heavy emphasis on subjectivity and the consequences of the individual will. In the aftermath of the Second World War and the Resistance, Sartre attempted to connect Marxism and Existentialism. Here he stresses the latter's hitherto under-emphasized social implications, and likens moral action in the world to the production of a work of art. (It should be noted that in his contemporary essay 'What Is Literature?', Sartre emphasized a concept of the *committed artist*, distinct both from a view of art as beyond politics and from the Stalinist reduction of art to politics.) Originally published as *L'Existentialisme est un humanisme*, Paris, 1946. These extracts are taken from the English translation by Philip Mairet, London, 1948, pp. 27–30 and 49. (See also VB6.)

If one considers an article of manufacture – as, for example, a book or a paper-knife – one sees that it has been made by an artisan who had a conception of it; and he has paid attention, equally, to the conception of a paper-knife and to the pre-existent technique of production which is a part of that conception and is, at bottom, a formula. Thus the paper-knife is at the same time an article producible in a certain manner and one which, on the other hand, serves a definite purpose, for one cannot suppose that a man would produce a paper-knife without knowing what it was for. Let us say, then, of the paper-knife that its essence – that is to say the sum of the formulae and the qualities which made its production and its definition possible – precedes its existence. The presence of such-and-such a paper-knife or book is thus determined before my eyes. Here, then, we are viewing the world from a technical standpoint, and we can say that production precedes existence.

When we think of God as the creator, we are thinking of him, most of the time, as a supernal artisan. Whatever doctrine we may be considering, whether it be a doctrine like that of Descartes, or of Leibnitz himself, we always imply that the will follows, more or less, from the understanding or at least accompanies it, so that when God creates he knows precisely what he is creating. Thus, the conception of man in the mind of God is comparable to that of the paper-knife in the mind of the artisan: God

makes man according to a procedure and a conception, exactly as the artisan manufactures a paper-knife, following a definition and a formula. Thus each individual man is the realization of a certain conception which dwells in the divine understanding. In the philosophic atheism of the eighteenth century, the notion of God is suppressed, but not, for all that, the idea that essence is prior to existence; something of that idea we still find everywhere, in Diderot, in Voltaire and even in Kant. Man possesses a human nature; that 'human nature,' which is the conception of human being, is found in every man; which means that each man is a particular example of a universal conception, the conception of Man. In Kant, this universality goes so far that the wild man of the woods, man in the state of nature, and the bourgeois are all contained in the same definition and have the same fundamental qualities. Here again, the essence of man precedes that historic existence which we confront in experience.

Atheistic existentialism, of which I am a representative, declares with greater consistency that if God does not exist there is at least one being whose existence comes before its essence, a being which exists before it can be defined by any conception of it. That being is man or, as Heidegger has it, the human reality. What do we mean by saying that existence precedes essence? We mean that man first of all exists, encounters himself, surges up in the world – and defines himself afterwards. If man as the existentialist sees him is not definable, it is because to begin with he is nothing. He will not be anything until later, and then he will be what he makes of himself. Thus, there is no human nature, because there is no God to have a conception of it. Man simply is. Not that he is simply what he conceives himself to be, but he is what he wills, and as he conceives himself after already existing – as he wills to be after that leap towards existence. Man is nothing else but that which he makes of himself. That is the first principle of existentialism. And this is what people call its 'subjectivity,' using the word as a reproach against us. But what do we mean to say by this, but that man is of a greater dignity than a stone or a table? For we mean to say that man primarily exists – that man is, before all else, something which propels itself towards a future and is aware that it is doing so. Man is, indeed, a project which possesses a subjective life, instead of being a kind of moss, or a fungus or a cauliflower. Before that projection of the self nothing exists; not even in the heaven of intelligence: man will only attain existence when he is what he purposes to be. Not, however, what he may wish to be. For what we usually understand by wishing or willing is a conscious decision taken – much more often than not – after we have made ourselves what we are. I may wish to join a party, to write a book or to marry – but in such a case what is usually called my will is probably a manifestation of a prior and more spontaneous decision. If, however, it is true that existence is prior to essence, man is responsible for what he is. Thus, the first effect of existentialism is that it puts every man in possession of himself as he is, and places the entire responsibility for his existence squarely upon his own shoulders. And, when we say that man is responsible for himself, we do not mean that he is responsible only for his own individuality, but that he is responsible for all men. The word 'subjectivism' is to be understood in two senses, and our adversaries play upon only one of them. Subjectivism means, on the one hand, the freedom of the individual subject and, on the other, that man cannot pass beyond human subjectivity. It is the latter which is the deeper meaning of existentialism. When we say that man chooses himself, we do mean that every one of us must choose himself; but by that we also mean that in choosing for himself he chooses for all men. For in effect, of all the actions a

man may take in order to create himself as he wills to be, there is not one which is not creative, at the same time, of an image of man such as he believes he ought to be. To choose between this or that is at the same time to affirm the value of that which is chosen; for we are unable ever to choose the worse. What we choose is always the better; and nothing can be better for us unless it is better for all. If, moreover, existence precedes essence and we will to exist at the same time as we fashion our image, that image is valid for all and for the entire epoch in which we find ourselves. Our responsibility is thus much greater than we had supposed, for it concerns mankind as a whole. If I am a worker, for instance, I may choose to join a Christian rather than a Communist trade union. And if, by that membership, I choose to signify that resignation is, after all, the attitude that best becomes a man, that man's kingdom is not upon this earth, I do not commit myself alone to that view. Resignation is my will for everyone, and my action is, in consequence, a commitment on behalf of all mankind. Or if, to take a more personal case, I decide to marry and to have children, even though this decision proceeds simply from my situation, from my passion or my desire, I am thereby committing not only myself, but humanity as a whole, to the practice of monogamy. I am thus responsible for myself and for all men, and I am creating a certain image of man as I would have him to be. In fashioning myself I fashion man.

* * *

[...] In our view, ... man finds himself in an organized situation in which he is himself involved: his choice involves mankind in its entirety, and he cannot avoid choosing. Either he must remain single, or he must marry without having children, or he must marry and have children. In any case, and whichever he may choose, it is impossible for him, in respect of this situation, not to take complete responsibility. Doubtless he chooses without reference to any pre-established values, but it is unjust to tax him with caprice. Rather let us say that the moral choice is comparable to the construction of a work of art.

But here I must at once digress to make it quite clear that we are not propounding an aesthetic morality, for our adversaries are disingenuous enough to reproach us even with that. I mention the work of art only by way of comparison. That being understood, does anyone reproach an artist when he paints a picture for not following rules established *a priori*? Does one ever ask what is the picture that he ought to paint? As everyone knows, there is no pre-defined picture for him to make; the artist applies himself to the composition of a picture, and the picture that ought to be made is precisely that which he will have made. As everyone knows, there are no aesthetic values *a priori*, but there are values which will appear in due course in the coherence of the picture, in the relation between the will to create and the finished work. No one can tell what the painting of tomorrow will be like; one cannot judge a painting until it is done. What has that to do with morality? We are in the same creative situation. We never speak of a work of art as irresponsible; when we are discussing a canvas by Picasso, we understand very well that the composition became what it is at the time when he was painting it, and that his works are part and parcel of his entire life.

It is the same upon the plane of morality. There is this in common between art and morality, that in both we have to do with creation and invention. We cannot decide *a priori* what it is that should be done. [...]

3 Jean Dubuffet (1901–1985) 'Notes for the Well-Lettered'

In the immediate aftermath of the Second World War, as after the First, artists were drawn to a foundational critique of the protocols of a culture which, for all its overt embrace of higher values had, in the last instance, failed to prevent the Holocaust. Dubuffet, who had practised as a full-time artist since 1942, coined the term 'Art Brut' for the collection he made of artefacts produced by children, the naive, the 'primitive' and the psychotic. These were first exhibited at the Galerie René Drouin in Paris in November 1947 as examples of an immediate creation, untainted by the decorum of a discredited civilization. Written during the spring and summer of 1945, Dubuffet's 'Notes' consisted of eighty-two dictionary-like entries, ranging from a few lines to over a page in length, from which the present seven are selected. Originally published in Dubuffet's *Prospectus*, Paris, 1946, pp. 47–99; reprinted in Dubuffet, *Prospectus et tous écrits suivants*, Paris, 1967, from which text the present translation is made.

Departing from the Formless

The point of departure is the surface one is to bring alive – canvas or a piece of paper – and the first stroke of colour or ink that one lays on it; the resulting effect, the resulting adventure. It is this stroke, the degree to which one enriches it and gives it direction, that shapes the work. A painting is not built like a house, following architectural specifications; but rather by facing away from the end result; gropings, going back-wards! Alchemist, it is not by looking at gold that you will discover how to make it. Go to your retorts, boil urine, look avidly at lead; that's your job. And you, painter, look to your palettes and rags, strokes of colour, patches and lines, that's where you'll find the keys you're looking for.

Painting Ensnared

'This is not painting! It's a line that you have drawn on the ground with your nail – and that? No better! It's soft fabric like a curtain or a tapestry. As for this, it looks like a railway signal. This looks like house painting! And this other one, which you've baked, it's not painting, it's pottery or pastry. This one is a piece of interior décor; this one should be a poster; this one's a book cover. Here's a piece of kitchenware, there's a coloured-in drawing. I wouldn't accept this at the paint counter. You mix everything up. A skin specialist doesn't treat liver diseases. I need works that are mutually comparable, so I can classify them, give them a relative ranking, in a well-defined category. And then? Well, I fix the prices accordingly. That's it, it's all clear.' Too clear, I say. I'm in favour of confusion. Do not confine art, cut it off from the real world, keep it in a trap. I want painting to be full of life – decorations, swatches of colour, signs and placards, scratches on the ground. These are its native soil.

The Native Soil Forgotten

There is no commerce between so-called artistic painting (which claims the exclusive right to this title) and that which is more moderately called house painting, or interior decorating. They don't know each other, don't speak to each other. This is

not good. Come on! Do both kinds of people spend their entire working lives with the same colours; thickening them, thinning them, applying them in all sorts of ways, yet not giving each other the slightest bit of advice? Can it be that they just do not meet? I once helped out an artist at the very beginning of his career. He walked straight past a paint merchant's, where there were large tins and barrels of paint of every sort of pigment, drawers full of the most stunning powders, without so much as a sidelong glance – he quickened his step. At a stationer's shop, he bought six small tubes of special artists' colours, smaller than those used for Vaseline or Secotine. Back home he squeezed a little from each tube, and sat down in front of an apple. Under his window a workman, armed with some cans of paint, was working on a lifesize shop sign of an innkeeper presenting a menu. But he noticed neither the workman nor his work. I met this artist twenty years later. He was still painting apples with his small tubes of paint. I mentioned the picture of the innkeeper on the façade of his house. It never occurred to him to look at it, he told me. I also mentioned the colours of his studio walls but he told me that artists are distracted and quirky people, so profoundly absorbed in their work that they never take note of things like that.

Bargain Hunter

Accidents which happen by chance. Admittedly, a slightly contrived chance, or provoked, or more or less consented to; used by the artist for profit – chances which are, quite rightly, the game that the artist hunts, which he constantly calls out to, watches and traps. Chances like: the slight unevenness, the small gaps resulting from the shaking of the brush (it sometimes happens that a line is more or less coloured than another), all of which cause the underlying tones to become more or less transparent. There are an infinite number of such accidents in a painting. They are very important for the picture's attractiveness. The distribution of tones, of light and shade, often results from such accidents. They often cause light to fall on one part of a face, for example; whereas the painter wanted to put the light on a different aspect of the subject. But the accident rules supreme: it occurred in that spot and the painter must accommodate it, turn it to advantage. How thrilling is the pursuit and exploitation of these favourable accidents; how full of surprises and lures the painter's game! It is no longer a matter of using docile colours, whose effects are known in advance, but rather of using their magical properties, those that seem to arise from a will of their own, which have more power than the strongest intentions of the artist! He uses these helpers, whose power is greater than his own, like someone who moulds in lead. It is as if the brushes are enchanted: they work wonders. Take a subject, such as a portrait of a human face, at a certain stage of the picture's development. I roughly work on a polychromatic background, paintbrush full of an unexpected colour – with black, for example, or green, or whatever; then a miracle is produced, a magic trick! This colour rapidly and sketchily slapped on, happily joins the colours it covers, whilst leaving them imperceptibly transparent in other places, in such a way that it forms gradations and links of tone that are so fine, so subtle, that no deliberate plan could have proposed them, let alone executed them. What does it matter at this point that you have used black or green or pink for this purpose, and that the portrait remains bright or dark as a consequence; you still have this effect of nuanced subtlety in any case. It also does not

matter that the path of the paintbrush has left a touch of black which was not dry; this will be a moustache. Instead of a female figure, which the artist originally proposed – though he lacked a detailed plan, and he was not particularly committed to the subject – it can now be a portrait of a man.

Never Work Hard

Let us reject tedious work. It goes against human nature, against the cosmic rhythms, it goes against man himself, to take trouble where none is needed. It is natural for him to apply himself to avoiding such work; to use every instrument that comes to hand, every favourable chance which can help him out, to make his work easier and more pleasant. Tedious work is inhuman and repugnant, every work which shows signs of it is ugly. It is pleasure and ease, without harshness and constraint, which create grace in every human gesture.

Two Dimensions

The purpose of painting is to decorate surfaces, and it therefore effects only two dimensions and excludes depth. The purpose is not to enrich depth, but to alter and adulterate it, to create a relief effect or *trompe-l'œil* by means of light and shade. There is an element of deception about this which is repellent. It offends against reason and taste, and it is clumsy and idle. Put a white dot in the middle of an apple, with shading of planes to suggest distance; close your eyes, and it seems like living sculpture – poor little contrivance! Let us find other ingenious ways to transcribe objects on to flat surfaces; make the surface speak its own surface-language and not a false three-dimensional language which is alien to it. Is a surface to be somehow completed, by filling it with holes and lumps and distances? That is to torture it. I rather favour the necessity of leaving it completely flat. My eyes are gratified when they come to rest on a completely flat surface, especially a rectangular one. The represented objects would be transferred onto it changed into pancakes, ironed flat.

Fanfare for the Common Man

There are no more great men, no more geniuses. We are finally free of these malevolent dummies. Genius was an invention of the Greeks, like the centaurs and the hippo-gryphs. There are as many geniuses as there are unicorns. We have been so scared of them for three thousand years.

It is not men who are great. It is man who is great. It is not wonderful to be exceptional. It is wonderful to be a man.

4 Jean Dubuffet (1901–1985) 'Crude Art Preferred to Cultural Art'

The Compagnie de l'Art Brut was formed in June 1948 initially to manage the collection of artefacts held at the Galerie Drouin, and, in addition, to promote the exhibition of works embodying similar tendencies but produced by professional artists. Founder members, as well as Dubuffet, included André Breton and Michel Tapié. 'L'Art Brut préféré aux arts

culturels' was the title of the group's major exhibition held at the Galerie Drouin in October and November 1949. It included over 200 works by sixty-three artists. Dubuffet's essay constituted the Preface to the catalogue, and came to be regarded as the group's manifesto. Reprinted in Dubuffet, 1967 (op. cit.), from which the present translation is made.

Anyone who undertakes, as we do, to look at the works of the *Irregulars*, will find his notion of the approved art of the museums, galleries and salons – let us call it *cultural art* – totally transformed. This type of approved art will not seem representative of art in general, rather merely the activity of a particular clique: a cohort of careerist intellectuals.

What country lacks its small clique of cultural arts; its troop of careerist intellectuals? It is obligatory. From one capital to another, they ape each other marvellously; they practise an artificial, Esperanto art tirelessly copied everywhere. Is art the right word? Does it actually have anything to do with art?

It is fairly widely thought that in considering the artistic production of intellectuals one is at the same time grasping the flower of production in general, since intellectuals, being drawn from the common people, cannot lack any of their qualities, having rather those additional qualities acquired by wearing out their trousers on the schoolroom bench – without allowing for the fact that intellectuals think themselves by definition far more intelligent than ordinary people. But is this really so? One also meets plenty of people with a far less favourable opinion of the intellectual type. The intellectual type seems to them directionless, impenetrable, lacking in vitamins, a swimmer in pap. Empty, without magnetism, without vision.

Perhaps the solid seat of the intellectual has been pulled out from under him. The intellectual's labours are always carried out while seated: at school, at conferences, at congresses. Often while dozing; sometimes while dead. Dead in one's seat.

For a long time, intelligence has been highly valued. When one says of someone that they are intelligent, has one not said everything? Nowadays people are growing disillusioned with this; they are beginning to demand other things. Intellectual qualities are less prized. People now value health and vitality. One can see that what was called intelligence is nothing more than a modicum of knowledge in the manipulation of simple, false and pointless algebraic formulae, having nothing to do with genuine vision (but rather obscuring it).

One cannot deny that on the level of vision, the light of the intellectual is far from bright. The imbecile (or those the intellectual calls imbeciles) shows greater aptitude. It might even be that this vision gets worn out by the school benches, along with the seat of the intellectual's pants. Imbecile perhaps, but sparks fly from him, unlike Mr Grammar School, who doesn't spark at all. Good for the imbecile! He is our man! [...]

There are still people, particularly the intellectuals, who do not clearly see that the intelligent are hopeless cases, and one needs to rely on the so-called imbeciles for moments of lucidity; indeed, they just laugh at the idea. They cannot take the idea seriously.

The intellectual is of course crazy about ideas; he loves to chew them over, and cannot imagine any other type of chewing gum.

One can with justification call art a chewing gum totally devoid of such ideas. One can sometimes lose sight of this. Ideas, and the algebra of ideas, may be a level of

knowledge, but art is another means of knowledge, whose levels are complete-
ly different: they are those of vision. Vision has nothing to do with intellectuals
and academics. Knowledge and intelligence are weak instruments compared to
vision.

Ideas are an inert gas. It is when vision is blinded that the intellectual pops his head
up.

Art exists to be a way of operating that does not involve ideas. When it is mixed with
ideas, art becomes oxidized and worthless. Let there be as few ideas as possible! Ideas
do not nourish art!

There are people (the present writer for example) who go so far as to maintain that
the art of these intellectuals is false art, the counterfeit currency of art, which is
intricately ornamented but unsound.

Certainly the ornament is of some slight interest, but whether it sounds true is more
interesting. Many slight works, brief, almost lacking form *ring* very loudly indeed; and
for that reason they are preferable to many monumental works by illustrious profes-
sionals.

It is enough for certain people just to tell them that the creator of a work is a
professional artist, so that the spell is immediately broken. Amongst artists, as amongst
card-players or lovers, professionals are a little like crooks. [...]

True art is never where it is expected to be: in the place where no one considers it,
nor names it. Art hates to be recognized and greeted by its name. It runs away
immediately. Art is a person in love with anonymity. As soon as it's unmasked, as
soon as someone points the finger, it runs away. It leaves in its place a prize stooge
wearing on its back a great placard marked ART, which everybody immediately
showers with champagne, and which the lecturers lead from town to town with a
ring through its nose. That is the false Art. That is the art which the public knows, the
art of the prize and the placard. The real Mr Art, no one recognizes. He walks
everywhere, everyone has met him, jostled him at every junction, but no one thinks
it could be him, Mr Art himself, of whom so much has been said. He does not have the
right air about him. You see, it is the false Mr Art who has the air of being the true one;
it is the real one who lacks this air. That means that one is deceived! So many people
deceive themselves!

It was in July 1945 that we undertook in both France and Switzerland, then in other
countries, methodical research into the relevant ways of producing that which we now
call Crude Art.

We understand by this works created by those untouched by artistic culture; in
which copying has little part, unlike the art of intellectuals. Similarly, the artists take
everything (subjects, choice of materials, modes of transposition, rhythms, writing
styles) from their own inner being, not from the canons of classical or fashionable
art. We engage in an artistic enterprise that is completely pure, basic; totally guided in
all its phases solely by the creator's own impulses. It is therefore an art which only
manifests invention, not the characteristics of cultural art which are those of the
chameleon and the monkey.

Before concluding this essay we want to say a word about the mad. Madness gives
man wings and helps his power of vision; many of the objects (almost half) that our
exhibition contains are works by people in psychiatric hospitals. We see no reason to
segregate them, unlike others. All the numerous dealings that we have had with our

friends have convinced us that the mechanisms of artistic creation are the same in them as in so-called normal people. This distinction between normal and abnormal seems to us to be quite far-fetched: who is normal? Where is he, your normal man? Show him to us! The artistic act, with the extreme tension that it implies, the high fever that accompanies it, can it ever be considered normal? Finally, mental 'illnesses' are extremely diverse – there are almost as many of them as there are sick people – and it seems quite arbitrary to label them all in the same way. Our point of view is that art is the same in all cases, and there is no more an art of the mad than there is an art of the dyspeptic, or an art for those with bad knees.

5 Antonin Artaud (1896–1948) from *Van Gogh: The Man Suicided by Society*

Artaud had been involved with the Surrealists in the 1920s, but broke with them in 1927 on political grounds. He published the manifesto of his own 'Theatre of Cruelty' in 1932. Continually subject to mental instability, he was treated from 1943 under the supervision of Dr Gaston Ferdière, a collector of psychotic art, who encouraged him to draw for therapeutic purposes. Written and pictorial forms of expression thus became inextricably linked for Artaud. He increasingly identified with the figure of van Gogh, as the utterer of truths unbearable to society. The long text from which the present extracts are taken was composed in response to the large van Gogh exhibition held in Paris in January–March 1947. Originally published as *Van Gogh le suicidé de la société*, Paris, September 1947, in a limited edition of 630 copies including reproductions of works by van Gogh. The present extracts are reproduced from the essay's Introduction, and are taken from the English translation by Helen Weaver in Susan Sontag (ed.), *Antonin Artaud: Selected Writings*, Los Angeles, 1976 and 1988, pp. 483–7. (The identity of the Dr L. criticized in the text remains unclear.)

One can speak of the good mental health of van Gogh who, in his whole life, cooked only one of his hands and did nothing else except once to cut off his left ear,

in a world in which every day one eats vagina cooked in green sauce or penis of newborn child whipped and beaten to a pulp,

just as it is when plucked from the sex of its mother.

And this is not an image, but a fact abundantly and daily repeated and cultivated throughout the world.

And this, however delirious this statement may seem, is how modern life maintains its old atmosphere of debauchery, anarchy, disorder, delirium, derangement, chronic insanity, bourgeois inertia, psychic anomaly (for it is not man but the world which has become abnormal), deliberate dishonesty and notorious hypocrisy, stingy contempt for everything that shows breeding,

insistence on an entire order based on the fulfillment of a primitive injustice,

in short, of organized crime.

Things are going badly because sick consciousness has a vested interest right now in not recovering from its sickness.

This is why a tainted society has invented psychiatry to defend itself against the investigations of certain superior intellects whose faculties of divination would be troublesome.

Gérard de Nerval was not mad, but society accused him of being mad in order to discredit certain very important revelations that he was about to make,

and besides being accused, he was also struck on the head, physically struck on the head on a certain night so that he would lose memory of the monstrous facts which he was about to reveal and which, as a result of this blow, were pushed back within him onto a supranatural level, because all society, secretly in league against his consciousness, was at that moment powerful enough to make him forget their reality.

No, van Gogh was not mad, but his paintings were bursts of Greek fire, atomic bombs, whose angle of vision, unlike all other paintings popular at the time, would have been capable of seriously upsetting the spectral conformity of the Second Empire bourgeoisie and of the myrmidons of Thiers, Gambetta, and Félix Faure, as well as those of Napoleon III.

For it is not a certain conformity of manners that the painting of van Gogh attacks, but rather the conformity of institutions themselves. And even external nature, with her climates, her tides, and her equinoctial storms, cannot, after van Gogh's stay upon earth, maintain the same gravitation.

All the more reason why on the social level institutions are falling apart and medicine resembles a stale and useless corpse which declares van Gogh insane.

In comparison with the lucidity of van Gogh, which is a dynamic force, psychiatry is no better than a den of apes who are themselves obsessed and persecuted and who posses nothing to mitigate the most appalling states of anguish and human suffocation but a ridiculous terminology,

worthy product of their damaged brains.

Indeed, the psychiatrist does not exist who is not a well-known erotomaniac.

And I do not believe that the rule of the confirmed erotomania of psychiatrists admits of a single exception.

I know one who objected, a few years ago, to the idea of my accusing as a group this way the whole gang of respected scoundrels and patented quacks to which he belonged.

I, Mr Artaud, am not an erotomaniac, he told me, and I defy you to show me a single piece of evidence on which you can base your accusation.

As evidence, Dr L., I need only show you yourself,

you bear the stigma on your mug,

you rotten bastard.

You have the puss of someone who inserts his sexual prey under his tongue and then turns it over like an almond as a way of showing contempt for it.

This is called feathering one's nest or having one's way.

If in coitus you have not succeeded in chuckling from the glottis in a certain way that you know, and in rumbling at the same time through the pharynx, the esophagus, the ureter, and the anus,

you cannot say that you are satisfied.

And through your internal organic thrills you have fallen into a rut which is the incarnate evidence of a foul lust,

and which you have been cultivating year after year, more and more, because socially speaking it does not come under the jurisdiction of the law,

but it comes under the jurisdiction of another law whereby it is the whole damaged consciousness that suffers, because by behaving in this way you prevent it from breathing.

You dismiss as delirious a consciousness that is active even as you strangle it with your vile sexuality.

And this was precisely the level on which poor van Gogh was chaste,

chaste as a seraph or a maiden cannot be, because it was in fact they

who fomented

and nourished in the beginning the vast machinery of sin.

And perhaps, Dr L., you belong to the race of iniquitous seraphim, but for pity's sake, leave men alone,

the body of van Gogh, untouched by any sin, was also untouched by madness which, indeed, sin alone can bring.

And I do not believe in Catholic sin,

but I do believe in erotic crime which in fact all the geniuses of the earth,

the authentic madmen of the asylums, have guarded themselves against,

or if not, it was because they were not (authentically) mad.

And what is an authentic madman?

It is a man who preferred to become mad, in the socially accepted sense of the word, rather than forfeit a certain superior idea of human honor.

So society has strangled in its asylums all those it wanted to get rid of or protect itself from, because they refused to become its accomplices in certain great nastinesses.

For a madman is also a man whom society did not want to hear and whom it wanted to prevent from uttering certain intolerable truths.

But, in this case, confinement is not its only weapon, and the concerted gathering of men has other means of overcoming the wills it wants to break.

Besides the minor spells of country sorcerers, there are the great sessions of world-wide spell-casting in which all alerted consciousness participates periodically.

Thus on the occasion of a war, a revolution, or a social upheaval still in the bud, the collective consciousness is questioned and questions itself, and makes its judgment.

This consciousness may also be aroused and called forth spontaneously in connection with certain particularly striking individual cases.

Thus there were collective magic spells in connection with Baudelaire, Poe, Gérard de Nerval, Nietzsche, Kierkegaard, Hölderlin, Coleridge,

and also in connection with van Gogh.

This may take place in the daytime, but generally, it is more likely to take place at night.

Thus strange forces are aroused and brought up into the astral vault, into that kind of dark dome which constitutes, over all human respiration, the venomous hostility of the evil spirit of the majority of people.

It is thus that the few rare lucid well-disposed people who have had to struggle on the earth find themselves at certain hours of the day or night in the depth of certain authentic and waking nightmare states, surrounded by the formidable suction, the formidable tentacular oppression of a kind of civic magic which will soon be seen appearing openly in social behavior.

In the face of this concerted nastiness, which has as its basis or fulcrum on the one hand sexuality and on the other hand the mass, or other psychic rites, it is not delirium to walk around at night in a hat with twelve candles on it to paint a landscape from nature;

for how else could poor van Gogh have managed to have light, as our friend the actor Roger Blin pointed out so justly the other day?

As for the cooked hand, that is heroism pure and simple;
as for the severed ear, that is straightforward logic,
and I repeat,
a world which, day and night, and more and more, eats the uneatable,
in order to carry out its evil designs,
has nothing to do on this point
but to shut up about it.

Post-Scriptum

Van Gogh did not die of a state of delirium properly speaking,

but of having been bodily the battlefield of a problem around which the evil spirit of humanity has been struggling from the beginning.

The problem of the predominance of flesh over spirit, or of body over flesh, or of spirit over both.

And where in this delirium is the place of the human self?

Van Gogh searched for his throughout his life, with a strange energy and determination,

and he did not commit suicide in a fit of madness, in dread of not succeeding,

on the contrary, he had just succeeded, and discovered what he was and who he was,

when the collective consciousness of society, to punish him for escaping from its clutches,

suicided him.

And this happened to van Gogh the way this always generally happens, during an orgy, a mass, an absolution, or some other rite of consecration, possession, succubation or incubation.

Thus it wormed its way into his body,
this society
absolved,
consecrated,
sanctified
and possessed,
erased in him the supernatural consciousness he had just achieved, and, like an inundation of black crows in the fibers of his internal tree,
overwhelmed him with one final surge,
and, taking his place,
killed him.

For it is the anatomical logic of modern man that he has never been able to live, has never thought of living, except as one possessed.

6 Jean-Paul Sartre (1905–1980) 'The Search for the Absolute'

Sartre became increasingly involved with the problems of art in the immediate post-war period. His emphasis on the body as the human being's 'anchorage in the world' initially led him to view the exiled German painter Wols (Wolfgang Schulze) as the Existential artist *par excellence* (see VB1), an assessment expressed in an essay of 1945. His writing on the sculptor Giacometti followed in 1948. The text represents a contemporary search for

origins, the felt need to begin again with the naked *thing*, rather than to work with the received conventions of cultural expression. An additional distinction of Sartre's essay is that it was one of the first vehicles through whcih these ideas were communicated to the English-speaking world. Originally published in the catalogue of the exhibition *Alberto Giacometti. Sculptures, Paintings, Drawings*, Pierre Matisse Gallery, New York, January–February 1948, from which the present extracts are taken.

One does not have to look long on the antediluvian face of Giacometti to sense this artist's pride and will to place himself at the beginning of the world. He does not recognize such a thing as Progress in the fine arts, he does not consider himself more 'advanced' than his contemporaries by preference, the man of Eyzies, the man of Altamira. In that drastic youthfulness of nature and of men, neither the beautiful nor the ugly yet existed, neither taste nor people possessing it; and there was no criticism: all this was still in the future. For the first time, the idea came to one man to sculpt another in a block of stone. There was the model: man. Not dictator, general, or athlete, he did not yet own those ornaments and decorations which would attract the sculptors of the future. There was only a long indistinct silhouette, moving against the horizon. But one could already see that the movements did not resemble those of things: they emanated from the figure like veritable beginnings, they outlined an airy future; to understand these motions, it was necessary to start from their goals – this berry to be picked, that thorn to be removed – and not from their causes. They never let themselves be separated or localized: I can consider separately from the tree itself this wavering branch; but I cannot think of an arm rising, a fist closing, apart from a human agent. A man raises his arm, a man clenches his fist; man is the indissoluble unity and the absolute source of his movements. Moreover, he is a symbol–charmer; signs are caught in his hair, shine in his eyes, dance between his lips, fall from his fingertips; he speaks with his whole body: if he runs he speaks, if he stops he speaks, if he sleeps, his sleep is worded. Now, here is the matter to be formed: a rock, a simple clot of space. [. . .] 'He is mad,' people tell you, 'men have made sculptures for three thousand years – and done pretty well, too – without so much fuss. Why doesn't he try to achieve something perfect, relying on some reliable technique, instead of seeming to ignore his predecessors?' But, for three thousand years, sculpture modelled only corpses. Sometimes they were laid out to sleep on tombs, sometimes they were seated on curule chairs, they were also perched on horses. But a dead man plus a dead horse do not equal the half of one living being. They lie, these people of the Museums, these people with white eyes. These arms pretend to move, but they float, steadied between high and low by supports of iron; these frozen forms contain within themselves an infinite dispersion; it is the imagination of the spectator, mystified by a gross resemblance, which lends movement, warmth and life, to the eternal collapse of matter. So one must begin again from scratch. After three thousand years, the task of Giacometti and of contemporary sculptors, is not to enrich the galleries with new works, but to prove that sculpture itself is possible. To prove it by sculpting, as Diogenes proved movement by walking. To prove it, like Diogenes, against Parmenides and Zeno. It was necessary to go to the very end, and see what can be done. Were the effort to fail, it would be impossible, in any case, to decide whether this meant the failure of the sculptor or of sculpture: others would come, who would begin again; Giacometti himself perpetually starts afresh. However, it is not a question of an infinite progression; there is a definite goal to be attained, a single problem to be solved: how to mould a man in stone without petrifying him? It is all or nothing: if the problem be solved, the number of statues matters little.

'Let me know how to make only one,' says Giacometti, 'and I will be able to make a thousand . . .' So long as he does not know this, Giacometti is not interested in statues at all, but only in sketches, insofar as they help him towards his goal. He breaks everything, and begins all over again. From time to time, friends are able to save a head, a young woman, a youth, from the massacre. He doesn't care, and goes back to his task. He has not had a single exhibition in fifteen years. Finally, having a show has become a necessity to him, but he is nevertheless disturbed; he writes to excuse himself: 'It is mainly because I don't want to be thought of as sterile and incapable of achieving anything, as a dry branch almost; then too, it is from fear of poverty (which my attitude could very well involve), that I have brought these sculptures to their present point (in bronze and photographed) but I am not too happy about them; they represent something of what I intended just the same, not quite.' What bothers him is that these moving outlines, always half-way between nothingness and being, always modified, bettered, destroyed and begun once more, setting out at last on their own and for good, are commencing a social career far from him. He will forget them. The marvellous unity of this life lies in its insistent search for the absolute. [. . .]

. . . Giacometti has a horror of the infinite. Not of the Pascalian infinite, of the infinitely great: there is another infinite, more devious, more secret, which slips away from divisibility: 'In space,' says Giacometti, 'there is too much.' This too much is the pure and simple coexistence of parts in juxtaposition. Most sculptors let themselves be taken in by this; they confuse the flaccidness of extension with largesse, they put too much in their works, they delight in the fat curve of a marble hip, they spread out, thicken, and expand the human gesture. Giacometti knows that there is nothing redundant in a living man, because everything there is functional; he knows that space is a cancer on being, and eats everything; to sculpt, for him, is to take the fat off space; he compresses space, so as to drain off its exteriority. This attempt may well seem desperate; and Giacometti, I think, two or three times came very near to despair. If, in order to sculpt, it is necessary to cut and then resew in this incompressible medium, why, then sculpture is impossible. 'Just the same,' he said, 'if I begin my statue, as they do, with the tip of the nose, then an infinity of time will not be too much before I get to the nostrils.' It was then that he made his discovery.

Here is Ganymede on his pedestal. If you ask how far away he is from me, I will reply that I don't know what you are talking about. By 'Ganymede', do you mean the young lad who was carried off by the eagle of Jupiter? In that case, I will say that from him to me there is no real relation of distance, for the simple reason that he does not exist. But perhaps you have in mind the marble block which the sculptor shaped in the image of the darling boy? In that case, we have something real to deal with, an existent mineral that we can measure. Painters have understood all this for a long time, because, in pictures, the unreality of the third dimension causes ipso facto the unreality of the other two. Thus the distance of the figures from me is imaginary. If I approach, I come closer to the canvas, not to the figures on it. Even if I put my nose against it, I should still see them twenty paces distant, since it was at twenty paces from me that they came to exist once and for all. Thus painting escapes the paradoxes of Zeno: even if I were to divide in two the space separating the foot of the Virgin from the foot of Saint Joseph, and each one of the two halves in two again, and so on infinitely, it would be a certain length of canvas that I should be dividing, and not the pavement supporting the Virgin and her husband. Sculptors have not recognized these elementary truths because they

have worked in a tridimensional space on real marble. And in spite of the fact that the product of their art was to be an imaginary man, they thought it possible to project him in a real space. This confusion of two spaces has had curious results: in the first place, when they worked from nature, instead of rendering what they saw – that is to say, the model, ten paces off – they outlined in the clay what they knew to be there – that is to say, the model. As they wanted their statue to give a spectator standing ten feet off from it the impression they had experienced before the model, it seemed to them logical to make a figure which would be for the spectator what the model had been for them; and that was only possible if the marble were here as the model was there. But what does it mean to be 'as it is' and 'there'? At ten paces, I form a certain image of that nude woman; if I approach her, and regard her from up close, I no longer recognize her: these craters, tunnels, cracks, this rough black hair, these smooth shiny surfaces, this whole lunar orography: how could all these qualities go to compose the sleek fresh skin that I admired from far off? Which is it then that the sculptor ought to imitate? However close he comes to this face, one can approach closer still. Thus the statue will never truly resemble what the model is or what the sculptor sees; one must construct it in accordance with certain rather contradictory conventions, imagining certain details which are not visible from so far off, under the pretext that they exist, and neglecting certain others which exist just the same, under the pretext that one does not see them. What does this mean if not that one finally leaves it to the spectator to recompose a satisfying figure? But, in that case, my relation to Ganymede will vary with the position; if I am near, I will discover details that from a distance I would miss. And this brings us to the paradox that I have real relations with an illusion; or, if you like, that my real distance from the block of marble has become one with my imaginary distance from Ganymede. Thus, it results that the properties of real space cover up and mask those of imaginary space: more especially, the real divisibility of the marble destroys the indivisibility of the figure. It is the stone which triumphs, along with Zeno. So the classical sculptor falls into dogmatism, believing he can eliminate his own glance, and sculpt human nature in general; but he does not know what he does because he does not make what he sees. Seeking the true, he has arrived at convention. And, as, in the last analysis, he leaves it to the visitor to animate these inert semblances, the classical seeker of the absolute ends by making his work subject to the relativity of the points of view one can adopt towards it. As to the spectator, he takes the imaginary for the real and the real for the imaginary; he seeks the indivisible, and everywhere encounters its opposite!

 In frontally opposing classicism, Giacometti has restored an imaginary and indivisible space to statues. In accepting relativity from the very start, he has found the absolute. This is because he was the first one to take it into his head to sculpt man as he appears, that is to say, from a distance. He confers on his plaster figures an absolute distance, as the painter does for those who live in his canvas. He creates his figure 'at ten paces,' 'at twenty paces,' and whatever you do, there it stays. By the same token, the figure places itself in the unreal, since its relation to you no longer depends on your relation to the block of plaster: art is liberated. One has to learn a classical statue, or come near to it: at each moment one sees new details, the parts appear separately, then parts of the parts, one ends by getting lost. One does not approach a sculpture of Giacometti. Do not expect this breast to swell to the degree that you come close to it: it will not change, and you, in approaching will have the strange impression that you are

stamping on the nipples; we have intimations of them, we divine them, now we are on the point of seeing them: another step or two, and we are about to have them; one more step, and everything vanishes: there remain the corrugations of the plaster; these statues only permit themselves to be seen from a respectful distance. However, everything is there: the whiteness, the roundness, the elastic subsidence of a beautiful ripe breast. Everything except matter: at twenty paces one thinks one sees, but one does not observe the tedious desert of adipose tissue; it is suggested, outlined, meant, but not given. We know now what squeezer Giacometti used to compress space: there is only one: distance. He puts distance within reach of your hand, he thrusts before your eyes a distant woman – and she remains distant, even when you touch her with your fingertips. The breast glimpsed and hoped for will never expose itself: it is only a hope; these bodies have only as much matter as is necessary for making promises. [...] What must be understood is that these figures, who are wholly and all at once what they are, do not permit one to study them. As soon as I see them, they spring into my visual field as an idea before my mind; the idea alone possesses such immediate translucidity, the idea alone is at one stroke all that it is. Thus Giacometti has resolved in his own way the problem of the unity of the multiple: he has just suppressed multiplicity. It is the plaster or the bronze which can be divided: but this woman who moves within the indivisibility of an idea or of a sentiment, has no parts, she appears totally and at once. It is to give sensible expression to this pure presence, to this gift of the self, to this instantaneous coming forth, that Giacometti resorts to elongation. The original movement of creation, that movement without duration, without parts, and so well imaged by these long, gracile limbs, traverses their Greco-like bodies, and raises them towards heaven. I recognize in them, more clearly than in an athlete of Praxiteles, the figure of man, the real beginning and absolute source of gesture. Giacometti has been able to give this matter the only truly human unity: the unity of the Act.

Such, I think, is the sort of Copernican revolution Giacometti has tried to introduce into sculpture. Before him the effort was to sculpt being, and that absolute melted away in an infinity of appearances. He has chosen to sculpt the situated appearance, and he has shown that in this way the absolute may be attained. He shows us men and women already seen. But not already seen by him alone. These figures are already seen as the foreign language we try to learn is already spoken. Each one of them reveals man as one sees him to be, as he is for other men, as he appears in an intersubjective world, not, as I said above, to entangle himself at ten or twenty paces, but at a proper human distance; each shows us that man is not there first and to be seen afterwards, but that he is the being whose essence is to exist for others. In perceiving this woman of plaster, I encounter athwart her, my own glance, chilled. Hence the delightful disquiet that seeing her puts me in: I feel compelled and I do not know to what end or by whom until I discover that I am compelled to see, and by myself. And then, often enough Giacometti likes to put us at a loss by placing, for example, a distant head on top of a near body, so that we no longer know what position to take, or how to synthesize what we see. But even without this, his ambiguous images disconcert, breaking as they do with the most cherished habits of our eyes: we have become so accustomed to the sleek mute creatures, made to cure us of the illness of having bodies: these domestic powers kept an eye on us when we were children; they bore witness in the parks to the conviction that the world is not dangerous, that nothing happens to anybody, that actually all that had happened to them was to die at their birth. But to the bodies of Giacometti something has happened: do they come, we ask, from a

concave mirror, from the fountain of youth, or from a camp of displaced persons? At first glance we seem to be up against the fleshless martyrs of Buchenwald. But a moment later we have a quite different conception; these fine and slender natures rise up to heaven, we seem to have come across a group of Ascensions, of Assumptions; they dance, they are dances, they are made of the same rarefied matter as the glorious bodies that were promised us. And when we have come to contemplate this mystic thrust, these emaciated bodies expand, what we see before us belongs to earth. This martyr was only a woman. But a woman complete, glimpsed, furtively desired, a woman who moved away and passed, with the comic dignity of those long impotent and breakable girls that high-heeled slippers carry lazily from bed to their bath, with the tragic horror of the grimy victims of a fire, given, refused, near, far, a woman complete whose delicious plumpness is haunted by a secret thinness, and whose terrible thinness by a suave plumpness, a complete woman, in danger on this earth, and yet not utterly of this earth, and who lives and tells us of the astonishing adventure of the flesh, our adventure. For she, like us, was born. [. . .]

7 Samuel Beckett (1906–1990) and Georges Duthuit (1891–1973) from *Three Dialogues*

The writers Beckett and Duthuit composed three 'dialogues' on contemporary painting in 1949. Their subjects were Tal Coat, André Masson and Bram Van Velde, three artists associated in the post-war Parisian art world with the school of informal abstraction. Although given the appearance of, and perhaps rooted in, conversations, the 'dialogues' are none the less manifestly literary. Their recurrent preoccupation is with the reconstruction from nothing of a broken world, a weight of responsibility to be borne, alone, by the individual: an imperative which results in the simultaneous necessity for and impossibility of action. Such a perspective aligns with that of the contemporary Theatre of the Absurd. The dialogues were originally published in *Transition*, no. 5, Paris, 1949, edited by Georges Duthuit. The present extracts are taken from the English version by the authors in Samuel Beckett and Georges Duthuit, *Proust: Three Dialogues*, London, 1965, pp. 97–126.

I Tal Coat

B: Total object, complete with missing parts, instead of partial object. Question of degree.

D: More. The tyranny of the discreet overthrown. The world a flux of movements partaking of living time, that of effort, creation, liberation, the painting, the painter. The fleeting instant of sensation given back, given forth, with context of the continuum it nourished.

B: In any case a thrusting towards a more adequate expression of natural experience, as revealed to the vigilant coenaesthesia. Whether achieved through submission or through mastery, the result is a gain in nature.

D: But that which this painter discovers, orders, transmits, is not in nature. What relation between one of these paintings and a landscape seen at a certain age, a certain season, a certain hour? Are we not on a quite different plane?

B: By nature I mean here, like the naïvest realist, a composite of perceiver and perceived, not a datum, an experience. All I wish to suggest is that the tendency and accomplishment of this painting are fundamentally those of previous painting, straining to enlarge the statement of a compromise.

D: You neglect the immense difference between the significance of perception for Tal Coat and its significance for the great majority of his predecessors, apprehending as artists with the same utilitarian servility as in a traffic-jam and improving the result with a lick of Euclidian geometry. The global perception of Tal Coat is disinterested, committed neither to truth nor to beauty, twin tyrannies of nature. I can see the compromise of past painting, but not that which you deplore in the Matisse of a certain period and in the Tal Coat of today.

B: I do not deplore. I agree that the Matisse in question, as well as the Franciscan orgies of Tal Coat, have prodigious value, but a value cognate with those already accumulated. What we have to consider in the case of Italian painters is not that they surveyed the world with the eyes of building-contractors, a mere means like any other, but that they never stirred from the field of the possible, however much they may have enlarged it. The only thing disturbed by the revolutionaries Matisse and Tal Coat is a certain order on the plane of the feasible.

D: What other plane can there be for the maker?

B: Logically none. Yet I speak of an art turning from it in disgust, weary of puny exploits, weary of pretending to be able, of being able, of doing a little better the same old thing, of going a little further along a dreary road.

D: And preferring what?

B: The expression that there is nothing to express, nothing with which to express, nothing from which to express, no power to express, no desire to express, together with the obligation to express.

D: But that is a violently extreme and personal point of view, of no help to us in the matter of Tal Coat.

B: ——

D: Perhaps that is enough for today.

* * *

III Bram van Velde

B: Frenchman, fire first.

D: Speaking of Tal Coat and Masson you invoked an art of a different order, not only from theirs, but from any achieved up to date. Am I right in thinking that you had van Velde in mind when making this sweeping distinction?

B: Yes. I think he is the first to accept a certain situation and to consent to a certain act.

D: Would it be too much to ask you to state again, as simply as possible, the situation and act that you conceive to be his?

B: The situation is that of him who is helpless, cannot act, in the event cannot paint, since he is obliged to paint. The act is of him who, helpless, unable to act, acts, in the event paints, since he is obliged to paint.

D: Why is he obliged to paint?

B: I don't know.

D: Why is he helpless to paint?

B: Because there is nothing to paint and nothing to paint with.

D: And the result, you say, is art of a new order?

B: Among those whom we call great artists, I can think of none whose concern was not predominantly with his expressive possibilities, those of his vehicle, those of humanity. The assumption underlying all painting is that the domain of the maker is the domain of the feasible. The much to express, the little to express, the ability to express much, the ability to express little, merge in the common anxiety to express as much as possible, or as truly as possible, or as finely as possible, to the best of one's ability. What – –

D: One moment. Are you suggesting that the painting of van Velde is inexpressive?

B: (A fortnight later) Yes.

D: You realize the absurdity of what you advance?

B: I hope I do.

D: What you say amounts to this: the form of expression known as painting, since for obscure reasons we are obliged to speak of painting, has had to wait for van Velde to be rid of the misapprehension under which it has laboured so long and so bravely, namely, that its function was to express, by means of paint.

B: Others have felt that art is not necessarily expression. But the numerous attempts made to make painting independent of its occasion have only succeeded in enlarging its repertory. I suggest that van Velde is the first whose painting is bereft, rid if you prefer, of occasion in every shape and form, ideal as well as material, and the first whose hands have not been tied by the certitude that expression is an impossible act.

D: But might it not be suggested, even by one tolerant of this fantastic theory, that the occasion of his painting is his predicament, and that it is expressive of the impossibility to express?

B: No more ingenious method could be devised for restoring him, safe and sound, to the bosom of Saint Luke. But let us, for once, be foolish enough not to turn tail. All have turned wisely tail, before the ultimate penury, back to the mere misery where destitute virtuous mothers may steal bread for their starving brats. There is more than a difference of degree between being short, short of the world, short of self, and being without these esteemed commodities. The one is a predicament, the other not.

D: But you have already spoken of the predicament of van Velde.

B: I should not have done so.

D: You prefer the purer view that here at last is a painter who does not paint, does not pretend to paint. Come, come, my dear fellow, make some kind of connected statement and then go away.

B: Would it not be enough if I simply went away?

D: No. You have begun. Finish. Begin again and go on until you have finished. Then go away. Try and bear in mind that the subject under discussion is not yourself, nor the Sufist Al-Haqq, but a particular Dutchman by name van Velde, hitherto erroneously referred to as an *artiste peintre*.

B: How would it be if I first said what I am pleased to fancy he is, fancy he does, and then that it is more than likely that he is and does quite otherwise? Would not that be an excellent issue out of all our afflictions? He happy, you happy, I happy, all three bubbling over with happiness.

D: Do as you please. But get it over.

B: There are many ways in which the thing I am trying in vain to say may be tried in vain to be said. I have experimented, as you know, both in public and in private, under duress, through faintness of heart, through weakness of mind, with two or three hundred. The pathetic antithesis possession-poverty was perhaps not the most tedious. But we begin to weary of it, do we not? The realization that art has always been bourgeois, though it may dull our pain before the achievements of the socially progressive, is finally of scant interest. The analysis of the relation between the artist and his occasion, a relation always regarded as indispensable, does not seem to have been very productive either, the reason being perhaps that it lost its way in disquisitions on the nature of occasion. It is obvious that for the artist obsessed with his expressive vocation, anything and everything is doomed to become occasion, including, as is apparently to some extent the case with Masson, the pursuit of occasion, and the every man his own wife experiments of the spiritual Kandinsky. No painting is more replete than Mondrian's. But if the occasion appears as an unstable term of relation, the artist, who is the other term, is hardly less so, thanks to his warren of modes and attitudes. The objections to this dualist view of the creative process are unconvincing. Two things are established, however precariously: the aliment, from fruits on plates to low mathematics and self-commiseration, and its manner of dispatch. All that should concern us is the acute and increasing anxiety of the relation itself, as though shadowed more and more darkly by a sense of invalidity, of inadequacy, of existence at the expense of all that it excludes, all that it blinds to. The history of painting, here we go again, is the history of its attempts to escape from this sense of failure, by means of more authentic, more ample, less exclusive relations between representer and representee, in a kind of tropism towards a light as to the nature of which the best opinions continue to vary, and with a kind of Pythagorean terror, as though the irrationality of pi were an offence against the deity, not to mention his creature. My case, since I am in the dock, is that van Velde is the first to desist from this estheticized automatism, the first to submit wholly to the incoercible absence of relation, in the absence of terms or, if you like, in the presence of unavailable terms, the first to admit that to be an artist is to fail, as no other dare fail, that failure is his world and the shrink from it desertion, art and craft, good housekeeping, living. No, no, allow me to expire. I know that all that is required now, in order to bring even this horrible matter to an acceptable conclusion, is to make of this submission, this admission, this fidelity to failure, a new occasion, a new term of relation, and of the act which, unable to act, obliged to act, he makes, an expressive act, even if only of itself, of its impossibility, of its obligation. I know that my inability to do so places myself, and perhaps an innocent, in what I think is still called an unenviable situation, familiar to psychiatrists. For what is this coloured plane, that was not there before. I don't know what it is, having never seen anything like it before. It seems to have nothing to do with art, in any case, if my memories are correct. (Prepares to go).

D: Are you not forgetting something?

B: Surely that is enough?

D: I understood your number was to have two parts. The first was to consist in your saying what you – er – thought. This I am prepared to believe you have done. The second –

B: (Remembering, warmly) Yes, yes, I am mistaken, I am mistaken.

8 Jacques Lacan (1901–1981) 'The Mirror-Phase as Formative of the Function of the I'

Lacan's principal legacy for work in the field of art and culture has been his development of the concept of the gendered subject. The use of this concept entails a challenge to that idea of the unitary and homogeneous Self which underlies expression-based theories of art, and which can ultimately be traced back to Descartes's 'Cogito': 'I think, therefore I am.' Lacan postulates two main stages in the development of consciousness, following an initial undifferentiated state which he designates with the pun 'hommelette'. These are the Imaginary and the Symbolic. The latter concerns the subject's entry into, and formation by the world of language. The former involves a pre-linguistic stage of consciousness focused around the visual recognition of images, which Lacan termed the 'mirror-phase'. His initial formulation of the mirror-phase was made as early as 1936, in an unpublished paper read to the 14th Congress of the International Psychoanalytical Association in Marienbad: 'Le Stade du miroir: Théorie d'un moment structurant et génétique de la constitution de la réalité'. During this period Lacan was associated with the Surrealist group and he published work in the Surrealist journal *Minotaure* which has been related to Salvador Dali's 'paranoiac criticism' (see IVC14). Traces of this connection remain evident in the present essay, 'Le Stade du miroir comme formateur de la fonction du je'. It was initially read to the International Psychoanalytic Congress in Zurich in July 1949. Reprinted in Lacan's *Ecrits*, Paris, 1966. English translation by Jean Roussel in *New Left Review*, London, no. 51, September–October 1968, pp. 71–7, from which the present version is taken.

The conception of the mirror-phase which I introduced at our last congress, thirteen years ago, has since become more or less established in the practice of the French group; I think it nevertheless worthwhile to bring it again to your attention, especially today, for the light that it sheds on the formation of the *I* as we experience it in psychoanalysis. It is an experience which leads us to oppose any philosophy directly issuing from the *Cogito*.

Some of you may perhaps remember our starting-point in a feature of human behaviour illuminated by a fact of comparative psychology. The human offspring, at an age when he is for a time, however short, outdone by the chimpanzee in instrumental intelligence, can nevertheless already recognize as such his own image in a mirror. [...]

This event can take place... from the age of six months, and its repetition has often compelled us to ponder over the startling spectacle of the nurseling in front of the mirror. Unable as yet to walk, or even to stand up, and narrowly confined as he is within some support, human or artificial (what, in France, we call a '*trotte-bébé*'), he nevertheless surmounts, in a flutter of jubilant activity, the obstructions of his support in order to fix his attitude in a more or less leaning-forward position, and bring back an instantaneous aspect of the image to hold it in his gaze.

For us, this activity retains the meaning we have given it up to the age of eighteen months. This meaning discloses a libidinal dynamism, which has hitherto remained problematic, as well as an ontological structure of the human world which accords with our reflections on paranoiac knowledge.

We have only to understand the mirror-phase *as an identification*, in the full sense which analysis gives to the term: namely, the transformation which takes place in the

subject when he assumes an image – whose predestination to this phase-effect is sufficiently indicated by the use, in analytical theory, of the old term *imago*.

This jubilant assumption of his mirror-image by the little man, at the *infans* stage, still sunk in his motor incapacity and nurseling dependency, would seem to exhibit in an exemplary situation the symbolic matrix in which the *I* is precipitated in a primordial form, before it is objectified in the dialectic of identification with the other, and before language restores to it, in the universal, its function as subject.

This form would have to be called the *Ideal-I*, if we wanted to restore it to a familiar scheme, in the sense that it will also be the root-stock for secondary identifications, among which we place the functions of libidinal normalization. But the important point is that this form situates the instance of the *ego*, before its social determination, in a fictional direction, which will always remain irreducible for the individual alone, or rather, which will only rejoin the development of the subject asymptotically, whatever the success of the dialectical syntheses by which he must resolve as *I* his discordance with his own reality.

The Body as Gestalt

The fact is that the total form of the body by which the subject anticipates in a mirage the maturation of his power is only given to him as *Gestalt*, that is to say in an exteriority in which this form is certainly more constituent than constituted, but in which it appears to him above all in a contrasting size that fixes it and a symmetry that inverts it which are in conflict with the turbulence of the motions which the subject feels animating him. Thus, this *Gestalt* – whose pregnancy should be regarded as linked to the species, though its motor style remains unrecognizable – by these twin aspects of its appearance, symbolizes the mental permanence of the *I*, at the same time as it prefigures its alienating destination; it is pregnant with the correspondences which unite the *I* with the statue in which man projects himself, with the phantoms which dominate him, or finally, with the automaton in which, in an ambiguous relation, the world of his fabrication tends to find completion.

Indeed, where *imagos* are concerned . . . the mirror-image would seem to be the threshold of the visible world, if we go by the mirror disposition which the *imago of our own body* presents in hallucinations or dreams, whether it concerns its individual features, or even its infirmities, or its object-projections; or if we notice the role of the mirror apparatus in the appearances of the *double*, in which psychic realities, however heterogeneous, manifest themselves.

That a *Gestalt* should be capable of formative effects in the organism is attested by a piece of biological experimentation which is itself so alien to the idea of psychic causality that it cannot bring itself to formulate its results in these terms. It nevertheless recognizes that it is a necessary condition for the maturation of the gonad of the female pigeon that it should see another member of its species, of either sex; so sufficient in itself is this condition that the desired effect may be obtained merely by placing the individual within reach of the field of reflection of a mirror. Similarly, in the case of the migratory locust, the transition within a generation from the solitary to the gregarious form, can be obtained by the exposure of the individual, at a certain stage, to the exclusively visual action of a similar image, provided it is animated by movements of a style sufficiently close to that characteristic of the species. Such facts are inscribed in an

order of homeomorphic identification which would itself fall within the larger question of the meaning of beauty as formative and erotogenic.

But facts of mimicry are no less instructive when conceived as cases of heteromorphic identification, inasmuch as they raise the problem of the significance of space for the living organism; psychological concepts hardly seem less appropriate for shedding light on these matters than ridiculous attempts to reduce them to the supposedly supreme law of adaptation. [...]

We have ourselves shown in the social dialectic which structures human knowledge as paranoiac why human knowledge has greater autonomy than animal knowledge in relation to the field of force of desire, but also why it is determined in the direction of that 'lack of reality' which surrealist dissatisfaction denounces in it. These reflections lead us to recognize in the spatial ensnarement exhibited in the mirror-phase, even before the social dialectic, the effect in man of an organic insufficiency in his natural reality – insofar, that is, as we attach any meaning to the word 'nature'.

We are therefore led to regard the function of the mirror-phase as a particular case of the function of the *imago*, which is to establish a relation of the organism to its reality – or, as they say, of the *Innenwelt* to the *Umwelt*. [...]

This development is lived as a temporal dialectic which decisively projects the formation of the individual into history; the *mirror-phase* is a drama whose internal impulse rushes from insufficiency to anticipation and which manufactures for the subject, captive to the lure of spatial identification, the succession of phantasies from a fragmented body-image to a form of its totality which we shall call orthopaedic – and to the assumption, finally, of the armour of an alienating identity, which will stamp with the rigidity of its structure the whole of the subject's mental development. Thus, to break out of the circle of the *Innenwelt* into the *Umwelt* generates the endless quadrature of the inventorying of the *ego*.

The Fragmented Body

This fragmented body, the term for which I have introduced into our theoretical frame of reference, regularly manifests itself in dreams when the movement of the analysis encounters a certain level of aggressive disintegration in the individual. It then appears in the form of disjointed limbs, or of those organs figured in exoscopy, growing wings and taking up arms for intestinal persecutions – the very same that the visionary Hieronymus Bosch has fixed, for all time, in painting, as they climbed, in the fifteenth century, to the imaginary zenith of modern man, but this form is even tangibly revealed at the organic level, in the lines of 'fragilization' which define the anatomy of phantasy, as exhibited in the schizoid and spasmodic symptoms of hysteria.

Correlatively, the formation of the *I* is symbolized in dreams by a fortress, or a stadium – its inner arena and enclosure, surrounded by marshes and rubbish-tips, dividing it into two opposed fields of contest where the subject flounders in quest of the haughty and remote inner castle, which, in its shape (sometimes juxtaposed in the same scenario), symbolizes the *id* in startling fashion. Similarly, on the mental plane, we find realized the structures of fortified works, the metaphor of which arises spontaneously, and as if issuing from the symptoms themselves, to describe the mechanisms of obsessional neurosis – inversion, isolation, reduplication, cancellation and displacement.

But were we to build on this merely subjective data, and should this be detached from the experiential condition which would make us derive it from a language technique, our theoretical enterprise would remain exposed to the charge of projecting itself into the unthinkable of an absolute subject. That is why we have to find in the present hypothesis, grounded in a conjunction of objective data, the guiding grid for a *method of symbolic reduction*.

It establishes in the *defences of the ego* a genetic order ... and situates (as against a frequently expressed prejudice) hysterical repression and its returns at a more archaic stage than obsessional inversion and its isolating processes, and the latter in turn as preliminary to paranoiac alienation, which dates from the deflection of the mirror *I* into the social *I*.

This moment in which the mirror-phase comes to an end inaugurates, by the identification with the *imago* of the fellow and the drama of primordial jealously ... the dialectic which will henceforth link the *I* to socially elaborated situations.

It is this moment that decisively tips the whole of human knowledge into mediatization through the desire of the other, constitutes its objects in an abstract equivalence by virtue of the competition of the other, and makes the *I* into that system for which every instinctual thrust constitutes a danger, even though it should correspond to a natural maturation – the very normalization of this maturation being henceforth dependent, in man, on a cultural go-between, as exemplified, in the case of the sexual object, by the Oedipus complex.

In the light of this conception, the term primary narcissism, by which analytical doctrine denotes the libidinal investment characteristic of that moment, reveals in those who invented it the most profound awareness of semantic latencies. But it also illuminates the dynamic opposition of that libido to sexual libido, which they tried to define when they invoked destructive and, indeed, death instincts, in order to explain the evident connection between narcissistic libido and the alienating function of the *I*, the aggressiveness which it releases in any relation to the other, albeit that of the most Samaritan aid.

Existentialism

They were encountering that existential negativity whose reality is so warmly advocated by the contemporary philosophy of being and nothingness.

But unfortunately that philosophy only grasps negativity within the confines of a self-sufficiency of consciousness, which, as one of its premises, links to the constitutive mis-recognitions of the *ego*, the illusion of autonomy to which it entrusts itself. This flight of fancy, for all that it draws, to an unusual extent, on borrowings from psychoanalytic experience, culminates in the pretension to provide an existential psychoanalysis.

At the climax of the historical attempt of a society to refuse to recognize that it has any function other than the utilitarian one, and in the anguish of the individual confronting the concentrational form of the social bond which seems to arise to crown this attempt, existentialism must be judged by the account it gives of the subjective dilemmas which it has indeed given rise to: the freedom which never claims more authenticity than when it is within the walls of a prison; the demand for commitment, expressing the impotence of a pure consciousness to master any situation; the voyeuristic-sadistic idealization of the sexual relationship; the personality which

only realizes itself in suicide; the awareness of the other which can only be satisfied by Hegelian murder. [...]

The sufferings of neurosis and psychosis are for us the school of the passions of the soul, just as the scourge of the psychoanalytic scales, when we compute the tilt of their threat to entire communities, gives us the index of the deadening of the passions of the city.

At this junction of nature and culture which is so persistently scanned by modern anthropology, psychoanalysis alone recognizes this knot of imaginary servitude which love must always undo again, or sever.

For such a task we place no reliance in altruistic feeling, we who lay bare the aggressiveness that underlies the activity of the philanthropist, the idealist, the pedagogue, and even the reformer.

In the recourse of subject to subject which we preserve, psychoanalysis can accompany the patient to the ecstatic limit of the '*Thou art that*', wherein is revealed to him the cipher of his mortal destiny, but it is not in our mere power as practitioners to bring him to that point where the real journey begins.

9 Jean-Michel Atlan (1913–1960) 'Abstraction and Adventure in Contemporary Art'

Born in Algeria from a Jewish background, Atlan went on to study philosophy at the Sorbonne in Paris. He took up painting during a period of feigned insanity after his arrest for Resistance activities. A Communist, he nonetheless rejected the doctrine of Socialist Realism and instead developed a mythic-primitivist technique and imagery to express the post-war condition. This perspective led Atlan to eventual involvement with the group Cobra (see also VC11 and 12). Cobra is an acronym of Copenhagen, Brussels and Amsterdam, the cities where the group was based; though it had of course a strong, albeit critical, focus on Paris. Eight issues of a journal of the same name were published between 1948 and 1951. The present text was first published in *Cobra* in April 1950. It was reprinted in the catalogue of the exhibition '*Paris – Paris: Créations en France 1937–1957*', Paris: Centre Pompidou, 1981, from which the present translation is made.

1 Contemporary painting, being essential adventure and creation, is threatened by two forms of conformity which we absolutely oppose:
 a) Banal realism, vulgar imitation of reality;
 b) Orthodox abstract art, new academicism which tries to substitute for living painting an interplay of solely decorative forms.

We believe that it is at the margin of official abstract art, and only there, that the most valuable works develop; just as it was at the margin of Impressionism during the last century that the greatness of the works of those great heretics, van Gogh and Gauguin, was established.

2 The fundamental pretension of theoreticians of abstract academicism, which is that painting is a spiritual progression of forms excluding all reference to nature, cannot stand up to clear analysis. All the works of current psychology tend on the contrary to establish that human vision is itself a creation, in which the imagination and nature participate equally. (The example of the ink blots and the Rorschach tests.)

It is just the same when these theoreticians assert that abstraction consitutes a new language which breaks with the aims and techniques of the past. This pretension is also ill-conceived.

a) Constructivism, Neo-Plasticism, etc. are examples of movements already fairly well advanced in age, years before the war.

b) The analysis of essential elements of pictorial language: form, light, colour, matter show that painting, whether it be figurative or not, is organized according to the same fundamental rhythms.

3 The forms which appear to us today as the most valuable, as much through their formal arrangement as by their expressive intensity, are not properly speaking either abstract or figurative. They participate precisely in these cosmic powers of *metamorphosis* where the true adventure is located. (From where there arise forms which are themselves and something other than themselves, birds and cacti, abstraction and new figuration.)

4 The creation of a work of art cannot be reduced to formulae, nor to some construction of more or less decorative forms, rather it supposes a *presence*, it is an adventure in which a man commits himself to struggle with the fundamental forces of nature.

To see this through to the bitter end, some of us today risk our necks. We turn our backs on vain quarrels about doctrine, resolutely committing ourselves to those directions which fashion and the public can barely follow.

10 Francis Ponge (1899–1988) 'Reflections on the Statuettes, Figures and Paintings of Alberto Giacometti'

In the immediate post-war period Giacometti came to be seen by many, including Sartre and Genet, as the pre-eminent Existentialist artist (see VB6). His attenuated human figures, alone in apparently vast tracts of space, seemed to sum up the sense of isolated individualism pervading the French avant-garde. The writer Francis Ponge eloquently summarized this view in an article 'Réflexions sur les statuettes, figures et peintures d'Alberto Giacometti', originally published in *Cahiers d'Art*, Paris, 1951, from the conclusion of which the present extract is translated. (Ellipses are in the original.)

Man...the human person...the free individual...the I...at once torturer and victim...at once hunter and prey...

Man – and man alone – reduced to a thread – in the dilapidation and misery of the world – who searches for himself – starting from nothing.

Exhausted, thin, emaciated, naked. Aimlessly wandering in the crowd.

Man anxious about man, in terror of man. Asserting himself one last time in a hieratic attitude of supreme elegance. The pathos of extreme emaciation, the individual reduced to a thread.

Man at the stake of his contradictions. No longer crucified. Burned. You are right, dear friend.

Man on a pavement like burning iron; who cannot lift his heavy feet.

Oh! Since Greek sculpture, what am I saying, since Laurens and Maillol, man has been well burned at the stake!

It is doubtless true that since Nietzsche and Baudelaire the destruction of values has accelerated . . .

They drip around him, his values, his fat; to feed the flames!

It is not only that Man has nothing more; but he is nothing more, than this I.

11 Albert Camus (1913–1960) 'Creation and Revolution' from *The Rebel*

Born in Algeria, Camus's principal employment after reading philosophy at university was as a journalist, first in Algeria and later in Paris. During the war he wrote for and later edited the clandestine Resistance newspaper *Combat*. After the war he gave up journalism and concentrated on literary and philosophical work. He came to represent a wing of Existentialism opposed to Sartre's increasing identification with Marxism, and the publication of his book *The Rebel* precipitated a public quarrel between the two. In this extract Camus links the freedom necessary for the production of art to the freedom paradoxically required by rebellion: totalitarianism snuffs out the liberating impulse to be found in both, and as such must be resisted in all its forms. Originally published as *L'Homme révolté*, Paris, 1951. Translated by Anthony Brower as *The Rebel*, London, 1953; reprinted 1962; the present extract is taken from pp. 237–42 of the 1962 reprint.

Creation and Revolution

In art, rebellion is consummated and perpetuated in the act of real creation, not in criticism or commentary. Revolution, in its turn, can only affirm itself in a civilization and not in terror or tyranny. The two questions posed, henceforth, by our times to a society caught in a dilemma – Is creation possible? Is the revolution possible? – are in reality only one question which concerns the renaissance of civilization.

The revolution and art of the twentieth century are tributaries of the same nihilism and live in the same contradiction. They deny what they affirm, however, even in their very actions, and both try to find an impossible solution through terror. The contemporary revolution believes that it is inaugurating a new world when it is really only the contradictory climax of the ancient world. Finally capitalist society and revolutionary society are one and the same thing to the extent that they submit themselves to the same means – industrial production – and to the same promise. But one makes its promise in the name of formal principles which it is quite incapable of incarnating and which are denied by the methods it employs. The other justifies its prophecy in the name of the only reality it recognizes and ends by mutilating reality. The society based on production is only productive, not creative.

Contemporary art, because it is nihilistic, also flounders between formalism and realism. Realism, moreover, is just as much bourgeois, when it is 'tough', as socialist when it becomes edifying. Formalism belongs just as much to the society of the past, when it takes the form of gratuitous abstraction, as to the society which claims to be the society of the future – when it becomes propaganda. Language destroyed by irrational negation becomes lost in verbal delirium; subject to determinist ideology it is summed up in the word of command. Half-way between the two lies art. If the rebel must simultaneously reject the frenzy of annihilation and the acceptance of totality, the artist must simultaneously escape from the passion for formality and the totalitarian aesthetic

of reality. The world today is one, in fact, but its unity is the unity of nihilism. Civilization is only possible if, by renouncing the nihilism of formal principles and nihilism without principles, the world rediscovers the road to a creative synthesis. In the same way, in art, the time of perpetual commentary and reportage is at the point of death; it announces the advent of creative artists.

But art and society, creation and revolution must, to prepare for this event, rediscover the source of rebellion where refusal and acceptance, in [the] unique and the universal, the individual and history balance each other in a condition of the most acute tension. Rebellion, in itself, is not an element of civilization. But it is a preliminary to all civilization. Rebellion alone, in the blind alley in which we live, allows us to hope for the future of which Nietzsche dreamed: 'Instead of the judge and the oppressor, the creator'. This formula certainly does not authorize the ridiculous illusion of a civilization controlled by artists. It only illuminates the drama of our times in which work, entirely subordinated to production, has ceased to be creative. Industrial society will only open the way to a new civilization by restoring to the worker the dignity of a creator; in other words, by making him apply his interest and his intelligence as much to the work itself as to what it produces. The type of civilization which is inevitable will not be able to separate, amongst classes as well as in the individual, the worker from the creator; any more than artistic creation dreams of form and foundation, history and the mind. In this way it will bestow on everyone the dignity which rebellion affirms. It would be unjust, and moreover Utopian, for Shakespeare to direct the shoemakers' union. But it would be equally disastrous for the shoemakers' union to ignore Shakespeare. Shakespeare without the shoemakers serves as an alibi for tyranny. The shoemaker without Shakespeare is absorbed by tyranny when he does not contribute to its propagation. Every act of creation denies, by its mere existence, the world of master and slave. The appalling society of tyrants and slaves in which we survive will only find its death and transfiguration on the level of creation.

But the fact that creation is necessary does not perforce imply that it is possible. A creative period in art is determined by the order of a particular style applied to the disorder of a particular time. It gives form and formulae to contemporary passions. [...] Today when collective passions have stolen a march on individual passions, the ecstasy of love can always be controlled by art. But the ineluctable problem is also to control collective passions and the historic struggle. The scope of art, despite the regrets of the plagiarists, has been extended from psychology to the human condition. When the passions of the times put the fate of the whole world at stake, creation wants to dominate the whole of destiny. But, at the same time, it maintains, in the face of totality, the affirmation of unity. In simple words, creation is then imperilled, first by itself, and then by the spirit of totality. To create, today, is to create dangerously.

Collective passions must, in fact, be lived through and experienced, at least relatively. At the same time that he experiences them, the artist is devoured by them. The result is that our period is rather the period of reportage than the period of the work of art. The exercise of these passions, finally, entails far greater chances of death than in the time of love and ambition, in that the only way of living collective passions is to be willing to die for them or by their hand. The greatest opportunity for authenticity is, today, the greatest defeat of art. If creation is impossible during wars and revolutions, then we shall have no creative artists, for war and revolution are our lot. The myth of unlimited production brings war in its train as inevitably as clouds announce a storm.

Wars lay waste to the West and kill a genius or two. Hardly has it arisen from the ruins when the bourgeois system sees the revolutionary system advancing upon it. The genius has not even had time to be reborn; the war which threatens us will, perhaps, kill all those who might have been geniuses. If a creative classicism is, nevertheless, proved possible, we must recognize that, even though it is rendered illustrious by one name alone, it will be the work of an entire generation. The chances of defeat, in the century of destruction, can only be compensated for by the hazard of numbers; in other words, the chance that of ten authentic artists one, at least, will survive, take charge of the first utterances of his brother artists and succeed in finding in his life both the time for passion and the time for creation. The artist, whether he likes it or not, can no longer be a solitary, except in the melancholy triumph which he owes to all his fellow-artists. Rebellious art also ends by revealing the 'We are' and with it the way to a burning humility.

Meanwhile, the triumphant revolution, in the aberrations of its nihilism, menaces those who, in defiance of it, claim to maintain the existence of unity in totality. One of the implications of history today, and still more of the history of tomorrow, is the struggle between the artists and the new conquerors, between the witnesses to the creative revolution and the founders of the nihilist revolution. As to the outcome of the struggle, it is only possible to make inspired guesses. At least we know that it must, hereafter, be carried on to the bitter end. Modern conquerors can kill, but do not seem to be able to create. Artists know how to create but cannot really kill. Murderers are only very exceptionally found among artists. In the long run, therefore, art in our revolutionary societies must die. But then the revolution will have lived its allotted span. Each time that the revolution kills in a man the artist that he might have been, it attenuates itself a little more. If, finally, the conquerors succeed in moulding the world according to their laws, it will not prove that quality is king but that this world is hell. In this hell, the place of art will coincide with that of vanquished rebellion, a blind and empty hope in the pit of despair. Ernst Dwinger in his *Siberian Diary* mentions a German lieutenant – for years a prisoner in a camp where cold and hunger were almost unbearable – who constructed himself a silent piano with wooden keys. In the most abject misery, perpetually surrounded by a ragged mob, he composed a strange music which was audible to him alone. And for us who have been thrown into hell, mysterious melodies and the torturing images of a vanquished beauty will always bring us, in the midst of crime and folly, the echo of that harmonious insurrection which bears witness, throughout the centuries, to the greatness of humanity.

But hell can endure for only a limited period and life will begin again one day. History may perhaps have an end; but our task is not to terminate it but to create it, in the image of what we henceforth know to be true. Art, at least, teaches us that man cannot be explained by history alone and that he also finds a reason for his existence in the order of nature. For him, the great god Pan is not dead. His most distinctive act of rebellion, while it affirms the value and the dignity common to all men, obstinately claims, so as to satisfy its hunger for unity, an integral part of the reality whose name is beauty. One can reject all history and yet accept the world of the sea and the stars. The rebels who wish to ignore nature and beauty are condemned to banish from history everything with which they want to construct the dignity of existence and of labour. Every great reformer tries to create in history what Shakespeare, Cervantes, Molière,

and Tolstoy knew how to create: a world always ready to satisfy the hunger for freedom and dignity which every man carries in his heart. Beauty, no doubt, does not make revolutions. But a day will come when revolutions will have need of beauty. The procedure of beauty, which is to resist the real while conferring unity upon it, is also the procedure of rebellion. Is it possible eternally to reject injustice without ceasing to acclaim the nature of man and the beauty of the world? Our answer is yes. This ethic, at once unsubmissive and loyal, is in any event the only one which lights the way to a truly realistic revolution. In upholding beauty, we prepare the way for the day of regeneration when civilization will give first place – far ahead of the formal principles and degraded values of history – to this living virtue on which is founded the common dignity of man and the world he lives in, and which we now have to define in the face of a world which insults it.

12 Michel Tapié (1909–1987) from *An Other Art*

A founder member of the Compagnie de l'Art Brut with Dubuffet and Breton in 1948, Tapié managed the Foyer de l'Art Brut at the Galerie René Drouin. Tapié later wrote of the need for 'temperaments ready to break up everything', and to re-route the public into a 'real future'. To this end all existing art forms, particularly geometric abstraction and derivatives of Cubism, were held to be inadequate. Tapié accordingly became prominent in the support and promotion of a tendency of informal abstract art, organizing the exhibition 'Signifiants de l'Informel' at the Studio Fachetti in Paris in 1951. His book *Un Art Autre: où il s'agit de nouveaux dévidages du réel* was published in Paris in 1952, from which edition the present extract is translated.

The direction of art now presents itself as the mystery appeared to St John of the Cross; sheer and without solace. Since Nietzsche and Dada art has seemed the most inhuman of adventures, from beginning to end. Only work which would justify such a description justifies the current pioneers. And what it earns has little to do with pleasure, but rather with the most vertiginous test which it is given to man to confront, which is to lean over the depths of himself without the protection of a railing. With this much at stake, ideas which seem unchangeable are questioned, if not swept away, once and for all.

Since Impressionism these notions of beauty, form, space, aesthetics, have all been to greater or lesser extents subject to question. However, until now, even the most aggressive works mishandled these ideas, turned their backs on them, attacked them, denied them; but in any case went *against* them (which is still a way of recognizing them). Current works operate totally *outside* these ideas, totally indifferent to them, as if ignorant of them, as if they had never existed. Dada was the great break. Until then, Cubism included, all the classical criteria were still in play despite the anarchic appearances; order, composition, balance, rhythm. These all directly descended from a humanism which was en route to exhaustion, but which had a continuing existence thanks to established routines, prevalent among both artists and collectors. Until Dada (and with the exception of the great German Expressionist movement, whose capital importance is only just being recognized) all the various 'isms' were only outwardly revolutionary, in a sort of Romanticism according to which adventure involved devaluing accepted laws in some spectacular act of sacrilegious negation. But there was no real

difference of approach, no recognition that these worn-out laws were a matter of total indifference, offering no real possibilities for the future.

When one visits collections of contemporary paintings, one does not have the impression that the lesson of Dada contributed much. One asks oneself how, after Dada, it is possible to continue such mediocre, useless production; how, above all, it is possible that people should waste their lives in such stimulating activities without knowing themselves to be impostors of the first water. However, I believe that there is something radically new, namely, people's awareness that it is impossible to create some new 'ism'; there is also a certain prudishness amongst artists in the handling of form, this stupid form whose name justifies so many pursuits to the detriment of intoxication with life and the development of mystery. Even those of us with the worst conscience now know that there is only adventure by the individual, and that form can only take its seat at the banquet which is contemporary art if it contents itself with a place just like the others, and is even prepared to give up its place to another. It thus gives itself a good alibi, which a habitual offender always needs. To the extent that our art is different, a new etiquette is worked out which does not improve old criteria, but rather is totally different in both its values and assumptions.

Our interest is not in movements, but in something much rarer, authentic Individuals. Movements have only ever existed because the majority of people follow the group in which they find security from their own cowardice. The only free person is the leader, if there really is a group, not just the little lifeless coteries so dear to the hearts of our modern intellectual milieux.

The individual only remains himself in collective experiences in so far as he takes these experiences in hand, by using them to develop his personal potential. This supposes a total confidence in oneself, as well as faith in something incommensurable and undiscussable, something precise and endless; on a scale as humanly superhuman as the NADA of St John of the Cross. In the face of this, the swarm of little movements with their history-making theological/critical quarrels about art are of negligible importance.

The individual worthy of this title is not a prisoner of his past, but rather of his future. He is not afraid that one can draw these apparent contradictions from him, since these are only the facile games of immature individuals; of weaklings who have never developed for fear of making some terrible mistake. On the contrary, such mistakes are a springboard for those whose works flourish in the generous spirit of the great adventure. The key to the work, then, is its ultimate or complete nature; no alchemist is worthy of this name until he has completed the great work and he does not deserve it during the necessary preliminary stages, during which the fools don't hesitate to pour out their hostility. These fools maliciously believe they can drag this individual back into their ranks, as his very existence is a challenge both to their presence and to the inevitable fact of their numerousness. Art is at the opposite extreme to universal suffrage.

But another confession: form has for too long lost all hope of becoming an incarnation of the god of formalism. Life has become totally estranged from form; expressiveness is no longer compatible with it. The sculptors of form, those who want all the beliefs of the great adventure to live in the sculpture, seek every means to express themselves *differently* than actually through form. Painters, with the apparent freedom of an infinitely multiple technique deliberately act without it. They behave with casual

indifference to the conventional wisdom, and act without form, in a profound anarchy. The Occidental world is finally discovering the Sign; it explodes it in the vehemence of a transcendental calligraphy, of a hyper-significance intoxicated with the cruel vertigo of a pure future.

13 Georg Baselitz (b. 1938) 'Pandemonium Manifestos'

Baselitz was born in what after the Second World War became East Germany. From the mid-1950s to the mid-1960s he mostly lived and worked in Berlin, the city at the very centre of the tensions of the Cold War as well as the site most redolent of Germany's fraught relations to its own past. Although chronologically the Manifestos coincided with moves among younger artists in America, England and France to deal with the newly emergent Consumer Society, temperamentally they are of a piece with the anguished post-war individualism of the previous phase. Baselitz actually cites Artaud in the Manifestos, and in his painting of the period he was influenced by Fautrier. In a German context dominated since the 1930s first by Nazi classicism and later by Socialist Realism, he turned to the Expressionist tradition. His paintings of the time attest to preoccupations with isolation and violence and are often prefixed with the letters 'P.D.' to affirm their relation to the 'Pandemonium' manifestos. Both were issued in Berlin, under the names of Baselitz and Eugen Schönebeck, in extremely limited editions: the first in November 1961, the second in February 1962. They are published in English translation in the exhibition catalogue *Georg Baselitz: Paintings 1960–83*, London, Whitechapel Art Gallery, 1983, from which the present text is taken.

1

> The poets lay in the kitchen sink,
> body in morass.
> The whole nation's spittle
> floated on their soup.
> They grew between mucous membranes
> into the root areas of humanity.
> Their wings did not carry them heavenward –
> they dipped their quills in blood,
> not a drop wasted writing –
> but the wind bore their songs,
> and those have shaken faith . . .

The poet are still throwing up their hands. Point to changes? Bitterness, impotence and negation are not expressed in gesture. Till it hurts! With a final, finite truth pouring out. No truck with those who can't wrap art up in a smell. I have no kind word to say to the amiable. They have proceeded by art-historical accretion, they have ruled neat lines under things, they have practised mystification with all the passion of a collector. The survivors' beds are not unmade – remnants of the last housework stuffed under the bed – the gelatinous threads have not become visible, the unfruitful troubles derided. The rest of history is instances. We have blasphemy on our side! They have escaped their sickbeds. Their simplifying methods have swept them on to the crests of the

waves. The ice beneath the foggy maze is broken. They are all frozen stiff – those who believe in fertility, those who believe in it – those who deny their pens and those who revere them. Fiery furrows in the ice, flowerlike crystals, crisscross icicles, starry sky torn open. Frozen nudes with encrusted skin – spilt trail of blood. The amiable are washed up, deposited as sediment. Faces that the moon pulls, in perspective, in the rivers, faces into which waste water drips. The toad that licks up the singers' spittle. Glowing crystal mountain. Homer, the water of thine eye, in the mountain lake. Caught in the curlicues of the manuals which invented the method.

Pacifying meditation, starting with the contemplation of the little toe. On the horizon, in the depths of the fog, you can always see faces. Under the blanket a being stirs, and behind the curtain someone laughs. In my eyes can be seen the altar of Nature, the sacrifice of flesh, bits of food in the drain, evaporation from the bedclothes, bleeding from stumps and aerial roots, oriental light on the pearly teeth of lovely women, gristle, negative shapes, spots of shadow, drops of wax, parades of epileptics, orchestrations of the flatulent, warty, mushy, and jellyfishy beings, bodily members, braided erectile tissue, mouldy dough, gristly growths in a desert landscape.

Withered, timorous conifers and flailing deciduous trees in the memory. Anthropo-morphic pot-bellied putty rocks (without Arcimboldi). M. Vrubel in the cold sacristy of a Byzantine stone church – in the memory form.

Redon in the fleece of a one-eyed sheep, in the garden where the soft-leaved plants have faces – in the memory form. I am warped, bloated and sodden with memories. The destinies that make no one look up: I have them all on record. By night, troubles soon come to mind, like starlings in late summer – a negative film. The influence of the stars is undeniable, the purity of the night sky is awesome, only the source is poisoned. The many killings, which I daily experience in my own person, and the disgrace of having to defend my excessive births, lead to a malady of age and experience. Ramparts are built, byways pursued, sweets on offer, and more and more slides, sleepier and sleepier.

They have harassed me. The alien rhythm betrays them into the craziest dances. I deplore their rhythmic function. They are special editions of passion. Their art is a breathing exercise – ecstatic, contemplative, misty, inward, mathematical. Art as a meditative action, as the manifestation of an in-group.

In me there are pre-pubertal enclaves (the smell when I was born); in me there is the greening of youth, love in decoration, the tower-building idea. The greening of youth and the coming autumn leaves are valid, even if I fall into paranoid decline in winter. In me the brewers of poison, the annihilators, the degenerates, have attained a place of honour.

The seat of all unfruitful religion. Piles of squatting background monks, spread out in tiers, rigidly staring. In me there is a dead-end slide, the longing for Grecian columns, the addiction to excess, the Mannerists' addiction to excess, a tangle of tendrils and artifices, coldness and devotion – it is always enforced love. Because revulsion often overcame me without warning. I took – and still take – delight in sullying my own moments of innocent openness. Flatchested and lacerated, I assail the hollow spaces. It has turned into impressiveness. Another procedure that shame demands. Shame is not Situationism, it is the slide into the abyss, it is frightening, it is mob delusion, it is a relapse into the pubertal ooze. Euphoria deepens abysses.

Case 13
Often saw original mind in E.,
but character mixed.
December joy: I am thy death.

2

Negation is a gesture of genius, not a wellspring of responsibility.

With solemn obsessiveness, autocratic elegance, with warm hands, pointed fingers, rhythmic love, radical gestures – we want to excavate ourselves, abandon ourselves irrevocably – as we have no questions, as we look at each other, as we are wordless, as we, noblest profanity – our lips kiss the canvas in constant embrace – as we pull sweat-rags through our veins and mendicantly, non-violently, corrosively, painfully carry our colour ordeal over into life, as we naturally sully our cave tomb with exuberance – what our sacrifice is, we are. In happy desperation, with inflamed senses, undiligent love, gilded flesh: vulgar Nature, violence, reality, fruitless – parents forgotten – in answer to the vanished question, in our looks at you, lust and blood, our bodies prove that we love. Audacious twinness (deux, deux, deux) springs from love. Doubly pregnant cave. We have moved into a locked cave of Pandemoniac origin. Dark images (splendour in front, squalor behind) – mighty infatuation with senseless death. No outstanding debts. No. Twenty-four hypocritical years purged to the last dregs, to the creatorial uniform death in the front-line city. Left to my own devices, with no fear of the sudden break, I look into myself. Now I am here! Hygienic solace maintains the advantage gained by my isolation. First my restless eyes – mould gathered between ecstatic reactions of erectile tissue, then caress the gristle in the randy evening hours. Fantastic reality! Nameless life passes by Fantastic reality – the picture of my great parturition. On a foray into the crematorium, I found I had set out into my own bloody nose, navel oozing, on a painful migration into my eyes. Then I shut myself into a blazing light and departed. The last note I heard hung sweetly in the air. The smell chews ivy. In tulip gardens, gates of retirement set up to the saturnine schizophrenic G. As we do not lose our way amid hybrid dough fantasies. Our friends are still deceased. Glad mourning is the breath of our cave. The rampart of broken fingernails (plucked in euphoria), a witness of resistance, preserves us from non-satanic tortures. Blunt fingers with no nails, tombs of the one minute in the place of collective sadness, Finger joints fill A.A.'s mouth. We are still the only friends of our happy intercourse. The enticing, seductive WE. Fastidious contemporaries, democratic visitors – wealth of this city. It stinks. We live through endless ecstasy. My secret. Paranoia, on to paranoia, in the outspread fingers, the knuckles that leave the gentle rhythm of paranoia on the wall. We love cigarettes with mourning-bands. We are capable of distinguishing, we are not blind, but we are deaf. We foment rebellion among epileptics. The sexual knots of pain enclosed in larval disguise. Physical weakness in the moment of climax. No intolerable signs of degeneracy. Honest depravity with a blasphemous stamp. The greatest Mannerist de-monstrance. Essential feigned isolation. This penetrable crust which contains Artaud (bursting sign). Colourful linens of esoteric light outdazzle the entry of pale youth. Social desolation lashed with dirty tricks – the age's style. Secretions of the flesh, sexual fantasy, embrace with kisses, direct love (two, two) – I see them! – timeless threads preserved among women. That is the Creatorium. A Pandemoniac redoubt

which makes further hope impossible. Demoniac vulgarity is constantly visible beauty. This is the essential malice. Demoniac vulgarity is constantly visible beauty. The men's god-substitute, praised in chorus of unanimous reserve. Herein have I chosen. The smell conceals a plainness. Nothing reflects, nothing evaporates. I always find myself thrown back, whereby historical instances no longer serve. I always find dwindling lust. The choice is indecisive, unemotive, lasting splendour, nevertheless, pathogenic. The torments of the jellyfish, who ever feels them? Secret malady ... uniform death – soothing, fetishistic agonies of conscience. The year of sweet apprehension once lived through, here surviving is now the most painful ordeal of all. I am in Pandemonium undergoing hygienic solace. My handsome, overdue body is in this (A.A.'s) especially colourful shadow. Passionate feelings of the crowd, corroborating clichés, visiting religious soul-brothels, with rhythm and click of backgammon, smiling inanely at the one thing that is painful. What is victorious about this? – Do you want to see me cry? Pandemoniac shots in the back along the roadbed – umbilical rails. Recognized a family that coughs among the hinds' udders in Saxony without need of inner help. More of these little nest explosions – such a lot of skin scrubbed away already. Glass eyes cool them off, Never note down an observation. A. Gallen! Standing barefoot on suppurating stumps of felled trees, shouting into madness. I have only now been offered the annual rings. Far and wide I shake drops of water from my feet. Poor A. Gallen. Death has long been abandoned as a school disease. I. Ducasse is fateful, without willingness to love. An epidemic of pederasts shitting blood – doubly fruitful in a religious sense, if none of you helps out the wings of words. In this I myself stand resurrected. All downright poetry. Cleared away. Here I lie in tulips – G.'s epitaph. I'm the vanguard of my journey. No picture without silk stockings as a guiding thread, no picture without this useless crowd of ecstatic faces in boxes. Extract from five-year professional training. As they can't say anything to me. I warned you. In spite of that, these passionate bonds – you all do know. No more materialstations. Of which there still remains – uniquely – one real possibility which has come my way. To let the unnamable bleed the crystallization of a miscarriage, to let exuded ice-up, is to transcend all automation – autism is a flower stalk.

Only one life – living withdrawn, in attacks against life. Mourn the loss – no mourning for the lost. Flying clods steered into Pandemonium. Feverish apertures feverishly filled. No impossible leadership without a hidden malady. Constant renewal of the toxins. Euphoria deepens the abysses. All withdraw. The fancy enjoyments have won. For all the rebellion, for all the loving embrace (insanity) I see you all drift away. Times of never-halting devastation. Upswing through Pandemoniac roofing to the ultimate vision. Cold snaps enforce moments of salvation, such as: calling a word to mind, all those poets in boxes, oil painting, care of adhesives, fear of looking at excrement, horizontal formats, remains of housework under the bed, trips to Paris, repression of exhibitionism, building blocks ... Pandemoniac upswing through the creatorial roofing to the ultimate vision, the Pandemoniac redoubt, which leaves no more room for hope. Ripped away all skin, the last simile, and cut oneself through to the quick. Ineluctable, unshakeable, upright stasis, where no end-products (precise pictures) are present. Past it goes, past it goes, through Circassia. Paranoid March, Ride of the Paranoids, Paranoids' Leap, paranoiacide, December joy ... and so I swim from your sight in sperm – away from the surprised eyes of my mother.

Irreconcilable with cognac and sober – fastidious democratic contemporaries. Asian-dom of the Season. Now the membrane borrowed from the sacrosanct surface, vibrating canvas (lending sexual maturity a helping hand), lovingly violated. Ripped away, the last skin, the last simile. On, far on, on into the white quick. Look good in boxes, all the heads, the poets, confusion of profusion. Lightning without God into bare woods, body of mine born into clearest water. Fearsome darkness in the ice crystal of one and only truth. Up, floated twisting celestial updraught to the final mission.

I am of invisible extent. Systematic mortification of the regions without sensation (grading off) in a single lapse of time. The infinity that blows from my mouth. I am on the moon as others are on the balcony. Life will go on.

All writing is crap.

14 Francis Bacon (1910–1992) Interview with David Sylvester

Bacon first exhibited paintings in London in the late 1930s, but his mature style dates from the end of the Second World War. His characteristic themes, very much of the temper of that time, concern violence, suffering and the aloneness of the human individual. Bacon disavows the literary and sees his paint as directly expressive, but his thought, as revealed in the present interview, remains consistent with the conceptualizations of the 1940s and early 1950s. Even after almost twenty years, when asked to account for his painting, he returns to preoccupations with despair, with the virtual arbitrariness of effort, and with life as a 'game without reason'. In effect, Bacon treats the historically specific concerns of the post-war conjuncture as universal truths of the modern condition. The interview was recorded by the BBC in October 1962, and broadcast on 23 March 1963. A version was printed as 'The Art of the Impossible' in the *Sunday Times Colour Magazine*, London, 14 July 1963. The present extracts are taken from the text as published in David Sylvester, *The Brutality of Fact: Interviews with Francis Bacon*, London, 1975, reprinted 1987, pp. 8–29.

DS: Have you ever had any desire at all to do an abstract painting?

FB: I've had a desire to do forms, as when I originally did three forms at the base of the Crucifixion [*Three Studies for Figures at the Base of a Crucifixion*, 1944]. They were influenced by the Picasso things which were done at the end of the 'twenties. And I think there's a whole area there suggested by Picasso, which in a way has been unexplored, of organic form that relates to the human image but is a complete distortion of it.

DS: After that triptych, you started to paint in a more figurative way: was it more out of a positive desire to paint figuratively or more out of a feeling that you couldn't develop that kind of organic form further at that time?

FB: Well, one of the pictures I did in 1946 [*Painting*], the one like a butcher's shop, came to me as an accident. I was attempting to make a bird alighting on a field. And it may have been bound up in some way with the three forms that had gone before, but suddenly the lines that I'd drawn suggested something totally different, and out of this suggestion arose this picture. I had no intention to do this picture; I never thought of it in that way. It was like one continuous accident mounting on top of another.

DS: Did the bird alighting suggest the umbrella or what?

FB: It suddenly suggested an opening-up into another area of feeling altogether. And then I made these things, I gradually made them. So that I don't think the bird suggested the umbrella; it suddenly suggested this whole image. And I carried it out very quickly, in about three or four days.

DS: It often happens, does it, this transformation of the image in the course of working?

FB: It does, but now I always hope it will arrive more positively. Now I feel that I want to do very, very specific objects, though made out of something which is completely irrational from the point of view of being an illustration. I want to do very specific things like portraits, and they will be portraits of the people, but, when you come to analyse them, you just won't know – or it would be very hard to see – how the image is made up at all. And this is why in a way it is very wearing; because it is really a complete accident.

DS: An accident in what sense?

FB: Because I don't know how the form can be made. For instance, the other day I painted a head of somebody [*Head I*, 1961], and what made the sockets of the eyes, the nose, the mouth were, when you analysed them, just forms which had nothing to do with eyes, nose or mouth; but the paint moving from one contour into another made a likeness of this person I was trying to paint. I stopped; I thought for a moment I'd got something much nearer to what I want. Then the next day I tried to take it further and tried to make it more poignant, more near, and I lost the image completely. Because this image is a kind of tightrope walk between what is called figurative painting and abstraction. It will go right out from abstraction but will really have nothing to do with it. It's an attempt to bring the figurative thing up onto the nervous system more violently and more poignantly. [...]

DS: In painting this *Crucifixion* [*Three Studies for a Crucifixion*, 1962], did you have the three canvases up simultaneously, or did you work on them quite separately?

FB: I worked on them separately and, gradually, as I finished them, I worked on the three across the room together. It was a thing that I did in about a fortnight, when I was in a bad mood of drinking, and I did it under tremendous hangovers and drink; I sometimes hardly knew what I was doing. And it's one of the only pictures that I've been able to do under drink. I think perhaps the drink helped me to be a bit freer.

DS: Have you been able to do the same in any picture that you've done since?

FB: I haven't. But I think with great effort I'm making myself freer. I mean, you either have to do it through drugs or drink.

DS: Or extreme tiredness?

FB: Extreme tiredness? Possibly. Or will.

DS: The will to lose one's will?

FB: Absolutely. The will to make oneself completely free. Will is the wrong word, because in the end you could call it despair. Because it really comes out of an absolute feeling of it's impossible to do these things, so I might as well just do anything. And out of this anything, one sees what happens. [...] You know in my case all painting – and the older I get, the more it becomes so – is accident. So I foresee it in my mind, I foresee it, and yet I hardly ever carry it out as I foresee it. It transforms itself by the actual paint. I use very large brushes, and in the way I work I don't in fact know very often what the paint will do, and it does many things which are very much better than I could

make it do. Is that an accident? Perhaps one could say it's not an accident, because it becomes a selective process which part of this accident one chooses to preserve. One is attempting, of course, to keep the vitality of the accident and yet preserve a continuity.

DS: What is it above all that happens with the paint? Is it the kind of ambiguities that it produces?

FB: And the suggestions. When I was trying in despair the other day to paint that head of a specific person, I used a very big brush and a great deal of paint and I put it on very, very freely, and I simply didn't know in the end what I was doing, and suddenly this thing clicked, and became exactly like this image I was trying to record. But not out of any conscious will, nor was it anything to do with illustrational painting. What has never yet been analysed is why this particular way of painting is more poignant than illustration. I suppose because it has a life completely of its own. It lives on its own, like the image one's trying to trap; it lives on its own, and therefore transfers the essence of the image more poignantly. So that the artist may be able to open up or rather, should I say, unlock the valves of feeling and therefore return the onlooker to life more violently. [...]

DS: Most of your paintings have been of single figures or single heads, but in the new *Crucifixion* triptych you've done a composition with several figures. Would you like to do that more often?

FB: I find it so difficult to do one figure that that generally seems enough. And, of course, I've got an obsession with doing the one perfect image.

DS: Which would have to be a single figure?

FB: In the complicated stage in which painting is now, the moment there are several figures – at any rate several figures on the same canvas – the story begins to be elaborated. And the moment the story is elaborated, the boredom sets in; the story talks louder than the paint. This is because we are actually in very primitive times once again, and we haven't been able to cancel out the story-telling between one image and another.

* * *

DS: You may not want a story, but you certainly seem to want subjects with a lot of dramatic charge when you choose a theme like the Crucifixion. Can you say what impelled you to do the triptych?

FB: I've always been very moved by pictures about slaughterhouses and meat, and to me they belong very much to the whole thing of the Crucifixion. There've been extraordinary photographs which have been done of animals just being taken up before they were slaughtered; and the smell of death. We don't know, of course, but it appears by these photographs that they're so aware of what is going to happen to them, they do everything to attempt to escape. I think these pictures were very much based on that kind of thing, which to me is very, very near this whole thing of the Crucifixion. I know for religious people, for Christians, the Crucifixion has a totally different significance. But as a nonbeliever, it was just an act of man's behaviour, a way of behaviour to another. [...]

DS: And is it the sort of mood implicit in some unique and possibly tragic situation that you want above all?

FB: No. I think, especially as I grow older, I want something much more specific than that. I want a record of an image. And with the record of the image, of course, comes a mood, because you can't make an image without its creating a mood.

DS: A record of an image you've seen in life?

FB: Yes. Of a person, or a thing, but with me it's nearly always a person.

DS: A particular person?

FB: Yes.

DS: But this was less so in the past?

FB: Less so in the past, but now it becomes more and more insistent, only because I think that, by being anchored in that way, there is the possibility of an extraordinary irrational remaking of this positive image that you long to make. And this is the obsession: how like can I make this thing in the most irrational way? So that you're not only remaking the look of the image, you're remaking all the areas of feeling which you yourself have apprehensions of. You want to open up so many levels of feeling if possible, which can't be done in . . . It's wrong to say it can't be done in pure illustration, in purely figurative terms, because of course it has been done. It has been done in Velasquez. That is, of course, where Velasquez is so different to Rembrandt, because, oddly enough, if you take the great late self-portraits of Rembrandt, you will find that the whole contour of the face changes time after time; it's a totally different face, although it has what is called a look of Rembrandt, and by this difference it involves you in different areas of feeling. But with Velasquez it's more controlled and, of course, I believe, more miraculous. Because one wants to do this thing of just walking along the edge of the precipice, and in Velasquez it's a very, very extraordinary thing that he has been able to keep it so near to what we call illustration and at the same time so deeply unlock the greatest and deepest things that man can feel. Which makes him such an amazingly mysterious painter. Because one really does believe that Velasquez recorded the court at that time and, when one looks at his pictures, one is possibly looking at something which is very, very near to how things looked. Of course the whole thing has become so distorted and pulled-out since then, but I believe that we will come back in a much more arbitrary way to doing something very, very like that – to being as specific as Velasquez was in recording an image. But of course so many things have happened since Velasquez that the situation has become much more involved and much more difficult, for very many reasons. And one of them, of course, which has never actually been worked out, is why photography has altered completely this whole thing of figurative painting, and totally altered it.

DS: In a positive as well as a negative way?

FB: I think in a very positive way. I think that Velasquez believed that he was recording the court at that time and recording certain people at that time; but a really good artist today would be forced to make a game of the same situation. He knows that the recording can be done by film, so that that side of his activity has been taken over by something else and all that he is involved with is making the sensibility open up through the image. Also, I think that man now realizes that he is an accident, that he is a completely futile being, that he has to play out the game without reason. I think that, even when Velasquez was painting, even when Rembrandt was painting, in a peculiar way they were still, whatever their attitude to life, slightly conditioned by certain types of religious possibilities, which man now, you could say, has had completely cancelled out for him. Now, of course, man can only attempt to make something very, very positive by trying to beguile himself for a time by the way he behaves, by prolonging possibly his life by buying a kind of immor-

tality through the doctors. You see, all art has now become completely a game by which man distracts himself; and you may say it has always been like that, but now it's entirely a game. And I think that that is the way things have changed, and what is fascinating now is that it's going to become much more difficult for the artist, because he must really deepen the game to be any good at all.

VC
Art and Society

1 Maurice de Vlaminck (1876–1958) 'Open Opinions on Painting'

After the defeat of France in 1940, Vlaminck became a leading figure in the cultural establishment of Vichy, and participated in the ambiguous episode of the so-called 'study voyage' to Germany in 1941, undertaken by a group of French artists on the initiative of Goebbels. The interest of this establishment, as exemplified in the reopening of the Musée d'Art Moderne in 1942, was to emphasize the national characteristics of the Parisian avant-garde, asserting continuity with the French tradition, and at the same time occluding any overtly leftist tendencies. Accordingly, Matisse, Braque and Bonnard remained in favour, whereas the Spaniard Picasso was marginalized. Vlaminck's criticism of Picasso was originally published as 'Opinions libre sur la peinture', *Comoedia*, Paris, 6 June 1942; reprinted in the catalogue of the exhibition *'Paris – Paris'* (op. cit.), p. 101, from which the present translation is made.

It is difficult to kill something that does not exist. But if it is true that there are dead people who must be killed, I shall try none the less. . . . It must be asked whether Picasso is aware of his shrewdness, and one is afraid of discovering a façade, where one thought to find a character. The slightly cheeky mask which he affects gives him the appearance of a sort of monster which takes you in with its simplicity. He detests being discovered in this.

. . . Pablo Picasso is guilty of having led French painting into the most mortal impasse, into an indescribable confusion. From 1900 to 1930, he has led it to negation, to powerlessness, to death. For alone with himself, Picasso is powerlessness made man; nature having refused him all real character, he has used his entire intelligence, all his malice to create a personality for himself . . .

Everything is fine for him! Dilettante, he plays music, but this music is a pot-pourri, he does not draw a line, he does not paint a stroke, without reminding you of some source.

Giorgione, El Greco, Steinlen, Lautrec, Greek figurines and funeral masks: he uses everything. Forain, Degas, Cézanne, African and Polynesian sculptures, he orchestrates everything. . . . The only thing that Picasso is incapable of doing, is a Picasso which is a Picasso!

. . . Picasso was encouraged by complicities of all kinds. His greatest hopes have been surpassed. He could not have hoped for more! The most deprived, the incapable, the failures devoid of all sensibility and of any gift, rallied around Pablo Picasso. They tagged along behind this hybrid and decorative art: 'Painting-by-numbers'.

If it is difficult to kill what does not exist, it is because in reality there is no Cubism: there is Picasso.... A collective aberration, which the critics encouraged, has alienated all good sense, all true sentiment. Cubism! Perversity of spirit, insufficiency, amoralism, as far from painting as pederasty is from love.

Picasso has suffocated, for many generations of artists, the spirit of creation, faith, sincerity in work and in life. For it is certain that a work of art has nothing to prove 'socially', it is certain that it must be human: a lesson!

At our last meeting in a gallery, we shook hands.

'We're getting old, Picasso,' I said to him.

'Me!' he replied with a bitter smile. 'I'm not getting old, I'm going out of fashion.'

2 Francis Klingender (1907–1955) from *Marxism and Modern Art*

Klingender's adoption of a binary view of art history wherein Realist tendencies are in continual conflict with Idealist ones, can be related both to Soviet artistic doctrine and, beyond that, to Lenin's claim that history itself embodies at each moment a struggle between two tendencies: the one ultimately progressive, the other reactionary. However, Klingender then proceeds to link this orthodox Communist tradition to the utopian socialism of the English nineteenth-century author and designer William Morris (see *Art in Theory 1815–1900*, VB4 and 5). Originally published as a pamphlet in the 'Marxism Today' series, under the title *Marxism and Modern Art: An Approach to Social Realism*, London 1943. The present extract is taken from the concluding section, pp. 47–9. (For a previous text by Klingender see IVB19.)

[...] The distinction between the principle of a given style and the works actually produced in it is analogous to that between a philosophical or scientific system and the concrete discoveries made within the framework of that system. A principle or system which tends to deflect the artist or thinker from reality is unconditionally inferior to one which directs his energies towards objective truth. But one need only think of Hegel to realize that some of the greatest advances in human understanding have been made within the framework of a reactionary system of thought – or rather in spite of it. In other words, style in art, like system in philosophy or hypothesis in science, is historically conditioned, transitory and *relative*, but if we use the term in the wider sense of a period style (e.g. Greek, Gothic, etc)., there is not a single style in the history of art which has not produced some concrete advances towards the *absolute*. It is the task of scientific criticism to discover these concrete achievements of permanent significance within their relative and transitory shell.

If the history of art is examined from this point of view, it will be found that there is a continuous tradition of realism which started with the dawn of art (e.g. in the Palaeolithic cave paintings) and which will survive to its end, for it reflects the productive intercourse between man and nature which is the basis of life. At that important phase in the development of society, when mental labour was divided from material labour, there emerged another, secondary tradition of spiritualistic, religious or idealistic art. This, too, is continuous until it will vanish with the final negation of the division of labour – i.e. in a Communist world. During this entire period of development, i.e. as long as society is divided into classes, the history of art is the

history of the ceaseless struggle and mutual inter-penetration of these two traditions. At successive, though widely overlapping phases corresponding to specific stages in the development of society, both these traditions, and also the results of their interplay, assume the historical *forms* which we call the 'Classical', 'Gothic', 'Baroque', etc., styles. A Marxist *history* of art should describe, first, the *struggle* which is *absolute* between these two opposite and mutually exclusive trends, and secondly, their fleeting, conditional and *relative union*, as manifested in the different styles and in each work of art, and it should explain both these aspects of art in terms of the social processes which they reflect. Marxist *criticism* consists in discovering the specific weight within each style, each artist and each single work of those elements which reflect objective truth in powerful and convincing imagery. But it should always be remembered that, unlike science which reduces reality to a blue-print or formula, the images of art reveal reality in its infinite diversity and many-sided richness. And it is in its infinite diversity and many-sided richness that art, too, must be appreciated.

Conclusion

Realism, the attitude of the artist who strives to reflect some essential aspect of reality and to face the problems set by life, is from its very nature popular. It reflects the outlook of those men and women who produce the means of life. It is the only standard which can bring art back to the people today. For, as Lenin told Clara Zetkin: 'it does not greatly matter what we ourselves think about art. Nor does it matter what art means to some hundreds or even thousands in a nation, like our own, of many millions. Art belongs to the people. Its roots should penetrate deeply into the very thick of the masses of the people. It should be comprehensible to these masses and loved by them. It should unite the emotions, the thoughts and the will of these masses and raise them to a higher level. It should awaken artists in these masses and foster their development.' [*On Lenin*. Moscow, 1925]

Such an aim may well seem utopian to the artist who is only too sadly aware of the havoc which a century and a half of unbridled commercialism has wrought with the aesthetic sensibility of our people. But instead of despairing, let him take heart from the words William Morris wrote in 1879, long before the signs could be discerned which herald a revival of popular art today:

'But I will say at least, Courage! for things wonderful, unhoped-for, glorious have happened even in this short while I have been alive.

'Yes, surely these times are wonderful and fruitful of change, which, as it wears and gathers new life even in its wearing, will one day bring better things for the toiling days of men, who, with freer hearts and clearer eyes, will once more gain the sense of outward beauty, and rejoice in it.

'Meanwhile, if these hours be dark, as, indeed, in many ways they are, at least do not let us sit deedless, like fools and fine gentlemen, thinking the common toil not good enough for us, and beaten by the muddle; but rather let us work like good fellows trying by some dim candle-light to set our workshop ready against tomorrow's daylight – that tomorrow, when the civilised world, no longer greedy, strifeful, and destructive, shall have a new art, a glorious art, made by the people and for the people, as a happiness to the maker and the user.' [*The Art of the People*, 1879]

3 Robert Motherwell (1915–1991) 'The Modern Painter's World'

The author was a member of the 'first generation' of the American Abstract Expressionist avant-garde, who untypically also maintained a prominent career as a writer and editor. Here he discusses those conditions of the contemporary world which force the artist into isolation, but which nonetheless his art cannot do other than represent. Originally delivered as a lecture at Mount Holyoke College, Massachusetts, in August 1944, first published in the magazine *Dyn*, New York, vol. 1, no. 6, November 1944, pp. 8–14, from which the present version is taken.

I must apologize for my subject, which is that of the relation of the painter to a middle-class world. This is not the most interesting relation by which to grasp our art. More interesting are the technical problems involved by the evolution of artistic structure. More fundamental is the individual problem, the capacity of an artist to absorb the shocks of reality, whether coming from the internal or external world, and to reassert himself in the face of such shocks, as when a dog shakes off water after emerging from the sea. The twentieth century has been one of tremendous crises in the external world, yet, artistically speaking, it has been predominantly a classic age. In such epochs it is architecture, not painting or poetry or music, which leads. Only modern architecture, among the great creations of twentieth-century art, is accepted quite naturally by everyone. Both Surrealist and 'non-figurative' painting, with which I am concerned in this lecture, are the feminine and masculine extremes of what, when we think of the post-impressionists, the fauves, the cubists, and the art which stems, in conception, from them, has been a classic age.

Great art is never extreme.

Criticism moves in a false direction, as does art, when it aspires to be a social science. The role of the individual is too great. If this were not so, we might all well despair. The modern states that we have seen so far have all been enemies of the artist; those states which follow may be, too.

Still, the social relation is a real one. [. . .]

The function of the artist is to express reality as *felt*. In saying this, we must remember that ideas modify feelings. The anti-intellectualism of English and American artists has led them to the error of not perceiving the connection between the feeling of modern forms and modern ideas. By feeling is meant the response of the 'body-and-mind' *as a whole* to the events of reality. [. . .]

The function of the *modern* artist is by definition the felt expression of modern reality. This implies that reality changes to some degree. This implication is the realization that history is 'real,' or, to reverse the proposition, that reality has a historical character. Perhaps Hegel was the first fully to feel this. With Marx this notion is coupled with the feeling of how *material* reality is.

It is because reality has a historical character that we feel the need for new art. The past has bequeathed us great works of art; if they were wholly satisfying, we should not need new ones. From this past art, we accept what persists qua eternally valuable, as when we reject the specific religious values of Egyptian or Christian art, and accept with gratitude their form. Other values in this past art we do not want. To say this is to

recognize that works of art are by nature pluralistic: they contain more than one *class* of values. It is the eternal values that we accept in past art. By eternal values are meant those which, humanly speaking, persist in reality in any space-time, like those of aesthetic form, or the confronting of death.

Not all values are eternal. Some values are historical – if you like, *social*, as when now artists especially value personal liberty because they do not find positive liberties in the concrete character of the modern state. It is the values of our own epoch which we cannot find in past art. This is the origin of our desire for new art. In our case, for *modern art* . . .

The term 'modern' covers the last hundred years, more or less. Perhaps it was Eugène Delacroix who was the first modern artist. But the popular association with the phrase 'modern art' like that of mediaeval art, is stronger than its historical denotation. The popular association with mediaeval art is religiousness. The popular association with modern art is its *remoteness* from the symbols and values of the majority of men. There is a break in modern times between artists and other men without historical precedent in depth and generality. Both sides are wounded by the break. There is even hate at times, though we all have a thirst for love.

The remoteness of modern art is not merely a question of language, of the increasing 'abstractness' of modern art. Abstractness, it is true, exists, as the result of a long, specialized internal development in modern artistic structure. But the crisis is the modern artist's rejection, almost *in toto*, of the values of the bourgeois world. In this world modern artists form a kind of *spiritual underground*.

Modern art is related to the problem of the modern individual's freedom. For this reason the history of modern art tends at certain moments to become the history of modern freedom. It is here that there is a genuine rapport between the artist and the working-class. At the same time, modern artists have not a social, but an individualist experience of freedom: this is the source of the irreconcilable conflict between the Surrealists and the political parties of the working-class.

The social condition of the modern world which gives every experience its form is the spiritual breakdown which followed the collapse of religion. This condition has led to the isolation of the artist from the rest of society. The modern artist's social history is that of a spiritual being in a property-loving world.

No synthesized view of reality has replaced religion. Science is not a view, but a method. The consequence is that the modern artist tends to become the last active spiritual being in the great world. It is true that each artist has his own religion. It is true that artists are constantly excommunicating each other. It is true that artists are not always pure, that sometimes they are concerned with their public standing or their material circumstance. Yet for all that it is the artists who guard the spiritual in the modern world.

The weakness of socialists derives from the inertness of the working-class. The weakness of artists derives from their isolation. Weak as they are, it is these groups who provide the *opposition*. The socialist is to free the working-class from the domination of property, so that the spiritual can be possessed by all. The function of the artist is to make actual the spiritual, so that it is there to be possessed. It is here that art instructs, if it does at all.

In the spiritual underground the modern artist tends to be reduced to a single subject, his ego . . . This situation tells us where to expect the successes and failures of modern art. If the artist's conception, from temperament and conditioning, of freedom is highly individualistic, his egoism then takes a romantic form. Hence the Surrealists' love at first sight for the Romantic period, for disoriented and *minor* artists: individualism limits *size*. If the artist, on the contrary, resents the limitations of such subjectivism, he tries to objectify his ego. In the modern world, the way open to the objectivization of the ego is through form. This is the tendency of what we call, not quite accurately, abstract art. Romanticism and formalism both are responses to the modern world, a rejection, or at least a reduction, of modern social values. [. . .]

* * *

The present ruling class was able to gain its freedom from the aristocracy by the accumulation of private property. *Property is the historical base of contemporary freedom.* The danger lies in thinking we own only our private possessions. Property creates the unfreedom of the majority of men. 'When this majority in turn secures its freedom by expropriating the bourgeoisie; the condition of its freedom is the unfreedom of the bourgeoisie; but whereas the bourgeoisie like all ruling classes, requires an unfree exploited class for its existence, the proletariat does not require to maintain the bourgeoisie in order to maintain its own freedom.' [Caudwell, *Illusion and Reality*.] There is hope therefore of ending the conflict inherent in class society.

The artist's problem is *with what to identify himself.* The middle-class is decaying, and as a conscious entity the working-class does not exist. Hence the tendency of modern painters to paint for each other.

* * *

The Surrealists had the laudable aim of bringing the spiritual to everyone. But in a period as demoralized as our own, this could lead only to the demoralization of art. In the greatest painting, the painter communes with himself. Painting is his thought's medium. Others are able to participate in this communion to the degree that they are spiritual. But for the painter to communicate with all, *in their own terms*, is for him to take on their character, not his own.

Painting is a medium in which the mind can actualize itself; it is a medium of thought. Thus painting, like music, tends to become its own content.

The medium of painting is color and space: drawing is essentially a division of space. Painting is therefore the mind realizing itself in color and space. The greatest adventures, especially in a brutal and *policed* period, take place in the mind.

Painting is a reality, among realities, which has been felt and formed.

It is the pattern of choices made, from the realm of possible choices, which gives a painting its form.

The content of painting is our response to the painting's qualitative character, as made apprehendable by its form. This content is the feeling 'body-and-mind.' The 'body-and-mind,' in turn, is an event in reality, the interplay of a sentient being and the external world. The 'body-and-mind' being the interaction of the animal self and the external world, is just reality itself. It is for this reason that the 'mind,' in realizing itself in one of its mediums, expresses the nature of reality as felt.

4 Renato Guttuso (1912–1987) 'Crisis of Renewal'

Guttuso was born and educated in Sicily, but his first significant involvement in art was with the anti-fascist Corrente group in Milan during the late thirties and early forties. He eventually settled in Rome, joining the outlawed Communist Party in 1940. His painting reflects the familiar dilemma of the revolutionary artist: a commitment, on the one hand, to intelligibility and socially significant subject-matter, while on the other trying to avoid the conservative aspects of the doctrine of Socialist Realism. In practice this meant trying to marry a commitment to realism with an acknowledgement of the legacy of Expressionism and Cubism, particularly as experienced through the impact of Picasso's *Guernica* (a work Guttuso had only seen in reproduction). After the end of the war there was intense debate in Italy about the social function of art, particularly between Communist Party intellectuals and those who opposed the idea of a socially committed realism in favour of claims for the autonomy of art. Guttuso was prominent among the former, declaring in a letter to the painter Ennio Morlotti: 'I think more and more of painting that can function as a wrenching scream, a manifestation of rage, of love or of justice, on the corners of the streets and in the angles of the city squares, rather than in the sad atmosphere of the museum, where a few specialists go once in a while to find it.' One of his many contributions to this debate was 'Crisis of Renewal' ('Crisi di Rinnovamento'), published in *Cosmopolita*, Rome, 30 December 1944, from which the present translation by Nicholas Walker has been made.

[...] We believe, and we are certainly not the first nor the only ones to believe, that culture as a whole can only be an expression of the dominant class and cannot fail to represent its laws.

We believe with Marx that if a certain class enjoys the monopoly of power in the means of production then it also possesses a monopoly of power in every other domain as well, including that of culture. For it makes use of this culture as an instrument of struggle. So it was in the pagan era, so it was with Christianity in the era of feudalism, and so too with capitalism in the bourgeois era. Capitalism and the philosophies associated with it have bestowed myriad freedoms on art, but on closer consideration these reveal themselves to be very impoverished freedoms. The freedom to place two eyes on the same side of the face, the freedom to paint a green horse or a blue nude. We have good reason to ask ourselves whether artists are actually freer today than when (in the days of Giotto, Titian or Velásquez) they were simply presented in advance with the relevant subject, the pictorial dimensions, the number and sometimes even the precise arrangement of figures, the type of landscape background (and I cannot say that Giotto or Titian ever complained that this restricted their creative freedom in any way).

Perhaps the debate has moved further on by now, but it was nonetheless necessary to draw attention, however vaguely and briefly, to the notions and ideas which have been fermenting for some time amongst those young artists and critics who claim to be facing a 'crisis of renewal'. It was necessary to point out the specific circumstances that affect us here in Italy, and from which we have recently escaped, or the widely diffused ideas to which many young people feel increasingly drawn with heightened awareness precisely on account of their painful experience with actual reality. It was necessary to mention this in order to clarify a crisis that is the crisis of an entire generation of young

artists who have grown up in a specific cultural climate, who have been educated, formed and poisoned by this climate; it is a generation that has also, in part, contributed to this climate of withdrawal, of intellectualism, of formalism, but has for some time now also revealed its dissatisfaction, has been seeking some real and authentic path of escape precisely because it is far too self-aware to content itself with mouthing simplistic solutions. A generation that felt called upon to defend the bottles of Morandi, even when it also felt called upon to resolve very different problems; a generation that was eager for experimentation and sought to appropriate many of the recent European achievements, and which, even though it shunned abstraction, still needed to express a certain faith and trust if it was to experience life; a generation that felt a natural bond with Picasso: whose unforgettable *Guernica*, in the wretched and magnificent pavilion of Red Spain at the Paris Exhibition of 1937, raised the banner of culture in defence of civilization against fascist barbarism. A generation that saw a truly revolutionary value and significance in the work of Picasso, even though it also knew that Picasso is not a painter of the future (and Picasso himself knows this even better than we do). But this generation saw his work as the expression of the society in which they live and as a revolt against that society.

These young artists allied themselves therefore with a culture which did not satisfy them, but one which nonetheless preserved those elements of revolt and transformation that would be required for any effective renewal in the future.

Today it looks as though we are advancing with leaps and bounds, as if we have finally liberated ourselves from the exhaustion imposed on us by fascism. The crisis of renewal is at work amongst the most self-aware of the young artists of today. But how can we emerge from this crisis? How can we bring about this renewal? We cannot forget that we are part of that same culture from which we emerge, and which we shall also inevitably be called upon increasingly to contradict. For no renewal can proceed from a 'tabula rasa'.

Lenin teaches us that proletarian culture is not born from a 'tabula rasa' either. Nor does it suddenly spring from the brain of one or other specialist in proletarian culture. He tells us that 'proletarian culture will have to emerge as the natural result of all the knowledge that humanity has acquired during the rule of capitalism and feudalism.'

We must strive with all our power to avoid proposing simplistic solutions that would actually resolve nothing. That is why we do not believe in formulating specific programmes. But we do denounce a crisis which has planted deep roots within ourselves. And we are not content to register the dissatisfaction which sprang from the need for culture and the defence of certain principles. We declare the will, the inner and necessary will, for an active intervention that will finally be more than an academic pastime. We demand to live (and we demand it of ourselves) precisely by exercising our profession as painters, sculptors, writers, just like other men, by struggling against the old world and helping to construct the new one. And finally we no longer want to work merely for ourselves, or a few of our friends, but in order to help others to live just as they too help us to live. For if the world is effectively transformed, then art can no longer assume the position of a passive spectator in relation to the development of those forces which accomplish, by their struggle, this transformation. We have certainly learnt this. It may not be that much, but it provides us with a better vantage point than that of those who have yet to learn it.

5 Pablo Picasso (1881–1973) 'Why I Joined the Communist Party'

The Salon d'Automne of October 1944 was known as the 'Salon de la Libération'. Following the attempted marginalization of his work during the Vichy period (see VC1), Picasso was fêted for his role as a symbolic figurehead with a retrospective of seventy-four paintings and five sculptures within the overall exhibition. In the same month he joined the French Communist Party (PCF). His reasons were given in an interview with Pol Gaillard which was cabled to New York and published in condensed form in *New Masses*, 24 October 1944. The original interview was then published in full in the French Communist Party newspaper *L'Humanité*, 29–30 October 1944. It was reprinted in Alfred H. Barr Jr, *Picasso: Fifty Years of his Art*, New York, 1946, pp. 267–8, from which the present translation is made. (For earlier texts by Picasso see IIB12 and IVD2.)

'I would have liked better to have replied to you by means of a picture,' he told us; 'I am not a writer, but since it is not very easy to send my colours by cable, I am going to try to tell you.' 'My membership of the Communist Party is the logical consequence of my whole life, of my whole work. For, I am proud to say, I have never considered painting as an art of simple amusement, of recreation; I have wished, by drawing and by colour, since those are my weapons, to reach ever further into an understanding of the world and of men, in order that this understanding might bring us each day an increase in liberation; I have tried to say, in my own way, that which I considered to be truest, most accurate, best, and this was naturally always the most beautiful, as the greatest artists know well. Yes, I am aware of having always struggled by means of my painting, like a genuine revolutionary. But I have come to understand, now, that that alone is not enough; these years of terrible oppression have shown me that I must fight not only through my art, but with all of myself. And so, I have come to the Communist Party without the least hesitation, since in reality I was with it all along. Aragon, Eluard, Cassou, Fougeron, all my friends know well; if I have not joined officially before now, it has been through 'innocence' of a sort, because I believed that my work and my membership at heart were sufficient; but it was already my Party. Is it not the Communist Party which works the hardest to know and to construct the world, to render the men of today and tomorrow clearer-headed, freer, happier? Is it not the Communists who have been the most courageous in France as in the USSR or in my own Spain? How could I have hesitated? For fear of committing myself? But on the contrary I have never felt freer, more complete! And then I was in such a hurry to rediscover a home country: I have always been an exile, now I am one no longer; until the time when Spain may finally receive me, the French Communist Party has opened its arms to me; there I have found all that which I most value: the greatest scholars, the greatest poets, and all those beautiful faces of Parisian insurgents which I saw during the days of August.'

6 Pablo Picasso (1881–1973) Statement to Simone Téry

Picasso's membership of the Communist Party caused tensions with the doctrine of Socialist Realism. In November 1944 and January 1945 he gave two interviews to Jerome Seckler, an American soldier and amateur artist, in which he denied that the colours and

forms in his works carried specifically symbolic meanings, and added, with obvious reference to the demands of Socialist Realism, that 'I can't use an ordinary manner just to have the pleasure of being understood.' Such arguments led to the claim that his Communism was without substance, and that he held art and politics to be unrelated. When told of this during another interview with the French journalist Simone Téry, Picasso, angered, took a sheet of paper and wrote out the following statement. It was originally published in *Les Lettres Françaises*, V, no. 48, Paris, 24 March 1945; reprinted in Barr, op. cit., p. 269, from which the present translation is made.

What do you think an artist is? An imbecile who, if he is a painter, has only eyes, if he's a musician has only ears, if he's a poet has a lyre in each chamber of his heart, or even, if he's a boxer, just muscles? On the contrary, he is at the same time a political being, constantly alert to the heart-rending, stirring or pleasant events of the world, taking his own complexion from them. How would it be possible to dissociate yourself from other men; by virtue of what ivory nonchalance should you distance yourself from the life which they so abundantly bring before you? No, painting is not made to decorate apartments. It is an instrument for offensive and defensive war against the enemy.

7 Frida Kahlo (1907–1954) on *Moses*

Kahlo began to paint in the mid-1920s during her convalescence from the accident that was to leave her permanently disabled. She married the painter Diego Rivera in 1929 and travelled widely with him in the United States during the 1930s. When André Breton visited Mexico in 1938 to meet Rivera and the exiled Trotsky (see IVD9), he immediately dubbed her work 'Surrealist', even though she had had no contact with the group. In his words, her painting was 'a ribbon around a bomb'. On his return to Paris, he included her work in an exhibition he organized about Mexico. She was the only woman artist discussed in his book *Surrealism and Painting*, of 1945. Subsequently, with the rise of feminist art history during the 1970s and 1980s, Kahlo's work was repositioned as representative of a private, specifically female sensibility (not least in contrast to the public, and hence supposedly male, orientation of the large-scale work of Rivera). The majority of Kahlo's published diary entries and letters are either of a personal nature (concerned with the effects of her disability and illness), or are devoted to the work and personality of her husband. There is little extended reflection on her own work. The present text is an exception. It was written out in 1945 in the form of a speech about her painting *Moses*, which was based on a reading of Freud's *Moses and Monotheism*. The latter was then a relatively recent work, having appeared in 1939. It was the last of Freud's works to be published in his lifetime, and deals with the role of the heroic leader. Kahlo was given the book to read by her patron, the engineer José Domingo Lavin, and on completion of the work he invited her to give a talk on the subject to a gathering at his house. Kahlo describes the symbolism of her picture but not its organization. Wider than it is high, the painting is divided into three approximately equal vertical parts. The centre panel depicts a large sun, below it a human foetus in the womb, and below that, Moses floating in his basket. This is flanked to right and left by multi-figure panels depicting a variety of both Eastern and Western deities as well as an array of human leaders, animals and plants. Dominated as it is by images of fecundity and procreation, the painting can be seen to express Kahlo's vitalist philosophy, according to which she viewed the universe as a fully integrated whole. As she wrote in a diary of 1950, 'Everything moves according to only one law – life ... All is all and one. Anguish and pain, pleasure and death

are nothing but a process in order to exist . . . We have always been hate-love-mother-child-plant-earth-light-lightning – world giver of worlds – universes and universal cells.' In 1945 Kahlo was awarded the Ministry of Education prize for the picture, which is now in a private collection in Houston. Kahlo's text is reprinted in full from the translation by Jorge Gonzalez Casanova and Daniela Garaiz in *Cartas Apasionadas. The Letters of Frida Kahlo*, selected and edited by Martha Zamora, San Francisco: Chronicle Books, 1995, pp. 120–4. (A *hacha perdida* is a 'lost axe'. 'Axe' is Mexican slang for an 'ace' or great person.)

Since this is the first time in my life that I have tried to explain one of my paintings to a group of more than three people, please forgive me if I get a little confused and if I'm very nervous.

About two years ago, José Domingo told me one day that he would like me to read Freud's 'Moses' and to paint, however I wanted, my interpretation of the book. This painting is the result of that conversation.

I read the book only once and started to do the painting with the first impression it had left on me. Yesterday, after I wrote these words for you, I reread it and I must confess that I find the painting very incomplete and very different from what should be the interpretation of what Freud analyzes so wonderfully in his 'Moses.' But now, unfortunately, I can't remove or add anything, so I will explain what I painted the way it is, as you can see here in the picture.

Of course, the central theme is Moses, or the birth of the Hero, but I generalized, in my own way (a very confused way), the facts and images that made the strongest impressions on me while reading the book. As far as I am concerned, you can tell me whether I blew it or not.

What I wanted to express more intensely and clearly was that the reason why people need to make up or imagine heroes and gods is pure fear . . . fear of life and fear of death.

I started painting the image of the infant Moses – Moses means 'he who was taken out of the waters' in Hebrew, and 'boy' in Egyptian. I painted him the way the legends describe him: abandoned inside a basket and floating down a river. From the artistic point of view, I tried to make the animal skin-covered basket look as much as possible like a uterus because, according to Freud, the basket is the exposed uterus and the water is the mother's water when she gives birth to a child. To emphasize that fact, I painted the human fetus in its last phase inside the placenta. The fallopian tubes, which resemble hands, spread out to the world.

On the sides of the newborn child, I placed the elements of his creation – the fertilized egg and the cellular division.

Freud analyzes in a very clear but – for my personality – complicated way, the important fact that Moses wasn't Jewish but Egyptian. But in the picture, I couldn't find a way to paint him as either, so I only painted him as a boy who generally represents Moses and all those who, according to the legend, had the same beginning and became important leaders to their people – in other words, heroes (smarter than the rest; that's why I drew the 'warning eye' on him). In this case, we can find Sargon, Cyrus, Romulus, Paris, etc. The other very interesting conclusion that Freud makes is that Moses – not being Jewish – gave the people he chose to guide and save a religion that was not Jewish either, but Egyptian. [This religion was] precisely the one that Amenhotep IV or Ikhnaton revived: the religion of Aton, the sun, which has its roots in the very ancient religion of On (Heliopolis). That's why I painted the sun as the center

of all religions, as the first god, and as creator and reproducer of life. This is the relationship between the three main figures in the center of this painting.

Like Moses, there have always been lots of 'high-class' reformers of religions and human societies. It could be said that they are a kind of messenger between the people they manipulate and the gods they invent to be able to do it. Many gods of this type still exist, as you know. Naturally, I didn't have enough space for all of them, so I placed on both sides of the sun those who, like it or not, are directly related to the sun. On the right are the Western [gods] and on the left the Oriental ones.

The Assyrian winged bull, Amon, Zeus, Osiris, Horus, Jehovah, Apollo, the Moon, the Virgin Mary, the Divine Providence, the Christian Trinity, Venus, and . . . the Devil. To the left, thunder, lightning, and the thunder's print, that is, Huraka, Kukulkan, and Gukamatz; Tlaloc, the magnificent Coatlicue (mother of all the gods), Quetzalcoatl, Tezcatlipoca, Centeotl, the Chinese god (dragon), and the Hindu one, Brahma. An African god is missing; I couldn't find one, but I could make some space for him. I can't tell you something about each one of the gods because of my overwhelming ignorance about their origin, importance, etc.

After painting the gods I had space for in their respective heavens, I wanted to divide the celestial world of imagination and poetry from the terrestrial world of fear of death. So I painted the human and animal skeletons that you can see here. The earth cups her hands to protect them. Between Death and the group where the heroes are there are no divisions, because heroes die too, and the generous earth picks them up without distinctions.

On the same earth, but with bigger heads in order to distinguish them from the heads of the crowd, I painted the heroes (very few of them, but well chosen), the religion reformers, the religion inventors or creators, the conquerors, and the rebels . . . that is, the 'bucktoothed' [powerful] ones.

To the right – I should have made this figure look much more important than any other – you can see Amenhotep IV, who became Ikhnaton, a young pharaoh of the eighteenth dynasty (1370–1350 B.C.). He imposed on his subjects a religion contrary to their tradition, rebellious toward polytheism, strictly monotheistic with distant roots in the On cult (Heliopolis): the religion of Aton and the Mosaic, both monotheistic. I didn't know how to transfer this whole important section of the book to the plastic arts.

Next, we have Christ, Zoroaster, Alexander the Great, Caesar, Mohammed, Luther, Napoleon, and the lost child, Hitler.

To the left [we can see] the wonderful Nefertiti, Ikhnaton's wife. I suppose that, in addition to being extraordinarily beautiful, she must have been a *hacha perdida* and a very intelligent collaborator with her husband. Buddha, Marx, Freud, Paracelsus, Epicurus, Genghis Khan, Gandhi, Lenin, and Stalin. The order is wrong, but I painted them according to my historic knowledge, which is also wrong. Between them and the run-of-the-mill crowd, I painted a sea of blood with which I represent war, inevitable and fecund.

And lastly, the powerful and never-sufficiently praised human mass composed of all kinds of . . . bugs: the warriors, the pacifists, the scientists, and the ignorant ones; the monument-makers, the rebels, the flag-carriers, the medal-bearers, the speakers, the crazy and the sane, the happy and the sad, the healthy and the ill, the poets and the fools, and all the rest of the people you'd like to have here in this

fucbulous pile. Only the ones in the front are clearly seen; the rest, in the confusion, who knows?

On the left side, in the forefront, is man, the constructor of four colors (the four races). On the right side, the mother, the creator, with her child in her arms. Behind them, the monkey.

[Here we have] the two trees that form a triumphal arch, with the new life that always sprouts from the trunk of old age. In the middle, at the bottom, the thing most important to Freud and many others: love, represented by the shell and the conch, the two sexes wrapped up by eternally new and living roots.

This is all I can tell you about my painting, but I'll accept all kinds of questions and comments. I won't get mad. Thank you very much.

<div align="right">Frida Kahlo</div>

8 Lucio Fontana (1899–1968) 'The White Manifesto'

Argentinian by birth, Fontana was educated in Italy in the classical–academic tradition, and in the 1920s was drawn to the Novecento movement in Milan. His work and ideas effected an important transition between the advanced movements of the pre-war years and the re-emergent European avant-gardism of the later 1950s and 1960s. During the 1930s he was briefly a member of Abstraction-Création in Paris (see IVA4), but he developed independent ideas concerning the irrational, and the synthesis of hitherto conventional distinctions in the making of art: as between, for example, painting and sculpture, or the avant-garde and kitsch. Particularly significant in the formation of this synthesis was Bataille's concept of the 'Informe', or of a 'base materialism' (see IVC12 and 13). As a result of his transgression of conventional categories Fontana remained for many years a comparatively neglected figure in standardly Modernist art histories. He spent the war years in Buenos Aires, where the 'Manifesto Blanco' was originally published in 1946. He was teaching at the time and the text was collectively produced with his students. It formed the basis for his subsequent concept of 'Spazialismo' (Spatialism) and for ensuing work based on the idea of 'an art in which our idea of art cannot intervene'. The manifesto was reprinted in facsimile, and in French translation, in the exhibition catalogue *Lucio Fontana*, Paris: Centre Pompidou, 1987, pp. 278–80. The present translation is made from the original Spanish.

We are continuing the evolution of art

Art is currently in a dormant phase. There is an energy which man cannot convey. In this manifesto we shall express it verbally.

For this reason we call on all those in the world of science who know that art is a fundamental requirement for our species, that they may direct part of their research towards discovering that malleable substance full of light, and instruments that will produce sounds which will enable the development of four-dimensional art.

We will provide the researchers with the necessary information. The ideas are irrefutable. They exist as seeds within the social fabric, awaiting expression by artists and thinkers.

All things arise from necessity and are of value in their own time.

The transformations of the material base of existence have determined man's psychological states throughout history.

The system which has directed civilization from the beginning is undergoing transformation.

Gradually, it is being replaced by another system, which is its opposite in both essence and form. The fabric and character of both society and the individual will be transformed. Each man will live in an organization integral to his work.

The great scientific discoveries are directed towards this new organization of our lives.

The discovery of new physical forces, the mastery of matter and space, have gradually imposed unprecedented conditions on mankind.

The application of these discoveries to all aspects of our lives brings about a change in human nature. Man's psychological make-up is transformed. We are living in a mechanical age, in which plaster and paint on canvas are no longer meaningful.

Since the discovery of the known artforms at various junctures throughout history, an analytical process has taken place within each one. Each has its own ordering principles independent of the others.

Everything that could be expressed has been done – all possibilities have come to light and have been developed.

Identical spiritual states have been expressed through music, architecture and poetry.

Man divided his energy in various ways, in response to the need for knowledge.

Wherever the limits of concrete explanation were reached, idealism came to predominate. The workings of nature were neglected. Man became aware of the process of intelligence. Everything lay in the possibilities of intelligence. Knowledge consisted in confused speculations which rarely attained truth.

Art (i.e. plastic or representational art) consisted of ideal portrayals of familiar forms through images which were idealistically seen as lifelike. The observer imagined that one object was, in fact, behind another; he imagined in the portrayal the actual difference between the muscles and the clothing.

Today knowledge acquired from experience has replaced creative, imaginative knowledge. We are aware of a world that exists and which is self-explanatory; a world which cannot be modified in any way by our ideas.

We need an art which is, of itself, valid; an art unsullied by our ideas.

The materialism anchored in every consciousness demands that art have its own values, free from the style of representation which is today stripped of all credibility. Twentieth-century man, shaped by materialism, has become inured to conventional forms of representation and to the constant re-telling of already familiar experiences. Abstraction has been developed as the culmination of successive transformations.

However, this new stage no longer corresponds to the demands of contemporary man.

What is required is a change in both essence and form. It is necessary to transcend painting, sculpture, poetry, and music. We require a greater art, which will be consistent with the demands of the new spirit.

The fundamental conditions of modern art have been clear since the thirteenth century, when space and depth were first represented. The great artists who followed gave renewed momentum to this tendency.

Baroque artists made great progress in this respect – their style of representation had a grandeur which has remained unsurpassed, imbuing the plastic arts with a sense of time. The figures appeared to leap out of the flat surface and to continue their represented movements in actual space.

This conception developed as a result of man's growing concept of existence. Then, for the first time, physics managed to explain nature through dynamics. As a means of explaining the universe, it was determined that movement was an inherent property of matter.

Having arrived at this evolutionary juncture, the need to represent movement was so great that it could not be met through the plastic arts. Therefore, the evolution continued through music. Painting and sculpture entered the neo-classical period, a stagnant point in the history of art, and the connection between art and time was ignored. Having conquered time, the need for movement grew increasingly clear. Progressive freedom from the restrictions of the church gave music greater and greater dynamism (Bach, Mozart, Beethoven). Art continued to develop around the notion of movement.

Music retained its dominant position for the next two hundred years, and since Impressionism it has developed parallel to the plastic arts. Since then, man's evolution has been a march towards movement which has developed in time and space. In painting, the elements which obscured the impression of dynamism have been progressively suppressed.

The Impressionists sacrificed drawing and composition. The Futurists eliminated some elements and reduced the importance of others as they were subordinated to sensation. Futurism adopted motion as its solitary goal and objective. The Cubists denied that their painting was dynamic; yet the real essence of Cubism was the vision of nature in movement. [. . .]

Man has exhausted pictorial and sculptural forms of art. His own experiences, overwhelmingly repeated time and time again, bear witness to the fact that these art forms are stagnating in values which are alien to our civilization, devoid of the possibility of any future development.

The peaceful, gentle life has come to an end. Speed has become a constant in the life of mankind.

The artistic era of colours and static forms is coming to an end. Man is becoming less and less responsive to fixed, motionless images. The old static images no longer satisfy the modern man who has been shaped by the need for action, and a mechanized lifestyle of constant movement. The aesthetics of organic motion have replaced the out-moded aesthetics of fixed forms.

Calling on this change in man's nature, the moral and psychological changes of all human relations and activities, we leave behind all known art-forms, and commence the development of an art based on the union of time and space.

The new art takes its elements from nature.

Existence, nature and matter come together in a perfect unity.

They develop in time and space.

Change is an essential property of existence.

Movement, the capacity to evolve and to develop, is a basic property of matter. The latter exists solely in movement, not in any other manner. Its development is eternal. Colour and sound, bound together in matter, come together in nature.

Matter, colour and sound in motion, are the phenomena whose simultaneous development makes up the new art.

Colour in matter, developing in space, assuming different forms. Sound produced by artefacts as yet unknown. Existing musical instruments are inadequate to meet the challenge of the required fullness and greatness of sound.

The construction of voluminous, changing shapes from a moving, malleable substance. Arranged in space, they integrate moving images in a synchronized form.

Thus, we are celebrating nature in all its plenitude. [...]

We demand an art which is free of all aesthetic artifice.

We use what is true and natural in man. We reject the false aesthetics invented by speculative art.

We will draw closer to nature than ever before in the history of art.

Our love of nature does not compel us to copy it. The sense of beauty which we get from the shape of a plant, or a bird, or the sexual feelings aroused by a woman's body, are developed and elevated in man according to his sensitivity. We reject the particular emotions which can be derived from certain shapes. We aim to draw together in synthesis all of man's experiences which, along with his natural temperament, constitute a true manifestation of existence.

As our point of departure we shall take the earliest artistic experiences. Prehistoric man, who first heard the sound made by striking a hollow object, found himself captivated by the rhythm. Driven by the power of the rhythm he must have danced into a state of euphoria. For primitive man, sensation was everything – the sensation of nature, wild and unknown, the sensation of music and rhythm. We intend to develop that original characteristic of man.

The subconscious, that magnificent well of images perceived by the mind, takes on the essence and form of those images and harbours the notions that make up man's nature. Thus, as the objective world is transformed, what the subconscious identifies with is also transformed, and this produces changes in man's mode of conception.

The subconscious determines the historical legacy of pre-civilized states and the manner of our adaptation to new lifestyles. The subconscious shapes, composes and transforms the individual. It gives him a sense of order, which comes from the world and is adopted by the individual. All artistic concepts are due to the workings of the subconscious.

Plastic art developed from its original base of natural shapes. The manifestations of the subconscious adapted easily to natural forms as a consequence of the idealized conception of existence.

Our material consciousness, that is, our need for things which are easily verifiable, demands that art-forms should flow directly from the individual and that they should assume natural form. An art based on forms created by the subconscious and balanced by reason, constitutes a true expression of existence and is the synthesis of a moment in time.

The position of the rational artists is false. In their effort to privilege reason and to deny the workings of the subconscious, they succeed only in rendering them less visible. We can see this process at work in their every endeavour.

Reason does not create. In creating shapes, it is subordinate to the subconscious. In all of his activities, man uses all of his faculties. Their free development is fundamental for creating and interpreting a new kind of art. Analysis and synthesis, meditation and spontaneity, construction and sensation, are all values which come together to work in union; and their development in experience is the only way to achieve a complete demonstration of being.

Society suppresses disparate energies and integrates them into a greater unified force. Modern science is based on the progressive unification of all its elements.

Humanity weaves together its knowledge and its values, in an historic process which has developed over hundreds of years.

A new, integrated art flows from this new state of consciousness, in which existence is shown in its totality.

After several millennia of analytical artistic development, the moment of synthesis has arrived. Prior to this moment, specialization was necessary. Now however this specialization amounts to a disintegration of the unity we envisage.

We imagine synthesis as the sum total of the physical elements: colour, sound, movement, time, space, integrated in physical and mental union. Colour, the element of space; sound, the element of time and movement, which develops in time and space. These are fundamental to the new art which encompasses the four dimensions of existence. Time and space.

The new art requires that all of man's energies be used productively in creation and interpretation. Existence is shown in an integrated manner, with all its vitality. *Colour Sound Movement*

(Bernardo Arias, Horacio Cazeneuve, Marcos Fridman, Pablo Arias, Rodolfo Burgos, Enrique Benito, Cesar Bernal, Luis Coll, Alfredo Hansen, Jorge Rocamonte)

9 Vladimir Kemenov (b. 1908) from 'Aspects of Two Cultures'

With the onset of the Cold War immediately following the defeat of Fascism, culture became a site of struggle between the two leading world powers. In the Soviet Union the doctrine of Socialist Realism was hardened again after a comparative relaxation during the years of the Popular Front. Kemenov's article is a root-and-branch attack on the avant-garde, for its 'decadence', 'individualism', and 'anti-humanism'. As a text published in English specifically for foreign consumption, it achieved considerable prominence as clinching evidence of Communist perfidy in the eyes of Western defenders of the avant-garde. Kemenov had studied at the first Moscow State University in the late 1920s, and, committed to the affirmation of Socialist Realism in the fine arts, had by 1938 risen to become Director of the Tretyakov Gallery. During the 1950s he became Deputy Minister of Culture of the USSR and that country's permanent representative to the United Nations cultural organization, UNESCO. From 1940 to 1948 he was Chairman of the All-Union Society for Cultural Relations with Foreign Countries, during which time he composed the present essay. It

was originally published in the *VOKS Bulletin* by the Society for Cultural Relations with Foreign Countries, Moscow 1947, pp. 20–36. It was reprinted in H. B. Chipp, *Theories of Modern Art*, Berkeley, CA, and London, 1968, pp. 490–6, from which the present extracts are taken.

The basic features of decadent bourgeois art are its falseness, its belligerent anti-realism, its hostility to objective knowledge and to the truthful portrayal of life in art. Here, too, the reactionary tendency in contemporary bourgeois art is presented under the banner of 'originality,' of struggle against 'bourgeois' ideology, etc. Those extreme forms represented by the various '-isms' of anti-realistic bourgeois art were led up to by the gradual renunciation by bourgeois artists of the finest traditions of bourgeois realism in the eighteenth and nineteenth centuries as well as of the realistic traditions of the art of Greece and the Renaissance. The decline of bourgeois art became most rapid at the end of the nineteenth and the beginning of the twentieth centuries, with the rise of the epoch of imperialism and the decay of bourgeois culture which it involved. [...]

* * *

For all the 'freedom' which artists won after they had driven life from the realm of their formalistic art, they nevertheless tried at the beginning of the century to justify this subjective anarchy by pseudo-scientific, technical, and other subterfuges in their work, writings and declarations... to prove its analytical character, and so on. However, very soon even this quasi-scientific terminology was discarded, and in contemporary bourgeois formalistic art the most rampant subjectivism, proclaiming the cult of mysticism and of the subconscious, has triumphed openly, and abnormal mental states are held up as examples of the complete creative freedom of the individual.

All these features of decadent bourgeois art were declared aspects of 'art for art's sake,' which is alleged to be alien to any semblance of ideological content. As a matter of fact, this 'pure' art actually disseminated reactionary ideas, ideas that were advantageous or useful to the capitalists. Formalistic artists ceased to be rebels and became the abject slaves of capital, even though from time to time they did assail capitalism, sometimes even sincerely. How are these different factors to be reconciled? Among certain formalistic artists in foreign countries a yawning chasm formed between their political views and public sympathies on the one hand, and their artistic practice on the other. This chasm proved so great that even the events of the world war against fascism, in which many of them participated as members of the allied armies or the resistance movement, could not change their views on art. They continued demonstratively to deny the ideological content of art and all connection between the aims of art and the interests of the wide masses.

Even those formalists, who, like Picasso, have repeatedly professed sympathy for the struggle of democracy against fascism show a marked unwillingness to apply the progressive aspects of their world outlook to their artistic practice. A yawning chasm still exists in their work to this day, resulting not merely in the failure of these artists to advance the struggle of their peoples against fascism and reaction by their creative efforts, but also, objectively, in their furthering (through their art) the very aims of the bourgeois reaction against which they vehemently protest in their political utterances and declarations.

By proclaiming 'art for art's sake,' void of all contact with the struggle, aspirations and interests of the wide masses, by cultivating individualism, the formalists are affirming the very thing the reactionaries want them to. They are playing into the hands of the decadent bourgeoisie who in their efforts to preserve their domination look with hatred upon the development of the consciousness of the masses, upon the growth of their sense of human dignity and their feeling of solidarity, upon any rousing of their activity through the means of realistic art rich in ideological content.

* * *

Soviet art is progressing along the path of socialist realism, a path pointed out by Stalin. It is this path that has led to the creation of a vital Soviet art, ideologically forward-looking and artistically wholesome: socialist in content and national in form; an art worthy of the great Stalin epoch.

As opposed to decadent bourgeois art, hypocritically hiding its reactionary class nature behind phrases such as 'pure art' and 'art for art's sake,' Soviet artists openly espouse the ideas of Bolshevism expressing the advanced ideas of the Soviet people who at present represent the most advanced people of the world, for they have built up Socialism, the most advanced form of contemporary society. As opposed to decadent bourgeois art with its anti-humanism, Soviet artists present the art of socialist human-ism, an art imbued with supreme love for man, with pride in the emancipated individual of the socialist land, with profound sympathy for that part of humanity living under the capitalist system, a system which cripples and degrades men. As opposed to decadent bourgeois art with its falseness, its rejection of a realistic, truthful reflection of life as it is, Soviet artists present the wholesome and integral art of socialist realism, expressed in profound artistic images reflecting true life, showing the struggle between the old and the new and the inevitable triumph of the new and progressive, an art mobilizing Soviet people for further victories. As opposed to decadent bourgeois art, divorced from the people, hostile to the interests of the democratic masses, permeated with biological individualism and mysticism, reactionary and anti-popular, Soviet artists present an art created for the people, inspired by the thoughts, feelings and achievements of the people, and which in its turn enriches the people with its lofty ideas and noble images.

Young Soviet art has already created works of world-wide significance. Soviet artists are inspired by great tasks and purposes. Soviet art is advancing along the true path indicated by the genius of Stalin.

Among the many burdens which the young Soviet republic inherited a quarter of a century ago from old landlord-bourgeois Russia, was the decadent, formalistic art of that time. All those 'original' tricks which the formalists of Europe and America take such pride in, were ousted by Soviet artists long ago as ridiculous anachron-isms.

The road travelled by Soviet art in overcoming formalism is of inestimable import-ance to the art culture of the whole world. The experience accumulated by Soviet artists will time and again stand the artists of other countries in good stead when they begin to look for a way out of the impasse of formalism and to create a genuine people's art. [...]

10 Robert Motherwell (1915–1991) and Harold Rosenberg (1906–1978) 'The Question of What Will Emerge Is Left Open'

The authors offer a refusal of the direction of artistic practice according to the mounting dictates of Cold War politics. The hope was that an essentially unplanned, open-ended inquiry would prove indigestible by the competing monoliths, and even constitute a kind of subversive third force with respect to both. In the event, liberalism was substantially able to turn such a programme to its own ends. Originally published as the opening statement in the first (and only) issue of Possibilities: An Occasional Review, *no. 1, New York, Winter 1947/8, p. 1. Reprinted in Chipp, op. cit., pp. 489–90, from which the present text is taken.*

This is a magazine of artists and writers who 'practice' in their work their own experience without seeking to transcend it in academic, group or political formulas.

Such practice implies the belief that through conversion of energy something valid may come out, whatever the situation one is forced to begin with.

The question of what will emerge is left open. One functions in an attitude of expectancy. As Juan Gris said: 'You are lost the instant you know what the result will be.'

Naturally the deadly political situation exerts an enormous pressure.

The temptation is to conclude that organized social thinking is 'more serious' than the act that sets free in contemporary experience forms which that experience has made possible.

One who yields to this temptation makes a choice among various theories of manipulating the known elements of the so-called objective state of affairs. Once the political choice has been made, art and literature ought of course be given up.

Whoever genuinely believes he knows how to save humanity from catastrophe has a job before him which is certainly not a part-time one.

Political commitment in our times means logically – no art, no literature. A great many people, however, find it possible to hang around in the space between art and political action.

If one is to continue to paint or write as the political trap seems to close upon him he must perhaps have the extremest faith in sheer possibility.

In his extremism he shows that he has recognized how drastic the political presence is.

11 Constant (Constant A. Nieuwenheuys) (b. 1920) 'Our Own Desires Build the Revolution'

Dutch by birth, Constant gravitated to Paris at the end of the war. He shared in the contemporary attraction to the primitive, and to a radical social vision which none the less rejected the conventional left-wing forms of Social Realism. Moving between Paris and Amsterdam, he initially identified with the post-war rump of Surrealism before becoming involved, along with Karl Appel, Asger Jorn and others, in the formation of the group Cobra in 1948 (see VB9). The present essay originally appeared in Cobra, *no. 4, Amsterdam, 1949, p. 3. It is reprinted, in an English translation by Lucy Lippard, in Chipp, op.cit., p. 601, from which the present extract is taken.*

For those of us whose artistic, sexual, social, and other desires are farsighted, experiment is a necessary tool for the knowledge of our ambitions – their sources, goals, possibilities, and limitations.

But what can be the purpose of going from one extreme to the other, like man, and of surmounting even those barriers erected by morals, aesthetics, and philosophy? What is the reason for this need to break the bonds which have kept us within the social system for hundreds of years and thanks to which we have been able to think, live, create? Is our culture incapable of prolonging itself and of leading us one day to the satisfaction of our desires?

In fact, this culture has never been capable of satisfying anyone, neither a slave, nor a master who has every reason to believe himself happy in a luxury, a lust, where all the individual's creative potential is centered.

When we say desire in the twentieth century, we mean the unknown, for all we know of the realm of our desires is that it continuously reverts to one immeasurable desire for freedom. As a basic task we propose liberation of social life, which will open the way to the new world – a world where all the cultural aspects and inner relationships of our ordinary lives will take on new meaning.

It is impossible to know a desire other than by satisfying it, and the satisfaction of our basic desire is revolution. Therefore, any real creative activity – that is, cultural activity, in the twentieth century – must have its roots in revolution. Revolution alone will enable us to make known our desires, even those of 1949. The revolution submits to no definition! Dialectical materialism has taught us that consciousness depends upon social circumstances, and when these prevent us from being satisfied, *our needs impel us to discover our desires.* This results in experiment, or the release of knowledge. Experiment is not only an instrument of knowledge, it is the very condition of knowledge in a period when our needs no longer correspond to the cultural conditions which should provide an outlet for them.

* * *

. . . Being free is like being strong; freedom appears only in creation or in strife – and these have the same goal at heart – fulfillment of life.

Life demands creation and beauty is life!

So if society turns against us and against our works, reproaching us for being practically 'incomprehensible,' we reply:

1 That humanity in 1949 is incapable of understanding anything but the necessary struggle for freedom.
2 That we do not want to be 'understood' either, but to be freed, and that *we are condemned to experiment by the same causes that drive the world into war.*
3 That we could not be creators in a passive world, and that today's strife sustains our inventiveness.
4 Finally, that humanity, once it has become creative, will have no choice but to discard aesthetic and ethical conceptions whose only goal has been the restraint of creation – those conceptions responsible for man's present lack of understanding for experiment.

Therefore, understanding is nothing more than recreating something born of the same desire.

Humanity (us included) is on the verge of discovering its own desires, and by satisfying them we shall make them known.

12 Asger Jorn (1914–1973) 'Forms Conceived as Language'

Born in Denmark, Jorn was active in the Parisian avant-garde of the late 1930s. He spent the war years in Denmark before returning to Paris in 1947. Although politically of the Left, and philosophically materialist, Jorn rejected Socialist Realism. He was a founder member of Cobra, and his continuing interest lay in children's drawings and primitive imagery. It was hoped that this resource would penetrate through accumulated layers of bourgeois artifice, as a kind of visual Ur-language, to enable an authentic and popular form of expression. The present extracts are translated by Paul Wood from 'Les formes conçues comme langage' in *Cobra* no.2, Brussels, March 1949. (The closing reference to 'a poor woman buying fish' is to a Socialist Realist painting, *Parisiennes au marché*, by André Fougeron.)

The problem of form is the essential problem of our society. The conflict that manifests itself between diverse conceptions of form is identical to the increasingly bitter conflict between social and political conceptions. [...] Only a materialist art is capable of resolving the problem of form and content ... It must restore art to its foundation in the senses. And we mean 'restore', since we believe that the origins of art are instinctive and thus materialist. It is the metaphysic of classicism that has managed to spiritualize and intellectualize art. It is unfortunate nowadays to see materialists marching along on their heads with a realism and a naturalism that are opposed to reality and to nature, that are based on *illusion*. A true realism, a materialist realism, consists in the discovery and the expression of forms appropriate to their content. But there is no content, save that of human interest. A true, materialist realism rejects the idealist equation of subjectivity with individualism that was denounced by Marx, and seeks forms of reality that are *common to the senses of all men*. [...] Thus the red flag is an immediately sensible revolutionary form that strikes the senses *of all men*, a synthesis of revolutionary reality and revolutionary aims, a common link and not an external allegory ... For a long time we have been able to identify with this red flag, whereas we can only accidentally identify ourselves with a poor woman buying fish.

13 André Fougeron (1912–1999) 'The Painter on his Battlement'

Fougeron was familiar with the Parisian avant-garde of the 1930s, and his early work reveals his awareness of Picasso and of the Expressionist tradition. He took part in the key exhibition of May 1941, 'Twenty Young Painters in the French Tradition', which was later to be seen as marking a form of cultural resistance to the German Occupation. However, Fougeron's left-wing politics and activity in the Resistance increasingly led him away from the avant-garde towards an adoption of the Communist Party's artistic policy of Socialist Realism. He became in effect the French Communist Party's official painter (though he was later to be attacked by Louis Aragon for deviation from Socialist Realism). In this essay he quotes the Communists'

principal cultural spokesman Laurent Casanova, who had confirmed the party's adherence to Socialist Realism in a policy speech to the 11th Party Congress at Strasbourg in June 1947. Originally published as 'Le peintre à son creneau' in *La Nouvelle Critique*, Paris, December 1948, from which the present translation is made. The French title plays on an untranslatable pun: 'creneau' means both 'battlement' and 'easel'.

The drama of reality expressed by the courageous gesture of the miner, hazarding his life to gain no more than the means of subsistence, can have only an intolerable aspect to one who sees the miners' oppression.

If we take this aspect of our present life as a starting-point, it becomes necessary to investigate why it is that the expression of reality remains so intolerable to those who are consciously or unconsciously on the side of the oppressors.

Nowadays, it is paramount that the artist should be oriented towards the formal interplay of lines and colours. Otherwise, he must accuse in his turn and commit himself to struggle. This is why one needs to judge the political significance of a realism yet to be created, like abstract art in 1948.

The premises of a new realism are to be derived from the richness of the feelings of a people considered as the major source of inspiration, and of *subject-matter*.

For the artist who is conscious of this richness, it is deserving of the skilful subordination of the relations of lines and colours. And slowly, from this point, works develop which are balanced from the point of view of content and form.

To be more precise: the realism of three apples on a plate is not at issue, on the grounds that the realization of this motif can allow as much evasion, as much aesthetic isolation, as an abstract painting can contain. It therefore remains necessary, above all, to accentuate the *social reality* of the subject. This will already be a serious assault on the aesthetic positions of the enemy, and, for the artists who courageously intend to carry this out, will provide the means to avoid a danger: that the effort of the painter will be futile '*if there is not at the outset the capacity for both the masses and the artist to be affected by the same things*' [Laurent Casanova, Report to the XIth Congress of the French Communist Party at Strasbourg].

Today the artist is a prisoner to the extent that he is afraid of creating a work with simple feelings, and that he is embarrassed by such feelings, instead of being proud of putting them to the test like all honest people.

It remains to unmask these impostures thoroughly. Because when confronted by abstract painting, we do not always have the requisite rigour of thought... The shoulder-shrugging of the aesthetes should not intimidate us; we should not underestimate our power in any domain. To be profane is one thing. To say that one does not understand anything, is quite another. Because it is true, there is nothing to understand. The problem is not to look for something to understand, but to *admit*.

Admit quite openly that there is nothing to understand; and at the same time take this as a measure of what one has done in the way of painting.

Painting was in the beginning cave paintings of wild animals, the terrifying food of our ancestors. Then of gods, that were believed capable of causing natural disasters. Finally, painting became a woman who gave her breast to a haloed child; a symbol of life, which renews itself ceaselessly, of a future desired to be ever more beautiful.

But today, to what idea of human evolution does painting find itself linked? 'To mine,' responds one voice. Which one? That of the mailing list of a good gallery. Properly counted, that adds up to 1500 names. Amongst decent amateurs who take delight in the visual harmony offered by the painter, how many of them think: 'Is painting a good venture in which to invest my money? What will it be worth in ten years' time?' This is the *elite*. Those who affirm it are those who can talk of nothing else. It is a lame response!

Today it is necessary to look for the elite elsewhere. That is the place where you will also find the source of inspiration necessary for an artistic renaissance: in the people, in the power of the people, because 'those who live, are those who fight' and art is always on the side of life.

15 November 1948.

14 Hans Sedlmayr (1896–1984) and Theodor Adorno (1903–1969) from the 'Darmstadt Colloquy'

The Darmstadt Colloquy was convened on the occasion of an exhibition of figurative and semi-figurative art in 1950. Discussion centred for the most part on the issue of abstract art, and on Sedlmayr's book, *Verlust der Mitte* of 1948 (translated as *Art in Crisis: The Lost Centre*), which achieved widespread readership as the most notable attack on modern art to be published in post-war Germany. Sedlmayr saw the development of an art of the 'sub-natural' as endangering to the contemporary 'self-image of man' and to its representation in art. (Dali and Ernst were among the artists he had in mind.) He believed that modern art must 'unite with the human'. For all their objection to his views, the defenders of abstract art implicitly assented to Sedlmayr's cultural pessimism and essentialism, representing abstraction as a new way to 'unite with the human' that would in the end be seen as continuous with the art of the past. Adorno alone objected, insisting on the specific complexities of modern art and holding out against its reconciliation with a conservative view of the past. Our text is translated by Nicholas Walker from Hans Gerhard Evers (ed.), *Darmstädter Gespräch: Das Menschenbild in unserer Zeit* ('The Darmstadt Colloquy: The Image of Man in our Times'), Darmstadt: Neue Darmstädter Verlagsanstalt, 1950, pp. 127, 215–16. (See also VIB6.)

Sedlmayer:

* * *

[...] The most spirited and trenchant critique of my own position is that mounted by Theodor Adorno [...] His critique can essentially be summarized thus (although he himself regarded this formulation as a considerable simplification): 'The main difference between our respective views of history may be rooted in the fact that you are an architect' – and that is incidentally what I 'originally' was, for I began my career as an architect and the history of architecture initially constituted my principal field of interest – 'whereas I am a musician. You entertain a static view of the world, whereas I entertain a dynamic one.' 'And what is supposed to follow from this?' I asked in reply. 'You believe in the essence of man, even if you also acknowledge certain historical and accidental variations in the human condition, whereas I cannot accept the idea of *the* essence of man. The so-called essence of man is a variable that depends upon his historical and economic situation.' The matter can hardly be expressed more clearly.

This is where opinions effectively differ and *this* is precisely the point on which we can no longer hope to establish agreement. [*Applause*]

* * *

Adorno:

[...] I find myself in a rather difficult position in the discussion here. For I strongly identify, it hardly needs to be said, with the cause of modern art in its extreme form. But I also have the feeling that modern artists are threatening to damage their cause in this discussion by arguing in an essentially apologetic manner. The basic tenor of their argument is that things are not really so bad after all. But the new art thereby simply makes itself innocuous. Sedlmayer's claim by contrast – and he himself emphasizes that our general positions are diametrically opposed – that the element of negativity is essential to modern art, seems to me to contain some truth. We should not simply content ourselves – and here I differ from Herr Roh – with saying: 'Just give us enough time and it will soon become apparent that we too belong with Raphael and Beethoven and so forth.' We do not, we cannot, and we should not wish to [*Applause*], because the idea of authenticity which they embody has become problematic for us. Earlier on Herr Roh objected that I have effectively neglected the element of harmony in modern art and in modern music. In a formal sense, of course, it is quite true that every late quartet by Beethoven or every painting by Picasso is meaningfully organized internally, that every particular aspect of such a work is a function of the whole and vice versa, just as much as in the case of traditional art. Understood in this sense, the concept of harmony certainly designates something that is comprehensively applicable. But I believe that we risk neglecting that essential moment of negativity if we move too rapidly to this level of the argument. However much I reject the kind of cultural conservatism expressed by Sedlmayer, he has here quite rightly identified something that is typically neglected by an all too naive and unchallenged faith in progress. I would express it dialectically in this way: the harmony of the modern work of art lies in explicitly acknowledging what remains lacerated and unreconciled and bringing it to unreserved and emphatic expression. For the only reconciling power we have lies precisely in this acknowledgement, in this attempt to find words for what is mute. Whereas every attempt to realize the element of harmony directly and unmediatedly in modern art, through recourse to the idea of the cosmic dimension for example, ultimately only tempts us to disavow our own precarious predicament, to build that very bridge to the past which should actually be dismantled. [...] I believe that every artist who has ever seriously engaged with his material knows that the dissonances with which he may have to work never simply appear as a beautiful harmonious sound in the end. But nor will such dissonances simply appear as a reflection of the fact that our world is so appalling. Both these claims are false by virtue of their limited character. For here we encounter a most remarkable relationship which demands an extremely subtle and extremely precise analysis. It involves the peculiar pull, the specific attraction that is exerted precisely by the non-harmonious elements, an enticement to adventure, to what has never yet been experienced. But it also involves the readiness to acknowledge grief and suffering, precisely by finding some sign for it. We must be able to recognize the manifold levels that are at work in modern art, to perceive what also ultimately resonates in a particular dissonance, a particular piece of music, to glimpse what is somehow concentrated within initially incompatible historical experiences. Only when we are capable of appreciating such richness of experience shall we be able to 'save' [*retten*] modern art without falling

back on apologetics, without thereby evacuating its force, without simply assimilating it to traditional art. For that is precisely what must be avoided. If there is such a thing as preserving the tradition, as salvaging the tradition, to paraphrase Juan Gris, it is only there where we no longer possess any immediate contact with the tradition at all. But whenever we try and appeal to tradition in the context of modern art, we simply end up obscuring the very concerns which are crucial to modern art and reducing them to certain notions of timeless universal beauty which have become so questionable to all of us. [*Applause*]

15 George Dondero (1883–1968) from *The Congressional Record*

Dondero was the United States Senator for Michigan. In the late 1940s he became the principal voice of American conservatism's attack on modern art, speaking for a position which was in principle shared by the then President Harry S. Truman. The wider context of this attack is the anti-Communist hearings of the House Un-American Activities Committee led by Senator Joseph McCarthy. In the first extract Dondero targets organized left-wing groups. In many respects his accusation of Communism in modern art mirrored the Stalinists' accusations of bourgeois individualism. The ironies of this did not pass unnoticed. Accordingly, Dondero sophisticated his argument in the speech represented in the second extract. Socialist Realism is now cast as the art of propaganda suitable for misleading the Communist rulers' own subject populations. Something more subtle is therefore required in order to destabilize the culture and society of Communism's enemies abroad. This is the role in the worldwide Communist conspiracy supposedly fulfilled by a predominantly abstract or expressive modern art. The two speeches were delivered on 25 March and 16 August 1949 respectively, and are published in *The Congressional Record* for 1949, pp. 3233–5 and 11584–7. The present extracts are taken from this source.

Communists Maneuver to Control Art in the United States

Mr Speaker, twenty-three of the officers and directors of the Artists' Equity Association are sponsoring the pro-Soviet Cultural and Scientific Conference now being held at the Waldorf-Astoria Hotel in New York. There will be mass picketing there this evening and perhaps tomorrow. I mention that as an introduction to the remarks I am now about to make on the subject of Communists' maneuver to control art in the United States.

Exposure of Communist infiltration in the United States has been directed principally toward the fields of government and labor. We have been neglectful of the knowledge that communism is a hydraheaded serpent that attacks the true democracies on all fronts, political, social, economic, scientific, cultural. Generally we have been blind to the fact that Communist standards of measurement and Communist undermining of our traditional values have made broad progress in one of our great cultural fields – the field of art. The average American has only limited knowledge of the importance of art in our national existence. Art is a large and important factor in our educational system, in our repositories of culture, as represented by such public institutions as libraries and museums, in our great endowments and philanthropic organizations, and, through commercial art, in our great fields of industry.

In the Communist campaign to undermine the standards of American culture through the substitution of Marxist standards, the comrades have followed the same practices, the same technique, which they have established in other fields. Fortunately, we are able to identify their propaganda in art, and if we are alert to contemporary activities, can put the finger on the latest moves in the campaign of Communist infiltration.

The Communist-front organization is the same in the field of art as it has been in the field of political ideology. A disguised structure is built up and, when its true purpose is disclosed to the public, it fades from view – to be followed by an organization with a new name, but controlled by the same Marxist individuals. [. . .]

* * *

The Artists' Equity Association was formed at a meeting held in the Modern Museum of Art in April of 1947. It seems to be rising phoenixlike out of the members of the American Artists' Congress which is described on page 5 of Citations, a pamphlet by an official Government agency, showing organizations and publications found to be Communist or Communist fronts, as typical of Communist-created and controlled organizations. This seeming immortality of the left-dominated culture groups is due to the apathy and confusion in artistic circles. In the Red camp, where they have tasted victory by measure of their continuous attention to organization, no such apathy exists. [. . .]

* * *

On the board of Artists Equity we find the name of Ben Shahn. He was one of the New Yorkers who worked with Mexican Red Diego Rivera on the mural which included Lenin in its design. It was removed from the walls of Radio City Building in New York. He was a member of the John Reed Club, listed in Citation as a Communist organization named in honor of John Reed, who was one of the earliest Communist leaders in the United States. Later he became a member of the American Artists' Congress and right up to the present he has continued his revolutionary aim. He is now in the National Council of Arts, Sciences, and Professions.

Max Weber, another of the many Artists' Equity Association key men who have long Red records, and who has received tremendous publicity throughout America, due to the predominance of Marxian critics rather than art critics on our papers, is quite a favorite among the appreciators of Communist culture. Even before the revolutionary Armory exhibition of 1913 he was an intimate of Picasso, the Communist artist in Paris, and was an influential factor in foisting a Communist international criterion into the judging of art in America. [. . .]

* * *

. . . One could continue at great length to enumerate the Communist-front connections of these officials in the Artists' Equity Association. However, these facts are portentous enough to convey the seriousness of the situation and to impress upon you the ulterior purpose behind this so-called art group, and to disclose its progress.

Through the aid of Marxist evaluators in the cultural sphere, leftists in art have succeeded in lowering, and are attempting to break down the standard to which artists of the past adhered – to be worthy of the calling of art.

The veritable wave of would-be painters, sculptors, with which America is drenched is directly traceable to the need of the Red culture group to create a numerically strong

Communist art movement. The fact that the quality of both art and artists is inferior in no way deters them – though it should strike a warning note to all real Americans.

* * *

We are dealing with a subtle enemy. Let every loyal citizen be on guard against this insidious menace to our way of life.

Modern Art Shackled to Communism

Mr Speaker, quite a few individuals in art, who are sincere in purpose, honest in intent, but with only a superficial knowledge of the complicated influences that surge in the art world of today, have written me – or otherwise expressed their opinions – that so-called modern or contemporary art cannot be Communist because art in Russia today is realistic and objective.

The left-wing art magazines advance the same unsound premises of reasoning, asserting in editorial spasms that modern art is real American art. They plead for tolerance, but in turn tolerate nothing except their own subversive 'isms.'

The human art termites, disciples of multiple 'isms' that compose so-called modern art, boring industriously to destroy the high standards and priceless traditions of academic art, find comfort and satisfaction in the wide dissemination of this spurious reasoning and wickedly false declaration, and its casual acceptance by the unwary. [...]

As I have previously stated, art is considered a weapon of communism, and the Communist doctrinaire names the artist as a soldier of the revolution. It is a weapon in the hands of a solider in the revolution against our form of government, and against any government or system other than communism.

From 1914 to 1920 art was used as a weapon of the Russian Revolution to destroy the Czarist Government, but when this destruction was accomplished, art ceased to be a weapon and became a medium of propaganda, picturing and extolling the imaginary wonders, benefits and happiness of existence under the socialized state.

Let me trace for you a main artery from the black heart of the isms of the Russian Revolution to the very heart of art in America.

In 1914 Kandinsky, a Russian-born Expressionist and nonobjective painter, who found it safer to live in Germany, returned to Russia, and three years later came the revolution. He is the man who preached that art must abandon the logical and adopt the illogical. He dominated a group of black knights of the isms, who murdered the art of the Russian academies. They were Cubists, Futurists, Expressionists, Construction-ists, Suprematists, Abstractionists, and the rest of the same ilk. Kandinsky was a friend of Trotsky, and after the revolution founded the Moscow Institute of Art Culture. He was Communist leader in Red art – the commissar of the isms.

Kandinsky remained in Russia until 1921, when the art of the isms began to feel the iron grip of the new art control, the art for the sake of propaganda, the art of social realism. Kandinsky went back to Germany.

The Communist art that has infiltrated our cultural front is not the Communist art in Russia today – one is the weapon of destruction, and the other is the medium of controlled propaganda. Communist art outside Russia is to destroy the enemy, and we are the enemy of communism. Communist art in Russia is to delude the Russian workers.

The art of the isms, the weapon of the Russian Revolution, is the art which has been transplanted to America, and today, having infiltrated and saturated many of our art centers, threatens to overawe, override and overpower the fine art of our tradition and inheritance. So-called modern or contemporary art in our own beloved country contains all the isms of depravity, decadence, and destruction.

What are these isms that are the very foundation of so-called modern art? They are the same old lot of the Russian Revolution, some with transparent disguises, and others added from time to time as new convulsions find a new designation. I call the roll of infamy without claim that my list is all-inclusive: dadaism, futurism, constructionism, suprematism, cubism, expressionism, surrealism, and abstractionism. All these isms are of foreign origin, and truly should have no place in American art. While not all are media of social or political protest, all are instruments and weapons of destruction. [. . .]

Cubism aims to destroy by designed disorder.

Futurism aims to destroy by the machine myth. [. . .]

Dadaism aims to destroy by ridicule.

Expressionism aims to destroy by aping the primitive and insane. [. . .]

Abstractionism aims to destroy by the creation of brainstorms.

Surrealism aims to destroy by the denial of reason.

* * *

[. . .] The evidence of evil design is everywhere, only the roll call of the art contortionists is different. The question is, what have we, the plain American people, done to deserve this sore affliction that has been visited upon us so direly; who has brought down this curse upon us; who has let into our homeland this horde of germ-carrying art vermin?

* * *

We are now face to face with the intolerable situation, where public schools, colleges, and universities, art and technical schools, invaded by a horde of foreign art manglers, are selling to our young men and women a subversive doctrine of 'isms,' Communist-inspired and Communist-connected which have one common, boasted goal – the destruction of our cultural tradition and priceless heritage. [. . .]

In my previous addresses on this subject, I have used the word infiltration in describing the present Red element in American art. This is an understatement. Communist art, aided and abetted by misguided Americans, is stabbing our glorious American art in the back with murderous intent.

16 Arthur M. Schlesinger Jr (b. 1917) from *The Politics of Freedom*

Schlesinger represented the so-called 'business liberal' wing of the American establishment. Unlike the conservatives, such as Dondero, Truman and McCarthy, these interests identified the individualism of modern art as a bulwark against Totalitarianism. Despite the fact that the Nazis had victimized Communists and modern artists under the rubric 'Kulturbolschewismus', and the additional fact that left-wing artists had organized against Fascism during and before the Second World War, the theory of Totalitarianism enabled liberal capitalism to identify the Nazi state under Hitler with the Soviet state under Stalin; and hence to equate Fascism and Communism *tout court*. One of the outcomes of this strategy was that the supposedly apolitical art of the post-war American avant-garde became deployed as an

element of no small significance in US international policy, as a token of freedom in the American way of life. Schlesinger's book, a wide-ranging and not merely cultural contribution to this perspective, was first published in 1950. It was reprinted as *The Vital Centre*, London and New York, 1970; the present extracts are taken from pp. 77–81 of that edition.

Lenin's terror, being attached to objective conditions, like a still-existing capitalism, had some limits. But Stalin's terror, operating after the liquidation of capitalism, is directed at thoughts – the 'vestiges of capitalism,' as Molotov calls them, adding that they 'are extremely persistent in people's consciousness.' It is consequently unlimited in its application. 'The tasks of the ideological front,' observes Zhdanov, '. . . are not removed, but, on the contrary, grow more important under conditions of peaceful development.' [. . .]

[. . .] Everything in a totalitarian state is eventually sucked into the vortex where totalitarian man interminably revindicates himself.

The recent Soviet campaign against cultural freedom and diversity becomes all too comprehensible in this light. The totalitarian man requires apathy and unquestioning obedience. He fears creative independence and spontaneity. He mistrusts complexity as a device for slipping something over on the régime; he mistrusts incomprehensibility as a shield which might protect activities the bureaucracy cannot control. After all, the mission of art is clear and definite. In the words of Konstantin Simonov, 'We must show the Soviet person – the builder of the future – in such a light that the audience and the whole world will see the moral and spiritual superiority of people who have been reared in a socialist society.' 'We have in real life, living,' adds Alexander Fadeyev, the secretary of the Soviet Writers Union, 'those heroes who created the new social order, who are the personification of the new moral values.'

The paintings of Picasso, the music of Stravinsky are strangely disturbing. They reflect and incite anxieties which are incompatible with the monolithic character of 'the Soviet person.' Their intricacy and ambiguity, moreover, make them hard for official-dom to control [. . .] Complexity in art further suggests the whole wicked view of 'cosmopolitanism' summed up for the Communists in the conception of Europe. 'It is not by chance that the Russian Communists attack Picasso,' Malraux has written. 'His painting is the presence of Europe in its most acute form. In the order of the spirit, all that which Russia calls formalism and which she has been deporting or tirelessly destroying for ten years, is Europe.'

The conclusion is clear. Let artists turn their back on Europe. Let them eschew mystery, deny anxiety and avoid complexity. Let them create only compositions which officials can hum, paintings which their wives can decipher, poems which the Party leaders can understand. This is the *Diktat* of the state. [. . .] The delicate phrases of Alexander Fadeyev at the World Congress of Intellectuals are characteristic: 'If hyenas could type and jackals could use a fountain pen,' they would write like T. S. Eliot, Dos Passos, Sartre and Malraux.

In an article for dissemination by the USSR Society for Cultural Relations with Foreign Countries, Vladimir Kemenov exhausts the arsenal of philistinism in his denun-ciations of Picasso, Henry Moore, Georgia O'Keeffe, even of individualists so compara-tively restrained as Cézanne and the impressionists. Modern art, says Kemenov, is 'a mixture of pathology and chicanery, which trace their origin to the daubs painted by the donkey's tail. . . . In order to analyze this work, the healthy normal people of the future

will seek the services not of the art expert, but the psychiatrist.' The healthy normal art of the future, one would gather, will be modeled on Alma–Tadema, if not on James Montgomery Flagg. Official Soviet painting today certainly bears out the inference.

The campaign against the free creation of music is even more notorious. Stravinsky, Prokofieff, Shostakovich and the others have sinned against the desired banalities of form and sound. 'This music,' observes the president of the Association of Soviet Composers, 'openly harks back to the primitive barbaric cultures of prehistoric society, and extols the eroticism, psychopathic mentality, sexual perversion, amorality, and shamelessness of the bourgeois hero of the twentieth century.' *Pravda* even lashes out periodically against the jazz bands: 'Instead of the popular Soviet songs . . . they reproduce melodies filled with tavern melancholy and alien to the Soviet people.' No form of esotericism is too small to be dangerous to totalitarianism.

The Communist slide rule has similarly produced absolute equations for literature, for the films, for philosophy, even for drama critics and for clowns. [. . .]

* * *

Yet the true horror from the western viewpoint lies in the fact that the artist practically always gives in. For every Mayakovsky, who kills himself, a thousand exhibit masochistic delight in accepting correction and promising never, never to do it again. [. . .]

No one should be surprised at the eagerness for personal humiliation. The whole thrust of totalitarian indoctrination, as we have seen, is to destroy the boundaries of individual personality. The moral balance of power is always with the Party as against the person. Those who cave in, as Dwight Macdonald accurately notes, do so not so much because they lack moral courage as because they lack good conscience. They can never be confident in asserting their own individuality against the Party; after all, Number One may always be right. The totalitarian psychosis thus sickens the whole society. [. . .]

17 Alfred H. Barr Jr (1902–1981) 'Is Modern Art Communistic?'

Barr had been prominently involved with the Museum of Modern Art, New York, since its foundation, and he had early first-hand experience of Stalinist and Nazi pressure on art. As conservative reaction mounted in post-war America, he was drawn to the defence of the avant-garde. The principal thrust of the present text, however, is directed against Communism, seen as the new enemy of victorious liberal capitalism in the wake of the Nazis' defeat. In its original format Barr's essay was illustrated by avant-garde images and figurative history paintings captioned respectively as 'Hated and Feared' and 'Admired and Honoured' in Soviet Russia and Nazi Germany. The debate continued until the final collapse of McCarthyism in the mid-1950s. Barr's article was originally published in the *New York Sunday Times Magazine*, 14 December 1952, pp. 22–3 and 28–30. It was later reprinted in his selected writings, *Defining Modern Art*, New York, 1986, pp. 214–19. (For a previous text by Barr see IVA7.)

Modern political leaders, even on our side of the Iron Curtain, feel strongly and express themselves eloquently against modern art. President Truman calls it 'merely the vaporings of half-baked lazy people' and believes 'the ability to make things look as they are is the first requisite of an artist.' After looking at an abstract mural at the United Nations building, General Eisenhower remarked: 'To be modern you don't have to be nuts.'

Prime Minister Churchill has been quoted as proposing assault, hypothetical but violent, on Picasso. Many others go further. Because they don't like and don't understand modern art they call it communistic. They couldn't be more mistaken.

Whatever a Western leader's point of view on artistic matters may be, he would not want to impose his taste upon his countrymen or interfere with their creative freedom. The totalitarian dictators of Nazi Germany and Soviet Russia, on the contrary, did want to: the modern artist's non-conformity and love of freedom cannot be tolerated within a monolithic tyranny and modern art is useless for the dictators' propaganda, because while it is still modern, it has little popular appeal. The dictators wanted to impose their artistic convictions. They could. They did and the Russians still do. Let's look at the record in Russia and Germany.

... In 1932, the dogma of Socialist Realism was proclaimed by Pravda and the formation of the Union of Soviet Artists was decreed by the Central Committee of the Communist party. The critic Milyutin wrote: 'Art, the object of which is to serve the masses, cannot be other than realistic. The attention of artists is concentrated on socialist construction ... our struggles ... the enemies of the people ... the heroes of the Soviet land. ...'

Abstraction or stylization of form, idealism or fantasy of subject were anathematized with such terms as formalism, Western decadence, leftist estheticism, petty-bourgeois degeneracy. Even realism that was too honestly factual was damned as naturalism. To practice these vices was to risk denunciation, isolation and starvation. To defend them involved more overt dangers.

One of the most frightening and shameful documents of our time is quoted at length in Kurt London's 'Seven Soviet Arts.' It records the inquisition conducted by a committee of fellow-painters upon the young artist Nikritin after he had submitted his canvas 'Old and New' to the Art Commission for the annual exhibition. The picture was not a great work but it was a sincere, thoughtful and loyal effort to paint an allegory of a changing world. Two of Nikritin's friends, subway workers, posed for the youthful figures and had admired it. They had even made suggestions about the composition. But to Gerassimov, Deineka and the other successful artists on the jury the picture was a 'defamation,' 'derived from the Italian Fascists,' 'deeply erotic, pathological,' 'individualistic,' a 'nightmare,' a 'catastrophe,' a 'terrible picture.' The painter Lecht disclosed the jury's feelings: 'Comrades, we have here a sample of the works about which Pravda warned us. ... What we see here is a calumny ... a class attack, inimical to Soviet power. The picture must be removed and the appropriate measures taken.'

Nikritin's reply was courageous, even desperate. He rejected the jury's attacks and expressed his belief that shortly there would be a demand for paintings 'actually realistic and contemporary and not photography like those which you assessed yesterday. ... Those works follow the line of least resistance. I confess what I think – perhaps I am speaking for the last time.'

The Committee did, however, approve another girl-and-boy-worker picture, Ryangina's 'Higher and Higher' of 1934, which shows an artist's acceptance of Milyutin's assertion: 'Life in the USSR is full of purpose, bright hopes, obvious progress, growth of culture and security for the masses. ... All this makes for buoyancy and cheerfulness and brightness in the creative work of Soviet artists.' By 1934 the objective, unsmiling realism of Katzman's 'Lace-makers' of 1928 would have been accused of naturalism. Ryangina, six years later, was insistently bright and cheerful and so was Deineka (one of

Nikritin's accusers) in his 'Future Flyers' of 1937. He had made commendable progress since his 'formalistic' 'Textile Workers' of 1927.

The heroism of the Red Army during the Civil Wars and, later, World War II, has been a very popular theme.

During the first twenty years of the USSR, pre-revolutionary triumphs of Russian arms were generally ignored but since the late Thirties Alexander Nevsky, Ivan the Terrible, Peter the Great, Suvarov and other imperial victors have often been celebrated by painters as well as in films. The patriotic painter, however, wisely found his favorite subject in the dictator himself. Every year, in the big exhibitions, Stalin appears in scores of paintings, Lenin in dozens, the two together in half-dozens. Alexander Gerassimov's twelve-foot-long 'Stalin and Voroshilov on the Walls of the Kremlin' of 1938 is characteristic. Three years earlier the painter had served as one of Nikritin's inquisitors. Favorite painter of the Red Army, Gerassimov is today perhaps the most influential artist in the USSR.

Russian artists who accommodate their art to the dictates of authority are well-paid and greatly honored. Their exhibitions are attended, we hear, by vast crowds and many of their works are bought for museums, factory club rooms, town halls, railroad stations, army barracks and museums.

Museums of historic art are also much visited and paintings of the past studied and admired, particularly such realistic history paintings of the late nineteenth century as Repin's 'Cossacks Sending a Jeering Message to the Sultan.' Colossal, quasi-photographic canvases by Repin and Surikov are held up as models to young painters.

Yet the most famous museum in Moscow is closed. The Museum of Modern Western Art comprises the collections of Morosov and Shchukin, assembled by those two great enthusiasts before 1914. Expropriated in 1919, it remains the greatest collection in the world of French painting of the post impressionist and early twentieth century schools. During the Twenties and Thirties the museum served as bait for foreign tourists. But apparently such formalistic canvases as Cézanne's still lifes, Gauguin's Tahitian scenes, and van Gogh's 'Walk in Arles,' not to mention a hundred Matisses and Picassos, seemed too powerfully subversive. The museum is barred, but Pravda continues to rage against the persistence of 'worshipers of bourgeois decaying art who regard as their spiritual teachers, Picasso and Matisse, cubists and artists of the formalist group.'

* * *

Modern art was to fare no better in Nazi Germany. Though the Nazi revolution of 1933 was anti-Communist and anti-Slav, Goebbels had made a careful study of Soviet techniques; and by 1939 the Nazi-Soviet pact suggested that even their ideological differences might not be too irreconcilable. Now, in 1952, the nationalistic arrogance of the Russians and the imperialistic achievements of the USSR might well make Hitler writhe in his grave with envy and chagrin.

Lenin personally disliked modern art, and so does Stalin, but Soviet art policies are based more on a dialectic of power than on personal feeling. Hitler did not merely dislike modern art, he hated it as only a frustrated academic artist could. And he found plenty of company among his brown-shirted battalions and considerable numbers of the general public who were smugly delighted to hear that the new art (which they

had never troubled to study or understand) had, in fact, been foisted on them by a conspiracy involving an international cartel of Jewish dealers, corrupt art critics, irresponsible museum officials and artists who were spiritually un-German, bolshevistic, Jewish and degenerate. The fact that none of the dozen foremost German artists were Jews and only two were Communists made no difference. The Big Lie triumphed.

Immediately after the revolution the Nazis took action. The *Kampfbund für deutsche Kultur*, which already had its skeleton corps of academic artists well-posted throughout Germany, now formed local committees with power to act. Modern painters and sculptors were everywhere denounced, their exhibitions closed, their works removed from museums, their teaching positions forfeited to reactionary successors. Critics and museum officials who had favored their work lost their jobs. A few were retained on evidence of good behavior.

Not only the works of the living 'degenerate' artists but also those of the dead were banned. Van Goghs..., Gauguins, Ensors, Lautrecs, Munchs were stripped from museum walls and sold abroad. And so were the works of Matisse, Beckmann, Kokoschka, Feininger, Picasso, Klee, Barlach and many others, including Chagall and Kandinsky, who were already exiles from Moscow. Probably the most famous of all German sculptures, Lehmbruck's 'Kneeling Woman,' passed from the National Gallery in Berlin to the Museum of Modern Art in New York. Meanwhile Hitler himself was collecting dozens of elaborate and vulgar historical paintings by the nineteenth century artist Hans Makart. [...]

... The Nazi academicians painted idealized figures of Luftwaffe and S. A. troopers such as Eber's 'The Call to Arms,' heroic scenes of German wars, old and recent, *gemütlich* German peasants such as Baumgartner's canvas, tempting Nordic nudes, Aryan allegories, pretty German landscapes, generals, the Nazi ringleaders, and above all the Fuehrer. [...]

Nazi art had a history only one-third as long as has its Soviet counterpart. During their coincident period – that is, 1933 to 1945 – they grew more and more alike in subject-matter, thanks largely to increasing Russian nationalism.

At the *Haus der Kunst* there was more slick, academic neo-classicism in evidence, at the All-Russian Artists' Annual more of the huge, incredibly elaborate, historical paintings of, say, Stalin proposing a toast at a party banquet, or Ivan the Terrible entering a conquered Polish town. Nazi architects at least knew clearly what Hitler wanted but 'Socialist Realism' has not proved a very clear beacon for Soviet architects no matter how eager they may be to conform to the party line.

It is obvious that those who equate modern art with totalitarianism are ignorant of the facts. To call modern art communistic is bizarre as well as very damaging to modern artists; yet it is an accusation frequently made. Most people are merely expressing a common dislike by means of a common prejudice. But this is a point of view which is encouraged by the more reckless and resentful academic artists and their political mouthpieces in Congress and elsewhere. It was given voice in the recent attack on the Metropolitan Museum by the National Sculpture Society, in the ridiculous but sinister debate in the Los Angeles City Council late in 1951, and in the well-coached speeches of Representative George A. Dondero of Michigan. Those who assert or imply that modern art is a subversive instrument of the Kremlin are guilty of fantastic falsehood.

18 Ben Shahn (1898–1969) 'The Artist and the Politician'

Shahn had been cited in Dondero's attack on the Left in American art (VC15). In the 1930s he had produced a well-known series of paintings of the contemporary martyrdom of Sacco and Vanzetti, two Italian immigrants, both anarchists, framed and subsequently executed for the murder of a security guard. The case had provoked world-wide protest. By the 1950s, however, Shahn had come to embrace a liberal, albeit still socially engaged, perspective in the arts, opposed to both Communism and American conservatism. In 1954 he represented the United States, alongside Willem de Kooning, at the Venice Biennale. Shahn's text was originally presented as part of anti-McCarthy protests at a conference of the Emergency Civil Liberties Committee in January 1953, and was then printed in *Rights*, the Committee's journal, in May 1953. It was reprinted for wider circulation in *Art News*, New York, September 1953, pp. 35 and 67. As a prelude to the Biennale it was published in Italian in the journal *Sele Arte*, November–December 1953.

The liberal of today – the altruist – the humanitarian – any citizen who feels his responsibility toward the public good – finds himself caught midway between two malignant forces.

 To the right of him stands the force of reaction, that has always opposed reform or progress, and that always will oppose reform or progress with whatever weapons it can lay its hands upon, including slander and calumny.

 To the left of the liberal stands the Communist contingent, ever alert to move in upon his good works, always ready to supply him with its little packages of shopworn dogma, to misappropriate his words, his acts and intentions. The liberal has long suffered such Communist invasion of his organizations. It has been his cross, and it has, over a period of years, thoroughly demoralized the great American liberal tradition.

 Together, these two forces have constituted an unholy team. The accusation of Communism is the most powerful scourge that has fallen into the hands of reaction since heresy ceased to be a public crime. And the liberal might better be able to silence this charge were it not for a constant and unwelcome espousal of his works by Communist groups and press – plus the uneasy fear that perhaps the charge may be true.

 In addition to his resentment at being called 'Communist,' our humanitarian American is often bitterly aware that his accusers are cynically indifferent to the real nature of Communism, or to the kind of threat that it actually is. The word is used to mask a variety of purposes. It is used by the philistine to vilify art or music or literature that is foreign to his understanding. The political reactionary applies the word to all views that he dislikes, or any movements toward reform. The unreconstructed industrialist terms all labor unions 'Communistic.' And then there was the amusing instance, during the Kefauver investigation, of the waterfront racketeer who appealed for some measure of sympathy on the ground that, anyway, he wasn't a Communist.

 When the radio commentator or performer goes off the air because of the 'Communism' charge, the public is immediately aware of the fact. When the artist or writer is dropped very few people know about it. But there has been a constant stream of such instances of boycott and suppression of individuals who have no possible recourse to fair trial and judgment, and not even any access to public sympathy.

 Then there have been the recent crusades against whole areas of art expression, not on aesthetic grounds, but on those of 'Communist infiltration.' Before going into some

of these, let me just note here that the art process, like that of science, literature or philosophy, lies within the realm of ideas. The painter is engaged in a search for certain forms of truth, and it hardly needs be pointed out here that in such an exploration, freedom of mind is axiomatic. The artist will carry on his work in any area where he feels real values may lie, or may be created. This activity is not subversive; it is the procedure of art. When Congressman Dondero made his ugly, and thoroughly unfounded attack against a number of artists, art critics and museum directors some time ago, an interesting and illuminating fact came to light. The Congressman had been supplied with his ammunition by a group of conservative illustrators whose work was, to a large extent, being replaced by more experimental forms of art – by points of view which were held by just those artists and museum directors who were accused of subversiveness.

Mr Dondero referred to the artists in such terms as 'germ-carrying art vermin,' as 'human art termites,' as 'international art thugs,' and professed to see in their work – even in abstract painting – a complicated plot to undermine Democracy, and substitute Communism. He spread the names of individual artists and museum people across the pages of the *Congressional Record*, coupled with misinformed statements, against which, as usual, there was no redress.

And it might just be noted here that Mr Dondero's remarks almost duplicated, epithet for epithet, an abusive essay against 'decadent Western art' that had appeared some months earlier in an official Soviet publication, *Voks Bulletin*.

In Los Angeles another great hubbub was raised against a city-wide art exhibition on the grounds of Communism. The Los Angeles City Council investigated. The President of the Council reported: 'This art is a replica of what appears in Communist newspapers. There's no doubt but that this is another instance of Communist infiltration.' Another comment from the same investigation runs: 'The art exhibit carries a definite Communist motif. Some people say they could do better painting blindfolded, with brushes tied to their elbows!' And a third: [this exhibition is] 'a collection of lines and daubs, with nothing that is uplifting, or spiritual.'

Another assault upon art occurred when the State Department, some time ago, was urged by members of the diplomatic corps abroad to get together a really good representative group of American pictures. They were to be exhibited in several foreign capitals, the object being to improve our cultural standing among our European friends.

The pictures were assembled with the expert advice of a number of museum officials. They were duly shipped, but were stopped in mid-Atlantic and returned home. The *New York Journal-American* had excoriated the collection – I daresay devoting to it more lineage than it had ever before granted to a single group of pictures. The protests of several congressmen put an end to the project.

By far the most sinister attack against art – against the arts – comes by way of a subrosa magazine called *Counter-Attack*. This sheet gathers material, much of it inaccurate and libelous, against individuals. It is circulated among advertisers, as well as the magazines and radio stations through which they advertise. It demands the boycotting of the individuals whom it has named, always with an implied threat of boycott of the magazine or radio station itself by advertisers if the artist, writer or performer is not dropped. *Counter-Attack* has its claque of letter-writers to finish off the threat and so far as I can learn, no one has had the courage to challenge it. One additional fillip is added to the infamy of this sheet by its being 'confidential.'

The artist who is singled out for treatment does not even know that he has been attacked unless some kind friend whispers it to him. He is just dropped, and that without any sort of open accusation, or any opportunity to answer the charges made. And, like the Los Angeles City Council, or like Congressman Dondero, *Counter-Attack* often adds its few judicious words of critical appraisal to the report of Communist connections.

The really shocking fact that we must face is this: that, throughout the country, people of the basest ignorance are sitting in judgment upon art, upon the universities, upon the very meaning of thinking itself. What tragic buffoonery lies in the investigation by an FBI man – any FBI man, even the best of them – into the meaning of art, into the motives of any humanist or liberal in politics, into whether education is or is not subversive, or whether a poem, or a piece of music, or a novel is a Communist threat!

Aside from the incalculable damage that such investigation and suppression do to our own culture, we might consider some of their international implications. It is conceded, even by generals, that however great may be our military prowess, our ultimate victory or defeat in the struggle with Communism will be a victory or defeat of ideas.

Our idea is Democracy. And I believe that it is the most appealing idea that the world has yet known. But if we, by official acts of suppression, play the hypocrite toward our own beliefs, strangle our own liberties, then we can hardly hope to win the world's unqualified confidence.

The need to reassure our friends is not a fancied one. *Fortune* magazine, some time ago, undertook a survey of European attitudes toward America and American culture, and turned up some interesting opinions. I will repeat a few:

From François Mauriac, French Catholic leader, this opinion: 'It is not what separates the United States and the Soviet Union that should frighten us, but what they have in common ... those two technocracies that think themselves antagonists, are dragging humanity in the same direction of dehumanization ... Man is treated as a means, and no longer as an end ... This is the indispensable condition of the two cultures that face each other.'

And from Jean-Paul Sartre: 'Thus, if France allows herself to be influenced by the whole of American culture, a living and livable situation there will come here and completely shatter our cultural tradition.'

Or, from Martin Cooper in England (and over a BBC broadcast): 'American influence has been harmful, for it has already begun the scaling down of aesthetic values, so as to be within the grasp of the average city dweller ... [it] will end, not with the debasement of taste, but with the disappearance of the word from our vocabulary.'

These are but a few samplings from a body of opinions, some of them much more violent. We may justly take exception to them, because they reveal, above all things, misunderstanding of us, and ignorance of our arts and literature.

But we cannot ignore the fact that such misunderstanding holds very real dangers for us. If writers, actors, artists, educators – the national custodians of our culture – continue to be semi-officially purged; if research foundations, universities, fellowships are to be combed through for dissident opinion, that process cannot remain a national secret. Indeed, it will probably be exaggerated in the telling! And it will increase European mistrust a thousandfold.

I wonder whether even the most intransigent national egotist in Congress really believes that we can live in a world alone, or that we can ignore the opinions of

mankind, or that we can buy our way, or threaten our way into the affections and confidence of the free nations.

The time is here – perhaps it's past due – for a reassertion of Democracy, a reawakening of freedom. The Emergency Civil Liberties Committee has been formed to stand by, to invoke, when necessary, those laws that were written to protect freedom. The rest of us are here resolved to confront intimidation, and the half-legalized infringement of our liberties with some stubborn resistance. To take such a stand is not just a matter of self-interest. It transcends that; it's a matter of much needed, and much wanting, patriotism.

19 Henry Moore (1898–1986) 'The Sculptor in Modern Society'

Moore had become a prominent public figure during and after the Second World War, having been a somewhat isolated avant-gardist for most of the 1930s. He publicly embraced a liberal humanism, which related domestically to the post-war Welfare State in Britain, and internationally to the ethos of the United Nations. In a manner characteristic of this position Moore tried to steer a course between complete state control of the arts as in the Stalinist Soviet Union, and laissez-faire capitalism which would leave the artist at the mercy of the market. The present text originally took the form of an address given to an international conference of artists at the Venice Biennale, organized by Unesco (the United Nations Educational, Cultural and Scientific Organization), 22–28 September 1952. It was first published in *Art News*, New York, vol. 5, no. 6, November 1952; reprinted in Philip James (ed.), *Henry Moore on Sculpture*, London, 1966, from pp. 84–90 of which the present extracts are taken.

[...] Sculpture, even more than painting (which generally speaking, is restricted to interiors) is a public art, and for that reason I am at once involved in those problems which we have met here to discuss – the relation of the artist to society – more particularly, the relation of the artist to the particular form of society which we have at this moment of history.

There have been periods – periods which we would like to regard as ideal prototypes of society – in which that relationship was simple. Society had a unified structure, whether communal or hierarchic, and the artist was a member of that society with a definite place and a definite function. There was a universal faith, and an accepted interplay of authority and function which left the artist with a defined task, and a secure position. Unfortunately our problems are not simplified in that way. We have a society which is fragmented, authority which resides in no certain place, and our function as artists is what we make it by our individual efforts. We live in a transitional age, between one economic structure of society which is in dissolution and another economic order of society which has not yet taken definite shape. As artists we do not know who is our master; we are individuals seeking patronage, sometimes from another individual, sometimes from an organization of individuals – a public corporation, a museum, an educational authority – sometimes from the State itself. This very diversity of patronage requires, on the part of the modern artist, an adaptability or agility that was not required of the artist in a unified society.

But that adaptability is always in a vertical direction, always within a particular craft. One of the features of our industrialized society is specialization – the division of

labour. [. . .] We know now that there are specific kinds of sensibility, belonging to distinct psychological types, and for that reason alone a certain degree of specialization in the arts is desirable.

The specialization, due to psychological factors in the individual artist, may conflict with the particular economic structure of society in which the artist finds himself. Paintings and sculpture, for example, might be regarded as unnecessary trimmings in a society committed by economic necessity to an extreme utilitarian form of architecture. The artist might then have to divert his energies to other forms of production – to industrial design, for example. No doubt the result would be the spiritual impoverishment of the society reduced to such extremes, but I only mention this possibility to show the dependence of art on social and economic factors. The artist should realize how much he is involved in the changing social structure, and how necessary it is to adapt himself to that changing structure.

From this some might argue that the artist should have a conscious and positive political attitude. Obviously some forms of society are more favourable to art than others, and it would be argued the artist should on that account take up a position on the political front. I would be more certain of his duty in this respect if we could be scientifically certain in our political analysis, but it must be obvious to the most superficial observer, that the relation between art and society has always been a very subtle one, and never of the kind that could be consciously planned. One can generalize about the significant relationship between art and society at particular points in history, but beyond describing such relationships in vague terms such as 'organic' and 'integrated', one cannot get near to the secret. We know that the Industrial Revolution has had a detrimental effect on the arts, but we cannot tell what further revolution or counter-revolution would be required to restore the health of the arts. We may have our beliefs, and we may even be actively political on the strength of those beliefs; but meanwhile we have to work, and to work within the contemporary social structure.

That social structure varies from country to country, but I think that broadly speaking we who are participating in this conference are faced with mixed or transitional economies. In my own country, at any rate, the artist has to satisfy two or three very different types of patron. In the first place there is the private patron, the connoisseur or amateur of the arts, who buys a painting or a piece of sculpture to indulge his own taste, to give himself a private and exclusive pleasure. In addition there are now various types of public patron, the museums, or art galleries that buy in the name of the people: the people of a particular town, or the people of the country as a whole. Quite different from such patrons are those architects, town-planners, organizations of various sorts who buy either from a sense of public duty, or to satisfy some sense of corporate pride.

This diversity of patronage must be matched by a certain flexibility in the artist. [. . .] It is usually assumed that if sufficient commissions were forthcoming from public authorities, all would be well with the arts. It is an assumption that takes no account of the fact that the tradition of modern art is an individualistic one, a craft tradition passing from artist to artist. We have only to look eastwards, beyond the Iron Curtain, to see that State patronage on an authoritarian basis requires quite a different tradition – a tradition in which the State that pays the artist calls the tune, in other words, determines the style. I am not making any judgment of the relative merits of the two traditions, but I think it should be made quite clear that the transition from private

patronage to public patronage would mean a radical reorganization of the ideals and practice of art. We have to choose between a tradition which allows the artist to develop his own world of formal inventions, to express his own vision and sense of reality; and one which requires the artist to conform to an orthodoxy, to express a doctrinaire interpretation of reality. It may be that in return for his loss of freedom the artist will be offered economic security; it may be that with such security he will no longer feel the need to express a personal philosophy, and that a common philosophy will still allow a sufficient degree of flexibility in interpretation to satisfy the artist's aesthetic sensibility. I think most artists, however, would prefer to feel their way towards a solution of this problem, and not have a solution imposed on them by dictation. The evolution of art cannot be forced, nor can it be retarded by an obstinate adherence to outworn conventions.

We already have considerable experience in the State patronage of art, even in countries which are still predominantly individualistic in their economy. [...] But can we rely on such courage and initiative in public bodies in a democratic society? Isn't there a primary duty in such a society to make sure that the people have the interest and eagerness that demand the best art just as surely as they demand the best education or the best housing? It is a problem beyond the scope of this address, but not beyond the scope of Unesco – the renewal of the sources of artistic inspiration among the people at large.

* * *

...Nothing is such a symptom of our disunity, of our cultural fragmentation, as this divorce of the arts. The specialization characteristic of the modern artist seems to have as its counterpart the atomization of the arts. If a unity could be achieved, say in the building of a new town, and planners, architects, sculptors, painters and all other types of artist could work together from the beginning, that unity, one feels, would nevertheless be artificial and lifeless because it would have been consciously imposed on a group of individuals, and not spontaneously generated by a way of life. That is perhaps the illusion underlying all our plans for the diffusion of culture. One can feed culture to the masses, but that does not mean that they will absorb it. In the acquisition of culture there must always be an element of discovery, of self-help; otherwise culture remains a foreign element, something outside the desires and necessities of everyday life. For these reasons I do not think we should despise the private collector and the dealer who serves him; their attitude to the work of art, though it may include in the one case an element of possessiveness or even selfishness and in the other case an element of profit-making, of parasitism, nevertheless such people circulate works of art in natural channels, and in the early stages of an artist's career they are the only people who are willing to take a risk, to back a young artist with their personal judgment and faith. The State patronage of art is rarely given to young and unknown artists, and I cannot conceive any scheme, outside the complete communization of the art profession such as exists in Russia, which will support the artist in his early career. The present system in Western Europe is a very arbitrary system, and entails much suffering and injustice. The artist has often to support himself for years by extra artistic work, usually by teaching, but this, it seems to me is preferable to a complete subordination of the artist to some central authority, which might dictate his style and otherwise interfere with his creative freedom. It is not merely a question of freedom. With the vast extension of means of communication, the growth of internationalism, the intense flare of publicity

which falls on the artist once he has reached any degree of renown, he is in danger of losing a still more precious possession – his privacy. The creative process is in some sense a secret process. The conception and experimental elaboration of a work of art is a very personal activity, and to suppose that it can be organized and collectivized like any form of industrial or agricultural production, is to misunderstand the very nature of art. The artist must work in contact with society, but that contact must be an intimate one. [...]

I believe that much can be done, by Unesco and by organizations like the Arts Council in my own country, to provide the external conditions which favour the emergence of art. I have said – and it is the fundamental truth to which we must always return – that culture (as the word implies) is an organic process. There is no such thing as a synthetic culture, or if there is, it is a false and impermanent culture. Nevertheless, on the basis of our knowledge of the history of art, on the basis of our understanding of the psychology of the artist, we know that there are certain social conditions that favour the growth and flourishing of art, others that destroy or inhibit that growth. An organization like Unesco, by investigating these laws of cultural development, might do much to encourage the organic vitality of the arts, but I would end by repeating that by far the best service it can render to the arts is to guarantee the freedom and independence of the artist.

20 David A. Siqueiros (1896–1974) 'Open Letter to the Painters, Sculptors and Engravers of the Soviet Union'

Siqueiros had remained a committed Communist since the 1920s. This had brought him into conflict with his fellow Mexican muralist Diego Rivera, especially during the period of the latter's Trotskyism (see IVD9). Despite his political orthodoxy Siqueiros maintained a critical purchase on what he saw as the decline of Socialist Realism as practised in the Soviet Union. For him it had become a formulaic art rooted in nineteenth-century academicism. His paper was read out as an address to the Soviet Academy of Art on 17 October 1955 during a visit to Russia. The present extract is taken from the translation by Sylvia Calles published in Siqueiros, *Art and Revolution*, London, 1975, pp. 176–82. (For earlier texts by Siqueiros see IVB4 and 16.)

* * *

I know that your art fulfils a political function of a magnitude unmatched in the history of the world. All your work is at the service of a social movement which has opened a new era for humanity, and you have the unlimited support of the first proletarian State. It is quite evident that with your painting, sculpture, engraving, posters, illustrations, stage design, etc., you have made the backward Russia of the Tsars into a country which leads in agriculture, industry, science, education, sport, in everything which makes men happy. There is no city great or small, no village, no factory, no railway station, recreational centre, school, theatre, where you have not expressed socialist ideology, and eulogised your great men and your heroes in work of all sizes. Both in the public squares and on the walls and interiors of hundreds of thousands of blocks of flats you have contributed to their ornamentation. You are repeating in a free society what others did in the condition of slavery; public art. Your art is an art of the state,

ideologically committed, eloquently purposeful, and for this reason realistic. It is a heroic art, an epic art. And this helps you to find technical solutions, for example the varnished tiles you are manufacturing. Of course, there is still a lot more to be done and this is what I would like to say something about.

I have been a member of the Mexican Communist Party since 1924, and we communists never limit ourselves to the analysis of positive facts; we examine every aspect of a problem, and criticise each other and ourselves. And this is what I propose to do with you.

In Mexico, where our painting is partly financed by the state, it is ideologically committed, realistic and interested in new techniques. We have been contaminated by *formalism* which is the natural product of bourgeois economy and submission to imperialism. Your own art has not been affected by this leprosy which has degraded the art of the capitalist world; but your art suffers from another form of *cosmopolitanism: formalistic academism* and *mechanical realism*. Between *French formalism* and *academism*, we can find an element of similarity: they both denationalise art and make it impersonal. The formalists in the manner of the School of Paris and the academicians in the manner of the Academy of Rome are as alike as two drops of water, whatever their nationality. [...]

I am sure you will agree with me that *realism* cannot be a fixed formula, an immutable law; the whole of the history of art, which shows the development of increasingly realistic forms, proves this. If we run quickly over the history of painting, from cave paintings, through Antiquity, the Middle Ages and the Renaissance, we shall find that this is absolutely true. We might agree with those who say that no work of art is superior to another work of art, and that therefore no period of art is superior to any other period of art, but this is not to deny the uninterrupted process of ever enriched forms in the direction of a realistic idiom ever richer, more civilised and more eloquent. Every period of art which has not been stifled by immovable formulas has striven to make its art more real. *Realism can never be anything but a means of creation in constant progress.* [...]

That you have forgotten this fact in the Soviet Union is evident in the perpetuation of *old realistic styles which belong to the immediate past*, rather like the *realism of American commercial advertising at the beginning of the century*; and I find this influence present also in the work of the Polish painters and in those of the other popular democracies. If we observe the process of your work over the last thirty-eight years, we shall find that your formal language has not progressed at all, you have merely improved your technique. But you must not forget that it is precisely the constant perfection of style in a limited, repetitive realistic area of creation which has always led to decadence. The painters who came immediately after the Renaissance were much more skilful than their predecessors, but their work is infinitely inferior. Raphael was formidable, but the Raphaelists who came after him were detestable – and this is just one example.

It is certainly not true that *every exaltation of form is formalism*, because in that case we should not be able to understand any of the great Venetian painters, nor Michelangelo, El Greco, Goya, Daumier, etc., or, in the case of Mexico, Orozco. The *formalists* worship form for its own sake, in a purely plastic exercise, and the true realists have always used form to *achieve greater plastic eloquence*, to give greater eloquence to their subject; when all is said and done, the realist speaks in a plastic idiom. Were it not so,

however true and beautiful the political content of our work, it would nevertheless be a poor artistic expression of which everyone would soon tire.

A study of the history of art will show us that art has always tended towards realism, while constantly perfecting its materials and tools. If we look at the four centuries of great Italian art, it is easy to see that the artists of each period were never satisfied with the materials and tools of their predecessors; on the contrary, they were always searching passionately for new processes. Their progress was not only parallel to the development of science, technique and industry, it was often ahead of them. They perfected tempera and oils, were always finding new and better pigments and – why should we not say so? – broadening the range of their professional 'tricks' so as to perfect their work. In Mexico we have had people who did the same thing and others who resolutely opposed them, and this is the reason that much of our painting uses age-old techniques, which renders it less politically eloquent. Painting, like all the plastic arts, is material and physical, and must therefore express itself in terms of its vehicle. In your case, Soviet comrades, it is even more serious, because none of you are interested in finding new material techniques, although you have a State more able than any other which has ever existed to provide you with the effective and moral means to achieve this transformation.

While all the great painters, at every period of history, systematically enriched the principles of composition and perspective, the painters of the School of Paris have not only not contributed anything in this sense but they have also lost all the discoveries of the previous twenty centuries. In our contemporary Mexican movement, although we were systematically opposed by those who clung to traditional formulae, we have tried to find solutions to this problem, as can be seen in much of our work. Soviet painters, on the other hand, have remained dominated by the methods of composition and perspective used by academics all over the world. And this has happened in the only country in the world where science has been placed at the service of the people and could give them enormous help.

No, neither the *forms of realism nor its material means are static*. It would be absurd to think that the masters of the past knew all there was to know about realism (they might have thought the same of their immediate predecessors), and it would be equally ridiculous to think that materials and tools discovered thousands of years ago are the last word.

Apart from the painting produced by the School of Paris (the greatest fiction in the bourgeois world of culture, because this type of art suppressed public art, denied ideological art and excluded the image of man and his environment, in favour of *pseudo-libertarian geometric forms*), there are only two important art expressions in the world today: the Mexican experience, today operating under increasingly adverse conditions, and the Soviet experience, operating under increasingly favourable conditions. There has recently been a collective move in the right direction in the popular democracies and in Italy and France, but this is still very new.

These two tendencies, through criticism and self-criticism, could help each other to eliminate their negative aspects and strengthen their positive ones.

Mexico has a great tradition of painting and an artistically gifted people; but Soviet painters are no less richly endowed in this respect, their tradition is magnificent and their painters very capable. Soviet painters have a professional discipline which we lack

and a faculty for expressing psychological phenomena which, in my opinion, is unequalled in the whole world. They are producing really monumental art, their art is intimately integrated with their architecture, but they must shake off the *routine forms* which are tying them down. [. . .]

21 Georg Lukács (1857–1971) 'The Ideology of Modernism'

This essay is Lukács's most developed critique of Modernism. It forms the first chapter of his book *The Meaning of Contemporary Realism*, perhaps the major intellectual defence of a Socialist Realism in literature and art. Its composition spanned the moment of the Soviet Communist Party's 20th Congress in February 1956, at which Khrushchev denounced Stalin, and the Hungarian Revolution later in the same year. Lukács became a member of Imre Nagy's independent government and was fortunate to escape with his life after the Russian invasion. The critique of Modernism which Lukács makes is thus inseparable from the criticism he was also able to make of Stalinist policy in the arts. In his preface composed in 1962 for the English edition, Lukács wrote of the 'disastrous legacy of Stalinism'. For Lukács the critique of what he called 'dogmatism' had to parallel the critique of Western Modernism and revisionism in order to arrive at a properly Marxist understanding of art. First published in Hungarian in Budapest in 1957, Lukács's book was issued in German in 1958; translated by John and Necke Mander as *The Meaning of Contemporary Realism*, London, 1963, from which the present extracts are taken (pp. 17–46). (For an earlier text by Lukács see IVB10.)

What determines the style of a given work of art? How does the intention determine the form? (We are concerned here, of course, with the intention realized in the work; it need not coincide with the writer's conscious intention.) The distinctions that concern us are not those between stylistic 'techniques' in the formalistic sense. It is the view of the world, the ideology or *Weltanschauung* underlying a writer's work, that counts. And it is the writer's attempt to reproduce this view of the world which constitutes his 'intention' and is the formative principle underlying the style of a given piece of writing. Looked at in this way, style ceases to be a formalistic category. Rather, it is rooted in content; it is the specific form of a specific content.

Content determines form. But there is no content of which man himself is not the focal point. However various the *données* of literature (a particular experience, a didactic purpose), the basic question is, and will remain: what is man?

Here is a point of division: if we put the question in abstract, philosophical terms, leaving aside all formal considerations, we arrive – for the realist school – at the traditional Aristotelean dictum (which was also reached by other than purely esthetic considerations): Man is *zoon politikon*, a social animal. The Aristotelean dictum is applicable to all great realistic literature. Achilles and Werther, Oedipus and Tom Jones, Antigone and Anna Karenina: their individual existence – their *Sein an sich*, in the Hegelian terminology; their 'ontological being,' as a more fashionable terminology has it – cannot be distinguished from their social and historical environment. Their human significance, their specific individuality, cannot be separated from the context in which they were created.

The ontological view governing the image of man in the work of leading modernist writers is the exact opposite of this. Man, for these writers, is by nature solitary, asocial, unable to enter into relationships with other human beings. [...]

The latter, of course, is characteristic of the theory and practice of modernism. I would like, in the present study, to spare the reader tedious excursions into philosophy. But I cannot refrain from drawing the reader's attention to Heidegger's description of human existence as a 'thrownness-into-being' (*Geworfenheit ins Dasein*). A more graphic evocation of the ontological solitariness of the individual would be hard to imagine. Man is 'thrown-into-being.' This implies, not merely that man is constitutionally unable to establish relationships with things or persons outside himself; but also that it is impossible to determine theoretically the origin and goal of human existence.

Man, thus conceived, is an ahistorical being. [...]

This view of human existence has specific literary consequences. Particularly in one category, of primary theoretical and practical importance, to which we must now give our attention: that of *potentiality*. Philosophy distinguishes between *abstract* and *concrete* (in Hegel, 'real') *potentiality*. These two categories, their interrelation and opposition, are rooted in life itself. [...]

* * *

Abstract potentiality belongs wholly to the realm of subjectivity; whereas concrete potentiality is concerned with the dialectic between the individual's subjectivity and objective reality. The literary presentation of the latter thus implies a description of actual persons inhabiting a palpable, identifiable world. Only in the interaction of character and environment can the concrete potentiality of a particular individual be singled out from the 'bad infinity' of purely abstract potentialities, and emerge as the determining potentiality of just this individual at just this phase of his development. This principle alone enables the artist to distinguish concrete potentiality from a myriad of abstractions.

But the ontology on which the image of man in modernist literature is based invalidates this principle. If the 'human condition' – man as a solitary being, incapable of meaningful relationships – is identified with reality itself, the distinction between abstract and concrete potentiality becomes null and void. The categories tend to merge. [...] If the distinction between abstract and concrete potentiality vanishes, if man's inwardness is identified with an abstract subjectivity, human personality must necessarily disintegrate.

T. S. Eliot described this phenomenon, this mode of portraying human personality, as

> Shape without form, shade without colour,
> Paralysed force, gesture without motion.

The disintegration of personality is matched by a disintegration of the outer world. In one sense, this is simply a further consequence of our argument. For the identification of abstract and concrete human potentiality rests on the assumption that the objective world is inherently inexplicable. Certain leading modernist writers, attempting a theoretical apology, have admitted this quite frankly. Often this theoretical impossibility of understanding reality is the point of departure, rather than the exaltation of subjectivity. But in any case the connection between the two is plain. [...]

Attenuation of reality and dissolution of personality are thus interdependent: the stronger the one, the stronger the other. Underlying both is the lack of a consistent view of human nature. Man is reduced to a sequence of unrelated experiential fragments; he is as inexplicable to others as to himself.

* * *

[...] I would maintain – we shall return to this point – that in modern writing there is a continuity from naturalism to the modernism of our day – a continuity restricted, admittedly, to underlying ideological principles. What at first was no more than dim anticipation of approaching catastrophe developed, after 1914, into an all-pervading obsession. And I would suggest that the ever-increasing part played by psychopathology was one of the main features of the continuity. At each period – depending on the prevailing social and historical conditions – psychopathology was given a new emphasis, a different significance and artistic function. ... in naturalism the interest in psychopathology sprang from an esthetic need; it was an attempt to escape from the dreariness of life under capitalism. ... Some years later the opposition acquired a moral slant. The obsession with morbidity had ceased to have a merely decorative function, bringing color into the grayness of reality, and become a moral protest against capitalism.

With Musil – and with many other modernist writers – psychopathology became the goal, the *terminus ad quem*, of their artistic intention. But there is a double difficulty inherent in their intention, which follows from its underlying ideology. There is, first, a lack of definition. The protest expressed by this flight into psychopathology is an abstract gesture; its rejection of reality is wholesale and summary, containing no concrete criticism. It is a gesture, moreover, that is destined to lead nowhere; it is an escape into nothingness. Thus the propagators of this ideology are mistaken in thinking that such a protest could ever be fruitful in literature. In any protest against particular social conditions, these conditions themselves must have the central place. The bourgeois protest against feudal society, the proletarian against bourgeois society, made their point of departure a criticism of the old order. In both cases the protest – reaching out beyond the point of departure – was based on a concrete *terminus ad quem*: the establishment of a new order. However indefinite the structure and content of this new order, the will toward its more exact definition was not lacking.

How different the protest of writers like Musil! The *terminus a quo* (the corrupt society of our time) is inevitably the main source of energy, since the *terminus ad quem* (the escape into psychopathology) is a mere abstraction. The rejection of modern reality is purely subjective. Considered in terms of man's relation with his environment, it lacks both content and direction. And this lack is exaggerated still further by the character of the *terminus ad quem*. For the protest is an empty gesture, expressing nausea or discomfort or longing. Its content – or rather lack of content – derives from the fact that such a view of life cannot impart a sense of direction. These writers are not wholly wrong in believing that psychopathology is their surest refuge; it is the ideological complement of their historical position.

This obsession with the pathological is not only to be found in literature. Freudian psychoanalysis is its most obvious expression. The treatment of the subject is only superficially different from that in modern literature. As everybody knows, Freud's starting point was 'everyday life.' In order to explain 'slips' and daydreams, however, he had to have recourse to psychopathology. In his lectures, speaking of resistance and

repression, he says: 'Our interest in the general psychology of symptom-formation increases as we understand to what extent the study of pathological conditions can shed light on the workings of the normal mind.' Freud believed he had found the key to the understanding of the normal personality in the psychology of the abnormal. This belief is still more evident in the typology of Kretschmer, which also assumes that psychological abnormalities can explain normal psychology. It is only when we compare Freud's psychology with that of Pavlov, who takes the Hippocratic view that mental abnormality is a deviation from a norm, that we see it in its true light.

Clearly, this is not strictly a scientific or literary-critical problem. It is an ideological problem, deriving from the ontological dogma of the solitariness of man. [...]

Let us now pursue the argument further. It is clear, I think, that modernism must deprive literature of a sense of *perspective*. This would not be surprising; rigorous modernists such as Kafka, Benn and Musil have always indignantly refused to provide their readers with any such thing. I will return to the ideological implications of the idea of perspective later. Let me say here that, in any work of art, perspective is of overriding importance. It determines the course and content; it draws together the threads of the narration; it enables the artist to choose between the important and the superficial, the crucial and the episodic. The direction in which characters develop is determined by perspective, only those features being described which are material to their development. The more lucid the perspective – as in Molière or the Greeks – the more economical and striking the selection.

Modernism drops this selective principle. It asserts that it can dispense with it, or can replace it with its dogma of the *condition humaine*. A naturalistic style is bound to be the result. This state of affairs – which to my mind characterizes all modernist art of the past fifty years – is disguised by critics who systematically glorify the modernist movement. By concentrating on formal criteria, by isolating technique from content and exaggerating its importance, these critics refrain from judgment on the social or artistic significance of subject matter. They are unable, in consequence, to make the esthetic distinction between *realism* and *naturalism*. This distinction depends on the presence or absence in a work of art of a 'hierarchy of significance' in the situations and characters presented. Compared with this, formal categories are of secondary importance. That is why it is possible to speak of the basically *naturalistic* character of modernist literature – and to see here the literary expression of an ideological continuity. This is not to deny that variations in style reflect changes in society. But the particular form this principle of naturalistic arbitrariness, this lack of hierarchic structure, may take is not decisive. We encounter it in the all-determining 'social conditions' of naturalism, in symbolism's impressionist methods and its cultivation of the exotic, in the fragmentation of objective reality in futurism and constructivism and the German *Neue Sachlichkeit*, or, again, in surrealism's stream of consciousness.

These schools have in common a basically static approach to reality. This is closely related to their lack of perspective. [...]

Part VI
The Moment of Modernism

VI
Introduction

The Cold War years from 1950 to 1956 mark a form of watershed in the development of modern art and its theory. An exhibition of Jackson Pollock's all-over abstract paintings in the former year marked a high point in the development of a specifically American form of modern art. By the same time, the other 'first generation' American painters had all established the canonical forms of their work. The first substantial representation of this work was included in a survey of Modern Art in the United States which toured throughout Europe in 1955–6, to be followed three years later by another exhibition concentrating on the painting of what was by then established as a distinct New York School. By 1956 the fact of American dominance in the international culture of modern art was established as firmly as French dominance had been half a century before.

The view of the early 1950s as a watershed in the development of art is complicated rather than contradicted by reference to other events at the end of the period proposed. 1956 was the year of the Suez crisis, of the Russian invasion of Hungary, and of Nikita Khrushchev's speech to the 20th Communist Party Congress, which initiated the long process of revision and review of Stalinism. It was also the year of Elvis Presley's 'Heartbreak Hotel', and of the London exhibition, 'This Is Tomorrow', the first redolent of the power and vitality of an emergent popular culture, or rather of a popular culture packaged and distributed for mass consumption; the second the occasion of the public emergence of Pop Art in Britain.

These coincident moments suggest forms of connection between considerable historical processes: the impoverishment of the old British empire on the one hand; the beginning of the long demise of the newer Russian one on the other; Paris finally displaced as the metropolitan centre of Modernism; New York in the ascendant; the old Left in crisis; a New Left struggling to distinguish itself and to define its theoretical ground, with one eye on the long task of de-Stalinizing Marxism, the other on the fascinating iconography of the consumer society (VIA1, 3 and 12). Meanwhile, outside the conventional geographical boundaries of Modernist culture, national liberation movements were emerging which would both hasten the demise of empires and foster the growth of discourses critical of Modernism's assumed centrality (see VIA5).

In fact, even as the work of the Abstract Expressionists was being conscripted to advertise the power and originality of American liberalism, the avant-garde representatives of a younger American generation were distancing themselves from all forms of the rhetoric of power, identifying the point of origin of art not with the individual struggle for expression in the face of circumstance, but, more paradoxically and more

fatalistically, with individuality as an inescapable circumstance in which expression is inescapably conventional (VIA13 and 14). As Jasper Johns and John Cage variously discovered, to conceive of avant-garde expression is merely to confront this paradox in its most acute form: 'anything goes' only in so far as there is a language in which to say it. The continuing presence of Marcel Duchamp in New York served to recall that there were precedents in Dadaism for the association of avant-gardism with irony. It could be said that Duchamp's death in 1968 marked less the closure of an individual oeuvre than the establishment of a reputation as central to Postmodernism as Picasso's had been to Modernism (see VIA23).

The characteristic concerns of the period issue in the later 1950s and early 1960s in works which combine insouciant celebration with sceptical analysis, in varying proportions. The need to achieve representation of a new sense of modernity is a clear preoccupation of the art and art theory of these years. The work of the Pop Artists reminds us that one central if neglected preoccupation of the modern tradition was to diagnose the character of modernity through the ephemeral appearances of modern urban life. Were the Baudelairean *flâneur* displaced from the Paris of the 1860s to be reincarnated in modernized form in the New York of the 1960s, he might have recognized his ironic but fascinated regard in the paintings of a Roy Lichtenstein or an Andy Warhol (VIA17 and 18). Their work shares with the theoretical work of Roland Barthes (VIA1) and even of Guy Debord (VIA3) the tendency to treat the modern as a form of surface, which is revealing of meaning and value by virtue of its very artificiality.

For other artists, representation of the experience of modernity entailed an assault on those notions of high art which were predicated on the supposed centrality of painting and sculpture. In Europe and Japan, as well as in America, the legacy of Dadaism was exploited as a resource of avant-garde strategies; a development confirmed by the emergence of the international Fluxus group (VIA11). For some, an exploration of different media and of less strictly specialized forms of practice offered a means of closing the gap between (modern) art and (modern) life (VIA4, 7, 9, 10 and 13). For others, removal of the privileged status accorded to painting and sculpture in the Modernist vein was to be the means to open the practices of art to a more relevant, more modern, social anthropology (VIA6). According to the theories of Marshall McLuhan, for instance, Modern Man had been subject to so rapid an evolution in his cognitive capacities that the redundancy of painting and sculpture could be assumed (VIA20).

The concept of culture as surface raises the issue of discrimination, and of the grounds on which differences are perceived, while the application of social-anthropological methods directs attention to the ways in which forms of discrimination function. For the artists of the Abstract Expressionist generation, as for their European contemporaries, the unquestioned significance of certain themes enabled the notional engagement of painting and sculpture with a repertoire of myths. This engagement was the guarantee of art's depth of content. But if myth is viewed rather as ideology, if the themes of mass communication and advertising can be considered as myths in the making, what price the claim to fundamental trans-historical significance? It had been an assumed condition of Modernist aesthetics that meaningful distinctions could be made between a 'serious' high art and a 'lightweight' mass culture, or between avant-garde and kitsch (see IVD11). This assumption was generally shared even by

those intellectuals on the Left who questioned whether or not the maintenance of the relevant differences in practice was the mark of a defensible society. These latter, that is to say, saw no real prospect of overcoming the relevant divisions short of a revolutionary transformation of society. If it now transpired that the ground of the critical distinctions had been seriously eroded, what were the implications? That what was required for the Good to become Popular – or vice versa – was not proletarian revolution after all, but the kind of swelling of the middle class which had occurred in the industrialized nations of the West? Or that the distinctions had never been better than ideological – that they were themselves mere functions of a modern mythology? Or were these not the alternatives they seemed, and had the actual historical process been the necessary condition for the disparagement of Modernist taste and of its claims? Were these various forms of scepticism about the concept of high art in fact the terms in which a different historical constituency now established itself as the arbiter of value in culture?

To entertain such questions was not simply to be faced with the class-character of Modernist culture; it was also to confront uncomfortable questions about the class-allegiances of the artistic and intellectual Left. After all the talk about the authenticity of working-class culture, how complacent could the Left afford to be about that which the swelling of the middle class had seemingly effected? A familiar theme is revived under the new conditions of the early 1960s: a preoccupation with art as a model of reconciliation, as that resource which allows us to think through both the problems of class division and the closures of patrician taste, to a concept of culture as a whole, or rather to the vision of a whole culture with which all can in theory identify (VIA12).

We have drawn attention to those aspects of the art and theory of the 1950s and early 1960s in which the nature of the experience of modernity becomes once again a pressing question. What serves to unite these practices and positions is their common engagement either with explicitly human themes and materials or with the identifiable forms of an explicitly contemporary culture, or both. As in earlier periods this form of engagement is contrasted with another, in which the experience of modernity is treated more as a limiting condition than as an essential qualification. This is the position which by the 1950s comes to be explicitly identified as Modernist, receiving its most forthright exposition in 1960 in Clement Greenberg's 'Modernist Painting' (VIB5). For the critic in the Modernist tradition the measure of art lies not in the vividness with which it represents the experience of modern life, but rather in its achievement, under the contingent conditions of the modern, of a level of quality for which previous art furnishes the only meaningful standard. It is through engagement with the demands of a specific medium, and through acceptance of the standards of achievement specific to that medium, that the artist engages to most enduring critical effect with historical and social conditions. If the artist's foremost responsibility is to the demands of a chosen medium, it does not follow that the problems of social existence are properly ignored. They may appear to be relegated, however. For the sheer indifference of the medium tends to disqualify those forms of interest and sentimentality with which such problems are frequently addressed. From this position, the true critical potential of art lies not in the prospect of its relevance, but rather in the possibility of its autonomy.

There is no reason in principle why those committed to this view of art should approve forms of abstract art over forms of art treating of explicitly human and cultural themes. During the 1960s, however, Modernist criticism was generally written in

defence of abstract painting and sculpture, and more specifically in defence of the form of painting described by Clement Greenberg as 'Post-Painterly Abstraction' (see VIB8) and the form of constructed sculpture practised by Anthony Caro and his followers (VIB13). It was the enterprise of Greenberg and subsequently of Michael Fried to argue that the quality they found in such work was the consequence of its submission to the inescapable demands of the medium – inescapable, that is to say, if the standards of the art of the past were to be maintained (VIB9 and 10). The argument presented was one which connected the preferred art of the present to the authentic art of the past by means of a retrospectively perceived logic of development. By this means a supposedly disinterested judgement could be justified in terms of a supposedly inexorable historical tendency.

It was a weakness in such theories that they tended to organize evidence in line with the very preferences the evidence was meant to test. The authority of Modernist taste, it seemed, was secured by reference to an authoritative Modernist canon. In the eyes of their opponents, the claim to disinterestedness of judgement appeared as a form of camouflage for the partiality of an elite. Such objections notwithstanding, the Modernist criticism of the 1960s was distinguished by its close attention to the practical character of the art in question, and by its evident engagement with the effects specific to the given medium (VIB10 and 14). For a brief period during the mid to late 1960s there appeared to be considerable convergence between the historical viewpoint of a developed form of Modernist criticism and the practical interests of a body of abstract painting and sculpture produced in America and England (VIB2, 4, 7, 11 and 13). This convergence involved a series of commitments held in common: to the priority of aesthetic quality over explicit social or political relevance in deciding the function of art; and to a concomitant belief in the autonomy of the aesthetic; to a further belief in the continuing centrality of painting and sculpture to the concept of high art; and finally to the position that the production of a distinctly 'high' art was still an absolutely defensible aim. For all their apparent indifference to arguments for the popularization of culture, certain claims for the autonomy of art had their attendant political defences. Theodor Adorno, for example, was concerned to argue that the principle of autonomy associated with forms of high art furnished a base of resistance to political and moral prescription (VIB6).

VIA
Art and Modern Life

1 Roland Barthes (1915–1980) from 'Myth Today'

The essays which composed Barthes's *Mythologies* were written between 1954 and 1956. Their publication had the effect of opening up whole areas of contemporary cultural *practice* to the methods of analysis hitherto confined to Structuralist theories of the production of meaning in *language*: films, cars, sports, food, as well as pulp fiction and photographs. The concluding theoretical essay, 'Myth Today', laid out the principles of this investigation based on the concept of 'secondary signification': a culturally and historically contingent but nonetheless enormously powerful system of underlying meanings encoded into images, artefacts and practices. This comparatively early text reveals the roots of Barthes's investigation in an attempt to develop the Marxist concept of ideology, to see how ideology actually *works*. It is also of note that this enterprise simultaneously established a distance from Zhdanovian (that is to say, orthodox Communist) attempts to relate culture to other areas of social life by reducing it to the status of a 'reflection'. Originally published Paris, 1957; English translation by Annette Lavers in *Mythologies*, London, 1972, pp. 117–74. The present extract constitutes the first two sections of the essay.

What is a myth, today? I shall give at the outset a first, very simple answer, which is perfectly consistent with etymology: *myth is a type of speech*.[1]

Myth is a type of speech

Of course, it is not *any* type: language needs special conditions in order to become myth: we shall see them in a minute. But what must be firmly established at the start is that myth is a system of communication, that it is a message. This allows one to perceive that myth cannot possibly be an object, a concept, or an idea; it is a mode of signification, a form. Later, we shall have to assign to this form historical limits, conditions of use, and reintroduce society into it: we must nevertheless first describe it as a form.

It can be seen that to purport to discriminate among mythical objects according to their substance would be entirely illusory: since myth is a type of speech, everything can be a myth provided it is conveyed by a discourse. Myth is not defined by the object of its message, but by the way in which it utters this message: there are formal limits to myth, there are no 'substantial' ones. Everything, then, can be a myth? Yes, I believe this, for the universe is infinitely fertile in suggestions. Every object in the world can pass from a closed, silent existence to an oral state, open to appropriation by society, for

there is no law, whether natural or not, which forbids talking about things. A tree is a tree. Yes, of course. But a tree as expressed by Minou Drouet is no longer quite a tree, it is a tree which is decorated, adapted to a certain type of consumption, laden with literary self-indulgence, revolt, images, in short with a type of social *usage* which is added to pure matter.

Naturally, everything is not expressed at the same time: some objects become the prey of mythical speech for a while, then they disappear, others take their place and attain the status of myth. Are there objects which are *inevitably* a source of suggestiveness, as Baudelaire suggested about Woman? Certainly not: one can conceive of very ancient myths, but there are no eternal ones; for it is human history which converts reality into speech, and it alone rules the life and the death of mythical language. Ancient or not, mythology can only have an historical foundation, for myth is a type of speech chosen by history: it cannot possibly evolve from the 'nature' of things.

Speech of this kind is a message. It is therefore by no means confined to oral speech. It can consist of modes of writing or of representations; not only written discourse, but also photography, cinema, reporting, sport, shows, publicity, all these can serve as a support to mythical speech. Myth can be defined neither by its object nor by its material, for any material can arbitrarily be endowed with meaning: the arrow which is brought in order to signify a challenge is also a kind of speech. True, as far as perception is concerned, writing and pictures, for instance, do not call upon the same type of consciousness; and even with pictures, one can use many kinds of reading: a diagram lends itself to signification more than a drawing, a copy more than an original, and a caricature more than a portrait. But this is the point: we are no longer dealing here with a theoretical mode of representation: we are dealing with *this* particular image, which is given for *this* particular signification. Mythical speech is made of a material which has *already* been worked on so as to make it suitable for communication: it is because all the materials of myth (whether pictorial or written) presuppose a signifying consciousness, that one can reason about them while discounting their substance. This substance is not unimportant: pictures, to be sure, are more imperative than writing, they impose meaning at one stroke, without analysing or diluting it. But this is no longer a constitutive difference. Pictures become a kind of writing as soon as they are meaningful: like writing, they call for a *lexis*.

We shall therefore take *language, discourse, speech*, etc., to mean any significant unit or synthesis, whether verbal or visual: a photograph will be a kind of speech for us in the same way as a newspaper article; even objects will become speech, if they mean something. This generic way of conceiving language is in fact justified by the very history of writing: long before the invention of our alphabet, objects like the Inca *quipu*, or drawings, as in pictographs, have been accepted as speech. This does not mean that one must treat mythical speech like language; myth in fact belongs to the province of a general science, coextensive with linguistics, which is *semiology*.

Myth as a semiological system

For mythology, since it is the study of a type of speech, is but one fragment of this vast science of signs which Saussure postulated some forty years ago under the name of *semiology*. Semiology has not yet come into being. But since Saussure himself, and sometimes independently of him, a whole section of contemporary research has

constantly been referred to the problem of meaning: psycho-analysis, structuralism, eidetic psychology, some new types of literary criticism of which Bachelard has given the first examples, are no longer concerned with facts except inasmuch as they are endowed with significance. Now to postulate a signification is to have recourse to semiology. I do not mean that semiology could account for all these aspects of research equally well: they have different contents. But they have a common status: they are all sciences dealing with values. They are not content with meeting the facts: they define and explore them as tokens for something else.

Semiology is a science of forms, since it studies significations apart from their content. I should like to say one word about the necessity and the limits of such a formal science. The necessity is that which applies in the case of any exact language. Zhdanov made fun of Alexandrov the philosopher, who spoke of '*the spherical structure of our planet*'. '*It was thought until now,*' Zhdanov said, '*that form alone could be spherical.*' Zhdanov was right: one cannot speak about structures in terms of forms, and vice versa. It may well be that on the plane of 'life', there is but a totality where structures and forms cannot be separated. But science has no use for the ineffable: it must speak about 'life' if it wants to transform it. Against a certain quixotism of synthesis, quite Platonic incidentally, all criticism must consent to the *ascesis*, to the artifice of analysis; and in analysis, it must match method and language. Less terrorized by the spectre of 'formalism', historical criticism might have been less sterile; it would have understood that the specific study of forms does not in any way contradict the necessary principle of totality and History. On the contrary: the more a system is specifically defined in its forms, the more amenable it is to historical criticism. To parody a well-known saying, I shall say that a little formalism turns one away from History, but that a lot brings one back to it. Is there a better example of total criticism than the description of saintliness, at once formal and historical, semiological and ideological, in Sartre's *Saint-Genet*? The danger, on the contrary, is to consider forms as ambiguous objects, half-form and half-substance, to endow form with a substance of form, as was done, for instance, by Zhdanovian realism. Semiology, once its limits are settled, is not a metaphysical trap: it is a science among others, necessary but not sufficient. The important thing is to see that the unity of an explanation cannot be based on the amputation of one or other of its approaches, but, as Engels said, on the dialectical co-ordination of the particular sciences it makes use of. This is the case with mythology: it is a part both of semiology inasmuch as it is a formal science, and of ideology inasmuch as it is an historical science: it studies ideas-in-forms.[2]

Let me therefore restate that any semiology postulates a relation between two terms, a signifier and a signified. This relation concerns objects which belong to different categories, and this is why it is not one of equality but one of equivalence. We must here be on our guard for despite common parlance which simply says that the signifier *expresses* the signified, we are dealing, in any semiological system, not with two, but with three different terms. For what we grasp is not at all one term after the other, but the correlation which unites them: there are, therefore, the signifier, the signified and the sign, which is the associative total of the first two terms. Take a bunch of roses: I use it to *signify* my passion. Do we have here, then, only a signifier and a signified, the roses and my passion? Not even that: to put it accurately, there are here only 'passionified' roses. But on the plane of analysis, we do have three terms; for these roses weighted

with passion perfectly and correctly allow themselves to be decomposed into roses and passion: the former and the latter existed before uniting and forming this third object, which is the sign. It is as true to say that on the plane of experience I cannot dissociate the roses from the message they carry, as to say that on the plane of analysis I cannot confuse the roses as signifier and the roses as sign: the signifier is empty, the sign is full, it is a meaning. Or take a black pebble: I can make it signify in several ways, it is a mere signifier; but if I weigh it with a definite signified (a death sentence, for instance, in an anonymous vote), it will become a sign. Naturally, there are between the signifier, the signified and the sign, functional implications (such as that of the part to the whole) which are so close that to analyse them may seem futile; but we shall see in a moment that this distinction has a capital importance for the study of myth as semiological schema.

Naturally these three terms are purely formal, and different contents can be given to them. Here are a few examples: for Saussure, who worked on a particular but methodologically exemplary semiological system – the language or *langue* – the signified is the concept, the signifier is the acoustic image (which is mental) and the relation between concept and image is the sign (the word, for instance), which is a concrete entity.[3] For Freud, as is well known, the human psyche is a stratification of tokens or representatives. One term (I refrain from giving it any precedence) is constituted by the manifest meaning of behaviour, another, by its latent or real meaning (it is, for instance, the substratum of the dream); as for the third term, it is here also a correlation of the first two: it is the dream itself in its totality, the parapraxis (a mistake in speech or behaviour) or the neurosis, conceived as compromises, as economies effected thanks to the joining of a form (the first term) and an intentional function (the second term). We can see here how necessary it is to distinguish the sign from the signifier: a dream, to Freud, is no more its manifest datum than its latent content: it is the functional union of these two terms. In Sartrean criticism, finally (I shall keep to these three well-known examples), the signified is constituted by the original crisis in the subject (the separation from his mother for Baudelaire, the naming of the theft for Genet); Literature as discourse forms the signifier; and the relation between crisis and discourse defines the work, which is a signification. Of course, this tri-dimensional pattern, however constant in its form, is actualized in different ways: one cannot therefore say too often that semiology can have its unity only at the level of forms, not contents; its field is limited, it knows only one operation: reading, or deciphering.

In myth, we find again the tri-dimensional pattern which I have just described: the signifier, the signified and the sign. But myth is a peculiar system, in that it is constructed from a semiological chain which existed before it: it *is a second-order semiological system*. That which is a sign (namely the associative total of a concept and an image) in the first system, becomes a mere signifier in the second. We must here recall that the materials of mythical speech (the language itself, photography, painting, posters, rituals, objects, etc.), however different at the start, are reduced to a pure signifying function as soon as they are caught by myth. Myth sees in them only the same raw material; their unity is that they all come down to the status of a mere language. Whether it deals with alphabetical or pictorial writing, myth wants to see in them only a sum of signs, a global sign, the final term of a first semiological chain. And it is precisely this final term which will become the first term of the greater system which it builds and of which it is only a part. Everything happens as if myth shifted the

formal system of the first significations sideways. As this lateral shift is essential for the analysis of myth, I shall represent it in the following way, it being understood, of course, that the spatialization of the pattern is here only a metaphor:

It can be seen that in myth there are two semiological systems, one of which is staggered in relation to the other: a linguistic system, the language (or the modes of representation which are assimilated to it), which I shall call the *language-object*, because it is the language which myth gets hold of in order to build its own system; and myth itself, which I shall call *metalanguage*, because it is a second language, *in which* one speaks about the first. When he reflects on a metalanguage, the semiologist no longer needs to ask himself questions about the composition of the language-object, he no longer has to take into account the details of the linguistic schema; he will only need to know its total term, or global sign, and only inasmuch as this term lends itself to myth. This is why the semiologist is entitled to treat in the same way writing and pictures: what he retains from them is the fact that they are both *signs*, that they both reach the threshold of myth endowed with the same signifying function, that they constitute, one just as much as the other, a language-object.

It is now time to give one or two examples of mythical speech. I shall borrow the first from an observation by Valéry.[4] I am a pupil in the second form in a French *lycée*. I open my Latin grammar, and I read a sentence, borrowed from Aesop or Phaedrus: *quia ego nominor leo*. I stop and think. There is something ambiguous about this statement: on the one hand, the words in it do have a simple meaning: *because my name is lion*. And on the other hand, the sentence is evidently there in order to signify something else to me. Inasmuch as it is addressed to me, a pupil in the second form, it tells me clearly: I am a grammatical example meant to illustrate the rule about the agreement of the predicate. I am even forced to realize that the sentence in no way *signifies* its meaning to me, that it tries very little to tell me something about the lion and what sort of name he has; its true and fundamental signification is to impose itself on me as the presence of a certain agreement of the predicate. I conclude that I am faced with a particular, greater, semiological system, since it is co-extensive with the language: there is, indeed, a signifier, but this signifier is itself formed by a sum of signs, it is in itself a first semiological system (*my name is lion*). Thereafter, the formal pattern is correctly unfolded: there is a signified (*I am a grammatical example*) and there is a global signification, which is none other than the correlation of the signifier and the signified; for neither the naming of the lion nor the grammatical example are given separately.

And here is now another example: I am at the barber's, and a copy of *Paris-Match* is offered to me. On the cover, a young Negro in a French uniform is saluting, with his eyes uplifted, probably fixed on a fold of the tricolour. All this is the *meaning* of the

picture. But, whether naïvely or not, I see very well what it signifies to me: that France is a great Empire, that all her sons, without any colour discrimination, faithfully serve under her flag, and that there is no better answer to the detractors of an alleged colonialism than the zeal shown by this Negro in serving his so-called oppressors. I am therefore again faced with a greater semiological system: there is a signifier, itself already formed with a previous system (*a black soldier is giving the French salute*); there is a signified (it is here a purposeful mixture of Frenchness and militariness); finally, there is a presence of the signified through the signifier.

Before tackling the analysis of each term of the mythical system, one must agree on terminology. We now know that the signifier can be looked at, in myth, from two points of view: as the final term of the linguistic system, or as the first term of the mythical system. We therefore need two names. On the plane of language, that is, as the final term of the first system, I shall call the signifier: *meaning (my name is lion, a Negro is giving the French salute)*; on the plane of myth, I shall call it: *form*. In the case of the signified, no ambiguity is possible: we shall retain the name *concept*. The third term is the correlation of the first two: in the linguistic system, it is the *sign*; but it is not possible to use this word again without ambiguity, since in myth (and this is the chief peculiarity of the latter), the signifier is already formed by the *signs* of the language. I shall call the third term of myth the *signification*. This word is here all the better justified since myth has in fact a double function: it points out and it notifies, it makes us understand something and it imposes it on us.

1 Innumerable other meanings of the word 'myth' can be cited against this. But I have tried to define things, not words.

2 The development of publicity, of a national press, of radio, of illustrated news, not to speak of the survival of a myriad rites of communication which rule social appearances, makes the development of a semiological science more urgent than ever. In a single day, how many really non-signifying fields do we cross? Very few, sometimes none. Here I am, before the sea; it is true that it bears no message. But on the beach, what material for semiology! Flags, slogans, signals, sign-boards, clothes, suntan even, which are so many messages to me.

3 The notion of *word* is one of the most controversial in linguistics. I keep it here for the sake of simplicity.

4 *Tel Quel*, II, p. 191.

2 Jirô Yoshihara (1905–1972) Gutai Manifesto

Members of the Gutai Bijutsu Kyôkai (Concrete Art Group) engaged in a range of activities from abstract painting to performance art. The group's senior figure was Jirô Yoshihara, who had practised as an abstract artist before the Second World War. He was a founder member of the Japanese Abstract Art Club in 1953, and then in 1954 organized Gutai in Osaka, with eighteen younger artists. Their periodical of the same name commenced publication in 1955, and achieved an international reputation. In 1958, the exhibition *International Art of a New Era* showed the work of Gutai artists alongside French 'art informel' painters and the Americans Jackson Pollock and Franz Kline. However, the work for which the group remains best known today was not informal abstract painting, but performance and installation–based work. In 1955 Kazuo Shiraga took gestural abstraction beyond painting through the act of writhing about in mud, while in 1956, Saburô Murakami hurled himself through screens of paper, and Sadamasa Motonoga suspended transparent polythene sheets between trees, partly filling them with coloured water. In 1960 the Gutai

group organized 'The International Festival of the Void' in Osaka in association with the French *informel* critic Michel Tapié. Thirty international artists were featured. The pioneering nature of these and similar activities was recognized by Allan Kaprow amongst others (see VIA7). It can now be seen as part of a widespread international tendency to 'move beyond' the traditional media of art, on the assumption that this would lead to a more direct engagement with the conditions of post-war modernity. (These conditions may have seemed to bear down with particular force in those nations whose social fabric had been severely disrupted by the Second World War, and which were then engaged in fundamental processes of recovery and transformation.) Yoshihara's 'Gutai Manifesto' was published in Osaka in December 1956. The present extracts are taken from the translation printed in full in Kristine Stiles and Peter Selz (eds.), *Theories and Documents of Contemporary Art*, Berkeley and London: University of California Press, 1996, pp. 695–8.

With our present-day awareness, the arts as we have known them up to now appear to us in general to be fakes fitted out with a tremendous affectation. Let us take leave of these piles of counterfeit objects on the altars, in the palaces, in the salons and the antique shops.

They are an illusion with which, by human hand and by way of fraud, materials such as paint, pieces of cloth, metals, clay or marble are loaded with false significance, so that, instead of just presenting their own material self, they take on the appearance of something else. Under the cloak of an intellectual aim, the materials have been completely murdered and can no longer speak to us.

Lock these corpses into their tombs. Gutai art does not change the material: it brings it to life. Gutai art does not falsify the material. In Gutai art the human spirit and the material reach out their hands to each other, even though they are otherwise opposed to each other. The material is not absorbed by the spirit. The spirit does not force the material into submission. If one leaves the material as it is, presenting it just as material, then it starts to tell us something and speaks with a mighty voice. Keeping the life of the material alive also means bringing its spirit to life. And lifting up the spirit means leading the material up to the height of the spirit.

Art is the home of the creative spirit, but never until now has the spirit created matter. The spirit has only ever created the spiritual. Certainly the spirit has always filled art with life, but this life will finally die as the times change. For all the magnificent life which existed in the art of the Renaissance, little more than its archaeological existence can be seen today.

What is still left of that vitality, even if passive, may in fact be found in Primitive Art and in art since Impressionism. These are either such things in which, due to skillful application of the paint, the deception of the material had not quite succeeded, or else those like Pointillist or Fauvist pictures in which the materials, although used to reproduce nature, could not be murdered after all. Today, however, they are no longer able to call up deep emotion in us. They already belong to a world of the past.

Yet what is interesting in this respect is that novel beauty which is to be found in the works of art and architecture of the past, even if, in the course of the centuries, they have changed their appearance due to the damage of time or destruction by disasters. This is described as the beauty of decay, but is it not perhaps that beauty which material assumes when it is freed of artificial make-up and reveals its original characteristics? The fact that the ruins receive us warmly and kindly after all, and that they attract us with their cracks and flaking surfaces, could this not really be a sign of the

material taking revenge, having recaptured its original life? In this sense I pay respect to Pollock's and Mathieu's works in contemporary art. These works are the loud outcry of the material, of the very oil or enamel paints themselves. The two artists grapple with the material in a way which is completely appropriate to it and which they have discovered due to their talents. This even gives the impression that they serve the material.

[. . .]

It is obvious to us that purely formalistic abstract art has lost its charm and it is a fact that the foundation of the Gutai Art Society three years ago was accompanied by the slogan that they would go beyond the borders of Abstract Art and that the name Gutaiism (concretism) was chosen. Above all we were not able to avoid the idea that, in contrast to the centripetal origin of abstraction, we of necessity had to search for a centrifugal approach.

In those days we thought, and indeed still do think today, that the most important merits of Abstract Art lie in the fact that it has opened up the possibility to create a new, subjective shape of space, one which really deserves the name creation.

[. . .]

After Pollock many Pollock imitators appeared, but Pollock's splendour will never be extinguished. The talent of invention deserves respect.

Kazuo Shiraga placed a lump of paint on a huge piece of paper, and started to spread it around violently with his feet. For about the last two years art journalists have called this unprecedented method 'the Art of committing the whole self with the body.' Kazuo Shiraga had no intention at all of making this strange method of creating a work of art public. He had merely found a method which enabled him to confront and unite the material he had chosen with his own spiritual dynamics. In doing so he achieved an extremely convincing level.

In contrast to Shiraga, who works with an organic method, Shōzō Shimamoto has been working with mechanical manipulations for the past few years. The pictures of flying spray created by smashing a bottle full of paint, or the large surface he creates in a single moment by firing a small, hand-made cannon filled with paint by means of an acetylene gas explosion, etc., display a breathtaking freshness.

Other works which deserve mention are those of Yasuo Sumi produced with a concrete mixer or of Toshio Yoshida, who uses only one single lump of paint. All their actions are full of a new intellectual energy which demands our respect and recognition.

[. . .]

Our group does not impose restrictions on the art of its members, providing they remain in the field of free artistic creativity. For instance, many different experiments were carried out with extraordinary activity. This ranged from an art to be felt with the entire body to an art which could only be touched, right through to Gutai music (in which Shōzō Shimamoto has been doing interesting experiments for several years). There is also a work by Shōzō Shimamoto like a horizontal ladder with bars which you can feel as you walk over them. Then a work by Saburo Murakami which is like a telescope you can walk into and look up at the heavens, or an installation made of plastic bags with organic elasticity, etc. Atsuko Tanaka started with a work of flashing light bulbs which she called 'Clothing.' Sadamasa Motonaga worked with water, smoke, etc. Gutai art attaches the greatest importance to all daring steps which lead

to an as yet undiscovered world. Sometimes, at first glance, we are compared with and mistaken for Dadaism, and we ourselves fully recognize the achievements of Dadaism, but we do believe that, in contrast to Dadaism, our work is the result of investigating the possibilities of calling the material to life.

We shall hope that a fresh spirit will always blow at our Gutai exhibitions and that the discovery of new life will call forth a tremendous scream in the material itself.

3 Guy Debord (1931–1994) Writings from the Situationist International

A thread runs through the French avant-garde from Baudelaire to Surrealism which focuses on the unexpected, the bizarre, the magical aspects of the condition of modernity; these aspects are supposedly experienced as revelations by those who know how to read the modern city (see *Art in Theory 1815–1900*, IIID7 and 8, and the present volume IIA6 and IVC3). Always incipiently revolutionary, after the effective demise of Surrealism in the post-war period, this cultural tradition was developed by the Situationist International: an organization formed in 1957, reaching a high point of effectiveness in the May Events of 1968, and disbanding in 1972. The SI emerged as a synthesis of the Movement for an Imaginist Bauhaus (itself descended from Cobra, and including Asger Jorn as a leading member [see VIA4]), and the Lettrist International (involving Guy Debord). Twelve issues of the *Internationale situationniste* bulletin were issued. Texts represented here embody the movement's key concepts: the dérive; detournement; and centrally, the concept of the spectacle. All extracts were written by Debord and are taken from the *Situationist International Anthology*, edited and translated by Ken Knabb, Berkeley, CA, 1981, pp. 50–4, 55, 307–8 and 74–5. (Individual titles and dates of composition and publication are given with the selections.)

I Report on the Construction of Situations...

Revolution and Counterrevolution in Modern Culture

First of all we think the world must be changed. We want the most liberating change of the society and life in which we find ourselves confined. We know that this change is possible through appropriate actions.

Our specific concern is the use of certain means of action and the discovery of new ones, means more easily recognizable in the domain of culture and mores, but applied in the perspective of an interaction of all revolutionary changes.

What is termed culture reflects, but also prefigures, the possibilities of organization of life in a given society. Our era is fundamentally characterized by the lagging of revolutionary political action behind the development of modern possibilities of production which call for a superior organization of the world. [...]

One of the contradictions of the bourgeoisie in its phase of liquidation is that while it respects the abstract principle of intellectual and artistic creation, it at first resists actual creations, then eventually exploits them. This is because it must maintain a sense of criticality and experimental research among a minority, but must channel this activity toward strictly compartmentalized utilitarian disciplines and avert any concerted over-all critique and research. In the domain of culture the bourgeoisie strives to divert the taste for innovation, which is dangerous for it in our era, toward certain degraded,

innocuous and confused forms of novelty. Through the commercial mechanisms that control cultural activity, avant-garde tendencies are cut off from the segments of society that could support them, segments already limited because of the general social conditions. [...]

The very notion of a collective avant-garde, with the militant aspect it implies, is a recent product of historical conditions that are simultaneously giving rise to the necessity for a coherent revolutionary program in culture and to the necessity to struggle against the forces that impede the development of such a program. Such groups are led to transpose into their sphere of activity organizational methods created by revolutionary politics, and their action is henceforth inconceivable without some connection with a political critique.

* * *

Toward a Situationist International

Our central idea is that of the construction of situations, that is to say, the concrete construction of momentary ambiances of life and their transformation into a superior passional quality. We must develop a methodical intervention based on the complex factors of two components in perpetual interaction: the material environment of life and the comportments which it gives rise to and which radically transform it.

Our perspectives of action on the environment ultimately lead us to the notion of unitary urbanism. Unitary urbanism is defined first of all by the use of the ensemble of arts and technics as means contributing to an integral composition of the milieu. This ensemble must be envisaged as infinitely more far-reaching than the old domination of architecture over the traditional arts, or than the present sporadic application to anarchic urbanism of specialized technology or of scientific investigations such as ecology. Unitary urbanism must, for example, dominate the acoustic environment as well as the distribution of different varieties of food and drink. It must include the creation of new forms and the detournement of previous forms of architecture, urbanism, poetry and cinema. Integral art, which has been talked about so much, can only be realized at the level of urbanism. But it can no longer correspond to any of the traditional aesthetic categories. [...]

Our action on behavior, linked with other desirable aspects of a revolution in mores, can be briefly defined as the invention of games of an essentially new type. The most general goal must be to extend the nonmediocre part of life, to reduce the empty moments of life as much as possible. One could thus speak of our action as an enterprise of quantitatively increasing human life, an enterprise more serious than the biological methods currently being investigated. This automatically implies a qualitative increase whose developments are unpredictable. The situationist game is distinguished from the classic conception of the game by its radical negation of the element of competition and of separation from everyday life. The situationist game is not distinct from a moral choice, the taking of one's stand in favor of what will ensure the future reign of freedom and play. This perspective is obviously linked to the inevitable continual and rapid increase of leisure time resulting from the level of productive forces our era has attained. It is also linked to the recognition of the fact that a battle of leisure is taking place before our eyes whose importance in the class struggle has not been sufficiently analyzed. So far, the ruling class has succeeded in

using the leisure the revolutionary proletariat wrested from it by developing a vast industrial sector of leisure activities that is an incomparable instrument for stupefying the proletariat with by-products of mystifying ideology and bourgeois tastes. The abundance of televised imbecilities is probably one of the reasons for the American working class's inability to develop any political consciousness. By obtaining by collective pressure a slight rise in the price of its labor above the minimum necessary for the production of that labor, the proletariat not only extends its power of struggle, it also extends the terrain of the struggle. New forms of this struggle then arise alongside directly economic and political conflicts. It can be said that revolutionary propaganda has so far been constantly overcome in these new forms of struggle in all the countries where advanced industrial development has introduced them. That the necessary changing of the infrastructure can be delayed by errors and weaknesses at the level of superstructures has unfortunately been demonstrated by several experiences of the twentieth century. It is necessary to throw new forces into the battle of leisure, and we will take up our position there. [...]

The construction of situations begins on the ruins of the modern spectacle. It is easy to see to what extent the very principle of the spectacle – nonintervention – is linked to the alienation of the old world. Conversely, the most pertinent revolutionary experiments in culture have sought to break the spectator's psychological identification with the hero so as to draw him into activity by provoking his capacities to revolutionize his own life. The situation is thus made to be lived by its constructors. The role played by a passive or merely bit-part playing 'public' must constantly diminish, while that played by those who cannot be called actors but rather, in a new sense of the term, 'livers,' must steadily increase.

So to speak, we have to multiply poetic subjects and objects – which are now unfortunately so rare that the slightest ones take on an exaggerated emotional import- ance – and we have to organize games of these poetic objects among these poetic subjects. This is our entire program, which is essentially transitory. Our situations will be ephemeral, without a future; passageways. The permanence of art or anything else does not enter into our considerations, which are serious. Eternity is the grossest idea a person can conceive of in connection with his acts. [...]

<div align="right">June 1957</div>

II Theory of the Dérive

Among the various situationist methods is the *dérive* [literally: 'drifting'], a technique of transient passage through varied ambiances. The dérive entails playful-constructive behavior and awareness of psycho-geographical effects; which completely distinguishes it from the classical notions of the journey and the stroll.

In a dérive one or more persons during a certain period drop their usual motives for movement and action, their relations, their work and leisure activities, and let them- selves be drawn by the attractions of the terrain and the encounters they find there. The element of chance is less determinant than one might think: from the dérive point of view cities have a psychogeographical relief, with constant currents, fixed points and vortexes which strongly discourage entry into or exit from certain zones.

But the dérive includes both this letting go and its necessary contradiction: the domination of psychogeographical variations by the knowledge and calculation of their

possibilities. In this latter regard, ecological science – despite the apparently narrow social space to which it limits itself – provides psychogeography with abundant data.

The ecological analysis of the absolute or relative character of fissures in the urban network, of the role of microclimates, of the distinct, self-contained character of administrative districts, and above all of the dominating action of centers of attraction, must be utilized and completed by psychogeographical methods. The objective passional terrain of the dérive must be defined in accordance both with its own logic and with its relations with social morphology. [...]

Chance plays an important role in dérives precisely because the methodology of psychogeographical observation is still in its infancy. But the action of chance is naturally conservative and in a new setting tends to reduce everything to an alternation between a limited number of variants, and to habit. Progress is nothing other than breaking through a field where chance holds sway by creating new conditions more favorable to our purposes. We can say, then, that the randomness of the dérive is fundamentally different from that of the stroll, but also that the first psychogeographical attractions discovered run the risk of fixating the dériving individual or group around new habitual axes, to which they will constantly be drawn back.

* * *

The lessons drawn from the dérive permit the drawing up of the first surveys of the psychogeographical articulations of a modern city. Beyond the discovery of unities of ambiance, of their main components and their spatial localization, one comes to perceive their principal axes of passage, their exits and their defenses. One arrives at the central hypothesis of the existence of psychogeographical pivotal points. One measures the distances that effectively separate two regions of a city, distances that may have little relation with the physical distance between them. With the aid of old maps, aerial photographs and experimental dérives, one can draw up hitherto lacking maps of influences, maps whose inevitable imprecision at this early stage is no worse than that of the first navigational charts; the only difference is that it is a matter no longer of precisely delineating stable continents, but of changing architecture and urbanism.

Today the different unities of atmosphere and of dwellings are not precisely marked off, but are surrounded by more or less extended and indistinct bordering regions. The most general change that the dérive leads to proposing is the constant diminution of these border regions, up to the point of their complete suppression.

(1956) *Internationale situationniste*, no. 2, December 1958

III Detournement As Negation And Prelude

Detournement, the reuse of preexisting artistic elements in a new ensemble, has been a constantly present tendency of the contemporary avant-garde both before and since the establishment of the SI. The two fundamental laws of detournement are the loss of importance of each detourned autonomous element – which may go so far as to lose its original sense completely – and at the same time the organization of another meaningful ensemble that confers on each element its new scope and effect.

Detournement has a peculiar power which obviously stems from the double meaning, from the enrichment of most of the terms by the coexistence within them of their old senses and their new, immediate senses. Detournement is practical because it is so

easy to use and because of its inexhaustible potential for reuse. Concerning the negligible effort required for detournement, we have already said, 'The cheapness of its products is the heavy artillery that breaks through all the Chinese walls of under-standing' (*Methods of Detournement*, May 1956). But these points would not by themselves justify recourse to this method, which the same text describes as 'clashing head-on against all social and legal conventions.' Detournement has a historical signifi-cance. What is it?

'Detournement is a game made possible by the capacity of *devaluation*,' writes Jorn in his study Detourned Painting (May 1959), and he goes on to say that all the elements of the cultural past must be 'reinvested' or disappear. Detournement is thus first of all a negation of the value of the previous organization of expression. It arises and grows increasingly stronger in the historical period of the decomposition of artistic expres-sion. But at the same time, the attempts to reuse the 'detournable bloc' as material for other ensembles express the search for a vaster construction, a new genre of creation at a higher level.

The SI is a very special kind of movement, of a nature different from preceding artistic avant-gardes. Within culture the SI can be likened to a research laboratory, for example, or to a party in which we are situationists but nothing that we do is situationist. This is not a disavowal for anyone. We are partisans of a certain future of culture, of life. Situationist activity is a definite craft which we are not yet prac-ticing.

Thus the signature of the situationist movement, the sign of its presence and contestation in contemporary cultural reality (since we cannot represent any common style whatsoever), is first of all the use of detournement. [. . .]

At this point in the world's development all forms of expression are losing all grip on reality and being reduced to self-parody. As the readers of this journal can frequently verify, present-day writing always has an element of parody. 'It is necessary,' states *Methods of Detournement*, 'to conceive of a parodic-serious stage where the accumula-tion of detourned elements, far from aiming at arousing indignation or laughter by alluding to some original work, will express our indifference toward a meaningless and forgotten original, and concern itself with rendering a certain sublimity.'

The parodic-serious expresses the contradictions of an era in which we find our-selves confronted with both the urgent necessity and the near impossibility of bringing together and carrying out a totally innovative collective action. An era in which the greatest seriousness advances masked in the ambiguous interplay between art and its negation; in which the essential voyages of discovery have been undertaken by such astonishingly incapable people.

Internationale situationniste, no. 3. December 1959

IV Preliminaries Towards Defining a Unitary Revolutionary Program

Capitalism: a Society Without Culture

* * *

5 Present culture as a whole can be characterized as alienated in the sense that every activity, every moment of life, every idea, every type of behavior, has a meaning only

outside itself, in an elsewhere which, being no longer in heaven, is only the more maddening to try and locate: a utopia, in the literal sense of the word, dominates the life of the modern world.

6 Having from the workshop to the laboratory emptied productive activity of all meaning for itself, capitalism strives to place the meaning of life in leisure activities and to reorient productive activity on that basis. Since production is hell in the prevailing moral schema, real life must be found in consumption, in the use of goods.

[...] The world of consumption is in reality the world of the mutual spectacularization of everyone, the world of everyone's separation, estrangement and nonparticipation. [...]

7 Outside of work, the spectacle is the dominant mode through which people relate to each other. It is only through the spectacle that people acquire a (falsified) knowledge of certain general aspects of social life, from scientific or technological achievements to prevailing types of conduct and orchestrated meetings of international statesmen. The relation between authors and spectators is only a transposition of the fundamental relation between directors and executants. It answers perfectly to the needs of a reified and alienated culture: the spectacle/spectator relation is in itself a staunch bearer of the capitalist order. The ambiguity of all 'revolutionary art' lies in the fact that the revolutionary aspect of any particular spectacle is always contradicted and offset by the reactionary element present in all spectacles.

This is why the improvement of capitalist society means to a great degree the improvement of the mechanism of spectacularization. This is obviously a complex mechanism, for if it must be most essentially the propagator of the capitalist order, it nevertheless must not appear to the public as the delirium of capitalism; it must involve the public by incorporating elements of representation that correspond – in fragments – to social rationality. It must sidetrack the desires whose satisfaction is forbidden by the ruling order. For example, modern mass tourism presents cities and landscapes not in order to satisfy authentic desires to live in such human or geographical milieus; it presents them as pure, rapid, superficial spectacles (spectacles from which one can gain prestige by reminiscing about). Similarly, striptease is the most obvious form of the degradation of eroticism into a mere spectacle.

8 The evolution and the conservation of art have been governed by these lines of force. At one pole, art is purely and simply recuperated by capitalism as a means of conditioning the population. At the other pole, capitalism grants art a perpetual privileged concession: that of pure creative activity, an alibi for the alienation of all other activities (which thus makes it the most expensive and prestigious status symbol). But at the same time, this sphere reserved for 'free creative activity' is the only one in which the question of what we do with life and the question of communication are posed practically and in all their fullness. Here, in art, lies the basis of the antagonisms between partisans and adversaries of the officially dictated reasons for living. The established meaninglessness and separation give rise to the general crisis of traditional artistic means – a crisis linked to the experience of alternative ways of living or to the demand for such experience. Revolutionary artists are those who call for intervention; and who have themselves intervened in the spectacle to disrupt and destroy it.

20 July 1960

V Perspectives for Conscious Alterations in Everyday Life

Capitalist civilization has not yet been superseded anywhere, but it continues to produce its own enemies everywhere. The next rise of the revolutionary movement, radicalized by the lessons of past defeats and with a program enriched in proportion to the practical powers of modern society (powers already constituting the potential material basis that was lacking in the so-called utopian currents of socialism – this next attempt at a total contestation of capitalism will know how to invent and propose a different use of everyday life, and will immediately base itself on new everyday practices, on new types of human relationships (being no longer unaware that any conserving, within the revolutionary movement, of the relations prevailing in the existing society imperceptibly leads to a reconstitution of one or another variant of this society).

Just as the bourgeoisie, in its ascending phase, had to ruthlessly liquidate everything that transcended earthly life (heaven, eternity), so the revolutionary proletariat – which can never, without ceasing to be revolutionary, recognize itself in any past or any models – will have to renounce everything that transcends everyday life. Or rather, everything that claims to transcend it: the spectacle, the 'historical' act or pronouncement, the 'greatness' of leaders, the mystery of specializations, the 'immortality' of art and its importance outside of life. In other words, it must renounce all the by-products of eternity that have survived as weapons of the world of the rulers.

The revolution in everyday life, breaking its present resistance to the historical (and to every kind of change), will create the conditions in which *the present dominates the past* and the creative aspects of life always predominate over the repetitive. [...]

The critique and perpetual re-creation of the totality of everyday life, before being carried out naturally by all people, must be undertaken in the present conditions of oppression, in order to destroy these conditions.

An avant-garde cultural movement, even one with revolutionary sympathies, cannot accomplish this. Neither can a revolutionary party on the traditional model, even if it accords a large place to criticism of culture (understanding by that term the entirety of artistic and conceptual means through which a society explains itself to itself and shows itself goals of life). This culture and this politics are worn out and it is not without reason that most people take no interest in them. The revolutionary transformation of everyday life, which is not reserved for some vague future but is placed immediately before us by the development of capitalism and its unbearable demands – the alternative being the reinforcement of the modern slavery – this transformation will mark the end of all unilateral artistic expression stocked in the form of commodities, at the same time as the end of all specialized politics.

This is going to be the task of a new type of revolutionary organization from its inception.

17 May 1961

4 Asger Jorn (1914–1973) 'Detourned Painting'

Jorn settled in Paris in 1956, where he was involved in the early stages of the Situationist International and was closely allied with Guy Debord (cf. the latter's definition of *detourne-*

ment as 'the reuse of preexisting artistic elements in a new ensemble', in VIA3). The following text was originally published as an introduction to an exhibition of Jorn's 'Detourned Paintings' – anarchic reworkings of found paintings – at the Galerie Rive Gauche in 1959. The artist resigned from the Situationist International in 1961 in response to increasingly hostile criticism of art from the group around Debord. In 1962 the Situationist International disqualified art from consideration as a legitimate site of revolutionary struggle. The English version of Jorn's text is taken from *On the passage of a few people through a rather brief moment in time: The Situationist International 1957–1972*, Cambridge, MA, and London: MIT Press, 1991, pp. 140–2. The article referred to in Jorn's note was actually published in *Helhesten: Tidsskrift for Kunst*, May 1941. (See also VC12.)

Intended for the general public. Reads effortlessly.

Be modern,
collectors, museums.
If you have old paintings,
do not despair.
Retain your memories
but detourn them
so that they correspond with your era.
Why reject the old
if one can modernize it
with a few strokes of the brush?
This casts a bit of contemporaneity
on your old culture.
Be up to date,
and distinguished
at the same time.
Painting is over.
You might as well finish it off.
Detourn.
Long live painting.

Intended for connoisseurs. Requires limited attention.

All works of art are objects and should be treated as such, but these objects are not ends in themselves: they are tools with which to influence spectators. The artistic object, despite its seemingly objectlike character, therefore presents itself as a link between two subjects, the creating and provoking subject on the one hand, and the receiving subject on the other. The latter does not perceive the work of art as a pure object, but as the sign of a human presence.

The problem for the artist is not to know if the work of art should be considered as an object or as a subject, since the two are inseparable. The problem is to capture and to formulate the desired tension in the work between appearance and sign.

The conception of art implicit in 'action painting' reduces art to an act in itself, in which the object, the work of art, is a mere trace, and in which there is no more communication with the audience. This is the attitude of the pure creator who does nothing but fulfill *himself* through the materials for his own pleasure.

This attitude is irreconcilable with an interest in the object as such, the work of art in its anonymity, that is, the experience of pleasure in its purity when facing a sculpture whose country of origin is unknown or whose period is uncertain. Here the object floats freely in space and time. My preoccupation with objectivity and subjectivity is situated above all between these two poles, or more precisely between my will and my intelligence. I must admit that as far as the third attitude is concerned, that of the spectator, it does not concern me much. Whether one intends it or not, in the end it is to him that everything happens.

The classic and Latin concept has always accorded a primacy to the object whereas the oriental concept ascribes everything to the subject. Ever since the establishment of the internal tension of European culture, the gothic, or northern, concept attempts to play within the dialectic of the two opposites. Therefore I am not limited by such a previously made choice.

The result is that this perspective leads one necessarily to consider all creations simultaneously as reinvestments, revalorizations of the act of humanity. The object, reality, or *presence* takes on value only as an agent of *becoming*. But it is impossible to establish a future without a past. The future is made through relinquishing or sacrificing the past. He who possesses the past of a phenomenon also possesses the sources of its becoming. Europe will continue to be the source of modern development. Here, the only problem is to know who should have the right to the sacrifices and to the relinquishments of this past, that is, who will inherit the futurist power. I want to rejuvenate European culture. I begin with art. Our past is full of becoming. One needs only to crack open the shells. *Détournement* is a game born out of the capacity for *devalorization*. Only he who is able to devalorize can create new values. And only there where there is *something* to devalorize, that is, an already established value, can one engage in devalorization. It is up to us to devalorize or to be devalorized according to our ability to reinvest in our own culture. There remain only two possibilities for us in Europe: to be sacrificed or to sacrifice. It is up to you to choose between the historical monument and the act that merits it.

The evidence of premeditation.

In 1939 I wrote my first article ('Intime banaliteter' [Intimate banalities] in the journal *Helhesten*) in which I expressed my love for sofa painting,[1] and for the last twenty years I have been preoccupied with the idea of rendering homage to it. Thus I act with full responsibility and after extensive reflection. Only my current situation has enabled me to accomplish the expensive task of demonstrating that the preferred sustenance of painting is painting.

In this exhibition I erect a monument in honor of bad painting. Personally, I like it better than good painting. But above all, this monument is indispensable, both for me and for everyone else. It is painting sacrificed. This sort of offering can be done gently the way doctors do it when they kill their patients with new medicines that they want to try out. It can also be done in barbaric fashion, in public and with pomp. This is what I like. I solemnly tip my hat and let the blood of my victims flow while intoning Baudelaire's hymn to beauty.

Note

[1] There, I wrote: 'Those who try to combat the production of painting are the enemies of today's best art. These forest lakes on colored paper, hanging in gilded frames in thousands of apartments, are among the most profound artistic inspirations.

The great masterpieces are nothing but accomplished banalities, and the deficiency of the majority of banalities is that they are not complete. These works do not push banality to the limit of its profundity; they fail to explore the full extent of its consequences; instead they rest on a foundation of aestheticism and spirituality. What one calls natural is liberated banality, obviousness.

Nowhere else but in Paris does one find gathered together so many things of bad taste. This is the very secret which explains why Paris remains the place where artistic inspiration is alive.'

5 Frantz Fanon (1925–1961) 'On National Culture'

Born in Martinique, Fanon studied there and in France before joining the French army during the Second World War. After the war he completed his medical studies and specialized in psychiatry. He was made head of the department of psychiatry at a hospital in Algeria in 1953. The following year he joined the FLN, the Algerian liberation movement. In 1956 he became editor of the FLN newspaper, 'The Freedom Fighter', based in Tunisia. His early book, *Black Skin, White Masks*, investigated racism in terms of the self-alienation experienced by colonized people in achieving self-identity (as in the case of those caught between the identifications Indian/British or Algerian/French). *The Wretched of the Earth* was published in 1961, the year of Fanon's death from leukaemia. In the context of the war for Algerian independence, it focuses on the need for armed struggle against the colonizers. Much contemporary post-colonial theory is based around the notion of 'difference' (see VIIIB17). As such it is critical of the essentialist idea of 'negritude', which had been widely influential in the post-war period. In the words of one of its leading advocates, the Senegalese writer Léopold Senghor, 'negritude' represented a 'humanism of the twentieth century'. Culturally, it mirrored some aspects of modernist theory in its vitalism and its stress on notions of underlying harmony and rhythm. Although Fanon recognized the significance of recovering cultural ideals obliterated by imperialism, he nonetheless argued strongly against 'negro-ism' for its potentially backward-looking aspects, arguing instead for the building of a national culture out of the contemporary political struggle for freedom. In essence, Fanon is arguing against the adoption of a cultural perspective which, however unintentionally, might replicate colonialist ideas of the 'primitive' or the archaic, and instead argues for a culture of modernity. 'On National Culture' was delivered to the Second Congress of Black Artists and Writers in Rome in 1959. It was subsequently incorporated as chapter 4 of *Les Damnés de la terre*. Our extracts are taken from the translation by Constance Farrington published as *The Wretched of the Earth*, 1965. We have used the Harmondsworth: Penguin edition, 1974, pp. 166–99. The extracts are from pp. 168–72 and 178–81.

Inside the political parties, and most often in offshoots from these parties, cultured individuals of the colonized race make their appearance. For these individuals, the demand for a national culture and the affirmation of the existence of such a culture represent a special battle-field. While the politicians situate their action in actual present-day events, men of culture take their stand in the field of history. Confronted with the native intellectual who decides to make an aggressive response to the colonial-ist theory of pre-colonial barbarism, colonialism will react only slightly, and still less because the ideas developed by the young colonized intelligentsia are widely professed by specialists in the mother country. It is in fact a commonplace to state that for several decades large numbers of research workers have, in the main, rehabilitated the African, Mexican and Peruvian civilizations. The passion with which native intellectuals defend the existence of their national culture may be a source of amazement; but those who condemn this exaggerated passion are strangely apt to forget that their own psyche and their own selves are conveniently sheltered behind a French or German culture which has given full proof of its existence and which is uncontested.

I am ready to concede that on the plane of factual being the past existence of an Aztec civilization does not change anything very much in the diet of the Mexican peasant of today. I admit that all the proofs of a wonderful Songhai civilization will not change the fact that today the Songhais are under-fed and illiterate, thrown between sky and water with empty heads and empty eyes. But it has been remarked several times that this passionate search for a national culture which existed before the colonial era finds its legitimate reason in the anxiety shared by native intellectuals to shrink away from that Western culture in which they all risk being swamped. Because they realize they are in danger of losing their lives and thus becoming lost to their people, these men, hot-headed and with anger in their hearts, relentlessly determine to renew contact once more with the oldest and most pre-colonial springs of life of their people.

Let us go farther. Perhaps this passionate research and this anger are kept up or at least directed by the secret hope of discovering beyond the misery of today, beyond self-contempt, resignation and abjuration, some very beautiful and splendid era whose existence rehabilitates us both in regard to ourselves and in regard to others. I have said that I have decided to go farther. Perhaps unconsciously, the native intellectuals, since they could not stand wonder-struck before the history of today's barbarity, decided to go back farther and to delve deeper down; and, let us make no mistake, it was with the greatest delight that they discovered that there was nothing to be ashamed of in the past, but rather dignity, glory and solemnity. The claim to a national culture in the past does not only rehabilitate that nation and serve as a justification for the hope of a future national culture. In the sphere of psycho-affective equilibrium it is responsible for an important change in the native. Perhaps we have not sufficiently demonstrated that colonialism is not simply content to impose its rule upon the present and the future of a dominated country. Colonialism is not satisfied merely with holding a people in its grip and emptying the native's brain of all form and content. By a kind of perverted logic, it turns to the past of the oppressed people, and distorts, disfigures and destroys it. This work of devaluing pre-colonial history takes on a dialectical significance today.

When we consider the efforts made to carry out the cultural estrangement so characteristic of the colonial epoch, we realize that nothing has been left to chance and that the total result looked for by colonial domination was indeed to convince the natives that colonialism came to lighten their darkness. The effect consciously

sought by colonialism was to drive into the natives' heads the idea that if the settlers were to leave, they would at once fall back into barbarism, degradation and bestiality. [...]

The native intellectual who decides to give battle to colonial lies fights on the field of the whole continent. The past is given back its value. Culture, extracted from the past to be displayed in all its splendour, is not necessarily that of his own country. Colonialism, which has not bothered to put too fine a point on its efforts, has never ceased to maintain that the Negro is a savage; and for the colonist, the Negro was neither an Angolan nor a Nigerian, for he simply spoke of 'the Negro'. For colonialism, this vast continent was the haunt of savages, a country riddled with superstitions and fanaticism, destined for contempt, weighed down by the curse of God, a country of cannibals – in short, the Negro's country. Colonialism's condemnation is continental in its scope. The contention by colonialism that the darkest night of humanity lay over pre-colonial history concerns the whole of the African continent. The efforts of the native to rehabilitate himself and to escape from the claws of colonialism are logically inscribed from the same point of view as that of colonialism. The native intellectual who has gone far beyond the domains of Western culture and who has got it into his head to proclaim the existence of another culture never does so in the name of Angola or of Dahomey. The culture which is affirmed is African culture. The Negro, never so much a Negro as since he has been dominated by the whites, when he decides to prove that he has a culture and to behave like a cultured person, comes to realize that history points out a well-defined path to him: he must demonstrate that a Negro culture exists.

And it is only too true that those who are most responsible for this racialization of thought, or at least for the first movement towards that thought, are and remain those Europeans who have never ceased to set up white culture to fill the gap left by the absence of other cultures. Colonialism did not dream of wasting its time in denying the existence of one national culture after another. Therefore the reply of the colonized peoples will be straight away continental in its breadth. In Africa, the native literature of the last twenty years is not a national literature but a Negro literature. The concept of Negro-ism, for example, was the emotional if not the logical antithesis of that insult which the white man flung at humanity. This rush of Negro-ism against the white man's contempt showed itself in certain spheres to be the one idea capable of lifting interdictions and anathemas. Because the New Guinean or Kenyan intellectuals found themselves above all up against a general ostracism and delivered to the combined contempt of their overlords, their reaction was to sing praises in admiration of each other. The unconditional affirmation of African culture has succeeded the unconditional affirmation of European culture. On the whole, the poets of Negro-ism oppose the idea of an old Europe to a young Africa, tiresome reasoning to lyricism, oppressive logic to high-stepping nature, and on one side stiffness, ceremony, etiquette and scepticism, while on the other frankness, liveliness, liberty and – why not? – luxuriance: but also irresponsibility. [...]

This historical necessity in which the men of African culture find themselves to racialize their claims and to speak more of African culture than of national culture will tend to lead them up a blind alley.

* * *

The native intellectual decides to make an inventory of the bad habits drawn from the colonial world, and hastens to remind everyone of the good old customs of the people, that people which he had decided contains all truth and goodness. The scandalized attitude with which the settlers who live in the colonial territory greet this new departure only serves to strengthen the native's decision. When the colonialists, who had tasted the sweets of their victory over these assimilated people, realize that these men whom they considered as saved souls are beginning to fall back into the ways of niggers, the whole system totters. Every native won over, every native who had taken the pledge not only marks a failure for the colonial structure when he decides to lose himself and to go back to his own side, but also stands as a symbol for the uselessness and the shallowness of all the work that has been accomplished. Each native who goes back over the line is a radical condemnation of the methods and of the regime; and the native intellectual finds in the scandal he gives rise to a justification and an encouragement to persevere in the path he has chosen.

If we wanted to trace in the works of native writers the different phases which characterize this evolution we would find spread out before us a panorama on three levels. In the first phase, the native intellectual gives proof that he has assimilated the culture of the occupying power. His writings correspond point by point with those of his opposite numbers in the mother country. His inspiration is European and we can easily link up these works with definite trends in the literature of the mother country. This is the period of unqualified assimilation. We find in this literature coming from the colonies the Parnassians, the Symbolists and the Surrealists.

In the second phase we find the native is disturbed; he decides to remember what he is. This period of creative work approximately corresponds to that immersion which we have just described. But since the native is not a part of his people, since he only has exterior relations with his people, he is content to recall their life only. Past happenings of the bygone days of his childhood will be brought up out of the depths of his memory; old legends will be reinterpreted in the light of a borrowed aestheticism and of a conception of the world which was discovered under other skies.

Sometimes this literature of just-before-the-battle is dominated by humour and by allegory; but often too it is symptomatic of a period of distress and difficulty, where death is experienced, and disgust too. We spew ourselves up; but already underneath laughter can be heard.

Finally, in the third phase, which is called the fighting phase, the native, after having tried to lose himself in the people and with the people, will on the contrary shake the people. Instead of according the people's lethargy an honoured place in his esteem, he turns himself into an awakener of the people; hence comes a fighting literature, a revolutionary literature, and a national literature. [...]

The native intellectual nevertheless sooner or later will realize that you do not show proof of your nation from its culture but that you substantiate its existence in the fight which the people wage against the forces of occupation. No colonial system draws its justification from the fact that the territories it dominates are culturally non-existent. You will never make colonialism blush for shame by spreading out little-known cultural treasures under its eyes. At the very moment when the native intellectual is anxiously trying to create a cultural work he fails to realize that he is utilizing techniques and language which are borrowed from the stranger in his country. He contents himself

with stamping these instruments with a hall-mark which he wishes to be national, but which is strangely reminiscent of exoticism. The native intellectual who comes back to his people by way of cultural achievements behaves in fact like a foreigner. Sometimes he has no hesitation in using a dialect in order to show his will to be as near as possible to the people; but the ideas that he expresses and the preoccupations he is taken up with have no common yardstick to measure the real situation which the men and the women of his country know. The culture that the intellectual leans towards is often no more than a stock of particularisms. He wishes to attach himself to the people; but instead he only catches hold of their outer garments. And these outer garments are merely the reflection of a hidden life, teeming and perpetually in motion. That extremely obvious objectivity which seems to characterize a people is in fact only the inert, already forsaken result of frequent, and not always very coherent adaptations of a much more fundamental substance which itself is continually being renewed. The man of culture, instead of setting out to find this substance, will let himself be hypnotized by these mummified fragments which because they are static are in fact symbols of negation and outworn contrivances. Culture has never the translucidity of custom; it abhors all simplification. In its essence it is opposed to custom, for custom is always the deterioration of culture. The desire to attach oneself to tradition or bring abandoned traditions to life again does not only mean going against the current of history but also opposing one's own people. When a people undertakes an armed struggle or even a political struggle against a relentless colonialism, the significance of tradition changes. All that has made up the technique of passive resistance in the past may, during this phase, be radically condemned. In an underdeveloped country during the period of struggle traditions are fundamentally unstable and are shot through by centrifugal tendencies. This is why the intellectual often runs the risk of being out of date. The peoples who have carried on the struggle are more impervious to demagogy; and those who wish to follow them reveal themselves as nothing more than common opportunists, in other words late-comers.

In the sphere of plastic arts, for example, the native artist who wishes at whatever cost to create a national work of art shuts himself up in a stereotyped reproduction of details. These artists, who have nevertheless thoroughly studied modern techniques and who have taken part in the main trends of contemporary painting and architecture, turn their back on foreign culture, deny it and set out to look for a true national culture, setting great store on what they consider to be the constant principles of national art. But these people forget that the forms of thought and what it feeds on, together with modern techniques of information, language and dress have dialectically reorganized the people's intelligences and that the constant principles which acted as safeguards during the colonial period are now undergoing extremely radical changes.

The artist who has decided to illustrate the truths of the nation turns paradoxically towards the past and away from actual events. What he ultimately intends to embrace are in fact the cast-offs of thought, its shells and corpses, a knowledge which has been stabilized once and for all. But the native intellectual who wishes to create an authentic work of art must realize that the truths of a nation are in the first place its realities. He must go on until he has found the seething pot out of which the learning of the future will emerge.

Before independence, the native painter was insensible to the national scene. He set a high value on non-figurative art, or more often was specialized in still-lifes. After

independence his anxiety to rejoin his people will confine him to the most detailed representation of reality. This is representative art which has no internal rhythms, an art which is serene and immobile, evocative not of life but of death. Enlightened circles are in ecstasies when confronted with this 'inner truth' which is so well expressed; but we have the right to ask if this truth is in fact a reality, and if it is not already outworn and denied, called in question by the epoch through which the people are treading out their path towards history.

6 Lawrence Alloway (1926–1990) 'The Arts and the Mass Media'

Alloway was a critic who worked in the early 1950s at the Institute of Contemporary Arts in London, where he was party to the formation of the Independent Group in 1952. The members of this group, which included Eduardo Paolozzi and Richard Hamilton, are generally credited with the establishment of Pop Art in Britain. Their typical work had two principal aspects. They were critical of the idea of an autonomous, disinterested, 'fine' art oriented around an exclusive notion of aesthetic quality, and more positively they attempted to confront the implications of the new mass media and of their products, both for an adequate theory of culture and for the practice of art. Published in *Architectural Design*, London, February 1958, pp. 34–5, from which the present text is taken. (For Greenberg's 'Avant-Garde and Kitsch' see IVD11.)

Before 1800 the population of Europe was an estimated 180 million; by 1900 this figure had risen to 460 million. The increase of population and the industrial revolution that paced it has, as everybody knows, changed the world. In the arts, however, traditional ideas have persisted, to limit the definition of later developments. As Ortega pointed out in *The Revolt of the Masses*: 'the masses are to-day exercising functions in social life which coincide with those which hitherto seemed reserved to minorities.' As a result the élite, accustomed to set æsthetic standards, has found that it no longer possesses the power to dominate all aspects of art. It is in this situation that we need to consider the arts of the mass media. It is impossible to see them clearly within a code of æsthetics associated with minorities with pastoral and upper-class ideas because mass art is urban and democratic.[...]

 If justice is to be done to the mass arts which are, after all, one of the most remarkable and characteristic achievements of industrial society, some of the common objections to it need to be faced. A summary of the opposition to mass popular art is in *Avant Garde and Kitsch* (*Partisan Review*, 1939, *Horizon*, 1940), by Clement Greenberg, an art critic and a good one, but fatally prejudiced when he leaves modern fine art. By kitsch he means 'popular, commercial art and literature, with their chromeotypes, magazine covers, illustrations, advertisements, slick and pulp fiction, comics, Tin Pan Alley music, tap dancing, Hollywood movies, etc.'. All these activities to Greenberg and the minority he speaks for are 'ersatz culture... destined for those who are insensible to the value of *genuine* culture... Kitsch, using for raw material the debased and academic simulacra of *genuine* culture welcomes and cultivates this insensibility' (my italics). Greenberg insists that 'all kitsch is academic', but only some of it is, such as Cecil B. De Mille-type historical epics which use nineteenth-century history-picture material. In fact, stylistically, technically, and iconographically the mass arts are anti-academic.

Topicality and a rapid rate of change are not academic in any usual sense of the word, which means a system that is static, rigid, self-perpetuating. Sensitiveness to the variables of our life and economy enable the mass arts to accompany the changes in our life far more closely than the fine arts which are a repository of time-binding values.

The popular arts of our industrial civilization are geared to technical changes which occur, not gradually, but violently and experimentally. The rise of the electronics era in communications challenged the cinema. In reaction to the small TV screen, movie makers spread sideways (CinemaScope) and back into space (Vista Vision). All the regular film critics opposed the new array of shapes, but all have been accepted by the audiences. Technical change as dramatized novelty (usually spurred by economic necessity) is characteristic not only of the cinema but of all the mass arts. Colour TV, the improvements in colour printing (particularly in American magazines), the new range of paper back books; all are part of the constant technical improvements in the channels of mass communication.

An important factor in communication in the mass arts is high redundancy. TV plays, radio serials, entertainers, tend to resemble each other (though there are important and clearly visible differences for the expert consumer). You can go into the movies at any point, leave your seat, eat an ice-cream, and still follow the action on the screen pretty well. The repetitive and overlapping structure of modern entertainment works in two ways: (1) it permits marginal attention to suffice for those spectators who like to talk, neck, parade; (2) it satisfies, for the absorbed spectator, the desire for intense participation which leads to a careful discrimination of nuances in the action.

There is in popular art a continuum from data to fantasy. Fantasy resides in, to sample a few examples, film stars, perfume ads, beauty and the beast situations, terrible deaths, sexy women. This is the aspect of popular art which is most easily accepted by art minorities who see it as a vital substratum of the folk, as something primitive. This notion has a history since Herder in the eighteenth century, who emphasized national folk arts in opposition to international classicism. Now, however, mass-produced folk art is international: Kim Novak, *Galaxy Science Fiction*, Mickey Spillane, are available wherever you go in the West.

However, fantasy is always given a keen topical edge; the sexy model is shaped by datable fashion as well as by timeless lust. Thus, the mass arts orient the consumer in current styles, even when they seem purely, timelessly erotic and fantastic. The mass media give perpetual lessons in assimilation, instruction in role-taking, the use of new objects, the definition of changing relationships, as David Riesman has pointed out. A clear example of this may be taken from science fiction. Cybernetics, a new word to many people until 1956, was made the basis of stories in *Astounding Science Fiction* in 1950. SF aids the assimilation of the mounting technical facts of this century in which, as John W. Campbell, the editor of *Astounding*, put it, 'A man learns a pattern of behaviour – and in five years it doesn't work.' Popular art, as a whole, offers imagery and plots to control the changes in the world; everything in our culture that changes is the material of the popular arts.

Critics of the mass media often complain of the hostility towards intellectuals and the lack of respect for art expressed there, but, as I have tried to show, the feeling is mutual. Why should the mass media turn the other cheek? What worries intellectuals is the fact that the mass arts spread; they encroach on the high ground. [. . .]

The definition of culture is changing as a result of the pressure of the great audience, which is no longer new but experienced in the consumption of its arts. Therefore, it is no longer sufficient to define culture solely as something that a minority guards for the few and the future (though such art is uniquely valuable and as precious as ever). Our definition of culture is being stretched beyond the fine art limits imposed on it by Renaissance theory, and refers now, increasingly, to the whole complex of human activities. Within this definition, rejection of the mass produced arts is not, as critics think, a defence of culture but an attack on it. The new role for the academic is keeper of the flame; the new role for the fine arts is to be one of the possible forms of communication in an expanding framework that also includes the mass arts.

7 Allan Kaprow (b. 1927) from *Assemblages, Environments and Happenings*

During the late 1950s and early 1960s, the author was a leading figure in the production of Happenings, principally amongst the New York avant-garde. He had earlier sketched out an interpretation of the 'legacy of Jackson Pollock' in which he read the implications of Pollock's work in terms of a move out of painting towards a synthetic art form involving performances. These were to take place in real space and time, drawing on the gamut of the products and processes of the modern, urbanized world: 'The young artist of today need no longer say "I am a painter" or "a poet" or "a dancer". He is simply an "artist". All of life will be open to him.' The text from which the present extracts are taken (pp. 151–5, 183–5, 187–96 and 207–8) was published in book form as *Assemblages, Environments and Happenings*, New York, 1966. The Preface states that it was 'largely written' in 1959, finished in 1960, and revised in 1961. It was further revised for its eventual publication, when extra texts by other Happenings artists were added.

A critical turning point has been reached in a major area of avant-garde effort, which I believe is entirely to the good but which is forcing upon us the possibly disagreeable task of revising some cherished assumptions regarding the nature of the plastic arts.

Certain advanced works being done at this moment are rapidly losing their traditional identities and something else, quite far-reaching in its implications, is taking their place.

On the one hand, looking broadly at the whole of recent modern art, the differences which were once so clear between graphic art and painting have practically been eliminated; similarly, the distinctions between painting and collage, between collage and construction, between construction and sculpture, and between some large constructions and a quasi architecture. [...]

This continuity is significant, the critical issue in fact; for drawing and painting, and in a large measure sculpture and the so-called minor arts, have until now been completely dependent upon the conditions set down by the structure of the house: one need only imagine a canvas without a flat wall and the cubic enframement of the room, a chair on an irregular floor ... Artists for at least a century have worked as though the only thing of importance were the work in front of them, a world unto itself. [...] But I am saying that it is important to recognize very clearly how deeply involved with each other on a primary level the plastic arts have been. Once you change the conditions for one, you

imply a conflict (a contrast at least, which is enough to call attention to the change) in the other. And these conditions are without any doubt changing now.

* * *

[...] In short, contemporary art has moved out of its traditional limits. Painting, which has been without question the most advanced and experimental of the plastic arts, has over and over provoked the question, 'Should the format or field always be the closed, flat rectangle?' by utilizing gestures, scribblings, large scales with no frame, which suggest to the observer that both the physical and metaphysical substance of the work continue indefinitely in all directions beyond the canvas...

More recently, a large body of diverse compositions referred to as Combines (Robert Rauschenberg's name for his own work), Neo-Dada, or Assemblage employs a variety of materials and objects in an equally varied range of formats, completely departing from the accepted norms required by 'painting' as we have known it. But this has brought sharply into focus the fact that *the room has always been a frame or format too*, and that this shape is inconsistent with the forms and expression emerging from the work in question.

Of course, some artists find a positive value in this contradiction and make use of it, as another generation (Pollock's, for example) used the confines of the canvas as the only limit to an intrinsically limitless form; much the same is true in jazz, whose beat is the constant which defines the degree of freedom achieved in improvisation. These relatively unchanging factors are felt to be a kind of home base. Yet this may be temporary, a transitional value for today, since a number of younger artists do not find such methods acceptable any longer; they feel them to be excess baggage at least, which often involves needless discords with the past, in which these methods originated. If there are to be measures and limits in art they must be of a new kind. Rather than fight against the confines of a typical room, many are actively considering working out in the open. They cannot wait for the new architecture.

It should be evident from the foregoing that this suggests a crisis of sorts. Quite apart from the aesthetic re-evaluation it forces upon us, its immediate practical effect is to render the customary gallery situation obsolete. [...]

* * *

The evolution of this art is bringing us to a quite different notion of what art is. With the emergence of the picture shop and museum in the last two centuries as a direct consequence of art's separation from society, art came to mean a dream world, cut off from real life and capable of only indirect reference to the existence most people knew. The gallery and museum crystallized this idea by insisting upon a 'shshsh — don't touch' atmosphere. Traditionally, it is supposed that art is born entirely from the heart or head and is then brought, all shiny and finished, to the showplace. Now, however, it is less and less conceived that way and is instead drawing its substance, appearances, and enthusiasms from the common world as we know it; and this, without any doubt, is a hint of how vestigial the gallery-museum situation is. With such a form as the Environment it is patently absurd to conceive it in a studio and then try to fit it into an exhibition hall. And it is even more absurd to think that since the work looks better in the studio because it was conceived there, that is the best and only place for it. The romance of the atelier, like that of the gallery and museum, will probably disappear in time. But meanwhile, the rest of the world has become endlessly available.

Environments are generally quiet situations, existing for one or for several persons to walk or crawl into, lie down, or sit in. One looks, sometimes listens, eats, drinks, or rearranges the elements as though moving household objects around. Other Environments ask that the visitor–participant recreate and continue the work's inherent processes. For human beings at least, all of these characteristics suggest a somewhat thoughtful and meditative demeanor.

Though the Environments are free with respect to media and appeals to the senses, the chief accents to date have been visual, tactile, and manipulative. Time (compared with space), sound (compared with tangible objects), and the physical presence of people (compared with the physical surroundings), tend to be subordinate elements. Suppose, however, one wanted to amplify the potentialities of these subordinates. The objective would be a unified field of components in which all were theoretically equivalent and sometimes exactly equal. It would require scoring the components more conscientiously into the work, giving people more responsibility, and the inanimate parts roles more in keeping with the whole. Time would be variously weighted, compressed, or drawn out, sounds would emerge forthrightly, and things would have to be set into greater motion. The event which has done this is increasingly called a 'Happening.'

Fundamentally, Environments and Happenings are similar. They are the passive and active sides of a single coin, whose principle is *extension*. Thus an Environment is not *less* than a Happening. It is not a movie set which has not yet seen action (like the blank canvas-arena of the 'action' painter). It is quite sufficient in its quieter mode even though, in the point of evolution, the Happening grew out of it. [. . .]

* * *

Although the Assemblages' and Environments' free style was directly carried into the Happenings, the use of standard performance conventions from the very start tended to truncate the implications of the art. The Happenings were presented to small, intimate gatherings of people in lofts, classrooms, gymnasiums, and some of the offbeat galleries, where a clearing was made for the activities. The watchers sat very close to what took place, with the artists and their friends acting along with assembled environmental constructions. The audience occasionally changed seats as in a game of musical chairs, turned around to see something behind it, or stood without seats in tight but informal clusters. Sometimes, too, the event moved in and amongst the crowd, which produced some movement on the latter's part. But, however flexible these techniques were in practice, there was always an audience in one (usually static) space and a show given in another.

This proved to be a serious drawback, in my opinion, to the plastic morphology of the works. [. . .]

Unfortunately, the fact that there was a tough nut to crack in the Happenings seems to have struck very few of its practitioners. Even today, the majority continues to popularize an art of 'acts' which often is well-done enough but fulfills neither its implications nor strikes out in uncharted territory.

But for those who sensed what was at stake, the issues began to appear. It would take a number of years to work them out by trial and error, for there is sometimes, though not always, a great gap between theory and production. But gradually a number of rules-of-thumb could be listed:

A *The line between art and life should be kept as fluid, and perhaps indistinct, as possible.* The reciprocity between the man made and the ready-made will be at its maximum potential this way. Something will always happen at this juncture, which, if it is not revelatory, will not be merely bad art — for no one can easily compare it with this or that accepted masterpiece. I would judge this a foundation upon which may be built the specific criteria of the Happenings ...

B *Therefore, the source of themes, materials, actions, and the relationships between them are to be derived from any place or period* except *from the arts, their derivatives, and their milieu.* When innovations are taking place it often becomes necessary for those involved to treat their tasks with considerable severity. In order to keep their eyes fixed solely upon the essential problem, they will decide that there are certain 'don'ts' which, as self-imposed rules, they will obey unswervingly. [...] Artistic attachments are still so many window dressings, unconsciously held on to to legitimize an art that otherwise might go unrecognized.

Thus it is not that the known arts are 'bad' that causes me to say 'Don't get near them'; it is that they contain highly sophisticated habits. By avoiding the artistic modes there is the good chance that a new language will develop that has its own standards. The Happening is conceived as an art, certainly, but this is for lack of a better word, or one that would not cause endless discussion. I, personally, would not care if it were called a sport. But if it is going to be thought of in the context of art and artists, then let it be a distinct art which finds its way into the art category by realizing its species outside of 'culture.' A United States Marine Corps manual on jungle-fighting tactics, a tour of a laboratory where polyethylene kidneys are made, the daily traffic jams on the Long Island Expressway, are more useful than Beethoven, Racine, or Michelangelo.

C *The performance of a Happening should take place over several widely spaced, sometimes moving and changing locales.* A single performance space tends toward the static and, more significantly, resembles conventional theater practice. It is also like painting, for safety's sake, only in the center of a canvas. Later on, when we are used to a fluid space as painting has been for almost a century, we can return to concentrated areas, because then they will not be considered exclusive. It is presently advantageous to experiment by gradually widening the distances between the events within a Happening. First along several points on a heavily trafficked avenue; then in several rooms and floors of an apartment house where some of the activities are out of touch with each other; then on more than one street; then in different but proximate cities; finally all around the globe. On the one hand, this will increase the tension between the parts, as a poet might by stretching the rhyme from two lines to ten. On the other, it permits the parts to exist more on their own, without the necessity of intensive coordination. Relationships cannot help being made and perceived in any human action, and here they may be of a new kind if tried-and-true methods are given up.

Even greater flexibility can be gotten by moving the locale itself [...]

D *Time, which follows closely on space considerations, should be variable and discontinuous.* It is only natural that if there are multiple spaces in which occurrences are scheduled, in sequence or even at random, time or 'pacing' will acquire an order that is determined more by the character of movements within environments than by a fixed

concept of regular development and conclusion. There need be no rhythmic coordination between the several parts of a Happening unless it is suggested by the event itself: such as when two persons must meet at a train departing at 5:47 P.M.

Above all, this is 'real' or 'experienced' time as distinct from conceptual time. If it conforms to the clock used in the Happening, as above, that is legitimate, but if it does not because a clock is not needed, that is equally legitimate. All of us know how, when we are busy, time accelerates, and how, conversely, when we are bored it can drag almost to a standstill. Real time is always connected with doing something, with an event of some kind, and so is bound up with things and spaces. [. . .]

Feeling this, why shouldn't an artist program a Happening over the course of several days, months, or years, slipping it in and out of the performers' daily lives? There is nothing esoteric in such a proposition, and it may have the distinct advantage of bringing into focus those things one ordinarily does every day without paying attention — like brushing one's teeth.

On the other hand, leaving taste and preference aside and relying solely on chance operations, a completely unforeseen schedule of events could result, not merely in the preparation but in the actual performance; or a simultaneously performed single moment; or none at all. (As for the last, the act of finding this out would become, by default, the 'Happening.')

But an endless activity could also be decided upon, which would apparently transcend palpable time — such as the slow decomposition of a mountain of sandstone. . . . In this spirit some artists are earnestly proposing a lifetime Happening . . .

The common function of these alternatives is to release an artist from conventional notions of a detached, closed arrangement of time-space. A picture, a piece of music, a poem, a drama, each confined within its respective frame, fixed number of measures, stanzas, and stages, however great they may be in their own right, simply will not allow for breaking the barrier between art and life. And this is what the objective is.

E *Happenings should be performed once only*. At least for the time being, this restriction hardly needs emphasis, since it is in most cases the only course possible. Whether due to chance, or to the lifespan of the materials (especially the perishable ones), or to the changeableness of the events, it is highly unlikely that a Happening of the type I am outlining could ever be repeated. Yet many of the Happenings have, in fact, been given four or five times, ostensibly to accommodate larger attendances, but this, I believe, was only a rationalization of the wish to hold on to theatrical customs. In my experience, I found the practice inadequate because I was always forced to do that which *could be repeated*, and had to discard countless situations which I felt were marvelous but performable only once. Aside from the fact that repetition is boring to a generation brought up on ideas of spontaneity and originality, to repeat a Happening at this time is to accede to a far more serious matter: compromise of the whole concept of Change. When the practical requirements of a situation serve only to kill what an artist has set out to do, then this is not a practical problem at all; one would be very practical to leave it for something else more liberating. [. . .]

In the near future, plans may be developed which take their cue from games and athletics, where the regulations provide for a variety of moves that make the outcome always uncertain. A score might be written, so general in its instructions that it could be adapted to basic types of terrain such as oceans, woods, cities, farms, and to basic kinds

of performers such as teenagers, old people, children, matrons, and so on, including insects, animals, and the weather. This could be printed and mail-ordered for use by anyone who wanted it. [...]

F *It follows that audiences should be eliminated entirely.* All the elements – people, space, the particular materials and character of the environment, time – can in this way be integrated.

* * *

[...] This short essay has been in one sense an account of an avant-garde. It has also been an analysis of a world view. It has proceeded on the assumption that at present any avant-garde art is primarily a philosophical quest and a finding of truths, rather than purely an aesthetic activity; for this latter is possible, if at all, only in a relatively stable age when most human beings can agree upon fundamental notions of the nature of the universe. If it is a truism that ours is a period of extraordinary and rapid change, with its attendant surprises and sufferings, it is no less true that in such a day all serious thought (discursive or otherwise) must try to find in it a pattern of sense. In its own fashion a truly modern art does just that.

Thus, for us now, the idea of a 'perfect work of art' is not only irrelevant because we do not know what are the conditions for such a phantasm, but it is, if desired, presumptuous and unreal. Though great works are surely possible and may be looked forward to, it is in the sense that they may be moments of profound vision into the workings of things, an imitation of life, so to speak, rather than artistic tours de force, i.e., cosmetics.

I have focused upon this concept of the real, suggesting a course of action in art that is related to what is likely our experience today, as distinct from what are our habits from the past. I have considered important those aspects of art which have been consciously intended to replace habit with the spirit of exploration and experiment. If some of the past is still meaningful, as it assuredly is, then what is to be retained in the present work is not archaistic mannerisms, easily recognized and praised for this reason, but those qualities of personal dignity and freedom always championed in the West. In respecting these, the ideas of this book are deeply traditional.

8 Piero Manzoni (1933–1963) 'Free Dimension'

By the end of the 1950s a disparate series of currents had emerged in the international avant-garde. In America, Japan, England and throughout Europe various younger artists were becoming critical of the conventional division of the arts, principally of what were seen as the restrictions and growing irrelevance of painting. What painting was held to be irrelevant to was the experience of the modern world. The anguished individualism of the post-war period was being replaced by a consciousness of, and frequently an anarchic alienation from, the new norm of the consumer society which was being rapidly established by the post-war economic boom. The resulting artistic stance frequently involved the re-appropriation of Dada strategies which had been occluded by decades of struggle against Fascism, a linked commitment to Communism, and resistance to the dominance of a Modernist mainstream focused on painting. Manzoni was one of the younger artists interested by

Fontana's work (see VC8). In 1957 he exhibited the first of his *Achromes*, monochromatic white paintings made by dipping canvas in kaolin. He also drew *Lines* of varying lengths on long rolls of paper, and in 1960 exhibited containers for *Bodies of Air*. His text instances the emergence of an anti-conventionalist tendency in Italy. It was originally issued on 4 January 1960 at the Galerie Azimut, Milan, of which he was a founder. It is reprinted in the exhibition catalogue *Identité Italienne*, Paris: Centre Pompidou, 1981, p. 46, from which the present translation is made.

New conditions and problems imply different methods and standards and the necessity of finding original solutions. One cannot leave the ground just by running and jumping: one needs wings. Changes are not sufficient; the transformations must be total.

This is why I do not understand painters who, whilst declaring themselves receptive to contemporary problems, still stand in front of a canvas as if it were a surface needing to be filled in with colours and forms, in a more or less personalized and conventional style. They draw a line, step back, stare complacently at their work with their head to one side, closing one eye. They approach it once again, draw another line, apply another stroke. This exercise continues until the canvas is covered: the painting is complete. A surface with limitless possibilities has been reduced to a sort of receptacle in which inauthentic colours, artificial expressions, press against each other. Why not empty the receptacle, liberate this surface? Why not try to make the limitless sense of total space, of a pure and absolute light, appear instead?

To suggest, to express, to represent: these are not problems today. I wrote about this some years ago; whether or not a painting is a representation of an object, of a fact, of an idea, or of a dynamic phenomenon, it is uniquely valuable in itself. It does not have to say anything, it only has to be. Two matched colours, or two tones of the same colour are already an alien element in the concept of a single, limitless, totally dynamic surface. Infinity is strictly monochromatic, or better still, colourless. Strictly speaking, does not a monochrome, in the absence of all rapport between colours, eventually become colourless?

The artistic problematic which has recourse to composition, to form, is deprived of all value; in total space, form, colour and dimensions have no sense. Here, the artist has achieved total freedom: pure matter is transformed into pure energy. Blue on blue or white on white to compose or to express oneself; both obstacles of space, and subjective reactions cease to exist; the entire artistic problematic is surpassed.

This is why I cannot understand artists of today who scrupulously fix the limits in which they place forms and colours, according to a rigorous balance. Why worry about the position of a line in space? Why determine this space? Why limit it? The composition of forms, their position in space, spatial depth, are all problems that do not concern us. A line can only be drawn, however, long, to the infinite; beyond all problems of composition or of dimensions. There are no dimensions in total space.

Furthermore, the questions concerning colour, chromatic relations (even if this only involves nuances) are shown to be useless. We can only open out a single colour or present a continuous and uninterrupted surface (excluding all interference of the superfluous, all possibility of interpretation). It is not a question of painting the contrary of everything. My intention is to present a completely white surface (or better still, an absolutely colourless or neutral one) beyond all pictorial phenomena, all

intervention alien to the sense of the surface. A white surface which is neither a polar landscape, nor an evocative or beautiful subject, nor even a sensation, a symbol or anything else: but a white surface which is nothing other than a colourless surface, or even a surface which quite simply 'is'. Being (the total being which is pure Becoming).

This undefined surface, uniquely living, which in the material contingency of the work cannot be infinite, can on the other hand be multiplied to the infinite, without the solution of continuity.

This appears more clearly in the *Lines*; in this case, no doubt remains. The line develops in length uniquely, to the infinite. Its only dimension is time. It goes without saying that a *line* is neither a horizon nor a symbol and its value is not linked to the fact that it is more or less beautiful, but rather to the fact that it is a line, that it exists, like a work which counts for what it is and not for its beauty or for what it evokes. But in this case the surface only retains its value as a vehicle. The same is true of the *Bodies of Air* (pneumatic sculptures) that one can let down or fill at leisure (from nothingness to the infinite); they are absolutely undefined spheres, because all intervention destined to give them a form (even formlessness) is illegitimate and illogical.

There is no question of forming, articulating; one cannot have recourse to complicated, parascientific solutions, to graphic compositions, to ethnographic fantasies, etc. Each discipline possesses in itself elements of solution. Expression, imagination, abstraction, are they not in themselves empty inventions? There is nothing to explain: just be, and live.

9 Pierre Restany (b. 1930) 'The New Realists'

The group 'Nouveau Réalisme' was formed in Paris on 27 October 1960 on the basis of a manifesto written the previous April by the critic Restany. Original members included Yves Klein (see VIIA1), who functioned as leader of the group, Arman, Daniel Spoerri and Jean Tinguely; Niki de Saint Phalle, César and Christo joined later. Their aim was to overcome the so-called 'gap between art and life' by dealing directly with reality. This 'reality' was principally the world of modern consumption and the mass media. The main areas of their practice included Action-spectacle, involving performances and Happening-like activities; *décollage*, involving the manipulation of torn advertising posters; and *assemblage*, involving the fixing and subsequent display of items randomly chosen from the world, such as all the items on a table at a given moment. The manifesto was originally issued on 16 April 1960 at the Galerie Apollinaire, Milan. It is reproduced in the catalogue *Identité Italienne* (op. cit.), p. 51, from which the present translation is made.

It is in vain that sober academics or honest people alarmed by the acceleration of the history of art, and the extraordinary debilitation of our modern period, have tried to stop the sun or to suspend the advance of time by following the opposite direction to that taken by the hands of a watch.

We are witnessing today the exhaustion and the ossification of all established vocabularies, of all languages, of all styles. Because of this deficiency – through exhaustion – of traditional means, individual initiatives, still scattered in Europe and America, confront each other; but they all tend, no matter what the range of their investigations, to define the normative bases of a new expressivity.

It is not just another formula in the medium of oil or enamel. Easel painting (like every other type of classical means of expression in the domain of painting or sculpture) has had its day. At the moment it lives on in the last remnants, still sometimes sublime, of its long monopoly.

What do we propose instead? The passionate adventure of the real perceived in itself and not through the prism of conceptual or imaginative transcription. What is its mark? The introduction of a sociological continuation of the essential phase of com-munication. Sociology comes to the assistance of consciousness and of chance, whether this be at the level of choice or of the tearing up of posters, of the allure of an object, of the household rubbish or the scraps of the dining-room, of the unleashing of mechanical susceptibility, of the diffusion of sensibility beyond the limits of its perception.

All of these initiatives (there are some, and there will be others) abolish the excessive distance created by categorical understanding between general, objective contingency and urgent individual expression. It is sociological reality in its entirety, the common good of all human activity, the great republic of our social exchanges, of our commerce in society, which is called to appear. Its artistic vocation must leave no doubt, if there are so many people who believe in the eternal immanence of allegedly noble genres and of painting in particular. At the stage, most essential in its urgency, of full affective expression and of the externalization of the individual creator, and through the naturally Baroque appearances of certain experiences, we are on the way to a new realism of pure sensibility. There, to say the least, is one of the paths of the future. With Yves Klein and Tinguely, Hains and Arman, Dufrêne and Villeglé, very diverse beginnings are thus poised around Paris. The ferment will be rich, still unknown in its full consequences, certainly iconoclastic (in consequence of the fault of icons and the stupidity of their admirers).

We are thus bathed in direct expressivity up to our necks, at forty degrees above the Dada zero, without aggressiveness, without a downright polemical intent, without any other justificatory itch than our realism. And that works positively. Man, if he shares in reintegrating himself in reality, identifies it with his own transcendence, which is emotion, feeling and finally, once again, poetry.

10 GRAV (Groupe de Recherche d'Art Visuel) 'Transforming the Current Situation of Plastic Art'

The 'Visual Art Research Group' consisted of six principal members, although there were eleven signatories to the group's manifesto. Of these six, the most prominent were the Argentinian artist Julio Le Parc and Yvaral (Jean–Pierre Vasarely). The latter was the son of the abstract-kinetic painter Victor Vasarely, a significant formative influence on GRAV by virtue of his commitment to collective activity and his critique of the idea of the individual artistic genius. The group was formed in Paris in July 1960, and disbanded in November 1968. The group held their first joint exhibition in 1961, on which occasion they published the pamphlet *Enough Mystification*. The present text, composed in October 1961, was issued to accompany the GRAV exhibition at the Maison des Beaux-Arts in Paris in the summer of 1962. The text was translated from the French by Davida Fineman. This translation was published in Jack Burnham, *Beyond Modern Sculpture* (London, 1968),

pp. 265–6, and subsequently reprinted in the exhibition catalogue *Force Fields. Phases of the Kinetic*, London: Hayward Gallery, 2000, pp. 265–6. It is reproduced here in full.

The Groupe de Recherche d'Art Visuel invites you to demystify the artistic phenomenon, to pool your activities so as to clarify the situation, and to set up new ground rules for appraisal. The Groupe de Recherche d'Art Visuel is made up of painters who are committing their activities to ongoing research and the visual production of primary basic data aimed at freeing plastic art from tradition. The Groupe de Recherche d'Art Visuel thinks it is helpful to offer its viewpoint, even though this viewpoint is not definitive and calls for subsequent analysis and other comparisons.

General Propositions of the 'Group for Research in the Visual Arts' (1961)
Relationship of the artist with society
This relationship is presently based upon:
The unique and isolated artist
The cult of the personality
The myth of creation
The overestimation of aesthetic and anti-aesthetic conceptions
Elaboration for the elite
The production of unique works of art
The dependence of art on the marketplace

Propositions to transform this relationship:
To strip the conception and the realization of works of art of all mystification and to reduce them to simple human activity
To seek new means of public contact with the works produced
To eliminate the category 'Work of Art' and its myths
To develop new appreciations
To create reproducible works
To seek new categories of realization beyond painting and sculpture
To liberate the public from the inhibitions and warping of appreciation produced by traditional aestheticism, by creating a new social-artistic situation

Relationship of the work to the eye
This relationship is presently based upon:
The eye considered as an intermediary
Extra-visual attractions (subjective or rational)
The dependence of the eye on a cultural and aesthetic level

Propositions to transform this relationship:
To totally eliminate the intrinsic values of the stable and recognizable form be it:
Form idealizing nature (classic art)
Form representing nature (naturalistic art)
Form synthesizing nature (cubist art)
Geometrizing form (constructivist art)
Rationalized form (concrete art)
Free form (informal art, tachism, etc.)

To eliminate the arbitrary relationships between forms (relationships of dimension, placement, colour, meanings, depths, etc.)

To displace the habitual function of the eye (taking cognizance through form and its relationships) toward a new visual situation based on peripheral vision and instability

To create an appreciation-time based on the relation of the eye and the work transforming the usual quality of time

Traditional plastic values
These values are presently based on the work which is:
unique
stable
definitive
subjective
obedient to aesthetic or anti-aesthetic laws

Propositions to transform these values:
To limit the work to a strictly visual situation
To establish a more precise relationship between the work and the human eye
Anonymity and homogeneity of form and relationships between forms
To stress visual instability and perception time
To search for a nondefinitive work which at the same time is exact, precise, and desired
To direct interest toward new variable visual situations based on constant results of the eye–art rapport
To state the existence of indeterminate phenomena in the structure and visual reality of the work, and from there to conceive of new possibilities which will open up a new field of investigation

11 George Maciunas (1931–1978) 'Neo-Dada in Music, Theater, Poetry, Art'

The loosely organized Fluxus group emerged in New York in 1961. Maciunas was a leading figure and was active also in Germany, where he was stationed for some time as a designer with the USAF. Fluxus embraced an international group of artists including George Brecht, Yoko Ono, Ben Vautier, Nam June Paik, LaMonte Young and Robert Morris. John Cage was an important influence, as were his associates Robert Rauschenberg and Merce Cunningham. In Germany the group's activities had a major impact on Joseph Beuys. Fluxus work took a variety of forms including music, dance, poetry, performance, film, publications, multiples and posters. The dominant impulse, as stated in the present manifesto, was a belief in the artificiality of the separation between life and art, and in the need to overcome that separation. The name Fluxus was meant to express this impulse, with its connotations of flow, fusion, etc. Elsewhere, in a short manifesto of 1963, Maciunas wrote of the need to: 'Purge the world of bourgeois sickness, "intellectual", professional & commercialized culture, Purge the world of dead art, imitation, artificial art, abstract art, illusionistic art, mathematical art, – Purge the world of Europeanism!' Instead, Maciunas advocated: 'Promote a revolutionary flood and tide in art, Promote living art, anti-art, promote Non-Art Reality to be grasped by all peoples, not only critics, dilettantes and professionals. FUSE the

cadres of cultural, social and political revolutionaries into united front and action.' The present manifesto was written for the Fluxus concert, 'Après John Cage', given in Wiesbaden, 9 June 1962. It is reprinted in full from the microfilm copy held by the Archiv Sohm, Staatsgalerie, Stuttgart.

Neo-dada, its equivalent, or what appears to be neo-dada manifests itself in very wide fields of creativity. It ranges from 'time' arts to 'space' arts; or more specifically from literary arts (time-art), through graphic-literature (time-space-art) to graphics (space-arts) through graphic-music (space-time-arts) to graphless or scoreless music (time-art), through theatrical music (space-time-art) to environments (space-arts). There exist no borderlines between one and the other extreme. Many works belong to several categories and also many artists create separate works in each category. Almost each category and each artist, however, is bound with the concept of Concretism ranging in intensity from pseudo concretism, surface concretism, structural concretism, method concretism (indeterminacy systems), to the extreme of concretism, which is beyond the limits of art, and therefore sometimes referred to as anti-art, or art-nihilism. The new activities of the artists therefore could be charted by reference to two coordinates: the horizontal coordinate defining transition from 'time' arts to 'space' arts and back to 'time' and 'space' etc., and the vertical coordinate defining transition from extremely artificial art, illusionistic art, then abstract art (not within the subject of this essay), to mild concretism, which becomes more and more concrete, or rather nonartificial till it becomes non-art, anti-art, nature, reality.

Concretists in contrast to illusionists prefer unity of form and content, rather than their separation. They prefer the world of concrete reality rather than the artificial abstraction of illusionism. Thus in plastic arts for instance, a concretist perceives and expresses a rotten tomato without changing its reality or form. In the end, the form and expression remain [the] same as the content and perception – the reality of rotten tomato, rather than an illusionistic image or symbol of it. In music a concretist perceives and expresses the material sound with all its inherent polychromy and pitchlessness and 'incidentalness', rather than the immaterial abstracted and artificial sound of pure pitch or rather controlled tones denuded of its pitch obliterating overtones. A material or concrete sound is considered one that has close affinity to the sound-producing material – thus a sound whose overtone pattern and the resultant polychromy clearly indicates the nature of material or concrete reality producing it. Thus a note sounded on a piano keyboard or a bel-canto voice is largely immaterial, abstract and artificial since the sound does not clearly indicate its true source or material reality – common action of string, wood, metal, felt, voice, lips, tongue, mouth etc. A sound, for instance, produced by striking the same piano itself with a hammer or kicking its underside is more material and concrete since it indicates in a much clearer manner the hardness of hammer, hollowness of piano sound box and resonance of string. Human speech or eating sounds are likewise more concrete for the same reason of source recognisability. These concrete sounds are commonly, although inaccurately, referred to as noises. They may be pitchless to a large extent, but their pitchlessness makes them polychromic, since the intensity of acoustic color depends directly on pitch-obliterating inharmonic overtones.

Further departure from [the] artificial world of abstraction is affected by the concept of indeterminacy and improvisation. Since artificiality implies human pre-determin-

ation, contrivance, a truer concretist rejects pre-determination of final form in order to perceive the reality of nature, the course of which, like that of man himself is largely indeterminate and unpredictable. Thus an indeterminate composition approaches greater concretism by allowing nature [to] complete its form in its own course. This requires the composition to provide a kind of framework, an 'automatic machine' within which or by which, nature (either in the form of an independent performer or indeterminate-chance compositional methods) can complete the art-form, effectively and independently of the artist-composer. Thus the primary contribution of a truly concrete artist consists in creating a *concept* or a *method* by which form can be created independently of him, rather than the form or structure. Like a mathematical solution such a composition contains: beauty in the method alone.

The furthest step towards concretism is of course a kind of art-nihilism. This concept opposes and rejects art itself since the very meaning of it implies artificiality whether in creation of form or method. To approach closer affinity with concrete reality and its closer understanding, the art-nihilist or anti-artists (they usually deny those definitions) either creates 'anti-art' or exercises nothingness. The 'anti-art' forms are directed primarily against art as a profession, against the artificial separation of a performer from [the] audience, or creator and spectator, of life and art; it is against the artificial forms or patterns or methods of art itself; it is against the purposefulness, formfulness and meaningfulness of art; anti-art is life, is nature, is true reality – it is one and all. Rainfall is anti-art, a babble of a crowd is anti-art, a sneeze is anti-art, a flight of a butterfly, or movements of microbes are anti-art. They are as beautiful and as worth to be aware of as art itself. If man could experience the world, the concrete world surrounding him, (from mathematical ideas to physical matter) in the same way he experiences art, there would be no need for art, artists and similar 'nonproductive' elements.

12 Raymond Williams (1921–1988) 'The Analysis of Culture'

Williams's intellectual origins were twofold. He embodied the characteristic left-wing interest in popular culture rather than merely the canon of high culture. But because of the crippling limitations on Marxist cultural theory after the years of Stalin, Williams's methods were initially drawn more from the academic literary–critical tradition of F. R. Leavis and the journal *Scrutiny*. These interests were amalgamated in two innovatory works of the late 1950s/early 1960s: *Culture and Society* and *The Long Revolution*. Williams's central contribution was to reorientate the concept of 'culture' away from its specialized, even elitist connotation as an index of aesthetic quality, towards a definition of culture as something lived, as a 'whole way of life'. The present extracts are taken from Part 1 of chapter 2 of *The Long Revolution*, London, 1961, pp. 57–70. (See also VIID14 and VIIIB7.)

There are three general categories in the definition of culture. There is, first, the 'ideal', in which culture is a state or process of human perfection, in terms of certain absolute or universal values. The analysis of culture, if such a definition is accepted, is essentially the discovery and description, in lives and works, of those values which can be seen to compose a timeless order, or to have permanent reference to the universal human condition. Then, second, there is the 'documentary', in which culture is the

body of intellectual and imaginative work, in which, in a detailed way, human thought and experience are variously recorded. The analysis of culture, from such a definition, is the activity of criticism, by which the nature of the thought and experience, the details of the language, form and convention in which these are active, are described and valued. Such criticism can range from a process very similar to the 'ideal' analysis, the discovery of 'the best that has been thought and written in the world', through a process which, while interested in tradition, takes as its primary emphasis the particular work being studied (its clarification and valuation being the principal end in view) to a kind of historical criticism which, after analysis of particular works, seeks to relate them to the particular traditions and societies in which they appeared. Finally, third, there is the 'social' definition of culture, in which culture is a description of a particular way of life, which expresses certain meanings and values not only in art and learning but also in institutions and ordinary behaviour. The analysis of culture, from such a definition, is the clarification of the meanings and values implicit and explicit in a particular way of life, a particular culture. Such analysis will include the historical criticism already referred to, in which intellectual and imaginative works are analysed in relation to particular traditions and societies, but will also include analysis of elements in the way of life that to followers of the other definitions are not 'culture' at all: the organization of production, the structure of the family, the structure of institutions which express or govern social relationships, the characteristic forms through which members of the society communicate. Again, such analysis ranges from an 'ideal' emphasis, the discovery of certain absolute or universal, or at least higher and lower, meanings and values, through the 'documentary' emphasis, in which clarification of a particular way of life is the main end in view, to an emphasis which, from studying particular meanings and values, seeks not so much to compare these, as a way of establishing a scale, but by studying their modes of change to discover certain general 'laws' or 'trends', by which social and cultural development as a whole can be better understood. [. . .]

The variations of meaning and reference, in the use of culture as a term, must be seen . . . not simply as a disadvantage, which prevents any kind of neat and exclusive definition, but as a genuine complexity, corresponding to real elements in experience. There is a significant reference in each of the three main kinds of definition, and, if this is so, it is the relations between them that should claim our attention. It seems to me that any adequate theory of culture must include the three areas of fact to which the definitions point, and conversely that any particular definition, within any of the categories, which would exclude reference to the others, is inadequate. Thus an 'ideal' definition which attempts to abstract the process it describes from its detailed embodiment and shaping by particular societies – regarding man's ideal development as something separate from and even opposed to his 'animal nature' or the satisfaction of material needs – seems to me unacceptable. A 'documentary' definition which sees value only in the written and painted records, and marks this area off from the rest of man's life in society, is equally unacceptable. Again, a 'social' definition, which treats either the general process or the body of art and learning as a mere by-product, a passive reflection of the real interests of the society, seems to me equally wrong. However difficult it may be in practice, we have to try to see the process as a whole, and to relate our particular studies, if not explicitly at least by ultimate reference, to the actual and complex organization.

[...] If we study real relations, in any actual analysis, we reach the point where we see that we are studying a general organization in a particular example, and in this general organization there is no element that we can abstract and separate from the rest. It was certainly an error to suppose that values or art-works could be adequately studied without reference to the particular society within which they were expressed, but it is equally an error to suppose that the social explanation is determining, or that the values and works are mere by-products. We have got into the habit, since we realized how deeply works or values could be determined by the whole situation in which they are expressed, of asking about these relationships in a standard form: 'what is the relation of this art to this society?' But 'society', in this question, is a specious whole. If the art is part of the society, there is no solid whole, outside it, to which, by the form of our question, we concede priority. The art is there, as an activity, with the production, the trading, the politics, the raising of families. To study the relations adequately we must study them actively, seeing all the activities as particular and contemporary forms of human energy. If we take any one of these activities, we can see how many of the others are reflected in it, in various ways according to the nature of the whole organization. It seems likely, also, that the very fact that we can distinguish any particular activity, as serving certain specific ends, suggests that without this activity the whole of the human organization at that place and time could not have been realized. Thus art, while clearly related to the other activities, can be seen as expressing certain elements in the organization which, within that organization's terms, could only have been expressed in this way. It is then not a question of relating the art to the society, but of studying all the activities and their interrelations, without any concession of priority to any one of them we may choose to abstract. If we find, as often, that a particular activity came radically to change the whole organization, we can still not say that it is to this activity that all the others must be related; we can only study the varying ways in which, within the changing organization, the particular activities and their interrelations were affected. Further, since the particular activities will be serving varying and sometimes conflicting ends, the sort of change we must look for will rarely be of a simple kind: elements of persistence, adjustment, unconscious assimilation, active resistance, alternative effort, will all normally be present, in particular activities and in the whole organization.

The analysis of culture, in the documentary sense, is of great importance because it can yield specific evidence about the whole organization within which it was expressed. We cannot say that we know a particular form or period of society, and that we will see how its art and theory relate to it, for until we know these, we cannot really claim to know the society. This is a problem of method, and is mentioned here because a good deal of history has in fact been written on the assumption that the bases of the society, its political, economic, and 'social' arrangements, form the central core of facts, after which the art and theory can be adduced, for marginal illustration or 'correlation'. There has been a neat reversal of this procedure in the histories of literature, art, science, and philosophy, when these are described as developing by their own laws, and then something called the 'background' (what in general history was the central core) is sketched in. Obviously it is necessary, in exposition, to select certain activities for emphasis, and it is entirely reasonable to trace particular lines of development in temporary isolation. But the history of a culture, slowly built up from such particular work, can only be written when the active relations are restored, and the activities seen

in a genuine parity. Cultural history must be more than the sum of the particular histories, for it is with the relations between them, the particular forms of the whole organization, that it is especially concerned. I would then define the theory of culture as the study of relationships between elements in a whole way of life. The analysis of culture is the attempt to discover the nature of the organization which is the complex of these relationships. Analysis of particular works or institutions is, in this context, analysis of their essential kind of organization, the relationships which works or institutions embody as parts of the organization as a whole. A key-word, in such analysis, is pattern: it is with the discovery of patterns of a characteristic kind that any useful cultural analysis begins, and it is with the relationships between these patterns, which sometimes reveal unexpected identities and correspondences in hitherto separately considered activities, sometimes again reveal discontinuities of an unexpected kind, that general cultural analysis is concerned.

It is only in our own time and place that we can expect to know, in any substantial way, the general organization. We can learn a great deal of the life of other places and times, but certain elements, it seems to me, will always be irrecoverable. Even those that can be recovered are recovered in abstraction, and this is of crucial importance. We learn each element as a precipitate, but in the living experience of the time every element was in solution, an inseparable part of a complex whole. The most difficult thing to get hold of, in studying any past period, is this felt sense of the quality of life at a particular place and time: a sense of the ways in which the particular activities combined into a way of thinking and living. [...] Almost any formal description would be too crude to express this nevertheless quite distinct sense of a particular and native style. And if this is so, in a way of life we know intimately, it will surely be so when we ourselves are in the position of the visitor, the learner, the guest from a different generation: the position, in fact, that we are all in, when we study any past period. Though it can be turned to trivial account, the fact of such a characteristic is neither trivial nor marginal; it feels quite central.

The term I would suggest to describe it is *structure of feeling*: it is as firm and definite as 'structure' suggests, yet it operates in the most delicate and least tangible parts of our activity. In one sense, this structure of feeling is the culture of a period: it is the particular living result of all the elements in the general organization. And it is in this respect that the arts of a period, taking these to include characteristic approaches and tones in argument, are of major importance. For here, if anywhere, this characteristic is likely to be expressed; often not consciously, but by the fact that here, in the only examples we have of recorded communication that outlives its bearers, the actual living sense, the deep community that makes the communication possible, is naturally drawn upon. I do not mean that the structure of feeling, any more than the social character, is possessed in the same way by the many individuals in the community. But I think it is a very deep and very wide possession, in all actual communities, precisely because it is on it that communication depends. And what is particularly interesting is that it does not seem to be, in any formal sense, learned. One generation may train its successor, with reasonable success, in the social character or the general cultural pattern, but the new generation will have its own structure of feeling, which will not appear to have come 'from' anywhere. For here, most distinctly, the changing organization is enacted in the organism: the new generation responds in its own ways to the unique world it is inheriting, taking up many continuities, that can be traced, and reproducing many

aspects of the organization, which can be separately described, yet feeling its whole life in certain ways differently, and shaping its creative response into a new structure of feeling.

Once the carriers of such a structure die, the nearest we can get to this vital element is in the documentary culture, from poems to buildings and dress-fashions, and it is this relation that gives significance to the definition of culture in documentary terms. This in no way means that the documents are autonomous. It is simply that, as previously argued, the significance of an activity must be sought in terms of the whole organization, which is more than the sum of its separable parts. What we are looking for, always, is the actual life that the whole organization is there to express. The significance of documentary culture is that, more clearly than anything else, it expresses that life to us in direct terms, when the living witnesses are silent. At the same time, if we reflect on the nature of a structure of feeling, and see how it can fail to be fully understood even by living people in close contact with it, with ample material at their disposal, including the contemporary arts, we shall not suppose that we can ever do more than make an approach, an approximation, using any channels.

We need to distinguish three levels of culture, even in its most general definition. There is the lived culture of a particular time and place, only fully accessible to those living in that time and place. There is the recorded culture, of every kind, from art to the most everyday facts: the culture of a period. There is also, as the factor connecting lived culture and period cultures, the culture of the selective tradition. [. . .]

It is very important to try to understand the operation of a selective tradition. [. . .] In a society as a whole, and in all its particular activities, the cultural tradition can be seen as a continual selection and re-selection of ancestors. Particular lines will be drawn, often for as long as a century, and then suddenly with some new stage in growth these will be cancelled or weakened, and new lines drawn. In the analysis of contemporary culture, the existing state of the selective tradition is of vital importance, for it is often true that some change in this tradition – establishing new lines with the past, breaking or re-drawing existing lines – is a radical kind of *contemporary* change. We tend to underestimate the extent to which the cultural tradition is not only a selection but also an interpretation. We see most past work through our own experience, without even making the effort to see it in something like its original terms. What analysis can do is not so much to reverse this, returning a work to its period, as to make the interpretation conscious, by showing historical alternatives; to relate the interpretation to the particular contemporary values on which it rests; and, by exploring the real patterns of the work, confront us with the real nature of the choices we are making. We shall find, in some cases, that we are keeping the work alive because it is a genuine contribution to cultural growth. We shall find, in other cases, that we are using the work in a particular way for our own reasons, and it is better to know this than to surrender to the mysticism of the 'great valuer, Time'. To put on to Time, the abstraction, the responsibility for our own active choices is to suppress a central part of our experience. The more actively all cultural work can be related, either to the whole organization within which it was expressed, or to the contemporary organization within which it is used, the more clearly shall we see its true values. Thus 'documentary' analysis will lead out to 'social' analysis, whether in a lived culture, a past period, or in the selective tradition which is itself a social organization. And the discovery of permanent contributions will lead to the same kind of general analysis, if we accept the process at this

level, not as human perfection (a movement towards determined values), but as a part of man's general evolution, to which many individuals and groups contribute. Every element that we analyse will be in this sense active: that it will be seen in certain real relations, at many different levels. In describing these relations, the real cultural process will emerge.

13 John Cage (1912–1992) 'On Robert Rauschenberg, Artist, and his Work'

Cage had met the dancer and choreographer Merce Cunningham before the Second World War. Shortly after, they formed their own dance company. Together they worked at the experimental Black Mountain College summer school in North Carolina in 1948, 1952 and 1953. There they came into contact with Robert Rauschenberg who by 1952 functioned as *de facto* artist in residence to the school. Rauschenberg became artistic adviser to the dance company in 1954. Jasper Johns met Rauschenberg, and through him Cage and Cunningham, also in 1954, in New York. This loose grouping came to constitute a significant departure in the New York avant-garde from the then dominant Abstract Expressionism. Instead of a hermetic art, Rauschenberg in particular aspired to re-introduce fragments from the outside world into his 'Combine Paintings'. The present essay was originally published in *Metro*, Milan, May 1961. It is reprinted in John Cage, *Silence*, Cambridge, MA, 1969, pp. 98–107, from which the present extracts are taken. (Passages in italics are quotations from Rauschenberg.)

Beauty is now underfoot wherever we take the trouble to look. (This is an American discovery.) Is when Rauschenberg looks an idea? Rather it is an entertainment in which to celebrate unfixity. [...]

As the paintings changed the printed material became as much of a subject as the paint (I began using newsprint in my work) causing changes of focus: A third palette. There is no poor subject (Any incentive to paint is as good as any other.). Dante is an incentive, providing multiplicity, as useful as a chicken or an old shirt. The atmosphere is such that everything is seen clearly, even in the dark night or when thumbing through an out-of-date newspaper or poem. This subject is unavoidable (*A canvas is never empty.*); it fills an empty canvas. And if, to continue history, newspapers are pasted onto the canvas and on one another and black paints are applied, the subject looms up in several different places at once like magic to produce the painting. If you don't see it, you probably need a pair of glasses. But there is a vast difference between one oculist and another, and when it is a question of losing eyesight the best thing to do is to go to the best oculist (i.e., the best painter: he'll fix you up). Ideas are not necessary. It is more useful to avoid having one, certainly avoid having several (leads to inactivity). [...]

There are three panels taller than they are wide fixed together to make a single rectangle wider than it is tall. Across the whole thing is a series of colored photos, some wider than tall, some taller than wide, fragments of posters, some of them obscured by paint. Underneath these, cutting the total in half, is a series of rectangular color swatches, all taller than wide. Above, bridging two of the panels, is a dark blue rectangle. Below and slightly out of line with the blue one, since it is on one panel only, is a gray rectangle with a drawing on it about halfway up. There are other things,

but mostly attached to these two 'roads' which cross: off to the left and below the swatches is a drawing on a rectangle on a rectangle on a rectangle (its situation is that of a farm on the outskirts of a mainstreet town). This is not a composition. It is a place where things are, as on a table or on a town seen from the air: any one of them could be removed and another come into its place through circumstances analogous to birth and death, travel, housecleaning, or cluttering. He is not saying; he is painting. (What is Rauschenberg saying?) The message is conveyed by dirt which, mixed with an adhesive, sticks to itself and to the canvas upon which he places it. Crumbling and responding to changes in weather, the dirt unceasingly does my thinking. He regrets we do not see the paint while it's dripping.

Rauschenberg is continually being offered scraps of this and that, odds and ends his friends run across, since it strikes them: This is something he could use in a painting. Nine times out of ten it turns out he has no use for it. Say it's something close to something he once found useful, and so could be recognized as his. Well, then, as a matter of course, his poetry has moved without one's knowing where it's gone to. He changes what goes on, on a canvas, but he does not change how canvas is used for paintings – that is, stretched flat to make rectangular surfaces which may be hung on a wall. These he uses singly, joined together, or placed in a symmetry so obvious as not to attract interest (nothing special). We know two ways to unfocus attention: symmetry is one of them; the other is the over-all where each small part is a sample of what you find elsewhere. In either case, there is at least the possibility of looking anywhere, not just where someone arranged you should. You are then free to deal with your freedom just as the artist dealt with his, not in the same way but, nevertheless, originally. This thing, he says, *duplication of images*, that is symmetry. All it means is that, looking closely, we see as it was everything is in chaos still.

To change the subject: 'Art is the imitation of nature in her manner of operation.' Or a net. [...]

[...] Now that Rauschenberg has made a painting with radios in it, does that mean that even without radios, I must go on listening even while I'm looking, everything at once, in order not to be run over?

Would we have preferred a pig with an apple in its mouth? That too, on occasion, is a message and requires a blessing. These are the feelings Rauschenberg gives us: love, wonder, laughter, heroism (I accept), fear, sorrow, anger, disgust, tranquillity.

There is no more subject in a *combine* than there is in a page from a newspaper. Each thing that is there is a subject. It is a situation involving multiplicity. (It is no reflection on the weather that such-and-such a government sent a note to another.) (And the three radios of the radio combine, turned on, which provides the subject?) Say there was a message. How would it be received? And what if it wasn't? Over and over again I've found it impossible to memorize Rauschenberg's paintings. I keep asking, 'Have you changed it?' And then noticing while I'm looking it changes. I look out the window and see the icicles. There, dripping water is frozen into object. The icicles all go down. Winter more than the others is the season of quiescence. There is no dripping when the paint is squeezed from a tube. But there is the same acceptance of what happens and no tendency towards gesture or arrangement. This changes the notion of what is beautiful. By fixing papers to canvas and then painting with black paint, black became infinite and previously unnoticed. [...]

There is in Rauschenberg, between him and what he picks up to use, the quality of encounter. For the first time. If, as happens, there is a series of paintings containing such and such a material, it is as though the encounter was extended into a visit on the part of the stranger (who is divine). (In this way societies uninformed by artists coagulate their experiences into modes of communication in order to make mistakes.) Shortly the stranger leaves, leaving the door open.

Having made the empty canvases (*A canvas is never empty.*), Rauschenberg became the giver of gifts. Gifts, unexpected and unnecessary, are ways of saying Yes to how it is, a holiday. The gifts he gives are not picked up in distant lands but are things we already have (with exceptions, of course: I needed a goat and the other stuffed birds, since I don't have any, and I needed an attic in order to go through the family things [since we moved away, the relatives write to say: Do you still want them?]), and so we are converted to the enjoyment of our possessions. Converted from what? From wanting what we don't have, art as pained struggle. Setting out one day for a birthday party, I noticed the streets were full of presents. Were he saying something in particular, he would have to focus the painting; as it is he simply focuses himself, and everything, *a pair of socks*, is appropriate, appropriate to poetry, a poetry of *infinite possibilities*. [...] The technique consists in having a *plan: Lay out stretcher on floor match markings and join.* Three stretchers with the canvas on them no doubt already stretched. Fulfilling this plan put the canvas in direct contact with the floor, the ground thereby activated. This is pure conjecture on my part but would work. More important is to know exactly the size of the door and techniques for getting a canvas out of the studio. (*Combines* don't roll up.) Anything beyond that size must be suitably segmented. [...]

The message changes in the *combine-drawings*, made with pencil, water color, and photographic transfer: (a) the work is done on a table, not on a wall; (b) there is no oil paint; (c) because of a + b, no dripping holds the surface in one plane; (d) there is not always the joining of rectangles since when there is, it acts as reminiscence of stretchers; (e) the outlines appear vague as in water or air (our feet are off the ground); (f) I imagine being upside down; (g) the pencil lines scan the images transferred from photographs; (h) it seems like many television sets working simultaneously all tuned differently. How to respond to this message? (And I remember the one in *Dante* with the outline of the toes of his foot above, the changed position and another message, the paper absorbing the color and spreading it through its wet tissues.) He has removed the why of asking why and you can read it at home or in a library. (These others are poems too.) Perhaps because of the change in gravity (*Monument* 1958), the project arose of illustrating a book. (A book can be read at a table; did it fall on the floor?) As for me, I'm not so inclined to read poetry as I am one way or another to get myself a television set, sitting up nights looking.

Perhaps after all there is no message. In that case one is saved the trouble of having to reply. As the lady said, 'Well, if it isn't art, then I like it.' Some (a) were made to hang on a wall, others (b) to be in a room, still others (a + b).

By now we must have gotten the message. It couldn't have been more explicit. Do you understand this idea? *Painting relates to both art and life. Neither can be made. (I try to act in that gap between the two.)* The nothingness in between is where for no reason at all every practical thing that one actually takes the time to do so stirs up the dregs that they're no longer sitting as we thought on the bottom. All you need do is stretch canvas,

make markings, and join. You have then turned on the switch that distinguishes man, his ability to change his mind: *If you do not change your mind about something when you confront a picture you have not seen before, you are either a stubborn fool or the painting is not very good.* Is there any need before we go to bed to recite the history of the changes and will we in that bed be murdered? And how will our dreams, if we manage to go to sleep, suggest the next practical step? Which would you say it was: wild, or elegant, and why? Now as I come to the end of my rope, I noticed the color is incredibly beautiful. And that embossed box.

I am trying to check my habits of seeing, to counter them for the sake of greater freshness. I am trying to be unfamiliar with what I'm doing.

[...] Where does beauty begin and where does it end? Where it ends is where the artist begins. In this way we get our navigation done for us. If you hear that Rauschenberg has painted a new painting, the wisest thing to do is to drop everything and manage one way or another to see it. That's how to learn the way to use your eyes, sunup the next day. If I were teaching, would I say *Caution Watch Your Step* or Throw yourself in where the fish are thickest? Of course, there are objects. Who said there weren't? The thing is, we get the point more quickly when we realize it is we looking rather than that we may not be seeing it. (Why do all the people who are not artists seem to be more intelligent?) And object is *fact*, not symbol. If any thinking is going to take place, it has to come out from inside the Mason jar which is suspended in *Talisman*, or from the center of the rose (is it red?) or the eyes of the pitcher (looks like something out of a movie) or – the farther one goes in this direction the more one sees nothing is in the foreground: each minute point is at the center. Did this happen by means of rectangles (the picture is 'cut' through the middle)? Or would it happen given this point of view? Not ideas but facts.

14 Jasper Johns (b. 1930) Interview with David Sylvester

Johns launched his career in art in 1954 with the painting *Flag*, having destroyed as much of his previous work as it was possible for him to trace. In addition to extending the series of *Flags*, in the later 1950s he painted *Targets* and *Numbers*, and some works including casts of fragments of the human body. Johns's output, and particularly his early work, has often been interpreted as a sustained meditation on meaning, its construction and its elusiveness. Thus interpreted, his work presents a marked contrast to the American avant-garde's then dominant preoccupation with self-expression. However, recent research has tended to imply that a complex range of self-reference is encoded into even these apparently impenetrable and enigmatic works. The present interview was recorded by the BBC in the spring of 1965, and was broadcast on 10 October 1965. It was printed in the exhibition catalogue *Jasper Johns: Drawings*, London, Arts Council of Great Britain, 1974, from which the present extracts are taken. (See also VIA23.)

DS: What was it first made you use things such as flags, targets, maps, numbers and letters and so on as starting-points?

JJ: They seemed to me pre-formed, conventional, depersonalized, factual, exterior elements.

DS: And what was the attraction of depersonalized elements?

JJ: I'm interested in things which suggest the world rather than suggest the person-
ality. I'm interested in things which suggest things which are, rather than in
judgments. The most conventional thing, the most ordinary thing – it seems to me
that those things can be dealt with without having to judge them; they seem to me to
exist as clear facts, not involving aesthetic hierarchy.

[...] But one also thinks of things as having a certain quality, and in time these
qualities change. The Flag, for instance, one thinks it has forty-eight stars and
suddenly it has fifty stars; it is no longer of any great interest. The Coke bottle,
which seemed like a most ordinary untransformable object in our society, suddenly
some years ago appeared quart-sized: the small bottle had been enlarged to make a
very large bottle which looked most peculiar except the top of the bottle remained
the same size – they used the same cap on it. The flashlight: I had a particular idea in
my mind what a flashlight looked like – I hadn't really handled a flashlight, since, I
guess, I was a child – and I had this image of a flashlight in my head and I wanted to
go and buy one as a model. I looked for a week for what I thought looked like an
ordinary flashlight, and I found all kinds of flashlights with red plastic shields, wings
on the sides, all kinds of things, and I finally found one that I wanted. And it made
me very suspect of my idea, because it was so difficult to find this thing I had
thought was so common. And about that old ale can which I thought was very
standard and unchanging, not very long ago they changed the design of that.

DS: So the flashlight you wanted was an ideal flashlight, without particular excres-
cences, a kind of universal flashlight, and in reality it was peculiarly elusive.

JJ: Yes, it turns out that actually the choice is quite personal and is not really based on
one's observations at all. [...]

DS: Obviously each new move is determined by what is already on the canvas; what
else is it determined by?

JJ: By what is not on the canvas.

DS: But there is a great number of possibilities of what might go on the canvas.

JJ: That is true, but one's thinking, just the process of thinking, excludes many
possibilities. And the process of looking excludes many possibilities, because from
moment to moment as we look we see what we see, at another moment in looking we
might see differently. At any one moment one can't see all the possibilities. And one
proceeds as one proceeds, one does something and then one does something else.

DS: But the marks you make are not made automatically?

JJ: But how are they made?

DS: That is what I would like to know. Are you conscious of the different ways in
which you are making them?

JJ: At times, yes. At times I am conscious of making a mark with some directional
idea which I've got from the painting. Sometimes I am conscious of making a mark
to alter what seems to me the primary concern of the painting, to force it to be
different, to strengthen, to weaken, in purely academic terms. At times I will attempt
to do something which seems quite uncalled-for in the painting, so that the work
won't proceed so logically from where it is, but will go somewhere else. At a certain
moment, a configuration of marks on the canvas may suggest one type of organiza-
tion or one type of academic idea or one type of emotional idea or whatever. And at
that moment one may decide to do two things – to strengthen it, by proceeding to do

everything you can do to reinforce it, or to deny it, by introducing an element which is not called for in that situation, and then to proceed from there towards a greater complexity.

DS: So you are aware that the painting has taken on a certain dominant emotional idea?

JJ: Emotional or visual or technical – one's awareness can be focussed on any kind of idea. I guess it's an idea: it is a suggestion.

DS: You are conscious that the painting might have a certain mood?

JJ: Certainly.

DS: Is it often a mood that you intended it to have in the first place or one that has simply evolved?

JJ: I think in my paintings it has evolved, because I'm not interested in any particular mood. Mentally my preference would be the mood of keeping your eyes open and looking, without any focussing, without any constricted viewpoint. I think paintings by the time they are finished tend to take on a particular characteristic. That is one of the reasons they are finished, because everything has gone in that direction, and there is no recovery. The energy, the logic, everything which you do takes a form in working; the energy tends to run out, the form tends to be accomplished or finalized. Then either it is what one intended (or what one is willing to settle for) or one has been involved in a process which has gone in a way that perhaps one did not intend, but has been done so thoroughly that there is no recovery from that situation. You have to leave that situation as itself, and then proceed with something else, begin again, begin a new work.

* * *

DS: You were saying before that you wanted to make something that somebody might find it interesting to look at. But what you are making is not simply an aesthetic object.

JJ: Did I say that?

DS: I think so, though you weren't sure of it.

JJ: If I said it, I would like now to deny it and say something else. I think when one is working, generally, one is not concerned with that sort of result. One goes about one's business and does what one has to do and one's energy runs out. And one isn't looking throughout, but then one looks at it as an object. It's no longer part of one's life process. At that moment, none of us being purely anything, you become involved with looking, judging, etc. I don't think it's a purposeful thing to make something to be looked at, but I think the perception of the object is through looking and through thinking. And I think any meaning we give to it comes through our looking at it.

DS: By the object you mean the work of art?

JJ: Yes, yes.

DS: But what of the objects you begin with?

JJ: The empty canvas?

DS: No. Not only the empty canvas; well, the motif, if you like, such as the letters, the Flag and so on, or whatever it may be.

JJ: I think it's just a way of beginning.

DS: In other words the painting is not about the elements with which you have begun.

JJ: No more than it is about the elements which enter it at any moment. Say, the painting of a flag is always about a flag, but it is no more about a flag than it is about a brush-stroke or about a colour or about the physicality of the paint, I think.

DS: Which is why you might as well use again and again such things as numbers or letters as the elements with which to begin, because the painting is not about those elements.

JJ: It is about them, but it is not only about them.

DS: But the process which is recorded as it were in the finished object, this process has an analogy to certain processes outside painting?

JJ: You said it.

DS: I'm asking you.

JJ: Well, it has this analogy: you do one thing and then you do another thing. If you mean that it pictures your idea of a process that is elsewhere I think that's more questionable. I think that at times one has the idea that that is true, and I think at times one has the idea that that is not true. Whatever idea one has, it's always susceptible to doubt, and to the possibility that something else has been or might be introduced to that arrangement which would alter it. What I think this means is, that, say in a painting, the processes involved in the painting are of greater certainty and of, I believe, greater meaning, than the referential aspects of the painting. I think the processes involved in the painting in themselves mean as much or more than any reference value that the painting has.

DS: And what would their meaning be?

JJ: Visual, intellectual activity, perhaps: 'recreation'.

DS: But, for example, I don't, in looking at your painting, have the sense that I can pin down references, but I feel there are references there, and that these are what give the paintings their intensity, and their sense that something important is happening or has happened. Is it possible that what has happened in the painting can be analogous to certain processes outside painting, for example, on the one hand, psychological processes, such as concentrating either one's vision or one's mind on something, attention wandering, returning, the process of clarifying, of losing, of remembering or of recalling, of clarifying again, or that again there might be an analogy to certain processes in nature, such as the process of disintegration and re-integration, the idea of something falling apart, the idea of something being held together?

JJ: I think it is quite possible that the painting can suggest those things. I think as a painter one cannot proceed to suggest those things, that, when you begin to work with the idea of suggesting, say, a particular psychological state of affairs, you have eliminated so much from the process of painting that you make an artificial statement which is, I think, not desirable. I think one has to work with everything and accept the kind of statement which results as unavoidable, or as a helpless situation. I think that most art which begins to make a statement fails to make a statement because the methods used are too schematic or too artificial. I think that one wants from painting a sense of life. The final suggestion, the final statement, has to be not a deliberate statement but a helpless statement. It has to be what you can't avoid saying, not what you set out to say. I think one ought to use everything one can use, all of the energy should be wasted in painting it, so that one hasn't the reserve of energy which is able

to use this thing. One shouldn't really know what to do with it, because it should match what one is already; it shouldn't just be something one likes. [. . .]

DS: Apart from any particular suggestion that the paint may make, are you conscious of the total texture of the paint's having a total general reference to something else? To be specific, do you feel that paint is in some way the embodiment of the quality of your sensations? What is the relation between what is in a painting and what you see when you look about you?

JJ: The relation is that there is always something to see and anywhere one looks one sees something.

DS: What is the difference between seeing when you look about you and seeing when you look at a painting?

JJ: At its best there is no difference.

DS: So that the painting is then in some way a crystallization or a trapping of the sensation you have when you look about you?

JJ: Perhaps, but I wouldn't want to push that idea. I think one likes to think there is no difference between the experience of looking at a work of art and looking at not a work of art. There probably is some difference, but I don't know what it is. In the work of art there is probably a more directed sense of seeing, but that is questionable too, because one can face a work and not have that sense.

DS: Of course the way a painting exists is nothing like the way reality exists, so what you are really trying to do is to invest the canvas and the paint with a life that does make the sensation of looking at it resemble the sensation of looking at reality. Is that what you are saying?

JJ: Well, that has perhaps been said, but I wouldn't like to exaggerate that idea, that the painting is a language which is separated from one's general experience. I think it is in part, but I don't think that it should be made too strong an idea.

DS: But the paint is more than the result of your making certain marks and arriving at an order which sometimes satisfies you?

JJ: What is it the result of, if it is not that?

DS: Well it is that. But is that all it is?

JJ: Well all it is is whatever you are willing to say – all it is is whatever you say it is; however you can use it, that's what it is. I think the experience of looking at painting involves putting the paint to use, taking the painting as something which exists. Then, what one sees one tends to suppose was intended by the artist. I don't know that that is so. I think one works and makes what one makes and then one looks at it and sees what one sees. And I think that the picture isn't pre-formed, I think it is formed as it is made; and might be anything. I think it resembles life, in that in any, say, ten-year period in one's life, anything one may intend might be something quite different by the time the time is up – that one may not do what one had in mind, and certainly one would do much more than one had in mind. But, once one has spent that time, then one can make some statement about it; but that is a different experience from the experience of spending the time. And I think the experience of looking at a painting is different from the experience of planning a painting or of painting a painting. And I think the statements one makes about finished work are different from the statements one can make about the experience of making it.

DS: Again and again you return to the way in which something is posed and then contradicted or departed from, so that you are constantly interested in the way in which intention and improvisation work together. In other words, it seems to me your constant pre-occupation is the interplay between affirmation and denial, expectation and fulfilment, the degree in which things happen as one would expect and the degree in which things happen as one would not expect.

JJ: Well, intention involves such a small fragment of our consciousness and of our mind and of our life. I think a painting should include more experience than simply intended statement. I personally would like to keep the painting in a state of 'shunning statement', so that one is left with the fact that one can experience individually as one pleases; that is, not to focus the attention in one way, but to leave the situation as a kind of actual thing, so that the experience of it is variable.

DS: In other words, if your painting says something that could be pinned down, what it says is that nothing can be pinned down, that nothing is pure, that nothing is simple.

JJ: I don't like saying that it says that. I would like it to be that.

15 Richard Hamilton (b. 1922) 'For the Finest Art, Try Pop'

Hamilton had been involved with the Independent Group at the Institute of Contemporary Arts, London, since the early 1950s. He designed and organized the exhibition 'Man, Machine and Motion' shown in 1955, a pictorial review of machines expanding human capacities for movement. In 1956 he collaborated with other members of the Independent Group on a contribution to the exhibition 'This Is Tomorrow' held at the Whitechapel Art Gallery, London. The exhibition aimed to demonstrate the possibilities of integrating different art forms and consisted of twelve environments, each produced by the collaboration of a painter, a sculptor and an architect. Hamilton's contribution prominently featured publicity material from the mass media. From 1956 onwards, he began to produce paintings, collages and objects drawing on the artefacts of contemporary consumer society. This range of work was accompanied by writing addressing the same characteristic concerns. The present text originally appeared in *Gazette*, no. 1, London, 1961. Reprinted in Richard Hamilton, *Collected Words 1953–1982*, London, 1982, pp. 42–3.

In much the way that the invention of photography cut away for itself a chunk of art's prerogative – the pictorial recording of visual facts – trimming the scope of messages which Fine Art felt to lie within its true competence, so has popular culture abstracted from Fine Art its role of mythmaker. The restriction of his area of relevance has been confirmed by the artist with smug enthusiasm so that decoration, one of art's few remaining functions, has assumed a ridiculously inflated importance.

It isn't surprising, therefore, to find that some painters are now agog at the ability of the mass entertainment machine to project, perhaps more pervasively than has ever before been possible, the classic themes of artistic vision and to express them in a poetic language which marks them with a precise cultural date-stamp.

It is the *Playboy* 'Playmate of the month' pull-out pin-up which provides us with the closest contemporary equivalent of the odalisque in painting. Automobile body stylists have absorbed the symbolism of the space age more successfully than any artist. Social

comment is left to TV and comic strip. Epic has become synonymous with a certain kind of film and the heroic archetype is now buried deep in movie lore. If the artist is not to lose much of his ancient purpose he may have to plunder the popular arts to recover the imagery which is his rightful inheritance.

Two art movements of the early part of this century insisted on their commitment to manifest the image of a society in flux: Dada, which denied the then current social attitudes and pressed its own negative propositions, and Futurism with its positive assertion of involvement. Both were fiercely, aggressively propagandist. Both were rebellious, or at least radical, movements. Dada anarchically seditious and Futurism admitting to a core of authoritarian dogma – each was vigorous and historically apposite.

A new generation of Dadaists has emerged today, as violent and ingenious as their forebears, but Son of Dada is accepted, lionized by public and dealers, certified by state museums – the act of mythmaking has been transferred from the subject-matter of the work to the artist himself as the content of his art.

Futurism has ebbed and has no successor, yet to me the philosophy of affirmation seems susceptible to fruition. The long tradition of bohemianism which the Futurists made their bid to defeat is anachronic in the atmosphere of conspicuous consumption generated by the art rackets.

Affirmation propounded as an avant-garde aesthetic is rare. The history of art is that of a long series of attacks upon social and aesthetic values held to be dead and moribund, although the avant-garde position is frequently nostalgic and absolute. The Pop-Fine-Art standpoint, on the other hand – the expression of popular culture in fine art terms – is, like Futurism, fundamentally a statement of belief in the changing values of society. Pop-Fine-Art is a profession of approbation of mass culture, therefore also antiartistic. It is positive Dada, creative where Dada was destructive. Perhaps it is Mama – a cross-fertilization of Futurism and Dada which upholds a respect for the culture of the masses and a conviction that the artist in twentieth century urban life is inevitably a consumer of mass culture and potentially a contributor to it.

16 Claes Oldenburg (b. 1929) from *Documents from The Store*

In New York in the late 1950s Oldenburg came into contact with the generation of younger artists reacting against Abstract Expressionism, and participated in various Happenings and other manifestations centred on the Judson Church. In 1960–1 he planned and executed the complex environmental work 'The Store'. This utilized commonly available commercial products and advertising imagery, its components being largely constructed from burlap, cardboard and plaster. It had its origins in objects and reliefs based on everyday items such as food and advertisements. The first version of 'I Am for an Art...' was initially composed for the catalogue of the exhibition 'Environments, Situations and Spaces' at the Martha Jackson Gallery, May–June 1961. The text was revised when Oldenburg opened The Store in his studio on East Second Street in December 1961. Both statements are taken from *Store Days: Documents from The Store (1961) and Ray Gun Theater (1962)*, selected by Claes Oldenburg and Emmett Williams, New York, Villefranche-sur-mer, Frankfurt am Main: Something Else Press, 1967, pp. 8 and 39–42.

I

this country is all bourgeois down to the last deathtail and most of the criticism is an exhortation to observe art and justice and good sense and humanity, which are also bourgeois values, so there is no escaping bourgeois values in America. The enemy is bourgeois culture nevertheless.

CITY AX or TAXI

Torrent

tame

torrential

hat song

hot seng

bed

If I could only forget the notion of art entirely. I really don't think you can win. Duchamp is ultimately labeled art too. The bourgeois scheme is that they wish to be disturbed from time to time, they like that, but then they envelop you, and that little bit is over, and they are ready for the next. There even exists within the b. values a code of possibilities for disturbance, certain 'crimes' which it requires some courage to do but which will eventually be rewarded within the b. scheme. B. values are human weakness, a civilization built on human weakness, non-resistance. They are disgusting. There are many difficult things to do within the b. values, but I would like to find some way to take a totally outside position. Bohemia is bourgeois. The beat is bourgeois – their values are pure sentimentality – the country, the good heart, the fallen man, the honest man, the gold-hearted whore etc. They would never think f.ex. of making the city a value of good.

Possibly art is doomed to be bourgeois. Two possible escapes from the bourgeois are 1. aristocracy and 2. intellect, where art never thrives too well. There again I am talking as if I want to create art outside b. values. Perhaps this can't be done, but why should I even want to create 'art' – that's the notion I've got to get rid of. Assuming that I wanted to create some thing what would that thing be? Just a thing, an object. Art would not enter into it. I make a charged object ('living'). An 'artistic' appearance or content is derived from the object's reference, not from the object itself or me. These things are displayed in galleries, but that is not the place for them. A store would be better (Store – place full of objects). Museum in b. concept equals store in mine.

II

I am for an art that is political-erotical-mystical, that does something other than sit on its ass in a museum.

I am for an art that grows up not knowing it is art at all, an art given the chance of having a starting point of zero.

I am for an art that embroils itself with the everyday crap & still comes out on top.

I am for an art that imitates the human, that is comic, if necessary, or violent, or whatever is necessary.

I am for an art that takes its form from the lines of life itself, that twists and extends and accumulates and spits and drips, and is heavy and coarse and blunt and sweet and stupid as life itself.

I am for an artist who vanishes, turning up in a white cap painting signs or hallways.

I am for art that comes out of a chimney like black hair and scatters in the sky.

I am for art that spills out of an old man's purse when he is bounced off a passing fender.

I am for the art out of a doggy's mouth, falling five stories from the roof.

I am for the art that a kid licks, after peeling away the wrapper.

I am for an art that joggles like everyones knees, when the bus traverses an excavation.

I am for art that is smoked, like a cigarette, smells, like a pair of shoes.

I am for art that flaps like a flag, or helps blow noses, like a handkerchief.

I am for art that is put on and taken off, like pants, which develops holes, like socks, which is eaten, like a piece of pie, or abandoned with great contempt, like a piece of shit.

I am for art covered with bandages, I am for art that limps and rolls and runs and jumps. I am for art that comes in a can or washes up on the shore.

I am for art that coils and grunts like a wrestler. I am for art that sheds hair.

I am for art you can sit on. I am for art you can pick your nose with or stub your toes on.

I am for art from a pocket, from deep channels of the ear, from the edge of a knife, from the corners of the mouth, stuck in the eye or worn on the wrist.

I am for art under the skirts, and the art of pinching cockroaches.

I am for the art of conversation between the sidewalk and a blind mans metal stick.

I am for the art that grows in a pot, that comes down out of the skies at night, like lightning, that hides in the clouds and growls. I am for art that is flipped on and off with a switch.

I am for art that unfolds like a map, that you can squeeze, like your sweetys arm, or kiss, like a pet dog. Which expands and squeaks, like an accordion, which you can spill your dinner on, like an old tablecloth.

I am for an art that you can hammer with, stitch with, sew with, paste with, file with.

I am for an art that tells you the time of day, or where such and such a street is.

I am for an art that helps old ladies across the street.

I am for the art of the washing machine. I am for the art of a government check. I am for the art of last wars raincoat.

I am for the art that comes up in fogs from sewer-holes in winter. I am for the art that splits when you step on a frozen puddle. I am for the worms art inside the apple. I am for the art of sweat that develops between crossed legs.

I am for the art of neck-hair and caked tea-cups, for the art between the tines of restaurant forks, for the odor of boiling dishwater.

I am for the art of sailing on Sunday, and the art of red and white gasoline pumps.

I am for the art of bright blue factory columns and blinking biscuit signs.

I am for the art of cheap plaster and enamel. I am for the art of worn marble and smashed slate. I am for the art of rolling cobblestones and sliding sand. I am for the art of slag and black coal. I am for the art of dead birds.

I am for the art of scratchings in the asphalt, daubing at the walls. I am for the art of bending and kicking metal and breaking glass, and pulling at things to make them fall down.

I am for the art of punching and skinned knees and sat-on bananas. I am for the art of kids' smells. I am for the art of mama-babble.

I am for the art of bar-babble, tooth-picking, beerdrinking, egg-salting, in-sulting. I am for the art of falling off a barstool.

I am for the art of underwear and the art of taxicabs. I am for the art of ice-cream cones dropped on concrete. I am for the majestic art of dog-turds, rising like cathedrals.

I am for the blinking arts, lighting up the night. I am for art falling, splashing, wiggling, jumping, going on and off.

I am for the art of fat truck-tires and black eyes.

I am for Kool-art, 7-UP art, Pepsi-art, Sunshine art, 39 cents art, 15 cents art, Vatronol art, Dro-bomb art, Vam art, Menthol art, L & M art, Ex-lax art, Venida art, Heaven Hill art, Pamryl art, San-o-med art, Rx art, 9.99 art, Now art, New art, How art, Fire sale art, Last Chance art, Only art, Diamond art, Tomorrow art, Franks art, Ducks art, Meat-o-rama art.

I am for the art of bread wet by rain. I am for the rat's dance between floors.

I am for the art of flies walking on a slick pear in the electric light. I am for the art of soggy onions and firm green shoots. I am for the art of clicking among the nuts when the roaches come and go. I am for the brown sad art of rotting apples.

I am for the art of meowls and clatter of cats and for the art of their dumb electric eyes.

I am for the white art of refrigerators and their muscular openings and closings.

I am for the art of rust and mold. I am for the art of hearts, funeral hearts or sweetheart hearts, full of nougat. I am for the art of worn meathooks and singing barrels of red, white, blue and yellow meat.

I am for the art of things lost or thrown away, coming home from school. I am for the art of cock-and-ball trees and flying cows and the noise of rectangles and squares. I am for the art of crayons and weak grey pencil-lead, and grainy wash and sticky oil paint, and the art of windshield wipers and the art of the finger on a cold window, on dusty steel or in the bubbles on the sides of a bathtub.

I am for the art of teddy-bears and guns and decapitated rabbits, exploded umbrellas, raped beds, chairs with their brown bones broken, burning trees, firecracker ends, chicken bones, pigeon bones and boxes with men sleeping in them.

I am for the art of slightly rotten funeral flowers, hung bloody rabbits and wrinkly yellow chickens, bass drums & tambourines, and plastic phonographs.

I am for the art of abandoned boxes, tied like pharaohs. I am for an art of watertanks and speeding clouds and flapping shades.

I am for U.S. Government Inspected Art, Grade A art, Regular Price art, Yellow Ripe art, Extra Fancy art, Ready-to-eat art, Best-for-less art, Ready-to-cook art, Fully

cleaned art, Spend Less art, Eat Better art, Ham art, pork art, chicken art, tomato art, banana art, apple art, turkey art, cake art, cookie art.

add:
I am for an art that is combed down, that is hung from each ear, that is laid on the lips and under the eyes, that is shaved from the legs, that is brushed on the teeth, that is fixed on the thighs, that is slipped on the foot.

square which becomes blobby

17 Andy Warhol (1930–1987) Interview with Gene Swenson

Born in Pittsburgh, Warhol had moved to New York in 1949. For most of the 1950s he was a successful graphic designer, particularly in the field of shoe illustration. In the later 1950s he began to exhibit his own drawings, and in 1960 produced his first canvases depicting comic strip characters. The canonical repeated Soup Cans, Disasters, Elvises and Marilyns followed in 1962. Throughout this period of his transition from graphic designer to full-blown avant-garde artist Warhol was able to purchase works by contemporaries such as Jasper Johns and Frank Stella, as well as by Marcel Duchamp. 'Pop Art' became established as the latest vanguard movement in New York in 1962. The present interview was initially published as 'What Is Pop Art? Interviews with Eight Painters (Part 1)', *Art News*, New York, November 1963. Reprinted in John Russell and Suzi Gablik (eds.), *Pop Art Redefined*, London, 1969, pp. 116–19, from which the present text is taken.

AW: Someone said that Brecht wanted everybody to think alike. I want everybody to think alike. But Brecht wanted to do it through Communism, in a way. Russia is doing it under government. It's happening here all by itself without being under a strict government; so if it's working without trying, why can't it work without being Communist? Everybody looks alike and acts alike, and we're getting more and more that way.
I think everybody should be a machine.
I think everybody should like everybody.
 Is that what Pop Art is all about?
AW: Yes. It's liking things.
 And liking things is like being a machine?
AW: Yes, because you do the same thing every time. You do it over and over again.
 And you approve of that?
AW: Yes, because it's all fantasy. It's hard to be creative and it's also hard not to think what you do is creative or hard not to be called creative because everybody is always talking about that and individuality. Everybody's always being creative. And it's so funny when you say things aren't, like the shoe I would draw for an advertisement was called a 'creation' but the drawing of it was not. But I guess I believe in both ways. All these people who aren't very good should be really good. Everybody is too good now, really. Like, how many actors are there? There are millions of actors. They're all pretty good. And how many painters are there? Millions of painters and all pretty good. How can you say one style is better than

another? You ought to be able to be an Abstract-Expressionist next week, or a Pop artist, or a realist, without feeling you've given up something. I think the artists who aren't very good should become like everybody else so that people would like things that aren't very good. It's already happening. All you have to do is read the magazines and the catalogues. It's this style or that style, this or that image of man – but that really doesn't make any difference. Some artists get left out that way, and why should they?

 Is Pop Art a fad?

AW: Yes, it's a fad, but I don't see what difference it makes. I just heard a rumor that G. quit working, that she's given up art altogether. And everyone is saying how awful it is that A. gave up his style and is doing it in a different way. I don't think so at all. If an artist can't do any more, then he should just quit; and an artist ought to be able to change his style without feeling bad. I heard that Lichtenstein said he might not be painting comic strips a year or two from now – I think that would be so great, to be able to change styles. And I think that's what's going to happen, that's going to be the whole new scene. That's probably one reason I'm using silk screens now. I think somebody should be able to do all my paintings for me. I haven't been able to make every image clear and simple and the same as the first one. I think it would be so great if more people took up silk screens so that no one would know whether my picture was mine or somebody else's.

 It would turn art history upside down?

AW: Yes.

 Is that your aim?

AW: No. The reason I'm painting this way is that I want to be a machine, and I feel that whatever I do and do machine-like is what I want to do.

 Was commercial art more machine-like?

AW: No, it wasn't. I was getting paid for it, and did anything they told me to do. If they told me to draw a shoe, I'd do it, and if they told me to correct it, I would – I'd do anything they told me to do, correct it and do it right. I'd have to invent and now I don't; after all that 'correction', those commercial drawings would have feelings, they would have a style. The attitude of those who hired me had feeling or something to it; they knew what they wanted, they insisted; sometimes they got very emotional. The process of doing work in commercial art was machine-like, but the attitude had feeling to it.

 Why did you start painting soup cans?

AW: Because I used to drink it. I used to have the same lunch every day, for twenty years, I guess, the same thing over and over again. Someone said my life has dominated me; I liked that idea. I used to want to live at the Waldorf Towers and have soup and a sandwich, like that scene in the restaurant in *Naked Lunch*....

 We went to see *Dr No* at Forty-second Street. It's a fantastic movie, so cool. We walked outside and somebody threw a cherry bomb right in front of us, in this big crowd. And there was blood. I saw blood on people and all over. I felt like I was bleeding all over. I saw in the paper last week that there are more people throwing them – it's just part of the scene – and hurting people. My show in Paris is going to be called 'Death in America'. I'll show the electric-chair pictures and the dogs in Birmingham and car wrecks and some suicide pictures.

 Why did you start these 'Death' pictures?

AW: I believe in it. Did you see the *Enquirer* this week? It had 'The Wreck that Made Cops Cry' – a head cut in half, the arms and hands just lying there. It's sick, but I'm sure it happens all the time. I've met a lot of cops recently. They take pictures of everything, only it's almost impossible to get pictures from them.

When did you start with the 'Death' series?

AW: I guess it was the big plane crash picture, the front page of a newspaper: 129 DIE. I was also painting the *Marilyns*. I realized that everything I was doing must have been Death. It was Christmas or Labor Day – a holiday – and every time you turned on the radio they said something like, '4 million are going to die'. That started it. But when you see a gruesome picture over and over again, it doesn't really have any effect.

But you're still doing 'Elizabeth Taylor' pictures.

AW: I started those a long time ago, when she was so sick and everybody said she was going to die. Now I'm doing them all over, putting bright colors on her lips and eyes.

My next series will be pornographic pictures. They will look blank; when you turn on the black lights, then you see them – big breasts and. . . . If a cop came in, you could just flick out the lights or turn to the regular lights – how could you say that was pornography? But I'm still just practising with these yet. Segal did a sculpture of two people making love, but he cut it all up, I guess because he thought it was too pornographic to be art. Actually it was very beautiful, perhaps a little too good, or he may feel a little protective about art. When you read Genet you get all hot, and that makes some people say this is not art. The thing I like about it is that it makes you forget about style and that sort of thing; style isn't really important.

Is 'Pop' a bad name?

AW: The name sounds so awful. Dada must have something to do with Pop – it's so funny, the names are really synonyms. Does anyone know what they're supposed to mean or have to do with, those names? Johns and Rauschenberg – Neo-Dada for all these years, and everyone calling them derivative and unable to transform the things they use – are now called progenitors of Pop. It's funny the way things change. I think John Cage has been very influential, and Merce Cunningham, too, maybe. Did you see that article in the *Hudson Review* ['The End of the Renaissance?', Summer, 1963]? It was about Cage and that whole crowd, but with a lot of big words like radical empiricism and teleology. Who knows? Maybe Jap and Bob were Neo-Dada and aren't any more. History books are being rewritten all the time. It doesn't matter what you do. Everybody just goes on thinking the same thing, and every year it gets more and more alike. Those who talk about individuality the most are the ones who most object to deviation, and in a few years it may be the other way around. Some day everybody will think just what they want to think, and then everybody will probably be thinking alike; that seems to be what is happening.

18 Roy Lichtenstein (1923–1997) Lecture to the College Art Association

A native of New York, Lichtenstein was educated and began his career as a designer in Ohio. Returning to New York in the late 1950s, he taught painting at New York State University,

initially in an Abstract Expressionist vein. His first paintings based on comic strips were exhibited at the Leo Castelli Gallery in 1961, where they were seen by Andy Warhol, who was then privately working on similar themes. The present text was originally delivered as a lecture to the College Art Association, Philadelphia, January 1964. It was first printed in Ellen H. Johnson, *American Artists on Art from 1940–1980*, New York, 1982, pp. 102–4, from which the present text is taken.

Although there was never an attempt on the part of Pop artists to form a movement (in fact in 1961 very few of these artists knew each other or were familiar with each other's work), there does seem to have been some critical point demanding expression which brought us to depart from whatever directions we were pursuing and to move toward some comment involving the commercial aspect of our environment.

There are many ways of looking at a phenomenon, of course, particularly a phenomenon as amorphous as an art movement, and there are many levels on which it can be discussed. I'm not sure an artist would have any more insight, that he could express in words, than a critic or an historian. But let me discuss one aspect that comes to my mind.

Aside from all of the influences which one can think of, and I have in mind movements and actual art products such as the three-dimensional Absinthe-Glass of Picasso, the Purist painting of Ozenfant and Le Corbusier, the use of actual common objects in collage, the Dada movement, the paintings of Stuart Davis, the paintings of Léger, the beer cans, targets and flags of Jasper Johns, the collages of Rauschenberg, the use of American objects in the happenings of Kaprow, Oldenburg, Dine, Whitman, Samaras and others. Aside from all these decided influences, and influences they were – particularly the happenings and environments, since both Oldenburg and Dine proceeded directly from happenings to Pop Art – it is at another level that I wish to describe the emergence of Pop Art.

Pop may be seen as a product of two twentieth-century tendencies: one from the outside – the subject matter; and the other from within – an esthetic sensibility. The subject matter, of course, is commercialism and commercial art; but its contribution is the isolation and glorification of 'Thing.' Commercial art is not our art, it is our subject matter and in that sense it is nature; but it is considered completely at odds with the major direction of art during and since the Renaissance and particularly at odds with our directly preceding movement – Abstract Expressionism. Commercial art runs contrary to a major art current in the sense that it concentrates on *thing* rather than *environment*: on *figure* rather than *ground*.

The esthetic sensibility to which I refer is anti-sensibility – *apparent* anti-sensibility. Anti-sensibility obviously is at odds with such concurrent and friendlier attitudes as contemplation, nuance, mystery and Zen, etc. Historical examples of anti-sensibility art – even recent examples – are hard to point to. The anti-sensibility façade fades and the sensibilities prevail. But if we can remember our first confrontation with certain modern works, the newer work seems cheapened, insensitive, brash and barbarous. It is not the rougher paint handling I refer to, but apparent lack of nuance and adjustment: for instance, our first look at *Les Demoiselles d'Avignon* of Picasso, or our first look at Mondrian or Pollock, or if we compare a Cubist collage or a Franz Kline with almost any old master painting. Compare a Daumier with a Botticelli. Courbet's audience

saw him as brash and artless in the mid-nineteenth century and van Gogh and the Fauves of course were seen in this light. But the modern works referred to here are not primarily anti-sensibility art – they represent many other qualities; but they do contain a bit of this element which is more strongly represented in Pop Art.

But works of art cannot really be the product of blunted sensibilities – it is only a style or posture. It is, however, the real quality of our subject matter – the particular awkward, bizarre and expedient commercial art styles which Pop Art refers to and amplifies. Since works of art cannot really be the product of blunted sensibilities, what seems at first to be brash and barbarous turns in time to daring and strength, and the concealed subtleties soon become apparent.

Anti-sensibility is the stance most characteristic, I think, of recent art in the sense that it is most unlike the Renaissance tendencies of transition, logical unfolding, purposeful nuance, and elegance. Although the anti-sensibilities stance appears as mindless, mechanical, gross and abrupt or as directed by prior or non-art decisions, its real meaning, I feel, lies in the artist's personal sensation of performing a difficult feat of bravado while really respecting all of the sensibilities. This is its meaning if it is successful – in Pop Art or any other style.

It may also have other meanings: Brassy courage, competition with the visual objects of modern life, naive American freshness, and so on.

In a strained analogous way perhaps we can see the twentieth-century tendency toward anti-sensibility in art joining the readymade real insensibility of our commercial environment to form Pop Art.

19 George Kubler (1912–1996) from *The Shape of Time*

The author was a Yale University academic. Though his work grew out of research initiated before the Second World War, it struck a chord among artists of a younger generation in the 1960s. Kubler argues the need to broaden the conception of art to include a much wider range of human artefacts over a much longer time-span than has been normal within the discipline of art history. In art-historical terms, he is critical of the Wölfflinian conception of evolving styles which lay behind much Modernist theory, and he invokes instead the precedent of Riegl (see *Art in Theory 1815–1900*, VA8 and 10). Robert Morris and Robert Smithson were among the artists who found in Kubler's arguments a stimulus for their own critique of the autonomous Modernist work, and for their desire to move art beyond the confines of the gallery (see VIIA6, VIIB3 and 4, VIID6). In their attempts to relate art to the large-scale technologies of the modern world, they invoked links with the often massive works of ancient cultures to which Kubler had helped draw attention. First published New Haven, 1962; the present extracts are taken from the third printing of 1965, pp. 1–3, 8–9, 31 and 32.

Let us suppose that the idea of art can be expanded to embrace the whole range of man-made things, including all tools and writing in addition to the useless, beautiful, and poetic things of the world. By this view the universe of man-made things simply coincides with the history of art. It then becomes an urgent requirement to devise better ways of considering everything men have made. This we may achieve sooner

by proceeding from art rather than from use, for if we depart from use alone, all useless things are overlooked, but if we take the desirableness of things as our point of departure, then useful objects are properly seen as things we value more or less dearly.

In effect, the only tokens of history continually available to our senses are the desirable things made by men. Of course, to say that man-made things are desirable is redundant because man's native inertia is overcome only by desire, and nothing gets made unless it is desirable.

Such things mark the passage of time with far greater accuracy than we know, and they fill time with shapes of a limited variety. Like crustaceans we depend for survival upon an outer skeleton, upon a shell of historic cities and houses filled with things belonging to definable portions of the past. Our ways of describing this visible past are still most awkward. The systematic study of things is less than five hundred years old, beginning with the description of works of art in the artists' biographies of the Italian Renaissance. The method was extended to the description of all kinds of things only after 1750. Today archaeology and ethnology treat of material culture in general. The history of art treats of the least useful and most expressive products of human industry. The family of things begins to look like a smaller family than people once thought.

The oldest surviving things made by men are stone tools. A continuous series runs from them to the things of today. The series has branched many times, and it has often run out into dead ends. Whole sequences of course ceased when families of artisans died out or when civilizations collapsed, but the stream of things never was completely stilled. Everything made now is either a replica or a variant of something made a little time ago and so on back without break to the first morning of human time. This continuous connection in time must contain lesser divisions.

The narrative historian always has the privilege of deciding that continuity cuts better into certain lengths than into others. He never is required to defend his cut, because history cuts anywhere with equal ease, and a good story can begin anywhere the teller chooses.

For others who aim beyond narration the question is to find cleavages in history where a cut will separate different types of happening. Many have thought that to make the inventory would lead toward such an enlarged understanding. The archaeologists and anthropologists classify things by their uses, having first separated material and mental culture, or things and ideas. The historians of art, who separate useful and aesthetic products, classify these latter by types, by schools, and by styles.

Schools and styles are the products of the long stock-taking of the nineteenth-century historians of art. This stock-taking, however, cannot go on endlessly; in theory it comes to an end with irreproachable and irrefutable lists and tables.

In practice certain words, when they are abused by too common use, suffer in their meaning as if with cancer or inflation. Style is one of these. [...]

* * *

[...] However useful it is for pedagogical purposes, the biological metaphor of style as a sequence of life-stages was historically misleading, for it bestowed upon the flux of events the shapes and the behavior of organisms. By the metaphor of the life-cycle a

style behaves like a plant. Its first leaves are small and tentatively shaped; the leaves of its middle life are fully formed; and the last leaves it puts forth are small again but intricately shaped. All are sustained by one unchanging principle of organization common to all members of that species, with variants of race occurring in different environments. By the biological metaphor of art and history, style is the species, and historical styles are its taxonomic varieties. As an approximation, nevertheless, this metaphor recognized the recurrence of certain kinds of events, and it offered at least a provisional explanation of them, instead of treating each event as an unprecedented, never-to-be-repeated *unicum*.

The biological model was not the most appropriate one for a history of things. Perhaps a system of metaphors drawn from physical science would have clothed the situation of art more adequately than the prevailing biological metaphors: especially if we are dealing in art with the transmission of some kind of energy; with impulses, generating centers, and relay points; with increments and losses in transit; with resistances and transformers in the circuit. In short, the language of electrodynamics might have suited us better than the language of botany; and Michael Faraday might have been a better mentor than Linnaeus for the study of material culture.

Our choice of the 'history of things' is more than a euphemism to replace the bristling ugliness of 'material culture.' This term is used by anthropologists to distinguish ideas, or 'mental culture,' from artifacts. But the 'history of things' is intended to reunite ideas and objects under the rubric of visual forms: the term includes both artifacts and works of art, both replicas and unique examples, both tools and expressions – in short all materials worked by human hands under the guidance of connected ideas developed in temporal sequence. From all these things a shape in time emerges. [...]

* * *

Only a few art historians have sought to discover valid ways to generalize upon the immense domain of the experience of art. These few have tried to establish principles for architecture, sculpture, and painting upon an intermediate ground partly in the objects and partly in our experience of them, by categorizing the types of organization we perceive in all works of art.

One strategy requires enlarging the unit of historical happening. At the beginning of the century F. Wickhoff and A. Riegl moved in this direction when they replaced the earlier moralizing judgment of 'degeneracy' that had been passed upon Late Roman art, with the hypothesis that one system or organization was being replaced by a new and different system of equal value. In Riegl's terms, one 'will-to-form' gave way to another. Such a division of history, along the structural lines marked by the frontiers between types of formal organization, has had reserved approval from almost all twentieth-century students of art and archaeology.

These proposals differed altogether from the notions of necessary sequence first advanced by the Swiss historian of art, Heinrich Wölfflin. [...]

The shapes of time are the prey we want to capture. The time of history is too coarse and brief to be an evenly granular duration such as the physicists suppose for natural time; it is more like a sea occupied by innumerable forms of a finite number of types. A net of another mesh is required, different from any now in use. [...]

20 Marshall McLuhan (1911–1980) 'Introduction' and 'Challenge and Collapse: The Nemesis of Creativity' from *Understanding Media*

The author, who began the 1960s as a relatively anonymous Canadian professor of literature, had by the middle of the decade become ubiquitous. His claims about the impact of the new mass media and the qualitative change in human consciousness which they supposedly brought about resulted in his own placement at the forefront of an international publicity machine. His first major statement of this theme, *The Gutenberg Galaxy*, appeared as early as 1952. The previous year he had published *The Mechanical Bride*, a study of the social effects of the motor car. McLuhan's key slogan that 'The Medium is The Message' and his claim that electronic communications were bringing about a return to a 'global village' implanted themselves in the thought of a period conscious of its own modernity. McLuhan's ideas became particularly influential in the arts. His claims about the immediacy of the image proposed an important role for a new generation eager to regard themselves as technically sophisticated visual communicators. The present extracts are from *Understanding Media*, London, 1964, pp. 3–6 and 64–6.

Introduction

After three thousand years of explosion, by means of fragmentary and mechanical technologies, the Western world is imploding. During the mechanical ages we had extended our bodies in space. Today, after more than a century of electric technology, we have extended our central nervous system itself in a global embrace, abolishing both space and time as far as our planet is concerned. Rapidly, we approach the final phase of the extensions of man – the technological simulation of consciousness, when the creative process of knowing will be collectively and corporately extended to the whole of human society, much as we have already extended our senses and our nerves by the various media. Whether the extension of consciousness, so long sought by advertisers for specific products, will be 'a good thing' is a question that admits of a wide solution. There is little possibility of answering such questions about the extensions of man without considering all of them together. Any extension, whether of skin, hand, or foot, affects the whole psychic and social complex. [...]

In the mechanical age now receding, many actions could be taken without too much concern. Slow movement insured that the reactions were delayed for considerable periods of time. Today the action and the reaction occur almost at the same time. We actually live mythically and integrally, as it were, but we continue to think in the old, fragmented space and time patterns of the pre-electric age.

Western man acquired from the technology of literacy the power to act without reacting. The advantages of fragmenting himself in this way are seen in the case of the surgeon who would be quite helpless if he were to become humanly involved in his operation. We acquired the art of carrying out the most dangerous social operations with complete detachment. But our detachment was a posture of noninvolvement. In the electric age, when our central nervous system is technologically extended to involve us in the whole of mankind and to incorporate the whole of mankind

in us, we necessarily participate, in depth, in the consequences of our every action. It is no longer possible to adopt the aloof and dissociated role of the literate Westerner.

The Theater of the Absurd dramatizes this recent dilemma of Western man, the man of action who appears not to be involved in the action. Such is the origin and appeal of Samuel Beckett's clowns. After three thousand years of specialist explosion and of increasing specialism and alienation in the technological extensions of our bodies, our world has become compressional by dramatic reversal. As electrically contracted, the globe is no more than a village. Electric speed in bringing all social and political functions together in a sudden implosion has heightened human awareness of responsibility to an intense degree. It is this implosive factor that alters the position of the Negro, the teen-ager, and some other groups. They can no longer be *contained*, in the political sense of limited association. They are now *involved* in our lives, as we in theirs, thanks to the electric media.

This is the Age of Anxiety for the reason of the electric implosion that compels commitment and participation, quite regardless of any 'point of view.' The partial and specialized character of the viewpoint, however noble, will not serve at all in the electric age. At the information level the same upset has occurred with the substitution of the inclusive image for the mere viewpoint. If the nineteenth century was the age of the editorial chair, ours is the century of the psychiatrist's couch. As extension of man the chair is a specialist ablation of the posterior, a sort of ablative absolute of backside, whereas the couch extends the integral being. The psychiatrist employs the couch, since it removes the temptation to express private points of view and obviates the need to rationalize events.

The aspiration of our time for wholeness, empathy and depth of awareness is a natural adjunct of electric technology. The age of mechanical industry that preceded us found vehement assertion of private outlook the natural mode of expression. Every culture and every age has its favorite model of perception and knowledge that it is inclined to prescribe for everybody and everything. The mark of our time is its revulsion against imposed patterns. We are suddenly eager to have things and people declare their beings totally. There is a deep faith to be found in this new attitude – a faith that concerns the ultimate harmony of all being.

* * *

Challenge and Collapse: The Nemesis of Creativity

[...] The new media and technologies by which we amplify and extend ourselves constitute huge collective surgery carried out on the social body with complete disregard for antiseptics. If the operations are needed, the inevitability of infecting the whole system during the operation has to be considered. For in operating on society with a new technology, it is not the incised area that is most affected. The area of impact and incision is numb. It is the entire system that is changed. The effect of radio is visual, the effect of the photo is auditory. Each new impact shifts the ratios among all the senses. What we seek today is either a means of controlling these shifts in the sense-ratios of the psychic and social outlook, or a means of avoiding them altogether. To have a disease without its symptoms is to be immune. No society has ever known enough about its actions to have developed immunity to its new extensions or technologies. Today we have begun to sense that art may be able to provide such immunity.

In the history of human culture there is no example of a conscious adjustment of the various factors of personal and social life to new extensions except in the puny and peripheral efforts of artists. The artist picks up the message of cultural and techno-logical challenge decades before its transforming impact occurs. He, then, builds models or Noah's arks for facing the change that is at hand. 'The war of 1870 need never have been fought had people read my *Sentimental Education*,' said Gustave Flaubert.

It is this aspect of *new* art that Kenneth Galbraith recommends to the careful study of businessmen who want to stay in business. For in the electric age there is no longer any sense in talking about the artist's being ahead of his time. Our technology is, also, ahead of its time, if we reckon by the ability to recognize it for what it is. To prevent undue wreckage in society, the artist tends now to move from the ivory tower to the control tower of society. Just as higher education is no longer a frill or luxury but a stark need of production and operational design in the electric age, so the artist is indispensable in the shaping and analysis and understanding of the life of forms, and structures created by electric technology.

The percussed victims of the new technology have invariably muttered clichés about the impracticality of artists and their fanciful preferences. But in the past century it has come to be generally acknowledged that, in the words of Wyndham Lewis, 'The artist is always engaged in writing a detailed history of the future because he is the only person aware of the nature of the present.' Knowledge of this simple fact is now needed for human survival. The ability of the artist to sidestep the bully blow of new technology of any age, and to parry such violence with full awareness, is age-old. Equally age-old is the inability of the percussed victims, who cannot sidestep the new violence, to recognize their need of the artist. To reward and to make celebrities of artists can, also, be a way of ignoring their prophetic work, and preventing its timely use for survival. The artist is the man in any field, scientific or humanistic, who grasps the implications of his actions and of new knowledge in his own time. He is the man of integral awareness.

The artist can correct the sense ratios before the blow of new technology has numbed conscious procedures. He can correct them before numbness and subliminal groping and reaction begin. If this is true, how is it possible to present the matter to those who are in a position to do something about it? If there were even a remote likelihood of this analysis being true, it would warrant a global armistice and period of stock-taking. If it is true that the artist possesses the means of anticipating and avoiding the consequences of technological trauma, then what are we to think of the world and bureaucracy of 'art appreciation'? Would it not seem suddenly to be a conspiracy to make the artist a frill, a fribble, or a Milltown? If men were able to be convinced that art is precise advance knowledge of how to cope with the psychic and social consequences of the next technology, would they all become artists? Or would they begin a careful translation of new art forms into social navigation charts? I am curious to know what would happen if art were suddenly seen for what it is, namely, exact information of how to rearrange one's psyche in order to anticipate the next blow from our own extended faculties. Would we, then, cease to look at works of art as an explorer might regard the gold and gems used as the ornaments of simple nonliterates?

At any rate, in experimental art, men are given the exact specifications of coming violence to their own psyches from their own counter-irritants or technology. For those

parts of ourselves that we thrust out in the form of new invention are attempts to counter or neutralize collective pressures and irritations. But the counter-irritant usually proves a greater plague than the initial irritant, like a drug habit. And it is here that the artist can show us how to 'ride with the punch,' instead of 'taking it on the chin.' It can only be repeated that human history is a record of 'taking it on the chin.'

21 Gerhard Richter (b. 1932) 'Notes 1964–1965'

In the early 1950s Richter studied at the Kunstakademie in Dresden, in what was then East Germany. He moved to the West in 1961 and entered the Kunstakademie in Düsseldorf, where his contemporaries included Sigmar Polke and Konrad Lueg (subsequently Konrad Fischer). In 1962 Richter began basing his paintings on black-and-white photographs, working in monochrome and blurring the imagery in such a manner as to emphasize the painterly process and materials. In 1963 he and Lueg staged an event ironically titled 'Demonstration in Support of Capitalist Realism' in a department store in Düsseldorf. The following notes were first published in Gerhard Richter, *Texte, Schriften und Interviews*, ed. Hans-Ulrich Obrist, Frankfurt am Main and Leipzig: Insel Verlag, 1994. Our version is taken from the translation by David Britt: Gerhard Richter, *The Daily Practice of Painting: Writings and Interviews 1962–1993*, London: Thames and Hudson in association with the Anthony d'Offay Gallery, 1995, pp. 31–9. (See also VIIIC8 and 9.)

The photograph took the place of all those paintings, drawings and illustrations that served to provide information about the reality that they represented. A photograph does this more reliably and more credibly than any painting. It is the only picture that tells the absolute truth, because it sees 'objectively'. It usually gets believed, even where it is technically faulty and the content is barely identifiable. At the same time, photography took on a religious function. Everyone has produced his own 'devotional pictures': these are the likenesses of family and friends, preserved in remembrance of them.

Photography altered ways of seeing and thinking. Photographs were regarded as true, paintings as artificial. The painted picture was no longer credible; its representation froze into immobility, because it was not authentic but invented.

Life communicates itself to us through convention and through the parlour games and laws of social life. Photographs are ephemeral images of this communication – as are the pictures that I paint from photographs. Being painted, they no longer tell of a specific situation, and the representation becomes absurd. As a painting, it changes both its meaning and its information content.

The photograph is the most perfect picture. It does not change; it is absolute, and therefore autonomous, unconditional, devoid of style. Both in its way of informing, and in what it informs of, it is my source.
* * *
The first time I painted from a photograph, I did so in a mixture of exhilaration and fear, partly because I was strongly affected by contemporary Fluxus events, and partly also because I once did a lot of photography myself and worked for a photographer for eighteen

months: the masses of photographs that passed through the bath of developer every day may have created a lasting trauma. There must be other reasons. I can't tell exactly.

* * *

Do you know what was great? Finding out that a stupid, ridiculous thing like copying a postcard could lead to a picture. And then the freedom to paint whatever you felt like. Stags, aircraft, kings, secretaries. Not having to invent anything any more, forgetting everything you meant by painting – colour, composition, space – and all the things you previously knew and thought. Suddenly none of this was a prior necessity for art.

If my paintings differ from the originals, this is not intentional on my part: it is not a matter of design but of technique. And technique lies outside my voluntary control and influence, because it is itself a reality, like the model, the photograph and the painting. Whether an object is on the right or on the left in the painting is utterly immaterial. If it is on the right, this must be correct in its own way, and it would be presumptuous to put it on the left.

As far as the surface is concerned – oil on canvas, conventionally applied – my pictures have little to do with the original photograph. They are totally painting (whatever that may mean). On the other hand, they are so like the photograph that the thing that distinguished the photograph from all other pictures remains intact.

* * *

When I paint from a photograph, this is part of the work process. It is never a defining characteristic of the vision: that is, I am not replacing reality with a reproduction of it, a 'Second-Hand World'. I use photography to make a painting, just as Rembrandt uses drawing or Vermeer the *camera obscura*. I could dispense with the photograph, and the result would still look like a painting from a photograph. *Reproductive* and *direct* are therefore meaningless terms.

* * *

I like everything that has no style: dictionaries, photographs, nature, myself and my paintings. (Because style is violence, and I am not violent.)

Theory has nothing to do with a work of art. Pictures which are interpretable, and which contain a meaning, are bad pictures. A picture presents itself as the Unmanageable, the Illogical, the Meaningless. It demonstrates the endless multiplicity of aspects; it takes away our certainty, because it deprives a thing of its meaning and its name. It shows us the thing in all the manifold significance and infinite variety that preclude the emergence of any single meaning and view.

I don't create blurs. Blurring is not the most important thing; nor is it an identity tag for my pictures. When I dissolve demarcations and create transitions, this is not in order to destroy the representation, or to make it more artistic or less precise. The flowing transitions, the smooth, equalizing surface, clarify the content and make the representation credible (an *alla prima* impasto would be too reminiscent of painting, and would destroy the illusion).

I blur things to make everything equally important and equally unimportant. I blur things so that they do not look artistic or craftsmanlike but technological, smooth and

perfect. I blur things to make all the parts a closer fit. Perhaps I also blur out the excess of unimportant information.

I am a Surrealist.

As a record of reality, the thing I have to represent is unimportant and devoid of meaning, though I make it just as visible as if it were important (because I paint everything as 'correctly', as logically and as credibly as it would appear in a photograph). I am not saying that the thing represented is abolished as such (the painting cannot be turned upside-down). The representation simply acquires a different meaning: it becomes the pretext for a picture. (Photography suits my purposes here: the photograph confronts me as a statement about a reality which I neither know nor judge, which does not interest me, and with which I do not identify.)

All that interests me is the grey areas, the passages and tonal sequences, the pictorial spaces, overlaps and interlockings. If I had any way of abandoning the object as the bearer of this structure, I would immediately start painting abstracts.

My sole concern is the object. Otherwise I would not take so much trouble over my choice of subjects; otherwise I would not paint at all. What fascinates me is the alogical, unreal, atemporal, meaningless occurring of an occurrence which is simultaneously so logical, so real, so temporal and so human, and for that reason so compelling. And I would like to represent it in such a way that this clash is maintained. That is why I have to avoid intervening or altering anything, for the sake of a simplicity that can thus be more general, definitive, lasting and comprehensive.

* * *

Art is not a substitute religion: it is a religion (in the true sense of the word: 'binding back', 'binding' to the unknowable, transcending reason, transcendent being). This does not mean that art has turned into something like the Church and taken over its functions (education, instruction, interpretation, provision of meaning). But the Church is no longer adequate as a means of affording experience of the transcendental, and of making religion real – and so art has been transformed from a means into the sole provider of religion: which means religion itself.

All things artificial and natural, whether in planned or fortuitous arrangements, have the capacity to turn into fetishes. Belief, for one: that is, making statements and predictions beyond the actual circumstances of time and place. And for another: depriving an object of its utilitarian value and believing in it.

If I were to exhibit a urinal today, this would be legitimate, because I would not be demonstrating anti-art but setting the urinal up as an altar and object of art and faith. I want to be like everyone else, think what everyone else thinks, do what is being done anyway.

I don't want to be a personality or to have an ideology. I see no sense in doing anything different. I never do see any sense. I think that one always does what is being done anyway (even when making something new), and that one is always making something

new. To have an ideology means having laws and guidelines; it means killing those who have different laws and guidelines. What is the good of that?

22 Tony Smith (1912–1981) from an Interview with Samuel Wagstaff Jr

Smith worked as an architect as well as a sculptor. Though a contemporary of Pollock, he was to make his principal impact in the 1960s. His description of the car ride along the unfinished New Jersey Turnpike was attractive to a generation of artists trying to come to terms with what seemed to them to be the limitations of the autonomous art object (VIIB3). Conversely, for Modernist critics defending the concept of an autonomous art, Smith's experience and the claims he made for it became paradigmatic of a *mis*understanding of the essential nature of modern art (see, in particular, Fried's 'Art and Objecthood', VIIA7). Published as 'Talking with Tony Smith', *Artforum*, New York, vol. 1, no. 4, December 1966, pp. 18–19, from which the present extracts are taken.

I view art as something vast. I think highway systems fall down because they are not art. Art today is an art of postage stamps. [...] I think of art in a public context and not in terms of mobility of works of art. Art is just there. [...]

When I was teaching at Cooper Union in the first year or two of the fifties, someone told me how I could get on to the unfinished New Jersey Turnpike. I took three students and drove from somewhere in the Meadows to New Brunswick. It was a dark night and there were no lights or shoulder markers, lines, railings, or anything at all except the dark pavement moving through the landscape of the flats, rimmed by hills in the distance, but punctuated by stacks, towers, fumes, and colored lights. This drive was a revealing experience. The road and much of the landscape was artificial, and yet it couldn't be called a work of art. On the other hand, it did something for me that art had never done. At first I didn't know what it was, but its effect was to liberate me from many of the views I had had about art. It seemed that there had been a reality there which had not had any expression in art.

The experience on the road was something mapped out but not socially recognized. I thought to myself, it ought to be clear that's the end of art. Most painting looks pretty pictorial after that. There is no way you can frame it, you just have to experience it. Later I discovered some abandoned airstrips in Europe – abandoned works, Surrealist landscapes, something that had nothing to do with any function, created worlds without tradition. Artificial landscape without cultural precedent began to dawn on me. There is a drill ground in Nuremberg, large enough to accommodate two million men. The entire field is enclosed with high embankments and towers. The concrete approach is three sixteen-inch steps, one above the other, stretching for a mile or so. [...]

23 Jasper Johns (b. 1930) Obituary of Marcel Duchamp

For previous information about Johns, see VIA14. The emergence of a new international avant-garde in the 1950s, and its consolidation in the 1960s, contributed much to the

retrospective elevation of Marcel Duchamp. For many years Duchamp had been a somewhat peripheral figure, a presence on the art scene as much for his reputation, elusiveness and entrepreneurial élan as for any actual art work, but undeniably marginal to the triumphant school of American abstract painting after the Second World War. The balance began to change however, first as American Modernism appeared to split into different currents, and subsequently as an explicitly post-Modernist sensibility began to dominate. Duchamp was now elected to a role equivalent to that which the more orthodox Modernist tradition had allotted to Picasso. By the time of his death in 1968, Duchamp's status was secure as the Great Predecessor of the Neo-Dadaist/conceptualist/post-Modernist avant-garde. It was in the circle around John Cage, and notably in the work of Johns and Robert Rauschenberg, that Duchamp's ideas were simultaneously excavated and explored. It was fitting therefore that Johns should contribute a short memorial essay for *Artforum*. The text was printed in bold typeface on a single full page of the magazine. Its final sentence gives the measure of Duchamp's status for the art of the later twentieth century. The obituary is here reprinted in full from *Artforum*, New York, November 1968, p. 6.

Marcel Duchamp [1887–1968]

The self attempts balance, descends. Perfume – the air was to stink of artists' egos. Himself, quickly torn to pieces. His tongue in his cheek.

Marcel Duchamp, one of this century's pioneer artists, moved his work through the retinal boundaries which had been established with Impressionism into a field where language, thought and vision act upon one another. There it changed form through a complex interplay of new mental and physical materials, heralding many of the technical, mental and visual details to be found in more recent art.

He said that he was ahead of his time. One guesses at a certain loneliness there. Wittgenstein said that '*Time has only one direction*' must be a piece of nonsense.

In the 1920s Duchamp gave up, quit painting. He allowed, perhaps encouraged, the attendant mythology. One thought of his decision, his willing this stopping. Yet on one occasion, he said it was not like that. He spoke of breaking a leg. 'You don't mean to do it,' he said.

The Large Glass. A greenhouse for his intuition. Erotic machinery, the Bride, held in a see-through cage – 'a Hilarious picture.' Its cross-references of sight and thought, the changing focus of the eyes and mind, give fresh sense to the time and space we occupy, negate any concern with art as transportation. No end is in view in this fragment of a new perspective. 'In the end you lose interest, so I didn't feel the necessity to finish it.'

He declared that he wanted to kill art ('for myself') but his persistent attempts to destroy frames of reference altered our thinking, established new units of thought, 'a new thought for that object.'

The art community feels Duchamp's presence and his absence. He has changed the condition of being here.

VIB
Modernist Art

1 Alain Robbe-Grillet (b. 1922) 'Commitment'

Robbe-Grillet was a novelist and the leading theoretician of the French *nouveau roman* (new novel) of the 1950s and early 1960s, in which the principle of the inseparability of form and content is given precedence over traditional conventions of narrative sequence. This text is taken from his *Towards a New Novel*, originally published in 1957 as *Pour un nouveau roman*. In defence of the autonomy of art, he argues against the equation of political with artistic revolution, and in particular against the tendency of Socialist Realism to create its types as exemplifications of its theories. He also argues against the notion of exemplary moral commitment which Sartre put forward in *Existentialism and Humanism* (VB2), taking the characteristically Modernist position that the commitment of the artist is realized through a primary engagement with the problems of the medium rather than the problems of society. The present text is taken from the translation by Barbara Wright, London, 1965, pp. 65–70.

Since writing in order to entertain is futile, and writing to make people believe has become suspect, the novelist thinks he can see another path: to write in order to teach. Tired of hearing armchair critics declare in their condescending way: 'I don't read novels any more, I've grown out of them, they're all right for women (who have nothing to do), personally I prefer reality....' and other such idiocies, the novelist falls back on didactic literature. There at least he hopes to get the upper hand again: reality is too baffling, too ambiguous, for everyone to be able to learn something from it. When it comes to proving something (whether it be showing up the poverty of man without God, or explaining the feminine heart, or arousing class-consciousness), then fiction must come into its own again: it will be so much more convincing!

Unfortunately, it then doesn't convince anyone any more; the moment the novel becomes suspect it runs the risk, on the contrary, of discrediting psychology, socialist morality and religion. Anyone interested in these disciplines will read essays, they are safer. And once again literature is rejected and put back into the category of the frivolous. The didactic novel has even rapidly become obnoxious to everyone.... And yet, a few years ago, we saw it take on a new lease of left-wing life, in different guise: 'commitment'; which is also, in the East, and more naïvely coloured, called 'socialist realism'.

Certainly the idea of a possible union between an artistic rebirth and a politico-economic revolution is one that springs very naturally to the mind. It is an idea which from the very beginning is attractive from the sentimental point of view, and which also

seems obviously to be supported by logic. And yet the problems posed by such an alliance are serious and difficult; urgent, but perhaps insoluble.

The connection, at first, seemed simple. On the one hand the artistic forms which have followed one another in the history of the nations seem to us to be linked to this or that type of society, to the preponderance of a certain class, to the operation of a tyranny or to the birth of a form of liberty. In France, for instance, in the field of literature, there is some justification for seeing a close relationship between Racine's tragedies and the development of a court aristocracy, between Balzac's novels and the triumph of the bourgeoisie, etc.

And as, on the other hand, most people, even conservatives, will readily agree that our great contemporary artists, whether writers or painters, belong, for the most part, (or did belong, when they were producing their greatest works) to the progressive parties, they are tempted to fabricate this idyllic blueprint: Art and Revolution, advancing hand in hand, fighting for the same cause, going through the same ordeals, facing the same dangers, gradually making the same conquests, and finally attaining the same apotheosis.

Unfortunately, though, the moment we move on to the practical level, things start to go wrong. The least we can say, today, is that the data of this problem are not so simple. We all know the comedies and tragedies which for the last fifty years have been disturbing, and still are disturbing, every attempt to bring about this marvellous union which people thought was both a love match and a marriage of convenience. How can we forget the successive surrenders and resignations, the resounding quarrels, the excommunications, the imprisonments, the suicides? How can we forget what has happened to painting, not to mention any other art, in the countries where the revolution has triumphed? How can we not smile at the accusations of 'decadence', of 'excess', of 'formalism', employed at random by the most zealous revolutionaries to describe everything which we think of value in contemporary art? How can we not fear that we may one day find ourselves prisoners in the same net?

It is too easy, and let's say so straight away, to blame bad leaders, bureaucratic routine, Stalin's lack of culture, the stupidity of the French communist party. We know from experience that it is just as difficult to try and plead the cause of art to any politician in any progressive organization. Let us be blunt about it: the socialist Revolution mistrusts revolutionary Art, and, what is more, it is not so obvious that it is wrong.

In fact, from the point of view of the revolution, everything must directly combine for the final goal: the liberation of the proletariat. . . . Everything, including literature and painting, etc. But it is quite different for the artist; even if his political convictions are of the strongest, even if he is a fervent militant, art can never be reduced to a means to a wider end, even if that end is the greatest and most exalted cause. Nothing can be more important to the artist than his work, and he soon discovers that he can only create *for nothing*; the slightest directive from outside paralyses him, to have to pay the slightest attention to didactics, or even to meaning, is an intolerable constraint; whatever his attachment to his party or to liberal ideas, at the moment of creation he can only be concerned with the problems of his art.

Now even at a time when art and society, after developing in similar ways, seem to be undergoing parallel crises, it is still clear that the problems raised by the one and the other cannot be solved in the same way. Later, no doubt, sociologists will discover new

similarities in their solutions. But for us, in any case – and this we must face honestly and with clarity – the fight is not the same. And we must also face the fact that today, as always, there is a direct conflict between the two points of view. Either art is nothing – and in that case painting, literature, sculpture and music might as well be enrolled in the service of the revolutionary cause, where they would be no more than instruments, comparable to motorised armies, machine tools and tractors, which have nothing to contribute but their direct and immediate efficacy.

Or else art will continue to exist in its own right; and in that case, at least so far as the artist is concerned, it will remain *the most important thing in the world*. In which case, in comparison with political activity, it will always seem to be lagging behind, useless, if not frankly reactionary. And yet we know from history that it is only this so-called gratuitous art that will turn out to be on the side of the trade unions and the barricades.

In the meantime this generous, but utopian, way of talking about a novel, a painting, or a statue as if they could carry the same weight in day to day action as a strike, or a mutiny, or the cry of a victim denouncing his torturers, is doing a disservice, in the final analysis, both to Art and to the Revolution. Too many such errors have been committed in the last few years in the name of socialist realism. The total artistic poverty of the works that claim the greatest affinity with it is certainly no accident: it is in the very idea of a work being created *for the purpose of* expressing some content of a social, political, economic, moral, etc., nature, that the falsehood lies.

Now, then, once and for all, we must stop taking it seriously when we are accused of being gratuitous, stop being afraid of 'art for art's sake' as if it were the worst of all evils, and stand firm against all the instruments of coercion that are brandished in front of us the moment we talk about anything other than the class struggle or the anti-colonial war.

And yet, not everything in the Soviet theory of so-called 'socialist realism' should be condemned *a priori*. In literature, for instance, did it not also imply a reaction against the accumulation of false philosophy which had finally invaded everything, from poetry to the novel? In its opposition to metaphysical allegories, in its fight against the abstract hinterlands that these allegories presuppose, as well as against purposeless verbal delirium, and against the vague sentimentality of the emotions, socialist realism might well have been a good influence.

For misleading ideologies and myths have no more place in it. This literature simply exposes man's situation, and that of the universe he has to contend with. And it is not only the worldly 'values' of bourgeois society that have disappeared, but with them any magic, religious or philosophical appeal to any sort of spiritual resource 'beyond' our visible world. The now fashionable themes of despair and the absurd are denounced as alibis which are too easy. Ilya Ehrenburg was not afraid to write, immediately after the war: 'Anguish is a bourgeois vice. *Our* answer lies in reconstruction.'

Given principles such as this, we had every reason to hope that they were proposing to purge people and things of their systematic *romanticism*, so that they could once again properly be described by that expression so dear to Lukács, which in any case is the only thing they can be – *what they are*. Reality would no longer be permanently situated elsewhere, but *here and now*, without ambiguity. The world would no longer find its justification in a hidden meaning, whatever it might be, because its existence

would lie only in its concrete, solid, material presence. Beyond what we see (what our senses perceive), there would henceforth be nothing.

Let us now consider the outcome. What does socialist realism offer us? Obviously, this time, what's good is good, and what's bad is bad. But that is the point: their concern with the evidence has nothing to do with what we observe in the world. Where is the progress if, to avoid the division into essence and appearance we fall into the manicheism of good and evil?

And there is something even more serious. When, in the less naïve stories, we come up against credible human beings, in a complex world endowed with a tangible existence, we soon discover that, in spite of everything, this world and these people have been constructed with a view to being interpreted. And anyway, their authors don't conceal the fact that what they are primarily trying to do is to illustrate, with the greatest possible precision, various types of historical, economic, social and political behaviour.

Now, from the point of view of literature, economic truths and Marxist theories about excess yield and usurpation are also hinterlands. If progressive novels are only to have any reality through these functional explanations of the visible world, which they have prepared in advance, tested and acknowledged, it is hard to see wherein their power of discovery or invention might lie. Above all, it would merely be one more new way of refusing the world its most certain quality – the simple fact that it is there. An explanation, whatever it may be, can only be superfluous when it comes face to face with the presence of things. A theory about their social function, if it has been responsible for their description, can only confuse their design, can only falsify them, on exactly the same grounds as the old psychological and moral theories, or the symbolism of allegories.

Which explains, after all, why socialist realism has no need of experiment in fictional forms, why it so utterly distrusts every new artistic technique, why what suits it best, as we see every day, is the most 'bourgeois' form of expression.

But for some time now some uneasiness has been felt in Russia and the Peoples' Republics. Responsible artists are now realizing that they are on the wrong track, and that in spite of appearances the so-called 'laboratory' experiments on the structure and language of the novel, even if the only people to be enthusiastic about them at first are the specialists, are perhaps not so useless as the revolutionary party pretends to think.

What is left of 'commitment', then? Sartre, who saw the danger of this moralistic literature, advocated a *moral* literature which would aim at arousing people's political consciences merely by stating the problems of our society, but would try to avoid a propagandist spirit by restoring the reader's liberty. Experience has shown that that too was utopian: the moment the writer starts worrying about conveying some meaning (exterior to the work of art), literature starts to retreat, to disappear.

Let us restore to the idea of commitment, then, the only meaning it can have for us. Rather than being of a political nature, commitment, for the writer, means to be fully aware of the current problems of his own language, convinced of their extreme importance, and desirous of solving them from within. Therein lies his sole possibility of remaining an artist, and also, no doubt, by means of some obscure and distant consequence, of maybe one day being of some use – maybe even to the revolution.

2 David Smith (1906–1965) 'Tradition and Identity'

The ethical basis of Smith's work is to be found in his commitment to improvisation, and to what is revealed of the artist in the process. This position implies a rejection both of traditional notions of realism and of those concepts of abstraction which presuppose that composition is governed by fundamental rational or naturalistic principles. This is the text of a speech given at Ohio University, Athens, Ohio, on 17 April 1959; printed in Garnett McCoy (ed.), *David Smith*, New York, 1973, pp. 146–8. (See also VA14.)

When I lived and studied in Ohio, I had a very vague sense of what art was. Everyone I knew who used the reverent word was almost as unsure and insecure.

Mostly art was reproductions, from far away, from an age past and from some golden shore, certainly from no place like the mud banks of the Auglaze or the Maumee, and there didn't seem much chance that it could come from Paulding County.

Genuine oil painting was some highly cultivated act that came like the silver spoon, born from years of slow method, applied drawing, watercoloring, designing, art structure, requiring special equipment of an almost secret nature, that could only be found in Paris or possibly New York, and when I got to New York and Paris I found that painting was made with anything at hand, building board, raw canvas, self-primed canvas, with or without brushes, on the easel, on the floor, on the wall, no rules, no secret equipment, no anything, except the conviction of the artist, his challenge to the world and his own identity.

Discarding the old methods and equipment will not of course make art. It has only been a symbol in creative freedom from the bondage of tradition and outside authority.

Sculpture was even farther away. Modeling clay was a mystic mess which came from afar. How sculpture got into metal was so complex that it could be done only in Paris. The person who made sculpture was someone else, an ethereal poetic character divinely sent, who was scholar, aesthetician, philosopher, Continental gentleman so sensitive he could unlock the crying vision from a log or a Galatea from a piece of imported marble.

I now know that sculpture is made from rough externals by rough characters or men who have passed through all polish and are back to the rough again.

The mystic modeling clay is only Ohio mud, the tools are at hand in garages and factories. Casting can be achieved in almost every town. Visions are from the imaginative mind, sculpture can come from the found discards in nature, from sticks and stones and parts and pieces, assembled or monolithic, solid form, open form, lines of form, or, like a painting, the illusion of form. And sculpture can be painting and painting can be sculpture and no authority can overrule the artist in his declaration. Not even the philosopher, the aesthetician, or the connoisseur.

I have spoken against tradition, but only the tradition of others who would hold art from moving forward. Tradition holding us to the perfections of others. In this context tradition can only say what art was, not what art is. Tradition comes wrapped in word pictures; these are traps which lead laymen into cliché thinking. This leads to analogy and comparative evaluation and conclusion, especially in the hands of historians. Where conclusions are felt, the understanding of art has been hampered and the innovations of the contemporary scene are often damned.

Art has its tradition, but it is a visual heritage. The artist's language is the memory from sight. Art is made from dreams, and visions, and things not known, and least of all from things that can be said. It comes from the inside of who you are when you face yourself. It is an inner declaration of purpose, it is a factor which determines artist identity.

The nature to which we all refer in the history of art is still with us, although somewhat changed; it is no longer anecdote or robed and blindfolded virtue, the bowl of fruit, or that very abstract reference called realistic; it is very often the simple subject called the artist. Identifying himself as the artist, he becomes his own subject as one of the elements in nature. He no longer dissects it, nor moralizes upon it; he is its part. The outside world of nature is equal, without accent, unquestioning. He is an element in the atmosphere called nature, his reference to nature is more like primitive man addressing it as 'thou' and not 'it.' Aura and association, all the parts into the whole expression, all actions in an emotional flow, manifest the artist as subject, a new position for the artist but natural to his time. Words become difficult, they can do little in explaining a work of art, let alone the position of the artist in the creative irrational flow of power and force which underlies the position and conception. Possibly I can explain my own procedure more easily. When I begin a sculpture I'm not always sure how it is going to end. In a way it has a relationship to the work before, it is in continuity with the previous work – it often holds a promise or a gesture toward the one to follow.

I do not often follow its path from a previously conceived drawing. If I have a strong feeling about its start, I do not need to know its end; the battle for solution is the most important. If the end of the work seems too complete and final, posing no question, I am apt to work back from the end, that in its finality it poses a question and not a solution.

Sometimes when I start a sculpture I begin with only a realized part; the rest is travel to be unfolded, much in the order of a dream.

The conflict for realization is what makes art, not its certainty, its technique, or material. I do not look for total success. If a part is successful, the rest clumsy or incomplete, I can still call it finished, if I've said anything new, by finding any relationship which I might call an origin.

I will not change an error if it feels right, for the error is more human than perfection. I do not seek answers. I haven't named this work nor thought where it would go. I haven't thought what it is for, except that it is made to be seen. I've made it because it comes closer to saying who I am than any other method I can use. This work is my identity. There were no words in my mind during its creation, and I'm certain words are not needed in its seeing; and why should you expect understanding when I do not? That is the marvel – to question but not to understand. Seeing is the true language of perception. Understanding is for words. As far as I am concerned, after I've made the work, I've said everything I can say.

3 Maurice Merleau-Ponty (1908–1961) from 'Eye and Mind'

Merleau-Ponty was responsible for revising phenomenological concepts of perception in line with a neo-Marxist account of the grounds of knowledge and experience. In his phenomen-

ology, perception involves a combination of language with bodily awareness. In his later work he was concerned to stress the limitations of philosophical concepts when dealing with visual experience. His writing was of importance to younger Modernist critics writing in the 1960s and early 1970s, and in particular to Michael Fried (see VIB9). This was the last work printed in the author's lifetime. Originally published as 'L'Oeil et l'esprit' in *Art de France*, vol. 1, no. 1, Paris, January 1961; English translation by Carleton Dallery in James M. Edie (ed.), *The Primacy of Perception*, Evanston, IL, 1964, pp. 159–90; the present extract is taken from the two concluding sections.

The entire modern history of painting, with its efforts to detach itself from illusionism and to acquire its own dimensions, has a metaphysical significance. This is not something to be demonstrated. Not for reasons drawn from the limits of objectivity in history and from the inevitable plurality of interpretations, which would prevent the linking of a philosophy and an event; the metaphysics we have in mind is not a body of detached ideas [*idées séparées*] for which inductive justifications could be sought in the experiential realm. There are, in the flesh of contingency, a structure of the event and a virtue peculiar to the scenario. These do not prevent the plurality of interpretations but in fact are the deepest reasons for this plurality. They make the event into a durable theme of historical life and have a right to philosophical status. In a sense everything that could have been said and that will be said about the French Revolution has always been and is henceforth within it, in that wave which arched itself out of a roil of discrete facts, with its froth of the past and its crest of the future. And it is always by looking more deeply into *how it came about* that we give and will go on giving new representations of it. As for the history of art works, if they are great, the sense we give to them later on has issued from them. It is the work itself that has opened the field from which it appears in another light. It changes *itself* and *becomes* what follows; the interminable reinterpretations to which it is *legitimately* susceptible change it only in itself. And if the historian unearths beneath its manifest content the surplus and thickness of meaning, the texture which held the promise of a long history, this active manner of being, then, this possibility he unveils in the work, this monogram he finds there – all are grounds for a philosophical meditation. But such a labour demands a long familiarity with history. We lack everything for its execution, both the competence and the place. Just the same, since the power or the fecundity of art works exceeds every positive causal or filial relation, there is nothing wrong with letting a layman, speaking from his memory of a few paintings and books, tell us how painting enters into his reflections; how painting deposits in him a feeling of profound discordance, a feeling of mutation within the relations of man and Being. Such feelings arise in him when he holds a universe of classical thought, en bloc, up against the explorations [*recherches*] of modern painting. This is a sort of history by contact, perhaps, never extending beyond the limits of one person, owing everything nevertheless to his frequentation of others...

'I believe Cézanne was seeking depth all his life,' says Giacometti. Says Robert Delaunay, 'Depth is the new inspiration.' Four centuries after the 'solutions' of the Renaissance and three centuries after Descartes, depth is still new, and it insists on being sought, not 'once in a lifetime' but all through life. It cannot be merely a question of an unmysterious interval, as seen from an aeroplane, between these trees nearby and those farther away. Nor is it a matter of the ways things are conjured away one by

another, as we see happen so vividly in a perspective drawing. These two views are very explicit and raise no problems. The enigma, though, lies in their bond, in what is between them. The enigma consists in the fact that I see things, each one in its place, precisely because they eclipse one another, and that they are rivals before my sight precisely because each one is in its own place. Their exteriority is known in their envelopment and their mutual dependence in their autonomy. Once depth is understood in this way, we can no longer call it a third dimension. In the first place, if it were a dimension, it would be the *first* one; there are forms and definite planes only if it is stipulated how far from me their different parts are. But a *first* dimension that contains all the others is no longer a dimension, at least in the ordinary sense of a *certain relationship* according to which we make measurements. Depth thus understood is, rather, the experience of the reversibility of dimensions, of a global 'locality' – everything in the same place at the same time, a locality from which height, width, and depth are abstracted, of a voluminosity we express in a word when we say that a thing is *there*. In search of depth Cézanne seeks this deflagration of Being, and it is all in the modes of space, in form as much as anything. Cézanne knows already what cubism will repeat: that the external form, the envelope, is secondary and derived, that it is not that which causes a thing to take form, that this shell of space must be shattered, this fruit bowl broken – and what is there to paint, then? Cubes, spheres, and cones (as he said once)? Pure forms which have the solidity of what could be defined by an internal law of construction, forms which all together, as traces or slices of the thing, let it appear between them like a face in the reeds? This would be to put Being's solidity on one side and its variety on the other. Cézanne made an experiment of this kind in his middle period. He opted for the solid, for space – and came to find that inside this space, a box or container too large for them, the things began to move, colour against colour; they began to modulate in instability. Thus we must seek space and its content *as* together. The problem is generalized; it is no longer that of distance, of line, of form; it is also, and equally, the problem of colour.

Colour is the 'place where our brain and the universe meet', he says in that admirable idiom of the artisan of Being which Klee liked to cite. It is for the benefit of colour that we must break up the form-spectacle. Thus the question is not of colours, 'simulacra of the colours of nature' [Delaunay]. The question, rather, concerns the dimension of colour, that dimension which creates identities, differences, a texture, a materiality, a something – creates them from itself, for itself. . . .

Yet (and this must be emphasized) there is no one master key of the visible, and colour alone is no closer to being such a key than space is. The return to colour has the merit of getting somewhat nearer to 'the heart of things' [Klee], but this heart is beyond the colour envelope just as it is beyond the space envelope. The *Portrait of Vallier* sets white spaces between the colours which take on the function of giving shape to, and setting off a being, more general than the yellow-being or green-being or blue-being. Also in the water-colours of Cézanne's last years, for example, space (which had been taken to be evidence itself and of which it was believed that the question of *where* was not to be asked) radiates around planes that cannot be assigned to any place at all . . .

Obviously it is not a matter of adding one more dimension to those of the flat canvas, of organizing an illusion or an objectless perception whose perfection consists in simulating an empirical vision to the maximum degree. Pictorial depth (as well

as painted height and width) comes 'I know not whence' to alight upon, and take root in, the sustaining support. The painter's vision is not a view upon the *outside*, a merely 'physical-optical' [Klee] relation with the world. The world no longer stands before him through representation; rather, it is the painter to whom the things of the world give birth by a sort of concentration or coming-to-itself of the visible. Ultimately the painting relates to nothing at all among experienced things unless it is first of all 'autofigurative'.[1] It is a spectacle of something only by being a 'spectacle of nothing',[2] by breaking the 'skin of things'[3] to show how the things become things, how the world becomes world. Apollinaire said that in a poem there are phrases which do not appear to have been *created*, which seem to have *formed themselves*. And Henri Michaux said that sometimes Klee's colours seem to have been born slowly upon the canvas, to have emanated from some primordial ground, 'exhaled at the right place'[4] like a patina or a mould. Art is not construction, artifice, meticulous relationship to a space and a world existing outside. It is truly the 'inarticulate cry', as Hermes Trismegistus said, 'which seemed to be the voice of the light.' And once it is present it awakens powers dormant in ordinary vision, a secret of pre-existence. When through the water's thickness I see the tiling at the bottom of a pool, I do not see it *despite* the water and the reflections there; I see it through them and because of them. If there were no distortions, no ripples of sunlight, if it were without this flesh that I saw the geometry of the tiles, then I would cease to see it *as* it is and where it is – which is to say, beyond any identical, specific place. I cannot say that the water itself – the aqueous power, the sirupy and shimmering element – is *in* space; all this is not somewhere else either, but it is not in the pool. It inhabits it, it materializes itself there, yet it is not contained there; and if I raise my eyes towards the screen of cypresses where the web of reflections is playing, I cannot gainsay the fact that the water visits it, too, or at least sends into it, upon it, its active and living essence. This internal animation, this radiation of the visible is what the painter seeks under the name of depth, of space, of colour.

Anyone who thinks about the matter finds it astonishing that very often a good painter can also make good drawings or good sculpture. Since neither the means of expression nor the creative gestures are comparable, this fact [of competence in several media] is proof that there is a system of equivalences, a Logos of lines, of lighting, of colours, of reliefs, of masses – a conceptless presentation of universal Being. The effort of modern painting has been directed not so much towards choosing between line and colour, or even between the figuration of things and the creation of signs, as it has been towards multiplying the systems of equivalences, towards severing their adherence to the envelope of things. This effort might force us to create new materials or new means of expression, but it could well be realized at times by the re-examination and reinvestment of those which existed already.

* * *

Because depth, colour, form, line, movement, contour, physiognomy are all branches of Being and because each one can sway all the rest, there are no separated, distinct 'problems' in painting, no really opposed paths, no partial 'solutions', no cumulative progress, no irretrievable options. There is nothing to prevent a painter from going back to one of the devices he has shied away from – making it, of course, speak differently. [...]

In 'working over' a favourite problem, even if it is just the problem of velvet or wool, the true painter unknowingly upsets the givens of all the other problems. His quest is total even where it looks partial. Just when he has reached proficiency in some area, he finds that he has reopened another one where everything he said before must be said again in a different way. The upshot is that what he has found he does not yet have. It remains to be sought out; the discovery itself calls forth still further quests. The idea of a universal painting, of a totalization of painting, of a fully and definitively achieved painting is an idea bereft of sense. For painters the world will always be yet to be painted, even if it lasts millions of years . . . it will end without having been conquered in painting.

Panofsky shows that the 'problems' of painting which magnetize its history are often solved obliquely, not in the course of inquiries instigated to solve them but, on the contrary, at some point when the painters, having reached an impasse, apparently forget those problems and permit themselves to be attracted by other things. Then suddenly, altogether off guard, they turn up the old problems and surmount the obstacle. This unhearing [*sourde*] historicity, advancing through the labyrinth by detours, transgression, slow encroachments and sudden drives, does not imply that the painter does not know what he wants. It does imply that what he wants is beyond the means and goals at hand and commands from afar all our *useful* activity.

1 'The spectacle is first of all a spectacle of itself before it is a spectacle of something outside of it.' –
 Translator's note from Merleau-Ponty's 1961 lectures.
2 C. P. Bru, *Esthétique de l'abstraction* (Paris, 1959), pp. 99, 86.
3 Henri Michaux, *Aventures de lignes.*
4 Ibid.

4 Roger Hilton (1911–1975) 'Remarks about Painting'

Hilton studied at the Slade School in London and during the 1930s spent time in Paris, where he studied at the Académie Ranson under Roger Bissière. After military service in 1940–2 he spent three years as a prisoner of war. During the early 1950s, his interest in abstract art was encouraged by friendship with the Dutch artist Constant (see VC11). The works he produced between 1953 and 1968 constitute the major English contribution to the widespread expressive tendency in post-war Modernist painting. In a number of distinctive works produced in the late 1950s and early 1960s he invested highly factitious and decorative surfaces with a sense of elusive emotional and sensuous content. In gouaches made while he was terminally ill and bedridden in 1973–5 he forged flagrantly decorative material from figurative themes treated with spontaneity and wit. The following text was written for the catalogue of an exhibition at the Galerie Lienhard, Zurich, in June 1961. We reproduce it from that source.

Art As An Instrument Of Truth

All my thinking about art is haunted by a mystical belief that in its practice one is tapping sources of truth. If it were not that one caught, in this practice, glimpses of some certainties, one would not continue it.

The combination artist-picture is a total machine which is one of the vital antennae – an intuitional one – which man uses in the exploration of his environment.

The painter today is like the ancient alchemists: he is concerned not so much with visible reality as with reality *tout court*. His pictures are not a picture of the world but an attempt to change it.

At heart everyone knows that beneath the everyday appearance of things are hidden truths which intuition alone can grasp. Today, when everything is put in question, man is trying again to orientate himself, to give himself a direction, to re-establish laws based on absolute truths. In crucial moments in the history of man such as we are living through today there is no excuse for fooling around.

I see art as an instrument of truth, or it is nothing.

The Confrontation Of Medium And Idea

I believe that art comes about only when there is a transfiguration of the artist's thought by its successful incorporation in one of the art forms: there has to be this confrontation of idea and medium. Without these two poles – the *idea*, implacable, thorny, remote, and the *medium*, fleshly, lecherous and lurid – and without the battle between them and the final sinking of each sovereignty in a common wholeness, there can be no art. For an idea to exist there must be a feeling, an intuition or an obsessional image. A painting occurs in the meeting between this image and what one could call paint's language. The sort of thing paint says is only found in painting messes, e.g. children's work, doors used by workmen for wiping their brushes, windows in new houses with blots of whitewash to show they are windows. All these are things which paint says if left to itself. The artist's job is to arrange a meeting between paint and an idea; in doing so, particulars will be transfigured into universals.

I believe there is a technique of painting, difficult to learn – which I include in the word medium. In figurative painting, the subject matter of a picture is not the artist's thought, it is also part of the medium. Figuration is one element, like chiaroscuro or perspective, which can be put in or left out. Its inclusion or exclusion is at the command of the medium which, once it has apprehended the artist's thought must translate it the only way it can. I speak here as if the medium were a sort of person. To the artist perhaps it seems like that. Hence the idea of the Muses. What in fact the artist has in his mind is his idea or thought on one side and his medium on the other. These are very different people. One of them is an awkward character who, however, possesses the great advantage of being able to leave the artist's brain and appear on a piece of canvas. The artist's job is to see that thought continually confronts medium, that it insists that medium arrange itself to express that thought and that it rejects medium's cajoleries about thoughts of its own.

It is a mistake to think of painting as decoration or illustration. A creative artist is a man who is struggling with an idea.

Painting Is Feeling

Painting is feeling. Just as much as a sentence describes, so a sequence of colours describes.

When I paint it is an affair of instinct and intuition. I feel the shape and colours inside myself. I have the feel of a work other than a vision of it. The picture is completed when the plastic form of this feel has made its appearance.

One must express oneself. There are situations, states of mind, moods, etc., which call for some artistic expression; because one knows that only some form of art is capable of going beyond them to give an intuitive contact with a superior sort of truths. The direct imitation of life or nature cannot express the complex human situation which exists for us all today.

All art is an attempt to exteriorise one's sensations and feelings, to give them a form.

Figuration And Abstraction

It may be thought that a technique which has been built up for the purposes of figurative art ceases to apply where non-figuration is concerned. But I think that the figurative parts of pictures are not, in a final analysis, what the picture is really concerned with. It follows that the technique has been built up not so much for the purposes of representing the visible world as for being an instrument capable of embodying men's inner truths. Abstraction has been due not so much to a positive thing but to the absence of a valid image.

Abstraction in itself is nothing. It is only a step towards a new sort of figuration, that is, one which is more true. However beautiful they may be, one can no longer depict women as Titian did. Renoir in his last pictures had already greatly modified her shape. Today one sees people who are changing abstraction into landscape (the easiest to do). For an abstract painter there are two ways out or on: he must give up painting and take to architecture, or he must reinvent figuration.

Now that we have conquered new plastic ground during the last fifty years, there is no reason why images should not return to painting without fear of repeating what has already been done.

Words And Painting

Words and painting don't go together. The more words that are written about painting, the less people will see the painting. Half the difficulty that people find in 'understanding' painting is that they think that they have to put it into words. The only way to understand painting is to look at a lot of it. No amount of reading about it will help. If a painter appears in words people think they are seeing a more intimate part of him than they do in his work. What in fact they are seeing is not him at all.

5 Clement Greenberg (1909–1994) 'Modernist Painting'

More than any other single text in English, this essay has come to typify the Modernist critical position on the visual arts. Its aim is to represent a logic of development supposedly connecting the most successful painting of the previous hundred years, and thus to justify the findings of taste as involuntary responses to the inexorable self-critical tendency of painting itself. Though clearly built on Greenberg's earlier analyses of avant-garde art and

culture (see IVD11 and VA1), <u>the argument of this essay relies less on social-historical forms of evidence and more upon the observation of technical changes in art itself.</u> At the time of its publication Greenberg was closely engaged with the painters Morris Louis and Kenneth Noland, whose form of abstract painting he was soon to label 'Post-Painterly Abstraction'. The essay can be read as a form of response to this work, which Greenberg saw as paradigmatic of the expression of feeling in art, and as preparing a position for it as the most advanced outcome of an unquestionable historical development. First published in *Forum Lectures* (Voice of America), Washington, DC, 1960. Reprinted with slight revisions in *Art & Literature*, Lugano, no. 4, Spring 1965, pp. 193–201, from which the present text is taken. (See also VIB8.)

Modernism includes more than just art and literature. By now it includes almost the whole of what is truly alive in our culture. It happens, also, to be very much of a historical novelty. Western civilization is not the first to turn around and question its own foundations, but it is the civilization that has gone furthest in doing so. I identify Modernism with the intensification, almost the exacerbation, of this self-critical tendency that began with the philosopher Kant. Because he was the first to criticize the means itself of criticism, I conceive of Kant as the first real Modernist.

The essence of Modernism lies, as I see it, in the use of the characteristic methods of a discipline to criticize the discipline itself – not in order to subvert it, but to entrench it more firmly in its area of competence. Kant used logic to establish the limits of logic, and while he withdrew much from its old jurisdiction, logic was left in all the more secure possession of what remained to it.

The self-criticism of Modernism grows out of but is not the same thing as the criticism of the Enlightenment. The Enlightenment criticized from the outside, the way criticism in its more accepted sense does; Modernism criticizes from the inside, through the procedures themselves of that which is being criticized. It seems natural that this new kind of criticism should have appeared first in philosophy, which is critical by definition, but as the nineteenth century wore on it made itself felt in many other fields. A more rational justification had begun to be demanded of every formal social activity, and Kantian self-criticism was called on eventually to meet and interpret this demand in areas that lay far from philosophy.

We know what has happened to an activity like religion that has not been able to avail itself of 'Kantian' immanent criticism in order to justify itself. At first glance the arts might seem to have been in a situation like religion's. Having been denied by the Enlightenment all tasks they could take seriously, they looked as though they were going to be assimilated to entertainment pure and simple, and entertainment itself looked as though it was going to be assimilated, like religion, to therapy. The arts could save themselves from this leveling down only by demonstrating that the kind of experience they provided was valuable in its own right and not to be obtained from any other kind of activity.

Each art, it turned out, had to effect this demonstration on its own account. What had to be exhibited and made explicit was that which was unique and irreducible not only in art in general, but also in each particular art. Each art had to determine, through the operations peculiar to itself, the effects peculiar and exclusive to itself. By doing this each art would, to be sure, narrow its area of competence, but at the same time it would make its possession of this area all the more secure.

It quickly emerged that the unique and proper area of competence of each art coincided with all that was unique to the nature of its medium. The task of self-criticism became to eliminate from the effects of each art any and every effect that might conceivably be borrowed from or by the medium of any other art. Thereby each art would be rendered 'pure', and in its 'purity' find the guarantee of its standards of quality as well as of its independence. 'Purity' meant self-definition, and the enterprise of self-criticism in the arts became one of self-definition with a vengeance.

Realistic, illusionist art had dissembled the medium, using art to conceal art. Modernism used art to call attention to art. The limitations that constitute the medium of painting – the flat surface, the shape of the support, the properties of pigment – were treated by the Old Masters as negative factors that could be acknowledged only implicitly or indirectly. Modernist painting has come to regard these same limitations as positive factors that are to be acknowledged openly. Manet's paintings became the first Modernist ones by virtue of the frankness with which they declared the surfaces on which they were painted. The Impressionists, in Manet's wake, abjured underpainting and glazing, to leave the eye under no doubt as to the fact that the colors used were made of real paint that came from pots or tubes. Cézanne sacrificed verisimilitude, or correctness, in order to fit drawing and design more explicitly to the rectangular shape of the canvas.

It was the stressing, however, of the ineluctable flatness of the support that remained most fundamental in the processes by which pictorial art criticized and defined itself under Modernism. Flatness alone was unique and exclusive to that art. The enclosing shape of the support was a limiting condition, or norm, that was shared with the art of the theater; color was a norm or means shared with sculpture as well as the theater. Flatness, two-dimensionality, was the only condition painting shared with no other art, and so Modernist painting oriented itself to flatness as it did to nothing else.

The Old Masters had sensed that it was necessary to preserve what is called the integrity of the picture plane: that is, to signify the enduring presence of flatness under the most vivid illusion of three-dimensional space. The apparent contradiction involved – the dialectical tension, to use a fashionable but apt phrase – was essential to the success of their art, as it is indeed to the success of all pictorial art. The Modernists have neither avoided nor resolved this contradiction; rather, they have reversed its terms. One is made aware of the flatness of their pictures before, instead of after, being made aware of what the flatness contains. Whereas one tends to see what is *in* an Old Master before seeing it as a picture, one sees a Modernist painting as a picture first. This is, of course, the best way of seeing any kind of picture, Old Master or Modernist, but Modernism imposes it as the only and necessary way, and Modernism's success in doing so is a success of self-criticism.

It is not in principle that Modernist painting in its latest phase has abandoned the representation of recognizable objects. What it has abandoned in principle is the representation of the kind of space that recognizable, three-dimensional objects can inhabit. Abstractness, or the non-figurative, has in itself still not proved to be an altogether necessary moment in the self-criticism of pictorial art, even though artists as eminent as Kandinsky and Mondrian have thought so. Representation, or illustration, as such does not abate the uniqueness of pictorial art; what does do so are the associations of the things represented. All recognizable entities (including pictures

themselves) exist in three-dimensional space, and the barest suggestion of a recogniz-able entity suffices to call up associations of that kind of space. The fragmentary silhouette of a human figure, or of a teacup, will do so, and by doing so alienate pictorial space from the two-dimensionality which is the guarantee of painting's independence as an art. Three-dimensionality is the province of sculpture, and for the sake of its own autonomy painting has had above all to divest itself of everything it might share with sculpture. And it is in the course of its effort to do this, and not so much – I repeat – to exclude the representational or the 'literary', that painting has made itself abstract.

At the same time Modernist painting demonstrates, precisely in its resistance to the sculptural, that it continues tradition and the themes of tradition, despite all appear-ances to the contrary. For the resistance to the sculptural begins long before the advent of Modernism. Western painting, insofar as it strives for realistic illusion, owes an enormous debt to sculpture, which taught it in the beginning how to shade and model towards an illusion of relief, and even how to dispose that illusion in a complementary illusion of deep space. Yet some of the greatest feats of Western painting came as part of the effort it has made in the last four centuries to suppress and dispel the sculptural. Starting in Venice in the sixteenth century and continuing in Spain, Belgium, and Holland in the seventeenth, that effort was carried on at first in the name of color. When David, in the eighteenth century, sought to revive sculptural painting, it was in part to save pictorial art from the decorative flattening-out that the emphasis on color seemed to induce. Nevertheless, the strength of David's own best pictures (which are predominantly portraits) often lies as much in their color as in anything else. And Ingres, his pupil, though subordinating color far more consistently, executed pictures that were among the flattest, least sculptural done in the West by a sophisticated artist since the fourteenth century. Thus by the middle of the nineteenth century all ambitious tendencies in painting were converging (beneath their differences) in an anti-sculptural direction.

Modernism, in continuing this direction, made it more conscious of itself. With Manet and the Impressionists, the question ceased to be defined as one of color versus drawing, and became instead a question of purely optical experience as against optical experience modified or revised by tactile associations. It was in the name of the purely and literally optical, not in that of color, that the Impressionists set themselves to undermining shading and modeling and everything else that seemed to connote the sculptural. And in a way like that in which David had reacted against Fragonard in the name of the sculptural, Cézanne, and the Cubists after him, reacted against Impres-sionism. But once again, just as David's and Ingres' reaction had culminated in a kind of painting even less sculptural than before, so the Cubist counter-revolution eventu-ated in a kind of painting flatter than anything Western art had seen since before Cimabue – so flat indeed that it could hardly contain recognizable images.

In the meantime the other cardinal norms of the art of painting were undergoing an equally searching inquiry, though the results may not have been equally conspicuous. It would take me more space than is at my disposal to tell how the norm of the picture's enclosing shape or frame was loosened, then tightened, then loosened once again, and then isolated and tightened once more by successive generations of Modernist painters; or how the norms of finish, of paint texture, and of value and color contrast, were tested and retested. Risks have been taken with all these, not only for the sake of new

expression, but also in order to exhibit them more clearly as norms. By being exhibited and made explicit they are tested for their indispensability. This testing is by no means finished, and the fact that it becomes more searching as it proceeds accounts for the radical simplifications, as well as radical complications, in which the very latest abstract art abounds.

Neither the simplifications nor the complications are matters of license. On the contrary, the more closely and essentially the norms of a discipline become defined the less apt they are to permit liberties ('liberation' has become a much abused word in connection with avant-garde and Modernist art). The essential norms or conventions of painting are also the limiting conditions with which a marked-up surface must comply in order to be experienced as a picture. Modernism has found that these limiting conditions can be pushed back indefinitely before a picture stops being a picture and turns into an arbitrary object; but it has also found that the further back these limits are pushed the more explicitly they have to be observed. The intersecting black lines and colored rectangles of a Mondrian may seem hardly enough to make a picture out of, yet by echoing the picture's enclosing shape so self-evidently they impose that shape as a regulating norm with a new force and a new completeness. Far from incurring the danger of arbitrariness in the absence of a model in nature, Mondrian's art proves, with the passing of time, almost too disciplined, too convention-bound in certain respects; once we have become used to its utter abstractness we realize that it is more traditional in its color, as well as in its subservience to the frame, than the last paintings of Monet are.

It is understood, I hope, that in plotting the rationale of Modernist art I have had to simplify and exaggerate. The flatness towards which Modernist painting orients itself can never be an utter flatness. The heightened sensitivity of the picture plane may no longer permit sculptural illusion, or *trompe-l'oeil*, but it does and must permit optical illusion. The first mark made on a surface destroys its virtual flatness, and the configurations of a Mondrian still suggest a kind of illusion of a kind of third dimension. Only now it is a strictly pictorial, strictly optical third dimension. Where the Old Masters created an illusion of space into which one could imagine oneself walking, the illusion created by a Modernist is one into which one can only look, can travel through only with the eye.

One begins to realize that the Neo-Impressionists were not altogether misguided when they flirted with science. Kantian self-criticism finds its perfect expression in science rather than in philosophy, and when this kind of self-criticism was applied in art the latter was brought closer in spirit to scientific method than ever before – closer than in the early Renaissance. That visual art should confine itself exclusively to what is given in visual experience, and make no reference to anything given in other orders of experience, is a notion whose only justification lies, notionally, in scientific consistency. Scientific method alone asks that a situation be resolved in exactly the same kind of terms as that in which it is presented – a problem in physiology is solved in terms of physiology, not in those of psychology; to be solved in terms of psychology, it has to be presented in, or translated into, these terms first. Analogously, Modernist painting asks that a literary theme be translated into strictly optical, two-dimensional terms before becoming the subject of pictorial art – which means its being translated in such a way that it entirely loses its literary character. Actually, such consistency promises nothing in the way of aesthetic quality or aesthetic results, and the fact that the best art of the

past seventy or eighty years increasingly approaches such consistency does not change this; now as before, the only consistency which counts in art is aesthetic consistency, which shows itself only in results and never in methods or means. From the point of view of art itself its convergence of spirit with science happens to be a mere accident, and neither art nor science gives or assures the other of anything more than it ever did. What their convergence does show, however, is the degree to which Modernist art belongs to the same historical and cultural tendency as modern science.

It should also be understood that the self-criticism of Modernist art has never been carried on in any but a spontaneous and subliminal way. It has been altogether a question of practice, immanent to practice and never a topic of theory. Much has been heard about programs in connection with Modernist art, but there has really been far less of the programmatic in Modernist art than in Renaissance or Academic art. With a few untypical exceptions, the masters of Modernism have betrayed no more of an appetite for fixed ideas about art than Corot did. Certain inclinations and emphases, certain refusals and abstinences seem to become necessary simply because the way to stronger, more expressive art seems to lie through them. The immediate aims of Modernist artists remain individual before anything else, and the truth and success of their work is individual before it is anything else. To the extent that it succeeds as art Modernist art partakes in no way of the character of a demonstration. It has needed the accumulation over decades of a good deal of individual achievement to reveal the self-critical tendency of Modernist painting. No one artist was, or is yet, consciously aware of this tendency, nor could any artist work successfully in conscious awareness of it. To this extent – which is by far the largest – art gets carried on under Modernism in the same way as before.

And I cannot insist enough that Modernism has never meant anything like a break with the past. It may mean a devolution, an unraveling of anterior tradition, but it also means its continuation. Modernist art develops out of the past without gap or break, and wherever it ends up it will never stop being intelligible in terms of the continuity of art. The making of pictures has been governed, since pictures first began to be made, by all the norms I have mentioned. The Paleolithic painter or engraver could disregard the norm of the frame and treat the surface in both a literally and a virtually sculptural way because he made images rather than pictures, and worked on a support whose limits could be disregarded because (except in the case of small objects like a bone or horn) nature gave them to the artist in an unmanageable way. But the making of pictures, as against images in the flat, means the deliberate choice and creation of limits. This deliberateness is what Modernism harps on: that is, it spells out the fact that the limiting conditions of art have to be made altogether human limits.

I repeat that Modernist art does not offer theoretical demonstrations. It could be said, rather, that it converts all theoretical possibilities into empirical ones, and in doing so tests, inadvertently, all theories about art for their relevance to the actual practice and experience of art. Modernism is subversive in this respect alone. Ever so many factors thought to be essential to the making and experiencing of art have been shown not to be so by the fact that Modernist art has been able to dispense with them and yet continue to provide the experience of art in all its essentials. That this 'demonstration' has left most of our old *value* judgments intact only makes it the more conclusive. Modernism may have had something to do with the revival of the reputations of Uccello, Piero, El Greco, Georges de la Tour, and even Vermeer, and it certainly

confirmed if it did not start other revivals like that of Giotto; but Modernism has not lowered thereby the standing of Leonardo, Raphael, Titian, Rubens, Rembrandt or Watteau. What Modernism has made clear is that, though the past did appreciate masters like these justly, it often gave wrong or irrelevant reasons for doing so.

Still, in some ways this situation has hardly changed. Art criticism lags behind Modernist as it lagged behind pre-Modernist art. Most of the things that get written about contemporary art belong to journalism rather than criticism properly speaking. It belongs to journalism – and to the millennial complex from which so many journalists suffer in our day – that each new phase of Modernism should be hailed as the start of a whole new epoch of art marking a decisive break with all the customs and conventions of the past. Each time, a kind of art is expected that will be so unlike previous kinds of art and so 'liberated' from norms of practice or taste, that everybody, regardless of how informed or uninformed, will be able to have his say about it. And each time, this expectation is disappointed, as the phase of Modernism in question takes its place, finally, in the intelligible continuity of taste and tradition, and as it becomes clear that the same demands as before are made on artist and spectator.

Nothing could be further from the authentic art of our time than the idea of a rupture of continuity. Art is, among many other things, continuity. Without the past of art, and without the need and compulsion to maintain past standards of excellence, such a thing as Modernist art would be impossible.

6 Theodor Adorno (1903–1969) from 'Commitment'

After the Second World War members of the Frankfurt School, who had been exiled in the USA during the Nazi years, returned to West Germany and re-established the Institute for Social Research in Frankfurt. Adorno became its Director after Horkheimer's retirement in 1959. Adorno remained hostile to overtly political art, a position which he had initially set out in his dialogue with Walter Benjamin in the 1930s (see IVD6 and 7). This debate was given renewed currency after the war by Sartre's essay 'What is Literature?', which had called for a committed art. In the present text Adorno reaffirms his belief in the critical power of autonomous art, a position which in the later 1960s was to bring him into conflict with a new generation of radical student activists. Adorno's is not, however, a claim for l'art pour l'art. Rather, it proceeds from an acknowledgement that the moral high ground of commitment was open to claim by the Right as readily as by the Left. Adorno had earlier claimed that to write poetry after Auschwitz would be barbaric. Without abandoning this claim he now reread it, not as a total prohibition on art but as a prohibition on committed art. For its very commitment required, as he put it, an *entente* with the world which was to be affected. The paradoxical result was that only the autonomous work of art could be the site of resistance to the competing interests of a debased reality. Written in 1962, the essay was published in English translation by F. McDonagh in A. Arato and E. Gebhardt (eds.), *The Essential Frankfurt School Reader*, Oxford, 1978, pp. 300–18. The present extracts form three of the essay's four concluding sections. (See also VC14.)

The Problem of Suffering

I have no wish to soften the saying that to write lyric poetry after Auschwitz is barbaric; it expresses in negative form the impulse which inspires committed literature. The

question asked by a character in Sartre's play *Morts Sans Sépulture*, 'Is there any meaning in life when men exist who beat people until the bones break in their bodies?', is also the question whether any art now has a right to exist; whether intellectual regression is not inherent in the concept of committed literature because of the regression of society. But Enzensberger's retort also remains true, that literature must resist this verdict, in other words, be such that its mere existence after Auschwitz is not a surrender to cynicism. Its own situation is one of paradox, not merely the problem of how to react to it. The abundance of real suffering tolerates no forgetting; Pascal's theological saying, *On ne doit plus dormir*, must be secularized. Yet this suffering, what Hegel called consciousness of adversity, also demands the continued existence of art while it prohibits it; it is now virtually in art alone that suffering can still find its own voice, consolation, without immediately being betrayed by it. The most important artists of the age have realized this. The uncompromising radicalism of their works, the very features defamed as formalism, give them a terrifying power, absent from helpless poems to the victims of our time. But even Schönberg's *Survivor of Warsaw* remains trapped in the aporia to which it, autonomous figuration of heteronomy raised to the intensity of hell, totally surrenders. There is something painful in Schönberg's compositions – not what arouses anger in Germany, the fact that they prevent people from repressing from memory what they at all costs want to repress. It is rather the way in which, by turning suffering into images, despite all their hard implacability, they wound our shame before the victims. For these are used to create something, works of art, that are thrown to the consumption of a world which destroyed them. The so-called artistic representation of the sheer physical pain of people beaten to the ground by rifle butts contains, however remotely, the power to elicit enjoyment out of it. The moral of this art, not to forget for a single instant, slithers into the abyss of its opposite. The esthetic principle of stylization, and even the solemn prayer of the chorus, make an unthinkable fate appear to have had some meaning; it is transfigured, something of its horror is removed. This alone does an injustice to the victims; yet no art which tried to evade them could stand upright before justice. Even the sound of despair pays its tribute to a hideous affirmation. Works of less than the highest rank are even willingly absorbed, as contributions to clearing up the past. When genocide becomes part of the cultural heritage in the themes of committed literature, it becomes easier to continue to play along with the culture which gave birth to murder. There is one nearly invariable characteristic of such literature. It is that it implies, purposely or not, that even in the so-called extreme situations, indeed in them most of all, humanity flourishes. Sometimes this develops into a dismal metaphysic which does its best to work up atrocities into 'limiting situations' which it then accepts to the extent that they reveal authenticity in men. In such a homely existential atmosphere, the distinction between executioners and victims becomes blurred; both, after all, are equally suspended above the possibility of nothingness, which of course is generally not quite so uncomfortable for the executioners.

* * *

French and German Cultural Traditions

In the history of French and German consciousness, the problem of commitment has been posed in opposite ways. In France, esthetics have been dominated, openly or covertly, by the principle of *l'art pour l'art*, allied to academic and reactionary tenden-

cies.[1] This explains the revolt against it. Even extreme *avant-garde* works have a touch of decorative allure in France. It is for this reason that the call to existence and commitment sounded revolutionary there. In Germany, the situation is the other way round. The liberation of art from any external end, although it was a German who first raised it purely and incorruptibly into a criterion of taste, has always been suspect to a tradition which has deep roots in German idealism. The first famous document of this tradition is that senior masters' bible of intellectual history, Schiller's *Treatise on the Theatre as a Moral Institution*. Such suspicion is not so much due to the elevation of mind to an Absolute that is coupled with it – an attitude that swaggered its way to hubris in German philosophy. It is rather provoked by the side that any work of art free of an ulterior goal shows to society. For this art is a reminder of that sensuous pleasure in which even – indeed especially – the most extreme dissonance, by sublimation and negation, partakes. German speculative philosophy granted that a work of art contains within itself the sources of its transcendence, and that its own sum is always more than it – but only therefore to demand a certificate of good behavior from it. According to this latent tradition, a work of art should have no being for itself, since otherwise it would – as Plato's embryonic state socialism classically stigmatized it – be a source of effeminacy and an obstacle to action for its own sake, the German original sin. Killjoys, ascetics, moralists of the sort who are always invoking names like Luther and Bismarck, have no time for esthetic autonomy; and there is also an undercurrent of servile heteronomy in the pathos of the categorical imperative, which is indeed on the one hand reason itself, but on the other a brute datum to be blindly obeyed. Fifty years ago Stefan George and his school were still being attacked as Frenchifying esthetes.

Today the curmudgeons whom no bombs could demolish have allied themselves with the philistines who rage against the alleged incomprehensibility of the new art. The underlying impulse of these attacks is petty bourgeois hatred of sex, the common ground of Western moralists and ideologists of socialist realism. No moral terror can prevent the side the work of art shows its beholder from giving him pleasure, even if only in the formal fact of temporary freedom from the compulsion of practical goals. Thomas Mann called this quality of art 'high spirits,' a notion intolerable to people with morals. Brecht himself who was not without ascetic traits – which reappear transmuted in the reserve of any great autonomous art towards consumption – rightly ridiculed culinary art; but he was much too intelligent not to know that pleasure can never be completely ignored in the total esthetic effect, no matter how relentless the work. The primacy of the esthetic object as pure refiguration does not smuggle consumption or false harmony back by a detour. Although the moment of pleasure, even when it is extirpated from the effect of a work, constantly returns to it, the principle that governs autonomous works of art is not the totality of their effects, but their own inherent structure. They are knowledge as nonconceptual objects. This is the source of their greatness. It is not something of which they have to persuade men, because it should be given to them. This is why today autonomous rather than committed works of art should be encouraged in Germany. Committed works all too readily credit themselves with every noble value, and then manipulate them at their ease. Under fascism, too, no atrocity was perpetrated without a moral veneer. Those who trumpet their ethics and humanity in Germany today are merely waiting for a chance to persecute those whom their rules condemn, and to exercise the same

inhumanity in practice of which they accuse modern art in theory. In Germany, commitment often means bleating what everyone is already saying or at least secretly wants to hear. The notion of a 'message' in art, even when politically radical, already contains an accommodation to the world: the stance of the lecturer conceals a clandestine entente with the listeners, who could only be truly rescued from illusions by refusal of it.

The Politics of Autonomous Art

The type of literature that, in accordance with the tenets of commitment but also with the demands of philistine moralism exists for man, betrays him by traducing that which alone could help him, if it did not strike a pose of helping him. But any literature which therefore concludes that it can be a law unto itself, and exist only for itself, degenerates into ideology no less. Art, which even in its opposition to society remains a part of it, must close its eyes and ears against it: it cannot escape the shadow of irrationality. But when it appeals to this unreason, making it a *raison d'être*, it converts its own malediction into a theodicy. Even in the most sublimated work of art there is a hidden 'it should be otherwise.' When a work is merely itself and no other thing, as in a pure pseudoscientific construction, it becomes bad art – literally pre-artistic. The moment of true volition, however, is mediated through nothing other than the form of the work itself, whose crystallization becomes an analogy of that other condition which should be. As eminently constructed and produced objects, works of art, even literary ones, point to a practice from which they abstain: the creation of a just life. The mediation is not a compromise between commitment and autonomy, nor a sort of mixture of advanced formal elements with an intellectual content inspired by genuinely or supposedly progressive politics. The content of works of art is never the amount of intellect pumped into them: if anything it is the opposite. Nevertheless, an emphasis on autonomous works is itself sociopolitical in nature. The feigning of a true politics here and now, the freezing of historical relations which nowhere seem ready to melt, oblige the mind to go where it need not degrade itself. Today, every phenomenon of culture, even if a model of integrity, is liable to be suffocated in the cultivation of kitsch. Yet paradoxically in the same epoch it is to works of art that has fallen the burden of wordlessly asserting what is barred to politics. Sartre himself has expressed this truth in a passage which does credit to his honesty.[2] This is not a time for political art, but politics has migrated into autonomous art, and nowhere more so than where it seems to be politically dead. An example is Kafka's allegory of toy guns, in which an idea of non-violence is fused with a dawning awareness of the approaching paralysis of politics. Paul Klee too belongs to any debate about committed and autonomous art: for his work, *écriture par excellence*, has roots in literature and would not have been what it was without them – or if it had not consumed them. During the First World War or shortly after, Klee drew cartoons of Kaiser Wilhelm as an inhuman iron-eater. Later, in 1920, these became – the development can be shown quite clearly – the *Angelus Novus*, the machine angel, who, though he no longer bears any emblem of caricature or commitment, flies far beyond both. The machine angel's enigmatic eyes force the onlooker to try to decide whether he is announcing the culmination of disaster or salvation hidden within it. But, as Walter Benjamin, who owned the drawing, said, he is the angel who does not give but takes.

¹ 'We know very well that pure art and empty art are the same thing and that aesthetic purism was a brilliant manoeuvre of the bourgeois of the last century who preferred to see themselves denounced as philistines rather than as exploiters.' *What is Literature?*, Jean-Paul Sartre, London, 1967, p. 17.

² See Jean-Paul Sartre, *L'Existentialisme est un Humanisme*, Paris, 1946, p. 105.

7 Barnett Newman (1905–1970) Interview with Dorothy Gees Seckler

Although Newman was the most evidently articulate of the New York School of painters, his first one-man shows of 1950 and 1951 were generally greeted with incomprehension, and it was not until the early 1960s that his work was widely recognized. From then on, however, his work was increasingly taken as a model for new forms of ambitious abstract art. In this interview he reiterates that strong concern for directness of expression and for the ethical content and purport of art which he shared with his contemporaries Rothko, Gottlieb and Still. First published in *Art in America*, vol. 50, no. 2, New York, Summer 1962, pp. 83 and 86–7. Reprinted as 'Frontiers of Space' in Barnett Newman, *Selected Writings and Interviews*, New York, 1990, pp. 247–51. (For earlier texts by Newman see VA2, 8, 9 and 11.)

SECKLER: A general public image of your work conceives of it as excessively logical, hieratic, involved with structure and intellectual dialectic.

NEWMAN: This is not art criticism. This is art politics. It is advanced by painters, and their institutional friends, to give themselves the cloak of romantic spontaneity. I repudiate all these charges. I like your phrase that I am concerned with the immediate and the particular without using a general formula for the painting process with its many particulars. My concern is with the fullness that comes from emotion, not with its initial explosion, or its emotional fallout, or the glow of its expenditure. The fact is, I am an intuitive painter, a direct painter. I have never worked from sketches, never planned a painting, never 'thought out' a painting. I start each painting as if I had never painted before. I present no dogma, no system, no demonstrations. I have no formal solutions. I have no interest in the 'finished' painting. I work only out of high passion.

* * *

SECKLER: How would you define your sense of space?

NEWMAN: I don't manipulate or play with space. I declare it. It is by my declaration that my paintings become full. All of my paintings have a top and a bottom. They are never divided; nor are they confined or constricted; nor do they jump out of their size. Since childhood I have always been aware of space as a space-dome. I remember years ago shocking my friends by saying I would prefer going to Churchill, Canada, to walk the tundra than go to Paris. For me space is where I can feel all four horizons, not just the horizon in front of me and in back of me because then the experience of space exists only as volume. In architecture the concern with volume is valid. Unfortunately, painting is still involved in the notion of space as architectural volumes – intricate small volumes, medium volumes, or pulsating total volumes. I am glad that by 1945 I got out of it.

Is space where the orifices are in the faces of people talking to each other, or is it not between the glance of their eyes as they respond to each other? Anyone standing in front of my paintings must feel the vertical domelike vaults encompass him to awaken

an awareness of his being alive in the sensation of complete space. This is the opposite of creating an environment. The environment is separate from the painting. A painter friend, [Gerome] Kamrowski, said it well: he said my paintings are hostile to the environment. The room space is empty and chaotic, but the sense of space created by my painting should make one feel, I hope, full and alive in a spatial dome of 180 degrees going in all four directions. This is the only real sensation of space. At the same time I want to make it clear that I never set out to paint space-domes per se. I am, I hope, involved in much more.

SECKLER: What about subject matter?

NEWMAN: The central issue of painting is the subject matter. Most people think of subject matter as what Meyer Schapiro has called 'object matter.' It is the 'object matter' that most people want to see in a painting. That is what, for them, makes the painting seem full. For me both the use of objects and the manipulation of areas for the sake of the areas themselves must end up being anecdotal. My subject is antianecdotal. An anecdote can be subjective and internal as well as of the external world, so that the expression of the biography of self or the intoxicated moment of glowing ecstasy must in the end also become anecdotal. All such painting is essentially episodic, which means it calls for a sequel. This must happen if a painting does not give a sensation of wholeness or fulfillment. That is why I have no interest in the episodic or ecstatic, however abstract. The excitement always ends at the brink and leaves the subject, so to speak, hanging there like the girl in *The Perils of Pauline*. The next painting repeats the excitement, in a kind of ritual. One expects the girl to be saved finally, but she is again left hanging on the brink, and so on and on. This is the weakness of the ecstatic and the episodic. It is an endless search for a statement of personality that never takes place. The truly passionate exists on a different level.

SECKLER: You have the reputation of being a slow worker.

NEWMAN: It is easy to be a fast worker. I have great admiration for raw, boundless energy, but I cannot work out of boredom, to keep myself busy or only to express myself – or to tell the story of my life – or to find my personality in painting by acting out some character. I paint out of high passion, and although my way of working may seem simple, for me it is difficult and complex.

It would be easy for me now to talk about the transcendental, the self, revelation, etc. All painting worth anything has all this. I prefer to talk on the practical or technical level. For example, drawing is central to my whole concept. I don't mean making *drawings*, although I have always done a lot of them. I mean the drawing that exists in my painting. Yet no writer on art has ever confronted that issue. I am always referred to in relation to my color. Yet I know that if I have made a contribution, it is primarily in my drawing. The impressionists changed the way of seeing the world through their kind of drawing; the cubists saw the world anew in their drawing; and I hope that I have contributed a new way of seeing through drawing. Instead of using outlines, instead of making shapes or setting off spaces, my drawing declares the space. Instead of working with the remnants of space, I work with the whole space.

SECKLER: Can you clarify the meaning of your work in relation to society?

NEWMAN: It is full of meaning, but the meaning must come from the seeing, not from the talking. I feel, however, that one of its implications is its assertion of freedom, its denial of dogmatic principles, its repudiation of all dogmatic life. Almost fifteen years ago Harold Rosenberg challenged me to explain what one of my

paintings could possibly mean to the world. My answer was that if he and others could read it properly it would mean the end of all state capitalism and totalitarianism. That answer still goes.

8 Clement Greenberg (1909–1994) from 'After Abstract Expressionism'

In this essay Greenberg's analysis of Modernist painting is concentrated upon American painting, and upon the transition from the 'first generation' painting of Rothko, Still and Newman to the 'Post-Painterly Abstraction' of a younger generation. In particular he stresses the priority to be accorded to the artist's initial conception in the assessment of current forms of abstract painting. First published in *Art International*, Lugano, VI, no. 8, October 1962, pp. 24–32, from which the present extract is taken. (See also VIB5.)

Like so much of painterly art before it, Abstract Expressionism has worked in the end to reduce the role of colour: unequal densities of paint become, as I have said, so many differences of light and dark, and these deprive colour of both its purity and its fullness. At the same time it has also worked against true openness, which is supposed to be another quintessentially painterly aim: the slapdash application of paint ends by crowding the picture plane into a compact jumble – a jumble that is another version, as we see it in de Kooning and his followers, of academically Cubist compactness. Still, Newman, and Rothko turn away from the painterliness of Abstract Expressionism as though to save the objects of painterliness – colour and openness – from painterliness itself. This is why their art could be called a synthesis of painterly and non-painterly or, better, a transcending of the differences between the two. Not a reconciling of these – that belonged to Analytical Cubism, and these three Americans happen to be the first serious abstract painters, the first abstract painters of *style*, really to break with Cubism.

Clyfford Still, who is one of the great innovators of modernist art, is the leader and pioneer here. Setting himself against the immemorial insistence on light and dark contrast, he asserted instead colour's capacity to act through the contrast of pure hues in relative independence of light and dark design. Late Impressionism was the precedent here, and as in the late Monet, the suppression of value contrasts created a new kind of openness. The picture no longer divided itself into shapes or even patches, but into zones and areas and fields of colour. This became essential, but it was left to Newman and Rothko to show how completely so. If Still's largest paintings, and especially his horizontal ones, fail so often to realize the monumental openness they promise, it is not only because he will choose a surface too large for what he has to say; it is also because too many of his smaller colour areas will fail really to function as areas and will remain simply patches – patches whose rustic-Gothic intricacies of outline halt the free flow of colour-space.

With Newman and Rothko, temperaments that might strike one as being natively far more painterly than Still's administer themselves copious antidotes in the form of the rectilinear. The rectilinear is kept ambiguous, however: Rothko fuzzes and melts all his dividing lines; Newman will insert an uneven edge as foil to his ruled ones. Like Still, they make a show of studiedness, as if to demonstrate their rejection of the mannerisms which have become inseparable by now from rapid brush or knife handling. Newman's

occasional brushy edge, and the torn but exact one left by Still's knife, are there as if to advertise both their awareness and their repudiation of the easy effects of spontaneity.

Still continues to invest in surface textures, and there is no question but that the tactile irregularities of his surfaces, with their contrasts of matt and shiny, paint coat and priming, contribute to the intensity of his art. But by renouncing tactility, and detail in drawing, Newman and Rothko achieve what I find a more positive openness and colour. The rectilinear is open by definition: it calls the least attention to drawing and gets least in the way of colour-space. A thin paint surface likewise gets least in the way of colour-space, by excluding tactile associations. Here both Rothko and Newman take their lead from Milton Avery, who took his from Matisse. At the same time colour is given more autonomy by being relieved of its localizing and denotative function. It no longer fills in or specifies an area or even plane, but speaks for itself by dissolving all definiteness of shape and distance. To this end – as Still was the first to show – it has to be warm colour, or cool colour infused with warmth. It has also to be uniform in hue, with only the subtlest variations of value if any at all, and spread over an absolutely, not merely relatively, large area. Size guarantees the purity as well as the intensity needed to suggest indeterminate space: more blue simply being bluer than less blue. This too is why the picture has to be confined to so few colours. Here again, Still showed the way, the vision of the two- or three-colour picture . . . being his in the first place (whatever help towards it he may have got from the Miró of 1924–1930).

But Newman and Rothko stand or fall by colour more obviously than Still does. (Where Newman often fails is in using natively warm colours like red and orange, Rothko in using pale ones, or else in trying to *draw*, as in his disastrous 'Seagram' murals.) Yet the ultimate effect sought is one of more than chromatic intensity; it is rather one of an almost literal openness that embraces and absorbs colour in the act of being created by it. Openness, and not only in painting, is the quality that seems most to exhilarate the attuned eyes of our time. Facile explanations suggest themselves here which I leave the reader to explore for himself. Let it suffice to say that by the new openness they have attained Newman, Rothko, and Still point to what I would risk saying is the only way to high pictorial art in the near future. And they also point to that way by their repudiation of virtuosity of execution.

Elsewhere I have written of the kind of self-critical process which I think provides the infra-logic of modernist art ('Modernist Painting'). [. . .] As it seems to me, Newman, Rothko, and Still have swung the self-criticism of modernist painting in a new direction simply by continuing it in its old one. The question now asked through their art is no longer what constitutes art, or the art of painting, as such, but what irreducibly constitutes *good* art as such. Or rather, what is the ultimate source of value or quality in art? And the worked-out answer appears to be: not skill, training, or anything else having to do with execution or performance, but conception alone. Culture or taste may be a necessary condition of conception, but conception is alone decisive. Conception can also be called invention, inspiration, or even intuition (in the usage of Croce, who did anticipate theoretically what practice has just now discovered and confirmed for itself). It is true that skill used to be a vessel of inspiration and do the office of conception, but that was when the best pictorial art was the most naturalistic pictorial art.

Inspiration alone belongs altogether to the individual; everything else, including skill, can now be acquired by any one. Inspiration remains the only factor in the

creation of a successful work of art that cannot be copied or imitated. This has been left to artists like Newman and Mondrian to make explicit (and it is really the only thing Newman and Mondrian have in common). Newman's pictures look easy to copy, and maybe they really are. But they are far from easy to conceive, and their quality and meaning lies almost entirely in their conception. That, to me, is self-evident, but even if it were not, the frustrated efforts of Newman's imitators would reveal it. The onlooker who says his child could paint a Newman may be right, but Newman would have to be there to tell the child *exactly* what to do. The *exact* choices of colour, medium, size, shape, proportion – including the size and shape of the support – are what alone determine the quality of the result, and these choices depend solely on inspiration or conception. Like Rothko and Still, Newman happens to be a conventionally skilled artist – need I say it? But if he uses his skill, it is to suppress the evidence of it. And the suppression is part of the triumph of his art, next to which most other contemporary painting begins to look fussy. [. . .]

9 Michael Fried (b. 1939) from *Three American Painters*

Fried is one of a group of American critics and art historians who were close to Greenberg in the early 1960s, taking his criticism as a source of methodological example and his theorization of Modernism as an explicit point of departure for their own work. Fried was concerned to amend the essentialism of Greenberg's account of Modernism and of its development. His distinct contribution has been to concentrate upon the specificity of the effects of paintings and sculptures, and thus to reintroduce considerations of spectatorship into Modernist criticism. By this shift of emphasis, the question of value in Modernist art is reframed in terms of historically specific kinds of relations between paintings and spectators, and therefore opened to inquiry. According to Fried's thesis, it is this historical character of Modernist art that justifies the application of a formal method of criticism. *Three American Painters* was first published as the catalogue introduction to an exhibition organized by Fried at the Fogg Art Museum, Harvard University, from 21 April to 30 May 1965. The painters in question were Kenneth Noland, Jules Olitski and Frank Stella. In an introductory note Fried asserted that his aim was 'to raise, even to force, the issue of quality'. The opening section reprinted here was based on a separate essay published under the title 'Modernist Painting and Formal Criticism' in *The American Scholar*, Autumn 1964.

> *. . . vous n'êtes que le premier*
> *dans la décrépitude de votre art.*
>
> Baudelaire to Manet, 1865

For twenty years or more almost all the best new painting and sculpture has been done in America; notably the work of artists such as de Kooning, Frankenthaler, Gorky, Gottlieb, Hofmann, Kline, Louis, Motherwell, Newman, Pollock, Rothko, Smith and Still – apart from those in the present exhibition – to name only some of the best. It could be argued, in fact, that the flowering of painting and, to a much lesser degree, of sculpture that has taken place in this country since the end of the Second World War is comparable to that which occurred in American poetry in the two

decades after 1912, as regards both the quality of the work produced and what might be called its intrinsic difficulty.

[...] It is one of the most important facts about the contemporary situation in the visual arts that the fundamental character of the new art has not been adequately understood. This is not altogether surprising. Unlike poets, painters and sculptors rarely practice criticism; and perhaps partly as a consequence of this, the job of writing about art has tended to pass by default to men and women who are in no way qualified for their profession. Moreover, the visual skills necessary to come to grips with the new painting and sculpture are perhaps even more rare than the verbal skills demanded by the new poetry. But if the inadequacy of almost all contemporary art criticism is not surprising, it is undeniably ironic, because the visual arts – painting especially – have never been more explicitly self-critical than during the past twenty years.

...This essay attempts an exposition of what, to my mind, are some of the most important characteristics of the new art. At the same time it tries to show why formal criticism, such as that practiced by Roger Fry or, more to the point, by Clement Greenberg, is better able to throw light upon the new art than any other approach. To do this, the development over the past hundred years of what Greenberg calls 'modernist' painting must be considered, because the work of the artists mentioned above represents, in an important sense, the extension in this country of a kind of painting that began in France with the work of Edouard Manet.[1] Sculpture is, to a certain extent, another story, and for reasons of space and simplicity will not be considered here.

Roughly speaking, the history of painting from Manet through Synthetic Cubism and Matisse may be characterized in terms of the gradual withdrawal of painting from the task of representing reality – or of reality from the power of painting to represent it[2] – in favor of an increasing preoccupation with problems intrinsic to painting itself. One may deplore the fact that critics such as Fry and Greenberg concentrate their attention upon the formal characteristics of the works they discuss; but the painters whose work they most esteem on formal grounds – e.g. Manet, the Impressionists, Seurat, Cézanne, Picasso, Braque, Matisse, Léger, Mondrian, Kandinsky, Miró – are among the finest painters of the past hundred years. This is not to imply that only the formal aspect of their paintings is worthy of interest. On the contrary, because recognizable objects, persons and places are often not entirely expunged from their work, criticism which deals with the ostensible subject of a given painting can be highly informative; and in general, criticism concerned with aspects of the situation in which it was made other than in a formal context can add significantly to our understanding of the artist's achievement. But criticism of this kind has shown itself largely unable to make convincing discriminations of value among the works of a particular artist; and in this century it often happens that those paintings that are most full of explicit human content can be faulted on formal grounds – Picasso's *Guernica* is perhaps the most conspicuous example – in comparison with others virtually devoid of such content. (It must be granted that this says something about the limitations of formal criticism as well as about its strengths. Though precisely *what* it is taken to say will depend on one's feelings about *Guernica*, etc.)

It is worth adding that there is nothing binding in the value judgments of formal criticism. All judgments of value begin and end in experience, or ought to and if someone does not feel that Manet's *Déjeuner sur l'herbe*, Matisse's *Piano Lesson* or

Pollock's *Autumn Rhythm* are superb paintings, no critical arguments can take the place of feeling it. On the other hand, one's experiences of works of art are always informed by what one has come to understand about them; and it is the burden of the formal critic both to objectify his intuitions with all the intellectual rigor at his command, and to be on his guard against enlisting a formalist rhetoric in defense of what he fears may be merely private enthusiasms.

It is also imperative that the formal critic bear in mind at all times that the objectivity he aspires toward can be no more than relative. But his detractors would do well to bear in mind themselves that his aspirations toward objectivity are given force and relevance by the tendency of the most important current in painting since Manet to concern itself increasingly and with growing self-awareness with formal problems and issues. [. . .]

Ever since the publication in 1888 of Heinrich Wölfflin's first book, *Renaissance und Barock*, many critics of style have tended to rely on a fundamentally Hegelian conception of art history, in which styles are described as succeeding one another in accord with an internal dynamic or dialectic, rather than in response to social, economic and political developments in society at large. One of the stock objections, in fact, to exclusively stylistic or formal criticism of the art of the past – for example, of the High Renaissance – is that it fails to deal with the influence of non-artistic factors upon the art of the time, and as a result is unable both to elucidate the full meaning of individual works and to put forward a convincing account of stylistic change. Such an objection, however, derives the real but limited validity it possesses from the fact that painting and sculpture during the Renaissance were deeply involved, as regards patronage and iconography, with both the Church and State. But by the late nineteenth and early twentieth century, the relation of art – as well as of the Church and State – to society appears to have undergone a radical change. And although the change in question cannot be understood apart from a consideration of economic and other non-artistic factors, by far the most important single, characteristic of the new *modus vivendi* between the arts and bourgeois society gradually arrived at during the first decades of the present century has been the tendency of ambitious art to become more and more concerned with problems and issues intrinsic to itself.[3]

All this has, of course, been recounted before. But what has not been sufficiently recognized is that in the face of these developments the same objections that are effective when directed against exclusively formal criticism of High Renaissance painting lose almost all their force and relevance. In comparison with what may be said in precise detail about the relations between High Renaissance art and the society in which it arose, only the most general statements – such as this one – may be made about the relation between modernist painting and modern society. In a sense, modernist art in this century finished what society in the nineteenth began: the alienation of the artist from the general preoccupations of the culture in which he is embedded, and the prizing loose of art itself from the concerns, aims and ideals of that culture. With the achievements of Cubism in the first and second decades of this century, if not before, painting and sculpture became free to pursue concerns intrinsic to themselves. This meant that it was now possible to conceive of stylistic change in terms of the decisions of individual artists to engage with particular formal problems thrown up by the art of the recent past; and in fact the fundamentally Hegelian conception of art history at work in the writings of Wölfflin and Greenberg, whatever its limitations

when applied to the art of the more distant past, seems particularly well suited to the actual development of modernism in the visual arts, painting especially.

I am arguing, then, that something like a dialectic of modernism has in effect been at work in the visual arts for roughly a century now; and by dialectic I mean what is essential in Hegel's conception of historical progression, as well as that of the young Marx, as expounded in this century by the Marxist philosopher Georg Lukács in his great work, *History and Class Consciousness*, and by the late Maurice Merleau-Ponty in numerous books and essays. More than anything else, the dialectic in the thought of these men is an ideal of action as radical criticism of itself founded upon as objective an understanding of one's present situation as one is able to achieve. There is nothing teleological about such an ideal: it does not aim toward a predetermined end, unless its complete incarnation in action can be called such an end. But this would amount to nothing less than the establishment of a perpetual revolution – perpetual because bent on unceasing radical criticism of itself. It is no wonder such an ideal has not been realized in the realm of politics; but it seems to me that the development of modernist painting over the past century has led to a situation that may be described in these terms. That is, while the development of modernist painting has not been directed toward any particular style of painting, at any moment – including the present one – the work of a relatively few painters appears more advanced, more radical in its criticism of the modernist art of the recent past, than any other contemporary work. The chief function of the dialectic of modernism in the visual arts has been to provide a principle by which painting can change, transform and renew itself, and by which it is enabled to perpetuate virtually intact, and sometimes even enriched, through each epoch of self-renewal, those of its traditional values that do not pertain directly to representation. Thus modernist painting preserves what it can of its history, not as an act of piety toward the past but as a source of value in the present and future.

For this reason, if for no other, it is ironic that modernist painting is often described as nihilistic and its practitioners characterized as irresponsible charlatans. In point of fact, the strains under which they work are enormous, and it is not surprising that, in one way or another, many of the finest modernist painters have cracked up under them. This tendency toward breakdown has been intensified in the past twenty years by the quickening that has taken place in the rate of self-transformation within modernism itself – a quickening that, in turn, has been the result of an increase in formal and historical self-awareness on the part of modernist painters. The work of such painters as Noland, Olitski and Stella not only arises largely out of their personal interpretations of the particular situations in which advanced painting found itself at crucial moments in their respective developments; their work also aspires to be adjudged, in retrospect, to have been necessary to the finest modernist painting of the future. 'History, according to Hegel, is the maturation of a future in the present, not the sacrifice of the present to an unknown future, and the rule of action according to him is not to be effective at any price, but above all to be fecund,' Merleau-Ponty has written. In this sense the ultimate criterion of the legitimacy of a putative advance in modernist painting is its fecundity. But if one seeks to test this criterion against the art of the recent past, one must bear in mind that the finest contemporary painting testifies to the fecundity not only of the art of Barnett Newman around 1950, but to that of de Kooning as well; and that this is so because of, not in spite of, the fact that Newman's art amounts to the most radical criticism of de Kooning's one can imagine.

One consequence of all this is that modernist painting has gone a long way toward effacing the traditional distinction between problems in morals and problems in art formulated by Stuart Hampshire in his essay 'Logic and Appreciation' as follows: 'A work of art is gratuitous. It is not *essentially* the answer to a question or the solution to a presented problem.' Whereas 'action in response to any moral problem is not gratuitous; it is imposed; that there should be some response is absolutely necessary. One cannot pass by a situation; one must pass *through* it in one way or another.'

Hampshire's distinction holds good, I think, for all painting except the kind I have been trying in this essay to define. Once a painter who accepts the basic premises of modernism becomes aware of a particular problem thrown up by the art of the recent past, his action is no longer gratuitous but imposed. He may be mistaken in his assessment of the situation. But as long as he believes such a problem exists and is important, he is confronted by a situation he cannot pass by, but must, in some way or other, pass through; and the result of this forced passage will be his art. This means that while modernist painting has increasingly divorced itself from the concerns of the society in which it precariously flourishes, the actual dialectic by which it is made has taken on more and more of the denseness, structure and complexity of moral experience – that is, of life itself, but life lived as few are inclined to live it: in a state of continuous intellectual and moral alertness.

The formal critic of modernist painting, then, is also a moral critic: not because all art is at bottom a criticism of life, but because modernist painting is at least a criticism of itself. And because this is so, criticism that shares the basic premises of modernist painting finds itself compelled to play a role in its development closely akin to, and potentially only somewhat less important than, that of new paintings themselves. Not only will such a critic expound the significance of new painting that strikes him as being genuinely exploratory, and distinguish between this and work that does not attempt to challenge or to go beyond the achievements of prior modernists; but in discussing the work of painters he admires he will have occasion to point out what seem to him flaws in putative solutions to particular formal problems; and, more rarely, he may even presume to call the attention of modernist painters to formal issues that, in his opinion, demand to be grappled with. Finally just as a modernist painter may be mistaken in his assessment of a particular situation, or having grasped the situation may fail to cope with it successfully, the formal critic who shares the basic premises of modernist painting runs the analogous risk of being wrong. And in fact it is inconceivable that he will not be wrong a fair amount of the time. But being wrong is preferable to being irrelevant; and the recognition that everyone involved with contemporary art must work without certainty can only be beneficial in its effects. For example, it points up the difficulty of trying to decide whose opinions on the subject among the many put forward deserve to be taken seriously – a decision about as hard to make as value-judgments in front of specific paintings.

It may be argued that this is an intolerably arrogant conception of the critic's job of work, and perhaps it is. But it has the virtue of forcing the critic who takes it up to run the same risks as the artist whose work he criticizes. In view of this last point it is not surprising that so few critics have chosen to assume its burdens.

[1] Although Manet is probably the first painter whom one would term 'modernist,' some of the problems and crises to which his paintings constitute a decisive and unexpected response are present in the work

of David, Géricault, Ingres, Delacroix and Courbet. Any account of the genesis of modernism would have to deal with these men.

2 This is more than just a figure of speech: it is a capsule description of what may be seen to take place in Manet's paintings. Manet's ambitions are fundamentally realistic. He starts out aspiring to the objective transcription of reality, of a world to which one wholly belongs, such as he finds in the work of Velasquez and Hals. But where Velasquez and Hals took for granted their relation to the worlds they belonged to and observed and painted, Manet is sharply conscious that his own relation to reality is far more problematic. And to paint his world with the same fullness of response, the same passion for truth, that he finds in the work of Velasquez and Hals, means that he is forced to paint not merely his world but his problematic relation to it: his own awareness of himself as *in* and yet *not of* the world. In this sense Manet is the first post-Kantian painter: the first painter whose awareness of himself raises problems of extreme difficulty that cannot be ignored: the first painter for whom consciousness itself is the great subject of his art.

Almost from the first – surely as early as the *Déjuner sur l'herbe* – Manet seems to have striven hard to make this awareness function as an essential part of his paintings, an essential aspect of their content. This accounts for the *situational* character of Manet's paintings of the 1860s: the painting itself is conceived as a kind of *tableau vivant* (in this respect Manet relates back to David), but a *tableau vivant* constructed so as to dramatize not a particular event so much as the beholder's alienation from that event. Moreover, in paintings like the *Déjeuner* and the *Olympia*, for example, the inhibiting, estranging quality of self-awareness is literally depicted within the painting: in the *Déjeuner* by the unintelligible gesture of the man on the right and the bird frozen in flight at the top of the painting; in the *Olympia* above all by the hostile, almost schematic cat; and in both by the distancing calm stare of Victorine Meurend.

But Manet's desire to make the estranging quality of self-awareness an essential part of the content of his work – a desire which, as we have seen, is at bottom realistic – has an important consequence: namely, that self-awareness in *this* particular situation necessarily entails the awareness that what one is looking at is, after all, merely a painting. And this awareness too must be made an essential part of the work itself. That is, there must be no question but that the painter *intended* it to be felt; and if necessary the spectator must be *compelled* to feel it. Otherwise the self-awareness (and the alienation) Manet is after would remain incomplete and equivocal.

For this reason Manet emphasizes certain characteristics which have nothing to do with verisimilitude but which assert that the painting in question is exactly that: a painting. For example, Manet emphasizes the flatness of the picture-surface by eschewing modelling and (as in the *Déjeuner*) refusing to depict depth convincingly, calls attention to the limits of the canvas by truncating extended forms with the framing-edge, and underscores the rectangular shape of the picture-support by aligning with it, more or less conspicuously, various elements within the painting. (The notions of emphasis and assertion are important here. David and Ingres rely on rectangular composition far more than Manet; and some of Ingres' forms have as little modelling as Manet's. But David and Ingres are not concerned to emphasize the rectangularity or the flatness of the canvas, but rather they make use of these to insure the stability of their compositions and the rightness of their drawing.)

No wonder Manet's art has always been open to contradictory interpretations: the contradictions reside in the conflict between his ambitions and his actual situation. (What one takes to be the salient features of his situation is open to argument; an uncharacteristically subtle Marxist could, I think, make a good case for focussing on the economic and political situation in France after 1848. In this note, however, I have stressed Manet's recognition of consciousness as a problem for art, as well as the estranging quality of his own consciousness of himself.) Manet's art represents the last attempt in Western painting to achieve a full equivalent to the great realistic painting of the past: an attempt which led, in quick inexorable steps, to the founding of modernism through the emphasis on pictorial qualities and problems in their own right. This is why Manet was so easily thrown off stride by the advent of impressionism around 1870: because his pictorial and formal innovations of the preceding decade had not been made for their own sakes, but in the service of a phenomenology that had already been worked out in philosophy, and had been objectified in some poetry (e.g. Blake), but which had not yet made itself felt in the visual arts. It was only at the end of his life that Manet at last succeeded in using what he had learned from Impressionism to objectify his own much more profound phenomenology, in the *Bar aux Folies-Bergère*. I intend to deal with all this elsewhere as soon as possible.

[3] This is dangerously over-simplified. I am convinced that something of the sort did in fact occur, and that it makes sense to speak of painting itself having become increasingly self-aware, both formally and historically, during the past century or more. But a lot of careful work would be required to give this notion the substance it requires. Moreover, the notion that there are problems 'intrinsic' to the art of painting is, so far as I can see, the most important question begged in this essay. It has to do with the concept of a 'medium,' and is one of the points philosophy and art criticism might discuss most fruitfully, if a dialogue between them could be established. Similarly, an examination of the 'grammar' (in the sense Wittgenstein gives to this word in the *Philosophical Investigations*) of a family of concepts essential to this essay – e.g., problem, solution, advance, logic, validity – would be more than welcome.

10 Michael Fried (b. 1939) from 'Shape as Form: Frank Stella's New Paintings'

This essay was written in specific response to a series of eccentrically shaped paintings made by Stella in 1966. The author's apparent aim, however, was to advance the theorization of recent abstract art in general. In this, the first of the essay's four sections, Fried reviews what he takes to be the technically significant developments in painting of the preceding twenty years. In discussion of the work in question he develops a useful distinction between literal and depicted shape. Originally published in *Artforum*, V, no. 3, New York, November 1966, pp. 18–27, from which the present extract is taken.

> The craving for simplicity. People would like to say: 'What really matters is only the colors.' You say this mostly because you wish it to be the case. If your explanation is complicated, it is disagreeable, especially if you don't have strong feelings about the thing itself.
>
> Wittgenstein

Frank Stella's new paintings investigate the viability of shape as such. By *shape as such* I mean not merely the silhouette of the support (which I will call literal shape), nor merely that of the outlines of elements in a given picture (which I will call depicted shape), but shape as a medium within which choices about both literal and depicted shapes are made, and made mutually responsive. And by the viability of shape, I mean its power to hold, to stamp itself out, and *in* – as verisimilitude and narrative and symbolism used to impress themselves – compelling conviction. Stella's undertaking in these paintings is therapeutic: to restore shape to health, at least temporarily, though of course its implied 'sickness' is simply the other face of the unprecedented importance shape has assumed in the finest modernist painting of the past several years – most notably, in the work of Kenneth Noland and Jules Olitski. It is only in their work that shape as such can be said to have become capable of holding, or stamping itself out, or compelling conviction – as well as, so to speak, capable of *failing* to do so. These are powers or potentialities – not to say responsibilities – which shape never until now possessed, and which have been conferred upon it by the development of modernist painting itself. In this sense shape has become something different from what it was in traditional painting or, for that matter, in modernist painting until recently. It has become, one might say, an object of conviction, whereas before it was merely . . . a kind of object. Stella's new pictures are a response to the recognition that shape itself may be

lost to the art of painting as a resource able to compel conviction, precisely because – as never before – it is being called upon to do just that.

The way in which this has come about is, in the fullest sense of the word, dialectical, and I will not try to do justice to its enormous complexity in these rough notes. An adequate account of the developments leading up to Stella's new paintings would, however, deal with the following:

1 *The emergence of a new, exclusively visual mode of illusionism in the work of Pollock, Newman and Louis.* No single issue has been as continuously fundamental to the development of modernist painting as the need to acknowledge the literal character of the picture-support. Above all this has tended to mean acknowledging its flatness or two-dimensionality. There is a sense in which a new illusionism was implicit in this development all along. [. . .] But the universal power of any mark to suggest something like depth belongs not so much to the art of painting as to the eye itself; it is, one might say, not something that has had to be *established* so much as something – a perceptual limitation – that cannot be escaped, whereas the dissolution of traditional drawing in Pollock's work, the reliance on large and generally rather warm expanses of barely fluctuating color in Newman's, and the staining of thinned (acrylic) pigment into mostly unsized canvas in Louis's were instrumental in the creation of a depth or space accessible to eyesight alone which, so to speak, specifically belongs to the art of painting.

2 *The neutralizing of the flatness of the picture-support by the new, exclusively optical illusionism.* In the work of Pollock and Newman, but even more in that of Louis, Noland and Olitski, the new illusionism both subsumes and dissolves the picture-surface – opening it, as Greenberg has said, from the rear – while simultaneously preserving its integrity. More accurately, it is the *flatness* of the picture-surface, and not that surface itself, that is dissolved, or anyway *neutralized*, by the illusion in question. The literalness of the picture-surface is not denied; but one's experience of that literalness is an experience of the properties of different pigments, of foreign substances applied to the surface of the painting, of the weave of the canvas, above all of color – but not, or not in particular, of the flatness of the support. (One could say that here the literalness of the picture-surface is not an aspect of the literalness of the support.) Not that literalness here is experienced as competing in any way with the illusionistic presence of the painting as a whole; on the contrary, one somehow *constitutes* the other. And in fact there is no distinction one can make between attending to the surface of the painting and to the illusion it generates: to be gripped by one is to be held, and moved, by the other.

3 *The discovery shortly before 1960 of a new mode of pictorial structure based on the shape, rather than the flatness, of the support.* With the dissolution or neutralizing of the flatness of the support by the new optical illusionism, the shape of the support – including its proportions and exact dimensions – came to assume a more active, more explicit importance than ever before. The crucial figures in this development are Frank Stella and Kenneth Noland. In Stella's aluminum stripe paintings of 1960, for example, $2\frac{1}{2}$-inch wide stripes begin at the framing-edge and reiterate the shape of that edge until the entire picture is filled; moreover, by actually shaping each picture – the canvases are rectangles with shallow (one stripe deep) notches at two corners or along the sides or both – Stella was able to make the fact that the literal shape

determines the structure of the entire painting completely perspicuous. That is, in each painting the stripes appear to have been generated by the framing-edge and, starting there, to have taken possession of the rest of the canvas, as though the whole painting self-evidently followed from, not merely the shape of the support, but its actual physical limits.

Noland too has shaped his pictures. [...] It cannot be emphasized too strongly, however, that Noland's chief concern throughout his career has been with color – or rather, with feeling *through* color – and not with structure: which makes the role that structural decisions and alterations have played in his development all the more significant. This is not to say that Noland's colorism has had to maintain itself in the teeth of his forced involvement with structural concerns. On the contrary, it is precisely his deep and impassioned commitment to making color yield major painting that has compelled him to discover structures in which the shape of the support is acknowledged lucidly and explicitly enough to compel conviction.

4 *The primary of literal over depicted shape.* In both Noland's and Stella's (stripe) paintings the burden of acknowledging the shape of the support is borne by the depicted shape, or perhaps more accurately, by the relation between it and the literal shape – a relation that declares the *primacy* of the latter. And in general the development of modernist painting during the past six years can be described as having involved the progressive assumption by literal shape of a greater – that is, more active, more explicit – importance than ever before, and the consequent subordination of depicted shape. It is as though depicted shape has become less and less capable of venturing on its own, of pursuing its own ends; as though unless, in a given painting, depicted shape manages to participate in – by helping to establish – the authority of the shape of the support, conviction is aborted and the painting fails. In this sense depicted shape may be said to have become dependent upon literal shape – and indeed unable to make itself felt as shape except by acknowledging that dependence.

11 Jules Olitski (b. 1922) 'Painting in Color'

Olitski came to prominence in the 1960s with atmospheric abstract paintings made by staining and spraying canvases with acrylic paints. Few artists of his generation have been the subject of such widely varying critical assessments. His work was central both to Greenberg's notion of 'Post-Painterly Abstraction' and to Fried's account of a new, exclusively optical form of illusionism in Modernist painting after Pollock. The same work was taken by commentators hostile to such criticism as exemplifying more bathetically than any other work the emptiness of criteria which reduce to judgements of taste. This text is a slightly revised and expanded version of a catalogue statement written by the artist for the XXXIII Venice Biennale, June 1966. First published in the present version in *Artforum*, New York, January 1967, p. 20.

Painting is made from inside out. I think of painting as possessed by a structure – i.e., shape and size, support and edge – but a structure born of the flow of color feeling. Color *in* color is felt at any and every place of the pictorial organization; in its immediacy – its particularity. Color must be felt throughout.

What is of importance in painting is paint. Paint can be color. Paint becomes painting when color establishes surface. The aim of paint surface (as with everything in visual art) is appearance – color that *appears* integral to material surface. Color is of inherent significance in painting. (This cannot be claimed, however, for any particular type of paint, or application of paint.)

I begin with color. The development of a color structure ultimately determines its expansion or compression – its outer edge. Outer edge is inescapable. I recognize the line it declares, as drawing. This line delineates and separates the painting from the space around and appears to be on the wall (strictly speaking, it remains in front of the wall). Outer edge cannot be visualized as being in some way within – it is the outermost extension of the color structure. The decision as to where the outer edge is, is final, not initial.

Wherever edge exists – both within a painting and at its limits – it must be felt as a necessary outcome of the color structure. Paint can be color and drawing when the edge of the painting is established as the final realization of the color structure.

The focus in recent painting has been on the lateral – a flat and frontal view of the surface. This has tended toward the use of flat color areas bounded by and tied inevitably to a structure composed of edges. Edge is drawing and drawing is on the surface. (Hard-edge or precision made line is no less drawing than any other kind.) Because the paint fills in the spaces between the edges, the color areas take on the appearance of overlay. Painting becomes subservient to drawing. When the conception of internal form is governed by edge, color (even when stained into raw canvas) appears to remain on or above the surface. I think, on the contrary, of color as being seen in and throughout, not solely on, the surface.

12 Stanley Cavell (b. 1926) 'A Matter of Meaning It'

Cavell is an American philosopher and aesthetician who has written extensively on the problems of Modernism in the arts. The effects of his dialogue with Fried are discernible in the writings of both. Fried's critique of Greenberg's essentialism benefits from the familiarity of Cavell with the philosophy of the later Wittgenstein, while in the present text the use of Caro's sculpture as example reflects a shared conviction of its significance. First published in W. H. Capitan and D. D. Merrill (eds.), *Art, Mind and Religion*, Pittsburgh, 1967; reprinted in Cavell, *Must We Mean What We Say? A Book of Essays*, New York, 1969, pp. 216–22, from which the present extract is taken.

[. . .] I might define the problem of modernism as one in which the question of value comes first as well as last: to classify a modern work as art is already to have staked value, more starkly than the (later) decision concerning its goodness or badness. Your interest in Mozart is not likely to draw much attention – which is why such interests can be, so to speak, academic. But an interest in Webern or Stockhausen or Cage is, one might say, revealing, even sometimes suspicious. (A Christian might say that in such interests, and choices, the heart is revealed. This is what Tolstoy saw.) Philosophers sometimes speak of the phrase 'work of art' as having an 'honorific sense,' as though that were a surprising or derivative fact about it, even one to be neutralized or ignored. But that works of art are valuable is analytically true of them; and that value is

inescapable in human experience and conduct is one of the facts of life, and of art, which modern art lays bare.

Of course there is the continuous danger that the question will be begged, that theory and evidence become a closed and vicious circle. I do not insist that this is always the case, but merely that unless this problem is faced here no problem of the right kind can come to focus. For if everything counted as art which now offers itself as art, then questions about whether, for example, figurative content, or tonality, or heroic couplets are still viable resources for painters, composers, and poets would not only never have arisen, but would make no sense. When there was a tradition, everything which seemed to count did count. (And that is perhaps analytic of the notion of 'tradition.') I say that Krenek's late work doesn't count, and that means that the way it is 'organized' does not raise for me the question of how music may be organized. I say that Caro's steel sculptures count, and that raises for me the question of what sculpture is: I had – I take it everyone had – thought (assumed? imagined? – but no one word is going to be quite right, and that must itself require a philosophical account) that a piece of sculpture was something *worked* (carved, chipped, polished, etc.); but Caro uses steel rods and beams and sheets which he does not work (e.g., bend or twist) but rather, one could say, *places*. I had thought that a piece of sculpture had the coherence of a natural object, that it was what I wish to call spatially closed or spatially continuous (or consisted of a group of objects of such coherence); but a Caro may be open and discontinuous, one of its parts not an outgrowth from another, nor even joined or connected with another so much as it is juxtaposed to it, or an inflection from it. I had thought a piece of sculpture stood on a base (or crouched in a pediment, etc.) and rose; but a Caro rests on the raw ground and some do not so much rise as spread or reach or open. I had heard that sculpture used to be painted, and took it as a matter of fashion or taste that it no longer was (in spite of the reconstructed praises of past glories, the idea of painted stone figures struck me as ludicrous); Caro paints his pieces, but not only is this not an external or additional fact about them, it creates objects about which I wish to say they are not painted, or not *colored*; they have color not the way, say, cabinets or walls do, but the way grass and soil do – the experience I recall is perhaps hit off by saying that Caro is not using colored beams, rods, and sheets, but beams and rods and sheets of color. It is almost as though the color helps de-materialize its supporting object. One might wish to say they are weightless, but that would not mean that these massively heavy materials seem light, but, more surprisingly, neither light nor heavy, resistant to the concept of weight altogether – as they are resistant to the concept of size; they seem neither large nor small. Similarly, they seem to be free of *texture*, so critical a parameter of other sculpture. They are no longer *things*. (Something similar seems to be true of the use of color in recent painting: it is not merely that it no longer serves as the color of something, nor that it is disembodied; but that the canvas we know to underlie it is no longer its *support* – the color is simply *there*, as the canvas is. How it got there is only technically (one could say it is no longer humanly) interesting; it is no longer *handled*.)

The problem this raises for me is exactly not to decide whether this is art (I mean, sculpture), nor to find some definition of 'sculpture' which makes the Caro pieces borderline cases of sculpture, or sculptures in some extended sense. The problem is that I am, so to speak, stuck with the knowledge that this is sculpture, in the same sense that any object is. The problem is that I no longer know what

sculpture is, why I call *any* object, the most central or traditional, a piece of sculpture. How *can* objects made this way elicit the experience I had thought confined to objects made so differently? And that this is a matter of experience is what needs constant attention; nothing more, but nothing less, than that. Just as it needs constant admission that one's experience may be wrong, or misformed, or inattentive and inconstant.

This admission is more than a reaffirmation of the first fact about art, that it must be felt, not merely known – or, as I would rather put it, that it must be known for oneself. It is a statement of the fact of life – the metaphysical fact, one could say – that apart from one's experience of it there is nothing to *be* known about it, no way of knowing that what you know is relevant. For what else is there for me to rely on but my experience? It is only if I accept (my experience of) the Caro that I have to conclude that the art of sculpture does not (or does no longer) depend on figuration, on being worked, on spatial continuity, etc. Then what does it depend on? That is, again, the sort of issue which prompted me to say that modern art lays bare the condition of art in general. Or put it this way: That an object is 'a piece of sculpture' is not (no longer) grammatically related to its 'being sculptured,' i.e., to its being the result of carving or chipping, etc., some material with some tool. Then we no longer know what kind of object a piece of sculpture (grammatically) is. That it is not a natural object is something we knew. But it also is not an artifact either – or if it is, it is one which defines no known craft. It is, one would like to say, a work of art. But what is it one will then be saying?

Two serious ambiguities... become particularly relevant here:

a) ...[Am I] addressing the question 'Is this music?' or 'Is this (music) art?'? I am very uncertain about this important alternation; but I want to suggest what it is I am uncertain about and why I take it to be important.

There is this asymmetry between the questions: If there is a clear answer to the question, 'Is this music (painting, sculpture...)?', then the question whether it is art is irrelevant, superfluous. If it is music then (analytically) it is art. That seems unprejudicial. But the negation does not: if it is not music then it is not art. But why does that seem prejudicial? Why couldn't we allow Pop Art, say, or Cage's evenings, or Happenings, to be entertainments of some kind without troubling about art? But we are troubled. Because for us, given the gradual self-definitions and self-liberations over the past century of the separate major arts we accept, Pop Art presents itself as, or as challenging, painting; Cage presents his work as, or as challenging the possibility of, music.... It would be enough to say that objects of Pop Art are not paintings or sculptures, that works of Cage and Krenek are not music – *if* we are clear what a painting is, what a piece of music is. But the trouble is that the genuine article – the music of Schoenberg and Webern, the sculpture of Caro, the painting of Morris Louis, the theatre of Brecht and Beckett – really does challenge the art of which it is the inheritor and voice. Each is, in a word, not merely modern, but modernist. Each, one could say, is trying to find the limits or essence, of its own procedures. And this means that it is not clear a priori what counts, or will count, as a painting, or sculpture or musical composition.... So we haven't got clear criteria for determining whether a given object is or is not a painting, a sculpture.... But this is exactly what our whole discussion has prepared us for. The task of the modernist artist, as of the

contemporary critic, is to find what it is his art finally depends upon; it doesn't matter that we haven't a priori criteria for defining a painting, what matters is that we realize that the criteria are something we must discover, discover in the continuity of painting itself. But my point now is that to discover this we need to discover what objects we *accept* as paintings, and why we so accept them. And to 'accept something as a painting' is to 'accept something as a work of art,' i.e., as something carrying the intentions and consequences of art: the nature of the acceptance is altogether crucial. So the original questions 'Is this music?' and 'Is this art?' are not independent. The latter shows, we might say, the spirit in which the former is relevantly asked.

b) To say that the modern 'lays bare' may suggest that there was something concealed in traditional art which hadn't, for some reason, been noticed, or that what the modern throws over – tonality, perspective, narration, the absent fourth wall, etc. – was something inessential to music, painting, poetry, and theater in earlier periods. These would be false suggestions. For it is not that now we finally know the true condition of art; it is only that someone who does not question that condition has nothing, or not the essential thing, to go on in addressing the art of our period. And far from implying that we now know, for example, that music does not require tonality, nor painting figuration nor theater an audience of spectators, etc., exactly what I want to have accomplished is to make all such notions problematic, to force us to ask, for example, what the art was which as a matter of fact did require, or exploit, tonality, perspective, etc. Why did it? What made such things media of art? It may help to say that the notion of 'modernism laying bare its art' is meant not as an interpretation of history (the history of an art), but as a description of the latest period of a history, a period in which each of the arts seems to be, even forced to be, drawing itself to its limits, purging itself of elements which can be foregone and which therefore seem arbitrary or extraneous – poetry wishing the abstraction and immediacy of lyricism; theater wishing freedom from entertainment and acting; music wishing escape from the rhythm or logic of the single body and its frame of emotion. . . . *Why* this has happened one would like to know, but for the moment what is relevant is that it has happened at a certain moment in history. For it was not always true of a given art that it sought to keep its medium pure, that it wished to assert its own limits, and therewith its independence of the other arts. Integrity could be assured without purity. So in saying that 'we do not know what is and what is not essentially connected to the concept of music' I am not saying that what we do not know is which one or more phenomena are always essential to something's being music, but that we have yet to discover what at any given moment has been essential to our accepting something as music. As was said, this discovery is unnecessary as long as there is a tradition – when everything which is offered for acceptance is the real thing. But so far as the possibility of fraudulence is characteristic of the modern, then the need for a grounding of our acceptance becomes an issue for aesthetics. I think of it as a need for an answer to the question, What is a medium of art?

Philosophers will sometimes say that sound is the medium of music, paint of painting, wood and stone of sculpture, words of literature. One has to find what problems have been thought to reach illumination in such remarks. What needs recognition is that wood or stone would not be a medium of sculpture *in the absence*

of the art of sculpture. The home of the idea of a *medium* lies in the visual arts, and it used to be informative to know that a given medium is oil or gouache or tempera or dry point or marble...because each of these media had characteristic possibilities, an implied range of handling and result. The idea of a medium is not simply that of a physical material, but of a material-in-certain-characteristic-applications. Whether or not there is anything to be called and any good purpose in calling anything, 'the medium of music,' there certainly are things to be called various media of music, namely the various ways in which various sources of sound (from and for the voice, the several instruments, the body, on different occasions) have characteristically been applied: the media are, for example, plain song, work song, the march, the fugue, the aria, dance forms, sonata form. It is the existence or discovery of such strains of convention that have made possible musical expression – presumably the role a medium was to serve. In music, the 'form' (as in literature, the genre) is the medium. It is within these that composers have been able to speak and to intend to speak, performers to practice and to believe, audiences to attend and to know. Grant that these media no longer serve, as portraits, nudes, odes, etc., no longer serve, for speaking and believing and knowing. What now is a medium of music? If one wishes now to answer, 'Sound. Sound itself,' that will no longer be the neutral answer it seemed to be, said to distinguish music from, say, poetry or painting (whatever it means to 'distinguish' things one would never have thought could be taken for one another); it will be one way of distinguishing (more or less tendentiously) music now from music in the tradition, and what it says is that there are no longer known structures which must be followed if one is to speak and be understood. The medium is to be discovered, or invented out of itself.

If these sketches and obscurities are of any use, they should help to locate, or isolate, the issue of Pop Art...Left to itself it may have done no harm, its amusements may have remained clean. But it was not made to be left to itself, any more than pin ball games or practical jokes or starlets are; and in an artistic-philosophical-cultural situation in which mass magazines make the same news of it they make of serious art and in which critics in elite magazines underwrite such adventures – finding new bases for aesthetics and a new future for art in every new and safe weirdness or attractiveness which catches on – it is worth saying: This is not painting; and it is not painting not because paintings *couldn't* look like that, but because serious painting doesn't; and it doesn't, not because serious painting is not forced to change, to explore its own foundations, even its own look; but because the *way* it changes – what will count as a relevant change – is determined by the commitment to painting as an *art*, in struggle with the history which makes it an art, continuing and countering the conventions and intentions and responses which comprise that history. It may be that the history of a given art has come to an end, a very few centuries after it has come to a head, and that nothing more can be said and meant in terms of that continuity and within those ambitions. It is as if the various anti-art movements claim to *know* this has happened and to provide us with distraction, or to substitute new gratifications for those well gone; while at the same time they claim the respect due only to those whose seriousness they cannot share; and they receive it, because of our frightened confusion. Whereas such claims, made from such a position, are no more to be honored than the failed fox's sour opinion about the grapes. [...]

13 William Tucker (b. 1935) and Tim Scott (b. 1937) 'Reflections on Sculpture'

Both sculptors studied with Anthony Caro at St Martin's School of Art in London in the late 1950s, both were teaching at St Martin's during the 1960s, and both exhibited in the 'New Generation' exhibition at the Whitechapel Art Gallery in 1965. This latter occasion was seen at the time as marking the emergence of a distinct school of abstract sculpture, informed by Caro's example and by a theorization of Modernism which had largely been developed by American critics with regard to American abstract painting. These 'Reflections' were originally published with the subtitle 'A commentary by Tim Scott on notes by William Tucker' in the catalogue of the exhibition *Tim Scott: Sculpture 1961–67* at the Whitechapel Art Gallery, London, June–July 1967 (unpaginated), from which the present text is taken.

OBJECT

The totals or unities created by man in his attempts to understand and control the world. (WT)

Isolation of the particular within our world. Investing of personal identification in the physical properties of the world around us. A chair, not because it is wood or round, but because of sitting, comfort, symbol. (TS)

MASS

a) Matter in general.

b) The solid earth under one's feet.

Weight; a feeling of substance; approaching knowledge of matter. Time; a feeling of permanence.

SPACE

The void, emptiness. Between things, above, about and below things, the air we breathe.

Tension; that part of the world we can activate by our presence, by our actions.

NUMBER AND ORDER

One-ness, two-ness, three-ness, etc. As in the Roman numerals I, II, III. The formal and symbolic characteristics of numbers.

One, the point, the centre.

Two, the pair, mirror-image, simple symmetry.

Three, the vertices of the triangle, the primitive series, instable, open, the air.

Four, the square, stability, the ground, the cycle ended.

The more plastic the expression, the more fundamental the symbol; in the end both seeing and knowing, sensation and memory, are identified.

Volume as volume – (mass)

Volume as plane – (configuration)

Volume as line – (direction)

Order; making sense by pattern. The quality of relationship. Measure; the order of dimension and the diagnosis of cause and effect in the physical world. Intensity; the degree of pattern and control that we can disperse around us.

The only means by which we can reduce physical property to a comprehensible mental structure (idea).

THE CENTRE

A point: the object exists for the sake of this point, exists through it and around it. The centre is the centre of gravity as it might exist for the figure outside it – i.e. we are aware of the object in the same way we are aware of our own centrality, by inference, passively: as we recognize our *selves* at the centre of our 'own' sensations. The object is fixed, still, because it is the centre. The spectator is free to move, because by attending to the object he has disposed of his centrality, and must seek it in the object.

The traditional concept of the 'heart'. We are incapable of constructive thought without recognition of centrality. It is the establishment of ego, of a point of meaning from which contact can be made. It is fundamental to all structural law.

LEVEL

Level in sculpture corresponds to distance in traditional perspective painting. The ground is the horizon: the rising layers above mediate between spectator and horizon. Distance between points (both internally and externally with relation to the spectator) physically exists, and is given and modulated by perspective.

Level is the degree of immediate visual perception. Immediate contact person to person takes place at eye level – the face. The visual discovery of the object corresponds to the level from which in distance this initial contact takes place. It is an anthropomorphic ratio.

Sculpture is a proposition about the physical world, about a finite order (completeness), and by implication about our existence in the world; the direction of the activity itself being toward the general, away from the personal.

Sculpture acts by displacement; it is the state *of being, the* state *of feeling, the* state *of experience, the* state *of physical awareness and sensation, the* state *of confrontation by physical phenomena; not these things themselves or an interpretation of them.*

Any object exists partly (1) because it physically *is*, it can be proved to have an independent existence in the world, partly (2) in the mind, so that it has identity, being of a kind, of a class, and partly (3) in the individual experience, personal and special to him.

Thus a tree, for example, is and grows: it has a word by which everyone can recognize it: and it has a particular meaning in the memory of every individual. Sculpture also must have the generality of the world: the identity of the object: the character of a human individual.

Any art generates the emotion and intelligence proper to that art. Sculpture seems so exposed to sentimentality and rhetoric that only a handful of sculptors have arrived at that point where pure sculptural emotion, pure sculptural intelligence, freed from the kinds of feeling or intelligence at work in the other arts, or in life, have been released. It is a creation of the mind first, before hand or eye. The object is a proposition – 'suppose such a thing should exist'. There is no longer any resistance in the traditional limits of sculpture, Imitation and Material. The sculptor must now take responsibility for

everything he does. Even the physical properties of matter are no longer inherent: they are assigned by the sculptor.

What distinguishes an object of sculpture from other objects (identity)? What special realm is there in the field of human experience which demands that there should be a sculpture (reality)?

Identity; that which distinguishes the essence of matter in the world. The characteristics given by accumulation of experience and the ability to make conscious choice within this. The ability to consciously choose and incorporate particular 'facts' available within the world structure in order to create an individual harmony and order, a remaking of the person.

Reality; the effect of comprehension of the real, and, causing this, the necessity for an equivalent to emotional perception of the real, underlie art. The particular form of an art is a conscious reduction of personal activity to means which will unfold the uniqueness of that 'realness' within its terms.

Sculpture penetrates the inhabited world. If it is not to be simply active ('dynamic') or aggressive in its passivity (simply 'being there'), it must have a complex double character which might be called 'reflective'; i.e. it exists and its structure reflects consciousness of its existence. It will have internality, without being withdrawn from the real into an internal world.

Sculpture has now the greatest freedom to comprehend its terms on the broadest basis. It is no longer confined by the restrictions of attitudes toward content and subject. It can achieve poetry in which the language itself is invented, is a product of pure analysis and conception.

14 Richard Wollheim (1923–2003) 'The Work of Art as Object'

Wollheim writes as a philosopher interested in aesthetics, psychology and modern art. His account of the 'conceptual hierarchy' of modern art is broadly compatible with the findings of Modernist criticism, and in particular with the views of Fried, who studied with him in London in 1961–2. The original version of this paper was published in *Studio International*, vol. 180, no. 928, London, December 1970. A revised version was published in Wollheim, *On Art and the Mind*, Cambridge, 1973. This was edited by the author for inclusion in C. Harrison and F. Orton (eds.), *Modernism, Criticism, Realism*, London and New York, 1984, pp. 10–17, from which the present text is taken.

If we wanted to say something about art that we could be quite certain was true, we might settle for the assertion that art is intentional. And by this we would mean that art is something we do, that works of art are things that human beings make. And the truth of this assertion is in no way challenged by such discoveries, some long known, others freshly brought to light, as that we cannot produce a work of art to order, that improvisation has its place in the making of a work of art, that the artist is not necessarily the best interpreter of his work, that the spectator too has a legitimate role to play in the organization of what he perceives. [. . .]

 Though much is unclear about the notion of activity, one thing seems clear. From the fact that art is something that we do, it follows that in the making of art a concept

enters into, and plays a crucial role in, the determination of what is made: or, to put it another way, that when we make a work of art, we make it under a certain description – though, of course, unless our attention is drawn to the question, we may not be in a position to give the description. Indeed [. . .] the truth seems to me to be that, on any given occasion, or in the case of any given work, there will be more than one concept involved, and the concepts that are involved will form some kind of hierarchy, with some concepts falling under others, either more or less organized. In the existence of such a conceptual hierarchy, regulative in the production of works of art, we find, I maintain, the justification for talking of a theory of art. In this lecture I want to look at the matter rather more generally, and I shall ask you to consider with me a theory of modern art. The theory I have in mind could not be called *the* theory of modern art, for there is evidently no such thing, but I would claim that it is the dominant theory. [. . .]

My suggestion is this: that for the mainstream of modern art, we can postulate a theory that emphasizes the material character of art, a theory according to which a work of art is importantly or significantly, and not just peripherally, a physical object. Such a theory, I am suggesting, underlies or regulates much of the art activity of our age, and it is it that accounts for many of the triumphs and perhaps not a few of the disasters of modern art. Within the concept of art under which most of the finest, certainly most of the boldest, works of our age have been made, the connotation of physicality moves to the fore.

The evidence for such a theory at work is manifold, the inspiration of the theory can be seen in a wide variety of phenomena which it thereby unifies: the increasing emphasis upon texture and surface qualities; the abandonment of linear perspective, at any rate as providing an overall grid within which the picture can be organized; the predilection for large areas of undifferentiated or barely fluctuating colour, the indifference to figuration; the exploitation of the edge, of the shaped or moulded support, of the unprimed canvas; and the physical juxtaposition of disparate or borrowed elements, sometimes stuck on, sometimes freestanding, to the central body of the work, as in collage or assemblages. These devices have, beyond a shadow of a doubt, contributed decisively to the repertoire of European art since, say, 1905: and any dispute about the presence of some such theory as I have produced would, I imagine, confine itself to the issue of how central these devices, and the modifications in art that they have brought about, are thought to be.

I want therefore to turn away from any central discussion of the theory to the qualifications that need to be entered if the theory, or the formulation of it, is to be adequate. I shall bring what I have to say under three general considerations. But in doing so, I shall give the theory itself a small twist towards greater specificity. I shall consider it exclusively in relation to painting, and I shall understand it as insisting upon the surface of a painting. In the context of a painting, for 'physicality' read 'possession of a surface'.

The first consideration, is this: The theory that I have been suggesting emphasizes or insists upon the physicality of the work of art, or the surface of the painting – emphasizes or insists upon them, but (this is the point) the theory did not discover or invent them. I am not, of course, making the self-evident point that even before 1905 paintings had surfaces. I am making the somewhat less evident point that before 1905 the fact that a painting had a surface, or the more general fact that works of art were physical, were not regarded as accidental or contingent facts about art.

For to read certain critics, certain philosophers of art, even certain contemporary artists, one might well think that before the beginning of the twentieth century the concept of art was totally without any connotation of materiality. Of course – it is conceded – in making their pictures earlier artists recognized that they were making physical objects. But for them the picture and the physical object were not equated, and the manipulation of the medium was seen more as a preliminary to the process of making art rather than as that process itself. For the picture was conceived of as something immaterial that burgeoned or billowed out from the canvas, panel or frescoed wall that provided its substrate. These things – canvas, panel, wall – were necessary for its existence, but it went beyond them, and the concept of it bore no reference to them.

Such a view of the past, which is artificially sustained by the very careless and utterly misleading use of the term 'illusionism' to characterize all forms of figurative painting, indeed all forms of representational painting, seems supported neither by empirical nor by theoretical considerations. Furthermore, there is a body of evidence against it. There are various moments in the history of European painting since the high Renaissance, when artists have shown a clear predilection for the values of surface, and they have employed selected means to bring out the physical quality of what they were working on or with. Take, for instance, the emergence of the brush-stroke as an identifiable pictorial element in sixteenth-century Venetian painting; the free sketching in of landscapes in the background of seventeenth- and eighteenth-century painting; or the distinctive use of cropped figures set up against the edge of the support in late nineteenth-century Parisian art. Now, of course, there is this difference: that to the earlier painters these devices were no more than a *possible* employment of painting, and for them the constraints of art lay elsewhere. It was, for instance, optional for Velazquez or for Gainsborough whether they expressed their predilection for the medium. What was necessary within their theory of art was that, if they did, it found expression within the depiction of natural phenomena. For, say, Matisse or Rothko, the priorities are reversed. But none of this suggests that the earlier painters thought that what they were doing was ancillary to painting. Between them and us what has happened is that some connotations of art that were previously recessive have moved to the fore, and vice versa.

The second consideration that touches upon the theory of modern art I have proposed seems to strike somewhat deeper. It is this: The theory emphasizes the physicality of art; it insists upon the fact that a painting has a surface. Indeed, by a ready trick of exaggeration the insisted-upon fact that a painting *has* a surface – a fact which, as we have seen, earlier generations did not overlook – can convert itself into the thesis that a painting *is*, or is no more than, a surface. Which gives us an extreme version of the theory, though not one unknown. However, a necessary modification is effected – once it is recognized that, in talking of a surface, the theory is irreducibly or ineliminably referring to *the surface of a painting*. In formulating the theory we can safely drop the phrase 'of a painting' only when the dropped phrase is understood. If the phrase is not merely dropped, but drops out of mind, the theory becomes incoherent. For to talk of a surface, without specifying what kind of surface it is, which means in effect what it is a surface of, picks out no kind of object of attention.

Perhaps one way of bringing out this consideration is to go back to the nature of the theory. For the theory, as we have seen, provides us, if it is adequate, with those concepts

under which a certain form of art – the art of our day – has been produced. However, it is clear that no one could set himself to produce a surface, unless he had some answer to the question what it was the surface of: nor could he endeavour to accentuate or work up a surface unless, once again, he thought of himself as accentuating or working up the surface of this or that kind of thing. To put it another way round: the instruction 'Make us aware or conscious of the surface' given in the studio, would take on quite different significances, if said, to someone throwing a stoneware pot, to someone painting in oil on primed canvas, to someone carving in marble, or to someone working in fresco. (Think, for instance, whether, in conformity to the instruction, the surface should be made smooth or rough.) Each of the recipients of the instruction would, in effect, fill it out from his knowledge of what he was doing, before he obeyed it. And, if he didn't know what he was doing, if, for instance, he was a complete beginner who hadn't as yet grasped the nature of the activity on which he had launched himself, he could not obey the instruction at all. It wouldn't be, simply, that he wouldn't know how to do what he had been asked to do: he wouldn't know what he had been asked to do. For him the instruction would mean about as much as 'Make it average-sized'.

The examples I have given might be misleading in one respect: for they might suggest that the further specification that is required before it becomes clear how the surface is to be worked refers exclusively to the material. The artist, in other words, needs to know what the surface is of just in the sense of what it is made of. This, however, would be erroneous. Not merely is this no more than part of what is required, but it is misleading even as to that. The distinction we need here is that between *a material* and *a medium*. A medium may embrace a material, though it may not, but, if it does, a medium is a material worked in a characteristic way, and the characteristics of the way can be understood only in the context of the art within which the medium arises.[1] 'Fidelity to material' is not so much an inadequate aesthetic, as some have thought, it is rather an inadequate formulation of an aesthetic: Bernini and Rodin were not faithful to marble, though they may have been faithful to marble as a material of sculpture. Given this distinction, the barest specification of the surface must be by reference to the medium which makes up or is laid on the surface. [. . .]

The third consideration that I want to raise in connection with the theory of modern art is this: The theory insists upon the physicality of the work of art – upon for instance, the surface of the painting. And this I have equally put by saying that the theory insists upon the fact that the painting has a surface. But from this it does not follow that a painting produced in conformity with this theory will insist upon the fact that it has a surface. Yet this is sometimes thought to follow both by critics and by artists: and consequential distortions are produced both in criticism – so that for instance, it is thought good enough to say of a painting that it insists upon the fact of its surface – and in art itself – so that we are confronted by objects which seek to acquire value from this insistence. [. . .]

Perhaps the best way of bringing out this consideration is to show how the theory, as it stands, can lead to anything but boring art. For the theory, in asserting that a painting has a surface, draws the painter's attention to the surface in a way or to a degree not contemplated by his predecessors. But if the theory were that the painting should assert that it has a surface, then not merely would no premium be placed on the use of the surface but the effect of the theory might well be to work against the use of the surface. For it might be felt that any such use would only interfere with the clarity

or the definitiveness of the painting's assertion. The *fact* of the surface might become eclipsed, wholly or partially, by the use of the surface. And in an aesthetic situation where the fact of the surface is reckoned the important thing, the use of the surface begins to look diversionary at best and probably hazardous.

To talk of the use of the surface and to contrast this with the fact of the surface, and to identify the former rather than the latter as the characteristic preoccupation of modern art, attributes to modern art a complexity of concern that it cannot renounce. For it is only if we assume such a complexity that there is any sense in which we can think of the surface as being used. Used, we must ask, for what? And the answer to this has to lie in that complexity of concern. – The point, I must emphasize, would not be worth making were it not for the widespread confusion which equates the autonomy of modern art with its single-mindedness, even with its simple-mindedness. To talk of the autonomy of art is to say something about where its concerns derive from, it is to say nothing about their number or their variety.

To talk of the surface being used, rather than of its existence being asserted, as a characteristic of modern painting, is not a point to make in the abstract. The point cannot be grasped without some kind of incursion into the substantive issue. What therefore I should like to do for the rest of this lecture is to consider three paintings, and try to make the point in relation to them. It is no accident that these paintings are amongst the masterpieces of twentieth-century art.

The first painting is *La Fenêtre Ouverte* painted by Matisse in Tangiers in 1913. Some of the things that I shall say about it will apply to the other great open-window paintings of Matisse, for instance the sombre *La Porte-fenêtre* of 1914 or the painting entitled *La Fenêtre*, or *Le Rideau Jaune*. In this painting we discern, amongst other things, Matisse's recurrent concern with the nature of the ground. Now, if we consider what is not so much the earliest painting we have, though it is often called that, as the precursor of painting – I refer to the cave art of the early Stone Age – there is no ground, there is simply the image.[2] With the introduction of the ground, the problem arises, How are we to conceive of the ground in a way that does not simply equate it with the gap between the figures or the absence of depiction? In the history of European painting we can see various answers to this question. One answer is for the painter to equate the ground with the background or, if this term is taken broadly enough, with the landscape, and then to organize the detail that this equation is likely to impose upon him in a hierarchical fashion, detail subsumed within detail, in a Chinese box-like fashion. This answer we can see as given in some of the finest achievements of European art – for instance, in such different kinds of work as the masterpieces of Van Eyck and Poussin. Another answer is to regard the ground as providing, still through representation, not so much content additional to the central figures, but a space in which the central figures are framed. Now for a variety of reasons neither of these two classic answers is open to Matisse. For Matisse – and here he exhibits two of the main thrusts of twentieth-century art – dispenses both with the notion of detail in the traditional sense and also with the commitment to a unitary and ordered spatial framework. And so the question returns. How is the ground to be conceived of except in purely negative terms? How – which is an extension of this question – is the frontier of the ground, of the line which encloses it, not to seem quite arbitrary? And it is at this point, to find an answer to this question, that Matisse resorts to the surface. It is here that he *uses* the surface. For what he does is to associate the ground so closely with the

surface – by which I mean that he charges the surface in such a way that it barely involves a shift of attention for us to move from seeing a certain expanse as ground to seeing it as surface – that we fully accept the size of the surface as determining the extent of the ground. To understand Matisse's use of the surface, we might say that through it he reconciles us to the ground without our hankering after any of the classic ways of treating the ground that Matisse has forsworn.

There is perhaps another line of thought in *La Fenêtre Ouverte* which is worth pursuing. What we see through the open window is a view. Now, at any rate for a painter there is, perhaps, a certain absurdity in thinking of a view as a view on to – well, a view on to nothing, which is rather what treating what is depicted through the frame of the window as mere ground implies. The view is – of course in a rather special, one might say in a rather professional, sense – an object. And now we can see a secondary use that Matisse makes of the surface. For by emphasizing the surface where it coincides with the ground, he leads us towards this painter's way of looking at or considering the view. Of course, Matisse isn't a clumsy painter, and he avoids that use of the surface which would make it look as though the open window were filled with a solid object. It is made clear, at one and the same time, that the view isn't an object but that it is as though it were.

The second painting I want to consider is one of Morris Louis's later canvases [*Alpha Phi*, 1961]. Louis's work at this stage was largely dominated by one preoccupation – apart, that is, from his interest in the physical look of the picture or how the surface looks. And this preoccupation can be described from two different points of view. From one point of view, it is a concern with colour: from another point of view it is a concern with patches – where patches are contrasted both with volumes, which are three-dimensional, and with shapes, which, though two-dimensional, are seen as suspended in, or visibly inhabit, three-dimensional space. Louis, in other words, wanted to introduce colour into the content of his paintings but to as great a degree as is humanly possible – or, better, visibly possible – he wanted consideration of the spatial relations between the coloured elements, or the bearers of colour, to recede. Now, I do not think that it is quite correct to say – as Michael Fried does in his otherwise perceptive account of these paintings[3] – that Louis's patches are non-representational: that is to say, I do not think that Louis wants us exclusively to see stained parts of the canvas. He seeks a form of representation where the representation of space or of anything spatial is at a minimum. And to achieve this effect, he uses the surface in such a way that so long as we look centrally at one of the patches we see it representationally. But, as our eyes move towards the edge of the patch, the representational element diminishes, and we become dominantly, then exclusively, aware of the canvas. In other words, representation gets negated at the very point where questions of spatiality – how does this patch stand to the next? – would begin to arise. The overall effect is that, in looking at Louis's patches, we seem aware of them as though they were embedded in, or pressed down upon, the surface – an effect, which, incidentally, we find, in a highly figurative context, in some of Goya's paintings. The surface, then, is used to control or to limit the operation of representation, so that colour can be encountered in what we might call a 'pure' mode: as predicated of extended but non-spatial elements.

The third painting that I want to consider is one of Rothko's canvases from the Four Seasons series, now hanging in the Tate [*Red on Maroon*, 1969]: to my mind, one of the

sublimest creations of our time. In comparison with Louis, even with Matisse, Rothko uses the surface in a highly complex way. And I shall only give one hint of how we might think of this. The greatness of Rothko's painting lies ultimately, I am quite sure, in its expressive quality, and if we wanted to characterize this quality – it would be a crude characterization – we would talk of a form of suffering and of sorrow, and somehow barely or fragilely contained. We would talk perhaps of some sentiment akin to that expressed in Shakespeare's *Tempest* – I don't mean expressed in any one character, but in the play itself. However, the immediacy of Rothko's canvas derives from the way in which this expressive quality is provided with a formal counterpart: and that lies in the uncertainty that the painting is calculated to produce, whether we are to see the painting as containing an image within it or whether we are to see the painting as itself an image. Whether we are to see it as containing a ring of flame or shadow – I owe this description of the fugitive image to the brilliant description of the Four Seasons paintings by Michel Butor in his essay 'Rothko: The Mosques of New York'[4] – or whether we are to look upon it as somewhat the equivalent of a stained glass window.[5]

Now, it is to bring about this uncertainty, as well as to preserve it from, or to prevent it from degenerating into, a mere oscillation of perception, which could, if I am right, be highly inimical to Rothko's expressive purpose, that he uses the surface as he does. For the use of the surface, or the way it manifests itself to us, simultaneously suggests forms within the painting and imposes unity across the painting. It suggests light falling upon objects and light shining through a translucent plane. Wherever a definitive reading begins to form itself, the assertion of surface calls this in doubt.

It is only now, when we have taken note of other, or more working, aspects of the theory of modern art as I have suggested it, that it seems to me appropriate to observe an aspect that might have seemed to some worthy of earlier attention: I mean the way it is likely to give rise to objects that manifest the only kind of beauty we find acceptable today.

[1] Stanley Cavell, *Must We Mean What We Say?* 1969.
[2] On this, see Meyer Schapiro, 'On Some Problems in the Semiotics of Visual Art: Field and Vehicle in Image-Signs', *Semiotica*, I, no. 3, 1969, pp. 223–42.
[3] Michael Fried, *Three American Painters*, Boston, 1965, pp. 19–20.
[4] Michael Butor, *Inventory*, trans. Richard Howard, London, 1970.
[5] I have benefited greatly from conversations with Peter Larisey, S.J.

Part VII
Institutions and Objections

VII
Introduction

Modernist judgements of quality and relevance, particularly as regards the diverse forms of American art since Pollock, came under foundational challenge in the mid-1960s: an attack which coincided with the quintessential formulation of Greenbergian Modernism itself. The apparent paradox thus presented by Modernism's fall from grace at the height of its powers is dissipated somewhat if we interpret its achievement of pre-eminence as a narrative wherein a powerful and exclusive critical approach to art (arguably powerful because of its exclusivity) became transformed into a managerial culture of art. On this account, that is to say, Modernism's hegemony was achieved at the price of sclerosis. The moment its exclusivity was seen to cut with the grain of temporal power rather than against it, its claims to critical virtue stood fatally compromised.

Always implicit in Greenberg's account of modern art as a process of self-purification was an essentialism, which Fried was later to try to dispel. A reading of Modernism as a process of reduction none the less proved attractive to representatives of a generation who otherwise reacted against the Greenbergian view. Donald Judd, Frank Stella, Carl Andre and somewhat differently Robert Morris all took up the implication that the tendency of modern art was progressively to expunge relational composition in the quest for a more unitary, less illusionistic form of work (VIIA2, 3, 5 and 6). In particular this seemed to militate against the continued viability of painting as an adequate vehicle, and to propose instead the substitution of 'real' relations in 'real' space for the illusionism in which painting, by its very nature, was forced to trade.

The reasoning lying behind this emphasis on 'wholeness' is nowhere made explicit. Two related implications are indicated, however. One concerns the refusal of compos-ition, of 'balancing', as an essentially archaic Cubist device, and the concomitant paring-down of the work towards a unity which was no longer the sum of parts, in any traditional sense. This in turn goes to a different order of validation which is premised on the association of 'composition' and the like with a European, and hence outmoded, 'dualistic' sensibility; that is to say, ultimately, with a tradition of Cartesian rationalism. Lying behind the rehearsal of the 'specific object' seems to have been a deeper sense that something altogether new – in a way that painting and sculpture could never be – was required by an altogether new form of life. The assumption was that such a life was being lived, pre-eminently, in modern America.

For Michael Fried, art had to 'compel conviction'. For Judd and others it had to be 'credible'. In one sense, there is little between these demands. It is hard, however, to escape another sense in which the one partakes of an idealization of art, seeking to escape the contingencies of literal reality, whereas the other seeks credibility in a kind

of adequacy to urban experience in a world of mass production. At least this is in part how matters appeared at the time. A world was at stake, or to put it slightly differently, a stake in a kind of world; and the options were fiercely contested. Fried's 'Art and Objecthood' appeared as an intervention in a debate already, by the summer of 1967, largely dominated by his opponents (VIIA7). His defence of the integrity of medium-specificity, and of the value of aesthetic experience conceived as essentially independent of time and place, was made against rival interests engaged in what he represented as moral and not merely aesthetic compromise. More to the point, Modernist aesthetics, as Fried conceived it, was imbued with an ethics.

But however passionately his position was defended, in 1967 Fried's argument had the air of a rearguard action. The position which Abstractionist Modernism had formerly occupied was already being usurped. Forms of art abounded in which the conventional distinctions between media were deliberately transgressed. In such work, increasing attention was paid to the contingent aspects of the context wherein art was in general encountered. This was just the kind of work that Fried had condemned as 'theatrical'. Neither was such work being done in isolation. It was paralleled by forms of art-critical revision which themselves took issue with both the premises and judgements of Modernism (VIID7 and 8).

It remains an open question where the line is to be drawn between Modernism and its opponents. In a manner quite distinct from later journalistic demarcations (between for example, 'abstract', 'Minimal' and 'Pop' art), Judd accounted positively for Noland's painting, as well as Oldenburg's sculpture, as part of a tendency towards specificity. There is a sense in which the reductionism underpinning the promulgation of the art object, as well as subsequent moves to 'dematerialize' the object, can all be read as a continuation of, rather than a movement beyond, Modernist essentialism. That is, it can be construed as a kind of ultimate Modernism, a striving to hitch the last, and hence most up-to-date wagon, onto a train coming from history. From this perspective, Greenberg's failure to accommodate so-called Minimal Art might be seen as a failure of nerve in face of the logic of his own position.

The literalist refusal of aestheticist Modernism as it was formulated by Greenberg and defended – in his own terms – by Michael Fried was fuelled by a quest for the core, a drive to strip away the inessentials from the practice of art. It resulted in a trek from paintings and sculptures, to 'specific' objects, to objects on the threshold of perception, to objects of thought, and to the assertion of art as an analytical proposition (VIIA3–6, 10 and 11). For all Judd's criticism of a dualism which derives from an outmoded European rationalism, it is not hard to see a wider idealism governing much of this process of reduction. In the hands of Morris and others, however, the 'literalism' (Fried's term) implicit in the drive to objects rapidly turned itself inside out and gave rise to an art which no aestheticist formalism could embrace. A materialism focused on the processing of mute stuff turned the hyper-formalism of the Minimalist object into 'anti-form' (VIIB4 and 11): a materialism reminiscent of nothing so much as Bataille's earlier valorization of the 'informe' (VIIB3, and see also IVC12). Attention turned towards 'making': a concern with processes of manipulation of materials, rather than their constitution into some object. Although given new force in the late 1960s, this concern can be seen to re-invoke aspects of Rosenberg's representation of Abstract Expressionism as 'action painting' (see VA16), as well as the subsequent extrapolation from this into 'Happenings' (see VIA7).

The effect of this materialism was to focus concern on context. Whereas Modernism had been indifferent to context, and whereas the 'specific object' for the most part unproblematically occupied a traditional gallery space, the concern with materials – particularly relatively formless materials – had the effect of inducing reflection upon the 'containers' which conferred form upon them. Principal among these was the gallery space itself. But once that was highlighted as constitutive of the work, rather than a neutral factor undeserving of attention, the possibility arose of making art which further problematized the conventions of spectatorship.

This occurred in two main ways. First, by siting the work outside the gallery. Land Art, Body Art and site-specific sculpture generated a phenomenologically informed focus upon the conditions of encounters with artworks: that is to say, the embodied perception of physical objects and events in time and space – precisely that which for Fried courted theatricality (VIIB3, 4, 13 and 14).

Alternatively, an analytical form of Conceptual Art problematized the primordial convention of art's visuality (VIIB1). This use of language to question the status and framing conditions of the art object led to a second-order practice explicitly concerned with the status of the modern art object. This practice was premised on the redundancy of any further expansions to the range of art's 'objects'. If the object had a role, it was to serve as the focus of inquiry into its own now manifest contingency (VIIB5 and 6). This contingency itself rapidly came to be understood as not merely physical, nor indeed merely conceptual, but social (VIIC9–13). What resulted was an engagement with the consequences of viewing the work of art as a commodity. It goes without saying that these practical options were neither exclusive nor distinct. They formed as it were the field of possibilities in which the avant-garde of the late 1960s and early 1970s conducted itself. Its prime axes were thus ontological and ideological.

A sense of the context of art was thus extended to embrace the invisible but powerful forces circumscribing its production. One of the key features of Modernism was that it was American, and that New York had supplanted Paris as capital of the avant-garde. In the later 1960s, for the first time since the end of the Second World War, European art regained a kind of parity (VIIB2). This internationalization of the avant-garde is not to be separated from a wider internationalism, which came at that period to contest a global status quo with its perceived headquarters in America (VIIC1). What 'American' meant, internationally, was not something with which all Americans were content to remain straightforwardly identified (VIIC2, 5 and 6).

This contestation extended over a long period from approximately the mid-1960s to the mid-1970s. It has, however, become identified with its high-water mark in 1968. '1968' as a name means many things, from forms of popular culture to military actions, from an excess of utopianism to a general strike. Its extraordinary constellation brought Maoism into alignment with the Civil Rights movement and opposition to the Vietnam war; it saw both the transformation of hitherto reactionary sections such as students into the cutting-edge of opposition, and the emergence of a widespread women's movement, with which new forms of women's art practice could be associated (VIIC3 and 7). Widespread assumptions of the passivity of the Western working class were shaken by the May Events in Paris where student rioting acted as a detonator to industrial militancy. In a world which embraced Bob Dylan, Jean-Luc Godard, Che Guevara and the Prague Spring there developed a sense of possibility. Not only was the status quo a brake on development, it seemed that it could be overcome. Precise

relations and influences between the climate of these times and the art produced in them are as hard to decide as they were undoubtedly crucial. What is certain is that a level of debate about the relation of art to politics was stimulated, and forms of organization were broached, in a fashion not seen since the 1920s and 1930s.

Interventions ranged from the sociological to the utopian, from the crusading to the ironic. Some measure of the atmosphere can be gleaned from the claim made in the pages of *Studio International* by the French writer Jean Clay in June 1970 that 'It is clear that we are witnessing the death throes of the cultural system maintained by the bourgeoisie in its galleries and its museums.' Some grounds for irony may be discerned in the continued willingness of multinational corporations to sponsor avant-garde manifestations (VIIB9). This should not, however, entirely trivialize the scale of reassessment, both aesthetic and cultural, which was prompted by Conceptual Art. The condition of modernity did come under critical scrutiny by artists once again. Where that scrutiny failed to extend to the art world itself as the determining site of practice it was possible to hear the rhetorical hollowness so often attendant on a commitment to sorting out other people's problems. But where an adequate measure of reflexivity was ensured, these debates both stimulated, and were themselves reciprocally fuelled by, the rediscovery of earlier ones. The contributions of Benjamin, Brecht, Lukács and others were reclaimed from the margins to which decades of Fascism, war and Cold War had consigned them.

This process was by no means straightforward, however. The art of the later 1960s and early 1970s was not directly comparable with the alignments of the 1930s. Neither, ultimately, was the world, except in the limited sense that international capitalism resisted successful challenge. One significant difference between the two periods was the virtual disappearance of Soviet Communism as an object of attraction to elements in the Western avant-garde. After the invasions of Hungary and Czechoslovakia and the split with China, as well as its consistent identification with reaction in art itself, the Soviet Union offered nothing to a Western avant-garde now more closely associated with the 'New Left'.

The avant-garde, it goes without saying, has never been systematically affiliated to any one political perspective. None the less, to the extent that it has maintained an oppositional cast it has been substantially affected by the terms in which a wider opposition has been conducted. The decline in intellectual prestige of the Soviet Union was a part of, though it should not be identified with, a wider historical crisis in Marxism. This could not leave the avant-garde unaffected. Particularly after the absorption of the wave of 1968, a wholesale intellectual re-examination of the premises of opposition began, focused particularly in France itself. 'French theory', however, had an international effect.

Two main emphases may be noted. First, what Perry Anderson has referred to as the 'exorbitation of language'. The powerful example of Roland Barthes helped fuel a tendency to perceive the mute objects and practices of the social world as encoding meaning, after the manner of a text (VIID5). In short order everything from paintings to objects, to practices, to sites, to people themselves, became legible as 'texts' to those equipped with the tools of semiology. One effect of global modernization has been for the developed economies of the West to export the ruder forms of manufacture and become increasingly dedicated to the processing of information. Knowledge is power, and the obsession with information has generated a weight of emphasis upon the

production of meanings which has quite eclipsed attention to production of a more basic kind. The conception of language as a structure of differences, a self-contained system through which we, as it were, happen to be able to refer to a world, stimulated a tendency to think in terms of relatively autonomous levels or practices rather than a world cohered according to some originary contradiction (VIID1).

Plural foci of determination have come to constitute a second persistent motif in the theory of the period, a fact one presumes to be not unconnected with the claimed pluralism of the social formations themselves. In particular the issue of gender came to the fore in the critical revisions which marked much of the theory of this period (VIID10). No other feature serves as clearly to mark out the radical cultural practice of the 1960s and after from its forerunners in the 1920s and 1930s as this more pluralist perception of the social production of meaning and its inscription through power.

Somewhat ironically, the work of the Marxist philosopher Louis Althusser did much for this approach (VIID3). His insistence upon ideology and ideological struggle as constitutive features of social organization, rather than detrimental aspects of bourgeois society alone, fuelled a notion of theoretical practice which, though itself short-lived, played a part in establishing a perspective wherein the 'political' was no longer perceived as being 'outside' culture, or art, or the institutional exchange of meaning. It was rather an aspect of those practices. In the hands of Michel Foucault the nexus of 'power–knowledge' became the point upon which the critical intellectual or artist should concentrate (VIID11). And power, from now on, was seen to be constituted by much more than its economic moment. Cultural constructions of authority and identity were widely questioned (VIID15). The articulation of Structuralism and semiotics to a Lacanian psychoanalysis wherein the human subject was understood as formed in the play of gender difference contained far-reaching implications for the avant-garde (see VB8). One of the main casualties of this rewriting of subjectivity was the concept of the artistic author, who in 'his' protean or expressive form had been so central to modern art (VIID2).

The questioning to which Modernism was thus subjected, in terms of the practices both of art and of art criticism, received support from diverse directions. In addition to French philosophy, contemporary Marxism and the philosophy of science provided methodological and theoretical resources (VIID4, 13 and 14). These methods offered means of address to questions which had been thrown up by the paradigm of Modernism. The answers, however, threatened to consign that paradigm, at least in its most recently dominant form, to history.

VIIA
Objecthood and Reductivism

1 Yves Klein (1928–1962) from 'The Evolution of Art towards the Immaterial'

In Klein's pursuit of the 'Immaterial' a connection may be discerned between the neo-Dadaism of the French Nouveaux Réalistes and the various forms of reductive Modernism which were to be practised in America during the 1960s. An exhibition of Klein's monochrome canvases (*Propositions monochromes*) took place in Paris in February–March 1956 at the Galerie Colette Allendy, and at about the same time he began to produce paintings and other objects painted a uniform deep blue. Two years later he presented an empty white-painted gallery as an exhibition (*Le vide*, Galerie Iris Clert, April–May 1958). The present text is extracted from the transcript of a lecture delivered on 3 June 1959 at the Sorbonne in Paris; this translation was published in the catalogue of an exhibition of Klein's work at the Gimpel Fils Gallery, London, 1973.

How did I happen to enter this blue period? Toward the end of 1955, I exhibited at the Colette Allendy Gallery a score of monochromatic surfaces, all of different colors, green, red, yellow, violet, blue, orange. That was the beginning, or at least the first public showing, of this style. I was attempting to show color, and I realized at the opening of the exhibition that the public, enslaved by visual habit, when presented with all those surfaces of different colors on the walls, reassembled them as components of polychromatic decoration. The public could not enter into the contemplation of the color of a single painting at a time, and that was very disappointing to me, because I precisely and categorically refuse to create on one surface even the interplay of two colors.

In my judgment two colors juxtaposed on one canvas compel the observer to see the spectacle of this juxtaposition of two colors, or of their perfect accord, but prevent him from entering into the sensitivity, the dominance, the purpose of the picture. This is a situation of the psyche, of the senses, of the emotions, which perpetuates a sort of reign of cruelty (laughter), and one can no longer plunge into the sensibility of pure color, relieved from all outside contamination.

Some will no doubt protest that my development has taken place very rapidly, in barely four years, and that nothing can occur in such a short time... I reply that, although indeed I did begin to exhibit my painting only in 1954 in Paris, I had already been working for a long time in that style, since 1946. This prolonged wait demonstrates precisely what I had been prepared to wait for. I had waited for something to become stable within me before I could reveal or verify what it was. The few friends of

that time who encouraged me are aware of it; I had begun monochromatic painting, in addition to the everyday activities of painting which were influenced by my parents, both of them artists, because it seemed that while working color kept winking at me. It enchanted me, besides, because in front of any painting, figurative or non-figurative I felt more and more that the lines and all their consequences, the contours, the forms, the perspectives, the compositions, became exactly like the bars on the window of a prison. Far away, amidst color, dwelt life and liberty. And in front of the picture I felt imprisoned, and I believe it is because of that same feeling of imprisonment that van Gogh exclaimed, 'I long to be freed from I know not what horrible cage!'

The painter of the future will be a colorist of a kind never seen before, and that will occur in the next generation. And without doubt it is through color that I have little by little become acquainted with the Immaterial. The outward influences which have impelled me to pursue this monochromatic path as far as the immateriality of today, are multiple: the reading of the Journal of Delacroix, that champion of color, whose work lies at the source of contemporary lyric painting; then a study of the position of Delacroix in relation to Ingres, champion of an academic art which fostered line and all its consequences, which in my opinion have brought today's art to the crisis of form, as in the beautiful and grandiose but dramatic adventure of Malevich or Mondrian's insoluble problem of spatial organization, which has encouraged the polychrome architecture from which our contemporary urban developments suffer so atrociously; finally, and above all, I received a profound shock when I discovered in the Basilica of Saint Francis of Assisi frescoes which are scrupulously monochromatic, uniform and blue, which I believe may be attributed to Giotto (but which might be by one of his pupils, or else by some follower of Cimabué or even one of the artists of the school of Siena, though the blue of which I speak is just of the same character and the same quality as the blue in the skies of Giotto which may be admired in the same basilica on the floor above). Were one to acknowledge that Giotto may have had only the figurative intention of showing a clear, cloudless sky, *that intention is nevertheless definitely monochromatic*.

I unhappily did not have the pleasure of discovering the writings of Gaston Bachelard till very late, only last year in the month of April 1958. To the question which is often asked me – why did you choose blue? – I will reply by borrowing yet again from Gaston Bachelard that marvelous passage concerning blue from his book *Air and Dreams*. This is primarily a Mallarmean document in which the poet, living in 'contented world-weariness amidst oblivious tarns', suffers from the irony of blueness. He perceives an excessively hostile blueness which strives with an indefatigable hand to 'fill the gaping blue holes wickedly made by birds'. In the realm of the blue air more than anywhere else one feels that the world is accessible to the most unlimited reverie. It is then that a reverie assumes true depth. The blue sky yawns beneath the dreams, the dream escapes from the two-dimensional image; soon in a paradoxical way the airborne dream exists only in depth, while the two other dimensions, in which picturesque and painted reverie are entertained, lose all visionary interest. The world is thus on the far side of an unsilvered mirror, there is an imaginary beyond, a beyond pure and insubstantial, and that is the dwelling place of Bachelard's beautiful phrase: 'First there is nothing, next there is a depth of nothingness, then a profundity of blue.' . . .

Blue has no dimensions, it is beyond dimensions, whereas the other colors are not. They are pre-psychological expanses, red, for example, presupposing a site radiating heat. All colors arouse specific associative ideas, psychologically material or tangible,

while blue suggests at most the sea and sky, and they, after all, are in actual, visible nature what is most abstract.

2 Carl Andre (b. 1935) 'Preface to Stripe Painting'

In 1959 the American sculptor Carl Andre shared a studio in New York with Frank Stella. At the time Andre was writing poetry and was working on large wooden sculptures indebted to the work of Constantin Brancusi. Stella was working on black-striped paintings, four of which were selected for exhibition in 'Sixteen Americans' at the Museum of Modern Art, New York, 16 December 1959–17 February 1960. The following text was written for the catalogue of that exhibition. It was first published in Dorothy C. Miller (ed.), *Sixteen Americans*, New York: Museum of Modern Art, 1959, p. 76, from which this text is taken.

Art is the exclusion of the unnecessary. Frank Stella has found it necessary to paint stripes. There is nothing else in his paintings. He is not interested in sensitivity or personality, either his own or those of his audience. He is interested in the necessities of painting. Symbols are counters passed among people. Frank Stella's painting is not symbolic. His stripes are the paths of brush on canvas. These paths lead only into painting.

3 Frank Stella (b. 1936) Pratt Institute Lecture

Stella's work first came to prominence with the inclusion of four striped black paintings in the exhibition 'Sixteen Americans' (see previous text). Both in his early work and in the present text Stella gave clear exposition to one of the distinguishing concerns of his generation of American artists: how to supersede the traditional concept of composition as a process of relating of parts. Although Yves Klein (VIIA1) and Piero Manzoni (VIA8) had voiced similar concerns at about the same time, this problem was widely identified by the American avant-garde of the 1960s as the legacy of a now outmoded European phase of Modernism. This is the text of a talk given to art students at the Pratt Institute, New York, at the time of the 'Sixteen Americans' exhibition. It was illustrated by diagrammatic drawings of Stella's work. The typescript was preserved in a notebook by Carl Andre and was published in Robert Rosenblum, *Frank Stella*, Harmondsworth and Baltimore, MD, 1971, p. 57, from which the present text is taken.

There are two problems in painting. One is to find out what painting is and the other is to find out how to make a painting. The first is learning something and the second is making something.

One learns about painting by looking at and imitating other painters. I can't stress enough how important it is, if you are interested at all in painting, to look and to look a great deal at painting. There is no other way to find out about painting. After looking comes imitating. In my own case it was at first largely a technical immersion. How did Kline put down that color? Brush or knife or both? Why did Guston leave the canvas bare at the edges? Why did H. Frankenthaler use unsized canvas? And so on. Then, and this was the most dangerous part, I began to imitate the intellectual and emotional processes of the painters I saw. So that rainy winter days in the city would

force me to paint Gandy Brodies, as bright clear days at the seashore would force me to paint De Staels. I would discover rose madder and add orange to make a Hofmann. Fortunately, one can stand only so much of this sort of thing. I got tired of other people's painting and began to make my own. I found, however, that I not only got tired of looking at my own paintings but that I also didn't like painting them at all. The painterly problems of what to put here and there and how to make it go with what was already there became more and more difficult and the solutions more and more unsatisfactory. Until finally it became obvious that there had to be a better way.

There were two problems which had to be faced. One was spatial and the other methodological. In the first case I had to do something about relational painting, i.e., the balancing of the various parts with and against each other. The obvious answer was symmetry – make it the same all over. The question still remained, though, of how to do this in depth. A symmetrical image or configuration placed on an open ground is not balanced out in the illusionistic space. The solution I arrived at – and there are probably quite a few, although I know of only one other, color density – forces illusionistic space out of the painting at a constant rate by using a regulated pattern. The remaining problem was simply to find a method of paint application which followed and complemented the design solution. This was done by using the house painter's technique and tools.

4 Ad Reinhardt (1913–1967) 'Art as Art'

Reinhardt's characteristic statements express an apparent conviction in the utter separation of art from life. At the time they were written, his strings of negations offered a strategic resistance to the types of claim for meaning in abstract art which had become prevalent in the literature of Abstract Expressionism. They also served to clear some theoretical space for the 'pure', contentless abstract paintings on which Reinhardt had been working since the early 1950s. During the 1960s his example was important for some American artists of a younger generation, and particularly for Joseph Kosuth (see VIIA11). Originally published in *Art International*, Lugano, VI, no. 10, December 1962.

The one thing to say about art is that it is one thing. Art is art-as-art and everything else is everything else. Art-as-art is nothing but art. Art is not what is not art.

The one object of fifty years of abstract art is to present art-as-art and as nothing else, to make it into the one thing it is only, separating and defining it more and more, making it purer and emptier, more absolute and more exclusive – non-objective, non-representational, non-figurative, non-imagist, non-expressionist, non-subjective. The only and one way to say what abstract art or art-as-art is, is to say what it is not.

The one subject of a hundred years of modern art is that awareness of art of itself, of art preoccupied with its own process and means, with its own identity and distinction, art concerned with its own unique statement, art conscious of its own evolution and history and destiny, toward its own freedom, its own dignity, its own essence, its own reason, its own morality and its own conscience. Art needs no justification with 'realism' or 'naturalism,' 'regionalism' or 'nationalism,' 'individualism' or 'socialism' or 'mysticism', or with any other ideas.

The one content of three centuries of European or Asiatic art and the one matter of three millennia of Eastern or Western art, is the same 'one significance' that runs through all the timeless art of the world. Without an art-as-art continuity and art-for-art's-sake conviction and unchanging art spirit and abstract point of view, art would be inaccessible and the 'one thing' completely secret.

The one idea of art as 'fine,' 'high,' 'noble,' 'liberal,' 'ideal' of the seventeenth century is to separate fine and intellectual art from manual art and craft. The one intention of the word 'aesthetics' of the eighteenth century is to isolate the art experience from other things. The one declaration of all the main movements in art of the nineteenth century is of the 'independence' of art. The one question, the one principle, the one crisis in art of the twentieth century centers in the uncompromising 'purity' of art, and in the consciousness that art comes from art only, not from anything else.

The one meaning in art-as-art, past or present, is art meaning. When an art object is separated from its original time and place and use and is moved into the art museum, it gets emptied and purified of all its meanings except one. A religious object that becomes a work of art in an art museum loses all its religious meanings. No one in his right mind goes to an art museum to worship anything but art, or to learn about anything else.

The one place for art-as-art is the museum of fine art. The reason for the museum of fine art is the preservation of ancient and modern art that cannot be made again and that does not have to be done again. A museum of fine art should exclude everything but fine art, and be separate from museums of ethnology, geology, archaeology, history, decorative arts, industrial arts, military arts, and museums of other things. A museum is a treasure house and tomb, not a counting-house or amusement center. A museum that becomes an art curator's personal monument or an art-collector-sanctifying establishment or an art-history manufacturing plant or an artists' market block is a disgrace. Any disturbance of a true museum's soundlessness, timelessness, airlessness, and lifelessness is a disrespect.

The one purpose of the art academy university is the education and 'correction of the artist'-as-artist, not the 'enlightenment of the public' or the popularization of art. The art college should be a cloister-ivyhall-ivory-tower-community of artists, an artists' union and congress and club, not a success school or service station or rest home or house of artists' ill-fame. The notion that art or an art museum or art university 'enriches life' or 'fosters a love of life' or 'promotes understanding and love among men' is as mindless as anything in art can be. Anyone who speaks of using art to further any local, municipal, national, or international relations is out of his mind.

The one thing to say about art and life is that art is art and life is life, that art is not life and that life is not art. A 'slice-of-life' art is no better or worse than a 'slice-of-art' life. Fine art is not a 'means of making a living' or a 'way of living a life,' and an artist who dedicates his life to his art or his art to his life burdens his art with his life and his life with his art. Art that is a matter of life and death is neither fine nor free.

The one assault on fine art is the ceaseless attempt to subserve it as a means to some other end or value. The one fight in art is not between art and non-art, but between true and false art, between pure art and action-assemblage art, between abstract and surrealist-expressionist anti-art, between free art and servile art. Abstract art has its own integrity, not someone else's 'integration' with something else. Any combining, mixing, adding, diluting, exploiting, vulgarizing, or popularizing abstract art deprives

art of its essence and depraves the artist's artistic consciousness. Art is free, but it is not a free-for-all.

The one struggle in art is the struggle of artists against artists, of artist against artist, of the artist-as-artist within and against the artist-as-man, -animal, or -vegetable. Artists who claim their artwork comes from nature, life, reality, earth or heaven, as 'mirrors of the soul' or 'reflections of conditions' or 'instruments of the universe,' who cook up 'new images of man' – figures and 'nature-in-abstraction' – pictures, are subjectively and objectively rascals or rustics. The art of 'figuring' or 'picturing' is not a fine art. An artist who is lobbying as a 'creature of circumstances' or logrolling as a 'victim of fate' is not a fine master artist. No one ever forces an artist to be pure.

The one art that is abstract and pure enough to have the one problem and possibility, in our time and timelessness, of the 'one single grand original problem' is pure abstract painting. Abstract painting is not just another school or movement or style but the first truly unmannered and untrammeled and unentangled, styleless, universal painting. No other art or painting is detached or empty or immaterial enough.

The one history of painting progresses from the painting of a variety of ideas with a variety of subjects and objects, to one idea with a variety of subjects and objects, to one subject with a variety of objects, to one object with a variety of subjects, then to one object with one subject, to one object with no subject, and to one subject with no object, then to the idea of no object and no subject and no variety at all. There is nothing less significant in art, nothing more exhausting and immediately exhausted, than 'endless variety.'

The one evolution of art forms unfolds in one straight logical line of negative actions and reactions, in one predestined, eternally recurrent stylistic cycle, in the same all-over pattern, in all times and places, taking different times in different places, always beginning with an 'early' archaic schematization, achieving a climax with a 'classic' formulation, and decaying with 'late' endless variety of illusionisms and expressionisms. When late stages wash away all lines of demarcation, framework, and fabric, with 'anything can be art,' 'anybody can be an artist,' 'that's life,' 'why fight it,' 'anything goes,' and 'it makes no difference whether art is abstract or representational,' the artists' world is a mannerist and primitivist art trade and suicide-vaudeville, venal, genial, contemptible, trifling.

The one way in art comes from art working and the more an artist works the more there is to do. Artists come from artists, art forms come from art forms, painting comes from painting. The one direction in fine or abstract art today is in the painting of the same one form over and over again. The one intensity and the one perfection come only from long and lonely routine preparation and attention and repetition. The one originality exists only where all artists work in the same tradition and master the same convention. The one freedom is realized only through the strictest art discipline and through the most similar studio ritual. Only a standardized, prescribed, and proscribed form can be imageless, only a stereotyped image can be formless, only a formularized art can be formulaless. A painter who does not know what or how or where to paint is not a fine artist.

The one work for a fine artist, the one painting, is the painting of the one-size canvas – the single scheme, one formal device, one color-monochrome, one linear division in each direction, one symmetry, one texture, one free-hand brushing, one rhythm, one working everything into one dissolution and one indivisibility, each

painting into one overall uniformity and non-irregularity. No lines or imaginings, no shapes or composings or representings, no visions or sensations or impulses, no symbols or signs or impastos, no decoratings or colorings or picturings, no pleasures or pains, no accidents or ready-mades, no things, no ideas, no relations, no attributes, no qualities – nothing that is not of the essence. Everything into irreducibility, unreproducibility, imperceptibility. Nothing 'usable,' 'manipulatable,' 'salable,' 'dealable,' 'collectible,' 'graspable.' No art as a commodity or a jobbery. Art is not the spiritual side of business.

The one standard in art is oneness and fineness, rightness and purity, abstractness and evanescence. The one thing to say about art is its breathlessness, lifelessness, deathlessness, contentlessness, formlessness, spacelessness, and timelessness. This is always the end of art.

5 Donald Judd (1928–1994) 'Specific Objects'

Judd's first one-man show was held at the Green Gallery in New York in 1964 after he had abandoned painting for work which took the form of reliefs and free-standing objects. This essay was first published the following year. It is noteworthy for its claim that the representative art of the modern is now neither painting nor sculpture but the virtual new medium of 'three-dimensional work'. On the question of the legacy of Abstract Expressionism, Judd thus stakes out a position in clear opposition to Greenberg's (as exemplified in VIB8). As a consequence of the forthrightness of his views and the consistently spare style of his work, Judd was identified as a leading figure in the form of apostate Modernism which came to be called Minimalism. This is an identification which Judd himself resisted, however. Despite the concentration of his own sculptural output on a quite restricted range of box-like forms, it is noteworthy that in this early formulation his conception of 'three-dimensional work' is exemplified by reference to a thoroughly heterogeneous range of examples. First published in *Arts Yearbook*, 8, New York, 1965, pp. 74–82; reprinted in Judd, *Complete Writings 1959–1975*, Halifax, Nova Scotia, 1975, from which the present text is taken.

Half or more of the best new work in the last few years has been neither painting nor sculpture. Usually it has been related, closely or distantly, to one or the other. The work is diverse, and much in it that is not in painting and sculpture is also diverse. But there are some things that occur nearly in common.

The new three-dimensional work doesn't constitute a movement, school or style. The common aspects are too general and too little common to define a movement. The differences are greater than the similarities. The similarities are selected from the work; they aren't a movement's first principles or delimiting rules. Three-dimensionality is not as near being simply a container as painting and sculpture have seemed to be, but it tends to that. But now painting and sculpture are less neutral, less containers, more defined, not undeniable and unavoidable. They are particular forms circumscribed after all, producing fairly definite qualities. Much of the motivation in the new work is to get clear of these forms. The use of three dimensions is an obvious alternative. It opens to anything. Many of the reasons for this use are negative, points against painting and sculpture, and since both are common sources, the negative reasons are those nearest common-age. 'The motive to change is always some uneasiness: nothing setting us upon the change of state, or upon any new action, but some uneasiness.' The positive reasons

are more particular. Another reason for listing the insufficiencies of painting and sculp-
ture first is that both are familiar and their elements and qualities more easily located.

The objections to painting and sculpture are going to sound more intolerant than
they are. There are qualifications. The disinterest in painting and sculpture is a
disinterest in doing it again, not in it as it is being done by those who developed the
last advanced versions. New work always involves objections to the old, but these
objections are really relevant only to the new. They are part of it. If the earlier work is
first-rate it is complete. New inconsistencies and limitations aren't retroactive; they
concern only work that is being developed. Obviously, three-dimensional work will not
cleanly succeed painting and sculpture. It's not like a movement: anyway, movements
no longer work: also, linear history has unraveled somewhat. The new work exceeds
painting in plain power, but power isn't the only consideration, though the difference
between it and expression can't be too great either. There are other ways than power
and form in which one kind of art can be more or less than another. Finally, a flat and
rectangular surface is too handy to give up. Some things can be done only on a flat
surface. Lichtenstein's representation of a representation is a good instance. But this
work which is neither painting nor sculpture challenges both. It will have to be taken
into account by new artists. It will probably change painting and sculpture.

The main thing wrong with painting is that it is a rectangular plane placed flat
against the wall. A rectangle is a shape itself; it is obviously the whole shape; it
determines and limits the arrangement of whatever is on or inside of it. In work before
1946 the edges of the rectangle are a boundary, the end of the picture. The composition
must react to the edges and the rectangle must be unified, but the shape of the rectangle
is not stressed; the parts are more important, and the relationships of color and form
occur among them. In the paintings of Pollock, Rothko, Still and Newman, and more
recently of Reinhardt and Noland, the rectangle is emphasized. The elements inside
the rectangle are broad and simple and correspond closely to the rectangle. The shapes
and surface are only those which can occur plausibly within and on a rectangular plane.
The parts are few and so subordinate to the unity as not to be parts in an ordinary
sense. A painting is nearly an entity, one thing, and not the indefinable sum of a group
of entities and references. The one thing overpowers the earlier painting. It also
establishes the rectangle as a definite form: it is no longer a fairly neutral limit. A
form can be used only in so many ways. The rectangular plane is given a life span. The
simplicity required to emphasize the rectangle limits the arrangements possible within
it. The sense of singleness also has a duration, but it is only beginning and has a better
future outside of painting. Its occurrence in painting now looks like a beginning, in
which new forms are often made from earlier schemes and materials.

The plane is also emphasized and nearly single. It is clearly a plane one or two inches
in front of another plane, the wall, and parallel to it. The relationship of the two planes
is specific; it is a form. Everything on or slightly in the plane of the painting must be
arranged laterally.

Almost all paintings are spatial in one way or another. Yves Klein's blue paintings
are the only ones that are unspatial, and there is little that is nearly unspatial, mainly
Stella's work. It's possible that not much can be done with both an upright rectangular
plane and an absence of space. Anything on a surface has space behind it. Two colors
on the same surface almost always lie on different depths. An even color, especially in
oil paint, covering all or much of a painting is almost always both flat and infinitely

spatial. The space is shallow in all of the work in which the rectangular plane is stressed. Rothko's space is shallow and the soft rectangles are parallel to the plane, but the space is almost traditionally illusionistic. In Reinhardt's paintings, just back from the plane of the canvas, there is a flat plane and this seems in turn indefinitely deep. Pollock's paint is obviously on the canvas, and the space is mainly that made by any marks on a surface, so that it is not very descriptive and illusionistic. Noland's concentric bands are not as specifically paint-on-a-surface as Pollock's paint, but the bands flatten the literal space more. As flat and unillusionistic as Noland's paintings are, the bands do advance and recede. Even a single circle will warp the surface to it, will have a little space behind it.

Except for a complete and unvaried field of color or marks, anything spaced in a rectangle and on a plane suggests something in and on something else, something in its surround, which suggests an object or figure in its space, in which these are clearer instances of a similar world – that's the main purpose of painting. The recent paintings aren't completely single. There are a few dominant areas, Rothko's rectangles or Noland's circles, and there is the area around them. There is a gap between the main forms, the most expressive parts, and the rest of the canvas, the plane and the rectangle. The central forms still occur in a wider and indefinite context, although the singleness of the paintings abridges the general and solipsistic quality of earlier work. Fields are also usually not limited, and they give the appearance of sections cut from something indefinitely larger.

Oil paint and canvas aren't as strong as commercial paints and as the colors and surfaces of materials, especially if the materials are used in three dimensions. Oil and canvas are familiar and, like the rectangular plane, have a certain quality and have limits. The quality is especially identified with art.

The new work obviously resembles sculpture more than it does painting, but it is nearer to painting. Most sculpture is like the painting which preceded Pollock, Rothko, Still and Newman. The newest thing about it is its broad scale. Its materials are somewhat more emphasized than before. The imagery involves a couple of salient resemblances to other visible things and a number of more oblique references, every-thing generalized to compatibility. The parts and the space are allusive, descriptive and somewhat naturalistic. [...]

Most sculpture is made part by part, by addition, composed. The main parts remain fairly discrete. They and the small parts are a collection of variations, slight through great. There are hierarchies of clarity and strength and of proximity to one or two main ideas. Wood and metal are the usual materials, either alone or together, and if together it is without much of a contrast. There is seldom any color. The middling contrast and the natural monochrome are general and help to unify the parts.

There is little of any of this in the new three-dimensional work. So far the most obvious difference within this diverse work is between that which is something of an object, a single thing, and that which is open and extended, more or less environmental. There isn't as great a difference in their nature as in their appearance, though. Old-enburg and others have done both. There are precedents for some of the characteristics of the new work. The parts are usually subordinate and not separate in Arp's sculpture and often in Brancusi's. Duchamp's ready-mades and other Dada objects are also seen at once and not part by part. Cornell's boxes have too many parts to seem at first to be structured. Part-by-part structure can't be too simple or too complicated. It has to seem

orderly. The degree of Arp's abstraction, the moderate extent of his reference to the human body, neither imitative nor very oblique, is unlike the imagery of most of the new three-dimensional work. Duchamp's bottle-drying rack is close to some of it. The work of Johns and Rauschenberg and assemblage and low-relief generally, Ortman's reliefs for example, are preliminaries. Johns's few cast objects and a few of Rauschenberg's works, such as the goat with the tire, are beginnings.

* * *

Stella's shaped paintings involve several important characteristics of three-dimensional work. The periphery of a piece and the lines inside correspond. The stripes are nowhere near being discrete parts. The surface is farther from the wall than usual, though it remains parallel to it. Since the surface is exceptionally unified and involves little or no space, the parallel plane is unusually distinct. The order is not rationalistic and underlying but is simply order, like that of continuity, one thing after another. A painting isn't an image. The shapes, the unity, projection, order and color are specific, aggressive and powerful.

Painting and sculpture have become set forms. A fair amount of their meaning isn't credible. The use of three dimensions isn't the use of a given form. There hasn't been enough time and work to see limits. So far, considered most widely, three dimensions are mostly a space to move into. The characteristics of three dimensions are those of only a small amount of work, little compared to painting and sculpture. A few of the more general aspects may persist, such as the work's being like an object or being specific, but other characteristics are bound to develop. Since its range is so wide, three-dimensional work will probably divide into a number of forms. At any rate, it will be larger than painting and much larger than sculpture, which, compared to painting, is fairly particular, much nearer to what is usually called a form, having a certain kind of form. Because the nature of three dimensions isn't set, given beforehand, something credible can be made, almost anything. Of course something can be done within a given form, such as painting, but with some narrowness and less strength and variation. Since sculpture isn't so general a form, it can probably be only what it is now – which means that if it changes a great deal it will be something else; so it is finished.

Three dimensions are real space. That gets rid of the problem of illusionism and of literal space, space in and around marks and colors – which is riddance of one of the salient and most objectionable relics of European art. The several limits of painting are no longer present. A work can be as powerful as it can be thought to be. Actual space is intrinsically more powerful and specific than paint on a flat surface. Obviously, anything in three dimensions can be any shape, regular or irregular, and can have any relation to the wall, floor, ceiling, room, rooms or exterior or none at all. Any material can be used, as is or painted.

A work needs only to be interesting. Most works finally have one quality. In earlier art the complexity was displayed and built the quality. In recent painting the complexity was in the format and the few main shapes, which had been made according to various interests and problems. A painting by Newman is finally no simpler than one by Cézanne. In the three-dimensional work the whole thing is made according to complex purposes, and these are not scattered but asserted by one form. It isn't necessary for a work to have a lot of things to look at, to compare, to analyze one by one, to contemplate. The thing as a whole, its quality as a whole, is what is interesting. The main things are alone and are more intense, clear and powerful. They are not

diluted by an inherited format, variations of a form, mild contrasts and connecting parts and areas. European art had to represent a space and its contents as well as have sufficient unity and aesthetic interest. Abstract painting before 1946 and most subsequent painting kept the representational subordination of the whole to its parts. Sculpture still does. In the new work the shape, image, color and surface are single and not partial and scattered. There aren't any neutral or moderate areas or parts, any connections or transitional areas. The difference between the new work and earlier painting and present sculpture is like that between one of Brunelleschi's windows in the Badia di Fiesole and the façade of the Palazzo Rucellai, which is only an undeveloped rectangle as a whole and is mainly a collection of highly ordered parts. [. . .]

6 Robert Morris (b. 1931) 'Notes on Sculpture 1–3'

Like Judd, Morris argues a claim to the Modernist inheritance in competition with the claims made by critics such as Greenberg and Fried on behalf of the abstract painting and sculpture of the 1960s. Although he begins by expanding the term 'sculpture' to cover a wider-than-normal range of avant-garde practices, he comes to adopt Judd's designation of them as 'three-dimensional work'. However, unlike Judd's his arguments were marked by an interest in gestalt theory and the European tradition of construction in art. His principal interests lie in the character of the sculptural object or situation as a determinant upon the spectator's experience, and, increasingly, in the exemplary character of forming techniques. Traditional Modernist theory tends implicitly or explicitly to distinguish the values of Modernism from the interests of scientific and technical modernization. To Morris, on the other hand, manufacture is an activity definitive of human existence; it follows that the use of industrial materials and processes should be seen as entirely *natural* to the modern artist. First published in three issues of *Artforum, New York*: vol. 4, no. 6, February 1966, pp. 42–4; vol. 5, no. 2, October 1966, pp. 20–3; vol. 5, no. 10, Summer 1967. Parts I and II were printed as conventional essays, from which the present versions are taken; part III as a series of nineteen isolated and non-sequential paragraphs, of which ten are reprinted here. (For 'Notes on Sculpture, Part 4' see VIIB4.)

Part I

> '*What comes into appearance must segregate in order to appear.*'
>
> Goethe

[. . .] In the interest of differences it seems time that some of the distinctions sculpture has managed for itself be articulated. To begin in the broadest possible way it should be stated that the concerns of sculpture have been for some time not only distinct from but hostile to those of painting. The clearer the nature of the values of sculpture becomes the stronger the opposition appears. Certainly the continuing realization of its nature has had nothing to do with any dialectical evolution that painting has enunciated for itself. The primary problematic concerns with which advanced painting has been occupied for about half a century have been structural. The structural element has been gradually revealed to be located within the nature of the literal qualities of the support. It has been a long dialogue with a limit. Sculpture, on the other hand, never having been involved with illusionism could not possibly have based the efforts of fifty years upon the rather pious, if somewhat contradictory, act of giving up this illusionism

and approaching the object. Save for replication, which is not to be confused with illusionism, the sculptural facts of space, light, and materials have always functioned concretely and literally. Its allusions or references have not been commensurate with the indicating sensibilities of painting. If painting has sought to approach the object, it has sought equally hard to dematerialize itself on the way. Clearer distinctions between sculpture's essentially tactile nature and the optical sensibilities involved in painting need to be made.

Tatlin was perhaps the first to free sculpture from representation and establish it as an autonomous form both by the kind of image, or rather non-image, he employed and by his literal use of materials. He, Rodchenko, and other Constructivists refuted Apollinaire's observation that 'a structure becomes architecture, and not sculpture, when its elements no longer have their justification in nature.' At least the earlier works of Tatlin and other Constructivists made references to neither the figure nor architecture. In subsequent years Gabo, and to a lesser extent Pevsner and Vantongerloo, perpetuated the Constructivist ideal of a non-imagistic sculpture that was independent of architecture. This autonomy was not sustained in the work of the greatest American sculptor, the late David Smith. Today there is a reassertion of the non-imagistic as an essential condition. [...]

[...] Mondrian went so far as to claim that 'Sensations are not transmissible, or rather, their purely qualitative properties are not transmissible. The same, however, does not apply to *relations* between sensations.... Consequently only *relations* between sensations can have an objective value...' This may be ambiguous in terms of perceptual facts but in terms of looking at art it is descriptive of the condition that obtains. It obtains because art objects have clearly divisible parts that set up the relationships. Such a condition suggests the alternative question: Could a work exist that has only one property? Obviously not, since nothing exists that has only one property. A single, pure sensation cannot be transmissible precisely because one perceives simultaneously more than one property as parts in any given situation: if color, then also dimension; if flatness, then texture, etc. However, certain forms do exist that, if they do not negate the numerous relative sensations of color to texture, scale to mass, etc., do not present clearly separated parts for these kinds of relations to be established in terms of shapes. Such are the simpler forms that create strong gestalt sensations. Their parts are bound together in such a way that they offer a maximum resistance to perceptual separation. In terms of solids, or forms applicable to sculpture, these gestalts are the simpler polyhedrons. [...] In the simpler regular polyhedrons, such as cubes and pyramids, one need not move around the object for the sense of the whole, the gestalt, to occur. One sees and immediately 'believes' that the pattern within one's mind corresponds to the existential fact of the object. Belief in this sense is both a kind of faith in spatial extension and a visualization of that extension. In other words, it is those aspects of apprehension that are not coexistent with the visual field but rather the result of the experience of the visual field. The more specific nature of this belief and how it is formed involve perceptual theories of 'constancy of shape,' 'tendencies toward simplicity,' kinesthetic clues, memory traces, and physiological factors regarding the nature of binocular parallax vision and the structure of the retina and brain. Neither the theories nor the experiences of gestalt effects relating to three-dimensional bodies are as simple and clear as they are for two-dimensions. But experience of solids establishes the fact that, as in flat forms, some configurations are dominated by wholeness, others tend

to separate into parts. This becomes clear if the other types of polyhedrons are considered. In the complex regular type there is a weakening of visualization as the number of sides increases. A sixty-four-sided figure is difficult to visualize, yet because of its regularity one senses the whole, even if seen from a single viewpoint. Simple irregular polyhedrons, such as beams, inclined planes, truncated pyramids, are relatively more easy to visualize and sense as wholes. The fact that some are less familiar than the regular geometric forms does not affect the formation of a gestalt. Rather, the irregularity becomes a particularizing quality. Complex irregular polyhedrons (for example, crystal formations) if they are complex and irregular enough can frustrate visualization almost completely, in which case it is difficult to maintain one is experiencing a gestalt. Complex irregular polyhedrons allow for divisibility of parts insofar as they create weak gestalts. They would seem to return one to the conditions of works that, in Mondrian's terms, transmit relations easily in that their parts separate. Complex regular polyhedrons are more ambiguous in this respect. The simpler regular and irregular ones maintain the maximum resistance to being confronted as objects with separate parts. They seem to fail to present lines of fracture by which they could divide for easy part-to-part relationships to be established. I term these simple regular and irregular polyhedrons 'unitary' forms. Sculpture involving unitary forms, being bound together as it is with a kind of energy provided by the gestalt, often elicits the complaint among critics that such works are beyond analysis.

Characteristic of a gestalt is that once it is established all the information about it, *qua* gestalt, is exhausted. (One does not, for example, seek the gestalt of a gestalt.) Furthermore, once it is established it does not disintegrate. One is then both free of the shape and bound to it. Free or released because of the exhaustion of information about it, as shape, and bound to it because it remains constant and indivisible.

Simplicity of shape does not necessarily equate with simplicity of experience. Unitary forms do not reduce relationships. They order them. If the predominant, hieratic nature of the unitary form functions as a constant, all those particularizing relations of scale, proportion, etc., are not thereby canceled. Rather they are bound more cohesively and indivisibly together. The magnification of this single most important sculptural value – shape – together with greater unification and integration of every other essential sculptural value makes, on the one hand, the multipart, inflected formats of past sculpture extraneous, and on the other, establishes both a new limit and a new freedom for sculpture.

Part II

Q: Why didn't you make it larger so that it would loom over the observer?
A: I was not making a monument.
Q: Then why didn't you make it smaller so that the observer could see over the top?
A: I was not making an object.
– Tony Smith's replies to questions about his six-foot steel cube.

The size range of useless three-dimensional things is a continuum between the monument and the ornament. Sculpture has generally been thought of as those objects not at the polarities but falling between. The new work being done today falls between the extremes of this size continuum. Because much of it presents an image of neither

figurative nor architectonic reference, the works have been described as 'structures' or 'objects.' The word *structure* applies either to anything or to how a thing is put together. Every rigid body is an object. A particular term for the new work is not as important as knowing what its values and standards are.

In the perception of relative size the human body enters into the total continuum of sizes and establishes itself as a constant on that scale. One knows immediately what is smaller and what is larger than himself. It is obvious, yet important, to take note of the fact that things smaller than ourselves are seen differently than things larger. The quality of intimacy is attached to an object in a fairly direct proportion as its size diminishes in relation to oneself. The quality of publicness is attached in proportion as the size increases in relation to oneself. This holds true so long as one is regarding the whole of a large thing and not a part. The qualities of publicness or privateness are imposed on things. This is because of our experience in dealing with objects that move away from the constant of our own size in increasing or decreasing dimension. Most ornaments from the past, Egyptian glassware, Romanesque ivories, etc., consciously exploit the intimate mode by highly resolved surface incident. The awareness that surface incident is always attended to in small objects allows for the elaboration of fine detail to sustain itself. Large sculptures from the past that exist now only in small fragments invite our vision to perform a kind of magnification (sometimes literally performed by the photograph) that gives surface variation on these fragments the quality of detail it never had in the original whole work. The intimate mode is essentially closed, spaceless, compressed, and exclusive.

While specific size is a condition that structures one's response in terms of the more or less public or intimate, enormous objects in the class of monuments elicit a far more specific response to size *qua* size. That is, besides providing the condition for a set of responses, large-sized objects exhibit size more specifically as an element. It is the more conscious appraisal of size in monuments that makes for the quality of 'scale.' The awareness of scale is a function of the comparison made between that constant, one's body size, and the object. Space between the subject and the object is implied in such a comparison. In this sense space does not exist for intimate objects. A larger object includes more of the space around itself than does a smaller one. It is necessary literally to keep one's distance from large objects in order to take the whole of any one view into one's field of vision. The smaller the object the closer one approaches it and, therefore, it has correspondingly less of a spatial field in which to exist for the viewer. It is this necessary greater distance of the objects in space from our bodies, in order that it be seen at all, that structures the non-personal or public mode. However, it is just this distance between object and subject that creates a more extended situation, for physical participation becomes necessary. Just as there is no exclusion of literal space in large objects, neither is there an exclusion of the existing light.

Things on the monumental scale, then, include more terms necessary for their apprehension than objects smaller than the body, namely, the literal space in which they exist and the kinesthetic demands placed upon the body.

A simple form like a cube will necessarily be seen in a more public way as its size increases from that of our own. It accelerates the valence of intimacy as its size decreases from that of one's own body. This is true even if the surface, material, and color are held constant. In fact it is just these properties of surface, color, material, that get magnified into details as size is reduced. Properties that are not read as detail in large works become

detail in small works. Structural divisions in work of any size are another form of detail. [. . .] There is an assumption here of different kinds of things becoming equivalent. The term 'detail' is used here in a special and negative sense and should be understood to refer to all factors in a work that pull it toward intimacy by allowing specific elements to separate from the whole, thus setting up relationships within the work. Objections to the emphasis on color as a medium foreign to the physicality of sculpture have also been raised previously, but in terms of its function as a detail a further objection can be raised. That is, intense color, being a specific element, detaches itself from the whole of the work to become one more internal relationship. The same can be said of emphasis on specific, sensuous material or impressively high finishes. A certain number of these intimacy-producing relations have been gotten rid of in the new sculpture. Such things as process showing through traces of the artist's hand have obviously been done away with. But one of the worst and most pretentious of these intimacy-making situations in some of the new work is the scientistic element that shows up generally in the application of mathematical or engineering concerns to generate or inflect images. This may have worked brilliantly for Jasper Johns (and he is the prototype for this kind of thinking) in his number and alphabet paintings, in which the exhaustion of a logical system closes out and ends the image and produces the picture. But appeals to binary mathematics, tensegrity techniques, mathematically derived modules, progressions, etc., within a work are only another application of the Cubist aesthetic of having reasonableness or logic for the relating parts. The better new work takes relationships out of the work and makes them a function of space, light, and the viewer's field of vision. The object is but one of the terms in the newer aesthetic. It is in some way more reflexive because one's awareness of oneself existing in the same space as the work is stronger than in previous work, with its many internal relationships. One is more aware than before that he himself is establishing relationships as he apprehends the object from various positions and under varying conditions of light and spatial context. Every internal relationship, whether it be set up by a structural division, a rich surface, or what have you, reduces the public, external quality of the object and tends to eliminate the viewer to the degree that these details pull him into an intimate relation with the work and out of the space in which the object exists.

* * *

While the work must be autonomous in the sense of being a self-contained unit for the formation of the gestalt, the indivisible and undissolvable whole, the major aesthetic terms are not in but dependent upon this autonomous object and exist as unfixed variables that find their specific definition in the particular space and light and physical viewpoint of the spectator. Only one aspect of the work is immediate: the apprehension of the gestalt. The experience of the work necessarily exists in time. *The intention is diametrically opposed to Cubism with its concern for simultaneous views in one plane.* Some of the new work has expanded the terms of sculpture by a more emphatic focusing on the very conditions under which certain kinds of objects are seen. The object itself is carefully placed in these new conditions to be but one of the terms. The sensuous object, resplendent with compressed internal relations, has had to be rejected. That many considerations must be taken into account in order that the work keep its place as a term in the expanded situation hardly indicates a lack of interest in the object itself. But the concerns now are for more control of and/or cooperation of the entire situation. Control is necessary if the variables of object, light, space, body, are to

function. The object itself has not become less important. It has merely become less *self* important. [...]

* * *

Part III Notes and Nonsequiturs

Structures. Such work is often related to other focuses but further, or more strongly, emphasizes its 'reasons' for parts, inflections, or other variables. The didacticism of projected systems or added information beyond the physical existence of the work is either explicit or implicit. Sets, series, modules, permutations or other simple systems are often made use of. Such work often transcends its didacticism to become rigorous. Sometimes there is a puritanical scepticism of the physical in it. The lesser work is often stark and austere, rationalistic and insecure.

The trouble with painting is not its inescapable illusionism *per se*. But this inherent illusionism brings with it a non-actual elusiveness or indeterminate allusiveness. The mode has become antique. Specifically, what is antique about it is the divisiveness of experience which marks on a flat surface elicit. There are obvious cultural and historical reasons why this happens. For a long while the duality of thing and allusion sustained itself under the force of profuse organizational innovations within the work itself. But it has worn thin and its premises cease to convince. Duality of experience is not direct enough. That which has ambiguity built into it is not acceptable to an empirical and pragmatic outlook. That the mode itself – rather than lagging quality – is in default seems to be shown by the fact that some of the best painting today does not bother to emphasize actuality or literalness through shaping of the support.

It is not in the uses of new, exotic materials that the present work differs much from past work. It is not even in the non-hierarchic, non-compositional structuring, since this was clearly worked out in painting. The difference lies in the kind of order which underlies the forming of this work. This order is not based on previous art orders, but is an order so basic to the culture that its obviousness makes it nearly invisible. The new three-dimensional work has grasped the cultural infrastructure of forming itself which has been in use, and developing, since Neolithic times and culminates in the technology of industrial production.

There is some justification for lumping together the various focuses and intentions of the new three-dimensional work. Morphologically there are common elements: symmetry, lack of traces of process, abstractness, non-hierarchic distribution of parts, non-anthropomorphic orientations, general wholeness. These constants probably provide the basis for a general imagery. The imagery involved is referential in a broad and special way: it does not refer to past sculptural form. Its referential connections are to manufactured objects and not to previous art. In this respect the work has affinities with Pop art. But the abstract work connects to a different level of the culture.

Much work is made outside the studio. Specialized factories and shops are used – much the same as sculpture has always utilized special craftsmen and processes. The shop methods of forming generally used are simple if compared to the techniques of advanced

industrial forming. At this point the relation to machine-type production lies more in the uses of materials than in methods of forming. That is, industrial and structural materials are often used in their more or less naked state, but the methods of forming employed are more related to assisted hand craftsmanship. Metalwork is usually bent, cut, welded. Plastic is just beginning to be explored for its structural possibilities; often it functions as surfacing over conventional supporting materials. Contact molding of reinforced plastics, while expensive, is becoming an available forming method which offers great range for direct structural uses of the material. Vacuum forming is the most accessible method for forming complex shapes from sheeting. It is still expensive. Thermoforming the better plastics – and the comparable method for metal, matched die stamping – is still beyond the means of most artists. Mostly the so-called industrial processes employed are at low levels of sophistication. This affects the image in that the most accessible types of forming lend themselves to the planar and the linear.

The most obvious unit, if not the paradigm, of forming up to this point is the cube or rectangular block. This, together with the right angle grid as method of distribution and placement, offers a kind of 'morpheme' and 'syntax' which are central to the cultural premise of forming. There are many things which have come together to contribute to making rectangular objects and right angle placement the most useful means of forming. The mechanics of production is one factor: from the manufacture of mud bricks to metallurgical processes involving continuous flow of raw material which gets segmented, stacked, and shipped. The further uses of these 'pieces' from continuous forms such as sheets to fabricate finished articles encourage maintenance of rectangularity to eliminate waste.

Tracing forming from continuous stock to units is one side of the picture. Building up larger wholes from initial bits is another. The unit with the fewest sides which inherently orients itself to both plumb and level and also close packs with its members is the cubic or brick form. There is good reason why it has survived to become the 'morpheme' of so many manufactured things. It also presents perhaps the simplest ordering of part to whole. Rectangular groupings of any number imply potential extension; they do not seem to imply incompletion, no matter how few their number or whether they are distributed as discrete units in space or placed in physical contact with each other. In the latter case the larger whole which is formed tends to be morphologically the same as the units from which it is built up. From one to many the whole is preserved so long as a grid-type ordering is used. Besides these aspects of manipulation, there are a couple of constant conditions under which this type of forming and distributing exists: a rigid base land mass and gravity. Without these two terms stability and the clear orientation of horizontal and vertical might not be so relevant. Under different conditions other systems of physical ordering might occur. Further work in space, as well as deep ocean stations, may alter this most familiar approach to the shaping and placing of things as well as the orientation of oneself with respect to space and objects.

Such work which has the feel and look of openness, extendibility, accessibility, publicness, repeatability, equanimity, directness, immediacy, and has been formed by clear decision rather than groping craft would seem to have a few social implications, none of

which are negative. Such work would undoubtedly be boring to those who long for access to an exclusive specialness, the experience of which reassures their superior perception.

The rectangular unit and grid as a method of physical extension are also the most inert and least organic. For the structural forms now needed in architecture and demanded by high speed travel the form is obviously obsolete. The more efficient compression-tension principles generally involve the organic form of the compound curve. In some way this form indicates its high efficiency – i.e., the 'work' involved in the design of stressed forms is somehow projected. The compound curve works, whereas planar surfaces – both flat and round – do not give an indication of special strength through design. Surfaces under tension are anthropomorphic: they are under the stresses of work much as the body is in standing. Objects which do not project tensions state most clearly their separateness from the human. They are more clearly objects. It is not the cube itself which exclusively fulfills this role of independent object – it is only the form that most obviously does it well. Other regular forms which invariably involve the right angle at some point function with equal independence. The way these forms are oriented in space is, of course, equally critical in the maintenance of their independence. The visibility of the principles of structural efficiency can be a factor which destroys the object's independence. This visibility impinges on the autonomous quality and alludes to performance of service beyond the existence of the object. What the new art has obviously not taken from industry is this teleological focus which makes tools and structures invariably simple. Neither does it wish to imitate an industrial 'look.' This is trivial. What has been grasped is the reasonableness of certain forms which have been in use for so long.

New conditions under which things must exist are already here. So are the vastly extended controls of energy and information and new materials for forming. The possibilities for future forming throw into sharp relief present forms and how they have functioned. In grasping and using the nature of made things the new three-dimensional art has broken the tedious ring of 'artiness' circumscribing each new phase of art since the Renaissance. It is still art. Anything that is used as art must be defined as art. The new work continues the convention but refuses the heritage of still another art-based order of making things. The intentions are different, the results are different, so is the experience.

7 Michael Fried (b. 1939) 'Art and Objecthood'

This was Fried's riposte to the claims of Judd and Morris, whom he designates as 'literalists'. Attacking what he identifies as a corrupted sensibility, Fried reiterates the 'abstractionist' account of Modernism and of its distinguishing characteristics and virtues. In Fried's view it is a symptom of the decadence of literalist art that it theatricalizes the relation between object and beholder, whereas the experience of authentic Modernist art involves the suspension both of objecthood and of the sense of duration. First published in *Artforum*, Summer 1967, from which the present text is drawn. This special issue devoted to 'American Sculpture' also included the third of Morris's 'Notes on Sculpture' (see VIIA6),

LeWitt's 'Paragraphs on Conceptual Art' (VIIA8) and an essay by Robert Smithson on 'The Development of an Air Terminal Site'. Publication of Fried's essay did much to dramatize a bifurcation within the Modernist tradition, and to make clear how deep the roots of this division lay within the conflicting philosophical commitments of Idealism and Materialism.

> Edwards's journals frequently explored and tested a meditation he seldom allowed to reach print; if all the world were annihilated, he wrote...and a new world were freshly created, though it were to exist in every particular in the same manner as this world, it would not be the same. Therefore, because there is continuity, which is time, 'it is certain with me that the world exists anew every moment; that the existence of things every moment ceases and is every moment renewed.' The abiding assurance is that 'we every moment see the same proof of a God as we should have seen if we had seen Him create the world at first.'
>
> Perry Miller, *Jonathan Edwards*

I

The enterprise known variously as Minimal Art, ABC Art, Primary Structures, and Specific Objects is largely ideological. It seeks to declare and occupy a position – one that can be formulated in words, and in fact has been formulated by some of its leading practitioners. If this distinguishes it from modernist painting and sculpture on the one hand, it also marks an important difference between Minimal Art – or, as I prefer to call it, *literalist* art – and Pop or Op Art on the other. From its inception, literalist art has amounted to something more than an episode in the history of taste. It belongs rather to the history – almost the *natural* history – of sensibility; and it is not an isolated episode but the expression of a general and pervasive condition. Its seriousness is vouched for by the fact that it is in relation both to modernist painting and modernist sculpture that literalist art defines or locates the position it aspires to occupy. (This, I suggest, is what makes what it declares something that deserves to be called a position.) Specifically, literalist art conceives of itself as neither one nor the other; on the contrary, it is motivated by specific reservations, or worse, about both; and it aspires, perhaps not exactly, or not immediately, to displace them, but in any case to establish itself as an independent art on a footing with either.

The literalist case against painting rests mainly on two counts: the relational character of almost all painting; and the ubiquitousness, indeed the virtual inescapability, of pictorial illusion. In Donald Judd's view,

> when you start relating parts, in the first place, you're assuming you have a vague whole – the rectangle of the canvas – and definite parts, which is all screwed up, because you should have a definite *whole* and maybe no parts, or very few.[1]

The more the shape of the support is emphasized, as in recent modernist painting, the tighter the situation becomes. [...] Painting is here seen as an art on the verge of exhaustion, one in which the range of acceptable solutions to a basic problem – how to organize the surface of the picture – is severely restricted. The use of shaped rather than rectangular supports can, from the literalist point of view, merely prolong the agony. The obvious response is to give up working on a single plane in favor of three dimensions. [...]

The literalist attitude toward sculpture is more ambiguous. Judd, for example, seems to think of what he calls Specific Objects as something other than sculpture, while Robert Morris conceives of his own unmistakably literalist work as resuming the lapsed tradition of Constructivist sculpture established by Tatlin, Rodchenko, Gabo, Pevsner, and Vantongerloo. But this and other disagreements are less important than the views Judd and Morris hold in common. Above all they are opposed to sculpture that, like most painting, is 'made part by part, by addition, composed' and in which 'specific elements...separate from the whole, thus setting up relationships within the work.' (They would include the work of David Smith and Anthony Caro under this description.) It is worth remarking that the 'part-by-part' and 'relational' character of most sculpture is associated by Judd with what he calls *anthropomorphism*: 'A beam thrusts; a piece of iron follows a gesture; together they form a naturalistic and anthropomorphic image. The space corresponds.' Against such 'multipart, inflected' sculpture Judd and Morris assert the values of wholeness, singleness, and indivisibility – of a work's being, as nearly as possible, 'one thing,' a single 'Specific Object.' [...] For both Judd and Morris...the critical factor is *shape*. Morris's 'unitary forms' are polyhedrons that resist being grasped other than as a single shape: the gestalt simply *is* the 'constant, known shape.' And shape itself is, in his system, 'the most important sculptural value.' Similarly, speaking of his own work, Judd has remarked that

> the big problem is that anything that is not absolutely plain begins to have parts in some way. The thing is to be able to work and do different things and yet not break up the wholeness that a piece has. To me the piece with the brass and the five verticals is above all *that shape*.

The shape is the object: at any rate, what secures the wholeness of the object is the singleness of the shape. It is, I believe, this emphasis on shape that accounts for the impression, which numerous critics have mentioned, that Judd's and Morris's pieces are *hollow*.

II

Shape has also been central to the most important painting of the past several years. In several recent essays I have tried to show how, in the work of Noland, Olitski, and Stella, a conflict has gradually emerged between shape as a fundamental property of objects and shape as a medium of painting. Roughly, the success or failure of a given painting has come to depend on its ability to hold or stamp itself out or compel conviction as shape – that, or somehow to stave off or elude the question of whether or not it does so. Olitski's early spray paintings are the purest example of paintings that either hold or fail to hold as shapes; while in his more recent pictures, as well as in the best of Noland's and Stella's recent work, the demand that a given picture hold as shape is staved off or eluded in various ways. What is at stake in this conflict is whether the paintings or objects in question are experienced as paintings or as objects: and what decides their identity as *painting* is their confronting of the demand that they hold as shapes. Otherwise they are experienced as nothing more than objects. This can be summed up by saying that modernist painting has come to find it imperative that it defeat or suspend its own objecthood, and that the crucial factor in this

undertaking is shape, but shape that must belong to *painting* – it must be pictorial, not, or not merely, literal. Whereas literalist art stakes everything on shape as a given property of objects, if not, indeed, as a kind of object in its own right. It aspires, not to defeat or suspend its own objecthood, but on the contrary to discover and project objecthood as such.

In his essay 'Recentness of Sculpture' Clement Greenberg discusses the effect of presence, which, from the start, has been associated with literalist work.[2] [...]

Presence can be conferred by size or by the look of non-art. Furthermore, what non-art means today, and has meant for several years, is fairly specific. In 'After Abstract Expressionism' Greenberg wrote that 'a stretched or tacked-up canvas already exists as a picture – though not necessarily as a *successful* one.'[3] For that reason, as he remarks in 'Recentness of Sculpture,' the 'look of non-art was no longer available to painting.' Instead, 'the borderline between art and non-art had to be sought in the three-dimensional, where sculpture was, and where everything material that was not art also was.' Greenberg goes on to say:

> The look of machinery is shunned now because it does not go far enough towards the look of non-art, which is presumably an 'inert' look that offers the eye a minimum of 'interesting' incident – unlike the machine look, which is arty by comparison (and when I think of Tinguely I would agree with this). Still, no matter how simple the object may be, there remain the relations and interrelations of surface, contour, and spatial interval. Minimal works are readable as art, as almost anything is today – including a door, a table, or a blank sheet of paper.... Yet it would seem that a kind of art nearer the condition of non-art could not be envisaged or ideated at this moment.

The meaning in this context of 'the condition of non-art' is what I have been calling objecthood. It is as though objecthood alone can, in the present circumstances, secure something's identity, if not as non-art, at least as neither painting nor sculpture; or as though a work of art – more accurately, a work of modernist painting or sculpture – were in some essential respect *not an object*.

There is, in any case, a sharp contrast between the literalist espousal of objecthood – almost, it seems, as an art in its own right – and modernist painting's self-imposed imperative that it defeat or suspend its own objecthood through the medium of shape. In fact, from the perspective of recent modernist painting, the literalist position evinces a sensibility not simply alien but antithetical to its own: as though, from that perspective, the demands of art and the conditions of objecthood are in direct conflict.

Here the question arises: What is it about objecthood as projected and hypostatized by the literalists that makes it, if only from the perspective of recent modernist painting, antithetical to art?

III

The answer I want to propose is this: the literalist espousal of objecthood amounts to nothing other than a plea for a new genre of theatre; and theatre is now the negation of art.

Literalist sensibility is theatrical because, to begin with, it is concerned with the actual circumstances in which the beholder encounters literalist work. Morris makes this explicit. Whereas in previous art 'what is to be had from the work is located strictly

within [it],' the experience of literalist art is of an object *in a situation* – one that, virtually by definition, *includes the beholder*. [...]

Morris believes that this awareness is heightened by 'the strength of the constant, known shape, the gestalt,' against which the appearance of the piece from different points of view is constantly being compared. It is intensified also by the large scale of much literalist work [...] The larger the object the more we are forced to keep our distance from it:

> It is this necessary, greater distance of the object in space from our bodies, in order that it be seen at all, that structures the nonpersonal or public mode [which Morris advocates]. However, it is just this distance between object and subject that creates a more extended situation, because physical participation becomes necessary.

The theatricality of Morris's notion of the 'nonpersonal or public mode' seems obvious: the largeness of the piece, in conjunction with its nonrelational, unitary character, *distances* the beholder – not just physically but psychically. It is, one might say, precisely this distancing that *makes* the beholder a subject and the piece in question ...an object. But it does not follow that the larger the piece the more securely its 'public' character is established; on the contrary, 'beyond a certain size the object can overwhelm and the gigantic scale becomes the loaded term.' Morris wants to achieve presence through objecthood, which requires a certain largeness of scale, rather than through size alone [...] ...the things that are literalist works of art must somehow *confront* the beholder – they must, one might almost say, be placed not just in his space but in his way. None of this, Morris maintains,

> indicates a lack of interest in the object itself. But the concerns now are for more control of... the entire situation. Control is necessary if the variables of object, light, space, body, are to function. The object has not become less important. It has merely become less self-important.

It is, I think, worth remarking that 'the entire situation' means exactly that: *all* of it – including, it seems, the beholder's *body*. There is nothing within his field of vision – nothing that he takes note of in any way – that, as it were, declares its irrelevance to the situation, and therefore to the experience, in question. On the contrary, for something to be perceived at all is for it to be perceived as part of that situation. Everything counts – not as part of the object, but as part of the situation in which its objecthood is established and on which that objecthood at least partly depends.

IV

Furthermore, the presence of literalist art, which Greenberg was the first to analyze, is basically a theatrical effect or quality – a kind of *stage* presence. It is a function, not just of the obtrusiveness and, often, even aggressiveness of literalist work, but of the special complicity that that work extorts from the beholder. Something is said to have presence when it demands that the beholder take it into account, that he take it *seriously* – and when the fulfillment of that demand consists simply in being *aware* of it and, so to speak, in acting accordingly. (Certain modes of seriousness are closed to the beholder by the work itself, i.e., those established by the finest painting and sculpture of the recent past.

But, of course, *those* are hardly modes of seriousness in which most people feel at home, or that they even find tolerable.) Here again the experience of being distanced by the work in question seems crucial: the beholder knows himself to stand in an indeterminate, open-ended – and unexacting – relation *as subject* to the impassive object on the wall or floor. In fact, being distanced by such objects is not, I suggest, entirely unlike being distanced, or crowded, by the silent presence of another *person*; the experience of coming upon literalist objects unexpectedly – for example, in somewhat darkened rooms – can be strongly, if momentarily, disquieting in just this way.

There are three main reasons why this is so. First, the size of much literalist work, as Morris's remarks imply, compares fairly closely with that of the human body. [...] Second, the entities or beings encountered in everyday experience in terms that most closely approach the literalist ideals of the nonrelational, the unitary and the wholistic are *other persons*. Similarly, the literalist predilection for symmetry, and in general for a kind of order that 'is simply order ... one thing after another,' is rooted, not, as Judd seems to believe, in new philosophical and scientific principles, whatever he takes these to be, but in *nature*. And third, the apparent hollowness of most literalist work – the quality of having an *inside* – is almost blatantly anthropomorphic. [...]

V

I am suggesting, then, that a kind of latent or hidden naturalism, indeed anthropomorphism, lies at the core of literalist theory and practice. The concept of presence all but says as much, though rarely so nakedly as in Tony Smith's statement, 'I didn't think of them [i.e., the sculptures he "always" made] as sculptures but as presences of a sort.' The latency or hiddenness of the anthropomorphism has been such that the literalists themselves have, as we have seen, felt free to characterize the modernist art they *oppose*, e.g., the sculpture of David Smith and Anthony Caro, as anthropomorphic – a characterization whose teeth, imaginary to begin with, have just been pulled. By the same token, however, what is wrong with literalist work is not that it is anthropomorphic but that the meaning and, equally, the hiddenness of its anthropomorphism are incurably theatrical. [...] *The crucial distinction that I am proposing so far is between work that is fundamentally theatrical and work that is not.* It is theatricality that, whatever the differences between them, links artists like Bladen and Grosvenor, both of whom have allowed 'gigantic scale [to become] the loaded term' (Morris), with other, more restrained figures like Judd, Morris, Andre, McCracken, LeWitt and – despite the *size* of some of his pieces – Tony Smith.[4] And it is in the interest, though not explicitly in the *name*, of theatre that literalist ideology rejects both modernist painting and, at least in the hands of its most distinguished recent practitioners, modernist sculpture.

In this connection Tony Smith's description of a car ride taken at night on the New Jersey Turnpike before it was finished makes compelling reading [see VIA22] [...] What seems to have been revealed to Smith that night was the pictorial nature of painting – even, one might say, the conventional nature of art. And *this* Smith seems to have understood not as laying bare the essence of art, but as announcing its end. In comparison with the unmarked, unlit, all but unstructured turnpike – more precisely, with the turnpike as experienced from within the car, traveling on it – art appears to have struck Smith as almost absurdly small ('All art today is an art of postage stamps,' he has said), circumscribed, conventional. . . . There was, he seems to have felt, no way

to 'frame' his experience on the road, that is, no way to make sense of it in terms of art, to make *art* of it at least as art then was. Rather, 'you just have to experience it' – as it *happens*, as it merely *is*. (The experience *alone* is what matters.) There is no suggestion that this is problematic in any way. The experience is clearly regarded by Smith as wholly accessible to everyone, not just in principle but in fact, and the question of whether or not one has really *had* it does not arise. [. . .]

. . . What *was* Smith's experience on the turnpike? Or to put the same question another way, if the turnpike, airstrips, and drill ground are not works of art, what *are* they? – What, indeed, if not empty, or 'abandoned', *situations?* And what was Smith's experience if not the experience of what I have been calling *theatre?* It is as though the turnpike, airstrips, and drill ground reveal the theatrical character of literalist art, only without the object, that is, *without the art itself* – as though the object is needed only within a *room* (or, perhaps, in any circumstances less extreme than these). In each of the above cases the object is, so to speak, *replaced* by something: for example, on the turnpike by the constant onrush of the road, the simultaneous recession of new reaches of dark pavement illumined by the onrushing headlights, the sense of the turnpike itself as something enormous, abandoned, derelict, existing for Smith alone and for those in the car with him. . . . This last point is important. On the one hand, the turnpike, airstrips, and drill ground belong to no one; on the other, the situation established by Smith's presence is in each case felt by him to be *his*. Moreover, in each case being able to go on and on indefinitely is of the essence. What replaces the object – what does the same job of distancing or isolating the beholder, of making him a subject, that the object did in the closed room – is above all the endlessness, or objectlessness, of the approach or on-rush or perspective. It is the explicitness, that is to say, the sheer persistence, with which the experience presents itself as directed at him from outside (on the turnpike from outside the *car*) that simultaneously makes him a subject – makes him subject – and establishes the experience itself as something like that of an object, or rather, of objecthood. [. . .]

VI

Smith's account of his experience on the turnpike bears witness to theatre's profound hostility to the arts, and discloses, precisely in the absence of the object and in what takes its place, what might be called the theatricality of objecthood. By the same token, however, the imperative that modernist painting defeat or suspend its objecthood is at bottom the imperative that it *defeat or suspend theatre*. And *this* means that there is a war going on between theatre and modernist painting, between the theatrical and the pictorial – a war that, despite the literalists' explicit rejection of modernist painting and sculpture, is not basically a matter of program and ideology but of experience, conviction, sensibility. [. . .]

The starkness and apparent irreconcilability of this conflict is something new. I remarked earlier that objecthood has become an issue for modernist painting only within the past several years. This, however, is not to say that *before* the present situation came into being, paintings, or sculptures for that matter, simply *were objects*. It would, I think, be closer to the truth to say that they *simply* were not. The risk, even the possibility, of seeing works of art as *nothing more* than objects did not exist. That this possibility began to present itself around 1960 was largely the result of develop-ments within modernist painting. Roughly, the more nearly assimilable to objects

certain advanced painting had come to seem, the more the entire history of painting since Manet could be understood – delusively, I believe – as consisting in the progressive (though ultimately inadequate) revelation of its essential objecthood,[5] and the more urgent became the need for modernist painting to make explicit its conventional – specifically, its *pictorial* – essence by defeating or suspending its own objecthood through the medium of shape. The view of modernist painting as tending toward objecthood is implicit in Judd's remark, 'The new [i.e., literalist] work obviously resembles sculpture more than it does painting, but it is nearer to painting'; and it is in this view that literalist sensibility in general is grounded. Literalist sensibility is, therefore, a response to the *same* developments that have largely compelled modernist painting to undo its objecthood – more precisely, the same developments *seen differently*, that is, in theatrical terms, by a sensibility *already* theatrical, already (to say the worst) corrupted or perverted by theatre. Similarly, what has compelled modernist painting to defeat or suspend its own objecthood is not just developments internal to itself, but the same general, enveloping, infectious theatricality that corrupted literalist sensibility in the first place and in the grip of which the developments in question – and modernist painting in general – are seen as nothing more than an uncompelling and presenceless kind of theatre. It was the need to break the fingers of this grip that made objecthood an issue for modernist painting.

Objecthood has also become an issue for modernist sculpture. This is true despite the fact that sculpture, being three-dimensional, resembles both ordinary objects and literalist work in a way that painting does not. Almost ten years ago Clement Greenberg summed up what he saw as the emergence of a new sculptural 'style,' whose master is undoubtedly David Smith, in the following terms:

> To render substance entirely optical, and form, whether pictorial, sculptural, or architectural, as an integral part of ambient space – this brings anti-illusionism full circle. Instead of the illusion of things, we are now offered the illusion of modalities: namely, that matter is incorporeal, weightless, and exists only optically like a mirage.[6]

Since 1960 this development has been carried to a succession of climaxes by the English sculptor Anthony Caro, whose work is far more *specifically* resistant to being seen in terms of objecthood than that of David Smith. A characteristic sculpture by Caro consists, I want to say, in the mutual and naked *juxtaposition* of the I-beams, girders, cylinders, lengths of piping, sheet metal, and grill that it comprises rather than in the compound *object* that they compose. The mutual inflection of one element by another, rather than the identity of each, is what is crucial – though of course altering the identity of any element would be at least as drastic as altering its placement. [...] The individual elements bestow significance on one another precisely by virtue of their juxtaposition: it is in this sense, a sense inextricably involved with the concept of meaning, that everything in Caro's art that is worth looking at is in its syntax. Caro's concentration upon syntax amounts, in Greenberg's view, to 'an emphasis on abstractness, on radical unlikeness to nature.'[7] And Greenberg goes on to remark, 'No other sculptor has gone as far from the structural logic of ordinary ponderable things.' It is worth emphasizing, however, that this is a function of more than the lowness, openness, part-by-partness, absence of enclosing profiles and centers of interest, unperspicuousness, etc., of Caro's sculptures. Rather they defeat, or allay, objecthood by

imitating, not gestures exactly, but the *efficacy* of gesture; like certain music and poetry, they are possessed by the knowledge of the human body and how, in innumerable ways and moods, it makes meaning. It is as though Caro's sculptures essentialize meaningfulness *as such* – as though the possibility of meaning what we say and do *alone* makes his sculpture possible. All this, it is hardly necessary to add, makes Caro's art a fountainhead of antiliteralist and antitheatrical sensibility. [. . .]

VII

At this point I want to make a claim that I cannot hope to prove or substantiate but that I believe nevertheless to be true: viz., that theatre and theatricality are at war today, not simply with modernist painting (or modernist painting and sculpture), but with art as such – and to the extent that the different arts can be described as modernist, with modernist sensibility as such. This claim can be broken down into three propositions or theses:

1 *The success, even the survival, of the arts has come increasingly to depend on their ability to defeat theatre.* This is perhaps nowhere more evident than within theatre itself, where the need to defeat what I have been calling theatre has chiefly made itself felt as the need to establish a drastically different relation to its audience. (The relevant texts are, of course, Brecht and Artaud.) For theatre *has* an audience – it *exists for* one – in a way the other arts do not; in fact, this more than anything else is what modernist sensibility finds intolerable in theatre generally. Here it should be remarked that literalist art, too, possesses an audience, though a somewhat special one: that the beholder is confronted by literalist work within a situation that he experiences as *his* means that there is an important sense in which the work in question exists for him *alone*, even if he is not actually alone with the work at the time. [. . .]

It is the overcoming of theatre that modernist sensibility finds most exalting and that it experiences as the hallmark of high art in our time. There is, however, one art that, by its very nature, *escapes* theatre entirely – the movies.[8] This helps explain why movies in general, including frankly appalling ones, are acceptable to modernist sensibility whereas all but the most successful painting, sculpture, music, and poetry is not. Because cinema escapes theatre – automatically, as it were – it provides a welcome and absorbing refuge to sensibilities at war with theatre and theatricality. At the same time, the automatic, guaranteed character of the refuge – more accurately, the fact that what is provided is a refuge from theatre and not a triumph over it, absorption not conviction – means that the cinema, even at its most experimental, is not a *modernist* art.

2 *Art degenerates as it approaches the condition of theatre.* Theatre is the common denominator that binds a large and seemingly disparate variety of activities to one another, and that distinguishes those activities from the radically different enterprises of the modernist arts. Here as elsewhere the question of value or level is central. For example, a failure to register the enormous difference in quality between, say, the music of Carter and that of Cage or between the paintings of Louis and those of Rauschenberg means that the real distinctions – between music and theatre in the first instance and between painting and theatre in the second – are displaced by the illusion that the barriers between the arts are in the process of crumbling (Cage and Rauschenberg being seen, correctly, as similar) and that the arts themselves are at last sliding

towards some kind of final, implosive, hugely desirable synthesis. Whereas in fact the individual arts have never been more explicitly concerned with the conventions that constitute their respective essences.

3 *The concepts of quality and value – and to the extent that these are central to art, the concept of art itself – are meaningful, or wholly meaningful, only within the individual arts. What lies* between *the arts is theatre.* It is, I think, significant that in their various statements the literalists have largely avoided the issue of value or quality at the same time as they have shown considerable uncertainty as to whether or not what they are making is art. To describe their enterprise as an attempt to establish a *new* art does not remove the uncertainty; at most it points to its source. Judd himself has as much as acknowledged the problematic character of the literalist enterprise by his claim, 'A work needs only to be interesting.' For Judd, as for literalist sensibility generally, all that matters is whether or not a given work is able to elicit and sustain (his) *interest.* Whereas within the modernist arts nothing short of *conviction* – specifically, the conviction that a particular painting or sculpture or poem or piece of music can or cannot support comparison with past work within that art whose quality is not in doubt – matters at all. (Literalist work is often condemned – when it is condemned – for being boring. A tougher charge would be that it is merely interesting.)

The interest of a given work resides, in Judd's view, both in its character as a whole and in the sheer *specificity* of the materials of which it is made [. . .] Like Judd's Specific Objects and Morris's gestalts or unitary forms, Smith's cube is *always* of further interest; one never feels that one has come to the end of it; it is inexhaustible. It is inexhaustible, however, not because of any fullness – *that* is the inexhaustibility of art – but because there is nothing there to exhaust. It is endless the way a road might be: if it were circular, for example.

Endlessness, being able to go on and on, even having to go on and on, is central both to the concept of interest and to that of objecthood. In fact, it seems to be the experience that most deeply excites literalist sensibility, and that literalist artists seek to objectify in their work – for example, by the repetition of identical units (Judd's 'one thing after another'), which carries the implication that the units in question could be multiplied *ad infinitum*. Smith's account of his experience on the unfinished turnpike records that excitement all but explicitly. [. . .]

Here finally I want to emphasize something that may already have become clear: the experience in question *persists in time*, and the presentment of endlessness that, I have been claiming, is central to literalist art and theory is essentially a presentment of endless, or indefinite, *duration*. Once again Smith's account of his night drive is relevant. . . Morris, too, has stated explicitly, 'The experience of the work necessarily exists in time' – though it would make no difference if he had not. The literalist preoccupation with time – more precisely, with the *duration of the experience* – is, I suggest, paradigmatically theatrical: as though theatre confronts the beholder, and thereby isolates him, with the endlessness not just of objecthood but of *time*; or as though the sense which, at bottom, theatre addresses is a sense of temporality, of time both passing and to come, *simultaneously approaching and receding*, as if apprehended in an infinite perspective. . .[9] This preoccupation marks a profound difference between literalist work and modernist painting and sculpture. It is as though one's experience of the latter *has* no duration – not because one *in fact* experiences a picture by Noland or

Olitski or a sculpture by David Smith or Caro in no time at all, but because *at every moment the work itself is wholly manifest*. [...] It is this continuous and entire present-ness, amounting, as it were, to the perpetual creation of itself, that one experiences as a kind of *instantaneousness*: as though if only one were infinitely more acute, a single infinitely brief instant would be long enough to see everything, to experience the work in all its depth and fullness, to be forever convinced by it. (Here it is worth noting that the concept of interest implies temporality in the form of continuing attention directed at the object, whereas the concept of conviction does not.) I want to claim that it is by virtue of their presentness and instantaneousness that modernist painting and sculpture defeat theatre. In fact, I am tempted far beyond my knowledge to suggest that, faced with the need to defeat theatre, it is above all to the condition of painting and sculpture – the condition, that is, of existing in, indeed of secreting or constituting, a continuous and perpetual *present* – that the other contemporary modernist arts, most notably poetry and music, aspire.

VIII

This essay will be read as an attack on certain artists (and critics) and as a defense of others. And of course it is true that the desire to distinguish between what is to me the authentic art of our time and other work, which, whatever the dedication, passion, and intelligence of its creators, seems to me to share certain characteristics associated here with the concepts of literalism and theatre, has largely motivated what I have written. In these last sentences, however, I want to call attention to the utter pervasiveness – the virtual universality – of the sensibility or mode of being that I have characterized as corrupted or perverted by theatre. We are all literalists most or all of our lives. Presentness is grace.

[1] This was said by Judd in an interview with Bruce Glaser, edited by Lucy R. Lippard and published as 'Questions to Stella and Judd,' *Art News*, LXV, no. 5, September 1966. The remarks attributed in the present essay to Judd and Morris have been taken from this interview, from Judd's essay 'Specific Objects,' *Arts Yearbook*, 8, 1965, or from Robert Morris's essays, 'Notes on Sculpture' and 'Notes on Sculpture, Part 2'... I should add that in laying out what seems to me the position Judd and Morris hold in common I have ignored various differences between them, and have used certain remarks in contexts for which they may not have been intended. [...]

[2] Published in the catalogue to the Los Angeles County Museum of Art's exhibition, 'American Sculpture of the Sixties.'

[3] [...] In its broad outline this is undoubtedly correct. There are, however, certain qualifications that can be made.

To begin with, it is not quite enough to say that a bare canvas tacked to a wall is not 'necessarily' a successful picture; it would, I think, be less of an exaggeration to say that it is not *conceivably* one. It may be countered that future circumstances might be such as to *make* it a successful painting; but I would argue that, for that to happen, the enterprise of painting would have to change so drastically that nothing more than the name would remain. (It would require a far greater change than that painting has undergone from Manet to Noland, Olitski, and Stella!) Moreover, seeing something as a painting in the sense that one sees the tacked-up canvas as a painting, and being convinced that a particular work can stand comparison with the painting of the past whose quality is not in doubt, are altogether different experiences: it is, I want to say, as though unless something compels conviction as to its quality it is no more than trivially or nominally a painting. This suggests that flatness and the delimitation of flatness ought not to be thought of as the 'irreducible essence of pictorial art' but rather as something like the *minimal conditions for something's being seen as a painting*; and that the crucial question is not what these minimal and, so to speak, timeless conditions are, but rather what, at a given moment, is capable of

compelling conviction, of succeeding as painting. This is not to say that painting *has no* essence; it *is* to claim that that essence – i.e., that which compels conviction – is largely determined by, and therefore changes continually in response to, the vital work of the recent past. The essence of painting is not something irreducible. Rather, the task of the modernist painter is to discover those conventions that, at a given moment, *alone* are capable of establishing his work's identity as painting.

[...] I would argue that what modernism has meant is that the two questions – What constitutes the art of painting? And what constitutes *good* painting? – are no longer separable; the first disappears, or increasingly tends to disappear, into the second. [...]

4 It is theatricality, too, that links all these artists to other figures as disparate as Kaprow, Cornell, Rauschenberg, Oldenburg, Flavin, Smithson, Kienholz, Segal, Samaras, Christo, Kusama...the list could go on indefinitely.

5 One way of describing this view might be to say that it draws something like a false inference from the fact that the increasingly explicit acknowledgment of the literal character of the support has been central to the development of modernist painting: namely, that literalness as such is an artistic value of supreme importance. [...]

6 'The New Sculpture,' *Art and Culture*, Boston, 1961, p. 144.

7 This and the following remark are taken from Greenberg's essay, 'Anthony Caro,' *Arts Yearbook*, 8, 1965. [...]

8 Exactly how the movies escape theatre is a beautiful question, and there is no doubt but that a phenomenology of the cinema that concentrated on the similarities and differences between it and the theatre – e.g., that in the movies the actors are not physically present, the film itself is projected *away* from us, the screen is not experienced as a kind of object existing, so to speak, in a specific physical relation to us, etc. – would be extremely rewarding. [...]

9 The connection between spatial recession and some such experience of temporality – almost as if the first were a kind of natural metaphor for the second – is present in much Surrealist painting (e.g., De Chirico, Dali, Tanguy, Magritte...). Moreover, temporality – manifested, for example, as expectation, dread, anxiety, presentiment, memory, nostalgia, stasis – is often the explicit subject of their paintings. There is, in fact, a deep affinity between literalists and Surrealist sensibility...Both employ imagery that is at once holistic and, in a sense, fragmentary, incomplete; both resort to a similar anthropomorphizing of objects or conglomerations of objects...both are capable of achieving remarkable effects of 'presence'; and both tend to deploy and isolate objects and persons in *situations* – the closed room and the abandoned artificial landscape are as important to Surrealism as to literalism.... This affinity can be summed up by saying that Surrealist sensibility, as manifested in the work of certain artists, and literalist sensibility are both *theatrical*. [...]

8 Sol LeWitt (b. 1928) 'Paragraphs on Conceptual Art'

LeWitt's work is characterized by the use of repetition and permutation and by the systematic exclusion of any individuality of touch. This is not, however, to say that LeWitt's output should be unproblematically identified with a tradition of rationalism in twentieth-century art. At the time this text was written his typical works were open-framed, rectangular structures presented in series. In 1968 he began formulating proposals for wall drawings, to be executed according to his instructions. Although the notion of a 'Conceptual Art' had been variously canvassed since the early 1960s, publication of this text provided the first public grounds for recognition of a movement. First published in *Artforum*, New York, vol. 5, no. 10, Summer 1967, pp. 79–83, from which the present text is taken.

[...] I will refer to the kind of art in which I am involved as conceptual art. In conceptual art the idea or concept is the most important aspect of the work.[1] When an artist uses a conceptual form of art, it means that all of the planning and decisions are made beforehand and the execution is a perfunctory affair. The idea becomes a machine that makes the art. This kind of art is not theoretical or illustrative of theories; it is

intuitive, it is involved with all types of mental processes and it is purposeless. It is usually free from the dependence on the skill of the artist as a craftsman. It is the objective of the artist who is concerned with conceptual art to make his work mentally interesting to the spectator, and therefore usually he would want it to become emotionally dry. There is no reason to suppose however, that the conceptual artist is out to bore the viewer. It is only the expectation of an emotional kick, to which one conditioned to expressionist art is accustomed, that would deter the viewer from perceiving this art.

Conceptual art is not necessarily logical. The logic of a piece or series of pieces is a device that is used at times only to be ruined. Logic may be used to camouflage the real intent of the artist, to lull the viewer into the belief that he understands the work, or to infer a paradoxical situation (such as logic vs. illogic).[2] The ideas need not be complex. Most ideas that are successful are ludicrously simple. Successful ideas generally have the appearance of simplicity because they seem inevitable. In terms of idea the artist is free to even surprise himself. Ideas are discovered by intuition.

What the work of art looks like isn't too important. It has to look like something if it has physical form. No matter what form it may finally have it must begin with an idea. It is the process of conception and realization with which the artist is concerned. Once given physical reality by the artist the work is open to the perception of all, including the artist. (I use the word 'perception' to mean the apprehension of the sense data, the objective understanding of the idea and simultaneously a subjective interpretation of both.) The work of art can only be perceived after it is completed.

Art that is meant for the sensation of the eye primarily would be called perceptual rather than conceptual. This would include most optical, kinetic, light and color art.

Since the functions of conception and perception are contradictory (one pre-, the other postfact) the artist would mitigate his idea by applying subjective judgment to it. If the artist wishes to explore his idea thoroughly, then arbitrary or chance decisions would be kept to a minimum, while caprice, taste and other whimsies would be eliminated from the making of the art. The work does not necessarily have to be rejected if it does not look well. Sometimes what is initially thought to be awkward will eventually be visually pleasing.

To work with a plan that is pre-set is one way of avoiding subjectivity. It also obviates the necessity of designing each work in turn. The plan would design the work. Some plans would require millions of variations, and some a limited number, but both are finite. Other plans imply infinity. In each case however, the artist would select the basic form and rules that would govern the solution of the problem. After that the fewer decisions made in the course of completing the work, the better. This eliminates the arbitrary, the capricious, and the subjective as much as possible. That is the reason for using this method.

When an artist uses a multiple modular method he usually chooses a simple and readily available form. The form itself is of very limited importance; it becomes the grammar for the total work. In fact it is best that the basic unit be deliberately uninteresting so that it may more easily become an intrinsic part of the entire work. Using complex basic forms only disrupts the unity of the whole. Using a simple form repeatedly narrows the field of the work and concentrates the intensity to the arrangement of the form. This arrangement becomes the end while the form becomes the means.

Conceptual art doesn't really have much to do with mathematics, philosophy or any other mental discipline. The mathematics used by most artists is simple arithmetic or simple number systems. The philosophy of the work is implicit in the work and is not an illustration of any system of philosophy.

It doesn't really matter if the viewer understands the concepts of the artist by seeing the art. Once out of his hand the artist has no control over the way a viewer will perceive the work. Different people will understand the same thing in a different way.

Recently there has been much written about minimal art, but I have not discovered anyone who admits to doing this kind of thing. There are other art forms around called primary structures, reductive, rejective, cool, and mini-art. No artist I know will own up to any of these either. Therefore I conclude that it is part of a secret language that art critics use when communicating with each other through the medium of art magazines. [...]

If the artist carries through his idea and makes it into visible form, then all the steps in the process are of importance. The idea itself, even if not made visual is as much a work of art as any finished product. All intervening steps – scribbles, sketches, drawings, failed work, models, studies, thoughts, conversations – are of interest. Those that show the thought process of the artist are sometimes more interesting than the final product.

Determining what size a piece should be is difficult. If an idea requires three dimensions then it would seem any size would do. The question would be what size is best. If the thing were made gigantic then the size alone would be impressive and the idea may be lost entirely. Again, if it is too small, it may become inconsequential. The height of the viewer may have some bearing on the work and also the size of the space into which it will be placed. The artist may wish to place objects higher than the eye level of the viewer, or lower. I think the piece must be large enough to give the viewer whatever information he needs to understand the work and placed in such a way that will facilitate this understanding. (Unless the idea is of impediment and requires difficulty of vision or access.)

Space can be thought of as the cubic area occupied by a three-dimensional volume. Any volume would occupy space. It is air and cannot be seen. It is the interval between things that can be measured. The intervals and measurements can be important to a work of art. If certain distances are important they will be made obvious in the piece. If space is relatively unimportant it can be regularized and made equal (things placed equal distances apart), to mitigate any interest in interval. Regular space might also become a metric time element, a kind of regular beat or pulse. When the interval is kept regular whatever is irregular gains more importance.

Architecture and three-dimensional art are of completely opposite natures. The former is concerned with making an area with a specific function. Architecture, whether it is a work of art or not, must be utilitarian or else fail completely. Art is not utilitarian. When three-dimensional art starts to take on some of the characteristics of architecture such as forming utilitarian areas it weakens its function as art. When the viewer is dwarfed by the large size of a piece this domination emphasizes the physical and emotive power of the form at the expense of losing the idea of the piece.

New materials are one of the great afflictions of contemporary art. Some artists confuse new materials with new ideas. There is nothing worse than seeing art that wallows in gaudy baubles. By and large most artists who are attracted to these materials

are the ones that lack the stringency of mind that would enable them to use the materials well. It takes a good artist to use new materials and make them into a work of art. The danger is, I think, in making the physicality of the materials so important that it becomes the idea of the work (another kind of expressionism).

Three-dimensional art of any kind is a physical fact. This physicality is its most obvious and expressive content. Conceptual art is made to engage the mind of the viewer rather than his eye or emotions. The physicality of a three-dimensional object then becomes a contradiction to its non-emotive intent. Color, surface, texture, and shape only emphasize the physical aspects of the work. Anything that calls attention to and interests the viewer in this physicality is a deterrent to our understanding of the idea and is used as an expressive device. The conceptual artist would want to ameliorate this emphasis on materiality as much as possible or to use it in a paradoxical way. (To convert it into an idea.) This kind of art then, should be stated with the most economy of means. Any idea that is better stated in two dimensions should not be in three dimensions. Ideas may also be stated with numbers, photographs, or words or any way the artist chooses, the form being unimportant.

These paragraphs are not intended as categorical imperatives but the ideas stated are as close as possible to my thinking at this time.[3] These ideas are the result of my work as an artist and are subject to change as my experience changes. I have tried to state them with as much clarity as possible. If the statements I make are unclear it may mean the thinking is unclear. Even while writing these ideas there seemed to be obvious inconsistencies (which I have tried to correct, but others will probably slip by). I do not advocate a conceptual form of art for all artists. I have found that it has worked well for me while other ways have not. It is one way of making art: other ways suit other artists. Nor do I think all conceptual art merits the viewer's attention. Conceptual art is only good when the idea is good.

[1] In other forms of art the concept may be changed in the process of execution.
[2] Some ideas are logical in conception and illogical perceptually.
[3] I dislike the term 'work of art' because I am not in favor of work and the term sounds pretentious. But I don't know what other term to use.

9 Sol LeWitt (b. 1928) 'Sentences on Conceptual Art'

By the time this text was published, Conceptual Art was widely recognized as an international avant-garde movement with a large number of adherents, and incorporating a number of theoretical positions in addition to LeWitt's. The 'Sentences' were originally published in *Art-Language*, Coventry, vol. 1, no. 1, May 1969 (for this opening issue alone designated 'The Journal of Conceptual Art').

1 Conceptual Artists are mystics rather than rationalists. They leap to conclusions that logic cannot reach.
2 Rational judgements repeat rational judgements.
3 Illogical judgements lead to new experience.
4 Formal Art is essentially rational.
5 Irrational thoughts should be followed absolutely and logically.

6 If the artist changes his mind midway through the execution of the piece he compromises the result and repeats past results.

7 The artist's will is secondary to the process he initiates from idea to completion. His wilfulness may only be ego.

8 When words such as painting and sculpture are used, they connote a whole tradition and imply a consequent acceptance of this tradition, thus placing limitations on the artist who would be reluctant to make art that goes beyond the limitations.

9 The concept and idea are different. The former implies a general direction while the latter are the components. Ideas implement the concept.

10 Ideas alone can be works of art; they are in a chain of development that may eventually find some form. All ideas need not be made physical.

11 Ideas do not necessarily proceed in logical order. They may set one off in unexpected directions but an idea must necessarily be completed in the mind before the next one is formed.

12 For each work of art that becomes physical there are many variations that do not.

13 A work of art may be understood as a conductor from the artist's mind to the viewer's. But it may never reach the viewer, or it may never leave the artist's mind.

14 The words of one artist to another may induce an ideas chain, if they share the same concept.

15 Since no form is intrinsically superior to another, the artist may use any form, from an expression of words, (written or spoken) to physical reality, equally.

16 If words are used, and they proceed from ideas about art, then they are art and not literature, numbers are not mathematics.

17 All ideas are art if they are concerned with art and fall within the conventions of art.

18 One usually understands the art of the past by applying the conventions of the present thus misunderstanding the art of the past.

19 The conventions of art are altered by works of art.

20 Successful art changes our understanding of the conventions by altering our perceptions.

21 Perception of ideas leads to new ideas.

22 The artist cannot imagine his art, and cannot perceive it until it is complete.

23 One artist may mis-perceive (understand it differently than the artist) a work of art but still be set off in his own chain of thought by that misconstrual.

24 Perception is subjective.

25 The artist may not necessarily understand his own art. His perception is neither better nor worse than that of others.

26 An artist may perceive the art of others better than his own.

27 The concept of a work of art may involve the matter of the piece or the process in which it is made.

28 Once the idea of the piece is established in the artist's mind and the final form is decided, the process is carried out blindly. There are many side-effects that the artist cannot imagine. These may be used as ideas for new works.

29 The process is mechanical and should not be tampered with. It should run its course.

30 There are many elements involved in a work of art. The most important are the most obvious.

31 If an artist uses the same form in a group of works, and changes the material, one
 would assume the artist's concept involved the material.
32 Banal ideas cannot be rescued by beautiful execution.
33 It is difficult to bungle a good idea.
34 When an artist learns his craft too well he makes slick art.
35 These sentences comment on art, but are not art.

10 Robert Barry (b. 1936) Interview with Arthur R. Rose

In January 1969 the avant-garde dealer Seth Siegelaub staged an exhibition in a temporarily
empty office space in New York. The exhibition was given the title of its duration, 'January
5–31 1969'. The artists involved were Robert Barry, Douglas Huebler, Joseph Kosuth and
Lawrence Weiner, each represented by a small selection of recent works, with others
documented in an accompanying catalogue. Among those listed were Weiner's *One Stand-*
ard Air Force dye marker thrown into the sea and Barry's *88 mc Carrier Wave (FM)*. To
provide publicity for the exhibition, the artists concocted four interviews, using the Du-
champian name 'Arthur R. Rose' for their fictitious interlocutor. These were originally
published in *Arts Magazine*, New York, vol. 43, no. 4, February 1969, pp. 22–3. Barry
here gives voice to that extreme form of reductivism which was characteristic of some
American forms of post-Minimal and Conceptual Art.

Q: How did you arrive at the kind of work you are now doing?

BARRY: It's a logical continuation of my earlier work. A few years ago when I was
 painting, it seemed that paintings would look one way in one place and, because of
 lighting and other things, would look different in another place. Although it was the
 same object, it was another work of art. Then I made paintings which incorporated as
 part of their design the wall on which they hung. I finally gave up painting for the wire
 installations (two of which are in the show). Each wire installation was made to suit the
 place in which it was installed. They cannot be moved without being destroyed.

 Color became arbitrary. I started using thin transparent nylon monofilament.
 Eventually the wire became so thin that it was virtually invisible. This led to my
 use of material which is invisible, or at least not perceivable in a traditional way.
 Although this poses problems, it also presents endless possibilities. It was at this
 point that I discarded the idea that art is necessarily something to look at.

Q: If your work is not perceivable, how does anyone deal with it or even know of its
 existence?

BARRY: I'm not only questioning the limits of our perception, but the actual nature
 of perception. These forms certainly do exist, they are controlled and have their own
 characteristic. They are made of various kinds of energy which exist outside the
 narrow arbitrary limits of our own senses. I use various devices to produce the
 energy, detect it, measure it, and define its form.

 By just being in this show, I'm making known the existence of the work. I'm
 presenting these things in an artistic situation using the space and the catalogue.
 I think this will be less of a problem as people become more acclimated to this art. As
 with any art, an interested person reacts in a personal way based on his own
 experience and imagination. Obviously, I can't control that.

Q: Exactly what kind of energy do you use?

BARRY: One kind of energy is electromagnetic waves. There is a piece in the show which uses the carrier wave of a radio station for a prescribed length of time, not as a means of transmitting information, but rather as an object. Another piece uses the carrier wave of a citizens band transmitter to bridge two distant points in New York and Luxembourg several times during the run of the show. Because of the position of the sun and favorable atmospheric conditions during January – the month of the show – *this* piece could be made. At another time, under different conditions, other locations would have to be used. There are two smaller carrier wave pieces which have just enough power to fill the exhibition space. They are very different in character, one being AM, the other being FM, but both will occupy the same space at the same time – such is the nature of the material.

Also in the show will be a room filled with ultrasonic sound. I've also used microwaves and radiation. There are many other possibilities which I intend to explore – and I'm sure there are a lot of things we don't yet know about, which exist in the space around us, and, though we don't see or feel them, we somehow know they are out there.

11 Joseph Kosuth (b. 1945) 'Art after Philosophy'

With the publication of this essay Kosuth successfully claimed a position as spokesman for the avant-garde idea of 'art as idea'. His extreme form of Modernist autonomy thesis is harnessed to a revaluation and revision of art history which posits Duchamp's readymades – rather than the paintings of Manet or Cézanne or the moment of Cubism – as the significant point of initiation of the modern. Following its initial publication, however, the essay was widely understood as a form of manifesto for an 'Analytical' tendency within the wider Conceptual Art movement. In the summer of 1969 Kosuth was invited to act as American Editor of the journal *Art-Language*, and he was to be associated with Art & Language until 1976 (see VIIB1 and 5). 'Art after Philosophy' was originally published in three parts in *Studio International*, London, vol. 178, nos. 915–17, October, November, December 1969, pp. 134–7, 160–1, 212–13. It has been much reprinted. Its theoretical argument is restricted to the first part, from which the present text is taken.

'The fact that it has recently become fashionable for physicists themselves to be sympathetic towards religion . . . marks the physicists' own lack of confidence in the validity of their hypotheses, which is a reaction on their part from the anti-religious dogmatism of nineteenth-century scientists, and a natural outcome of the crisis through which physics has just passed.' – A. J. Ayer.

'Once one has understood the *Tractatus* there will be no temptation to concern oneself any more with philosophy, which is neither empirical like science nor tauto-logical like mathematics; one will, like Wittgenstein in 1918, abandon philosophy, which, as traditionally understood, is rooted in confusion.' – J. O. Urmson.

Traditional philosophy, almost by definition, has concerned itself with the *unsaid.* The nearly exclusive focus on the *said* by twentieth-century analytical linguistic philoso-phers is the shared contention that the *unsaid* is *unsaid* because it is *unsayable*. Hegelian philosophy made sense in the nineteenth century and must have been soothing to a

century that was barely getting over Hume, the Enlightenment, and Kant.[1] Hegel's philosophy was also capable of giving cover for a defence of religious beliefs, supplying an alternative to Newtonian mechanics, and fitting in with the growth of history as a discipline, as well as accepting Darwinian Biology.[2] He appeared to give an acceptable resolution to the conflict between theology and science, as well.

The result of Hegel's influence has been that a great majority of contemporary philosophers are really little more than *historians* of philosophy, Librarians of the Truth, so to speak. One begins to get the impression that there 'is nothing more to be said.' And certainly if one realizes the implications of Wittgenstein's thinking, and the thinking influenced by him and after him, 'Continental' philosophy need not seriously be considered here.[3]

* * *

The twentieth century brought in a time which could be called 'the end of philosophy and the beginning of art'. I do not mean that, of course, strictly speaking, but rather as the 'tendency' of the situation. Certainly linguistic philosophy can be considered the heir to empiricism, but it's a philosophy in one gear.[4] And there is certainly an 'art condition' to art preceding Duchamp, but its other functions or reasons-to-be are so pronounced that its ability to function clearly as art limits its art condition so drastically that it's only minimally art. In no mechanistic sense is there a connection between philosophy's 'ending' and art's 'beginning', but I don't find this occurence entirely coincidental. Though the same reasons may be responsible for both occurrences the connection is made by me. I bring this all up to analyse art's function and subsequently its viability. And I do so to enable others to understand the reasoning of my – and, by extension, other artists' – art, as well as to provide a clearer understanding of the term 'Conceptual art'.[5]

The Function of Art

'The main qualifications to the lesser position of painting is that advances in art are certainly not always formal ones.' – Donald Judd (1963).

'Half or more of the best new work in the last few years has been neither painting nor sculpture.' – Donald Judd (1965).

'Everything sculpture has, my work doesn't.' – Donald Judd (1967).

'The idea becomes a machine that makes the art.' – Sol LeWitt (1965).

'The one thing to say about art is that it is one thing. Art is art-as-art and everything else is everything else. Art as art is nothing but art. Art is not what is not art.' – Ad Reinhardt (1963).

'The meaning is the use.' – Wittgenstein.

'A more functional approach to the study of concepts has tended to replace the method of introspection. Instead of attempting to grasp or describe concepts bare, so to speak, the psychologist investigates the way in which they function as ingredients in beliefs and in judgements.' – Irving M. Copi.

'Meaning is always a presupposition of function.' – T. Segerstedt.

'... The subject-matter of conceptual investigations is the *meaning* of certain words and expressions – and not the things and states of affairs themselves about which we talk, when using those words and expressions.' – G. H. Von Wright.

'Thinking is radically metaphoric. Linkage by analogy is its constituent law or principle, its causal nexus, since meaning only arises through the causal *contexts* by

which a sign stands for (takes the place of) an instance of a sort. To think of anything is to take it *as* of a sort (as a such and such) and that 'as' brings in (openly or in disguise) the analogy, the parallel, the metaphoric grapple or ground or grasp or draw by which alone the mind takes hold. It takes no hold if there is nothing for it to haul from, for its thinking is the haul, the attraction of likes.' – I. A. Richards.

In this section I will discuss the separation between aesthetics and art; consider briefly Formalist art (because it is a leading proponent of the idea of aesthetics as art), and assert that art is analogous to an analytic proposition, and that it is art's existence as a tautology which enables art to remain 'aloof' from philosophical presumptions.

It is necessary to separate aesthetics from art because aesthetics deals with opinions on perception of the world in general. In the past one of the two prongs of art's function was its value as decoration. So any branch of philosophy which dealt with 'beauty' and thus, taste, was inevitably duty bound to discuss art as well. Out of this 'habit' grew the notion that there was a conceptual connection between art and aesthetics, which is not true. This idea never drastically conflicted with artistic considerations before recent times, not only because the morphological characteristics of art perpetuated the continuity of this error, but as well, because the apparent other 'functions' of art (depiction of religious themes, portraiture of aristocrats, detailing of architecture, etc.) used art to cover up art.

When objects are presented within the context of art (and until recently objects always have been used) they are as eligible for aesthetic consideration as are any objects in the world, and an aesthetic consideration of an object existing in the realm of art means that the object's existence or functioning in an art context is irrelevant to the aesthetic judgement.

The relation of aesthetics to art is not unlike that of aesthetics to architecture, in that architecture has a very specific *function* and how 'good' its design is is *primarily* related to how well it performs its function. Thus, judgements on what it looks like correspond to taste, and we can see that throughout history different examples of architecture are praised at different times depending on the aesthetics of particular epochs. Aesthetic thinking has even gone so far as to make examples of architecture not related to 'art' at all, works of art in themselves (e.g. the pyramids of Egypt).

Aesthetic considerations are indeed *always* extraneous to an object's function or 'reason to be'. Unless of course, that object's 'reason to be' is strictly aesthetic. An example of a purely aesthetic object is a decorative object, for decoration's primary function is 'to add something to, so as to make more attractive; adorn; ornament',[6] and this relates directly to taste. And this leads us directly to 'Formalist' art and criticism.[7] Formalist art (painting and sculpture) is the vanguard of decoration, and, strictly speaking, one could reasonably assert that its art condition is so minimal that for all functional purposes it is not art at all, but pure exercises in aesthetics. Above all things Clement Greenberg is the critic of taste. Behind every one of his decisions is an aesthetic judgement, with those judgements reflecting his taste. And what does his taste reflect? The period he grew up in as a critic, the period 'real' for him: the fifties.[8]

How else can one account for, given his theories – if they have any logic to them at all, – his disinterest in Frank Stella, Ad Reinhardt, and others applicable to his historical scheme? Is it because [...] their work doesn't suit his taste?

But in the philosophic *tabula rasa* of art, 'if someone calls it art,' as Don Judd has said, 'it's art.' Given this, formalist painting and sculpture can be granted an 'art condition', but only by virtue of its presentation in terms of its art idea (e.g. a rectangularly-shaped canvas stretched over wooden supports and stained with such and such colours, using such and such forms, giving such and such a visual experience, etc.). If one looks at contemporary art in this light one realizes the minimal creative effort taken on the part of formalist artists specifically, and all painters and sculptors (working as such today) generally.

This brings us to the realization that formalist art and criticism accepts as a definition of art one which exists solely on morphological grounds. While a vast quantity of similarly looking objects or images (or visually related objects or images) may seem to be related (or connected) because of a similarity of visual/experiential 'readings', one cannot claim from this an artistic or conceptual relationship.

It is obvious then that formalist criticism's reliance on morphology leads necessarily with a bias toward the morphology of traditional art. And in this sense their criticism is not related to a 'scientific method' or any sort of empiricism (as Michael Fried, with his detailed descriptions of paintings and other 'scholarly' paraphernalia would want us to believe). Formalist criticism is no more than an analysis of the physical attributes of particular objects which happen to exist in a morphological context. But this doesn't add any knowledge (or facts) to our understanding of the nature or function of art. And nor does it comment on whether or not the objects analysed are even works of art, in that formalist critics always by-pass the conceptual element in works of art. Exactly why they don't comment on the conceptual element in works of art is precisely because formalist art is only art by virtue of its resemblance to earlier works of art. It's a mindless art. Or, as Lucy Lippard so succinctly described Jules Olitski's paintings: 'they're visual *Muzak*.'[9]

Formalist critics and artists alike do not question the nature of art, but as I have said elsewhere: 'Being an artist now means to question the nature of art. If one is questioning the nature of painting, one cannot be questioning the nature of art. If an artist accepts painting (or sculpture) he is accepting the tradition that goes with it. That's because the word art is general and the word painting is specific. Painting is a *kind* of art. If you make paintings you are already accepting (not questioning) the nature of art. One is then accepting the nature of art to be the European tradition of a painting–sculpture dichotomy.'[10]

The strongest objection one can raise against a morphological justification for traditional art is that morphological notions of art embody an implied *a priori* concept of art's possibilities. And such an *a priori* concept of the nature of art (as separate from analytically framed art propositions or 'work' which I will discuss later) makes it, indeed, *a priori*: impossible to question the nature of art. And this questioning of the nature of art is a very important concept in understanding the function of art.

The function of art, as a question, was first raised by Marcel Duchamp. In fact it is Marcel Duchamp whom we can credit with giving art its own identity. (One can certainly see a tendency toward this self-identification of art beginning with Manet and Cézanne through to Cubism,[11] but their works are timid and ambiguous by comparison with Duchamp's). 'Modern' art and the work before seemed connected by virtue of their morphology. Another way of putting it would be that art's 'language' remained the same, but it was saying new things. The event that made conceivable the realization

that it was possible to 'speak another language' and still make sense in art was Marcel Duchamp's first unassisted *Readymade*. With the unassisted *Readymade*, art changed its focus from the form of the language to what was being said. Which means that it changed the nature of art from a question of morphology to a question of function. This change – one from 'appearance' to 'conception' – was the beginning of 'modern' art and the beginning of 'conceptual' art. All art (after Duchamp) is conceptual (in nature) because art only exists conceptually.

The 'value' of particular artists after Duchamp can be weighed according to how much they questioned the nature of art; which is another way of saying 'what they *added* to the conception of art' or what wasn't there before they started. Artists question the nature of art by presenting new propositions as to art's nature. And to do this one cannot concern oneself with the handed-down 'language' of traditional art, as this activity is based on the assumption that there is only one way of framing art propositions. But the very stuff of art is indeed greatly related to 'creating' new propositions.

The case is often made – particularly in reference to Duchamp – that objects of art (such as the readymades, of course, but all art is implied in this) are judged as *objets d'art* in later years and the artists' *intentions* become irrelevant. Such an argument is the case of a preconceived notion ordering together not necessarily related facts. The point is this: aesthetics, as we have pointed out, are conceptually irrelevant to art. Thus, any physical thing can become *objet d'art*, that is to say, can be considered tasteful, aesthetically pleasing, etc. But this has no bearing on the object's application to an art context; that is, its *functioning* in an art context. (E.g. if a collector takes a painting, attaches legs, and uses it as a dining-table it's an act unrelated to art or the artist because, *as art*, that wasn't the artist's *intention*.)

And what holds true for Duchamp's work applies as well to most of the art after him. In other words, the value of Cubism – for instance – is its idea in the realm of art, not the physical or visual qualities seen in a specific painting, or the particularization of certain colours or shapes. For these colours and shapes are the art's 'language', not its meaning conceptually as art. To look upon a Cubist 'masterwork' *now* as art is nonsensical, conceptually speaking, as far as art is concerned. (That visual information which was unique in Cubism's language has now been generally absorbed and has a lot to do with the way in which one deals with painting 'linguistically'. [E.g. what a Cubist painting meant experimentally and conceptually to, say, Gertrude Stein, is beyond our speculation because the same painting then 'meant' something different than it does now.]) The 'value' now of an original Cubist painting is not unlike, in most respects, an original manuscript by Lord Byron, or *The Spirit of St Louis* as it is seen in the Smithsonian Institute. (Indeed, museums fill the very same function as the Smithsonian Institute – why else would the *Jeu de Paume* wing of the Louvre exhibit Cézanne's and van Gogh's palettes as proudly as they do their paintings?) Actual works of art are little more than historical curiosities. As far as *art* is concerned van Gogh's paintings aren't worth any more than his palette is. They are both 'collector's items'.[12]

Art 'lives' through influencing other art, not by existing as the physical residue of an artist's ideas. The reason why different artists from the past are 'brought alive' again is because some aspect of their work becomes 'useable' by living artists. That there is no 'truth' as to what art is seems quite unrealized.

What is the function of art, or the nature of art? If we continue our analogy of the forms art takes as being art's *language* one can realize then that a work of art is a kind of

proposition presented within the context of art as a comment on art. We can then go further and analyse the types of 'propositions'.

A. J. Ayer's evaluation of Kant's distinction between analytic and synthetic is useful to us here: 'A proposition is analytic when its validity depends solely on the definitions of the symbols it contains, and synthetic when its validity is determined by the facts of experience.'[13] The analogy I will attempt to make is one between the art condition and the condition of the analytic proposition. In that they don't appear to be believable as anything else, or be about anything (other than art) the forms of art most clearly finally referable only to art have been forms closest to analytical propositions.

Works of art are analytic propositions. That is, if viewed within their context – as art – they provide no information what-so-ever about any matter of fact. A work of art is a tautology in that it is a presentation of the artist's intention, that is, he is saying that that particular work of art *is* art, which means, is a *definition* of art. Thus, that it is art is true *a priori* (which is what Judd means when he states that 'if someone calls it art, it's art').

Indeed, it is nearly impossible to discuss art in general terms without talking in tautologies – for to attempt to 'grasp' art by any other 'handle' is to merely focus on another aspect or quality of the proposition which is usually irrelevant to the art work's 'art condition'. One begins to realize that art's 'art condition' is a conceptual state. That the language forms which the artist frames his propositions in are often 'private' codes or languages is an inevitable outcome of art's freedom from morphological constrictions; and it follows from this that one has to be familiar with contemporary art to appreciate it and understand it. Likewise one understands why the 'man on the street' is intolerant to artistic art and always demands art in a traditional 'language'. (And one understands why formalist art sells 'like hot cakes'.) Only in painting and sculpture did the artists all speak the same language. What is called 'Novelty Art' by the Formalists is often the attempt to find new languages, although a new language doesn't necessarily mean the framing of new propositions: e.g. most kinetic and electronic art.

Another way of stating in relation to art what Ayer asserted about the analytic method in the context of language would be the following: The validity of artistic propositions is not dependent on any empirical, much less any aesthetic, presupposition about the nature of things. For the artist, as an analyst, is not directly concerned with the physical properties of things. He is concerned only with the way (1) in which art is capable of conceptual growth and (2) how his propositions are capable of logically following that growth.[14] In other words, the propositions of art are not factual, but linguistic in *character* – that is, they do not describe the behaviour of physical, or even mental objects; they express definitions of art, or the formal consequences of definitions of art. Accordingly, we can say that art operates on a logic. For we shall see that the characteristic mark of a purely logical enquiry is that it is concerned with the formal consequences of our definitions (of art) and not with questions of empirical fact.[15]

To repeat, what art has in common with logic and mathematics is that it is a tautology; i.e., the 'art idea' (or 'work') and art are the same and can be appreciated as art without going outside the context of art for verification.

On the other hand, let us consider why art cannot be (or has difficulty when it attempts to be) a synthetic proposition. Or, that is to say, when the truth or falsity of its assertion is verifiable on empirical grounds. Ayer states: '. . . The criterion by which we determine the validity of an a priori or analytical proposition is not sufficient to determine the validity of an empirical or synthetic proposition. For it is characteristic

of empirical propositions that their validity is not purely formal. To say that a geometrical proposition, or a system of geometrical propositions, is false, is to say that it is self-contradictory. But an empirical proposition, or a system of empirical propositions, may be free from contradiction, and still be false. It is said to be false, not because it is formally defective, but because it fails to satisfy some material criterion.'[16]

The unreality of 'realistic' art is due to its framing as an art proposition in synthetic terms: one is always tempted to 'verify' the proposition empirically. Realism's synthetic state does not bring one to a circular swing back into a dialogue with the larger framework of questions about the nature of *art* (as does the work of Malevich, Mondrian, Pollock, Reinhardt, early Rauschenberg, Johns, Lichtenstein, Warhol, Andre, Judd, Flavin, LeWitt, Morris, and others), but rather, one is flung out of art's 'orbit' into the 'infinite space' of the human condition.

Pure Expressionism, continuing with Ayer's terms, could be considered as such: 'A sentence which consisted of demonstrative symbols would not express a genuine proposition. It would be a mere ejaculation, in no way characterizing that to which it was supposed to refer.' Expressionist works are usually such 'ejaculations' presented in the morphological language of traditional art. If Pollock is important it is because he painted on loose canvas horizontally to the floor. What *isn't* important is that he later put those drippings over stretchers and hung them parallel to the wall. (In other words what is important in art is what one *brings* to it, not one's adoption of what was previously existing.) What is even less important to art is Pollock's notions of 'self-expression' because those *kinds* of subjective meanings are useless to anyone other than those involved with him personally. And their 'specific' quality puts them outside of art's context.

[. . .] As Ayer has stated: 'There are no absolutely certain empirical propositions. It is only tautologies that are certain. Empirical questions are one and all hypotheses, which may be confirmed or discredited in actual sense-experience. And the propositions in which we record the observations that verify these hypotheses are themselves hypotheses which are subject to the test of further sense-experience. Thus there is no final proposition.'[17]

What one finds all throughout the writings of Ad Reinhardt is this very similar thesis of 'art-as-art', and that 'art is always dead, and a "living" art is a deception'.[18] Reinhardt had a very clear idea about the nature of art, and his importance is far from being recognized.

Forms of art that can be considered synthetic propositions are verifiable by the world, that is to say, to understand these propositions one must leave the tautological-like framework of art and consider 'outside' information. But to consider it as art it is necessary to ignore this same outside information, because outside information (experiential qualities, to note) have their own intrinsic worth. And to comprehend this worth one does not need a state of 'art condition'.

From this it is easy to realize that art's viability is not connected to the presentation of visual (or other) kinds of experience. That that may have been one of art's extraneous functions in the preceding centuries is not unlikely. After all, man in even the nineteenth-century lived in a fairly standardized visual environment. That is, it was ordinarily predictable as to what he would be coming into contact with day after day. His visual environment in the part of the world in which he lived was fairly consistent. In our time we have an experientally drastically richer environment. One can fly all over the

earth in a matter of hours and days, not months. We have the cinema, and colour television, as well as the man-made spectacle of the lights of Las Vegas or the skyscrapers of New York City. The whole world is there to be seen, and the whole world can watch man walk on the moon from their living rooms. Certainly art or objects of painting and sculpture cannot be expected to compete experientially with this?

The notion of 'use' is relevant to art and its 'language'. Recently the box or cube form has been used a great deal within the context of art. (Take for instance its use by Judd, Morris, LeWitt, Bladen, Smith, Bell, and McCracken – not even mentioning the quantity of boxes and cubes that came after.) The difference between all the various uses of the box or cube form is directly related to the differences in the intentions of the artists. Further, as is particularly seen in Judd's work, the use of the box or cube form illustrates very well our earlier claim that an object is only art when placed in the context of art.

A few examples will point this out. One could say that if one of Judd's box forms was seen filled with debris, seen placed in an industrial setting, or even merely seen sitting on a street corner, it would not be identified with art. It follows then that understanding and consideration of it as an art work is necessary *a priori* to viewing it in order to 'see' it as a work of art. Advance information about the concept of art and about an artist's concepts is necessary to the appreciation and understanding of contemporary art. Any and all of the physical attributes (qualities) of contemporary works if considered separately and/or specifically are irrelevant to the art concept. The art concept (as Judd said, though he didn't mean it this way) must be considered in its whole. To consider a concept's parts is invariably to consider aspects that are irrelevant to its art condition – or like reading *parts* of a definition.

It comes as no surprise that the art with the least fixed morphology is the example from which we decipher the nature of the general term 'art'. For where there is a context existing separately of its morphology and consisting of its function one is more likely to find results less conforming and predictable. It is in modern art's possession of a 'language' with the shortest history that the plausibility of the abandonment of that 'language' becomes most possible. It is understandable then that the art that came out of Western painting and sculpture is the most energetic, questioning (of its nature), and the least assuming of all the general 'art' concerns. In the final analysis, however, all of the arts have but (in Wittgenstein's terms) a 'family' resemblance.

Yet the various qualities relatable to an 'art condition' possessed by poetry, the novel, the cinema, the theatre, and various forms of music, etc., is that aspect of them most relatable to the function of art as asserted here. [...]

'We see now that the axioms of a geometry are simply definitions, and that the theorems of a geometry are simply the logical consequences of these definitions. A geometry is not in itself about physical space; in itself it cannot be said to be "about" anything. But we can use a geometry to reason about physical space. That is to say, once we have given the axioms a physical interpretation, we can proceed to apply the theorems to the objects which satisfy the axioms. Whether a geometry can be applied to the actual physical world or not, is an empirical question which falls outside the scope of geometry itself. There is no sense, therefore, in asking which of the various geometries known to us are false and which are true. In so far as they are all free from contradiction, they are all true. The proposition which states that a certain

application of a geometry is possible is not itself a proposition of that geometry. All that the geometry itself tells us is that if anything can be brought under the definitions, it will also satisfy the theorems. It is therefore a purely logical system, and its propositions are purely analytic propositions.' – A. J. Ayer[19]

Here then I propose rests the viability of art. In an age when traditional philosophy is unreal because of its assumptions, art's ability to exist will depend not only on its *not* performing a service – as entertainment, visual (or other) experience, or decoration – which is something easily replaced by kitsch culture and technology, but rather, it will remain viable by *not* assuming a philosophical stance; for in art's unique character is the capacity to remain aloof from philosophical judgements. It is in this context that art shares similarities with logic, mathematics and, as well, science. But whereas the other endeavours are useful, art is not. Art indeed exists for its own sake.

In this period of man, after philosophy and religion, art may possibly be one endeavour that fulfills what another age might have called 'man's spiritual needs'. Or, another way of putting it might be that art deals analogously with the state of things 'beyond physics' where philosophy had to make assertions. And art's strength is that even the preceding sentence is an assertion, and cannot be verified by art. Art's only claim is for art. Art is the definition of art.

[1] Morton White, *The Age of Analysis*, Mentor Books, New York, p. 14.

[2] Ibid., p. 15.

[3] I mean by this Existentialism and Phenomenology. Even Merleau-Ponty, with his middle-of-the-road position between Empiricism and Rationalism, cannot express his philosophy without the use of words (thus using concepts); and following this, how can one discuss experience without sharp distinctions between ourselves and the world?

[4] The task such philosophy has taken upon itself is the only 'function' it could perform without making philosophic assertions.

[5] I would like to make it clear, however, that I intend to speak for no one else. I arrived at these conclusions alone, and indeed, it is from this thinking that my art since 1966 (if not before) evolved. Only recently did I realize after meeting Terry Atkinson that he and Michael Baldwin share similar, though certainly not identical, opinions to mine.

[6] *Webster's New World Dictionary of the American Language*.

[7] The conceptual level of the work of Kenneth Noland, Jules Olitski, Morris Louis, Ron Davis, Anthony Caro, John Hoyland, Dan Christensen *et al.* is so dismally low, that any that is there is supplied by the critics promoting it. This is seen later.

[8] Michael Fried's reasons for using Greenberg's rationale reflect his background (and most of the other formalist critics) as a 'scholar', but more of it is due to his desire, I suspect, to bring his scholarly studies into the modern world. One can easily sympathize with his desire to connect, say, Tiepolo with Jules Olitski. One should never forget, however, that an historian loves history more than anything, even art.

[9] Lucy Lippard . . . , in her *Hudson Review* review of the last painting exhibition of the Whitney Annual.

[10] 'Four interviews', by Arthur R. Rose; *Arts Magazine*, February 1969.

[11] As Terry Atkinson pointed out in his introduction to *Art-Language* (vol. 1, no. 1), the Cubists never questioned *if* art had morphological characteristics, but *which* ones in *painting* were acceptable.

[12] When someone 'buys' a Flavin he isn't buying a light show, for if he was he could just go to a hardware store and get the goods for considerably less. He isn't 'buying' anything. He is subsidizing Flavin's activity as an artist.

[13] A. J. Ayer, *Language, Truth, and Logic*, Dover, New York, p. 78.

[14] Ibid., p. 57.

[15] Ibid., p. 57.

[16] Ibid., p. 90.

17 Ibid., p. 94.
18 Ad Reinhardt's retrospective catalogue (Jewish Museum) written by Lucy Lippard, p. 12.
19 Ayer, p. 82.

12 Daniel Buren (b. 1938), Olivier Mosset (b. 1944), Michel Parmentier (b. 1938) and Niele Toroni (b. 1937) Statement

This text was issued as a flyer on the occasion of a joint demonstration by the four artists at the Salon de la Jeune Peinture, Musée d'Art Moderne, Paris, on 3 January 1967. As a form of strategically reduced 'signature' each artist was represented by a simple stylistic motif deployed on canvases of identical size: Buren by vertical red and white stripes; Mosset by a black circle on a white ground; Parmentier by horizontal bands of grey and white; and Toroni by square blue imprints of a flat brush on a white ground. The work was withdrawn at the end of the day. During the following year Buren, Mosset and Toroni continued to paint the 'same' paintings. At the time of writing the work of Buren and Toroni remains identifiable through their respective use of the same basic motifs. English translation published in Michel Claura, 'Paris Commentary', *Studio International*, London, vol. 177, no. 907, January 1969, p. 47.

Because painting is a game,
Because painting is the application (consciously or otherwise) of the rules of composition,
Because painting is the freezing of movement,
Because painting is the representation (or interpretation or appropriation or disputation or presentation) of objects,
Because painting is a springboard for the imagination,
Because painting is spiritual illustration,
Because painting is justification,
Because painting serves an end,
Because to paint is to give aesthetic value to flowers, women, eroticism, the daily environment, art, dadaism, psychoanalysis and the war in Vietnam,
We are not painters.

13 Daniel Buren (b. 1938) 'Beware'

In this essay, written for the catalogue of a Conceptual Art exhibition, Buren aimed both to distance himself from a Conceptual Art tendency and to establish the distinctive character of his own project. His declared aim is to reduce painting to an essential state, by this means to effect a rupture with traditional concepts of development in art, and to reinstate painting as a practice of theory as distinct from decoration or craft. First published as 'Mise en garde' in *Konzeption/Conception*, Städtisches Museum, Leverkusen, July–August 1969; revised and extended January 1970; this revised text was translated by Charles Harrison and published in full in *Studio International*, London, vol. 179, no. 920, March 1970, pp. 100–4, from which the present version is taken. (Italicized passages within square brackets signify Buren's 1970 revisions of the 1969 original. The extensions to this original version have largely been eliminated from the present text, however.)

II What is this work?

Vertically striped sheets of paper, the bands of which are 8.7 cms wide, alternate white and colored, are stuck over internal and external surfaces: walls, fences, display windows, etc.; and/or cloth/canvas support, vertical stripes, white and colored bands each 8.7 cms, the two ends covered with dull white paint.

I record that this is my work for the last four years, without any evolution or way out. This is the past: it does not imply either that it will be the same for another ten or fifteen years or that it will change tomorrow. [...]

[...] The points to be examined are described below and each will require to be examined separately and more thoroughly later....

a) *The Object, the Real, Illusion.* Any art tends to decipher the world, to visualize an emotion, nature, the subconscious, etc....Can we pose a question rather than replying always in terms of hallucinations? This question would be: can one create something that is real, nonillusionistic, and therefore not an art-object? One might reply – and this is a real temptation for an artist – in a direct and basic fashion to this question and...believe the problem *solved*, because it was *raised*, and [*for example*] present no object but a concept. This is responding too directly to need, it is mistaking a desire for reality, it is making like an artist. In fact, instead of questioning or acquainting oneself with the problem raised, one provides a solution, and what a solution! One avoids the issue and passes on to something else. Thus does art progress from form to form, from problems raised to problems solved, accruing successive layers of concealment. To do away with the object as an illusion – the real problem – through its replacement by a concept [*or an idea*] – utopian or ideal(istic) or imaginary solution – is to believe in a moon made of green cheese, to achieve one of those conjuring tricks so beloved of twentieth-century art. Moreover it can be affirmed, with reasonable confidence, that as soon as a concept is announced, and especially when it is 'exhibited as art,' under the desire to do away with the object, *one merely replaces it* in fact. The exhibited concept becomes *ideal-object*, which brings us once again to art as it is, i.e., the illusion of something and not the thing itself. In the same way that writing is less and less a matter of verbal transcription, painting should no longer be the vague vision/illusion, even mental, of a phenomenon (nature, subconsciousness, geometry...) but *VISUALITY of the painting itself*. In this way we arrive at a notion that is thus allied more to a method and not to any particular inspiration; a method which requires – in order to make a direct attack on the problems of the object properly so-called – that painting itself should create a mode, a specific system, that would no longer direct attention, but that is 'produced to be looked at.'

b) *The Form.* As to the internal structure of the proposition, the contradictions are removed from it; no 'tragedy' occurs on the reading surface, no horizontal line, for example, chances to cut through a vertical line. Only the imaginary horizontal line of delimitation of the work at the top and at the bottom 'exists,' but in the same way that it 'exists' only by mental reconstruction, it is mentally demolished simultaneously, as it is evident that the external size is arbitrary (a point that we shall explain later on).

The succession of vertical bands is also arranged methodically, always the same [*x,y,x,y,x,y,x,y,x,y,x, etc....*], thus creating no composition on the inside of the surface or area to be looked at, or, if you like, a minimum or zero or neutral composition. These notions are understood in relation to art in general and not through internal considerations. This neutral painting however is not freed from obligations. On the contrary, thanks to its neutrality or absence of style, it is extremely rich in information about itself (its exact position as regards other work) and especially information about other work; thanks to the absence of any formal problem its potency is all expended upon the realms of thought. One may also say that this painting no longer has any plastic character, but that it is *indicative* or *critical*. Among other things, indicative/critical of its own process. This zero/neutral degree of form is 'binding' in the sense that the total absence of conflict eliminates all concealment (all mythification or secrecy) and consequently brings silence. One should not take neutral painting for uncommitted painting.

Lastly, this formal neutrality would not be formal at all if the internal structure of which we have just spoken (vertical white and colored bands) was linked to the external form (size of the surface presented to view). The internal structure being immutable, if the exterior form were equally so, one would soon arrive at the creation of a quasi-religious archetype which, instead of being neutral, would become burdened with a whole weight of meanings, one of which – and not the least – would be as the idealized image of neutrality. On the other hand, the continual variation of the external form implies that it has no influence on the internal structure, which remains the same in every case. The internal structure remains uncomposed and without conflict. If, however, the external form or shape did not vary, a conflict would immediately be established between the combination or fixed relationship of the bandwidths, their spacing (internal structure), and the general size of the work. This type of relationship would be inconsistent with an ambition to avoid the creation of an illusion. We would be presented with a problem all too clearly defined – here that of neutrality to zero degree – and no longer with the thing itself posing a question, in its own terms.

Finally, we believe confidently in the validity of a work or framework questioning its own existence, presented to the eye. The framework, which we have just analyzed clinically, has in fact no importance whatsoever in terms of form or shape; it is at zero level, a minimum but *essential* level. We shall see later how we shall work to cancel out the form itself so far as possible. In other words, it is time to assert *that formal problems have ceased to interest us*. This assertion is the logical consequence of actual work produced over four years where the formal problem was forced out and disqualified as a pole of interest.

Art is the form that it takes. The form must unceasingly renew itself to insure the development of what we call new art. A change of form has so often led us to speak of a new art that one might think that inner meaning and form were/are linked together in the mind of the majority – artists and critics. Now, if we start from the assumption that new, i.e., 'other,' art is in fact never more than the same thing in a new guise, the heart of the problem is exposed. To abandon the search for a new form at any price means trying to abandon the history of art as we know it: it means passing from the *Mythical* to the *Historical*, from the *Illusion* to the *Real*.

c) *Color.* In the same way that the work which we propose could not possibly be the image of some thing (except itself, of course), and for the reasons defined above could

not possibly have a finalized external form, there cannot be one single and definitive color. The color, if it was fixed, would mythify the proposition and would become the zero degree of color X, just as there is navy blue, emerald green or canary yellow.

One color and one color only, repeated indefinitely or at least a great number of times, would then take on multiple and incongruous meanings. All the colors are therefore used simultaneously, without any order of preference, but systematically.

That said, we note that if the problem of form (as pole of interest) is dissolved by itself, the problem of color, considered as subordinate or as self-generating at the outset of the work and by the way it is used, is seen to be of great importance. The problem is to divest it of all emotional or anecdotal import. [...]

d) *Repetition*. The consistency – i.e., the exposure to view in different places and at different times, as well as the personal work, for four years – obliges us to recognize manifest visual repetition at first glance. We say at 'first glance,' as we have already learned from sections (a) and (b) that there are divergences between one work and another; however, the essential, that is to say the internal, structure remains immutable. One may therefore, with certain reservations, speak of repetition. This repetition provokes two apparently contradictory considerations: on the one hand, the reality of a certain form (described above), and on the other hand, its *cancelling-out* by successive and identical confrontations, which themselves negate any originality that might be found in this form, despite the systematization of the work. We know that a single and unique 'picture' as described above, although neutral, would be charged by its very uniqueness with a symbolic force that would destroy its vocation of neutrality. Likewise by repeating an identical form, or identical color, we would fall into the pitfalls mentioned in sections (b) and (c). Moreover we would be burdened with every unwanted religious tension if we undertook to idealize such a proposition or allowed the work to take on the ancedotal interest of a test of strength in response to a stupid bet.

There remains only one possibility; the repetition of this neutral form, with the divergences we have already mentioned. This repetition, thus conceived, has the effect of reducing to a minimum the potency, however slight, of the proposed form such as it is, of revealing that the external form (shifting) has no effect on the internal structure (alternate repetition of the bands) and of highlighting the problem raised by the color in itself. This repetition also reveals in point of fact that visually there is no *formal evolution* – even though there is a change – and that, in the same way that no 'tragedy' or composition or tension is to be seen in the clearly defined scope of the work exposed to view (or presented to the eye), no tragedy or tension is perceptible in relation to the creation itself. The tensions abolished in the very surface of the 'picture' have also been abolished – up to now – in the time category of this production. *The repetition is the ineluctable means of legibility of the proposition itself.*

This is why, if certain isolated artistic forms have raised the problem of neutrality, they have never been pursued in depth to the full extent of their proper meaning. By remaining 'unique' they have lost the neutrality we believe we can discern in them. (Among others, we are thinking of certain canvases by Cézanne, Mondrian, Pollock, Newman, Stella.)

Repetition also teaches us that there is no perfectibility. A work is at zero level or it is not at zero level. To approximate means nothing. In these terms, the few canvases of the artists mentioned can be considered only as empirical approaches to the problem.

Because of their empiricism they have been unable to divert the course of the 'history' of art, but have rather strengthened the idealistic nature of art history as a whole.

e) *Differences*. With reference to the preceding section, we may consider that repetition would be the right way (or one of the right ways) to put forward our work in the internal logic of its own endeavor. Repetition, apart from what its use revealed to us, should, in fact, be envisaged as a 'method' and not as an end. A method that definitively rejects, as we have seen, any repetition of the mechanical type, i.e., the geometric repetition (superimposable in every way, including color) of a like thing (color + form/shape). To repeat in this sense would be to prove that a single example already has an energy that denies all neutrality, and that repetition could change nothing.

One rabbit repeated 10,000 times would give no notion whatever of neutrality or zero degree, but eventually the identical image, 10,000 times, of the same rabbit. The repetition that concerns us is therefore fundamentally the presentation of the same thing, but under an objectively *different* aspect. To sum up, manifestly it appears to us of no interest always to show precisely the same thing and from that to deduce that there is repetition. The repetition that interests us is that of a method and not a mannerism (or trick): it is a repetition with differences. One could even say that it is these differences that make the repetition, and that it is not a question of doing the same in order to say that it is identical to the previous – which is a tautology (redundancy) – but rather a *repetition of differences with a view to a same (thing)*.
* * *

f) *Anonymity*. From the ... preceding sections there emerges a relationship which itself leads to certain considerations; this is the relationship that may exist between the 'creator' and the proposition we are attempting to define. First fact to be established: *he is no longer the owner of his work*. Furthermore, it is not *his* work, but *a* work. The neutrality of the purpose – 'painting as the subject of painting' – and the absence from it of considerations of style forces us to acknowledge a certain anonymity. This is obviously not anonymity in the person who proposes this work, which once again would be to solve a problem by presenting it in a false light – why should we be concerned to know the name of the painter of the Avignon *Pietà* – but of *the anonymity of the work itself as presented*. This work being considered as common property, there can be no question of claiming the authorship thereof, possessively, in the sense that there are authentic paintings by Courbet and valueless forgeries. As we have remarked, the projection of the individual is nil; we cannot see how he could claim his work as belonging to him. In the same way we suggest that the same proposition made by X or Y would be identical to that made by the author of this text. If you like, the study of past work forces us to admit that there is no longer, as regards the form defined above – when it is presented – any truth or falsity in terms of conventional meaning that can be applied to both these terms relating to a work of art. [...] It may also be said that the work of which we speak, because neutral/anonymous, is indeed the work of someone, but that this someone has no importance whatsoever [*since he never reveals himself*], or, if you like, the importance he may have is totally archaic. Whether he signs 'his' work or not, it nevertheless remains anonymous.

g) *The Viewpoint – the Location*. Lastly, one of the external consequences of our proposition is the problem raised by the location where the work is shown. In fact

the work, as it is seen to be without composition and as it presents no accident to divert the eye, becomes itself the accident in relation to the place where it is presented. The indictment of any form considered *as such*, and the judgment against such forms on the facts established in the preceding paragraphs, leads us to question the finite space in which this form is seen. It is established that the proposition, in whatever location it be presented, does not 'disturb' that location. The place in question appears as it is. It is seen in its actuality. This is partly due to the fact that the proposition is not distracting. Furthermore, being only its own subject matter, its own location is the proposition itself, which makes it possible to say, paradoxically: the proposition in question 'has no real location.'

In a certain sense, one of the characteristics of the proposition is to reveal the 'container' in which it is sheltered. One also realizes that the influence of the location upon the significance of the work is as slight as that of the work upon the location.

This consideration, in course of work, has led us to present the proposition in a number of very varied places. If it is possible to imagine a constant relationship between the container (location) and the contents (the total proposition), this relationship is always annulled or reinvoked by the next presentation. This relationship then leads to two inextricably linked although apparently contradictory problems:

i) revelation of the location itself as a new space to be deciphered;

ii) the questioning of the proposition itself, insofar as its repetition (see sections [d] and [e]) in different 'contexts,' visible from different viewpoints, leads us back to the central issue: What is exposed to view? What is the nature of it? The multifariousness of the locations where the proposition is visible permits us to assert the unassailable persistence that it displays in the very moment when its nonstyle appearance merges it with its support.

It is important to demonstrate that while remaining in a very well-defined cultural field – as if one could do otherwise – it is possible to go outside the cultural location in the primary sense (gallery, museum, catalogue . . .) without the proposition, considered as such, immediately giving way. This strengthens our convinction that the work proposed, insofar as it raises the question of viewpoint, is posing what is in effect a new question, since it has been commonly assumed that the answer follows as a matter of course.

We cannot get bogged down here in the implications of this idea: we will merely observe for the record that all the works that claim to do away with the object (Conceptual or otherwise) are essentially dependent *upon the single viewpoint* from which they are 'visible,' a priori considered (or even not considered at all) as ineluctable. A considerable number of works of art (the most exclusively idealist, e.g., Readymades of all kinds) 'exist' only because the location in which they are seen is taken for granted as a matter of course.

In this way, the location assumes considerable importance by its fixity and its inevitability; becomes the 'frame' (*and the security that presupposes*) at the very moment when they would have us believe that what takes place inside shatters all the existing frames (manacles) in the attaining of pure 'freedom.' A clear eye will recognize what is meant by freedom in art, but an eye that is a little less educated will see better what it is all about when it has adopted the following idea: that the location (outside or inside) where a work is seen is its frame (its *boundary*).

III Preamble

One might ask why so many precautions must be taken instead of merely putting one's work out in the normal fashion, leaving comment to the critics and other professional gossip columnists. The answer is very simple: complete rupture with art – such as it is envisaged, such as it is known, such as it is practised – has become the only possible means of proceeding along the path of no return upon which thought must embark; and this requires a few explanations. This rupture requires as a first priority the revision of the history of art as we know it, or, if you like, its radical dissolution. Then if one rediscovers any *durable and indispensable criteria* they must be used not as a release from the need to imitate or to sublimate, but as a [*reality*] that should be restated. A [*reality*] in fact which, although already 'discovered' would have to be challenged, therefore to be created. For it may be suggested that, at the present time [*all the realities*] that it has been possible to point out to us or that have been recognized, are not *known*. To recognize the existence of a problem certainly does not mean the same as to know it. Indeed, if some problems have been solved empirically (or by rule of thumb), we cannot then say that we know them, because the very empiricism that presides over this kind of discovery obscures the solution in a maze of carefully maintained enigmas.

But artworks and the practice of art have served throughout, in a parallel direction, to signal the existence of certain problems. This recognition of their existence can be called practice. The exact knowledge of these problems will be called theory (not to be confused with all the aesthetic 'theories' that have been bequeathed to us by the history of art).

It is this *knowledge* or *theory* that is now indispensable for a perspective upon the rupture – a rupture that can then pass into the realm of fact. *The mere recognition* of the existence of pertinent problems *will not suffice for us*. It may be affirmed that all art up to the present day has been created on the one hand only *empirically* and on the other out of idealistic thinking. If it is possible to think again or to think and create theoretically/scientifically, the *rupture* will be achieved and thus the word 'art' will have lost the meanings – numerous and divergent – which at present encumber it. We can say, on the basis of the foregoing, that the rupture, if any, can be (can only be) epistemological. This rupture is/will be the resulting logic of a theoretical work at the moment when the history of art (which is still to be made) and its application are/will be envisaged theoretically: theory and theory alone, as we well know, can make possible a revolutionary practice. Furthermore, not only is/will theory be indissociable from its own practice, but again it may/will be able to give rise to other original kinds of practice.

Finally, as far as we are concerned, *it must be clearly understood that when theory is considered as producer/creator, the only theory or theoretic practice is the result presented/ the painting* or, according to Althusser's definition: 'Theory: a specific form of practice.'

We are aware that this exposition of facts may be somewhat didactic; nevertheless we consider it indispensable to proceed in this way at this time.

VIIB
Attitudes to Form

1 Terry Atkinson (b. 1939) and Michael Baldwin (b. 1945) 'Air Show'

In 1968 the formation of Art & Language gave a name to the various collaborative practices which had developed between four English artists: Atkinson, Baldwin, David Bainbridge and Harold Hurrell. One of the group's typical procedures was to propose a theoretical model which pursued the implications of some current avant-garde works or proposals, and then to subject this to logical and speculative examination. In the process, new conceptual objects were generated which were intentionally resistant to normal critical procedures (see VIIB5). In the present essay a volume of air is taken as a hypothetical object. The implication is that the conceptual framework within which an object is singled out determines what kind of object it is that is singled out. References in the text to the 'air-conditioning situation' are to a contemporary, and comparable, project; the 'perusal tradition', with its attendant 'rhapsody', indicates the conventional condition of spectatorship. The argument is conducted with an eye to American Modernism, and particularly to the forms of object proposed by the Minimalists. The present text is taken from the booklet *Frameworks – Air Conditioning*, written in 1967 and published as a limited edition by Art & Language Press, Coventry, in 1968. This was reprinted with some corrections in *Art & Language*, Eindhoven (van Abbe Museum), 1980, pp. 1–14, from which the present text is taken.

The fog bank is a macroscopic aggregate. There is no theoretical primacy here for this macroscopic aspect. That is, its importance or unimportance is shown up by raising and answering internal questions to the framework.

There is no rhapsody here.

The macroscopic aggregate can be subjected to a micro-reductive examination. The horizontal dimensions of a 'column' of air, atmosphere, 'void', etc. can be indicated and established (for all 'external' and practical purposes) by a visible demarcation in terms of horizontal dimensions, axis, etc. This could be done in a number of ways: e.g. through the indication of some points of contiguity with other 'things', or through the computation of a particular physical magnitude – e.g. temperature or pressure differences, etc. (this is not necessarily to advocate an instrumental situation). None of this is to say that a complete, if only 'factual' or constructual, specification is to be expected.

Obviously, when one talks of a column, there is some reference to a visual situation (from whence the vocabulary may or may not find support). There is a comparison to be made here between the 'air-conditioning situation' and the fog bank, in which the obvious physical differences between the 'matter' which constitutes the indicators of

this or that 'boundary' can be made out. This is not to describe the difference between boundaries per se, nor is it to exclude the possibility of regarding 'boundaries' as 'entifications' of geometrical gaps.

Mostly, anyway, the questions of 'demarcation' are external ones of a practical nature. Still, they remain securely rooted in the perusal tradition, so long as one considers them in the context of particularizing characteristics at an observational level.

A lot of emphasis was placed on the microscopic mechanical aspects of procedure and process in the air-conditioning situation; it's easy to raise and answer the same sort of question here. The objection to doing this is based in a rejection of the problems of 'visualization' (and 'identification' in that context) on theoretical grounds. The microscopic picture has a counterweight origin in the macroscopic aspect of a situation. Whilst articulation on and identification of air as a 'thing' conforms to this tradition, the molecular mechanical concept of 'particle', 'flux' (of energy), and the 'thing', 'particle' identity systems appear to be incompatible. What is interesting about thermodynamics is that it is restricted to the formulation of necessary conditions for an occurrence . . .

There is a challenge to the million years habit of identifying 'things'. The recognizance of something as something is another question bound up with aspects of things, and not solely with 'identification' per se. The structure of kinetic theory, for example, is built on the (extralinguistic, extralogical) mechanics of so-called 'common-sense' objects. There is a rooted assumption that the laws and concepts of Newtonian mechanics, 'proved' by experience to be valid for 'day to day objects', continue to have the same meaning beyond the macroscopic-microscopic domain as they do within it. The kinetic theory represents the micro-reductive approach to the study of the properties of material aggregates. It interprets thermal phenomena in terms of properties and interactions of the constituents of material assemblies. Thermodynamics, on the other hand, is not based on any definite assumptions as to the ultimate constitution of matter. The foundations are in very few general empirical principles (appertaining to the behaviour of complex thermal systems).

Since the Greeks, speculation concerning the identity of matter has run directly toward the atomic theory. Bridgman held that there seems to be no logical or empirical justification for this. Rather, it seemed to him that it was a psychological fact that the search to 'identify' things demands the atomic particle concept. Persistently, even in a science like meteorology, which treats critically of thermal systems, the methodological and definitory approach is such that it draws exclusively from the kinetic theory of identity. (It is of interest to point out, here, that the meteorological phenomena which are most disruptive, etc. are usually those with a visible aspect (macroscopic). 'Invisible fog' is self-contradictory in all common contexts of usage – (i.e. 'Invisible' contradicts the formal signs 'fog' or 'cloud'. And both signs refer to the characteristics (in terms of 'visibility') of the meteorological objects to which they are assigned.)

The point here is not to make the gravamen of the discussion that people compulsively picture both assemblies which are such that they do fit the 'picturing' function and assemblies such that they do not. The suggestion is, rather, that the concept of identities like flux of heat and flux of energy might be inchoative; and that not only in the sense that the identity of heat and energy may be made clearer. This is a case of wondering about various aspects – the heat/energy identity is only held out on the grounds of a possible analogy with a situation internally relevant to these consider-

ations: the prime consideration is that in the further development of what at the moment appear to be 'enigmatic' entities, there might be raised interpellations concerning e.g. the concept of identity, etc. One of the big troubles in seeking extrapolations is that it is the function of extrapolations to explain and explanation always involves reducing terms to something familiar. And we do not want to get casuistically stuck with 'picturing', or with the pure or the alloy of visualization.

The air will have volume, determined by what we call the thermo-dynamic factors in the situation. Here we are talking about the fact that experience has learnt us to expect that everything has a volume and a temperature. It would be relevant here to examine the concepts of volume and temperature. Volume is calculated by measuring the various lengths and then multiplying the resulting measurements (height, length, width). The proper definition of length is that it is an extensive concept; that is larger amounts can be formed by reduplicating smaller amounts. [...]

[...] we measure temperature by the same sort of unit that we use to measure volume, namely a unit of length. Defining temperature by relating it to expansion characteristics of particular materials is in most respects a satisfactory definition. But should a proper definition of temperature involve only an arbitrary specification of only a unit and not of a whole scale? The problem of the temperature scale was solved conceptually by the Second Law of Thermodynamics. The law revealed how a selected temperature unit could be reduplicated without reference to the particular properties of a particular substance, thereby giving temperature a fundamental definition.

It is relevant, here, to consider how far the conviction that atomic theories support the means whereby any phenomenon may be described and explained (and the view that theories are for explanation at all) corresponds to the one which seems to indicate a preoccupation of artists with 'exegesis' etc. from entities which paradigmatically instantiate assertions like '...is over there, in that place' etc; and how much can be shown up of a theoretical situation which is at most gerrymandered.

Schlesinger writes in his book 'Method in the Physical Sciences': '...This conviction was shared by a number of other philosophers, notable among them Pierre Duhem. They argue that a priori metaphysical doctrines and empirical evidence was what motivated scientists in their search for atomic theories to explain heat phenomena. The metaphysical doctrines in question derived, according to Mach and Duhem, from the mechanistic world view, which permeated all nineteenth century philosophy, a view in which mechanics was regarded as the most fundamental of all the sciences. Those who shared this belief in the superior status of mechanics were naturally keen to accept the hypothesis of the atomic theory of matter. It enabled them with the aid of kinetic theory, to explain thermal phenomena in terms of the mechanical properties of the molecules, thus reducing the science of heat to the science of mechanics. They believed that ultimately all science would be reduced to mechanics.'

It might be suggested that infatuation with the art 'object' (in the obdurate 'material' sense of 'object') had a connection with an analogous psychological fact. There has been a strong prejudice to correlate the category of 'existence' with a mechanical explanation and to glorify that category in non-cognitive contexts. There is, in this glorification, an inured disparagement of the category of possibility. The constants of the present situation are in no way held up in the concept of 'enduring substances'. Those invariant connections or categories are assumed which are capable of indicating and supporting (and of functioning as paradigms) developments (etc.) in the theoretical situation. (And

this is not to put in a plea for some revision of the necessary questions of interpreta-
tion.)...There is little point in dwelling on prognostications concerning relevant
procedures and attitudes – certainly in so far as one could easily fall into a dialectical
carve-up of the various fields and purposes, etc. there is a danger of constantly asking
outside questions. [...]

 [...] The theory is satisfactorily fomented on a lot of axes. One is that of 'mention' –
i.e. that a 'thing' is mentioned fulfils (or may fulfil) a condition for its coming up for the
count. (And it should be pointed out here that 'mention' is distinct from 'use'.) That
this or that achieves 'mention' presupposes no external questions about it. And there is
no indication of its being defective in any way (e.g. being fictional, etc.). To argue a
distinction between a construct of the air-show theory and those of the perusal situation
is pointless: one would have to argue through the common confusion centering on the
mutual dependence of opposite determinations. Syncretism is difficult with concepts
which (on analogy with terms) remain multiply ambiguous. And this is one way to look
at a lot of the concepts which enter much of the outside question-raising. [...]

Note

The specificity of a work as an indication of the legitimacy etc. of the mode which
carries it: the preference statements which push up properties like those fall into
theological esthetics (Pythagorean) rather than any other discipline. Similarly with
the things which are said for 'simple forms', etc.

 It is obvious that the elements of a given framework (and this includes the constitu-
ents of construct contexts) are not at all bound to an eleminative specifying system.
There is a case for a new type of element specification (which might go towards
ameliorating the problematic character of external questions) which does not presup-
pose a certain ontological or physical status (depending on the context) for it to come-
up for the count. This is perhaps to look at the syntagmatic and syntactical aspects of
internal questions (certainly in the theoretical situation), viz. the introduction of certain
terms, and the rejection of certain questions which, with respect to the framework
itself, are devoid of cognitive content. And this, synallagmatically related to the internal
introduction of new descriptive terms, etc. which provide an appropriate and consistent
non-eliminative context for nomological implication (say) to get pulled out. (If one
talked of new 'specifications' there would be no hint of 'additional elements'.) A
reassertion is that the acceptance of a framework is not an invitation to ask outside
questions. [...]

 One point is that this approach, falling into a methodological framework, offers one a
purchase on various assertions of material implication, irrespective of the mode in
which this or that assertion might find its range of application and irrespective of its
structural or theoretical position, etc. Certainly, in much work which purports to be
theoretical, there is a failure to analyse the meanings of nomological (implications)
conditionals (i.e. those conditionals which express causal connection). (And all this is in
the connection of inside questions.) The framework might be a lot more catholic than it
looks. [...]

* * *

 The characteristic 'perusal situation', together with its analytically explicated notions
of 'proximity', 'remoteness' and 'visibility', 'identify-ability,' etc. (and 'operational'

definition) is one where assertive objects and eccentric detail can only be shouted down with contrasting rhapsodies and requirements, or with partial 'paradigms' of alternatives ('smooth' places, etc.). A mode which takes a far less catholic view of these notions and concepts is just as well qualified to come up for the count.

The question could be asked whether or not the entities one is considering are theoretical ones (about which only internal questions are to be asked – as they may be in the theoretical framework). Certainly, so far as the tenets of the perusal situation are concerned. The point is that external questions are of little cognitive value.

It seems wrong that all the entities which are to come up for the count should be 'translatable' into the 'perusal situation' (i.e. the direct 'observation' situation). It is not for us to decide whether or not this or that thing is 'operationally respectable'. (From now on, the strict phenomenalist is going to object that we are dealing with theoretical fictions in those situations where one didn't go around with instruments, etc. – filling in the referential blanks, so to speak.) We don't comprehend here any generalized (i.e. with an overall application) definite rules of construction. Now, forgetting the strong objection that to predicate 'exists', etc. of anything says nothing, to say that '. . . is a real thing' isn't the same as saying '. . . is made of real gold', etc. (This is not to say that assertions like the former are necessarily legitimate.) Anyway, saying it isn't much, but it is to deny that a concept which is not 'operationally' defined can only get justification for being around by being well established in a theory – there is not only one sort of non-operational concept (i.e. non-perusal concept) and there is not only one sort of theoretical entity. The concept of a line of electric force (the term 'force' itself is a metaphorical one (cf. Turbayne, 'The Myth of Metaphor')) has as much right to come up for the count as any other (concept) but its status remains different from those concepts which are not purely fictional (e.g. logical constructions, etc.).

A concept which is different, but not all that different from that of a line of electric force is that of 'the sensibility of the 60s' (it doesn't matter whether or not one approves of it here) which is just a 'useful' fiction: providing people with some sort of picture to help them in discerning distribution, etc. of various constructs, etc.

A conceivably persistent objection that there has so far been no indication that one is concerned with anything other than 'fictional entities' (in so far as it doesn't seem to matter if that's what they are), whereas paintings, sculptures, series of numbers, etc. on boards, etc. are 'real' things – concrete entities – offering actual, concrete experiences, etc., can be answered only by the evincing of at least possible instrumental tests, etc. or by bringing in 'imaginability' criteria. When a statement is made, to the effect that, say, a sculpture is made of 'real' gold, or that it's a 'real' solid, etc. there is an implication that it's not made of an imitation, or that it's not defective in some way, etc. Something like that can be said of the things in a framework – but not about the things themselves. It's said of the concept of the thing. The question as to whether or not one can say that something is 'real' here is not one that comes up naturally; the circumstances in which the question might arise would be those in which one is looking for concepts' defects (e.g. being fictional).

The objector would just be asserting that these 'things' don't occur in the series clouds, paintings, bricks, and molecules – the perusal situation.

No one is likely to deny that microscopic particles are acceptable in the aesthetic domain, no less than bricks, etc., but one might expect some resistance to the view that things which don't even come within the range of instrumental operations (or some

kind, however gerrymandered, of 'verificationist' theory, etc.) still qualify for the count. It's no more than a contingent fact that people are incapable of differentiating between temperatures of, say, 50°C and 51°C of the surface of two objects without the use of 'instruments' of some sort: it is maintained here that the 'things' which come up for the count ('Air Show' – not 'air-conditioned rooms') get their meanings from the part they play in the theory: and this is to suggest that there are theoretical reasons why it is pointless to hope for an entry into the perusal – even 'observational' – situation.

* * *

A question to be asked is, how many axes of interpretation are to be entertained in this connection? Another is, how far away has one got here from 'frameworks'? It seems that we don't just have to open-up criteria of 'acceptability'.

2 Michelangelo Pistoletto (b. 1933) 'Famous Last Words'

In the late 1960s Pistoletto became a leading figure in the Italian 'Arte Povera' avant-garde grouping, though he had pursued a successful independent career before 'Arte Povera' was broached, and was never to confine himself to the concentration on basic materials advocated by the group's critical apologist, Germano Celant. Pistoletto commenced as a painter, concentrating on self-portraits. By 1962, however, he had begun to consider the mirror as itself an element to explore. He began the long series of 'mirror paintings' which have continued throughout his career: reflective surfaces onto which are printed or stuck still images of figures going about a variety of daily activities, and underpinned by meditations on identity and doubling. In the mid-sixties Pistoletto began a different type of work which broke with the normal conventions according to which the development of an artist's oeuvre involves the refinement of a certain style. The 'Minus Objects' were a heterogeneous collection of objects and structures, apparently devoid of either stylistic or thematic coherence. At this time, he also engaged in a variety of performance-related activities with the Turin-based collective *Zoo*. Some of these involved the Minus Objects, as when a sphere made of pulped and compressed daily newspapers was trundled round the city streets in 1967. In the present two-part text, which dates from that year, Pistoletto discusses the ideas behind the mirror paintings before going on to talk about 'new work', that is, the series of 'Minus Objects'. Our version is taken in full from the translation by Henry Martin published in the exhibition catalogue *Pistoletto*, edited by Germano Celant, New York: Rizzoli, 1989, pp. 72–3.

The Speculation

When a man realizes that he has two lives, an abstract one for his mind and a concrete one which is also for his mind, he ends up either like a madman, who, out of fear, hides one of his lives and plays the other as a role, or like the artist, who has no fear and who is willing to risk the both of them.

Man has always attempted to double himself as a means of attempting to know himself. The recognition of one's own image in a pool of water like recognizing oneself in a mirror was perhaps one of the first real hallucinations that man experienced. And a part of man's mind has always remained attached to that reproduction of himself. With the passage of time, this doubling, this process of duplication came to be used in ways which were ever more systematic, and ever more convinced. The mind created

representation on the basis of the reflection of the self. And art has become one of the specialties of this representation.

Man began to use reflection as a strategical point for the measurement of the universe. No longer content with the first hallucination of himself, he convinced himself that he could double the entirety of the universe. This was his way of trying to understand it.

Mathematics was constructed out of the realization that oneself plus another could make two and that oneself minus another was one. And at the beginning, the lesson was rather brutal. It was not simply a matter of what happens today when we hide one of two apples behind our backs to show baby that there is only one. At the beginning, 'minus one' meant that one of the two was dead, that the much loved mother or father or brother, who when added to the self had made two, was no longer among the living.

And thus the experience of life and death was made abstract, and addition became a positive sign and subtraction became a negative sign. The complicating intelligence then elaborated these signs into multiplications and divisions, creating an ever more majestic series of hallucinations, and everything in life ordered itself in the mind in terms of two extreme and contrary, positive, and negative possibilities.

It seems paradoxical that drugs today should be prohibited when one stops to think that our civilization itself is the fruit of one mammoth mind-shaking hallucination. But, perhaps, it is feared that drugs constitute a kind of inverse reflection that could dismantle the entirety of the set-up.

At any rate, man began to measure the universe in terms of his own direct experience of life and death, and then he went on to the great work of creating good and evil. In the light of the day he said 'white' and in the darkness of the night he said 'black.' And, always remaining at the center of things, he created perspective. The world was seen in terms of vanishing points and points of view with respect to the position of man's eye at about five feet above ground level, and from that point he created high and low.

Past and future, near and distant, profound and superficial, true and false, single and multiple, subjective and objective, static and dynamic. These are a few examples of the complex of antinomies that has grown up around the human being as the fruit of his mind. In constant and ever more gigantic expansion, the process began with the first man who walked the earth, and it has continued until today. The world that we daily inhabit both physically and mentally is made up of the conflict between the two extreme halves of every proposition and every evaluation.

When my need to understand things began to face up to the consideration of life itself, I instinctively understood all of the conflicts in this system of doubling, all of the things of the universe. Looking at works of art, I felt the force with which I was constrained to oscillate between one dimension of experience, which was abstract and mental, and another dimension of experience which was concrete and physical. And it was in the fact of representation that I discovered the poles that were in simultaneous attraction and repulsion, my literal presence as proposed by the mirror and my intellectual presence as proposed by my painting. These two presences of myself were the two lives that were at one and the same time tearing me in two and calling me with urgency to the task of their unification.

At the time when I first began to paint, the art of the avantgarde was abstract. It was directing its attention only to the second life, the reflected life. This reflected life seemed to have become so true as to be able to convince us that it was by now the only

life which was livable and Pollock had truly attempted to live it. In every moment, and with all of the will of living, his every gesture violently transferred itself to the canvas to such an extent he no longer knew what to do with physical life. Not even madness could save him, since, as an artist, he was incapable of play-acting. There was nothing left but death.

My way of risking each of my two lives has been a matter of directly superimposing my painted image upon my reflected image. By becoming but one single thing, my two 'characters' have ceased acting out the drama of the death of one of them for the benefit of the other. And thus, being and non-being, question and answer, doubt and certainty, and all of the other antinomies have unified their terms into one single element. The culture projected by the mirror is thrown back upon the mirror and we stand in front of a new hallucination, the hallucination of reflection in reverse. The entire system of representation has been flip-flopped like turning a sleeve inside out. By means of the arc of reverberations which is literally pertinent to these paintings (the abstract reflected by life, and life reflected by the abstract), the system has arrived at a reflection of itself, like a dog that chases its own tail. The experience which these paintings offer is the experience of finding oneself in a vehicle of extraordinary speed which is capable in a single instant of making a round trip from today to the remotest past and back again.

The Being

The purpose and the result of my mirror paintings was to carry art to the edges of life in order to verify the entire system in which both of them function. After this, there remains only one choice. On the one hand, there is the possibility of a monstrous involution and a return into the system of doubling and conflict, and, on the other hand, there is the possibility of revolution and leaving the system altogether. One can bring life to art, as Pollock did, or one can choose to bring art into life but no longer in terms of metaphor.

I don't want to talk, now, about my new works one at a time. Since they are each different from the other, that would require numerous descriptions of the various contingent factors and motivations that went into their making. I want to talk about the vision that I have had as a result of the mirror paintings since 1964.

Some time ago, I wrote this sentence on the wall of my studio: 'One must prepare oneself for being.' My every action is in this direction. Nothing is more opposed to being than the so much loved ambiguity of art. The ambiguity of art is simply a matter of putting two things in relationship, so as to be able to observe the representation of their conflict. It is what the Romans were doing when they put the lions and the Christians in the arena so as to be able to enjoy the spectacle. The discovery that flint can make fire is a very primitive hallucination, and a new civilization cannot be organized by using the two halves of man's mind like two pieces of flint. There must be no spark between the two things, no spark between us and ourselves. If we remain suspended between ourselves and our representation, we ourselves are the spark and the conflict.

The error was all a matter of giving two functions to the intellect. The intellect is capable of raising questions, but it cannot give answers. But, nonetheless, we have always attempted to make it give answers, as if the middle of the day could create the

heart of night, or vice versa. The day and the night follow upon one another, but they are two separate things with two different natures.

We believed that the day and the night were but a single thing with two possibilities, that life and death were but a single thing with two possibilities, that the intellect was a single thing with two possibilities. Yes, the intellect is a single thing, but it has only one possibility. If the intellect raises the questions, we must out-flank it, step to one side, and use another mechanism for the answers. The intellect now is frustrated since it has continuously failed to do two tasks, and the other mechanisms have atrophied.

In my new work, every piece grows out of an immediate stimulus of the intellect, but they in no way function as definitions, justifications, or answers. They do not represent me. Each successive work or action is the product of the contingent and isolated intellectual or perceptual stimulus that belongs to one moment only. After every action, I step to one side, and proceed in a direction different from the direction formulated by my object, since I refuse to accept it as an answer. Predetermined directions are contrary to man's liberty. To predetermine something means to make a commitment for tomorrow; it means that tomorrow I will no longer be free. To adhere to a predetermined idea means to reflect oneself in the past and to deprive oneself of free will. Unity of language must be predetermined, and it demands that we adhere to it. To believe in one's own language means to play one's own role. Languages are posited as fictions between us and the others in the midst of a mass of individuals who play-act themselves and who are always ready to be manipulated by the directors. There are certain men of extraordinary intelligence who are frustrated by some kind of a personal complex or another, and they are turned themselves into theatrical characters on the basis of it and they believe in the character so thoroughly that they presume to make even the others play it. These are society's directors, the ones who send the actors to kill and be killed by the evil that they, the directors, have perceived in themselves. And all of this happens when it would have been sufficient to make a little step to one side, proceed on one's own way, and abandon the complexes without instrumentalizing them.

The way in which I move now is by stepping to one side. Every piece I make is a liberation and not a construction intended to represent me. I am not reflected in the pieces, and others cannot reflect upon me by means of them. Every piece I make is destined to proceed on its own way by itself, without dragging me along behind it, since I am already somewhere else and doing something different. There is no longer any sense in the problem of being up to date in form. The problem is not to change the forms and leave the system intact but rather to take the forms intact out of the system. In order to do this, it is necessary to be absolutely free. And worrying about whether or not the forms are up to date means not being free to consider the forms of the past. And, since we do not yet possess the forms of the future, liberty within the system means liberty to do only one thing. As far as I am concerned, there are no such things as forms that are more or less up to date. All forms, materials, ideas, and means are available and to be used. Walking by means of stepping to one side takes us out of the system that goes straight ahead. There is no goal before us with laurels for the first to arrive and ashes for the last. The wild race for the abstract point structures itself into a system of battles between both individuals and masses. When we move ahead by stepping to one side, the race between the individuals becomes a series of parallels, since every individual proceeds individually, without projecting himself out of himself

onto abstract points or other individuals. When we move in this way there are no such things as better or worse, since everybody is what he is and does what he does. Nobody has any need to pretend in order to prove that he is the better, and communication becomes very easy without the structures of language, since it is easy to understand who everybody is and what he is like. For communication and understanding, we will finally be able to develop all of the possibilities of the mechanism of perception.

3 Robert Smithson (1938–1973) 'A Sedimentation of the Mind: Earth Projects'

Like his artistic works, Smithson's writings of the later 1960s combine eclecticism, imaginativeness and irony in their critical address to the categories and protocols of a more standard Modernist aesthetics. His early 'earth projects' were not simply proposals for forms of site-specific work; more significantly, they were strategic incursions into the no-man's-land between the aesthetic preserves of Modernism and the disregarded margins of the modern industrial world. In turn, Smithson explored the natural world as the ground on which the ideological character of our concepts is revealed. This essay was originally published in *Artforum*, New York, September 1968; reprinted in Nancy Holt (ed.), *The Writings of Robert Smithson*, New York, 1979, pp. 82–91, from which the present text is taken. (Smithson refers to texts by Tony Smith and Michael Fried printed in VIA22 and VIIA7 respectively. See also VIID6.)

The earth's surface and the figments of the mind have a way of disintegrating into discrete regions of art. Various agents, both fictional and real, somehow trade places with each other – one cannot avoid muddy thinking when it comes to earth projects, or what I will call 'abstract geology.' One's mind and the earth are in a constant state of erosion, mental rivers wear away abstract banks, brain waves undermine cliffs of thought, ideas decompose into stones of unknowing, and conceptual crystallizations break apart into deposits of gritty reason. Vast moving faculties occur in this geological miasma, and they move in the most physical way. This movement seems motionless, yet it crushes the landscape of logic under glacial reveries. This slow flowage makes one conscious of the turbidity of thinking. Slump, debris slides, avalanches all take place within the cracking limits of the brain. The entire body is pulled into the cerebral sediment, where particles and fragments make themselves known as solid consciousness. A bleached and fractured world surrounds the artist. To organize this mess of corrosion into patterns, grids, and subdivisions is an esthetic process that has scarcely been touched. [. . .]

Primary Envelopment

At the low levels of consciousness the artist experiences undifferentiated or unbounded methods of procedure that break with the focused limits of rational technique. Here tools are undifferentiated from the material they operate on, or they seem to sink back into their primordial condition. Robert Morris . . . sees the paint brush vanish into Pollock's 'stick,' and the stick dissolve into 'poured paint' from a container used by Morris Louis. What then is one to do with the *container*? This entropy of technique leaves one with an empty limit, or no limit at all. All differentiated technology becomes meaningless to the artist who knows this state. 'What the Nominalists call the grit in the machine,' says

T. E. Hulme in *Cinders*, 'I call the fundamental element of the machine.' The rational critic of art cannot risk this abandonment into 'oceanic' undifferentiation, he can only deal with the limits that come after this plunge into such a world of non-containment.

At this point I must return to what I think is an important issue, namely Tony Smith's 'car ride' on the 'unfinished turnpike.' 'This drive was a revealing experience. The road and much of the landscape was artificial, and yet it couldn't be called a work of art.' . . . He is talking about a sensation, not the finished work of art; this doesn't imply that he is anti-art. Smith is describing the state of his mind in the 'primary process' of making contact with matter. This process is called by Anton Ehrenzweig 'dedifferentiation,' and it involves a suspended question regarding 'limitlessness' (Freud's notion of the 'oceanic') that goes back to *Civilization and its Discontents*. Michael Fried's shock at Smith's experiences shows that the critic's sense of limit cannot risk the rhythm of dedifferentiation that swings between 'oceanic' fragmentation and strong determinants. Ehrenzweig says that in modern art this rhythm is 'somewhat onesided' – toward the oceanic. Allan Kaprow's thinking is a good example – 'Most humans, it seems, still put up fences around their acts and thoughts'. . . . Fried thinks he knows who has the 'finest' fences around their art. Fried claims he rejects the 'infinite,' but this is Fried writing in *Artforum*, February 1967 on Morris Louis, 'The dazzling blankness of the untouched canvas at once repulses and engulfs the eye, like an infinite abyss, the abyss that opens up behind the least mark that we make on a flat surface, or would open up if innumerable conventions both of art and practical life did not restrict the consequences of our act within narrow bounds.' The 'innumerable conventions' do not exist for certain artists who *do* exist within a physical 'abyss.' Most critics cannot endure the suspension of *boundaries* between what Ehrenzweig calls the 'self and the non-self.' They are apt to dismiss Malevich's *Non Objective World* as poetic debris, or only refer to the 'abyss' as a rational metaphor 'within narrow bounds.' The artist who is physically engulfed tries to give evidence of this experience through a limited (mapped) revision of the original unbounded state. I agree with Fried that limits are not part of the primary process that Tony Smith was talking about. There is different experience before the physical abyss than before the mapped revision. Nevertheless, the quality of Fried's *fear* (dread) is high, but his experience of the abyss is low – a weak metaphor – 'like an infinite abyss.'

The bins or containers of my *Non-Sites* gather *in* the fragments that are experienced in the physical abyss of raw matter. The tools of technology become a part of the Earth's geology as they sink back into their original state. Machines like dinosaurs must return to dust or rust. One might say a 'de-architecturing' takes place before the artist sets his limits outside the studio or the room.

* * *

From Steel to Rust

As 'technology' and 'industry' began to become an ideology in the New York Art World in the late '50s and early '60s, the private studio notions of 'craft' collapsed. The products of industry and technology began to have an appeal to the artist who wanted to work like a 'steel welder' or a 'laboratory technician.' This valuation of the material products of heavy industry, first developed by David Smith and later by Anthony Caro, led to a fetish for steel and aluminum as a medium (painted or unpainted). Molded steel and cast aluminum are machine manufactured, and as a result they bear

the stamp of technological ideology. Steel is a hard, tough metal, suggesting the permanence of technological values. It is composed of iron alloyed with various small percentages of carbon; steel may be alloyed with other metals, nickel, chromium, etc., to produce specific properties such as hardness and resistance to rusting. Yet, the more I think about steel itself, devoid of the technological refinements, the more *rust* becomes the fundamental property of steel. Rust itself is a reddish brown or reddish yellow coating that often appears on 'steel sculpture,' and is caused by oxidation (an interesting non-technological condition), as during exposure to air or moisture; it consists almost entirely of ferric oxide, Fe_2O_3 and ferric hydroxide, $Fe(OH)_3$. In the technological mind rust evokes a fear of disuse, inactivity, entropy, and ruin. Why steel is valued over rust is a technological value, not an artistic one.

By excluding technological processes from the making of art, we began to discover other processes of a more fundamental order. The breakup or fragmentation of matter makes one aware of the sub-strata of the Earth before it is overly refined by industry into sheet metal, extruded I-beams, aluminum channels, tubes, wire, pipe, cold-rolled steel, iron bars, etc. I have often thought about non-resistant processes that would involve the actual sedimentation of matter or what I called 'Pulverizations' back in 1966. Oxidation, hydration, carbonatization, and solution (the major processes of rock and mineral disintegration) are four methods that could be turned toward the making of art. The smelting process that goes into the making of steel and other alloys separates 'impurities' from an original ore, and extracts metal in order to make a more 'ideal' product. Burnt-out ore or slag-like rust is as basic and primary as the material smelted from it. Technological ideology has no sense of *time* other than its immediate 'supply and demand,' and its laboratories function as blinders to the rest of the world. Like the refined 'paints' of the studio, the refined 'metals' of the laboratory exist within an 'ideal system.' Such enclosed 'pure' systems make it impossible to perceive any other kinds of processes other than the ones of differentiated technology.

Refinement of matter from one state to another does not mean that so-called 'impurities' of sediment are 'bad' – the earth is built on sedimentation and disruption. A refinement based on all the matter that has been discarded by the technological ideal seems to be taking place. The coarse swathes of tar on Tony Smith's plywood mock-ups are no more or less refined than the burnished or painted steel of David Smith. Tony Smith's surfaces display more of a sense of the 'prehistoric world' that is not reduced to ideals and pure gestalts. The fact remains that the mind and things of certain artists are not 'unities,' but *things* in a state of arrested disruption. One might object to 'hollow' volumes in favor of 'solid materials,' but no materials are solid, they all contain caverns and fissures. Solids are particles built up around flux, they are objective illusions supporting grit, a collection of surfaces ready to be cracked. All chaos is put into the dark inside of the art. By refusing 'technological miracles' the artist begins to know the corroded moments, the carboniferous states of thought, the shrinkage of mental mud, in the geologic chaos – in the strata of esthetic consciousness. The refuse between mind and matter is a mine of information.

The Dislocation of Craft – And Fall of the Studio

Plato's *Timaeus* shows the demiurge or the artist creating a model order, with his eyes fixed on a non-visual order of ideas, and seeking to give the purest representation of

them. The 'classical' notion of the artist copying a perfect mental model has been shown to be an error. The modern artist in his 'studio,' working out an abstract grammar within the limits of his 'craft,' is trapped in but another snare. When the fissures between mind and matter multiply into an infinity of gaps, the studio begins to crumble and fall like The House of Usher, so that mind and matter get endlessly confounded. Deliverance from the confines of the studio frees the artist to a degree from the snares of craft and the bondage of creativity. Such a condition exists without any appeal to 'nature.' Sadism is the end product of nature, when it is based on the biomorphic order of rational creation. The artist is fettered by this order, if he believes himself to be creative, and this allows for his servitude which is designed by the vile laws of Culture. Our culture has lost its sense of death, so it can kill both mentally and physically, thinking all the time that it is establishing the most creative order possible.

The Dying Language

The names of minerals and the minerals themselves do not differ from each other, because at the bottom of both the material and the print is the beginning of an abysmal number of fissures. Words and rocks contain a language that follows a syntax of splits and ruptures. Look at any *word* long enough and you will see it open up into a series of faults, into a terrain of particles each containing its own void. [...]
* * *

The Wreck of Former Boundaries

The strata of the Earth is a jumbled museum. Embedded in the sediment is a text that contains limits and boundaries which evade the rational order, and social structures which confine art. In order to read the rocks we must become conscious of geologic time, and of the layers of prehistoric material that is entombed in the Earth's crust. When one scans the ruined sites of prehistory one sees a heap of wrecked maps that upsets our present art historical limits. A rubble of logic confronts the viewer as he looks into the levels of the sedimentations. The abstract grids containing the raw matter are observed as something incomplete, broken and shattered.

The Value of Time

For too long the artist has been estranged from his own 'time.' Critics, by focusing on the 'art object,' deprive the artist of any existence in the world of both mind and matter. The mental process of the artist which takes *place* in time is disowned, so that a commodity value can be maintained by a system independent of the artist. Art, in this sense, is considered 'timeless' or a product of 'no time at all'; this becomes a convenient way to exploit the artist out of his rightful claim to his temporal processes. The arguments for the contention that time is unreal is a fiction of language, and not of the material of time or art. Criticism, dependent on rational illusions, appeals to a society that values only commodity type art separated from the artist's mind. By separating art from the 'primary process,' the artist is cheated in more ways than one. Separate 'things,' 'forms,' 'objects,' 'shapes,' etc., with beginnings and endings are mere convenient fictions: there is only an uncertain disintegrating order that transcends

the limits of rational separations. The fictions erected in the eroding time stream are apt to be swamped at any moment. The brain itself resembles an eroded rock from which ideas and ideals leak.

[...] Any critic who devalues the *time* of the artist is the enemy of art and the artist. The stronger and clearer the artist's *view* of time the more he will resent any slander on this domain. By desecrating this domain, certain critics defraud the work and mind of the artist. Artists with a weak view of time are easily deceived by this victimizing kind of criticism, and are seduced into some trivial history. An artist is enslaved by time, only if the time is controlled by someone or something other than himself. The deeper an artist sinks into the time stream the more it becomes *oblivion*; because of this, he must remain close to the temporal surfaces. Many would like to forget time altogether, because it conceals the 'death principle' (every authentic artist knows this). Floating in this temporal river are the remnants of art history, yet the 'present' cannot support the cultures of Europe, or even the archaic or primitive civilizations; it must instead explore the pre- and post-historic mind; it must go into the places where remote futures meet remote pasts.

4 Robert Morris (b. 1931) 'Notes on Sculpture 4: Beyond Objects'

Written two years after the third of Morris's 'Notes on Sculpture' (VIIA6), this text marks a shift in preoccupations in that it theorizes an *anti*-formal tendency within the American avant-garde which had its counterparts in England and on the European continent. Morris's critique of the concept of the finished artistic product may be seen as extending the critique of relational composition pursued in his and Judd's earlier writings. Here he pursues the McLuhanite notion that developments in the formal characteristics of artistic work are connected to broad changes in the nature of perception (see VIA20). What Morris intends by the practice of art is not a form of craft leading to the production of objects, but a restless agency in this process of change. First published in *Artforum*, New York, April 1969, pp. 50–4, from which the present text is taken.

II

> Then, the field of vision assumes a peculiar structure. In the center there is the favored object, fixed by our gaze; its form seems clear, perfectly defined in all its details. Around the object, as far as the limits of the field of vision, there is a zone we do not look at, but which, nevertheless, we see with an indirect, vague, inattentive vision...If it is not something to which we are accustomed, we cannot say what it is, exactly, that we see in this indirect vision.
>
> <div align="right">Ortega y Gasset</div>

> Our attempt at focusing must give way to the vacant all-embracing stare.
>
> <div align="right">Anton Ehrenzweig</div>

If one notices one's immediate visual field, what is seen? Neither order nor disorder. Where does the field terminate? In an indeterminate peripheral zone, none the less actual or unexperienced for its indeterminacy, that shifts with each movement of the eyes. What are the contents of any given sector of one's visual field? A heterogeneous

collection of substances and shapes, neither incomplete nor especially complete (except for the singular totality of figures or moving things). Some new art now seems to take the conditions of the visual field itself (figures excluded) and uses these as a structural basis for the art. Recent past art took the conditions within individual things – specific extension and shape and wholeness of one material – for the project of reconstituting objects as art. The difference amounts to a shift from a figure-ground perceptual set to that of the visual field. Physically, it amounts to a shift from discrete, homogeneous objects to accumulations of things or stuff, sometimes very heterogeneous. It is a shift that is on the one hand closer to the phenomenal fact of seeing the visual field and on the other is allied to the heterogeneous spread of substances that make up that field. In another era, one might have said that the difference was between a figurative and landscape mode. Fields of stuff which have no central contained focus and extend into or beyond the peripheral vision offer a kind of 'landscape' mode as opposed to a self-contained type of organization offered by the specific object.

Most of the new work under discussion is still a spread of substances or things that is clearly marked off from the rest of the environment and there is not any confusion about where the work stops. In this sense, it is discrete but not object-like. It is still separate from the environment so in the broadest sense is figure upon a ground. Except for some outside work which removes even the frame of the room itself, here the 'figure' is literally the 'ground.' But work that extends to the peripheral vision cannot be taken in as a distinct whole and in this way has a different kind of discreteness from objects. The lateral spread of some of the work subverts either a profile or plan view reading. (In the past I have spread objects or structures into a 25 to 30 foot square area and the work was low enough to have little or no profile and no plan view was possible even when one was in the midst of the work. But in these instances, the regularity of the shape and homogeneity of the material held the work together as a single chunk.) Recent work with a marked lateral spread and no regularized units or symmetrical intervals tends to fracture into a continuity of details. Any overall wholeness is a secondary feature often established only by the limits of the room. It is only with this type of recent work that heterogeneity of material has become a possibility again; now any substances or mixtures of substances and the forms or states these might take – rods, particles, dust, pulpy, wet, dry, etc., are potentially useable. Previously, it was one or two materials and a single or repetitive form to contain them. Any more and the work began to engage in part to part and part to whole relationships. Even so, Minimal art, with two or three substances, gets caught in plays of relationships between transparencies and solids, voids and shadows and the parts separate and the work ends in a kind of demure and unadmitted composition.

Besides lateral spread, mixing of materials, and irregularity of substances, a reading other than a critical part to part or part to whole is emphasized by the indeterminate aspect of work which has physically separate parts or is loose or flexible. Implications of constant change are in such work. Previously, indeterminacy was a characteristic of perception in the presence of regularized objects – i.e., each point of view gave a different reading due to perspective. In the work in question indeterminacy of arrangement of parts is a literal aspect of the physical existence of the thing.

The art under discussion relates to a mode of vision which Ehrenzweig terms variously as scanning, syncretistic, or dedifferentiated – a purposeful detachment from holistic readings in terms of gestalt-bound forms. This perceptual mode seeks

significant clues out of which wholeness is sensed rather than perceived as an image and neither randomness, heterogeneity of content, nor indeterminancy are sources of confusion for this mode. It might be said that the work in question does not so much acknowledge this mode as a way of seeing as it hypostatizes it into a structural feature of the work itself. By doing this, it has used a perceptual accommodation to replace specific form or image control and projection. This is behind the sudden release of materials that are soft or indeterminate or in pieces which heretofore would not have met the gestalt-oriented demand for an imagistic whole. It is an example of art's restructuring of perceptual relevance which subsequently results in an almost effortless release of a flood of energetic work.

III

Yet perception has a history; it changes during our life and even within a very short span of time; more important, perception has a different structure on different levels of mental life and varies according to the level which is stimulated at one particular time. Only in our conscious experience has it the firm and stable structure which the gestalt psychologists postulated.

Anton Ehrenzweig

... catastrophes of the past accompanied by electrical discharges and followed by radio-activity could have produced sudden and multiple mutations of the kind achieved today by experimenters... The past of mankind, and of the animal kingdoms, too, must now be viewed in the light of the experience of Hiroshima and no longer from the portholes of the Beagle.

Immanuel Velikovsky

Changes in form can be thought of as a vertical scale. When art changes, there are obvious form changes. Perceptual and structural changes can be thought of as a horizontal scale, a horizon even. These changes have to go with relevance rather than forms. And the sense of a new relevance is the aspect that quickly fades. Once a perceptual change is made, one does not look at it but uses it to see the world. It is only visible at the point of recognition of the change. After that, we are changed by it but have also absorbed it. The impossibility of reclaiming the volitivity of perceptual change leaves art historical explanations to pick the bones of dead forms. In this sense, all art dies with time and is impermanent whether it continues to exist as an object or not. A comparison of '50s and '60s art that throws into relief excessive organic forms opposed to austere geometric ones can only be a lifeless formal comparison. And the present moves away from Minimal art are not primarily formal ones. The changes involve a restructuring of what is relevant.

What was relevant to the '60s was the necessity of reconstituting the object as art. Objects were an obvious first step away from illusionism, allusion and metaphor. They are the clearest type of artificial independent entity, obviously removed and separate from the anthropomorphic. It is not especially surprising that art driving toward greater concreteness and away from the illusory would fasten on the essentially idealistic imagery of the geometric. Of all the conceivable or experienceable things, the symmetrical and geometric are most easily held in the mind as forms. The demand for images that could be mentally controlled, manipulated, and above all, isolated was

on the one hand an esthetic preconception and on the other a methodological necessity. Objects provided the imagistic ground out of which '60s art was materialized. And to construct objects demands preconception of a whole image. Art of the '60s was an art of depicting images. But depiction as a mode seems primitive because it involves implicitly asserting forms as being prior to substances.[1] If there is no esthetic investment in the priority of total images then projection or depiction of form is not a necessary mode. And if the method of working does not demand pre-thought images, then geometry, and consequently objects, is not a preferential form and certainly not a necessary one to any method except construction.

Certain art is now using as its beginning and as its means, stuff, substances in many states – from chunks, to particles, to slime, to whatever – and pre-thought images are neither necessary nor possible. Alongside this approach is chance, contingency, indeterminacy – in short, the entire area of process. Ends and means are brought together in a way that never existed before in art. In a very qualified way, Abstract Expressionism brought the two together. But with the exception of a few artists, notably Pollock and Louis, the formal structure of Cubism functioned as an end toward which the activity invariably converged and in this sense was a separate end, image, or form prior to the activity. Any activity, with perhaps the exception of unfocused play, projects some more or less specific end and in this sense separates the process from the achievement. But images need not be identified with ends in art. Although priorities do exist in the work under discussion, they are not preconceived imagistic ones. The priorities have to do with acknowledging and even predicting perceptual conditions for the work's existence. Such conditions are neither forms nor ends nor part of the process. Yet they are priorities and can be intentions. The work ... involves itself with these considerations – that which is studio-produced as well as that which deals with existing exterior zones of the world. The total separation of ends and means in the production of objects, as well as the concern to make manifest idealized mental images, throws extreme doubt on the claim that the Pragmatic attitude informs Minimal art of the '60s. To begin with the concrete physicality of matter rather than images allows for a change in the entire profile of three-dimensional art: from particular forms, to ways of ordering, to methods of production and, finally, to perceptual relevance.

So far all art has made manifest images whether it arrived at them (as the art in question) or began with them. The open, lateral, random aspect of the present work does in fact provide a general sort of image. Even more than this, it recalls an aspect of Pollock's imagery by these characteristics. Elsewhere I have made mention of methodological ties to Pollock through emphasis in the work on gravity and a direct use of materials. But to identify its resultant 'field' aspect very closely with Pollock's work is to focus on too narrow a formalistic reading. Similar claims were made when Minimal art was identified with the forms found in previous Constructivism.

One aspect of the work worth mentioning is the implied attack on the iconic character of how art has always existed. In a broad sense art has always been an object, static and final, even though structurally it may have been a depiction or existed as a fragment. What is being attacked, however, is something more than art as icon. Under attack is the rationalistic notion that art is a form of work that results in a finished product. Duchamp, of course, attacked the Marxist notion that labour was an index of value, but Readymades are traditionally iconic art objects. What art now has in its hands is mutable stuff which need not arrive at the point of being finalized with respect

to either time or space. The notion that work is an irreversible process ending in a static icon-object no longer has much relevance.

The detachment of art's energy from the craft of tedious object production has further implications. This reclamation of process refocuses art as an energy driving to change perception. (From such a point of view the concern with 'quality' in art can only be another form of consumer research – a conservative concern involved with comparisons between static, similar objects within closed sets.) The attention given to both matter and its inseparableness from the process of change is not an emphasis on the phenomenon of means. What is revealed is that art itself is an activity of change, of disorientation and shift, of violent discontinuity and mutability, of the willingness for confusion even in the service of discovering new perceptual modes.

At the present time the culture is engaged in the hostile and deadly act of immediate acceptance of all new perceptual art moves, absorbing through institutionalized recognition every art act. The work discussed has not been excepted.

[1] This reflects a certain cultural experience as much as a philosophic or artistic assertion. An advanced technological, urban environment is a totally manufactured one. Interaction with the environment tends more and more toward information processing in one form or another and away from interactions involving transformations of matter. The very means and visibility for material transformations become more remote and recondite. Centers for production are increasingly located outside the urban environment in what are euphemistically termed 'industrial parks.' In these grim, remote areas the objects of daily use are produced by increasingly obscure processes and the matter transformed is increasingly synthetic and unidentifiable. As a consequence our immediate surroundings tend to be read as 'forms' that have been punched out of unidentifiable, indestructible plastic or unfamiliar metal alloys. It is interesting to note that in an urban environment construction sites become small theatrical arenas, the only places where raw substances and processes of its transformation are visible and the only places where random distributions are tolerated.

5 Art & Language (Terry Atkinson, b. 1939)
Editorial introduction to *Art-Language*

The first issue of the journal *Art-Language* was published in Coventry in May 1969, with Atkinson, Bainbridge, Baldwin and Hurrell listed as editors. Besides writings by the editors there were contributions from the Americans LeWitt, Weiner and Dan Graham. The unsigned introduction was written principally by Atkinson. It may be noted that where Kosuth proposes a new tradition initiated by Duchamp's readymades (VIIA11), the position of Art & Language is that what is primarily at issue in Conceptual Art is rather the nature of 'art work' than the condition of the 'art-object'. (For a later editorial see VIIC14.)

[...] Suppose the following hypothesis is advanced: that this editorial, in itself an attempt to evince some outlines as to what 'conceptual art' is, is held out as a 'conceptual art' work. At first glance this seems to be a parallel case to many past situations within the determined limits of visual art, for example the first Cubist painting might be said to have attempted to evince some outlines as to what visual art is, whilst, obviously, being held out as a work of visual art. But the difference here is one of what shall be called 'the form of the work.' Initially what conceptual art seems to be doing is questioning the condition that seems to rigidly govern the form of visual art – that visual art remains visual.

During the past two years, a number of artists have developed projects and theses, the earliest of which were initially housed pretty solidly within the established constructs of visual art. Many of these projects, etc., have evolved in such a manner that their relationship to visual art conventions has become increasingly tenuous. The later projects particularly are represented through objects, the visual form of which is governed by the form of the conventional signs of written language (in this case English). The content of the artist's idea is expressed through the semantic qualities of the written language. As such, many people would judge that this tendency is better described by the category name 'art theory' or 'art criticism'; there can be little doubt that works of 'conceptual art' can be seen to include both the periphery of art criticism and of art theory, and this tendency may well be amplified. With regard to this particular point, criteria bearing upon the chronology of art theory may have to be more severely and stringently accounted for, particularly in terms of evolutionary analogies. For example the question is not simply: 'Are works of art theory part of the kit of the conceptual artist, and as such can such a work, when advanced by a conceptual artist, come up for the count as a work of conceptual art?' But also: 'Are past works of art theory now to be counted as works of conceptual art?' What has to be considered here is the intention of the conceptual artist. It is very doubtful whether an art theoretician could have advanced one of his works as a work of 'conceptual art' in (say) 1964, as the first rudiments of at least an embryonic awareness of the notion of 'conceptual art' were not evident until 1966. The intention of the 'conceptual artist' has been separated off from that of the art theoretician because of their previously different relationships and standpoints toward art, that is, the nature of their involvement in it.

If the question is formed the other way round, that is, not as 'Does art theory come up for the count as a possible sector of "conceptual art"?' but as, 'Does "conceptual" art come up for the count as a possible sector of art theory?' then a rather vaguely defined category is being advanced as a possible member of a more established one. Perhaps some qualification can be made for such an assertion. The development of some work by certain artists both in Britain and the USA does not, if their intentions are to be taken into account, simply mean a matter of a transfer of function from that of artist to that of art theoretician, it has necessarily involved the intention of the artist to count various theoretical constructs as artworks. This has contingently meant, either (1) If they are to be 'left alone' as separate, then redefining carefully the definitions of both art and art theory, in order to assign more clearly what kind of entity belongs to which category. If this is taken up it usually means that the definition of art is expanded, and art theoreticians then discuss the consequences and possibilities of the new definitions, the traditional format of the art theoretician discussing what the artist has implied, entailed, etc., by his 'creative act'. Or (2) To allow the peripheral area between the two categories some latitude of interpretation and consequently account the category 'art theory' a category that the category 'art' might expand to include. The category 'maker of visual art' has been traditionally regarded as solely the domain of the visual-art object producer (i.e., the visual-art artist). There has been a hierarchy of languages headed by the 'direct readout from the object' language, which has served as the creative core, and then various support languages acting as explicative and elucidatory tools to the central creative core. The initial language has been what is called 'visual,' the support languages have taken on what shall be called here 'conventional written sign' language-form. What is surprising is that although the central core has

been seen to be an ever evolving language, no account up to the present seems to have taken up the possibility of this central core evolving to include and assimilate one or other or all of the support languages. It is through the nature of the evolution of the works of 'conceptual art' that the implicated artists have been obliged to take account of this possibility. Hence these artists do not see the appropriateness of the label 'art theoretician' necessarily eliminating the appropriateness of the label 'artist.' Inside the framework of 'conceptual art' the making of art and the making of a certain kind of art theory are often the same procedure.

Within a context such as this the initial question can be posed with a view to a more specific inquiry. The question: 'Can this editorial, in itself an attempt to evince some outlines as to what "conceptual art" is, come up for the count as a work of conceptual art?' Firstly, the established notions of what the presentation of art and the procedures of art-making entail have to be surveyed. The question 'Can this editorial come up for the count as a work of art within a developed framework of the visual art convention?' can only be answered providing some thorough account is given of what is meant by 'developed' here. At the present we do not, as a norm, expect to find works of visual art in magazines, we expect critical, historical, etc., comment upon them, photographic reproductions, etc. The structures of the identity of art-objects have consecutively been placed under stress by each new movement in art, and the succession of new movements has become more rapid this century. In view of this phenomenon perhaps the above question can be altered to: 'Can this editorial come up for the count as a member of the extended class "visual artwork"?' Here 'extended' replaces 'developed' and can, perhaps, be made to point out the problem as follows:

Suppose an artist exhibits an essay in an art exhibition (the way a print might be exhibited). The pages are simply laid out flat in reading order behind glass within a frame. The spectator is intended to read the essay 'straight,' like a notice might be read, but because the essay is mounted in an art ambience it is implied that the object (paper with print upon it) carries conventional visual art content. The spectator being puzzled at not really being able to grasp any direct visual-art-readout meaning starts to read it (as a notice might be read). It goes as follows:

'On why this is an essay'

The appearance of this essay is unimportant in any strong sense of visual-art appearance criteria. The prime requirement in regard to this essay's appearance is that it is reasonably legible. Any decisions apart from this have been taken with a view to what it should not look like as a point of emphasis over what it should look like. These secondary decisions are aimed at eliminating as many appearance similarities to established art-objects as possible.

Thus if the essay is to be evaluated in terms of the content expressed in the writing (WHICH IT IS), then in an obvious established sense many people would say that if it has a connection with art at all, that it fits better into the category 'art criticism' or 'art theory.' Such a statement at least admits the observation that when an artist uses '(a piece of) writing' in this context then he is not using such an object in the way that art audiences are accustomed to it being used. But further it admits of a rather more bigoted view, that is this essay belongs more to art criticism or art theory because it is formed of writing and in this sense it looks more like art criticism or art theory than it

looks like art; that is, that this object (a piece of writing) does not have sufficient appearance criteria to be identified as a member of the class 'art-object' – it does not look like art. This observation has a strong assumption behind it that the making of a traditional art-object (i.e., one to be judged within the visual evaluative framework) is a necessary condition for the making of art. Suppose there are some areas (say) pertaining to art at present which are of such a nature that they need not, maybe cannot, any longer meet the requirements that have previously been required as a necessary mode of an object coming up for the count as a member of the class 'artwork.' This necessary mode is formulated as follows (say): the recognition of art in the object is through some aspect(s) of the visual qualities of the object as they are directly perceived.

The question of 'recognition' is a crucial one here. There has been a constantly developing series of methods throughout the evolution of the art whereby the artist has attempted to construct various devices to ensure that his intention to count the object as an art-object is recognized. This has not always been 'given' within the object itself. The more recently established ones have not necessarily, and justifiably so, meant the obsolescence of the older methods. A brief account of this series may help to illuminate matters further.

1 To construct an object possessing all the morphological characteristics already established as necessary to an object in order that it can count as an artwork. This would of course assume that such established categories (e.g., painting, sculpture) had already evolved through a period in which the relevant rules and axioms had initially to be developed.

2 To add new morphological characteristics to the older established ones within the framework of one object (e.g., as with the advent of the technique of collage), where certain of the morphological characteristics of the object could be recognized as the type criterion for assigning the objects of the category 'painting' and other (newer) ones grafted onto them could not be so easily placed (e.g., in the introduction of Cubist collages and the collages made by Schwitters). [...]

3 To place an object in a context where the attention of any spectator will be conditioned toward the expectancy of recognizing art-objects. For example placing what up to then had been an object of alien visual characteristics to those expected within the framework of an art ambience, or by virtue of the artist declaring the object to be an art-object whether or not it was within an art ambience. Using these techniques what appeared to be entirely new morphologies were held out to qualify for the status of members of the class 'art-object.' For example Duchamp's 'Ready-mades' and Rauschenberg's *Portrait of Iris Clert*. There is some considerable overlap here with the type of object mentioned in No. (2), but here the prime question seems to emphasize even more whether or not they count as art-objects and less and less whether or not they are good or bad (art-objects). David Bainbridge's *Crane*, which shifted status according to his 'sliding scale' intentions as to where it was placed at different times, threw up an apparently even thicker blanket of questions regarding the morphology of art-objects. In contrast to Duchamp's 'Ready-mades,' which took on art-object status according to Duchamp's act of (say) purchase (e.g., *Bottle Rack*) entailing an asymmetrical transfer or rather superimposition of the identity 'art-object' onto that of 'bottle rack,' Bainbridge's *Crane* sometimes is a member of the class 'art-object and crane' and sometimes simply is only a member of the class 'crane.' Its qualification as a

member of the class 'art-object' is not conceived as being reliant upon the object's morphological characteristics but on Bainbridge's and Atkinson's list of intentions acknowledging two kinds of ambience, art and not-an-art ambience. Here the identity (art-object or crane) is symmetrical. [. . .]

4 The concept of using 'declaration' as a technique for making art was used by Terry Atkinson and Michael Baldwin for purposes of the 'Air-Conditioning Show' and 'Air Show,' which were formulated in 1967. For example the basic tenet of the 'Air Show' was a series of assertions concerning a theoretical usage of a column of air comprising a base of one square mile and of unspecified distance in the vertical dimension. No particular square mile of the earth's surface was specified. The concept did not entail any such particularized location. [. . .]

No. (4) differs from Nos. (1), (2), and (3) in the following way. The first three methods use a concrete existential object, the latter simply a theoretical one. This factor of 'use' is important here. The existential object upon which the 'content' of No. (4) is formulated (i.e., paper with print upon it) is not the art-object, the art-object is not an object that can be directly perceived, the 'object' component is merely specified. Once having established writing as a method of specifying points in an inquiry of this kind, there seems no reason to assume that inquiries pertaining to the art area should necessarily have to use theoretical objects simply because art in the past has required the presence of a concrete object before art can be thought of as 'taking place'; having gained the use of such a wide-ranging instrument as 'straight' writing, then objects, concrete and theoretical, are only two types of entity that can count, a whole range of other types of entities become candidates for art usage. Some of the British artists involved in this area have constructed a number of hypotheses using entities that might be regarded as alien to art. Most of these inquiries do not exhibit the framework of the established art-to-object relationship and (if you like) they are not categorically asserted as members of the class 'art-object,' nor for that matter is there a categorical assertion that they are art ('work'); but such a lack of absolute assertion does not prohibit them from being tentatively asserted as having some important interpellations for the art area.

This concept of presenting an essay in an art gallery, the essay being concerned with itself in relation to it being in an art gallery, helps fix its meaning. When it is used as it is in this editorial, then the art gallery component has to be specified. The art gallery component in the first essay is a concrete entity, the art gallery component in the second case (here) is a theoretical component, the concrete component is the words 'in an art gallery.' Lists (1), (2), (3), and (4) above might be followed by (5), the essay in the gallery, and (6) the essay possessing the paragraph specifying the theoretical art gallery; it is more likely that the nuances of (5) and (6) could be included in an expanded version of (4).

The British 'conceptual artists' are still attempting to go into this notion of the meta-strata of art-language. Duchamp wrote early in the century that he 'wanted to put painting back into the service of the mind.' There are two things to be especially taken into account here, 'painting' and 'the mind.' Leaving aside here ontological questions concerning 'the mind,' what the British artists have, rightly or wrongly, analyzed out and constructed might be summarized in words something like: 'There is no question of putting painting, sculpture, et al., back in the service of the mind (because

as painting and scultpure it has only served the mind within the limits of the language of painting and sculpture and the mind cannot do anything about the limits of painting and sculpture after a certain physical point, simply because those are the limits of painting and sculpture). Painting and sculpture have physical limits and the limit of what can be said in them is finally decided by precisely those physical limits.' Painting and sculpture, et al., have never been out of the service of the mind, but they can only serve the mind to the limits of what they are. The British conceptual artists found at a certain point that the nature of their involvements exceeded the language limits of the concrete object. Soon after they found the same thing with regard to theoretical objects. Both put precise limits on what kind of concepts can be used. There has never been any question of these latter projects coming up for the count as members of the class 'painting' or the class 'sculpture,' or the class 'art-object,' which envelops the classes 'painting' and 'sculpture.' There is some question of these latter projects coming up for the count as members of the class 'artwork.'

* * *

Something might now be said noting the relationship of the psychology of perception with regard to 'conceptual art.' It is today widely agreed that the psychology of perception is of some importance in the study of visual art. The practice of this study by art theoreticians, for example Ehrenzweig, Arnheim, etc., has at least clarified some questions within the context of visual 'visual art,' which have enabled the conceptual artists to say these (such and such) projects have not such and such characteristics, in this way they have influenced what the formulative hypotheses of some of conceptual art is not about. Such concepts as whether art consecrates our ordinary modes of seeing and whether or not we are able, in the presence of art, to suspend our ordinary habits of seeing are strongly linked with inquiries into Gestalt hypotheses and other theories of perception; the limits of visual art are often underlined in inquiries into how we see. The British group have noted particularly and with deep interest the various Gestalt hypotheses that Robert Morris (for example) had developed in the notes on his sculpture-objects. These notes seem to have been developed as a support and an elucidation for Morris' sculpture. The type of analysis that the British group have spent some considerable time upon is that concerning the linguistic usage both of plastic art itself and of its support languages. These theses have tended to use the language form of the support languages, namely word-language, and not for any arbitrary reason, but for the reason that this form seems to offer the most penetrating and flexible tool with regard to some prime problems in art today. Merleau-Ponty is one of the more recent contributors to a long line of philosophers who have, in various ways, stressed the role of visual art as a corrective to the abstractness and generality of conceptual thought – but what is visual art correcting conceptual thought out of – into? In the final analysis such corrective tendencies may simply turn out to be no more than a 'what we have we hold' conservatism without any acknowledgement as to how art can develop. Richard Wollheim has written, '. . . but it is quite another matter, and one I suggest, beyond the bounds of sense, even to entertain the idea that a form of art could maintain itself outside a society of language-users.' I would suggest it is not beyond the bounds of sense to maintain that an art form can evolve by taking as a point of initial inquiry the language-use of the art society.

6 Ian Burn (1939–1993) and Mel Ramsden (b. 1944)
'The Role of Language'

Together with Roger Cutforth, Burn and Ramsden formed the Society for Theoretical Art and Analyses in New York in 1969. Two years later they merged their separate collaboration with Art & Language. This text argues for the position, shared at the time with the members of Art & Language in England, that language is the condition of 'seeing' (and not vice versa, as assumed in much modern art theory). The essay was written in 1969. First published (as September 1968) in G. de Vries (ed.), *Über Kunst/On Art*, Cologne, 1974, pp. 90–4, from which the present text is taken.

It seems, in seeing an object, I can construe (translate) that object within many seemingly complete 'languages' of perception. Another person seeing the same object may construe a similar number of 'languages', none of which need necessarily coincide with mine. If, for instance, we both adopt the same physical object as 'subject-of-consideration', in what sense can we say we are adopting the *same* object? . . . If each sets out to define that object by (e.g.) 'content', then are we in a position to say that what we call 'content' is physically existing in the object? If not, then such 'content' is merely part of that construal, it is subject to interpretation, and there is no position from which it can be described in any objective way. Accepting then that no 'content' exists *as a fact*, what are we implying when we say we recognize content? It seems to suggest that we are dealing with numerous types, perhaps levels or stratifications, of language which in turn are appropriate for numerous types, again perhaps stratifications, of (empirical) data. If each thing we make or do is merely a statement within a *particular* language, then it is not necessarily related to nor need correspond to any other language – it can only relate if we have the disposition to impose a relationship between those languages. It is at this point that a 'content' is imposed in order to evince that relationship, e.g., we formulate that the 'content' of A is of the kind 'x', and that the 'content' of B is also of the kind 'x', thus we can talk of a relationship between A and B. It's not possible to construe one language into another or to correlate them in any way without intervening such a 'content'. To say that one language is more or less complete than another is again to infer that our familiarity with one language is more in one case than the other. We do not directly identify or recognize, we only recognize the language(s) which are appropriate for the material. In many instances our familiarity with a language is so (culturally) inbred that we confuse the language with a kind of 'reality' or brute facts. In seeing, we typically substitute an appropriate language for the actual object in order to facilitate our 'seeing' of it – our language screens the object, it's the grid which structures our perceiving.

In terms of *intention*, if one is dealing with an object then one is more strongly committed to one's attitude of seeing (language) in this particular case than to any physical attributes. If one can conceptually distinguish that 'language' as a 'thing-in-itself', one might very well claim certain rights to it, e.g. to 'put a signature on it', rather than to any physical manifestation. The object then can be as ordinary or common or accessible as one chooses . . . since that is not what one is directly committed to – one is not committed to a particular object but only to the fact of an object being there in

order that one can have an attitude about it, i.e., a particular language of seeing. One's commitment then can lie in the direction of the language.

It becomes crucial to realize the significance of the ties between the language we use and what (and how) we see.

It's been pointed out that there is no common noun which is associated with the verb 'see' in the way that, for example, the noun 'sound' is associated with the verb 'hear'. Is there then nothing which acts for vision in the way that *sound* does when I hear footsteps.... 'I hear the sound of footsteps', but 'I see the (what?) of a man'? While it could be merely an accident of vocabulary, it seems more likely that perception has a different relationship to language than do any of our other senses. And it may be also that, for those things we do see (i.e., objects), our language is rich enough that we have no need of any 'intermediary' term to describe what we see (– we can describe more readily what we see than what we hear, touch, smell, or taste). If this is so, then there is something in how we describe what we see which needs to be pointed to as problematic – there is more difficulty in grasping the separation between 'the seeing of something' and 'what it is that's seen' than there is, for instance, between 'the sound' and 'the footsteps'. Language seems to enter into our 'seeing' more directly than with the other senses. This could be taken as implying a stronger (more developed) interdependence between 'perception' and 'language' and so must raise many questions about the kind of relationship which exists between how we see and how we talk of what we see.

The words which can be used to describe the kinds of 'seeing' are many – from which it might be taken that there are many possible ways which we undertake the act of perceiving, that is, again, independent of what is perceived. For example, 'see', 'look at', 'examine', 'scrutinize', 'gaze', 'discern', 'scan', 'look for', 'watch', and so on. (Compare how many words we have to describe 'hearing'.)

The distinction between 'task' and 'achievement' verbs is exemplified by 'looking' and 'seeing'. From this it's concluded that 'achievement' verbs (i.e., 'see') stand not for activities but for the outcome of activities, an outcome which is a part of a single extended process. But this distinction can be misleading since 'looking' can be used typically as either 'looking for' or 'looking at'. And, while 'looking for' certainly does imply some kind of resulting outcome (a successful or otherwise achievement), there are many typical uses of 'looking at' which do not imply any such outcome of activities and which seemingly are identical with (or at least similar to) 'seeing' (– e.g., 'I am looking at this page' and 'I am seeing this page', whereas 'I am looking for this page' obviously means something else).

Suppose the distinction is maintained for the 'looking for' kind of 'looking' and that this process results in the outcome of 'seeing (something)' – I look for (something) and then I see (that something). But frequently I see things without looking for them – is this still an achievement verb then even though it is not the outcome of a preceding activity? If something is within my field of vision, then it hardly occasions my 'looking for' it before I see it. I may examine or scrutinize it without necessarily having looked for it in the first place (though I must have come to see it in some way or other). If I have two reproductions of a landscape, then I may see a detail in one and look for it in the other; but seeing it in the second case would seem to depend more on the conditions of seeing in the first case than on any interim 'looking for'. The 'single continuous activity' notion doesn't seem to account for very much in that case.

Then, if we must limit the applicability of the distinction to this degree, we must begin to doubt how useful it can be as an over-all distinction. A problem arises with all such distinctions when one tries to make them generally applicable. Distinctions are applicable (meaningful) in particular contexts and, within that context, they may have significance (meaningfulness) because they are useful in some sense. But usefulness in one context does not imply usefulness in any other; extending a distinction into another context can be simply misleading without at all being useful.

Thus whatever attitude we have to seeing may depend very much on the kinds of distinctions we typically use in language, and in fact on the way in general that we set out to describe our visual experiences. It may mean that, to establish any new modes or nuances of 'seeing', the mode (or such conditions as will allow for it) must first be established in an appropriate language.

7 Lawrence Weiner (b. 1940) Statements

A tendency to disparage or to avoid the production of finite artistic objects was one among the various outcomes of American Minimalism. Weiner occupies a central place within this specific tendency, if only by virtue of the consistency with which his position has been maintained. His attitude towards the realization and distribution of his work remains exemplary of the libertarian cultural ethics of the later 1960s. The statement of 12 October 1969 is based on a conversation with Ursula Meyer and was originally published in Meyer (ed.), *Conceptual Art*, New York, 1972, pp. 217–18. The specification 'The artist . . . receivership', cited at the end of the statement, was first published in the catalogue of 'January 5–31 1969', Seth Siegelaub, New York, and has since tended to accompany all publication of Weiner's work. The passage 'If for to exist . . . are not' was appended when the specification was reprinted in the catalogue of 'Documenta 5', Kassel, 1972.

I do not mind objects, but I do not care to make them.

The object – by virtue of being a unique commodity – becomes something that might make it impossible for people to see the art for the forest.

People, buying my stuff, can take it wherever they go and can rebuild it if they choose. If they keep it in their heads, that's fine too. They don't have to buy it to have it – they can have it just by knowing it. Anyone making a reproduction of my art is making art just as valid as art as if I had made it.

Industrial and socioeconomic machinery pollutes the environment and the day the artist feels obligated to muck it up further art should cease being made. If you can't make art without making a permanent imprint on the physical aspects of the world, then maybe art is not worth making. In this sense, any permanent damage to ecological factors in nature not necessary for the furtherance of human existence, but only necessary for the illustration of an art concept, is a crime against humanity. For art being made by artists for other human beings should never be utilized against human beings, unless the artist is willing to renounce his position as an artist and take on the position of a god. Being an artist means doing a minimum of harm to other human beings.

Big egocentric expensive works become very imposing. You can't put twenty-four tons of steel in the closet.

If art has a general aspect to it and if someone receives a work in 1968 and chooses to have it built, then either tires of looking at it or needs the space for a new television set,

he can erase it. If – in 1975 – he chooses to have it built again – he has a piece of 1975 art. As materials change, the person who may think about the art, as well as the person who has it built, approach the material itself in a contemporary sense and help to negate the preciousness of 1968 materials . . . I personally am more interested in the *idea* of the material than in the material itself.

Art that imposes conditions – human or otherwise – on the receiver for its appreciation in my eyes constitutes aesthetic fascism.

My own art never gives directions, only states the work as an accomplished fact.

1 The artist may construct the work
2 The work may be fabricated
3 The work need not to be built

Each being equal and consistent with the intent of the artist the decision as to condition rests with the receiver upon the occasion of receivership
If for to exist within a cultural context

1 An art may be constructed by an artist
2 An art may be fabricated
3 An art need not to be built

A reasonable assumption would be
that all are equal and consistent with the condition of art
and the relevant decisions as to condition
upon receivership are not

8 Victor Burgin (b. 1941) 'Situational Aesthetics'

Burgin was exposed to the ideas of Judd and Morris while studying in America. Returning to London in 1969, he was to be a central figure in the development of Conceptual Art in England. The present essay proposes that the concepts of artistic object and artistic form should be dissociated from the world of manufactured things and redefined in terms of the structures of psychological experience. Burgin's contemporary work was intended to give practical effect to this proposal. Like many others at the time, the author associates an avant-garde 'laterally proliferating complex of activities' with a counter-conservative critique of institutions. Originally published in *Studio International*, vol. 178, no. 915, October 1969, pp. 118–21, from which the present version is taken. (For later texts by Burgin see VIIC13 and VIIIB5.)

Some recent art, evolving through attention both to the conditions under which objects are perceived and to the processes by which aesthetic status is attributed to certain of these, has tended to take its essential form in message rather than in materials. In its logical extremity this tendency has resulted in a placing of art entirely within the linguistic infrastructure which previously served merely to support art. In its less hermetic manifestations art as message, as 'software', consists of sets of conditions, more or less closely defined, according to which particular concepts may be demon-

strated. This is to say, aesthetic *systems* are designed, capable of generating objects, rather than individual objects themselves. Two consequences of this work process are: the specific nature of any object formed is largely contingent upon the details of the situation for which it is designed; through attention to time, objects formed are intentionally located partly in real, exterior, space and partly in psychological, interior, space.

* * *

Accepting the shifting and ephemeral nature of perceptual experience, and if we accept that both real and conceptual objects are appreciated in an analogous manner, then it becomes reasonable to posit aesthetic objects which are located partly in real space and partly in psychological space. Such a placing of aesthetic objects however involves both a revised attitude towards materials and a reversal of function between these materials and their context.

Cage is hopeful in claiming, 'We are getting rid of ownership, substituting use'; attitudes towards materials in art are still informed largely by the laws of conspicuous consumption, and aesthetic commodity hardware continues to pile while utilitarian objects, whose beauty might once have been taken as conclusive proof of the existence of God, spill in inconceivable profusion from the cybernated cornucopias of industry. Each day we face the intractability of materials which have outstayed their welcome. Many recent attitudes to materials in art are based in an emerging awareness of the interdependence of all substances within the ecosystem of earth. The artist is liable to see himself not as a creator of new material forms but rather as a coordinator of existing forms, and may therefore choose to *subtract* materials from the environment. As art is being seen increasingly in terms of behaviour so materials are being seen in terms simply of quantity rather than of quality. [...]

Once materials are selected according to largely fortuitous criteria, depending on their location, their individual status is diminished. The identification of art relies upon the recognition of cues which signal that the type of behaviour termed aesthetic appreciation is to be adopted. These cues help form a context which reveals the art object. The object itself, in being displayed, may be termed overt and in the case of the visual arts it has been predominantly substantial. Any attempt to make an 'object' of non-overt and insubstantial conceptual forms demands that substantial materials located in exterior space-time be used in a manner which subverts their 'objectness' in order to identify them as 'situational cues'.

Perceptual fields are not experienced as objects in themselves. Perception is a continuum, a precipitation of event fragments decaying in time, above all a *process*. An object analogue may, however, be posited by locating points within the perceptual continuum. Two rope triangles placed in Greenwich Park earlier this year represent an attempt to 'parenthesize' a section of perceptual experience in time. General instructions for this work are:

1 Two units co-exist in time.
2 Spatial separation is such that units may not simultaneously be directly perceived.
3 Units isomorphic to degree that encounter with second is likely to evoke recollection of first.

By the above definition the units may be said to bracket the perceptual data subjectively experienced between them. The 'object', therefore may be defined as

consisting of three elements: First unit. Recollection of intervening space-time. Second unit. [...]

Visual information concerning duration is gained, as it is gained when we observe motion, from observations of shift in perceptual field. In travelling past an object we are presented with an apparent configurational evolution from which we may abstract a number of discrete states. Comparison of expired configurations with the configuration of the moment tells us we are in motion relative to the object. An exercise of a similar nature is involved when we observe change in a place to which we have returned after an absence, we compare and contrast past and present configurations, or more accurately, we superimpose a memorized configuration upon a configuration present to the retina. Pragmatically, within this complex of shifting appearances, we have workable systems of establishing space-time coordinates for navigation and prediction, but true locations exist only in the abstract as points of zero dimensions. Locations such as those given by the National Grid are fixed by definition, but the actual spaces to which they refer are in continual flux and so impossible to separate from time.

Time, in the perception of exterior events, is the observation of succession linked with muscular-navigational memories – a visceral identification with change. Similarly kinaesthetic modes of appreciation are applied to the subjective transformation of these events in interior time and in recollection. All behaviour has these space-time parameters in common. To distinguish, therefore, between 'arts of space' and 'arts of time' is literally unrealistic. The misconception is based in materialism, it springs, again, from a focus upon the *object* rather than upon the behaviour of the perceiver. Theatre and cinema are not arts of 'time' but arts of *theatrical* and *cinematic* time, governed by their own conventions and the limitations of their hardware. The Parthenon is not 'timeless' but, simply, set in *geological* time. It is a mistake to refer to 'time' as if it were singular and absolute. A full definition of the term would require a plurality of times and would accommodate such contrasting scales as the times of galaxies and of viruses. The current occupation with time and ecology, the consciousness of *process*, is necessarily counter-conservative. Permanence is revealed as being a relationship and not an attribute. Vertical structuring, based in hermetic, historically given concepts of art and its cultural role, has given way to a laterally proliferating complex of activities which are united only in their common definition as products of artistic *behaviour*. This situation in art is the corollary of a general reduction in the credibility of institutions and many find much recent art implicitly political. One may disagree, however, with those who would locate motivations in as doctrinaire an attitude as 'Disgust with the decadence of Western civilization'.

Art *intended* as propaganda is almost invariably both aesthetically tedious and politically impotent. The process-oriented attitudes described here are not intentionally iconoclastic and one should be suspicious of easy comparisons with Dada. It does not follow, because some institutions have been ignored, that they are under attack. It seems rather less likely that the new work will result in the overthrow of the economy than that it will find a new relationship with it; one based, perhaps, in the assumption that art is justified as an *activity* and not merely as a means of providing supplementary evidence of pecuniary reputability. As Brecht observed, we are used to judging a work by its suitability for the apparatus. Perhaps it is time to judge the apparatus by its suitability for the work.

9 John A. Murphy (b. 1929) Sponsor's Statement for 'When Attitudes become Form'

From 22 March to 27 April 1969, the exhibition 'When Attitudes become Form; Works – Concepts – Processes – Situations – Information' was staged at the Kunsthalle, Berne, transferring in revised form to the Institute of Contemporary Arts, London, from 28 September to 27 October 1969. It provided a substantial international survey of those avant-garde tendencies of the later 1960s which, for all their heterogeneity, were united both by their distance from the standard Modernist paradigms of painting and sculpture, and by their variable but oft-rehearsed proximity to the radical temper of the times. The exhibition was sponsored by Philip Morris Europe. The present statement signed by the president of the company was printed in the catalogue for the London showing.

The works assembled for this exhibit have been grouped by many observers of the art scene under the heading 'new art'. We at Philip Morris feel it is appropriate that we participate in bringing these works to the attention of the public, for there is a key element in this 'new art' which has its counterpart in the business world. That element is innovation – without which it would be impossible for progress to be made in any segment of society.

Just as the artist endeavours to improve his interpretation and conceptions through innovation, the commercial entity strives to improve its end product or service through experimentation with new methods and materials. Our constant search for a new and better way in which to perform and produce is akin to the questionings of the artists whose works are represented here.

For a number of years, we have been involved in sponsorship of the arts in its many diverse forms – through purchase of works, commissioning of young artists, presentation of major exhibits, and so forth.

These activities are not adjuncts to our commercial function, but rather an integral part. As businessmen in tune with our times, we at Philip Morris are committed to support the experimental. We hope that those who attend this exhibit will be as stimulated while viewing it as we have been during its preparation.

10 Germano Celant (b. 1940) from *Art Povera*

Arte Povera (Poor Art) was a specifically Italian variant of the anti-formal and putatively libertarian tendencies which mushroomed in the later 1960s. Among the artists involved were Giovanni Anselmo, Alighiero Boetti, Jannis Kounellis, Mario Merz, Michelangelo Pistoletto, Emilio Prini and Gilberto Zorio. Arte Povera was first identified as a distinct movement through an exhibition in Genoa in 1967. Celant was closely associated as propagandist and curator. The present text is taken from Celant (ed.), *Arte Povera*, Milan, 1969, translated as *Art Povera. Conceptual, Actual or Impossible Art?*, London, 1969, pp. 225–30.

Animals, vegetables and minerals take part in the world of art. The artist feels attracted by their physical, chemical and biological possibilities, and he begins again to feel the need to make things of the world, not only as animated beings, but as a producer of magic and marvelous deeds. The artist-alchemist organizes living and vegetable matter

into magic things, working to discover the root of things, in order to re-find them and extol them. His work, however, does include in its scope the use of the simplest material and natural elements (copper, zinc, earth, water, rivers, land, snow, fire, grass, air, stone, electricity, uranium, sky, weight, gravity, height, growth, etc.) for a description or representation of nature. What interests him instead is the discovery, the exposition, the insurrection of the magic and marvelous value of natural elements. Like an organism of simple structure, the artist mixes himself with the environment, camouflages himself, he enlarges his threshold of things. What the artist comes in contact with is not re-elaborated; he does not express a judgement on it, he does not seek a moral or social judgement, he does not manipulate it. He leaves it uncovered and striking, he draws from the substance of the natural event – that of the growth of a plant, the chemical reaction of a mineral, the movement of a river, of snow, grass and land, the fall of a weight – he identifies with them in order to live the marvelous organization of living things.

Among living things he discovers also himself, his body, his memory, his gestures – all that which directly lives and thus begins again to carry out the sense of life and of nature, a sense that implies, according to Dewey, numerous subjects: the sensory, sensational, sensitive, impressionable and sensuous. [. . .]

He abolishes his role of being an artist, intellectual, painter or writer and learns again to perceive, to feel, to breathe, to walk, to understand, to make himself a man. Naturally, to learn to move oneself, and to re-find one's own existence does not mean to admire or to recite, to perform new movements, but to make up continuously mouldable material.

What follows is: impossibility to believe in discussion for imagery, in the communication of new explanatory and didactic information, in the structure that imposes regularity, behaviour, synthesis that leans upon a moralistic, industrial subject; estrangement, therefore, from the existing archetype and continuous renewal of himself; total aversion for discussion and aspiration towards continuity, towards aphasia, towards immobility, for a progressive identification of consciousness and praxis. The first discoveries of this dispossession are the finite and infinite moments of life; the work of art and work that identifies itself with life; the dimension of life as lasting without end; immobility as a possibility of leaving contingent circumstances in order to plunge into time; the explosion of the individual dimension as an aesthetic and feeling communion with nature; unconsciousness as a method of consciousness of the world; the search of psycho-physical disturbances plurally sensitive and steadfast; the loss of identity with himself, for an abandonment of reassuring recognition that is continually imposed upon him by others and by the social system; the object-subject as physical presence continuously changing, as a trial of existence that becomes continuous, chaotic, spatial and differs temporally. 'Art comes,' states Cage, 'from a kind of experimental condition in which one experiments with living.' To create art, then, one identifies with life and to exist takes on the meaning of re-inventing at every moment a new fantasy, pattern of behaviour, aestheticism, etc. of one's own life. What is important is not to justify it or to reflect it in the work or in the product, but to live it as work. [. . .]

Thus, art begins creating to place itself as a possibility in material (vegetable, animal, mineral and mental); its own dimension that identifies itself with knowledge and perception, becomes 'living in art', that fantastic existence continually at variance

with daily reality that opposes the building of art, that resulting from the place of art – from visual research to pop art, from minimal to funk art. A work of art – that of pop, op, minimal and funk artists – that is ready not for an intervention but for an interpretation of reality, a discussion on the images that tend towards a clarification and a criticism of the methods of communication (comic books, photographs, mass-media, technologically produced objects, micro-perceptive structures, etc.). To create art as a critic of popular and optical images that collaborate for the clarification of the social system, but block the crushing energy of life, nature, the world of things and do away with the sensory significance of any kind of work; to create as an intervention that is carried out by means of the intellectual scheme of critical-historical literature, photographic advertising, imaginary, objective means, structurally psychological, perceptive, in order to domesticate in prefixed schemes the vitality of real daily life; to create art that moves itself within the linguistic systems in order to remain language, an act to live by means of continual isolation; to create art as cultural kleptomania that lives on the assumption of the destructive charges of other languages (politics, sociology and technology); finally to create art as a separate language that speculates on codes and on instruments of communication in order to live in a dimension of exclusiveness and recognition that makes it an aristocratic and class question, an action that scratches at the whole of the superstructure without blunting the natural structure of the world.

On the other hand, the asystematic procedure of life that becomes contemporaneously, time, experience, love, art, work, politics, thought, action, science, daily living – poor in choices and assumptions – if not contingent and necessary; a life as an expression of creative existence, working, mental politics. There it creates work, art, thought, love, politics and complex living that lets itself be used by the connexions of the system; here a living in work, in art, in thought, in politics deprived of recognizable, disoriented, infinite, undiscussible constancy, given the uncertainty of the evolutionary cycle of daily reality. To live in work, in art, in politics, in science as a free design of itself, tying itself to the rhythm of life for an exhaustion, immediate and contingent, of real life in action, in facts and in thought.

In the first case, being, living, working makes art and politics 'rich', interrupting the chain of the causal in order to maintain in life the manipulation of the world, an attempt to conserve also 'the man well endowed when faced with nature'; in the second case, life, work, art, politics, behaviour, thought 'poveri', employed in the inseparableness of experience and consciousness with the political and mental event, with contingency, with the infinite, with the ahistorical, with the chain of individual and social motivation, with man, with environment, with space, with time, with the social situation . . . The delcared intention of doing away with every discussion, misunderstanding and coherence (coherence is in fact a characteristic of concatenation of the system), the need of feeling life continually going on, the necessity, dictated by nature itself, to advance at jumps, without having to collect with exactness the confines that govern modifications. Yesterday, therefore, life, art, existence, manifestation of oneself, manipulation, political beings, involved because based on a scientific and technological imagination, on the highly specialized superstructure of communication, on marked moments; a life, an art, a manifestation in itself, a manipulation, categorical and class-conscious, that – separating itself from the real, as speculative actions – isolates artistic, political and behavioural art with the aim of placing it in a competitive position with life: a life, an art, a policy, a

manifestation of itself, a metamorphic manipulation, that through agglomeration and collation, reduces reality to fantasy; a life, an art, a behaviour, a manipulation, frustrated – as a receptacle of all of the real and intellectual impotence of daily life – a life, an art, a moralistic policy, in which judgement is contradictory, imitating and passing the real, to the real itself, with a transgression of the intellectual aspect in that which is really needed. Today, in life or art or politics one finds in the anarchy and in the continuousness of nomadic behaviour, the greatest level of liberty for a vital and fantastic expression; life or art or politics, as a stimulus to verify continuously its own level of mental and physical existence, as urgency of a presence that eliminates the manipulation of life, in order to bring about again the individuality of every human and natural action; an innocent art, or a marvelousness of life, more political spontaneity since it precedes knowledge, reasoning, culture, not justifying itself, but lives in the continuous enchantment or horror of daily reality – a daily reality that is more like stupefying, horrible poetic entity, like changing physical presence, and never allusive to alienation.

Thus, art, life, politics 'poveri' are not apparent or theoretical, they do not believe in 'putting themselves on show', they do not abandon themselves in their definition, not believing in art, life, politics 'poveri', they do not have as an objective the process of the representation of life; they want only to feel, know, perform that which is real, understanding that what is important is not life, work, action, but the condition in which life, work and action develop themselves.

It is a moment that tends towards deculturization, regression, primitiveness and repression, towards the pre-logical and pre-iconographic stage, towards elementary and spontaneous politics, a tendency towards the basic element in nature (land, sea, snow, minerals, heat, animals) and in life (body, memory, thought), and in behaviour (family, spontaneous action, class struggle, violence, environment).

The reality, in which one participates every day, is in its dull absurdity a political deed. It is more real than any intellectually recognizable element. Thus, art, politics and life 'poveri', as reality do not send back or postpone, but they offer themselves as self representatives, presenting themselves in the state of essence.

11 Eva Hesse (1936–1970) Interview with Cindy Nemser

Born into a German Jewish family, Hesse was taken to America in 1939. She studied at Cooper Union and at Yale University School of Art, turning from painting to three-dimensional work during a year in Germany in 1965. During her short working life in New York she developed a highly individual form of sculpture, using such materials as string, latex and fibreglass, exploring contrasts of scale and texture, and increasingly articulating the forms of her work in relation to walls, floor and ceiling. She was a central figure among the artists involved in the exploration of processes and materials that developed in the wake of early Minimal Art, and showed in representative exhibitions, including 'Eccentric Abstractions' at the Fischbach Gallery in 1966 and 'Anti-Form' at the John Gibson Gallery and '9 at Castelli Warehouse', both in 1968. Her first one-person show was held at the Fischbach Gallery in 1968. A retrospective exhibition of her work was staged at the Guggenheim Museum in 1972. Cindy Nemser, 'An Interview with Eva Hesse' was first published in *Artforum*, New York, vol. 7, no. 9, May 1970, pp. 59–63. Our excerpts are taken from this source.

Do you identify with any particular school of painting?

I don't think I ever did any traditional paintings – except what you call Abstract Expressionism. I most loved de Kooning and Gorky, but that was personal – not for what I could take from them. But I know the importance of Kline and Pollock and now I would say Pollock before anyone, but I didn't feel that way when I was growing up. Oldenburg is an artist that I really believe in. I respect his writings, his person, his energy, his art, the whole thing. He has humor, and he has his own use of materials. But I don't think I've taken or used those materials in any way. I don't think I've ever done that with anybody's work. To me, Oldenburg is wholly abstract. The same with Andy Warhol. He too is high on my favorite list . . . He is the most as an artist that you could be. His art and his statements and his person are so equivalent. He and his work are the same. It is what I want to be, the most Eva can be as an artist and as a person . . . I feel very close to Carl Andre. I feel, let's say, emotionally connected to his work. It does something to my insides. His metal plates were the concentration camp for me.

If Carl knew your response to his work what would be his reaction?

I don't know! Maybe it would be repellent to him that I would say such a thing about his art. He says you can't confuse life and art. But I think art is a total thing. A total person giving a contribution. It is an essence, a soul, and that's what it's about . . . In my inner soul art and life are inseparable. It becomes more absurd and less absurd to isolate a basically intuitive idea and then work up some calculated system and follow it through – that supposedly being the more intellectual approach – than giving precedence to soul or presence or whatever you want to call it . . . I am interested in solving an unknown factor of art and an unknown factor of life. For me it's a total image that has to do with me and life. It can't be divorced as an idea or composition or form. I don't believe art can be based on that. In fact my idea now is to counteract everything I've ever learned or been taught about those things – to find something that is inevitable that is my life, my feeling, my thoughts. This year, not knowing whether I would survive or not was connected with not knowing whether I would ever do art again. One of my first visions when I woke up from my operation was that I didn't have to be an artist to justify my existence, that I had a right to live without being one.

How do you feel about craftsmanship in the process of your work?

I do think there is a state of quality that is necessary, but it is not based on correctness. It has to do with the quality of the piece itself and nothing to do with neatness or edges. It's not the artisan quality of the work, but the integrity of the piece . . . I'm not conscious of materials as a beautiful essence . . . For me the great involvement is for a purpose – to arrive at an end – not that much of a thing in itself . . . I am interested in finding out through working on the piece some of the potential and not the preconceived. . . . As you work, the piece itself can define or redefine the next step, or the next step combined with some vague idea . . . I want to allow myself to get involved in what is happening and what can happen and be completely free to let that go and change . . . I do, however, have a very strong feeling about honesty – and in the process, I like to be, it sounds corny, true to whatever I use, and use it in the least pretentious and most direct way . . . If the

material is liquid, I don't just leave it or pour it. I can control it, but I don't really want to change it. I don't want to add color or make it thicker or thinner. There isn't a rule. I don't want to keep any rules. That's why my art might be so good, because I have no fear. I could take risks . . . My attitude toward art is most open. It is totally unconservative – just freedom and willingness to work. I really walk on the edge . . .

How do the materials relate to the content of your work?

It's not a simple question for me . . . First, when I work it's only the abstract qualities that I'm working with, which is the material, the form it's going to take, the size, the scale, the positioning, where it comes from, the ceiling, the floor . . . However I don't value the totality of the image on these abstract or esthetic points. For me, as I said before, art and life are inseparable. If I can name the content, then maybe on that level, it's the total absurdity of life. If I am related to certain artists it is not so much from having studied their works or writings, but from feeling the total absurdity in their work.

Which artists?

Marcel Duchamp, Yvonne Rainer, Jasper Johns, Carl Andre, Sartre, Samuel Beckett . . .

Absurdity?

It's so personal . . . Art and work and art and life are very connected and my whole life has been absurd. There isn't a thing in my life that has happened that hasn't been extreme – personal health, family, economic situations. My art, my school, my personal friends were the best things I ever had. And now back to extreme sickness – all extreme – all absurd. Now art being the most important thing for me, other than existing and staying alive, became connected to this, now closer meshed than ever, and absurdity is the key word . . . It has to do with contradictions and oppositions. In the forms I use in my work the contradictions are certainly there. I was always aware that I should take order versus chaos, stringy versus mass, huge versus small, and I would try to find the most absurd opposites or extreme opposites . . . I was always aware of their absurdity and also their formal contradictions and it was always more interesting than making something average, normal, right size, right proportion . . .

How about motifs, the circle for instance? You used it quite frequently in your early work.

I think that there is a time element in my use of the circle. It was a sequence of change and maturation. I think I am less involved in it now . . . In the last works I did, just about a year ago, I was less interested in a specific form like the circle or square or rectangle . . . I was really working to get to a non-anthropomorphic, non-geometric, non-non . . . [. . .]

Why do you repeat a form over and over again?

Because it exaggerates. If something is meaningful, maybe it's more meaningful said ten times. It's not just an esthetic choice. If something is absurd, it's much more

exaggerated, more absurd if it's repeated . . . I don't think I always do it, but repetition does enlarge or increase or exaggerate an idea or purpose in a statement . . . At times I thought, 'The more thought the greater the art,' but now I wonder about that . . . I think there is a lot that I'll just let happen and maybe it will come out the better for it . . . Maybe if I really believe in me, trust me, without any calculated plan, who knows what will happen . . . [. . .]

Your most recent work seems more free and daring than ever.

I would like to do that now – well, why not? I used to plan a lot and do everything myself. Then I started to take the chance – no, I needed the help. It was a little difficult at first. I worked with two people, but we got to know each other well enough, and I got confident enough, and just prior to when I was sick I would not state the problem or plan the day. I would let more happen and let myself be used in a freer way and they also – their participation was more their own, more flexible. I wanted to see within a day's work or within three days' work what we would do together with a general focus but not anything specified. I really would like, when I start working again, to go further into this whole process. It doesn't mean total chance, but more freedom and openness.

Has the new openness changed your work?

I can think of one thing that it changed. Prior to that time, the process of my work used to take a long time. First because I did most of it myself, and then when I planned the larger pieces and worked with someone, they were more formalistic. Then, when we started working less formalistically or with greater chance the whole process became speeded up . . . The whole attitude was different, and that is more the attitude that I want to work with now, in fact, even increased, even more exaggerated. [. . .]

How can you ignore the formal aspects of art?

So I am stuck with esthetic problems. But I want to reach out past . . . I want to give greater significance to my art. I want to extend my art perhaps into something that doesn't exist yet . . .

Like falling off the edge?

That's a nice way of saying it. Yes, I would like to do that.

12 Joseph Beuys (1921–1986) 'Not Just a Few Are Called, But Everyone'

Beuys's thought can be related to a tradition of social idealism wherein it is not the business of the artist to function politically in any material or organizational sense to bring about change in the world, but to do so through the example of his art. He was the most prominent European member of the Fluxus movement during the early 1960s – one of various

tendencies which sought to merge art and life in the face of more strictly Modernist attempts to legislate their separation (see VIA11). He was Professor of Sculpture at the Kunstakademie in Düsseldorf from 1961 until 1972, when he was dismissed following his attempt to implement a principle of unrestricted admission. Through his work and his example he shaped a distinct German contribution to the broad avant-garde tendencies of the later 1960s and early 1970s. His ideal of democracy was based on the presupposition that creative potential is universal. This interview with Georg Jappe was translated by John Wheelwright; first published in *Studio International*, London, vol. 184, no. 950, December 1972, pp. 226–8, from which the present text is taken. (See also VIIC8 and VIIIC7.)

JB: Things start with answers to questions . . . But since there have been these large classes I don't carry on individual conversations – in a desperate situation like that private conversations aren't so effective – so everyone can learn something from every correction. That way each student learns from others' problems as well as his own.

GJ: Is that a sort of group therapy?

JB: Yes. Private problems, too – with some exceptions – are publicly discussed. It is part of group therapy that people should put their private hang-ups into words, and the questions that have mounted up and whatever anyone has on their mind. Sometimes it is really like a special school for the handicapped, developing the most primitive forms; the students bring up the most diverse things, out of the sculpture, painting and drawing fields. I have no fixed teaching plan. Everyone must build upon the basis of his own aim and then express it in a question so that something is cleared up. To begin with I refuse any pre-ordained theme; everyone must put his own theme forward. Then the conversation about how this fits in with theoretical principles begins. [. . .] I don't believe that an art school, which should stress new artistic concepts, should lay emphasis on fixed places to work in the school. That sort of thinking is tied up with the idea of art as a craft, with the work-bench and the drawing-table. The need for that is only now felt by a few – and those who want a place to work can still have it – because the majority is striving for movement and sees the school as a meeting-point. Discussions can arise spontaneously there, though some are also announced beforehand, on questions the students themselves have brought up, for example the question of space, or the difference between concrete plastic art and sculpture.

GJ: What does that distinction mean?

JB: It is often maintained that in my class everything is conceptual or political. But I put great value on something coming out of it that is sensuously accessible according to the broad principles of the theory of recognition. [. . .] Thought and speech should be seen as plastic in the same way that a sculptor sees a plastic object. My main interest here is to begin with speech and to let the materialization follow as a composite of thought and action. The most important thing to me is that man, by virtue of his products, has experience of how he can contribute to the whole and not only produce articles but become a sculptor or architect of the whole social organism. The future social order will take its shape from compatibility with the theoretical principles of art. Just as a relief must be unravelled and must come to life – because plasticity feels ill, as I say to my pupils in such cases – so must the organization of society. My concept of organization is an artistic one insofar as it must come to fruition according to the laws of organisms and in organic form. And that is what

concrete plastic art does. Sculpture is more abstract, geometrical, a matter of assembly; concrete plastic art fulfils itself in elemental organic ways, like animals developing, like blood working its way through the veins or the moving water of a river. [...] Art can be learned, though a certain talent is a prerequisite, but hard work is part of the process. Art comes from intelligence, one must have something to say, but on the other side, that of capability, one must be able to express it. And then sense of proportion, of mass, of form, and feel for symmetry. Of course this is subjective, but no judgements can possibly be made outside the terms of reference of the subject. Scientific objectivity cannot stretch to objective judgements about art. Objective judgements on art are not directly rationalizable, but they are expressible; for example, it may be that in a work overloaded with content no overall formal coherence emerges. The pouring into form of streams of emotion that has not been thought out, the psychedelic belches that well up without being reflected upon and without being touched by the polarizing influence of form, these are a form of illness, a sort of cancerous psychical tumour. Then one goes on to the therapy: don't take what boils up inside you so seriously, grasp something real outside, so that everything doesn't stick in a state of chaos. [...]

GJ: Why do you turn almost all your energy towards education and enlightenment?

JB: It is the consequence of widening the concept of art. The 'Political Office' has self-determination as its focus. And art has the same focus. Every man is a plastic artist who must determine things for himself. In an age of individuation, away from collective groupings, self-determination is the central concept. But one should not lose sight of actual practice, daily coming into being under one's hands. My pedagogic and political categories result from 'Fluxus'. To impose forms on the world around us is the beginning of a process that continues into the political field. Discussion used to centre on the participation of the public and it became apparent that actionism as a sort of joint play was not enough; the participant must also have something to contribute from the resources of his own thought. A total work of art is only possible in the context of the whole of society. Everyone will be a necessary co-creator of a social architecture, and, so long as anyone cannot participate, the ideal form of democracy has not been reached. Whether people are artists, assemblers of machines or nurses, it is a matter of participating in the whole. Art looks more towards a field where sensitivity is developed into an organ of cognition and hence explores areas quite different from formal logic. I have to admit that only quite a small minority is still in a position to understand pictures. The times educate people to think in terms of abstract concepts ... most people think they have to comprehend art in intellectual terms – in many people the organs of sensory and emotional experience have atrophied. Concepts must be elaborated which relate to this state of consciousness, so as to express quite different associations of force. Many people spoke of mysticism. Basically, though, I am interested in getting as far as talking of a picture of man that cannot be constrained by the prevailing scientific concepts. For this, man needs the Aesthetic Education. The isolated concept of art education must be done away with, and the artistic element must be embodied in every subject, whether it is our mother tongue, geography, mathematics or gymnastics. I am pleading for a gradual realization that there is no other way except that people should be artistically educated. This artistic education alone provides a sound base for an efficient society. The achievements of our society are channeled and

determined by power relationships. But it is not just a few who are called to determine how the world will be changed – but everyone. In a true democracy there are no other differences than capability; democracy can only develop freely when all restrictive mechanisms are gone. One of the greatest of these restrictive mechanisms is the present-day school, because it does not develop people but channels them.

13 Lea Vergine, from 'The Body as Language'

Vergine is an Italian writer and curator, active in the field of contemporary art since the 1970s. 'The Body as Language' was among her earliest and most influential publications (see VIIIB2). Vergine collected photographic documentation and analysis of the work of over sixty artists active in the then newly emerging field of Body/Performance art. The collection was prefaced by the long essay from which our present extracts are taken. Vergine takes up the language of psychoanalysis to draw out both the critical potential and the pathological dangers of the new art. *Il corpo come linguaggio* was first published in Milan in 1974. Our extracts are taken from the translation by Henry Martin, published in a new edition with an afterword by Lea Vergine as *Body Art and Performance. The Body as Language*, Milan: Skira, 2000. Our extracts are from pp. 7–9, 15–16 and 26.

The body is being used as an art language by an ever greater number of contemporary painters and sculptors, and even though the phenomenon touches upon artists who represent different currents and tendencies, who use widely differing art techniques, and who come from a variety of cultural and intellectual backgrounds, certain characteristics of this way of making art are nonetheless to be found in all of its manifestations. It always involves, for example, a loss of personal identity, a refusal to allow the sense of reality to invade and control the sphere of the emotions, and a romantic rebellion against dependence upon both people and things. Tenderness is always the goal aimed for and missed and therefore surrounded by frustration. And this is always accompanied by the anguish that derives from the absence of an 'adult' and altruistic form of love.

At the basis of Body Art . . . one can discover the unsatisfied need for a love that extends itself without limit in time – the need to be loved for what one is and for what one wants to be – the need for a kind of love that confers unlimited rights – the need for what is called *primary love*. This is what gives this art its dimension of inevitable delusion and failure. This unobtained love is what transforms itself into the aggressivity that is typical of all of these actions, events, photo-sequences and performances. It is also redirected to other versions of the self, and the self is doubled, camouflaged, and idealized. It is turned into the love of the romance of the self. This avid need for love becomes narcissism in the fetus that we continue to be, but to be loved in this way is the only power that might once again give sense to the lives of so many of us.

If the word 'art' can still legitimately be used, the art of the artists presented in this book is the art of the bourgeois intellectuals who struggle constantly against the bourgeoisie and who are attempting to separate what is from what has ceased to be, in order once again to be able to use it to recreate a culture. It's the same old opposition to the capitalistic co-opt of all the forms of art production and this helps to explain why so many of the actions are full of Nietzsche, Expressionism, and Existentialism.

The individual is obsessed by the obligation to act as a function of 'the other,' obsessed by the obligation to exhibit himself in order to be able *to be*. The over-riding desire is to live collective *ethos* and *pathos*, to grasp the *existent* in all of its brutal physicality, to communicate something that has been previously felt but that is lived in the very moment of communication, to return to the origins without leaving the present, to lead the individual to relationship with both himself and others, to lead the individual, in short, back to his specific mode of existence...

The accent is placed on *nature*, the desire to go beyond the values of current morality, organic phenomena (which are considered primary), accident, innocence, and the spontaneity to which our behavior and our customs must return in order to be able to step back away from the artificial conventions of society. All of this is an attempt to eliminate culture – which is to say the whole nexus of cultivated ways of living, the concept of encyclopedism as opposed to the concept of consciousness, the collective formation of social groups within institutions that define and condition them, crystallization as opposed to evolution.

The individual is placed at the center of a continuous process that is carried ahead with persistences and repetitions, and with the hardheadedness of insisting upon a sensational event as well as an exasperating analysis of all the possibilities of every moment of every function of every part of the body – with all the activism of incessant movement and experimentation and an enormous expense of energy. In ninety per cent of the cases, the artists we are talking about are persons full of apprehension, but they are also extremely acute observers who are interested in new forms of cognition and who go about their business with attention and vigilance... Like Artaud, they want an intimate acquaintance with all of the possibilities of self-knowledge that can stem from the body and the investigation of the body. The body is stripped bare in an extreme attempt to acquire the right to a rebirth back into the world. Most of the time, the experiences we are dealing with are authentic, and they are consequently cruel and painful. *Those who are in pain will tell you that they have the right to be taken seriously.*

These artists do not 'take a long look at life,' and their forms of expression are not genteel. They make no *a priori* exclusions and in most of them suffering is not transformed into mysticism. This is particularly true when they are involved in the investigation of our infirmities and the monstrous organization of the real. It's a question of facing up to death through life, rummaging around in the under and seamy sides of life, bringing to light the *secret* and the hidden. Only by experimenting a little at a time with death does one come to understand a little bit more about life – only by showing the precariousness of everything that we are accustomed to call normal... Instead of giving us a story and a character, these artists become both story and character. They are looking for the human being who isn't castrated by the functionalism of society – the man who lives outside of the laws of profit. What's important is not to know, but to know that one knows. This is a state in which culture is no longer of any conceivable use. Once the productive forces of the unconscious have been liberated, what follows is a continuous and hysterical dramatization of the conflicts between desire and defense, license and prohibition, latent and manifest content, memory and resistance, castration and self-conservation, life impulses and death impulses, voyeurism and exhibition, impulses towards sadism and masochistic pleasure, destructive fantasy and cathartic fantasy. If we were interested in looking for analogies in psychopathology, we could find them in the intemperances of neurolabil-

ity, in hysterical crises (emotional reactions that lack proportion to their external causes), in abandonment neuroses, in inhibitions with respect to adult development, in autoerotism, in obsessive manias, in aspirations to omnipotence, in oral avidity, in sadistic allusivity. If we were interested in relations to perversion, we could talk about fetishism, transvestism, voyeurism, kleptomania, paedophilia, necrophilia, sadomasochism, rupophobia, scatophagia. A search for psychotic symptoms would lead our attention to the aspects of the work connected to dissociation, melancholy, delirium, depression, and persecution manias. But this procedure would lack commitment. The use of a terminology borrowed from psychopathology is incapable of leading to an understanding of the appeal of this *reductio ad absurdum* that many of the artists now considered *avant-garde* are intent upon practicing, and practicing at their own risk.

* * *

The attitude of ritualism gives further strength to a search for relationship between aesthetic activity and *regressive pleasure*. The discomfort of unrequited desire, the hazard implicit in our precarious existence, and the continuous tension that is experienced when faced with the prospects of hypotheses that may never become realizable are all understood to be *quotidian* situations that lead inevitably to a state of anguish for the *being-in-the-world*, and likewise to the pain that results from the impossibility of finding a real relationship with it. This, then, is what gives rise to the *catastrophe reaction* and the *protection delirium*. [...]

Thus, the significant terms of this art are the things that are outside of us, our bodies, what happens *inside* of us and what happens *to* us. Objects have the task of being the proof that others are either *together* with us or not, and this is communicated to us by the physiognomy of objects. The relationship between the artist and the other is a question of being close to or distant from objects. We observe the recuperation of the love object (which is always, finally, an elaboration of the original maternal image that we have lost) and we also observe the refurbishment of this image in the external world as a kind of compensation for the charges of affective energy that have remained deluded within us.

One's own life, the proofs of one's own existence, and the entire sphere of everything 'private' are used as repertory material. Anything and everything can be pressed into service: any action from any moment of any day, photographs of oneself, or x-rays, or medical test graphs, one's own voice, all of the possible relationships one can have with one's excrement or one's genitals, reconstructions of one's past or the theatrical presentation of one's dreams, the inventory of the events of family history, gymnastics, mime and acrobacy, blows and wounds. 'The body is a part of every perception. It is the immediate past in so far as it still emerges in the present that flees away from it. This means that it is at one and the same time a point of view and a point of departure – a point of view and a point of departure that I *am* and that I also *go beyond* as I move off towards what I must become.' (Jean-Paul Sartre). Some of the artists activate a displacement, an inversion, or a censure through anthropological citations or oneiric inventions; others bring forth paradoxical and terrifying narrations; still others give themselves over to the elaboration of their personal myths and turn their attention to infantile shocks and adolescent transfers. We end up with the individual who is nothing more than an individual. *Homo* is neither *faber*, nor *ludens*, nor *sapiens*. He is simply a man without the myth, without morality, apologue, or allegory; he is only a man full of the fear of uninterrupted banality, full of damning affections and disaffections. He lives

with his acts of piety and obscenity, with his red and impure intestines, with his taste for decadence and expiation. In the same way that many small children use their excrements as a tool for affirming themselves in the eyes of the adults around them, many of the artists involved in Body Art and performances also exalt the excretory functions and the uses and abuses of all of the body's orifices. Obsessive neuroses are no longer renounced nor is coprophilia censured; everything that derives from anal eroticism is accepted and put to use. And this is not as if to say '*homo sum, humani nihil a me alienum puto.*' It is rather an alarming documentation of a pernicious autism and of a frenzied and sadistic self-satisfaction not only with respect to the artist in performance but also to the spectator – true and proper neoplasms of sadomasochistic perversion.

The fear of death is also a part of our 'phylogenetic heredity.' And anxiety is a particular state of discomfort that arises as a response to the danger of loss. But it is also true that whenever a desire for something is repressed, the libido attached to it is transformed into anxiety and that anxiety is connected to waiting. Anxiety robs the individual of self-assuredness, and his *being with the others* takes place in a dimension of false hope. Repressed instincts are the dangers that menace the condition of civilized man. It is thus necessary to demolish the conventions of decency that support the great lie, necessary to destroy the artificial screen that separates the *public* from the *private*. Every latrine is a drawing room, every drawing room a latrine. The distinction between sublime and vulgar no longer makes sense.

* * *

The artist's attempt to function in a *different* or *alternative* manner is an expression of the desire to eliminate the habitual position of prestige that his role comports. It is also an attempt to clear the field of interpersonal relations from the forms of alienation that art and culture continually produce and that contribute to render relationships frustrating and non-emancipatory. The objective is to eliminate aesthetic specificity and cultural deprivation. Competitivity, destructivity and the guilt feelings that accompany them are exasperated by the civilization of automation. Thus the enjoyment of something tragically total or absolute along with what might be called the nostalgia for a prenatal situation (to be found transferred into the relationship between artist and public) eliminates or distances the suspicion that the goals of this kind of communication are obscured or secretive. The public is needed to complete the event; it must be involved in a collective experience that leads it to reconsider its quotidian existence and the rules of its ordinary behavior. That is enough about the norms of passive contemplation: now the public is to serve as a sounding box. The relationship between public and artist becomes a relationship of complicity. The artist offers his hand to the spectator and the success of the operation depends upon how and how much the spectator is willing to accept it. The gesture of the artist who makes the proposition acquires significance only if his actions are met by an act of *recognition* on the part of the spectator. The artist needs to feel that the others are receptive to him, that they are willing to play the game of accepting his provocations and that they will give him back his 'projections.' It is indispensable that the public co-operate with him, since what he needs is to be *confirmed* in his identity. The behavior of the spectator is a gratification for the artist just as the behavior of the artist is a gratification for the spectator. When the public allows itself to be *used*, the artist has found an 'other' who is willing to give him reassurance in the fantasy or utopianizing world that he is attempting to make

visible, and the experiment works the other way round as well. But sometimes the situation becomes a question of 'anything goes' and we end up with reciprocal deception. This is due to the fact that the spectator is a masochist desirous of being *punished*. (The function of punishment would be to eliminate feelings of guilt in order to allow the possibility for a successive moment of pleasure.) And thus we approach a kind of aesthetic terrorism which is based upon a vigorous opposition to the phenomena of elitist and consumer art.

14 Bruce Nauman (b. 1941) Interview with Michele De Angelus

Born in Indiana, in the American mid-West, Nauman studied at the University of Wisconsin before moving to California. In common with many other young artists who emerged from college in the mid-1960s, Nauman turned away from the conventional media of painting and sculpture and began to work in what has been called the 'expanded field' of art activity. His mix of object-making, installation, photography, performance and video work has proved both influential upon and symptomatic of the disparate range of practices that have come to the fore of artistic culture since the 1960s. Throughout, however, his work has been animated by questions concerning the nature and boundaries of art activity, and the position of art in the wider culture. This has led to a perennial testing of the limits, not so much of what can be art (in so far as it now appears that anything and everything can be claimed as 'art'), but of what remains interesting and significant, assuming the relaxation of any constraint. The present interview was recorded for the Archives of American Art between 27 and 30 May 1980. Nauman began by talking about his early interest in music, mentioning in particular Philip Glass, Steve Reich, Terry Riley, LaMonte Young and John Coltrane, in terms of structures that seemed to repeat without progression. This led on to a discussion of his interest in processes involving repetition, in the accidents which tend to occur in repeated processes, and in the tensions that can result. Our extracts begin with Nauman's discussion of his early photographs and video tapes involving actions in rooms, and of the art to which he was responding at the time. They are drawn from the interview as reprinted in the exhibition catalogue *Bruce Nauman*, London: Hayward Gallery, 1998, pp. 120–8.

BN: A lot of the films were about dance or exercise problems or repeated movements, as were the performances. You have the repeated action, and at the same time, over a long period of time you have mistakes or at least a chance, changes, and you get tired and all kinds of things happen, so there's a certain tension that you can exploit once you begin to understand how those things function. And a lot of the videotapes were about that. [...]

MDA: A lot of those have to do with position in relation to rooms, it seemed to me. What were you thinking of in doing those?

BN: Well, by that time there was. I think, I don't know exactly, but a certain amount of that had to do with my response to the Bob Morris and Don Judd stuff that was in the magazines. Also, I think a really important piece for me, that I'd forgotten about for years and remembered not too long ago, was a show of some kind... in San Francisco. There were two pieces of Richard Tuttle's, early pieces. And especially because I knew so few people, I spent a lot of time at the studio kind of reassessing,

or assessing, why, why are you an artist and what do you do, and finally that's what the work came out . . . that question, why is anyone an artist and what do artists do. I paced around a lot, so I tried to figure out a way of making that function as the work. And so some of that early work after I got out of school had to do with how I spent my time. I drank a lot of coffee, so those photographs of coffee thrown away, . . . of hot coffee spilled. [. . .]

MDA: Were you in any way taking on the idea that this wasn't what artists had been doing as art up to that point?

BN: No. Well, I think there's always, when you feel you aren't getting a lot of attention anyway, or there's a very small audience that you have, then I think that a certain amount of testing can . . . I think that you do things to find out if you believe in it in the first place, just like often you'll say things in conversation, just to test, and so you do that. I think a lot of work is done that way, which doesn't make a fake or anything, it's the only way you find out is to do it.

[. . .] that was the examination, what is the function of an artist. Why am I an artist is the same question. And a lot of the reading that I was doing at that time. I think that I finally realized that the sculpture I had made in college revolved around that reinforcement (a lot of people doing work that was art about art). I needed to work out of a broader social context, and I needed to get more of what I thought and what I knew about it into the work . . . I was reading, I think a lot of word/visual puns and other pieces come from reading Nabokov. I was reading Wittgenstein's *Philosophical Investigations*, which I think doesn't provide you with anything except a way to question things. You can have an argument and follow it until you find out that it makes sense or doesn't make sense, but it was still useful to me to find out that it didn't go to anywhere or it was wrong. [. . .]

I wasn't interested in a boring situation and I think what was important was that . . . , there always was a beginning and an end, but it seemed to me that if it went on long enough, if somebody could come in and watch it, you could give them an hour or a half hour or two hours or whatever, but what I always wanted to be careful about was to have the structure include enough tensions in either random error or getting tired and making a mistake, whatever, that there always was some structure programmed into the event. And I really was interested in tensions, not in the tension of sitting there for a long time and having nothing change. And I think the pieces that were successful, were successful for those reasons, and the pieces that weren't successful failed because they didn't have enough structure built into them. [. . .]

MDA: I'm curious about the way your work manipulates the spectator. Do you feel any kind of responsibility about that? It's clearly an aim in a lot of the work.

BN: Well, maybe at the simplest level, but when I do something that's of interest to me, or the experience of the work is interesting, I don't know, that's confusing – well, then I just have to assume that some number of people will, if I've done a good job and made some interesting statement, be interested in that, too. And so I don't in that sense feel that it's a manipulation. I think that, but of course it's real complicated because I'm involved in the whole discovery of the piece and what's left is the piece

which I made. I seldom have a lot of interest in it once it's finished; I've done what I set out to do or got someplace and found something out about it. In the end all you can do is trust that my needs and the situation are general enough that other people can become involved in it. And I know they're quite often quite demanding, but I think that's all right, too. . . . I was talking to Peter Schjeldahl, he's a poet and critic, and we were talking about where the work came from and that we both felt that our work came a lot out of frustration and anger. So a lot of the work is about that, frustration and anger, it was the social situation, not so much out of specific personal incidents but out of the world or mores or any cultural dissatisfaction, or disjointedness or something, and it doesn't always appear that way in the work, I think. Somehow it generates work; it generates energy from the work. [. . .]

MDA: But this art doesn't affect the culture in a larger sense. It's not like social work or something. [. . .]

BN: Oh, no. I think that people make a mistake about that. Art can never . . . have any direct political or social impact on culture. But I would think that art is what's used in history; it's what's kind of left. And that's how we view history, as through art and writing, art in the broad sense: music and writing and all that, . . . you know art is political in the sense that it pokes at the edges of what's accepted or what's acceptable, or because it does investigate why people do art or why people do anything, or how the culture can and should function. I think art's about those things, and art is a very indirect way of pursuing those kinds of thoughts. So the impact has to be indirect, but at the same time I think it can be real. I think it's almost impossible to predict or say what it is, but it certainly doesn't apply to the political situation today or tomorrow, except in an abstract and more general way. I think that with art on philosophy . . . , if you think of art as discipline, the people that are interesting are the people that are exploring the structure of the discipline. In that sense they're breaking the discipline down, too, as they're expanding it. They tend to break down what's there. Certainly there are artists who function entirely within the discipline. I would find those people uninteresting. Not that they're not talented or skilled or all those things, but it's not of interest to me. In that sense there's a great deal of confusion, because it doesn't require being able to draw or being able to paint well or know colors, it doesn't require any of those specific things that are in the discipline, to be interesting. On the other hand, if you don't have any skill at all, then you can't communicate, either, so it's an interesting edge between – that edge is interesting for those reasons.

VIIC
Political Aspects

1 Hélio Oiticica (1937–1980) 'Appearance of the Supra-Sensorial'

Oiticica was born and studied in Rio de Janeiro. In the later 1950s and early 1960s he made geometric constructions and reliefs, and he was involved with the Brazilian Neo-Concrete movement in 1959–61. His views on the function of art were strongly affected by his belief in the need for political reform, and by his faith in cultural change as a means to its achievement. In a text written in 1967, he argued, 'There is currently in Brazil the need to take positions in regard to political, social, and ethical problems, a need which increases daily and requires urgent formulation, since it is the crucial issue in the creative field.' (From 'General Scheme of the New Objectivity', first published in the catalogue for the exhibition 'Nova Objetividade Brasileira' at the Museu de Arte Moderna, Rio de Janeiro, 1967.) During the later 1960s he designed environments and made costumes intended to transform their wearers into animate sculptures. These drew upon an indigenous tradition of street fiestas and parades, in intentional resistance to the norms of cosmopolitan modernist art. As Oiticica envisaged it, the viewer who fully participated in his work was joining a critical experiment in the exercise of freedom. In 1970 he travelled to New York on a Guggenheim Fellowship, remaining there for the next eight years. The following text was written in November/December 1967 and was first published as 'O aparacimento do suprasensorial na arte Brasileira' in *Revista GAM*, Rio de Janeiro, no. 13, 1968. Our complete text is taken from the English translation in Guy Brett et al., *Hélio Oiticica*, Rotterdam: Witte de With; Minneapolis: Walker Art Center, 1992, pp. 127–30.

Sculpture changed, as painting did, shedding the old conditioning to which it had been subject, breaking the base, attaining mobility, and becoming a hybrid product, the object. Everything else derived from painting or sculpture leads to the object, which is therefore a path, a passage to this new synthesis. The work, the poem (as seen in the Brazilian 'Neo-concrete' experience), purified itself with the appearance of the poem-object. What is the object then? A new category, or a new mode of aesthetic proposition? While containing these two meanings, the most important proposition of the object, of the makers of objects, in my view would be that of a new perceptual behaviour, created through increasing spectator participation, eventually overcoming the object as the end of aesthetic expression. For me, in my development, the object was a passage to experiences increasingly engaged with the individual behaviour of each spectator: I must insist that the search, here, is not for a 'new conditioning' of the participator, but an overturning of every conditioning in the quest for individual liberty, through increasingly open propositions, aimed at making each person find

within themselves, through accessibility, through improvisation, their internal liberty, the path for a creative state – what Mario Pedrosa prophetically defined as the 'experimental exercise of liberty.' It is useless to want to pursue a new aestheticism through the object, or limit oneself to 'discoveries' and pseudo-advanced novelties through works and propositions. When I created and defined the idea of 'New Objectivity', it was to pin-point a characteristic state of this evolution as seen in the Brazilian avant-gardes, not to stratify concepts and create new categories: 'object', and 'environmental art'. The work of Lygia Clark is decisive for understanding this phenomenon among us. First in her transformation of the picture, which announced its demise, and later with her magnificent discovery of the *Bicho* (Animal) which transformed and finished with sculpture, she made the most daring creative propositions: the most important and significant of Brazilian art. The emerging propositions either turn to the object (word, box, etc., spanning all modes, up to the 'thing' and the 'appropriation'), or to the environment, catalyzing its elements, but aiming at the proposition in its essence. In passing, let it be said that since I became conscious of the 'environment' (from 1960 onwards), I have always considered the object as one of its orders (hence the *Nuclei, Penetrables, Bolides, Parangolés*, and *Environmental Manifestations* – orders towards an entirety, already seeking a 'life-experience proposition' for today). There is no wish here to create an aesthetic of the object or of the environment; this would be a lesser aspect of the problem, one whose significance is limited to the space and time within this evolution. What matters, still, is the internal structure of the proposition, its 'objectivity'. The concept of 'New Objectivity' does not seek, as many think, to 'dilute' structures, but to give them a total meaning, overcoming the structuralism created by the propositions of abstract art, making it grow on all sides, like a plant, until it embraces an idea focused on the liberty of the individual, furnishing him with propositions which are open to his imaginative, interior exercise – this would be one of the ways, provided in this case by the artist, of de-alienating the individual, of making him objective in his socio-ethical behaviour. The very making of the work would be violated, as would interior 'elaboration' since the real 'making' would be the individual's life-experience.

I came, then, to formulate the concept of the 'suprasensorial'. It would be difficult, in this note, to define and express it in all its vigour – I intend soon to publish a text on the subject: 'The Search for the Suprasensorial'. It is an attempt to generate creative exercises through increasingly open propositions, dispensing with even the object as it has come to be categorized. These are not painting-sculpture-poem fusions, palpable works, though they may exhibit this aspect; they are directed at the senses in order that, through them, through 'total perception', they may lead the individual to a 'suprasensation', to the expansion of his usual sensory capacities, to the discovery of his internal creative centre, of his dormant expressive spontaneity, linked to the quotidian. This implies a series of arguments which it is impossible to discuss here: questions of a social, ethical, political, etc., order. The first effective group experience in this direction, is being organized collectively: besides myself, Lygia Pape, with her proposition of the 'seed', where she discovers improvisation and corporal expressiveness as an introduction to creation, as an invitation to gesture and rhythm: the rediscovery of body-expression – the poet Raimundo Amado, in an experience with word and sound, and the resultant action; Lygia Clark, with her *Sensorial Helmets*, seeking what she calls 'infrasensorial life-experience'. In my propositions, I seek to 'open' the participator to

himself – there is a process of interior expansion, a dive into the self, necessary for such a discovery of the creative process – action would be the completion of it. Everything is valid according to each case in these propositions, especially the appeal to the senses: touch, smell, hearing, etc., but not in order to 'investigate' them through a stimulus-reaction process, purely limited to the sensory, as with 'Op Art'. By proposing and indicating an interior expansion within the spectator, it already aims at the suprasensorial. Suprasensorial stability would be represented by hallucinogenic states (with or without hallucinogenic drugs, since suprasensorial life-experiences of various kinds also lead to a similar state; drugs would be the classic exemplary state of the suprasensorial) and, to complete the polarity, the complementary state, in other words, the non-hallucinogenic. This is something to be discussed in detail elsewhere, since it is liable to provoke passions for and against. This entire experience into which art flows, the issue of liberty itself, of the expansion of the individual's consciousness, of the return to myth, the rediscovery of rhythm, dance, the body, the senses, which finally are what we have as weapons of direct, perceptual, participatory knowledge, immediately provokes reactions from conformists of all kinds, since it (the experience) represents the liberation from those prejudices of social conditioning to which the individual is subject. The stance, then, is revolutionary in the total sense of behaviour – do not be mistaken, we will be labeled insane at every opportunity: that is part of the reactionary scheme. Art is no longer an instrument of intellectual domination, can no longer be used as something 'supreme', unattainable, as pleasure for the whisky-drinking bourgeois or the speculative intellectual: the only art of the past which will remain is that which can be apprehended as direct emotion, what can release the individual from his oppressive conditioning, giving him a new dimension which responds to his behaviour. The rest will fall, since it was an instrument of domination. One thing is definite and certain: the search for the suprasensorial, for man's life-experiences, is the 'discovery of the will', through the 'experimental exercise of liberty' (Pedrosa), by the individual to which it opens itself. Only truths matter here, in themselves, without metaphorical transposition.

2 Dan Graham (b. 1942) Presentation to an Open Hearing of the Art Workers' Coalition

Graham's early works of the mid-1960s were text- and text-and-photograph based, usually intended for publication in magazines. These included *Poem-Schema*, which enumerated all the types of words used in the piece itself, and *Untitled (Figurative)*, which inserted a supermarket check-out bill between two glossy advertisements in *Harper's Bazaar*. The best-known remains *Homes For America* of 1966. Graham enumerated different styles of tract housing, kinds of decoration, available colours and so on, presented in a neutral report-like manner, along with a range of 'documentary'-type photographs. The effect was to make a complex point with considerable economy, concerning Modernist art and contemporary vanguard style ('Minimalism') and their relation to a wider social modernity. In the later 1960s and through the 1970s Graham worked predominantly in film, video and performance. In 1969 he made the following contribution to a meeting of the nascent Art Workers' Coalition. The purpose of the meeting was to decide 'what should be the program of the Art Workers regarding museum reform', and 'to establish the Program of an Open Art Workers' Coalition' (see also VIIC6). Graham's presentation reflects a deep disillusion with

the pervasive commodification of art on the part of sections of the avant-garde. In doing so it illuminates the relation between the often apparently hermetic practices of the new avant-garde of the sixties, and a wider social critique. The 'Open Hearing' of the Art Workers' Coalition took place on 10 April 1969. Graham's Presentation was published by the AWC in its report on the hearing, also in 1969. It was subsequently reprinted in Alexander Alberro and Blake Stimson (eds.), *Conceptual Art. A Critical Anthology*, Cambridge, MA: MIT Press, 2000, pp. 92–4, which is the source for our text.

The subject is the artist, the object is to make art *free*.

The art world stinks; it is made of people who collectively dig the shit; now seems to be the time to get the collective shit out of the system.

Where does the cycle begin? Let's begin with the individual painter or sculptor ensconced 'high' in his loft world, making his pile of shit (perhaps he is really shitting, in his mind's eye, on the world) having ingested art information and raw material from the shared world, pissing his time away, the labor of his love perhaps to be redeemed, to be *realized* at some other time.

The stuff is transformed when it is transposed into imposed 'higher' values. First, a gallery, then, perhaps a museum, and further extended by translation into the data of art information when reproduced in an art magazine; at which point the artist, seeing the transposition, is pissed off. As time is transposed, money is transposed into private worth for the artist and a 'high' *quality* for the collector and art critic in this business society. The art world is a collection of people who dig the dirt, or pay the artist to dig it for him, to get a 'piece' of the action – the games people play – for personal fun and profit ('a profitable experience'). Everybody has their private part (parts) to contribute – for the media it's just another slice of life/entertainment.

It's time it seems to leave all this shit behind; the art world is poisoned; get out to the country or take a radical stance. (According to the dictionary, 'root,' the root of radical and the root of root are the same – does dirt or evil really have roots?)

Should art be a lever against the Establishment? Make art dangerous? but art is only one item among the dangerous commodities being circulated in this society and, unattractive as it may be, one of the less lethal. *Withhold?* – a closed system dies of suffocation.

The writer in the past has been presented with an analogous problem. All magazines in order to survive are forced to present a well-known point of view to identify readers with advertisements just as in the past the structure of the book as object functioned to re-press the author's private, interior perspective or vision of life to the private reader who has bought the unique illusion as he reads through the narrative – linear, progressive, continuous from beginning to vanishing end point – his perspective is supposed to be altered by a novel insight into the world; he is changed; in Marx, Zola and Brecht's time he was hopefully motivated to change affect into effecting changes back in the *outside* world. Magazines – art magazines – continued this fiction of assuming private points-of-view whose sum they must assume to be the collective view of its readership and advertisers. They depend exclusively for their economic existence on selling ads to galleries for the most part. For what it's worth to the readers who will buy it, the critic who must sell it, quality in art is all that counts (time is money which counts/man is the measure of all things). For the writer, and recently, some so-called conceptual artists, there is a simple solution: buy the ads himself – the cycle thus feeds back on itself; invest in oneself – it's a free society.

Actually, it's not the artists, the galleries, the collectors, the critics or the art magazines who support the structure at all – but the United States government – you and me – geared to corporate needs – which through the tax structure make it profitable to run a non-profitable art 'business' to buy and donate 'works' to museums (in the process serving the sole purpose of feeding artists and Madison Avenue types in the overall process of making a lot of money for yourself), etc., etc.

The conceptual artist conceives of a pure art without material base, conceived simply by giving birth to new ideas – an art that would ideally mean and not be of baseball or Monopoly in the den, a game without ball, bat, gravity, dice or money. But it's free and like sex, with a minimum of two people (subject/object; inside/outside; yin/yang; receiver/sender; people who take pictures of each other just to prove that they really existed) anyone can play, making their rules as they go along.

The artist labored under the myth of trying to define himself (and his time) in terms of his work – his unique contribution – his *raison d'être*; rather than be defined by society in their image.

But art is an inevitable part of the larger order of society, its language and world shared and interdependent with the language, 'vision' and stuff of its specific Time, Life, place and function.

All human brains perceive and think partially in symbols which have a relationship to external signs available to all which reduce to various interrelated language systems which relate to the larger social order at a given moment.

What does the artist have in common with his friends, his public, his society? Information about himself, themselves and all ourselves – which is not reduced to ideas or material, but shares in both categories as it has a past, present and future time/ space. It is neither subjective or objective 'truth;' it simply is – it is both a residue 'object' and neutral 'ethereal' media transcribed – transcribed upon/translation – translating the content of single and collective man's internal and external position, work, ideas, activities.

The artist is not a machine; the artist shares in mankind's various media of expression having no better 'secrets' or necessarily seeing more inside or outside of things than any other person; often he is more calculating; he wants things to be as interesting as possible; to give and have return pleasure; to contribute to the life-enhancing social covenant. Perhaps young artists, with their new naivete have replaced the old naivete of their fathers.

My opinion (more later): we must go back to the old notion of socially 'good works' as against the private, aesthetic notion of 'good work' – i.e.: art to go public.

3 Mierle Laderman Ukeles (b. 1939) 'Maintenance Art Manifesto'

Ukeles's manifesto represents the increasing emergence in the art work of the late 1960s and 1970s both of 'women's issues' (that is, in this case, issues related to the sexual division of labour in society), and of women as artists. It was written c.1969. Although some women did, historically, establish careers in modern art – some of them prominently – there can be no doubt that the Modernism of the time was implicated in the wider sexism of the society at large. With the emergence of the women's movement in the sixties this situation began to change, in art no less than in other walks of life. In 1973, Lucy Lippard (see VIIC4) organized

the exhibition 'c.7,500' which consisted exclusively of the work of women artists active in the new avant-garde. Ukeles' 'Maintenance Art Manifesto' is an early example of vanguard art informed by an explicitly feminist politics. She establishes a distinction between 'Development' and 'Maintenance' activities, the former constituting what is conventionally regarded as 'creative' work, the latter that which is usually marginalized, despite the fact that maintenance constitutes, so to speak, the seven-eighths of the iceberg upon which the more highly regarded activities depend. Ukeles proposed to carry out 'maintenance'-type activities as artwork. Thus, in performances in 1973 at Wadsworth Athenaeum, Hartford, Connecticut, she scrubbed the museum steps, polished museum display cases, and locked up the offices of museum workers. The manifesto was in two parts, the first titled 'Ideas', the second a description of a proposed exhibition. The first section is reprinted here from the text as published in Lucy R. Lippard, *Six Years: the dematerialization of the art object from 1966 to 1972*, Berkeley, Los Angeles and London: University of California Press (1973), 1997 edition, pp. 220–1.

IDEAS

A. *The Death Instinct* and *The Life Instinct*.

The Death Instinct: separation, individuality, Avant-Garde par excellence; to follow one's own part to death – do your own thing, dynamic change.

The Life Instinct: unification, the eternal return, the perpetuation and maintenance of the species, survival systems and operation, equilibrium.

B. Two basic systems: *Development* and *Maintenance*.

The sourball of every revolution: after the revolution who's going to pick up the garbage on Monday morning?

Development: pure individual creation; the new; change; progress; advance; excitement; flight or fleeing.

Maintenance: Keep the dust off the pure individual creation; preserve the new; sustain the change; protect progress; defend and prolong the advance; renew the excitement; repeat the flight.

Show your work – show it again

Keep the contemporary art museum groovy

Keep the home fires burning

Development systems are partial feedback systems with major room for change.

Maintenance systems are direct feedback systems with little room for alteration.

C. *Maintenance is a drag;* it takes all the fucking time, literally; the mind boggles and chafes at the boredom; the culture confers lousy status and minimum wages on maintenance jobs; housewives = no pay.

Clean your desk, wash the dishes, clean the floor, wash your clothes, wash your toes, change the baby's diaper, finish the report, correct the typos, mend the fence, keep the customer happy, throw out the stinking garbage, watch out – don't put things in your nose, what shall I wear, I have no sox, pay your bills, don't litter, save string, wash your hair, change the sheets, go to the store. I'm out of perfume, say it again – he doesn't understand, seal it again – it leaks, go to work, this art is dusty, clear the table, call him again, flush the toilet, stay young.

D. *Art:*

Everything I say is Art is Art. Everything I do is Art is Art. 'We have no Art, we try to do everything well.' (Balinese saying à la McLuhan and Fuller.)

Avant-garde art, which claims utter development, is infected by strains of mainten-
ance ideas, maintenance activities, and maintenance materials.

Conceptual and Process Art especially claim pure development and change, yet
employ almost purely maintenance processes.

E. The exhibition of Maintenance Art, 'CARE,' would zero in on maintenance,
exhibit it, and yield, by utter opposition, a clarity of issues.

4 Lucy Lippard (b. 1937) 'Interview with Ursula Meyer' and 'Postface' to *Six Years*

In 1968 the critics Lucy Lippard and John Chandler published an article entitled 'The
Dematerialization of Art'. Lippard then expanded this into a book, *Six Years*, a listing of
the principal artists, events and works of the years 1966 to 1972: the period conventionally
associated with Conceptual Art. The book's 'Preface' reprinted an interview conducted in
December 1969 between Lippard and the German critic Ursula Meyer. It speculated on
connections between Conceptual Art, a critique of the current international market structure
of art, and the then emergent 'counter-culture'. The book also contained a 'Postface' written
for its publication, in which Lippard reflected on the failure of some of those aspirations. The
present extracts are taken from *Six Years: the dematerialization of the art object*, New York
and London, 1973, pp. 7–9 and 263–4.

Interview with Ursula Meyer

UM: Do you think visual art may eventually function in a different context al-
together?

LL: Yes, but there's going to have to be an immense educational process to get
people to even begin to look at things, to say nothing of look at things the way artists
look at things. [. . .]

UM: Do you believe the impact of what is happening now – with conceptual art and
what I call the other culture – that impact is going to hit the so-called art world, the
galleries, the museums? What changes do you envisage?

LL: Unfortunately I don't think there are going to be many changes taking place
immediately. I think the art world is probably going to be able to absorb conceptual
art as another 'movement' and not pay too much attention to it. The art establish-
ment depends so greatly on objects which can be bought and sold that I don't expect
it to do much about an art that is opposed to the prevailing systems. Whenever
I lecture and start talking about the possibility of no art or non-art in the future, I
have to admit I think *I'm* going to be able to tell who the artists are anyway. Maybe
another culture, a new network will arise. It's already clear that there are very
different ways of seeing things and thinking about things within the art world
even as it stands now, not as clear as the traditional New York 'uptown' and
'downtown' dichotomy, but it has something to do with that.

One of the important things about the new dematerialized art is that it provides a
way of getting the power structure out of New York and spreading it around to
wherever an artist feels like being at the time. Much art now is transported by the
artist, or *in* the artist himself, rather than by watered-down, belated circulating
exhibitions or by existing information networks such as mail, books, telex, video,

radio, etc. The artist is traveling a lot more, not to sightsee, but to get his work out. New York is the center because of the stimulus here, the bar and studio dialogue. Even if we get the art *works* out of New York, even if the objects do travel, they alone don't often provide the stimulus that they do combined with the milieu. But when the artists travel, whether they're liked or disliked, people are exposed directly to the art and to the ideas behind it in a more realistic, informal situation. Another idea that has come up often recently that interests me very much is that of the artist working as an interruptive device, a jolt, in present societal systems. Art has always been that, in a way, but John Latham and his APG group in London, among others, are trying to deal with it more directly.

UM: There's a strange reawakening in Europe now.

LL: It may be more fertile for new ideas and new ways of disseminating art than the United States. Certainly Canada is. Charles Harrison has pointed out that Paris and the various European cities are in the position that New York was in around 1939. There is a gallery and museum structure, but it is so dull and irrelevant to new art that there's a feeling that it can be bypassed, that new things can be done, voids filled. Whereas in New York, the present gallery-money-power structure is so strong that it's going to be very difficult to find a viable alternative to it. The artists who are trying to do non-object art are introducing a drastic solution to the problem of artists being bought and sold so easily, along with their art. Not, God knows, that the artists making conventional objects want that any more than anyone else, but their work unfortunately lends itself more easily to capitalist marketing devices. The people who buy a work of art they can't hang up or have in their garden are less interested in possession. They are patrons rather than collectors. That's why all this seems so inapplicable to museums, because museums are basically acquisitive.

UM: That one word 'idea' contradicts any sort of central establishment. You might have many idea centers that are made by living artists rather than one chauvinistic art enterprise.

LL: Yes. I was politicized by a trip to Argentina in the fall of 1968, when I talked to artists who felt that it was immoral to make their art in the society that existed there. It becomes clear that today everything, even art, exists in a political situation. I don't mean that art itself has to be seen in political terms or look political, but the way artists handle their art, where they make it, the chances they get to make it, how they are going to let it out, and to whom – it's all part of a life style and a political situation. It becomes a matter of artists' power, of artists achieving enough solidarity so they aren't at the mercy of a society that doesn't understand what they are doing. I guess that's where the other culture, or alternative information network, comes in – so we can have a choice of ways to live without dropping out.

Postface

Hopes that 'conceptual art' would be able to avoid the general commercialization, the destructively 'progressive' approach of modernism were for the most part unfounded. It seemed in 1969 . . . that no one, not even a public greedy for novelty, would actually pay money, or much of it, for a xerox sheet referring to an event past or never directly perceived, a group of photographs documenting an ephemeral situation or condition, a project for work never to be completed, words spoken but not recorded; it seemed that

these artists would therefore be forcibly freed from the tyranny of a commodity status and market-orientation. Three years later, the major conceptualists are selling work for substantial sums here and in Europe; they are represented by (and still more unexpected – showing in) the world's most prestigious galleries. Clearly, whatever minor revolutions in communication have been achieved by the process of dematerializing the object (easily mailed work, catalogues and magazine pieces, primarily art that can be shown inexpensively and unobtrusively in infinite locations at one time), art and artist in a capitalist society remain luxuries.

On the other hand, the esthetic contributions of an 'idea art' have been considerable. An informational, documentary idiom has provided a vehicle for art ideas that were encumbered and obscured by formal considerations. It has become obvious that there is a place for an art which parallels (rather than replaces or is succeeded by) the decorative object, or, perhaps still more important, sets up new critical criteria by which to view and vitalize itself (the function of the Art-Language group and its growing number of adherents). Such a strategy, if it continues to develop, can only have a salutory effect on the way all art is examined and developed in the future.

Conceptual art has not, however, as yet broken down the real barriers between the art context and those external disciplines – social, scientific, and academic – from which it draws sustenance. While it has become feasible for artists to deal with technical concepts in their own imaginations, rather than having to struggle with constructive techniques beyond their capacities and their financial means, interactions between mathematics and art, philosophy and art, literature and art, politics and art, are still at a very primitive level. There are some exceptions, among them certain works by Haacke, Buren, Piper, the Rosario group, Huebler. But, for the most part, the artists have been confined to art quarters, usually by choice. As yet the 'behavioral artists' have not held particularly rewarding dialogues with their psychologist counterparts, and we have had no feedback on the Art-Language group from the linguistic philosophers they emulate. 'Art use' of elementary knowledge, already accepted and exhausted, oversimplification, and unsophistication in regard to work accomplished in other fields are obvious barriers to such interdisciplinary communication.

The general ignorance of the visual arts, especially their theoretical bases, deplorable even in the so-called intellectual world; the artist's well-founded despair of ever reaching the mythical 'masses' with 'advanced art', the resulting ghetto mentality predominant in the narrow and incestuous art world itself, with its resentful reliance on a very small group of dealers, curators, critics, editors, and collectors who are all too frequently and often unknowingly bound by invisible apron strings to the 'real world's' power structure – all of these factors may make it unlikely that conceptual art will be any better equipped to affect the world any differently than, or even as much as, its less ephemeral counterparts. Certainly, few of the artists are directly concerned with this aspect of their art, nor can they be, since art that begins with other than an internal, esthetic goal rarely produces anything more than illustration or polemic. The fact remains that the mere survival of something still called Art in a world so intolerant of the useless and uningratiating indicates that there is some hope for the kind of awareness of that world which is uniquely imposed by esthetic criteria, no matter how bizarre the 'visual' manifestations may initially appear to those unacquainted with the art context.

5 *Artforum*: from 'The Artist and Politics: a Symposium'

In America in the late 1960s the Civil Rights issue and the Anti-Vietnam War movement forced the question of the political relations and commitments of artists on to the agenda in a way not seen since the end of the Second World War. The issue was exacerbated when in May 1970 four students taking part in a protest against the United States' illegal invasion of Cambodia were shot at and killed by National Guardsmen at Kent State University, Ohio. During the summer of 1970, *Artforum*, then the leading American art magazine, circulated a question to a number of artists. Twelve replies of varying lengths were published, in alphabetical order; which is to say not in order of seniority or prominence in the art world. They appeared in *Artforum*, New York, September 1970, pp. 35–9. The question and seven replies, some extracted, are here reprinted from this source. (Judd's response refers to demands issued by the Art Workers' Coalition. These are printed in their definitive form in VIIC6.)

A growing number of artists have begun to feel the need to respond to the deepening political crisis in America. Among these artists, however, there are serious differences concerning their relations to direct political actions. Many feel that the political implications of their work constitute the most profound political action they can take. Others, not denying this, continue to feel the need for an immediate, direct political commitment. Still others feel that their work is devoid of political meaning and that their political lives are unrelated to their art. What is your position regarding the kinds of political action that should be taken by artists?

Given: Art as a branch of agriculture.
Hence:
1 We must farm to sustain life.
2 We must fight to protect life.
3 Farming is one aspect of the social–political–economic struggle.
4 Fighting is one aspect of the social–political–economic struggle.
5 We must be fighting farmers and farming fighters.
6 There is no merit in growing potatoes in the shape of machine guns.
7 There is no merit in making edible machine guns.
8 Life is the link between politics and art.
9 Settle for nothing less than concrete analysis of concrete situations leading to concrete actions.
10 Silence is assent.

<div align="right">CARL ANDRE</div>

I think the time for political action by artists is now and I believe action should be taken in the art world and in the world at large. Political action need not inhibit art-making; the two activities are dissimilar, not incompatible. In fact all art is eventually political.
[...]
 While the political power of art is easily seen in the past, the political effects of art today appear somewhat obscure. This is probably because any contemporary time presents so much material and allows so few conclusions. Aristotle, in the *Poetics*, provides the most direct analysis, describing artists who imitate the past, artists

who imitate the present, and artists who imitate the future (ranking them in an ascending order of value). Past seeking, the preterit mode, sustains the conservative heart, which longs for that idealized childhood where authorities were strong, rules were clear and properties were unequivocally possessed. These desires are reinforced by reactionary art. There is no doubt why Nixon removed all the abstract art from the White House when he moved in. Abstract art seldom provokes a clear affection for the past.

Art which mirrors the present moves in a different way, from another cause and toward another effect. Its mainspring is the status quo. It is unidealized, displaying both the good and bad aspects of the now. Pop Art is the most obvious example but Machine Art, technological light works and most painting and sculpture in plastics are also typical. Other commemorators of the contemporary scene are Earth Art (reflecting the ways of our environment); the New Realism (recording the peoples and places of today); Protest Art (reproducing sado-masochistic brutalities); and that pair of sexual solipsisms currently known as Concept Art and Color Painting (rejoicing in the separative forces of our old friend, the mind–body problem). It is interesting to observe how intimately these art movements are joined to modern media, with their heavy reliance on promotion for distribution of products (and it is no accident to find their best customers in the bourgeoisie), for all these art ways and works of the present are entertainment commodities. They posit no radical changes and deal with conundrums, not problems. Their net political effect is a tacit support of the present system.

There is a radical art in America today, an art which innovates and is aimed at the future, but elucidation of its effects must wait until that future. [...] The most far-reaching endeavour has been reordering of subject matter so that the art object itself dominates its particular parts. Figure/grounds and hierarchical arrangements give way to paintings that picture their own shapes and pigments and sculptures that render their own shapes and matter. [...] These new ways have political implications that bear on the sovereignty of the subject and the nature and ramifications of self-determination.

JO BAER

You have asked what kind of political action should be taken by artists, and I can answer only that any particular artist should take whatever political action he wants to. Political things should not affect the making of art because political activity and art-making have never mixed to art's advantage, and my guess is that most artists are better off out of politics. But it is an individual's choice. As a subject it really does not merit the attention you are giving it.

WALTER DARBY BANNARD

I think of myself as a container, and what I do as an eruption of what I am. Where do you get nourished? That's where you have something to do. The body of the octopus is full. Its tentacles need only be directed to the caverns of waiting mouths.

[...] I have stipulated that the art-changers take upon themselves the tax burden – that dead artists support live artists through trust funds collected by taxing the profits from the auction block. Dead artists support live ones spiritually, so it isn't much of a peculiar demand that they support us financially. In fact our voices would be a lot

stronger if our blood were nourished by our dead compatriots instead of the market system. We can use the system as a pipeline, directing the fuel to where the need is signalled. Artists are sensitive people and they are hurt by the rock throwers while standing in line waiting for bread. Artists are the saints of the world eating the continual last supper. The better the food, the richer the art.

It's all a matter of economics, not politics. Throughout the centuries of art-making there have been wars, investigations, pogroms. The artist does battle on his own field, and resents being forced into combat with strangers, by a government that does not nourish him.

ROSEMARIE CASTORO

I've always thought that my work had political implications, had attitudes that would permit, limit or prohibit some kinds of political behavior and some institutions. Also, I've thought that the situation was pretty bad and that my work was all I could do. My attitude of opposition and isolation, which has slowly changed in regard to isolation in the last five years or so, was in reaction to the events of the fifties: the continued state of war, the destruction of the UN by the Americans and the Russians, the rigid useless political parties, the general exploitation and both the Army and McCarthy.

Part of the reason for my isolation was the incapacity to deal with it all, in any way, and also work. Part was that recent art had occurred outside of most of the society. Unlike now, very few people were opposed to anything, none my age that I knew. The most important reason for isolation was that I couldn't think about the country in a general way. Most of the general statements I read seemed doctrinaire and sloppy, both typical of general statements. Most of the advice seemed utopian, impractical or rather fascistic itself; I couldn't think of any great explanations and gradually came to the conclusion that there weren't any. All the institutions and their actions seemed like the explanations, overblown and unsubstantial. So my work didn't have anything to do with the society, the institutions and grand theories. It was one person's work and interests; its main political conclusion, negative but basic, was that it, myself, anyone shouldn't serve any of these things, that they should be considered very sceptically and practically. A person shouldn't be used by an organization of two on up. Most of the emotions and beliefs given to institutions should be forgotten; the bigger the institution the less it should get; I never understood how anyone could love the United States, or hate it for that matter; I've never understood the feelings of nationalism. Ask what your country can do for you.

My interest in actually doing something grew partly because my work became easier, clearer, more interesting, so that I didn't feel I would be swamped by other interests; partly by the example of the civil rights movement, that things could change a little; by the Vietnam war, which presented a situation of either/or – I marched in the first Fifth Avenue parade and I hate group activities (Ad Reinhardt was the only artist I recognized); by the realization that politics, the organization of society, was something itself, that it had its own nature and could only be changed in its own way. Art may change things a little but not much; I suspect one reason for the popularity of American art is that the museums and collectors didn't understand it enough to realize that it was against much in the society. [. . .]

It sounds obvious, but isn't so in terms of what happens, that everyone is a citizen, an equal part of a social organization, a political, public entity, an individual in a group

that is only a sum of individuals. The citizen, individual, person has his interests and rights. He or she's not or shouldn't be an economic, military, or institutional entity. I think the main confusion of both the right and left is the confusion of politics, public action, with economics. On both sides the individual is turned into an economic being. It's incredibly stupid that a person's reason for being should be the production of cars, whether here or in Russia. The people in both places are educated to be useful persons, producers, and not citizens. [...]

There is a big difference between the politics of citizens and the politics of interest groups. Obviously interest groups are a lot less important and necessary. Often they prevent people from acting as citizens. But if they don't they're legitimate. I think there should be an artists' organization functioning as an interest group. There's no reason why the organization shouldn't oppose the war in Vietnam, for example, as long as it knows it does so as an interest group and as long as the members act first as citizens. Certainly one thing an interest group should have is a sense of the integrity of its activity. One thing of the several I have against the Art Workers Coalition is that they were using art for all sorts of things. An activity shouldn't be used for a foreign purpose except when the purpose is extremely important and when nothing else can be done. I thought the suggestion of the Art Workers that a separate section of the Modern be permanently given to black artists and another to artists without galleries to be useless corruptions of the nature of the activity, one aspect of which is that art is good, middling and bad. Neither, as they think, are all artists equal; citizens are equal, not workers, not doctors, not anything. I'm also unimpressed by SoHo (I hope the name disappears); it's too narrow an interest group. Unlike the Art Workers, an artists' organization should decide what it wants and go after it practically and politically. If museum boards should be one third money and otherwise, one third staff and one third artists, as I think they should be, state that and talk to the museums. Allow some for differences in the museums, and those who refuse without reasons can be struck. Why is the Modern so interesting? Why be so eager to demonstrate, to use a tactic that was originally used for a much more serious purpose? [...]

DON JUDD

The artist does not have to *will* a response to the 'deepening political crisis in America.' Sooner or later the artist is implicated or devoured by politics without even trying. My 'position' is one of sinking into an awareness of global squalor and futility. The rat of politics always gnaws at the cheese of art. The trap is set. If there's an original curse, then politics has something to do with it. Direct political action becomes a matter of trying to pick poison out of boiling stew. The pain of this experience accelerates a need for more and more actions. 'Actions speak louder than words.' Such loud actions pour in on one like quicksand – one doesn't have to start one's own action. Actions swirl around one so fast they appear inactive. From a deeper level of 'the deepening political crisis,' the best and the worst actions run together and surround one in the inertia of a whirlpool. The bottom is never reached, but one keeps dropping into a kind of political centrifugal force that throws the blood of atrocities onto those working for peace. The horror becomes so intense, so imprisoning that one is overwhelmed by a sense of *disgust*. [...]

ROBERT SMITHSON

May the immediate political response be that as a human being all I can comment upon is what action an Artist *could* take and to even imply what action Artists *should* take would constitute a fascism as abhorrent if not more repugnant as that which has brought the sorry situation to bear originally.

The major problem still remains the same: the old esthetic workhorse of content and intent. Art as it becomes useful, even to the extent of entering the culture, becomes for me no longer Art but History. History being perhaps the most viable tool of Politics. All Art as it becomes known becomes Political regardless of the intent of the Artist.

All Art then is capable of becoming political by its own or by the volition of the culture, changing via this process from Art to History.

So-called Art whose original intent and most often content is political or social does not concern me as an Artist. They are for me only varied forms of sociological propaganda; albeit sometimes extremely creative advertising.

I accept fully the responsibility for the position of my Art in Culture Politics – but hold firmly that my actions as a man constitute only that. The political and sociological actions of one man with no vocational trimmings as props.

Artists are but one vocational unit in a sociological system and if I believed that their political and social opinions or needs were either above or below any other vocational unit, I should cease my activities.

Be there hopefully a day when men no longer need any other title than man to function politically. Then perhaps there shall be no political function for them.

LAWRENCE WEINER

6 Art Workers' Coalition: Statement of Demands

The Art Workers' Coalition was born of a specifically art-world controversy. On 3 January 1969 the kinetic artist Takis unilaterally withdrew a work from an exhibition at the Museum of Modern Art, New York. This action instigated a protest concerning the rights of artists to maintain control over their work, which rapidly mushroomed in the form of demonstrations by artists. In February '13 Demands' were issued to the Museum. Though remaining rooted in questions of artists' rights and museum reform, the AWC quickly broadened its remit to take in questions of the representation of women and black artists, and to protest against the continuation of the war in Vietnam. Robert Morris, Carl Andre and Lucy Lippard were among the leading art-world figures involved. The original list of 'Demands' was revised throughout 1969 and was published in definitive form in March 1970. It was reprinted in Lucy Lippard, 'The Art Workers' Coalition: not a history', in *Studio International*, London, November 1970, pp. 171–2, from which the present text is taken. (See also VIIC2.)

A. WITH REGARD TO ART MUSEUMS IN GENERAL THE ART WORKERS' COALITION MAKES THE FOLLOWING DEMANDS:

1 The Board of Trustees of all museums should be made up of one-third museum staff, one-third patrons and one-third artists, if it is to continue to act as the policy-making body of the museum. All means should be explored in the interest of a more open-minded and democratic museum. Art works are a cultural heritage that belong to the people. No minority has the right to control them; therefore, a board of trustees chosen on a financial basis must be eliminated.

2 Admission to all museums should be free at all times and they should be open evenings to accommodate working people.

3 All museums should decentralize to the extent that their activities and services enter Black, Puerto Rican and all other communities. They should support events with which these communities can identify and control. They should convert existing structures all over the city into relatively cheap, flexible branch-museums or cultural centres that could not carry the stigma of catering only to the wealthier sections of soceity.

4 A section of all museums under the direction of Black and Puerto Rican artists should be devoted to showing the accomplishments of Black and Puerto Rican artists, particularly in those cities where these (or other) minorities are well represented.

5 Museums should encourage female artists to overcome centuries of damage done to the image of the female as an artist by establishing equal representation of the sexes in exhibitions, museum purchases and on selection committees.

6 At least one museum in each city should maintain an up-to-date registry of all artists in their area, that is available to the public.

7 Museum staffs should take positions publicly and use their political influence in matters concerning the welfare of artists, such as rent control for artists' housing, legislation for artists' rights and whatever else may apply specifically to artists in their area. In particular, museums, as central institutions, should be aroused by the crisis threatening man's survival and should make their own demands to the government that ecological problems be put on a par with war and space efforts.

8 Exhibition programs should give special attention to works by artists not represented by a commercial gallery. Museums should also sponsor the production and exhibition of such works outside their own premises.

9 Artists should retain a disposition over the destiny of their work, whether or not it is owned by them, to ensure that it cannot be altered, destroyed, or exhibited without their consent.

B. UNTIL SUCH TIME AS A MINIMUM INCOME IS GUARANTEED FOR ALL PEOPLE, THE ECONOMIC POSITION OF ARTISTS SHOULD BE IMPROVED IN THE FOLLOWING WAYS:

1 Rental fees should be paid to artists or their heirs for all work exhibited where admissions are charged, whether or not the work is owned by the artist.

2 A percentage of the profit realized on the re-sale of an artist's work should revert to the artist or his heirs.

3 A trust fund should be set up from a tax levied on the sales of the work of dead artists. This fund would provide stipends, health insurance, help for artists' dependants and other social benefits.

7 Valie Export (b. 1940) 'Woman's Art'

The Austrian artist Valie Export belongs to the second generation of Vienna Actionists. During the 1970s she worked mostly with film, text and performance. The following text is one of the earliest documents of feminist art to be published in the German language. It was

written in March 1972, as a manifesto for the exhibition 'MAGNA', and was first published as 'Woman's Art' in *Neues Forum*, vol. XX, no. 228, Vienna, January 1973, p. 47. Our translation, by Nicholas Walker, is taken from this source.

THE PLACE OF ART IN THE WOMEN'S MOVEMENT IS THE PLACE OF WOMEN IN THE ART MOVEMENT

THE HISTORY OF WOMAN IS THE HISTORY OF MAN,

precisely because man has defined the image of woman. men create and control the social and communicative media like art and science, word and image, dress and architecture, social intercourse and the division of labour. men have reproduced their image of women within these media. they have shaped women in accordance with the patterns established by these media and women have done likewise. if reality is a social construction and men are its engineers then we are confronted by a masculine reality.

women have not yet become properly aware of themselves because they have not found a voice in the sense that they have been excluded from those media. this is what i mean when i demand that women acquire a voice so that they can become aware of themselves. in order to develop an image of woman as defined for ourselves and so transform the way the social role of woman is represented, we women must participate in the construction of reality through the elements of the media.

because this will not be freely allowed to happen without resistance, we shall have to struggle! if we women wish to accomplish our aims: equal social rights, self-determination, a new self-awareness on the part of women, we shall have to express them in all domains of life. this struggle will have far-reaching consequences not just for ourselves, but equally for men, for children, for the family, for the church ... in short for the state, and will bring about changes in life as a whole.

women must therefore employ all media as a means of societal struggle and as a means of social progress in order to liberate culture from masculine values. they will also undertake this in art. if men have succeeded through the millennia in expressing their ideas of the erotic, of sex and beauty, their mythology of strength, virility and discipline in sculptures, paintings, novels, films, dramas, drawing etc., and thereby in influencing the consciousness of us all, then the time has come

AND IT IS THE TIME

for us women to employ art as an expressive means of influencing the consciousness of everyone, in order to allow our ideas to permeate the social construction of reality and to create a human reality. until now art has largely been created by men, it has usually been men who have treated the subjects of life in general, and the problems of emotional life, men who have provided their views, their answers, their solutions. now we must articulate our views! we must destroy all these notions of love, fidelity, family, motherhood, spouse, notions which have not been determined by ourselves, and create new ones which correspond to our sensibility and our wishes.

to change the art imposed on us by man is to destroy the facets of woman constructed by man. through the processes of civilization the new values we bring to art will assign new values to us as women. art can be significant for the women's movement to the extent that we strike new meanings – our meanings – from art: this spark can ignite the process of self-determination. the question concerning what women can give to art and art can give to women, can be answered thus: to translate

the specific situation of the woman into the artistic context is to construct signs and signals which, first, constitute new artistic messages and forms of expression and, second, retrospectively change the situation of women.

art can be a medium of our self-determination, and this introduces new values into art. these values will change reality via the processes of cultural signification, and do so in the direction of women's needs.

THE FUTURE OF WOMAN WILL BE THE HISTORY OF WOMAN.

8 Joseph Beuys (1921–1986) 'I Am Searching for Field Character'

Beuys invokes a concept of 'direct democracy' in an essentially hierarchy-less social organism. To this end his concept of a 'Fifth International', assuming the priority of Consciousness over Being (or at least, of 'energy' over 'matter'), is advanced as a riposte to the philosophical materialism of the Communist (Third), and Trotskyist (Fourth) Internationals. Dated 1973, Beuys's statement was published in English translation by Caroline Tisdall in the exhibition catalogue *Art into Society, Society into Art*, London: Institute of Contemporary Arts, 1974, p. 48, from which the present text is taken. (See also VIIB12 and VIIIC7.)

Only on condition of a radical widening of definition will it be possible for art and activities related to art to provide evidence that art is now the only evolutionary-revolutionary power. Only art is capable of dismantling the repressive effects of a senile social system that continues to totter along the deathline: to dismantle in order to build A SOCIAL ORGANISM AS A WORK OF ART.

This most modern art discipline – Social Sculpture/Social Architecture – will only reach fruition when every living person becomes a creator, a sculptor, or architect of the social organism. Only then would the insistence on participation of the action art of FLUXUS and Happening be fulfilled; only then would democracy be fully realized. Only a conception of art revolutionized to this degree can turn into a politically productive force, coursing through each person, and shaping history.

But all this, and much that is as yet unexplored, has first to form part of our consciousness: insight is needed into objective connections. We must probe (theory of knowledge) the moment of origin of free individual productive potency (creativity). We then reach the threshold where the human being experiences himself primarily as a spiritual being, where his supreme achievements (work of art), his active thinking, his active feeling, his active will, and their higher forms, can be apprehended as sculptural generative means, corresponding to the exploded concepts of sculpture divided into its elements – indefinite – movement – definite (see theory of sculpture), and are then recognized as flowing in the direction that is shaping the content of the world right through into the future.

This is the concept of art that carries within itself not only the revolutionizing of the historic bourgeois concept of knowledge (materialism, positivism), but also of religious activity.

EVERY HUMAN BEING IS AN ARTIST who – from his state of freedom – the position of freedom that he experiences at first-hand – learns to determine the other positions in the TOTAL ART WORK OF THE FUTURE SOCIAL ORDER. Self-determination and participation in the cultural sphere (freedom); in the structuring of

laws (democracy); and in the sphere of economics (socialism). Self-administration and decentralization (three-fold structure) occurs: FREE DEMOCRATIC SOCIALISM.

THE FIFTH INTERNATIONAL is born.

Communication occurs in reciprocity: it must never be a one-way flow from the teacher to the taught. The teacher takes equally from the taught. So oscillates – at all times and everywhere, in any conceivable internal and external circumstance, between all degrees of ability, in the work place, institutions, the street, work circles, research groups, schools – the master/pupil, transmitter/receiver, relationship. The ways of achieving this are manifold, corresponding to the varying gifts of individuals and groups. THE ORGANIZATION FOR DIRECT DEMOCRACY THROUGH REFERENDUM is one such group. It seeks to launch many similar work groups or information centres, and strives towards world-wide cooperation.

9 Hans Haacke (b. 1936) Statement

Haacke's early work involved the production of self-contained systems, such as the process of condensation within a glass box, as part of the international series of breaks from conventional Modernism which occurred in the mid-1960s. As the 1960s progressed, however, his art became politicized and his attention turned from natural to social systems. Increasingly he has devoted his work to the exposure of those systems wherein conservative political and economic interests may be seen to use cultural sponsorship as a legitimating screen for their other activities. The art of the museum has been a recurring focus for him. Originally published in *Art into Society, Society into Art* (op. cit.), p. 63, from which the present text is taken.

Products which are considered 'works of art' have been singled out as culturally significant objects by those who at any given time and social stratum wield the power to confer the predicate 'work of art' unto them; they cannot elevate themselves from the host of man-made objects simply on the basis of some inherent qualities.

Today museums and comparable art institutions, like e.g. the ICA in London, belong to that group of agents in a society who have a sizable, although not an exclusive, share, in this cultural power on the level of so-called 'high-art'.

Irrespective of the 'avant-garde' or 'conservative', 'rightist' or 'leftist' stance a museum might take, it is, among other things, a carrier of socio-political connotations. By the very structure of its existence, it is a political institution. This is as true for museums in Moscow or Peking as for a museum in Cologne or the Guggenheim Museum. The question of private or public funding of the institution does not affect this axiom. The policies of publicly financed institutions are obviously subject to the approval of the supervising governmental agency. In turn, privately funded institutions naturally reflect the predilections and interests of their supporters. Any public museum receiving private donations may find itself in a conflict of interests. On the other hand the indirect subsidy of many private institutions through exemption from taxes and partial funding of their programs could equally create problems. Often, however, there exists in fact if not by design a tolerance or even a congruence of the respective ideological persuasions.

In principle the decisions of museum officials, ideologically highly determined or receptive to deviations from the norm, follow the boundaries set by their employers. These boundaries need not be expressly stated in order to be operative. Frequently museum officials have internalized the thinking of their superiors to a degree that it becomes natural for them to make the 'right' decisions and a congenial atmosphere reigns between employee and employer. Nevertheless it would be simplistic to assume that in each case museum officials are faithfully translating the interests of their superiors into museum policy, particularly since new cultural manifestations are not always recognizable as to their suitability or opposition to the parties concerned. The potential for confusion is increased by the fact that the convictions of an 'artist' are not necessarily reflected in the objective position his/her work takes on the socio-political scale and that this position could change over the years to the point of reversal.

Still, in order to gain some insight into the forces that elevate certain products to the level of 'works of art' it is helpful – among other investigations – to look into the economic and political underpinnings of the institutions, individuals and groups who share in the control of cultural power.

Strategies might be developed for performing this task in ways that its manifestations are liable to be considered 'works of art' in their own right. Not surprisingly some museums do not think they have sufficient independence to exhibit such a portrait of their own structure and try to dissuade or even censor works of this nature, as has been demonstrated. Fortunately art institutions and other cultural power agents do not form a monolithic block, so that the public's access to such works might be limited but not totally prevented.

Bertolt Brecht's 1934 appraisal of the 'Five Difficulties in Writing the Truth' is still valid today. They are the need for 'the courage to write the truth, although it is being suppressed; the intelligence to recognize it, although it is being covered up; the judgement to choose those in whose hands it becomes effective; the cunning to spread it among them.'

There are no 'artists', however, who are immune to being affected and influenced by the socio-political value-system of the society in which they live and of which all cultural agencies are a part, no matter if they are ignorant of these contraints or not ('artist' like 'work of art' are put in quotation marks because they are predicates with evaluative connotations deriving their currency from the relative ideological frame of a given cultural power group). So-called 'avant-garde art' is at best working close to the limitations set by its cultural/political environment, but it always operates within that allowance.

'Artists' as much as their supporters and their enemies, no matter of what ideological coloration, are unwitting partners in the art-syndrome and relate to each other dialectically. They participate jointly in the maintenance and/or development of the ideological make-up of their society. They work within that frame, set the frame and are being framed.

10 Marcel Broodthaers (1924–1976) 'To be *bien pensant* . . . or not to be. To be blind'

Broodthaers was born and educated in Brussels, initially studying chemistry before turning to poetry. After the end of the Second World War he was involved with Belgian Surrealism and

became acquainted with Magritte, publishing poetry in 1948 in *Le surréalisme révolutionnaire*. Subsequently, in the early 1960s, Broodthaers redefined his practice as art. His first exhibition took place in Brussels in April 1964, consisting of surviving copies of his last book of poems, *Pense-Bête*, set in plaster. Until around 1968, he continued to make enigmatic objects, mixing text with things such as mussel shells and eggshells. These works follow in a Surrealist tradition, as well as showing the influence of French *nouveau réalisme*, though Broodthaers criticized the latter for 'quietly assenting to the forms of modern civilization'. In 1968 he began the work for which he remains best known. The *Musée d'art moderne. Section des aigles* was shown in several manifestations ranging from an installation in Broodthaers's own Brussels apartment to the 1972 'Documenta' exhibition in Kassel. Consisting of images of eagles drawn from a variety of fine art and popular cultural sources, it represented a deliberately unsystematic, but wide-ranging, reflection on the classificatory procedures whereby institutions like museums frame cultural products for consumption. Towards the end of his life, Broodthaers moved to Düsseldorf, where he continued to produce installations in a variety of media concerned with the problem of the commodification of art in contemporary society. The present text was composed in 1975. Translated by Paul Schmidt, it was printed in Benjamin H. D. Buchloh (ed.), *Broodthaers. Writings, Interviews, Photographs*, a special issue of October, no. 42, 1987, p. 35. According to Buchloh's editorial comment, 'Monsieur de la Palice' is a character from a French folk song who pronounces truisms.

What is Art? Ever since the nineteenth century the question has been posed incessantly to the artist, to the museum director, to the art lover alike. I doubt, in fact, that it is possible to give a serious definition of Art, unless we examine the question in terms of a constant, I mean the transformation of art into merchandise. This process is accelerated nowadays to the point where artistic and commercial values have become superimposed. If we are concerned with the phenomenon of reification, then Art is a particular representation of the phenomenon – a form of tautology. We could then justify it as affirmation, and at the same time carve out for it a dubious existence. We would then have to consider what such a definition might be worth. One fact is certain: commentaries on Art are the result of shifts in the economy. It seems doubtful to us that such commentaries can be described as political.

Art is a prisoner of its phantasms and its function as magic; it hangs on our bourgeois walls as a sign of power, it flickers along the peripeties of our history like a shadow-play – but is it artistic? To read the Byzantine writing on the subject reminds us of the sex of angels, of Rabelais, or of debates at the Sorbonne. At the moment, inopportune linguistic investigations all end in a single gloss, which its authors like to call criticism. Art and literature . . . which of the moon's faces is hidden? And how many clouds and fleeting visions there are.

I have discovered nothing here, not even America. I choose to consider Art as a useless labor, apolitical and of little moral significance. Urged on by some base inspiration, I confess I would experience a kind of pleasure at being proved wrong. A guilty pleasure, since it would be at the expense of the victims, those who thought I was right.

Monsieur de la Palice is one of my customers. He loves novelties, and he, who makes other people laugh, finds my alphabet a pretext for his own laughter. My alphabet is painted.

All of this is quite obscure. The reader is invited to enter into this darkness to decipher a theory or to experience feelings of fraternity, those feelings that unite all men, and particularly the blind.

11 Mel Ramsden (b. 1944) from 'On Practice'

Ramsden and Ian Burn merged their collaborative practice with Art & Language in 1970. By 1975 some thirty people were associated with the name, equally divided between England and New York. Three issues of *The Fox* were published by an Art & Language Foundation in New York, with an editorial board which included Ramsden and Joseph Kosuth. The declared aim of the journal was to establish a basis for community practice through critical address to the contingent conditions of the New York art world. *The Fox* was instrumental in the Artists' Meeting for Cultural Change, which formed as a kind of revival of the Art Workers' Coalition. The title of Ramsden's essay makes ironic reference to a pamphlet by Mao Tse-tung, recalling the latter's dictum, 'If you want knowledge, you must take part in the practice of changing reality.' First published in *The Fox*, New York, April 1975, pp. 66–83, from which the present opening and concluding extracts are taken. (See also VIIB6.)

[. . .] Consider the following: that the administrators, dealers, critics, pundits, etc. who once seemed the neutral servants of art are now, especially in New York, becoming its masters. Has adventuristic New York art of the Seventies (perhaps uncontrollably) become a function of the market-system? Isn't the way this market vectors human relations now a massive controlling factor in the way we now vector human relations? A simplified and possibly even misleading account of how the above has come about might sound something like this: there is prevalent in the New York art world a ludicrous model of the individual in society (I say the New York art world but it does hold, I am sure, for other places too, no matter how far-flung. This is because most art 'centers' and art-schools (etc.) fall for modernist hegemony – this can be known as 'The New York connection'). This model may be generally and partially characterized as the idealist separation of private from political-social life. Such a separation has led to the celebration of indulgent individual 'freedom.' This appears to me to have had two alarming results: adventuristic art of the Seventies has become an insular and boring spectacle of fads, intoxications, diversions, infatuations and even the odd pseudo-revolution, all under the platitudinous guise of massive evidence of 'creativity' and 'artistic freedom.' (This 'freedom' some will always persist in citing as evidence that in this society the artist suffers no overt governmental controls and hence may still be 'a rebel'; a freedom which, on the other hand, others cite as fundamental to 'bourgeois ideology' and its 'illusion of freedom'.) Tied intimately to all this, as an essential part of the same 'form of life,' is the astonishing increase in art-world *assessors*: entrepreneurs, critics, curators, gallery staff, etc. In other words, *bureaucrats*. These bureaucrats administer the above 'manifestations of freedom' by alienating them, treating them as a kind of gloss for the mode of existence of middle-life market-relations. This is a mode of existence in which we become prices on the media-market, in which we become commodities, a mode of existence in which what counts is the demand for *what the market defines* as your talents, in which all relationships have their monetary value, and it is their monetary value that *matters*. It is a mode of existence in which we become slaves to the 'blind urge' to production-consumption and are thus assessed and administered by the bureaucrats only because the latter are closer to the sources of control (are higher in the market hierarchy). The above may be a bit vulgar but under these conditions I still think our activities become (except insofar as they

perpetuate-stabilize the market) largely arbitrary. The reason is that the bureaucrats are able to subsume anything, even the rare cranky-iconoclastic work. The products may change, modifications occur all the time (an endless spectacle), but the form of life remains the same: the ruling market provides the standard of intelligibility. One question to raise about this standard of intelligibility is whether the market-relations are really *separate* from what we do? That is to say, just how far has market-standing been *internalized?* [...]

* * *

Doing without the object...seemed at first and most obviously to grow from questions raised by the Minimalism of Judd, et al. of the mid-sixties. The need for us all to go-on after their utilization of objects in (...as the cant goes) an extremely robust 'literal' way, produced an art-form which didn't, in the conventional sense, appear to need objects at all – again in the conventional sense. Now suppose I pursue this line of argument: it could be said that trying to refine and extend the Modern Art tradition after Minimalism produced, in the form of Conceptual Art, a *contradiction*. This seems okay. It seems to lead on to noting that in the Marxist sense, a contradiction is a process wherein the normal operation of a 'social or cultural system' produces a condition which tends to undermine normal operation itself. Hence change comes to take place because the system creates, through its own internal contradictions, the conditions for its own breakdown. Such a characterization of revolutionary change is, interestingly enough, also fairly consistent with T. S. Kuhn's 'paradigm shifts': a system breaks down when 'anomalies' in one paradigm model force new paradigms to come into existence. Thus in both dialectical social analysis (Marxism) and an extremely fashionable segment of contemporary Philosophy of Science, 'revolution' is considered sufficiently characterized as a dialectical movement out from a set of entrenched norms. So, it seemed...whereas the AWC had been disarmed by an essentially inadequate reform program, Conceptual Art might indeed be such a 're-volution.' It *wasn't*, and there were reasons. First of all it wasn't even a contradiction because it was basically limited to insular-tautological spectacle. It wasn't *enough*; it was a diversification, not a contradiction because this is the way the institutions *make* things work today. That is, today institutions have become autonomous. They constitute a bureaucratic tyranny which brooks no opposition. They are in other words *logically separate* from (our) practice. This implies that the just-doing-my-job artist's role also severs the ties with social practice insofar as it is bureaucratic. To put all this another way: it may be that the range of maneuvers now available to us under Modern Art are simply *out of phase* with the institutional conditions inherent under late-capitalism. Hence, if our labor and means of production seem to be our own free possessions to do with as we please, 'freely' so to speak, it's only because we naively operate according to an outmoded model of competitive capitalism. And this is just out of phase today, given the kunst star media-life which easily and greedily coerces (our) practice. The inability to really bring about change, Conceptual Art notwithstanding, is because our mode of operation is 'professionalized', specialized, autonomous, and essentially quaintly harm-less (but essential) to the mode of operation of the market-structures. The basis of control of such a market is its *role* structuring and the artist as a-willing-or-not-conscious-or-not efficient economic unit. Of course we've all moralistically refused to see these problems as anything other than incidental, or, at best, somebody else's business. The situation becomes, to me, even more vain as we ourselves finally become

our own entrepreneurs-pundits, the middle-life of the market our sole reality. To increase the frenzied manipulation of spectacle is absolutely fundamental to New York Adventurism. The Cultural imperialism unwittingly exported everywhere by this adventurism is heinous and alienating – finally even to those who produce the exports. The bureaucracy will subsume even the most persistent iconoclasm unless we begin to act on the realization that its real source of control lies in our very concept of our own 'private' individual selves. The far-out and the outlandish is deeply rooted in the US as evidence of freedom and of the truly moral – it is the lack of examination of such a concept that makes most present day radical-art radical-daft instead of radical-fundamental.

12 Ian Burn (1939–1993) 'The Art Market: Affluence and Degradation'

Burn was involved in the early development of Conceptual Art and co-founded the Society for Theoretical Art and Analyses with Roger Cutforth and Mel Ramsden in New York in 1969. He worked in New York with Ramsden (see VIIB6) and subsequently as a member of Art & Language before returning to his native Australia in 1976. His essay contributed to that critical engagement with the conditions of the New York art world which developed within the American wing of Art & Language. It was not published in either of the group's own journals, however, but in the mainstream publication *Artforum*, in April 1975, pp. 34–7, from which the present text is taken. The essay was reprinted in the *Artforum Anthology*, New York, 1984.

Impending economic crisis has forced many deeply lurking problems into the open. Art sales are declining and there is an air of pessimism. The sense of opulence of the 1960s has gone to dust. As artists, we have tended to understand the art market only in its reward capacity, preferring to ignore the 'dismal science' of economics. But no longer, it seems. While it may once have seemed an exaggeration of economic determinism to regard works of art as 'merely' commodities in an economic exchange, it is now pretty plain that our entire lives have become so extensively constituted in these terms that we cannot any longer pretend otherwise. Not only do works of art end up as commodities, but there is also an overwhelming sense in which works of art *start off* as commodities.

Faced with this impasse, we need alternate historical perspectives in order to throw light on some of the most basic of social relations, to perceive the lacuna between what we think we do and what we actually do in the world. The historical relations of up-to-date modern art are the market relations of a capitalist society. That much I believe is obvious to everyone. What we have seen more recently is the power of market values to distort all other values, so even the concept of what is and is not acceptable as 'work' is defined *first and fundamentally* by the market and only secondly by 'creative urges' (etc.). This has been the price of internalizing an intensely capitalistic mode of production.

Given this, shouldn't we be scrutinizing certain historically unique aspects of our market relations? How have these wrought fundamental changes in the 'art' produced? I know many of us are grateful beneficiaries of this market. Nonetheless, we have all ended up victims of its capriciousness, the 'principles' of modern art having trapped us

in a panoptical prison of our own making. Simply, this is the realization that if the arts were really democratized, we as producers of an elite art would no longer have any means of functioning – wanting to abolish elitism in modern art is tantamount to wanting to abolish modern art itself.

* * *

Putting this into a familiar New York perspective: we have all been enticed by the prospect of endless market expansion which it seems, oddly enough, we have internalized in the idea of an endlessly innovative avant-gardist growth. This supports the power of the market by providing subtly pervasive means of cultural and intellectual control, through implicit direction and the supplying of a categorical check on the 'evolution' of art. In addition, the unprecedented concentration of capital invested by the market in this avant-gardist elite has successfully had the effect of reducing 'unnecessary' competition, if not eliminating it altogether. Today it is surely beyond any doubt that this popular idea of a 'permanent revolution' in art is actively designed never to fulfil any personal and social relationship. From this point of view, it is a set of empty gestures which threaten none of the market requirements and end up being a sheer celebration of the new individuality, arrogantly and, finally, stupidly set against the idea of sociality. [. . .]

In case it appears I am overstating the role of United States capitalism in all this, let me emphasize the obvious, that the history of modern art from its beginnings was nurtured within a number of industrialized societies, not just America. Looking closer at that history, with its unrelenting emphasis on an 'art-for-art's-sake' ideology, we become conscious of the ever-increasing role played by a neutered formalism – at the expense of our possibility of content. The stress on exclusively formal innovation had the aftermath of content in its last gasp being reduced to such vacua as 'colour', 'edge', 'process', 'ideas', 'image', etc. plus a lot of fatuous jargon about qualities symbolized through these (cf. especially Greenberg's account of modernism, but also most issues of *Artforum* and other magazines). This is formalism taken to its ultimate empty conclusions: it is what we have lauded as pure art . . . the impossibility of content, of saying anything whatsoever. The tradition of formalism has left me largely incapable of expressing through 'my art' those very things about which I have the greatest misgivings – and so incapable of changing anything through 'my art'. These ideological fetters have conclusively eradicated every possibility of a social practice in relation to art, even the thought of it – the expression of modern art has become the rejection of society and of our social beings. Now, obviously the United States isn't to blame for all of this, but it certainly deserves a lot of the credit for bringing it to a remarkable and unprecedented pitch. No longer just producing an art for a privileged middle-class, it has burgeoned into a spectacularly elitist art, remote even from its own producers' actual lives and problems.

What can you expect to challenge in the real world with 'colour', 'edge', 'process', systems, modules, etc. as your arguments? Can you be any more than a manipulated puppet if these are your 'professional' arguments? Moreover, when you add to this picture thousands upon thousands of artists in all corners of the modern art empire tackling American formalism in the belief that it is the one 'true art' – that's when it is possible to see how preposterous and finally downright degrading it has become!

Needless to say, it is easy for me to identify with some points of the classic nineteenth-century theses about alienation. There it was argued that alienation is the

process whereby human values are projected outside of us and achieve an existence independent of us, and over us, and this is an essential condition for the functioning of capitalism. We are all familiar with the romanticized notions about the work of art 'embodying the soul of the artist'. Well, perhaps historically this has taken on mythic proportions, but there is a very real sense in which everything produced ought to bear some personal relation to who makes it. However, once my work of art enters the art market, it takes on a power independent of me and this strikes me as a form of estrangement from what I have produced, an alienation from my own experiences; and the more I produce the more I deprive myself of my 'means of life'. Yet I find I can only maintain myself by continuing in the same fashion. So, while I may retain economic ownership over my labour and means of production (thus giving me a sense of 'freedom'), I am still psychologically and socially alienated from what I produce. Once entering the market, it becomes an object foreign to me – but without the market I don't recognize it, because it is defined via the market which I have internalized. Don't we all experience this to greater or lesser degrees? As a result, myself-as-an-artist has become a stranger to me, a figure over whom I have little power or control. This is today's blunt reality of alienation. No longer merely having lost the product of our labour, our ability to create is profoundly impaired . . . and this is also expressed in my relation to you, and burgeons in the relation you can have to what I produce.

Often-heard remarks implying that it is not enough to be 'just an artist' are merely public admissions that, as a role in society, 'artist' is a sterile one. More pointedly, this sheds light on the prevailing concept of 'artist': it has become an integral part of the meaning of the concept 'artist' that it is politically conservative (or, at its more adventuristic, reactionary), and that remains its sole possible political role – hence its continuing great value as propaganda for an imperious culture. This is clearly reflected in the desperation of more and more artists to escape their political impotence, in their attempts to reconcile the paradoxicality of their lives wrought by being hopefully 'radical' in politics but necessarily 'conservative' in art.[1]

The inside story of this is that there is no 'radical theory' in the arts today, and there can be none while the present state of affairs prevails. That also explains something about the extreme poverty of 'critical theory', since a critical theory which sets itself the task of revealing the various forms of conflict and exploitation needs to be informed by some (prospect of) radical theory, something which denies the current ideology and economic class values embodied in modern art. Current and recent art criticism has become at best a means of policing and regulating, at worst a sheer celebration of the impotence of the status quo.

In this light, most of the chatter about 'plurality' in the contemporary scene comes over as so much liberal claptrap. What use is a sort of 'freedom' which can have no other effect than reinforcing the status quo? [. . .]

* * *

Whatever we are able to accomplish now, my point is that transforming our reality is no longer a question of just making more art – it is a matter of realizing the enormous social vectoring of the problem and opportunistically taking advantage of what social tools we have. Of one thing I am certain: anything we might call radical theory in the arts will have to be solidly constructed in all its social dimensions. But even then it may not be a question of how much we might accomplish, since it might take something as

catastrophic as a collapse in the economic structure of this society to have any substantial effect on the careening superstructure of modern American art.

[1] This point can also be made concerning the contradictions apparent in looking at art produced by feminist artists, black artists and various underprivileged groups: while their social thinking is radical, fertile and engaging, what we see of the art produced is too often as embarrassingly dull, uniform and bureaucratic as everyone else's.

13 Victor Burgin (b. 1941) from 'Socialist Formalism'

In the early 1970s Burgin's work became increasingly politicized, and he turned particularly to the critical use of advertising techniques: offsetting photographs and texts to point up the persistence of social and sexual contradictions behind the façade of the conventional advertisement. For Burgin, painting and other forms of fine art practised under the rubric of the 'autonomy of art' became complicit in the exploitative social structure which his, principally photographic, art was now concerned to unmask. In his attempt to gain critical purchase on the 'expressive' protocols of Modernism in art, he invoked the practical tradition of Russian Constructivism, and the theoretical legacy of linguistic semiology. The present essay was first published in *Studio International*, vol. 191, no. 980, London, March/April 1976, from which the present extracts are taken. (See also VIIB8 and VIIIB5.)

While contemporary Western art practice is currently polarized between Modernism and 'conceptualism' *both* are being viewed in terms of a Modernist *politique* – in terms of a Modernist aesthetics and a Modernist version of history. The inability of most critics to deal with conceptualism on anything but an *ad hoc* basis stems from this fundamental category error, as does the failure of most conceptualists to found their practice in anything other than *laissez-faire* subjectivism. The consolidation of conceptualist practices along the socialist lines which have been implicit from their inception demands a reading of formalist aesthetics, of history, and of current priorities, different from that now predominating in the Western art community.

Conceptualism administered a rebuff to the Modernist demand for aesthetic confections and for formal novelty for its own sake. It disregarded the arbitrary and fetishistic restrictions which 'Art' placed on technology – the anachronistic daubing of woven fabrics with coloured mud, the chipping apart of rocks and the sticking together of pipes – all in the name of timeless aesthetic values. However, once beyond the official enclosures of 'legitimate' art practice many found that they had exchanged their prison for a desert. They learned that there is nothing to be made of a conceptual-*ism*, defined in opposition to Modernism, other than an 'official opposition'; and that there is nothing to be made of Modernist art history other than a history of Modernism.

My remarks here, very far from being comprehensive, are intended to point off the highroad of Western bourgeois aesthetics to areas where conceptualism may be better grounded for the completion of its metamorphosis from an essentially Modernist avant-garde to a socialist art practice. They will concern Russian art in the decade following the October revolution, normally presented as a story of the arbitrary suppression of modern art by philistine communism; and (representing a general concern with 'mass media') advertising, normally not presented at all in an art context.

The Western assessment of the 'importance' of Malevich amongst modern Russian artists is readily understood: his work, his concern for 'the spiritual in art', is easily accommodated within the western tradition of Romantic formalism. This movement of accommodation disengages all Russian art of the revolutionary period from its real historical context in order to insert it in the familiar, spuriously historical, sequence 'from Cubism to Modernism' which in fact is an anti-history, an ideology. It also ignores the *difference* between Western and Russian formalism.

Modernism is typically defined in opposition to Realism. In classic Realism there is assumed an unmediated presentation of the referent through the sign (unmediated that is save for 'noise' in the physical channel of communication – problems of mediation in Realism tending to become confused with questions of technique exercised in the interests of conformity to some prevailing model of reality). Realism is primarily 'about' content and major debates within Realism concern subject–matter alone (witness the recurring 'crisis of content' in nineteenth-century painting).

With the hindsight granted us by Saussure we can today see that classic Realism rests upon a mistaken concept of signification: the sign is assumed to be 'transparent', allowing unproblematical access to the referent. Cubism we can see as constituting a radical critique of this concept, a practice compatible with a recognition of the disjunction of signifier and signified within the sign. Post-cubist Modernism, however, did not develop as a scientific aesthetics based upon a critique of the sign, but rather as a normative aesthetics based upon a notion of territoriality.

The brand of formalism propounded by Greenberg and Fried is in direct line of descent from the attempt by Bell and Fry to 'free' art from concerns not 'peculiarly its own'. In the earlier of these two periods of formalist criticism, particularly with Bell, recourse is made to a Kantian ontology (a *noumenal* world 'behind' mere appearances) in order to justify abstraction. American Modernism ostensibly sees the art object as justified solely as an end in itself, but it remains determined by the earlier English version in that in the same movement in which it sheds idealism it loses the last vestige of any concern with content. (The ghost of idealism haunts Modernism to this day – it was minimal sculpture which came closest to a materialist abstractionism.)

In Russia the move towards the immanent modes of analysis of formalism was first accomplished by the Symbolist philologists Potebnya and Veselovsky. Their emphasis on the distinction between poetic and prosaic language isolated language itself as the primary object of literary studies.[1] The Formalist critics of *OPOYAZ* (Society for the Study of Poetic Language) and the Moscow Linguistic Circle retained this distinction, Jakobson, in a well-known dictum, declaring the proper object of literary studies to be not literature but 'literariness' (*literaturnost*).

The Russian Formalists, however, rejected the Symbolist notion of a 'higher reality'. They also rejected the Symbolist notion of form in which form, the perceivable, was conceived in opposition to content, the intelligible. They extended the notion of form to cover all aspects of a work. Todorov writes: ' . . . the Symbolists tended to divide the literary product into form (i.e. sound), which was vital and content (i.e. ideas), which was external to art. The Formalist approach was completely opposed to this aesthetic appreciation of 'pure form'. They no longer saw form as opposed to some other internal element of a work of art (normally its content) and began to conceive it as the totality of the work's various components. Thus every element inside a work of art is, according to the exact measure of its appropriateness to it, a formal part of the whole . . . This

makes it essential to realise that the 'form' of a work is not its only formal element: its content may equally be formal.'[2] Russian Formalism was therefore substantially advanced beyond its Western contemporary, the formalism of Fry and Bell, in which considerations of content were arbitrarily banished in a quasi-legal ruling.

* * *

The period from 1917 to 1932 does not present the simple story of suppression preferred in the West. Decisions on aesthetic questions were entirely avoided by the party until 1925. The notion that a fully formed state aesthetic policy was desirable did not emerge until the thirties. By 1920, however, 'laboratory art' Constructivism had already been condemned by the constructivist artists themselves as an anachronistic perpetuation of bourgeois vested interests. These productivists went on to develop, in industry and in mass media, practices compatible with their revolutionary socialist politics. In some respects they were 'overtaken on the left' by *Proletkult*, but both factions eventually foundered against the growing influence of conservatism after NEP – that moment depicted in some accounts as an improvement in post-revolutionary cultural conditions, but which the artists and critics of *Lef* recognized as a betrayal of the revolution.

We may integrate the concerns of Russian Formalism and Factography within a modern Western art problematic: the first requirement of a socialist art practice is that it should engage those codes and contents which are *in the public domain*. These present themselves, and thus ideology, as natural and whole; a socialist art practice aims to deconstruct these codes, to unpick the apparently seamless ideological surface they present.

The propaganda message is ineffective to the extent that it endorses the very codes which frame the ideology it would oppose; it is these which appropriate it as 'mere propaganda'. Anthony Wilden puts it: '...the response to the indifference of the system cannot simply be a strident dogmatism...the first line of defence against the violence of the rhetoric of the establishment is to learn something about rhetoric. And that means to learn something about communication. But a line of defence is not enough: the victims must take the offensive. What is required – at this admittedly minimal level – is a *guerrilla rhetoric*. And for a guerrilla rhetoric, you must know what your enemy knows, why and how he knows it, and how to contest him on any ground.'[3]

Wilden is speaking here of the rhetoric of the academic establishment in which: 'The necessary isolation of a system from its context in order that it may be studied...is generally used, implicitly...to justify the isolation of the researcher from *his* context: from his past, from his social and academic position, from his future expectations, from his economic status in a hierarchical system of privilege, from his conscious or unconscious positive or negative commitment to a set of ideological and political views – all of which one may expect to discover in various transformations in his work.'[4] Wilden's remarks, however, may be extended to all the forms of discourse which collectively constitute the symbolic representation of our official culture; notably, those which are encountered in the mass media.

Fortini quotes a certain communist spokesman: 'Continue as writers. We do not want to make a corporal of a man whose voice can move an army'; and then comments that '...the writer whose "voice can move an army" is in fact the bureaucrat of letters,

the specialist in propaganda, integrated in mystification.'[5] It is such specialists as these who today compose commercial publicity.

Without doubt advertising constitutes one of the most massive ideological interventions in our cultural life. Why then does it receive such a disproportionately small amount of 'serious' attention, compared say with cinema? One answer to this question is cultural: British intellectuals tend to have an 'English Lit' background and the analysis of (what they take to be) animated books suits them very well. Another reason is phenomenological: whereas the cinema readily constitutes itself as an object, advertising is received as an environment and as such tends to pass unremarked (like ideology itself). Nevertheless it is advertising which is closest to that mass-consumed art form, the product of an anonymous collective, which cinema becomes in the imagination of 'left' film commentators when they take time off from writing about films by famous men. It is as much an autonomous category of communication as is the cinema, and should be studied as such.

* * *

In a 1934 essay the Prague linguist and aesthetician Jan Mukarovsky referred, in passing, to the triad of theories which even today still frame the thinking of our Western art community. He warned: 'Without semiological orientation the art theorist will always be open to the temptation to treat the work of art as a purely formal construction or else as an immediate reflex of the mental or physiological moods of the author or of the distinct reality expressed by the work, viz, the ideological, economic, social and cultural situation of the contemporary milieu.'[6]

These are the points between which well-worn paths are still being trodden today – Formalism, expression theory, Realism. 'Only the semiological viewpoint,' Mukarovsky continues, 'allows theorists to grasp the autonomous existence and fundamental dynamics of the artistic structure and to grasp the development of art as an immanent movement which also has a constant dialectical relation to the development of the other domains of culture.'

Russian art of the twenties represents an exemplary attempt to deal with that interdependence of form and ideology for which Aleksei Gan, in *Constructivism* (1922), coined the term 'tectonic': 'Painting, sculpture, theatre, these are the material forms of the bourgeois capitalist aesthetic culture which satisfies the "spiritual" demands of the consumer of a disorganised social order... The tectonic as a discipline should lead the Constructivist in practice to a synthesis of a new content and the new form. He must be a marxist-educated man who has once and for all outlived art and really advanced on industrial material. The tectonic is his guiding star, the brain of experimental and practical activity... the tectonic unites the ideological and the formal.'[7] [see IIID7]

The Left front's advance on industrial materials led them into direct engagement with mass communication codes and practices. Today such 'mass media' constitute *en bloc* a popular Art. We took the example of advertising: advertising is an 'art' form in that it constitutes an autonomous genre of aesthetically dimensioned message structures (which although they may be analysed in terms of other structures are not reducible to them) – devices whose (contingent) function is to renew our perception of, and enthusiasm for, consumer values. Advertising is 'popular' in the sense that its codes are commonly understood: assuming literacy, advertisements yield more or less non-aberrant de-codings within most social sub-groups.

Although we cannot currently affect the publicity messages emitted, we may subvert the messages received. A task for socialist art is to unmask the mystifications of bourgeois culture by laying bare its codes, by exposing the devices through which it constructs its self-image. Another job for socialist art is to expose the contradictions in our class society, to show up what double-think there is in our second-nature. Qualifications for the first job include a knowledge of semiotics; qualifications for the second job include a knowledge of politics and economics. As we only know society through its representations, then both jobs will have to be done by the same man. (The inmates of art educational institutions generally receive only courses in connoisseurship; on their release, their progress towards self-reeducation is a difficult one.)

To date there is little evidence that the self-professing left of our art community has grasped Gan's 'tectonic' principle in its application within our own media-dominated culture. Seemingly oblivious to the formal aspects of ideology, they address each other in a shop-worn rhetoric long ago appropriated by bourgeois ideology as 'leftist dogma'. Thus they obligingly fill the benches which bourgeois culture allocates to the 'official opposition', endorsing the existing structure of social relations.

John Berger has observed: 'Publicity turns consumption into a substitute for democracy. The choice of what one eats (or wears or drives) takes the place of significant political choice.'[8] Vanguardism in art has become just another way of offering the consumer a choice. Body art or art-language, the ingredients disappear behind the packaging and a mindless loyalty to the label is rapidly established and just as rapidly lost. There is therefore nothing more contradictory at this present historical juncture than a left avant-garde, and nothing more depressing than attempts to invent one.

[1] References to literature are unavoidable when discussing the visual arts in Russia at the beginning of the present century. In addition to the early lead taken by Formalist literary criticism the political framework of art tended to be discussed primarily in terms of literature; party decisions on the arts were made first in respect of literature with other arts following suit. To make such literary references, however, is not to misrepresent the theoretical context of the visual arts, as contacts between the various arts were extensive both before the October revolution and into the late twenties.

[2] Tzvetan Todorov, 'Some approaches to Russian Formalism', *20th Century Studies*, December 1972, p. 10.

[3] Anthony Wilden, *System and Structure*, Tavistock, 1972, p. xxvi.

[4] Ibid., p. xxii.

[5] Franco Fortini, 'The Writers' Mandate and the End of Anti-Fascism', *Screen*, vol. 15, no. 1, 1974, pp. 42–3.

[6] Jan Mukarovsky, 'L'Art comme fait sémiologique', *Actes du huitième congrès internationale de philosophie à Prague 2–7 septembre 1934*, Prague, 1936 (unpublished translation, BFI, London).

[7] Aleksei Gan, *Constructivism*, 1922 (signed 1920) in Camilla Gray, *The Great Experiment: Russian Art 1863–1922*, Thames & Hudson, 1962, p. 285.

[8] John Berger, *Ways of Seeing*, BBC and Penguin, 1972, p. 149.

14 Art & Language: Editorial to *Art-Language*

If the Conceptual Art movement remained unpopular with the art market throughout the 1970s, by the middle of the decade certain forms of Conceptual Art had achieved respectability in those intellectual circles where the methods of semiology had become virtually *de rigueur*. As some Conceptual artists, Burgin among them, turned to semiological methods in their critique of fine art, Art & Language was to turn to painting, with its traditional depth and

opacity, as a form of resistance to the academic appropriation of pictures-and-texts. The polemic of this editorial is directed against the privileging of cultural and artistic avant-gardism through forms of academic specialism. Originally printed on the cover and first inside page of *Art-Language*, Banbury, vol. 3, no. 3, June 1976. (The ellipses in the present text are original and do not denote editorial excisions.) (For an earlier editorial see VIIB5.)

... THE TIMELESS LUMPENNESS OF A RADICAL CULTURAL LIFE; the gangrenous excrescence, stylishly exposed in the quiet salons. The market for the dry delicacies of pretentious gentility, the over-fed opinion, the corpulent... choice, the leisured appropriation, 'society' and society in harmony are an objective condition of the class struggle. The privileged low-life of high culture is the massification of the people, is the enemy of inquiry, is an insult to, and sometimes an egregious product of, the achievement and goals of working-class movements, a denial of the real objectives of the working-class movement. It is not, however, the life of the unwitting fool. It has its own agencies.

The conditions of the production of high culture are not somehow apart from these machinations in brutality... and the artists are not exempt from the charge of conniv-ance at the proliferation of force, violence: the barbarism of imperialism. Their 'status' as an economic hors concours serves the aim of the ruling classes in their continuing domination. It avails no one of a glimpse of 'freedom'. It is a status which allows a parvenu sincerity, the treachery of the successful product, to be deified in a fideism of 'culture', a fideism in the interests of the ruling class.

Don't think that artists are somehow the victims of an underdetermined predestin-ation: their attempts to fix forever their relations with 'the rest of the world', irrespect-ive of social change, are the last defensive gasps of an entirely static instrument of capitalism: empty-headed, it parasitizes the ectoderm of social change in the effort to be the better fed by its masters.

And radical artists produce articles and exhibitions about photos, capitalism, corrup-tion, war, pestilence, trench-foot and issues, possessed by that venal shade of empiricism which guards their proprietorial interests. Most people laugh easily at old fools' hack aestheticism; the by now undifferentiated mass of pretence and piety. It is similarly easy to avoid debate with the serious, anorexic autohagiographers who've shoved (?) and wheedled their way into the (what?) praxis of a ludicrous and equivalent 'specialism'. The air (and the aether) is toxic with the confident exhalations of their apprehension. Club-foot-Ph.D.-standards-as-style is nothing new in the global sales-pitch. American football helmets and meaningless photos are serious objects of contemplation (and ...) if you happen to be obsessed by your career as the nexus of historiography. Heaven knows, anything must go; and it even goes against the sanction imposed by the appropriate Lebensphilosophie: the manières of 'semiotique' and the manières of 'social purpose' even sell that short. The artist, the bourgeois ideologist without 'virtue', is just like anyone else without 'virtue': his 'terror' is gratuitous and ultimately suicidal.

VIID
Critical Revisions

1 Jacques Derrida (b. 1930) 'The Exorbitant: Question of Method' and 'The Engraving and the Ambiguities of Formalism', from *Of Grammatology*

No claim in the contemporary critical literature has been more hotly contested, nor arguably more misunderstood, than Derrida's 'il n'y a pas de hors-texte' (approximately: 'there is nothing outside of the text'; or 'there is no outside-the-text'). By those wishing to distance themselves from the interventionist requirements of the Marxist tradition, the statement has been taken as licence to deny the very existence of a 'real' world outside of language. For historical materialists, on the other hand, it has come to represent the acme of a resurgent idealism, linked to the conservative political turn in the Western democracies since the mid-1970s. It is, however, equally plausible to read Derrida's text as a claim which would sit relatively conventionally within most modern philosophies: that there is no Archimedean point outside of language from which the truth claims of language itself can be surveyed. It is in a sense the extremity of the relativist inference Derrida draws from this which has ensured the resonance of his claim. In the second extract he considers the implication of this argument for the concept of art, finding against formalism. Despite the claim that 'il n'y pas de hors texte,' in art it is 'the represented and not the representer, the expressed and not the expression' which matters; *at the same time as* this 'represented' can never achieve an unmediated presence. Both extracts proceed from reflections on the philosophy of Jean-Jacques Rousseau (the internal quotation is from his *Essay on the Origin of Languages*). Originally published as *De la grammatologie*, Paris, 1967, Derrida's book was translated into English by Gayatri Chakravorti Spivak as *Of Grammatology*, Baltimore, MD, 1976, pp. 158–60, 207–10 and 215, from which the present extracts are taken.

[The] question is . . . not only of Rousseau's writing but also of our reading. We should begin by taking rigorous account of this *being held within [prise]* or this *surprise*: the writer writes in a language and in a logic whose proper system, laws, and life his discourse by definition cannot dominate absolutely. He uses them only by letting himself, after a fashion and up to a point, be governed by the system. And the reading must always aim at a certain relationship, unperceived by the writer, between what he commands and what he does not command of the patterns of the language that he uses. This relationship is not a certain quantitative distribution of shadow and light, of weakness or of force, but a signifying structure that critical reading should *produce*.

What does produce mean here? In my attempt to explain that, I would initiate a justification of my principles of reading. A justification, as we shall see, entirely negative, outlining by exclusion a space of reading that I shall not fill here: a task of reading.

To produce this signifying structure obviously cannot consist of reproducing, by the effaced and respectful doubling of commentary, the conscious, voluntary, intentional relationship that the writer institutes in his exchanges with the history to which he belongs thanks to the element of language. This moment of doubling commentary should no doubt have its place in a critical reading. To recognize and respect all its classical exigencies is not easy and requires all the instruments of traditional criticism. Without this recognition and this respect, critical production would risk developing in any direction at all and authorize itself to say almost anything. But this indispensable guardrail has always only *protected*, it has never *opened*, a reading.

Yet if reading must not be content with doubling the text, it cannot legitimately transgress the text toward something other than it, toward a referent (a reality that is metaphysical, historical, psychobiographical, etc.) or toward a signified outside the text whose content could take place, could have taken place outside of language, that is to say, in the sense that we give here to that word, outside of writing in general. That is why the methodological considerations that we risk applying here to an example are closely dependent on general propositions that we have elaborated above; as regards the absence of the referent or the transcendental signified. *There is nothing outside of the text* [there is no outside-text; *il n'y a pas de hors-texte*]. And that is neither because Jean-Jacques' life, or the existence of Mamma or Thérèse *themselves*, is not of prime interest to us, nor because we have access to their so-called 'real' existence only in the text and we have neither any means of altering this, nor any right to neglect this limitation. All reasons of this type would already be sufficient, to be sure, but there are more radical reasons. What we have tried to show by following the guiding line of the 'dangerous supplement,' is that in what one calls the real life of these existences 'of flesh and bone,' beyond and behind what one believes can be circumscribed as Rousseau's text, there has never been anything but writing; there have never been anything but supplements, substitutive significations which could only come forth in a chain of differential references, the 'real' supervening, and being added only while taking on meaning from a trace and from an invocation of the supplement, etc. And thus to infinity, for we have read, *in the text*, that the absolute present, Nature, that which words like 'real mother' name, have always already escaped, have never existed; that what opens meaning and language is writing as the disappearance of natural presence.

Although it is not commentary, our reading must be intrinsic and remain within the text. That is why, in spite of certain appearances, the locating of the word *supplement* is here not at all psychoanalytical, if by that we understand an interpretation that takes us outside of the writing toward a psychobiographical signified, or even toward a general psychological structure that could rightly be separated from the signifier. This method has occasionally been opposed to the traditional doubling commentary; it could be shown that it actually comes to terms with it quite easily. *The security with which the commentary considers the self-identity of the text, the confidence with which it carves out its contour, goes hand in hand with the tranquil assurance that leaps over the text toward its presumed content, in the direction of the pure signified.* [. . .]

If it seems to us in principle impossible to separate, through interpretation or commentary, the signified from the signifier, and thus to destroy writing by the writing that is yet reading, we nevertheless believe that this impossibility is historically articulated. It does not limit attempts at deciphering in the same way, to the same degree, and according to the same rules. Here we must take into account the history of the text in general. When we speak of the writer and of the encompassing power of the language to which he is subject, we are not only thinking of the writer in literature. The philosopher, the chronicler, the theoretician in general, and at the limit everyone writing, is thus taken by surprise. But, in each case, the person writing is inscribed in a determined textual system. Even if there is never a pure signified, there are different relationships as to that which, from the signifier, *is presented* as the irreducible stratum of the signified. For example, the philosophical text, although it is in fact always written, includes, precisely as its philosophical specificity, the project of effacing itself in the face of the signified content which it transports and in general teaches. Reading should be aware of this project, even if, in the last analysis, it intends to expose the project's failure. The entire history of texts, and within it the history of literary forms in the West, should be studied from this point of view. With the exception of a thrust or a point of resistance which has only been very lately recognized as such, literary writing has, almost always and almost everywhere, according to some fashions and across very diverse ages, lent itself to this *transcendent* reading, in that search for the signified which we here put in question, not to annull it but to understand it within a system to which such a reading is blind. [...]

* * *

If art operates through the sign and is effective through imitation, it can only take place within the system of a culture, and the theory of art is a theory of mores. A 'moral' impression, contrary to a ' "sensible" impression,' is recognized through the fact that it places its force in a sign. Aesthetics passes through a semiology and even through an ethnology. The effects of aesthetic signs are only determined within a cultural system. 'Unless the influence of sensations upon us is due mainly to moral causes, why are we so sensitive to impressions that mean nothing to the uncivilized? Why is our most touching music only a pointless noise to the ear of a West Indian? Are his nerves of a different nature from ours?' [Rousseau, *Essay on The Origin of Languages*, chapter XV].

Medicine itself must take account of the semiological culture within which it must heal. As with the therapeutic art, the therapeutic effects of art are not natural in as much as they work through signs; and if the cure is a language, the remedies must make themselves understood to the sick through the code of his culture:

> The healing of tarantula bites is cited as proof of the physical power of sounds. But in fact this evidence proves quite the opposite. What is needed for curing those bitten by this insect are neither isolated sounds, nor even the same tunes. Rather, each needs tunes with familiar melodies and understandable lyrics. Italian tunes are needed for Italians; for Turks, Turkish tunes. Each is affected only by accents familiar to him. His nerves yield only to what his spirit pre-disposes [for] them. One must speak to him in a language he understands, if he is to be moved by what he is told. The cantatas of Bernier are said to have cured the fever of a French musician. They would have given one to a musician of any other nation. [*Essay*, Chapter XV]

Rousseau does not go so far as to consider that the symptoms themselves belong to a culture and that the bite of a tarantula might have different effects in different places. But the principle of such a conclusion is clearly indicated in his explication. There is a single exception, which is more than simply strange, within this ethno–semiotics: cooking, or rather taste. Rousseau condemns gluttony without mercy. One might wonder why: 'I know of only one affective sense in which there is no moral element: that is taste. And, accordingly, gluttony is the main vice only of those who have no sense of taste' (ibid.). 'Who have no sense of taste' means here, of course, 'who do nothing but taste,' who have nothing but uneducated and uncultivated sensations.

As the value of *virtuality* or potentiality further introduces here an element of transition and confusion, of graduality and of shifts within the rigor of distinctions and within the functioning of concepts – limits of animality, childhood, savagery, etc. – one must admit that 'moral impressions' through signs and a system of differences can always be already discerned, although confusedly, in the animal. 'Something of this moral effect is perceivable even in animals.' We realized the need for this hesitation in connection with pity, and at the same time with imitation [. . .]

From this irreducibility of the semiotic order, Rousseau also draws conclusions against the sensationalism and materialism of his own century: 'Colors and sounds can do much, as representations and signs, very little simply as objects of sense' [*Essay*]. The argument for art as signifying text is at the service of metaphysics and of spiritualist ethics: 'I believe that had these ideas been better developed, we should have been spared many stupid arguments about ancient music. But in this century when all the operations of the soul have to be materialized, and even human feeling deprived of all morality, I am deluded if the new philosophy does not become as destructive of good taste as of virtue' [*Essay*].

We must be attentive to the ultimate finality of the esteem which the sign enjoys. According to a general rule which is important for us, attention to the signifier has the paradoxical effect of reducing it. Unlike the concept of the supplement which, of course, *signifies* nothing, simply replaces a lack, the signifier, as it is indicated in the grammatical form of this word and the logical form of the concept, signifies a signified. One cannot separate its effectiveness from the signified to which it is tied. It is not the body of the sign that acts, for that is all sensation, but rather the signified that it expresses, imitates, or transports. It would be wrong to conclude that, in Rousseau's critique of sensationalism, it is the sign itself that exhausts the operation of art. We are moved, 'excited,' by the represented and not by the representer, by the expressed and not by the expression, by the inside which is exposed and not by the outside of the exposition. Even in painting, representation comes alive and touches us only if it imitates an object, and, better, if it expresses a passion: 'It is the drawing, the imitation, which gives life and spirit to these colors. The passions they express are what stir ours . . . The strokes of a touching picture affect us even in a print' [*Essay*].

The engraving: art being born of imitation, only belongs to the work proper as far as it can be retained in an engraving, in the reproductive impression of its *outline*. If the beautiful loses nothing by being reproduced, if one recognizes it in its sign, in the sign of the sign which a copy must be, then in the 'first time' of its production there was already a reproductive essence. The engraving, which copies the models of art, is nonetheless the model for art. If the origin of art is the possibility of the engraving, the death of art and art as death are prescribed from the very birth of the work. The

principle of life, once again, is confounded with the principle of death. Once again, Rousseau desires to separate them but once again, he accedes within his description and within his text to that which limits or contradicts his desire.

On the one hand, in fact, Rousseau does not doubt that imitation and formal outline are the property of art and he inherits, as a matter of course, the traditional concept of *mimesis*; a concept that was first that of the philosophers whom Rousseau, one must remember, accused of having killed song. This accusation could not be radical, since it moved within the conceptuality inherited from this philosophy and of the metaphysical conception of art. The outline that lends itself to the print or engraving, the line which *is imitated*, belongs to all the arts, to the arts of space as much as to the arts of duration, to music no less than to painting. In both it outlines the space of imitation and the imitation of space.

> Music is no more the art of combining sounds to please the ear than painting is the art of combining colors to please the eye. If there were no more to it than that, they would both be natural sciences rather than fine arts. Imitation alone raises them to this level. But what makes painting an imitative art? Drawing. What makes music another? Melody. [*Essay*, Chapter XIII]

The *outline* (design or melodic line) is not only what permits imitation and the recognition of the represented in the representer. It is the element of formal difference which permits the contents (colored or sonorous substance) to appear. By the same token, it cannot *give rise to* [literally *provide space* for] art (techné) as *mimesis* without constituting it forthwith as a *technique of imitation*. If art lives from an originary reproduction, the outline that permits this reproduction, opens in the same stroke the space of calculation, of grammaticality, of the rational science of intervals, and of those 'rules of imitation' that are fatal to energy. Let us recall: 'And, to the degree that the rules of imitation proliferated, imitative language was enfeebled' [*Essay*]. Imitation is therefore at the same time the life and the death of art. Art and death, art and its death are comprised in the space of the *alteration* of the originary *iteration* (*iterum*, anew, does it not come from Sanskrit *itara*, other?); of repetition, reproduction, representation; or also in space as the possibility of iteration and the exit from life placed outside of itself.

For the outline is spacing itself, and marking figures, it shapes the surfaces of painting as much as the time of music:

> The role of melody in music is precisely that of drawing in a painting. This is what constitutes the strokes and figures, of which the harmony and the sounds are merely the colors. But, it is said, melody is merely a succession of sounds. No doubt. And drawing is only an arrangement of colors. An orator uses ink to write out his compositions: does that mean ink is a very eloquent liquid? [*Essay*, Chapter XIII]

Thus disengaging a concept of formal difference, criticizing with vigor an aesthetic that one might call substantialist rather than materialist, more attentive to sensory content than to formal composition, Rousseau yet places a great deal of the burden of art – here music – upon the *outline*. That is to say to what can give rise to cold calculation and the rules of imitation. According to a logic with which we are now

familiar, Rousseau confronts that danger *by opposing good form to bad form*, the form of life to the form of death, *melodic* to *harmonic* form, form with imitative content to form without content, form full of sense to empty abstraction. *Rousseau reacts against formalism. In his eyes formalism is also a materialism and a sensationalism.*

* * *

What does Rousseau say without saying, see without seeing? That substitution has always already begun; that imitation, principle of art, has always already interrupted natural plenitude; that, having to be a *discourse*, it has always already broached presence in differance; that in Nature it is always that which supplies Nature's lack, a voice that is substituted for the voice of Nature.

2 Michel Foucault (1926–1984) 'What Is an Author?'

Existentialism, indeed artistic Modernism in general, privileged the author. The sense of the self-contained human individual, reaching its high point in the artist, has deep roots in the desires and self-images of Western societies. The twin quests for authenticity and originality which are inscribed right across the body of modern art find their fulfilment in tragic authors, or more particularly in their biographies: van Gogh and Jackson Pollock being perhaps the stereotypical examples. This form of privilege came under challenge from the wave of Structuralist influence which passed across French thought in the 1960s, spreading out-wards as part of an intellectual project which, in its origins at least, was manifestly radical with respect to bourgeois convention. Thinkers as diverse as Lacan (VB8), Althusser (VIID3), Barthes (VIID5) and Foucault all questioned the status of the homogeneous individual, seen now as an ideological construct. Foremost among the casualties of this attack was the concept of the author. The critique of the author has sometimes been ridiculed as a denial of the existence of biological individuals. Its force is rather to locate the individual within a system of conventions, rules, norms, grammars and so forth which, in effect, articulate him – or 'speak' him. The 'death of the author' points to a revision of critical priorities. Originally given as a talk at the Société Française de Philosophie, and first published in the *Bulletin de la Société Française de Philosophie*, no. 63, Paris, 1969. Revised version translated by Josue V. Harari in Harari (ed.), *Textual Strategies: Perspectives in Post-Structuralist Criticism*, Ithaca, NY, 1979, pp. 141–60, from which the present extracts are taken. (See also VIID11.)

The coming into being of the notion of 'author' constitutes the privileged moment of *individualization* in the history of ideas, knowledge, literature, philosophy, and the sciences. Even today, when we reconstruct the history of a concept, literary genre, or school of philosophy, such categories seem relatively weak, secondary, and superimposed scansions in comparison with the solid and fundamental unit of the author and the work.

* * *

... An author's name is not simply an element in a discourse (capable of being either subject or object, of being replaced by a pronoun, and the like); it performs a certain role with regard to narrative discourse, assuring a classificatory function. Such a name permits one to group together a certain number of texts, define them, differentiate them from and contrast them to others. In addition, it establishes a relationship among

the texts. Hermes Trismegistus did not exist, nor did Hippocrates – in the sense that Balzac existed – but the fact that several texts have been placed under the same name indicates that there has been established among them a relationship of homogeneity, filiation, authentification of some texts by the use of others, reciprocal explication, or concomitant utilization. The author's name serves to characterize a certain mode of being of discourse: the fact that the discourse has an author's name, that one can say 'this was written by so-and-so' or 'so-and-so is its author,' shows that this discourse is not ordinary everyday speech that merely comes and goes, not something that is immediately consumable. On the contrary, it is a speech that must be received in a certain mode and that, in a given culture, must receive a certain status.

It would seem that the author's name, unlike other proper names, does not pass from the interior of a discourse to the real and exterior individual who produced it; instead, the name seems always to be present, marking off the edges of the text, revealing, or at least characterizing, its mode of being. The author's name manifests the appearance of a certain discursive set and indicates the status of this discourse within a society and a culture. It has no legal status, nor is it located in the fiction of the work; rather, it is located in the break that founds a certain discursive construct and its very particular mode of being. As a result, we could say that in a civilization like our own there are a certain number of discourses that are endowed with the 'author-function,' while others are deprived of it. A private letter may well have a signer – it does not have an author; a contract may well have a guarantor – it does not have an author. An anonymous text posted on a wall probably has a writer – but not an author. The author-function is therefore characteristic of the mode of existence, circulation, and functioning of certain discourses within a society.

Let us analyze this 'author-function' as we have just described it. In our culture, how does one characterize a discourse containing the author-function? In what way is this discourse different from other discourses? [. . .]

First of all, discourses are objects of appropriation. The form of ownership from which they spring is of a rather particular type, one that has been codified for many years. We should note that, historically, this type of ownership has always been subsequent to what one might call penal appropriation. Texts, books, and discourses really began to have authors (other than mythical, 'sacralized' and 'sacralizing' figures) to the extent that authors became subject to punishment, that is, to the extent that discourses could be transgressive. In our culture (and doubtless in many others), discourse was not originally a product, a thing, a kind of goods; it was essentially an act – an act placed in the bipolar field of the sacred and the profane, the licit and the illicit, the religious and the blasphemous. Historically, it was a gesture fraught with risks before becoming goods caught up in a circuit of ownership. [. . .]

The author-function does not affect all discourses in a universal and constant way, however. This is its second characteristic. In our civilization, it has not always been the same types of texts which have required attribution to an author. There was a time when the texts that we today call 'literary' (narratives, stories, epics, tragedies, comedies) were accepted, put into circulation, and valorized without any question about the identity of their author; their anonymity caused no difficulties since their ancientness, whether real or imagined, was regarded as a sufficient guarantee of their status. On the other hand, those texts that we now would call scientific – those dealing with

cosmology and the heavens, medicine and illnesses, natural sciences and geography – were accepted in the Middle Ages, and accepted as 'true,' only when marked with the name of their author. 'Hippocrates said,' 'Pliny recounts,' were not really formulas of an argument based on authority; they were the markers inserted in discourses that were supposed to be received as statements of demonstrated truth.

A reversal occurred in the seventeenth or eighteenth century. Scientific discourses began to be received for themselves, in the anonymity of an established or always redemonstrable truth; their membership in a systematic ensemble, and not the reference to the individual who produced them, stood as their guarantee. The author-function faded away, and the inventor's name served only to christen a theorem, proposition, particular effect, property, body, group of elements, or pathological syndrome. By the same token, literary discourses came to be accepted only when endowed with the author-function. We now ask of each poetic or fictional text: from where does it come, who wrote it, when, under what circumstances, or beginning with what design? The meaning ascribed to it and the status or value accorded it depend upon the manner in which we answer these questions. And if a text should be discovered in a state of anonymity – whether as a consequence of an accident or the author's explicit wish – the game becomes one of rediscovering the author. [...] In order to 'rediscover' an author in a work, modern criticism uses methods similar to those that Christian exegesis employed when trying to prove the value of a text by its author's saintliness. In *De viris illustribus*, Saint Jerome explains that homonymy is not sufficient to identify legitimately authors of more than one work: different individuals could have had the same name, or one man could have, illegitimately, borrowed another's patronymic. The name as an individual trademark is not enough when one works within a textual tradition.

How then can one attribute several discourses to one and the same author? How can one use the author-function to determine if one is dealing with one or several individuals? Saint Jerome proposes four criteria: (1) if among several books attributed to an author one is inferior to the others, it must be withdrawn from the list of the author's works (the author is therefore defined as a constant level of value); (2) the same should be done if certain texts contradict the doctrine expounded in the author's other works (the author is thus defined as a field of conceptual or theoretical coherence); (3) one must also exclude works that are written in a different style, containing words and expressions not ordinarily found in the writer's production (the author is here conceived as a stylistic unity); (4) finally, passages quoting statements that were made, or mentioning events that occurred after the author's death must be regarded as interpolated texts (the author is here seen as a historical figure at the crossroads of a certain number of events).

Modern literary criticism, even when – as is now customary – it is not concerned with questions of authentication, still defines the author the same way: the author provides the basis for explaining not only the presence of certain events in a work, but also their transformations, distortions, and diverse modifications (through his biography, the determination of his individual perspective, the analysis of his social position, and the revelation of his basic design). The author is also the principle of a certain unity of writing – all differences having to be resolved, at least in part, by the principles of evolution, maturation, or influence. The author also serves to neutralize the contradictions that may emerge in a series of texts: there must be – at a certain level

of his thought or desire, of his consciousness or unconscious – a point where contradictions are resolved, where incompatible elements are at last tied together or organized around a fundamental or originating contradiction. Finally, the author is a particular source of expression that, in more or less completed forms, is manifested equally well, and with similar validity, in works, sketches, letters, fragments, and so on. Clearly, Saint Jerome's four criteria of authenticity (criteria which seem totally insufficient for today's exegetes) do define the four modalities according to which modern criticism brings the author-function into play.

* * *

[...] Perhaps it is time to study discourses not only in terms of their expressive value or formal transformations, but according to their modes of existence. The modes of circulation, valorization, attribution, and appropriation of discourses vary with each culture and are modified within each. The manner in which they are articulated according to social relationships can be more readily understood, I believe, in the activity of the author-function and in its modifications, than in the themes or concepts that discourses set in motion.

It would seem that one could also, beginning with analyses of this type, re-examine the privileges of the subject. I realize that in undertaking the internal and architectonic analysis of a work (be it a literary text, philosophical system, or scientific work), in setting aside biographical and psychological references, one has already called back into question the absolute character and founding role of the subject. Still, perhaps one must return to this question, not in order to re-establish the theme of an originating subject, but to grasp the subject's points of insertion, modes of functioning, and system of dependencies. Doing so means overturning the traditional problem, no longer raising the questions 'How can a free subject penetrate the substance of things and give it meaning? How can it activate the rules of a language from within and thus give rise to the designs which are properly its own?' Instead, these questions will be raised: 'How, under what conditions and in what forms can something like a subject appear in the order of discourse? What place can it occupy in each type of discourse, what functions can it assume, and by obeying what rules?' In short, it is a matter of depriving the subject (or its substitute) of its role as originator, and of analyzing the subject as a variable and complex function of discourse.

Second, there are reasons dealing with the 'ideological' status of the author. The question then becomes: How can one reduce the great peril, the great danger with which fiction threatens our world? The answer is: One can reduce it with the author. The author allows a limitation of the cancerous and dangerous proliferation of significations within a world where one is thrifty not only with one's resources and riches, but also with one's discourses and their significations. The author is the principle of thrift in the proliferation of meaning. As a result, we must entirely reverse the traditional idea of the author. We are accustomed ... to saying that the author is the genial creator of a work in which he deposits, with infinite wealth and generosity, an inexhaustible world of significations. We are used to thinking that the author is so different from all other men, and so transcendent with regard to all languages that, as soon as he speaks, meaning begins to proliferate, to proliferate indefinitely.

The truth is quite the contrary: the author is not an indefinite source of significations which fill a work; the author does not precede the works, he is a certain functional principle by which, in our culture, one limits, excludes, and chooses; in short, by which

one impedes the free circulation, the free manipulation, the free composition, decomposition, and recomposition of fiction. In fact, if we are accustomed to presenting the author as a genius, as a perpetual surging of invention, it is because, in reality, we make him function in exactly the opposite fashion. One can say that the author is an ideological product, since we represent him as the opposite of his historically real function. (When a historically given function is represented in a figure that inverts it, one has an ideological production.) The author is therefore the ideological figure by which one marks the manner in which we fear the proliferation of meaning.

In saying this, I seem to call for a form of culture in which fiction would not be limited by the figure of the author. It would be pure romanticism, however, to imagine a culture in which the fictive would operate in an absolutely free state, in which fiction would be put at the disposal of everyone and would develop without passing through something like a necessary or constraining figure. Although, since the eighteenth century, the author has played the role of the regulator of the fictive, a role quite characteristic of our era of industrial and bourgeois society, of individualism and private property, still, given the historical modifications that are taking place, it does not seem necessary that the author-function remain constant in form, complexity, and even in existence. I think that, as our society changes, at the very moment when it is in the process of changing, the author-function will disappear, and in such a manner that fiction and its polysemic texts will once again function according to another mode, but still with a system of constraint – one which will no longer be the author, but which will have to be determined or, perhaps, experienced.

All discourses, whatever their status, form, value, and whatever the treatment to which they will be subjected, would then develop in the anonymity of a murmur. We would no longer hear the questions that have been rehashed for so long: 'Who really spoke? Is it really he and not someone else? With what authenticity or originality? And what part of his deepest self did he express in his discourse?' Instead, there would be other questions, like these: 'What are the modes of existence of this discourse? Where has it been used, how can it circulate, and who can appropriate it for himself? What are the places in it where there is room for possible subjects? Who can assume these various subject-functions?' And behind all these questions, we would hear hardly anything but the stirring of an indifference: 'What difference does it make who is speaking?'

3 Louis Althusser (1918–1990) from 'Ideology and Ideological State Apparatuses'

Althusser's philosophical work began as an intervention in the crisis of Marxism generated by the legacy of Stalin: an ambitious attempt to re-read Marx himself, and thereby set Marxist theory on a new intellectual footing. (For relevant texts by Marx see *Art in Theory 1815–1900*, IIA10 and IIIA8.) Initially this involved a break with the concept of 'humanism', which Althusser regarded as merely ideological, in favour of a conception, influenced by Structuralism, of individual subjectivity as a product of the action of general social forces. In this phase of his thought, 'ideology' was counterposed to a rigorous view of Marxism as science. In the later 1960s, however, increasingly under the influence of Maoism, and of the Events of 1968, Althusser's thought turned through 180 degrees. Marxism's virtue no longer lay in its status as a (scientific) theory of social formations, but in its partisanship

as theoretical *practice* in the class struggle. The sphere of ideology became a crucial site of this struggle: the intellectual and moral means whereby class societies reproduced themselves and where revolutionaries challenged them. Originally published as 'Idéologies et appareils idéologiques d'état (Notes pour une recherche)', in *La Pensée*, Paris, 151, June 1970, pp. 3–38. Translated into English by Ben Brewster as 'Ideology and Ideological State Apparatuses' in *Lenin and Philosophy and Other Essays*, London, 1971, pp. 123–73, from which the present extracts are taken.

Infrastructure and Superstructure

On a number of occasions I have insisted on the revolutionary character of the Marxist conception of the 'social whole' insofar as it is distinct from the Hegelian 'totality'. I said (and this thesis only repeats famous propositions of historical materialism) that Marx conceived the structure of every society as constituted by 'levels' or 'instances' articulated by a specific determination: the *infrastructure*, or economic base (the 'unity' of the productive forces and the relations of production) and the *superstructure*, which itself contains two 'levels' or 'instances': the politico-legal (law and the State) and ideology (the different ideologies, religious, ethical, legal, political, etc.). [...]

It is easy to see that this representation of the structure of every society as an edifice containing a base (infrastructure) on which are erected the two 'floors' of the superstructure, is a metaphor, to be quite precise, a spatial metaphor: the metaphor of a topography (*topique*). Like every metaphor, this metaphor suggests something, makes something visible. What? Precisely this: that the upper floors could not 'stay up' (in the air) alone, if they did not rest precisely on their base.

Thus the object of the metaphor of the edifice is to represent above all the 'determination in the last instance' by the economic base. The effect of this spatial metaphor is to endow the base with an index of effectivity known by the famous terms: the determination in the last instance of what happens in the upper 'floors' (of the superstructure) by what happens in the economic base.

* * *

[...] The great theoretical advantage of the Marxist topography, i.e. of the spatial metaphor of the edifice (base and superstructure) is simultaneously that it reveals that questions of determination (or of index of effectivity) are crucial; that it reveals that it is the base which in the last instance determines the whole edifice; and that, as a consequence, it obliges us to pose the theoretical problem of the types of 'derivatory' effectivity peculiar to the superstructure, i.e. it obliges us to think what the Marxist tradition calls conjointly the relative autonomy of the superstructure and the reciprocal action of the superstructure on the base.

The greatest disadvantage of this representation of the structure of every society by the spatial metaphor of an edifice, is obviously the fact that it is metaphorical: i.e. it remains *descriptive*.

It now seems to me that it is possible and desirable to represent things differently. NB, I do not mean by this that I want to reject the classical metaphor, for that metaphor itself requires that we go beyond it. And I am not going beyond it in order to reject it as outworn. I simply want to attempt to think what it gives us in the form of a description.

I believe that it is possible and necessary to think what characterizes the essential of the existence and nature of the superstructure *on the basis of reproduction*. Once one takes the point of view of reproduction, many of the questions whose existence was indicated by the spatial metaphor of the edifice, but to which it could not give a conceptual answer, are immediately illuminated. [. . .]

The State

The Essentials of the Marxist Theory of the State

* * *

. . . The Marxist classics have always claimed that (1) the State is the repressive State apparatus, (2) State power and State apparatus must be distinguished, (3) the objective of the class struggle concerns State power, and in consequence the use of the State apparatus by the classes (or alliance of classes or of fractions of classes) holding State power as a function of their class objectives, and (4) the proletariat must seize State power in order to destroy the existing bourgeois State apparatus and, in a first phase, replace it with a quite different, proletarian, State apparatus, then in later phases set in motion a radical process, that of the destruction of the State (the end of State power, the end of every State apparatus). [. . .]

The State Ideological Apparatuses

* * *

In order to advance the theory of the State it is indispensable to take into account not only the distinction between *State power* and *State apparatus*, but also another reality which is clearly on the side of the (repressive) State apparatus, but must not be confused with it. I shall call this reality by its concept: *the ideological State apparatuses*.

What are the ideological State apparatuses (ISAs)?

They must not be confused with the (repressive) State apparatus. Remember that in Marxist theory, the State Apparatus (SA) contains: the Government, the Administration, the Army, the Police, the Courts, the Prisons, etc., which constitute what I shall in future call the Repressive State Apparatus. Repressive suggests that the State Apparatus in question 'functions by violence' – at least ultimately (since repression, e.g. administrative repression, may take non-physical forms).

I shall call Ideological State Apparatuses a certain number of realities which present themselves to the immediate observer in the form of distinct and specialized institutions. I propose an empirical list of these which will obviously have to be examined in detail, tested, corrected and reorganized. With all the reservations implied by this requirement, we can for the moment regard the following institutions as Ideological State Apparatuses (the order in which I have listed them has no particular significance):

- the religious ISA (the system of the different Churches),
- the educational ISA (the system of the different public and private 'Schools'),
- the family ISA,
- the legal ISA,
- the political ISA (the political system, including the different Parties),

- the trade-union ISA,
- the communications ISA (press, radio and television, etc.),
- the cultural ISA (Literature, the Arts, sports, etc.).

I have said that the ISAs must not be confused with the (Repressive) State Apparatus. What constitutes the difference?

As a first moment, it is clear that while there is *one* (Repressive) State Apparatus, there is a *plurality* of Ideological State Apparatuses. Even presupposing that it exists, the unity that constitutes this plurality of ISAs as a body is not immediately visible.

As a second moment, it is clear that whereas the – unified – (Repressive) State Apparatus belongs entirely to the *public* domain, much the larger part of the Ideological State Apparatuses (in their apparent dispersion) are part, on the contrary, of the *private* domain. Churches, Parties, Trade Unions, families, some schools, most newspapers, cultural ventures, etc., etc., are private.

We can ignore the first observation for the moment. But someone is bound to question the second, asking me by what right I regard as Ideological *State* Apparatuses, institutions which for the most part do not possess public status, but are quite simply *private* institutions. As a conscious Marxist, Gramsci already forestalled this objection in one sentence. The distinction between the public and the private is a distinction internal to bourgeois law, and valid in the (subordinate) domains in which bourgeois law exercises its 'authority'. The domain of the State escapes it because the latter is 'above the law': the State, which is the State *of* the ruling class, is neither public nor private; on the contrary, it is the precondition for any distinction between public and private. The same thing can be said from the starting-point of our State Ideological Apparatuses. It is unimportant whether the institutions in which they are realized are 'public' or 'private'. What matters is how they function. Private institutions can perfectly well 'function' as Ideological State Apparatuses. A reasonably thorough analysis of any one of the ISAs proves it.

But now for what is essential. What distinguishes the ISAs from the (Repressive) State Apparatus is the following basic difference: the Repressive State Apparatus functions 'by violence', whereas the Ideological State Apparatuses *function 'by ideology'*.
* * *
[...] If the ISAs 'function' massively and predominantly by ideology, what unifies their diversity is precisely this functioning, insofar as the ideology by which they function is always in fact unified, despite its diversity and its contradictions, *beneath the ruling ideology*, which is the ideology of 'the ruling class'. Given the fact that the 'ruling class' in principle holds State power (openly or more often by means of alliances between classes or class fractions), and therefore has at its disposal the (Repressive) State Apparatus, we can accept the fact that this same ruling class is active in the Ideological State Apparatuses insofar as it is ultimately the ruling ideology which is realized in the Ideological State Apparatuses, precisely in its contradictions. Of course, it is a quite different thing to act by laws and decrees in the (Repressive) State Apparatus and to 'act' through the intermediary of the ruling ideology in the Ideological State Apparatuses. We must go into the details of this difference – but it cannot mask the reality of a profound identity. To my knowledge, *no class can hold State power over a long period without at the same time exercising its hegemony over and in the State Ideological Apparatuses.* [...]

This last comment puts us in a position to understand that the Ideological State Apparatuses may be not only the *stake*, but also the *site* of class struggle, and often of bitter forms of class struggle. [...]

* * *

On the Reproduction of the Relations of Production

Ideology is a 'Representation' of the Imaginary Relationship of Individuals to their Real Conditions of Existence

In order to approach my central thesis on the structure and functioning of ideology, I shall first present two theses, one negative, the other positive. The first concerns the object which is 'represented' in the imaginary form of ideology, the second concerns the materiality of ideology.

THESIS I: Ideology represents the imaginary relationship of individuals to their real conditions of existence.

We commonly call religious ideology, ethical ideology, legal ideology, political ideology, etc., so many 'world outlooks'. Of course, assuming that we do not live one of these ideologies as the truth (e.g. 'believe' in God, Duty, Justice, etc.), we admit that the ideology we are discussing from a critical point of view, examining it as the ethnologist examines the myths of a 'primitive society', that these 'world outlooks' are largely imaginary, i.e. do not 'correspond to reality'.

However, while admitting that they do not correspond to reality, i.e. that they constitute an illusion, we admit that they do make allusion to reality, and that they need only be 'interpreted' to discover the reality of the world behind their imaginary representation of that world (ideology = *illusion/allusion*).

* * *

All [such] interpretations thus take literally the thesis which they presuppose, and on which they depend, i.e. that what is reflected in the imaginary representation of the world found in an ideology is the conditions of existence of men, i.e. their real world.

Now I can return to a thesis which I have already advanced: it is not their real conditions of existence, their real world, that 'men' 'represent to themselves' in ideology, but above all it is their relation to those conditions of existence which is represented to them there. It is this relation which is at the centre of every ideological, i.e. imaginary, representation of the real world. It is this relation that contains the 'cause' which has to explain the imaginary distortion of the ideological representation of the real world. Or rather, to leave aside the language of causality it is necessary to advance the thesis that it is the *imaginary nature of this relation* which underlies all the imaginary distortion that we can observe (if we do not live in its truth) in all ideology.

To speak in a Marxist language, if it is true that the representation of the real conditions of existence of the individuals occupying the posts of agents of production, exploitation, repression, ideologization and scientific practice, does in the last analysis arise from the relations of production, and from relations deriving from the relations of production, we can say the following: all ideology represents in its necessarily imaginary distortion not the existing relations of production (and the other relations that derive from them), but above all the (imaginary) relationship of individuals to the relations of production and the relations that derive from them. What is represented in ideology is therefore not the system of the real relations which govern the existence of

individuals, but the imaginary relation of those individuals to the real relations in which they live.

If this is the case, the question of the 'cause' of the imaginary distortion of the real relations in ideology disappears and must be replaced by a different question: why is the representation given to individuals of their (individual) relation to the social relations which govern their conditions of existence and their collective and individual life necessarily an imaginary relation? And what is the nature of this imaginariness? [...]

THESIS II: Ideology has a material existence.

I have already touched on this thesis by saying that the 'ideas' or 'representations', etc., which seem to make up ideology do not have an ideal (*idéale* or *idéelle*) or spiritual existence, but a material existence. [...]

This hypothetical thesis of the not spiritual but material existence of 'ideas' or other 'representations' is indeed necessary if we are to advance in our analysis of the nature of ideology. Or rather, it is merely useful to us in order the better to reveal what every at all serious analysis of any ideology will immediately and empirically show to every observer, however critical.

While discussing the ideological State apparatuses and their practices, I said that each of them was the realization of an ideology (the unity of these different regional ideologies – religious, ethical, legal, political, aesthetic, etc. – being assured by their subjection to the ruling ideology). I now return to this thesis: an ideology always exists in an apparatus, and its practice, or practices. This existence is material.

Of course, the material existence of the ideology in an apparatus and its practices does not have the same modality as the material existence of a paving-stone or a rifle. But, at the risk of being taken for a Neo-Aristotelian (NB Marx had a very high regard for Aristotle), I shall say that 'matter is discussed in many senses', or rather that it exists in different modalities, all rooted in the last instance in 'physical' matter.

Having said this, let me move straight on and see what happens to the 'individuals' who live in ideology, i.e. in a determinate (religious, ethical, etc.) representation of the world whose imaginary distortion depends on their imaginary relation to their conditions of existence, in other words, in the last instance, to the relations of production and to class relations (ideology = an imaginary relation to real relations). I shall say that this imaginary relation is itself endowed with a material existence.

Now I observe the following.

An individual believes in God, or Duty, or Justice, etc. [...]

The individual in question behaves in such and such a way, adopts such and such a practical attitude, and, what is more, participates in certain regular practices which are those of the ideological apparatus on which 'depend' the ideas which he has in all consciousness freely chosen as a subject. [...]

...Every 'subject' endowed with a 'consciousness' and believing in the 'ideas' that his 'consciousness' inspires in him and freely accepts, must '*act* according to his ideas', must therefore inscribe his own ideas as a free subject in the actions of his material practice. If he does not do so, 'that is wicked'.

Indeed, if he does not do what he ought to do as a function of what he believes, it is because he does something else, which, still as a function of the same idealist scheme, implies that he has other ideas in his head as well as those he proclaims, and that he acts according to these other ideas, as a man who is either 'inconsistent' ('no one is willingly evil') or cynical, or perverse.

In every case, the ideology of ideology thus recognizes, despite its imaginary distortion, that the 'ideas' of a human subject exist in his actions, or ought to exist in his actions, and if that is not the case, it lends him other ideas corresponding to the actions (however perverse) that he does perform. This ideology talks of actions: I shall talk of actions inserted into *practices*. *And* I shall point out that these practices are governed by the *rituals* in which these practices are inscribed, within the *material existence of an ideological apparatus*, be it only a small part of that apparatus: a small mass in a small church, a funeral, a minor match at a sports' club, a school day, a political party meeting, etc. [...]

I shall therefore say that, where only a single subject (such and such an individual) is concerned, the existence of the ideas of his belief is material in that *his ideas are his material actions inserted into material practices governed by material rituals which are themselves defined by the material ideological apparatus from which derive the ideas of that subject*. Naturally, the four inscriptions of the adjective 'material' in my proposition must be affected by different modalities: the materialities of a displacement for going to mass, of kneeling down, of the gesture of the sign of the cross, or of the *mea culpa*, of a sentence, of a prayer, of an act of contrition, of a penitence, of a gaze, of a hand-shake, of an external verbal discourse or an 'internal' verbal discourse (consciousness), are not one and the same materiality. I shall leave on one side the problem of a theory of the differences between the modalities of materiality.

It remains that in this inverted presentation of things, we are not dealing with an 'inversion' at all, since it is clear that certain notions have purely and simply disappeared from our presentation, whereas others on the contrary survive, and new terms appear.

Disappeared: the term *ideas*.

Survive: the terms *subject, consciousness, belief, actions*.

Appear: the terms *practices, rituals, ideological apparatus*. [...]

Ideas have disappeared as such (insofar as they are endowed with an ideal or spiritual existence), to the precise extent that it has emerged that their existence is inscribed in the actions of practices governed by rituals defined in the last instance by an ideological apparatus. It therefore appears that the subject acts insofar as he is acted by the following system (set out in the order of its real determination): ideology existing in a material ideological apparatus, prescribing material practices governed by a material ritual, which practices exist in the material actions of a subject acting in all consciousness according to his belief.

But this very presentation reveals that we have retained the following notions: subject, consciousness, belief, actions. From this series I shall immediately extract the decisive central term on which everything else depends: the notion of the *subject*.

And I shall immediately set down two conjoint theses:

1 there is no practice except by and in an ideology;
2 there is no ideology except by the subject and for subjects.

I can now come to my central thesis.

Ideology Interpellates Individuals as Subjects

This thesis is simply a matter of making my last proposition explicit: there is no ideology except by the subject and for subjects. Meaning, there is no ideology except

for concrete subjects, and this destination for ideology is only made possible by the subject: meaning, *by the category of the subject* and its functioning.

By this I mean that, even if it only appears under this name (the subject) with the rise of bourgeois ideology, above all with the rise of legal ideology, the category of the subject (which may function under other names: e.g., as the soul in Plato, as God, etc.) is the constitutive category of all ideology, whatever its determination (regional or class) and whatever its historical date – since ideology has no history.

I say: the category of the subject is constitutive of all ideology, but at the same time and immediately I add that *the category of the subject is only constitutive of all ideology insofar as all ideology has the function (which defines it) of 'constituting' concrete individuals as subjects.* In the interaction of this double constitution exists the functioning of all ideology, ideology being nothing but its functioning in the material forms of existence of that functioning.

In order to grasp what follows, it is essential to realize that both he who is writing these lines and the reader who reads them are themselves subjects, and therefore ideological subjects (a tautological proposition), i.e. that the author and the reader of these lines both live 'spontaneously' or 'naturally' in ideology in the sense in which I have said that 'man is an ideological animal by nature'.

That the author, insofar as he writes the lines of a discourse which claims to be scientific, is completely absent as a 'subject' from 'his' scientific discourse (for all scientific discourse is by definition a subject-less discourse, there is no 'Subject of science' except in an ideology of science) is a different question which I shall leave on one side for the moment.

As St Paul admirably put it, it is in the 'Logos', meaning in ideology, that we 'live, move and have our being'. It follows that, for you and for me, the category of the subject is a primary 'obviousness' (obviousnesses are always primary): it is clear that you and I are subjects (free, ethical, etc. . . .). Like all obviousnesses, including those that make a word 'name a thing' or 'have a meaning' (therefore including the obvious-ness of the 'transparency' of language), the 'obviousness' that you and I are subjects – and that that does not cause any problems – is an ideological effect, the elementary ideological effect. It is indeed a peculiarity of ideology that it imposes (without appearing to do so, since these are 'obviousnesses') obviousnesses as obviousnesses, which we cannot *fail to recognize* and before which we have the inevitable and natural reaction of crying out (aloud or in the 'still, small voice of conscience'): 'That's obvious! That's right! That's true!' [. . .]

4 Thomas Kuhn (1922–1996) from 'Postscript – 1969' to *The Structure of Scientific Revolutions*

Conventional theory tended to assume that knowledge grows cumulatively. It was Kuhn's achievement to point out that rather than proceeding in an ascending curve, knowledge could be plural: what counted as knowledge at any one time tended to be related more powerfully than had hitherto been realized to the interests of the community which the knowledge served. Kuhn's central concept was the 'paradigm'. Paradigmatic works functioned by overthrowing or challenging the norms of a given practice when those norms had begun to seem constricting, incoherent, or otherwise no longer immune to

challenge. The implications of the new paradigm would then be worked out over many years in a period of 'normal' endeavour. As such, all paradigms marginalize or disqualify practices which no longer conform to their criteria. Thus physics or astronomy disqualifies astrology; chemistry disqualifies alchemy. By the same token paradigmatic Modernist art theory disqualified the coherent spatial illusion which had been a prerequisite of academic competence. Kuhn's relevance lay not least in the widespread perception that that paradigm itself no longer compelled assent by the late 1960s. He also offered some reasoned grounds for confidence in trying things out and trying things on. Kuhn's work was originally published as *The Structure of Scientific Revolutions*, Chicago, 1962. The second edition of 1970 contained the 'Postscript' from which the present extracts are taken.

Exemplars, Incommensurability, and Revolutions

[...] To understand why science develops as it does, one need not unravel the details of biography and personality that lead each individual to a particular choice, though that topic has vast fascination. What one must understand, however, is the manner in which a particular set of shared values interacts with the particular experiences shared by a community of specialists to ensure that most members of the group will ultimately find one set of arguments rather than another decisive.

That process is persuasion, but it presents a deeper problem. Two men who perceive the same situation differently but nevertheless employ the same vocabulary in its discussion must be using words differently. They speak, that is, from ... incommensurable viewpoints. How can they even hope to talk together much less to be persuasive. Even a preliminary answer to that question demands further specification of the nature of the difficulty. I suppose that, at least in part, it takes the following form.

The practice of normal science depends on the ability, acquired from exemplars, to group objects and situations into similarity sets which are primitive in the sense that the grouping is done without an answer to the question, 'Similar with respect to what?' One central aspect of any revolution is, then, that some of the similarity relations change. Objects that were grouped in the same set before are grouped in different ones afterward and vice versa. Think of the sun, moon, Mars, and earth before and after Copernicus; of free fall, pendular, and planetary motion before and after Galileo; or of salts, alloys, and a sulphur-iron filing mix before and after Dalton. Since most objects within even the altered sets continue to be grouped together, the names of the sets are usually preserved. Nevertheless, the transfer of a subset is ordinarily part of a critical change in the network of interrelations among them. Transferring the metals from the set of compounds to the set of elements played an essential role in the emergence of a new theory of combustion, of acidity, and of physical and chemical combination. In short order those changes had spread through all of chemistry. Not surprisingly, therefore, when such redistributions occur, two men whose discourse had previously proceeded with apparently full understanding may suddenly find themselves responding to the same stimulus with incompatible descriptions and generalizations. Those difficulties will not be felt in all areas of even their scientific discourse, but they will arise and will then cluster most densely about the phenomena upon which the choice of theory most centrally depends.

Such problems, though they first become evident in communication, are not merely linguistic, and they cannot be resolved simply by stipulating the definitions of trouble-some terms. Because the words about which difficulties cluster have been learned in part from direct application to exemplars, the participants in a communication break-down cannot say, 'I use the word "element" (or "mixture", or "planet", or "uncon-strained motion") in ways determined by the following criteria.' They cannot, that is, resort to a neutral language which both use in the same way and which is adequate to the statement of both their theories or even of both those theories' empirical conse-quences. Part of the difference is prior to the application of the languages in which it is nevertheless reflected.

The men who experience such communication breakdowns must, however, have some recourse. The stimuli that impinge upon them are the same. So is their general neural apparatus, however differently programmed. Furthermore, except in a small, if all-important, area of experience even their neural programming must be very nearly the same, for they share a history, except the immediate past. As a result, both their everyday and most of their scientific world and language are shared. Given that much in common, they should be able to find out a great deal about how they differ. The techniques required are not, however, either straightforward, or comfortable, or parts of the scientist's normal arsenal. Scientists rarely recognize them for quite what they are, and they seldom use them for longer than is required to induce conversion or convince themselves that it will not be obtained.

Briefly put, what the participants in a communication breakdown can do is recognize each other as members of different language communities and then become translators. Taking the differences between their own intra- and inter-group discourse as itself a subject for study, they can first attempt to discover the terms and locutions that, used unproblematically within each community, are neverthless foci of trouble for inter-group discussions... Having isolated such areas of difficulty in scientific communi-cation, they can next resort to their shared everyday vocabularies in an effort further to elucidate their troubles. Each may, that is, try to discover what the other would see and say when presented with a stimulus to which his own verbal response would be different. If they can sufficiently refrain from explaining anomalous behavior as the consequence of mere error or madness, they may in time become very good predictors of each other's behavior. Each will have learned to translate the other's theory and its consequences into his own language and simultaneously to describe in his language the world to which that theory applies. That is what the historian of science regularly does (or should) when dealing with out-of-date scientific theories.

Since translation, if pursued, allows the participants in a communication breakdown to experience vicariously something of the merits and defects of each other's points of view, it is a potent tool both for persuasion and for conversion. But even persuasion need not succeed, and, if it does, it need not be accompanied or followed by conversion. The two experiences are not the same, an important distinction that I have only recently fully recognized.

To persuade someone is, I take it, to convince him that one's own view is superior and ought therefore supplant his own. That much is occasionally achieved without recourse to anything like translation. In its absence many of the explanations and problem-statements endorsed by the members of one scientific group will be opaque to the other. But each language community can usually produce from the start a few

concrete research results that, though describable in sentences understood in the same way by both groups, cannot yet be accounted for by the other community in its own terms. If the new viewpoint endures for a time and continues to be fruitful, the research results verbalizable in this way are likely to grow in number. For some men such results alone will be decisive. They can say: I don't know how the proponents of the new view succeed, but I must learn; whatever they are doing, it is clearly right. That reaction comes particularly easily to men just entering the profession, for they have not yet acquired the special vocabularies and commitments of either group.

Arguments statable in the vocabulary that both groups use in the same way are not, however, usually decisive, at least not until a very late stage in the evolution of the opposing views. Among those already admitted to the profession, few will be persuaded without some recourse to the more extended comparisons permitted by translation. Though the price is often sentences of great length and complexity... many additional research results can be *translated* from one community's language into the other's. As translation proceeds, furthermore, some members of each community may also begin vicariously to understand how a statement previously opaque could seem an explanation to members of the opposing group. The availability of techniques like these does not, of course, guarantee persuasion. For most people translation is a threatening process, and it is entirely foreign to normal science. Counter-arguments are, in any case, always available, and no rules prescribe how the balance must be struck. Nevertheless, as argument piles on argument and as challenge after challenge is successfully met, only blind stubbornness can at the end account for continued resistance.

That being the case, a second aspect of translation, long familiar to both historians and linguists, becomes crucially important. To translate a theory or worldview into one's own language is not to make it one's own. For that one must go native, discover that one is thinking and working in, not simply translating out of, a language that was previously foreign. That transition is not, however, one that an individual may make or refrain from making by deliberation and choice, however good his reasons for wishing to do so. Instead, at some point in the process of learning to translate, he finds that the transition has occurred, that he has slipped into the new language without a decision having been made. Or else, like many of those who first encountered, say, relativity or quantum mechanics in their middle years, he finds himself fully persuaded of the new view but nevertheless unable to internalize it and be at home in the world it helps to shape. Intellectually such a man has made his choice, but the conversion required if it is to be effective eludes him. He may use the new theory nonetheless, but he will do so as a foreigner in a foreign environment, an alternative available to him only because there are natives already there. His work is parasitic on theirs, for he lacks the constellation of mental sets which future members of the community will acquire through education.

The conversion experience that I have likened to a gestalt switch remains, therefore, at the heart of the revolutionary process. Good reasons for choice provide motives for conversion and a climate in which it is more likely to occur. Translation may, in addition, provide points of entry for the neutral reprogramming that, however inscrutable at this time, must underlie conversion. But neither good reasons nor translation constitute conversion, and it is that process we must explicate in order to understand an essential sort of scientific change.

The Nature of Science

[...] A number of those who have taken pleasure from [this book] have done so less because it illuminates science than because they read its main theses as applicable to many other fields as well. I see what they mean and would not like to discourage their attempts to extend the position, but their reaction has nevertheless puzzled me. To the extent that the book portrays scientific development as a succession of tradition-bound periods punctuated by non-cumulative breaks, its theses are undoubtedly of wide applicability. But they should be, for they are borrowed from other fields. Historians of literature, of music, of the arts, of political development, and of many other human activities have long described their subjects in the same way. Periodization in terms of revolutionary breaks in style, taste, and institutional structure have been among their standard tools. If I have been original with respect to concepts like these, it has mainly been by applying them to the sciences, fields which had been widely thought to develop in a different way. Conceivably the notion of a paradigm as a concrete achievement, an exemplar, is a second contribution. I suspect, for example, that some of the notorious difficulties surrounding the notion of style in the arts may vanish if paintings can be seen to be modeled on one another rather than produced in conformity to some abstracted canons of style.

This book, however, was intended also to make another sort of point, one that has been less clearly visible to many of its readers. Though scientific development may resemble that in other fields more closely than has often been supposed, it is also strikingly different. To say, for example, that the sciences, at least after a certain point in their development, progress in a way that other fields do not, cannot have been all wrong, whatever progress itself may be. One of the objects of the book was to examine such differences and begin accounting for them.

Consider, for example, the reiterated emphasis . . . on the absence or, as I should now say, on the relative scarcity of competing schools in the developed sciences. Or remember my remarks about the extent to which the members of a given scientific community provide the only audience and the only judges of that community's work. Or think again about the special nature of scientific education, about puzzle-solving as a goal, and about the value system which the scientific group deploys in periods of crisis and decision. The book isolates other features of the same sort, none necessarily unique to science but in conjunction setting the activity apart.

About all these features of science there is a great deal more to be learned. Having opened this postscript by emphasizing the need to study the community structure of science, I shall close by underscoring the need for similar and, above all, for comparative study of the corresponding communities in other fields. How does one elect and how is one elected to membership in a particular community, scientific or not? What is the process and what are the stages of socialization to the group? What does the group collectively see as its goals; what deviations, individual or collective, will it tolerate; and how does it control the impermissible aberration? A fuller understanding of science will depend on answers to other sorts of questions as well, but there is no area in which more work is so badly needed. Scientific knowledge, like language, is intrinsically the common property of a group or else nothing at all. To understand it we shall need to know the special characteristics of the groups that create and use it.

5 Roland Barthes (1915–1980) 'From Work to Text'

Barthes's thesis relates to the de-centring of the subject noted in respect of the theories of Lacan, Althusser and Foucault. Here, instead of the work – say, a work of art – being a primary, essentially self-contained thing, whose priority over all acts of seeing it, reading it, discussing it, etc., is given, the whole set of these transactions is reconceptualized. Thus the process of establishing a meaning becomes radically contingent, the product of a variety of shifting interchanges rather than the divination of the semantic heart of the work. The work, so to speak, loses its pre-eminence and steps down into a field of interactions, all conceived as of more or less equal moment. These interactions Barthes designates as 'play'. The result is a resolutely anti-hierarchical conception of the production of meaning, rather than a grasping of the author's Truth: the false truth, as it were, of authority. Originally published as 'De l'œuvre au texte' in *Revue d'esthétique*, Paris, no. 3, 1971; English translation by Stephen Heath in Roland Barthes, *Image, Music, Text*, London, 1977, pp. 155–64, from which the present text is taken. (For an earlier text by Barthes see VIA1.)

It is a fact that over the last few years a certain change has taken place (or is taking place) in our conception of language and, consequently, of the literary work which owes at least its phenomenal existence to this same language. The change is clearly connected with the current development of (amongst other disciplines) linguistics, anthropology, Marxism and psychoanalysis (the term 'connection' is used here in a deliberately neutral way: one does not decide a determination, be it multiple and dialectical). What is new and which affects the idea of the work comes not necessarily from the internal recasting of each of these disciplines, but rather from their encounter in relation to an object which traditionally is the province of none of them. It is indeed as though the *interdisciplinarity* which is today held up as a prime value in research cannot be accomplished by the simple confrontation of specialist branches of knowledge. Interdisciplinarity is not the calm of an easy security; it begins *effectively* (as opposed to the mere expression of a pious wish) when the solidarity of the old disciplines breaks down – perhaps even violently, via the jolts of fashion – in the interests of a new object and a new language neither of which has a place in the field of the sciences that were to be brought peacefully together, this unease in classification being precisely the point from which it is possible to diagnose a certain mutation. The mutation in which the idea of the work seems to be gripped must not, however, be over-estimated: it is more in the nature of an epistemological slide than of a real break. The break, as is frequently stressed, is seen to have taken place in the last century with the appearance of Marxism and Freudianism; since then there has been no further break, so that in a way it can be said that for the last hundred years we have been living in repetition. What History, our History, allows us today is merely to slide, to vary, to exceed, to repudiate. Just as Einsteinian science demands that *the relativity of the frames of reference* be included in the object studied, so the combined action of Marxism, Freudianism and structuralism demands, in literature, the relativization of the relations of writer, reader and observer (critic). Over against the traditional notion of the *work*, for long – and still – conceived of in a, so to speak, Newtonian way, there is now the requirement of a new object, obtained by the sliding or overturning of former categories. That object is the *Text*. I know the word is fashionable (I am myself often led to use it) and therefore regarded by some with suspicion, but that is exactly why I should like

to remind myself of the principal propositions at the intersection of which I see the Text as standing. The word 'proposition' is to be understood more in a grammatical than in a logical sense: the following are not argumentations but enunciations, 'touches', approaches that consent to remain metaphorical. Here then are these propositions; they concern method, genres, signs, plurality, filiation, reading and pleasure.

1. The Text is not to be thought of as an object that can be computed. It would be futile to try to separate out materially works from texts. In particular, the tendency must be avoided to say that the work is classic, the text avant-garde; it is not a question of drawing up a crude honours list in the name of modernity and declaring certain literary productions 'in' and others 'out' by virtue of their chronological situation: there may be 'text' in a very ancient work, while many products of contemporary literature are in no way texts. The difference is this: the work is a fragment of substance, occupying a part of the space of books (in a library for example), the Text is a methodological field. The opposition may recall (without at all reproducing term for term) Lacan's distinction between 'reality' and 'the real': the one is displayed, the other demonstrated; likewise, the work can be seen (in bookshops, in catalogues, in exam syllabuses), the text is a process of demonstration, speaks according to certain rules (or against certain rules); the work can be held in the hand, the text is held in language, only exists in the movement of a discourse (or rather, it is Text for the very reason that it knows itself as text); the Text is not the decomposition of the work, it is the work that is the imaginary tail of the Text; or again, *the Text is experienced only in an activity of production*. It follows that the Text cannot stop (for example on a library shelf); its constitutive movement is that of cutting across (in particular, it can cut across the work, several works).

2. In the same way, the Text does not stop at (good) Literature; it cannot be contained in a hierarchy, even in a simple division of genres. What constitutes the Text is, on the contrary (or precisely), its subversive force in respect of the old classifications. How do you classify a writer like Georges Bataille? Novelist, poet, essayist, economist, philosopher, mystic? The answer is so difficult that the literary manuals generally prefer to forget about Bataille who, in fact, wrote texts, perhaps continuously one single text. If the Text poses problems of classification (which is furthermore one of its 'social' functions), this is because it always involves a certain experience of limits (to take up an expression from Philippe Sollers). Thibaudet used already to talk – but in a very restricted sense – of limit-works (such as Chateaubriand's *Vie de Rancé*, which does indeed come through to us today as a 'text'); the Text is that which goes to the limit of the rules of enunciation (rationality, readability, etc.). Nor is this a rhetorical idea, resorted to for some 'heroic' effect: the Text tries to place itself very exactly *behind* the limit of the *doxa* (is not general opinion – constitutive of our democratic societies and powerfully aided by mass communications – defined by its limits, the energy with which it excludes, its *censorship*?). Taking the word literally, it may be said that the Text is always *paradoxical*.

3. The Text can be approached, experienced, in reaction to the sign. The work closes on a signified. There are two modes of signification which can be attributed to this signified: either it is claimed to be evident and the work is then the object of a literal science, of philology, or else it is considered to be secret, ultimate, something to be sought out, and the work then falls under the scope of a hermeneutics, of an

interpretation (Marxist, psychoanalytic, thematic, etc.); in short, the work itself functions as a general sign and it is normal that it should represent an institutional category of the civilization of the Sign. The Text, on the contrary, practises the infinite deferment of the signified, is dilatory; its field is that of the signifier and the signifier must not be conceived of as 'the first stage of meaning', its material vestibule, but, in complete opposition to this, as its *deferred* action. Similarly, the *infinity* of the signifier refers not to some idea of the ineffable (the unnameable signified) but to that of a *playing*; the generation of the perpetual signifier (after the fashion of a perpetual calender) in the field of the text (better, of which the text is the field) is realized not according to an organic progress of maturation or a hermeneutic course of deepening investigation, but, rather, according to a serial movement of disconnections, over-lappings, variations. The logic regulating the Text is not comprehensive (define 'what the work means') but metonymic; the activity of associations, contiguities, carryings-over coincides with a liberation of symbolic energy (lacking it, man would die); the work – in the best of cases – is *moderately* symbolic (its symbolic runs out, comes to a halt); the Text is *radically* symbolic: *a work conceived, perceived and received in its integrally symbolic nature is a text*. Thus is the Text restored to language; like language, it is structured but off-centred, without closure (note, in reply to the contemptuous suspicion of the 'fashionable' sometimes directed at structuralism, that the epistemological privilege currently accorded to language stems precisely from the discovery there of a paradoxical idea of structure: a system with neither close nor centre).

4. The Text is plural. Which is not simply to say that it has several meanings, but that it accomplishes the very plural of meaning: an *irreducible* (and not merely an acceptable) plural. The Text is not a co-existence of meanings but a passage, an overcrossing; thus it answers not to an interpretation, even a liberal one, but to an explosion, a dissemination. The plural of the Text depends, that is, not on the ambiguity of its contents but on what might be called the *stereographic plurality* of its weave of signifiers (etymologically, the text is a tissue, a woven fabric). The reader of the Text may be compared to someone at a loose end (someone slackened off from any imaginary); this passably empty subject strolls – it is what happened to the author of these lines, then it was that he had a vivid idea of the Text – on the side of a valley, a *oued* flowing down below (*oued* is there to bear witness to a certain feeling of unfamiliarity); what he perceives is multiple, irreducible, coming from a disconnected, heterogeneous variety of substances and perspectives: lights, colours, vegetation, heat, air, slender explosions of noises, scant cries of birds, children's voices from over on the other side, passages, gestures, clothes of inhabitants near or far away. All these *incidents* are half-identifiable: they come from codes which are known but their combination is unique, founds the stroll in a difference repeatable only as difference. So the Text: it can be it only in its difference (which does not mean its individuality), its reading is semelfactive (this rendering illusory any inductive-deductive science of texts – no 'grammar' of the text) and nevertheless woven entirely with citations, references, echoes, cultural languages (what language is not?), antecedent or contemporary, which cut across it through and through in a vast stereophony. The intertextual in which every text is held, it itself being the text-between of another text, is not to be confused with some origin of the text: to try to find the 'sources', the 'influences' of a work, is to fall in with the myth of filiation; the citations which go to make up a text are

anonymous, untraceable, and yet *already read*: they are quotations without inverted commas. The work has nothing disturbing for any monistic philosophy (we know that there are opposing examples of these); for such a philosophy, plural is the Evil. Against the work, therefore, the text could well take as its motto the words of the man possessed by demons (Mark 5: 9): 'My name is Legion: for we are many.' The plural of demoniacal texture which opposes text to work can bring with it fundamental changes in reading, and precisely in areas where monologism appears to be the Law: certain of the 'texts' of Holy Scripture traditionally recuperated by theological monism (historical or anagogical) will perhaps offer themselves to a diffraction of meanings (finally, that is to say, to a materialist reading), while the Marxist interpretation of works, so far resolutely monistic, will be able to materialize itself more by pluralizing itself (if, however, the Marxist 'institutions' allow it).

5. The work is caught up in a process of filiation. Are postulated: a *determination* of the work by the world (by race, then by History), a *consecution* of works amongst themselves, and a *conformity* of the work to the author. The author is reputed the father and the owner of his work: literary science therefore teaches *respect* for the manuscript and the author's declared intentions, while society asserts the legality of the relation of author to work (the '*droit d'auteur*' or 'copyright', in fact of recent date since it was only really legalized at the time of the French Revolution). As for the Text, it reads without the inscription of the Father. Here again, the metaphor of the Text separates from that of the work: the latter refers to the image of an *organism* which grows by vital expansion, by 'development' (a word which is significantly ambiguous, at once biological and rhetorical); the metaphor of the Text is that of the *network*; if the Text extends itself, it is as a result of a combinatory systematic (an image, moreover, close to current biological conceptions of the living being). Hence no vital 'respect' is due to the Text: it can be *broken* (which is just what the Middle Ages did with two nevertheless authoritative texts – Holy Scripture and Aristotle); it can be read without the guarantee of its father, the restitution of the inter-text paradoxically abolishing any legacy. It is not that the Author may not 'come back' in the Text, in his text, but he then does so as a 'guest'. If he is a novelist, he is inscribed in the novel like one of his characters, figured in the carpet; no longer privileged, paternal, aletheological, his inscription is ludic. He becomes, as it were, a paper-author: his life is no longer the origin of his fictions but a fiction contributing to his work; there is a reversion of the work on to the life (and no longer the contrary); it is the work of Proust, of Genet which allows their lives to be read as a text. The word 'bio-graphy' re-acquires a strong, etymological sense, at the same time as the sincerity of the enunciation – veritable 'cross' borne by literary morality – becomes a false problem: the I which writes the text, it too, is never more than a paper-I.

6. The work is normally the object of a consumption; no demagogy is intended here in referring to the so-called consumer culture but it has to be recognized that today it is the 'quality' of the work (which supposes finally an appreciation of 'taste') and not the operation of reading itself which can differentiate between books: structurally, there is no difference between 'cultured' reading and casual reading in trains. The Text (if only by its frequent 'unreadability') decants the work (the work permitting) from its consumption and gathers it up as play, activity, production, practice. This means that the Text requires that one try to abolish (or at the very least to diminish) the distance between writing and reading, in no way by intensifying the projection of

the reader into the work but by joining them in a single signifying practice. The distance separating reading from writing is historical. In the times of the greatest social division (before the setting up of democratic cultures), reading and writing were equally privileges of class. Rhetoric, the great literary code of those times, taught one to *write* (even if what was then normally produced were speeches, not texts). Significantly, the coming of democracy reversed the word of command: what the (secondary) School prides itself on is teaching to *read* (well) and no longer to write (consciousness of the deficiency is becoming fashionable again today: the teacher is called upon to teach pupils to 'express themselves', which is a little like replacing a form of repression by a misconception). In fact, *reading*, in the sense of consuming, is far from *playing* with the text. 'Playing' must be understood here in all its polysemy: the text itself *plays* (like a door, like a machine with 'play') and the reader plays twice over, playing the Text as one plays a game, looking for a practice which re-produces it, but, in order that that practice not be reduced to a passive, inner *mimesis* (the Text is precisely that which resists such a reduction), also playing the Text in the musical sense of the term. The history of music (as a practice, not as an 'art') does indeed parallel that of the Text fairly closely: there was a period when practising amateurs were numerous (at least within the confines of a certain class) and 'playing' and 'listening' formed a scarcely differentiated activity; then two roles appeared in succession, first that of the performer, the interpreter to whom the bourgeois public (though still itself able to play a little – the whole history of the piano) delegated its playing, then that of the (passive) amateur, who listens to music without being able to play (the gramophone record takes the place of the piano). We know that today post-serial music has radically altered the role of the 'interpreter', who is called on to be in some sort the co-author of the score, completing it rather than giving it 'expression'. The Text is very much a score of this new kind: it asks of the reader a practical collaboration. Which is an important change, for who executes the work? (Mallarmé posed the question, wanting the audience to produce the book.) Nowadays only the critic executes the work (accepting the play on words). The reduction of reading to a consumption is clearly responsible for the 'boredom' experienced by many in the face of the modern ('unreadable') text, the avant-garde film or painting: to be bored means that one cannot produce the text, open it out, *set it going*.

7. This leads us to pose (to propose) a final approach to the Text, that of pleasure. I do not know whether there has ever been a hedonistic aesthetics (eudæmonist philosophies are themselves rare). Certainly there exists a pleasure of the work (of certain works); I can delight in reading and re-reading Proust, Flaubert, Balzac, even – why not? – Alexandre Dumas. But this pleasure, no matter how keen and even when free from all prejudice, remains in part (unless by some exceptional critical effort) a pleasure of consumption; for if I can read these authors, I also know that I cannot *re-write* them (that it is impossible today to write 'like that') and this knowledge, depressing enough, suffices to cut me off from the production of these works, in the very moment their remoteness establishes my modernity (is not to be modern to know clearly what cannot be started over again?). As for the Text, it is bound to *jouissance*, that is to a pleasure without separation. Order of the signifier, the Text participates in its own way in a social utopia; before History (supposing the latter does not opt for barbarism), the Text achieves, if not the transparence of social relations, that at least of language relations: the Text is that space where no language has a hold over any other, where languages circulate (keeping the circular sense of the term).

These few propositions, inevitably, do not constitute the articulations of a Theory of the Text and this is not simply the result of the failings of the person here presenting them (who in many respects has anyway done no more than pick up what is being developed round about him). It stems from the fact that a Theory of the Text cannot be satisfied by a metalinguistic exposition: the destruction of meta-language, or at least (since it may be necessary provisionally to resort to meta-language) its calling into doubt, is part of the theory itself: the discourse on the Text should itself be nothing other than text, research, textual activity, since the Text is that *social* space which leaves no language safe, outside, nor any subject of the enunciation in position as judge, master, analyst, confessor, decoder. The theory of the Text can coincide only with a practice of writing.

6 Robert Smithson (1938–1973) 'Cultural Confinement'

By 1972 Smithson was established as the leading figure working in the area of Land Art, one of the principal strategies of which was to move the work out of the confines of the gallery towards a more directly critical relation to the modern world. The aim was to revise the parameters of art and in so doing to question the commodity status increasingly accorded to Modernist art within that world. Smithson's statement was first published in German in the catalogue to the international exhibition 'Documenta 5', Kassel, 1972, section 17, p. 74. It was subsequently published in English in *Artforum*, New York, October 1972; reprinted in Nancy Holt (ed.), *The Writings of Robert Smithson*, New York, 1979, pp. 132–3, from which the present text is taken. (See also VIIB3.)

Cultural confinement takes place when a curator imposes his own limits on an art exhibition, rather than asking an artist to set his limits. Artists are expected to fit into fraudulent categories. Some artists imagine they've got a hold on this apparatus, which in fact has got a hold of them. As a result, they end up supporting a cultural prison that is out of their control. Artists themselves are not confined, but their output is. Museums, like asylums and jails, have wards and cells – in other words, neutral rooms called 'galleries.' A work of art when placed in a gallery loses its charge, and becomes a portable object or surface disengaged from the outside world. A vacant white room with lights is still a submission to the neutral. Works of art seen in such spaces seem to be going through a kind of esthetic convalescence. They are looked upon as so many inanimate invalids, waiting for critics to pronounce them curable or incurable. The function of the warden–curator is to separate art from the rest of society. Next comes integration. Once the work of art is totally neutralized, ineffective, abstracted, safe, and politically lobotomized it is ready to be consumed by society. All is reduced to visual fodder and transportable merchandise. Innovations are allowed only if they support this kind of confinement.

Occult notions of 'concept' are in retreat from the physical world. Heaps of private information reduce art to hermeticism and fatuous metaphysics. Language should find itself in the physical world, and not end up locked in an idea in somebody's head. Language should be an ever developing procedure and not an isolated occurrence. Art shows that have beginnings and ends are confined by unnecessary modes of *representation* both 'abstract' and 'realistic.' A face or a grid on a canvas is still a representation. Reducing representation to writing does not bring one closer to the physical world.

Writing should generate ideas into matter, and not the other way around. Art's development should be dialectical and not metaphysical.

I am speaking of a dialectics that seeks a world outside of cultural confinement. Also, I am not interested in art works that suggest 'process' within the metaphysical limits of the neutral room. There is no freedom in that kind of behavioral game playing. The artist acting like a B. F. Skinner rat doing his 'tough' little tricks is something to be avoided. Confined process is no process at all. It would be better to disclose the confinement rather than make illusions of freedom.

I am for an art that takes into account the direct effect of the elements as they exist from day to day apart from representation. The parks that surround some museums isolate art into objects of formal delectation. Objects in a park suggest static repose rather than any ongoing dialectic. Parks are finished landscapes for finished art. A park carries the values of the final, the absolute, and the sacred. Dialectics have nothing to do with such things. I am talking about a dialectic of nature that interacts with the physical contradictions inherent in natural forces as they are – nature as both sunny and stormy. Parks are idealizations of nature, but nature in fact is not a condition of the ideal. Nature does not proceed in a straight line, it is rather a sprawling development. Nature is never finished. When a finished work of twentieth-century sculpture is placed in an eighteenth-century garden, it is absorbed by the ideal representation of the past, thus reinforcing political and social values that are no longer with us. Many parks and gardens are re-creations of the lost paradise or Eden, and not the dialectical sites of the present. Parks and gardens are pictorial in their origin – landscapes created with natural materials rather than paint. The scenic ideals that surround even our national parks are carriers of a nostalgia for heavenly bliss and eternal calmness.

Apart from the ideal gardens of the past, and their modern counterparts – national and large urban parks, there are the more infernal regions – slag heaps, strip mines, and polluted rivers. Because of the great tendency toward idealism, both pure and abstract, society is confused as to what to do with such places. Nobody wants to go on a vacation to a garbage dump. Our land ethic, especially in that never-never land called the 'art world' has become clouded with abstractions and concepts.

Could it be that certain art exhibitions have become metaphysical junkyards? Categorical miasmas? Intellectual rubbish? Specific intervals of visual desolation? The warden–curators still depend on the wreckage of metaphysical principles and structures because they don't know any better. The wasted remains of ontology, cosmology, and epistemology still offer a ground for art. Although metaphysics is outmoded and blighted, it is presented as tough principles and solid reasons for installations of art. The museums and parks are graveyards above the ground – congealed memories of the past that act as a pretext for reality. This causes acute anxiety among artists, in so far as they challenge, compete, and fight for the spoiled ideals of lost situations.

7 Leo Steinberg (b. 1920) from *Other Criteria*

Steinberg's book of essays *Other Criteria* was received as a powerful counter to what was seen in the early 1970s as an increasingly barren and entrenched formalist orthodoxy. In

particular the long essay of the same title surveyed modern art from the late nineteenth century to the then present, contesting Greenberg's account over a broad front, and relating Modernist work to a changing continuum of self-reference and representation of the world going back to the Renaissance. Thus the mention of the Old Masters' 'three ways of conceiving the picture plane' refers to an argument earlier in the essay that the matter of 'art drawing attention to art' has not been peculiar to modern art. Steinberg argues that the art of the Old Masters, though illusionistic, also involved self-referential devices intended to draw the spectator's attention to the art. This was achieved by a range of devices: '. . . by radical color economies, or by eerie proportional attenuation; by multiplication of detail . . . by quotations and references to other art . . . They did it by abrupt internal changes of scale, or by shifting reality levels.' Finally 'the "recall to art" may be engineered by the subject matter itself' through devices such as internal spectators, the juxtaposition of windows with framed paintings, or mirrors filled with reflections. For Steinberg such pictures 'soliloquize about the capacities of the surface and the nature of illusion itself'. In the final section of the essay, reprinted here, Steinberg postulated a significant development to this tradition occurring after the end of the Second World War and particularly evident in the work of Rauschenberg (see VIA13). He dubbed this phase, presciently, as 'post-Modernist' painting. The essay had its origins in a lecture given at the Musem of Modern Art, New York, in March 1968. A substantial version was first published as 'Reflections on the State of Criticism', in *Artforum*, New York, in March 1972. It appeared in its definitive form in *Other Criteria*, London and New York, 1972, pp. 61–98, from which this excerpt is taken.

The Flatbed Picture Plane

I borrow the term from the flatbed printing press – 'a horizontal bed on which a horizontal printing surface rests' (Webster). And I propose to use the word to describe the characteristic picture plane of the 1960s – a pictorial surface whose angulation with respect to the human posture is the precondition of its changed content.

It was suggested earlier that the Old Masters had three ways of conceiving the picture plane. But one axiom was shared by all three interpretations, and it remained operative in the succeeding centuries, even through Cubism and Abstract Expressionism: the conception of the picture as representing a world, some sort of worldspace which reads on the picture plane in correspondence with the erect human posture. The top of the picture corresponds to where we hold our heads aloft; while its lower edge gravitates to where we place our feet. Even in Picasso's Cubist collages, where the Renaissance worldspace concept almost breaks down, there is still a harking back to implied acts of vision, to something that was once actually seen.

A picture that harks back to the natural world evokes sense data which are experienced in the normal erect posture. Therefore the Renaissance picture plane affirms verticality as its essential condition. And the concept of the picture plane as an upright surface survices the most drastic changes of style. Pictures by Rothko, Still, Newman, de Kooning, and Kline are still addressed to us head to foot – as are those of Matisse and Miró. They are revelations to which we relate visually as from the top of a columnar body; and this applies no less to Pollock's drip paintings and the poured *Veils* and *Unfurls* of Morris Louis. Pollock indeed poured and dripped his pigment upon canvases laid on the ground, but this was an expedient. After the first color skeins had gone down, he would tack the canvas on to a wall – to get acquainted with it, he used to say; to see where it wanted to go. He lived with the painting in its uprighted

state, as with a world confronting his human posture. It is in this sense, I think, that the Abstract Expressionists were still nature painters. Pollock's drip paintings cannot escape being read as thickets; Louis' *Veils* acknowledge the same gravitational force to which our being in nature is subject.

But something happened in painting around 1950 – most conspicuously (at least within my experience) in the work of Robert Rauschenberg and Dubuffet. We can still hang their pictures – just as we tack up maps and architectural plans, or nail a horseshoe to the wall for good luck. Yet these pictures no longer simulate vertical fields, but opaque flatbed horizontals. They no more depend on a head-to-toe correspondence with human posture than a newspaper does. The flatbed picture plane makes its symbolic allusion to hard surfaces such as tabletops, studio floors, charts, bulletin boards – any receptor surface on which objects are scattered, on which data is entered, on which information may be received, printed, impressed – whether coherently or in confusion. The pictures of the last fifteen to twenty years insist on a radically new orientation, in which the painted surface is no longer the analogue of a visual experience of nature but of operational processes.

To repeat: it is not the actual physical placement of the image that counts. There is no law against hanging a rug on a wall, or reproducing a narrative picture as a mosaic floor. What I have in mind is the psychic address of the image, its special mode of imaginative confrontation, and I tend to regard the tilt of the picture plane from vertical to horizontal as expressive of the most radical shift in the subject matter of art, the shift from nature to culture.

A shift of such magnitude does not come overnight, nor as the feat of one artist alone. Portents and antecedents become increasingly recognizable in retrospect – Monet's *Nymphéas* or Mondrian's transmutation of sea and sky into signs plus and minus. And the picture planes of a Synthetic Cubist still life or a Schwitters collage suggest like-minded reorientations. But these last were small objects; the 'thingness' of them was appropriate to their size. Whereas the event of the 1950s was the expansion of the work-surface picture plane to the man-sized environmental scale of Abstract Expressionism. Perhaps Duchamp was the most vital source. His *Large Glass* begun in 1915, or his *Tu m'* of 1918, is no longer the analogue of a world perceived from an upright position, but a matrix of information conveniently placed in a vertical situation. And one detects a sense of the significance of a ninety-degree shift in relation to a man's posture even in some of those Duchamp 'works' that once seemed no more than provocative gestures: the *Coatrack* nailed to the floor and the famous *Urinal* tilted up like a monument.[1]

But on the New York art scene the great shift came in Rauschenberg's work of the early 1950s. Even as Abstract Expressionism was celebrating its triumphs, he proposed the flatbed or work-surface picture plane as the foundation of an artistic language that would deal with a different order of experience. The earliest work which Rauschenberg admits into his canon – *White Painting with Numbers* – was painted in 1949 in a life class at the Art Students' League, the young painter turning his back on the model. Rauschenberg's picture, with its cryptic meander of lines and numbers, is a work surface that cannot be construed into anything else. Up and down are as subtly confounded as positive-negative space of figure-ground differential. You cannot read it as masonry, nor as a system of chains or quoins, and the written ciphers read every

way. Scratched into wet paint, the picture ends up as a verification of its own opaque surface.

In the year following, Rauschenberg began to experiment with objects placed on blueprint paper and exposed to sunlight. Already then he was involved with the physical material of plans; and in the early 1950s used newsprint to prime his canvas – to activate the ground, as he put it – so that his first brush-stroke upon it took place in a gray map of words.

In retrospect the most clownish of Rauschenberg's youthful pranks take on a kind of stylistic consistency. Back in the fifties, he was invited to participate in an exhibition on the nostalgic subject of 'nature in art' – the organizers hoping perhaps to promote an alternative to the new abstract painting. Rauschenberg's entry was a square patch of growing grass held down with chicken wire, placed in a box suitable for framing and hung on the wall. The artist visited the show periodically to water his piece – a transposition from nature to culture through a shift of ninety degrees. When he erased a de Kooning drawing, exhibiting it as 'Drawing by Willem de Kooning erased by Robert Rauschenberg,' he was making more than a multifaceted psychological gesture; he was changing – for the viewer no less than for himself – the angle of imaginative confrontation; tilting de Kooning's evocation of a worldspace into a thing produced by pressing down on a desk.

The paintings he made towards the end of that decade included intrusive non-art attachments: a pillow suspended horizontally from the lower frame (*Canyon*, 1959); a grounded ladder inserted between the painted panels which made up the picture (*Winter Pool*, 1959–60); a chair standing against a wall but ingrown with the painting behind (*Pilgrim*, 1960). Though they hung on the wall, the pictures kept referring back to the horizontals on which we walk and sit, work and sleep.

When in the early 1960s he worked with photographic transfers, the images – each in itself illusionistic – kept interfering with one another; intimations of spatial meaning forever canceling out to subside in a kind of optical noise. The waste and detritus of communication – like radio transmission with interference; noise and meaning on the same wavelength, visually on the same flatbed plane.

This picture plane, as in the enormous canvas called *Overdraw* (1963), could look like some garbled conflation of controls system and cityscape, suggesting the ceaseless inflow of urban message, stimulus, and impediment. To hold all this together, Rauschenberg's picture plane had to become a surface to which anything reachable-thinkable would adhere. It had to be whatever a billboard or dashboard is, and everything a projection screen is, with further affinities for anything that is flat and worked over – palimpsest, canceled plate, printer's proof, trial blank, chart, map, aerial view. Any flat documentary surface that tabulates information is a relevant analogue of his picture plane – radically different from the transparent projection plane with its optical correspondence to man's visual field. And it seemed at times that Rauschenberg's work surface stood for the mind itself – dump, reservoir, switching center, abundant with concrete references freely associated as in an internal monologue – the outward symbol of the mind as a running transformer of the external world, constantly ingesting incoming unprocessed data to be mapped in an overcharged field.

To cope with his symbolic program, the available types of pictorial surface seemed inadequate; they were too exclusive and too homogeneous. Rauschenberg found that his imagery needed bedrock as hard and tolerant as a workbench. If some collage element,

such as a pasted-down photograph, threatened to evoke a topical illusion of depth, the surface was casually stained or smeared with paint to recall its irreducible flatness. The 'integrity of the picture plane' – once the accomplishment of good design – was to become that which is given. The picture's 'flatness' was to be no more of a problem than the flatness of a disordered desk or an unswept floor. Against Rauschenberg's picture plane you can pin or project any image because it will not work as the glimpse of a world, but as a scrap of printed material. And you can attach any object, so long as it beds itself down on the work surface. The old clock in Rauschenberg's 1961 *Third Time Painting* lies with the number 12 on the left, because the clock face properly uprighted would have illusionized the whole system into a real vertical plane – like the wall of a room, part of the given world. Or, in the same picture the flattened shirt with its sleeves outstretched – not like wash on a line, but – with paint stains and drips holding it down – like laundry laid out for pressing. The consistent horizontality is called upon to maintain a symbolic continuum of litter, workbench, and data-ingesting mind.

Perhaps Rauschenberg's profoundest symbolic gesture came in 1955 when he seized his own bed, smeared paint on its pillow and quilt coverlet, and uprighted it against the wall. There, in the vertical posture of 'art,' it continues to work in the imagination as the eternal companion of our other resource, our horizontality, the flat bedding in which we do our begetting, conceiving, and dreaming. The horizontality of the bed relates to 'making' as the vertical of the Renaissance picture plane related to seeing.

I once heard Jasper Johns say that Rauschenberg was the man who in this century had invented the most since Picasso. What he invented above all was, I think, a pictorial surface that let the world in again. Not the world of the Renaissance man who looked for his weather clues out of the window; but the world of men who turn knobs to hear a taped message, 'precipitation probability ten percent tonight,' electronically transmitted from some windowless booth. Rauschenberg's picture plane is for the consciousness immersed in the brain of the city.

The flatbed picture plane lends itself to any content that does not evoke a prior optical event. As a criterion of classification it cuts across the terms 'abstract' and 'representational,' Pop and Modernist. Color field painters such as Noland, Frank Stella, and Ellsworth Kelly, whenever their works suggest a reproducible image, seem to work with the flatbed picture plane, i.e. one which is man-made and stops short at the pigmented surface; whereas Pollock's and Louis's pictures remain visionary, and Frankenthaler's abstractions, for all their immediate modernism, are – as Lawrence Alloway recently put it – 'a celebration of human pleasure in what is not man-made.'[2]

Insofar as the flatbed picture plane accommodates recognizable objects, it presents them as man-made things of universally familiar character. The emblematic images of the early Johns belong in this class; so, I think, does most of Pop Art. When Roy Lichtenstein in the early sixties painted an Air Force officer kissing his girl goodbye, the actual subject matter was the mass-produced comic-book image; ben-day dots and stereotyped drawing ensured that the image was understood as a representation of printed matter. The pathetic humanity that populate Dubuffet's pictures are rude man-made graffiti, and their reality derives both from the material density of the surface and from the emotional pressure that guided the hand. Claes Oldenburg's drawing, to quote his own words, 'takes on an "ugliness" which is a mimicry of the scrawls and patterns of street graffiti. It celebrates irrationality, disconnection, violence, and stunted expression – the damaged life forces of the city street.'[3]

And about Andy Warhol, David Antin once wrote a paragraph which I wish I had written:

> In the Warhol canvases, the image can be said to barely exist. On the one hand this is part of his overriding interest in the 'deteriorated image,' the consequence of a series of regressions from some initial image of the real world. Here there is actually a series of images of images, beginning from the translation of the light reflectivity of a human face into the precipitation of silver from a photo-sensitive emulsion, this negative image developed, re-photographed into a positive image with reversal of light and shadow, and consequent blurring, further translated by telegraphy, engraved on a plate and printed through a crude screen with low-grade ink on newsprint, and this final blurring and silkscreening in an imposed lilac color on canvas. What is left? The sense that there is something out there one recognizes and yet can't see. Before the Warhol canvases we are trapped in a ghastly embarrassment. This sense of the arbitrary coloring, the nearly obliterated image and the persistently intrusive feeling. Somewhere in the image there is a proposition. It is unclear.[4]

The picture conceived as the image of an image. It's a conception which guarantees that the presentation will not be directly that of a worldspace, and that it will nevertheless admit any experience as the matter of representation. And it readmits the artist in the fullness of his human interests, as well as the artist-technician.

The all-purpose picture plane underlying this post-Modernist painting has made the course of art once again non-linear and unpredictable. What I have called the flatbed is more than a surface distinction if it is understood as a change within painting that changed the relationship between artist and image, image and viewer. Yet this internal change is no more than a symptom of changes which go far beyond questions of picture planes, or of painting as such. It is part of a shakeup which contaminates all purified categories. The deepening inroads of art into non-art continue to alienate the connoisseur as art defects and departs into strange territories leaving the old stand-by criteria to rule an eroding plain.

[1] Cf. also Duchamp's suggestion to 'use a Rembrandt as an ironing-board' (*Salt Seller: The Writings of Marcel Duchamp*, ed. Michel Sanouillet and Elmer Peterson, New York, 1973, p. 32). NB: not a dart board or bulletin board, but a horizontal work surface.

[2] 'Frankenthaler as Pastoral,' *Art News*, November 1971, p. 68.

[3] Quoted in Eila Kokkinen, review of *Claes Oldenburg: Drawings and Prints*, in *Arts*, November 1969, p. 12.

[4] 'Warhol: The Silver Tenement,' *Art News*, Summer 1966, p. 58.

8 Rosalind Krauss (b. 1940) 'A View of Modernism'

The author was a contemporary of Michael Fried on the faculty at Harvard University. Together they did much to introduce the Modernist criticism of Clement Greenberg to a more established academic environment, as well as substantially developing and sophisticating the premises of that criticism themselves. By the early 1970s, however, Fried had essentially abandoned contemporary criticism for art history, and Krauss was increasingly disturbed by the apparent inability of Greenbergian Modernism to address what was palpably the most trenchant and interesting art of the day. Accordingly she began to adumbrate the idea of a 'larger' Modernist self-critical sensibility which the entrenched

Greenbergian paradigm had, through its very rigidity, begun to violate. A transitional work, the essay none the less marks a moment in the slackening of the hold of Greenberg's Modernism on one of its most sophisticated exponents. Published in *Artforum*, New York, September 1972, pp. 48–51, from which the present text is taken. (See also VIID12 and VIIIA4.)

One day while the show, 'Three American Painters' was hanging at the Fogg Museum at Harvard, Michael Fried and I were standing in one of the galleries. To our right was a copper painting by Frank Stella, its surface burnished by the light which flooded the room. A Harvard student who had entered the gallery approached us. With his left arm raised and his finger pointing to the Stella, he confronted Michael Fried. 'What's so good about that?' he demanded. Fried looked back at him. 'Look,' he said slowly, 'there are days when Stella goes to the Metropolitan Museum. And he sits for hours looking at the Velázquez, utterly knocked out by them and then he goes back to his studio. What he would like more than anything else is to paint like Velázquez. But what he knows is that that is an option that is not open to him. So he paints stripes.' Fried's voice had risen. 'He wants to be Velázquez *so he paints stripes*.'

I don't know what the boy thought, but it was clear enough to me. That statement, which linked Velázquez' needs to Stella's in the immense broad jump of a single sentence, was a giant ellipsis whose leap cleared three centuries of art. But in my mind's eye it was more like one of those strobe photographs in which each increment of the jumper's act registers on the single image. I could see what the student could not, and what Fried's statement did not fill in for him. Under the glittering panes of that skylight, I could visualize the logic of an argument that connected hundreds of separate pictorial acts into the fluid clarity of a single motion, an argument that was as present to me as the paintings hanging in the gallery – their clean, spare surfaces tied back into the faint grime of walls dedicated to the history of art. If Fried had not chosen to give the whole of that argument to the student, he had tried to make the student think about one piece of the obvious: that Stella's need to say something through his art was the same as a seventeenth-century Spaniard's; only the point in time was different. In 1965, the fact that Stella's stripes were involved with what he wanted to say – a product, that is, of *content* – was clear enough to me.

* * *

The content question has been always just under the surface of the writing of most 'modernist' critics. So when Michael Fried wrote the extended essay for his exhibition, 'Three American Painters' [see VIB9], he of course called attention to his experience 'that both Noland and Olitski are primarily painters of feeling and that what I take to be their preeminence among their contemporaries chiefly resides not in the formal intelligence of their work, which is of the very highest order, but in the depth and sweep of feeling which this intelligence makes possible.' In characterizing the 'passion, eloquence and fragile power' of Noland's painting, or in speaking of Noland as 'a tense, critical, almost hurting presence in his work,' Fried pointed to both color and design (or structure) as the sources of these. But he confined his analysis to the structure and not the color, because the first being the result of rational decisions could be usefully described, while the second being arbitrary could not. And the partialness of this analysis was not seen as a kind of cheating or shying away from the responsibility to confront the total work, because it was precisely in that very mixture of rationality and

arbitrariness that the work's meaning was seen to reside. Fried saw Noland's painting as a response to a general 'crisis of meaning' generated by a particular history – one that made imperative the invention of a self-evident, reflexive structure and drove lyricism onto an increasingly narrow highland of color.

That whole story . . . is offered in evidence of the fact that most people who attack the 'modernist' critical position, do so by omitting or distorting various parts of that position. Of course, they could reply that they cannot be expected to take into account what is left out of most 'modernist' writing; that if questions of content and feeling really are central to 'modernist' critics, they themselves are keeping it a secret since such questions are never really up front in what they write. But upfrontness is a rather tricky criterion when discussing a large body of theory. It's a bit like saying that the philosophical position of Wittgenstein is an argument for behaviorism because that's what is up front in his writing. Yet anyone reading the late Wittgenstein must realize that his work taken as a whole offers an impassioned and profound attack on behaviorism, along with idealism. It is simply a method of argumentation that is up front.

With 'modernism,' too, it was precisely its methodology that was important to a lot of us who began to write about art in the early 1960s. That method demanded lucidity. It demanded that one not talk about anything in a work of art that one could not point to. It involved tying back one's perceptions about art in the present to what one knew about the art of the past. It involved a language that was open to some mode of testing. [. . .]

In the '50s we had been alternately tyrannized and depressed by the psychologizing whine of 'Existentialist' criticism. It had seemed evasive to us – the impenetrable hedge of subjectivity whose prerogatives we could not assent to. The remedy had to have, for us, the clear provability of an 'if x then y.' The syllogism we took up was historical in character, which meant that it read only in one direction; it was progressive. No à rebours was possible, no going backward against the grain. The history we saw from Manet to the Impressionists to Cézanne and then to Picasso was like a series of rooms en filade. Within each room the individual artist explored, to the limits of his experience and his formal intelligence, the separate constituents of his medium. The effect of his pictorial act was to open simultaneously the door to the next space and close out access to the one behind him. The shape and dimensions of the new space were discovered by the next pictorial act; the only thing about that unstable position that was clearly determined beforehand was its point of entrance. [. . .] Insofar as modernism was tied to the objective datum of that history, it had, I thought, nothing to do with 'sensibility.'

Obviously modernism is a sensibility – one that reaches out past that small band of art critics of which I was a part, to include a great deal more than, and ultimately to criticize, what I stood for. One part of that sensibility embraces analysis as an act of humility, trying to catch itself in the middle of the very act of judgement, to glimpse itself unawares in the mirror of consciousness. The attention to self-reflexivity, or what the Structuralist critics term dédoublement, is thus one of the most general features of the larger modernist sensibility. And because of that attention, another part of the modernist sensibility feels extreme wariness over the question of perspective. [. . .]

Perspective is the visual correlate of causality that one thing follows the next in space according to rule. In that sense, despite differences of historical development, it can be likened to the literary tradition of the omniscient narrator and the conventional plot, . . . and within that temporal succession – given as a spatial analogue – was secreted the

'meaning' of both that space and those events. And it is that very prior assumption of meaning that the larger modernist sensibility abhors. [. . .]

We can no longer fail to notice that if we make up schemas of meaning based on history, we are playing into systems of control and censure. We are no longer innocent. 'For if the norms of the past serve to measure the present, they also serve to construct it.' If someone asks us what's so good about a painting by Stella and our answer is that he has to paint stripes because of Manet, etc., etc., and Impressionism, etc., etc., and then Cubism, and then onto a history of the necessity of flatness, what we have made the Stella painting into is a particular kind of screen onto which we project a special form of narrative. The flatness that modernist criticism reveres may have expunged spatial perspective, but it has substituted a temporal one – i.e., history. It is this history that the modernist critic contemplates looking into the vortex of, say, Stella's concentric stripes: a perspective view that opens backward into that receding vista of past doors and rooms, which because they are not re-enterable, can only manifest themselves in the present by means of diagrammatic flatness.

Modernist criticism is innocent. And its innocence obtains on three counts: it refuses to see the temporality which it never tires of invoking – 'the entire history of painting since Manet' – as that perspectival armature on which it structures the art in question (and on which that art has increasingly tended to structure itself); it thinks of that history as 'objective' – beyond the dictates of sensibility, beyond ideology; and it is unself-critically prescriptive. Failing to see that its 'history' is a perspective, *my* perspective – only, that is to say, a point of view – modernist criticism has stopped being suspicious of what it sees as self-evident, its critical intelligence having ceased to be wary of what it has taken as given. Although its disclaimers to being a prescriptive position are sincerely meant, it has failed to put a check on the ways that its belief in the 'reality' of a certain version of the past has led it to construct (in its coercive sense) the present. [. . .]

9 Jean Baudrillard (b. 1929) 'Ethic of Labour, Aesthetic of Play'

Marxism had dominated French intellectual life since the end of the Second World War. In the wake of the failure of 1968 it came under increasing critical scrutiny. Here Jean Baudrillard establishes the ground for what would later become a central preoccupation in the cultural theory and 'postmodernist' art of the 1980s. For him Marx's critique of political economy merely serves to reduplicate the work-ethic of modern capitalism; no less tied to it is the sphere of the remainder, of art and aesthetic play. Both together constitute for Baudrillard a 'mirror of production' rather than a workable strategy for overcoming capitalism. Instead he argues that in the modern world the critique of political economy must itself be subject to transformation through a focus on the characteristic feature of that modernity: its overload of information, knowledges, and meanings. Baudrillard proposes to focus not on material exchange but on symbolic exchange; to offer a materialist critique of what he calls the 'political economy of the sign'. The present extracts are taken from Chapter 1 of *Le Miroir de production*, Paris, 1973, translated into English by Mark Poster as *The Mirror of Production*, St Louis, MO, 1975, pp. 35–51.

This logic of material production, this dialectic of modes of production, always returns beyond history to a generic definition of man as a dialectical being; a notion intelligble only through the process of the objectification of nature. This position is heavy with

consequences to the extent that, even through the vicissitudes of his history, man (whose history is also his 'product') will be ruled by this clear and definitive reason, this dialectical scheme that acts as an implicit philosophy. Marx develops it in the *1844 Manuscripts*; Marcuse revives it in his critique of the economic concept of labor: '... labor is an ontological concept of human existence as such.'[1] [...] The dialectical culmination of all of this is the concept of nature as 'the inorganic body of man:' the naturalization of man and the humanization of nature.[2]

On this dialectical base, Marxist philosophy unfolds in two directions: an ethic of labor and an esthetic of non-labor. The former traverses all bourgeois and socialist ideology. It exalts labor as value, as end in itself, as categorical imperative. Labor loses its negativity and is raised to an absolute value. But is the 'materialist' thesis of man's generic productivity very far from this 'idealist' sanctification of labor? [...]

Confronted by the *absolute* idealism of labor, dialectical materialism is perhaps only a *dialectical* idealism of productive forces. We will return to this to see if the dialectic of means and end at the heart of the principle of the transformation of nature does not already virtually imply the autonomization of means (the autonomization of science, technology, and labor; the autonomization of production as generic activity; the autonomization of the dialectic itself as the general scheme of development).[3]

The regressive character of this work ethic is evidently related to what it represses: Marx's chief discovery regarding the double nature of labor (his discovery of abstract and measurable social labor). In the fine points of Marxist thought, confronting the work ethic is an esthetic of non-work or play itself based on the dialectic of quantity and quality. Beyond the capitalist mode of production and the quantitative measure of labor, this is the perspective of a definitive qualitative mutation in communist society: the end of alienated labor and the free objectification of man's own powers. [...]

This realm beyond political economy called play, non-work, or non-alienated labor, is defined as the reign of a finality without end. In this sense it is and remains an *esthetic*, in the extremely Kantian sense, with all the bourgeois ideological connotations which that implies. Although Marx's thought settled accounts with bourgeois morality, it remains defenseless before its esthetic, whose ambiguity is more subtle but whose complicity with the general system of political economy is just as profound. Once again, at the heart of its strategy, in its analytic distinction between quantity and quality, Marxist thought inherits the esthetic and humanistic virus of bourgeois thought, since the concept of quality is burdened with all the finalities – whether those concrete finalities of use value, or those endless ideal and transcendent finalities. Here stands the defect of all notions of play, freedom, transparence, or disalienation: it is the defect of the *revolutionary imagination* since, in the ideal types of play and the free play of human faculties, we are still in a process of repressive desublimation. In effect, the sphere of play is defined as the fulfillment of human rationality, the dialectical culmination of man's activity of incessant objectification of nature and control of his exchanges with it. It presupposes the full development of productive forces; it 'follows in the footsteps' of the reality principle and the transformation of nature. Marx clearly states that it can flourish only when founded on the reign of necessity. Wishing itself beyond labor but *in its continuation*, the sphere of play is always merely the esthetic sublimation of labor's constraints. With this concept we remain rooted in the problematic of necessity and freedom, a typically bourgeois problematic whose double ideological expression has

always been the institution of a reality principle (repression and sublimation, the principle of labor) and its formal overcoming in an ideal transcendence.

Work and non-work: here is a 'revolutionary' theme. It is undoubtedly the most subtle form of the type of binary, structural opposition discussed above. The end of the end of exploitation by work is this reverse fascination with non-work, this reverse mirage of free time (forced time–free time, full time–empty time: another paradigm that fixes the hegemony of a temporal order which is always merely that of production). Non-work is still only the repressive desublimation of labor power, the antithesis which acts as the alternative. Such is the sphere of non-work: even if it is not immediately conflated with leisure and its present bureaucratic organization, where the desire for death and mortification and its management by social institutions are as powerful as in the sphere of work; even if it is viewed in a radical way which *represents it* as other than the mode of 'total disposability' or 'freedom' for the individual to 'produce' himself as value, to 'express himself,' to 'liberate himself' as a (conscious or unconscious) authentic *content*, in short, as the ideality of time and of the individual as an empty form to be filled finally by his freedom. The finality of value is always there. It is no longer inscribed in *determined* contents as in the sphere of productive activity; henceforth it is a *pure form*, though no less determining. Exactly as the pure institutional form of painting, art, and theater shines forth in anti-painting, anti-art, and anti-theater, which are emptied of their contents, the pure form of labor shines forth in non-labor. Although the concept of non-labor can thus be fantasized as the abolition of political economy, it is bound to fall back into the sphere of political economy as the sign, and only the sign, of its abolition. It already escapes revolutionaries to enter into the programmatic field of the 'new society.'

* * *

Comprehending itself as a form of the rationality of production superior to that of bourgeois political economy, the weapon Marx created turns against him and turns his theory into the dialectical apotheosis of political economy. At a much higher level, his critique falters under his own objection to Feuerbach of making a radical critique of the *contents* of religion but in a completely religious *form*. Marx made a radical critique of political economy, but still in the form of political economy. These are the ruses of the dialectic, undoubtedly the limit of all 'critique.' The concept of critique emerged in the West at the same time as political economy and, as the quintessence of Enlightenment rationality, is perhaps only the subtle, long-term expression of the system's expanded reproduction. The dialectic does not avoid the fate of every critique. Perhaps the inversion of the idealist dialectic into a materialist dialectic was only a metamorphosis; perhaps the very logic of political economy, capital, and the commodity is dialectical; and perhaps, under the guise of producing its fatal internal contradiction, Marx basically only rendered a descriptive theory. The logic of representation – of the duplication of its object – haunts all rational discursiveness. Every critical theory is haunted by this surreptitious religion, this desire bound up with the construction of its object, this negativity subtly haunted by the very form that it negates.

This is why Marx said that after Feuerbach the critique of religion was basically completed (cf. *Critique of Hegel's Philosophy of Right*) and that, to overcome the ambiguous limit beyond which it can no longer go (the reinversion of the religious form beneath the critique), it is necessary to move resolutely to a different level: precisely to the

critique of political economy, which alone is radical and which can definitively resolve the problem of religion by bringing out the true contradictions. *Today we are exactly at the same point with respect to Marx.* For us, *the critique of political economy is basically completed.* The materialist dialectic has exhausted its content in reproducing its form. At this level, the situation is no longer that of a critique: it is inextricable. And following the same revolutionary movement as Marx did, we must move to a radically different level that, beyond its critique, permits the definitive resolution of political economy. This level is that of symbolic exchange and its theory. And just as Marx thought it necessary to clear the path to the critique of political economy with a critique of the philosophy of law, the preliminary to this radical change of terrain is the critique of the metaphysic of the signifier and the code, in all its current ideological extent. For lack of a better term, we call this the critique of the political economy of the sign.

1 H. Marcuse, 'On the Concept of Labor', *Telos*, 16, Summer 1973 pp. 11–12.
2 Engels, always a naturalist, goes so far as to exalt the role played by work in the transition from ape to man.
3 But this autonomization is the key which turns Marxism toward Social Democracy, to its present revisionism, and to its total positivist decay (which includes bureaucratic Stalinism as well as Social Democratic liberalism).

10 Laura Mulvey (b. 1941) from 'Visual Pleasure and Narrative Cinema'

In the 1970s the British journal *Screen* did much to introduce an English-speaking audience to French theories of culture and, in particular, to those theories of film which were rooted in structuralism and semiology. Laura Mulvey's influential study linked types of looking, and the pleasures to be derived from them, to gender differences in society. Not merely 'differences', one should add, nor yet merely 'society'. Rather, it was emphasized that these differences took the form of inequality and oppression within a capitalist, but more particularly, patriarchal, society. Mulvey linked the pleasures of film and, by extension, of much modern art, to an essentially repressive social structure. Her article set out, as she said, to destroy these pleasures. Initially delivered as a paper at the University of Wisconsin in Spring 1973, the essay was first published in *Screen*, 16, no. 3, London, Autumn 1975, pp. 6–18, from which the present extracts are taken. (Reprinted in Mulvey, *Visual and Other Pleasures*, London, 1989.)

I Introduction

A. A Political Use of Psychoanalysis

This paper intends to use psychoanalysis to discover where and how the fascination of film is reinforced by preexisting patterns of fascination already at work within the individual subject and the social formations that have molded him. It takes as starting point the way film reflects, reveals, and even plays on the straight, socially established interpretation of sexual difference that controls images, erotic ways of looking, and spectacle. It is helpful to understand what the cinema has been, how its magic has worked in the past, while attempting a theory and a practice that will challenge this cinema of the past. Psychoanalytic theory is thus appropriated here as a political

weapon, demonstrating the way the unconscious of patriarchal society has structured film form.

The paradox of phallocentrism in all its manifestations is that it depends on the image of the castrated woman to give order and meaning to its world. An idea of woman stands as linchpin to the system: it is her lack that produces the phallus as a symbolic presence, it is her desire to make good the lack that the phallus signifies. Recent writing in *Screen* about psychoanalysis and the cinema has not sufficiently brought out the importance of the representation of the female form in a symbolic order in which, in the last resort, it speaks castration and nothing else. To summarize briefly: the function of woman in forming the patriarchal unconscious is twofold; she first symbolizes the castration threat by her real absence of a penis and second thereby raises her child into the symbolic. Once this has been achieved, her meaning in the process is at an end, it does not last into the world of law and language except as a memory that oscillates between memory of maternal plenitude and memory of lack. Both are posited on nature (or on 'anatomy' in Freud's famous phrase). Woman's desire is subjected to her image as bearer of the bleeding wound: she can exist only in relation to castration and cannot transcend it. She turns her child into the signifier of her own desire to possess a penis (the condition, she imagines, of entry into the symbolic). Either she must gracefully give way to the word, the Name of the Father and the Law, or else struggle to keep her child down with her in the half-light of the imaginary. Woman, then, stands in patriarchal culture as signifier for the male other, bound by a symbolic order in which man can live out his fantasies and obsessions through linguistic command by imposing them on the silent image of woman still tied to her place as bearer of meaning, not maker of meaning.

There is an obvious interest in this analysis for feminists, a beauty in its exact rendering of the frustration experienced under the phallocentric order. It gets us nearer to the roots of our oppression, it brings an articulation of the problem closer, it faces us with the ultimate challenge: how to fight the unconscious structured like a language (formed critically at the moment of arrival of language) while still caught within the language of the patriarchy. There is no way in which we can produce an alternative out of the blue, but we can begin to make a break by examining partriarchy with the tools it provides, of which psychoanalysis is not the only but an important one. We are still separated by a great gap from important issues for the female unconscious that are scarcely relevant to phallocentric theory: the sexing of the female infant and her relationship to the symbolic, the sexually mature woman as nonmother, maternity outside the signification of the phallus, the vagina . . . But, at this point, psychoanalytic theory as it now stands can at least advance our understanding of the status quo, of the patriarchal order in which we are caught.

B. *Destruction of Pleasure as a Radical Weapon*

As an advanced representation system, the cinema poses questions of the ways the unconscious (formed by the dominant order) structures ways of seeing and pleasure in looking. Cinema has changed over the last few decades. It is no longer the monolithic system based on large capital investment exemplified at its best by Hollywood in the 1930s, 1940s, and 1950s. Technological advances (16mm, etc.) have changed the economic conditions of cinematic production, which can now be artisanal as well as

capitalist. Thus it has been possible for an alternative cinema to develop. However self-conscious and ironic Hollywood managed to be, it always restricted itself to a formal mise-en-scène reflecting the dominant ideological concept of the cinema. The alternative cinema provides a space for a cinema to be born that is radical in both a political and an aesthetic sense and challenges the basic assumptions of the mainstream film. This is not to reject the latter moralistically, but to highlight the ways in which its formal preoccupations reflect the psychical obsessions of the society that produced it, and, further, to stress that the alternative cinema must start specifically by reacting against these obsessions and assumptions. A politically and aesthetically avant-garde cinema is now possible, but it can still only exist as a counterpoint.

The magic of the Hollywood style at its best (and of all the cinema that fell within its sphere of influence) arose, not exclusively but in one important aspect, from its skilled and satisfying manipulation of visual pleasure. Unchallenged, mainstream film coded the erotic into the language of the dominant patriarchal order. In the highly developed Hollywood cinema it was only through these codes that the alienated subject, torn in his imaginary memory by a sense of loss, by the terror of potential lack in fantasy, came near to finding a glimpse of satisfaction: through its formal beauty and its play on his own formative obsessions. This essay will discuss the interweaving of that erotic pleasure in film, its meaning, and in particular the central place of the image of woman. It is said that analyzing pleasure, or beauty, destroys it. That is the intention of this essay. The satisfaction and reinforcement of the ego that represent the high point of film history hitherto must be attacked; not in favor of a reconstructed new pleasure, which cannot exist in the abstract, or of intellectualized unpleasure, but to make way for a total negation of the ease and plenitude of the narrative fiction film. The alternative is the thrill that comes from leaving the past behind without rejecting it, transcending outworn or oppressive forms, or daring to break with normal pleasurable expectations in order to conceive a new language of desire.

II Pleasure in Looking – Fascination with the Human Form

A. The cinema offers a number of possible pleasures. One is scopophilia. There are circumstances in which looking itself is a source of pleasure, just as, in the reverse formation, there is pleasure in being looked at. Originally, in his *Three Essays on Sexuality*, Freud isolated scopophilia as one of the component instincts of sexuality that exist as drives quite independently of the erotogenic zones. At this point he associated scopophilia with taking other people as objects, subjecting them to a controlling and curious gaze. His particular examples center around the voyeuristic activities of children, their desire to see and make sure of the private and the forbidden (curiosity about other people's genital and bodily functions, about the presence or absence of the penis and, retrospectively, about the primal scene). In this analysis scopophilia is essentially active. (Later, in *Instincts and Their Vicissitudes*, Freud developed his theory of scopophilia further, attaching it initially to pregenital auto-eroticism, after which the pleasure of the look is transferred to others by analogy. There is a close working here of the relationship between the active instinct and its further development in a narcissistic form.) Although the instinct is modified by other factors, in particular the constitution of the ego, it continues to exist as the erotic basis for pleasure in looking at another person as object. At the extreme, it can become fixated

into a perversion, producing obsessive voyeurs and Peeping Toms, whose only sexual satisfaction can come from watching, in an active controlling sense, an objectified other.

At first glance, the cinema would seem to be remote from the undercover world of the surreptitious observation of an unknowing and unwilling victim. What is seen of the screen is so manifestly shown. But the mass of mainstream film, and the conventions within which it has consciously evolved, portray a hermetically sealed world that unwinds magically, indifferent to the presence of the audience, producing for them a sense of separation and playing on their voyeuristic fantasy. Moreover, the extreme contrast between the darkness in the auditorium (which also isolates the spectators from one another) and the brilliance of the shifting patterns of light and shade on the screen helps to promote the illusion of voyeuristic separation. Although the film is really being shown, is there to be seen, conditions of screening and narrative conventions give the spectator an illusion of looking in on a private world. Among other things, the position of the spectators in the cinema is blatantly one of repression of their exhibitionism and projection of the repressed desire onto the performer.

B. The cinema satisfies a primordial wish for pleasurable looking, but it also goes further, developing scopophilia in its narcissistic aspect. The conventions of mainstream film focus attention on the human form. Scale, space, stories are all anthropomorphic. Here, curiosity and the wish to look intermingle with a fascination with likeness and recognition: the human face, the human body, the relationship between the human form and its surroundings, the visible presence of the person in the world. Jacques Lacan has described how the moment when a child recognizes its own image in the mirror is crucial for the constitution of the ego [see VB8]. Several aspects of this analysis are relevant here. The mirror phase occurs at a time when the child's physical ambitions outstrip his motor capacity, with the result that his recognition of himself is joyous in that he imagines his mirror image to be more complete, more perfect than he experiences his own body. Recognition is thus overlaid with misrecognition: the image recognized is conceived as the reflected body of the self, but its misrecognition as superior projects this body outside itself as an ideal ego, the alienated subject, which, reintrojected as an ego ideal, gives rise to the future generation of identification with others. This mirror moment predates language for the child.

Important for this essay is the fact that it is an image that constitutes the matrix of the imaginary, of recognition/misrecognition and identification, and hence of the first articulation of the 'I' of subjectivity. This is a moment when an older fascination with looking (at the mother's face, for an obvious example) collides with the initial inklings of self-awareness. Hence it is the birth of the long love affair/despair between image and self-image that has found such intensity of expression in film and such joyous recognition in the cinema audience. Quite apart from the extraneous similarities between screen and mirror (the framing of the human form in its surroundings, for instance), the cinema has structures of fascination strong enough to allow temporary loss of ego while simultaneously reinforcing the ego. The sense of forgetting the world as the ego has subsequently come to perceive it (I forgot who I am and where I was) is nostalgically reminiscent of that presubjective moment of image recognition. At the same time the cinema has distinguished itself in the production of ego ideals as expressed in particular in the star system, the stars centering both screen presence

and screen story as they act out a complex process of likeness and difference (the glamorous impersonates the ordinary).

III Woman as Image, Man as Bearer of the Look

A. In a world ordered by sexual imbalance, pleasure in looking has been split between active/male and passive/female. The determining male gaze projects its fantasy onto the female figure, which is styled accordingly. In their traditional exhibitionist role women are simultaneously looked at and displayed, with their appearance coded for strong visual and erotic impact so that they can be said to connote *to-be-looked-at-ness*. Woman displayed as sexual object is the leitmotiv of erotic spectacle: from pinups to striptease, from Ziegfeld to Busby Berkeley, she holds the look, plays to, and signifies male desire. Mainstream film neatly combined spectacle and narrative. (Note, however, how in the musical song-and-dance numbers break the flow of the diegesis.) The presence of woman is an indispensable element of spectacle in normal narrative film, yet her visual presence tends to work against the development of a story line, to freeze the flow of action in moments of erotic contemplation. [...]

B. An active/passive heterosexual division of labor has similarly controlled narrative structure. According to the principles of the ruling ideology and the psychical structures that back it up, the male figure cannot bear the burden of sexual objectification. Man is reluctant to gaze at his exhibitionist like. Hence the split between spectacle and narrative supports the man's role as the active one of forwarding the story, making things happen. The man controls the film fantasy and also emerges as the representative of power in a further sense: as the bearer of the look of the spectator, transferring it behind the screen to neutralize the extradiegetic tendencies represented by woman as spectacle. This is made possible through the processes set in motion by structuring the film around a main controlling figure with whom the spectator can identify. As the spectator identifies with the main male protagonist, he projects his look onto that of his like, his screen surrogate, so that the power of the male protagonist as he controls events coincides with the active power of the erotic look, both giving a satisfying sense of omnipotence. A male movie star's glamorous characteristics are thus not those of the erotic object of the gaze, but those of the more perfect, more complete, more powerful ideal ego conceived in the original moment of recognition in front of the mirror. The character in the story can make things happen and control events better than the subject/spectator, just as the image in the mirror was more in control of motor coordination. In contrast to woman as icon, the active male figure (the ego ideal of the identification process) demands a three-dimensional space corresponding to that of the mirror recognition in which the alienated subject internalized his own representation of this imaginary existence. He is a figure in a landscape. Here the function of film is to reproduce as accurately as possible the so-called natural conditions of human perception. Camera technology (as exemplified by deep focus in particular) and camera movements (determined by the action of the protagonist), combined with invisible editing (demanded by realism), all tend to blur the limits of screen space. The male protagonist is free to command the stage, a stage of spatial illusion in which he articulates the look and creates the action.

C 1. Sections III A and B have set out a tension between a mode of representation of woman in film and conventions surrounding the diegesis. Each is associated with a look: that of the spectator in direct scopophilic contact with the female form displayed for his enjoyment (connoting male fantasy) and that of the spectator fascinated with the image of his like set in an illusion of natural space, and through him gaining control and possession of the woman within the diegesis. (This tension and the shift from one pole to the other can structure a single text. Thus both in *Only Angels Have Wings* and *To Have and Have Not* the film opens with the woman as object of the combined gaze of spectator and all the male protagonists in the film. She is isolated, glamorous, on display, sexualized. But as the narrative progresses, she falls in love with the main male protagonist and becomes his property, losing her outward glamorous characteristics, her generalized sexuality, her showgirl connotations; her eroticism is subjected to the male star alone. By means of identification with him, through participation in his power, the spectator can indirectly possess her too.)

But in psychoanalytic terms, the female figure poses a deeper problem. She also connotes something that the look continually circles around but disavows: her lack of a penis, implying a threat of castration and hence unpleasure. Ultimately, the meaning of woman is sexual difference, the absence of the penis is visually ascertainable, the material evidence on which is based the castration complex essential for the organization of entrance to the symbolic order and the Law of the Father. Thus the woman as icon, displayed for the gaze and enjoyment of men, the active controllers of the look, always threatens to evoke the anxiety it originally signified. The male unconscious has two avenues of escape from this castration anxiety: preoccupation with the reenactment of the original trauma (investigating the woman, demystifying her mystery), counterbalanced by the devaluation, punishment, or saving of the guilty object (an avenue typified by the concerns of the *film noir*); or else complete disavowal of castration by the substitution of a fetish object or turning the represented figure itself into a fetish so that it becomes reassuring rather than dangerous (hence overvaluation, the cult of the female star). This second avenue, fetishistic scopophilia, builds up the physical beauty of the object, transforming it into something satisfying in itself. The first avenue, voyeurism, on the contrary, has associations with sadism: pleasure lies in ascertaining guilt (immediately associated with castration), asserting control, and subjecting the guilty person through punishment or forgiveness. This sadistic side fits in well with narrative. Sadism demands a story, depends on making something happen, forcing a change in another person, a battle of will and strength, victory/defeat, all occurring in a linear time with a beginning and an end. Fetishistic scopophilia, on the other hand, can exist outside linear time as the erotic instinct is focused on the look alone. These contradictions and ambiguities can be illustrated more simply by using works by Hitchcock and von Sternberg, both of whom take the look almost as the content or subject matter of many of their films. Hitchcock is the more complex, as he uses both mechanisms. Von Sternberg's work on the other hand, provides many pure examples of fetishistic scopophilia.

* * *

IV Summary

The psychoanalytic background that has been discussed in this essay is relevant to the pleasure and unpleasure offered by traditional narrative film. The scopophilic instinct

(pleasure in looking at another person as an erotic object) and, in contradistinction, ego libido (forming identification processes) act as formations, mechanisms, which this cinema has played on. The image of woman as (passive) raw material for the (active) gaze of men takes the argument a step further into the structure of representation, adding a further layer demanded by the ideology of the patriarchal order as it is worked out in its favorite cinematic form – illusionistic narrative film. The argument returns again to the psychoanalytic background in that woman as representation signifies castration, inducing voyeuristic or fetishistic mechanisms to circumvent her threat. None of these interacting layers is intrinsic to film, but it is only in the film form that they can reach a perfect and beautiful contradiction, thanks to the possibility in the cinema of shifting the emphasis of the look. It is the place of the look that defines cinema, the possibility of varying it and exposing it. This is what makes cinema quite different in its voyeuristic potential from, say, striptease, theater, shows, etc. Going far beyond highlighting a woman's to-be-looked-at-ness, cinema builds the way she is to be looked at into the spectacle itself. Playing on the tension between film as controlling the dimension of time (editing, narrative) and film as controlling the dimension of space (changes in distance, editing), cinematic codes create a gaze, a world, and an object, thereby producing an illusion cut to the measure of desire. It is these cinematic codes and their relationship to formative external structures that must be broken down before mainstream film and the pleasure it provides can be challenged.

To begin with (as an ending), the voyeuristic-scopophilic look that is a crucial part of traditional filmic pleasure can itself be broken down. There are three different looks associated with cinema: that of the camera as it records the profilmic event, that of the audience as it watches the final product, and that of the characters at each other within the screen illusion. The conventions of narrative film deny the first two and subordinate them to the third, the conscious aim being always to eliminate intrusive camera presence and prevent a distancing awareness in the audience. Without these two absences (the material existence of the recording process, the critical reading of the spectator), fictional drama cannot achieve reality, obviousness, and truth. Nevertheless, as this essay has argued, the structure of looking in narrative fiction film contains a contradiction in its own premises: the female image as a castration threat constantly endangers the unity of the diegesis and bursts through the world of illusion as an intrusive, static, one-dimensional fetish. Thus the two looks, materially present in time and space are obsessively subordinated to the new erotic needs of the male ego. The camera becomes the mechanism for producing an illusion of Renaissance space, flowing movements compatible with the human eye, an ideology of representation that revolves around the perception of the subject; the camera's look is disavowed in order to create a convincing world in which the spectator's surrogate can perform with verisimilitude. Simultaneously, the look of the audience is denied an intrinsic force: as soon as fetishistic representation of the female image threatens to break the spell of illusion, and the erotic image on the screen appears directly (without mediation) to the spectator, the fact of fetishization, concealing as it does castration-fear, freezes the look, fixates the spectator, and prevents him from achieving any distance from the image in front of him.

This complex interaction of looks is specific to film. The first blow against the monolithic accumulation of traditional film conventions (already undertaken by radical filmmakers) is to free the look of the camera into its materiality in time and space and the look of the audience into dialectics, passionate detachment. There is no doubt that this

destroys the satisfaction, pleasure, and privilege of the 'invisible guest,' and highlights how film has depended on voyeuristic active/passive mechanisms. Women, whose image has continually been stolen and used for this end, cannot view the decline of the traditional film form with anything much more than sentimental regret.

11 Michel Foucault (1926–1984) A Lecture

This lecture does not specifically address problems of art and culture, but the argument represented has been central to thought about culture and the practice of art in the present period. Foucault proposes a radical departure from the governing norms of traditional avant-garde practice, playing on the passages between certain forms of cultural and political 'vanguardism' which are connected if far from isomorphic. The lecture is informed by his own work on control and punishment, and by his findings regarding the forms of 'knowledge' which are typically controlled and punished. He draws attention to a widespread modern refusal to accept global criteria of rationality, and hence of emancipation and freedom, as these criteria had become enshrined both in the official Communist movement *and* in Western liberalism. Contrary to the methods of both liberal and Marxist analysis, he proposes a 'non-economic analysis of power'. To this end he makes a tactical connection, under the term 'genealogy', between 'erudite knowledge' and a disregarded, more or less plebeian cluster of rules of thumb for negotiating a hostile world. This new constellation of knowledges is opposed, foundationally, to the assumptions of an avant-garde. The upshot is a heightened focus on the variant mechanisms of power: on the questions of who exercises it, how, to what ends, and by what strategies it may be interrupted. The consequence of Foucault's work has been to affirm critical activity in the predominantly institutional nexuses of 'power-knowledge' over the attractions of the 'universal intellectual'. The ideas here articulated have come to constitute an agenda for radical cultural practice on the part of a generation as motivated by social concerns as it has been wary of global solutions to them. Delivered on 7 January 1976 in Paris, and transcribed and translated by Alessandro Fontana and Pasquale Pasquino in Colin Gordon (ed.), *Michel Foucault. Power/Knowledge*, London, 1980. The present version is taken from pp. 78–89 of that edition. (For an earlier text by Foucault see VIID2.)

[. . .] It seems to me that the work we have done could be justified by the claim that it is adequate to a restricted period, that of the last ten, fifteen, at most twenty years, a period notable for two events which for all they may not be really important are nonetheless to my mind quite interesting.

On the one hand, it has been a period characterized by what one might term the efficacy of dispersed and discontinuous offensives. There are a number of things I have in mind here. I am thinking, for example, where it was a case of undermining the function of psychiatric institutions, of that curious efficacy of localised anti-psychiatric discourses. These are discourses which you are well aware lacked and still lack any systematic principles of coordination of the kind that would have provided or might today provide a system of reference for them. I am thinking of the original reference towards existential analysis or of certain directions inspired in a general way by Marxism, such as Reichian theory. Again, I have in mind that strange efficacy of the attacks that have been directed against traditional morality and hierarchy, attacks which again have no reference except perhaps in a vague and fairly distant way to Reich and Marcuse. On the other hand there is also the efficacy of the attacks upon the legal and

penal system, some of which had a very tenuous connection with the general and in any case pretty dubious notion of class justice, while others had a rather more precisely defined affinity with anarchist themes. Equally, I am thinking of the efficacy of a book such as *L'Anti-Oedipe* [Deleuze and Guattari], which really has no other source of reference than its own prodigious theoretical inventiveness: a book, or rather a thing, an event, which has managed, even at the most mundane level of psychoanalytic practice, to introduce a note of shrillness into that murmured exchange that has for so long continued uninterrupted between couch and armchair.

I would say, then, that what has emerged in the course of the last ten or fifteen years is a sense of the increasing vulnerability to criticism of things, institutions, practices, discourses. A certain fragility has been discovered in the very bedrock of existence – even, and perhaps above all, in those aspects of it that are most familiar, most solid and most intimately related to our bodies and to our everyday behaviour. But together with this sense of instability and this amazing efficacy of discontinuous, particular and local criticism, one in fact also discovers something that perhaps was not initially foreseen, something one might describe as precisely the inhibiting effect of global, *totalitarian theories*. It is not that these global theories have not provided nor continue to provide in a fairly consistent fashion useful tools for local research: Marxism and psychoanalysis are proofs of this. But I believe these tools have only been provided on the condition that the theoretical unity of these discourses was in some sense put in abeyance, or at least curtailed, divided, overthrown, caricatured, theatricalised, or what you will. In each case, the attempt to think in terms of a totality has in fact proved a hindrance to research.

So, the main point to be gleaned from these events of the last fifteen years, their predominant feature, is the *local* character of criticism. That should not, I believe, be taken to mean that its qualities are those of an obtuse, naive or primitive empiricism; nor is it a soggy eclecticism, an opportunism that laps up any and every kind of theoretical approach; nor does it mean a self-imposed ascetism which taken by itself would reduce to the worst kind of theoretical impoverishment. I believe that what this essentially local character of criticism indicates in reality is an autonomous, non-centralised kind of theoretical production, one that is to say whose validity is not dependent on the approval of the established régimes of thought.

It is here that we touch upon another feature of these events that has been manifest for some time now: it seems to me that this local criticism has proceeded by means of what one might term 'a return of knowledge'. What I mean by that phrase is this: it is a fact that we have repeatedly encountered, at least at a superficial level, in the course of most recent times, an entire thematic to the effect that it is not theory but life that matters, not knowledge but reality, not books but money etc.; but it also seems to me that over and above, and arising out of this thematic, there is something else to which we are witness, and which we might describe as an *insurrection of subjugated knowledges*.

By subjugated knowledges I mean two things: on the one hand, I am referring to the historical contents that have been buried and disguised in a functionalist coherence or formal systemisation. Concretely, it is not a semiology of the life of the asylum, it is not even a sociology of delinquency, that has made it possible to produce an effective criticism of the asylum and likewise of the prison, but rather the immediate emergence of historical contents. And this is simply because only the historical contents allow us to rediscover the ruptural effects of conflict and struggle that the order imposed by

functionalist or systematising thought is designed to mask. Subjugated knowledges are thus those blocs of historical knowledge which were present but disguised within the body of functionalist and systematizing theory and which criticism – which obviously draws upon scholarship – has been able to reveal.

On the other hand, I believe that by subjugated knowledges one should understand something else, something which in a sense is altogether different, namely, a whole set of knowledges that have been disqualified as inadequate to their task or insufficiently elaborated: naive knowledges, located low down on the hierarchy, beneath the required level of cognition or scientificity. I also believe that it is through the re-emergence of these low-ranking knowledges, these unqualified, even directly disqualified knowledges (such as that of the psychiatric patient, of the ill person, of the nurse, of the doctor – parallel and marginal as they are to the knowledge of medicine – that of the delinquent, etc.), and which involve what I would call a popular knowledge (*le savoir des gens*) though it is far from being a general commonsense knowledge, but is on the contrary a particular, local, regional knowledge, a differential knowledge incapable of unanimity and which owes its force only to the harshness with which it is opposed by everything surrounding it – that it is through the re-appearance of this knowledge, of these local popular knowledges, these disqualified knowledges, that criticism performs its work.

However, there is a strange kind of paradox in the desire to assign to this same category of subjugated knowledges what are on the one hand the products of meticulous, erudite, exact historical knowledge, and on the other hand local and specific knowledges which have no common meaning and which are in some fashion allowed to fall into disuse whenever they are not effectively and explicitly maintained in themselves. Well, it seems to me that our critical discourses of the last fifteen years have in effect discovered their essential force in this association between the buried knowledges of erudition and those disqualified from the hierarchy of knowledges and sciences.

In the two cases – in the case of the erudite as in that of the disqualified knowledges – with what in fact were these buried, subjugated knowledges really concerned? They were concerned with a *historical knowledge of struggles*. In the specialised areas of erudition as in the disqualified, popular knowledge there lay the memory of hostile encounters which even up to this day have been confined to the margins of knowledge.

What emerges out of this is something one might call a genealogy, or rather a multiplicity of genealogical researches, a painstaking rediscovery of struggles together with the rude memory of their conflicts. And these genealogies, that are the combined product of an erudite knowledge and a popular knowledge, were not possible and could not even have been attempted except on one condition, namely that the tyranny of globalizing discourses with their hierarchy and all their privileges of a theoretical avant-garde was eliminated.

Let us give the term *genealogy* to the union of erudite knowledge and local memories which allows us to establish a historical knowledge of struggles and to make use of this knowledge tactically today. This then will be a provisional definition of the genealogies which I have attempted to compile with you over the last few years.

You are well aware that this research activity, which one can thus call genealogical, has nothing at all to do with an opposition between the abstract unity of theory and the concrete multiplicity of facts. It has nothing at all to do with a disqualification of the speculative dimension which opposes to it, in the name of some kind of scientism,

the rigour of well established knowledges. It is not therefore via an empiricism that the genealogical project unfolds, nor even via a positivism in the ordinary sense of that term. What it really does is to entertain the claims to attention of local, discontinuous, disqualified, illegitimate knowledges against the claims of a unitary body of theory which would filter, hierarchize and order them in the name of some true knowledge and some arbitrary idea of what constitutes a science and its objects. Genealogies are therefore not positivistic returns to a more careful or exact form of science. They are precisely anti-sciences. Not that they vindicate a lyrical right to ignorance or non-knowledge: it is not that they are concerned to deny knowledge or that they esteem the virtues of direct cognition and base their practice upon an immediate experience that escapes encapsulation in knowledge. It is not that with which we are concerned. We are concerned, rather, with the insurrection of knowledges that are opposed primarily not to the contents, methods or concepts of a science, but to the effects of the centralizing powers which are linked to the institution and functioning of an organized scientific discourse within a society such as ours. Nor does it basically matter all that much that this institutionalization of scientific discourse is embodied in a university, or, more generally, in an educational apparatus, in a theoretical-commercial institution such as psychoanalysis or within the framework of reference that is provided by a political system such as Marxism; for it is really against the effects of the power of a discourse that is considered to be scientific that the genealogy must wage its struggle.

To be more precise, I would remind you how numerous have been those who for many years now, probably for more than half a century, have questioned whether Marxism was, or was not, a science. One might say that the same issue has been posed, and continues to be posed, in the case of psychoanalysis, or even worse, in that of the semiology of literary texts. But to all these demands of: 'Is it or is it not a science?', the genealogies or the genealogists would reply: 'If you really want to know, the fault lies in your very determination to make a science out of Marxism or psychoanalysis or this or that study'. If we have any objection against Marxism, it lies in the fact that it could effectively be a science. In more detailed terms, I would say that even before we can know the extent to which something such as Marxism or psychoanalysis can be compared to a scientific practice in its everday functioning, its rules of construction, its working concepts, that even before we can pose the question of a formal and structural analogy between Marxist or psychoanalytic discourse, it is surely necessary to question ourselves about our aspirations to the kind of power that is presumed to accompany such a science. It is surely the following kinds of question that would need to be posed: What types of knowledge do you want to disqualify in the very instant of your demand: 'Is it a science'? Which speaking, discoursing subjects – which subjects of experience and knowledge – do you then want to 'diminish' when you say: 'I who conduct this discourse am conducting a scientific discourse, and I am a scientist'? Which theoretical-political avant-garde do you want to enthrone in order to isolate it from all the discontinuous forms of knowledge that circulate about it? When I see you straining to establish the scientificity of Marxism I do not really think that you are demonstrating once and for all that Marxism has a rational structure and that therefore its propositions are the outcome of verifiable procedures; for me you are doing something altogether different, you are investing Marxist discourses and those who uphold them with the effects of a power which the West since Medieval times has attributed to science and has reserved for those engaged in scientific discourse.

By comparison, then, and in contrast to the various projects which aim to inscribe knowledges in the hierarchical order of power associated with science, a genealogy should be seen as a kind of attempt to emancipate historical knowledges from that subjection, to render them, that is, capable of opposition and of struggle against the coercion of a theoretical, unitary, formal and scientific discourse. It is based on a reactivation of local knowledges – of minor knowledges, as Deleuze might call them – in opposition to the scientific hierarchisation of knowledges and the effects intrinsic to their power: this, then, is the project of these disordered and fragmentary genealogies. If we were to characterize it in two terms, then 'archaeology' would be the appropriate methodology of this analysis of local discursivities, and 'genealogy' would be the tactics whereby, on the basis of the descriptions of these local discursivities, the subjected knowledges which were thus released would be brought into play.

* * *

What is at stake in all these genealogies is the nature of this power which has surged into view in all its violence, aggression and absurdity in the course of the last forty years, contemporaneously, that is, with the collapse of Fascism and the decline of Stalinism. What, we must ask, is this power – or rather, since that is to give a formulation to the question that invites the kind of theoretical coronation of the whole which I am so keen to avoid – what are these various contrivances of power, whose operations extend to such differing levels and sectors of society and are possessed of such manifold ramifications? What are their mechanisms, their effects and their relations? The issue here can, I believe, be crystallized essentially in the following question: is the analysis of power or of powers to be deduced in one way or another from the economy? Let me make this question and my reasons for posing it somewhat clearer. It is not at all my intention to abstract from what are innumerable and enormous differences; yet despite, and even because of these differences, I consider there to be a certain point in common between the juridical, and let us call it, liberal, conception of political power (found in the *philosophes* of the eighteenth century) and the Marxist conception, or at any rate a certain conception currently held to be Marxist. I would call this common point an economism in the theory of power. By that I mean that in the case of the classic, juridical theory, power is taken to be a right, which one is able to possess like a commodity, and which one can in consequence transfer or alienate, either wholly or partially, through a legal act or through some act that establishes a right, such as takes place through cession or contract. Power is that concrete power which every individual holds, and whose partial or total cession enables political power or sovereignty to be established. This theoretical construction is essentially based on the idea that the constitution of political power obeys the model of a legal transaction involving a contractual type of exchange (hence the clear analogy that runs through all these theories between power and commodities, power and wealth). In the other case – I am thinking here of the general Marxist conception of power – one finds none of all that. Nonetheless, there is something else inherent in this latter conception, something which one might term an economic functionality of power. This economic functionality is present to the extent that power is conceived primarily in terms of the role it plays in the maintenance simultaneously of the relations of production and of a class domination which the development and specific forms of the forces of production have rendered possible. On this view, then, the historical *raison d'être* of political power is to be found in the economy. Broadly speaking, in the

first case we have a political power whose formal model is discoverable in the process of exchange, the economic circulation of commodities; in the second case, the historical *raison d'être* of political power and the principle of its concrete forms and actual functioning, is located in the economy. Well then, the problem involved in the researches to which I refer can, I believe, be broken down in the following manner: in the first place, is power always in a subordinate position relative to the economy? Is it always in the service of, and ultimately answerable to, the economy? Is its essential end and purpose to serve the economy? Is it destined to realize, consolidate, maintain and reproduce the relations appropriate to the economy and essential to its functioning? In the second place, is power modelled upon the commodity? Is it something that one possesses, acquires, cedes through force or contract, that one alienates or recovers, that circulates, that voids this or that region? Or, on the contrary, do we need to employ varying tools in its analysis – even, that is, when we allow that it effectively remains the case that the relations of power do indeed remain profoundly enmeshed in and with economic relations and participate with them in a common circuit? If that is the case, it is not the models of functional subordination or formal isomorphism that will characterize the interconnection between politics and the economy. Their indissolubility will be of a different order. [. . .]

12 Rosalind Krauss (b. 1940) 'Notes on the Index, Part 1'

In the early 1970s Krauss had moved away from a Greenbergian conception of Modernism in art to a view embracing what she termed a 'larger modernism' (see VIID8). By the end of the decade, much influenced by contemporary French theory, she was articulating a sense of full-blown 'Postmodernism' as the condition under which art and criticism now operated. 'Notes on the Index' attempts to go beneath the surface diversity of then contemporary art to divine an underlying structural logic. Drawing on the theory of language which differentiates between different kinds of sign, Krauss speculates that postmodernist artistic production is distinguished by a preoccupation with *indexical* signs, signs that is which have a direct relationship to their meanings rather than an arbitrarily conventional one. Shadows, footprints, etc. are paradigmatic of such signs: characteristically, they are *traces*. (For another attempt to define a logic of postmodernism, see VIIIA3.) 'Notes on the Index' was originally published in two parts in *October*, numbers 3 and 4, Spring and Fall 1977. Both were reprinted in Krauss's *The Originality of the Avant-Garde and Other Modernist Myths*, Cambridge, MA, and London: MIT Press, 1986, pp. 196–209 and 210–19. Our extracts are taken from Part 1, which is dated at the end of the published text to 1976. (See also VIID8 and VIIIA4.)

1. Almost everyone is agreed about '70s art. It is diversified, split, factionalized. Unlike the art of the last several decades, its energy does not seem to flow through a single channel for which a synthetic term, like Abstract-Expressionism, or Minimalism, might be found. In defiance of the notion of collective effort that operates behind the very idea of an artistic 'movement', '70s art is proud of its own dispersal. 'Post-Movement Art in America' is the term most recently applied.[1] We are asked to contemplate a great plethora of possibilities in the list that must now be used to draw a line around the art of the present: video; performance; body art; conceptual art; photo-realism in painting and an associated hyper-realism in sculpture; story art;

monumental abstract sculpture (earthworks); and abstract painting, characterized, now, not by rigor but by a willful eclecticism. It is as though in that need for a list, or proliferating string of terms, there is prefigured an image of personal freedom, of multiple options now open to individual choice or will, whereas before these things were closed off through a restrictive notion of historical style.

Both the critics and practitioners of recent art have closed ranks around this 'pluralism' of the 1970s. But what, really, are we to think of that notion of multiplicity? It is certainly true that the separate members of the list do not look alike. If they have any unity, it is not along the axis of a traditional notion of 'style'. But is the absence of a collective style the token of a real difference? Or is there not something else for which all these terms are possible manifestations? Are not all these separate 'individuals' in fact moving in lockstep, only to a rather different drummer from the one called style?

2. My list began with video [...] I am thinking about *Airtime*, the work that Vito Acconci made in 1973, where for 40 minutes the artist sits and talks to his reflected image. Referring to himself, he uses 'I', but not always. Sometimes he addresses his mirrored self as 'you'. 'You' is a pronoun that is also filled, within the space of his recorded monologue, by an absent person, someone he imagines himself to be address-ing. But the referent for this 'you' keeps slipping, shifting, returning once again to the 'I' who is himself, reflected in the mirror. Acconci is playing out the drama of the shifter – in its regressive form.

3. The shifter is Jakobson's term for that category of linguistic sign which is 'filled with signification' only because it is 'empty.'[2] The word 'this' is such a sign, waiting each time it is invoked for its referent to be supplied. 'This chair,' 'this table,' or 'this...' and we point to something lying on the desk. 'Not that, *this*,' we say. The personal pronouns 'I' and 'you' are also shifters. As we speak to one another, both of us using 'I' and 'you', the referents of those words keep changing places across the space of our conversation. I am the referent of 'I' only when I am the one who is speaking. When it is your turn, it belongs to you.

The gymnastics of the 'empty' pronominal sign are therefore slightly complicated. And though we might think that very young children learning language would acquire the use of 'I' and 'you' very early on, this is in fact one of the last things to be correctly learned. Jakobson tells us, as well, that the personal pronouns are among the first things to break down in cases of aphasia.

4. *Airtime* establishes, then, the space of a double regression. Or rather, a space in which linguistic confusion operates in concert with the narcissism implicit in the performer's relationship to the mirror. But this conjunction is perfectly logical, par-ticularly if we consider narcissism – a stage in the development of personality sus-pended between auto-eroticism and object-love – in the terms suggested by Lacan's concept of the 'mirror stage.' Occurring sometime between the ages of six and 18 months, the mirror stage involves the child's self-identification *through* his double: his reflected image. In moving from a global, undifferentiated sense of himself towards a distinct, integrated notion of selfhood – one that could be symbolized through an individuated use of 'I' and 'you' – the child recognizes himself as a separate object (a psychic *gestalt*) by means of his mirrored image. The self is felt, at this stage, only as an *image* of the self; and insofar as the child initially recognizes himself as an other, there is inscribed in that experience a primary alienation. Identity (self-definition) is primally fused with identification (a felt connection to someone else). It is within that condition

of alienation – the attempt to come to closure with a self that is physically distant – that the Imaginary takes root. And in Lacan's terms, the Imaginary is the realm of fantasy, specified as a-temporal, because disengaged from the conditions of history. For the child, a sense of history, both his own and particularly that of others, wholly independent of himself, comes only with the full acquisition of language. For, in joining himself to language, the child enters a world of conventions which he has had no role in shaping. Language presents him with an historical framework pre-existent to his own being. Following the designation of spoken or written language as constituted of that type of sign called the symbol, Lacan names this stage of development the Symbolic and opposes it to the Imaginary.

5. This opposition between the Symbolic and the Imaginary leads us to a further comment on the shifter. For the shifter is a case of linguistic sign which partakes of the symbol even while it shares the features of something else. The pronouns are part of the symbolic code of language insofar as they are arbitrary: 'I' we say in English, but '*je*' in French, '*ego*' in Latin, '*ich*' in German . . . But insofar as their meaning depends on the existential presence of a given speaker, the pronouns (as is true of the other shifters) announce themselves as belonging to a different type of sign: the kind that is termed the index. As distinct from symbols, indexes establish their meaning along the axis of a physical relationship to their referents. They are the marks or traces of a particular cause, and that cause is the thing to which they refer, the object they signify. Into the category of the index, we would place physical traces (like footprints), medical symptoms, or the actual referents of the shifters. Cast shadows could also serve as the indexical signs of objects. . . .

6. *Tu m'* is a painting Marcel Duchamp made in 1918. It is, one might say, a panorama of the index. Across its ten-foot width parade a series of cast shadows, as Duchamp's readymades put in their appearance via the index. The readymades themselves are not depicted. Instead the bicycle wheel, the hatrack, and a corkscrew, are projected onto the surface of the canvas through the fixing of cast shadows, signifying these objects by means of indexical traces. Lest we miss the point, Duchamp places a realistically painted hand at the center of the work, a hand that is pointing, its index finger enacting the process of establishing the connection between the linguistic shifter 'this . . .' and its referent. Given the role of the indexical sign within this particular painting, its title should not surprise us. *Tu m'* is simply 'you'/'me' – the two personal pronouns which, in being shifters, are themselves a species of index.

7. [. . .] Duchamp's relationship to the issue of the indexical sign, or rather, the way his art serves as a matrix for a related set of ideas which connect to one another through the axis of the index, is too important a precedent (I am not concerned here with the question of 'influence') for '70s art, not to explore it. For as we will see, it is Duchamp who first establishes the connection between the index (as a type of sign) and the photograph.

* * *

9. [. . .] Up to 1912 Duchamp had been concerned as a painter almost exclusively with autobiography. Between 1903 and 1911 his major subject was that of his family, and life as it was lived within the immediate confines of his home. This series of explicit portraiture – his father, his brothers playing chess, his sisters playing music – climaxes with the artist's own self-portrait as *The Sad Young Man on a Train* (1911).[3] In most of these portraits there is an insistent naturalism, a direct depiction of the persons

who formed the extensions of Duchamp's most intimate world. Only by the end, in *The Sad Young Man* ... do we find that directness swamped by the adoption of a cubist-informed pictorial language, a language Duchamp was to continue to use for just six more months and then to renounce, with a rather bitter and continuing series of castigations, forever. It was as if cubism forced for Duchamp the issue of whether pictorial language could continue to signify directly, could picture a world with anything like an accessible set of contents. It was not that self-portraiture was displaced within Duchamp's subsequent activity. But only that the project of depicting the self took on those qualities of enigmatic refusal and mask with which we are familiar.

10. The *Large Glass* is of course another self-portrait. In one of the little sketches Duchamp made for it and included in the *Green Box* he labels the upper register 'MAR' and the lower half 'CEL.' And he retains these syllables of his own name in the title of the finished work: *La mariée mise à nu par ses célibataires même*; the MAR of *mariée* linked to the CEL of *célibataires*; the self projected as double. Within this field of the split self-portrait we are made to feel the presence of the index. The 'Sieves,' for example, are colored by the fixing of dust that had fallen on the prone surface of the glass over a period of months. The accumulation of dust is a kind of physical index for the passage of time. *Dust Breeding (Elevage de poussière)* Duchamp calls it, in the photograph of the work's surface that Man Ray took and Duchamp included in the notes for the *Large Glass*. The signatures of both men appear along the bottom of the photograph.

Man Ray intersects with Duchamp's career not only in this document for the *Large Glass* but in those other photographic occasions of Duchamp's work: in the production of the film *Anémic Cinéma*; and in the transvestite portraits of Duchamp/ Rrose Sélavy. Which is interesting. Because Man Ray is the inventor of the Rayograph – that subspecies of photo which forces the issue of photography's existence as an index. [. . .]

But the photogram only forces, or makes explicit, what is the case of *all* photography. Every photograph is the result of a physical imprint transferred by light reflections onto a sensitive surface. The photograph is thus a type of icon, or visual likeness, which bears an indexical relationship to its object. Its separation from true icons is felt through the absoluteness of this physical genesis, one that seem to short-circuit or disallow those processes of schematization or symbolic intervention that operate within the graphic representations of most paintings. If the Symbolic finds its way into pictorial art through the human consciousness operating behind the forms of representation, forming a connection between objects and their meaning, this is not the case for photography. Its power is as an index and its meaning resides in those modes of identification which are associated with the Imaginary. [. . .]

Whatever else its power, the photograph could be called sub- or pre-symbolic, ceding the language of art back to the imposition of things.

11. [. . .] If Duchamp was indeed thinking of the *Large Glass* as a kind of photograph, its processes become absolutely logical: not only the marking of the surface with instances of the index and the suspension of the images as physical substances within the field of the picture; but also, the opacity of the image in relation to its meaning. The notes for the *Large Glass* form a huge, extended caption, and like the captions under newspaper photographs, which are absolutely necessary for their intelligibility, the very

existence of Duchamp's notes – their preservation and publication – bears witness to the altered relationship between sign and meaning within this work. In speaking of the rise of photography in the late 19th century, Walter Benjamin writes, 'At the same time picture magazines begin to put up signposts for [the viewer], right ones or wrong ones, no matter. For the first time, captions have become obligatory. And it is clear that they have an altogether different character than the title of a painting. The directives which the captions give to those looking at pictures in illustrated magazines soon become even more explicit and more imperative in the film where the meaning of each single picture appears to be prescribed by the sequence of all preceding ones.'[4] The photograph heralds a disruption in the autonomy of the sign. A meaninglessness surrounds it which can only be filled in by the addition of a text.

It is also, then, not surprising that Duchamp should have described the Readymade in just these terms. It was to be a 'snapshot' to which there was attached a tremendous arbitrariness with regard to meaning, a breakdown of the relatedness of the linguistic sign [. . .]

The readymade's parallel with the photograph is established by its process of production. It is about the physical transposition of an object from the continuum of reality into the fixed condition of the art-image by a moment of isolation, or selection. And in this process, it also recalls the function of the shifter. It is a sign which is inherently 'empty,' its signification a function of only this one instance, guaranteed by the existential presence of just this object. It is the meaningless meaning that is instituted through the terms of the index.

12. [. . .] As I have been presenting it, Duchamp's work manifests a kind of trauma of signification, delivered to him by two events: the development, by the early teens, of an abstract (or abstracting) pictorial language; and the rise of photography. His art involved a flight from the former and a peculiarly telling analysis of the latter.

13. If we are to ask what the art of the '70s has to do with all of this, we could summarize it very briefly by pointing to the pervasiveness of the photograph as a means of representation. It is not only there in the obvious case of photo-realism, but in all those forms which depend on documentation – earthworks, particularly as they have evolved in the last several years, body art, story art – and of course in video. But it is not just the heightened presence of the photograph itself that is significant. Rather it is the photograph combined with the explicit terms of the index. For, everywhere one looks in '80s art, one finds instances of this connection. In the work that Dennis Oppenheim made in 1975 called *Identity Stretch*, the artist transfers the image (index) of his own thumbprint onto a large field outside of Buffalo by magnifying it thousands of times and fixing its traces in the ground in lines of asphalt. The meaning of this work is focused on the pure installation of presence by means of the index. And the work as it is presented in the gallery involves the documentation of this effort through an arrangement of photographs.

Or, the panels that comprise the works of Bill Beckley are also documents of presence, fixed indexically. A recent object combines photographic enlargements of fragments of the artist's body with a panel of text giving us the 'story' of his physical position at a given time and place.

Or, David Askevold's work *The Ambit: Part I* (1975) is likewise made up of photographic panels captioned by text. In his case, like Oppenheim's, we find the index pure and simple: the images are of the cast shadows of an outstretched arm falling

onto a luminous plane. The text speaks of an interruption of meaning: '. . . an abstraction within the order of reference which resembles another and also is the identity within this order.' The meaning of these three works involves the filling of the 'empty' indexical sign with a particular presence. The implication is that there is no convention for meaning independent of or apart from that presence.

This sense of isolation from the workings of a convention which has evolved as a succession of meanings through painting and sculpture in relation to a history of style is characteristic of photo-realism. For there the indexical presence of either the photograph or the body-cast demands that the work be viewed as a deliberate short-circuiting of issues of style. Countermanding the artist's possible formal intervention in creating the work is the overwhelming physical presence of the original object, fixed in this trace of the cast.

14. The functioning of the index in the art of the present, the way that it operates to substitute the registration of sheer physical presence for the more highly articulated language of aesthetic conventions (and the kind of history which they encode) [. . .] involve a much wider field than the types of objects I have just named. They include a shifting conception of abstract art as well. [. . .]

[1] This is the title of a book by Alan Sondheim, *Individuals: Post Movement Art in America*, New York, Dutton, 1977.

[2] See, Roman Jakobson, 'Shifters, verbal categories, and the Russian verb,' *Russian Language Project*, Harvard University Press, 1957; also, Émile Benveniste, 'La nature des pronoms,' in *Problèmes de linguistique générale*, Paris, Gallimard, 1966.

[3] The inscription on the back of this painting reads: *Marcel Duchamp nu (esquisse) Jeune homme triste dans un train/ Marcel Duchamp*.

[4] Walter Benjamin, 'The Work of Art in the Age of Mechanical Reproduction,' in *Illuminations*, New York, Schocken Books, 1969, p. 226.

13 Fredric Jameson (b. 1934) from 'Reflections on the Brecht–Lukács Debate'

In the radical climate of the 1970s the far-reaching Marxist cultural debate of the 1930s was rediscovered, after having been occluded by decades of the Cold War. In 1977 several contributions were gathered and republished under the title *Aesthetics and Politics*. Frederic Jameson, by then established as a leading Marxist intellectual, contributed an Afterword to the collection in which he surveyed the materials of the debate. His conclusion was that not only Socialist Realism but its protagonist Modernism were now both inadequate to the experience of modern society: the former through its archaism and its assumption of the transparency of representation; the latter for the way in which the emancipatory promise of its disinterested aesthetic had been subverted by the commodification of art. Jameson held out the necessity of reinventing a new 'realism' appropriate to *this* world. First published as 'Reflections in Conclusion' to Adorno et al., *Aesthetics and Politics*, London, 1977, pp. 196–213; reprinted under the present title in Jameson, *The Ideologies of Theory, Vol. 2, The Syntax of History*, London and Minneapolis, 1988, pp. 133–47. (For a later text by Jameson see VIIIA10.)

[. . .] Politically, the classical Marxian notion of the necessity, during the transition to socialism, of a 'dictatorship of the proletariat' – that is, a withdrawal of effective power

from those with a vested interest in the re-establishment of the old order – has surely not become outmoded. Yet it may emerge conceptually transformed when once we think of it together with the necessity for a cultural revolution that involves collective re-education of all the classes. This is the perspective in which Lukács's emphasis on the great bourgeois novelists seems most inadequate to the task, but it is one in which the anti-bourgeois thrust of the great modernisms also appears inappropriate. It is then that Bloch's meditation on the *Erbe*, on the repressed cultural difference of the past and the Utopian principle of the invention of a radically different future, will for the first time come into its own, at a point when the conflict between Realism and Modernism recedes behind us.

But surely in the West, and perhaps elsewhere as well, that point is still beyond us. In our present cultural situation, if anything, both alternatives of realism and of modernism seem intolerable to us: realism because its forms revive older experiences of a kind of social life (the classical inner city, the traditional opposition city/country) which is no longer with us in the already decaying future of consumer society: modernism because its contradictions have proved in practice even more acute than those of realism. An aesthetic of novelty today – already enthroned as the dominant critical and formal ideology – must seek desperately to renew itself by ever more rapid rotations of its own axis: modernism seeking to become post-modernism without ceasing to be modern. Thus today we witness the spectacle of a predictable return, after abstraction has itself become a tired convention, to figurative art, but this time to a figurative art – so-called hyperrealism or photorealism – which turns out to be the representation, not of things themselves, but of the latter's photographs: a representational art which is really 'about' art itself! In literature, meanwhile, amidst a weariness with plotless or poetic fiction, a return to intrigue is achieved, not by the latter's rediscovery, but rather by pastiche of older narratives and depersonalized imitation of traditional voices, similar to Stravinsky's pastiche of the classics criticized by Adorno's *Philosophy of Music*.

In these circumstances, indeed, there is some question whether the ultimate renewal of modernism, the final dialectical subversion of the now automatized conventions of an aesthetics of perceptual revolution, might not simply be... realism itself! For when modernism and its accompanying techniques of 'estrangement' have become the dominant style whereby the consumer is reconciled with capitalism, the habit of fragmentation itself needs to be 'estranged' and corrected by a more totalizing way of viewing phenomena. In an unexpected dénouement, it may be Lukács – wrong as he might have been in the 1930s – who has some provisional last word for us today. Yet this particular Lukács, if he be imaginable, would be one for whom the concept of realism has been rewritten in terms of the categories of *History and Class Consciousness*, in particular those of reification and totality. Unlike the more familiar concept of alienation, a process that pertains to activity and in particular to work (dissociating the worker from his labour, his product, his fellow workers and ultimately from his very 'species being' itself), reification is a process that affects our cognitive relationship with the social totality. It is a disease of that mapping function whereby the individual subject projects and models his or her insertion into the collectivity. The reification of late capitalism – the transformation of human relations into an appearance of relationships between things – renders society opaque: it is the lived source of the mystifications on which ideology is based and by which domination and exploitation are

legitimized. Since the fundamental structure of the social 'totality' is a set of class relationships – an antagonistic structure such that the various social classes define themselves in terms of that antagonism and by opposition with one another – reification necessarily obscures the class character of that structure, and is accompanied, not only by anomie, but also by that increasing confusion as to the nature and even the existence of social classes which can be abundantly observed in all the 'advanced' capitalist countries today. If the diagnosis is correct, the intensification of class consciousness will be less a matter of a populist or ouvrierist exaltation of a single class by itself, than of the forcible reopening of access to a sense of society as a totality, and of the reinvention of possibilities of cognition and perception that allow social phenomena once again to become transparent, as moments of the struggle *between* classes.

Under these circumstances, the function of a new realism would be clear; to resist the power of reification in consumer society and to reinvent that category of totality which, systematically undermined by existential fragmentation on all levels of life and social organization today, can alone project structural relations between classes as well as class struggles in other countries, in what has increasingly become a world system. Such a conception of realism would incorporate what was always most concrete in the dialectical counter-concept of modernism – its emphasis on violent renewal of perception in a world in which experience has solidified into a mass of habits and automatisms. Yet the habituation which it would be the function of the new aesthetic to disrupt would no longer be thematized in the conventional modernistic terms of desacralized or dehumanizing reason, of mass society and the industrial city or technology in general, but rather as a function of the commodity system and the reifying structure of late capitalism.

Other conceptions of realism, other kinds of political aesthetics, obviously remain conceivable. The Realism/Modernism debate teaches us the need to judge them in terms of the historical and social conjuncture in which they are called to function. To take an attitude of partisanship towards key struggles of the past does not mean either choosing sides, or seeking to harmonize irreconcilable differences. In such extinct yet still virulent intellectual conflicts, the fundamental contradiction is between history itself and the conceptual apparatus which, seeking to grasp its realities, only succeeds in reproducing their discord within itself in the form of an enigma for thought, an aporia. It is to this aporia that we must hold, which contains within its structure the crux of a history beyond which we have not yet passed. It cannot of course tell us what our conception of realism ought to be; yet its study makes it impossible to us not to feel the obligation to reinvent one.

14 Raymond Williams (1921–1988) 'Dominant, Residual and Emergent'

Williams's Marxism, which in his earlier work had tended to be subsumed within the innovatory conceptions of his own thought, had by the 1970s become more explicitly acknowledged. By then Williams's own work had contributed significantly to the enrichment of an area of study the barrenness of which had earlier been the principal cause of his oblique entry into the field. Here, building on his already established conception of culture as a 'way of life', he attempted to analyse the dynamics of such a phenomenon at any given

moment: for a culture thus conceived will not be a static arrangement of forms, but a continually changing interplay of forces, some rising in significance, some on the decline. Published as chapter 8 of *Marxism and Literature*, Oxford, 1977, pp. 121–8. (See also VIA12 and VIIIB9.)

The complexity of a culture is to be found not only in its variable processes and their social definitions – traditions, institutions, and formations – but also in the dynamic interrelations, at every point in the process, of historically varied and variable elements. In what I have called 'epochal' analysis, a cultural process is seized as a cultural system, with determinate dominant features: feudal culture or bourgeois culture or a transition from one to the other. This emphasis on dominant and definitive lineaments and features is important and often, in practice, effective. But it then often happens that its methodology is preserved for the very different function of historical analysis, in which a sense of movement within what is ordinarily abstracted as a system is crucially necessary, especially if it is to connect with the future as well as with the past. In authentic historical analysis it is necessary at every point to recognize the complex interrelations between movements and tendencies both within and beyond a specific and effective dominance. It is necessary to examine how these relate to the whole cultural process rather than only to the selected and abstracted dominant system. Thus 'bourgeois culture' is a significant generalizing description and hypothesis, expressed within epochal analysis by fundamental comparisons with 'feudal culture' or 'socialist culture'. However, as a description of cultural process, over four or five centuries and in scores of different societies, it requires immediate historical and internally comparative differentiation. Moreover, even if this is acknowledged or practically carried out, the 'epochal' definition can exert its pressure as a static type against which all real cultural process is measured, either to show 'stages' or 'variations' of the type (which is still historical analysis) or, at its worst, to select supporting and exclude 'marginal' or 'incidental' or 'secondary' evidence.

Such errors are avoidable if, while retaining the epochal hypothesis, we can find terms which recognize not only 'stages' and 'variations' but the internal dynamic relations of any actual process. We have certainly still to speak of the 'dominant' and the 'effective', and in these senses of the hegemonic. But we find that we have also to speak, and indeed with further differentiation of each, of the 'residual' and the 'emergent', which in any real process, and at any moment in the process, are significant both in themselves and in what they reveal of the characteristics of the 'dominant'.

By 'residual' I mean something different from the 'archaic', though in practice these are often very difficult to distinguish. Any culture includes available elements of its past, but their place in the contemporary cultural process is profoundly variable. I would call the 'archaic' that which is wholly recognized as an element of the past, to be observed, to be examined, or even on occasion to be consciously 'revived', in a deliberately specializing way. What I mean by the 'residual' is very different. The residual, by definition, has been effectively formed in the past, but it is still active in the cultural process, not only and often not at all as an element of the past, but as an effective element of the present. Thus certain experiences, meanings, and values which cannot be expressed or substantially verified in terms of the dominant culture, are nevertheless lived and practised on the basis of the residue – cultural as well as social – of some previous social and cultural institution or formation. It is crucial to distinguish

this aspect of the residual, which may have an alternative or even oppositional relation to the dominant culture, from that active manifestation of the residual (this being its distinction from the archaic) which has been wholly or largely incorporated into the dominant culture. In three characteristic cases in contemporary English culture this distinction can become a precise term of analysis. Thus organized religion is predominantly residual, but within this there is a significant difference between some practically alternative and oppositional meanings and values (absolute brotherhood, service to others without reward) and a larger body of incorporated meanings and values (official morality, or the social order of which the other-worldly is a separated neutralizing or ratifying component). Again, the idea of rural community is predominantly residual, but is in some limited respects alternative or oppositional to urban industrial capitalism, though for the most part it is incorporated, as idealization or fantasy, or as an exotic – residential or escape – leisure function of the dominant order itself. Again, in monarchy, there is virtually nothing that is actively residual (alternative or oppositional), but, with a heavy and deliberate additional use of the archaic, a residual function has been wholly incorporated as a specific political and cultural function – marking the limits as well as the methods – of a form of capitalist democracy.

A residual cultural element is usually at some distance from the effective dominant culture, but some part of it, some version of it – and especially if the residue is from some major area of the past – will in most cases have had to be incorporated if the effective dominant culture is to make sense in these areas. Moreover, at certain points the dominant culture cannot allow too much residual experience and practice outside itself, at least without risk. It is in the incorporation of the actively residual – by reinterpretation, dilution, projection, discriminating inclusion and exclusion – that the work of the selective tradition is especially evident. This is very notable in the case of versions of 'the literary tradition', passing through selective versions of the character of literature to connecting and incorporated definitions of what literature now is and should be. This is one among several crucial areas, since it is in some alternative or even oppositional versions of what literature is (has been) and what literary experience (and in one common derivation, other significant experience) is and must be, that, against the pressures of incorporation, actively residual meanings and values are sustained.

By 'emergent' I mean, first, that new meanings and values, new practices, new relationships and kinds of relationship are continually being created. But it is exceptionally difficult to distinguish between those which are really elements of some new phase of the dominant culture (and in this sense 'species-specific') and those which are substantially alternative or oppositional to it: emergent in the strict sense, rather than merely novel. Since we are always considering relations within a cultural process, definitions of the emergent, as of the residual, can be made only in relation to a full sense of the dominant. Yet the social location of the residual is always easier to understand, since a large part of it (though not all) relates to earlier social formations and phases of the cultural process, in which certain real meanings and values were generated. In the subsequent default of a particular phase of a dominant culture there is then a reaching back to those meanings and values which were created in actual societies and actual situations in the past, and which still seem to have significance because they represent areas of human experience, aspiration, and achievement which the dominant culture neglects, undervalues, opposes, represses, or even cannot recognize.

The case of the emergent is radically different. It is true that in the structure of any actual society, and especially in its class structure, there is always a social basis for elements of the cultural process that are alternative or oppositional to the dominant elements. One kind of basis has been valuably described in the central body of Marxist theory: the formation of a new class, the coming to consciousness of a new class, and within this, in actual process, the (often uneven) emergence of elements of a new cultural formation. Thus the emergence of the working class as a class was immediately evident (for example, in nineteenth-century England) in the cultural process. But there was extreme unevenness of contribution in different parts of the process. The making of new social values and institutions far outpaced the making of strictly cultural institutions, while specific cultural contributions, though significant, were less vigorous and autonomous than either general or institutional innovation. A new class is always a source of emergent cultural practice, but while it is still, as a class, relatively subordinate, this is always likely to be uneven and is certain to be incomplete. For new practice is not, of course, an isolated process. To the degree that it emerges, and especially to the degree that it is oppositional rather than alternative, the process of attempted incorporation significantly begins. This can be seen, in the same period in England, in the emergence and then the effective incorporation of a radical popular press. It can be seen in the emergence and incorporation of working-class writing, where the fundamental problem of emergence is clearly revealed, since the basis of incorporation, in such cases, is the effective predominance of received literary forms – an incorporation, so to say, which already conditions and limits the emergence. But the development is always uneven. Straight incorporation is most directly attempted against the visibly alternative and oppositional class elements: trade unions, working-class political parties, working-class life styles (as incorporated into 'popular' journalism, advertising, and commercial entertainment). The process of emergence, in such conditions, is then a constantly repeated, an always renewable, move beyond a phase of practical incorporation: usually made much more difficult by the fact that much incorporation looks like recognition, acknowledgement, and thus a form of *acceptance*. In this complex process there is indeed regular confusion between the locally residual (as a form of resistance to incorporation) and the generally emergent.

Cultural emergence in relation to the emergence and growing strength of a class is then always of major importance, and always complex. But we have also to see that it is not the only kind of emergence. This recognition is very difficult, theoretically, though the practical evidence is abundant. What has really to be said, as a way of defining important elements of both the residual and the emergent, and as a way of understanding the character of the dominant, is that *no mode of production and therefore no dominant social order and therefore no dominant culture ever in reality includes or exhausts all human practice, human energy, and human intention*. This is not merely a negative proposition, allowing us to account for significant things which happen outside or against the dominant mode. On the contrary it is a fact about the modes of domination, that they select from and consequently exclude the full range of human practice. What they exclude may often be seen as the personal or the private, or as the natural or even the metaphysical. Indeed it is usually in one or other of these terms that the excluded area is expressed, since what the dominant has effectively seized is indeed the ruling definition of the social.

It is this seizure that has especially to be resisted. For there is always, though in varying degrees, practical consciousness, in specific relationships, specific skills, specific perceptions, that is unquestionably social and that a specifically dominant social

order neglects, excludes, represses, or simply fails to recognize. A distinctive and comparative feature of any dominant social order is how far it reaches into the whole range of practices and experiences in an attempt at incorporation. There can be areas of experience it is willing to ignore or dispense with: to assign as private or to specialize as aesthetic or to generalize as natural. Moreover, as a social order changes, in terms of its own developing needs, these relations are variable. Thus in advanced capitalism, because of changes in the social character of labour, in the social character of communications, and in the social character of decision-making, the dominant culture reaches much further than ever before in capitalist society into hitherto 'reserved' or 'resigned' areas of experience and practice and meaning. The area of effective penetration of the dominant order into the whole social and cultural process is thus now significantly greater. This in turn makes the problem of emergence especially acute, and narrows the gap between alternative and oppositional elements. The alternative, especially in areas that impinge on significant areas of the dominant, is often seen as oppositional and, by pressure, often converted into it. Yet even here there can be spheres of practice and meaning which, almost by definition from its own limited character, or in its profound deformation, the dominant culture is unable in any real terms to recognize. Elements of emergence may indeed be incorporated, but just as often the incorporated forms are merely facsimiles of the genuinely emergent cultural practice. Any significant emergence, beyond or against a dominant mode, is very difficult under these conditions; in itself and in its repeated confusion with the facsimiles and novelties of the incorporated phase. Yet, in our own period as in others, the fact of emergent cultural practice is still undeniable, and together with the fact of actively residual practice is a necessary complication of the would-be dominant culture.

This complex process can still in part be described in class terms. But there is always other social being and consciousness which is neglected and excluded: alternative perceptions of others, in immediate relationships; new perceptions and practices of the material world. In practice these are different in quality from the developing and articulated interests of a rising class. The relations between these two sources of the emergent – the class and the excluded social (human) area – are by no means necessarily contradictory. At times they can be very close and on the relations between them much in political practice depends. But culturally and as a matter of theory the areas can be seen as distinct.

What matters, finally, in understanding emergent culture, as distinct from both the dominant and the residual, is that it is never only a matter of immediate practice; indeed it depends crucially on finding new forms or adaptations of form. Again and again what we have to observe is in effect a *pre-emergence*, active and pressing but not yet fully articulated, rather than the evident emergence which could be more confidently named. It is to understand more closely this condition of pre-emergence, as well as the more evident forms of the emergent, the residual, and the dominant, that we need to explore the concept of structures of feeling.

15 Edward Said (1935–2003) from *Orientalism*

When *Orientalism* was first published in 1978 the study of non-Western cultures was largely anthropological. It is in part an effect of its publication that, since then, the field has

expanded to include a wide range of perspectives in cultural studies, literary criticism and art history. This development of the critical debate has also coincided with an increasing internationalization of cultural and artistic *production*. Said's book, it goes without saying, was not the single cause of these developments. The points at issue are implicated in the very constitution of culture in the wider modern period, while critical consciousness of their relevance has been stimulated by those political and economic processes now referred to under the name of globalization. The publication of *Orientalism* nevertheless remains a significant early marker of a sea-change in our understanding of art and culture. Said was born in Palestine. He studied first in Egypt and subsequently in the United States, where he went on to make his academic career. Noam Chomsky has said of Said's work that it 'helps us to understand who we are and what we must do if we aspire to be moral agents, not servants of power'. Our extracts are taken from the Introduction to *Orientalism*, first published London: Routledge and Kegan Paul, 1978. We have used the Harmondsworth: Penguin edition, 1991, pp. 2–8.

[...] By Orientalism I mean several things, all of them, in my opinion, interdependent. The most readily accepted designation for Orientalism is an academic one, and indeed the label still serves in a number of academic institutions. Anyone who teaches, writes about, or researches the Orient – and this applies whether the person is an anthropologist, sociologist, historian, or philologist – either in its specific or its general aspects, is an Orientalist, and what he or she does is Orientalism. Compared with *Oriental studies* or *area studies*, it is true that the term *Orientalism* is less preferred by specialists today, both because it is too vague and general and because it connotes the high-handed executive attitude of nineteenth-century and early twentieth-century European colonialism. Nevertheless books are written and congresses held with 'the Orient' as their main focus, with the Orientalist in his new or old guise as their main authority. The point is that even if it does not survive as it once did, Orientalism lives on academically through its doctrines and theses about the Orient and the Oriental.

Related to this academic tradition, whose fortunes, transmigrations, specializations, and transmissions are in part the subject of this study, is a more general meaning for Orientalism. Orientalism is a style of thought based upon an ontological and epistemological distinction made between 'the Orient' and (most of the time) 'the Occident.' Thus a very large mass of writers, among whom are poets, novelists, philosophers, political theorists, economists, and imperial administrators, have accepted the basic distinction between East and West as the starting point for elaborate theories, epics, novels, social descriptions, and political accounts concerning the Orient, its people, customs, 'mind,' destiny, and so on. *This* Orientalism can accommodate Aeschylus, say, and Victor Hugo, Dante and Karl Marx. A little later in this introduction I shall deal with the methodological problems one encounters in so broadly construed a 'field' as this.

The interchange between the academic and the more or less imaginative meanings of Orientalism is a constant one, and since the late eighteenth century there has been a considerable, quite disciplined – perhaps even regulated – traffic between the two. Here I come to the third meaning of Orientalism, which is something more historically and materially defined than either of the other two. Taking the late eighteenth century as a very roughly defined starting point Orientalism can be discussed and analyzed as the corporate institution for dealing with the Orient – dealing with it by making statements about it, authorizing views of it, describing it, by teaching it, settling it,

ruling over it: in short, Orientalism as a Western style for dominating, restructuring, and having authority over the Orient. I have found it useful here to employ Michel Foucault's notion of a discourse, as described by him in *The Archaeology of Knowledge* and in *Discipline and Punish*, to identify Orientalism. My contention is that without examining Orientalism as a discourse one cannot possibly understand the enormously systematic discipline by which European culture was able to manage – and even produce – the Orient politically, sociologically, militarily, ideologically, scientifically, and imaginatively during the post-Enlightenment period. Moreover, so authoritative a position did Orientalism have that I believe no one writing, thinking, or acting on the Orient could do so without taking account of the limitations on thought and action imposed by Orientalism. In brief, because of Orientalism the Orient was not (and is not) a free subject of thought or action. This is not to say that Orientalism unilaterally determines what can be said about the Orient, but that it is the whole network of interests inevitably brought to bear on (and therefore always involved in) any occasion when that peculiar entity 'the Orient' is in question. [. . .]

I have begun with the assumption that the Orient is not an inert fact of nature. It is not merely *there*, just as the Occident itself is not just *there* either. We must take seriously Vico's great observation that men make their own history, that what they can know is what they have made, and extend it to geography: as both geographical and cultural entities – to say nothing of historical entities – such locales, regions, geographical sectors as 'Orient' and 'Occident' are man-made. Therefore as much as the West itself, the Orient is an idea that has a history and a tradition of thought, imagery, and vocabulary that have given it reality and presence in and for the West. The two geographical entities thus support and to an extent reflect each other.

Having said that, one must go on to state a number of reasonable qualifications. In the first place, it would be wrong to conclude that the Orient was *essentially* an idea, or a creation with no corresponding reality. When Disraeli said in his novel *Tancred* that the East was a career, he meant that to be interested in the East was something bright young Westerners would find to be an all-consuming passion; he should not be interpreted as saying that the East was *only* a career for Westerners. There were – and are – cultures and nations whose location is in the East, and their lives, histories, and customs have a brute reality obviously greater than anything that could be said about them in the West. About that fact this study of Orientalism has very little to contribute, except to acknowledge it tacitly. But the phenomenon of Orientalism as I study it here deals principally, not with a correspondence between Orientalism and Orient, but with the internal consistency of Orientalism and its ideas about the Orient (the East as career) despite or beyond any correspondence, or lack thereof, with a 'real' Orient. My point is that Disraeli's statement about the East refers mainly to that created consistency, that regular constellation of ideas as the pre-eminent thing about the Orient, and not to its mere being, as Wallace Stevens's phrase has it.

A second qualification is that ideas, cultures, and histories cannot seriously be understood or studied without their force, or more precisely their configurations of power, also being studied. To believe that the Orient was created – or, as I call it, 'Orientalized' – and to believe that such things happen simply as a necessity of the imagination, is to be disingenuous. The relationship between Occident and Orient is a relationship of power, of domination, of varying degrees of a complex hegemony... The Orient was Orientalized not only because it was discovered to be 'Oriental'

in all those ways considered commonplace by an average nineteenth-century European, but also because it *could be* – that is, submitted to being – *made* Oriental. There is very little consent to be found, for example, in the fact that Flaubert's encounter with an Egyptian courtesan produced a widely influential model of the Oriental woman; she never spoke of herself, she never represented her emotions, presence, or history. *He* spoke for and represented her. He was foreign, comparatively wealthy, male, and these were historical facts of domination that allowed him not only to possess Kuchuk Hanem physically but to speak for her and tell his readers in what way she was 'typically Oriental.' My argument is that Flaubert's situation of strength in relation to Kuchuk Hanem was not an isolated instance. It fairly stands for the pattern of relative strength between East and West, and the discourse about the Orient that it enabled.

This brings us to a third qualification. One ought never to assume that the structure of Orientalism is nothing more than a structure of lies or of myths which, were the truth about them to be told, would simply blow away. I myself believe that Orientalism is more particularly valuable as a sign of European-Atlantic power over the Orient than it is as a veridic discourse about the Orient (which is what, in its academic or scholarly form, it claims to be). Nevertheless, what we must respect and try to grasp is the sheer knitted-together strength of Orientalist discourse, its very close ties to the enabling socio-economic and political institutions, and its redoubtable durability. After all, any system of ideas that can remain unchanged as teachable wisdom (in academies, books, congresses, universities, foreign-service institutes) from the period of Ernest Renan in the late 1840s until the present in the United States must be something more formidable than a mere collection of lies. Orientalism, therefore, is not an airy European fantasy about the Orient, but a created body of theory and practice in which, for many generations, there has been a considerable material investment. Continued investment made Orientalism, as a system of knowledge about the Orient, an accepted grid for filtering through the Orient into Western consciousness, just as that same investment multiplied – indeed, made truly productive – the statements proliferating out from Orientalism into the general culture.

Gramsci has made the useful analytic distinction between civil and political society in which the former is made up of voluntary (or at least rational and noncoercive) affiliations like schools, families, and unions, the latter of state institutions (the army, the police, the central bureaucracy) whose role in the polity is direct domination. Culture, of course, is to be found operating within civil society, where the influence of ideas, of institutions, and of other persons works not through domination but by what Gramsci calls consent. In any society not totalitarian, then, certain cultural forms predominate over others, just as certain ideas are more influential than others; the form of this cultural leadership is what Gramsci has identified as *hegemony*, an indispensable concept for any understanding of cultural life in the industrial West. It is hegemony, or rather the result of cultural hegemony at work, that gives Orientalism the durability and the strength I have been speaking about so far. Orientalism is never far from what Denys Hay has called the idea of Europe, a collective notion identifying 'us' Europeans as against all 'those' non-Europeans, and indeed it can be argued that the major component in European culture is precisely what made that culture hegemonic both in and outside Europe: the idea of European identity as a superior one in comparison with all the non-European peoples and cultures. There is in addition the hegemony of

European ideas about the Orient, themselves reiterating European superiority over Oriental backwardness, usually overriding the possibility that a more independent, or more skeptical, thinker might have had different views on the matter.

In a quite constant way, Orientalism depends for its strategy on this flexible *positional* superiority, which puts the Westerner in a whole series of possible relationships with the Orient without ever losing him the relative upper hand. And why should it have been otherwise, especially during the period of extraordinary European ascendancy from the late Renaissance to the present? The scientist, the scholar, the missionary, the trader, or the soldier was in, or thought about, the Orient because he *could be there*, or could think about it, with very little resistance on the Orient's part. Under the general heading of knowledge of the Orient, and within the umbrella of Western hegemony over the Orient during the period from the end of the eighteenth century, there emerged a complex Orient suitable for study in the academy, for display in the museum, for reconstruction in the colonial office, for theoretical illustration in anthropological, biological, linguistic, racial, and historical theses about mankind and the universe, for instances of economic and sociological theories of development, revolution, cultural personality, national or religious character. Additionally, the imaginative examination of things Oriental was based more or less exclusively upon a sovereign Western consciousness out of whose unchallenged centrality an Oriental world emerged, first according to general ideas about who or what was an Oriental, then according to a detailed logic governed not simply by empirical reality but by a battery of desires, repressions, investments, and projections.

Part VIII
Ideas of the Postmodern

VIII
Introduction

Inquiry into the *artistic* character of the postmodern might well commence at that point in the later 1960s when the virtue and authority of Modernism itself first came under sustained examination from within the actual practice of modern art. The explicit theorization of the postmodern was a concern of the late 1970s and 1980s, however; which is to say of a period which extends approximately from the end of the Vietnam War in 1975 to the reunification of Germany fifteen years later. Each of these events marked a defeat for one of the two superpowers whose opposition had defined the Cold War. America has survived as a major power, though its economic standing has declined. The Soviet Union now no longer exists, having fragmented into its constituent parts during the final decade of the century.

The intellectual culture of the Cold War had been characterized by a structure of oppositions and contrasts, not simply between East and West or between Communism and capitalism, but between those values which each was supposed to stand for in the eyes of the other. This reciprocating structure was constantly *available* to be mobilized in argument, as a kind of background against which virtually any position could be first located, and then distinguished from its assumed rhetorical opposite. Thus wherever Modernist art served as a model of apolitical virtue there would be a tendency to disparage Realism as the cultural form of a political dogmatism; while to those for whom Realism betokened social and historical relevance and purposeful instruction, Modernist abstraction seemed redolent of bourgeois idealism and mystification.

In thus associating the opposed terms of modern art theory with forms of political opposition and cliché we do not mean to reduce the one to a function of the other. Our purpose is twofold. On the one hand, we mean to suggest that interest in the concept of Postmodernism in the arts grew on the fertile ground of substantial historical change. On the other, we mean to suggest that while the end of the Cold War may have seemed to come suddenly, a review of the art and art theory of the 1970s and 1980s will show an accelerating breakdown in the familiar structure of rhetorical oppositions. The intellectual structure dividing Modernism from Realism, penetrated by the criticism of the late 1930s, had been carefully repaired during the Cold War years. But it had been breached once again well before the fall of the Berlin Wall.

In making this point we do not accord priority to artistic and intellectual changes over more historically basic forms of change. On the contrary, we mean to suggest that some of the conditions leading to the 'new (geo-political) world order' may have been identical with some of those which led to a postmodern relaxation and redrawing of conceptual boundaries in the theorization of art.

How one does one's singling out determines what gets singled out. The aim of a theory of postmodern art will be to identify some new set of characteristics. This will involve both the critical abandonment of the supposedly outmoded paradigm, and the singling out of some set of examples of art in which these new characteristics are supposedly exhibited. There can be no theory of the *postmodern* – no sensible identification of some art as postmodern art – which does not assume a certain means of identifying the modern. To claim the status of 'postmodern' for some form of art is to reveal the nature of one's beliefs and attitudes concerning the modern. Similarly, to talk of Postmodern*ism* is to assume a certain meaning and value for Modernism. Fredric Jameson, for instance, suggests that the artistic signs of the postmodern are to be recognized in works which abjure all claim to spontaneity and directness of expression, making use instead of forms of pastiche and discontinuity (VIIIA10). But it could well be argued that pastiche and discontinuity are deployed to telling effect in the works of such paradigmatically modern artists as Manet and Picasso; that they are in fact modes of representation endemic to Modernist art. Jameson's Postmodernism thus appears to be established with regard to a Modernism stripped of complexity. Craig Owens offers a similar account of current art, but forms his concept of the postmodern with regard to Modernism as a critical rather than a practical tradition, thus avoiding the danger of Jameson's approach (VIIIA3). Owens's argument is that Modernist criticism systematically misrepresents the way in which modern art actually works. His paradigm Modernist observer is someone who insistently and mistakenly intuits complete and immanent meanings in face of what are in fact complex and discontinuous allegories. Postmodernism as thus conceived is not immediately a new form of the practice of art, but rather a critical redirection of tradition on the basis of a revised understanding of the immediate past.

The relation between these two approaches raises the question of the status of theory and criticism relative to the current practice of art. We have surveyed a large body of theory in this concluding section (although it could have been much larger), not in order to favour a particular approach to that question, but rather in recognition that the question is itself substantial, if only because involvement with the fascinations of theory was such a marked characteristic of the modern art of the 1980s and 1990s. In 1954 Clement Greenberg could write that 'Art is a matter strictly of experience, not of principles...' (*Art and Culture*, 1961, p. 133). This position was strongly opposed during the Conceptual Art movement of the late 1960s and 1970s on both general and specific grounds. The general case was that the relations between experience and principles are not such as can be reduced to bald statements of priority, or to a one-way traffic, with experience always informing principles, and principles never serving to illuminate experiences. The specific case was that for all its claim to an absolute empiricism, Modernist criticism was engaged in the dogmatization of expression: that it was tending to define and even to constitute the expressive artistic objects of its own regard, in precise reversal of the supposed one-way traffic. As a form of corrective, various of the Conceptual artists proposed that works of art theory should be accorded the conjectural status of works of art. The weak form of justification of this proposal was that it would lead to the uncovering of new forms of exotic art object. The stronger form was that it would serve to overcome the typically Modernist division of labour between art objects and interpretations, or between producers and explainers.

During the same period, however, the discourses of modern art were caught by the flaring of theory which had commenced in France in the area of literary and linguistic

studies. Science and philosophy were also badly burned in the area of their supposedly rational principles. In an intellectual world suddenly reduced to competing narratives, literature laid claim to dominance. Whereas the earlier use of language by artists had had the force of a breaking of the acceptable boundaries of art, by the 1980s artists like Mary Kelly, Barbara Kruger and Jenny Holzer, who saw themselves as having broken with the protocols of Modernism, were laying claim to language, but to language already conceivable as a form of art, and not subject to confusion with literature. At the same time critics were tending to claim a first-order status for themselves, but the claim was in virtue of criticism conceived as a form of writing, not as a form of art.

If there is a postmodern theory of the arts, then, it is to be sorted from a complex mix of historical and art-historical reconsiderations, political theories, literary theories, practices and critiques of practices, which have nothing so much in common as their self-orientation with respect to the idea of the modern and to the supposed culture of Modernism. In face of these considerable and diverse resources, we offer a schematic breakdown into three broad themes with regard to which that orientation has been both established and disputed: Postmodernism as a critique of the myth of originality; Postmodernism as a critique of the grounds of difference; and Postmodernism as a critique of historical narratives.

The first of our themes concerns the combined implications of two theoretical propositions: that there is no one natural 'reality' which is available to us to explain our beliefs and sensations; and that the prizing of originality in art and writing, so central to the whole value-structure of Modernism, is shown up as a form of idealization in face of the convergence of philosophical, psychoanalytical and literary theory upon a single point: that in so far as any form of utterance has meaning, it has it only by virtue of its relation to other utterances; it follows that to single out any one work as a discrete 'text' is merely to pull a single thread apart from the 'textile' within which it has its semantic place. The French writer Jean Baudrillard has given a sociological slant to the critique of originality. His concept of 'Hyper-Realism' designates an experience of the contemporary world which is radically 'unoriginal', in the sense that it is an experience of signs and simulations taken for 'real' (see VIIIA1). Assuming the validity of this framework, we might see the postmodernist artist as one who treats the 'hyper-real' surface as a kind of nature, in order knowingly and ironically to play with the power of its simulations (VIIIA9 and 11).

Those preoccupied with the second of our themes start from the assumption that Modernism refers to the typical forms of a hegemonic culture. This culture is defined as Western in its orientation, capitalist in its determining economic tendency, bourgeois in its class-character, white in its racial complexion, and masculine in its dominant gender. Others of the characteristics of this culture, such as its investment in the separation of the 'high' from the 'popular' arts, its tendency to forms of specialization and abstruseness, and its individualism, are seen as following from these. For those thus persuaded of the character of Modernism – or persuaded, at least, of the inescapable implication of Modernist art in the values of modern culture thus characterized – to talk of a postmodern culture or of postmodern forms of art is to talk of forms of opposition to hegemony. It is to conceive of work which articulates the 'meanings of the dominated' – Modernism's 'others' – and which, in doing so, gives imaginative realization to the reversal of powers (VIIIB1, 6, 12 and 17). The tools for this work are the available tools of liberation. Classically, so far as the twentieth century

is concerned, these were found in the Marxist intellectual tradition and in Freudian psychoanalysis, and in various forms of transaction between the two. The Marxist tradition has been considerably extended through its application to the analysis of colonialism (VIIIB12 and 16). Since the later 1970s the resources of Freudian theory have been substantially transformed by feminists in pursuit of relevant insights and critiques (VIIB2, 6 and 10). The two resources have been brought together in analysis of the mechanisms of social and psychological power and control. Analysis along these lines has also been a concern of the work of Michel Foucault, though his work constitutes a mediation of the intellectual traditions of Marx and Freud by the legacy of Nietzsche (see VIID11).

At issue under the last of our three themes is the question of the continuity of our culture and our values. On what grounds should we now examine, criticize and compare appeals for continuity of values and institutions on the one hand, and appeals for radical change on the other? For the conservative Daniel Bell, writing in 1978, Modernism was characterized by a disruptive agnosticism (VIIIC1). Now that its oppositional impetus was exhausted, the hope of the postmodern lay in a return to consensus based on the shared need for moral and economic order. For Jürgen Habermas, on the other hand, Bell's formation of the postmodern is effectively a revivified anti-Modernism (VIIIC3). A strong resource of aesthetic resistance remains necessary as a counter to the increasing power and autonomy of economic and administrative systems. The value of Modernism lies in its continued maintenance of just this resource. A third position is represented by Jean-François Lyotard (VIIIC2 and 4). In opposition to Bell he equates the postmodern with a continuing scepticism regarding the possibility of an underlying consensus. Unlike Habermas, however, he sees the scepticism of Modernism as tinged with a form of nostalgia for the experience of an unattainable wholeness or presence. This is perhaps the very wholeness which Owens's typical Modernist observer intuits even when it is not there to be found (VIIIA3). But the pursuit of wholeness is disqualified in Lyotard's view not so much by the actuality of art, as by the changed and changing character of quotidian experience. The task of the postmodern, as Lyotard sees it, is to 'wage a war on totality'. According to this view, postmodern forms of art are those which make manifest the very impossibility of presenting that which cannot be presented. It should be noted that while each of the writers cited speaks *for* a different view of the postmodern, he also articulates that view *from* a different country (respectively the United States, Germany and France), which is to say from within the different determining conditions of specific social, historical and political frameworks. The critique and revision of notions of history, whether national or more broadly cultural, was increasingly addressed in practice by artists during the 1990s; among them were some whose professional lives had been lived entirely under the liberal regimes of the West, and others with direct experience of political and colonial oppression and the break-up of empire (VIIIC10–15).

If different artists and writers tend to stress one rather than another of these broad themes it is nevertheless clear that no one of the three can be considered independently of any of the others. The critique of history, for example, must clearly take account of the position from which history is written. An 'art history' which is an apparently disinterested narrative of 'original' works may actually depend for its coherence on a traditional *stereotype* of originality, and may thus be unresponsive to the work of those who challenge the authority of that tradition and that stereotype. And so on.

It should also be noted that where the postmodern theory of the 1980s and early 1990s was written and read in English, it was generally written and read under regimes which were both conservative and largely philistine. If Lyotard's 'war on totality' was waged with any success during the decade, it was waged in the face of considerable attempts to restore 'fundamental values' in cultural as in social policy. Over the same period there appear to have been substantial if by no means sensational gains in the representation of women and of racial and sexual minorities in the making of art and of artistic theory. Yet these gains were accompanied by a large-scale backing down from the larger social goals with which Modernism was widely identified. In both the United States and Britain the gap between rich and poor widened during the 1980s and 1990s. It is not always easy under these conditions to distinguish between committed and co-opted art.

So how are we to conceive of the postmodern and what are we to take as its typical artistic forms? Should we emphasize those forms which may be defined as forms of high art, precisely through their difference from and resistance to the incoming tides of the media – forms which, by the same token, may exhibit a familiar indifference under new conditions (VIIIB13)? Or should we associate the postmodern with the activities of those who would remove the typically Modernist barrier (as they see it) between the 'high arts' and 'popular culture', whose independent artistic works take a mechanically reproducible form, either to make the pleasures of art in principle available to all, or in order to insinuate a critical aesthetic content into the existing media of mass-distribution, or both (VIIIA8, VIIIB4)? Is there a form of postmodernist Hyper-Realism to be identified in the productions of those who take the commodities of the consumer world as forms of a modern 'nature' – a nature which they then represent in the form of pastiche (VIIIA9 and 11)? Or should we identify the postmodern as a culture made by and representative of those typically marginalized by Modernism: women, the racially disadvantaged and the colonized, members of the working class, members of oppressed sexual or political minorities, variously converging in their purpose to reflect back to Modernism an inescapable representation of its *own* Otherness (VIIIB3, 12, 16 and 17, VIIIC13–15)? Or alternatively, is it possible apparently to acknowledge both the interconnectedness and the unoriginality of all utterance, yet to persist in the attempt to achieve expression; and if so is this not an enterprise in which the postmodern and the modern are as one (VIIIB14 and 15, C8, 9 and 12)?

Whatever conclusions might be drawn from our wider project, and from its survey of some 350 years of *Art in Theory*, we are in no position to prescribe answers to these questions, or to suggest the future direction that art might take. At the time of writing, however, one thing seems clear. If art now has an end in view, it is the museum, but the museum envisaged not as the site of historical classification and understanding, but as the place of spectacle. In the present representation of art, the authority for long vested in the figures of the historian, the critic and the theorist has now been assumed, for better or worse, by the curator (VIIIC16).

VIIIA
The Critique of Originality

1 Jean Baudrillard (b. 1929) 'The Hyper-realism of Simulation'

The development of Baudrillard's 'critique of the political economy of the sign' turned in the early 1970s into a thesis that reality itself, as something separable from signs of it, had vanished in the information-saturated, media-dominated contemporary world. This condition Baudrillard dubbed 'hyper-realism'. Tellingly, his points of reference for this thesis are predominantly drawn from the world of art: Surrealism, the *nouveau roman*, Andy Warhol, Pop art and photography. The upshot is a conception of the contemporary world as radically abstract, a 'place' from which reality has absented itself and all is 'simulacrum'. This is, as Baudrillard himself confesses, an aestheticization; but as such it is unapologetic. It is perhaps in the very extremity of this implausible abstraction that the compelling power of Baudrillard's conception has lain. Originally published as a section of *L'Echange symbolique et la mort*, Paris, 1976; translated by Charles Levin as *Symbolic Exchange and Death* in J. Fekete (ed.), *The Structural Allegory*, Minneapolis, 1984; this translation reprinted in Mark Poster (ed.), *Jean Baudrillard: Selected Writings*, Stanford, CA, 1988, pp. 143–7, from which the present text is taken.

[. . .] Reality itself founders in hyperrealism, the meticulous reduplication of the real, preferably through another, reproductive medium, such as photography. From medium to medium, the real is volatilized, becoming an allegory of death. But it is also, in a sense, reinforced through its own destruction. It becomes *reality for its own sake*, the fetishism of the lost object: no longer the object of representation, but the ecstasy of denial and of its own ritual extermination: the hyperreal.

Realism had already inaugurated this process. The rhetoric of the real signaled its gravely altered status (its golden age was characterized by an innocence of language in which it was not obliged to redouble what it said with a reality effect). Surrealism remained within the purview of the realism it contested – but also redoubled – through its rupture with the Imaginary. The hyperreal represents a much more advanced stage insofar as it manages to efface even this contradiction between the real and the imaginary. Unreality no longer resides in the dream or fantasy, or in the beyond, but in the *real's hallucinatory resemblance to itself*. To escape the crisis of representation, reality loops around itself in pure repetition, a tendency that was already apparent, before the days of pop art and pictorial neorealism, in the *nouveau roman*. There, the project was already to enclose the real in a vacuum, to extirpate all psychology and subjectivity in order to render a pristine objectivity. In fact, this objectivity was only that of the pure gaze – an objectivity at last liberated from the object, which is no more

than the blind relay of the look that scans it. It attempts a kind of circular seduction in which one can easily mark the unconscious undertaking to become invisible.

This is certainly the impression created by the neonovel: the rage for eliding meaning in a blind and meticulous reality. Both syntax and semantics have disappeared. There is no longer an apparition, but an arraignment of the object, the eager examination of its scattered fragments: neither metaphor nor metonymy, but a successive immanence beneath the police agency of the look. This objective microscopics makes reality swim vertiginously, arousing the dizziness of death within the confines of representation for its own sake. The old illusions of relief, perspective, and spatial and psychological depth linked to the perception of the object give way to an optics functioning on the surface of things, as if the gaze had become the molecular code of the object . . .

A possible definition of the real is: *that for which it is possible to provide an equivalent representation*. This definition is contemporary with science, which postulates a universal system of equivalences (classical representation was not so much a matter of equivalence as of transcription, interpretation, commentary). At the conclusion of this process of reproduction, the real becomes not only that which can be reproduced, but that which is always already reproduced: the hyperreal. But this does not mean that reality and art are in some sense extinguished through total absorption in one another. Hyperrealism is something like their mutual fulfillment and overflowing into one another through an exchange at the level of simulation of their respective foundational privileges and prejudices. Hyperrealism is only beyond representation because it functions entirely within the realm of simulation. There, the whirligig of representation goes made, but with an implosive insanity which, far from being ex-centric, casts longing eyes at the center, toward its own repetition *en abîme*. Like the distancing effect within a dream, which tells one that one is dreaming, but only in behalf of the censor, in order that we continue dreaming, hyperrealism is an integral part of a coded reality, which it perpetuates without modifying.

In fact, we must interpret hyperrealism inversely: today, *reality itself is hyperrealistic*. The secret of surrealism was that the most banal reality could become surreal, but only at privileged moments, which still derived from art and the imaginary. Now the whole of everyday political, social, historical, economic reality is incorporated into the simulative dimension of hyperrealism; we already live out the 'aesthetic' hallucination of reality. The old saying, 'reality is stranger than fiction,' which belonged to the surrealist phase of the aestheticization of life, has been surpassed. There is no longer a fiction that life can confront, even in order to surpass it; reality has passed over into the play of reality, radically disenchanted, the 'cool' cybernetic phase supplanting the 'hot' and phantasmatic . . .

There once existed a specific class of objects that were allegorical, and even a bit diabolical, such as mirrors, images, works of art (and concepts?); of course, these too were simulacra, but they were transparent and manifest . . . they had their own style and characteristic savoir faire. In these objects, pleasure consisted more in discovering something 'natural' in what was artificial and counterfeit. Today, the real and the imaginary are confounded in the same operational totality, and aesthetic fascination is simply everywhere. It involves a kind of subliminal perception, a kind of sixth sense for fakery, montage, scenarios, and the overexposure of reality in the lighting of models. This is no longer a productive space, but a kind of ciphering strip, a coding and

decoding tape, a tape recording magnetized with signs. It is an aesthetic reality, to be sure, but no longer by virtue of art's premeditation and distance, but through a kind of elevation to the second power, via the anticipation and the immanence of the code. An air of nondeliberate parody clings to everything – a tactical simulation – like an undecidable game to which is attached a specifically aesthetic pleasure, the pleasure in reading (*lecture*) and in the rules of the game...

For a long time now art has prefigured this transformation of everyday life. Very quickly, the work of art redoubled itself as a manipulation of the signs of art: this oversignification, or as Lévi-Strauss would call it, this 'academicism of the signifier,' introduced art to the sign form. Thus art entered the phase of its own indefinite *reproduction*; everything that redoubles in itself, even ordinary, everyday reality, falls in the same stroke under the sign of art, and becomes aesthetic. The same goes for production, of which one can say that today it is commencing this aesthetic doubling at the point where, having expelled all content and finality, it becomes, in a way, abstract and nonfigurative. It begins to express the pure form of production; it takes itself, like art, as its own teleological value.

Art and industry can thus exchange signs: art, in order to become a reproductive machine (Andy Warhol), without ceasing to be art, since this machine is only a sign; and production, in order to lose all social purpose and thus to verify and exalt itself at last in the hyperbolic and aesthetic signs of prestige that are the great industrial combines, the 400-meter-high business blocks and the statistical mysteries of the GNP ... In this vertigo of serial signs – shadowless, impossible to sublimate, immanent in their repetition – who can say where the reality of what they simulate resides? Apparently, these signs repress nothing ... even the primary process is abolished. The cool universe of digitality absorbs the worlds of metaphor and of metonymy, and the principle of simulation thus triumphs over both the reality principle and the pleasure principle.

2 Pierre Bourdieu (1930–2002) 'Being Different'

Bourdieu studied philosophy at the École Normale Supérieure before embarking on a career in anthropology and sociology. His early work was in the field of education, studied as a system of social reproduction. Since the 1960s his main focus has been on the cultural field, likewise regarded as a system which functions to reproduce social difference – in the end, that is, inequality – not least through the acquisition and deployment of what Bourdieu terms 'cultural capital'. Bourdieu's intellectual project was to develop a position free from the subjectivism of phenomenology and Existentialism on the one hand, and from the objectivism of Marxism and structuralism on the other. His key concept is that of the cultural *field*. This has been characterized as a form of radical contextualization. In the English-speaking world at least, Bourdieu's wide-ranging social-scientific investigations have been seen as reinforcing the postmodernist opposition to the various kinds of formalist aesthetics which underpinned traditional theories of artistic Modernism. Bourdieu's most influential study in this respect has been *Distinction* (Paris 1979, English translation 1984), in which he investigates the social ground of aesthetic taste, concluding that 'art and cultural consumption are predisposed, consciously and deliberately or not, to fulfil a social function of legitimating social differences.' Our present text is a subsection from a longer essay, 'The Production of Belief: Contribution to an Economy of Symbolic Goods', originally published in

Actes de la recherche en sciences sociales 13, February 1977, pp. 3–43. Though much of Bourdieu's investigation focuses on the literary field, in this brief, relatively self-contained text, he explicitly discusses the functioning of the avant-garde in the field of the 'visual arts'. We have used the translation by Richard Nice, published in *The Field of Cultural Production. Essays on Art and Literature*, edited and introduced by Randal Johnson, Cambridge, Oxford and London: Polity Press, 1993, pp. 106–11.

It is not sufficient to say that the history of the field is the history of the struggle for the monopolistic power to impose the legitimate categories of perception and appreciation. The *struggle itself* creates the history of the field; through the struggle the field is given a temporal dimension. The ageing of authors, works or schools is something quite different from the product of a mechanical slippage into the past. It is the continuous creation of the battle between those who have made their names [*fait date*] and are struggling to stay in view and those who cannot make their own names without relegating to the past the established figures, whose interest lies in freezing the movement of time, fixing the present state of the field for ever. On one side are the dominant figures, who want continuity, identity, reproduction; on the other, the newcomers, who seek discontinuity, rupture, difference, revolution. To 'make one's name' [*faire date*] means making one's *mark*, achieving recognition (in both senses) of one's *difference* from other producers, especially the most consecrated of them; at the same time, it means *creating a new position* beyond the positions presently occupied, *ahead* of them, in the *avant-garde*. To introduce difference is to produce time. Hence the importance, in this struggle for life and survival, of the *distinctive marks* which, at best, aim to identify what are often the most superficial and most visible properties of a set of works or producers. Words – the names of schools or groups, proper names – are so important only because they make things. These distinctive signs produce existence in a world in which the only way to *be* is to be *different*, to 'make one's name', either personally or as a group. The names of the schools or groups which have proliferated in recent painting (pop art, minimal art, process art, land art, body art, conceptive art [*sic*], *arte povera*, Fluxus, new realism, *nouvelle figuration*, support-surface, *art pauvre*, op art, kinetic art, etc.) are pseudo-concepts, *practical* classifying tools which create resemblances and differences by naming them; they are produced in the *struggle for recognition* by the artists themselves or their accredited critics and function as *emblems* which distinguish galleries, groups and artists and therefore the products they make or sell.

As the newcomers come into existence, i.e. accede to legitimate difference, or even, for a certain time, exclusive legitimacy, they necessarily push back into the past the consecrated producers with whom they are compared, 'dating' their products and the taste of those who remain attached to them. Thus the various galleries or publishing houses, like the various artists or writers, are distributed at every moment according to their artistic age, i.e. according to the age of their mode of artistic production and the degree to which this generative scheme, which is also a scheme of perception and appreciation, has been canonized and secularized. The field of the galleries reproduces *in synchrony* the history of artistic movements since the late nineteenth century. Each major gallery was an avant-garde gallery at some time or other, and it is that much more famous and that much more capable of consecrating (or, which amounts to the same thing, sells that much more dearly), the more distant its *floruit*, the more widely known and recognized its 'brand' ('geometrical abstract' or 'American pop') but also the more

it is encapsulated in that 'brand' ('Durand-Ruel, the Impressionist dealer'), in a pseudo-concept which is also a destiny.

At every moment, in whichever field (the field of class struggles, the field of the dominant class, the field of cultural production), the agents and institutions involved in the game are at once contemporaries and out of phase. The field of the present is just another name for the field of struggles (as shown by the fact that an author of the past is present exactly in so far as he or she is at stake) and contemporaneity in the sense of presence in the same present, in the present and presence of others, exists, in practice, only in the struggle which synchronizes discordant times (so that, as I hope to show elsewhere, one of the major effects of great historical crises, of the events which *make history* [*font date*], is that they synchronize the times of fields defined by specific structural durations). But the struggle which *produces* contemporaneity in the form of the confrontation of different times can only take place because the agents and groups it brings together are not present in the same present. One only has to think of a particular field (painting, literature or the theatre) to see that the agents and institutions who clash, objectively at least, through competition and conflict, are separated in time and in terms of time. One group, situated at the vanguard, have no contemporaries with whom they exchange recognition (apart from other avant-garde producers), and therefore no audience, except in the future. The other group, commonly called the 'conservatives', only recognize their contemporaries in the past. The temporal movement resulting from the appearance of a group capable of 'making history' by establishing an advanced position induces a displacement of the structure of the field of the present, i.e. of the chronological hierarchy of the opposing positions in a given field (e.g. pop art, kinetic art and figurative art). Each position is moved down one rung in the chronological hierarchy which is at the same time a social hierarchy. The avant-garde is at every moment separated by an artistic generation (the gap between two modes of artistic production) from the consecrated avant-garde, which is itself separated by another artistic generation from the avant-garde that was already consecrated at the moment it entered the field. This is why, in the space of the artistic field as in social space, distances between styles or lifestyles are never better measured than in terms of time.

The consecrated authors who dominate the field of production also dominate the market; they are not only the most expensive or the most profitable but also the most readable and the most acceptable because they have become part of 'general culture' through a process of familiarization which may or may not have been accompanied by specific teaching. This means that through them, the strategies directed against their domination always additionally hit the distinguished consumers of their distinctive products. To bring a new producer, a new product and a new system of tastes on to the market at a given moment is to push the whole set of producers, products and systems of tastes into the past. The process whereby the field of production becomes a temporal structure also defines the temporal status of taste. Because the different positions in the hierarchical space of the field of production (which can be equally well identified by the names of institutions, galleries, publishers and theatres or by the names of artists or schools) are at the same time tastes in a social hierarchy, every transformation of the structure of the field leads to a displacement of the structure of tastes, i.e. of the system of symbolic distinctions between groups. Oppositions homologous with those existing today between the taste of avant-garde artists, the taste of 'intellectuals', advanced

'bourgeois' taste and provincial 'bourgeois' taste, which find their means of expression on markets symbolized by the Sonnabend, Denise René and Durand-Ruel galleries, would have been able to express themselves equally effectively in 1945, when Denise René represented the avant-garde, or in 1875, when Durand-Ruel was in that position.

This model is particularly relevant nowadays, because owing to the near-perfect unification of the artistic field and its history, each artistic act which 'makes history' by introducing a new position into the field 'displaces' the whole series of previous artistic acts. Because the whole series of pertinent events is practically present in the latest, in the same way that the six digits already dialled on the telephone are contained in the seventh, an aesthetic act is irreducible to any other act in a different place in the series and the series itself tends towards uniqueness and irreversibility. As Marcel Duchamp points out, this explains why *returns* to past styles have never been more frequent than in these times of frenetic pursuit of originality: 'The characteristic of the century now coming to an end is that it is like a double-barrelled gun. Kandinsky and Kupka invented abstraction. Then abstraction died. No one was going to talk about it any more. It came back thirty-five years later with the American abstract expressionists. You could say that cubism reappeared in an impoverished form in the post-war Paris school. Dada came back in the same way. A second shot, second wind. It's a phenomenon typical of this century. You didn't find that in the eighteenth or nineteenth centuries. After the Romantics, came Courbet. And Romanticism never came back. Even the pre-Raphaelites aren't a rehash of the Romantics.'[1]

In fact, these are always *apparent* returns, since they are separated from what they rediscover by a negative reference to something which was itself the negation (of the negation of the negation, etc.) of what they rediscover (when, that is, the intention is not simply of pastiche, a parody which presupposes all the intervening history). In the present stage of the artistic field, there is no room for naïveté, and every act, every gesture, every event, is, as a painter nicely put it, 'a sort of nudge or wink between accomplices'. In and through the games of distinction, these winks and nudges, silent, hidden references to other artists, past or present, confirm a complicity which excludes the layperson, who is always bound to miss what is essential, namely the interrelations and interactions of which the work is only the silent trace. Never has the very structure of the field been present so practically in every act of production.

Never too has the irreducibility of the work of cultural production to the artist's own labour appeared so clearly. The primary reason is that the new definition of the artist and of artistic work brings the artist's work closer to that of the 'intellectual' and makes it more dependent than ever on 'intellectual' commentaries. Whether as critics but also the leaders of a school (e.g. Restany and the new realists), or as fellow-travellers contributing their reflexive discourse to the production of a work which is always in part its own commentary or to reflection of an art which often itself incorporates a reflection on art, intellectuals have never before so directly participated, through their work on art and the artist, in an artistic work which always consists partly of *working on oneself* as an artist. Accompanied by historians writing the chronicles of their discoveries, by philosophers who comment on their 'acts' and who interpret and over-interpret their works, artists can constantly invent the distinguishing strategies on which their artistic survival depends, only by putting into their practice the practical mastery of the objective truth of their practice, thanks to the combination of knowingness and naïveté, calculation and innocence, faith and bad faith that is required by *mandarin games*,

cultivated games with the inherited culture, whose common feature is that they identify 'creation' with the introduction of *deviations* [*écarts*], which only the initiated can perceive, with respect to forms and formulae that are known to all. The emergence of this new definition of the artist and his or her craft cannot be understood independently of the transformations of the artistic field. The constitution of an unprecedented array of institutions for recording, preserving and analysing works (reproductions, catalogues, art journals, museums acquiring the most modern works, etc.), the growth in the personnel employed, full-time or part-time, in the *celebration* of works of art, the increased circulation of works and artists, with great international exhibitions and the increasing number of chains of galleries with branches in many countries – all combine to favour the establishment of an unprecedented relationship between the body of interpreters and the work of art, analogous to that found in the great esoteric traditions; to such an extent that one has to be blind not to see that discourse about a work is not a mere accompaniment, intended to assist its perception and appreciation, but a stage in the production of the work, of its meaning and value. But once again it is sufficient to quote Marcel Duchamp:

Q. But to come back to your ready-mades, I thought that R. Mutt, the signature on *The Fountain*, was the manufacturer's name. But in the article by Rosalind Krauss, I read: 'R. Mutt, a pun on the German, Armut, or poverty'. 'Poverty' would entirely change the meaning of *The Fountain*.

M. D. Rosalind Krauss? The redhead? It isn't that at all. You can deny it. Mutt comes from Mott Works, the name of a big firm that makes sanitary equipment. But Mott was too close, so I made it Mutt, because there was a strip cartoon in the papers in those days, Mutt and Jeff, everybody knew it. So right from the start there was a resonance. Mutt was a fat little guy, and Jeff was tall and thin ... I wanted a different name. And I added Richard ... Richard is a good name for a loo! You see, it's the opposite of poverty ... But not even that, just R. – R. Mutt.

Q. What possible interpretation is there of the *Bicycle Wheel*? Should one see it as the integration of movement into the work of art? Or as a fundamental point of departure, like the Chinese who invented the wheel?

M. D. That machine has no intention, except to get rid of the appearance of a work of art. It was a whim, I didn't call it a work of art. I wanted to throw off the desire to create works of art. Why do works have to be static? The thing – the bicycle wheel – came before the idea. Without any intention of making a song and dance about it, not at all so as to say '*I* did that, and nobody has ever done it before me.' Besides, the originals have never been sold.

Q. What about the geometry book left out in the weather? Can one say that it's the idea of integrating time and space? With a pun on 'géométrie dans l'espace' (solid geometry) and 'temps', the rain and sun that transforms the book?

M. D. No, no more than the idea of integrating movement and sculpture. It was a joke. A pure joke. To denigrate the solemnity of a book of principles.

Here we see, directly exposed, the injection of meaning and value by commentary and commentary on commentary – to which the naïve but knowing exposure of the falsity of the commentary contributes in its turn. The ideology of the inexhaustible work of art, or of 'reading' as re-creation masks – through the quasi-exposure which is

often seen in matters of faith – the fact that the work is indeed made not twice, but a hundred times, by all those who are interested in it, who find a material or symbolic profit in reading it, classifying it, deciphering it, commenting on it, combating it, knowing it, possessing it. Enrichment accompanies ageing when the work manages to enter the game, when it becomes a stake in the game and so incorporates some of the energy produced in the struggle of which it is the object. The struggle, which sends the work into the past, is also what ensures it a form of survival; lifting it from the state of a dead letter, a mere thing subject to the ordinary laws of ageing, the struggle at least ensures it has the sad eternity of academic debate.

1 Interview published in *VH101*, 3, Autumn 1970, pp. 55–61.

3 Craig Owens (1950–1990) from 'The Allegorical Impulse: Towards a Theory of Postmodernism'

With the sudden decline of canonical Modernism in the late 1960s an apparent diversity of art practices emerged on to the international scene; a scene, it should be noted, in which American dominance also came to be challenged for the first time in a generation. Since then various attempts have been made to divine an underlying impulse which can be seen as cohering the apparently heterodox surface appearance of contemporary art. One of the most ambitious readings is Owens's. Following Walter Benjamin and Paul De Man, he notes that Modernist critical theory occludes allegory as a mode of artistic signification. He claims it is the apparent re-emergence of allegorical modes in the period after Modernism which renders that art so different from, indeed incomprehensible to, Modernist criteria of artistic quality. Just as provocatively, Owens also claims to detect allegorical moments in much Modernist practice itself: the implication being that Modernist theory misrepresented its own. The result is a theory of Postmodernist art as an art whose purpose is 'no longer to proclaim its autonomy, its self sufficiency, its transcendence; rather it is to narrate its own contingency, insufficiency and lack of transcendence'. Originally published as a two-part article in *October*, Cambridge, MA, no. 12, Spring 1980, pp. 67–86, and no. 13, Summer 1980, pp. 59–80. Reprinted in Brian Wallis (ed.), *Art After Modernism*, New York and Boston, 1984, pp. 203–35. The present extracts are taken from the first part of the essay.

> Every image of the past that is not recognized by the present as one of its own concerns threatens to disappear irretrievably.
>
> > Walter Benjamin, 'Theses on the Philosophy of History'

[...] To impute an allegorical motive to contemporary art is to venture into proscribed territory, for allegory has been condemned for nearly two centuries as aesthetic aberration, the antithesis of art. In *Aesthetic* Croce refers to it as 'science, or art aping science'; Borges once called it an 'aesthetic error.' Although he surely remains one of the most allegorical of contemporary writers, Borges nevertheless regards allegory as an outmoded, exhausted device, a matter of *historical* but certainly not critical interest. Allegories appear in fact to represent for him the distance between the present and an irrecoverable past:

> I know that at one time the allegorical art was considered quite charming... and is now intolerable. We feel that, besides being intolerable, it is stupid and frivolous.[1] [...]

This statement is doubly paradoxical, for not only does it contradict the allegorical nature of Borges' own fiction, it also denies allegory what is most proper to it: its capacity to rescue from historical oblivion that which threatens to disappear. Allegory first emerged in response to a similar sense of estrangement from tradition; throughout its history it has functioned in the gap between a present and a past which, without allegorical reinterpretation, might have remained foreclosed. A conviction of the remoteness of the past, and a desire to redeem it for the present – these are its two most fundamental impulses. They account for its role in psychoanalytic inquiry, as well as its significance for Walter Benjamin, the only twentieth-century critic to treat the subject without prejudice, philosophically.[2] Yet they fail to explain why allegory's *aesthetic* potential should appear to have been exhausted long ago; nor do they enable us to locate the historical breach at which allegory itself receded into the depths of history.

Inquiry into the origins of the modern attitude toward allegory might appear as 'stupid and frivolous' as its topic were it not for the fact that an unmistakably allegorical impulse has begun to reassert itself in various aspects of contemporary culture: in the Benjamin revival, for example, or in Harold Bloom's *The Anxiety of Influence*. Allegory is also manifest in the historical revivalism that today characterizes architectural practice, and in the revisionist stance of much recent art-historical discourse: T. J. Clark, for example, treating mid-nineteenth-century painting as political 'allegory.' In what follows, I want to focus this reemergence through its impact on both the practice and the criticism of the visual arts. There are, as always, important precedents to be accounted for: Duchamp identified both the 'instantaneous state of Rest' and the 'extra-rapid exposure,' that is, the photographic aspects,[3] of the *Large Glass* as 'allegorical appearance'; *Allegory* is also the title of one of Rauschenberg's most ambitious combine paintings from the fifties. Consideration of such works must be postponed, however, for their importance becomes apparent only after the suppression of allegory by modern theory has been fully acknowledged.

In order to recognize allegory in its contemporary manifestations, we first require a general idea of what in fact it is, or rather what it *represents*, since allegory is an attitude as well as a technique, a perception as well as a procedure. Let us say for the moment that allegory occurs whenever one text is doubled by another; the Old Testament, for example, becomes allegorical when it is read as a prefiguration of the New. This provisional description – which is not a definition – accounts for both allegory's origin in commentary and exegesis, as well as its continued affinity with them: as Northrop Frye indicates, the allegorical work tends to prescribe the direction of its own commentary. It is this metatextual aspect that is invoked whenever allegory is attacked as interpretation merely appended *post facto* to a work, a rhetorical ornament or flourish. Still, as Frye contends, 'genuine allegory is a structural element in literature; it has to be there, and cannot be added by critical interpretation alone.'[4] In allegorical structure, then, one text is *read through* another, however fragmentary, intermittent, or chaotic their relationship may be; the paradigm for the allegorical work is thus the palimpsest. [...]

Conceived in this way, allegory becomes the model of all commentary, all critique, insofar as these are involved in rewriting a primary text in terms of its figural meaning. I am interested, however, in what occurs when this relationship takes place *within* works of art, when it describes their structure. Allegorical imagery is appropriated imagery; the allegorist does not invent images but confiscates them. He lays claim to

the culturally significant, poses as its interpreter. And in his hands the image becomes something other (*allos* = other + *agoreuei* = to speak). He does not restore an original meaning that may have been lost or obscured; allegory is not hermeneutics. Rather, he adds another meaning to the image. If he adds, however, he does so only to replace: the allegorical meaning supplants an antecedent one; it is a supplement. This is why allegory is condemned, but it is also the source of its theoretical significance.

The first link between allegory and contemporary art may now be made: with the appropriation of images that occurs in the works of Troy Brauntuch, Sherrie Levine, Robert Longo, and others – artists who generate images through the reproduction of other images. The appropriated image may be a film still, a photograph, a drawing; it is often itself already a reproduction. However, the manipulations to which these artists subject such images work to empty them of their resonance, their significance, their authoritative claim to meaning. [...] Brauntuch's images simultaneously proffer and defer a promise of meaning; they both solicit and frustrate our desire that the image be directly transparent to its signification. As a result, they appear strangely incomplete – fragments or runes which must be *deciphered*.

Allegory is consistently attracted to the fragmentary, the imperfect, the incomplete – an affinity which finds its most comprehensive expression in the ruin, which Benjamin identified as the allegorical emblem par excellence. Here the works of man are reabsorbed into the landscape; ruins thus stand for history as an irreversible process of dissolution and decay, a progressive distancing from origin. [...]

With the allegorical cult of the ruin, a second link between allegory and contemporary art emerges: in site-specificity, the work which appears to have merged physically into its setting, to be embedded in the place where we encounter it. The site-specific work often aspires to a prehistoric monumentality; Stonehenge and the Nazca lines are taken as prototypes. Its 'content' is frequently mythical, as that of the *Spiral Jetty*, whose form was derived from a local myth of a whirlpool at the bottom of the Great Salt Lake; in this way Smithson exemplifies the tendency to engage in a *reading* of the site, in terms not only of its topographical specifics but also of its psychological resonances. Work and site thus stand in a dialectical relationship. (When the site-specific work is conceived in terms of land reclamation, and installed in an abandoned mine or quarry, then its 'defensively recuperative' motive becomes self-evident.)

Site-specific works are impermanent, installed in particular locations for a limited duration, their impermanence providing the measure of their circumstantiality. Yet they are rarely dismantled but simply abandoned to nature; Smithson consistently acknowledged as part of his works the forces which erode and eventually reclaim them for nature. In this, the site-specific work becomes an emblem of transience, the ephemerality of all phenomena; it is the *memento mori* of the twentieth century. Because of its impermanence, moreover, the work is frequently preserved only in photographs. This fact is crucial, for it suggests the allegorical potential of photography. 'An appreciation of the transience of things, and the concern to rescue them for eternity, is one of the strongest impulses in allegory.'[5] And photography, we might add. As an allegorical art, then, photography would represent our desire to fix the transitory, the ephemeral, in a stable and stabilizing image. In the photographs of Atget and Walker Evans, insofar as they self-consciously preserve that which threatens to disappear, that desire becomes the *subject* of the image. If their photographs are allegorical, however, it

is because what they offer is only a fragment, and thus affirms its own arbitrariness and contingency.

We should therefore also be prepared to encounter an allegorical motive in photomontage, for it is the 'common practice' of allegory 'to pile up fragments ceaselessly, without any strict idea of a goal.'[6] This method of construction led Angus Fletcher to liken allegorical structure to obsessional neurosis;[7] and the obsessiveness of the works of Sol LeWitt, say, or Hanne Darboven suggests that they too may fall within the compass of the allegorical. Here we encounter yet a third link between allegory and contemporary art: in strategies of accumulation, the paratactic work composed by the simple placement of 'one thing after another' – Carl Andre's *Lever* or Trisha Brown's *Primary Accumulation*. One paradigm for the allegorical work is the mathematical progression. [...]

Allegory concerns itself, then, with the projection – either spatial or temporal or both – of structure as sequence; the result, however, is not dynamic, but static, ritualistic, repetitive. It is thus the epitome of counter-narrative, for it arrests narrative in place, substituting a principle of syntagmatic disjunction for one of diegetic combination. In this way allegory superinduces a vertical or paradigmatic reading of correspondences upon a horizontal or syntagmatic chain of events. The work of Andre, Brown, LeWitt, Darboven, and others, involved as it is with the externalization of logical procedure, its projection as a spatiotemporal experience, also solicits treatment in terms of allegory.

This projection of structure as sequence recalls the fact that, in rhetoric, allegory is traditionally defined as a single metaphor introduced in continuous series. If this definition is recast in structuralist terms, then allegory is revealed to be the projection of the metaphoric axis of language onto its metonymic dimension. Roman Jakobson defined this projection of metaphor onto metonymy as the 'poetic function,' and he went on to associate metaphor with poetry and romanticism, and metonymy with prose and realism. Allegory, however, implicates *both* metaphor and metonymy; it therefore tends to 'cut across and subtend all such stylistic categorizations, being equally possible in either verse or prose, and quite capable of transforming the most objective naturalism into the most subjective expressionism, or the most determined realism into the most surrealistically ornamental baroque.'[8] This blatant disregard for aesthetic categories is nowhere more apparent than in the reciprocity which allegory proposes between the visual and the verbal: words are often treated as purely visual phenomena, while visual images are offered as script to be deciphered. [...]

As much as this may recall the linguistic conceits of conceptual artists Robert Barry and Lawrence Weiner, whose work is in fact conceived as large, clear letters on the wall, what it in fact reveals is the essentially pictogrammatical nature of the allegorical work. In allegory, the image is a hieroglyph; an allegory is a rebus – writing composed of concrete images. Thus we should also seek allegory in contemporary works which deliberately follow a discursive model: Rauschenberg's *Rebus*, or Twombly's series after the allegorical poet Edmund Spenser.

This confusion of the verbal and the visual is however but one aspect of allegory's hopeless confusion of all aesthetic mediums and stylistic categories (hopeless, that is, according to any partitioning of the aesthetic field on essentialist grounds). The allegorical work is synthetic; it crosses aesthetic boundaries. This confusion of genres, anticipated by Duchamp, reappears today in hybridization, in eclectic works which ostentatiously combine previously distinct art mediums.

Appropriation, site-specificity, impermanence, accumulation, discursivity, hybrid-ization – these diverse strategies characterize much of the art of the present and distinguish it from its modernist predecessors. They also form a whole when seen in relation to allegory, suggesting that postmodernist art may in fact be identified by a single, coherent impulse, and that criticism will remain incapable of accounting for that impulse as long as it continues to think of allegory as aesthetic error. We are therefore obliged to return to our initial questions: When was allegory first proscribed, and for what reasons?

The critical suppression of allegory is one legacy of romantic art theory that was inherited uncritically by modernism. [...]

In the visual arts, it was in large measure allegory's association with history painting that prepared for its demise. From the Revolution on, it had been enlisted in the service of historicism to produce image upon image of the present *in terms of* the classical past. This relationship was expressed not only superficially, in details of costume and physiognomy, but also structurally through a radical condensation of narrative into a single, emblematic instant – significantly, Barthes calls it a hieroglyph – in which the past, present, and future, that is, the *historical* meaning, of the depicted action might be read. This is of course the doctrine of the most pregnant moment, and it dominated artistic practice during the first half of the nineteenth century. Syntagmatic or narrative associations were compressed in order to compel a vertical reading of (allegorical) correspondences. Events were thus lifted out of a continuum; as a result, history could be recovered only through what Benjamin has called 'a tiger's leap into the past':

> Thus to Robespierre ancient Rome was a past charged with the time of the now which he blasted out of the continuum of history. The French Revolution viewed itself as Rome reincarnate. It evoked ancient Rome the way fashion evokes costumes of the past. Fashion has a flair for the topical, no matter where it stirs in the thickets of long ago; it is a tiger's leap into the past.[9]

Although for Baudelaire this allegorical interpenetration of modernity and classical antiquity possessed no small theoretical significance, the attitude of the avant-garde which emerged at mid-century into an atmosphere rife with historicism was succinctly expressed by Proudhon, writing of David's *Leonidas at Thermopylae*:

> Shall one say ... that it is neither Leonidas and the Spartans, nor the Greeks and Persians who one should see in this great composition; that it is the enthusiasm of '92 which the painter had in view and Republican France saved from the Coalition? But why this allegory? What need to pass through Thermopylae and go backward twenty-three centur-ies to reach the heart of Frenchmen? Had we no heroes, no victories of our own?[10]

So that by the time Courbet attempted to rescue allegory for modernity, the line which separated them had been clearly drawn, and allegory, conceived as antithetical to the modernist credo *Il faut être de son temps*, was condemned, along with history painting, to a marginal, purely historical existence.

Baudelaire, however, with whom that motto is most closely associated, never con-demned allegory; in his first published work, the *Salon of 1845*, he defended it against the 'pundits of the press': 'How could one hope ... to make them understand that allegory is one of the noblest branches of art?'[11] The poet's endorsement of allegory is only

apparently paradoxical, for it was the relationship of antiquity to modernity that provided the basis for his theory of modern art, and allegory that provided its form. [...] If the modern artist was exhorted to concentrate on the ephemeral, however, it was *because* it was ephemeral, that is, it threatened to disappear without a trace. Baudelaire conceived modern art, at least in part, as the rescuing of modernity for eternity. [...]

Benjamin's primary insight – 'Baudelaire's genius, which drew its nourishment from melancholy, was an allegorical one'[12] – effectively situates an allegorical impulse at the origin of modernism in the arts and thus suggests the previously foreclosed possibility of an alternate reading of modernist works, a reading in which their allegorical dimension would be fully acknowledged. Manet's manipulation of historical sources, for example, is inconceivable without allegory; was it not a supremely allegorical gesture to reproduce in 1871 the *Dead Toreador* as a wounded Communard, or to transpose the firing squad from the *Execution of Maximilian* to the Paris barricades? And does not collage, or the manipulation and consequent transformation of highly significant fragments, also exploit the atomizing, disjunctive principle which lies at the heart of allegory? These examples suggest that, in practice at least, modernism and allegory are *not* antithetical, that it is in theory alone that the allegorical impulse has been repressed. It is thus to theory that we must turn if we are to grasp the full implications of allegory's recent return.

Near the beginning of 'The Origin of the Work of Art,' Heidegger introduces two terms which define the 'conceptual frame' within which the work of art is conventionally located by aesthetic thought:

> The art work is, to be sure, a thing that is made, but it says something other than the mere thing itself is, *allo agoreuei*. The work makes public something other than itself; it manifests something other; it is an allegory. In the work of art something other is brought together with the thing that is made. To bring together is, in Greek, *sumballein*. The work is a symbol.[13]

By imputing an allegorical dimension to every work of art, the philosopher appears to repeat the error, regularly lamented by commentators, of generalizing the term *allegory* to such an extent that it becomes meaningless. Yet in this passage Heidegger is reciting the litanies of philosophical aesthetics only in order to prepare for their dissolution. The point is ironic, and it should be remembered that irony itself is regularly enlisted as a variant of the allegorical; that words can be used to signify their opposites is in itself a fundamentally allegorical perception.

Allegory and symbol – like all conceptual pairs, the two are far from evenly matched. In modern aesthetics, allegory is regularly subordinated to the symbol, which represents the supposedly indissoluble unity of form and substance which characterizes the work of art as pure presence. Although this definition of the art work as informed matter is, we know, as old as aesthetics itself, it was revived with a sense of renewed urgency by romantic art theory, where it provided the basis for the philosophical condemnation of allegory. According to Coleridge, 'The Symbolical cannot, perhaps, be better defined in distinction from the Allegorical, than that it is always itself *a part of* that, of the whole of which it is the representative.'[14] The symbol is a synecdoche, a part representing the whole. [...]

Coleridge's is thus an expressive theory of the symbol, the presentational union of 'inner essence' and outward expression, which are in fact revealed to be identical. For essence is nothing but that element of the whole which has been hypostasized as its essence. The theory of expression thus proceeds in a circle: while designed to explain the effectivity of the whole on its constituent elements, it is nevertheless those elements themselves which react upon the whole, permitting us to conceive the latter in terms of its 'essence.' In Coleridge, then, the symbol is precisely that part of the whole to which it may be reduced. The symbol does not represent essence; it *is* essence.

On the basis of this identification, the symbol becomes the very emblem of artistic *intuition*: 'Of utmost importance to our present subject is this point, that the latter (the allegory) cannot be other than spoken consciously; whereas in the former (the symbol) it is very possible that the general truth represented may be working unconsciously in the writer's mind during the construction of the symbol.'[15] The symbol is thus a motivated sign; in fact, it represents linguistic motivation as such. For this reason Saussure substituted the term *sign* for *symbol*, for the latter is 'never wholly arbitrary; it is not empty, for there is the rudiment of a natural bond between the signifier and the signified.'[16] If the symbol is a motivated sign, then allegory, conceived as its antithesis, will be identified as the domain of the arbitrary, the conventional, the unmotivated.

This association of the symbol with aesthetic intuition, and allegory with convention, was inherited uncritically by modern aesthetics; thus Croce in *Aesthetic*:

> Now if the symbol be conceived as inseparable from the artistic intuition, it is a synonym for the intuition itself, which always has an ideal character. There is no double bottom to art, but one only; in art all is symbolical because all is ideal. But if the symbol be conceived as separable – if the symbol can be on one side, and on the other the thing symbolized, we fall back into the intellectualist error: the so-called symbol is the exposition of an abstract concept, an allegory; it is science, or art aping science. But we must also be just towards the allegorical. Sometimes it is altogether harmless. Given the *Gerusalemme liberata*, the allegory was imagined afterwards; given the *Adone of Marino*, the poet of the lascivious afterwards insinuated that it was written to show how 'immoderate indulgence ends in pain'; given a statue of a beautiful woman, the sculptor can attach a label to the statue saying that it represents *Clemency* or *Goodness*. This allegory that arrives attached to a finished work post festum does not change the work of art. What is it then? It is an expression externally added to another expression.[17]

In the name of 'justice,' then, and in order to preserve the intuitive character of every work of art, including the allegorical, allegory is conceived as a *supplement*, 'an expression externally added to another expression.' Here we recognize that permanent strategy of Western art theory which excludes from the work everything which challenges its determination as the unity of 'form' and 'content.' Conceived as something added or superadded to the work after the fact, allegory will consequently be detachable from it. In this way modernism can recuperate allegorical works for itself, on the condition that what makes them allegorical be overlooked or ignored. Allegorical meaning does indeed appear supplementary; we can appreciate Bellini's *Allegory of Fortune*, for example, or read *Pilgrim's Progress* as Coleridge recommended, without regard for their iconographic significance. Rosemond Tuve describes the viewer's 'experience of a genre-picture – or so he had thought it – turning into . . . [an] allegory before his eyes, by something he learns (usually about the history and thence the deeper

significance of the image).'[18] Allegory *is* extravagant, an expenditure of surplus value; it is always *in excess*. Croce found it 'monstrous' precisely because it encodes two contents within one form. Still, the allegorical supplement is not only an addition, but also a replacement. It takes the place of an earlier meaning, which is thereby either effaced or obscured. Because allegory usurps its object it comports within itself a danger, the possibility of perversion: that what is 'merely appended' to the work of art be mistaken for its 'essence.' Hence the vehemence with which modern aesthetics – formalist aesthetics in particular – rails against the allegorical supplement, for it challenges the security of the foundations upon which aesthetics is erected. [. . .]

[1] Jorge Luis Borges, 'From Allegories to Novels,' in *Other Inquisitions, 1937–1952*. trans. Ruth L. C. Simms, Austin, Texas, 1964, pp. 155–6.

[2] On allegory and psychoanalysis, see Joel Fineman, 'The Structure of Allegorical Desire,' *October*, no. 12, Spring 1980, pp. 47–66. Benjamin's observations on allegory are to be found in the concluding chapter of *The Origin of German Tragic Drama*, trans. John Osborne (London, 1977).

[3] See Rosalind Krauss, 'Notes on the Index: Seventies Art in America,' *October*, no. 3, Spring 1977, pp. 68–81.

[4] Northrop Frye, *Anatomy of Criticism*, Princeton, NJ, 1957, p. 54.

[5] Benjamin, op. cit., p. 223

[6] Ibid., p. 178.

[7] Angus Fletcher, *Allegory: The Theory of a Symbolic Mode*, Ithaca, NY, 1964, pp. 279–303.

[8] Fineman, 'Allegorical Desire,' p. 51.

[9] Walter Benjamin, 'Theses on the Philosophy of History,' in *Illuminations*, trans. Harry Zohn, New York, 1969, p. 255.

[10] Quoted in George Boas, 'Courbet and His Critics,' in *Courbet in Perspective*, ed. Petra ten-Doesschate Chu (Englewood Cliffs, NJ, 1977, p. 48.

[11] Charles Baudelaire, 'Salon of 1845' in *Art in Paris 1845–1862*, ed. and trans. Jonathan Mayne, New York, 1965, p. 14.

[12] Walter Benjamin, 'Paris – the Capital of the Nineteenth Century,' trans. Quintin Hoare, in *Charles Baudelaire*, p. 170.

[13] Martin Heidegger, 'The Origin of the Work of Art,' *Poetry, Language, Thought*, trans. Albert Hofstadter, New York, pp. 19–20.

[14] Samuel Taylor Coleridge, *Coleridge's Miscellaneous Criticism*, ed. Thomas Middleton Raysor, Cambridge, Mass., 1936 p. 99 (italics added).

[15] Coleridge, *Miscellaneous Criticism*, p. 99. This passage should be compared with Goethe's famous condemnation of allegory: 'It makes a great difference whether the poet starts with a universal idea and then looks for suitable particulars, or beholds the universal *in* the particular. The former method products allegory, where the particular has status merely as an instance, an example of the universal. The latter, by contrast, is what reveals poetry in its true nature: it speaks forth a particular without independently thinking of or referring to a universal, but in grasping the particular in its living character *it implicity apprehends the universal along with it*.' Quoted in Philip Wheelwright, *The Burning Fountain*, Bloomington, Indiana, 1968, p. 89 (italics added).

[16] Ferdinand de Saussure, *Course in General Linguistics*, trans. Wade Baskin, New York, 1966, p. 68.

[17] Benedetto Croce, *Aesthetic*, trans. Douglas Ainslie, New York, 1966, pp. 34–35.

[18] Rosemond Tuve, *Allegorical Imagery: Some Medieval Books and their Posterity*, Princeton, NJ, 1966, p. 26.

4 Rosalind Krauss (b. 1940) from 'The Originality of the Avant-Garde'

For earlier examples of Krauss's critical writing, tracing her move away from Modernism to an articulated sense of artistic Postmodernism, see VIID8 and 12. One of the foundation

stones of the edifice of Modernism had been the impulse to originality. Structuralism, and later influential conceptions linked to Poststructuralism, such as Baudrillard's 'simulacrum', now gave rise to profound scepticism about this; indeed to viewing the originality-claim in tandem with its partner, the protean, creative Author, as an ideological symptom, rather than an unchallengeable axiom. Originally published in *October*, no. 18, Cambridge, MA, Fall 1981. Reprinted in Krauss, *The Originality of the Avant-Garde and Other Modernist Myths*, Cambridge, MA, and London, 1986, pp. 151–70, from which the present extracts are taken.

[. . .] The avant-garde artist has worn many guises over the first hundred years of his existence: revolutionary, dandy, anarchist, aesthete, technologist, mystic. He has also preached a variety of creeds. One thing only seems to hold fairly constant in the vanguardist discourse and that is the theme of originality. By originality, here, I mean more than just the kind of revolt against tradition that echoes in Ezra Pound's 'Make it new!' or sounds in the futurists' promise to destroy the museums that cover Italy as though 'with countless cemeteries.' More than a rejection or dissolution of the past, avant-garde originality is conceived as a literal origin, a beginning from ground zero, a birth. Marinetti, thrown from his automobile one evening in 1909 into a factory ditch filled with water, emerges as if from amniotic fluid to be born – without ancestors – a futurist. This parable of absolute self-creation that begins the first *Futurist Manifesto* functions as a model for what is meant by originality among the early twentieth-century avant-garde. For originality becomes an organicist metaphor referring not so much to formal invention as to sources of life. The self as origin is safe from contamination by tradition because it possesses a kind of originary naiveté. Hence Brancusi's dictum, 'When we are no longer children, we are already dead.' Or again, the self as origin has the potential for continual acts of regeneration, a perpetuation of self-birth. Hence Malevich's pronouncement. 'Only he is alive who rejects his convictions of yesterday.' The self as origin is the way an absolute distinction can be made between a present experienced *de novo* and a tradition-laden past. The claims of the avant-garde are precisely these claims to originality.

Now, if the very notion of the avant-garde can be seen as a function of the discourse of originality, the actual practice of vanguard art tends to reveal that 'originality' is a working assumption that itself emerges from a ground of repetition and recurrence. One figure, drawn from avant-garde practice in the visual arts, provides an example. This figure is the grid.

Aside from its near uniquity in the work of those artists who thought of themselves as avant-garde – their numbers include Malevich as well as Mondrian, Léger as well as Picasso, Schwitters, Cornell, Reinhardt and Johns as well as Andre, LeWitt, Hesse, and Ryman – the grid possesses several structural properties which make it inherently susceptible to vanguard appropriation. One of these is the grid's imperviousness to language. 'Silence, exile, and cunning,' were Stephen Dedalus's passwords: commands that in Paul Goodman's view express the self-imposed code of the avant-garde artist. The grid promotes this silence, expressing it moreover as a refusal of speech. The absolute stasis of the grid, its lack of hierarchy, of center, of inflection, emphasizes not only its anti-referential character, but – more importantly – its hostility to narrative. This structure, impervious both to time and to incident, will not permit the projection of language into the domain of the visual, and the result is silence.

This silence is not due simply to the extreme effectiveness of the grid as a barricade against speech, but to the protectiveness of its mesh against all intrusions from outside. No echoes of footsteps in empty rooms, no scream of birds across open skies, no rush of distant water – for the grid has collapsed the spatiality of nature onto the bounded surface of a purely cultural object. With its proscription of nature as well as of speech, the result is still more silence. And in this new-found quiet, what many artists thought they could hear was the beginning, the origins of Art.

For those for whom art begins in a kind of originary purity, the grid was emblematic of the sheer disinterestedness of the work of art, its absolute purposelessness, from which it derived the promise of its autonomy. We hear this sense of the originary essence of art when Schwitters insists, 'Art is a primordial concept, exalted as the godhead, inexplicable as life, indefinable and without purpose.' And the grid facilitated this sense of being born into the newly evacuated space of an aesthetic purity and freedom.

While for those for whom the origins of art are not to be found in the idea of pure disinterest so much as in an empirically grounded unity, the grid's power lies in its capacity to figure forth the material ground of the pictorial object, simultaneously inscribing and depicting it, so that the image of the pictorial surface can be seen to be born out of the organization of pictorial matter. For these artists, the grid-scored surface is the image of an absolute beginning.

Perhaps it is because of this sense of a beginning, a fresh start, a ground zero, that artist after artist has taken up the grid as the medium within which to work, always taking it up as though he were just discovering it, as though the origin he had found by peeling back layer after layer of representation to come at last to this schematized reduction, this graph-paper ground, were *his* origin, and his finding it an act of originality. Waves of abstract artists 'discover' the grid; part of its structure one could say is that in its revelatory character it is always a new, a unique discovery.

And just as the grid is a stereotype that is constantly being paradoxically rediscovered, it is, as a further paradox, a prison in which the caged artist feels at liberty. For what is striking about the grid is that while it is most effective as a badge of freedom, it is extremely restrictive in the actual exercise of freedom. Without doubt the most formulaic construction that could possibly be mapped on a plane surface, the grid is also highly inflexible. Thus just as no one could claim to have invented it, so once one is involved in deploying it, the grid is extremely difficult to use in the service of invention. And thus when we examine the careers of those artists who have been most committed to the grid, we could say that from the time they submit themselves to this structure their work virtually ceases to develop and becomes involved, instead, in repetition. Exemplary artists in this respect are Mondrian, Albers, Reinhardt, and Agnes Martin.

But in saying that the grid condemns these artists not to originality but to repetition, I am not suggesting a negative description of their work. I am trying instead to focus on a pair of terms – originality and repetition – and to look at their coupling unprejudicially; for within the instance we are examining, these two terms seem bound together in a kind of aesthetic economy, interdependent and mutually sustaining, although the one – originality – is the valorized term and the other – repetition or copy or reduplication – is discredited.

We have already seen that the avant-garde artist above all claims originality as his right – his birthright, so to speak. With his own self as the origin of his work, that production will have the same uniqueness as he; the condition of his own singularity

will guarantee the originality of what he makes. Having given himself this warrant, he goes on, in the example we are looking at, to enact his originality in the creation of grids. Yet as we have seen, not only is he – artist *x*, *y*, or *z* – *not* the inventor of the grid, but *no one* can claim this patent: the copyright expired sometime in antiquity and for many centuries this figure has been in the public domain.

Structurally, logically, axiomatically, the grid *can only be repeated*. And, with an act of repetition or replication as the 'original' occasion of its usage within the experience of a given artist, the extended life of the grid in the unfolding progression of his work will be one of still more repetition, as the artist engages in repeated acts of self-imitation. That so many generations of twentieth-century artists should have maneuvered themselves into this particular position of paradox – where they are condemned to repeating, as if by compulsion, the logically fraudulent original – is truly compelling.

But it is no more compelling than that other, complementary fiction: the illusion not of the originality of the artist, but of the originary status of the pictorial surface. This origin is what the genius of the grid is supposed to manifest to us as viewers: an indisputable zero-ground beyond which there is no further model, or referent, or text. Except that this experience of originariness, felt by generations of artists, critics, and viewers is itself false, a fiction. The canvas surface and the grid that scores it do not fuse into that absolute unity necessary to the notion of an origin. For the grid *follows* the canvas surface, doubles it. It is a representation of the surface, mapped, it is true, onto the same surface it represents, but even so, the grid remains a figure, picturing various aspects of the 'originary' object: through its mesh it creates an image of the woven infrastructure of the canvas; through its network of coordinates it organizes a metaphor for the plane geometry of the field: through its repetition it configures the spread of lateral continuity. The grid thus does not reveal the surface, laying it bare at last; rather it veils it through a repetition.

As I have said, this repetition performed by the grid must follow, or come after, the actual, empirical surface of a given painting. The representational text of the grid however also precedes the surface, comes *before* it, preventing even that literal surface from being anything like an origin. For behind it, logically prior to it, are all those visual texts through which the bounded plane was collectively organized as a pictorial field. The grid summarizes all these texts: the gridded overlays on cartoons, for example, used for the mechanical transfer from drawing to fresco; or the perspective lattice meant to contain the perceptual transfer from three dimensions to two; or the matrix on which to chart harmonic relationships, like proportion; or the millions of acts of enframing by which the picture was reaffirmed as a regular quadrilateral. All these are the texts which the 'original' ground plane of a Mondrian, for example, repeats – and, by repeating, represents. Thus the very ground that the grid is thought to reveal is already riven from within by a process of repetition and representation; it is always already divided and multiple.

What I have been calling the fiction of the originary status of the picture surface is what art criticism proudly names the opacity of the modernist picture plane, only in so terming it, the critic does not think of this opacity as fictitious. Within the discursive space of modernist art, the putative opacity of the pictorial field must be maintained as a fundamental concept. For it is the bedrock on which a whole structure of related terms can be built. All those terms – singularity, authenticity, uniqueness, originality, original – depend on the originary moment of which this surface is both the empirical

and the semiological instance. If modernism's domain of pleasure is the space of auto-referentiality, this pleasure dome is erected on the semiological possibility of the pictorial sign as nonrepresentational and nontransparent, so that the signified becomes the redundant condition of a reified signifier. But from *our* perspective, the one from which we see that the signifier cannot be reified; that its objecthood, its quiddity, is only a fiction; that every signifier is itself the transparent signified of an already-given decision to carve it out as the vehicle of a sign – from *this* perspective there is no opacity, but only a transparency that opens onto a dizzying fall into a bottomless system of reduplication.

This is the perspective from which the grid that signifies the pictorial surface, by representing it, only succeeds in locating the signifier of another, prior system of grids, which have beyond them, yet another, even earlier system. This is the perspective in which the modernist grid is . . . logically multiple: a system of reproductions without an original. This is the perspective from which the real condition of one of the major vehicles of modernist aesthetic practice is seen to derive not from the valorized term of that couple which I invoked earlier – the doublet, *originality repetition* – but from the discredited half of the pair, the one that opposes the multiple to the singular, the reproducible to the unique, the fraudulent to the authentic, the copy to the original. But this is the negative half of the set of terms that the critical practice of modernism seeks to repress, *has* repressed.

From this perspective we can see that modernism and the avant-garde are functions of what we could call the discourse of originality, and that that discourse serves much wider interests – and is thus fueled by more diverse institutions – than the restricted circle of professional art-making. The theme of originality, encompassing as it does the notions of authenticity, originals, and origins, is the shared discursive practice of the museum, the historian, and the maker of art. [. . .]

* * *

What would it look like not to repress the concept of the copy? What would it look like to produce a work that acted out the discourse of reproductions without originals, that discourse which could only operate in Mondrian's work as the inevitable subversion of his purpose, the residue of representationality that he could not sufficiently purge from the domain of his painting? The answer to this, or at least one answer, is that it would look like a certain kind of play with the notions of photographic reproduction that begins in the silkscreen canvases of Robert Rauschenberg and has recently flowered in the work of a group of younger artists whose production has been identified by the critical term *pictures*. I will focus on the example of Sherrie Levine, because it seems most radically to question the concept of origin and with it the notion of originality.

Levine's medium is the pirated print, as in the series of photographs she made by taking images by Edward Weston of his young son Neil and simply rephotographing them, in violation of Weston's copyright. But as has been pointed out about Weston's 'originals,' these are already taken from models provided by others; they are given in that long series of Greek kouroi by which the nude male torso has long ago been processed and multiplied within our culture. Levine's act of theft, which takes place, so to speak, in front of the surface of Weston's print, opens the print from behind to the series of models from which it, in turn, has stolen, of which it is itself the reproduction. The discourse of the copy, within which Levine's act must be located has, of course, been developed by a variety of writers, among them Roland Barthes. I am thinking of his characterization, in

S/Z, of the realist as certainly not a copyist from nature, but rather a 'pasticher,' or someone who makes copies of copies. As Barthes says:

> To depict is to . . . refer not from a language to a referent, but from one code to another. Thus realism consists not in copying the real but in copying a (depicted) copy . . . Through secondary mimesis [realism] copies what is already a copy.[1]

In another series by Levine in which the lush, colored landscapes of Eliot Porter are reproduced, we again move through the 'original' print, back to the origin in nature and – as in the model of the picturesque – through another trap door at the back wall of 'nature' into the purely textual construction of the sublime and its history of degeneration into ever more lurid copies.

Now, insofar as Levine's work explicitly deconstructs the modernist notion of origin, her effort cannot be seen as an *extension* of modernism. It is, like the discourse of the copy, postmodernist. Which means that it cannot be seen as avant-garde either.

Because of the critical attack it launches on the tradition that precedes it, we might want to see the move made in Levine's work as yet another step in the forward march of the avant-garde. But this would be mistaken. In deconstructing the sister notions of origin and originality, postmodernism establishes a schism between itself and the conceptual domain of the avant-garde, looking back at it from across a gulf that in turn establishes a historical divide. The historical period that the avant-garde shared with modernism is over. That seems an obvious fact. What makes it more than a journalistic one is a conception of the discourse that has brought it to a close. This is a complex of cultural practices, among them a demythologizing criticism and a truly postmodernist art, both of them acting now to void the basic propositions of modernism, to liquidate them by exposing their fictitious condition. It is thus from a strange new perspective that we look back on the modernist origin and watch it splintering into endless replication.

[1] Roland Barthes, *S/Z*, trans. Richard Ritter, New York, 1974, p. 55.

5 Hal Foster (b. 1955) from 'Subversive Signs'

A contributor to the journal *Art in America* in the early 1980s, Foster became one of the most prominent of a new generation of American critics active in the wake of Modernism. In particular he edited the collection of essays published in America in 1983 as *The Anti-Aesthetic*, and in Britain in 1985 as *Post Modern Culture*. In his introduction to that book Foster identified two types of Postmodernism: a Postmodernism of complicity in contemporary capitalism, and a Postmodernism of resistance to it. It is with the latter that he has identified his own critical practice. The present essay was included in his collection *Recodings: Art, Spectacle, Cultural Politics*, Seattle, 1985; the present extract is taken from pp. 99–100 of that edition. An earlier version had appeared in *Art in America*, November 1982, pp. 88–93.

A writer – by which I mean not the possessor of a function or the servant of an art, but the subject of a praxis – must have the persistence of the watcher who

stands at the crossroads of all other discourses (*trivialis* is the etymological attribute of the prostitute who waits at the intersection of three roads).

Roland Barthes, '*Leçon*'

The most provocative American art of the present is situated at such a crossing – of institutions of art and political economy, of representations of sexual identity and social life. More, it assumes its purpose to be so sited, to lay in wait for these discourses so as to riddle and expose them or to seduce and lead them astray. Its primary concern is not with the traditional or modernist proprieties of art – with refinement of style or innovation of form, æsthetic sublimity or ontological reflection on art as such. And though it is aligned with the critique of the institution of art based on the presentational strategies of the Duchampian readymade, it is not involved, as its minimalist antecedents were, with an epistemological investigation of the object or a phenomenological inquiry into subjective response. In short, this work does not bracket art for formal or perceptual experiment but rather seeks out its affiliations with other practices (in the culture industry and elsewhere); it also tends to conceive of its subject differently.

The artists active in this work (Martha Rosler, Sherrie Levine, Dara Birnbaum, Barbara Kruger, Louise Lawler, Allan McCollum, Jenny Holzer, Krzysztof Wodiczko . . .) use many different forms of production and modes of address (photo-text collage, constructed or projected photographs, videotapes, critical texts, appropriated, arranged or surrogate art works, etc.), and yet they are alike in this: each treats the public space, social representation or artistic language in which he or she intervenes as both a target and a weapon. This shift in practice entails a shift in position: the artist becomes a manipulator of signs more than a producer of art objects, and the viewer an active reader of messages rather than a passive contemplator of the æsthetic or consumer of the spectacular. This shift is not new – indeed, the recapitulation in this work of the 'allegorical procedures' of the readymade, (dadaist) photomontage and (pop) appropriation is significant – yet it remains strategic if only because even today few are able to accept the status of art as a social sign entangled with other signs in systems productive of value, power and prestige.

The situational æsthetics of this art – its special attention to site, address and audience – is prepared by the varied institutional critique of such artists as Daniel Buren, Michael Asher, Dan Graham, Hans Haacke, Marcel Broodthaers, Lawrence Weiner, John Baldessari and Joseph Kosuth. Yet if Kruger, Holzer et al. inherit the conceptual critique of the given parameters of art production and reception, they do so not uncritically. For just as the conceptual artists extended the minimalist analysis of the art object, so too these later artists have opened up the conceptual critique of the art institution in order to intervene in ideological representations and languages of everyday life. [. . .]

6 Sherrie Levine (b. 1947) Statement

Levine's early work was formed under the legacy of American West-Coast Conceptual Art, and by the now ubiquitous experience of learning about art primarily through photographic reproductions. That work consisted of the appropriation of images by canonical male artists, often in the form of photographs taken from plates in art books devoted to the

Modernist tradition. In this way she raised issues of plagiarism and property rights, which lurk in the margins of art's exchange value. Levine's present Statement itself mimics her strategy of appropriation. Commencing with a citation from the Expressionist painter Franz Marc (some of whose animal pictures she had also photographically appropriated), she ends her Statement with a variation on the oft-quoted conclusion from Roland Barthes's seminal essay, 'The Death of the Author': 'The birth of the reader must be at the cost of the death of the author.' Levine's statement was first published in the magazine *Style*, Vancouver, March 1982, p. 48, which formed the catalogue of the exhibition 'Mannerism: A Theory of Culture', Vancouver Art Gallery, March–April 1982.

The world is filled to suffocating. Man has placed his token on every stone. Every word, every image, is leased and mortgaged. We know that a picture is but a space in which a variety of images, none of them original, blend and clash. A picture is a tissue of quotations drawn from the innumerable centers of culture. Similar to those eternal copyists Bouvard and Pécuchet, we indicate the profound ridiculousness that is precisely the truth of painting. We can only imitate a gesture that is always anterior, never original. Succeeding the painter, the plagiarist no longer bears within him passions, humours, feelings, impressions, but rather this immense encyclopedia from which he draws. The viewer is the tablet on which all the quotations that make up a painting are inscribed without any of them being lost. A painting's meaning lies not in its origin, but in its destination. The birth of the viewer must be at the cost of the painter.

7 Art & Language (Michael Baldwin b. 1945, Mel Ramsden b. 1944, Charles Harrison b. 1942) 'Letter to a Canadian Curator'

This letter concerns the conditions of production of Art & Language's *Portraits of V. I. Lenin in the Style of Jackson Pollock* of 1979–80. In the search for methodological materials with which to describe these conditions, reference is made to an essay by T. J. Clark, 'Preliminaries to a Possible Treatment of *Olympia* in 1865' (*Screen*, vol. 21, no. 1, London, Spring 1980, pp. 18–41), and to the discussion of 'Hysteria as Communication' in Thomas Szasz, *The Myth of Mental Illness* (London and New York, 1961, pp. 133–43). The letter was written in January 1982 to accompany a showing of paintings from the 'Lenin/Pollock' series in the exhibition 'Mannerism: A Theory of Culture' at the Vancouver Art Gallery, 27 March–25 April 1982, and was originally addressed to Jo-Anne Birnie Danzker, curator of the exhibition. It was first published under the heading 'Correspondence' in *Style*, Vancouver, March 1982, pp. 11–12; reprinted as 'Letter to a Canadian Curator' in *Art-Language*, vol. 5, no. 1, Banbury, October 1982, pp. 32–5, from which the present text is taken. (See also VIIB1 and 5, VIIC14.)

[...] Mannerism is a propitious theme. Indeed, it seems to us sometimes that we are working at (and with) the margins of an extravagant Mannerist pantomime. It is tempting, perhaps too tempting, to look for analogies with late Renaissance Mannerism. E. H. Gombrich has pointed out in his essay 'The Renaissance Conception of Artistic Progress and its Consequences' that 'mannerism comes to its climax at the moment when the inherent ambiguities of the renaissance idea of artistic progress become apparent'. Looking at the historiographically stable Modernism of the Sixties and early Seventies, the apparent mannerism of today seems

causally dependent upon the contradictions in 'mainstream' Modernism. Punk-art, artistic Rocking, 'bad painting', right-wing enthusiasm for 50s' epigones create hiatuses for differentiation and identification. These are frequently vague and fugitive. There is little in the way of stability in interests and conventions to enable a clear differentiation of the *symptoms* of decadence and ruin from critical activity in respect of decadence and ruin. We are all stalked by decadence. It is the cultural material we have to work with.

There has been a lot of naively revisionist 'instability' noticeable in the art-world recently. New Wave 'Americans', young 'Italians' and Born Again 'German' Neoexpressionists have moved in to occupy a territory formerly held by the cosmopolitan and progressively secure artists of the Sixties and Seventies. Many of the latter have rightly pointed to the Natopolitan interests of 'new' Euro-art and to the axis of dealer interests lying behind this art. What has not been noted is that its discourses are hysterical.

Hysteria is a psychiatric syndrome. People are reduced to it when the idioms of conversation fail. In art's first world, conversation has failed in a collapse of differential semantics. A sense of hysteria can also be traced to the apparently relentless appetite of the art-world's bureaucracy. It is staffed by individuals who know that the prestige and power of their profession can be inflated according to their defining with ever increasing zeal more and more products as falling within their domain of legitimation. In international relations, this is called Imperialism. As critics, curators and middle-men of every variety neglect method, explanation and causal determinations to promote and manage their client discoveries, as discourse vanishes beneath administrative perks and privileges, as the little inventories of cultural tourism proliferate the necessities of parapractical obloquy emerge and that which is serious or historically vivid must manifest itself in a masque or travesty of the indolent and fraudulent – in double meaning, displacement, irony, mendacity, absurdity – in a debacle of fugitive and often demented themes.

It may be that we are indeed engaged in a kind of mannerism, in 'works that seem to tremble on the brink of one commitment or another' and which present formidable difficulties in respect of historical codification and classification. If there is a psychologically unifying thread throughout this work it appears to be locatable in concepts like hinting, parody, travesty, alluding, bluffing, forgery, double-talk etc. These are not conducive to stability within the rationalising apparatus of curatorial control. Tim Clark, in his article on Manet's 'Olympia', . . . stumbles across some of these problems of differentiation and identification. Speaking of 'Olympia' he says 'it is an open question whether what we are studying here is an instance of subversive refusal of established codes or of simple ineffectiveness.' The resolution of this 'open question' will always be compromised, partial. It ends, in fact, in a hiatus. The difference between expressionist fervour and mere incompetence, insularity and particularity, ineffectiveness and subversion is a difference resolvable in circumstances of concrete contingency, not in the security of a proprietorial and managerial overview. Within the hiatus of undecidability may lie a half-life for contemporary cultural production.

Without wishing to overcook an analogy, it is of interest that Thomas Szasz has suggested that it is difficult to distinguish between 'genuine' hysteria and malingering. For the psychiatrist, the nub of this difficulty is the failure to distinguish between the ambiguous message as object or representation. Between 'hysteria', 'impersonation of

hysteria', 'explicit' or 'inexplicit' malingering there lies a vexed hiatus of differentiation and undecidability. Such problems may be isomorphs of the problems of differentiation encountered in distinguishing 'a subversive refusal of established codes' and 'simple ineffectiveness', ineptitude or incompetence. Hysterical behaviour is observable in both the oppressed and fearful *and* in frauds and liars. The point is that to make the necessary differentiations and to act upon them, the actions and differentiations are of a qualitively different character according to whether you are in a contingent or dependent position or at an Archimedian point of overview – an independent position. And *who* is to elect him- or herself art's psychiatrist?

It seems to be of some significance to sort out the dependency relationships in hysterical behaviour. It is a pantomime *coercively* directed at particular individuals, not at an abstract 'audience'. It 'modifies' the power relationships between people. The ambiguity and multiple meaning of hysteria generates a hiatus of uncertainty in which genuine mistakes can be made. Again, it is in such a hiatus that the furtive and ghettoized half-lives of the art-world reside. But *who* is to elect him- or herself art's psychiatrist?

Benjamin's 'The Origins of German Trauerspiels' and 'On Some Motifs in Baudelaire' relate the allegories of the Baroque to those of Romanticism and the 20th Century – e.g., to Surrealism. Like the allegories of the Baroque, 20th Century cultural production takes place during a period of decline, decay and disfiguration. One of Benjamin's (or Brecht's?) principles of form was to collect and reproduce 'the contradictions of the present' without resolution. Speaking of Baudelaire, Benjamin describes strange and unusual correspondences emerging as unintended consequences of speech, of work, of wandering (the flânerie of the flâneur). The result of flânerie is an allegorical art that reveals the physiognomy of the present as 'ruin' and juxtaposes to the ruins of the bourgeoisie, elements of dream, memory and fantasy stimulated by shock but revealing or anticipating a different collective character of experience.

Suppose we substitute the particular relations or systems of necessary misrepresentation for Benjamin's presumably 'dialectical' contradictions? One of the ways in which we might generate a possible critique or redescription of those misrepresentations is to try to put them into such a critically informative relationship to one another that one is forced to attempt to reconstruct the genetic circumstances whereby such misrepresentations have come to be generated. This may be akin to what has somewhat sleekly been dubbed 'a montage of discourses'. In the *Portraits of V.I. Lenin in the Style of Jackson Pollock* the conditions which produced the Social Realist orthodoxy and the orthodoxy of US Modernism are conjuncturally significant. The representations (or misrepresentations) of the Eastern Bloc and the representations (or misrepresentations) of Natopolitan 'freedom' are not, simultaneously, thinkable. Their amalgamation into a quasi identity, their mutual exclusivity and lack of boundaries generates an uneasy peace, a detente of mutual reproach and intimacy. [. . .]

8 Barbara Kruger (b. 1945) ' "Taking" Pictures'

Kruger's early career was as art director on women's magazines published by Condé Nast. Beginning in the early 1980s, she put this experience to use in a series of works reminiscent of advertisements and billboards. Her typical work of this time involved the combination of a monochrome photographic image with a brief declarative statement in large type. This

combination of text and image would usually allude to some tendency to oppression or hypocrisy in the contemporary world. The tendencies her work specifically addresses are those based in relations of gender. The binary opposition 'We/You' has been an explicit or implicit function in all her montages, the 'We' referring to women in general, the 'You' to the male spectator. The present statement was published in *Screen*, vol. 23, no. 2, London, July–August 1982, p. 90.

There can be said to exist today a kind of oppositional situation in the arts (principally on a theoretical level only, as the marketplace tends to customize all breeds of activity); the laboratorial or studio versus certain productive or more clearly, reproductive procedures. As parody frees ceremony from ritual, so its 'making alike' allows for a disengaged (or supposedly) distanced reading.

This strategy is employed by a number of artists working today. Their production, contextualized within the art subculture, frequently consists of an appropriation or 'taking' of a picture, the value of which might already be safely ensconced within the proven marketability of media imagery. Using, and or informed by fashion and journalistic photography, advertising, film, television, and even other artworks (photos, painting and scupture), their quotations suggest a consideration of a work's 'original' use and exchange values, thus straining the appearance of naturalism. Their alterations might consist of cropping, reposing, captioning, and redoing, and proceed to question ideas of competence, originality, authorship and property.

On a parodic level, this work can pose a deviation from the repetition of stereotype, contradicting the surety of our initial readings. However, the implicit critique within the work might easily be subsumed by the power granted its 'original' thus serving to further elevate cliché. This might prove interesting in the use of repetition as a deconstructive device, but this elevation of cliché might merely shift the ornamental to the religious. And as an adoration the work can read as either another buzz in the image repertoire of popular culture or as simply a kitschy divinity. However, the negativity of this work, located in its humour, can merely serve to congratulate its viewers on their contemptuous acuity. Perhaps the problem is one of implicitness, that what is needed is, again, an alternation, not only called 'from primary to secondary', but from implicit to explicit, from inference to declaration.

9 Peter Halley (b. 1953) 'Nature and Culture'

During the 1980s, Halley produced 'abstract' paintings in a self-consciously postmodern manner: which is to say, for example, that in their formats they resemble the tradition of Modernist geometric abstraction, while with such materials as textured interior decorating paint and/or Day-Glo colours, they tend to mock the high seriousness of that tradition. At the same time the 'abstract' configurations of Halley's work are instinct with the possibility of a reference to such iconic forms of the modern as circuits, conduits and cells – and thus to the panoply of communicative and repressive agencies in the modern world. In its preoccupation with the power of signs and of simulation Halley's thought bears the marks of French Poststructuralist theory. His art is both alert to and plays upon the myths of art in a culture whose principal contribution to art, as he sees it, has been its commodification. Originally published in *Arts Magazine*, New York, September 1983. Reprinted in Halley, *Collected Essays 1981–87*, Zurich, 1988. The present extracts are taken from pp. 63–73 of that edition.

Just a decade ago, having 'soul' was said to be the cure for the alienation with which consciousness in the industrialized world was plagued. In the mechanized, repressed, bourgeois world, it was argued, people had been stripped of their vitality, spontaneity, and emotionality. Thus, an utterance that had 'soul,' that was endowed with spirituality, could be said to play a role in returning humankind to its oneness with nature, to its 'essence.'

Today, however, thinking about these issues has changed, at least in the art world. Ideas like 'soul' and spirituality, are viewed by many as a means by which bourgeois culture has consolidated its position by denying its historicity. To say that a work of art is spiritual is to attribute to it universal, timeless value. It also suggests that the society which encourages and validates works with such attributes is itself timelessly and universally valid.

This radical and sudden transformation of opinion itself provokes examination. Such transformed judgments are the result of a tidal wave of intellectual change that has washed over the art world in the present decade. An art practice that had been dominant since the Second World War has been completely swept away and replaced by another.

The practice of art from World War II to the end of the last decade was dominated by ideas derived from phenomenology, existentialism, and Jungian transcendentalism. The post-war period attributed to modernism a vanguard, heroic role, not in the political sense, but in the sense that it claimed that art was capable of reuniting humans with some lost essence and that art was able, as well, to release hidden, heretofore unaccomplished potentialities in the human being.

* * *

[...] The art of this period is overwhelmingly concerned with the situation of the individual as a perceiving and deciding entity. But before one can dismiss the production of this epoch as merely a typical manifestation of late industrialism concerned with preserving the mythic importance of the individual and of some absolute nature upon which the individual can act, one must remember that this era was formed and determined by another historical event, an event whose influence must be considered separately from the smooth progression of the stages of the development of capital.

If the art of this period can be seen as positing a relationship between the individual and nature, it is perhaps because World War II constituted an event that acted upon those who experienced it as nature. This mammoth event, although certainly caused by social forces, eventually evolved, for a considerable portion of the world's people, into a phenomenon not very different from a devastating flood or fire. World War II constituted a 'natural disaster' insofar as it tore asunder the seamless web of signs that constitutes modern civilization. It left countless persons in a situation in which they were faced not with the codes that their societies had invented for them but rather with an unintended hole in the 'empire of signs.'

One has only to look at the tenets of Sartrean existentialism, which advocates so many of the same values as Abstract Expressionism, to realize the extent to which the experience of the Second World War influenced the era. For Sartre, as for the Abstract Expressionists, responsibility, action, 'good faith,' and the problem of inventing meaning and morality were the basic issues. It is as if to say that in the codeless world that war on such a scale had created, a world in which the usual laws of market and class – the mechanics of the bourgeois universe as it should be – were in abeyance, philosophy

and art should be simply about the possible actions and decisions that a human being who has been stripped of his social role can undertake.

Why then, at the end of the '70s, did this transcendentalist, phenomenologically-oriented approach which had been dominant for thirty years abruptly disappear to be replaced by a new practice that looks exclusively to the mass media for its repertory of images, that rejects the phenomenology of art-making as pretentious and mandarin, that interprets language as a closed set without reference to extra-human reality? Why did a new practice emerge, that substitutes for phenomenological study a fascination with sociological and political reality, that rejects the positivism of both the physical and social sciences, and replaces the cult of originality with myriad variations on the theme of repetition?

And how and why, around 1980, did a group of French texts loosely referred to as post-structuralist or structuralist, which includes works written from ten to twenty years earlier by Roland Barthes, Michel Foucault, Jacques Derrida, and Jean Baudrillard, suddenly gain favor in the intellectual climate of the art world, influencing both artists and theorists and at the same time heralding and effecting the sudden vanquishing of nature from this world of culture?

To start with, it is impossible not to recognize that the generation of artists responsible for this upheaval is the first to be born after World War II and that, conversely, the significant figures whose work was formed by the experience of the war have gradually disappeared. Consequently, the existentialist values of the World War II generation have faded away, while the younger generation which (in the Western world, at least) has never experienced such a situation, in which all the rules are found inapplicable, has become fixated on rules, that is, on language. [...]

Or perhaps, unless one would seek an explanation in a formalist theory that connects the development of intellectual trends to the necessary lag in the translation of crucial texts, or that explains artistic change by the inevitable entropy of intellectual movements, one must return to a discussion of socio-economic factors which links cultural change to events in the development of industrial society and of capitalism. From this point of view, structuralism and the new art both reflect a transition from an industrial to a post-industrial society; from a society of expanding markets to a society of stagnant growth in which wealth is more redistributed than created; from a culture in which production, innovation, and individualism are mythologized in the name of creativity to a society that stresses the manipulation of what already exists, be it capital or cultural signs. This is the culture that structuralism describes or which can at the same time be said to create structuralism. The conditions of such a post-industrial society have existed in Europe since the end of World War II, when the first structuralist texts appeared there. In the United States, the conditions of post-industrialism have only appeared in the last few years, in the wake of Vietnam (with the curb it imposed on American colonial ambitions), and of the oil crises of the '70s, which effectively brought to an end the growth of the American economy. Along with the arrival of post-industrial conditions, a new structuralist-oriented art practice has appeared in the United States.

The advent of post-industrialism has also seemed to make obsolete the very concept of nature, giving rise to a critique of the reign of nature in art. If the industrial period represents the era in which nature was viewed as real, society can today be seen as entering an era in which bourgeois culture is severing its bond with this nature and

completing the process by which it has established its own mode of thought, its own consciousness, as referent. Increasingly, the important 'others' of the industrial period have been eliminated – wilderness is bracketed by law, while tribal and folk modes of social organization have been almost completely assimilated (there remains only the difficult question of the unconscious). [. . .]

Bourgeois culture is increasingly seizing the opportunity to 'simulate' (in Baudrillard's terminology) the crucial powers that were assigned to nature's dominion – the power of thought, repeated in the computer, which 'realizes' bourgeois dualism; the ability to create life, accomplished chemically and mechanically; and the ability to create space itself in the binary circuitry of computer-animation devices. Thus the circle of bourgeois thought is finally completed; the bourgeois world is made to refer back only to itself. Recently even the human heart, perhaps the most natural of objects in the old order, has been reconstituted according to the thought processes of bourgeois consciousness.

Advertising's recent appropriation of the vocabularies of nature and post-war modernism makes apparent the extent of this change, which is a triumph of the market over nature. That beer, detergent, and makeup are now called 'natural' is significant. Today the name 'Nature Valley' refers to a kind of breakfast cereal; cigarettes have been given such transcendentalist labels as 'True,' 'Light,' and 'Now.'

Yet a number of troubling questions are provoked by recent structuralist art practice. First, there is the question of how artists can address the world of the simulacrum. If indeed the post-industrialist world is characterized by signs that simulate rather than represent, how can an artist communicate this situation? Is it possible to represent a simulation? If not, it only remains for the artist to engage in the practice of simulation himself or herself. But by so doing, an uncertain situation is set up. The practice of simulation by the artist can be seen as an endorsement of the culture of simulacra. But one wonders if such an endorsement is desirable if, as Marxist critics believe, post-industrial culture constitutes a further level of social alienation. Artists who subscribe to a serious structuralist practice still seem to be in the process of answering this question. But, as Hal Foster has pointed out, the work of the so-called neo-expressionist artists clearly validates the new social conditions by its simulation of the modernist notion of the masterpiece.

Fredric Jameson has observed that cultural analysis is today dominated by two separate trends. On one hand, there is the theory of the simulacrum, as developed by Baudrillard. On the other, there is the work of Michel Foucault, which sees contemporary culture not as a shimmering surface of autonomous signs, but as a place in which the technologies of surveillance, normalization, and categorization have ever broadening control over social life. In contrast to Baudrillard's vision of the detached signifier, Foucault finds hidden behind the various signifiers of contemporary society the veiled signified of power, in the form of the consolidation of class position. One questions why artists and art theorists today have been attracted so exclusively to Baudrillard's rather than to Foucault's interpretation of social relationships. One wonders if perhaps Baudrillard's brilliant world of surfaces is not more seductive than Foucault's bleak excavation of the spaces of regimentation. And one wonders if artist and audience, seduced by this shimmering world have not been deflected away from the investigation of crucial issues about society's structure.

10 Fredric Jameson (b. 1934) 'The Deconstruction of Expression'

In 1982 Jameson delivered his pioneering study 'Postmodernism and Consumer Society' as a talk at the Whitney Museum of American Art in New York. He subsequently developed this paper into the longer essay 'Post-Modernism: or the Cultural Logic of Late Capitalism', from which the present extract is taken. His name has become increasingly identified with the theorization of the postmodern, and this wide-ranging essay is arguably his major statement on the issue. In seven sections it deals with architecture, art, literature, commodities and the relationship of culture to the late capitalist economy. Its central claim is that in the conditions of that stage of capitalism the Modernist tradition simply cannot retain its critical raison d'être: it has been absorbed as the official culture. 'Postmodernism' is not therefore a merely stylistic departure. In Jameson's periodizing hypothesis Modernism is construed as a long wave extending from the late nineteenth century to some time after the Second World War, which is now a spent force. Postmodernism is seen as the succeeding 'cultural dominant', and it is the essay's main task to delineate its properties as such. The present extract is restricted to a discussion of art. Here Jameson contrasts the canonical expressive Modernism of van Gogh and Munch with the putatively postmodern work of Andy Warhol. The essay was first published in *New Left Review*, London, 146, July/August 1984, pp. 53–92. Our extracts are from pp. 58–64. (See also VIID13.)

'Peasant Shoes'

We will begin with one of the canonical works of high modernism in visual art, van Gogh's well-known painting of the peasant shoes, an example which as you can imagine has not been innocently or randomly chosen. I want to propose two ways of reading this painting, both of which in some fashion reconstruct the reception of the work in a two-stage or double-level process.

I first want to suggest that if this copiously reproduced image is not to sink to the level of sheer decoration, it requires us to reconstruct some initial situation out of which the finished work emerges. Unless that situation – which has vanished into the past – is somehow mentally restored, the painting will remain an inert object, a reified end-product, and be unable to be grasped as a symbolic act in its own right, as praxis and as production.

This last term suggests that one way of reconstructing the initial situation to which the work is somehow a response is by stressing the raw materials, the initial content, which it confronts and which it reworks, transforms, and appropriates. In van Gogh, that content, those initial raw materials, are, I will suggest, to be grasped simply as the whole object world of agricultural misery, of stark rural poverty, and the whole rudimentary human world of backbreaking peasant toil, a world reduced to its most brutal and menaced, primitive and marginalized state.

Fruit trees in this world are ancient and exhausted sticks coming out of poor soil; the people of the village are worn down to their skulls, caricatures of some ultimate grotesque typology of basic human feature types. How is it then that in van Gogh such things as apple trees explode into a hallucinatory surface of colour, while his village stereotypes are suddenly and garishly overlaid with hues of red and green? I will briefly suggest, in this first interpretative option, that the willed and violent transform-

ation of a drab peasant object world into the most glorious materialization of pure colour in oil paint is to be seen as a Utopian gesture: as an act of compensation which ends up producing a whole new Utopian realm of the senses, or at least of that supreme sense – sight, the visual, the eye – which it now reconstitutes for us as a semi-autonomous space in its own right – part of some new division of labour in the body of capital, some new fragmentation of the emergent sensorium which replicates the specializations and divisions of capitalist life at the same time that it seeks in precisely such fragmentation a desperate Utopian compensation for them.

There is, to be sure, a second reading of van Gogh which can hardly be ignored when we gaze at this particular painting, and that is Heidegger's central analysis in *Der Ursprung des Kunstwerkes*, which is organized around the idea that the work of art emerges within the gap between Earth and World, or what I would prefer to translate as the meaningless materiality of the body and nature and the meaning-endowment of history and of the social. We will return to that particular gap or rift later on; suffice it here to recall some of the famous phrases, which model the process whereby these henceforth illustrious peasant shoes slowly recreate about themselves the whole missing object-world which was once their lived context. 'In them,' says Heidegger, 'there vibrates the silent call of the earth, its quiet gift of ripening corn and its enigmatic self-refusal in the fallow desolation of the wintry field.' 'This equipment,' he goes on, 'belongs to the *earth* and it is protected in the *world* of the peasant woman . . . Van Gogh's painting is the disclosure of what the equipment, the pair of peasant shoes, *is* in truth . . . This entity emerges into the unconcealment of its being,' by way of the mediation of the work of art, which draws the whole absent world and earth into revelation around itself, along with the heavy tread of the peasant woman, the loneliness of the field path, the hut in the clearing, the worn and broken instruments of labour in the furrows and at the hearth. Heidegger's account needs to be completed by insistence on the renewed materiality of the work, on the transformation of one form of materiality – the earth itself and its paths and physical objects – into that other materiality of oil paint affirmed and foregrounded in its own right and for its own visual pleasures; but has nonetheless a satisfying plausibility.

'Diamond Dust Shoes'

At any rate, both of these readings may be described as *hermeneutical*, in the sense in which the work in its inert, objectal form, is taken as a clue or a symptom for some vaster reality which replaces it as its ultimate truth. Now we need to look at some shoes of a different kind, and it is pleasant to be able to draw for such an image on the recent work of the central figure in contemporary visual art. Andy Warhol's *Diamond Dust Shoes* evidently no longer speaks to us with any of the immediacy of van Gogh's footgear: indeed, I am tempted to say that it does not really speak to us at all. Nothing in this painting organizes even a minimal place for the viewer, who confronts it at the turning of a museum corridor or gallery with all the contingency of some inexplicable natural object. On the level of the content, we have to do with what are now far more clearly fetishes, both in the Freudian and in the Marxian sense (Derrida remarks, somewhere, about the Heideggerian *Paar Bauernschuhe*, that the van Gogh footgear are a heterosexual pair, which allows neither for perversion nor for fetishization). Here,

however, we have a random collection of dead objects, hanging together on the canvas like so many turnips, as shorn of their earlier life-world as the pile of shoes left over from Auschwitz, or the remainders and tokens of some incomprehensible and tragic fire in a packed dancehall. There is therefore in Warhol no way to complete the hermeneutic gesture, and to restore to these oddments that whole larger lived context of the dance hall or the ball, the world of jetset fashion or of glamour magazines. Yet this is even more paradoxical in the light of biographical information: Warhol began his artistic career as a commercial illustrator for shoe fashions and a designer of display windows in which various pumps and slippers figured prominently. Indeed, one is tempted to raise here – far too prematurely – one of the central issues about postmodernism itself and its possible political dimensions: Andy Warhol's work in fact turns centrally around commodification, and the great billboard images of the Coca-Cola bottle or the Campbell's Soup Can, which explicitly foreground the commodity fetishism of a transition to late capital, *ought* to be powerful and critical political statements. If they are not that, then one would surely want to know why, and one would want to begin to wonder a little more seriously about the possibilities of political or critical art in the postmodern period of late capital.

But there are some other significant differences between the high modernist and the postmodernist moment, between the shoes of van Gogh and the shoes of Andy Warhol, on which we must now very briefly dwell. The first and most evident is the emergence of a new kind of flatness or depthlessness, a new kind of superficiality in the most literal sense – perhaps the supreme formal feature of all the postmodernisms to which we will have occasion to return in a number of other contexts.

Then we must surely come to terms with the role of photography and the photographic/negative in contemporary art of this kind: and it is this indeed which confers its deathly quality on the Warhol image, whose glacéd x-ray elegance mortifies the reified eye of the viewer in a way that would seem to have nothing to do with death or the death obsession or the death anxiety on the level of content. It is indeed as though we had here to do with the inversion of van Gogh's Utopian gesture: in the earlier work, a stricken world is by some Nietzschean fiat and act of the will transformed into the stridency of Utopian colour. Here, on the contrary, it is as though the external and coloured surface of things – debased and contaminated in advance by their assimilation to glossy advertising images – has been stripped away to reveal the deathly black-and-white substratum of the photographic negative which subtends them. Although this kind of death of the world of appearance becomes thematized in certain of Warhol's pieces – most notably, the traffic accidents or the electric chair series – this is not, I think, a matter of content any longer but of some more fundamental mutation both in the object world itself – now become a set of texts or simulacra – and in the disposition of the subject.

The Waning of Affect

All of which brings me to the third feature I had in mind to develop here briefly, namely what I will call the waning of affect in postmodern culture. Of course, it would be inaccurate to suggest that all affect, all feeling or emotion, all subjectivity, has vanished from the newer image. Indeed, there is a kind of return of the repressed in *Diamond Dust Shoes*, a strange compensatory decorative exhilaration, explicitly desig-

nated by the title itself although perhaps more difficult to observe in the reproduction. This is the glitter of gold dust, the spangling of gilt sand, which seals the surface of the painting and yet continues to glint at us. Think, however, of Rimbaud's magical flowers 'that look back at you', or of the august premonitory eye-flashes of Rilke's archaic Greek torso which warn the bourgeois subject to change his life: nothing of that sort here, in the gratuitous frivolity of this final decorative overlay.

The waning of affect is, however, perhaps best initially approached by way of the human figure, and it is obvious that what we have said about the commodification of objects holds as strongly for Warhol's human subjects, stars – like Marilyn Monroe – who are themselves commodified and transformed into their own images. And here too a certain brutal return to the older period of high modernism offers a dramatic shorthand parable of the transformation in question. Edvard Munch's painting *The Scream* is of course a canonical expression of the great modernist thematics of alienation, anomie, solitude and social fragmentation and isolation, a virtually programmatic emblem of what used to be called the age of anxiety. It will here be read not merely as an embodiment of the expression of that kind of affect, but even more as a virtual deconstruction of the very aesthetic of expression itself, which seems to have dominated much of what we call high modernism, but to have vanished away – for both practical and theoretical reasons – in the world of the postmodern. The very concept of expression presupposes indeed some separation within the subject, and along with that a whole metaphysics of the inside and the outside, of the wordless pain within the monad and the moment in which, often cathartically, that 'emotion' is then projected out and externalized, as gesture or cry, as desperate communication and the outward dramatization of inward feeling. And this is perhaps the moment to say something about contemporary theory, which has among other things been committed to the mission of criticizing and discrediting this very hermeneutic model of the inside and the outside and of stigmatizing such models as ideological and metaphysical. But what is today called contemporary theory – or better still, theoretical discourse – is also, I would want to argue, itself very precisely a postmodernist phenomenon. It would therefore be inconsistent to defend the truth of its theoretical insights in a situation in which the very concept of 'truth' itself is part of the metaphysical baggage which poststructuralism seeks to abandon. What we can at least suggest is that the poststructuralist critique of the hermeneutic, of what I will shortly call the depth model, is useful for us as a very significant symptom of the very postmodernist culture which is our subject here.

Overhastily, we can say that besides the hermeneutic model of inside and outside which Munch's painting develops, there are at least four other fundamental depth models which have generally been repudiated in contemporary theory: the dialectical one of essence and appearance (along with a whole range of concepts of ideology or false consciousness which tend to accompany it); the Freudian model of latent and manifest, or of repression (which is of course the target of Michel Foucault's programmatic and symptomatic pamphlet *La Volonté de savoir*); the existential model of authenticity and inauthenticity, whose heroic or tragic thematics are closely related to that other great opposition between alienation and disalienation, itself equally a casualty of the post-structural or postmodern period; and finally, latest in time, the great semiotic opposition between signifier and signified, which was itself rapidly unravelled and deconstructed during its brief heyday in the 1960s and 70s. What replaces these various

depth models is for the most part a conception of practices, discourses and textual play, whose new syntagmatic structures we will examine later on: suffice it merely to observe that here too depth is replaced by surface, or by multiple surfaces (what is often called intertextuality is in that sense no longer a matter of depth). [. . .]

Euphoria and Self-Annihilation

Returning now for one last moment to Munch's painting, it seems evident that *The Scream* subtly but elaborately deconstructs its own aesthetic of expression, all the while remaining imprisoned within it. Its gestural content already underscores its own failure, since the realm of the sonorous, the cry, the raw vibrations of the human throat, are incompatible with its medium (something underscored within the work by the homunculus' lack of ears). Yet the absent scream returns more closely towards that even more absent experience of atrocious solitude and anxiety which the scream was itself to 'express'. Such loops inscribe themselves on the painted surface in the form of those great concentric circles in which sonorous vibration becomes ultimately visible, as on the surface of a sheet of water – in an infinite regress which fans out from the sufferer to become the very geography of a universe in which pain itself now speaks and vibrates through the material sunset and the landscape. The visible world now becomes the wall of the monad on which this 'scream running through nature' (Munch's words) is recorded and transcribed: one thinks of that character of Lautréamont who, growing up inside a sealed and silent membrane, on sight of the monstrousness of the deity, ruptures it with his own scream and thereby rejoins the world of sound and suffering.

All of which suggests some more general historical hypothesis: namely, that concepts such as anxiety and alienation (and the experiences to which they correspond, as in *The Scream*) are no longer appropriate in the world of the postmodern. The great Warhol figures – Marilyn herself, or Edie Sedgewick – the notorious burn-out and self-destruction cases of the ending 1960s, and the great dominant experiences of drugs and schizophrenia – these would seem to have little enough in common anymore, either with the hysterics and neurotics of Freud's own day, or with those canonical experiences of radical isolation and solitude, anomie, private revolt, van Gogh-type madness, which dominated the period of high modernism. This shift in the dynamics of cultural pathology can be characterized as one in which the alienation of the subject is displaced by the fragmentation of the subject.

Such terms inevitably recall one of the more fashionable themes in contemporary theory – that of the 'death' of the subject itself = the end of the autonomous bourgeois monad or ego or individual – and the accompanying stress, whether as some new moral ideal or as empirical description, on the *decentring* of that formerly centred subject or psyche. (Of the two possible formulations of this notion – the historicist one, that a once-existing centred subject, in the period of classical capitalism and the nuclear family, has today in the world of organizational bureaucracy dissolved; and the more radical poststructuralist position for which such a subject never existed in the first place but constituted something like an ideological mirage – I obviously incline towards the former; the latter must in any case take into account something like a 'reality of the appearance'.)

We must add that the problem of expression is itself closely linked to some conception of the subject as a monad-like container, within which things are felt which are

then expressed by projection outwards. What we must now stress, however, is the degree to which the high-modernist conception of a unique *style*, along with the accompanying collective ideals of an artistic or political vanguard or avant-garde, themselves stand or fall along with that older notion (or experience) of the so-called centred subject.

Here too Munch's painting stands as a complex reflexion on this complicated situation: it shows us that expression requires the category of the individual monad, but it also shows us the heavy price to be paid for that precondition, dramatizing the unhappy paradox that when you constitute your individual subjectivity as a self-sufficient field and a closed realm in its own right, you thereby also shut yourself off from everything else and condemn yourself to the windless solitude of the monad, buried alive and condemned to a prison-cell without egress.

Postmodernism will presumably signal the end of this dilemma, which it replaces with a new one. The end of the bourgeois ego or monad no doubt brings with it the end of the psychopathologies of that ego as well – what I have generally here been calling the waning of affect. But it means the end of much more – the end for example of style, in the sense of the unique and the personal, the end of the distinctive individual brushstroke (as symbolized by the emergent primacy of mechanical reproduction). As for expression and feelings or emotions, the liberation, in contemporary society, from the older *anomie* of the centred subject may also mean, not merely a liberation from anxiety, but a liberation from every other kind of feeling as well, since there is no longer a self present to do the feeling. This is not to say that the cultural products of the postmodern era are utterly devoid of feeling, but rather that such feelings – which it may be better and more accurate to call 'intensities' – are now free-floating and impersonal. [...]

11 Haim Steinbach (b. 1944), Jeff Koons (b. 1955), Sherrie Levine (b. 1947), Philip Taaffe (b. 1955), Peter Halley (b. 1953), Ashley Bickerton (b. 1959) 'From Criticism to Complicity'

The discussion between these leading members of New York's art world of the 1980s addresses an important shift in emphasis in the concerns of a 'postmodern' art: an interest not in rejecting the world of commodities, but rather in working with and from within the now pervasive condition of commodification of values in general. The discussion, moderated by Peter Nagy, took place at the Pat Hearn Gallery, New York, 2 May 1986. It was edited by David Robbins and published in *Flash Art*, Milan, no. 129, Summer 1986, pp. 46–9, from which the present extracts are taken.

PETER NAGY: In what ways does this new work depart from or elaborate upon work done by the Pictures generation of appropriators (that being the group associated, early on, with Metro Pictures: Sherrie Levine, Richard Prince, Troy Brauntuch, etc.)? Haim, would you address that question, because your work is in many ways an elaboration of those strategies...

HAIM STEINBACH: [...] Whereas most of the Pictures-generation artists have been lifting images to make their work, I have been using objects. The discourse this art has been engaged in questions the position of the subject in relation to the image/

object. There has been a growing awareness of the way that media affect our viewing of reality in a pictorial fashion. In a sense, the media have been turning us into tourists and voyeurs outside our own experience. The Pictures artists have been involved in questioning their own position as producers of art in relation to the mythic baggage of subjectivity and individuality, of which they have become acutely self-conscious. There has been a shift in the activities of the new group of artists in that there is a renewed interest in locating one's desire, by which I mean one's own taking pleasure in objects and commodities, which includes what we call works of art. There is a stronger sense of being complicit with the production of desire, what we traditionally call beautiful seductive objects, than being positioned somewhere out-side of it. In this sense the idea of criticality in art is also changing.

ASHLEY BICKERTON: If we're going to draw a difference, it's going to have to be between the original program, as outlined by critics such as Douglas Crimp and Craig Owens, and the tendencies now beginning to emerge with the younger artists. A key operative word that may be useful right now would be 'truth': I feel the Pictures group was after a particular deconstruction or breakdown of the process of the corruption as a poetic form, a platform or launching pad for poetic discourse in itself. Through tactile choices and presentation, the art object has now been placed in a discursive relationship with the larger scenario of the political and social reality of which it is a part. In a self-conscious and ongoing dialogue with the social, political, and intellectual climate of the time and place it will operate in, and with the entire process of its absorption. Much of the work produced by the Pictures group was essentially deconstructive and task-oriented in its spectacular didacticism. It was a cool approach to hot culture, whereas this new work of which we speak has more to do with information in general, specifically the schism that exists between infor-mation and assumed meanings, particularly how the formal elaboration of infor-mation necessarily affects its possible meanings. This work has a somewhat less utopian bent than its predecessor.

PN: So we've learned some strategies from the Pictures generation.

AB: We've consciously learned and incorporated strategies from a lot of art-historical sources. I tend to think that right now, at least from this vantage point, with the wash of contrary information we have witnessed in the postwar period, with the comings and goings of all sorts of different isms, we're now able to step back and merge, in fact to *implode* a variety of different strategies and epistemologies into the total art object that is capable of speaking of its own predicament as well as in general. This would oppose it to the directed programmatic operative of original Pictures practice.

PN: How integral are notions of leftist politics or cultural subversion in the work?

* * *

PETER HALLEY: I think that Marxian thought really has to be integrated into one's thinking, but I identify myself more with a New Left position, in which an absurdist or existential position is integrated with Marxian concepts. In addition, I'd like to bring in figures, like McLuhan, who are also involved with a kind of political thinking. I think it's difficult nowadays to talk about a political situation: along with reality, politics is sort of an outdated notion. We are now in a post-political situation. As an artist, one ends up aspiring to make an art object that is a situationist object, in and of itself, in the way it's put together. Rather than addressing topical issues, I think that a work of art has to address critical issues: the topical political

issues of the day, to the extent they exist, are certainly of concern to people as individuals, but in a work of art it is the structural questions behind those topical issues that are important. For me, the most political component in a work of art – and it's a component that the work of everybody on this panel shares – is the idea that the work be conceived in such a way that anyone could do it. That's what I've always admired about Warhol or Stella – that one has a sense that one could actually participate in the making of the work. Finally, I find myself strongly interested in addressing postindustrial issues: the issues of the situation of the suburbanized middle classes in postindustrial countries. That's not to say that what's going on with other classes that are in even worse shape isn't of interest, but those situations seem to me more clear cut. It's precisely the ambiguity and the sort of unknown quality of life in the subdivision that seems worth addressing.

PN: [...] It seems to me that (and perhaps this accounts for the great success that so much of this work has achieved so quickly) in each of the individual works of art, there are two separate dialectics operating: on one hand, the work is appealing to an audience primarily composed of artists and intellectuals, and on the other to an audience primarily composed of collectors and dealers. I'm wondering how conscious the artist is of designing a work of art for audiences that are, in fact, very different, very far apart.

HS: In my case, I spend a lot of time shopping, and I find the commodities that I look at to be very often addressed to a general audience, of which I am a part. On one hand there is an art context, out of which I come, and through which I think about what it means to present an object with another object or with another form. On the other hand I use groupings or arrangements of objects that are already pre-set for a general audience.

PN: So you're saying it's pretty unconscious on your part.

HS: I am conscious that in many ways today the distinctions between an elite as opposed to a more general audience are becoming blurred. There is an equalizing factor at work in the way things are produced now giving an illusion of a shared freedom, of one audience. This kind of dynamic interests me, and I attempt to deal with it in my work.

PHILIP TAAFFE: Generally, I'm opposed to a difficult level of hermeticism within a work. I want the work to be as open as possible. I want my work to be freely experienced.

JEFF KOONS: To me, the issue of being able to capture a general audience and also have the art stay on the highest orders is of great interest. I think anyone can come to my work from the general culture: I don't set up any kind of requirement. Almost like television. I tell a story that is easy for anyone to enter into and on some level enjoy, whether they enjoy just a little glitter of it and get excited by that or may be, like with the *Equilibrium Tanks*, they get a kick out of the sensationalism of seeing basketballs just hover. The objects and the other images that are interconnected to the body of work have other contexts and, depending on how much the viewer wants to enter it, they can try to get more out of it and start dealing in art vocabulary instead of just sensational or personal vocabulary, and start to deal with abstractions of ideas and of context. So, I purposely always try at least to get the mass of people in the door, and if they can go farther, if they want to continue to deal in an art vocabulary I hope that that would happen, because by all means I am not trying to exclude high-art

vocabulary. [...] I would like to offer up a term that has had vital currency in the process of my own thinking: contingency. I think that through this procession of contingencies, discourses are being pulled together into the object itself, promoting an awareness of the fact that all meanings are contingent upon some other meaning, where meanings are appropriated for their relationship to external forces, the larger social schema in which they're involved.

* * *

PN: Finally, much of the new sculpture can be understood specifically in terms of the idea of the anxiety of the object, whether consumer commodity, fetish, or art object. I'm wondering if this anxiety is actually the anxiety of late capitalist culture, and the anxiety of the situation of the artist within late capitalist culture, as well as perhaps the anxiety of the collector's complicated and conflicting relationship within capitalism.

HS: The anxiety of late capitalist culture is in us: in the futility we experience in value systems when faced with our reality; in the futility we find in moralizing as a way of determining what's good or bad. Is there such a thing as a consumer object, a fetish object, an art object, or is it our relation to it that concerns us?

JK: As far as the relationship to the object, in a capitalist society we're repaid, for the work that we do, with objects. And in the objects we can see personality traits of individuals, and we treat them like individuals. Some of these objects tend to be stronger than we are, and will out-survive us. That's a threatening situation to be confronted with.

AB: It's not just sculpture that is concerned with this development. After years of pulling the object off the wall, smearing it across the fields in the Utah desert, and playing it out with our bodily secretions, the artwork has not awkwardly but aggressively asserted itself back into the gallery context: the space of art – but this with an aggressive discomfort and a complicit defiance.

[...]

SHERRIE LEVINE: I think there is a long modernist tradition of endgame art – starting with dada and the suprematists (if you like), and a lot of artists have made the last painting ever to be made. It's a no-man's land that a lot of us enjoy moving around in, and the thing is not to lose your sense of humor, because it's only art.

12 Julia Kristeva (b. 1941) Interview with Catherine Francblin

Bulgarian by birth, Kristeva arrived in Paris in 1966 on a doctoral research fellowship. She quickly became establisjed at the centre of French intellectual life. In common with many of the French Left in the late 1960s she was drawn to both semiotics and Maoism (cf. VIID3), and – a more enduring commitment – to the feminist movement. By the 1980s Kristeva's main work was in psychoanalysis, particularly in fields concerning religion and myth. In the present interview she relates images deriving from the Catholic tradition, deeply embedded in Western culture, to the widespread contemporary imagery of the mass media and popular culture. She also contrasts Modernism and Postmodernism in psychoanalytic terms: seeing the former as engaged in 'psychic unlinking', the latter as drawing together fragments into an eclectic unity. The interview was originally published in *Flash Art*, no. 126, February–March 1986, pp. 44–7, from which the present extracts are taken. (See also VIIIC5.)

JK: [...] It seems important to me never to neglect the transverbal dimension in communication, to take into account the visual factor, the plastic aspect of the icon as signifier, which lends itself more readily to playfulness, to invention, to interpretation, than verbal thought, which can have a repressive intellectual weight. Catholicism understood the cathartic role of the image well. Catharsis is not the equivalent, of course, of a treatment of the symptom or traumatism, but it can provide a sort of pleasure and thus a rebirth for the psychic economy. It was perhaps believed – both by American psycho-analysis and by a certain Lacanianism – that it would be possible to do without the imaginary once one got to a more logical treatment, a more rational way of looking at symptoms. That was not, in my opinion, Freud's view, the 'fundamental rule' of analysis which is free association bears witness to the importance that he attached to the imaginary. It is perhaps not excessive to suppose that symbolical elaboration, which has recently been so valued, leads to a truth that is established once and for all, a truth for which the imaginary appears to be limited to a pleasure principle that is inferior to the reality principle that is to be reached. But it is possible that this sort of demand, a rather stoic one, is only applicable for certain individuals who are particularly mature and autonomous. The present-day unfurling of images in a mass-media culture, the unfurling of regressive content, adolescent, infantile and sentimental, would tend to show that the rational, responsible individual is a pure fantasy of psychoanalysis. The need for the imaginary, in fact, never ceases to make itself felt and is never exhausted.

CF: Would the imaginary realm to which television and comic strips appeal play the same cathartic role as the imaginary appealed to by sacred texts?

JK: Certainly. Mass-media culture is less codified, it is not as universal, we do not have *one* book to put into images and forms, but several; that is why we have this explosion of forms and images. They may seem mediocre compared to the great myths that speak to us of life and death, but the 'minor details' transmitted on the analyst's couch and on TV are not without effect on our day-to-day ailments, just like sacred images. We are living through a fragmentation of the imaginary. It is less majestic, less impressive than a cathedral, but the same mechanism in the psychic apparatus is involved.

CF: The works of young artists inspired by popular images might therefore be our sacred images.

JK: Indeed I believe that these images have a therapeutic impact. They are as passing flashes because they capture at a given moment an anxiety transmitted by such and such a comic strip, or TV image, an anxiety that they frame and represent so that your attention is drawn to it here and now, in the same way that analytic practice does. As far as knowing whether these works have 'value' or not, that is another question. That is the question that all of contemporary art poses. Yet isn't it true that our culture as a whole is involved in a change of the scale of value in the Nietzschean sense? [...] A discourse on art does not depend only upon the personality of the interpreter, but also upon his strategy. He may wish to insist upon the continuity between the ancients and the moderns. [...] There may be another strategy, which demands that one accentuate the idea of a rupture and affirm novelty. Both strategies are justified, because in my opinion rupture and continuity are both present at once. Only the accents are different. Modern art puts the accent on psychic unlinking, on the pulverizing of the image. From this point of view, it evokes the experience of a

VIIIB
Figures of Difference

1 Edward Said (1935–2003) from 'Opponents, Audiences, Constituencies, and Community'

Said's book *Orientalism* (see VIID15) treats specifically of its subject as, in his own words, 'a Western style for dominating, restructuring, and having authority over the Orient'. As the following text demonstrates, his work has general application in the diagnosis of those mechanisms of imperialism which are covertly at work in representation – at work, that is to say, both in forms of representation and in the formation of those disciplines which make forms of representation their business. Originally given as an address to a symposium on 'The Politics of Interpretation' at the University of Chicago's Center for Continuing Education, 30 October–1 November 1981; first published in *Critical Inquiry*, Chicago, vol. 9, no. 1, 1982; reprinted in W. J. T. Mitchell (ed.), *The Politics of Interpretation*, Chicago and London, 1983, pp. 7–32, from which the present extract is taken.

[. . .] Unlike France, high culture in America is assumed to be above politics as a matter of unanimous convention. And unlike England, the intellectual center here is filled not by European imports (although they play a considerable role) but by an unquestioned ethic of objectivity and realism, based essentially on an epistemology of separation and difference. Thus each field is separate from the others because the subject matter is separate. Each separation corresponds immediately to a separation in function, institution, history, and purpose. Each discourse 'represents' the field, which in turn is supported by its own constituency and the specialized audience to which it appeals. The mark of true professionalism is accuracy of representation of society, vindicated in the case of sociology, for instance, by a direct correlation between representation of society and corporate and/or governmental interests, a role in social policymaking, access to political authority. Literary studies, conversely, are realistically *not* about society but about masterpieces in need of periodic adulation and appreciation. Such correlations make possible the use of words like 'objectivity,' 'realism,' and 'moderation' when used in sociology or in literary criticism. And these notions in turn assure their own confirmation by careful selectivity of evidence, the incorporation and subsequent neutralization of dissent (also known as pluralism), and networks of insiders, experts whose presence is due to their conformity, not to any rigorous judgment of their past performance (the good team player always turns up).

[. . .] The particular mission of the humanities is, in the aggregate, to represent *noninterference* in the affairs of the everyday world. As we have seen, there has been a

historical erosion in the role of letters since the New Criticism, and I have suggested that the conjuncture of a narrowly based university environment for technical language and literature studies with the self-policing, self-purifying communities erected even by Marxist, as well as other disciplinary, discourses, produced a very small but definite function for the humanities: to represent humane marginality, which is also to preserve and if possible to conceal the hierarchy of powers that occupy the center, define the social terrain, and fix the limits of use functions, fields, marginality, and so on. Some of the corollaries of this role for the humanities generally and literary criticism in particular are that the institutional presence of humanities guarantees a space for the deployment of free-floating abstractions (scholarship, taste, tact, humanism) that are defined in advance as indefinable; that when it is not easily domesticated, 'theory' is employable as a discourse of occultation and legitimation; that self-regulation is the ethos behind which the institutional humanities allow and in a sense encourage the unrestrained operation of market forces that were traditionally thought of as subject to ethical and philosophical review.

Very broadly stated, then, noninterference for the humanist means laissez-faire: 'they' can run the country, we will explicate Wordsworth and Schlegel. It does not stretch things greatly to note that non-interference and rigid specialization in the academy are directly related to what has been called a counterattack by 'highly mobilized business elites' in reaction to the immediately preceding period during which national needs were thought of as fulfilled by resources allocated collectively and democratically. [...]

...The politics of interpretation demands a dialectical response from a critical consciousness worthy of its name. Instead of noninterference and specialization, there must be *interference*, a crossing of borders and obstacles, a determined attempt to generalize exactly at those points where generalizations seem impossible to make. One of the first interferences to be ventured, then, is a crossing from literature, which is supposed to be subjective and powerless, into those exactly parallel realms, now covered by journalism and the production of information, that employ representation but are supposed to be objective and powerful. [...]

...We need to think about breaking out of the disciplinary ghettos in which as intellectuals we have been confined, to reopen the blocked social processes ceding objective representation (hence power) of the world to a small coterie of experts and their clients, to consider that the audience for literacy is not a closed circle of three thousand professional critics but the community of human beings living in society, and to regard social reality in a secular rather than a mystical mode, despite all the protestations about realism and objectivity.

Two concrete tasks...strike me as particularly useful. One is to use the visual faculty (which also happens to be dominated by visual media such as television, news photography, and commercial film, all of them fundamentally immediate, 'objective,' and ahistorical) to restore the nonsequential energy of lived historical memory and subjectivity as fundamental components of meaning in representation. Berger calls this an alternative use of photography: using photomontage to tell other stories than the official sequential or ideological ones produced by institutions of power. [...] Second is opening the culture to experiences of the Other which have remained 'outside' (and have been repressed or framed in a context of confrontational hostility) the norms manufactured by 'insiders.' An excellent example is Malek Alloula's *Le Harem colonial*,

a study of early twentieth-century postcards and photographs of Algerian harem women. The pictorial capture of colonized people by colonizer, which signifies power, is reenacted by a young Algerian sociologist, Alloula, who sees his own fragmented history in the pictures, then reinscribes this history in his text as the result of understanding and making that intimate experience intelligible for an audience of modern European readers.

In both instances, finally, we have the recovery of a history hitherto either misrepresented or rendered invisible. Stereotypes of the Other have always been connected to political actualities of one sort or another, just as the truth of lived communal (or personal) experience has often been totally sublimated in official narratives, institutions, and ideologies. But in having attempted – and perhaps even successfully accomplishing – this recovery, there is the crucial next phase: connecting these more politically vigilant forms of interpretation to an ongoing political and social praxis. Short of making that connection, even the best-intentioned and the cleverest interpretive activity is bound to sink back into the murmur of mere prose. For to move from interpretation to its politics is in large measure to go from undoing to doing, and this given the currently accepted divisions between criticism and art, is risking all the discomfort of a great unsettlement in ways of seeing and doing. One must refuse to believe, however, that the comforts of specialized habits can be so seductive as to keep us all in our assigned places.

2 Mary Kelly (b. 1941) 'Re-Viewing Modernist Criticism'

In Kelly's work as an artist the supposed objectivity of Modernist criticism is challenged from the position of a feminist practice which makes sexual difference its explicit material. In this essay she discusses what she takes to be the legacies of the avant-garde practices of the later 1960s and early 1970s: a concern not with the constraints of specific media but with the conditions of production of meaning; an awareness of the determining role of the institutional contexts of distribution and reception of art; and an acknowledgement of the significance of sexuality as a property not simply of artistic authors but also of the 'readers' of artistic texts. Originally published in *Screen*, London, vol. 22, no. 3, Autumn 1981, pp. 41–62, from which the present text is taken.

[...] In this article, modernism is defined as a determinant discursive field with reference to critical writing since 1945. It is maintained that modernist discourse is produced at the level of the statement, by the specific practices of art criticism, by the art activities implicated in the critic/author's formulations, and by the institutions which disseminate and disperse the formulations as events. [...]

The Pictorial Paradigm

In a note to the article 'Photography and Aesthetics,' Peter Wollen remarks. 'The category of "modernism" has increasingly been captured by those who see twentieth-century art primarily in terms of reflexivity and ontological exploration.'[1] If it is possible to define this capture in other terms as the predominance of a particular discourse within the hierarchy of discourses which constitute modernism as a discursive field, then the

effectivity of that discourse can be described more exactly as the production of a norm for pictorial representation which does not necessarily correspond to definite pictures, but rather to a set of general assumptions concerning 'Modern Art.' Further, if these assumptions are not seen to be based on the consensus of a homogeneous mass audience of art viewers, but formed within calculated practices of reviewing, publishing, and exhibiting art for a specific public, then the reading of artistic texts is always in some sense subjected to the determining conditions of these practices, crucially those of criticism. [...]

* * *

Criticism's function is to initiate that work which art history eventually accomplishes in the form of the 'biographic narrative' that is, as Griselda Pollock describes it 'the production of an artistic subject for works of art'.[2] The critic's dilemma is the production of artistic subjects for works of art at a time when their authenticity (and market value) are still tentative. Modernist criticism became particularly precarious when it concerned the installation of creative purposes behind objects which were recalcitrant to such efforts or even, in the case of some conceptual work, absent altogether.

The Crisis of Artistic Authorship

Greenberg's writing is often cited as the apodictic core of modernist criticism: but it is far from coherent. Rather, it marks a point of diffraction, of incoherence in that discourse. His particular attention to the materiality of the object allowed a divergence from the ontological norm which was furthered by developments of art practice and which, consequently, required a restatement of modernism's central themes at a moment when the vacuity of that project was keenly perceived in contrast to the aims and intentions of some of the artists to whom he referred.

* * *

...Greenberg's attempt to establish the objective purposiveness of the art object, to define its particular forms of adaption to definite ends in terms of material substrate, is continually undermined by the exigencies of a subjective judgment of *taste*. And here an altogether different order of purpose emerges. The only necessary condition for *judging* good art is common sense; but for *producing* good art, genius is required. With reference to Kant's *Critique*, genius is the mental disposition (*ingenium*) through which nature gives the rule to art. No definite rule can be given for the products of genius, hence originality is its first property. At this point the modernist discourse emerges as the site of an insistent contradiction which is indicated in Greenberg's criticism and repeated in the opposing strategies of the institutions of education on the one hand and those of entertainment and art patronage on the other. The former exacts a formal field of knowledge about art, an empirical domain of teachable crafts, while the latter requires a transcendental field of aesthetic experience and reflection founded on the unteachable tenets of genius and originality. During the 1960s artistic practices attempted to repudiate the notions of genius, originality, and taste, by introducing material processes, series, systems, and ideas in place of an art based on self-expression. [...]

[...] What is made more explicit, more transparent by the so-called 'dematerialization' of the object, is that *the production of authenticity requires more than an author for the object; it exacts the 'truth' of the authorial discourse.*

By putting himself in circulation, the performance artist parodied the commercial exchange and distribution of an artistic personality in the form of a commodity. Nevertheless, for criticism, performance art initiated an appropriate synthesis of the disparate elements that had fractured the modernist discourse. On the one hand it provided the empirical domain with a universal object – the body, and on the other, to the transcendental field, it brought the incontestable authenticity of the artist's experience of his own body.

With Lea Vergine's account of 'body art,' . . . criticism seems to subside once again in the direction of ontology [see VIIB13]. She speaks of 'the individual obsessed by the obligation to exhibit himself in order to be'.[3] But she is anxious to point out that this move is more than a revival of expressionism. The use of the body in art is not simply a return to origins, 'the individual is led back to a specific mode of existence.' Moreover these activities, 'phenomena' as she puts it, also document a style of living that remains 'outside of art.' The critic finds in the analysis of the artist's *actual experience*, the third term which metaphorically grounds the experience of nature (the body) and art (the culture). [. . .]

. . . the authenticity of body art cannot be inscribed at the level of a particular morphology, it must be chiselled into the world in accordance with direct experience. The discourse of the body in art is more than a repetition of the eschatological voices of abstract expressionism; the actual experience of the body fulfills the prophecy of the painted mark. It is also more than a confirmation of the positivist aspirations of the *Art of the Real*. The art of the 'real body' does not pertain to the truth of a visible form, but refers back to its essential content: the irreducible, irrefutable experience of *pain*. The body, as artistic text, bears the authenticating imprint of pain like a signature; Vergine insists, 'the experiences we are dealing with are authentic, and they are consequently cruel and painful. Those who are in pain will tell you that they have the right to be taken seriously.'[4] (It is no longer a question of good art, but of serious artists.) [. . .]

. . . The specific contribution of feminists in the field of performance has been to pose the question of sexual difference across the discourse of the body in a way which focuses on the construction not of the individual but of the sexed subject. The body is not perceived as the repository of an artistic essence: it is *seen* as a kind of hermeneutic image. The so-called 'enigma of femininity' is formulated as the problem of representation (images of women, how to change them) and then resolved by the discovery of a true identity behind the patriarchal façade. This true identity is 'the essence in women' according to Ulrike Rosenbach, who defines feminist art as 'the elucidation of the woman-artist's identity; of her body, of her psyche, her feelings, her position in society.'[5]

Clearly the question of the body and the question of sexuality do not necessarily intersect. When they do, for instance in this particular discourse, the body is decentered and it is radically split; positioned; not simply *my* body, but *his* body, *her* body. Here, no third term emerges to salvage a transcendental sameness for aesthetic reflection. Within this system of representation, actual experience merely confirms an irrevocable difference in the field of the other.

Partially because of this intransigence, feminist art has been problematic for criticism; how does the critic authenticate the work of art when the author is sexed and 'his' truth no longer universal? Consequently, most of this work has been marginalized by or excluded from the so-called 'mainstream' even when the critic's concerns have included areas such as psychoanalysis . . . Moreover the predominant forms of feminist

writing on art continue to counterpose a visible form to a hidden content; excavating a different, but similarly fundamental order of truth – the truth of the woman, her original feminine identity. But in practice what persistently emerges as a result of foregrounding the question of representation, particularly the image, is more in the order of an underlying contradiction than an essential content. The woman artist 'sees' her experience as a woman particularly in terms of the 'feminine position,' as object of the look, but she must also account for the 'feeling' she experiences as the artist, occupying the 'masculine position' as subject of the look. The former she defines as the socially prescribed position of the woman, one to be questioned, exorcised, or over-thrown . . . while the implications of the latter (that there can be only one position with regard to active looking and that is masculine) cannot be acknowledged and is con-strued instead as a kind of psychic truth – a natural, instinctual, preexistent, and essential femininity. Frequently, in the process of its production, the feminist text repudiates its own essentialism and testifies instead to the insistent bisexuality of the drives. It would seem to be a relevant project for feminist criticism to take this further – to examine how that contradiction (the crisis of positionality) is articulated in particular practices and to what extent it demonstrates that masculine and feminine positions are never finally fixed – for the artist, her work, or her public. [. . .]

Following the paradoxical logic of modernism's demand for objective purposes as well as transcendental truths, avant-garde practices between 1965 and the mid-1970s initiated areas of work that divided the very field of which they were an effect. The potential of that divergence has not been completely realized. First, the materiality of the practice: initially defined in terms of the constraints of a particular medium, it must now be redefined as a specific production of meaning. Secondly, sociality, raised as the question of context, i.e. the gallery system (inside vs. outside), and the commodification of art (object vs. process, action, idea, etc.). This must be reconsidered as the question of institutions, of the conditions which determine the reading of artistic texts and the strategies which would be appropriate for interventions (rather than 'alternatives') in that context. Thirdly, sexuality, posed as the problem of images of women and how to change them, must be reformulated as a concern with positionality, with the produc-tion of readers as well as authors for artistic texts and crucially, with the sexual overdetermination of meaning which takes place in that process.

The dominant critical practices of that same period have, however, so consistently converged on the traditional vanishing point of the artistic subject, self-possessed and essentially creative, that it is not surprising now to find a certain consolidation of that position in artistic practices themselves, in the return of painterly signifiers and their privileged site – the classical pictorial text. Finally, a further question is raised – why theoretical criticism, with a very different history from that discussed so far, was also unable to sustain the discontinuities in the modernist discourse and develop an accessible critique.

Exhibition and System

Critical writing on art which places emphasis on the analysis of signifying practice rather than on the exhortation or description of artistic auteurs, generally acknowledges that art forms are inscribed within the social context that gives rise to them. Neverthe-less, there is a problematic tendency to constitute the pictorial text as the paradigmatic

insistence of that inscription in a way which forecloses the question of its institutional placing. The pictorial paradigm constructs the artistic text as both essentially singular and as centrally concerned with the practice of painting; but, as Hubert Damisch has pointed out, when painting is considered at the semiotic level, that is with reference to its internal system, it functions as an epistemological obstacle – an obstacle never surmounted, only prodded by an endless redefinition of the sign or averted altogether by taking the semantic route.[6] Perhaps to some extent this accounts for what appears to be a certain impasse in the area of art criticism when compared, for instance, with developments in film theory.

Critical texts have focused either on analysis of the individual *tableau* (sometimes an individual artist's *oeuvre*) or on the construction of general cultural categories and typologies of art. This work has been both necessary and important. The arguments outlined here are not so much against such contributions as for a reconsideration of what might constitute appropriate terms for the analysis of current practices in art. This reconsideration is prompted firstly by developments within particular practices. Feminist art, for instance, cannot be posed in terms of cultural categories, typologies, or even certain insular forms of textual analysis, precisely because it entails the assessment of political interventions, campaigns, and commitments as well as artistic strategies. In this instance, interpretation is not simply a matter of what can be discovered at the interior of a composition. Secondly, a reconsideration of critical methods is required if one takes account of the specific conditions which determine the organization of artistic texts and their readings at the present time; that is, *the temporary exhibition and its associated field of publications – the catalogue, the art book, and the magazine.* From this point of view, 'art' is never given in the form of individual works but is constructed as a category in relation to a complex configuration of texts.

In terms of analysis, the exhibition system marks a crucial intersection of discourses, practices, and sites which define the institutions of art within a definite social formation. Moreover, it is exactly here, within this inter-textual, inter-discursive network, that the work of art is produced as text.

Rather schematically, it can be said that at one level an exhibition is a discursive practice involving the selection, organization, and evaluation of artistic texts according to a particular genre (the one-person show, the group show, the theme exhibition, the historical survey, and the Annual, Biennial, etc.), displayed in certain types of institutions (museums, galleries), within specific legal structures (contractual agreements, fees, insurance), and preserved by definite material techniques in a number of ways (catalogues, art books, magazines). At another level, an exhibition is a system of meanings – a discourse – which, taken as a complex unit or enunciative field, can be said to constitute a group of statements; the individual works comprising fragments of imaged discourse or utterances which are anchored by the exhibition's titles, subheadings, and commentary, but at the same time unsettled, exceeded, or dispersed in the process of their articulation as events. [...]

The exhibition has a definite substantive duration. In its phenomenal form the installation is subject to the constraints of a definite site, it is only reproducible in a limited sense, but the catalogue remains. It is infinitely reproducible and, moreover, it constitutes the determinant means of institutional control over the continued distribution of works of art. In this context, the absence of a catalogue also becomes significant. Artists generally maintain that the catalogue is more important than the exhibition

itself. It gives a particular permanence to temporary events, an authenticity in the form of historical testimony. Together with art books and magazines, exhibition catalogues constitute the predominant forms of receiving and, in a certain sense, possessing images of art. The exhibition remains the privileged mode of reception in terms of the viewer's access to the 'original' work, but far more often the reader's knowledge of art is based on reproductions in books and magazines. Critical theories of art founded on the notion of artisanal production fail to recognize that these historically specific means of organization, circulation, distribution, not only determine the reception – reading, viewing, reviewing, reworking – of artistic texts, but also have an effect on the signifying practices themselves. [...]

[1] Peter Wollen, 'Photography and Aesthetics,' *Screen*, 19, no. 4, Winter 1978/9, p. 27, n. 22.
[2] Griselda Pollock, 'Artists, Mythologies and Media – Genius, Madness and Art History,' *Screen*, vol. 21, no. 3, Autumn 1980, pp. 57–96.
[3] Lea Vergine, in *Il corpo come linguaggio*, Milan, 1974, p. 3.
[4] Ibid., p. 5.
[5] Ulrike Rosenbach, *Körpersprache*, Frankfurt, 1975.
[6] See Hubert Damisch, 'Eight Theses For (or Against?) a Semiology of Painting,' *enclitic* 3, no. 1, Spring 1979, pp. 1–15.

3 Ana Mendieta (1948–1985) 'Art and Politics'

Mendieta was born in Havana and was sent to the USA by her parents in 1961, at the time of the Cuban revolution. At the University of Iowa she first studied painting and then entered a Multimedia and Video Art programme, gaining a Master's degree in Fine Arts in 1977. She visited Mexico frequently between 1971 and 1978 and travelled to Cuba in 1980 and 1981. She married the sculptor Carl Andre in 1975 and moved to New York in 1978. In 1983 she travelled to Rome on an American Academy Fellowship. Her best-known group of works is the *Silueta* series, in which an image of her body is left in the landscape, sculpted from mud, woven from grass, burnt on the ground, or otherwise marked out from natural materials. Her *Rupestrian Sculptures* were carved in the rocks at the Escaleras de Jaruco in Cuba. On her death Andre was charged with her murder but acquitted. The following text was read by Mendieta at the New Museum of Contemporary Art, New York, on 18 February 1982. It is printed in *Ana Mendieta*, Ediciones Poligrapha, Barcelona, 1996, pp. 167–8, from which our version is taken.

[...] The question of integrity in aesthetics is rather a mind-boggling question for me, because I am an artist who feels that art is first of all a matter of vocation. Now vocation is a limiting factor, which extends even to the kind of art an artist is able to make. In other words, I believe an artist is even limited to what he or she can give life to. I make the art I make because it's the only kind I can make. I have no choice. The Spanish philosopher Ortega y Gasset said: 'To be a hero, to be heroic, is to be oneself.' I think the statement is particularly significant to the attitude an artist must have in society. Being endowed with thought, how can a person go through life without questioning himself? And being endowed with feeling, how can he or she remain indifferent?

It is only with a real and long enough awakening that a person becomes present to himself, and it is only with this presence that a person begins to live like a human being.

To know oneself is to know the world, and it is also paradoxically a form of exile from the world. I know that it is this presence of myself, this self-knowledge which causes me to dialogue with the world around me by making art.

I would like to make some general statements about culture. I like to think of culture as the memory of history. However, according to Lévi-Strauss, culture is the combination of customs, beliefs, habits, and aptitudes acquired by man as a member of society. I believe that art, although it is a material part of culture, its greatest value is its spiritual role and the influence that it exercises in society, because art is the result of a spiritual activity of man and its greatest contribution is to the intellectual and moral development of man. Culture is a historical phenomenon that evolves at the same level as society, and that is the problem we are facing today. To establish its empire over nature, it has been necessary for man to dominate other men, and to treat part of humanity like objects. Western civilization's most pervasive task has been the spread of technology and its claim to culture seems to be devoted to the assimilation of technology. I'd like to ask a question. Who speaks for the US today? And I'd like to answer the question. The advertising agencies.

I think that we all know that there are two cultures within this culture. One is the culture in which the ruling class, the reactionary class, pushes to paralyze the social development of man in an effort to have all society identify with, and serve their own interests. They banalize, mix, distort, and simplify life. They have no use for anything pure or real. They call this stylizing. In this way, they create a product, a style, which dominates mass communications, and now also the arts, in all of its manifestations. They call this cosmopolitan and international style. Believe me, friends, imperialism is not a problem of extension, but of reproduction. This is an old technique, it was not invented here. It was used in ancient times by the Egyptians, the Greeks, the Romans. And so, authentic cultural traditions and manifestations in the arts denounce the falsehood of the civilizing mission of the ruling class. So, to mention what I said in my opening remarks, that to me art is a matter of vocation, must seem ridiculous to the bourgeois. The risk that real culture is running today is that if the cultural institutions are governed by people who are part of the ruling class, then art can become invisible because they will refuse to assimilate it.

I feel that the very fact that you are here today is proof that there is another culture aside from ruling class culture. You know, the greatest comfort that great works of art give to me is not only my experience of them, but also the fact that they were created and that they exist. Now I'm sure that a lot of them were created in as adverse conditions as what we have today. And so that's proof, you know, that we will survive. And so the question of integrity in aesthetics is coming up again historically. It is a personal question which each artist faces. It is a constant struggle. Hard times are coming, but I believe we who are artists will continue making our work. We will be ignored but we will be here. Thank you.

4 Krzysztof Wodiczko (b. 1943) 'Public Projection'

Wodiczko is a Polish artist based in New York. His text concerns the form of work he was engaged in at the time of writing: the projection of carefully selected images on to the walls

of public buildings. This work is explicitly distinguished from the liberal urban decoration of 'art in public places'. It is Wodiczko's position that precedents for a critical public art are to be found in those avant-garde practices which were until recently consigned to the margins of modern art history, among them the synthetic theatre of the Futurists, the agit-prop activities of the Constructivists, and the 'unitary urbanism' of the Situationists. From this point of view, it is in these margins that the prehistory of the postmodern is to be discovered. Originally published in the *Canadian Journal of Political and Social Theory/ Revue canadienne de théorie politique et sociale*, vol. 7, nos. 1–2, Winter/Spring 1983, pp. 184–7, from which the present text is taken.

> It's not a matter of emancipating truth from every system of power (which would be a chimera, for truth is already power) but of detaching the power of truth from the forms of hegemony, social, economic and cultural, within which it operates at the present time.
>
> Michel Foucault, *Truth and Power*

The Body

We are looking at the multiple sites of its body, and at the shapes of its external organs; the colonnades, porticos, domes, helmets, arches, columns, pilasters, pediments, stairs, doors, windows. Attracted by its appearance, we begin to gravitate around its body. Gazing, viewing, observing, and staring, we are trying to fathom its mysterious grammar. Standing face to face with the front, pacing along the façade, touring all of the elevations of its vast structure, we are being transformed into the mediums of a gigantic cultural seance. We are being drawn into the magnetic field of its architectural appeal and symbolic influence.

The Aura

Crossing the monstrous shade of its elevation, we are halted by the blow of a cool wind which is cruising around the corners of its lofty massif. As we approach its body, we are confronted by an intimate protective warmth radiating through the walls, wings, and open doors, confused with the heavy breath of the air conditioning ventilators.

We feel desire to identify with or to become part of the building. We recognize the familiarity of our body and of that of the building. We feel a drive to 'complete' the building and we desire to be 'completed' by it. We sense that there is something about us which is incomplete, and which can only be completed by a full integration with the building.

Superficially, we resent the authority of its massive monumental structure. We rebel against a tyranny of its deaf, motionless, immortal walls, yet in our heart of hearts, we not only allow ourselves to be outwitted by an academic methodicalness of the hierarchal order, charm, loftiness of its parts, and the harmony of its proportional body, but, more dangerously, we will allow ourselves to become intoxicated and seduced by its structural ability to embody, and to artistically grasp our intimate, unspoken drive for the disciplined collaboration with its power.

Social Body

Its body is both individual and social; its harmony is based upon the same discipline, governing a totality of relationships of the whole structure to the parts and of each part

to the other. This embodies and physically represents the concept of the organization of a utopian society in the form of a disciplined-disciplining body, allowing for both the multidirectional flow of power and the controlled circulation of the individual bodies.

The Father

In the process of our socialization, the very first contact with a public building is no less important than the moment of social confrontation with the father, through which our sexual role and place in society is constructed. Early socialization through patriarchal sexual discipline is extended by the later socialization through the institutional architecturalization of our bodies.

Thus the spirit of the father never dies, continuously living as it does in the building which was, is, and will be embodying, structuring, mastering, representing, and reproducing his 'eternal' and 'universal' presence as a patriarchal wisdom-body of power.

The Medium

The building is not only an institutional 'site of the discourse of power', but, more importantly, it is a metainstitutional, spatial medium for the continuous and simultaneous symbolic reproduction of both the general myth of power and of the individual desire for power.

For these purposes, the building is 'sculptured' to operate as an ascetic structure, thus assisting in the process of inspiring and symbolically concretizing (reflecting) our mental projections of power.

Social Effect

The prime occupation of the building is to remain still, to be rooted permanently to the ground, abstaining from any visible movement.

This static occupation – annexation of time and territory – creates both a dynamic and a somnambulistic social effect. The 'aura' of the unmoving building hypnotically animates and sustains our ritualistic movement around its body.

Circulating around and between the buildings, we cannot stop moving. We are unable to concentrate and focus on their bodies. This establishes an absent-minded relation to the building, an unconscious contact, a passive gaze.

By imposing our permanent circulation, our absent-minded perception, by ordering our gaze, by structuring our unconscious, by embodying our desire, masking and mythifying the relations of power, by operating under the discreet camouflage of a cultural and aesthetic 'background', the building constitutes an effective medium and ideological instrument of power.

The Method of Projection

We must stop this ideological 'ritual', interrupt this journey-in-fiction, arrest the somnambulistic movement, restore a public focus, a concentration on the building and its architecture. What is implicit about the building must be exposed as explicit; the myth must be visually concretized and unmasked. The absent-minded, hypnotic

relation with architecture must be challenged by a conscious and critical public discourse taking place in front of the building.

Public visualization of this myth can unmask the myth, recognize it 'physically', force it to the surface and hold it visible, so that the people on the street can observe and celebrate its final formal capitulation.

This must happen at the very place of myth, on the site of its production, on its body – the building.

Only physical, public projection of the myth on the physical body of myth (projection of myth on myth), can successfully demythify the myth.

The look, the appearance, the costume, the mask of the buildings is the most valuable and expensive investment. In the power discourse of the 'public' domain, the architectural form is the most secret and protected property.

Public Projection involves questioning both the function and the ownership of this property.

In defending the public as the communal against the public as the private, the projection reveals and is effected by the political contradictions of the culture of capitalism.

As a private property, the architectural appearance is well protected by the police, the guards, and the city by-laws.

The attack must be unexpected, frontal, and must come with the night when the building, undisturbed by its daily functions, is asleep and when its body dreams of itself, when the architecture has its nightmares.

This will be a symbol-attack, a public psychoanalytical seance, unmasking and revealing the unconscious of the building, its body, the 'medium' of power.

By introducing the technique of an outdoor slide montage and the immediately recognizable language of popular imagery, the Public Projection can become a communal, aesthetic counter-ritual. It can become an urban night festival, an architectural 'epic theatre', inviting both reflection and relaxation, where the street public follows the narrative forms with an emotional engagement and a critical detachment.

Warning

Slide projectors must be switched off before the image loses its impact and becomes vulnerable to the appropriation by the building as a decoration.

Post Scriptum

> ...It may be noted, by the way, that there is no better start for thinking than laughter.
> And, in particular, the convulsion of the diaphragm usually provides better opportunities
> for thought than convulsion of the soul.

<div style="text-align: right">Walter Benjamin, 'The Author as Producer'</div>

<div style="text-align: right">Toronto</div>

5 Victor Burgin (b. 1941) from 'The Absence of Presence'

In 1969, the London showing of the exhibition 'When Attitudes become Form' had drawn attention to an international Conceptual Art movement and to the existence of relevant work

in Britain (see VIIB8). In 1984 an exhibition was mounted at Kettle's Yard Gallery, Cambridge, and the Fruitmarket Gallery, Edinburgh, which reviewed that work and some subsequent developments under the title '1965 to 1972 – when attitudes became form'. The catalogue included essays by Burgin, who exhibited in the original London show, and by Charles Harrison, who curated it. Burgin asserts the radicalism of Conceptual Art vis-à-vis the hegemony of Greenbergian Modernism, and he defends its legacy in face of a return to convention with the painting revival of the late 1970s and early 1980s. Originally published in the exhibition catalogue *1965 to 1972 – when attitudes became form*, Cambridge and Edinburgh, 1984, pp. 17–24, from which the present extract is taken. The essay was subsequently included in Burgin's *The End of Art Theory*, London, 1986. In his conclusion to that book (p. 205) he wrote, '"Art theory", understood as those interdependent forms of art history, aesthetics, and criticism which began in the Enlightenment and culminated in the recent period of "high modernism", is now at an end. In our present so-called "post-modern" era the end of art theory *now* is identical with the objective of *theories of representation* in general: a critical understanding of the modes and means of symbolic articulation of our *critical* forms of sociality and subjectivity.' Later, in correspondence with the editors (February 1992), he added: 'I rarely refer to art *as such* in my more recent articles... However, as I've pointed out, what might appear to be my neglect of "art" is fully consistent with my view of the proper end of art theory.' (See also VIIB8 and VIIC13.)

The 'conceptual art' of the late 1960s to early 1970s was an affront to established values, hostility to the new work being often so intense as to suggest that more than merely aesthetic values were at stake. Today the excitement has died down, recollected in tranquillity conceptual art is now being woven into the seamless tapestry of 'art history'. This assimilation however is being achieved only at the cost of amnesia in respect of all that was most radical in conceptual art. I want to say something of what I believe has been repressed in the almost universal tendency, in the art-world of the 1980s, to 'lose' an entire decade – the 1970s – as a period in which 'nothing happened'. As what characterizes the present moment in the art-world is a certain notion of 'post-modernism', now being used to support a wholesale 'return to painting', then I shall address my remarks to these issues. In order to show you these objects from my own vantage-point however I shall have to pass by way of some history and theory which may at times appear to be leading nowhere in particular. I ask for your patience, there is no other route.

The conceptualism of the late 1960s was a revolt against modernism – specifically, we should add, as formulated in the writings of the American critic Clement Greenberg. Greenberg defined modernism as the historical tendency of an art practice towards complete self-referential autonomy, to be achieved by scrupulous attention to all that is *specific* to that practice: its own traditions and materials, its own *difference* from other art practices. This Greenbergian project is actually a particular nuancing of a more general set of assumptions. Simply put, the underlying assumptions of Greenberg's modernism go something like this: *Art* is an activity characteristic of humanity since the dawn of civilization. In any epoch the *Artist*, by virtue of special gifts, expresses that which is finest in humanity (as Greenberg puts it, 'the historical essence of civilization'). The visual artist achieves this through modes of understanding and expression which are 'purely visual' – radically distinct from, for example, verbalization. This special characteristic of art necessarily makes it an autonomous sphere of activity, completely separate from the everyday world of social and political life. The

autonomous nature of visual art means that questions asked of it may only be properly put, and answered, in its own terms – all other forms of interrogation are irrelevant. In the modern world the function of art is to preserve and enhance its own special sphere of civilizing human values in an increasingly dehumanizing technological environment.

If these beliefs sound familiar – perhaps even self-evident – it is because they long ago became part of the received common-sense we in the West learn at our mother's knee. They are the extension, into the twentieth century, of ideas which first began to emerge in the late eighteenth century as part of what we know today as 'romanticism' (although some are of much earlier origin). [...]

* * *

[...] Greenberg's aesthetics are the terminal point of this historical trajectory. There is another history of art, however, a history of *representations* (hardly a dramatic revelation, and no more avant-gardist, or 'fashionable', than is the Warburg Institute). For me, and some other erstwhile conceptualists, conceptual art opened onto that *other* history, a history which opens onto history. Art practice was no longer to be defined as an artisanal activity, a process of crafting fine objects in a given medium, it was rather to be seen as a set of operations performed in a *field* of signifying practices, perhaps centred on a medium but certainly not bounded by it. The field of concern was to be, as I put it in a publication of 1973, 'the semiotic practices of a society seen, in their segmentation of the world, as a major factor in the social construction of the world, and thus of the values operative within it'.[1] As a statement of intent, this had the advantage of being sufficiently vague to allow *anything* to happen. The ensuing decade has been a period of working-out and working-through various specific responses to the problem of going beyond conceptual art. I have mentioned the re-emergence, out of conceptual-ism, of attention to the political; an initial, and continuing, consequence has been the production of work in which political issues of the day are represented – often, and it seems to me increasingly, by means of painting. Another response, one which has tended to eschew such means, has been based less upon a notion of the 'representation of politics' and more on a systematic attention to the *politics of representation*.

* * *

[...] Late modernism stood for *order* – the obedience to function of the International Style, the respect for 'specificity' and 'tradition' in Greenberg's aesthetics – everything in its proper place, doing its duty, fulfilling its preordained rôle in patriarchal culture. We should remember that the word 'patriarchy' does not refer to 'men' in general, but to the *rule of the father*. It is precisely the terms of this rule, the terms of centralized *authority*, which are at stake across the various forms of today's politics, including the politics of culture. It seems likely that 'conceptualism' is destined, for the moment at least, to be represented as that 'movement' which, by undermining 'modernism', paved the way for 'post-modernism'. None of the 'isms' here however were, or are, unitary phenomena; nor do such cultural phenomena simply give way to one another like television programmes in an evening's viewing. Aesthetically, culturally, politically, conceptualism comprised both tendencies for change and conservative tendencies. The same is true of this present period of 'post-modernism'. What we can see happening in art today is a return to the symbolic underwriting of the patriarchal principle by means of the reaffirmation of the primacy of *presence*. The function of the insistence upon presence is to eradicate the threat to narcissistic self-integrity (the threat to the body of 'art', the body politic) which comes from *taking account* of difference, *division* (rather

than effectively *denying* difference by valorizing one term of an opposition in order to suppress the other): division of form from content (political subject-matter can be fetishised as 'presence' just as much as can the avoidance of any subject-matter whatsoever); division of the private (art as 'private experience') from the social (which after all only maps the division of family life from work in industrial capitalist societies, including those in the East); division of the word from the image . . . division of the masculine from the feminine in the interests of producing 'men' and 'women'; division of theory from practice; division of the inside of the institution from its outside (for example, the almost complete isolation of art-historical and critical discourse from the wider analytical discourses – including psychoanalysis and semiotics – which surround them); and so on. What was radical in conceptual art, and what, I am thankful to say, has not yet been lost sight of, was the work it required – beyond the *object* – of recognizing, intervening within, realigning, reorganizing, these networks of differences in which the very definition of 'art' and what it *represents* is constituted: the glimpse it allowed us of the possibility of the absence of 'presence', and thus the possibility of *change*.

But nevertheless . . .

I have remarked that the history and pre-history of modern art in our patriarchal, phallocentric, culture is stamped by the presence of fetishism, the fetishism of presence. I do not intend to imply that art is to be *reduced* to fetishism, or that fetishism lies 'behind' all representations in a relation of cause to effect – I would rather prefer a metaphor used by Foucault in a different context and speak of the 'capillary action' of fetishism. Fundamental to Freud's account of fetishism is what he calls 'disavowal' – that splitting between knowledge and belief which takes the characteristic form, 'I know very well, but nevertheless . . .' Disavowal is the *form* of fetishism – that which operates to protect a sense of narcissistic self-integrity by effacing difference, otherness, the *outside*. Today, what has become in effect the 'official' posture of the art establishment is a disavowal in respect of history.

I have been using the expression 'post-modernism' to refer to art produced after Greenberg's late modernism lost its ideological hegemony – the moment of conceptualism and after. But if the expression 'post-modernism' is to take on anything more than such a merely tautological meaning then we have to look beyond the self-defined boundaries of the 'art world' – *Art* – to the more general cultural/political/intellectual *epistemological* upheavals of the post-war period. If, for expository convenience, and in the manner of allegory, we were to 'personify' a figure of 'pre-modernism' then it would be characterized by the self-knowing, punctual, subject of humanism, 'expressing' itself, and/or its world (a world simply there, as 'reality') via a transparent language. 'Modernism' came in with the social, political, and technological revolutions of the early twentieth century and is to be characterized by an existentially uneasy subject speaking of a world of 'relativity' and 'uncertainty' while uncomfortably aware of the conventional nature of language. The 'post-modernist' subject must live with the fact that not only are its languages 'arbitrary' but it is *itself* an 'effect of language', a precipitate of the very symbolic order of which the humanist subject supposed itself to be the master. 'Must live with', *but nevertheless* may live 'as if' its condition were other than it is; may live 'as if' the grand narrative of humanist history, 'the greatest story

ever told', were not yet, long ago, over – over at the turn of the century, with Marx, Freud, and Saussure; over with nuclear weaponry and micro-chip technology; over, in the second half of the twentieth century, with the ever-increasing political conscious-ness of women and the 'third world'. Yes, we know the twentieth century has happened, and yet nevertheless it hasn't; thus, to speak only of this country, the press reporting of the Falklands conflict and the Royal marriage, and the return to heroism in painting and to hard-won images as dutiful and competent as a Victorian embroidery sampler.

'Truth' was a principal character in the allegorical canvases of humanism; in post-modernist allegories Truth has been replaced by the twins 'Relativity' and 'Legitim-ation'. A response to the radical heterogeneity of the possible has always been the homogeneity of the *permissible* – expressed in terms of narrative, in terms of allegory; offering us the images of those rôles we may adopt, those subjects we may become, if we are ourselves to become socially *meaningful*. It is these narratives, these subjects, which are at issue now in the moment of post-modernism. All this rummaging through the iconographic jumble of the past is symptomatic of it – in art and in fashion as well as, increasingly, in politics. As I have observed, this archaeological activity may reveal the foundations of our 'modern' belief-systems, simultaneously clearing the ground for reconstruction which will not *obliterate* the past but which will maintain, precisely, its *difference*; or the activity may end where it began, in nostalgia, in repetition, in the affirmation that the present and the past are somehow the *same*. It is the repression of difference in order to preserve, unthreatened, the same, which generates the symptom 'fetishism'. Psychoanalysis shows us how jealously, and with what skill, we guard our symptoms; they are not something we wish to give up for they speak our *desire*. But the same desire may find other symptomatic means, may find alternative symbolic forms (they are not all equal in terms of their consequences) *en route* to a 'redistribution of capital' in the economy of desire. In the meantime, the consequence of modern art's disavowal of modern history remains its almost total failure to be about anything of consequence.

¹ Victor Burgin, *Work and Commentary*, London, 1973.

6 Jacqueline Rose (b. 1943) 'Sexuality in the Field of Vision'

The psychoanalytic theory of Freud is unquestionably revealing of the gender of its author, and for that reason if no other has been a target for feminists engaged on the critique of patriarchy. Yet, to the extent that psychoanalysis furnishes means to uncover the mechan-isms of repression, it has also been associated with the pursuit of emancipation. During the 1970s a number of feminists turned to Freud, and to Lacan's revisions of Freud, for theoretical support in their emphasis on the role of the experiencing subject. Nowhere is the masculine bias of Freud's work so evident as in his pairing of the idea that infant males see women as castrated versions of themselves with the idea that women suffer envy for the penis they lack. In some recent feminist theory this mutually reinforcing pair of assumptions has been given a new emphasis and a new value: it is seen as revealing on the one hand of the contingent and constructed character of sexual difference, and on the other of a continual apprehension on the part of the male lest he lack that by which his authority is supposedly secured – an apprehension which is transmitted to the subject female in the

form of a demand. Against the background of this revision, Rose proposes a critique of the formality of the visual image which is at one and the same time a raising of the question of sexual difference, and a destabilizing of those norms according to which a certain reassuring representation of difference is supposed to be maintained. Written for the catalogue of the exhibition *Difference: On Representation and Sexuality*, Museum of Contemporary Art, New York, December–February 1984–5 and ICA, London, September–October 1985, pp. 31–3. (The exhibition included works by Ray Barrie, Victor Burgin, Hans Haacke, Mary Kelly, Silvia Kolbowski, Barbara Kruger, Sherrie Levine, Yve Lomax, Jeff Wall and Marie Yates.) The essay is reprinted in Jacqueline Rose, *Sexuality in the Field of Vision*, London, 1986, pp. 225–33, from which the present text is taken.

[...] Freud often related the question of sexuality to that of visual representation. Describing the child's difficult journey into adult sexual life, he would take as his model little scenarios, or the staging of events, which demonstrated the complexity of an essentially visual space, moments in which perception *founders* (the boy child refuses to believe the anatomical difference that he sees)[1] or in which pleasure in looking tips over into the register of *excess* (witness to a sexual act in which he reads his own destiny, the child tries to interrupt by calling attention to his presence).[2] Each time the stress falls on a problem of seeing. The sexuality lies less in the content of what is seen than in the subjectivity of the viewer, in the relationship between what is looked at and the developing sexual knowledge of the child. The relationship between viewer and scene is always one of fracture, partial identification, pleasure and distrust. As if Freud found the aptest analogy for the problem of our identity as human subjects in failures of vision or in the violence which can be done to an image as it offers itself to view. For Freud, with an emphasis that has been picked up and placed at the centre of the work of Jacques Lacan, our sexual identities as male or female, our confidence in language as true or false, and our security in the image we judge as perfect or flawed, are fantasies. And these archaic moments of disturbed visual representation, these troubled scenes, which expressed and unsettled our groping knowledge in the past, can now be used as theoretical prototypes to unsettle our certainties once again. Hence one of the chief drives of an art which today addresses the presence of the sexual in representation – to expose the fixed nature of sexual identity as a fantasy and, in the same gesture, to trouble, break up, or rupture the visual field before our eyes.

The encounter between psychoanalysis and artistic practice is therefore *staged*, but only in so far as that staging has *already taken place*. It is an encounter which draws its strength from that repetition, working like a memory trace of something we have been through before. It gives back to repetition its proper meaning and status: not lack of originality or something merely derived (the commonest reproach to the work of art), nor the more recent practice of appropriating artistic and photographic images in order to undermine their previous status; but repetition as insistence, that is, as the constant pressure of something hidden but not forgotten – something that can only come into focus now by blurring the field of representation where our normal forms of self-recognition take place.

The affinity between representation and sexuality is not confined to the visual image. In fact, in relation to other areas of theoretical analysis and activity, recognition of this affinity in the domain of the artistic image could be said to manifest something of a lag. In one of his most important self-criticisms,[3] Barthes underlined the importance of psychoanalysis in pushing his earlier exposé of ideological meanings into a critique of

the possibility of meaning itself. In his case studies Freud had increasingly demonstrated that the history of the patient did not consist of some truth to be deciphered behind the chain of associations which emerged in the analytic setting; it resided within that chain and in the process of emergence which the analysis brought into effect. Lacan immediately read in this the chain of language which slides from unit to unit, producing meaning out of the relationship between terms; its truth belongs to that movement and not to some prior reference existing outside its domain. The divisions of language are in themselves arbitrary and shifting: language rests on a continuum which gets locked into discrete units of which sexual difference is only the most strongly marked. The fixing of language and the fixing of sexual identity go hand in hand; they rely on each other and share the same forms of instability and risk. Lacan read Freud through language, but he also brought out, by implication, the sexuality at work in all practices of the sign. Modernist literary writing could certainly demonstrate, alongside the syntactic and narrative shifts for which it is best known, oscillations in the domain of sexuality, a type of murking of the sexual proprieties on which the politer world of nineteenth-century realist fiction had been based. Although the opposition between the two forms of writing has often been overstated, it is no coincidence that, in order to illustrate this tension between 'readerly' and 'writerly' fiction, Barthes chose a story in which the narrative enigma turns on a castrato (Balzac's *Sarrasine*).[4] The indecipherable sexuality of the character makes for the trouble and the joy of the text.

It is worth pausing over the implications of this for a modernist and postmodernist artistic practice which is increasingly understood in terms of a problematic of reading and a theory of the sign. Again, the historical links are important. Freud takes modern painting as the image of the unconscious. But the modernist suspension of the referent, with its stress on the purity of the visual signifier, belongs equally with Saussure who, at the same time, was criticising the conception of language as reference and underlining the arbitrary nature of the sign (primacy to the signifier instead of language as a nomenclature of the world). Lacan's move then simply completes the circuit by linking Saussure back to Freud. The unconscious reveals that the normal divisions of language and sexuality obey the dictates of an arbitrary law undermining the very possibility of reference for the subject since the 'I' can no longer be seen to correspond to some pre-given and permanent identity of psycho-sexual life. The problem of psychic identity is therefore immanent of the problem of the sign.

The same link (of language and the unconscious) can be made to that transition to postmodernism which has been read as a return of the referent, but the referent as a problem, not as a given. Piles of cultural artefacts bring back something we recognise but in a form which refuses any logic of the same. The objects before the spectator's eyes cannot be ordered: in their disjunctive relation, they produce an acuter problem of vision than the one which had resulted when reference was simply dropped from the frame. Above all – to return to the analogy with the analytic scene – these images require a reading which neither coheres them into a unity, nor struggles to get behind them into a realm of truth. The only possible reading is one which repeats their fragmentation of a cultural world they both echo and refuse.

At each point of these transitions – artistic and theoretical – something is called into question at the most fundamental level of the way we recognize and respond to our own subjectivity and to a world with which we are assumed to be familiar, a world we both do and do not know. Yet in each of these instances, it is precisely the psychoanalytic

concepts of the unconscious and sexuality, specifically in their relationship to language, which seem to be lost.

Thus the modernist stress on the purity of the visual signifier easily dissolves into an almost mystic contemplation. Language can be used to rupture the smoothness of the visual image but it is language as pure mark uninformed by the psychoanalytic apprehension of the sign. Cultural artefacts are presented as images within images to rob them of the values they seem naturally to embody, but the fundamental sexual polarity of that culture is not called into account. Finally, meaning is seen to reside in these images as supplement, allegory or fragment, but with no sexual residue or trace – the concept of textuality is lifted out of psychoanalytic and literary theory but without the sexual definition that was its chief impetus and support.

Across a range of instances, language, sexuality and the unconscious *in their mutual relation* appear as a present-absence which all these moments seem to brush against, or elicit, before falling away. The elisions can be summarized schematically:

- purity of the visual signifier and the unconscious as mystique (no language);
- language as rupture of the iconicity of the visual sign (no unconscious);
- cultural artefacts as indictment of the stereotype (no sexual difference);
- reading as supplement, process or fragment (no sexual determinacy of the signifier or of visual space).

Artists engaged in sexual representation (representation *as* sexual) come in at precisely this point, calling up the sexual component of the image, drawing out an emphasis that exists *in potentia* in the various instances they inherit and of which they form a part. Their move is not therefore one of (moral) corrective. They draw on the tendencies they also seek to displace, and clearly belong, for example, within the context of that postmodernism which demands that reference, in its problematized form, re-enter the frame. But the emphasis on sexuality produces specific effects. First, it adds to the concept of cultural artefact or stereotype the political imperative of feminism which holds the image accountable for the reproduction of norms. Secondly, to this feminist demand for scrutiny of the image, it adds the idea of a sexuality which goes beyond the issue of content to take in the parameters of visual form (not just what we see but how we see – visual space as more than the domain of simple recognition). The image therefore submits to the sexual reference, but only in so far as reference itself is questioned by the work of the image. And the aesthetics of pure form are implicated in the less pure pleasures of looking, but these in turn are part of an aesthetically extraneous political space. The arena is simultaneously that of aesthetics and sexuality, and art and sexual politics. The link between sexuality and the image produces a particular dialogue which cannot be covered adequately by the familiar opposition between the formal operations of the image and a politics exerted from outside.

The engagement with the image therefore belongs to a political intention. It is an intention which has also inflected the psychoanalytic and literary theories on which such artists draw. The model is not one of applying psychoanalysis to the work of art (what application could there finally be which does not reduce one field to the other or inhibit by interpretation the potential meaning of both?). Psychoanalysis offers a specific account of sexual difference but its value (and also its difficulty) for feminism,

lies in the place assigned to the woman in that differentiation. In his essay on Leonardo, Freud himself says that once the boy child sees what it is to be a woman, he will 'tremble for his masculinity' henceforth.[5] If meaning oscillates when a castrato comes onto the scene, our sense must be that it is in the normal image of the man that our certainties are invested and, by implication, in that of the woman that they constantly threaten collapse.

A feminism concerned with the question of looking can therefore turn this theory around and stress the particular and limiting opposition of male and female which any image seen to be flawless is serving to hold in place. More simply, we know that women are meant to *look* perfect, presenting a seamless image to the world so that the man, in that confrontation with difference, can avoid any apprehension of lack. The position of woman as fantasy therefore depends on a particular economy of vision (the importance of 'images of women' might take on its fullest meaning from this). Perhaps this is also why only a project which comes via feminism can demand so unequivocally of the image that it renounce all pretensions to a narcissistic perfection of form.

At the extreme edge of this investigation, we might argue that the fantasy of absolute sexual difference, in its present guise, could be upheld only from the point when painting restricted the human body to the eye. That would be to give the history of the image in Western culture a particularly heavy weight to bear. For, even if the visual image has indeed been one of the chief vehicles through which such a restriction has been enforced, it could only operate like a law which always produces the terms of its own violation. It is often forgotten that psychoanalysis describes the psychic law to which we are subject, but only in terms of its *failing*. This is important for a feminist (or any radical) practice which has often felt it necessary to claim for itself a wholly other psychic and representational domain. Therefore, if the visual image in its aesthetically acclaimed form serves to maintain a particular and oppressive mode of sexual recognition, it does so only partially and at a cost. Our previous history is not the petrified block of a singular visual space since, looked at obliquely, it can always be seen to contain its moments of unease. We can surely relinquish the monolithic view of that history, if doing so allows us a form of resistance which can be articulated *on this side of* (rather than beyond) the world against which it protests. [...]

1 Sigmund Freud, 'Some Psychical Consequences of the Anatomical Distinction between the Sexes', (1925), in *The Standard Edition of the Complete Psychological Works*, London, 1955–74, XIX, p. 252.
2 Freud, *From the History of an Infantile Neurosis* ('*The Wolfman*') (1914), *Standard Edition* (op. cit.), XVII, pp. 29–47.
3 Roland Barthes, 'Change the Object Itself', in *Image, Music, Text*, essays selected and translated by Stephen Heath, London, 1977.
4 Barthes, *S/Z* Paris, 1970. English translation by Richard Miller, New York, 1974.
5 'Leonardo da Vinci and a Memory of his Childhood', (1910), *Standard Edition* (op. cit.), XI, p. 95.

7 Niklas Luhmann (1927–1998) 'The Work of Art and the Self-Reproduction of Art'

Luhmann was a high-ranking civil servant until an encounter with the influential American sociologist Talcott Parsons. He subsequently became a prolific social philosopher, and was attached to the University of Bielefeld. His work is distanced from the liberal tendencies of

the second-generation Frankfurt School by its rigorous anti-subjectivity and by its basis in general systems theory. Thus, in Luhmann's usage such concepts as 'autonomy', 'self-reference' and 'context' do not refer specifically to the working conditions of human individuals or to the defining properties of their productions; rather they may be employed in the description of any entity that is definable as a system, from an amoeba to the New York artworld. In contrast to Adorno's view that art offers a critical 'counter-position to society', Luhmann proposes two hypotheses: the first is that communication is the stuff that is transformed into social structures, in measure according to its improbability; the second is that art is realized as a 'performance of society'. According to this view, the current condition of art is a realistic function of the system that art now is and is in turn a part of – a system characterized by the necessity of self-reference. 'By suffering its own condition,' he writes elsewhere, 'art shows just how it is.' For all the unmitigated abstraction of Luhmann's writing, it is enlivened by considerable knowledge about art, and by a surprising openness to current practice. His *Art as a Social System* (1995) was published in English translation in 2000. While it offers a social theory of art, it has little methodologically in common with the social history of art, and even less with cultural studies. The article excerpted here was originally published as 'Das Kunstwerk und die Selbstreproduktion der Kunst' in Hans Ulrich Gumbrecht and K. Ludwig Pfeiffer (eds.), *Stil: Geschichten und Funktionen eines kulturwissenschaftlichen Diskurselements*, Frankfurt am Main: Suhrkamp Verlag, 1986, pp. 620–72 (extending a previous version published in *Delfin*, 3, in 1984). Our text is translated from pp. 620, 621, 622–6.

I

The following analyses are governed by two abstractions.[1] In the first place they ignore all differences between the particular arts. Whether it is a question of literature or theatre, music or the visual arts – we are concerned with all of them precisely in so far as they are regarded in the domain of social communication (under whatever criteria) as works of art. We are interested in the consequences of the progressive differentiation of art according to the specific code of the beautiful/the ugly, and the particular differences between the arts are initially irrelevant here.

In the second place the formulation of the problem itself is governed by a second abstraction that requires further elucidation in its own right. We can identify certain types of systems in reality which could be described, following a suggestion of Humberto Maturana (1982), as 'autopoietic systems'. These systems generate the elements of which they are composed precisely by means of those very elements. They are therefore closed and self-referential systems or, speaking more precisely, systems whose relation to their own environment is based upon closed operational connections that essentially circle back upon themselves. This kind of self-reference is not merely a kind of self-reflection, i.e. it is not merely a system that can observe and describe its own identity. What is decisive is this: everything that functions as a unity within the system acquires this unity through the system itself, and this holds not only for the structures and processes involved, but equally for the individual elements which cannot be broken down any further with regard to the system itself. (For more on these systems cf. N. Luhmann 1984a.)

[...] My hypothesis is that the structure of modern society facilitates the formation of functionally specific autopoietic subsystems [*Teilsysteme*]. The way in which this happens is determined by the functional differentiation of the social system as a whole. This process of functional differentiation enables society to differentiate the

most important subsystems with respect to their social function even further, and thereby to detach them more emphatically from their intra-social *environment* [*Umwelt*]. The importance of the input and output in relation to other social subsystems is thus decreased. That is why the attempt to characterize art in terms of such input is coming to appear increasingly inadequate. Nor is it possible for the demands or requirements of other important subsystems, the demand for decorative products, for example, to determine what counts as art. Art thus becomes a self-determining and self-generating system that regulates itself according to its own internal coherences and contradictions.[2] The self-description of art, its own semantics and aesthetic theory, must therefore renounce the idea of 'imitatio'.[3]

If this is the case, then the external (sociological) description of art, as well as the internal (aesthetic) theory of art, will have to be adjusted accordingly. This demands a theory that can grasp that, and how, art is capable of surviving and developing *under social conditions* as a *closed* system of self-production (precisely not therefore as some kind of 'free-floating' phenomenon!). This is exactly what a theory of autopoietic systems attempts to accomplish by distinguishing the organized form of autopoietic reproduction from the limitations imposed by the domain in which this autopoiesis takes place.

* * *

Contrary to Adorno, what is at issue here is not 'the autonomization of art vis-à-vis society' (as formulated in Adorno 1970, p. 334), but rather its *autonomization within society*. Nor do we believe that the social character of art resides in the negativity it displays in 'counter-position to society' (Adorno 1970, p. 335). It resides rather in the fact that the freeing of art for a specific function can only be conceived as an intrinsic *accomplishment of society itself*. The autonomy which art has acquired in the modern age, therefore, is not something that would emphatically contradict its own dependence upon society, or that would force art into some hopeless niche on the outside of things. On the contrary, art shares the fate of modern society precisely in so far as art too must come to terms with the fact that it has now become an autonomous system.

The fact that art has differentiated itself as an autopoietic functional system within modern society is particularly clear from the fate that has befallen every attempt to question the traditional criteria of the beauty, the representational function, even the symbolic qualities of the work of art. For the questioning itself thereby becomes an active feature in the autopoiesis of art. The repudiation of every expressive intention is itself interpreted as a particularly refined, concealed and essentially indirect expressive intention – in spite of all assurance to the contrary (cf. D. R. Hofstadter 1979, pp. 703ff.). The reduction of the image to naked objects, if that is the intention, is effectively frustrated by the 'frame effect'.[4] The accomplishment of an artistic operation, like the operation of any other self-referential system, must rely on certain presuppositions, even if it is only the presupposition that some initial connection with the system is necessary. Even the unrestricted freedom in the choice of form or subject would not do anything to change this. The operations create 'inviolate levels' for themselves, and these are nothing but an inevitable relation to the actively accomplished autopoiesis of art. One can certainly try and avoid the ossification of this presupposition and render it dynamic through application of specific operations, but this only reveals the process of autopoiesis all the more clearly. The only alternative would be: abandon the system entirely.

II

Art likes to consider itself free of function. But this is nothing but a protective gesture against the threat of absorption into other functional spheres or a perpetuation of an ancient tradition that has always regarded art as emancipated from all utilitarian considerations. Within modern society the differentiation of art is only possible in relation to a specific function that can be fulfilled in this system alone. Functional differentiation signifies: the independence of individual functional spheres with their own specific and irreducible codes. But it also signifies the dissolution of older multifunctional roles, and thus a renunciation of the idea of redundancy. And that means: no functional system can be replaced by another. Art cannot, for example, be replaced by politics, and nor can politics be replaced by art. Functional systems are self-substituting forms of organization. In modern society, therefore, art either has a function or possesses no closed structure of self-reproduction, that is to say, no autonomy.

[...] In an initially rather undefined sense we may regard the function of art as *the confrontation of reality (familiar to everyone) with a different version of that reality*. Art allows the world to appear within the world, and we shall see that this takes place by means of the differentiation of form and context, and thus by means of a distinction internal to art itself. This serves to indicate the contingency of the normal view of reality, to indicate that things might also be different. More beautiful, for example. Or less marked by contingency. Or laden with still veiled significance. This indication is articulated with specific artistic means over against the normal view of reality. That is why the older theories of art had emphasized the production of astonishment and surprise as a characteristic feature of art. This could not signify an end in itself, however, not some perfect and permanent state of surprise, but only a transitional state on the way to something else. The question concerning what such astonishment and surprise is supposed to effect leads us on to the question concerning the function of art, and the progressive differentiation of art can easily be read off from the series of answers that have been provided to this question. In this sense differentiation is a historical process and is dependent upon what is regarded as the function of art at any one time.

Initially the indication of some alternative version of reality is and naturally remains determined by what the alternative version of reality is meant to suggest. We may think of an ideal, more beautiful and more meaningful world and, taking this as our vantage point, of religion and/or the political identity of the city or the source of government, etc. Via long and intricate byways, however, all such supporting references are gradually relinquished, or reconstructed in terms of secondary embellishing accomplishments of the art system. As a result the function of art seems ultimately to consist in the production of 'world contingency' [*Weltkontingenz*] itself. The accepted everyday version of reality thereby reveals itself as something that is constantly changing. It thus finds itself transformed into a multi-contextual reality that can always be read differently – demoted on the one hand, but precisely thereby also elevated on the other. In its own terms the work of art intrinsically reveals that, and how, the contingently generated, that which is not intrinsically necessary, ultimately appears precisely as something necessary in so far as the work of art, through a kind of self-limitation,

deprives itself of any possibility of being otherwise. This may originally be intended, as in the case of Dürer, as a more complex description of reality itself, but with the advancing differentiation of art and science such reliance upon reality also becomes obsolete. Functioning without such support, art will finally concentrate all its means precisely on generating contingency itself. And the contingent production of something that subsequently comes to appear necessary is itself just one possibility of art. Other possibilities here include: the incorporation of intentional paradoxes and strategically placed ambiguities, of deliberately 'estranging' features, of references and allusions, of riddles and enigmas, of provocations designed to disturb those who would merely like to 'enjoy' – that is, appropriate – the work of art, but find themselves at once attracted and repelled, like Kafka's K. Even in the early modern period art was already undertaking to deceive the viewer in various ways (who could only properly admire the work of art in appreciating how the relevant deception was accomplished). Today we are also familiar with the situation where the work ridicules the prospective viewer who would seek meaning or inspiration from art. But here again technique is serving a different purpose. Rejection, deception, and ridicule are not ends in themselves. They are merely a transitional phase on the path towards an operation that can be described as that of unmasking reality, towards the final conclusion: since the work of art actually exists and can be convincingly experienced as such (if it can!), then something must be wrong with the world (cf. S. J. Schmidt 1984). With the world that is! – and precisely not with art which is, after all, quite evidently the master of its own possibilities.

It is not difficult to see that progressive differentiation in the service of this function yields an autopoietic system of art in its own right. If the task is precisely to confront reality with some alternative, then the required inspiration and example cannot be drawn from the reality in question, but only from art itself. As André Malraux insisted on pointing out: artists orient themselves not to objects but to their predecessors. And if we can still conceive of an artistic programme of 'imitatio' or 'realism', it will have to be pursued very differently, and more successfully, than it was in the past. But the programme of 'l'art pour l'art' does not represent an autonomous autopoietic system either, but is merely a misunderstanding of the latter. For 'l'art pour l'art' simply attempts to turn the system itself into a programme within the system and thereby fails to grasp the elementary fact that autonomy, far from undermining all relations to the external environment, precisely presupposes and governs them. The autopoiesis of art is actually destroyed if dependency is effectively interpreted as the negation of dependency. Fortunately, however, such a programme is doomed to failure – and for quite identifiable reasons.

[See the bibliography for full details of the following references.]

[1] This also involves a further restriction: I shall ignore certain other theoretically grounded analyses of art, like the interpretation of art as a symbolically generalized medium of communication. For more on this cf. N. Luhmann 1981a, pp. 245–66.

[2] Cf. the contrast between 'input-type description' and 'closure-type description' in F. Varela 1983, pp. 147–64 and Varela 1984, pp. 25–32.

[3] This transition is already accomplished once 'imitatio' is only permitted as a form of self-imitation, i.e. as the imitation of the perfection of classical art. Cf. for example R. De Piles 1727, p. 48, as an exception to the rule: 'tacher d'estre plus que copiste'.

[4] One is almost tempted to say 'fame effect', but I am referring here to the analysis in E. Goffman 1974.

[5] For this rather misleading formulation cf. D. R. Hofstadter 1979, pp. 686 ff.

[6] For a general systems-theoretical account cf. H. v. Foerster 1960, pp. 31–50.

8 W. J. T. Mitchell (b. 1942) 'Image and Word' and 'Mute Poesy and Blind Painting'

At the time of writing, Mitchell is editor of the journal *Critical Inquiry* and combines a chair in English Language and Literature with membership of the Committee on Art and Design at the University of Chicago. His book *Iconology: Image, Text, Ideology*, is a study of the ways in which images have been thought about, written about and talked about. Assertions and counter-assertions about the relative priorities of the verbal and the visual have been among the more fruitless accompaniments to the development of Modernist criticism. Where the 'innocent eye' is valued, the 'literary' is typically disparaged. Mitchell's work is notable for its thesis that where the conceptual boundaries are drawn between the verbal and the visual is a historical and an ideological matter, and thus open to inquiry. The present extracts are taken from *Iconology*, Chicago and London, 1986, pp. 42–6 and 116–19.

Image and Word

The recognition that pictorial images are inevitably conventional and contaminated by language need not cast us into an abyss of infinitely regressive signifiers. What it does imply for the study of art is simply that something like the Renaissance notion of *ut pictura poesis* and the sisterhood of the arts is always with us. The dialectic of word and image seems to be a constant in the fabric of signs that a culture weaves around itself. What varies is the precise nature of the weave, the relation of warp and woof. The history of culture is in part the story of a protracted struggle for dominance between pictorial and linguistic signs, each claiming for itself certain proprietary rights on a 'nature' to which only it has access. At some moments this struggle seems to settle into a relationship of free exchange along open borders; at other times (as in Lessing's *Laocoon*) the borders are closed and a separate peace is declared. Among the most interesting and complex versions of this struggle is what might be called the relationship of subversion, in which language or imagery looks into its own heart and finds lurking there its opposite number. One version of this relation has haunted the philosophy of language since the rise of empiricism, the suspicion that beneath words, beneath ideas, the ultimate reference in the mind is the image, the impression of outward experience printed, painted, or reflected in the surface of consciousness. It was this subversive image that Wittgenstein sought to expel from language, which the behaviorists sought to purge from psychology, and which contemporary art-theorists have sought to cast out of pictorial representation itself. The modern pictorial image, like the ancient notion of 'likeness,' is at last revealed to be linguistic in its inner workings.

Why do we have this compulsion to conceive of the relation between words and images in political terms, as a struggle for territory, a contest of rival ideologies? ... a short answer may be provided here: the relationship between words and images reflects, within the realm of representation, signification, and communication, the relations we posit between symbols and the world, signs and their meanings. We imagine the gulf between words and images to be as wide as the one between words and things, between (in the largest sense) culture and nature. The image is the sign that pretends not to be a sign, masquerading as (or, for the believer, actually achieving)

natural immediacy and presence. The word is its 'other,' the artificial, arbitrary production of human will that disrupts natural presence by introducing unnatural elements into the world – time, consciousness, history, and the alienating intervention of symbolic mediation. Versions of this gap reappear in the distinctions we apply to each type of sign in its own turn. There is the natural, mimetic image, which looks like or 'captures' what it represents, and its pictorial rival, the artificial, expressive image which cannot 'look like' what it represents because that thing can only be conveyed in words. There is the word which is a natural image of what it means (as in onomato-poeia) and the word as arbitrary signifier. And there is the split in written language between 'natural' writing by pictures of objects, and the arbitrary signs of hieroglyphics and the phonetic alphabet.

What are we to make of this contest between the interests of verbal and pictorial representation? I propose that we historicize it, and treat it, not as a matter for peaceful settlement under the terms of some all-embracing theory of signs, but as a struggle that carries the fundamental contradictions of our culture into the heart of theoretical discourse itself. The point, then, is not to heal the split between words and images, but to see what interests and powers it serves. This view can only be had, of course, from a standpoint which begins with skepticism about the adequacy of any particular theory of the relation of words and images, but which also preserves an intuitive conviction that there is some difference that is fundamental. It seems to me that Lessing, for instance, is absolutely right insofar as he regards poetry and painting as radically different modes of representation, but that his 'mistake' (which theory still participates in) is the reification of this difference in terms of analogous oppositions like nature and culture, space and time.

What sorts of analogies would be less reified, less mystifying, more appropriate as a basis for historical criticism of the word–image difference? One model might be the relation between two different languages that have a long history of interaction and mutual translation. This analogy is, of course, far from perfect. It immediately loads the case in favor of language, and it minimizes the difficulties in making connections between words and images. We know how to connect English and French literature more precisely than we do English literature and English painting. The other analogy which offers itself is the relationship between algebra and geometry, the one working by arbitrary phonetic signs read progressively, the other displaying equally arbitrary figures in space. The attraction of this analogy is that it looks rather like the relation of word and image in an illustrated text, and the relation between the two modes is a complex one of mutual translation, interpretation, illustra-tion, and embellishment. The problem with the analogy is that it is too perfect: it seems to hold out an impossible ideal of systematic, rule-governed translation between word and image. Sometimes an impossible ideal can be useful, however, so long as we recognize its impossibility. The advantage of the mathematical model is that it suggests the interpretive and representational complementarity of word and image, the way in which the understanding of one seems inevitably to appeal to the other.

In the modern era the main direction of this appeal would seem to be from the image, conceived as a manifest, surface content or 'material,' to the word, conceived as the latent, hidden meaning lying behind the pictorial surface. In *The Interpretation of Dreams* Freud comments on 'the incapacity of dreams' to express logical, verbal

connections and latent dream-thoughts by comparing 'the psychical material out of which dreams are made' to the material of visual art:

> The plastic arts of painting and sculpture labour, indeed, under a similar limitation as compared with poetry, which can make use of speech; and here once again the reason for their incapacity lies in the nature of the material which these two forms of art manipulate in their effort to express something. Before painting became acquainted with the laws of expression by which it is governed, it made attempts to get over this handicap. In ancient paintings small labels were hung from the mouths of the persons represented, containing in written characters the speeches which the artist despaired of representing pictorially.

For Freud, psychoanalysis is a science of the 'laws of expression' that govern the interpretation of the mute image. Whether that image is projected in dreams or in the scenes of everyday life, analysis provides the method for extracting the hidden verbal message from the misleading and inarticulate pictorial surface.

But we have to remind ourselves that there is a countertradition which conceives of interpretation as going in just the opposite direction, from a verbal surface to the 'vision' that lies behind it, from the proposition to the 'picture in logical space' that gives it sense, from the linear recitation of the text to the 'structures' or 'forms' that control its order. The recognition that these 'pictures' which Wittgenstein found residing in language are no more natural, automatic, or necessary than any other sorts of images we produce may put us in a position to make use of them in a less mystified way. Chief among these uses would be, on the one hand, a renewed respect for the eloquence of images and, on the other hand, a renewed faith in the perspicuousness of language, a sense that discourse does project worlds and states of affairs that can be pictured concretely and tested against other representations. Perhaps the redemption of the imagination lies in accepting the fact that we create much of our world out of the dialogue between verbal and pictorial representations, and that our task is not to renounce this dialogue in favor of a direct assault on nature but to see that nature already informs both sides of the conversation.

Mute Poesy and Blind Painting

The most fundamental difference between words and images would seem to be the physical, 'sensible' boundary between the realms of visual and aural experience. What could be more basic than the brute necessity for eyesight in the appreciation of painting, and the sense of hearing for the understanding of language? Even the legendary founder of the *ut pictura poesis* tradition, Simonides of Ceos, acknowledges that, at best, 'painting is *mute* poesy.' It may aspire to the eloquence of words, but it can only attain the kind of articulateness available to the deaf and mute, the language of gesture, of visible signs and expressions. Poetry, on the other hand, may aspire to become a 'speaking picture,' but it would be more accurate to describe its actual attainment in Leonardo da Vinci's words, as a kind of 'blind painting.' The 'images' of poetry may speak, but we cannot really see them.

I don't wish to dwell on these reductions of the arts to the senses proper to their apprehension, only to note a few problems that come up if one tries to found a system on them. The first symptom of difficulty is a certain asymmetry in the relative 'necessity' of each sense to its appropriate medium. The ear does not seem to be nearly

as necessary to language as the eye is to painting. The eye, in fact, can stand in rather well for the ear in language acquisition. The deaf learn to read, write, and to converse by lip-reading and vocal mimicry learned through touch. Perhaps that is why we don't normally speak of poetry, literature, or language as 'aural' arts or media with the same assurance that we do in referring to painting and sculpture as visual arts. If it seems a bit odd to speak of poetry as the 'aural art,' the designation of painting and the other plastic arts as 'visual' seems relatively secure.

How secure is that? It depends, of course, on what one means by 'visual.' One of the most influential stylistic formulas ever developed in art history treats the visual, not as the universal condition of all painting, but as a characteristic of a particular style that has meaning only by contrast with a particular historical alternative, the 'tactile.' I allude to Heinrich Wölfflin's famous distinction between classical painting (which is tactile, sculpturesque, symmetrical, and closed) in contrast to the baroque (which is visual, painterly, asymmetrical, and open).[1] Of course Wölfflin was using the terms 'visual' and 'tactile' as metaphors for differences in things that (we want to say) have to be understood as *literally* visual. We can't apprehend a tactile painting through our sense of touch, and we can't apprehend any painting whatsoever without a sense of sight.

Or can we? What does it mean to 'apprehend a painting'? Or perhaps we should ask the question another way: what can the blind know of painting? For someone like Milton, who stocked his memory with the masterpieces of Renaissance art before going blind, the answer is, a great deal. But suppose we took the case of the person blind from birth. The answer, I suggest, is still a great deal. The blind can know anything they want to know about a painting, including what it represents, what it looks like, what sort of color scheme is involved, what sort of compositional arrangements are employed. This information must come to them indirectly, but the question is not how they come to know about a painting, but what they can know. It is entirely conceivable that an intelligent, inquisitive blind observer who knew what questions to ask could 'see' a great deal more in a painting than the clearest-sighted dullard. How much of our normal, visual experience of painting is in fact mediated by one sort of 'report' or another, from the things we are taught to see in and say about pictures, the labels we learn to apply and manipulate, to the descriptions, commentaries, and reproductions on which we rely to tell us about pictures?

But surely no matter how complete, detailed, and articulate the conception of a picture might be to a blind person, there is something essential in painting (or in a painting) that is forever closed off from the apprehension of the blind. There is just the sheer experience of seeing the unique particularity of an object, an experience for which there are no substitutes. But that is just the point: there are so many substitutes, so many supplements, crutches, and mediations. And there are never more of them than when we claim to be having 'the sheer experience of seeing the unique particularity of an object.' This sort of 'pure' visual perception, freed from concerns with function, use, and labels, is perhaps the most highly sophisticated sort of seeing that we do; it is not the 'natural' thing that the eye does (whatever that would be). The 'innocent eye' is a metaphor for a highly experienced and cultivated sort of vision. When this metaphor becomes literalized, when we try to postulate a foundational experience of 'pure' vision, a merely mechanical process uncontaminated by imagination, purpose, or desire, we invariably rediscover one of the few maxims on which Gombrich and Nelson Goodman

agree: 'the innocent eye is blind.' The capacity for a purely physical vision that is supposed to be forever inaccessible to the blind turns out to be itself a kind of blindness.

It would be perverse, I suppose, to push this point any further, especially when my only purpose is to apply a bit of pressure to the sense of literalness and necessity that surrounds the notion of painting as a visual art. Let us concede that vision is a 'necessary condition' for the apprehension of painting; it is certainly not a sufficient one, and there are many other 'necessary conditions' – consciousness, perhaps even self-consciousness, and whatever skills are required for the interpretation of the kind of image in question. At any rate, the point here is simply to call attention to a certain reification or essentializing of the senses in relation to the generic differences between words and images, a reification much like the ones that occur with the categories of space and time, nature and convention. The visual and the aural have the distinct advantage of basing these differences in physiology; the structure of sensation becomes the foundation for a structure of sensibility, aesthetic mode, and even categories of judgement and understanding. As with time and space, nature and convention, the tendency is to think of the visual/aural structure of symbols as a natural division, one which dictates certain necessary limits to what can (or ought to) be expressed by those symbols. In this case, the natural seems to be the physical, bodily conditions of human sentience. Against this reified 'nature' we must set the historicity of the body and the senses, the intuition (first developed by nineteenth-century German art historians like Riegl) that 'vision' has a history, and that our ideas of what vision is, what is worth looking at, and why, are all deeply imbedded in social and cultural history. Eye and ear, and their associated structures of sensibility, are in this respect no different from the other figures of difference between words and images: they are categories of power and value, ways of enlisting nature in our causes and crusades.

[1] *Principles of Art History*, trans. M. Hottinger, London, 1932.

9 Raymond Williams (1921–1988) 'When Was Modernism?'

In this paper published after his death Williams discusses the processes of exclusion and co-option by which a stable image of Modernism has been established, but established, in his view, through consumable images of estrangement and alienation. He argues for a vision of possible community sustained by a tradition of neglected and marginalized works – by which he appears to mean some form of legacy of the Realist tradition. This text is based on notes of a lecture delivered at Bristol University in 1987. Originally published in Williams (ed. T. Pinkney), *The Politics of Modernism: Against the New Conformists*, London, 1989, pp. 32–5, from which this concluding passage is taken. (See also VIA12 and VIID14.)

[...] 'Modernism' as a title for a whole cultural movement and moment has ... been retrospective as a general term since the 1950s, thereby stranding the dominant version of 'modern' or even 'absolute modern' between, say, 1890 and 1940. We still habitually use 'modern' of a world between a century and half a century old. When we note that in English at least (French usage still retaining some of the meaning for which the term was coined) 'avant-garde' may be indifferently used to refer to Dadaism seventy years

after the event or to recent fringe theatre, the confusion both willed and involuntary which leaves our own deadly separate era in anonymity becomes less an intellectual problem and more an ideological perspective. By its point of view, all that is left to us is to become post-moderns.

Determining the process which fixed the moment of Modernism is a matter, as so often, of identifying the machinery of selective tradition. If we are to follow the Romantics' victorious definition of the arts as outriders, heralds, and witnesses of social change, then we may ask why the extraordinary innovations in social realism, the metaphoric control and economy of seeing discovered and refined by Gogol, Flaubert or Dickens from the 1840s on, should not take precedence over the conventionally Modernist names of Proust, Kafka, or Joyce. The earlier novelists, it is widely acknowledged, make the latter work possible; without Dickens, no Joyce. But in excluding the great realists, this version of Modernism refuses to see how they devised and organized a whole vocabulary and its structure of figures of speech with which to grasp the unprecedented social forms of the industrial city. By the same token, in painting, the Impressionists in the 1860s also defined a new vision and a technique to match in their rendering of modern Parisian life, but it is of course only the Post-Impressionists and the Cubists who are situated in the tradition.

The same questions can be put to the rest of the literary canon and the answers will seem as arbitrary: the Symbolist poets of the 1880s are superannuated by the Imagists, Surrealists, Futurists, Formalists and others from 1910 onwards. In drama, Ibsen and Strindberg are left behind, and Brecht dominates the period from 1920 to 1950. In every case in these oppositions the late-born ideology of modernism selects the later group. In doing so, it aligns the later writers and painters with Freud's discoveries and imputes to them a view of the primacy of the subconscious or unconscious as well as, in both writing and painting, a radical questioning of the processes of representation. The writers are applauded for their denaturalizing of language, their break with the allegedly prior view that language is either a clear, transparent glass or a mirror, and for making abruptly apparent in the very texture of their narratives the problematic status of the author and his authority. As the author appears in the text, so does the painter in the painting. The self-reflexive text assumes the centre of the public and aesthetic stage, and in doing so declaratively repudiates the fixed forms, the settled cultural authority of the academies and their bourgeois taste, and the very necessity of market popularity (such as Dickens's or Manet's).

These are indeed the theoretic contours and specific authors of 'modernism', a highly selected version of the modern which then offers to appropriate the whole of modernity. We have only to review the names in the real history to see the open ideologizing which permits the selection. At the same time, there is unquestionably a series of breaks in all arts in the late nineteenth century: breaks, as we noted, with forms (the three-decker novel disappears) and with power, especially as manifested in bourgeois censorship – the artist becomes a dandy or an anti-commercial radical, sometimes both.

Any explanation of these changes and their ideological consequences must start from the fact that the late nineteenth century was the occasion for the greatest changes ever seen in the media of cultural production. Photography, cinema, radio, television, reproduction and recording all make their decisive advances during the period identified as Modernist, and it is in response to these that there arise what in the first instance

were formed as defensive cultural groupings, rapidly if partially becoming competitively self-promoting. The 1890s were the earliest moment of the movements, the moment at which the manifesto (in the new magazine) became the badge of self-conscious and self-advertising schools. Futurists, Imagists, Surrealists, Cubists, Vorticists, Formalists and Constructivists all variously announced their arrival with a passionate and scornful vision of the new, and as quickly became fissiparous, friendships breaking across the heresies required in order to prevent innovations becoming fixed as orthodoxies.

The movements are the products, at the first historical level, of changes in public media. These media, the technological investment which mobilized them, and the cultural forms which both directed the investment and expressed its preoccupations, arose in the new metropolitan cities, the centres of the also new imperialism, which offered themselves as transnational capitals of an art without frontiers. Paris, Vienna, Berlin, London, New York took on a new silhouette as the eponymous City of Strangers, the most appropriate locale for art made by the restlessly mobile émigré or exile, the internationally anti-bourgeois artist. From Apollinaire and Joyce to Beckett and Ionesco, writers were continuously moving to Paris, Vienna and Berlin, meeting there exiles from the Revolution coming the other way, bringing with them the manifestos of post-revolutionary formation.

Such endless border-crossing at a time when frontiers were starting to become much more strictly policed and when, with the First World War, the passport was instituted, worked to naturalize the thesis of the *non*-natural status of language. The experience of visual and linguistic strangeness, the broken narrative of the journey and its inevitable accompaniment of transient encounters with characters whose self-presentation was bafflingly unfamiliar, raised to the level of universal myth this intense, singular narrative of unsettlement, homelessness, solitude and impoverished independence: the lonely writer gazing down on the unknowable city from his shabby apartment. The whole commotion is finally and crucially interpreted and ratified by the City of Emigrés and Exiles itself, New York.

But this version of Modernism cannot be seen and grasped in a unified way, whatever the likenesses of its imagery. Modernism thus defined *divides* politically and simply – and not just between specific movements but even *within* them. In remaining anti-bourgeois, its representatives either choose the formerly aristocratic valuation of art as a sacred realm above money and commerce, or the revolutionary doctrines, promulgated since 1848, of art as the liberating vanguard of popular consciousness. Mayakovsky, Picasso, Silone, Brecht are only some examples of those who moved into direct support of Communism, and D'Annunzio, Marinetti, Wyndham Lewis, Ezra Pound of those who moved towards Fascism, leaving Eliot and Yeats in Britain and Ireland to make their muffled, nuanced treaty with Anglo-Catholicism and the celtic twilight.

After Modernism is canonized, however, by the post-war settlement and its accompanying, complicit academic endorsements, there is then the presumption that since Modernism is *here* in this specific phase or period, there is nothing beyond it. The marginal or rejected artists become classics of organized teaching and of travelling exhibitions in the great galleries of the metropolitan cities. 'Modernism' is confined to this highly selective field and denied to everything else in an act of pure ideology, whose first, unconscious irony is that, absurdly, it stops history dead. Modernism being

the terminus, everything afterwards is counted out of development. It is *after*; stuck in the post.

The ideological victory of this selection is no doubt to be explained by the relations of production of the artists themselves in the centres of metropolitan dominance, living the experience of rapidly mobile émigrés in the migrant quarters of their cities. They were exiles one of another, at a time when this was still not the more general experience of other artists, located as we would expect them to be, at home, but without the organization and promotion of group and city – simultaneously located *and* divided. The life of the émigré was dominant among the key groups, and they could and did deal with each other. Their self-referentiality, their propinquity and mutual isolation all served to represent the artist as necessarily estranged, and to ratify as canonical the works of radical estrangement. So, to *want* to leave your settlement and settle nowhere like Lawrence or Hemingway, becomes presented, in another ideological move, as a normal condition.

What has quite rapidly happened is that Modernism quickly lost its anti-bourgeois stance, and achieved comfortable integration into the new international capitalism. Its attempt at a universal market, transfrontier and transclass, turned out to be spurious. Its forms lent themselves to cultural competition and the commercial interplay of obsolescence, with its shifts of schools, styles and fashion so essential to the market. The painfully acquired techniques of significant *dis*connection are relocated, with the help of the special insensitivity of the trained and assured technicists, as the merely technical modes of advertising and the commercial cinema. The isolated, estranged images of alienation and loss, the narrative discontinuities, have become the easy iconography of the commercials, and the lonely, bitter, sardonic and sceptical hero takes his ready-made place as star of the thriller.

These heartless formulae sharply remind us that the innovations of what is called Modernism have become the new but fixed forms of our present moment. If we are to break out of the non-historical fixity of *post*-modernism, then we must search out and counterpose an alternative tradition taken from the neglected works left in the wide margin of the century, a tradition which may address itself not to this by now exploitable because quite inhuman rewriting of the past but, for all our sakes, to a modern *future* in which community may be imagined again.

10 Louise Bourgeois (b. 1911) Statements from an Interview with Donald Kuspit

Bourgeois was born in France, where she studied mathematics and art. In 1938 she married the American art historian Robert Goldwater and moved to New York, where she enrolled in the Art Students League as a student of painting. During the war she was in touch with the community of expatriate Surrealists in America. Her first exhibition of sculpture was held in 1949. In her work of the 1950s and 1960s she pursued a late Surrealist repertoire of suggestive forms in a wide range of techniques and materials, including carving in wood and marble, casting in bronze and latex, moulding in plaster and, increasingly, various forms of assemblage. It is a constant characteristic of her work that it constructs a semi-fictitious author whose preoccupations and memories are inviting to a Freudian analysis. Her work began to attract considerable attention during the 1970s with the rise of feminism and the

widespread reaction against Modernism. During the 1980s and 1990s she exhibited a number of complex large-scale works using a wide range of materials. Her work was featured at the opening of Tate Modern in London in 2000, when the concourse was dominated by her *Maman* (a steel-and-marble sculpture in the form of a spider) and *I Do, I Undo, I Redo* (three nine-metre-high steel towers topped by mirrors). The interview with Donald Kuspit was first published in Kuspit, *Louise Bourgeois*, New York: Random House and Elizabeth Avedon Editions/Vintage Contemporary Artists, 1988, pp. 19–82. 'Statements from an Interview with Donald Kuspit' is printed in Louise Bourgeois, *Destruction of the Father, Reconstruction of the Father: Writings and Interviews 1923–1997*, Cambridge, MA: MIT Press, 1998, pp. 162–7. Our excerpts are taken from this latter source.

I work very hard and I never – never! – get people to understand what I mean. I want them to understand tenacity as a virtue, as an end in itself. More than that, they must understand that I had to equate sex and murder, sex and death. They could never understand the problem of this equation. I should be softer on myself. I should not pursue such a mystery, but it is still a mystery and I still pursue it . . . the fear of death destroys your sense of the edge in sex. It is this same moment, when death and sex are one, that I want to get in my work.

* * *

Art is a privilege, a blessing, a relief. Privilege means that you are a favorite, that what you do is not completely to your credit, not completely due to you, but is a favor conferred upon you. Privilege entitles you when you deserve nothing. Privilege is something you have and others don't. Art was a privilege given to me, and I had to pursue it, even more than the privilege of having children. The whole art mechanism is the result of many privileges, and it was a privilege to be part of it. . . . The privilege was the access to the unconscious. It is a fantastic privilege to have access to the unconscious. I had to be worthy of this privilege, and to exercise it. It was a privilege also to be able to sublimate. A lot of people cannot sublimate. They have no access to their unconscious. There is something very special in being able to sublimate your unconscious, and something very painful in the access to it. But there is no escape from it, and no escape from access once it is given to you, once you are favored with it, whether you want it or not. . . . To escape you have to have a place to go. You have to have the courage to face risk. You have to have independence. All these things are gifts. They are blessings. . . . Sublimation is a gift; lots of people cannot sublimate. The life of the artist is basically a denial of sex. I really think my power of sublimation, my power of total recall, is due to the education my parents gave me – the discipline and also the notion of what you can expect.

My feminism expresses itself in an intense interest in what women do. But I'm a complete loner. It doesn't help me to associate with people; it really doesn't help me. What helps me is to realize my own disabilities and to expose them. Another very sad statement is that I truly like only the people who help me. It is a very, very sad statement.

* * *

I am not interested in art history, in the academies of styles, a succession of fads. Art is not about art. Art is about life, and that sums it up. This remark is made to the whole academy of artists who have attempted to derive the art of the late 1980s, to try to relate it to the study of the history of art, which has nothing to do with art. It has to do with

appropriation. It has to do with the attempt to prove that you can do better than the next one, and that a famous art history teacher is better than the common artist. If you are a historian, you have to have the dignity of a historian. You don't have to prove that you are better than the artist.

What modern art means is that you have to keep finding new ways to express yourself, to express the problems, that there are no settled ways, no fixed approach. This is a painful situation, and modern art is about this painful situation of having no absolutely definite way of expressing yourself. This is why modern art will continue, because this condition remains: it is the modern human condition . . . it is about the hurt of not being able to express yourself properly, to express your intimate relations, your unconscious, to trust the world enough to express yourself directly in it. It is about trying to be sane in this situation, of being tentatively and temporarily sane by expressing yourself. All art comes from terrific failures and terrific needs that we have. It is about the difficulty of being a self because one is neglected. Everywhere in the modern world there is neglect, the need to be recognized, which is not satisfied. Art is a way of recognizing oneself, which is why it will always be modern.

11 Richard Rorty (b. 1931) 'Private Irony and Liberal Hope'

Rorty is an American philosopher, educated at the University of Chicago and at Yale. His *Philosophy and the Mirror of Nature*, published in 1979, offered a pragmatist's rejection of representationalism – the view that our access to the world is never direct, but is gained only through ideas in which the world is represented. However, Rorty's objection was not made on the grounds that 'reality' will indeed avail us of tests for our beliefs. Rather he questioned the right of philosophy to arbitrate over whether or not our representations are justified, arguing instead that the only grounding there can be for either our public or our private values is the commitment to them that a given community or individual can maintain in face of a liberal appreciation of the values of others. This position, which Rorty describes as 'liberal ironism', is further developed in his *Contingency, Irony and Solidarity*, Cambridge: Cambridge University Press, 1989. 'Private Irony and Liberal Hope' forms the fourth chapter of this book. Our excerpt is taken from the opening to the chapter, pp. 73–5. If Modernism could justifiably be taken as representing a kind of essentialist 'common sense', then Rorty's 'ironist' might be conceived as a paradigmatically Postmodernist figure.

All human beings carry about a set of words which they employ to justify their actions, their beliefs, and their lives. These are the words in which we formulate praise of our friends and contempt for our enemies, our long-term projects, our deepest self-doubts and our highest hopes. They are the words in which we tell, sometimes prospectively and sometimes retrospectively, the story of our lives. I shall call these words a person's 'final vocabulary.'

It is 'final' in the sense that if doubt is cast on the worth of these words, their user has no noncircular argumentative recourse. Those words are as far as he can go with language; beyond them there is only helpless passivity or a resort to force. A small part of a final vocabulary is made up of thin, flexible, and ubiquitous terms such as 'true,' 'good,' 'right,' and 'beautiful.' The larger part contains thicker, more rigid, and more parochial terms, for example, 'Christ,' 'England,' 'professional standards,' 'decency,'

'kindness,' 'the Revolution,' 'the Church,' 'progressive,' 'rigorous,' 'creative.' The more parochial terms do most of the work.

I shall define an 'ironist' as someone who fulfills three conditions: (1) She has radical and continuing doubts about the final vocabulary she currently uses, because she has been impressed by other vocabularies, vocabularies taken as final by people or books she has encountered; (2) she realizes that argument phrased in her present vocabulary can neither underwrite nor dissolve these doubts; (3) insofar as she philosophizes about her situation, she does not think that her vocabulary is closer to reality than others, that it is in touch with a power not herself. Ironists who are inclined to philosophize see the choice between vocabularies as made neither within a neutral and universal metavocabulary nor by an attempt to fight one's way past appearance to the real, but simply by playing the new off against the old.

I call people of this sort 'ironists' because their realization that anything can be made to look good or bad by being redescribed, and their renunciation of the attempt to formulate criteria of choice between final vocabularies, puts them in the position which Sartre called 'meta-stable': never quite able to take themselves seriously because always aware that the terms in which they describe themselves are subject to change, always aware of the contingency and fragility of their final vocabularies, and thus of their selves. . . .

The opposite of irony is common sense. For that is the watchword of those who unselfconsciously describe everything important in terms of the final vocabulary to which they and those around them are habituated. To be commonsensical is to take for granted that statements formulated in that final vocabulary suffice to describe and judge the beliefs, actions and lives of those who employ alternative final vocabularies. . . .

When common sense is challenged, its adherents respond at first by generalizing and making explicit the rules of the language game they are accustomed to play (as some of the Greek Sophists did, and as Aristotle did in his ethical writings). But if no platitude formulated in the old vocabulary suffices to meet an argumentative challenge, the need to reply produces a willingness to go beyond platitudes. At that point, conversation may go Socratic. The question 'What is *x*?' is now asked in such a way that it cannot be answered simply by producing paradigm cases of *x*-hood. So one may demand a definition, an essence.

To make such Socratic demands is not yet, of course, to become an ironist in the sense in which I am using this term. It is only to become a 'metaphysician,' in a sense of that term which I am adapting from Heidegger. In this sense, the metaphysician is someone who takes the question 'What is the intrinsic nature of (e.g., justice, science, knowledge, Being, faith, morality, philosophy)?' at face value. He assumes that the presence of a term in his own final vocabulary ensures that it refers to something which *has* a real essence. The metaphysician is still attached to common sense, in that he does not question the platitudes which encapsulate the use of a given final vocabulary, and in particular the platitude which says there is a single permanent reality to be found behind the many temporary appearances. He does not redescribe but, rather, analyzes old descriptions with the help of other old descriptions.

The ironist, by contrast, is a nominalist and a historicist. She thinks nothing has an intrinsic nature, a real essence. So she thinks that the occurrence of a term like 'just' or 'scientific' or 'rational' in the final vocabulary of the day is no reason to think that Socratic inquiry into the essence of justice or science or rationality will take one much

beyond the language games of one's time. The ironist spends her time worrying about the possibility that she has been initiated into the wrong tribe, taught to play the wrong language game. She worries that the process of socialization which turned her into a human being by giving her a language may have given her the wrong language, and so turned her into the wrong kind of human being. But she cannot give a criterion of wrongness. So, the more she is driven to articulate her situation in philosophical terms, the more she reminds herself of her rootlessness by constantly using terms like 'Weltanschauung,' 'perspective,' 'dialectic,' 'conceptual framework,' 'historical epoch,' 'language game,' 'redescription,' 'vocabulary,' and 'irony.'

The metaphysician responds to that sort of talk by calling it 'relativistic' and insisting that what matters is not what language is being used but what is *true*. Metaphysicians think that human beings by nature desire to know. They think this because the vocabulary they have inherited, their common sense, provides them with a picture of knowledge as a relation between human beings and 'reality,' and the idea that we have a need and a duty to enter into this relation. It also tells us that 'reality,' if properly asked, will help us determine what our final vocabulary should be. So metaphysicians believe that there are, out there in the world, real essences which it is our duty to discover and which are disposed to assist in their own discovery. They do not believe that anything can be made to look good or bad by being redescribed – or, if they do, they deplore this fact and cling to the idea that reality will help us resist such seductions.

By contrast, ironists do not see the search for a final vocabulary as (even in part) a way of getting something distinct from this vocabulary right. They do not take the point of discursive thought to be *knowing*, in any sense that can be explicated by notions like 'reality,' 'real essence,' 'objective point of view,' and 'the correspondence of language to reality.' They do not think its point is to find a vocabulary which accurately represents something, a transparent medium. For the ironists, 'final vocabulary' does not mean 'the one which puts all doubts to rest' or 'the one which satisfies our criteria of ultimacy, or adequacy, or optimality.' They do not think of reflection as being governed by criteria. Criteria, on their view, are never more than the platitudes which contextually define the terms of a final vocabulary currently in use. [. . .]

12 Gayatri Chakravorti Spivak (b. 1942) 'Who Claims Alterity?'

Indian by birth, the author is Professor in the Humanities at Columbia University, New York. She published the English translation of Derrida's seminal *De la grammatologie* in 1976. Since then she has been particularly concerned with issues of gender and ethnicity, and has become established as a leading contributor to one form of intellectual conjuncture identified with Postmodernism. The present text has its origins in a symposium on 'Remaking History', the specific project of which was to challenge the supposedly Eurocentric and masculine orthodoxy of history writing. Unlike many who share this supposition, Spivak retains an investment in the Marxist tradition. For her, though class is a relatively abstract matter when compared to other lived conditions such as race or gender, it is nevertheless a determination which is ignored at their peril by those who write in the name of 'alternatives'. Her own particular focus within class-analysis is not with the sphere of the economic *per se*, but with the operation of power, and with its effects in culture upon those marginalized by its operation. In the present text she maintains a salutary scepticism towards claims for 'alternative' status made within the framework of what she dubs 'transnational postmodern-

ity'. In her view certain forms of demagogy and glamour are easily confused with opposition to a stereotyped status quo. Her proposed means to avoid such confusion is a 'scrupulous intervention' in the often 'tedious register' of education. First published in Barbara Kruger and Phil Mariani (eds.), *Remaking History: DIA Art Foundation Discussions in Contemporary Culture No. 4*, Seattle, 1989, pp. 269–92, from which the present text is taken.

As a postcolonial, I am concerned with the appropriation of 'alternative history' or 'histories.' I am not a historian by training. I cannot claim disciplinary expertise in remaking history in the sense of rewriting it. But I can be used as an example of how historical narratives are negotiated. The parents of my parents' grandparents' grandparents were made over, not always without their consent, by the political, fiscal, and educational intervention of British imperialism, and now I am independent. Thus I am, in the strictest sense, a postcolonial. As a caste Hindu, I had access to the culture of imperialism, although not the best or most privileged access. Let me, then, speak to you as a citizen of independent India, and raise the necessary critical and cautionary voice about false claims to alternate histories. False claims and false promises are not euphoric topics. I am also a feminist who is an old-fashioned Marxist and some of that will enter into this discussion of the cultural politics of alternative historiographies.

How are historical narratives put together? In order to get to something like an answer to that question, I will make use of the notions of writing and reading in the most general sense. We produce historical narratives and historical explanations by transforming the socius, upon which our production is *written* into more or less continuous and controllable bits that are *readable*. How these readings emerge and which ones get sanctioned have political implications on every possible level.

The masterwords implicated in Indian decolonization offered four great legitimizing codes consolidated by the national bourgeoisie by way of the culture of imperialism: nationalism, internationalism, secularism, culturalism. If the privileged subject operated by these codes masquerades as the subject of an alternative history, we must meditate upon how they (we) are written, rather than simply read their masque as historical exposition. [...]

[...] Of all the tools for developing alternative histories – gender, race, ethnicity, class – class is surely the most abstract. It is only when we forget this that we can set aside class-analysis as essentialist. In the volumes of *Capital*, Marx asks the German worker to grasp, as a preliminary to the planned change involved in remaking history, the abstract determinations of what is otherwise merely suffered as concrete misery. In the language that I have been using, one might summarize Marx as saying that the logic of capitalism weaves the socius like the textile of a particular set of relationships. Power and validation within it are secured by denying that web and transforming/displacing it into 'natural' readability. I think it is not excessive to see these general senses of reading and writing at work, for example, when Marx asks the worker to understand (read?) the coat s/he produces as having more signification than it does as itself. Capital is a writing, which we must not read merely in terms of producing objects for use, a few for ourselves and many more for others, and not being given enough money to get more for ourselves. Reading the *archives* of capitalism, Marx produces a critique, not of cultural, but of economic politics – hence a critique of *political* economy, political economism. In the current global postcolonial context, our model must be a critique of political culture, political culturalism, whose vehicle is the writing of readable histories, mainstream or alternative. I think it might be useful to write power in Marx this way:

'Power is the name that one attributes to a complex strategical situation – the social relations of production – forming a particular society, where "society" is shorthand for the dominance of (a) particular mode(s) of production of value.'

The most useful way to think value is as something 'contentless and simple' that must be presupposed as the name of what is produced by the human body/mind machine – a thing that is not pure form, cannot appear by itself, and is immediately coded. . . . this coding operation is not merely economic, it can be understood in the fields of gendering and colonialism. This does not involve allegiance to the narrative of the evolution of the modes of production as the only lexicon of readability, nor the presupposition that class-analysis is the only instrument of readability. (As for the strategy for dealing with the sexism of Marxists, it seems to me not very different from that for dealing with the sexism of non- or anti-Marxists.)

Yet this counterintuitive thought of value should not make us imagine that we can ourselves escape the codes inscribing the real. We are obliged to deal in narratives of history, even believe them. [. . .]

It seems obvious to some of us that the disenfranchised *female* in decolonized space, being doubly displaced by it, is the proper carrier of a critique of pure class-analysis. Separated from the mainstream of feminism, this figure, the figure of the gendered subaltern, is singular and alone. Insofar as such a figure can be represented among us . . . it is, first, as an object of knowledge, further, as a native-informant style subject of oral histories who is patronizingly considered incapable of strategy towards us, and finally, as imagined subject/object, in the real field of literature. There is, however, a rather insidious fourth way. It is to obliterate the differences between this figure and the indigenous elite woman abroad, and claim the subjectship of an as-yet-unreadable alternative history that is only written in the general sense I invoke above.

This fourth person is a 'diasporic postcolonial.' [. . .]

[. . .] For the moment let us hold onto the fact that de-colonization does quite seriously represent a rupture for the colonized. It is counterintuitive to point at its repetitive negotiations. But it is precisely these counterintuitive imaginings that must be grasped when history is said to be remade, and a rupture is too easily declared because of the intuition of freedom that a merely political independence brings for a certain class. Such graspings will allow us to perceive that neocolonialism is a displaced repetition of many of the old lines laid down by colonialism. It will also allow us to realize that the stories (or histories) of the postcolonial world are not necessarily the same as the stories coming from 'internal colonization,' the way the metropolitan countries discriminate against disenfranchised groups in their midst. The diasporic postcolonial can take advantage (most often unknowingly, I hasten to add) of the tendency to conflate the two in the metropolis. Thus this frequently innocent inform-ant, identified and welcomed as the agent of an alternative history, may indeed be the site of a chiasmus, the crossing of a double contradiction: the system of production of the national bourgeoisie at home, and, abroad, the tendency to represent neocolonial-ism by the semiotic of 'internal colonization.'

Throw into this chiastic field a phenomenon I invoke often: the shift into transna-tionalism in the early seventies through the computerization of the big stock exchanges. Of course, changes in the mode of production of value do not bring about matching changes in the constitution of the subject. But one is often surprised to notice how neatly the ruses change in that arena that engages in coding subject-production:

cultural politics. And the universities, the journals, the institutes, the exhibitions, the publishers' series are rather overtly involved here. Keeping the banal predictability of the cultural apparatus in transnational society firmly in mind, it can be said that the shift into transnationalism brought a softer and more benevolent Third Worldism into the Euramerican academy. This was indeed *ricorso* from the basically conservative social scientific approach that matched the initial dismantling of the old empires. It is in this newer context that the postcolonial diasporic can have the role of an ideologue. This 'person' (although we are only naming a subject-position here), belonging to a basically collaborative elite, can be uneasy for different kinds of reasons with being made the object of unquestioning benevolence as an inhabitant of the new Third World. (S)he is more at home in producing and simulating the effect of an older world constituted by the legitimizing narratives of cultural and ethnic specificity and continuity, all feeding an almost seamless national identity – a species of 'retrospective hallucination.'

This produces a comfortable 'other' for transnational postmodernity, 'ground-level activity,' 'emergent discourses.' The radical critic can turn her attention on this hyperreal Third World to find, in the name of an alternative history, an arrested space that reproaches postmodernity. In fact, most postcolonial areas have a class-specific access to the society of information-command telematics inscribed by micro-electronic transnationalism. And indeed, the discourse of cultural specificity and difference, packaged for transnational consumption along the lines sketched above, is often deployed by this specific class. What is dissimulated by this broad-stroke picture is the tremendous complexity of postcolonial space, especially womanspace.

As I must keep repeating, remaking history is a tall order, and we must not take collective enthusiasm or conviction as its sole guarantee. [. . .]

* * *

Now, if one returns to the melancholy story of the years of Independence, whose shadow fell on my childhood, then one begins to see that cultural, communal (religious), and class heterogeneity native to the subcontinent has been asserting itself in spite of the unifying hopes on assorted sides, based on those assorted concept-metaphors: Nationalism, Secularism, Internationalism, Culturalism.

Any extended discussion of remaking history in decolonization must take into account the dangerous fragility *and* tenacity of these concept-metaphors. Briefly, it seems possible to say that an alternative and perhaps equally fragile mode of resistance to them can only come through a strategic acceptance of the centrifugal potential of the plurality and heterogeneity native to the subcontinent. Yet heterogeneity is an elusive and ambivalent resource (except in metropolitan 'parliamentary' or academic space) as the recent past in India, and indeed on the globe, have shown. Its direct manipulation for electoral or diplomatic results constitutes devastation. (Manipulation in commercial interest can lead to a dynamic 'public culture.')

It is only in situations like this that institutionally placed cultural workers have the obligation to speak predictively. These scrupulous interventions are in fact our only contribution to the project of remaking history or sustaining ever-shifting voices with an alternative edge. In a sense our task is to make people ready to listen, and that is not determined by argument. Indirect and maddeningly slow, forever running the risk of demagogy and coercion mingled with the credulous vanity and class interests of teacher

and student, it is still only institutionalized education in the human sciences that is a long-term and collective method for making people want to listen. As far as I can see, remaking (the discipline of) history has its only chance on this unglamorous and often tedious register.

Therefore I propose the persistent establishment and re-establishment, the repeated consolidating in undoing, of a strategy of education and classroom pedagogy attending to provisional resolutions of oppositions as between secular and nonsecular, national and subaltern, national and international, cultural and socio/political by teasing out their complicity. Such a strategy of strategies must speak 'from within' the emancipatory master narratives even while taking a distance from them. It must resolutely hold back from offering phantasmatic hegemonic nativist counternarratives that implicitly honor the historical withholding of the 'permission to narrate.' The new culturalist alibi, working within a basically elitist culture industry, insisting on the continuity of a native tradition untouched by a Westernization whose failures it can help to cover, legitimizes the very thing it claims to combat. [. . .]

* * *

[. . .] My contractual situation as a postcolonial is in a place where I see claims to the subjectship of alternative histories coming, and being called for, in an often unexamined way. A literary pedagogy, choosing texts carefully, can at least prepare another space that makes visible the fault lines in slogans of the European Enlightenment – nationalism, internationalism, secularism, culturalism – the bulwark of nativism, without participating in their destruction. This, strictly speaking, is de(con)structive pedagogy. Like all good teaching in the humanities, it is hopeful and interminable. It presupposes and looks forward to a future anterior of achieved solidarity and thus nurses 'the present.' In the strictest sense, then, (para)logical: morpho-genetic (giving rise to new ways of reading, writing, teaching *in the strongest sense*), without terminal teleological innovation. Its 'present' is a field of value–coding, in a sense of 'value' that is logically (not necessarily chronologically) prior to the economic; the political, the economic, the affective are entangled there. [. . .]

13 Richard Serra (b. 1939) from The Yale Lecture

The American artist Serra first came to prominence in the late 1960s with three-dimensional works which exploited the innate properties of heavy materials. His typical works of the 1970s and 1980s were relatively simple configurations of steel units, so placed and arranged as to establish a dramatic and often threatening presence bearing on the spectator's physical and psychological environment. The avowed intention of this work is that it should maintain a critical presence or difference in relation to its context and not be co-opted either as decoration or as reinforcement of any institutional purpose. In March 1989 Serra's massive *Tilted Arc* was removed by a government agency from the Federal Plaza in New York for which it had been commissioned ten years earlier. It was destroyed in the process. An issue of principle was raised as to whether this was a justifiable implementation of adverse critical judgement or an unjustifiable suppression of the right to freedom of speech – in effect an act of censorship. This issue was widely debated in the press and tried in the US District Court, where it was judged that the decision to remove *Tilted Arc* was justified to the extent that it was motivated by a lack of aesthetic appeal in the work. Serra's lecture, developed from earlier notes concerning a similarly aborted sculpture project (*Sight Point*) in

the mid-1980s, was given at Yale University in January 1990 in the wake of the *Tilted Arc* controversy. It was published in *Kunst & Museumjournaal*, Amsterdam, vol. 1, no. 6, 1990, pp. 23–33, from which the present extract is taken.

My decision early on, to build site-specific works in steel took me out of the traditional studio. The studio has been replaced by urbanism and industry. I rely upon the industrial sector to build my work, upon structural and civil engineers, upon surveyors, laborers, transporters, riggers, construction workers, etcetera... Steel mills, shipyards and fabricating plants have become my on the road extended studios. I began to work steel mills when I was seventeen to support my education. These mills have since provided a source for material, inspiration, fabrication and construction.

Usually I analyse the capacity of a mill, a plant, a fabricator; study their equipment, look to their processing of materials, their manufacturing of products, study their tools, whether it be a forge, a roller, a brake, whether they are making ingots, nosecones, turbines, shells or pistons. Whatever is made and how it is formed becomes a handbook of my concern. I consider their most advanced processes and how I can interact with them. I try to extend their tool potential in relation to what I need to accomplish. To be able to enter into a steel mill, a shipyard, a thermal plant and extend both their work and my needs is a way of becoming an active producer within a given technology, not a manipulator or consumer of a found industrial product.

The history of welded sculpture in this century has had little influence on my work. Most traditional sculpture until the mid-century was based on a relationship of part to whole. That is, the steel elements were collaged pictorially and compositionally together. Most of the welding was a way of gluing and adjusting parts which through their internal structure were not self supporting. This is clearly evidenced in most Modernist sculpture, be it Gonzalez, Picasso, Smith or Calder. To work with steel not as a picture making element, but as a building material in terms of mass, weight, counterbalance, loadbearing capacity, point load, compression, friction and statics has been totally divorced from the history of sculpture, however, it has found direct application within the histories of architecture, technology and industrial building. It is the logic of towers, dams, silos, bridges, skyscrapers, tunnels, etcetera... Sculptors for the most part have ignored the results of the industrial revolution failing to investigate these fundamental processes and methods of steel making, engineering and construction. The builders I have looked to have therefore been those who explored the potential of steel as one of the most advanced materials for construction: Roebling, Maillart, Mies van der Rohe.

In most of my work the construction and decision-making processes are revealed. Material, formal, contextual decisions are self-evident. The concept of site-specific sculpture has nothing to do with opinion or belief. It is a concept which can be verified in each case. The process of conception can be reconstructed and the specificity of a work in relation to its site can be measured by its effects on the site. The fact that the technological process is revealed depersonalizes and demythologizes the idealization of the sculptor's craft. The work does not enter into the fictitious realm of the 'master'. I would just as soon have the work available to anyone's inspection. The evidence of the process can become part of the content. Not that it is the content, but it is discernible for anyone who wants to be involved with that aspect of my working process. My works do not signify any esoteric self-referentiality. The problem of self-referentiality does

not pose itself once a work enters the public domain. How the work alters the site is the issue, not the persona of the author.

Site-specific works deal with the environmental components of given places. The scale, size and location of site-specific works are determined by the topography of the site, whether it be urban or landscape or architectural enclosure. The works become part of the site and restructure both conceptually and perceptually the organization of the site. My works never decorate, illustrate or depict a site.

The specificity of site-oriented works means that they are conceived for, dependent on and inseparable from their location. Scale, size and placement of sculptural elements result from an analysis of the particular environmental components of a given context. The preliminary analysis of a given site takes into consideration not only formal but social and political characteristics of the site. Site-specific works invariably manifest a value judgement about the larger social and political context of which they are part. Based on the interdependence of work and site, site-specific works address the content and context of their site critically. Site-specific solutions demonstrate the possibility of seeing the simultaneity of newly developed relationships between sculpture and context. A new behavioural and perceptual orientation to a site demands a new critical adjustment to one's experience of the place. Site-specific works primarily engender a dialogue with their surroundings. Site-specific works emphasize the comparison between two separate languages (their own language and the language of their surroundings). Unlike Modernist works that give the illusion of being autonomous from their surroundings, and which function critically only in relation to the language of their own medium, site-specific works emphasise the comparison between two separate languages that can therefore use the language of one to criticize the language of the other. To quote Bertrand Russell on this problem: 'Every language has a structure about which one can say nothing in that language. There must be another language, dealing with the structure of the first and processing a new structure about which one cannot say anything except in a third language – and so forth.'

It is the explicit intention of site-specific works to alter their context. Le Corbusier understood this as early as 1932. He wrote in a letter to Victor Nekrasov: 'You have in Moscow, in the churches of the Kremlin, many magnificent Byzantine frescoes. In certain cases, these paintings do not undermine the architecture. But I am not sure they add to it, either; this is the whole problem of the fresco. I accept the fresco not as something which gives emphasis to the wall, but on the contrary as a means to destroy the wall violently, to remove any notion of its stability, weight, etcetera. I accept Michelangelo's "Last Judgement" in the Sistine Chapel, which destroys the wall; and I accept the Sistine Chapel's ceiling as well, which completely distorts the very notion of ceiling. The dilemma is simple: if the Sistine Chapel's wall and ceiling were intended to be preserved as form, they should not have been painted with frescoes, it means that someone wanted to remove forever their original architectural character and create something else, which is acceptable.'

This concept ought to be understood and protected. However, the contextual issues of site-specific works remain problematic. Site specificity is not a value in itself. Works which are built within the contextual frame of governmental, corporate, educational and religious institutions run the risk of being read as tokens of those institutions. One way of avoiding ideological cooptation is to choose leftover sites which cannot be the object of ideological misinterpretation. However, there is no neutral site. Every context

has its frame and ideological overtones. It is a matter of degree. But there are sites where it is obvious that artwork is being subordinated to/accommodated to/adapted to/subservient to/required to/useful to...In such cases it is necessary to work in opposition to the constraints of the context, so that the work cannot be read as an affirmation of questionable ideologies and political power. I am not interested in art as affirmation or in art as manifestation of complicity.

I think that if sculpture has any potential at all, it has the potential to work in contradiction to the places and spaces where it is created. I am interested in work where the artist is a maker of 'anti-environment'. This is impossible if the sculpture is built in the studio, then taken out of the studio and adjusted to a site. You can't build work in one context and indiscriminately place it in another. Portable objects moved from one place to another often fail for this reason. The history of Modernist public sculpture offers countless examples of these site-adjusted follies. An iron deer on a front lawn has more contextual significance than most arbitrarily placed site adjusted sculptures. I must say that I have not fully escaped this dilemma, since I receive few site-specific commissions but have a desire to work continuously.

Large scale site-specific projects which do not allow for secondary sale are hardly ever considered to be a worthy investment. For that reason the concept of site specificity and corporate sponsorship are antithetical. Corporate sponsorship for the art breeds economic opportunism and reinforces palatable artistic conventions. Artists who willingly accept corporate support likewise submit to corporate control. In effect, they become puppet creators. Their hands and minds are set in motion by external strings: supply upon demand, accommodation with consent. Corporate funded art-works are often advertised as public service. Slogans such as 'art for the people' mask the cynicism of commercial and political manipulation, which would like to make believe that we all live in a homogenous society of consumers. Cultural and educational inequalities based on economic inequality are a reality which needs to be revealed and not glossed over by a populist notion of art for the people. This aspiration of art cannot be to serve and thereby reaffirm the status quo by delivering products which give people what they want and supposedly need. Marketing is based on this premise. By mimicking the strategies of the media, Warhol became the master of art as a commercial enterprise. The more one betrays one's language to commercial interests, the greater the possibility that those in authority will reward one's efforts. If artifacts do not accord with the consumerist needs of people, if they don't submit to exploitation and marketing strategies, they can be voted ad hoc into oblivion. Tolerance exists only for officially sanctioned ideas. Submission is at the core of the problem. For sure there is relief in submission to authority. But how much of our autonomy do we cede to a government for example that pursues policies which we find contradictory to our basic beliefs. At one point one must say that such and such a policy is nonsense. If one remains silent and does not speak out, it is tantamount to abdicating responsibility [...]

14 Mike Kelley (b. 1954) 'Dirty Toys: Mike Kelley Interviewed'

Mike Kelley studied at Cal Arts in Los Angeles and remained on the West Coast after graduating. In 1977 he and fellow Cal Arts student Tony Oursler formed 'The Poetics', a punk-rock band which stayed together for the next six years. Besides the making of

paintings, drawings, objects and comic strips, his activities during the 1980s included installations, performances and further collaborative work with rock bands. His work typically draws upon the diverse field of American popular culture. In the early 1990s he came to widespread attention with a series of handmade dolls and stuffed animals. These were shown in an exhibition that opened at the Carnegie Museum of Art in Pittsburgh in the winter of 1991 and travelled to the Kunsthalle in Basel and the ICA in London in the following year. The following text is taken from 'Dirty Toys: Mike Kelley Interviewed' (by Ralph Rugoff), originally published in *XXIst Century*, 1, New York, Winter 1991/1992, pp. 4–11, reprinted in Thomas Kellein (ed.), *Mike Kelley*, Stuttgart: Cantz Verlag, 1992, pp. 86–94. Our excerpt is taken from pp. 87–90 of the reprinted version.

[...]

RR: What about the social position of the artist, who in many ways is still commonly represented as a type of child, irresponsible and unfettered by cultural and economic restraints?

MK: The artist's social position may be one of irresponsibility, but that doesn't mean he actually is irresponsible. That's one of the complexities of art production. The surface meaning is often not its deep meaning. You can say art is useless, but then you have to ask, 'What's the use of the useless person in society?' There is use for him. So then what does 'irresponsible' mean?

As an artist, you actually live in a very public environment. That's your job. That's why the myth of the artist as somebody who lives alone in some garret is absolutely ridiculous. Artists are some of the most public people there are. They're like a small business or a cottage industry, but one that is hooked into surrounding institutions.

In terms of the alliance of the artist, I think more to the point is the whole modernist cult of the child, in which the child was seen as this innocent figure of pure, unsocialized creativity. Which is a crock of shit, and is part of the problem, not part of the solution. [...]

RR: In the last decade, when so many artists relied on images and image-making procedures borrowed from mass media culture, why have you so persistently embraced the aesthetics of the handmade?

MK: I'm of the generation of artists for whom there was an extreme reaction against the handmade and clichéd ideas of self-expression, including the notion that the handmade art object revealed a personal, expressive psychology. I still think there is every reason to rebel against that idea, but I also think that to fixate on corporate modes of image-making and on mass-produced imagery is wrongheaded, because it's really easy for that style to become overly classical, despite the rhetoric of populism surrounding it.

I think it's possible now to start to look at handmade things in a different way. It's no longer heroic, as it used to be – the handmade now is pitiful and it doesn't necessarily have anything to do with emotion or a personal psychology. With my doll works, the viewer isn't led to reflect on the psychology of the artist but on the psychology of the culture. In that way, it's not different from work that mimics advertising, but you escape the classical overtones of advertising and mass production. We speak the same language, but I wanted to speak it in a way that reveals the economics of the situation.

In reality, it's very expensive and totally outside the economic capabilities of the common person to do large-scale photographic work. Whenever I see these giant photo pieces cranked out by any of the innumerable artists in the Cal Arts tradition, I can't get past the economics of it. Now all I think of is money. In the case of someone like Cindy Sherman, it's a little different because the images she produces are so disgusting that when you think about them in relation to the economics of producing them, you're shocked. You wonder, how could anybody spend so much money on such a disgusting thing? – and that works to her advantage.

RR: Yet now that prices for your work are taking off, people are saying they can't see a Mike Kelley without thinking of the price tag.

MK: But with my work those economics are totally about the ritualized nature of the commodity, not about the expense of producing it. In a way, the fact that this doll I paid fifty cents for is now selling for forty thousand dollars makes the work even stronger – it shows the strange position that art plays within the culture and how worth is determined. You can say that's terrible, but that's the way everything operates. Worth in this culture is dependent upon money, and people won't talk about the issues involved in the work unless the thing that gives it value in the culture is applied to it.

RR: In presenting spotless commodities as art, the other commodity artists reinforce, rather than critique, the market mentality?

MK: Perhaps; though I refuse to speak of art ever reinforcing culture more than anything else does. It seems to me that art has to be ritually separated from life in order to be art, so to talk about it as anything more than a mirror seems problematic. Even the worst examples of commodity art still picture the system in a way that makes it conscious, so you can talk about it, and I think that's a good thing.

RR: If art is a mirror, do you see it as politically neutral?

MK: I always think about art in terms of visual communication and representation. For instance, in body art, where artists might use their physical body as a medium, you don't talk about them in terms of their fullness as a human being, you talk about them as some sort of notion of a human being. It's through talking about them in that removed way, realizing them as a structure or an ideogram, that you can then politicize them.

But you have to get to the political through this ritualized process. That process is short-circuited in a lot of agitprop work, which is very naïve in the way it oversimplifies psychological processes. When you reduce the notion of art to simplistic ways of thinking and one-to-one relationships, I find you get dangerously close to fascistic ideas. I prefer to keep all these distinctions messier.

RR: So are you saying art's sphere of influence is limited to individual experience, that it is unable to effect social change?

MK: One of the big lies of Modernism is that certain changes in aesthetics would change culture completely, forever. Instead, I think it's a continuous process – art may not effect lasting changes, but by changing certain representations, art changes ideas about things. If you make certain notions of behavior hip enough so that

enough people want them, then the culture has to accommodate those behaviors. Things might flip back, but at least it shows that the possibility of change is there. [...]

RR: How much does your own work depend on conventions of the 'normal' for its effect? The pathetic quality of your stuffed animal pieces, for instance, obviously plays off their setting in the pristine and sublime world of the gallery.

MK: Even if my work wasn't presented in the art world, it could function similarly, because the culture is similarly defined. For instance, when I was a kid, there were things in the hippie subculture like Mickey Rat or Rat Fink, both of which were inversions of Mickey Mouse. That stuff wasn't meant for a high-art audience, but it was reactionary in the same way as some of my work. So you don't need the art world to react against, because the culture at large is a mirror of the art world.

RR: Your work consistently aims to explode categories of high and low by conflating them and creating something difficult to classify.

MK: Culturally speaking, the only way you know if something is 'quality' is by virtue of the classificatory systems that have been set up. Yet for me, pleasure comes from bouncing off those definitions and categories. So quality things are precisely those things that are hard to classify. Those are the interesting things.

15 Martin Kippenberger (1953–1997) from *B*: interview with Jutta Koether

In the 1980s Kippenberger was associated with other Hamburg-based artists including Büttner and Oehlen (see VIIIC12) and held similar views to Oehlen's on the politics of painting at the time. The production of paintings formed only a small part of his activity, however. He also made objects, sculptures and installations, designed posters, undertook a ghost-written novel, ran a bar, formed a large collection of the work of other artists, and adopted a practice in the use of exhibitions which was diametrically opposed to the idea of ratification through the museum retrospective. Much of his production was delegated to assistants. Kippenberger's presence in the Germany of the 1980s and early 1990s may be compared to Warhol's in the New York of the 1960s and 1970s. Like Warhol, though in a more extrovert and aggressive fashion, Kippenberger reflected back to the culture the materials of its own fascination with the contemporary image of the artist. The publication *B: Gespräche mit Martin Kippenberger* ('Conversations with Martin Kippenberger'), Ostfilden: Cantz, 1994, refers explicitly to Warhol's 'novel', *A*. The conversations from which it is composed were recorded over several years. The original transcriptions are totally unedited. The interview with Jutta Koether was recorded in 1991 and originally appeared in this publication, pp. 13–26. Our translation, by Nicholas Walker, is taken from pp. 14–19. Explanatory footnotes have been added by the editors, with thanks to Sebastian Zeidler.

KIPPENBERGER: [...] *Art isn't being made any more, it's just being looked at!* The American women, for example, are the specialists here. From Jenny Holzer, Barbara Kruger, Louise Lawler through to Andrea Fraser, they just look at art, work it up a bit, and that's the art of today. No more crochet-work, the way Rosemarie Trockel

did it,[1] as a parody of the womanly arts, no more crude painting, or 'manly work', but simply explanation, investigation, representation.

That's what an artist has to understand! Artists who attempt to grasp the totality are the fixed points of the art world, and everything revolves around them – not Lüpertz and co., post-post expressionism, post-post Neo-Geo, Imi Knoebel. That's all basically irrelevant at present. So why on earth go there? People are still inventing a thousand excuses to decorate walls. But you don't see the intensity any more. It's claptrap. *The mark of a good artist is this: don't be old, don't be new, be good! If you go along to someone's exhibition, and see good as well as bad pictures, then that's good!* The capacity to spark controversy. But please don't regard everything as equally good. Lüpertz and Knoebel are invariably perfect. That's the trouble. If everything is good, nothing counts. Our Lord surely had a very different idea at the beginning: *for there shall be good and evil!*

But you just don't see any dialectical approaches in art now. Ergo: a load of artists you might as well forget about!

KOETHER: So what is your own position here? Do you see yourself on the side of the new 'women's art' you were just describing or in league with other artists who specifically work in terms of the viewing, distribution and communication of art? Do you set a good example for the realization of your own guidelines?

KIPPENBERGER: Yes, I'm a woman too [laughs]. It's quite true! I too just mean well for humanity. Women often enough hold back to help support the others. I feel that way too. I'm not a 'proper' painter, a 'proper' sculptor, I only look at all this from the outside, I make an occasional intervention, try to do my bit as best I can. I don't aim to provoke people, I just try to appease them.

KOETHER: But there are some differences here. You end up presenting yourself in everything, just like the 'egomaniacal artist'. If we wish to continue the comparison with women, I would point out that Andrea Fraser doesn't do that, or if so, only in terms of a specifically defined role as 'self-presenting person'.[2]

KIPPENBERGER: Well I effectively present myself entirely and unambiguously as a living vehicle. With others this is perhaps better styled and more precisely calculated in relation to the project. *With me role-playing wouldn't really work because I haven't got a style. No way do I have a style.* The evidence for this is already there in my childhood. My father always told me I really had to have a style, and I was terrified that I would never be able to bring off a Chagall, or a Dubuffet, the kind of stuff we had at home. Until I realized that my style is just there where the personality is. This gets presented through performances, individual objects and actions, decisions, and a kind of history arises out of that. For art is only perceived after the event anyway, from the outside, rather than in the moment when it arises. I would say that twenty years is the right time scale here. Only then can we identify what kind of effect the work, the artist, has really had. The main thing is what people will still SAY about me. Whether I created a good atmosphere or not. And I try to work in such a way that people can say: Kippenberger was good fun! Plus the fact that I selected and worked up a few trifles from various different areas.[3] It's not that easy to operate this way. You can't simply be provocative, but you can't simply do pretty stuff either. My own rules for achieving this are these: I shouldn't provide anything for dentists,[4] and I wouldn't want to be taken for someone whose pictures would hang nicely over the mantelpiece. I admit that I also do small pictures, to pay for my meals, and they

actually do look bloody good 'over the mantelpiece'. But they are meant to be the exceptions. About two percent of my production is this sort of thing. I permit myself this – it's my luxury! And hopefully this leads to more of my paintings being entirely misunderstood by the public. I simply have to work for the moment, given the very short amount of time available to you as an individual. I exploit all the possibilities that come my way to construct something that stands for itself, that speaks for itself. For I'd sooner see museum directors hang before I receive forms of 'recognition', like 'hanging in a museum'. And that will never happen.

KOETHER: Isn't that a different way of describing the fact that museums are afraid to buy or have no desire to buy Kippenberger objects or pictures, while you, Kippenberger, are simply making a virtue out of a necessity and go about devising self-help programmes[5] which then become a permanent part of the productive rationale behind your work?

KIPPENBERGER: It's not that I am waiting for them. That would take too long. Ultimately you just have to do your own work when you do. Everyone does this, including the artist. The satisfaction lies in getting the stuff out. Since the things can't be seen in the museum, can't be made available, that is, to more than a handful of people, after the exhibition, after they have seen the light of day, I simply pursue my work through other channels, via books, publications of every kind, posters, performances, and now through teaching and delegating. Museums are antiquarian rubbish, although everyone already knows I am the one who understood the eighties. Look at the case of Sigmar Polke. Everyone knew he was the man of the seventies, yet there was still a terrific amount of hesitation, and it was ages before they finally bought any of it. Too much truth is simply unbearable for these institutions!

* * *

[. . .] Buying other people's work allows me to revisit and re-evaluate everything – including myself. The professional colleagues I feel particularly close to are: Albert Oehlen, as painter, and Mike Kelley, as American joker – the witty theoretical way of depicting NY women, expensively and in full colour, etc. *Actually I see the collecting as part of my work!* It's really much the same to me whether the artist whose works I am buying has a 'future' or not. All this self-indulgent moaning is just rubbish, as long as I can get something out of a certain work, and know how to relate it somehow to other things. There is also another consequence here: to finance this part of my work, the collecting, I have to sell more pictures myself. For collecting has its price, obviously.

KOETHER: In other words, collecting as an element of the self-maintaining circuit that is powered by the personality Kippenberger?

KIPPENBERGER: Hubert Kiekol, Meuser, Förg, these are also part of my collection. So you never really get to imagine, I've done all THAT myself! My original approach was to take things I liked from other people and incorporate them into my own production, the sculptures, objects, books etc.[6] Today, as I've said, the collection itself is part of this production. Of course I still quote unconsciously from others, but these days I usually approach my own work 'freshly, piously, joyfully, freely'. Or it is also shaped by what my assistants build into 'my production' according to Kippenberger-guidelines, but they work away at 'my view' with their own means and skills. I believe it is increasingly important to be permanently clear about the context in which you exhibit and live. To determine what this context is, to build up your own

network, is a crucial task for the artist. That is what I am working on now. *And not merely in order to produce this connection, but also to make it visible, to make it ineliminably manifest.* To establish this connection for posterity, where 'posterity' can already mean tomorrow. I want to exercise an influence upon the way in which this time of ours gets discussed. That's only reasonable. You can't simply steer clear of the issues of the day. Of course you don't have the strength to keep on claiming that you're so extraordinary that you stand above such things (and are a very good artist to boot!). So you have to work at making some contribution, of preparing foundations. Marcel Broodthaers, for example, has created this collection-cum-exhibition, the Museum of the Eagle. It provides illustrations of life. So if I decide merely to write from now on, the response of the surrounding environment would obviously form part of it, and other people's pictures would provide my illustrations.

* * *

Jörg Immendorff's old advice to 'Stop Painting' is worth repeating again and again because it has never been heeded. But it would now have to be understood in a different way. For it is no longer a fundamental challenge, and not yet even a luxury, but rather must be interpreted as a scientific proposition. You can no longer expect art from guys in French berets. *Art treated as science has the dull beauty of a joke without a punch-line, but is full of subtleties. Must be able to narrate the joke very well and tell us all about it! [...] It's the sound that makes the music!* That's what it's all about. [...]

Editorial notes

1 In the early 1980s Trockel produced a series of crocheted sweaters displaying the swastika amongst other patterns.
2 In the late 1980s Fraser performed an 'action' in which she dressed up as a bluestocking history of art graduate and delivered a gallery-style lecture to a group of hapless tourists: she talked not about art but about security systems and corporate sponsors. The artistic persona here was constructed as a fabricated character solely for the duration of the 'action' and functioned as a focus for the supposedly extra-artistic discourses that affect the presentation of art in the museum context. In strong contrast to this, Martin Kippenberger managed to publicize his *entire* character twenty-four hours a day, effectively personifying the messy conflation of art and life, albeit in a highly fashion-conscious manner.
3 From the domains of painting, sculpture, politics, fashion, etc.
4 Regarded in Germany as proverbial collectors of modern pictures suitable for hanging in surgery waiting-rooms.
5 At the time of the interview Kippenberger was a guest teacher at the art academy in Frankfurt. Rather than expressly teaching painting he toured the galleries with the students and warned them about the dangers attendant upon trying to exhibit their work in such conditions.
6 Such as the painting by Gerhard Richter which Kippenberger notoriously used as a table-top.

16 Peter Wollen (b. 1938) 'Into the Future: Tourism, Language and Art'

Wollen has published widely on art and culture, especially on film and photography. His first book was *Signs and Meaning in the Cinema* (1969). Much influenced by French theory, his early writings were particularly associated with the journal *Screen* (see also VIID10 and VIIIB2). Several of these, conceived as 'semiotic counter-strategies', were collected in *Readings and*

Writings (1982). The present essay began as a free-standing paper, published in 1990, but was later revised to form the closing chapter of Wollen's book *Raiding the Icebox*. The latter offers a kind of alternative history of the modern movement, relating shifts in 'fine art' to changes in fields such as fashion, industrial production, political change and tourism. 'Into the Future' is concerned with the phenomenon of 'globalization'. Wollen seeks to relate the current internationalization of art to earlier moments of Modernism's encounter with other cultures, characterized respectively as 'colonialist' (exemplified by 'primitivism'), and 'anti-colonialist' (exemplified by the incursion of the Mexican muralists into a North American cultural discourse). He proceeds to argue that the contemporary situation evidences a different epoch, characterized by a mixing of codes. Postmodernist *and* post-colonialist, it marks a qualitatively new stage in the globalization of capital, and its culture. Our text is taken from *Raiding the Icebox. Reflections on Twentieth Century Culture*, London: Verso, 1993, pp. 190–212.

As we look back over the twentieth century from our present post-colonial vantage point and try to understand the ways in which massive culture contact has shaped the history of art, both in the core and in the periphery, we can see three main phases, which themselves correspond to phases in core–periphery relations: colonialism, anti-colonialism, and post-colonialism (though with some lags and leads). The first of these was marked by the ethnographic plunder of Third World artefacts by anthropologists and museums, and the subsequent appropriation of these artefacts for 'hybridized' use by avant-garde artists as a resource in their overthrow of nineteenth-century academicism. Here, the emblematic moments were Picasso's visits to the Trocadero ethnographic collection in Paris and the painting of the *Demoiselles d'Avignon*. The second of these phases was characterized by the bold attempt of a group of artists from Mexico (*los tres grandes*: Rivera, Siqueiros, Orozco) after the Mexican Revolution to create a pan-American art in which the southern (Hispanic and Indian) periphery would be hegemonic, rather than the Eurocentric north. Ultimately this project faltered and fell. Its emblematic moment was the destruction of Diego Rivera's mural in the Rockefeller Center, New York. This, in turn, led to a revival of the first phase on a new basis. Eventually, after the dismantling of the old colonial empires and the exhaustion and crisis of modernism itself, we entered a third phase, marked by what we might call the global development of 'para-tourist' art, alongside and as an alternative to the postmodernism of the core. Here a crucial moment was the installation of the exhibition Magiciens de la Terre in Paris in 1989 which – whatever the intentions of its organizers – gave us an unprecedented opportunity to see a range of art from many different cultures and settings across the whole world, including but not limited to the Western art world. [. . .]

But today . . . we are in the shrinking world of transnational capital, telecommunications and mass tourism. . . . Not only is this a post-colonial era, in which most Third World countries have already acquired their own post-colonial history and even their own repression of history, but it is also a postmodern era, in which the artistic modernism initiated by Picasso, and Americanized by Pollock, finally entered into crisis. Plainly, the nature of culture contact, both in general economic and political terms but also in artistic terms, has also changed drastically. This does not mean that it has diminished. In most respects, it has intensified, but the modes of contact have changed, as have both metropolitan and peripheral cultures themselves. [. . .]

Two shifts in the nature of culture contact have clearly affected the arts. The first is the end of the privileged position held by ethnographers. Ethnographers traditionally formed part of the apparatus of colonial rule, alongside traders, administrators and

missionaries. Although their discipline gradually broke free from this compromised position (and, indeed, in France the influence of surrealism, from Leiris to Lévi-Strauss, contributed to this), it was none the less ethnographers who largely established the image of Third World art from which metropolitan artists drew. It was ethnographers who stuffed the museums full of artefacts and wrote both popular and scholarly accounts of them. It was from classic ethnography that Western culture acquired the idea of archaic, ceremonial societies, repositories for the phantasmatic construction of otherness and purity. While such societies indeed existed, ethnographers tended to minimize the reality of culture contact (of which, indeed, they themselves were a significant part). This pose is no longer possible.

Second, in the Third World countries themselves, art forms developed that were themselves a response to contact. The most important of these was tourist art. Tourist art, of course, has existed as long as there have been trading contacts, going back centuries. For instance, the Haida people, Northwest Coast Native Americans living in the Queen Charlotte Islands, developed an original form of tourist art, argillite sculpture, within a few decades of the first contacts in the eighteenth century (with Captain Cook), during the period of the fur trade. But the great shift from 'authentic' or 'tribal' art to 'tourist' art as the main focus for contact with the West took place in the past forty years. In very disparate places all over the world, artists began to produce for an organized craft-centre, hotel and export trade, a trade that was a significant money-earner in many countries. Co-ops, workshops and wholesaling and marketing institutions were set up. Eventually the shift takes place from tourist to para-tourist art, to forms that may draw from tourist art but also go beyond it into new areas of originality and complexity. Often, this shift can even be traced back to the efforts of a single *animateur*, who may be Western, often an artist who encouraged more ambitious production, both in scale and in quality control. This was the story, for instance, in the settlement of Papunya, in central Australia, after Geoff Bardon arrived there in 1971 and the acrylic movement got underway; or in Port Harrison in Baffin Land, where James Houston, after 1948, encouraged Inuit soapstone sculpture and set up trading arrangements with the Hudson's Bay Company. Similarly, Frank McEwen, in Salisbury, now Harare, encouraged local sculptors and sold their work at the shop of the Rhodesian National Gallery.

The collapse or erosion of the institutions of traditional art created a vacuum which was first filled by the opportunistic structures of tourist art. But some of the artists were then able to use the *animateurs* as resources to expand the ambition, complexity and scope of their work. The makers of this new para-tourist art themselves have to find a new institutional support system, which will be ambiguously enabling and exploiting. The balance between exploitation and enablement will depend on the political and economic dynamics of each specific situation. In many ways, this development of para-tourist art from tourist art can be compared to the development of expanded pidgin or creole languages. In a pioneering article, Paula Ben-Amos compared the basic forms of tourist art to pidgin languages, similarly despised by linguists and scholars, but now at last being revalued. Tourist art, like pidgin, reduces and simplifies, striving for intelligibility to an alien target group of foreigners, and, like pidgin, it uses makeshift means of expression around a central core of universal features. Today we can see pidgins, not as ignorant garbling, but as innovative adaptations, signs of an ability to create structures of communication in the most unpromising

situations. This is all the more true of creoles, which in emergency situations develop out of pidgins to form complete new vernacular languages. In other cases, there is a more gradual process of borrowing and merging, as pidgins, old vernaculars and emergent creoles coexist and interact.

* * *

The Third World is changing rapidly in many different ways. The notion of a 'Third World' was always a portmanteau concept into which many radically different types of society and culture were crammed, and as the relations between the core and the periphery change and a new world system begins to emerge, it will open up yet new fields of difference. Cultures within the peripheries will change at different rates and in different directions. We can be sure, however, that these changes will take place along the triple axes of migration, urbanization and culture contact. The choice between an authentic nationalism and a homogenizing modernity will become more and more outmoded. Questions of cultural identity, both in the core and the peripheries, become more complex as we begin to understand that there is no single model of a hybrid or composite culture, but many different possibilities. One advantage of the linguistic paradigms – creole, vernacular, Esperanto, etcetera – is that they can provide us with a precise sense of the range of options available. Salman Rushdie recently wrote elo-quently of his wish to celebrate 'hybridity, impurity, intermingling, the transformation that comes of new and unexpected combinations of human beings, cultures, ideas, politics, movies, songs'. If the vision of a creolized para-tourist art is one possible outcome of such an intermingling, it will take many different forms, inflected by different types and pressures of culture contact, by different patterns of tourism, by different matrices of the vernacular and the migrant. But we are entitled to hope that in the visual arts, as elsewhere, we are entering an epoch in which invention and regeneration will come from the periphery, free from the self-obsession of the increas-ingly provincial culture of the metropolis.

The redistribution of core and periphery throughout the world will have a decentral-izing effect, at least for a transitional period. The industrial metropolis has become increasingly divided between North America, Western Europe and East Asia. The old 'socialist camp' has fragmented. The Third World has produced its own regional cores and peripheries as uneven development has promoted some areas and demoted others. At the same time, while ruling elites in the Third World become drawn ever more organically into the hegemonic system of world trade and investment, so large sections of the population in the metropolis, often ethnic minorities, are peripheralized and virtually excluded from the system. Within this new format of world capitalism, capital itself becomes increasingly fluid and mobile. The metropolis agglomerates into new competing superstates while the margins shatter under the stress of national and ethnic rivalries. The world is full of multinational companies, global agencies and affluent world travellers at the same time as it sees national diasporas, desperate waves of refugees and unstable patterns of migrant labour. In this context, the crisis of Fordism has not only thrown modernism into crisis, it has globalized the crisis. The pattern of global cultural flows and exchanges is changing rapidly in ways that go beyond a simple process of contamination, on the one hand, and predation, on the other.

Modernism saw itself self-consciously as the culmination of the long history of Western culture. Yet, against the grain, it always contained currents that challenged the norms of Western culture: in Orientalism, in surrealism, in *Mexicanidad* and so on.

These currents were systematically assimilated into the Western tradition, with their most dangerous residues dismissed or expelled, under the banner of purism, but they served also to create the elements of a counter-tradition, which implicitly challenged the ruling norms. The time has come now to look back critically over the history of modernism and to pick up those threads which run counter to its orthodoxy. Within the West, debate over the crisis of modernism has been displaced on to a provincial debate about 'postmodernism': a strange, eclectic brew which appears in many different forms. Plainly, this dominant trope of 'postmodernism', which first surfaced at the beginning of the seventies, expresses the confusion caused by the simultaneous and persistent crisis of Fordism in the economy and of high modernism in the arts. Yet the discourse of postmodernism, even more than that of modernism, has been stiflingly Eurocentric.

Indeed, the very term 'postmodern' reveals the extent to which the new trends that first became widely noted in the early seventies were linked to the great twentieth-century movements of modernism, which had finally triumphed only in the period after the Second World War, only a few decades before, and which had arguably reached their finale (or perhaps their curtain call) in 1968.

* * *

The long history of modernism and postmodernism, began, I would argue, with Champfleury and his 1869 volume of popular prints, *Histoire de l'imagerie populaire*. Champfleury had written about popular prints long before, in 1854, and the print of the Wandering Jew on which his friend Courbet based his *The Meeting* (1856) is the same one that Champfleury later used as his frontispiece. Next, of course, came the Japanese prints with their influence on Manet and Degas and Lautrec, then the Russian *lubki*, with their impact in Larionov, Goncharova and Malevich, then Mexican catchpenny prints, which were an inspiration for Orozco, Rivera and Siqueiros. Picasso, of course, followed American newspaper comics and Matisse revered the cheap Japanese woodblocks (*crepons*) he bought from booksellers' stalls by the banks of the Seine. From the beginning, modernism developed out of the circulation of images from low to high and periphery to core and, by doing so, challenged the aesthetic hierarchies of the *anciens régimes*. On this subversive and unstable base an aesthetic of rationalism and functionalism was later superimposed, after the collapse of the *anciens régimes* precipitated by the First World War. Artists and art theorists rallied to a utopian dream of a new society modelled on the exemplary modernity of new American technology and new Fordist industrial organization. But the circulation of images and discourses was never completely blocked and with the collapse of high modernism, it simply re-emerged.

Since Champfleury, at least, this discursive circulation has been the acknowledged or unacknowledged constant of modern art. It is important to stress that this circulation has always been a two-way process, and yet the two contrary flows have been customarily treated in very different ways. On the one hand, the flow from low to high and from periphery to core has been discussed in terms of appropriation and innovation, while the opposite flow has been seen as vulgarization and its end product has been dismissed as kitsch. In this perspective, the argument against tourist art simply recapitulates the argument against kitsch, seen now in terms of global mass consumption rather than of the effects of mass production within the core. Again the flow from core to periphery and its appropriation by artists on the periphery is nothing new. The

rich nineteenth-century tradition of Haida soapstone carving developed directly because of the new market of sailors and travellers, who began to visit the Northwest Coast for trade or for tourism. At the same time, Qajar painting in Iran developed as a complex synthesis of traditional Persian with imported Frankish forms. Spanish baroque was appropriated by indigenous artists in Mexico, and increasingly complex forms emerged (as we can see, for instance, in the work of Frida Kahlo and, more recently, artists on both sides of the Mexican–United States frontier). Indeed this new baroque once again is beginning to redefine Americanness, in a complex composite of differential times and cultures.

As the world economy becomes increasingly globalized and core and periphery are redistributed across old boundaries, this process can only accelerate and become more elaborate. The old barriers between 'Western' art and 'Third World' art (once known, symptomatically, as 'primitive' art) will dissolve even further – in both directions. Thus artists as diverse as Jean-Michel Basquiat or Audrey Flack or Francisco Clemente or Cheri Samba can be seen not in simple terms of identity and difference but as part of a dynamic system of aesthetic circulation. Modernism is being succeeded not by a totalizing Western postmodernism but by a hybrid new aesthetic in which the new corporate forms of communication and display will be constantly confronted by new vernacular forms of invention and expression. Creativity always comes from beneath, it always finds an unexpected and indirect path forward and it always makes use of what it can scavenge by night.

17 Homi K. Bhabha (b. 1949) on 'hybridity' and 'moving beyond'

Bhabha is a leading theorist of cultural post-colonialism and globalization. He has remarked that his own identity mirrors the hybridity of which he writes: born in India, educated at Bombay (Mumbai) and Oxford, and now teaching in the US. His initial impact came from a series of essays published in the 1980s and subsequently collected in *The Location of Culture*. He is particularly associated with ideas of 'boundaries' and 'crossings', and with the concept of 'hybridity'. Much of his work is rooted in discussion of literature. An exception to this is the 1998 catalogue essay Bhabha devoted to the work of the sculptor Anish Kapoor. Likewise, in the present extracts he uses the work of four visual artists to illustrate his argument about border crossing and post-colonial identity as preconditions, in his words, for reinscribing 'our human, historic commonality'. The four are: the African-American installation artist Renée Green, the Mexican-American performance artist Guillermo Gomez-Peña, the Puerto Rican-American sculptor Pepon Osorio, and the American photographer Alan Sekula. Our extract is taken from 'Border Lives: The Art of the Present', the opening section of the Introduction to *The Location of Culture*, London and New York: Routledge, 1994, pp. 1–9.

> A boundary is not that at which something stops but, as the Greeks recognized, the boundary is that from which *something begins its presencing*.
>
> Martin Heidegger, 'Building, dwelling, thinking'

Border Lives: the Art of the Present

It is the trope of our times to locate the question of culture in the realm of the *beyond*. At the century's edge, we are less exercised by annihilation – the death of the author –

or epiphany – the birth of the 'subject'. Our existence today is marked by a tenebrous sense of survival, living on the borderlines of the 'present', for which there seems to be no proper name other than the current and controversial shiftiness of the prefix 'post': *postmodernism, postcolonialism, postfeminism*. . . .

The 'beyond' is neither a new horizon, nor a leaving behind of the past. . . . Beginnings and endings may be the sustaining myths of the middle years; but in the *fin de siècle*, we find ourselves in the moment of transit where space and time cross to produce complex figures of difference and identity, past and present, inside and outside, inclusion and exclusion. For there is a sense of disorientation, a disturbance of direction, in the 'beyond': an exploratory, restless movement caught so well in the French rendition of the words *au-delà* – here and there, on all sides, *fort/ da*, hither and thither, back and forth.

The move away from the singularities of 'class' or 'gender' as primary conceptual and organizational categories, has resulted in an awareness of the subject positions – of race, gender, generation, institutional location, geopolitical locale, sexual orientation – that inhabit any claim to identity in the modern world. What is theoretically innovative, and politically crucial, is the need to think beyond narratives of originary and initial subjectivities and to focus on those moments or processes that are produced in the articulation of cultural differences. These 'in-between' spaces provide the terrain for elaborating strategies of selfhood – singular or communal – that initiate new signs of identity, and innovative sites of collaboration, and contestation, in the act of defining the idea of society itself.

It is in the emergence of the interstices – the overlap and displacement of domains of difference – that the intersubjective and collective experiences of *nationness*, community interest, or cultural value are negotiated. How are subjects formed 'in-between', or in excess of, the sum of the 'parts' of difference (usually intoned as race/class/gender, etc.)? How do strategies of representation or empowerment come to be formulated in the competing claims of communities where, despite shared histories of deprivation and discrimination, the exchange of values, meanings and priorities may not always be collaborative and dialogical, but may be profoundly antagonistic, conflictual and even incommensurable? [. . .]

Terms of cultural engagement, whether antagonistic or affiliative, are produced performatively. The representation of difference must not be hastily read as the reflection of *pre-given* ethnic or cultural traits set in the fixed tablet of tradition. The social articulation of difference, from the minority perspective, is a complex, on-going negotiation that seeks to authorize cultural hybridities that emerge in moments of historical transformation. The 'right' to signify from the periphery of authorized power and privilege does not depend on the persistence of tradition; it is resourced by the power of tradition to be reinscribed through the conditions of contingency and contradictoriness that attend upon the lives of those who are 'in the minority'. The recognition that tradition bestows is a partial form of identification. In restaging the past it introduces other, incommensurable cultural temporalities into the invention of tradition. This process estranges any immediate access to an originary identity or a 'received' tradition. The borderline engagements of cultural difference may as often be consensual as conflictual; they may confound our definitions of tradition and modernity; realign the customary boundaries between the private and the public, high and low; and challenge normative expectations of development and progress.

I wanted to make shapes or set up situations that are kind of openMy work has a lot to do with a kind of fluidity, a movement back and forth, not making a claim to any specific or essential way of being.[1]

Thus writes Renée Green, the African-American artist. She reflects on the need to understand cultural difference as the production of minority identities that 'split' – are estranged unto themselves – in the act of being articulated into a collective body:

Multiculturalism doesn't reflect the complexity of the situation as I face it daily It requires a person to step outside of him/herself to actually see what he/she is doing. I don't want to condemn well-meaning people and say (like those T-shirts you can buy on the street) 'It's a black thing, you wouldn't understand.' To me that's essentialising blackness.[2]

Political empowerment, and the enlargement of the multiculturalist cause, come from posing questions of solidarity and community from the interstitial perspective. Social differences are not simply given to experience through an already authenticated cultural tradition; they are the signs of the emergence of community envisaged as a project – at once a vision and a construction – that takes you 'beyond' yourself in order to return, in a spirit of revision and reconstruction, to the political *conditions* of the present:

Even then, it's still a struggle for power between various groups within ethnic groups about what's being said and who's saying what, who's representing who? What is a community anyway? What is a black community? What is a Latino community? I have trouble with thinking of all these things as monolithic fixed categories.[3]

If Renée Green's questions open up an interrogatory, interstitial space between the act of representation – who? what? where? – and the presence of community itself, then consider her own creative intervention within this in-between moment. Green's 'architectural' site-specific work, *Sites of Genealogy* (Out of Site, The Institute of Contemporary Art, Long Island City, New York), displays and displaces the binary logic through which identities of difference are often constructed – Black/White, Self/Other. Green makes a metaphor of the museum building itself, rather than simply using the gallery space:

I used architecture literally as a reference, using the attic, the boiler room, and the stairwell to make associations between certain binary divisions such as higher and lower and heaven and hell. The stairwell became a liminal space, a pathway between the upper and lower areas, each of which was annotated with plaques referring to blackness and whiteness.[4]

The stairwell as liminal space, in-between the designations of identity, becomes the process of symbolic interaction, the connective tissue that constructs the difference between upper and lower, black and white. The hither and thither of the stairwell, the temporal movement and passage that it allows, prevents identities at either end of it from settling into primordial polarities. This interstitial passage between fixed identifications opens up the possibility of a cultural hybridity that entertains difference without an assumed or imposed hierarchy:

I always went back and forth between racial designations and designations from physics or other symbolic designations. All these things blur in some way.... To develop a genealogy of the way colours and noncolours function is interesting to me.[5]

'Beyond' signifies spatial distance, marks progress, promises the future; but our intimations of exceeding the barrier or boundary – the very act of going *beyond* – are unknowable, unrepresentable, without a return to the 'present' which, in the process of repetition, becomes disjunct and displaced. The imaginary of spatial distance – to live somehow beyond the border of our times – throws into relief the temporal, social differences that interrupt our collusive sense of cultural contemporaneity. The present can no longer be simply envisaged as a break or a bonding with the past and the future, no longer a synchronic presence: our proximate self-presence, our public image, comes to be revealed for its discontinuities, its inequalities, its minorities. Unlike the dead hand of history that tells the beads of sequential time like a rosary, seeking to establish serial, causal connections, we are now confronted with what Walter Benjamin describes as the blasting of a monadic moment from the homogeneous course of history, 'establishing a conception of the present as the "time of the now"'.[6]

If the jargon of our times – postmodernity, postcoloniality, postfeminism – has any meaning at all, it does not lie in the popular use of the 'post' to indicate sequentiality – *after*-feminism; or polarity – *anti*-modernism. These terms that insistently gesture to the beyond, only embody its restless and revisionary energy if they transform the present into an expanded and ex-centric site of experience and empowerment. For instance, if the interest in postmodernism is limited to a celebration of the fragmentation of the 'grand narratives' of postenlightenment rationalism then, for all its intellectual excitement, it remains a profoundly parochial enterprise.

The wider significance of the postmodern condition lies in the awareness that the epistemological 'limits' of those ethnocentric ideas are also the enunciative boundaries of a range of other dissonant, even dissident histories and voices – women, the colonized, minority groups, the bearers of policed sexualities. For the demography of the new internationalism is the history of postcolonial migration, the narratives of cultural and political diaspora, the major social displacements of peasant and aboriginal communities, the poetics of exile, the grim prose of political and economic refugees. It is in this sense that the boundary becomes the place from which *something begins its presencing* in a movement not dissimilar to the ambulant, ambivalent articulation of the beyond that I have drawn out: 'Always and ever differently the bridge escorts the lingering and hastening ways of men to and fro, so that they may get to other banksThe bridge *gathers* as a passage that crosses.'[7]

The very concepts of homogeneous national cultures, the consensual or contiguous transmission of historical traditions, or 'organic' ethnic communities – *as the grounds of cultural comparativism* – are in a profound process of redefinition. The hideous extremity of Serbian nationalism proves that the very idea of a pure, 'ethnically cleansed' national identity can only be achieved through the death, literal and figurative, of the complex interweavings of history, and the culturally contingent borderlines of modern nationhood. This side of the psychosis of patriotic fervour, I like to think, there is overwhelming evidence of a more transnational and translational sense of the hybridity of imagined communities. [...]

Postcoloniality, for its part, is a salutary reminder of the persistent 'neo-colonial' relations within the 'new' world order and the multinational division of labour. Such a perspective enables the authentication of histories of exploitation and the evolution of strategies of resistance. Beyond this, however, postcolonial critique bears witness to those countries and communities – in the North and the South, urban and rural – constituted, if I may coin a phrase, 'otherwise than modernity'. Such cultures of a postcolonial *contra-modernity* may be contingent to modernity, discontinuous or in contention with it, resistant to its oppressive, assimilationist technologies; but they also deploy the cultural hybridity of their borderline conditions to 'translate', and therefore reinscribe, the social imaginary of both metropolis and modernity. Listen to Guillermo Gomez-Peña, the performance artist who lives, amongst other times and places, on the Mexico/US border:

> hello America
> this is the voice of *Gran Vato Charollero*
> *broadcasting from the hot deserts of Nogales, Arizona*
> zona de libre cogercio
> 2000 megaherz en todas direciones
>
> you are celebrating Labor Day in Seattle
> while the Klan demonstrates
> against Mexicans in Georgia
> *ironia*, 100% *ironia*[8]

Being in the 'beyond', then, is to inhabit an intervening space, as any dictionary will tell you. But to dwell 'in the beyond' is also, as I have shown, to be part of a revisionary time, a return to the present to redescribe our cultural contemporaneity; to reinscribe our human, historic commonality; *to touch the future on its hither side*. In that sense, then, the intervening space 'beyond', becomes a space of intervention in the here and now. To engage with such invention, and intervention, as Green and Gomez-Peña enact in their distinctive work, requires a sense of the new that resonates with the hybrid chicano aesthetic of *'rasquachismo'* as Tomas Ybarra-Frausto describes it:

> the utilization of available resources for syncretism, juxtaposition, and integration. *Rasquachismo* is a sensibility attuned to mixtures and confluence...a delight in texture and sensuous surfaces...self-conscious manipulation of materials or iconography...the combination of found material and satiric wit...the manipulation of *rasquache* artifacts, code and sensibilities from both sides of the border.[9]

The borderline work of culture demands an encounter with 'newness' that is not part of the continuum of past and present. It creates a sense of the new as an insurgent act of cultural translation. Such art does not merely recall the past as social cause or aesthetic precedent; it renews the past, refiguring it as a contingent 'in-between' space, that innovates and interrupts the performance of the present. The 'past-present' becomes part of the necessity, not the nostalgia, of living.

Pepon Osorio's *objets trouvés* of the Nuyorican (New York/Puerto Rican) community – the statistics of infant mortality, or the silent (and silenced) spread of AIDS in the Hispanic community – are elaborated into baroque allegories of social alienation.

But it is not the high drama of birth and death that captures Osorio's spectacular imagination. He is the great celebrant of the migrant act of survival, using his mixed-media works to make a hybrid cultural space that forms contingently, disjunctively, in the inscription of signs of cultural memory and sites of political agency. *La Cama* (*The Bed*) turns the highly decorated four-poster into the primal scene of lost-and-found childhood memories, the memorial to a dead nanny Juana, the *mise-en-scène* of the eroticism of the 'emigrant' everyday. Survival, for Osorio, is working in the interstices of a range of practices: the 'space' of installation, the spectacle of the social statistic, the transitive time of the body in performance.

Finally, it is the photographic art of Alan Sekula that takes the borderline condition of cultural translation to its global limit in *Fish Story*, his photographic project on harbours: 'the harbour is the site in which material goods appear in bulk, in the very flux of exchange.'[10] The harbour and the stockmarket become the *paysage moralisé* of a containerized, computerized world of global trade. Yet, the non-synchronous time–space of transnational 'exchange', and exploitation, is embodied in a navigational allegory:

> Things are more confused now. A scratchy recording of the Norwegian national anthem blares out from a loudspeaker at the Sailor's Home on the bluff above the channel. The container ship being greeted flies a Bahamian flag of convenience. It was built by Koreans working long hours in the giant shipyards of Ulsan. The underpaid and the understaffed crew could be Salvadorean or Filipino. Only the Captain hears a familiar melody.[11]

Norway's nationalist nostalgia cannot drown out the babel on the bluff. Transnational capitalism and the impoverishment of the Third World certainly create the chains of circumstance that incarcerate the Salvadorean or the Filipino/a. In their cultural passage, hither and thither, as migrant workers, part of the massive economic and political diaspora of the modern world, they embody the Benjaminian 'present': that moment blasted out of the continuum of history. Such conditions of cultural displacement and social discrimination – where political survivors become the best historical witnesses – are the grounds on which Frantz Fanon, the Martinican psychoanalyst and participant in the Algerian revolution, locates an agency of empowerment:

> As soon as I *desire* I am asking to be considered. I am not merely here-and-now, sealed into thingness. I am for somewhere else and for something else. I demand that notice be taken of my *negating activity* [my emphasis] insofar as I pursue something other than life; insofar as I do battle for the creation of a human world – that is a world of reciprocal recognitions.

> I should constantly remind myself that the real *leap* consists in introducing invention into existence.
> In the world in which I travel, I am endlessly creating myself.
> And it is by going beyond the historical, instrumental hypothesis that I will initiate my cycle of freedom.[12]

Once more it is the desire for recognition, 'for somewhere else and for something else' that takes the experience of history *beyond* the instrumental hypothesis. Once again, it is the space of intervention emerging in the cultural interstices that introduces creative invention into existence. And one last time, there is a return to the perform-

ance of identity as iteration, the re-creation of the self in the world of travel, the resettlement of the borderline community of migration. Fanon's desire for the recognition of cultural presence as 'negating activity' resonates with my breaking of the time-barrier of a culturally collusive 'present'.

1 Renée Green interviewed by Elizabeth Brown, from catalogue published by Allen Memorial Art Museum, Oberlin College, Ohio.
2 Interview conducted by Miwon Kwon for the exhibition 'Emerging New York Artists', Sala Mendonza, Caracas, Venezuela (xeroxed manuscript copy).
3 Ibid., p. 6.
4 Renée Green in conversation with Donna Harkavy, Curator of Contemporary Art at the Worcester Museum.
5 Ibid.
6 W. Benjamin, 'Theses on the philosophy of history', in his *Illuminations* (London: Jonathan Cape, 1970), p. 265.
7 M. Heidegger, 'Building, dwelling, thinking', in *Poetry, Language, Thought* (New York: Harper & Row, 1971), pp. 152–3.
8 G. Gomez-Peña, *American Theatre*, vol. 8, no. 7, October 1991.
9 T. Ybarra-Frausto, 'Chicano movement/chicano art' in I. Karp and S. D. Lavine (eds) (Washington and London: Smithsonian Institution Press, 1991), pp. 133–4.
10 A. Sekula, *Fish Story*, manuscript, p. 2.
11 Ibid., p. 3.
12 F. Fanon, *Black Skin, White Masks*, Introduction by H. K. Bhabha (London: Pluto, 1986), pp. 218, 229, 231.

VIIIC
The Condition of History

1 Daniel Bell (b. 1919) from 'Modernism and Capitalism'

Bell is a conservative American sociologist associated with the related concepts of the 'post-industrial society' and the 'end of ideology'. In his schema it is 'theoretical knowledge' that is the central dynamic of change in the advanced societies of the late twentieth century, and not, for example, the conflict of classes as proposed in Marxist theory. In this essay Bell identifies Modernism both as the 'avowed enemy' of the ruling class and as the new 'regnant orthodoxy of the day'. As such it is disruptive of the desirable authority of judgements of value and destructive of the possibility of a shared moral order. In Bell's new version of the Call to Order, the agnostic impetus of Modernism awaits its postmodern counter from 'the deepest needs of individuals sharing a common awakening'. First published in *Partisan Review*, vol. 45, New York, 1978, pp. 206–22, and reprinted as a preface to the second edition of Bell's *The Cultural Contradictions of Capitalism* in the same year. The present extract is taken from sections IV–VII of the original version.

IV

The realm of culture is the realm of meanings, the effort in some imaginative form to make sense of the world through the expressiveness of art and ritual, particularly those 'incomprehensions' such as tragedy and death that arise out of the existential predicaments which every self-conscious human being must confront at some point in his life. In these encounters, one becomes aware of the fundamental questions – what Goethe called *Urphänomen* – which frame all others. Religion, as the oldest effort to comprehend these 'mysteries,' has historically been the source of cultural symbols.

If science is the search for the unity of nature, religion has been the quest for the unity of culture in the different historical periods of civilizations. To close that circle, religion has woven tradition as the fabric of meaning and guarded the portals of culture by rejecting those works of art which threatened the moral norms of religion.

The modern movement disrupts that unity. It does so in three ways: by insisting on the autonomy of the aesthetic from moral norms; by valuing more highly the new and experimental; and by taking the self (in its quest for originality and uniqueness) as the touchstone of cultural judgment. The most aggressive outrider of the movement is the self-proclaimed avant-garde which calls itself Modernism. I see Modernism as the agency for the dissolution of the bourgeois world view and, in the past half-century, as gaining hegemony in the culture.

The difficulties of defining Modernism are notorious. Schematically, I would specify three different dimensions:

1 Thematically Modernism has been a rage against order, and in particular, bourgeois orderliness. The emphasis is on the self, and the unceasing search for experience. If Terence once said, 'Nothing human is alien to me,' the Modernist could say with equal fervor, 'Nothing inhuman is alien to me.' Rationalism is seen as devitalizing; the surge to creativity is propelled by an exploration of the demonic. In that exploration, one cannot set aesthetic limits (or even moral norms) to this protean reach of the imagination. The crucial insistence is that experience is to have no boundaries to its cravings, that there be 'nothing sacred.'

2 Stylistically, there is a common syntax in what I have called 'the eclipse of distance.' This is the effort to achieve immediacy, impact, simultaneity, and sensation by eliminating aesthetic and psychic distance. In diminishing aesthetic distance, one annihilates contemplation and envelops the spectator in the experience. By eliminating psychic distance, one emphasizes (in Freudian terms) the 'primary process' of dream and hallucination, of instinct and impulse. In all this Modernism rejects the 'rational cosmology' that was introduced into the arts during the Renaissance and codified by Alberti: of foreground and background in pictorial space; of beginning, middle, and end, or sequence, in time; and the distinction of genres and the modes of work appropriate to each genre. This eclipse of distance, as a formal syntax, cuts across all the arts: in literature, the 'stream of consciousness'; in painting, the elimination of the 'interior distance' within the canvas: in music the upset of the balance of melody and harmony; in poetry, the disruption of the ordered meter. In the broadest sense, this common syntax repudiates mimesis as a principle of art. [. . .]

3 The preoccupation with the medium. In all periods of cultural history, artists have been conscious of the nature and complexity of the medium as a formal problem in transmuting the 'pre-figured' into the 'figured' result. In the last twenty-five years, we have seen a preoccupation not with the content or form (i.e., style and genre), but with the medium of art itself: with the actual texture of paint and materials in painting, with the abstract 'sounds' in music, with phonology or even 'breath' in poetry, and with the abstract properties of language in literature – often to the exclusion of anything else. Thus it is the encaustic surface, not the image, that generates excitement in the paintings of Jasper Johns; the aleatory or chance factors in the music of John Cage; the aspirate rather than the syllable, as a measure of line in poetry of Robert Creeley – all of these as expressions of the self, rather than formal explorations of the limits and nature of the medium itself.

Modernism has, beyond dispute, been responsible for one of the great surges of creativity in Western culture. The period from 1850 to 1930 probably saw more varied experiments in literature, poetry, music and painting – if not more great masterpieces – than any previous period we have known. Much of this arose out of the creative tension of culture, with its adversary stance, against the bourgeois social structure [. . .]

There has been a price. One cost has been the loss of coherence in culture, particularly in the spread of an antinomian attitude to moral norms and even to the idea of cultural judgment itself. The greater price was exacted when the distinction between art and life became blurred so that what was once permitted in the *imagination* (the novels of murder, lust, perversity) has often passed over into *fantasy*, and is acted

out by individuals who want to make their lives a work of art, and when, with the 'democratization' of criticism, the touchstone of judgment is no longer some consensual agreement on standards, but each 'self's' judgment as to how art enhances that 'self.'

Changes in culture interact with a social structure in complicated ways. Where there is a patronage system, the patron – be it prince, or church, or state – commissions a work of art, and the cultural needs of the institution, such as the Church, or the tastes of the prince, or the demands for glorification by the State, will shape the regnant style of the time. But where art is bought and sold, the market is where culture and social structure cross. One would expect that where culture has become a commodity the bourgeois taste would prevail. But in extraordinary historical fact, this has not been the case.

The phrase 'cultural hegemony' – identified with the Italian Marxist Antonio Gramsci – signifies the dominance of a single group in shaping the prevailing world view which gives a people an interpretation of the age. [...]

Marxists have assumed that under capitalism there has...been a single cultural hegemony – the ideas of the 'ruling class.' Yet the astonishing fact is that in the past hundred years, if there has been a dominant influence – in the high culture at least – it has been the avowed enemy of that class, Modernism.

At the start the capitalist economic impulse and the cultural drive of modernity shared a common source, the ideas of liberty and liberation, whose embodiments were 'rugged individualism' in economic affairs and the 'unrestrained self' in culture. Though the two had a common origin in the repudiation of tradition and the authority of the past, an adversary relation between them quickly developed. One can say, as Freud would, that the discipline required by work was threatened by the libidinal energies diverted to culture. This may perhaps be true, but it is abstract. What would seem to be the more likely historical explanation is that the bourgeois attitudes of calculation and methodical restraint came into conflict with the impulsive searchings for sensation and excitement that one found in Romanticism, and which passed over into Modernism. The antagonism deepened as the organization of work and production became bureaucratized and individuals were reduced to roles, so that the norms of the workplace were increasingly at variance with the emphasis on self-exploration and self-gratification. The thread connecting Blake to Byron to Baudelaire – who is the avatar of Modernism – may not be literal, but it is a figurative symbolic lineage.

So long as work and wealth had a religious sanction, they possessed a transcendental justification. But when that ethic eroded, there was a loss of legitimation, for the pursuit of wealth alone is not a calling that justifies itself. As Schumpeter once shrewdly remarked: The stock exchange is a poor substitute for the Holy Grail. The central point is that – at first, for the advanced social groups, the intelligentsia and the educated social classes, and later for the middle class itself – *the legitimations of social behavior passed from religion to modernist culture.* And with it there was a shift in emphasis from 'character,' which is the unity of moral codes and disciplined purpose, to an emphasis on 'personality,' which is the enhancement of self through the compulsive search for individual differentiation. In brief, not work but the 'life style' became the source of satisfaction and criterion for desirable behavior in the society.

Yet paradoxically, the life style that became the imago of the free self was not that of the businessman, expressing himself through his 'dynamic drive,' but that of the artist defying the conventions of the society. Increasingly, it is the artist who begins to

dominate the audience, and to impose his judgment as to what is to be desired and bought. The paradox is completed when the bourgeois ethic, having collapsed in the society, finds few defenders in the culture (do any writers defend *any* institutions?) and Modernism as an attack on orthodoxy, has triumphed and become the regnant orthodoxy of the day.

V

Any tension creates its own dialectic. Since the market is where social structure and culture cross, what has happened is that in the last fifty years, the economy has been geared to producing the life styles paraded by the culture. Thus, not only has there been a contradiction *between* the realms, but that tension has produced a further contradiction *within* the economic realm itself. In the world of capitalist enterprise, the nominal ethos in the spheres of production and organization is still one of work, delayed gratification, career orientation, devotion to the enterprise. Yet, on the marketing side, the sale of goods, packaged in the glossy images of glamour and sex, promotes a hedonistic way of life whose promise is the voluptuous gratification of the lineaments of desire. The consequence of this contradiction is that a corporation finds its people being straight by day and swingers by night.

What has happened in society in the last fifty years – as a result of the erosion of the religious ethic and the increase in discretionary income – *is that the culture has taken the initiative in promoting change,* and the economy has been geared to meeting these new wants. In this respect, there has been a significant reversal in the historical pattern of social change. During the rise of capitalism – in the 'modernization' of any traditional society – one could more readily change the economic structure of a society: by forcing people off the land into factories, by imposing a new rhythm and discipline of work, by using brutal means or incentives . . . to raise capital. But the superstructure – the patterns of family life, the attachments to religion and authority, the received ideas that shaped people's perceptions of a social reality – was more stubbornly resistant to change.

Today, by contrast, it is the economic structure that is the more difficult to change. Within the enterprise, the heavy bureaucratic layers reduce flexible adaptation, while union rules inhibit the power of management to control the assignment of jobs. In the society, the economic enterprise is subject to the challenges of various veto groups (e.g., on the location of plants or the use of the environment) and subject more and more to regulation by government.

But in the culture, fantasy reigns almost unconstrained. The media are geared to feeding new images to people, to unsettling traditional conventions, and the highlighting of aberrant and quirky behavior which becomes images for others to imitate. The traditional is stodgy, and the 'orthodox' institutions such as family and church are on the defensive about their inability to change. Yet if capitalism has been routinized, Modernism has been trivialized. After all, how often can it continue to shock, if there is nothing shocking left? If experiment is the norm, how original can anything new be? And like all bad history, Modernism has repeated its end, once in the popgun outbursts of Futurism and Dadaism, the second time in the phosphorescent parodies of Pop paintings and the mindless minimalism of conceptual art. The exclamation points that end each sentence of the Manifestoes, have simply become four dots that trail away in the tedium of endless repetition.

In the revelation of wisdom, the Owl of Minerva flies at dusk because life had become gray on gray [a paraphrase from the Preface to Hegel's *Philosophy of Right*]. In the victorious apocalypse of Modernism, the dawn is a series of gaudy colors whirling in strobismic light. Today, Modernism has become not the work of serious artists but the property of the *culturati*, the 'cultural mass,' the distribution sector of cultural production, for whom the shock of the old has become the chic of the new. The *culturati* have carried over, in rhetoric, the adversary stance against bourgeois orderliness and sobriety, yet they impose a conformity of their own on those who deviate from its guarded canons. [. . .]

In this double contradiction of capitalism, what has been established in the last thirty years has been the tawdry rule of fad and fashion: of 'multiples' for the *culturati*, hedonism for the middle classes, and pornotopia for the masses. And in the very nature of fashion, it has trivialized the culture.

VI

Has Modernism been 'co-opted,' as Herbert Marcuse suggests? In one dimension, yes. It has been converted into a commodity for promotion and profit. But in the deeper transformations of structure, that process can only undermine the foundations of capitalism itself. The sociological truism is that a societal order is shored up by its legitimations, which provide the defenses against its despisers. But the legitimation of the culture, as I have argued, is the quest for self-gratification and the expression of 'personality.' It attacks established orthodoxy in the name of personal autonomy and heterodoxy. Yet what modern culture has failed to understand is that orthodoxy is not the guardian of an existent order, but is itself a judgment on the adequacy and moral character of beliefs, from the standpoint of 'right reason.' The paradox is that 'heterodoxy' itself has become conformist in liberal circles and exercises that conformity under the banner of an antinomian flag. It is a prescription, in its confusions, for the dissolution of a shared moral order. [. . .]

VII

[. . .] We stand, I believe, with a clearing ahead of us. The exhaustion of Modernism, the aridity of Communist life, the tedium of the unrestrained self, and the meaninglessness of the monolithic political chants, all indicate that a long era is coming to a slow close. The impulse of Modernism was to leap beyond: beyond nature, beyond culture, beyond tragedy – to explore the *apeiron*, the boundless, driven by the self-infinitizing spirit of the radical self. Bourgeois society sundered economics from moral norms to allow the individual to pursue his own self-defined wants, yet at the same time sought to bend the culture to its restricted moral norms. Modernism was the major effort to break away from those restrictions in the name of experience, the aesthetic and the experimental and, in the end, broke all boundaries. Yet if we now seek to return economics to moral norms, is there not a similar warranty for culture?

We are groping for a new vocabulary whose keyword seems to be limits: a limit to growth, a limit to the spoliation of the environment, a limit to arms, a limit to the tampering with biological nature. Yet if we seek to establish a set of limits in the economy and technology, will we also set a limit to the exploration of those cultural

experiences which go beyond moral norms and embrace the demonic in the delusion that all experience is 'creative'? Can we set a limit to hubris? The answer to that question could resolve the *cultural* contradiction of capitalism and its deceptive double, *semblable et frère*, the culture of modernity ['Hypocrite lecteur – mon semblable – mon frère', Baudelaire, *Les Fleurs du Mal*]. It would leave only the economic and political mundane to be tamed.

2 Jean-François Lyotard (1924–1998) Introduction to *The Postmodern Condition*

The French philosopher Lyotard was for a time a member of the group Socialisme ou Barbarie (Socialism or Barbarity). In thus drawing its name from a well-known essay by Rosa Luxemburg, the group signalled a position within the classical socialist tradition, yet distinct from its corruption under the Stalinism of the official Communist movement. This identification lost pertinence after 1968, however, and Lyotard repositioned himself at the forefront of those seeking new explanations for the conditions of contemporary capitalism. The study which the following passage introduces was produced by request of the Conseil des Universités of the government of Québec, and was first published as *La Condition post-moderne: rapport sur le savoir*, Paris, 1979. Although he addresses similar evidence to Bell, Lyotard draws quite contrary conclusions. Where Bell sees the institutionalization of Modernist scepticism and experimentalism as favourable to the implementation of a new consensus in a restabilized economic order, Lyotard equates the postmodern with scepticism as to the possibility of an underlying consensus and with recognition of the inevitability of differences and incommensurabilities. His Postmodernism is thus a form of critically revivified Modernism, retaining the intellectual prospect of a new form of social existence. The present text is taken from pp. xxiii–xxv in the translation by Geoff Bennington and Brian Massumi, published as *The Postmodern Condition: A Report on Knowledge*, Minneapolis and Manchester, 1984.

[...] Science has always been in conflict with narratives. Judged by the yardstick of science, the majority of them prove to be fables. But to the extent that science does not restrict itself to stating useful regularities and seeks the truth, it is obliged to legitimate the rules of its own game. It then produces a discourse of legitimation with respect to its own status, a discourse called philosophy. I will use the term *modern* to designate any science that legitimates itself with reference to a metadiscourse of this kind making an explicit appeal to some grand narrative, such as the dialectics of Spirit, the hermeneutics of meaning, the emancipation of the rational or working subject, or the creation of wealth. For example, the rule of consensus between the sender and addressee of a statement with truth-value is deemed acceptable if it is cast in terms of a possible unanimity between rational minds: this is the Enlightenment narrative, in which the hero of knowledge works toward a good ethico-political end – universal peace. As can be seen from this example, if a metanarrative implying a philosophy of history is used to legitimate knowledge, questions are raised concerning the validity of the institutions governing the social bond: these must be legitimated as well. Thus justice is consigned to the grand narrative in the same way as truth.

Simplifying to the extreme, I define *postmodern* as incredulity toward metanarratives. This incredulity is undoubtedly a product of progress in the sciences: but that progress

in turn presupposes it. To the obsolescence of the metanarrative apparatus of legitimation corresponds, most notably, the crisis of metaphysical philosophy and of the university institution which in the past relied on it. The narrative function is losing its functors, its great hero, its great dangers, its great voyages, its great goal. It is being dispersed in clouds of narrative language elements – narrative, but also denotative, prescriptive, descriptive, and so on. Conveyed within each cloud are pragmatic valencies specific to its kind. Each of us lives at the intersection of many of these. However, we do not necessarily establish stable language combinations, and the properties of the ones we do establish are not necessarily communicable.

Thus the society of the future falls less within the province of a Newtonian anthropology (such as structuralism or systems theory) than a pragmatics of language particles. There are many different language games – a heterogeneity of elements. They only give rise to institutions in patches – local determinism.

The decision makers, however, attempt to manage these clouds of sociality according to input/output matrices, following a logic which implies that their elements are commensurable and that the whole is determinable. They allocate our lives for the growth of power. In matters of social justice and of scientific truth alike, the legitimation of that power is based on its optimizing the system's performance – efficiency. The application of this criterion to all of our games necessarily entails a certain level of terror, whether soft or hard: be operational (that is, commensurable) or disappear.

The logic of maximum performance is no doubt inconsistent in many ways, particularly with respect to contradiction in the socio-economic field: it demands both less work (to lower production costs) and more (to lessen the social burden of the idle population). But our incredulity is now such that we no longer expect salvation to rise from these inconsistencies, as did Marx.

Still, the postmodern condition is as much a stranger to disenchantment as it is to the blind positivity of delegitimation. Where, after the metanarratives, can legitimacy reside? The operativity criterion is technological; it has no relevance for judging what is true or just. Is legitimacy to be found in consensus obtained through discussion, as Jürgen Habermas thinks? Such consensus does violence to the heterogeneity of language games. And invention is always born of dissension. Postmodern knowledge is not simply a tool of the authorities; it refines our sensitivity to differences and reinforces our ability to tolerate the incommensurable. Its principle is not the expert's homology, but the inventor's paralogy.

Here is the question: is a legitimation of the social bond, a just society, feasible in terms of a paradox analogous to that of scientific activity? What would such a paradox be?

* * *

3 Jürgen Habermas (b. 1929) 'Modernity – An Incomplete Project'

This text originated in September 1980 as an address given on receipt of the Theodor W. Adorno prize from the city of Frankfurt. As the most distinguished of the Frankfurt School's 'second generation', Habermas maintains that commitment to the critical potential of Modernist high art for which Adorno had been a forceful spokesman. In line with this commitment he interprets recent theorization of the postmodern as a form of legitimation of

those reactionary tendencies to which Modernism was always opposed. Noting a coincidence of interests between the putatively postmodern and the anti-modern, he argues that a resource of aesthetic resistance remains necessary as a counter to the increasing autonomy of economic and administrative systems. Habermas's argument is distinguished from more positive assessments of a 'postmodern condition' by his continued recourse to the notion of a shared 'life world', against which emancipatory claims can be measured. The position of many 'postmodernists' is that it is precisely the *loss* of a shared space which puts the postmodern condition out of the reach of older programmes inspired by Marxism. Conversely, for Habermas, this very position is itself tantamount to a new conservatism. This address was repeated as the James lecture at the New York Institute for the Humanities, New York University, March 1981, and published in the present translation by Seyla Ben-Habib as 'Modernity versus Postmodernity' in *New German Critique*, 22, Winter 1981; reprinted under the present title in H. Foster (ed.), *Postmodern Culture*, London, 1985 (originally *The Anti-Aesthetic*, Seattle, 1983), pp. 3–15, from which the present text is taken.

The Discipline of Aesthetic Modernity

The spirit and discipline of aesthetic modernity assumed clear contours in the work of Baudelaire. Modernity then unfolded in various avant-garde movements and finally reached its climax in the Café Voltaire of the dadaists and in surrealism. Aesthetic modernity is characterized by attitudes which find a common focus in a changed consciousness of time. This time consciousness expresses itself through metaphors of the vanguard and the avant-garde. The avant-garde understands itself as invading unknown territory, exposing itself to the dangers of sudden, shocking encounters, conquering an as yet unoccupied future. The avant-garde must find a direction in a landscape into which no one seems to have yet ventured.

But these forward gropings, this anticipation of an undefined future and the cult of the new mean in fact the exaltation of the present. The new time consciousness, which enters philosophy in the writings of Bergson, does more than express the experience of mobility in society, of acceleration in history, of discontinuity in everyday life. The new value placed on the transitory, the elusive and the ephemeral, the very celebration of dynamism, discloses a longing for an undefiled, immaculate and stable present.

This explains the rather abstract language in which the modernist temper has spoken of the 'past.' Individual epochs lose their distinct forces. Historical memory is replaced by the heroic affinity of the present with the extremes of history – a sense of time wherein decadence immediately recognizes itself in the barbaric, the wild and the primitive. We observe the anarchistic intention of blowing up the continuum of history, and we can account for it in terms of the subversive force of this new aesthetic consciousness. Modernity revolts against the normalizing functions of tradition; modernity lives on the experience of rebelling against all that is normative. This revolt is one way to neutralize the standards of both morality and utility. This aesthetic consciousness continuously stages a dialectical play between secrecy and public scandal; it is addicted to a fascination with that horror which accompanies the act of profaning, and yet is always in flight from the trivial results of profanation.

On the other hand, the time consciousness articulated in avant-garde art is not simply ahistorical; it is directed against what might be called a false normativity in history. The modern, avant-garde spirit has sought to use the past in a different way; it disposes those pasts which have been made available by the objectifying scholarship of

historicism, but it opposes at the same time a neutralized history which is locked up in the museum of historicism.

Drawing upon the spirit of surrealism, Walter Benjamin constructs the relationship of modernity to history in what I would call a posthistoricist attitude. He reminds us of the self-understanding of the French Revolution: 'The Revolution cited ancient Rome, just as fashion cites an antiquated dress. Fashion has a scent for what is current, whenever this moves within the thicket of what was once.' This is Benjamin's concept of the *Jetztzeit*, of the present as a moment of revelation; a time in which splinters of a messianic presence are enmeshed. In this sense, for Robespierre, the antique Rome was a past laden with momentary revelations.

Now, this spirit of aesthetic modernity has recently begun to age. It has been recited once more in the 1960s; after the 1970s, however, we must admit to ourselves that this modernism arouses a much fainter response today than it did fifteen years ago. Octavio Paz, a fellow-traveller of modernity, noted already in the middle of the 1960s that 'the avant-garde of 1967 repeats the deeds and gestures of those of 1917. We are experiencing the end of the idea of modern art.' The work of Peter Bürger has since taught us to speak of 'post-avant-garde' art; this term is chosen to indicate the failure of the surrealist rebellion. But what is the meaning of this failure? Does it signal a farewell to modernity? Thinking more generally, does the existence of a post-avant-garde mean there is a transition to that broader phenomenon called post-modernity?

This is in fact how Daniel Bell, the most brilliant of the American neoconservatives, interprets matters. In his book, *The Cultural Contradictions of Capitalism*, Bell argues that the crises of the developed societies of the West are to be traced back to a split between culture and society. Modernist culture has come to penetrate the values of everyday life; the life-world is infected by modernism. Because of the forces of modernism, the principle of unlimited self-realization, the demand for authentic self-experience and the subjectivism of a hyperstimulated sensitivity have come to be dominant. This temperament unleashes hedonistic motives irreconcilable with the discipline of professional life in society, Bell says. Moreover, modernist culture is altogether incompatible with the moral basis of a purposive, rational conduct of life. In this manner, Bell places the burden of responsibility for the dissolution of the Protestant ethic (a phenomenon which had already disturbed Max Weber) on the 'adversary culture.' Culture in its modern form stirs up hatred against the conventions and virtues of everyday life, which has become rationalized under the pressures of economic and administrative imperatives.

I would call your attention to a complex wrinkle in this view. The impulse of modernity, we are told on the other hand, is exhausted; anyone who considers himself avant-garde can read his own death warrant. Although the avant-garde is still considered to be expanding, it is supposedly no longer creative. Modernism is dominant but dead. For the neoconservative the question then arises: how can norms arise in society which will limit libertinism, re-establish the ethic of discipline and work? What new norms will put a brake on the levelling caused by the social welfare state so that the virtues of individual competition for achievement can again dominate? Bell sees a religious revival to be the only solution. Religious faith tied to a faith in tradition will provide individuals with clearly defined identities and existential security.

Cultural Modernity and Societal Modernization

One can certainly not conjure up by magic the compelling beliefs which command authority. Analyses like Bell's, therefore, only result in an attitude which is spreading in Germany no less than in the States: an intellectual and political confrontation with the carriers of cultural modernity. [...]

Neoconservatism shifts onto cultural modernism the uncomfortable burdens of a more or less successful capitalist modernization of the economy and society. The neoconservative doctrine blurs the relationship between the welcomed process of societal modernization on the one hand, and the lamented cultural development on the other. The neoconservative does not uncover the economic and social causes for the altered attitudes towards work, consumption, achievement and leisure. Consequently, he attributes all of the following – hedonism, the lack of social identification, the lack of obedience, narcissism, the withdrawal from status and achievement competition – to the domain of 'culture.' In fact, however, culture is intervening in the creation of all these problems in only a very indirect and mediated fashion.

In the neoconservative view, those intellectuals who still feel themselves committed to the project of modernity are then presented as taking the place of those unanalyzed causes. The mood which feeds neoconservatism today in no way originates from discontent about the antinomian consequences of a culture breaking from the museums into the stream of ordinary life. This discontent has not been called into life by modernist intellectuals. It is rooted in deep-seated reactions against the process of *societal* modernization. Under the pressures of the dynamics of economic growth and the organizational accomplishments of the state, this social modernization penetrates deeper and deeper into previous forms of human existence. I would describe this subordination of the life-worlds under the system's imperatives as a matter of disturbing the communicative infrastructure of everyday life.

Thus, for example, neopopulist protests only express in pointed fashion a widespread fear regarding the destruction of the urban and natural environment and of forms of human sociability. There is a certain irony about these protests in terms of neoconservatism. The tasks of passing on a cultural tradition, of social integration and of socialization require adherence to what I call communicative rationality. But the occasions for protest and discontent originate precisely when spheres of communicative action, centered on the reproduction and transmission of values and norms, are penetrated by a form of modernization guided by standards of economic and administrative rationality – in other words, by standards of rationalization quite different from those of communicative rationality on which those spheres depend. But neoconservative doctrines turn our attention precisely away from such societal processes: they project the causes, which they do not bring to light, onto the plane of a subversive culture and its advocates.

To be sure, cultural modernity generates its own aporias as well. Independently from the consequences of *societal* modernization and within the perspective of *cultural* development itself, there originate motives for doubting the project of modernity. Having dealt with a feeble kind of criticism of modernity – that of neoconservatism – let me now move our discussion of modernity and its discontents into a different domain that touches on these aporias of cultural modernity -- issues that often serve

only as a pretense for those positions which either call for a postmodernity, recommend a return to some form of premodernity, or throw modernity radically overboard.

The Project of Enlightenment

The idea of modernity is intimately tied to the development of European art, but what I call 'the project of modernity' comes into focus only when we dispense with the usual concentration upon art. Let me start a different analysis by recalling an idea from Max Weber. He characterized cultural modernity as the separation of the substantive reason expressed in religion and metaphysics into three autonomous spheres. They are: science, morality and art. These came to be differentiated because the unified world-views of religion and metaphysics fell apart. Since the eighteenth century, the problems inherited from these older world-views could be arranged so as to fall under specific aspects of validity: truth, normative rightness, authenticity and beauty. They could then be handled as questions of knowledge, or of justice and morality, or of taste. Scientific discourse, theories of morality, jurisprudence, and the production and criticism of art could in turn be institutionalized. Each domain of culture could be made to correspond to cultural professions in which problems could be dealt with as the concern of special experts. This professionalized treatment of the cultural tradition brings to the fore the intrinsic structures of each of the three dimensions of culture. There appear the structures of cognitive-instrumental, of moral-practical and of aesthetic-expressive rationality, each of these under the control of specialists who seem more adept at being logical in these particular ways than other people are. As a result, the distance grows between the culture of the experts and that of the larger public. What accrues to culture through specialized treatment and reflection does not immediately and necessarily become the property of everyday praxis. With cultural rationalization of this sort, the threat increases that the life-world, whose traditional substance has already been devalued, will become more and more impoverished.

The project of modernity formulated in the eighteenth century by the philosophers of the Enlightenment consisted in their efforts to develop objective science, universal morality and law, and autonomous art according to their inner logic. At the same time, this project intended to release the cognitive potentials of each of these domains from their esoteric forms. The Enlightenment philosophers wanted to utilize this accumulation of specialized culture for the enrichment of everyday life – that is to say, for the rational organization of everyday social life.

Enlightenment thinkers of the cast of mind of Condorcet still had the extravagant expectation that the arts and sciences would promote not only the control of natural forces but also understanding of the world and of the self, moral progress, the justice of institutions and even the happiness of human beings. The twentieth century has shattered this optimism. The differentiation of science, morality and art has come to mean the autonomy of the segments treated by the specialist and their separation from the hermeneutics of everyday communication. This splitting off is the problem that has given rise to efforts to 'negate' the culture of expertise. But the problem won't go away: should we try to hold on to the *intentions* of the Enlightenment, feeble as they may be, or should we declare the entire project of modernity a lost cause? I now want to return to the problem of artistic culture, having explained why, historically, aesthetic modernity is only a part of cultural modernity in general.

The False Programs of the Negation of Culture

Greatly oversimplifying, I would say that in the history of modern art one can detect a trend towards ever greater autonomy in the definition and practice of art. The category of 'beauty' and the domain of beautiful objects were first constituted in the Renaissance. In the course of the eighteenth century, literature, the fine arts and music were institutionalized as activities independent from sacred and courtly life. Finally, around the middle of the nineteenth century an aestheticist conception of art emerged, which encouraged the artist to produce his work according to the distinct consciousness of art for art's sake. The autonomy of the aesthetic sphere could then become a deliberate project: the talented artist could lend authentic expression to those experiences he had in encountering his own de-centered subjectivity, detached from the constraints of routinized cognition and everyday action.

[...] But by the time of Baudelaire, who repeated this *promesse de bonheur* via art, the utopia of reconciliation with society had gone sour. A relation of opposites had come into being; art had become a critical mirror, showing the irreconcilable nature of the aesthetic and the social worlds. This modernist transformation was all the more painfully realized, the more art alienated itself from life and withdrew into the untouchableness of complete autonomy. Out of such emotional currents finally gathered those explosive energies which unloaded in the surrealist attempt to blow up the autarkical sphere of art and to force a reconciliation of art and life.

But all those attempts to level art and life, fiction and praxis, appearance and reality to one plane; the attempts to remove the distinction between artifact and object of use, between conscious staging and spontaneous excitement; the attempts to declare everything to be art and everyone to be an artist, to retract all criteria and to equate aesthetic judgment with the expression of subjective experiences – all these undertakings have proved themselves to be sort of nonsense experiments. These experiments have served to bring back to life, and to illuminate all the more glaringly, exactly those structures of art which they were meant to dissolve. They gave a new legitimacy, as ends in themselves, to appearance as the medium of fiction, to the transcendence of the artwork over society, to the concentrated and planned character of artistic production as well as to the special cognitive status of judgments of taste. The radical attempt to negate art has ended up ironically by giving due exactly to these categories through which Enlightenment aesthetics had circumscribed its object domain. The surrealists waged the most extreme warfare, but two mistakes in particular destroyed their revolt. First, when the containers of an autonomously developed cultural sphere are shattered, the contents get dispersed. Nothing remains from a desublimated meaning or a destructured form; an emancipatory effect does not follow.

Their second mistake has more important consequences. In everyday communication, cognitive meanings, moral expectations, subjective expressions and evaluations must relate to one another. Communication processes need a cultural tradition covering all spheres – cognitive, moral-practical and expressive. A rationalized everyday life, therefore, could hardly be saved from cultural impoverishment through breaking open a single cultural sphere – art – and so providing access to just one of the specialized knowledge complexes. The surrealist revolt would have replaced only one abstraction.
[...]

A reified everyday praxis can be cured only by creating unconstrained interaction of the cognitive with the moral-practical and the aesthetic-expressive elements. Reification cannot be overcome by forcing just one of those highly stylized cultural spheres to open up and become more accessible. [. . .]

Alternatives

I think that instead of giving up modernity and its project as a lost cause, we should learn from the mistakes of those extravagant programs which have tried to negate modernity. Perhaps the types of reception of art may offer an example which at least indicates the direction of a way out.

Bourgeois art had two expectations at once from its audiences. On the one hand, the layman who enjoyed art should educate himself to become an expert. On the other hand, he should also behave as a competent consumer who uses art and relates aesthetic experiences to his own life problems. This second, and seemingly harmless, manner of experiencing art has lost its radical implications exactly because it had a confused relation to the attitude of being expert and professional.

To be sure, artistic production would dry up, if it were not carried out in the form of a specialized treatment of autonomous problems and if it were to cease to be the concern of experts who do not pay so much attention to exoteric questions. Both artists and critics accept thereby the fact that such problems fall under the spell of what I earlier called the 'inner logic' of a cultural domain. But this sharp delineation, this exclusive concentration on one aspect of validity alone and the exclusion of aspects of truth and justice, break down as soon as aesthetic experience is drawn into an individual life history and is absorbed into ordinary life. The reception of art by the layman, or by the 'everyday expert,' goes in a rather different direction than the reception of art by the professional critic.

Albrecht Wellmer has drawn my attention to one way that an aesthetic experience which is not framed around the experts' critical judgments of taste can have its significance altered: as soon as such an experience is used to illuminate a life-historical situation and is related to life problems, it enters into a language game which is no longer that of the aesthetic critic. The aesthetic experience then not only renews the interpretation of our needs in whose light we perceive the world. It permeates as well our cognitive significations and our normative expectations and changes the manner in which all these moments refer to one another. Let me give an example of this process.

This manner of receiving and relating to art is suggested in the first volume of the work *The Aesthetics of Resistance* by the German-Swedish writer Peter Weiss. Weiss describes the process of reappropriating art by presenting a group of politically motivated, knowledge-hungry workers in 1937 in Berlin. These were young people who, through an evening high-school education, acquired the intellectual means to fathom the general and social history of European art. Out of the resilient edifice of this objective mind, embodied in works of art which they saw again and again in the museums in Berlin, they started removing their own chips of stone, which they gathered together and reassembled in the context of their own milieu. This milieu was far removed from that of traditional education as well as from the then existing regime. These young workers went back and forth between the edifice of European art and their own milieu until they were able to illuminate both.

In examples like this which illustrate the reappropriation of the expert's culture from the standpoint of the life-world, we can discern an element which does justice to the intentions of the hopeless surrealist revolts, perhaps even more to Brecht's and Benjamin's interests in how art works, which having lost their aura, could yet be received in illuminating ways. In sum, the project of modernity has not yet been fulfilled. And the reception of art is only one of at least three of its aspects. The project aims at a differentiated relinking of modern culture with an everyday praxis that still depends on vital heritages, but would be impoverished through mere traditionalism. This new connection, however, can only be established under the condition that societal modernization will also be steered in a different direction. The life-world has to become able to develop institutions out of itself which set limits to the internal dynamics and imperatives of an almost autonomous economic system and its administrative complements.

If I am not mistaken, the chances for this today are not very good. More or less in the entire Western world a climate has developed that furthers capitalist modernization processes as well as trends critical of cultural modernism. The disillusionment with the very failures of those programs that called for the negation of art and philosophy has come to serve as a pretense for conservative positions. Let me briefly distinguish the anti-modernism of the 'young conservatives' from the premodernism of the 'old conservatives' and from the postmodernism of the neoconservatives.

The 'young conservatives' recapitulate the basic experience of aesthetic modernity. They claim as their own the revelations of a decentered subjectivity, emancipated from the imperatives of work and usefulness, and with this experience they step outside the modern world. On the basis of modernistic attitudes they justify an irreconcilable antimodernism. They remove into the sphere of the far-away and the archaic the spontaneous powers of imagination, self-experience and emotion. To instrumental reason they juxtapose in Manichean fashion a principle only accessible through evocation, be it the will to power or sovereignty, Being or the Dionysiac force of the poetical. In France this line leads from Georges Bataille via Michel Foucault to Jacques Derrida.

The 'old conservatives' do not allow themselves to be contaminated by cultural modernism. They observe the decline of substantive reason, the differentiation of science, morality and art, the modern world view and its merely procedural rationality, with sadness and recommend a withdrawal to a position *anterior* to modernity. Neo-Aristotelianism, in particular, enjoys a certain success today. In view of the problematic of ecology, it allows itself to call for a cosmological ethic. [...]

Finally, the neoconservatives welcome the development of modern science, as long as this only goes beyond its sphere to carry forward technical progress, capitalist growth and rational administration. Moreover, they recommend a politics of defusing the explosive content of cultural modernity. According to one thesis, science, when properly understood, has become irrevocably meaningless for the orientation of the life-world. A further thesis is that politics must be kept as far aloof as possible from the demands of moral-practical justification. And a third thesis asserts the pure immanence of art, disputes that it has a utopian content, and points to its illusory character in order to limit the aesthetic experience to privacy. (One could name here the early Wittgenstein, Carl Schmitt of the middle period, and Gottfried Benn of the late period.) But with the decisive confinement of science, morality and art to autonomous spheres separated from the life-world and administered by experts, what remains from the

project of cultural modernity is only what we would have if we were to give up the project of modernity altogether. As a replacement one points to traditions which, however, are held to be immune to demands of (normative) justification and validation.

This typology is like any other, of course, a simplification, but it may not prove totally useless for the analysis of contemporary intellectual and political confrontations. I fear that the ideas of antimodernity, together with an additional touch of premodernity, are becoming popular in the circles of alternative culture. When one observes the transformations of consciousness within political parties in Germany, a new ideological shift (*Tendenzwende*) becomes visible. And this is the alliance of postmodernists with premodernists. It seems to me that there is no party in particular that monopolizes the abuse of intellectuals and the position of neoconservatism. [. . .]

4 Jean-François Lyotard (1924–1998) 'What Is Postmodernism?'

In this postscript to his earlier publication, Lyotard takes issue with Habermas and with the latter's equation of Postmodernism with anti-Modernism, arguing instead that the postmodern and the modern are continually bound in a dialectical relationship, so that the postmodern supersedes the modern only in order itself to become the modern. Within the terms of this framework, however, Lyotard proposes a new distinction: on the one hand those forms of art which cater in whatever fashion to the nostalgia for an unattainable wholeness or sense of presence (an echo, perhaps, of the 'presentness' valued by Fried in VIIA7); on the other those ingenious forms – for which he now reserves the name of postmodern – through which the very impossibility of this attainment is what is presented. First published as 'Réponse à la question: qu'est-ce que le postmoderne?' in *Critique*, Paris, no. 419, April 1982. This translation by Régis Durand published as 'Answering the Question: "What is Postmodernism?"', in I. and S. Hassan (eds.), *Innovation/Renovation*, Madison, WI, 1983; reprinted as an appendix to the English edition of Lyotard, *The Postmodern Condition*, op. cit., pp. 71–82, from which the present text is taken.

A Demand

This is a period of slackening – I refer to the color of the times. From every direction we are being urged to put an end to experimentation, in the arts and elsewhere. I have read an art historian who extols realism and is militant for the advent of a new subjectivity. I have read an art critic who packages and sells 'Transavantgardism' in the marketplace of painting. I have read that under the name of postmodernism, architects are getting rid of the Bauhaus project, throwing out the baby of experimentation with the bathwater of functionalism. I have read that a new philosopher is discovering what he drolly calls Judaeo-Christianism, and intends by it to put an end to the impiety which we are supposed to have spread. [. . .] I have read from the pen of a reputable historian that writers and thinkers of the 1960 and 1970 avant-gardes spread a reign of terror in the use of language, and that the conditions for a fruitful exchange must be restored by imposing on the intellectuals a common way of speaking, that of the historians. I have been reading a young philosopher of language who complains that Continental thinking, under the challenge of speaking machines, has surrendered to the machines the concern for reality, that it has substituted for the referential paradigm that of 'adlinguisticity' (one speaks about speech, writes about writing, intertextuality),

and who thinks that the time has now come to restore a solid anchorage of language in the referent. I have read a talented theatrologist for whom postmodernism, with its games and fantasies, carries very little weight in front of political authority, especially when a worried public opinion encourages authority to a politics of totalitarian surveillance in the face of nuclear warfare threats.

I have read a thinker of repute who defends modernity against those he calls the neoconservatives. Under the banner of postmodernism, the latter would like, he believes, to get rid of the uncompleted project of modernism, that of the Enlightenment. Even the last advocates of *Aufklärung*, such as Popper or Adorno, were only able, according to him, to defend the project in a few particular spheres of life – that of politics for the author of *The Open Society*, and that of art for the author of *Ästhetische Theorie*. Jürgen Habermas (everyone had recognized him) thinks that if modernity has failed, it is in allowing the totality of life to be splintered into independent specialties which are left to the narrow competence of experts, while the concrete individual experiences 'desublimated meaning' and 'destructured form,' not as a liberation but in the mode of that immense *ennui* which Baudelaire described over a century ago.

Following a prescription of Albrecht Wellmer, Habermas considers that the remedy for this splintering of culture and its separation from life can only come from 'changing the status of aesthetic experience when it is no longer primarily expressed in judgments of taste,' but when it is 'used to explore a living historical situation,' that is, when 'it is put in relation with problems of existence.' For this experience then 'becomes a part of a language game which is no longer that of aesthetic criticism'; it takes part 'in cognitive processes and normative expectations'; 'it alters the manner in which those different moments *refer* to one another.' What Habermas requires from the arts and the experiences they provide is, in short, to bridge the gap between cognitive, ethical, and political discourses, thus opening the way to a unity of experience.

My question is to determine what sort of unity Habermas has in mind. Is the aim of the project of modernity the constitution of sociocultural unity within which all the elements of daily life and of thought would take their places as in an organic whole? Or does the passage that has to be charted between heterogeneous language games – those of cognition, of ethics, of politics – belong to a different order from that? And if so, would it be capable of effecting a real synthesis between them? [...]

Realism

The demands I began by citing are not all equivalent. They can even be contradictory. Some are made in the name of postmodernism, others in order to combat it. It is not necessarily the same thing to formulate a demand for some referent (and objective reality), for some sense (and credible transcendence), for an addressee (and audience), or an addressor (and subjective expressiveness) or for some communicational consensus (and a general code of exchanges, such as the genre of historical discourse). But in the diverse invitations to suspend artistic experimentation, there is an identical call for order, a desire for unity, for identity, for security, or popularity (in the sense of *Öffentlichkeit*, of 'finding a public'). Artists and writers must be brought back into the bosom of the community, or at least, if the latter is considered to be ill, they must be assigned the task of healing it.

There is an irrefutable sign of this common disposition: it is that for all those writers nothing is more urgent than to liquidate the heritage of the avant-gardes. [...]

* * *

As for the artists and writers who question the rules of plastic and narrative arts and possibly share their suspicions by circulating their work, they are destined to have little credibility in the eyes of those concerned with 'reality' and 'identity'; they have no guarantee of an audience. Thus it is possible to ascribe the dialectics of the avant-gardes to the challenge posed by the realisms of industry and mass communication to painting and the narrative arts. Duchamp's 'ready made' does nothing but actively and parodistically signify this constant process of dispossession of the craft of painting or even of being an artist. As Thierry de Duve penetratingly observes, the modern aesthetic question is not 'What is beautiful?' but 'What can be said to be art (and literature)?'

Realism, whose only definition is that it intends to avoid the question of reality implicated in that of art, always stands somewhere between academicism and kitsch. When power assumes the name of a party, realism and its neoclassical complement triumph over the experimental avant-garde by slandering and banning it – that is, provided the 'correct' images, the 'correct' narratives, the 'correct' forms which the party requests, selects, and propagates can find a public to desire them as the appropriate remedy for the anxiety and depression that public experiences. The demand for reality – that is, for unity, simplicity, communicability, etc – did not have the same intensity nor the same continuity in German society between the two world wars and in Russian society after the Revolution: this provides a basis for a distinction between Nazi and Stalinist realism.

What is clear, however, is that when it is launched by the political apparatus, the attack on artistic experimentation is specifically reactionary: aesthetic judgment would only be required to decide whether such or such work is in conformity with the established rules of the beautiful. Instead of the work of art having to investigate what makes it an art object and whether it will be able to find an audience, political academicism possesses and imposes a priori criteria of the beautiful, which designate some works and a public at a stroke and forever. The use of categories in aesthetic judgment would thus be of the same nature as in cognitive judgment. To speak like Kant, both would be determining judgments: the expression is 'well formed' first in the understanding, then the only cases retained in experience are those which can be subsumed under this expression.

When power is that of capital and not that of a party, the 'transavantgardist' or 'postmodern' (in Jencks's sense) solution proves to be better adapted than the anti-modern solution. Eclecticism is the degree zero of contemporary general culture: one listens to reggae, watches a western, eats McDonald's food for lunch and local cuisine for dinner, wears Paris perfume in Tokyo and 'retro' clothes in Hong Kong; knowledge is a matter for TV games. It is easy to find a public for eclectic works. By becoming kitsch, art panders to the confusion which reigns in the 'taste' of the patrons. Artists, gallery owners, critics, and public wallow together in the 'anything goes,' and the epoch is one of slackening. But this realism of the 'anything goes' is in fact that of money; in the absence of aesthetic criteria, it remains possible and useful to assess the value of works of art according to the profits they yield. Such realism accommodates all tendencies, just as capital accommodates all 'needs,' providing that the tendencies

and needs have purchasing power. As for taste, there is no need to be delicate when one speculates or entertains oneself.

Artistic and literary research is doubtly threatened, once by the 'cultural policy' and once by the art and book market. What is advised, sometimes through one channel, sometimes through the other, is to offer works which, first, are relative to subjects which exist in the eyes of the public they address, and second, works so made ('well made') that the public will recognize what they are about, will understand what is signified, will be able to give or refuse its approval knowingly, and if possible, even to derive from such work a certain amount of comfort.

The interpretation which has just been given of the contact between the industrial and mechanical arts, and literature and the fine arts is correct in its outline, but it remains narrowly sociologizing and historicizing – in other words, one-sided. Stepping over Benjamin's and Adorno's reticences, it must be recalled that science and industry are no more free of the suspicion which concerns reality than are art and writing. To believe otherwise would be to entertain an excessively humanistic notion of the mephistophelian functionalism of sciences and technologies. There is no denying the dominant existence today of techno-science, that is, the massive subordination of cognitive statements to the finality of the best possible performance, which is the technological criterion. But the mechanical and the industrial, especially when they enter fields traditionally reserved for artists, are carrying with them much more than power effects. The objects and the thoughts which originate in scientific knowledge and the capitalist economy convey with them one of the rules which supports their possibility: the rule that there is no reality unless testified by a consensus between partners over a certain knowledge and certain commitments.

This rule is of no little consequence. It is the imprint left on the politics of the scientist and the trustee of capital by a kind of flight of reality out of the metaphysical, religious, and political certainties that the mind believed it held. This withdrawal is absolutely necessary to the emergence of science and capitalism. No industry is possible without a suspicion of the Aristotelian theory of motion, no industry without a refutation of corporatism, of mercantilism, and of physiocracy. Modernity, in whatever age it appears, cannot exist without a shattering of belief and without discovery of the 'lack of reality' of reality, together with the invention of other realities.

What does this 'lack of reality' signify if one tries to free it from a narrowly historicized interpretation? The phrase is of course akin to what Nietzsche calls nihilism. But I see a much earlier modulation of Nietzschean perspectivism in the Kantian theme of the sublime. I think in particular that it is in the aesthetic of the sublime that modern art (including literature) finds its impetus and the logic of avant-gardes finds its axioms.

The sublime sentiment, which is also the sentiment of the sublime, is, according to Kant, a strong and equivocal emotion: it carries with it both pleasure and pain. Better still, in it pleasure derives from pain. Within the tradition of the subject, which comes from Augustine and Descartes and which Kant does not radically challenge, this contradiction, which some would call neurosis or masochism, develops as a conflict between the faculties of a subject, the faculty to conceive of something and the faculty to 'present' something. Knowledge exists if, first, the statement is intelligible, and second, if 'cases' can be derived from the experience which 'corresponds' to it. Beauty exists if a certain 'case' (the work of art), given first by the sensibility without any

conceptual determination, the sentiment of pleasure independent of any interest the work may elicit, appeals to the principle of a universal consensus (which may never be attained).

Taste, therefore, testifies that between the capacity to conceive and the capacity to present an object corresponding to the concept, an undetermined agreement, without rules, giving rise to a judgment which Kant calls reflective, may be experienced as pleasure. The sublime is a different sentiment. It takes place, on the contrary, when the imagination fails to present an object which might, if only in principle, come to match a concept. We have the Idea of the world (the totality of what is), but we do not have the capacity to show an example of it. We have the Idea of the simple (that which cannot be broken down, decomposed), but we cannot illustrate it with a sensible object which would be a 'case' of it. We can conceive the infinitely great, the infinitely powerful, but every presentation of an object destined to 'make visible' this absolute greatness or power appears to us painfully inadequate. Those are Ideas of which no presentation is possible. Therefore, they impart no knowledge about reality (experience); they also prevent the free union of the faculties which gives rise to the sentiment of the beautiful; and they prevent the formation and the stabilization of taste. They can be said to be unpresentable.

I shall call modern the art which devotes its 'little technical expertise' (*son 'petit technique'*), as Diderot used to say, to present the fact that the unpresentable exists. To make visible that there is something which can be conceived and which can neither be seen nor made visible: this is what is at stake in modern painting. But how to make visible that there is something which cannot be seen? Kant himself shows the way when he names 'formlessness, the absence of form,' as a possible index to the unpresentable. He also says of the empty 'abstraction' which the imagination experiences when in search for a presentation of the infinite (another unpresentable): this abstraction itself is like a presentation of the infinite, its 'negative presentation.' He cites the command-ment, 'Thou shalt not make graven images' (Exodus), as the most sublime passage in the Bible in that it forbids all presentation of the Absolute. Little needs to be added to those observations to outline an aesthetic of sublime paintings. As painting, it will of course 'present' something though negatively; it will therefore avoid figuration or representation. It will be 'white' like one of Malevitch's squares; it will enable us to see only by making it impossible to see; it will please only by causing pain. One recognizes in those instructions the axioms of avant-gardes in painting, inasmuch as they devote themselves to making an allusion to the unpresentable by means of visible presentations. The systems in the name of which, or with which, this task has been able to support or to justify itself deserve the greatest attention; but they can originate only in the vocation of the sublime in order to legitimize it, that is, to conceal it. They remain inexplicable without the incommensurability of reality to concept which is implied in the Kantian philosophy of the sublime.

It is not my intention to analyze here in detail the manner in which the various avant-gardes have, so to speak, humbled and disqualified reality by examining the pictorial techniques which are so many devices to make us believe in it. Local tone, drawing, the mixing of colors, linear perspective, the nature of the support and that of the instrument, the treatment, the display, the museum: the avant-gardes are perpetually flushing out artifices of presentation which make it possible to subordinate thought to the gaze and to turn it away from the unpresentable. If Habermas, like Marcuse, understands this task of

derealization as an aspect of the (repressive) 'desublimation' which characterizes the avant-garde, it is because he confuses the Kantian sublime with Freudian sublimation, and because aesthetics has remained for him that of the beautiful.

The Postmodern

What, then, is the postmodern? What place does it or does it not occupy in the vertiginous work of the questions hurled at the rules of image and narration? It is undoubtedly a part of the modern. All that has been received, if only yesterday (*modo, modo*, Petronius used to say), must be suspected. What space does Cézanne challenge? The Impressionists'. What object do Picasso and Braque attack? Cézanne's. What presupposition does Duchamp break with in 1912? That which says one must make a painting, be it cubist. And Buren questions that other presupposition which he believes had survived untouched by the work of Duchamp: the place of presentation of the work. In an amazing acceleration, the generations precipitate themselves. A work can become modern only if it is first postmodern. Postmodernism thus understood is not modernism at its end but in the nascent state, and this state is constant.

Yet I would like not to remain with this slightly mechanistic meaning of the word. If it is true that modernity takes place in the withdrawal of the real and according to the sublime relation between the presentable and the conceivable, it is possible, within this relation, to distinguish two modes (to use the musician's language). The emphasis can be placed on the powerlessness of the faculty of presentation, on the nostalgia for presence felt by the human subject, on the obscure and futile will which inhabits him in spite of everything. The emphasis can be placed, rather, on the power of the faculty to conceive, on its 'inhumanity' so to speak (it was the quality Apollinaire demanded of modern artists), since it is not the business of our understanding whether or not human sensibility or imagination can match what it conceives. The emphasis can also be placed on the increase of being and the jubilation which result from the invention of new rules of the game, be it pictorial, artistic, or any other. What I have in mind will become clear if we dispose very schematically a few names on the chessboard of the history of avant-gardes: on the side of melancholia, the German Expressionists, and on the side of *novatio*, Braque and Picasso, on the former Malevitch and on the latter Lissitsky, on the one Chirico and on the other Duchamp. The nuance which distinguishes these two modes may be infinitesimal; they often coexist in the same piece, are almost indistinguishable; and yet they testify to a difference (*un différend*) on which the fate of thought depends and will depend for a long time, between regret and assay.

* * *

Here, then, lies the difference: modern aesthetics is an aesthetic of the sublime, though a nostalgic one. It allows the unpresentable to be put forward only as the missing contents; but the form, because of its recognizable consistency, continues to offer to the reader or viewer matter for solace and pleasure. Yet these sentiments do not constitute the real sublime sentiment, which is in an intrinsic combination of pleasure and pain: the pleasure that reason should exceed all presentation, the pain that imagination or sensibility should not be equal to the concept.

The postmodern would be that which, in the modern, puts forward the unpresentable in presentation itself; that which denies itself the solace of good forms, the consensus of a taste which would make it possible to share collectively the nostalgia

for the unattainable; that which searches for new presentations, not in order to enjoy them but in order to impart a stronger sense of the unpresentable. A postmodern artist or writer is in the position of a philosopher: the text he writes, the work he produces are not in principle governed by preestablished rules, and they cannot be judged according to a determining judgment, by applying familiar categories to the text or to the work. Those rules and categories are what the work of art itself is looking for. The artist and the writer, then, are working without rules in order to formulate the rules of what *will have been done*. Hence the fact that work and text have the characters of an *event*; hence also, they always come too late for their author, or, what amounts to the same thing, their being put into work, their realization (*mise en œuvre*) always begin too soon. *Post modern* would have to be understood according to the paradox of the future (*post*) anterior (*modo*).

It seems to me that the essay (Montaigne) is postmodern, while the fragment (*The Athenaeum*) is modern.

Finally, it must be clear that it is our business not to supply reality but to invent allusions to the conceivable which cannot be presented. And it is not to be expected that this task will effect the last reconciliation between language games (which, under the name of faculties, Kant knew to be separated by a chasm), and that only the transcendental illusion (that of Hegel) can hope to totalize them into a real unity. But Kant also knew that the price to pay for such an illusion is terror. The nineteenth and twentieth centuries have given us as much terror as we can take. We have paid a high enough price for the nostalgia of the whole and the one, for the reconciliation of the concept and the sensible, of the transparent and the communicable experience. Under the general demand for slackening and for appeasement, we can hear the mutterings of the desire for a return of terror, for the realization of the fantasy to seize reality. The answer is: Let us wage a war on totality; let us be witnesses to the unpresentable; let us activate the differences and save the honor of the name.

5 Julia Kristeva (b. 1941) 'Powers of Horror'

The gradual shift in the emphasis of Kristeva's work – from linguistics to psychoanalysis – is consistent with a conclusion reached by many intellectuals during the 1970s, and particularly by those espousing forms of feminism: that it is the psychoanalyst's couch and not the class struggle that is now the true site of liberation. Kristeva's work is exceptional in its *literary* power. Her critique of scientific and rationalistic accounts of language is given practical effect through the actual poetic eloquence of her writing. Like both Bell and Lyotard, Kristeva addresses a condition of loss of faith in unified rational or religious systems, though unlike them she sees the individual subject's sense of abjection as the basic condition which these systems serve to mask. Originally published as the eponymously titled chapter 11 of Kristeva, *Pouvoirs de l'horreur*, Paris, 1980. Translated by Leon S. Roudiez as *Powers of Horror: An Essay on Abjection*, New York, 1982. The present text is taken from pp. 207–10 of that edition. (See also VIIIA12.)

Throughout a night without images but buffeted by black sounds; amidst a throng of forsaken bodies beset with no longing but to last against all odds and for nothing, on a

page where I plotted out the convolutions of those who, in transference, presented me with the gift of their void – I have spelled out abjection. Passing through the memories of a thousand years, a fiction without scientific objective but attentive to religious imagination, it is within literature that I finally saw it carrying, with its horror, its full power into effect.

On close inspection, all literature is probably a version of the apocalypse that seems to me rooted, no matter what its socio-historical conditions might be, on the fragile border (borderline cases) where identities (subject/object, etc.) do not exist or only barely so – double, fuzzy, heterogeneous, animal, metamorphosed, altered, abject.

[. . .] I have sought . . . to demonstrate on what mechanism of subjectivity (which I believe to be universal) such horror, its meaning as well as its power, is based. By suggesting that literature is its privileged signifier, I wish to point out that, far from being a minor, marginal activity in our culture, as a general consensus seems to have it, this kind of literature, or even literature as such, represents the ultimate coding of our crises, of our most intimate and most serious apocalypses. Hence its nocturnal power, 'the great darkness' (Angela of Foligno). Hence its continual compromising: 'Literature and Evil' (Georges Bataille). Hence also its being seen as taking the place of the sacred, which, to the extent that it has left us without leaving us alone, calls forth the quacks from all four corners of perversion. Because it occupies its place, because it hence decks itself out in the sacred power of horror, literature may also involve not an ultimate resistance to but an unveiling of the abject: an elaboration, a discharge, and a hollowing out of abjection through the Crisis of the Word.

If 'something maternal' happens to bear upon the uncertainty that I call abjection, it illuminates the literary scription of the essential struggle that a writer (man or woman) has to engage in with what he calls demonic only to call attention to it as the inseparable obverse of his very being, of the other (sex) that torments and possesses him. Does one write under any other condition than being possessed by abjection, in an indefinite catharsis? Leaving aside adherents of a feminism that is jealous of conserving its power – the last of the power-seeking ideologies – none will accuse of being a usurper the artist who, even if he does not know it, is an undoer of narcissism and of all imaginary identity as well, sexual included.

And yet, in these times of dreary crisis, what is the point of emphasizing the horror of being?

Perhaps those that the path of analysis, or scription, or of a painful or ecstatic ordeal has led to tear the veil of the communitarian mystery, on which love of self and others is set up, only to catch a glimpse of the abyss of abjection with which they are underlaid – they perhaps might be able to read this book as something other than an intellectual exercise. For abjection, when all is said and done, is the other facet of religious, moral, and ideological codes on which rest the sleep of individuals and the breathing spells of societies. Such codes are abjection's purification and repression. But the return of their repressed makes up our 'apocalypse,' and that is why we cannot escape the dramatic convulsions of religious crises.

In the end, our only difference is our unwillingness to have a face-to-face confrontation with the abject. Who would want to be a prophet? For we have lost faith in One Master Signifier. We prefer to foresee or seduce; to plan ahead, promise a recovery, or

esthetize; to provide social security or make art not too far removed from the level of the media.

In short, who, I ask you, would agree to call himself abject, subject of or subject to abjection?

Nothing preordains the psychoanalyst to take the place of the mystic. Psychoanalytic establishments seem even less suited to this, so much does their intrinsic perversion consign them to mummifying transference in the production of mini-paranoids if not merely stereotyped besotments. And yet, it would perhaps be possible for an analyst (if he could manage to stay in the only place that is his, *the void*, that is, the unthinkable of metaphysics) to begin hearing, actually to listen to himself build up a discourse around the braided horror and fascination that bespeaks the incompleteness of the speaking being but, because it is heard as a narcissistic crisis on the outskirts of the feminine, shows up with a comic gleam the religious and political pretensions that attempt to give meaning to the human adventure. For, facing abjection, meaning has only a scored, rejected, ab-jected meaning – a comical one. 'Divine,' 'human,' or 'for some other time,' the comedy or the enchantment can be realized, on the whole, only by reckoning with the impossible for later or never, but set and maintained right here.

Fastened to meaning like Raymond Roussel's parrot to its chain, the analyst, since he interprets, is probably among the rare contemporary witnesses to our dancing on a volcano. If he draws perverse jouissance from it, fine; provided that, in his or her capacity as a man or woman without qualities, he allow the most deeply buried logic of our anguish and hatred to burst out. Would he then be capable of X-raying horror without making capital out of its power? Of displaying the abject without confusing himself for it?

Probably not. Because of knowing it, however, with a knowledge undermined by forgetfulness and laughter, an abject knowledge, he is, she is preparing to go through the first great demystification of Power (religious, moral, political, and verbal) that mankind has ever witnessed; and it is necessarily taking place within that fulfillment of religion as sacred horror, which is Judeo-Christian monotheism. In the meantime, let others continue their long march toward idols and truths of all kinds, buttressed with the necessarily righteous faith for wars to come, wars that will necessarily be holy.

Is it the quiet shore of contemplation that I set aside for myself, as I lay bare, under the cunning, orderly surface of civilizations, the nurturing horror that they attend to pushing aside by purifying, systematizing, and thinking; the horror that they seize on in order to build themselves up and function? I rather conceive it as a work of disappointment, of frustration, and hollowing – probably the only counterweight to abjection. While everything else – its archeology and its exhaustion – is only literature: the sublime point at which the abject collapses in a burst of beauty that overwhelms us – and 'that cancels our existence' (Céline).

6 Donald Judd (1928–1994) from '... not about master-pieces but why there are so few of them'

During the early 1960s Judd wrote art criticism in a characteristically forthright style. In the long essay from which the present extract is taken, he assumes the authority of a now established artist to argue that there has been a decline in the quality of new art. He

attributes this decline to ignorance of historical conditions and of the values of art, and argues the need for 'virtually a whole civilization, new knowledge and attitudes' to oppose commerce. He also diagnoses a widespread confusion of the issue of quality with the issues of democracy on the one hand and fashion on the other. Originally published as 'A long discussion not about master-pieces but why there are so few of them' in two parts in *Art in America*, New York, September 1984, pp. 9–19, and October 1984, pp. 9–15. The present extracts are taken from Part I.

'Everything is against them.'

Gertrude Stein

The quality of new art has been declining for fifteen years. There are some probable reasons for this, but none which finally explain the fundamental fact of why. There have been almost no first-rate artists in this time. Neither do similar reasons explain why there were so many in the late '40s and early '50s and the late '50s and early '60s. Despite all that's wrong in this society it's the responsibility of the new artists to occur. The explanation that the times and the society are bad is pointless. Probably they have always been and the issue is whether too bad or a little better. The reason for doing nothing is always wrong. There is also the responsibility of the older artists to uphold a high quality. At present they do this in their work, but not otherwise... The presence of good artists is exceedingly given by themselves; it's the ultimate, obdurate fact. Reform may allow new artists but not necessarily. It has been shown many times that more money or a greater audience guarantee nothing. Wide or narrow, the condition in which art is made is much more important. There is a limit to the use of art and art doesn't tolerate frivolity and abuse.

The most general reasons for the present difficulty of art and for recurrent difficulties are pretty obvious, even trite, but considering the meager knowledge that I plan to complain of they must be stated. One of the main attitudes of the present is that the past is merely a toy store, so some history is necessary. Later I want to emphasize that most of the past is inaccessible to us.

In the last 200 years or so the society has changed from a rural one to an industrial one, and the economic leadership from the top of the one to the top of the other. At the same time the population has grown unimaginably. The majority of the society, as the descendants of peasants, brand new people who remember little, has had to be educated. There were not enough educated people to do this; the group was originally very small. As they taught their much more numerous successors, the level couldn't be maintained, until finally only bare information was taught, if science, and academic nonsense, if the arts. In Texas I once went with a teacher to a lecture by a woman well-known there for having taught 'creative writing' in high school for a lifetime. Her idea of creative was not even rudimentary, for example, decorate the sentence and never simply say 'it's raining.' Two hundred younger teachers listened to her impoverished schema, understanding, by their questions, even less. Presumably the next day they went to work and taught 4000 students less than that. This is the fundamental knowledge of the society. And some of those students will go on to become rich businessmen, a few the trustees of museums and universities, or politicians. So similarly there is always a lower rising wave curious about art who remember less. And now even artists.

Education is the ultimate problem in the United States, and in Europe too, although better there. It's the ultimate problem of civilization and everything depends on it, certainly politics and the wars. The Europeans were ignorant and foolish enough to almost destroy each other over matters already obsolescent, and so damaged the world's only high civilization. This left the world to two large and backward nations bent on being equally ignorant and foolish, and more conclusive. The United States was not so great in the last century, but seems to have been better then than now, with much discussion of purposes and some sense of communality. Now the literature seems like that of another country.

Ever since Bernini no first-rate artist has worked for an institution. Religion as an institution was no longer credible to serious artists. It's to the credit of artists that for them dying institutions invalidate themselves earlier than for others. Many artists continued to believe in a personal variant of Christianity, but religion was no longer an advance in the understanding of humanity and of nature. By now religion is just another superstition. Before Bernini religion was the nature of the world and of man, and for the most part, despite corruption and suppression, its morality and cosmology opposed commerce and mundane power. For a century there has been no counterforce to power and commerce, nothing to say that the existence of the individual and of the world, their relationship, that between individuals, and activities which signify these, such as art, are not a matter of business and are not to be bought and sold.

Religion was good riddance but art, architecture and music no longer had an institutional support. They could only make and sell and so live within the context of commerce. As the distance increased from the standards of the church and of the nobility, and with the increasing ignorance, there was less and less restraint upon the businessmen, the final one being that it's after all necessary to understand and maintain the value of the commodity. Today art is only a cut above being an ordinary commodity and close to being manipulated as any compliant commodity should be. [. . .]

At best there's nothing wrong with commerce. And it's hard to overrate the importance of economics. Business is often straightforward, and as a source of income for artists, if matter-of-fact, it's best. Demand is a reality. Business is much preferable to patronage by the central government's bureaucrats or by the often appalling *nouveau riche* and their kids, rotten before they are ripe, as Diderot said of the Russians improved by Peter. But buying and selling and even raising or making essentials is just that. It's a necessary basis for civilization, even a part, but it's not civilization itself. There's no real way to glorify business just as it's hard to glorify eating and sleeping. Business doesn't deserve the power and prestige surrounding it. Business is only business.

Commerce is nearly the only activity in this society. Even the central government is an aspect of commerce, by selling weapons, an outrageous and despicable business. Virtually a whole civilization, new knowledge and attitudes, must be built to oppose commerce. This counterforce has to be new, can't be one or all of the ever more debased religions, which are too ignorant to be ethical, political or even 'spiritual.' The opposition can't be an institution but must be lots of diverse and educated people arguing and objecting. These people must have real knowledge and judgment and they must have an influence upon the less educated majority. Art of a high quality should be part of the opposition to commerce but art is close to being forced underground by it, as architecture has been recently, and music and dance throughout this century. And

also too much of science, although there is more opposition in science than elsewhere. For a century there have usually been two versions of each art, one real, but poor and underground, and one fake, although rich and conspicuous. The latter ingests the former as needed. [...]

Art used to have issues, as Barnett Newman called them. For fifteen years the issues have grown fewer and weaker. Now we're all supposed to be 'doing our own thing.' Art will become the occasional gesture of the isolated person. It's considered undemocratic to say that someone's work is more developed or more broad in thought or more advanced, as complex as that term may be, than someone else's. It's not nice to say that my work is better than yours. This vapid attitude is part of the same throughout the society. The one small idea in this attitude is that art should be democratic. But politics alone should be democratic. Art is intrinsically a matter of quality. A commitment to democracy in politics is included in the synthesis that is very good art. One ploy in the ongoing destruction of democracy in politics is to pass democracy along to weak groups and activities that are irrelevant to the politicians. If a serious chance for democracy arises in the central government everyone is horrified. [...] Anyway, in art and elsewhere everyone is not equal and it's hypocrisy and confusion to pretend so. Let the governments allow the citizens to be equal as citizens in the places where they live. Quality of thought and effort, except in the role of citizens, is not part of this. It should be rewarded, not denigrated. [...]

[...] The last general point is that few understand how past and over the past is. But also that the present is presently the past, and all that's good that arrives there should be conserved assiduously. The people most fond of symbols from the past are also the ones most heedless of its reality. The guy in Tucson with the Spanish-Colonial TV set is the one who bulldozed the adobe houses in the old part of town. This tourist's view of the past devalues issues and reality in the present. It fits that conservatives in the United States are not real conservatives. (Liberals are not liberals, either.) It's necessary to life to understand the past and preserve it; it's life to do something now. [...]

Obviously we understand much, and profoundly, in past art and architecture but it is a delusion to believe that we understand everything. It's not possible to understand everything about art and architecture even if it's done now. The full meaning of what's seen fades quickly. The intrigue of an old style partially supplants the relevance of the present but much is lost. In art and architecture it's impossible to use forms from the past. They become symbols, and not profound ones either, but on the order of the colonial TV set. Form is a wobbly word to use because form and content is a false division derived from another false division, thought and feeling. Certainly form and content, whatever, are made of generalizations but also they are made of particulars, obdurate and intimate. The particulars tend to escape later understanding. The only instance in which the past is more than usually relevant to the present is when the continuity is very strong, bringing the past to the present. This may be the case in the language and literature of Iceland. It might be so in the architecture of Italy. But few artists and architects now have any experience of even the recent past. Despite differences, we – Europeans, European Colonials, Japanese and some others – grow up in the middle-class industrial society, all with the same government education. The poor are just poor and the rich only have more expensive symbols.

The most recent situations in art and architecture depend on the exploitation of history, done by some who are ignorant and naive for a corresponding audience, but worse, done by some who are cynical. If something new is to look important it has to look like something that has become important, which takes time. The work of Matisse and Newman, of most good artists since Bernini, cannot at first have looked important in this extrinsic sense. Instant importance is a lot easier to make than real importance and far easier to sell. David Rabinowitch said about this air of importance that it's the essence of academicism.

The audience only remembers that the art resembling what they are looking at is reproduced in all the books. They don't realize that the work in the books was new and original, and cannot be a type. They don't understand that the type has been produced afterwards by a few second-rate artists and many mediocre ones, the whole declining steadily to banality, pedantry and insincerity.

* * *

Much is made now of the catchword 'post-modern,' which includes more every day. This term has been made by changing the meaning of the word 'modern' from 'now,' which is all it ever meant, to a meaning as a style, which the word cannot mean, since no style can include such diversity. Wright, van der Rohe and Corbusier are thrown together and tossed off as being 'modern.' This 'modern' means only earlier and by now opprobriously established, and 'postmodern' means modern. I've thought of an even better label, 'post-contemporary.' 'Post-modern' is being used to obscure the issue of quality by claiming a presentness and a popularity supposedly superior to that of acknowledged art and architecture, no matter how good they are and in fact regardless of their pertinence, democracy and acceptance so far. This is cant. It's hypocrisy to seem to criticize the work of the recent past, especially by ascribing spurious purposes and meanings to it, while indiscriminately mining the greater past. It's setting up a straw man to supersede to identify 'modern' with the 'international style,' a commercial simplification of van der Rohe's work, made by the same architects, Johnson for one, who now say that the style is cold and repetitious, as they made it, and that it must be replaced by another, hopefully diverse and entertaining. The elaboration of the term 'post-modern' is not due to real change but is due to naked fashion and the need to cover it with words. [. . .]

7 Joseph Beuys (1921–1986), Jannis Kounellis (b. 1936), Anselm Kiefer (b. 1945), Enzo Cucchi (b. 1950) from 'The Cultural-Historical Tragedy of the European Continent'

The present discussion marks a continuation of that strand in modern artistic theory which has sought from its outset to relate radical art to radical politics, yet without subsuming art *in* politics. This project has taken different forms, but utopianism has been one of its persistent characteristics, and another has been its tendency to stress consciousness and feeling as prerequisites for material change (rather than material change as a prerequisite for change of consciousness). The discussions took place in 1985 under the auspices of Parkett Verlag, Zurich, and were moderated by Jean Christophe Ammann. An extract was published in *Flash Art*, 128, Milan, May / June 1986, pp. 36–9, from which the present text is taken.

ANSELM KIEFER: For me there have always been people who are ignorant, others who are less ignorant, and others still who are very intelligent.

JOSEPH BEUYS: This is a question of individuality, a matter of personal fate. There will always be various levels of ability. But in the future all abilities will be malleable, the level will be elevated.

JANNIS KOUNELLIS: Yes, but a monument like the Cologne Cathedral indicates a centralization, encompasses a culture, and points the way for future development. Without signs like this we would run the risk of becoming nomads.

BEUYS: The Cologne Cathedral is a bad sculpture. It would make a good train station. Chartres is better. But what Kounellis says about the cathedral is a nice image. The old cathedrals were built in a world that was still round, but that in the meantime has been constricted by materialism. There was an internal necessity to narrow it like that, since in that way human consciousness became sharpened, especially in its analytic functions. Now we have to carry out a synthesis with all our powers, and build a new cathedral.

KIEFER: It makes me feel terribly uncomfortable if what Beuys means is that humanity would change if we change a concept. There have always been different kinds of people.

BEUYS: That goes without saying. It's a matter of raising the level in every domain. We agree that throughout history it's enough to see how people furnished their apartments. They've never lived so degradingly. [. . .] At the same time, the way one lives is an important and elementary expression of one's artistic sense. The esthetic sense is disturbed nowadays like never before in history. So let's build the cathedral!

KOUNELLIS: Right. This excess of nomadism and of rejecting culture creates an absurd situation.

KIEFER: The declining level is obvious. But last time we asked ourselves why the innocent, primitive native, as soon as he gets a plastic bowl, throws away his own.

BEUYS: They've become susceptible because nowadays the old tribal cultures are no longer valid. [. . .] It would be better if these people could develop themselves. But, of course, they are subjugated to capitalism and usually die out because of it. You can see this quite well with the Basque problem. The Basques are really the abandoned vestige of some nomadic people. There are thousands of theories that they came from Asia and, perhaps as punishment by some tribal chief, were left behind. Now they are there, trying time and again to preserve their old tribal culture. But they haven't developed their own literature, everything proceeds according to oral tradition. Now they are, with good reason, making very specific demands.

JEAN-CHRISTOPHE AMMANN: *Why do you mention the example of the Basques?*

BEUYS: Because the context of the European Economic Community, within which the Basques find themselves, corresponds to the machinations in the system of the Western monetary economy. That is, the Spanish government doesn't give the Basques any autonomy, and therefore a problem arises – like in Northern Ireland. In Spain I proposed that the Basques should be given full autonomy. The Spanish claim that the Basques would then degenerate because they have no indigenous culture. But then I said that they did indeed have their own culture, just by virtue of the fact that they wanted self-determination. It's even possible that these people, just

like us at this table, work out a concept for their own economy which could be paradigmatic for many people. If the Basques were given self-determination, it would certainly be much different. That would provide a good opportunity to develop something paradigmatic, which we could view like a work of art. We could then possibly sit down together with them and develop something paradigmatic for the whole world.

ENZO CUCCHI: The Basques' method is interesting because they use terrorism, but I don't know where terrorism leads us to.

BEUYS: Terrorism doesn't lead to a solution of the question. It leads us to a totally boring, conservative social system.

CUCCHI: That's not what I meant. I just wonder which feelings are inherent in terrorism nowadays, what form it takes. Both the Basques and the Northern Irish use this code. [. . .]

KOUNELLIS: Within Europe there are many peoples who want to be independent, for example, the Sicilians, the Sardinians, the Corsicans, and others.

BEUYS: That's very positive.

KOUNELLIS: Yes, but it's also very positive to speak about the Cologne Cathedral. Not only those who want to separate are positive.

BEUYS: The Chartres Cathedral is positive when one sees that such attempts at independence lead to another system, so that the Corsicans, the Sardinians, the Basques, the Irish, and the Scottish can build a cathedral at all. I'm convinced that the Basques are doing it right. I'm not so sure about the Scottish. You really have to begin with a small group and introduce a different principle into an easily receptive community. The idea of the cathedral means a different understanding of culture, justice, spirit, economy and so forth. If the Spanish would give the Basques autonomy, I'd go there immediately and the Basques would say: 'We need nothing more desperately than such talks, since everything has to be erected from new foundations. We don't want to give everything a new basis, the basis of art.' They want the body of society to be like a work of art. But terrorism hinders these attempts, since it provides the larger countries and powers with new arguments to keep implementing police force, to become a military state.

Capitalism is happy to have terrorism. It's artificially bred by capitalism. [. . .] Regarding the broadened concept of art, I'm searching for the dumbest person. And when I've found the dumbest person on the lowest possible level, then I've surely found the most intelligent one, the one potentially most endowed. And that person is the bearer of creativity. The so-called intelligence that people jam into their heads like a knife only produces a superficial view, and this intelligence must be destroyed. Dullness has to take a hand, because all the other powers exist in it like a wild volition, a fantastic sensitivity and perhaps an entirely different perception. Maybe they already exist in heaven.

KIEFER: That's your personal idea, Beuys.

BEUYS: No. It goes beyond me as a person. My personal self is absolutely uninteresting. I'm just trying to describe power relations in the world, which are like they are today, and tomorrow must be different. And I'm trying to make that clear with examples. [. . .] We're not here talking together to improve our relationship, which is good anyway. We're here to build the cathedral.

KOUNELLIS: The construction of the cathedral is the construction of a visible language.

BEUYS: That's an important detail. But today everything is possible, and so the cathedral isn't materialized. We've agreed to build a cathedral and to arrive at a really human culture. But we haven't agreed upon how the cathedral should look, or from what material it'll be made.

KOUNELLIS: Beuys has suffered severely, more than all of us. That's a feeling I have, because he's suspicious about openly discussing fundamental things.

BEUYS: Openness is, of course, a somewhat obsolete concept. Many people think they are quite progressive and 'with it' if they speak about so-called openness. But openness has to be precisely defined. Otherwise, openness means nothing more than that everything is possible. However, I claim nearly nothing is possible. In order to have access to every single point of view, you really need an astute sense of perception. But if one wants to arrive at a consensus, openness must take on a totally determined form, a condensation, and that's the opposite image of openness. Openness is also a term used in propaganda. We've been seduced by this word. People spoke of openness, of a pluralistic society, in other words, and claimed that in the end everything is possible: and they just didn't want any particular ways and principles, as these require a precisely worked-out form.

KOUNELLIS: But we're individuals who don't let ourselves be influenced.

BEUYS: Openness should be human, related to the individual anthropologically; open for what the other means.

KOUNELLIS: We're talking about an openness in the interior of Europe, where cultures are very close despite differences.

BEUYS: Present-day culture is, however, really not determined by the Gothic dome, but rather by a leading economic system that has shoved art out to the periphery or into nonexistence. And when the whole system goes bankrupt because the economic culture is on a wrong footing, then art will once again have a good chance to construct an authentic culture in every way, rather than a stifled formation. I simply refuse to accept that this microphone on the table in front of us is not supposed to belong to culture.

KOUNELLIS: As long as the microphone is on the table like that, it can't belong to culture. But when Beuys puts it on felt, then it becomes a part of culture, because Beuys has the power to transform the microphone into culture.

BEUYS: But the power only benefits me, it leads back to my individual actions and not to the cathedral.

KOUNELLIS: No, it benefits us all and that also has something to do with the cathedral. [...]

BEUYS: [...] Regarding art as the only way to build the cathedral, I really do need the spoken language.

KIEFER: Before an artist has died, one can't completely tell what he meant with his work in its entire spectrum.

BEUYS: But I can certainly say what I mean.

KIEFER: What you have said, however, is only a small part of the real range.

BEUYS: It's just not true that the artist says something only after his death. But perhaps it's true that a dead artist is better than a living one.

8 Gerhard Richter (b. 1932) from 'Interview with Benjamin Buchloh'

Richter had first attracted attention in the mid-1960s with blurred paintings based on photographs. These were followed by pictures of cities and landscapes which combined painterliness with the appearance of artificiality. Richter also made paintings in monochrome grey and others based on colour charts. During the 1980s he produced a number of paintings in a bold, apparently gestural style which were actually the results of careful contrivance. His work has consistently raised complex questions about the nature of expression in art. Buchloh is a critic and art historian of German extraction working in America, where he has been associated with the social-historical revision of modern art history. This discussion takes place self-consciously under the conditions theorized by Bell, Habermas, Lyotard and Kristeva. Originally conducted in 1986, and printed as 'Interview with Gerhard Richter' by Benjamin H. D. Buchloh, with translation by Stephen Duffy, in Roald Nasgaard and I. Michael Danoff, *Gerhard Richter: Paintings*, catalogue of an exhibition at the Museum of Contemporary Art, Chicago, and the Art Gallery of Toronto, Ontario, published London and New York, 1988, pp. 19–29, from which the present extracts are taken. (See also VIA21 and VIIIC9.)

On Iconography and Photography

B: Your painting from photos in the early 1960s does have an antiartistic quality; it denies the autographical, the creative, the original. So to a certain degree you do follow Duchamp and Warhol. Moreover, your painting negates the importance of content in that it presents motifs chosen at random.

R: The motifs were never random; I had to make much too much of an effort for that, just to be able to find photos I could use.... Perhaps it was good if it seemed as if everything had been accidental and random.

B: What were the criteria for the selection of photos in your iconography?

R: They very definitely were concerned with content. Perhaps I denied that earlier, when I maintained that it had nothing to do with content, that for me it was only a matter of painting a photo and demonstrating indifference.

B: And now some critics are trying to ascribe to you this significance of iconographic content ... *Airplane* stands for death; *Pyramids* and *Accident* stand for death. It seems to me somewhat forced to construct a continuity of the death motif in your painting.

R: And you think that there I was seeking motifs that were supposed to be just a little bit shocking, while in reality they were completely indifferent for me? [...] Perhaps it's just a little exaggerated to speak of a death thematic there. But I do think that the pictures have something to do with death and with pain.

B: But this content is not the determining, the motivating power behind the selection.

R: I'm not exactly sure about that; it's hard for me to reconstruct what my motivation was then. I only know that there are reasons related to content which explain why I selected a particular photo and why I particularly wanted to represent this or that event.

B: In spite of the fact that content can no longer be communicated by iconographic portrayal? There again you've got a contradiction. Even though you knew that a

death thematic, for example, could not be communicated by the mere portrayal, you nevertheless tried it, knowing perfectly well that it was actually impossible.

R: Well, in the first place it's not impossible at all. A picture of a dead dog shows a dead dog. It only becomes difficult when you want to communicate something beyond that, when the content is too complicated to be depicted with a simple portrayal. But that doesn't mean that representation can't accomplish anything.

B: Were you aware of the criteria that you used in the selection? How did you go about selecting photos?

R: I looked for photos that showed my actuality, that related to me. And I selected black-and-white photos because I noticed that they depicted that more forcefully than color photos, more directly, with less artistry, and therefore more believably. That's also the reason why I preferred those amateur family photos, those banal objects and snapshots.

B: And the pictures of the Alps and the City Pictures?

R: They came about when I no longer wanted to do the figurative photo pictures and wanted something different; when I no longer wanted an obvious statement or limited, discernible narrative. So these dead cities and Alps attracted me, rubble heaps in both cases, mute stuff. It was an attempt to communicate a more universal kind of content.

B: But if it had really been this kind of content that mattered to you, how do you explain the fact that at the same time you were introducing nonfigurative pictures in your work? Color Charts, for example, or other abstract pictures which arose in parallel with the figurative ones. This simultaneity confused most of your critics. They saw you as a painter who knew all the tricks and the techniques, who was a master of all the iconographic conventions that he was simultaneously depreciating. It's that which makes your work particularly attractive to some observers just now. Your work looks as though it were presenting the entire universe of twentieth-century painting in a giant, cynical retrospective.

R: That is certainly a misunderstanding. I see there neither tricks, nor cynicism, nor craftiness. On the contrary, it strikes me as almost amateurish to see how directly I went at everything, to see how easy it is to discern all that I was thinking and trying to do there. So I also don't know exactly what you mean now by the contradiction between figurative and abstract painting.

B: Let me take as an example Table, one of your first pictures. Table contains both elements: a completely abstract, gestural, self-reflexive quality, on the one hand, and, on the other, the representational function. And that is really one of the great dilemmas in the twentieth century, this seeming conflict, or antagonism, between painting's representational function and its self-reflexion. These two positions are brought very close together indeed in your work. But aren't they being brought together in order to show the inadequacy and bankruptcy of both?

R: Bankruptcy, no; inadequacy, always.

B: Inadequate by what standard? The expressive function?

R: By the standard of what we demand from painting.

B: Can this demand be formulated?

R: Painting should be accomplishing more.

B: So you would dispute the charge that has so often been made against you, that you have cynically acquiesced to the ineffectuality of painting?

R: Yes. Because I know for a fact that painting is not ineffectual. I would only like it to accomplish more.

B: In other words the simultaneity of the opposing strategies of representational function and self-reflexion has nothing to do with a reciprocal transcendence of them? It's rather an attempt to realize this demand upon painting with different means?

R: Yes, roughly.

B: So you saw yourself at the beginning of the 1960s not as the heir to a historically divided and fragmented situation, in which there was no pictorial strategy that still had real validity...?

R: And I see myself as the heir to an enormous, great, rich culture of painting, and of art in general, which we have lost, but which nevertheless obligates us. In such a situation it's difficult not to want to restore that culture, or, what would be just as bad, simply to give up, to degenerate.

B: That naturally brings you to the edge of a political discussion, which you perhaps wouldn't care for. But how would you account for this loss, if not politically, socially, or historically? The way you speak now, it sounds almost like Theodor Adorno's famous statement, 'After Auschwitz lyrical poetry is no longer possible.' Is that a position that would apply to you?

R: No. Lyrical poetry does exist, even after Auschwitz.

B: But when you say that one can no longer paint this way....

R: ...then I meant first of all a particular quality which we have lost.

B: Because of what?

R: Well, photography is surely an external factor that has contributed to the fact that we are now unable to paint in a particular manner and that we can no longer produce a certain artistic quality.

B: It is also possible to express that in a simple historical way and argue that pictures have lost their descriptive and representational function, among other reasons because photography does it so perfectly. Hence this task is simply no longer given. The high artistic quality of old pictures, which you mention, is based historically and materially in part upon this descriptive and representational function.

R: But this quality cannot be explained by means of the representational function alone. This perfection of execution, of composition, or whatever, we would have lost it even without photography. Literature and music are bogged down in the same misery. People love Mozart and Glenn Gould because that's exactly what new composers are no longer able to offer. But music hasn't been replaced by anything comparable to photography.

B: Well, if this loss has not been caused by the development of the new technology for reproduction; or by the experience of hitherto unsuspected historical catastrophes, as is maintained in Adorno's remark about Auschwitz; or by the destruction of bourgeois culture; or by any political qualities – you've rejected all of these, provisionally at least, as explanations...?

R: No, they have all contributed, naturally. But I'm most inclined to see the fundamental issue as the 'loss of the center.'

B: In Sedlmayr's sense? Surely you're not serious? [Hans Sedlmayr, *Art in Crisis: The Lost Centre*, trans. Brian Battershaw, London, 1957.]

R: I am. Because with this term he said something really true. But he drew false conclusions from it. He wanted to restore the lost center. . . . I don't want to restore it at all.

B: No, but you must still be able to describe it. It's still a historical process.

R: All right. But it's a matter of very definite, new, real facts that have changed our consciousness and our society, have overturned religion, and have thereby also changed the function of the State. There are only a few necessary conventions that still exist, regulate things, keep things practical. Otherwise everything is gone.

B: Is painting one of these conventions?

R: No. The criteria for painting are conventions, and they are harmful because they are determined ideologically. They hinder enlightenment. That's why I think so highly of psychoanalysis, because it removes prejudices and makes us mature, independent, so that we can act more truly, more humanly, without God, without ideology.

B: It's also what you would demand for painting?

R: Yes.

B: On the one hand, then, you see this process as irreversible and least of all reconstructible by cultural means. . . .

R: . . . that would only delay it. . . .

B: . . . and political means seem to you at least problematic or dubious, or not accessible.

R: Nothing can be expected from politics because politics operates more with belief than with enlightenment.

B: Then you see the role of art as more important than merely liquidating a false bourgeois cultural inheritance? Although it is true to say that that is one of its functions, is it not?

R: To liquidate? Yes, that too.

B: But at the same time it has another function, and that's what leads to the contradiction. What is the other function, if it's not a political one?

R: Above all, it doesn't just destroy, it produces something, another picture.

B: Of autonomy?

R: Yes.

B: How is the painted picture supposed to provide an example of this autonomy today?

R: A picture is *one* important possibility, among others, which one can use. In the worst possible case, it's only an offer to those who are interested in it.

B: But with respect to the demand to liquidate the bourgeois heritage and at the same time to construct a new autonomy, isn't the limitation to the praxis of painting, which you have imposed on yourself, a handicap? Shouldn't one assume that there are other, more radical means that would further hasten the liquidation process and contribute more directly to the emancipation process?

R: No, in this respect I'm extremely conservative. That seems to me like saying that language is no longer useful because it's a bourgeois inheritance, or that now we should print texts on cups or chair legs instead of in books. I'm still bourgeois enough to eat with a knife and fork, and to paint with oil on canvas.

B: So all attempts to use aesthetic means to accelerate one side of this dialectic seem to be unacceptable to you. Would you then also criticize Duchamp retrospectively, since he gave up painting for exactly this reason?

R: I'm not sure that those were the reasons. In any case, you can never derive from them the obligation to give up painting. It's lamentable to understand Duchamp in this way and instead to engage in politics and criticism.

B: Lamentable in what way? With respect to the liquidation of bourgeois culture or to its emancipatory potential?

R: Because it doesn't accomplish anything. It's neither artistic activity nor political activity, it's dilettantism.

B: Let's try to make that concrete. Would you see it as a condition of your current painting to find your way further along in the dilemma which you have seen yourself facing from the beginning – that is, on the one hand, to play out the real conditions of mass culture, which you see represented for example in photos, and, on the other, to oppose this to the esoteric and elitist conditions of the high culture which you are a part of as an artist? In this sense you're working out of this dialectic and exposing yourself constantly to this contradiction; and there is practically no solution which you can accept. Is that still a condition? Or is that a condition that was valid only for the 1960s?

R: Neither then nor now can I see these conditions in this way.

B: But the Cézanne quotation speaks directly to this. When you say, 'For me some photos are better than the best Cézanne,' that seems to me to express precisely this contradiction.

R: Yes, but that doesn't mean that I could immediately change something through painting. And it certainly doesn't mean that I could do so without painting.

B: Why have you so expressly denied the real political demand in your own art?

R: Because politics just isn't for me. Because art has an entirely different function. Because I can only paint. Call it conservative if you want.

B: But perhaps precisely in the limitation to the medium of painting there is not only a conservative position, but also a critical dimension, one that calls into question the claim to political immediacy in the work of someone like Beuys, for example.

R: Naturally I would want to see in my limitation to painting a critical stance toward much that displeases me, and which concerns not only painting.

B: So you don't despair fundamentally of the validity of the demand that art should realize a political critique?

R: Apparently. But the decisive thing is that I have to begin from my possibilities, from the conditions that constitute my basis, my potential.

B: Which you would claim are unchangeable?

R: Largely unchangeable.

On the Monochrome Gray Paintings and Abstract Paintings

[...]

B: The claim for pictorial meaning still exists. Then even your Abstract Paintings should convey a content?

R: Yes.

B: They're not the negation of content, not simply the facticity of painting, not an ironic paraphrase of contemporary expressionism?

R: No.

B: Not a perversion of gestural abstraction? Not ironic?

R: Never! What sorts of things are you asking? How is it that my pictures are supposed to be without content? What content is it that the Abstract Expressionists are supposed to have in contrast to me? [...] the only difference is that different means are used to produce a different effect.

B: Not so. Because ... ordered relationships just don't exist anymore, neither in the color system nor in the compositional system.

R: I can't see it that way; I can't see that there's no longer any composition or chromatic relationships. When I put one color form next to another, then it automatically relates to the other.

B: Yes, but these are different forms structured in different ways, and according to different laws of relationship, up to the point of recognition that even absolute negation is a composition. But everything in your Abstract Paintings aims to transcending traditional, relational orders, because an infinite variety of structurally heterogeneous elements is visible as a possibility.

R: Yes, but I still have somehow to bring everything into the right relation. A relation that becomes more and more difficult the further a picture has progressed. At the beginning everything is still easy and indefinite, but gradually relations emerge that register as appropriate ones: that's the opposite of randomness.

B: Certainly. But that amounts to a different kind of perception, and thus to a different form, possibly precisely the opposite of traditional compositional and chromatic relations.

R: Perhaps. In any case, my method or my expectation which, so to speak, drives me to painting, is opposition.

B: What is it that you expect?

R: Just that something will emerge that is unknown to me, which I could not plan, which is better, cleverer, than I am, something which is also more universal. In fact, I've already tried that in a more direct way with the *1000* or *4000 Colors*, in the expectation that a picture would emerge there.

B: What kind of picture?

R: One that represents our situation more accurately, more truthfully; that has something anticipatory; something also that can be understood as a proposal, yet more than that; not didactic, not logical, but very free, and effortless in its appearance, despite all the complexity.

B: Your pictures do have all these qualities in the best cases. They seem effortless, yet painted with verve, with indifference and virtuosity at the same time. But to come back again to the question of content, if a picture is made with an obvious emphasis on the way it was produced, how is it possible for you to say that a smeared surface or one treated mechanically with the palette knife doesn't represent pure process or pure materiality? If these qualities weren't important for you, then you wouldn't apply the color that way. To do so is to take away from the picture's color, composition, and structure every possibility of producing transcendental meaning, beyond the pure materiality of the picture as a picture. I believe that you have introduced a kind of painting that is process-referential as one of its many possibil-

ities, but . . . you no longer insist on it as the only aspect. Rather, it's one character-istic among others.

R: Then why do I trouble to make it so complicated?

B: Perhaps because it's important for you to recite all the aspects, like a catalogue; because what really interests you is a rhetoric of painting, and a simultaneous analysis of it.

R: If it were only a demonstration of material, how the jagged yellow surface arises there against the blue-green background, then how is it possible to generate a narrative or to evoke moods?

B: Mood? You think that your painting really evokes emotional experience?

R: Yes, and aesthetic pleasure as well.

B: That's a different matter. I see aesthetic pleasure too. But mood, not at all.

R: What is mood then?

B: Mood has an explicit emotional, spiritual, psychological quality

R: That's just what's there.

B: Only in the weakest parts, fortunately.

R: You don't really believe that just the dumb showing of brush strokes, of the rhetoric of painting and its elements, could accomplish something, say something, express some kind of yearning?

B: Yearning for what?

R: For lost qualities, for a better world; for the opposite of misery and hopeless-ness.

B: The yearning to be able to adhere to the notion of culture as a contemplative spectacle and maintain credibility at the same time?

R: I could also say salvation. Or hope. The hope that I can still accomplish something with painting.

B: But that's again so general: accomplish in what respect? Cognitively, emotionally, psychologically, politically?

R: All at once – how do I know?

B: If you're going to maintain that, that art can have this function – other artists would deny it entirely – then it's all the more paradoxical that you insist at the same time that you can do so only through the means of painting. Put differently: do you think that this discrepancy becomes concrete in your pictures?

R: Yes, possibly.

B: Do you think that in the end these pictures are conservative, conservative in the sense in which Marcel Broodthaers' art appears to be conservative?

R: In terms of the means, oil on canvas, even more conservative. I always thought highly of Broodthaers because I knew him personally. But the pictures themselves I never really understood. In terms of my intentions, I'm certainly not conservative. And I know that painting per se does not have to be conservative. That's why I can go on in the same way, only trying to do better, if possible.

B: The question is how far one can push this contradiction. How long can one keep this dialectic alive before it turns into an empty pose? How long can one go on asserting this contradiction, without attempting to get beyond it?

R: I have no idea what contradiction you're talking about.

B: It's the contradiction of knowing full well that with the methods you're using you can't achieve what you want, but being unwilling to change your methods.

R: But that's not a contradiction. That's just the normal state of things. Call it our normal misery if you want. It certainly couldn't be changed by choosing different means or methods.

B: Because all methods are equivalent?

R: No, because they're all similarly inadequate. But primarily I have to ask myself, what are my means and what can I accomplish with them.

B: But under certain historical conditions, painting had different functions, and it did have the possibility of affecting historical reality.

R: When I think about contemporary political painting, I prefer Barnett Newman. At least he did some magnificent paintings.

B: So it's said. Magnificent in what respect?

R: I can't describe it now, what moved me there. I believe that his paintings are among the most important.

B: Perhaps that too is a mythology which would have to be investigated anew. Precisely because it's so hard to describe, and because *belief* is inadequate in the confrontation with contemporary paintings.

R: Belief is inescapable; it's part of us.

B: Do your pictures demand belief or analysis? What would be more important to you?

R: I would accept both. You they challenge to analysis, others to belief.

B: So it would be perfectly all right if someone fell on his knees in front of one of your pictures and broke out in tears, as Rothko demanded for his paintings?

R: Unfortunately, it's not possible for painting to have such an effect. In that respect music is better off.

On the Rhetoric of Painting

B: What about the objectification of the painting process itself? When you no longer paint the large pictures with a small brush, but rather with a house painter's brush or another instrument like a rake, doesn't that introduce anonymity and objectification into the painting process, just as permutation and 'chance' objectify the color relations and the compositional order?

R: Not at all.

B: Doesn't the change in the technical means of pictorial production imply a critical calling into question of the artistic process?

R: It changes the pictures only in one respect: they get louder; they can't be overlooked so easily.

B: I was talking about the instruments, that is, that the instruments also influence the perception of the picture. Thus the fact that a monochrome picture was painted with paint rollers has a decisive influence upon the perception of the picture. Similarly here, in the large pictures, where the brush strokes suddenly have the character of wide strokes, they take on a different dimension. I would describe it as a quasi-mechanical or anonymous quality.

R: Not really in this case. A brush is still a brush. It doesn't matter whether it's five millimeters wide or fifty centimeters wide.

B: So in the case of the two *Yellow Brush Strokes*, there's no new dimension because of their being disproportionately large?

R: That's something else again. These two brush strokes only seem as if they were drawn with a large brush. In reality they were painted using many small brushes.

B: But here in the case of the two large pictures, a new dimension emerges not only because of the size, but also because the techniques and the act of painting have been brought to the limits of the possible...

R: To the physical limits?

B: Yes, but also to the limits for perceiving the act as an act of painting. Practically speaking, a different dimension opens up beyond that, one that can no longer be seen as subjective.

R: They're just as subjective as the small ones; they're just more spectacular.

B: There's no question about their being spectacular, even in a smaller format.... the scheme of your Abstract Paintings has a declamatory quality about it... they always have a spectacular or a certain rhetorical quality. You show the various possibilities as mere possibilities, but they simply exist alongside one another or opposed to one another, without having another function.

R: As if one were giving a meaningless speech?

B: Yes...

R: ...a speech with pathos, which takes everyone in because it sounds good, which has all the formalities of a speech, but which communicates nothing?

B: That description doesn't sound good. But one could also say that someone is giving a pathetic speech with the intention of presenting analytically the possibilities of speech, of pathos, and of rhetoric. In other words, you are making the spectacle of painting visible in its rhetoric, without practicing it.

R: What sense would that have? That would be the last thing I'd want.

B: Then you don't see the Abstract Paintings as a kind of reflection on the history of painting, as I've tried to suggest? And yet that's precisely how they differ from all the other kinds of abstract and gestural painting which we know. They don't just have a rhetorical quality. They also seem to be a kind of meditation on what once was possible, but which, at precisely that moment, is no longer useful. I can imagine that many observers think you're still seriously practicing things that once were possible.

R: That would be more accurate for the Landscapes and for some of the Photo Paintings. At times I've referred to them as cuckoos' eggs, because people took them for something which they weren't at all. That was part of the reason for their popular quality, which I fundamentally affirm. But that's changed entirely; now it's a genuine appreciation.

B: That would also mean that the pictures are parodistic. But that's what's so astonishing, because these pictures have no parodistic quality.

R: They have a normal seriousness. I can't put a name on it. I've always seen it as something musical. There's a lot in the construction, in the structure, that reminds me of music. It seems so self-evident to me, but I couldn't possibly explain it.

B: That's one of the oldest clichés around. People always have resorted to music in order to save the foundations of abstract painting.

R: Possibly. But I also mentioned music in order to raise another objection.

B: To the idea of a catalogue of the rhetorical possibilities of painting?

R: I see no sense in exhibiting painting's old, lost possibilities. I want to say something. I'm interested in new possibilities.

B: But reflection on rhetoric as a highly determined system of expression is indeed an extremely important method, especially in present-day literary criticism. People have started to understand that it's really much more important to attend to the linguistic conventions and the rhetorical laws that literary statements obey; it used to be only the content of the statement that people were concerned with.

R: Is it my private error then, if I always want to do something different from what I've just produced?

B: That may not be an error so much as a private dilemma, a gap between demand and capacity. But that's an important element in your work. If you were nothing but a rhetorician, in the sense of an analytic investigation of the rhetoric of painting, your work wouldn't be so interesting. That's something others can do. But if you refuse to see it at all as a rhetoric of painting, how would you yourself describe the details of the pictorial elements? When one sees, for example, how spatial, linear, and chromatic elements are placed next to one another in an artificial enumeration, and with this declamatory quality; or how certain techniques of applying color are presented as in a painting manual: some are layered with the knife, some are thickly brushed, some are finely painted, some are softened, some are direct traces, some are nebulous areas – there's something systematic, carefully considered and prepared, as you yourself just said, in the enumeration, in the contrasts and the combinations.

R: It works emotionally. It occasions moods, both as a whole and in the details.

B: That's just what is so difficult to decide, whether they do generate emotions at all, and, if so, which. As I said, the pictures are remarkable in that they never occasion associations.

R: They do occasion associations. To a certain extent they recall natural experiences, even rainfall, if you will. Pictures can't help functioning that way. That's where they derive their effect, from the fact that they never cease to remind us of nature, from the fact that they are almost naturalistic. They are in a way.

B: But then 'naturalistic' would have to be defined. Not naturalistic in relation to nature?

R: Only to nature. We just don't have anything else.

B: The fact that nature seems to you to be the only analogy or model, the only visible ordered, nonhierarchical structure, the fact that you can't imagine a utopian social structure that would correspond to this natural ideal, that's the Romantic element in your thinking.

R: That's not Romantic. That's a matter of division of labor. Some people put forward social models, others pictures; each group does the best it can.

B: That's not a direct answer to my question. Why is nature for you the only utopian dimension of experience free from domination? Why is it inconceivable for you to consider or to discuss in social and political terms the idea of an existence free from domination? Why is your only recourse that to the metaphor of nature, like a Romantic?

R: No, like a painter. The reason I don't argue in 'socio-political terms' is that I want to produce a picture and not an ideology. It's always its factuality, and not its ideology, that makes a picture good.

B: That's precisely what I see in the fact that color is treated like a material process. Color becomes an object that is presented and altered by these instruments. It remains the same in all these diverse structures. It shows how it was produced,

what instruments were used. There's practically no external reference that would motivate the appearance or the structure of the colors. These phenomena are all self-referential. Does this interpretation still seem too narrow to you?

R: Yes. Because the whole process does not exist for its own sake; it's only justified when it uses all these beautiful methods and strategies to produce something.

B: What could it produce besides belief in images?

R: A painting, and thus a model. And when I think now of your interpretation of Mondrian, where his pictures can also be understood as models of society, then I can also regard my abstractions as parables, as images of a possible form of social relations. Seen in this way, what I'm attempting in each picture is nothing other than this: to bring together, in a living and viable way, the most different and the most contradictory elements in the greatest possible freedom. Not paradise.

9 Gerhard Richter (b. 1932) Notes

These are entries from the artist's private journal, translated and published for the first time on the occasion of an exhibition of his work at the Tate Gallery, London, 30 October 1991–12 January 1992, and reproduced in the catalogue, *Gerhard Richter*, London: Tate Gallery, 1991, pp. 123–4, from which the present text is taken. (See also VIA21 and VIIIC8.)

12.2.90

Accept that I can plan nothing.

Any consideration that I make about the 'construction' of a picture is false and if the execution is successful then it is only because I partially destroy it or because it works anyway, because it is not disturbing and looks as though it is not planned.

Accepting this is often intolerable and also impossible, because as a thinking, planning human being it humiliates me to find that I am powerless to that extent, making me doubt my competence and any constructive ability. The only consolation is that I can tell myself that despite all this I *made* the pictures even when they take the law into their own hands, do what they like with me although I don't want them to, and simply come into being somehow. Because anyway I am the one who has to decide what they should ultimately look like (the making of pictures consists of a large number of yes and no decisions and a yes decision at the end). Seen like this the whole thing seems quite natural to me though, or better nature-like, living, in comparison with the social sphere as well.

30.5.90

The invention of the readymade seems to me to be the invention of reality, in other words the radical discovery that reality in contrast with the view of the world image is the only important thing. Since then painting no longer represents reality but is itself reality (produced by itself). And sometime or other it will again be a question of denying the value of this reality in order to produce pictures of a better world (as before).

4.9.90

The 'dictatorship of the proletariat' has long since become reality, especially here in the Western democracies, and here in the most tolerable way. Mass society is the better term, as the masses don't have a class enemy any more and dictatorship transformed itself into material constraints. By its presence, and by being as they are, the masses create a quasi-natural structure of conditions and happenings that runs with very little planning, often chaotically and potentially catastrophically. Hierarchical systems, including socialism, are being superseded by a self-organizing 'liveliness' (without a plan, without an ideology, without all the world designs and world pictures that never work).

24.10.90

It does not seem useful that we become fewer and fewer and come to an end when we have learned so much. Over and over again, later generations have to strive for decades to regain a standard of experience long since reached before.

The much despised 'artistic scene of today' is quite harmless and friendly when we do not compare it with false claims: it has nothing to do with traditional values that we uphold (or which elevate us), it has virtually nothing at all to do with art. Thus the 'art scene' is not despicable, cynical or without spirit but as a temporarily blossoming, busily proliferating scene it is only a variation on a perpetual social game that fulfils needs for communication, in the same way as sport, stamp collecting or breeding cats. Art happens despite this, rarely and always unexpectedly, never because we make it happen.

10 Jeff Wall (b. 1946) from a discussion

Born in Vancouver, Wall practised as an artist before studying History of Art at the Courtauld Institute in London. His subsequent work has been made using a full range of modern photographic techniques and has combined reference to de facto genres of photography with allusion to fine art traditions and expectations. A representative image by Wall from the 1980s or 1990s plays on the meeting of different pictorial traditions and cultures: on the one hand it evokes the expectations of narrative and sequence associated with the film still and the snapshot, on the other it exhibits the crafted formality associated with painting conceived as a high art. In the following passage Wall invokes Charles Baudelaire's programme for a critical 'painting of modern life' (see *Art in Theory 1815–1900*, IIID8), as it might be conceived in the aftermath of Conceptual Art. This material has been taken from a discussion between Wall and the art historians Serge Guilbaut, T. J. Clark and Anne Wagner, originally published in *Parachute*, Montreal, no. 59, September 1990, pp. 4–10.

[. . .] The most orthodox way of thinking about culture now is to talk always about discontinuities, breaks, ruptures, leaps. As Walter Benjamin said, the only way to think legitimately about tradition is in terms of discontinuities. I accept that, but I think that it is possible to forget the meaning of something in ritually referring to it all the time. So, it's necessary, too, to develop language-forms which express the continuous aspects of

the development of vanguardist culture, or post-modern culture, or whatever you want to call it. Discontinuity does not exist in isolation from what seems to be its polar opposite, so I think it is just as valid to talk about reinventions and rediscoveries, not to mention preservations. Some of the problems set in motion in culture not only in the 1920s, but in the 1820s and even in the 1750s, are still being played out, are still unresolved, we are still engaged in them. I guess that's why, at a certain point, I felt that a return to the idea of *la peinture de la vie moderne* was legitimate. Between the moment of Baudelaire's positioning this as a programme and now, there is a continuity which is that of capitalism itself. There have been so many theories about how capitalism has changed; it has changed but it still continues, changed, renewed, decayed, and opposed in new ways. The opposition to and critique of capitalism – the whole of what could be called 'anti-capitalist culture' – has also emerged and become a foundation of the concept of Modernism and modern art, too. I feel I'm working within and with a dialectic of capitalism and anti-capitalism, both of which have continuous histories within, and as, modernity.

* * *

[...] To make it simple, there is The Good and there is The Bad. There are conditions under which one is obliged to show the almost terminal imprisonment of people in repressed, exploitative relationships. That is a large part of the programme of what we used to call 'realism', and I can adhere to that. But I remember having an interesting discussion a few years ago with a friend, Susan Harrison, and she said that it seemed that artists (I *think* she meant male artists) think they're being more 'critical' and 'objective' if they show misery. But she said you could be just as critical and objective, if that's what you want to be, about joy and friendship. This affected me a lot in my thinking about the development of a version of the 'painting of modern life'. The social order itself, when you look at it studiously, never ceases to provide support for a programme or images of subjection and unfreedom, and we need those images, but not exclusively. So I have worked on pictures about resistance, survival, communication and of dialogue, scenes of empathy, and empathetic representations. I actually think that there is no polar separate distinction between those two streams in what I'm doing; the distinction is more fluid.

* * *

...I don't really see the audience as unified or homogeneous. It is essentially splintered, inwardly divided. So, it's possible (although I don't focus too much on this in practice) that my pictures are worked out with certain splinters of The Audience in mind, or at least in the front of my mind. But, in general, my primary objective is to create a sort of identity crisis with the viewer in some form, maybe even a subliminal one. I do go through a sort of continuous process of 'imagining the viewer'. I think all artists, in the process of making a work, hypothesize an audience, invent an imaginary audience which is exactly the one which will appreciate that work profoundly. When Stendhal dedicated *The Red and the Black* to 'The Happy Few', he was doing that. This is a utopia of artists, the hypothetical world and its imaginary population.

Another way of looking at it is that one sets in motion a sequence of identifications, recognitions, mis-recognitions, de-identifications and re-identifications, in which the audience is continually decomposed, fractured, reformed and re-identified with itself. Anybody who has had a long relationship with a work of art knows how that happens over time. [...]

I think that this process of misrecognition, of a crisis of identification in relation to representations happens in all experience, even in personal or interpersonal experience. In that sense it is objective, a condition of experience as well as a content of it.

The fact that I accept the fact that viewers of works cannot be marshalled into seeing the work in any specified way doesn't mean that I accept the idea that no signification necessarily means anything specific. There's a difference between the two attitudes. The process of experience of a work, while it must be open to the associations brought to it by different people, is still structured and regulated and contains determinations. I think it is controlled, above all, by genre, by the generic character of the picture-types and the types of subject. Bakhtin said that genre was the collective, accumulated meaning of things that has come through time and the mutations of social orders. It is the foundation of the guarantee of objectivity, the basis of the 'truth content' of representations...

...I think that this process, this phenomenology if you like, which forms the interior of the experience of any representation, in no way supports the idea of a unified, monadic subject....The idea that previous concepts of the self were rock-solid, impacted monadological ones was one of those exaggerations which the 1960s and 1970s discourse is so famous for. The interrogation of the notion of the subject in which we're still involved has changed the language-forms of culture irreversibly, and brought about a kind of Copernican revolution in which the practice of representation has been revolutionized. Representational art, like mine, which rests upon a notion of the unbroken continuity of certain aspects of modern culture, must be looked at and experienced through a dialectical understanding of the suspicions that have been brought against the unification of the dramatic space of the picture. My view is that those suspicions have transformed the atmosphere within which representations have meaning in culture, but that they have not withdrawn the legitimacy of the process or technique of – the need for – representation. No alternative has been created; however, all representation, mine included, has been augmented with a kind of critical icono-phobia, an inner antagonism which compels representations to rebuild themselves with a different legitimacy. That is, the arrogant, domineering identity which Western figuration had been loaded with in the kind of language which had defined it for a long time has itself been cracked, and different identities have been able to emerge. Some of those which were animated by a very radical idea of themselves and culture, have opened up what you might call iconophobic representations, types of work in which the denunciation of the metaphysics, the laws, the power mechanisms inherent in the earlier identification process of representation are the main concern. I think there is some exaggeration in that denunciation: but I think that that exaggeration is a necessary form of thinking now. What is maybe not so clearly seen is that iconographic critique simultaneously legitimates itself and the tradition of representation in the process of helping to break up the solidified identity of the idea of representation as it had come down through a kind of worn-out and corrupt humanist tradition. Ironically, it makes representations more visible now, more useful, more open to the aspirations of different people.

* * *

The concept of the unified subject, the unified person, or the monadic person, is a historical condition which we move through in a historical process which can't be jumped over. The new situation in which representation exists is a kind of transitional one, maybe. Through it, we've been able to see the inner fragmentations of what previously seemed to be traditionally unified works, their inner suturings, inner twists, self-denials and so on. That has always been my experience of older art. The paradigmatic image of, say, realism, which was worked out in the 1970s, the one that suggested that realism was naive in that it unreflectively configured a reality too complex for it, that probably had to be expressed in order to break the spell that such realism had on many people, even after decades of avant-gardist fragmentations. The fact I feel that that critique itself moved too linearly to a polar opposite position, and became somewhat sterile in the process, doesn't mean that I could deny the necessity of the process of critique. I feel absolutely the opposite, and don't think that my pictures have any point of contact with the neo-conservative return to tradition, which counterposes figuration and representation against Modernism and experimentalism. My work comes out of the process of experimental critique, but is itself an experimental critique of aspects of that process. [. . .]

I think it's important to see that Conceptual and post-Conceptual attitudes and approaches have played an important part in what we could see as a radical reworking of the field of art history in the same period in which the kind of artistic experimentation we've been talking about was elaborated. Since my pictures and my work as a teacher have a connection with the fact that, as a young artist, I went to university and studied art history rather than going to art school, this topic is of particular interest to me. For example, when the concept of a painting of modern life emerged with particular crystal clarity in the nineteenth century, it changed the way the history of art could be seen. It was possible to rethink the modernity of the works of earlier artists. The way Manet worked with seventeenth-century Spanish painting is a central example. At this point, I think a certain very important evolution in the history of Western art was taking place. Manet's art could be seen as the last of the long tradition of Western figuration, and of course at the same time, as the beginning of avant-gardism. The avant-garde counter-movement against the idea of the painting of modern life of course built itself entirely upon it. Whether you look at Rodchenko, Arp or Pollock, you will see that the attitude towards tradition and the antagonistic acceptance of the logos of tradition, derives from the idea of building monumental forms which express and explain what exists in modernity – so they are actually counter-monumental. So it seems to me that the general programme of the painting of modern life (which doesn't have to be painting, but could be) is somehow the most significant evolutionary development in Western modern art, and the avant-garde's assault on it oscillates around it as a counter-problematic which cannot found a new overall programme. This thinking both transformed art history and came out of its developing relationship with the whole discourse of modernity, out of the re-articulation of art history on the basis of the new critical theories of the 1960s and 1970s. This new situation provides the means for rebuilding that neglected field, aesthetics, as well. For me, none of my work could have been done without the turmoil within art history. [. . .]

11 Diedrich Diederichsen (b. 1957) 'Which Side are You on, Cultural Worker?'

Diederichsen originally studied German literature, but in the early 1980s co-founded the music journal *Spex*, which supplemented its provision of rock music criticism and cultural theory with sections on art and literature. One lesson that some artists of the time derived from observation of – or actual engagement in – the alternative music scene was that more valid and usable insights were to be gained by embracing activity at the heart of 'late' capitalist contradiction than by seeking critical distance and virtue in the margins. Writing as a critic of the visual arts during the late 1980s and early 1990s, Diederichsen supported the work of Georg Immendorff, and of the Hamburg artists Martin Kippenberger, Werner Büttner and Albert Oehlen. The following text, translated by Nicholas Walker, is taken from an untitled catalogue essay on the work of Immendorff, originally published in *Immendorff's Handbuch der Akademie für Adler*, Cologne: Buchhandlung Walter König, 1990, pp. 7–11. Some small corrections have been made by the author subsequent to that edition. Among the 'many possibilities' unavailable to painting to which Diederichsen refers are those facilities included under the 'electronic communications revolution'. The 'March through the Institutions' was a strategy envisaged by the German generation of '68. At the time when Diederichsen was writing, Lothar Späth was a prominent and wealthy right-wing politician and Gloria von Thurn and Taxis a rich heiress known for her progressive tastes and hairdos.

Current thinking on art is as paralysed as it is because, amongst other things, art is incapable of recovering from the idealist dream of the Other, of the negative, of the non-relational, of the asocial, whether in its political or its dandified form, or of recovering from the failure of that dream. We have realized that, for the present, there is nothing outside the system, at least as far as visual and plastic arts are concerned, that can possibly hope to exercise any influence whatsoever; and it is their historical fate that they have only enjoyed any development – becoming the most official and representative of all state arts through a concatenation of specific historical circumstances and their own self-induced impotence – to the extent that art has merely absorbed the advances that derived from this essentially conservative function. All of this has led contemporary artists to waver between the desperate attempt to salvage negativity (though we should not despise the heroic aspects of this project which is hopelessly idealistic as a totality) and a kind of cynicism which simply abandons itself to the futility of state art and its utterly museal function and seems quite prepared to fulfil that role, if in a slightly melancholic tone, without much further ado. But it is precisely here, where it has been so markedly instrumentalized and exploited by the powers that be, that the arts are capable of unfolding a multiplicity of functions, of disclosing unexplored areas not yet put up for sale, areas which invite further reflection and different kinds of discourse and which cannot present themselves so easily elsewhere and in other cultural domains. This is also a result of the hectic activity generated by the plurality of *possibilities*, a plurality which painting, perhaps to its own advantage, is also incapable of mastering.

Art today finds itself in a position which can be compared with that of the hard sciences. The artist is like a physicist who cannot promote his work if he is not prepared to co-operate with the most powerful financial sponsors. On the other hand, he must also understand their intentions and attempt to counteract them, not by pursuing the bathetic strategy of the 'March through the Institutions' but by obeying the instinct of

the good artist who knows his own interests. This is still based on the ultimately idealist thought, which can never be verified, that in the final analysis all good art must serve the people, must express what is happening in the topical struggles of the present. In areas like rock music and the comic strip messages concerning these contemporary struggles are passed within an almost hermetic circle from one 'combatant' to another in the relevant coded form. But visual and plastic art finds itself in a very different position today, when it is largely a servant of the state or Deutsche Bank, an instrument for promoting politicians or corporations, an immediate expression of the ultimate form of war and exploitation that is perpetrated against human beings and the planet itself. It simply has the choice between being the golden watch-chain of Lothar Späth or the hairspray of Gloria von Thurn und Taxis. Art clings to the powers that be and is also simultaneously the furthest removed from them. It is further removed from the people than any other medium and is therefore also the furthest removed and the most remote from the havoc which power wreaks upon the people in particular (precisely in so far as it stifles in the people the very kind of self-realizing aspirations that it desires for the artist). Art is also thereby freed to establish contact with the new, correct and uncoded energies of the people themselves, those from which, as Mao says, 'the right ideas of human beings arise.' If the visual and plastic arts could acquire an appropriate consciousness of this condition of their own existence, an awareness that was not simply consumed by the emotions and resentments with which we are all familiar, but would preserve that contradiction in their paintings and exhibits as a great and unmissable joke, that would be a considerable achievement for the present.

12 Albert Oehlen (b. 1954) in conversation with Wilfred Dickhoff and Martin Prinzhorn

The 1980s saw the emergence of a new generation of painters in Germany, for the most part deploying overtly expressionistic styles in large formats. In Hamburg the work of Martin Kippenberger, Werner Büttner and Albert Oehlen was distinguished from this prevailing tendency by its ironic prodigality and variety, and by its acknowledgement of the implications of Conceptual Art for subsequent painting. Among these implications was the fact that the artist was now confronted by a wealth of possible media, none of which was necessarily any better legitimated than any other, and none of which was particularly inviting to the exercise of traditional artistic competences. In such a circumstance, in which anything that *didn't* look like a painting or sculpture might come up for the count as avant-garde art, perhaps the four-square canvas, which identified itself clearly as belonging to an artistic genre, might establish some critical expectations to build on. Diedrich Diederichsen has suggested that at a certain point Oehlen 'began to look at painting as a Punk musician... might have looked at conventional Rock'. The resulting works of the 1980s are replete with signifiers of antagonism, ambiguity and insouciance. Our text is translated by Nicholas Walker from 'Albert Oehlen im Gespräch mit Wilfred Dickhoff und Martin Prinzhorn', *Kunst heute 7*, Cologne: Kiepenhauer and Witsch, 1991, pp. 33–4, 41–3, 53–68, 79–83.

Part V

INTERVIEWER: Since the mid-eighties you have described your work as 'post-non-representational art' [*postungegenständliche Kunst*]. What precisely do you mean by that?

OEHLEN: All painting presents you with an absurd position. It involves the reduction of something three-dimensional to something two-dimensional, and that's already an abstraction. If you didn't perform this abstraction, you would have to try and paint directly onto the object itself, or try to become the object itself. The work, the reconfiguration of reality that results from incorporating it into the painting, is itself such a radical transformation that it no longer matters subsequently whether you can still recognize an apple or not. The difference here isn't really so massive, as compared with the 'achievement' you have already accomplished. And thus you have your picture as a product right in front of you. And it corresponds to what you have learnt, what you have managed to do, the pains you have taken with it etc. . . . Once you are really clear about the achievements of abstract painting, you no longer need to paint in an abstract manner. In retrospect the difference is not so great after all. [. . .]

INTERVIEWER: What then does a post-non-representational painting look like?

OEHLEN: I try and paint a picture where it doesn't matter whether anything can be recognized or not, but which somehow remains compelling. But 'compelling' here doesn't mean instantly explicable. You can explain gestural painting very quickly. This guy clearly went wild, he used this or that particular brush to dab, coat, or flick the paint, he worked quickly, he worked slowly, the paint was fluid, not so fluid, etc., etc. Perhaps he worked more than an arm's length away from the thing. In explaining a picture this way, you already have some sort of schema for your thinking. You are supposed to admire the guy's expressiveness or his mastery of spatial relations. You should also be able to glimpse what he's after, though the problem that was to be solved shouldn't be too obvious. You shouldn't be able to say immediately at a glance: 'Well yes, this clever guy is investigating the effect of that green diagonal slash with a dot on the end in that red zone with those fuzzy contours intruding at the top.' Irrespective of whether such an investigation actually produces an interesting result, it certainly wouldn't make you change your life in any way as a consequence. Ever since the Bronze Age painting has had a subject [*Sujet*] that filled the picture in its entirety. This was followed by the idea that the subject had to be a theme [*Thema*] that also possessed existence independently of the picture, that could always be developed or even sometimes discussed in its own right. This has now been super-seded in turn by the motif [*Motif*] which, though an identifiable component of the painting or work of art, actually also betrays the other meaning associated with the German word: that of motive and incentive. And this aspect is also evident in what was formerly called the subject or theme. I want to paint a picture where it is quite clear what I am actually doing. Hence the question: is it worth doing it, what if someone were to watch me right now? This question should always be in your mind.

Of course, you can dodge the issue in all kinds of ways, by saying, for instance, 'that's what I dreamt last night, so now I'm going to paint it.' But this excludes any further questioning. In short: a post-non-representational painting is one that is legitimated neither by its process of production, nor by virtuosity, nor by an idea, but that can be passed on like a joke, even though it must avoid the anecdotal.

Part VI

INTERVIEWER: You always draw your vocabulary from the external world, from reality. This means that art itself never becomes a subject for you.

OEHLEN: You can always adopt the vocabulary of art, of course, as a witticism, as a pointer to what's happening in art, or as something that has now acquired reality through the general recognition it enjoys. A peace-proclaiming Picasso dove, for instance, isn't a great virtuoso piece of work any more. It's just a painful blue dot. It could even drive you mad, nauseate you, even inspire bellicose sentiments in you, whatever. It's no longer a free independent work of art, and thus a kind of reality. In this respect it can establish some connection with art, but quotations aren't intrinsically interesting. Immendorff's propaganda paintings aren't as important as they are because they attempted to propagandize or persuade people. They are good because they are so importunate, bold enough to suggest, incredibly enough, that a work of art can suddenly express an opinion about something. There's an insolence there. It's an example of banalization as a fundamental feature of the avant-garde. An importunate obtrusion upon reality. I naturally feel a commitment to these things. That is why we – Büttner, Kippenberger and myself – took our vocabulary from reality, but that reality is itself a fractured terrain. For us this meant, pre-eminently, the newspapers, the news that was in the papers. Everything we made some use of – notions, problems, apparent problems – came from the newspapers because at the time we told ourselves, reasonably enough, that this was what was going on. We don't want this stuff to remain private after all – it has to be clearly, and embarrassingly, accessible to everyone.

INTERVIEWER: If the political is simply about denouncing grievances, then it surely doesn't do justice either to art or to the grievance. You don't pedantically want to call the police in with every exposure you make. You want to make an art that can make the arrest itself as it were. [. . .]

OEHLEN: I think the main thing as an artist is that you realize that art leads a life of its own, that is, quite independently of the reality of social life, of work, etc. And realize that art cannot intervene in life, irrespective of whatever heroic ideals you may entertain. But this doesn't mean that you simply abandon your own position. As a human being you strive for a certain thing, and commit yourself to it, and as an artist you formulate, in complete freedom, what you think and what you wish to do.

But to pretend that art itself can make life better is a lie. And this lie is useful to certain ideologies, and is indeed required by them. So you can pretend that if we could all go out and do a lot of painting then the world would be a better place. The reality is that if the world were a better place, then we wouldn't need to do such senseless things as painting pictures, making pottery, and that sort of thing. Absolute utopia is a world without art because living itself would be the art: a liberated form of work, a liberated form of life. If you want to try and imagine pure happiness, art wouldn't have any place there any more. For art always reflects, plays with, works upon our self-image, our consciousness, our pride. But such things will no longer exist then. You simply imagine this great swamp of pleasure, of eating, boozing, fucking, sleeping – my imagination fails to describe a liberated society . . . There would no longer be any place for reading, painting. . . .

INTERVIEWER: If art can't change anything politically, does that also imply that art should be formulated in a language quite different from that of politics?

OEHLEN: By no means. Perhaps I failed to make myself clear in what I just said. I should have made the distinction between art that is critical of society and political art. Let's keep this in mind from now on. A political art is always a possibility, of

course, and it shouldn't be anything really special, at least if you define politics as the unfolding of interests that are shared and contested. What would be unpolitical, would be to see all this as some impenetrable mystery. So I suggest that one should proceed as a materialist, should exclude all metaphysical issues or challenge them.

INTERVIEWER: Amen to that!

OEHLEN: Yes, you bastard! So when some politically committed artist posts his critical messages against society through the dead letterbox of metaphysics, he is being quite unpolitical. Much of this art which is so critical of society reminds me of some voodoo priest sticking pins in dolls (Ronald Reagan, the atomic bomb, the Poll Tax, etc.). This is just the other side of the coin called Absolute Beauty.

Part VII

[...]

INTERVIEWER: In the early eighties there was a generally prevailing atmosphere of 'everything is permitted' which often led to a kind of aesthetic of indifference. You have always rejected that. Your programme demanded *rigour in content*, and looked upon the history of art as a suitable quarry. What for you was the significance of this attitude of 'Wir dürfen alles' [We can now try anything]?

OEHLEN: First of all, every decent young art student worth their salt wants to attempt something new. At that time everyone was saying 'painting is dead,' it's all 'over'. That is how we felt too. And of course it looked like that ten years ago. If Francis Bacon is the best painter in the world, then painting really is dead. People tended to reject everything as so much bourgeois crap. I hated everything that was knocking around then, except for Polke, Dieter Roth, Immendorff, and perhaps Andy Warhol, though I imputed various concerns to him which to this day I am not really sure were concerns of his at all. But now I don't mind one way or the other. For you begin to respect one artist, and then another one, though not overmuch . . . At the beginning you are just an upstart. But every young person should be an arse-hole now and then. Definitely. Today this attitude 'Wir dürfen alles' is accepted by everyone. The idea at the time was really that every artistic means, every technique deserved the punishment it received. And we believed that if you produce as many different kinds of things as possible, or if you leave it quite unclear what genre you are actually working in, this would only serve to enhance content. Today I no longer believe this.

[...]

I don't really know what there is categorically to say in favour of painting, but I am sure that certain arguments against it are absolutely wrong. The main reason why I made the decision to paint is that I think this is the real centre of art. And to pursue formally new directions – video, or performance art, or whatever – or to do nothing at all, would only limit one's expressive options. It would all be overshadowed by technical issues, by the novelty. And everything else is even more out of the question. If formal considerations become too powerful, this only distracts from what you want to say substantively – with an installation, in other words, you will never be able to get to what matters, as you can with something that is less interesting technically. You have to realize that these discoveries, made at the forefront of technological science, are basically achievements of the military and the powers that be. So if you just rush out to provide some corresponding form of literature

or, like today, start working away at computer art, you seem to renounce art's option of doing something essentially different, and end up panting along behind.

The other stupid reaction would be to fall back on the idyllic. To seek out an idyllic space for oneself and pretend that things are not what they are, simply to repudiate all this scientific and technological knowledge. The only real possibility is to use precisely what has been weakened, like the novel or like painting which I think has been weakened by photography, to use, as it were, the second-most-modern medium, or the second-most-modern means, or the second-most-modern philosophical attitude, and continue working from there.

Always aware, of course, of what is going on around you. This is, after all, also how modern art came into being.

INTERVIEWER: Why did you pursue representational art in the early eighties?

OEHLEN: It is the bourgeois expectation of art that the artist should essentially investigate formal problems. On the leftist scene, to which we felt we belonged at the time, it was generally assumed that any artistic statement either glorified something, some prevailing state of affairs for example, or fundamentally criticized it instead. Thus you were often called upon to serve some cause or other. At the time this was a reaction to the cult of pure art and its associated claim that all significance was internal to art itself. We couldn't possibly accept that. 'So let's proceed in the opposite direction for a change.' This was the only way we could develop art at the time. In putting painterly problems last you got to a sort of art that really mattered, because that was what was left after all the experimenting. In fact it works the other way around: you throw out what is unimportant. You paint something, certain effects are produced, and you think: Why did you go and do that, that's not really necessary, and you just kick it out as well. And in the end you prefer turning out white canvases. Of course, it is important every now and then to turn out white canvases, but it's quite meaningless if you actually have no idea of what you are leaving out in the first place. But if you leave something out, you paint a hole, and when you try to paint a hole, you marvel.

INTERVIEWER: At what?

OEHLEN: At how difficult this is.

INTERVIEWER: Better to turn out the white canvases, then?

OEHLEN: Well there is also anxiety involved here of course. That's why we should leave it at that. It's a waste of time and material, and simply tries the patience of your fellow human beings, though they are the least of my worries. They're just misguided loafers. Most of the people who spend time looking at art are just a load of zombies. That's not so tragic. But you are still answerable to yourself for those particular movements of the brush. You can always try and justify yourself by saying: 'I have just documented my mood between 12.19 and 12.22 a.m. It is a testimony of these three minutes.' This betrays both anxiety and arrogance. Or you can play stupid and argue: 'I am a scientist and my task is to demonstrate this and that.' So you find yourself a little subject, like 'Analysing the various nuances between yellow and yellow', and say to yourself: 'I am a painter, where is my niche? Oh! this one is free, with some effort I'm sure I can get in there.' But what holds for entomologists doesn't necessarily hold for artists.

INTERVIEWER: In your earlier work, and in the *Facharbeiterficken* text, there is some strong thematic friction with the political convictions of the seventies, for here

politically relevant categories are removed from the context of politics or political art and then reassembled.

OEHLEN: Since Büttner and Herold were co-authors here your question touches them as well. The concepts we used back then were mostly drawn from Maoist terminology and they helped us to identify and to ridicule a certain pomposity in art which confronted us at the time. For us Art meant Art School. It seemed rather preposterous to me that while one was supposed to receive some sort of professional training, people ended up messing around on paper and calling the result a 'work'. We always combined our artistic claims with political concepts at that time. When these two aspects come into conflict you will always hear the same old jokes at the expense of art. And that's fair enough. One can only indulge in this kind of self-demeaning talk because outright malice would be intolerable.

INTERVIEWER: Do you think these early works are exacting some kind of 'retribution' on political culture itself, or attempting to arrive at a more adequate political position?

OEHLEN: It was a sort of retribution on political culture in so far as its characteristic dichotomy between high and low culture, both then and now, seemed essentially stunting, but also too tedious and in a sense too modest. You have to try and imagine the almost unimaginable hopelessness of the period, of the late seventies. Political art was assigned to certain critical spirits who specialized in some particular form of critique. Like Staeck or Hrdlicka, or basically people with big mouths.[1] Immendorff was considered a burnt-out history painter, the socialist realism of the GDR was regarded as boring, but whenever someone in West Germany tried their hand at 'critical realism' the results weren't that different anyway. It was just like literature or political cabaret at the time, when Tucholsky was recited *ad nauseam*, and artists had to paint working-class families in the prescribed fashion. And that just seemed to us to be another way of conniving with the system, a hopeless surrender basically indistinguishable from the behaviour of those who played with chemicals, shoved objects around or just leaned things against walls, etc. In contrast to all this the left-wing radical Maoist terminology and its inexorably opinionated character seemed an excellent antidote, with the added advantage that its critical analyses were correct. We had no counter-model of our own to offer, but I still believe, as I did then, that it is quite right to criticize even if you can't think of anything better yourself. You're twenty years old, your balls are burning, you hate everyone ten years older than yourself. And when all they're doing is producing rubbish, that's as good a starting-point as any. The advantage of this revolutionary arrogance is that it lets you go beyond what's around at the time without having to turn out parodies or to provide a neat alternative project of your own. [. . .]

The idea behind conceptual art was that a formalism carried to extremes amounted to the most realistic realism. This was a historical given from which you could begin to go on. I think this concept started to crumble at that moment because everything that came after naturally wanted to be a realism though it would always also be a formalism, and the concepts won't yield another interesting contradiction beyond that of formalism–realism anyway. So you can simply abandon them now that the relevant point has successfully been made. Since it's no longer necessary to exclude your objects and images, and other formerly discredited intentions or techniques, and keep insisting on this as the truly contemporary achievement of

art, you can concern yourself in future with something else. And that includes representational painting, without making a special thing of it, but also without calling for a return to representation. But simply in order to make the point, now all these issues have been clarified, that everything is possible once again, although with different aims in view. And I think we have extended the debate, and tried to force it to extremes, by bringing alleged propaganda into it as well.

And I might add that it is a characteristic feature of the petty-bourgeois mind to feel responsible for everything. This is a fundamental mistake, and a politically powerful one, because almost everything depends on it. Every polity, every modern state depends upon its citizens feeling that they are responsible for everything. And the more they believe this, the less it is actually the case. Now artists who actually try and realize this idea on a large scale are basically doing the right thing precisely because they take propaganda at its face value and attempt to realize its aims. And the failure of the intervention or programme in question only reveals the falsehood of the propaganda and somehow also serves to exempt the artists from it. But this kind of instantaneous engagement, this instantaneous response to the latest massacre, the latest outrage, and to the most immediately visible form of suffering, exploitation, environmental vandalism etc., this is naturally the most reactionary response as well – it is the 'Sting Effect': pleading the cause of the rain-forest because that is the most obvious issue around.[2] [. . .]

In my view it is no longer possible to represent reality because it is no longer necessary to do so. For reality is plain for all to see, is entirely visible. The sources of information, like television and newspapers, are there in abundance. Nothing is lacking in this respect. As if a painting were capable of making anything more intelligible than it already is.

You can hardly paint the wretched conditions of the industrial proletariat better than you can make a television programme or simply make a visit to someone's house. That's far more effective. Elaborating such things artistically ends up with an innocuous result.

INTERVIEW: What do you think of artists like Louise Lawler or Hans Haacke who engage quite concretely and directly with political events?

OEHLEN: I think these people do indeed contribute something formally to art because they go about it in such a bluntly dogmatic way, because they set to work like lawyers in a lawsuit between neighbours: 'a branch of your cherry-tree is hanging over my back garden.' But the price a painting fetches can't really be the whole problem.[3] It's easy to get the measure of this approach and it ends up rather innocuous. The intrinsically laudable aim of Haacke and others, and their followers, all of whom were still dominant in the seventies, was to investigate the conditions of art, they identified the right things and thought in a materialist way. On the other hand, in the course of time, they lost sight of the reason why they wanted to investigate these conditions at all. Or of the relationship they had to what they were effectively investigating. For the real task was to salvage something, or to preserve something or, as I see it, to seek a certain authenticity [*Authentizität*], and ask where such a thing is still possible. And then the question which inevitably arose: the authenticity of what precisely? And the only answer was to pursue representational art as crassly as possible, to produce content-oriented art. To retrieve this representational approach (which had rightly been effectively ignored or abandoned by people as an

expression of mere convention or mystification), while making it clear, of course, that you are a very different personality, that your attitude is very different from that of the last generation or the artists who last worked with representation, and that the question is therefore automatically answered in a very different way. And the whole aspect of content also becomes a very different story in the process. It is no longer a matter, as it was perhaps at the beginning, of remembering what it was all about before, but of suddenly discovering that it works. [. . .]

INTERVIEWER: With regard to 'beauty' you once said that it stands for 'being *specially in the right*, whereas purity and authenticity need not be remotely reactionary at all. As witness pure shit and pure-clean underwear.'

OEHLEN: Well, the notion that art might produce implicitly satisfying things that serve to embellish the world or render its contradictions more bearable is simply reactionary, whereas the true essence of art lies precisely in the conflict of concepts and ideas. And that's beautiful. But it is not an intrinsic value. Simply a kind of approval. Abstractly considered, 'beautiful' is a concept of approval that has no value of its own, not one you could describe in its own right. It's a way of saying something is 'good', and that's all it is. I don't think it can mean anything other than 'good'. At the moment when art, this conflict of ideas, gets impressed within the material, then the system, for want of a better word, naturally always attempts to exercise the maximum possible control over it. But it is futile to torture yourself, with every effort and fibre of your being, precisely in order to avoid being co-opted in this way. [. . .]

Editorial notes

1 Klaus Staeck, Professor of Graphic Arts in Heidelberg, self-appointed executor of John Heartfield's artistic legacy and well-known campaigner for the German Social Democratic Party; Alfred Hrdlicka, a political artist from Austria, figurative sculptor in the expressive-realist manner.

2 Oehlen is referring to the British pop singer and campaigner for environmental issues.

3 Oehlen is referring to a work by Hans Haacke that documented the provenance and the increasing financial value of Manet's still life of asparagus, and to Louise Lawler's photographs of Modernist paintings, with price tags attached, in the sale rooms of Christie's and Sotheby's.

13 Olu Oguibe (b. 1964) 'In the "Heart of Darkness"'

Oguibe is an African writer and curator who works much of the time in the United States. He has held the Chair in African Art studies at the University of Florida, and edited *Nka*, the journal of contemporary African art. He was co-author, with Okwui Enwezor, of *Reading the Contemporary. African Art From Theory to the Marketplace* (1999). He is curator of Documenta XI. The present essay was originally published as the introduction to a special issue of *Third Text* edited by Oguibe and devoted to aspects of art and culture from Africa. Our extracts are taken from 'In the "Heart of Darkness"', *Third Text. Third World Perspectives on Contemporary Art & Culture*, 23, London, Summer 1993, pp. 3–8.

I

Prehistory. History. Post-history. It is evidence of the arrogance of occidental culture and discourse that even the concept of history should be turned into a colony whose

borders, validities, structures and configurations, even life tenure are solely and entirely decided by the West. This way history is constructed as a validating privilege which it is the West's to grant, like United Nations recognition, to sections, nations, moments, discourses, cultures, phenomena, realities, peoples. In the past fifty years, as occidental individualism grew with industrial hyperreality, it has indeed become more and more the privilege of individual discourses and schools of thought to grant, deny, concede, and retract the right to history. Time and history, we are instructed, are no longer given. Indeed history is to be distinguished from History, and the latter reserved for free-market civilisation, which, depending on the school of thought, would either die or triumph with it. [...]

What comes out very clearly...is the consignment of the rest of humanity outside the Old and New West into inconsequence. [...] Humanity is synonymous with the Group of Seven and Eastern Europe. Under Reaganism-Thatcherism even the spatial definition of history severely retracts to the Pre-Columbian.

The contest for History is central to the struggle for a redefinition and eventual decimation of centrism and its engendering discourse. Without restituting History to other than just the Occident, or more accurately, recognising the universality of the concept of History while perhaps leaving its specific configurations to individual cultures, it is untenable and unrealistic to place such other temporal and ideological concepts as Modernism, Modernity, Contemporaneity, Development, in the arena. If Time is a colony, then nothing is free.

II

Premodernism. Modernism. Postmodernism. For the West erase Premodernism. For the rest replace with Primitivism. It is tempting to dwell on the denial of modernity to Africa or cultures other than the West. The underlying necessity to consign the rest of humanity to antiquity and atrophy so as to cast the West in the light of progress and civilisation has been sufficiently explored by scholars. If not for the continuing and pervading powers and implications of what Edward Said has described as structures of reference, it would be improper to spend time on the question. It is important to understand that while counter-centrist discourse has a responsibility to explore and expose these structures, there is an element of concessionism in tethering all discourse to the role and place of the outside. To counter perpetually a centre is to recognise it. In other words discourse – our discourse – should begin to move in the direction of dismissing, at least in discursive terms, the concept of a centre, not by moving it, as Ngugi has suggested, but in superseding it. It is in this context that any meaningful discussion of modernity and 'modernism' in Africa must be conducted, not in relation to the idea of an existing centre or a 'Modernism' against which we must all read our bearings, but in recognition of the multiplicity and culture-specificity of modernisms and the plurality of centres. [...]

III

It is equally in the above light that the concept of an African culture, or an Africanity, which is quite often taken for granted, is problematic. It seems to me that we cannot discuss an African modernity or 'modernism' without agreeing first on either the

fictiveness of 'Africanity' or the imperative of a plurality of 'modernisms' in Africa. [. . .]

Many have argued, prominent among them the Afrocentrist school, the antiquity of a Black or African identity, an argument which falls flat upon examination. On the other hand, history reveals the necessity for such unifying narratives in the manufacture of cultures of affirmation and resistance. The danger in not recognising the essential fictiveness of such constructs, however, is that a certain fundamentalism, a mega-nationalism, emerges – all the more dangerous for its vagueness – which excises, elides, confiscates, imposes and distorts. Some will argue that history, after all, is perception, in other words, distortion. But if we were to accept this wholesale and without question, we would have no business trying to 'correct' history, unless, also, to correct is merely to reconfigure, to counter-distort. [. . .]

IV

The history, or histories, of what we severally refer to as 'modern' or 'contemporary' 'African' art illustrates the above problems and dangers. From the point when it became acceptable to speak of a 'history of contemporary African' art, attempts at this history have run into often unacknowledged tight corners by ducking into the safety of earlier fictions of 'Africa'. The most obvious manifestation of this is in the seeming racio-geographical delineation of the 'African', which, we are often told, basically refers to sub-Saharan Africa. The obvious intent of this definition, of course, is to distinguish the African from the Arab, although the spatial boundaries specified by the register, sub-Saharan, effectively ridicule this intent. A less apparent intent, and indeed a more important one, is to place the Arab a notch above the 'African' on the scale of cultural evolution.

It is sufficient not to question this intent here, but to point out that the signifying register proves grossly inadequate. Not only does it wholly ignore the impossibility of hard edges between cultures and societies in the region it describes, and the long history of Arab-Negro interaction, together with all the subtleties and undecidables of racial translations, indeed the impurity of designates, it equally ignores internal disparities within the so-called 'African' cultures. To play on the surface, it is never quite clear where East Africa fits on this cultural map of Africa, given not only the territorial problems of locating Somalia below the Sahara, but also of eliding Zanzibar's long history of Arabisation. In a significant sense, then, the construction of a 'sub-Saharan' Africa not only ignores geographical inconsistencies but equally ignores accepted discursive positions in the West which not only recognise the triumph of History as the Impure but underlie the construction of Europe.

We see double standards. But that is hardly the most important point. We also find that essential tendency to ignore indigenous historical perceptions and constructs. The Outsider, whether occidental scholarship or Diasporic Negro discourse, quickly established delineations without acknowledging the possibility that these may not be shared by those whose histories are at the centre of discourse.

On the other hand, what we see are not double standards at all but a consistent referent. For, when we examine the continual construction of Europe such discrepancies are equally apparent. The most interesting examples are the ready admission of Israel into Europe and the struggle to exclude Turkey. In other words, in the end, the

use of the designate, 'sub-Saharan' in the definition of the 'African' is only a cheap ruse masking other, less innocent referents. The bottom is not only race, but history as well. History as vassal.

Needless to say, white people in South Africa, Asians in Uganda, as well as other diasporic populations and communities, fall outside of this definition. Cultural Africa, therefore, is no longer contained by that lame composite, sub-Saharan, which now needs a further qualifier: 'excluding white [South] Africans'. But then, how would the Outside justify the condescension toward Africans, or its employment of The African in the satisfaction of its need for the exotic, if Arabs, with their 'long history' of civilisation, or white [South] Africans were to be part of that construct?

On the political front, however, arguments have been stronger on the side of an all-embracing Africanity which supersedes disparities and differences and aspires towards the construction, not invention, of a new and credible Africanity. This is the position of Nkrumah's Pan-Africanism, and remains the ground argument of the Pan-African movement. Culturally, the argument is not only to recognise a plurality of Africanities but also aspire towards the active formulation of a singular African 'identity', somewhat along the lines of Pan-Europeanism and the construction of the West. For Outsider cultural historians and culture brokers, however, such strategies must be reserved for Europe.

* * *

VI

Several other problems and questions hinge on the above. If, after all, we reject the 'sub-Saharan' qualifier, we effectively subvert a host of other qualifiers and paradigmatic premises. The 'peculiarities' and particularities attributed to 'sub-Saharan' art which in turn sustain temporal and formalistic categorisations become untenable. Such conveniences of Outsider scholarship as the 'problems of transition' from the 'traditional' or the 'African' to the modern, or the question of Africa's 'identity crisis' and concern over the endangerment of 'authentic' African culture, all prove very problematic indeed. If Africa is not some easily definable species or category that yields to anthropology's classifications and labels, neither are its cultural manifestations.

'Transition' from 'antiquity' to the modern ceases to amaze and exoticise or evoke voyeuristic admiration or pity because antiquity ceases to exist. The supposed distress of Africans caught in a no-man's land between Europe and their 'authentic' selves becomes a lot more difficult to locate or explicate. Ethnographic categories usually applied with ease to sequester 'African' culture into temporal boxes are no longer easy to administer. What, for instance, would we qualify as 'transitional' art in Egypt that we cannot locate in Spain? What is client-driven art within the minority community of South Africa? How easily would we lament the 'corrosive influences' of Europe on the Somali of the Northern coast?

That is to pull one leg from the stool. In strict discursive terms, of course, none of the categories, delineations and constructs mentioned above has any relevance even within the context of a delimited 'Africa', especially since none of them is ever applied in the description and study of Europe or the West. African scholars could have bought into any of them, and indeed still do, but that is hardly the issue. The point, instead, is that such constructs as sequester specific societies and cultures and not others emanate

from less innocent structures of reference the briefs of which are to create foils and negations of the Occident. So we can speak about 'transitional' art in Africa, and never in Europe. We may speak of 'Township' art in Africa, or at times of 'popular art', and these would connote different forms and manifestations from those in Europe. We may qualify nearly a century of artforms in Africa as 'contemporary' while applying the same term to only a strain of current art and discourse in Europe. We may take modernism in Europe for granted and have great difficulty in finding the same in Africa. The assimilation of Outsider culture into European art is considered the most significant revolution of its time while the same is bemoaned in Africa as a sign of the disintegration and corrosion of the native by civilisation. Or, on the other hand, Africans are to be patted on the head for making a 'successful transition' into modernity. Why, whoever thought they could emerge unscathed!

To discuss the 'problems' of modernity and modernism in Africa is simply to buy into the existing structures of reference which not only peculiarise modernity in Africa but also forbode crisis. What needs be done is to reject that peculiarisation and all those structures and ideational constructs that underlie it.

VII

To reject the exoticisation of Africa is to destroy an entire world-view carefully and painstakingly fabricated over several centuries. This is the imperative for any meaningful appreciation of culture in Africa today, and it would be unrealistic to expect it easily from those who invented the old Africa for their convenience. It dismisses an existing discourse and signifies a reclaiming process which leaves history and the discursive territory to those who have the privileged knowledge and understanding of their societies to formulate an own discourse. This is not to suggest an exclusionist politics, but to reassert what is taken for granted by the West and terminate the ridiculous notion of the 'intimate outsider' speaking for the native. It recognises that there is always an ongoing discourse and the contemplation of life and its socio-cultural manifestations is not dependent on self-appointed outsiders.

Otherisation is unavoidable, and for every One, the Other is the Heart of Darkness. The West is as much the Heart of Darkness to the Rest as the latter is to the West. Invention and contemplation of the Other is a continuous process evident in all cultures and societies. But in contemplating the Other, it is necessary to exhibit modesty and admit relative handicap since the peripheral location of the contemplator precludes a complete understanding. This ineluctability is the Darkness.

Modernity as a concept is not unique. Every new epoch is modern till it is superseded by another, and this is common to all societies. Modernity equally involves, quite inescapably, the appropriation and assimilation of novel elements. Often these are from the outside. In the past millennium the West has salvaged and scrounged from cultures far removed from the boundaries which it so desperately seeks to simulate. The notion of tradition, also, is not peculiar to any society or people, nor is the contest between the past and the present. To configure these as peculiar and curious is to be simple-minded. It is interesting, necessary even, to study and understand the details of each society's modernity, yet any such study must be free from the veils of Darkness to claim prime legitimacy. To valorise one's modernity while denying the imperative of transition in an Other is to denigrate and disparage.

The West may require an originary backwoods, the 'Heart of Darkness' against which to gauge its progress. Contemporary discourse hardly proves to the contrary. However, such darkness is only a simulacrum, only a vision through our own dark glasses. In reality, there is always a lot of light in the 'Heart of Darkness'.

14 Ilya Kabakov (b. 1933) on installations

Born in the Ukraine, Kabakov graduated from art college in Moscow in 1957 as a graphic designer, and thereafter pursued his official career as an illustrator of children's books. However, in the hall of mirrors that was Soviet society, in which nothing was what it seemed and nothing seemed to be what it was, Kabakov was also an unofficial vanguard artist. Influenced at first by Western movements such as Surrealism and Abstract Expressionism (not least for their apparent absurdism and individualism, respectively), he and others, including Eric Bulatov, Vitali Komar and Alexander Melamid, were affected by the conceptualist turn of the 1960s. This led to a shift in their work away from a decontextualized echo of Western Modernism towards a meditation on the characteristic forms of official Soviet culture. From the early seventies Kabakov drew on his experience as an illustrator to produce albums combining texts and drawings, some of which told stories of imaginary 'unofficial' artists, in effect taking avant-gardism as its subject and ruining it. Kabakov also produced large painting-like works which mixed visual and verbal codes, simultaneously parodying abstract art and referring to the realities of Soviet culture. As 'restructuring' and 'openness' (*perestroika* and *glasnost*) affected the Soviet Union, Kabakov's work began to be exhibited abroad, and in 1988 he moved to the West. Since then his work has consisted of large-scale installations on themes largely drawn from life in the Soviet Union in the period leading up to that society's collapse. As if to underline the changes which have taken place, Kabakov represented Russia at the 1993 Venice Biennale. The two short texts reproduced here reflect Kabakov's thinking on installations. 'In the Installations' is taken from *The Text as the Basis of Visual Expression*, edited by Zdenek Felix, Cologne: Oktagon, 2000, pp. 359–61. The interview with Robert Storr of the Museum of Modern Art, New York, was conducted in 1994. It was published in *Art in America*, New York, January 1995, pp. 60–9 and 125. Our extract is from the interview's concluding section, pp. 68, 69 and 125.

In the Installations

I have been living 'abroad' for four years now, and I have often been asked about the differences in both lifestyles and artistic principles which are accepted in Russia and 'here'. And whether I could formulate these distinctions in one sentence.

Yes, it seems that I do have such a formulation. It concerns the distinct correlation between an object and its environment 'here' and in Russia. Thanks to the principle of freedom or for some other reason, it is possible that the space surrounding the object in the West (as usual, what is meant here is Western Europe and North America) is virtually ignored, attention is focused on the thing, the article, the object. This attention is all-embracing. The object is being dissected and assembled, everyone is interested in how it functions, it is imbued with all inventiveness. The objects in their turn look beautiful, they are always new, clean, shining, brightly painted, each one has its own individuality, one could say that they are almost animated, they have an independent life. The interrelationships between these objects, however, are exaggeratedly indifferent. They are often arranged next to one another to emphasize that there

is no connection whatsoever between them. Such objects are especially indifferent to the surrounding space. Only one thing is demanded from that space: that it mustn't interfere with the object existing and demonstrating itself. On a utilitarian level, this presupposes protection and the creation of comfortable circumstances for these objects: unrestrained arrangement, cleanliness, optimal temperature within the room, protection from humidity and cold. On a visual level, this means good, even light, neutral paint on the walls, but the main thing is that the space shouldn't draw attention to itself, it shouldn't impede concentration on the object. In principle, it's as though the space shouldn't exist at all. If it is created intentionally, with the goal of creating an impression, it is shaped from those same objects which vary to the point of indifference (like in a store) or are similar to the point of indifference (this is how the spatial objects of Hanne Darboven and Allan McCollum seem to me).

In Russia (somehow I can't say 'in the East', after all, Russia is not entirely in the East), everything is just the opposite. Items as real objects don't have any significance there, for a few reasons. In the first place, they are all old, dusty, broken, 'previously used', and if they are still new, they are poorly made, don't work, ugly, shapeless. In the second place, they mostly don't serve pragmatic goals – to work, to help, to make life easier (they are not capable of this at all) – but symbolic goals: objects act as indicators of the social membership of its owner, his social status. Therefore, it's not important for us 'what kind of thing it is' and how it works, but where and in what sense it is presented. For us, a thing doesn't speak about itself, but about the one who owns it and why he owns it.

These incidental circumstances, which are often insignificant for a Western person, have an extraordinary significance in our country and are 'read' instantaneously as the most important information. This inseparable connection between the material object and remote meanings creates a dense contextuality around any object, thing or event. These 'circumstances' are a lot more important for us than the thing, object, event itself. And that's why the space where you find yourself in or where something is located or occurring plays the paramount role. The same thing located in a store or located in your home is really two different things. The very same table in your home and in an office is two different tables. A conversation at the train station or a conversation about the very same thing in the office is two different conversations. You yourself (and everyone knows this by his or her own experience) are completely different at the post office or at the market, in an official establishment or at home: your individuality entirely depends on the space you find yourself in. This is why our premises are so saturated, why they say and command so much, why they dominate and control everything that resides in them or winds up in them accidentally. I am not only talking, I repeat, about horrible places like a prison, a police station or the train station. Literally all habitable spaces – schools, houses, stores, post offices, hospitals, cafeterias, workshops – they all have the same repressive, stifling nature. What automatically comes to mind is the medieval notion of the 'genius' or spirit of a place which seizes anyone who comes there.

How does this 'spirit of the place' seize you? In the first place, the rooms are always deconstructive, asymmetrical to the point of absurdity or, on the contrary, insanely symmetrical. In the second place, they look dull, oppressing, semi-dark, but this is not so because the windows are small or weak lamps are on. The main thing is that the light both during the day and at night is arranged so excruciatingly, so awkwardly that it

creates a peculiar discomfort distinctive to that place alone. The third important feature of our rooms' effect is their wretched, ridiculous preparation from the planning stage to the realization: everything is crooked, unfinished, full of stains, cracks; even in the most durable materials, there is something temporary, strange, made haphazardly, just to 'pass'.

What is especially depressing is the fact that everything is old, but at the same time it isn't clear when it was made, it doesn't have all the noble 'patina of time', the marks of 'wonderful days of old', it is old in the sense of being decrepit and useless. All of this despite the fact that it might have been made and painted only yesterday, already appears outdated, marked for disposal. There is an impression of dust and dirt in every place and in everything – on the walls, at the ceiling, on the floor, in the corners. But the sensation is even stronger that these rooms, including private apartments, do not belong to anyone, that they are no-one's and that, in essence, no-one cares in the least about them. No-one loves them, people live in them temporarily and will leave not remembering them at all, like a train station, an underground crosswalk or a toilet at the bus station.

As for me, I was always unbelievably sensitive to other people's places into which I have constantly been thrown since my earliest childhood. Did the experience of my family leave its mark? For example, after my mother and I had been evacuated during the war, I lived in dormitories from the age of 10 to 24: first at the art school, and then at the institute. Perhaps it was also my mother's fate, forcing her to move from corner to corner and live in Moscow for 16 years without a living permit, moving from one landlady to another?

Without a doubt, this led to a heightened socialization of my consciousness. However, this did not only happen to me, but to all the people surrounding me as well. Whether we wanted this or not, whether we hid from this or not, our external life, like thick syrup, seeped into each pore of our existence; total 'sociality' dominated and corrected each of our actions, opinions, impressions, lifestyles. We are not only talking about the repressiveness of the Soviet governmental structure with its control, bureaucracy, disdain of private existence, its ideological 'wind' or, more precisely, storm from which there was no salvation, no matter how you ran away or hid from it.

Sociality, being completely interlinked, was the natural means of survival, the very same traditional Russian 'commune' which later also entered Soviet reality, in which you as a voluntary or subordinated participant were forever drowned, dissolved. But on the other hand, the commune saved you, supported you, didn't let you disappear or perish in loneliness, in despair, in a state of material or moral neglect. Every second of your life, you belonged to some kind of community – at work or in your own circle, whether you were busy with something or just relaxing. The atmosphere of the surrounding space was, in essence, its 'spirit' which I spoke about above. And you caught this spirit immediately, all you had to do was to enter this or that space.

But how can everything that has been said be tied to the notions of 'belonging to no-one', to the neglect, indifference of these places, these buildings? One idea doesn't contradict the other one. The spirit of community, concentrated on a small group (a group of families, a professional studio, a clan of friends), is capable of making the surrounding space 'positive': one's home, or a small club, or one's studio. But the very same community, inflated to a state level, although it is perhaps envisioned according to the same principle of a large family with a father (a monarch, first secretary) at the

head, leads to the opposite and thus catastrophic result: to 'belonging to no-one', to uselessness, to transforming everything into places of 'common use', it leads to destruction, to mortification of everything, even of a family home, to the overall dissolution of things in a unified stuffy statal space that is 'no-one's' . . .

If we turn to the difference between artistic principles in our country and in the West in this sense, it can be formulated this way: if in the West, the object is exhibited as the main hero and the surrounding space doesn't exist at all, 'we', on the contrary, should perhaps primarily exhibit 'space' and only then arrange objects in it. This theoretically leads to the necessity of creating a special kind of installation – the 'total' installation.

Interview with Robert Storr

RS: I want to ask you about the general theory of installation. When Minimalism was first attacked in this country by critics like Michael Fried, they said that unlike the great, self-contained art of the past, which was unaltered by the presence or absence of spectators, Minimalism required the participation of the viewer in a space that was theatrical. The interesting point is that recent attacks on installation art repeat exactly the same argument. I'm struck by the fact that Judd, who represents the great Minimalist tradition, found common ground with you. The two of you represent very different things esthetically, but what you share is a notion of the necessary circumstance of participation.

IK: You could say it this way: Minimalism is therapeutic and at the same time educational. That is, a person is supposed to move from a state of chaos to inner equilibrium and focused attention. He should be more inside himself.

RS: Would you say that the challenge of installation is to present a chaotic situation, but one that moves the viewer's imagination to some kind of concentrated under-standing?

IK: There are many kinds of installations. At Marfa there is an enormous installation of Donald's work, and when you visit it you feel unbelievably liberated from all that is chaotic; you have an enormous sense of an almost cosmic order. My installations are oriented toward the viewer as well, but a viewer who is standing before a broken vase and thinking, 'This vase existed, and now it is no more. Why did it break? Was it a good vase?' There is uncertainty and a melancholic question to which there is no answer. I imagine the viewer as a child who is facing an ocean of questions and doesn't know how they are connected to each other or where to find the answers.

RS: There are people who happily spend hours with allegorical or Surrealist paintings, figuring out the relation of the parts within the picture, but the same people are often disinclined to think about a three-dimensional installation in the same way. Is there something in the nature of the experience that is so different?

IK: I think that today everyone familiar with art knows how to look at a painting. Even if a nail is hammered into it or a stool is hanging before it, everyone knows that it is a painting and there exists a means for looking at it, one developed historically and gained individually by education and a lot of experience. Painting is like a senile grandmother living in a family. She has been crazy for a long time, she urinates and defecates, but everyone in her own family knows how to treat her, how to talk to her. No one is surprised at what she does.

It is a completely different situation with installation art, which is like a little girl who has just been born; she is still an infant, and no one knows what she will grow into. Moreover, she has been born into a family in which a grandmother is already living, and everyone says, 'We know everything about your grandmother, but where did you come from, what new things can you tell us? And if you behave badly we'll just throw you out because we don't know if you'll even survive.' In the same way, people just don't know what installation art is; they don't realize that this little girl has moved in with us forever.

I know from experience that virtually no one knows how to see the installation as a work of art. The spatial elements pose the same problems as in painting. But these problems have long been studied in painting: a canvas smeared with yellow paint is immediately seen as the face of a person. But when viewers see a special combination of light and space, they think that it is either an architectural feature or a poorly painted room.

The task is complicated further by the fact that the origins of the Western and Eastern European installations are different. As far as I can judge, the roots of Western installation lie in Happenings and Actions; the installation is actually the remains of events frozen in time, like the installations of Beuys, Kounellis and Merz. The origins of the East European installations lie in painting. Here the viewer falls into the painting, makes the passage to the other side of the glass, enters into the painting. The Western installation is oriented toward the object, toward the appearance of different objects after the action. The Eastern installation is oriented toward space, toward the atmosphere of a particular situation.

RS: When I organized '*Dis*locations' at MOMA in 1991, some people said that there should have been explanatory placards at the entrance to each installation so that people would know how to look at them. My assumption was that the whole point of encountering installation work is to enter a space where you don't know where you are and you have to learn how to imaginatively put it together. That's something that once had to be done with modern painting. But now the surprise of modern painting has been made official, whereas the surprise of installation art has not. In a way, learning how to look at installations might teach people what they have forgotten to see in paintings.

IK: You are touching upon the most important dilemma facing any viewer of a work of art: whether to gain concrete knowledge and then leave, or to immerse yourself in what is offered. To receive information and then depart is the first temptation, and what aids in this departure are the explanations and inscriptions which accompany the work. The important thing is that when we read we are probably doing it so that we don't have to look anymore. As pertains to the tendency to immerse oneself, for this there cannot be explanatory texts. For this it is crucial that you are alone and that you are near the work of art in solitude.

Works of art, I think, consist of a series of traps, or concealments, through which the viewer has to pass. There is a naive notion that past art was easy to understand but today's art is too closed and yields itself poorly to discovery. Old paintings, however, are just as closed as today's; it's just that they have been discovered many times and a method now exists for revealing them. But there are still a lot of good closed things. I stood before *Las Meniñas* recently, and it was like standing in front of many closed doors.

RS: Then installation may save painting rather than kill it off.

IK: Absolutely. In installations people actually stand and look at the paintings contained within them.

RS: So you make these rooms that are filled with the evidence of people, in order that one person can be there alone, can discover a kind of isolation in that room full of the presence of others.

IK: Yes. It may sound bombastic, but this is what happens in a temple. We are all together, and each of us feels good because of the presence of the thing in whose name we are standing here.

RS: The irony of the situation today is that people read newspapers, watch television and read books at home, and they go to museums to be alone. Their public thinking is done in private and their private thinking is done in public.

IK: Brilliant. A person goes to a public place to be alone. And at home we do our public thing.

15 Doris Salcedo (b. 1958) Interview with Charles Merewether

Salcedo was born and educated in Bogotá, Colombia and continues to live and work there. Her sculpture addresses themes derived from the experience of life in Colombia and other countries in Latin America, though her education in art was much affected by a period spent in New York in the early 1980s. In particular she has singled out her encounter with the work of Joseph Beuys, which confirmed her emerging feelings of opposition to a more conventional Modernist sculptural tradition. Rather than pursuing the aesthetic autonomy of the work of art, Salcedo became attracted by Beuys's notion of 'social sculpture' (see VIIB12 and VIIC8). She has also invoked the work of Nauman, Smithson and Matta–Clark. These specifically *artistic* influences have been mediated for her by a felt need to address contemporary *social* issues generated by the violence which permeates life in Colombia. At the same time, however, Salcedo denies that her work 'illustrates' the tragedies out of which it is made, and in the present interview paradoxically affirms the autonomy of the art work. No less than her predecessors in the modern movement, Salcedo finds her avowedly hybrid, 'post-modernist' sculpture caught between the requirement that it succeed as art (on pain of subsiding into illustration), and the requirement that it be animated by significant social content (on pain of subsiding into irrelevance). The interview was first published in the catalogue to Salcedo's *Unland* exhibition at the San Francisco Museum of Modern Art in 1999. It was translated from the Spanish by Merewether and Sylvia Korwek. We have used the text as reprinted in Nancy Princenthal, Carlos Basualdo and Andreas Huyssen, *Doris Salcedo*, London: Phaidon, 2000, pp. 134–45.

CHARLES MEREWETHER Concerning your work *Unland* (1995–98) you have spoken of how each table draws upon a specific story of incidents happening in Colombia. How do you conceive your work in relation to these stories? Can you say something about the importance of art for you, that is, what you believe art is able to bring to the subject and to the viewer that is of special value?

DORIS SALCEDO Anyone who has been witness to the violent death of someone else, especially of a loved one, has lived an experience similar to that of a tragic hero, such as Gilgamesh. Life's trajectory for the victims of violence in Colombia is already

defined by this kind of encounter with death, the same as for Gilgamesh. Their lives acquire death as their only content. The confrontation with death, and especially with the death of a loved one, provokes what Aristotle called both terror and compassion. [...]

The civil war in Colombia defines a reality that imposes itself on my work at every level of its production. The precariousness of the materials that I use is already given in the testimonies of the victims. As a result, as an artist, I don't have the opportunity to choose the themes that inform a piece. The oft-celebrated freedom of the artist is a myth.

The Lithuanian philosopher Emmanuel Levinas has helped us understand that the other precedes me and claims my presence before I exist. In that sense, there is a delay that can never be made up. 'My presence does not respond to the extreme urgency of its assignment. It only accuses me of having been late,' writes Levinas. I work with this delay that cannot be made up. As a result, everything precedes me, everything makes its presence felt with such urgency that I am not the one who chooses; my themes are given to me, reality is given to me, the presence of each victim imposes itself.

MEREWETHER In the installation of *Unland* the placement of each table and the lighting seem very important to creating the conditions for its viewing and for our understanding. For me, it creates an aura of silence in which to view the three tables as single, almost isolated pieces and, at the same time, as sharing something in common. Can you say something about this in view of your experience of listening to these stories, their remembrance, and the presentation of *Unland*?

SALCEDO Just as it happens to heroes, for the victims of violence, the world becomes strange to them, and they enclose themselves in complete – mute – silence. Franz Rosenzweig writes in *The Star of Redemption* that the only language for a tragic hero is silence.

In art, silence is already a language – a language prior to language – of the unexpressed and the inexpressible: 'Art is the transmission without words of what is the same in all human beings... The tragic hero's silence is silent in all art and is understood in all art without a single word.' Rosenzweig says that art does not create a community. In art, all remains silent. The silence of the victim of the violence in Colombia, my silence as an artist and the silence of the viewer come together during the precise moment of contemplation and only in the very space where that contemplation occurs. [...]

The silent contemplation of each viewer permits the life seen in the work to reappear. Change takes place, as if the experience of the victim were reaching out, beyond, as if making a bridge over the space between one person and another. To make this connection possible is the important thing. 'Duration is essentially memory, conscience and liberty. It is conscience and liberty because it is, primordially, memory,' wrote the French philosopher Gilles Deleuze.

The experience is intimate and can only be made visible in the space, the space permits that the experience endures. The sculpture presents the experience of the victim as something present – a reality that resounds within the silence of each human being that gazes upon it.

It is because of this that the work of art preserves life, offering the possibility that an intimacy develops in a human being when he or she receives something of the experience of another. Art sustains the possibility of an encounter between people who come from quite distinct realities.

MEREWETHER How might you speak of an ethics of remembering when there is, at times, a need to forget as much as there is an absence of memory, or amnesia? What role does memory play in your work, both in terms of your method of working and for the audience?

SALCEDO Over the past few years the question of memory has been abused and exhausted as a theme. Given that mourning is a permanent presence in my work, the notion of memory is also ambiguous, since it is always confronted with a doubt, with an aporia. One struggles between the necessity of being faithful to the memory of the other, to keep that loved one alive within us, and with the necessity of overcoming that impossible mourning with forgetting.

My work deals with the fact that the beloved – the object of violence – always leaves his or her trace imprinted on us. Simultaneously, the art works to continue the life of the bereaved, a life disfigured by the other's death. Derrida says, 'Everything that we inscribe in the living present of our relation to others already carries, always, the signature of the memories from beyond the grave.'

My work speaks of the continuation of life, a life disfigured, as Derrida would say. Memory must work between the figure of the one who has died and the life disfigured by the death. As a result, I would say that the only way in which I confront memory in my work is to begin with the failure of memory. [...]

My works are for the victims of violence. I try to be a witness of the witness. I look for an intimate proximity with the victims of violence that allows me to stand in for them. One must feel close to another in order to stand in for him or her and create an artwork out of another's experience. As a result, the work is made using his or her testimony as its foundation. It is not my rational intent but rather the experience of the victim that tells us about trauma, pain, loss.

As a sculptor, I am aware of every detail that informs the life of the victim: the corporeality, the feelings, the vulnerability, the failings, the space, his or her life's trajectory and language. I don't formulate the experience of the victim, rather, I assemble it so that it remains forever a presence in the present moment.

In my work, I do not try to elaborate or transform the grief or overcome the traumas of another being. I can only give form to works which, once completed, are autonomous creatures, independent of my intentions. Sculpture for me is the giving of a material gift to that being who makes his or her presence felt in my work. [...] Living amidst war, my role is to think of war, both from the point of view of the victim and of the perpetrator. I am interested in war as a part of human history, as a central activity of all societies in the past as well as in the present. The enemies change, the forms of annihilation change, the weapons change, but the nature of war is the same. When I take the case of Colombia, I do so because that is the reality that I know best. I do not speak of the violence in Colombia from a nationalist perspective. I focus on the individual and not on the acts of violence that define the State. I am not interested in denouncing before an international audience what is

happening in my country here and now. I am aware that art has a precarious capacity to denounce.

Moreover, violence is present in the whole world and in all of us. As a result, I am interested in questioning the elements of violence endemic to human nature. Cruelty, indolence and hatred towards others are universal. I look for the possibility of making the connection between the one particular and harsh event that takes place in Colombia and the equally cruel and harsh everyday life that takes place elsewhere. Perhaps in other places it occurs in a more hidden and subtle way, yet one that is no less painful or unjust. As Levinas says, there are a thousand ways of spilling blood. For example, when we are sophisticated and cruel, one way to spill blood is to make the other person blush.

MEREWETHER What do you want those people who know little or nothing about the specific subject to take away with them, to remember?

SALCEDO As an artist, I do not try to control the experience of the viewer. I simply reveal – *expose* – an image. I use this word *expose* (*exponer*) because it implies vulnerability. The image is not finished in my studio; I complete it *in situ*, in the very space where the viewer will encounter it. What I propose is that everything that takes place in that space, once I have finished the work, occurs within the viewer's own space. Each person will – or will not – approach an artwork according to his or her spirit. What the viewers might come to feel, to remember, or to comprehend, is entirely dependent on their internal code.

MEREWETHER Can you say more about this in relation to the notion of community? And do you see your work as a way of trying to create different forms of community based on absence, loss, shared values and responsibility to each other?

SALCEDO The notion of community is born when the individual opens him or herself to others. To accompany someone to his or her death, step by step, opens us to the other, and leads us to forget our own existence, it unites us to that other, who will then remain inscribed inside us. The exhaustive investigation that I carry out on the deaths of the victims of violence, on the actual deed of the murder, leads me to accompany them, step by step, to that death, and in that sense I feel as though they are inscribed in me. Therefore, I assume responsibility towards the bereaved.

Without responsibility an idea of a community is also impossible. That is why I try to keep in mind the famous line from Dostoyevsky's *The Brothers Karamazov* that is also so close to what Levinas writes and which seems to me a good model to emulate, a proposition that we should all make our own: 'We are all responsible for everyone else – but I am more responsible than all the others.'

16 Franco Moretti (b. 1950) 'MoMA2000: The Capitulation'

The Museum of Modern Art in New York has since the 1930s been associated with the chronological account of modern art, and with that form of the account that has been identified as specifically Modernist. Throughout the mid-century its representation of modern

art appeared unmatched in qualitative terms, thanks to a combination of imaginative discrimination – particularly on the part of the first curator Alfred H. Barr – with levels of funding and patronage that European museums were unable to match. In white-painted galleries hung with notable masterpieces in unassuming frames, the visitor could trace a narrative of art in the twentieth century that led from Cézanne, via the Cubism of Braque and Picasso and the Fauvism of Matisse, through the twin currents of Surrealism and Abstract Art, to the American Abstract Expressionism of the 1940s and 1950s and the Post-Painterly Abstraction and Pop Art of the 1960s. So long as that narrative held sway – as it generally did until the early 1970s – the sheer authority of MOMA's collection remained unquestioned. But as Modernism itself came to be described and criticized, both as an historical account and as a system of values, so the museum's representational function and character were subject to sceptical scrutiny. In the year 2000 MOMA drastically revised the installation and presentation of its collection, replacing the traditional chronological hang with an arrange-ment in which works were grouped under themes. In the same year Tate Modern opened at Bankside in London as an offshoot of the old Tate Gallery at Millbank, its size, novelty and cosmopolitanism effectively consigning the parent institution to secondary status as the national museum of British art. Like MOMA 2000, Tate Modern presented its holdings under topical themes, abandoning the chronological principle that had prevailed while the modern collections were still held at Millbank. How should we interpret these fundamental changes in the presentation of major collections? As progressive responses to criticism; as belated attempts to keep up with intellectual fashion; or, as, suggested in the following text, as market-led betrayals of the critical purport of Modernism itself? Franco Moretti is an Italian Marxist literary critic who moved to the US and at the time of writing was teaching at Columbia University in New York. His publications include *Signs taken for Wonders* (1983), *Modern Epic* (1996) and *The Atlas of the European Novel 1800–1900* (1998). 'MoMA2000: The Capitulation' was originally published in *New Left Review*, London, second series, 4, July–August 2000, pp. 98–102, from which our complete version is taken.

I

A few months ago, The Museum of Modern Art of New York had a very large exhibition, entitled 'modern*starts*'. So large, in fact, that it was not shown alongside the permanent collections but instead of them (it occupied all three floors of the Museum). Given that 'modern*starts*' was just the beginning of the 'MoMA2000' project, and that the MoMA itself will move into a new building in four or five years, when the *Statement from the Director* spoke of 'a unique opportunity for the Museum to literally reconfigure many of its galleries', it was clear what was happening: they were trying to imagine a Modernism for the twenty-first century. What would it look like?

II

'modern*starts*' came in three parts ('People', 'Places' and 'Things'), with smaller sections entitled 'Actors, Dancers, Bathers', 'Guitars', 'Unreal City' or 'Tables and Objects'. It was a thematic exhibition, organized around subject-matter: train stations, trees, naked bodies, whatever. Not promising, in general. But since we are still looking for a coherent explanation of the Modernist big bang of ninety years ago, and you never know where a solution may come from – why not. After all, if the richest collection of Modernist art in the world reshuffles all its cards, and it turns out that aesthetic experiments somehow

'clustered' around two or three major themes, it would be fantastic. Not just an exhibition, but a true intellectual breakthrough: 'an experiment designed to offer a different understanding of modern art', as the Director said; while the Press people described it as 'unprecedented', 'unusual', 'unparalleled', 'provocative', 'fresh', 'major' and 'innovative', all in the first sixteen lines of their blurb. (Then they realized they'd forgotten 'radical', 'rethinking', 'probing' and 'unconventional', and got them all in, in the first sentence of the press release.) This is unfair, you will say, press packs are not for real. Maybe. But when I asked to have a brief chat with someone – anyone – involved in the project, to get a sense of what they had in mind, I was told that I should read the press release first, and only then could a meeting perhaps be arranged. I said I wasn't interested in the press release. They insisted. So I read it.

III

Anyway. Thematics and Modernism, such an odd pair, you go to the MoMA in high spirits. And quickly realize that 'modern*starts*' is indeed epoch-making, but in a totally unexpected way. Having seen it twice, and read the catalogue, the thematic thesis – namely, that the themes chosen can explain major Modernist 'starts' – is clearly untenable. Sure, they talk of the role of the metropolis and the war, but that's obvious, it's been a commonplace for eighty years now; it's even sort of true: but new, no. And when the claim is made more directly, it's a disaster. When the press release for 'Places' asserts that 'the unique quality of light in the port of Saint-Tropez influenced the use of the pointillist dots in Signac's *The Buoy*', of 1894, this is already very unconvincing, and becomes simply unreal a few lines later, when the same 'careful technique, a "pointillist" method' is said to arise four years earlier, on the opposite side of France, in Seurat's *The Channel at Gravelines, Evening*. (That pointillism originates in neither place does not help.)

IV

But if the thematic arrangement does not open your eyes, it is quite effective at closing them. Take the wall caption for the section 'Composing with the figure': speaking of Picasso's *Girl with Mandolin*, it states that 'we must puzzle out precisely what it represents', just like the other paintings, which 'offer similar puzzles to be deciphered'. Viewers are invited (twice) to treat Modernist technique as an odd arrangement of pieces: implicitly, as soon as the puzzle is solved, and the 'real' object has been teased out, it can simply be forgotten. 'We surely would never know what an actual guitar looks like from any one of these works,' says the wall caption of 'Guitars': 'Without exception, the artists rely upon our knowing what a guitar looks like in order to decipher the guitar from the fragmented parts.' Here even grammar (that 'guitar' repeated three times in two sentences, to make absolutely sure we won't miss it) reveals that the MoMA wants viewers to see 'through' the technique (collage, Cubism, whatever), and to focus on the 'actual' object instead. And indeed, if you manage to 'forget' that you are looking at a collage, Picasso's guitar becomes much more visible. *Why* you should do that, however, is a mystery. Since the emancipation of technique is the greatest feat of Modernism, treating it as a mere puzzle to be overcome destroys the whole point of this art. To see a guitar, you don't need the MoMA.

V

The peak of thematic euphoria is reached with four works by Kandinsky, in a room entitled 'Seasons and Moments'. Kandinsky painted them for the vestibule of Edwin R. Campbell, which has been reconstructed for the exhibition, so that the four panels can again be seen in their original position. Great idea. And it's breathtaking, the vestibule is small, maybe four metres across, so you're always a little too close to the canvases, everything blurs and bleeds, if you step back you end up with two or three of them simultaneously in view, at unwieldy angles. It's a fantastic experience of hyperstimulation and disorientation: 'too much for my bourgeois head,' as Thomas Buddenbrook would have said: the kind of impact that Modernism must have had then (and is so difficult to imagine now). Great. But for the MoMA the important thing is that these works are also known as 'The Four Seasons' (which is *not* their actual title: that is *Panel for Edwin R. Campbell No. 1, 2, 3, 4*), and all the wall caption has to say is that 'the so-called *Four Seasons* contain what look like simplified details from nature.' Whence a lively argument among three high-school students next to me on whether a certain shape could be seen as a pumpkin: which would identify the canvas as 'Fall', and give rise to a whole four-season sequence. They could have had the aesthetic experience of their lives; but the Museum sent them looking for pumpkins instead.

VI

A transparent Modernism, which emphasizes 'the actual guitar' at the expense of technique: silly, but inevitable result of a thematic model. But why on earth did the MoMA choose thematics in the first place? 'What did we want to achieve?' wonders Elderfield in 'Making modern*starts*'. And he replies, humbly: 'We wanted to offer something that is questioning and partial, instead of something that pretends to be definitive and comprehensive.' Mmmm. But three pages later: 'it was thought that, at the end of the century, the Museum's examination of its *entire* collection from beginning to end might be examined thematically. Thus, the Museum's whole cura-torial staff embarked on a study of large, overarching themes.' Now, how exactly is this a 'questioning and partial' idea? Sounds very definitive to me, if not mandatory, what with the whole staff embarking, the *entire* collection in italics (as if someone had raised an objection), the examination that must be examined . . . It's so superstitious, this turn to thematics, so unreflexive . . . Could it be hiding something? In planning 'People', writes Elderfield, they had initially imagined a section on 'Abstraction/Decompos-ition'; but after 'quite a long time we realized that, by dealing with Abstraction separately, we were creating enormous problems for ourselves, and quite possibly for the viewer.' Fascinating. For the MoMA, Abstraction is a *problem* ('enormous'). And one sees why, it is a formal category which disrupts the thematic monolith of 'mod-ern*starts*'. And then, worse, Abstraction is a sign of the old MoMA, which championed it in all its forms, from Cubism to Abstract Expressionism. Well, this 'most famous (if not, infamous) way that the Museum of Modern Art had arranged its narratives' is over.

VII

Why thematics? Because it downplays Abstraction. Enough of the old and difficult Modernism, let's join the figurative revival of the postmodern decades instead. So, after literature and music (return of plot, return of melody), the Counter-Modernist reaction is complete: the citadel of Modernism in the visual arts has raised the white flag. This is the only 'unprecedented' feat of MoMA2000. As I was looking at walls of guitars and pumpkins, I kept thinking of a passage in Schönberg's *Harmonielehre*, from 1922, where the author, very politely, like the good bourgeois that he was, points out that it is 'the imperfection of our senses that drives us to those compromises through which we achieve order. Such order is however not demanded by the object, but by the subject.' What Schönberg means here is something a little crazy, namely that human beings ('our senses') have become obstacles to aesthetic production because of their 'imperfection'. A little crazy, indeed: but if you decide to compose not-for-our-senses, the strangest new worlds suddenly become imaginable. And for better or worse, this is what Modernism did.

Since 1922, however, our senses (and commonsenses) have regained the upper hand, and the figurative revival is the final chapter of the story. It's an amazing restoration of order – of the market, as Perry Anderson writes in his recent *Origins of Postmodernity*: the market that had somehow been eluded in the Modernist years. For a brief moment, the gate of the iron cage had remained open, and a season of incredible technical freedom ensued. Then the market slowly resumed its control of aesthetic production (as of everything else), and the gate was shut down again. Now the Museum of Modern Art has locked it, and congratulated itself for doing so.

Bibliography

This bibliography combines the following types of reference in one alphabetical listing, with cross-reference where appropriate.

1 Sources for all those texts which are printed and excerpted in the anthology, with dates of original publication given in brackets, by author. (For example, Braque, G., 'Thoughts on Painting' (1917), in E. Fry, 1986; in this case a cross-reference to 'Fry, E.' will give the recent source in the anthology *Cubism*, London and New York, 1986.) The editorial prefaces to the individual anthologized texts should be consulted for more detailed references to original occasions of publication.

2 Collections of theoretical and critical materials in which these and related texts may be found, by artist/author (e.g. Kandinsky 1982, Léger 1973, Malevich 1969), or by editor for compilations from more than one artist/author (e.g. Bann, Bowlt, Lippard).

3 Sources for relevant texts which are not themselves included in the anthology but which are referred to or quoted within either editorial matter or anthologized texts (e.g. Bernard 1912, Duhamel 1930, Lukács 1934).

4 Relevant sources for those authors referred to within anthologized texts, whose work falls outside the scope of the anthology on chronological or other grounds, but whose ideas have nevertheless played a significant part in the development of thought about art during the twentieth century (e.g. Baudelaire, Hegel, Marx, Wagner).

5 Some further sources for twentieth-century material of relevance to concerns addressed in the anthology (e.g. Bell 1928, Caute, Eagleton).

AAA Yearbooks, New York, 1969
Abstraction-Création, editorial statements from *Cahiers* nos. 1 and 2, Paris, 1932–3 (IVA4)
Adler, B. (ed.), *Utopia. Dokumente der Wirklichkeit*, Weimar, 1921
Adorno, T. W., Letter to Benjamin (1936), in Adorno et al., 1977 (IVD7)
Adorno, T. W. (1950), *see* Sedlmayr, H. and Adorno, T. W.
Adorno, T. W., 'Commitment' (1962), in Arato and Gebhardt, 1978 (VIB6)
Adorno, T. W., *The Jargon of Authenticity* (1964), London, 1973
Adorno, T. W., *Aesthetic Theory* (1970), London and Boston, 1984; new edn. Minneapolis, 1992
Adorno, T. W., *The Philosophy of Modern Music*, London, 1973
Adorno, T. W. et al., *Aesthetics and Politics*, London, 1977
AKhRR, 'Declaration' (1922), in Bowlt, 1988 (IVB2)
AKhRR, 'The Immediate Tasks of AKhRR' (1924), in Bowlt, 1988 (IVB3)
Alberro, A. and Stimson, B. (eds.), *Conceptual Art: A Critical Anthology*, Cambridge, MA, and London, 2000

Alloway, L., 'The Arts and the Mass Media', in *Architectural Design*, London, February 1958 (VIA6)

Althusser, L., *For Marx* (1965), London, 1969

Althusser, L., 'Ideology and Ideological State Apparatuses' (1969), in Althusser, 1971 (VIID3)

Althusser, L., *Lenin and Philosophy and Other Essays*, London, 1971

American Abstract Artists, editorial statement (1938), in *AAA Yearbooks*, New York, 1969 (IVA12)

Anderson, P., *Considerations on Western Marxism*, London, 1976

Anderson, P., *In the Tracks of Historical Materialism*, London, 1983

Anderson, P., *The Origins of Postmodernity*, London, 1998.

Andre, C., 'Preface to Stripe Painting', in *Sixteen Americans*, New York, 1959 (VIIA2)

Apollinaire, G., 'The Cubists' (1911), in Apollinaire, 1972 (IIB2)

Apollinaire, G., 'On the Subject in Modern Painting' (1912), in Apollinaire, 1972 (IIB3)

Apollinaire, G., The New Painting: Art Notes' (1912), in Apollinaire, 1972 (IIB4)

Apollinaire, G., *The Cubist Painters: Aesthetic Meditations* (1913), New York, 1944 (IIB5)

Apollinaire, G., 'The New Spirit and the Poets' (1918), in Apollinaire, 1971 (IIIA2)

Apollinaire, G., *Selected Writings of Guillaume Apollinaire*, ed. R. Shattuck, New York, 1971

Apollinaire, G., *Apollinaire on Art*, ed. L. Breunig, London, 1972

Apollonio, U., *Futurist Manifestos*, London and New York, 1973

Aragon, L., *Paris Peasant* (1924), London 1971

Aragon, L. et al., 'Declaration of the Bureau de Recherches Surréalistes' (1925), in M. Nadeau, *The History of Surrealism*, New York, 1965 (IVC4)

Arato, A. and Gebhardt, E., *The Essential Frankfurt School Reader*, Oxford and New York, 1978

ARBKD (Asso), 'Manifesto' and 'Statutes' (1928), in Schneede, 1979 (IVB7)

Arnheim, R., *Art and Visual Perception*, London and New York, 1956

Arnold, M., 'Culture and Anarchy' (1869), in *Matthew Arnold. Selected Poetry and Prose*, New York, 1953

Arp, H., catalogue introduction (1915), in Poley, 1978 (IIIC1)

Art & Language (T. Atkinson), Editorial Introduction to *Art-Language* (1969), in de Vries, 1974, and Art & Language, 1980 (VIIB5)

Art & Language, Editorial to *Art-Language*, Banbury, vol. 3, no. 3, June 1976 (VIIC14)

Art & Language, *Art & Language*, Eindhoven (Van Abbe Museum), 1980

Art & Language, 'Letter to a Canadian Curator' (1982), in *Art-Language*, Banbury, vol. 5, no. 1, October 1982 (VIIIA7)

Art & Language *see also* Atkinson, T. and Baldwin, M.; Burn, I.; Burn, I. and Ramsden, M.; and Ramsden, M.

Art Workers' Coalition, Statement of Demands (1970), in Lippard, 1971(a) (VIIC6)

Artaud, A., *Van Gogh: The Man Suicided by Society* (1947), in Artaud, 1988 (VB5)

Artaud, A., *Antonin Artaud. Selected Writings*, ed. S. Sontag, Los Angeles, 1988

Artforum, 'The Artist and Politics: a Symposium', *Artforum*, New York, September 1970 (VIIC5)

Asso *see* ARBKD

Atkinson, T., *see also* Art & Language, 1969, 1980

Atkinson, T. and Baldwin, M., 'Air Show' (1967), in *Art & Language*, 1980 (VIIB1)

Atlan, J.-M., 'Abstraction and Adventure in Contemporary Art' (1950), in *Paris-Paris*, Paris (Centre Pompidou), 1981 (VB9)

Aurier, G.-A., 'Les peintres symbolistes', *Revue Encyclopédique*, Paris, April 1892; repr., in G.-A. Aurier, *Oeuvres posthumes de G.-Albert Aurier*, Paris, 1893

Ayer, A. J., *Language, Truth and Logic* (1936), 2nd edn, London, 1946

Bachelard, G., *The Psychoanalysis of Fire* (1938), Boston and London, 1964

Bachelard, G., *L'Air et les Songes*, Paris, 1943

Bachelard, G., *The Poetics of Reverie* (1960), New York, 1969

Bacon, F., Interview with David Sylvester (1962), in Bacon 1987 (VB14)

Bacon, F., *The Brutality of Fact*, ed. D. Sylvester, London, rev. edn 1987

Bahr, H., *Expressionism* (1916), London, 1920 (IB18)

Baldwin, M. *see* Atkinson, T. and Baldwin, M.

Baldwin, M. *see also* Art & Language

Ball, H., 'Dada Fragments' (1916–17), first published in Ball, *Flight from Time*, Leipzig and Munich, 1927; in Motherwell, 1951 (IIIB1)

Bann, S. (ed.), *The Tradition of Constructivism*, London and New York, 1974

Barnes, B., *Interests and the Growth of Knowledge*, London, 1977

Barr, A. H. Jr., *Cubism and Abstract Art*, New York (Museum of Modern Art), 1936 (IVA7)

Barr, A. H. Jr., *Picasso: Fifty Years of his Art*, New York (Museum of Modern Art), 1946

Barr, A. H. Jr., 'Is Modern Art Communistic?' (1952), in Barr, 1986 (VC17)

Barr, A. H. Jr., *Defining Modern Art*, New York, 1986

Barry, R., Interview with Arthur R. Rose (1969), in Battcock, 1973 (VIIA10)

Barthes, R., 'Myth Today' (1956), in Barthes, 1972 (VIA1)

Barthes, R., *Mythologies* (1957), London, 1972

Barthes, R., 'The Death of the Author' (1968), in Barthes, 1977

Barthes, R., *S/Z* (1970), New York, 1974

Barthes, R., 'Change the Object Itself' (1971), in Barthes, 1977

Barthes, R., 'From Work to Text' (1971), in Barthes, 1977 (VIID5)

Barthes, R., *Image, Music, Text*, London, 1977

Barthes, R., *Camera Lucida: Reflections on Photography* (1980), London, 1982

Baselitz, G., 'Pandemonium Manifestos' (1961–2), in Georg Baselitz, *Paintings 1960–1983*, London (Whitechapel Art Gallery), 1983 (VB13)

Bataille, G., 'The *Lugubrious Game*' (1929), in Bataille, 1968 (IVC13)

Bataille, G., 'Critical Dictionary' (1929–30), in Bataille, 1968 (IVC12)

Bataille, G., *Documents*, Paris, 1968

Bataille, G., *Oeuvres complètes*, Paris, 1970

Battcock, G. (ed.), *The New Art*, New York, 1966

Battcock, G. (ed.), *Minimal Art*, New York, 1968

Battcock, G. (ed.), *Idea Art*, New York, 1973

Baudelaire, C., *The Painter of Modern Life and Other Essays by Charles Baudelaire*, ed. J. Mayne, Oxford, 1964 (*Art in Theory 1815–1900*, IIID8)

Baudelaire, C., *Art in Paris 1845–1862: Salons and other exhibitions reviewed by Charles Baudelaire*, ed. J. Mayne, Oxford, 1965, repr. 1981 (*Art in Theory 1815–1900*, IID13)

Baudelaire, C., *Oeuvres complètes*, ed. Y. G. le Dantec, rev. C. Pichois, Paris, 1961

Baudrillard, J., *For a Critique of the Political Economy of the Sign* (1972), St Louis, MO, 1981

Baudrillard, J., 'Ethic of Labour, Aesthetic of Play' (1973), in Baudrillard, 1975 (VIID9)

Baudrillard, J., *The Mirror of Production* (1973), St Louis, MO, 1975

Baudrillard, J., 'The Hyper-realism of Simulation' (1976), in Baudrillard, 1988 (VIIIA1)

Baudrillard, J., *Jean Baudrillard. Selected Writings*, ed. M. Poster, Stanford, CA, 1988

Baxendall, L. (ed.), *Radical Perspectives in the Arts*, Harmondsworth, 1972

Beckett, S. and Duthuit, G., *Three Dialogues: Tal Coat, André Masson, Bram Van Velde* (1949) in S. Beckett and G. Duthuit, *Proust. Three Dialogues*, London, 1965 (VB7)

Beckmann, M., 'Creative Credo' (1918/20), in V. Miesel, 1970 (IIIB11)

Bell, C., *Art* (1914), Oxford, 1987 (IB16)

Bell, C., *Civilization* (1928), London, 1932

Bell, D., *The End of Ideology* (1960), rev. edn, New York, 1965

Bell, D., *The Cultural Contradictions of Capitalism*, New York, 1976, rev. edn 1978

Bell, D., 'Beyond Modernism, Beyond Self' (1977), in Bell, *Sociological Journeys 1960–1980*, London and New York, 1980

Bell, D., 'Modernism and Capitalism', in Bell, 1978 (VIIC1)

Benjamin, W., *The Origin of German Tragic Drama* (1928), London, 1977

Benjamin, W., 'The Author as Producer' (1934), in Benjamin, 1983 (b) (IVC17)

Benjamin, W., 'The Work of Art in the Age of Mechanical Reproduction' (1936), in Benjamin, 1973 (IVD6)

Benjamin, W., *Illuminations* (1955), ed. H. Arendt, London, 1973

Benjamin, W., *Charles Baudelaire: A Lyric Poet In The Era of High Capitalism* (1955/71), London, 1983 (a)

Benjamin, W., *Understanding Brecht* (1966), London, 1983 (b)

Benjamin, W., *One-Way Street and Other Writings*, New York and London, 1979

Benton, T. and C. and Sharp, D. (eds), *Form and Function*, London, 1975

Berger, J., 'Another Way of Telling', *Journal of Social Reconstruction*, London, 1, January–March 1980

Berger, J., *Ways of Seeing*, London, 1972

Bergson, H., *Matter and Memory* (1896), New York, 1960

Bergson, H., *Creative Evolution* (1907), London, 1911 (IIA4)

Berman, M., *All That Is Solid Melts Into Air. The Experience of Modernity*, New York, 1982

Bernard, E., *Souvenirs sur Paul Cézanne*, Paris, 1912

Beuys, J., 'Not just a few are called, but everyone', conversation with G. Jappe, *Studio International*, vol. 184, no. 950, London, December 1972 (VIIB12)

Beuys, J., 'I am searching for Field Character' (1973), in Beuys, 1990 (VIIC8)

Beuys, J., *Energy Plan for the Western Man*, New York, 1990

Beuys, J., Kounellis, J., Kiefer, A., Cucchi, E., 'The Cultural-Historical Tragedy of the European Continent', *Flash Art*, no. 128, Milan, May–June 1986 (VIIIC7)

Bhabha, H., *The Location of Culture*, London and New York, 1994 (VIIIB17)

Bhabha, H. (ed.), *Nation and Narration*, London, 1990

Bickerton, A. *see* Steinbach et al., 1986

Blavatsky, H. P., *The Secret Doctrine*, London, 1888

Bloch, E., 'Discussing Expressionism' (1938/62), in Adorno et al., 1977 (IVD8)

Blok, A., 'Nature and Culture' (1908), in Blok, 1946 (IIA5)

Blok, A., 'The Decline of Humanism' (1918), in Blok, 1946 (IIIB7)

Blok, A., *The Spirit of Music*, London, 1946

Bloom, H., *The Anxiety of Influence*, Oxford and New York, 1973

Boccioni, U., et al., 'Futurist Painting: Technical Manifesto' (1910), in *Futurist Painting*, London (Sackville Gallery), 1912; repr. in Apollonio, 1973 (IIA7)

Borges, J.-L., 'From Allegories to Novels', in Borges, *Other Inquisitions*, Austin, TX, 1964

Bourdieu, P., 'Being Different' (1977), in *The Field of Cultural Production*, Cambridge, 1993 (VIIIA2)

Bourdieu, P., *Distinction* (1979), London, 1984

Bourgeois, L., Interview with Donald Kuspit, in *Louise Bourgeois. Destruction of the Father, Reconstruction of the Father: Writings and Interviews 1923–1997*, Cambridge, MA, 1998 (VIIIB10)

Bowlt, J., *Russian Art of the Avant Garde*, rev. edn., London and New York, 1988

Braque, G., 'Thoughts on Painting' (1917), in E. Fry, 1986 (IIB11)

Brecht, B., 'Popularity and Realism' (1938), in Adorno et al., 1977 (IVC18)

Breton, A., (first) 'Manifesto of Surrealism' (1924), in Breton, 1969 (IVC2)

Breton, A., *Surrealism and Painting* (1928), London, 1936 IVC5)

Breton, *Nadja* (1928), New York, 1960

Breton, A., 'Second Manifesto of Surrealism' (1929), in Breton, 1969 (IVC6)

Breton, A., *Manifestoes of Surrealism*, Ann Arbor, MI, 1969

Breton, A., Rivera, D. and Trotsky, L., 'Towards a Free Revolutionary Art' (1938), in Trotsky, 1970 (IVD9)

Brett, G., *Hélio Oiticica*, Rotterdam and Minneapolis, 1992

Brik, O., 'The So-called "Formal Method"' (1923), in *Form*, Brighton, no. 10, October 1969 (IIID10)

Brik, O., 'From Picture to Calico-Print' (1924), in *Form*, Brighton, no. 10, October 1969 (IIID11)

Brik, O., 'Photography versus Painting' (1926), in D. Elliott (ed.), *Rodchenko*, Oxford (Museum of Modern Art), 1979 (IVC8)

Britt, D., *Gerhard Richter, The Daily Practice of Painting. Writings and Interviews 1962–1993*, London, 1995

Broodthaers, M., 'To be *bien pensant* . . . or not to be' (1975), in Buchloh, 1987 (VIIC10)

Buchloh, B. H. D., *Neo-avantgarde and Culture Industry*, Cambridge, MA, 2000

Buchloh, B. H. D. (ed.), *Broodthaers. Writings, Interviews, Photographs*, Cambridge, MA, 1987

Buren, D., 'Beware' (1969), in de Vries, 1974, Buren, 1991 (VIIA13)

Buren, D., *Daniel Buren: Les Ecrits 1965–1990*, 3 vols, Bordeaux (Musée d'Art Contemporain), 1991

Buren, D., Mosset, O., Parmentier, M., Toroni, N., Statement (1967), *Studio International*, London, vol. 177, no. 907, January 1969 (VIIA12)

Bürger, P., *Theory of the Avant Garde* (1972), Manchester and Minneapolis, 1984

Burgin, V., 'Situational Aesthetics' (1969), in de Vries, 1974 (VIIB8)

Burgin, V., *Work and Commentary*, London, 1972

Burgin, V., 'Socialist Formalism', *Studio International*, London, vol. 191, no. 980, March–April 1976 (VIIC13)

Burgin, V., 'The Absence of Presence' (1984), in Burgin, 1986 (VIIIB5)

Burgin, V., *The End of Art Theory*, London, 1986

Burgin, V. (ed.), *Thinking Photography*, London, 1982

Burke, E., *A Philosophical Enquiry into the Origin of Our Ideas of the Sublime and Beautiful* (1757), Bloomington, IN, 1968 (*Art in Theory 1648–1815*, IIIB6)

Burn, I., 'The Art Market: Affluence and Degradation' (1975), in *Artforum Anthology*, New York, 1984 (VIIC12)

Burn, I. and Ramsden, M., 'The Role of Language' (1969), in de Vries, 1974 (VIIB6)

Butor, M., *Inventory*, London, 1970

Cage, J., 'On Robert Rauschenberg, Artist, and his Work' (1961), in Cage, 1969 (VIA13)

Cage, J., *A Year From Monday*, London, 1968

Cage, J., *Silence*, Cambridge, MA, 1969

Cage, J., *M: Writing '67–'72*, London, 1973

Callinicos, A., *Against Postmodernism*, Cambridge, 1989

Caro, A., Noland, K. and Olitski, J., edited conversation, in *Monad*, London (Chelsea College of Art), vol. 1 no. 1, Summer 1964

Carrà, C., 'Our Antiquity' (1916–18), in Carrà, 1971 (IIIA4)

Carrà, C., *Metaphysical Art*, ed. M. Carrà, London and New York, 1971

Carroll, D., *Paraesthetics*, London and New York, 1987

Casanova, L., *Le Communisme, la pensée et l'art*, Paris, 1947

Caudwell, C., *Illusion and Reality* (1937), London, 1971

Caudwell, C., *Studies in a Dying Culture* (1938), London, 1971

Caute, D., *Sixty-Eight: The Year of the Barricades*, London, 1988

Cavell, S., 'A Matter of Meaning It' (1967), in Cavell, 1969 (VIB12)

Cavell, S., *Must We Mean What We Say?*, New York, 1969

Celant, G., *Art Povera*, London and Milan, 1969 (VIIB10)

Cézanne, P., *Cézanne's Letters*, ed. J. Rewald (1941), Oxford, 1976 (IA6; see also *Art in Theory 1815–1900*, IVA5 and VIB17)

Cézanne, P. *see also* Bernard, E., Denis, M., 1910

Chandler, J. *see* Lippard, L. and Chandler, J.

Cheney, S., *A Primer of Modern Art* (1924), rev. edn., New York, 1939

Cheney, S., *Expressionism in Art*, New York, 1934

Chipp, H. B., *Theories of Modern Art*, Berkeley, CA, Los Angeles and London, 1968

Chirico, G. de, 'Mystery and Creation' (1913), in *London Bulletin*, London, no. 6, October 1938 (IA11)

Chirico, G. de, 'The Return to the Craft' (1920), in Carrà, 1971 (IIIA6)

Chomsky, N., *Language and Mind*, New York, 1972

Chomsky, N., *Problems of Knowledge and Freedom*, London, 1972

Clark, T. J., *Image of the People* (1973), London, 1982

Clark, T. J., *The Absolute Bourgeois* (1973), London, 1982

Clark, T. J., 'Preliminaries to a Possible Treatment of Olympia in 1865', in *Screen*, vol. 21, no. 1, London, Spring 1980. Revised and expanded in chapter 2 of Clark, *The Painting of Modern Life*, London, 1985

Clark, T. J., 'Clement Greenberg's Theory of Art' (1982), in Frascina, 1985

Clay, J., 'Some aspects of bourgeois art', in *Studio International*, London, June 1970

Clifford, J., *The Predicament of Culture* (1979–1986), Cambridge, MA, 1988

Coleridge, S. T., *Coleridge's Miscellaneous Criticism*, ed. T. M. Raysor, Cambridge, MA, 1936

Collingwood, R. G., 'Good Art and Bad Art', in *The Principles of Art* (1938), Oxford, 1958 (IVD10)

Communist Party (Soviet Union), Central Committee, 'Decree on the Reconstruction of Literary and Artistic Organizations' (1932), in Bowlt, 1988 (IVB11)

Constant (Constant A. Nieuwenheuys), 'Our Own Desires Build the Revolution' (1949), in Chipp, 1968 (VC11)

Crimp, D., 'Pictures', *October* 8, Cambridge, MA, Spring 1979

Croce, B., *Aesthetic* (1902), New York, 1966

Croce, B., *Guide to Aesthetics* (1913), Indianapolis, 1965 (IB15)

Cucchi, E. *see* Beuys et al., 1986

Dali, S., 'The Stinking Ass' (1930), in Lippard (ed.) 1971(b) (IVC14)

Damisch, H., 'Eight Theses For (or Against?) a Semiology of Painting', *Enclitic*, Los Angeles, vol. 3, no. 1, Spring 1979

Davis, S., 'Abstract Painting in America' (1935), in Kelder, 1971 (IVB17)

Davis, S., 'A Medium of 2 Dimensions' (1935), in Kelder, 1971 (IVB17)

De Stijl, 'Manifesto 1' (1918/22), in Bann, 1974 (IIIC4)

Debord, G., *The Society of the Spectacle* (1967), Detroit, 1983

Debord, G., Writings from the Situationist International, in K. Knabb (ed.), 1981 (VIA3)

Delacroix, E., *The Journal of Eugène Delacroix* (1822–63), London, 1951 (see *Art in Theory 1815–1900*, IA3 and 15, IIIA4, IIIB2)

Delaunay, R., 'On the Construction of Reality in Pure Painting' (1912), in Delaunay, 1957 (IIA8)

Delaunay, R., *Du Cubisme à l'art abstrait, documents inédits*, ed. P. Francastel, Paris, 1957

Deleuze, G. and Guattari, F., *Anti-Oedipus* (1972), Minneapolis, 1983

DeMan, P., *Blindness and Insight* (1971), London, 1983

DeMan, P., *Allegories of Reading*, New Haven, 1979

Denis, M., 'From Gauguin and Van Gogh to Neo-Classicism' (1909), in Denis, 1912 (IA9)

Denis, M., trans. R. Fry, 'Cézanne', *Burlington Magazine*, London, XVI, Jan.–Feb. 1910 (IA8)

Denis, M., *Théories 1890–1910*, Paris, 1912 (see also *Art in Theory 1815–1900*, VC10)

Derain, A., 'On Raphael' (1920), in *Les Réalismes 1919–1939*, Paris (Centre Pompidou), 1980 (IIIA9)

Derain, A., *Lettres à Vlaminck*, Paris, 1955 (IB3)

Derrida, J., *Of Grammatology* (1967), Baltimore, MD, 1976

Derrida, J., 'The Exorbitant: Question of Method', and 'The Engraving and the Ambiguities of Formalism', in Derrida, 1976 (VIID1)

Derrida, J., *The Truth in Painting* (1978), Chicago, 1987

Derrida, J., *Writing and Difference*, London, 1978

Descartes, R., *A Discourse on Method and Other Writings*, (*c*.1637), London, 1968

Dewey, J., *Art as Experience*, New York, 1934

Diederichsen, D., 'Which Side Are You On, Cultural Worker?', in *Immendorffs Handbuch der Akademie für Adler*, Cologne, 1990 (VIIIC11)

Dix, O., 'The Object Is Primary' (1927), in Schneede, 1979 (IVB6)

Doesburg, T. van, Lissitsky, E. and Richter, H., 'Declaration of the International Fraction of Constructivists of the First International Congress of Progressive Artists', in *De Stij*, Scheveningen, V, 4, 1923 (IIIC16)

Doesburg, T. van, *Principles of Neo-Plastic Art* (1925), London, 1969 (IIIC5)

Dondero, G., 'Communists Maneuver to Control Art in the United States', and 'Modern Art Shackled to Communism', in *Congressional Record*, Washington, DC, 1949 (VC15)

Dubuffet, J., 'Notes for the well-lettered' (1945), in Dubuffet 1967 (VB3)

Dubuffet, J., 'Crude Art Preferred to Cultural Art' (1948), in Dubuffet 1967 (VB4)

Dubuffet, J., *Prospectus et tous écrits suivants*, Paris, 1967

Duchamp, M., 'The Richard Mutt Case' (1917), in Lippard, 1971(b) (IIIB2)

Duchamp, M., *Dialogues with Marcel Duchamp* (1967), ed. P. Cabanne, London and New York, 1971

Duchamp, M., *Salt Seller: The Writings of Marcel Duchamp*, ed. M. Sanouillet and E. Peterson, New York, 1973

Duhamel, G., *Scènes de la vie future*, Paris, 1930

Dumouchel, P. and Dupuy, J.-P. (eds), *L'auto-organisation: de la physique au politique*, Paris, 1983

Duthuit, G. *see* Beckett, S. and Duthuit, G.

Duve, T. de, *Kant After Duchamp*, Cambridge, MA, 1996

Eagleton, T., *The Ideology of the Aesthetic*, Oxford, 1990

Ehrenburg, I. *see* Lissitsky, E. and Ehrenburg, I.

Ehrenzweig, A., *The Hidden Order of Art*, London, 1967

Einstein, C., *Negerplastik* (1915), Munich, 1920 (IB17)

Eliot, T. S., *Notes Towards the Definition of Culture*, London, 1948

Endell, A., 'The Beauty of Form and Decorative Art' (1897–98), in Benton and Sharp, 1975 (IB1)

Engels, F., Letter to Margaret Harkness (1888), in Marx and Engels, 1973 (see *Art in Theory 1815–1900*, VB6)

Engels, F. *see also* Marx, K. and Engels, F.

Ernst, M., 'What is Surrealism?' (1934), in *Max Ernst: Gemälde. Plastiken. Collagen. Frottagen. Bücher*, Stuttgart, 1979 (IVC16)

Ernst, M., *Beyond Painting* (1936), New York, 1948

Evers, H. G. (ed.), *Darmstädter Gespräch: Das Menschenbild in unserer Zeit*, Darmstadt, 1950

Export, V., 'Woman's Art', in *Neues Forum*, Vienna, vol. XX, no. 228, January 1973 (VIIC7)

Fanon, F., *Black Skin, White Masks* (1952), London, 1968

Fanon, F., 'On National Culture' (1959), in *The Wretched of the Earth*, Harmondsworth, 1974 (VIA5)

Felix, Z., *Ilya Kabakov. The Text as the Basis of Visual Expression*, Cologne, 2000

Feuerbach, L., *The Essence of Christianity* (1841), London, 1854 (see *Art in Theory 1815–1900*, IIA8)

Fineman, J., 'The Structure of Allegorical Desire', *October*, Cambridge, MA, 12, Spring 1980

Fischer, E., *The Necessity of Art* (1959), Baltimore, MD, and London, 1963

Fletcher, A., *Allegory: The Theory of a Symbolic Mode*, Ithaca, NY, 1964

Foerster, H. von, 'On Self-Organizing Systems and their Environments', in Yovits and Cameron, 1960

Fontana, L., 'Manifesto Blanco', Buenos Aires, 1946 (VC8)

Fortini, F., 'The Writers' Mandate and the End of Anti-Fascism', *Screen*, London, vol. 15, no. 1, 1974

Foster, H. (ed.), *Post Modern Culture* (as *The Anti-Aesthetic*, Seattle, 1983), London 1985(a)

Foster, H., 'Subversive Signs', in Foster, 1985(b) (VIIIA5)

Foster, H., *Recodings: Art, Spectacle, Cultural Politics*, Seattle, 1985(b)

Foster, H. (ed.), *DIA Art Foundation Discussions in Contemporary Culture No. 1*, Seattle, 1987

Foster, H. (ed.), *Vision and Visuality. DIA Art Foundation Discussions in Contemporary Culture No. 2*, Seattle, 1988

Foucault, M., *The Order of Things* (1966), New York, 1970

Foucault, M., *The Archaeology of Knowledge* (1969), New York, 1972

Foucault, M., 'What is an Author?' (1969), in Harari, 1979 (VIID2)

Foucault, M., *Discipline and Punish. The Birth of the Prison* (1975), New York, 1977(a)

Foucault, M., 'A Lecture' (1976), in Foucault, 1980 (VIID11)

Foucault, M., *Language, Counter-Memory, Practice. Selected Essays and Interviews*, Ithaca, NY, 1977(b)

Foucault, M., *Power/Knowledge. Selected Interviews and Other Writings 1972–1977*, Brighton, 1980

Foucault, M., *The History of Sexuality* (3 vols: 1976, 1984), New York, 1978, 1984

Fougeron, A., 'The Painter on his Battlement', in *La Nouvelle Critique*, Paris, December 1948 (VC13)

Frascina, F. (ed.), *Pollock and After: The Critical Debate*, London, 1985

Frascina, F. and Harrison, C. (eds), *Modern Art and Modernism: A Critical Anthology*, London, 1982

Fraser, R., *1968: A Student Generation in Revolt*, London, 1988

Freud, S., 'On Dreams', in Freud, 1953–74 (IA3)

Freud, S., *The Standard Edition of the Complete Psychological Works of Sigmund Freud*, 24 vols, ed. J. Strachey, London, 1953–74. (See especially: vols IV and V, *The Interpretation of Dreams* (1900), and *On Dreams* (1901); vol. VI *The Psychopathology of Everyday Life* (1901); vol. VII, *Three Essays on Sexuality* (1905); vol. IX, *Delusions and Dreams in Jensen's 'Gradiva'* (1907); vol. XI, *Leonardo da Vinci and a Memory of his Childhood* (1910); vol. XIII, *Totem and Taboo* (1913); vol. XIV, *Instincts and their Vicissitudes* (1915); vol. XVII, *From the History of an Infantile Neurosis* (*The Wolfman* (1914–18), and *The Uncanny* (1919)); vol. XIX, *Some Psychical Consequences of the Anatomical Distinction Between the Sexes* (1925); vol. XXI, *Fetishism* (1927), and *Civilisation and Its Discontents* (1929). Vol. XXI also contains a 'List of Writings by Freud dealing mainly or largely with Art, Literature or the Theory of Aesthetics'.)

Freud, S., *Art and Literature*, The Penguin Freud Library, vol. 14, ed. A. Dixon, London, 1985

Fried, M., *Three American Painters*, Harvard (Fogg Art Museum), 1965, repr. in Fried, 1998. (VIB9)

Fried, M., 'Shape as Form', in *Artforum*, New York, November 1966 repr. in Fried, 1998. (VIB10)

Fried, M., 'The Achievement of Morris Louis', in *Artforum*, New York, February 1967, repr. in Fried, 1998.

Fried, M., 'Art and Objecthood' (1967), in Battcock, 1968, Philipson and Gudel, 1980, repr. in Fried, 1998. (VIIA7)

Fried, M., *Absorption and Theatricality. Painter and Beholder in the Age of Diderot*, Los Angeles, 1980

Fried, M., *Art and Objecthood: Essays and Reviews*, Chicago and London, 1998.

Fry, E., *Cubism*, London and New York, 1986

Fry, R., 'An Essay in Aesthetics' (1909), in Fry, 1920 (IB7)

Fry, R., *Vision and Design* (1920), Oxford, 1981

Fry, R., *Transformations*, London, 1926

Fry, R., *Cézanne: A Study of his Development*, London, 1927

Frye, N., *Anatomy of Criticism*, Princeton, NJ, 1957

Gablik, S. *see* Russell, J. and Gablik, S.

Gabo, N., 'The Constructive Idea in Art', in Martin, Nicholson, Gabo, 1937 (IVA9)

Gabo, N. and Pevsner, A., 'The Realistic Manifesto' (1920), in H. Read (ed.), *Gabo*, London, 1957 (IIIC10)

Gabo, N. *see also* Martin, J. L., Nicholson, B. and Gabo, N. (eds.)

Gan, A., *Constructivism* (1922), excerpts in C. Gray, *The Great Experiment: Russian Art 1863–1922*, London and New York, 1962, Bann, 1974, Bowlt, 1988 (IIID7)

Garvin, P. L., *A Prague School Reader on Esthetics, Literary Structure and Style*, Washington, DC, 1964

Gaudier-Brzeska, H., 'Gaudier-Brzeska Vortex' (1914), in Pound, 1916 (IIA13)

Gaudier-Brzeska, H., 'Vortex Gaudier-Brzeska (Written from the Trenches)' (1915), in Pound, 1916 (IIA13)

Gauguin, P., Letter to Fontainas (1899), in Gauguin, 1943 (IA2; see also *Art in Theory 1815–1900*, VIB18, VIC9 and 12

Gauguin, P., *Letters to Ambroise Vollard and André Fontainas*, ed. J. Rewald, San Francisco, 1943

Gebhardt, E. *see* Arato, A. and Gebhardt, E.

Gleizes, A. and Metzinger, J., *Cubism* (1912), in Herbert, 1974 (IIB7)

Gleizes, A., 'The Dada Case' (1920), in Motherwell, 1951 (IIIA8)

Goethe, J. W. von, *Elective Affinities* (1807), Chicago, 1963

Goethe, J. W. von, *Goethe's Theory of Colours* (1810), London (1840), London 1967 (*Art in Theory 1648–1815*, VIIA9; see also ibid. VA4, VB7, VIIA1 and *Art in Theory 1815–1900*, IA12)

Goffman, E., *Frame Analysis: An Essay on the Organization of Experience*, New York, 1974

Gombrich, E., *Art and Illusion. A Study in the Psychology of Pictorial Representation* (1956), 5th edn, London and Washington, DC, 1977

Goodman, N., *Languages of Art*, Bloomington, IN, 1976

Gottlieb, A., Rothko, M. and Newman, B., Statement (1943), in Johnson, 1982 (VA2)

Gottlieb, A., Statement (1947), in Tuchman, 1971 (VA7)

Graham, D., Presentation to an Open Hearing of the Art Workers' Coalition (1969), in Alberro and Stimson, 2000 (VIIC2)

Gramsci, A., *Selections From the Prison Notebooks of Antonio Gramsci*, ed. Q. Hoare and G. Nowell-Smith, London, 1971

Gramsci, A., *Selections From the Cultural Writings*, ed. D. Forgacs and G. Nowell-Smith, London, 1985

GRAV (Groupe de Recherche d'Art Visuel), 'Transforming the Current Situation of Plastic Art', in *Force Fields. Phases of the Kinetic*, London, 2000 (VIA10)

Gray, C., *The Russian Experiment in Art 1863–1922*, London, 1971

Greenberg, C., 'Avant-Garde and Kitsch' (1939), in Greenberg, 1961, and Greenberg, 1986 (IVD11)

Greenberg, C., 'Towards a Newer Laocoon' (1940), in Greenberg, 1986 (VA1)

Greenberg, C., 'The Decline of Cubism' (1948), in Greenberg, 1986 (VA10)

Greenberg, C., 'Abstract, Representational and so forth' (1954), in Greenberg, 1961

Greenberg, C., 'Modernist Painting' (1961 revised 1965), in Greenberg, ed. J. O'Brian, vol. 4, 1993 (VIB5)

Greenberg, C., *Art and Culture: Critical Essays* (1961), Boston, 1965

Greenberg, C., 'After Abstract Expressionism', in *Art International*, Lugano, VI, no. 8, October 1962 (VIB8)

Greenberg, C., 'Complaints of an Art Critic' (1967), in Harrison and Orton, 1984

Greenberg, C., *The Collected Essays and Criticism*, ed. J. O'Brian, 4 vols, Chicago and London, 1986, 1993

Gris, J., reply to a questionnaire in *L'Esprit Nouveau*, Paris, no. 5, February 1921 (IIIA11)

Gropius, W., reply to Arbeitsrat für Kunst questionnaire (1919), in Miesel, 1970 (IIIB10)

Gropius, W., 'The Theory and Organization of the Bauhaus' (1923), in H. Bayer, W. Gropius and I. Gropius (eds), *Bauhaus 1919–1928*, New York (Museum of Modern Art), 1938; repr. Boston, 1959 (IIIC15)

Grosz, G., 'My New Pictures' (1920/1), in Miesel, 1970 (IIIB13)

Grosz, G., 'My Life' (1928), in Schneede, 1979; excerpt trans. in Institute for Foreign Cultural Relations, *Prints and Drawings of the Weimar Republic*, Stuttgart, 1985 (IVB8)

Grosz, G., *A Small Yes and A Big No* (1955), London, 1982

Grosz, G. and Herzfelde, W., 'Art Is in Danger' (1925), in Lippard, 1971(b) (IVC7)

Guattari, F. *see* Deleuze, G. and Guattari, F.

Gudel, P. J. *see* Philipson, M. and Gudel, P. J.

Gumbrecht, H. U. and Pfeiffer, K. Ludwig (eds), *Stil: Geschichten und Funktionen eines kulturwissenschaftlichen Diskurselements*, Frankfurt am Main, 1986

Guttuso, R., 'Crisis of Renewal', in *Cosmopolita*, Rome, 1944 (VC4)

Haacke, H., Statement in *Art into Society, Society into Art*, London (Institute of Contemporary Arts), 1974 (VIIC9)

Haacke, H., *Framing and Being Framed*, Halifax, Nova Scotia, 1975

Habermas, J., *Knowledge and Human Interests* (1968), Cambridge, 1987

Habermas, J., 'Modernity – An Incomplete Project' (1980), in Foster, 1983/85(a) (VIIIC3)

Habermas, J., *The Philosophical Discourse of Modernity* (1985), Cambridge, MA, 1987

Hadjinicolau, N., *Art History and Class Struggle* (1973), London, 1978

Halley, P., 'Nature and Culture' (1983), in Halley, 1988 (VIIIA9)

Halley, P., *Collected Essays 1981–87*, Zurich (Bischofberger Gallery), 1988

Halley, P. *see also* Steinbach et al., 1986

Hamilton, R., 'For the Finest Art, Try Pop' (1961), in Hamilton 1982 (VIA15)

Hamilton, R., *Collected Words 1953–1982*, London, 1982

Hampshire, S., 'Logic and Appreciation', in *Aesthetics and Language*, ed. W. Elton, Oxford, 1954

Harari, J. V., *Textual Strategies: Perspectives in Post-Structuralist Criticism*, Ithaca, NY, 1979

Harman, C., *The Fire Last Time. 1968 and After*, London, 1988

Harrison, C., *Modernism*, London, 1997

Harrison, C., *Essays on Art & Language* (1991), Cambridge, MA, 2001

Harrison, C., *Conceptual Art & Painting: Further Essays on Art & Language*, Cambridge, MA, 2001

Harrison, C. and Orton, F. (eds), *Modernism, Criticism, Realism. Alternative Contexts for Art*, London, 1984

Harrison, C. *see also* Art & Language; Frascina, F. and Harrison, C.

Hartlaub, G. F., 'Reply to a Questionnaire', in *Das Kunstblatt*, Berlin, VI, 9, September, 1922 (IIIA12)

Hassan, I. and S., *Innovation/Renovation*, Madison, Wisconsin, 1983

Hauser, A., *The Philosophy of Art History*, New York, 1963

Hausmann, R. *see* Hülsenbeck, R. and Hausmann, R.

Hegel, G. W. F., *The Phenomenology of Spirit* (1807), Oxford, 1977

Hegel, G. W. F., *Aesthetics: Lectures on Fine Art* (*c*.1828), Oxford, 1975 (see *Art in Theory 1815– 1900*, IA10)

Hegel, G. W. F., *The Introduction to Hegel's Philosophy of Fine Art*, intr. B. Bosanquet, London, 1905

Hegel, G. W. F., *Philosophy of Fine Art*, London, 1920

Hegel, G. W. F. *On Art, Religion and Philosophy*, ed. J. Glenn Gray, New York, 1970

Heidegger, M., *Being and Time* (1931), New York, 1962

Heidegger, M., 'The Origin of the Work of Art' (1950), in *Heidegger, Basic Writings*, ed. D. F. Krell, New York, 1977

Hepworth, B., 'Sculpture', in Martin, Nicholson, Gabo, 1937 (IVA11)

Herbert, R. L., *Modern Artists on Art*, New York, 1974

Herzfelde, W. *see* Grosz, G. and Herzfelde, W.

Hesse, E., Interview with Cindy Nemser, *Artforum*, New York, May 1970 (VIIB11)

Hilton, R., 'Remarks About Painting', Zurich, 1961 (VIB4)

Hitler, A., speech inaugurating the 'Great Exhibition of German Art' (1937), in Chipp, 1968 (IVB20)

Hoch, H., 'The painter' (*c*.1920), in Lavin, 1993 (IIIC19)

Hofmann, H., 'On the Aims of Art' (1931), in *The Fortnightly*, Campbell, CA, 26 February 1932 (IVA3)

Hofmann, H., *Search for the Real and Other Essays*, ed. S. T. Weeks and B. H. Hayes Jr., Andover, MA (Addison Gallery of American Art), 1948

Hofstadter, D. R., *Gödel, Escher, Bach: An Eternal Golden Braid*, Hassocks, Sussex, 1979

Huelsenbeck, R., 'First German Dada Manifesto'/'Collective Dada Manifesto' (1918/1920), in Motherwell, 1951 (IIIB4)

Huelsenbeck, R., *En Avant Dada* (1920), in Motherwell, 1951 (IIIB6)

Huelsenbeck, R. and Hausmann, R., 'What is Dadaism and what does it want in Germany?' (1919), in Motherwell, 1951 (IIIB5)

Hulme, T. E., 'Cinders. A New Weltanschauung' (post 1924), in Hulme, 1965

Hulme, T. E., *Speculations. Essays on Humanism and the Philosophy of Art*, ed. H. Read (1924), London, 1965

Hulme, T. E., *Further Speculations*, ed. S. Hynes, Minneapolis, 1955

Hume, D., 'Of The Standard of Taste' (1758), in Hume, *Of the Standard of Taste and Other Essays*, ed. J. W. Lenz, Indianapolis and New York, 1965 (see *Art in Theory 1648–1815*, IIIB5)

Huyssen, A., *After the Great Divide: Modernism, Mass Culture and Postmodernism*, Bloomington, IN, and London, 1986

Identité Italienne, Paris (Centre Pompidou), 1981

Inch, P. and Fatet, A., *Wols. Aphorisms and Pictures*, Gillingham, 1971

Irigaray, L., *This Sex Which Is Not One* (1977), Ithaca, NY, 1985

Itten, J., 'Analysis of Old Master Art', in Adler, 1921 (IIIC13)

Jakobson, R., 'The Metaphoric and Metonymic Poles' (1954), in R. Jakobson and M. Halle, *Fundamentals of Language*, The Hague and New York, 1956

Jameson, F., 'Reflections in Conclusion' (1977), in Jameson, 1988 (as 'Reflections on the Brecht-Lukács Debate') (VIID13)

Jameson, F., 'Postmodernism and Consumer Society', in Foster, 1983/85(a)

Jameson, F., 'The Deconstruction of Expression', from 'Postmodernism, or the Cultural Logic of Late Capitalism' (1984), in Jameson, 1991 (VIIIA10)

Jameson, F., *The Ideologies of Theory. Essays 1971–1986*, 2 vols, London, 1988

Jameson, F., *Late Marxism*, London and New York, 1990

Jameson, F., *Postmodernism or The Cultural Logic of Late Capitalism*, London, 1991

Jeanneret, C. E. and Ozenfant, A., 'Purism' (1920), in Herbert, 1974 (IIIA7)

John Reed Club of New York, 'Draft Manifesto' (1932), in Shapiro, 1973 (IVB12)

Johns, J., Interview with David Sylvester (1965), in *Jasper Johns Drawings*, London (Arts Council), 1974 (VIA14)

Johns, J., Obituary of Marcel Duchamp, *Artforum*, New York, November 1968 (VIA23)

Johnson, E. H., *American Artists on Art. 1940–1980*, New York, 1982

Jorn, A., 'Forms Conceived as Language' (1949), in *Aftermath*, London (Barbican Art Gallery), 1982 (VC12)

Jorn, A., 'Detourned Painting' (1959), in *On the passage of a few people through a rather brief moment in time: the Situationist International 1957–1972*, Cambridge, MA, and London, 1991 (VIA4)

Judd, D., 'Specific Objects' (1965), in Judd, 1975 (VIIA5)

Judd, D., *Complete Writings 1959–1975*, Halifax, Nova Scotia, 1975

Judd, D., '. . . not about master-pieces but why there are so few of them' (1984), in Judd, 1987 (VIIIC6)

Judd, D., *Complete Writings 1975–1986*, Eindhoven (Van Abbemuseum), 1987

Jung, C. G., *The Collected Works of C. G. Jung*, 19 vols, London and Princeton, NJ, 1953–75. (See especially: vol. 9, part 1, *The Archetypes and the Collective Unconscious*, 2nd edn, 1968; vol. 9, part 2, *Aion: Researches into the Phenomenology of the Self* [previously, *Researches into the History of Symbols*], 2nd edn, 1968; vol. 10, *Civilisation in Transition*, 2nd edn, 1970; vol. 12, *Psychology and Alchemy*, 2nd edn, 1968; vol. 13, *Alchemical Studies*, 1968; vol. 14, *Mysterium Coniunctionis: An Enquiry into the Separation and Synthesis of Psychic Opposites in Alchemy*, 2nd edn, 1970; vol. 15, *The Spirit in Man, Art and Literature*, 1966.)

Jung, C. G., on the concept of the 'archetype', in *Four Archetypes: Mother. Rebirth. Spirit. Trickster*, London, 1986 (IVA6)

Kabakov, I., Interview with Robert Storr, *Art in America*, New York, January, 1995 (VIIIC14)

Kabakov, I., 'In the Installations' in Felix, 2000 (VIIIC14)

Kahlo, F., 'Moses' (1945), in Zamora, 1995 (VC7)

Kahnweiler, D.-H., *The Rise of Cubism* (1916–20), New York, 1949 (IIB10)

Kandinsky, W., *Concerning the Spiritual in Art* (1911/12), in Kandinsky, 1982 (IB8)

Kandinsky, W., the Cologne Lecture (1914), in Kandinsky, 1982 (IB9)

Kandinsky, W., 'Plan for the Physico-psychological Department of the Russian Academy of Artistic Sciences' (1923), in Bowlt, 1988 (IIIC12)

Kandinsky, W., *Complete Writings on Art*, ed. K. Lindsay and P. Vergo, London, 1982

Kant, I., *Critique of Pure Reason* (1781), London and New York, 1934

Kant, I., *Critique of Judgement* (1790), Oxford, 1952 (*Art in Theory 1648–1815*, VA10; see also VA8)

Kaplan, D. *see* Manners, R. A. and Kaplan, D.

Kaprow, A., 'The Legacy of Jackson Pollock', in *Art News*, New York, October 1958

Kaprow, A., *Environments, Assemblages and Happenings*, New York, 1965 (VIA7)

Kelder, D., *Stuart Davis*, New York, 1971

Kelley, M., 'Dirty Toys: Mike Kelley interviewed', in *Mike Kelley*, Stuttgart, 1992 (VIIIB14)

Kelly, M., 'Re-Viewing Modernist Criticism' (1981), in Wallis, 1984 (VIIIB2)

Kelly, M., *Post-Partum Document*, London, 1983

Kemenov, V., 'Aspects of Two Cultures' (1947), in Chipp, 1968 (VC9)

Khrushchev, N., Speech to the Twentieth Congress of the Communist Party of the Soviet Union (1956), in *Khrushchev Remembers*, London and New York, 1971 (as 'Khrushchev's Secret Speech')

Kiefer, A. *see* Beuys et al., 1986

Kierkegaard, S., *The Concept of Irony* (1841), New York, 1965 (see *Art in Theory 1815–1900*, IID4, 10 and 14)

Kippenberger, M., Interview with Jutta Koether, in *Gespräche mit Martin Kippenberger*, Ostfilden, 1994 (VIIIB15)

Klee, P., *On Modern Art* (1924/1945), intro. H. Read, London, 1948 (IVA1)

Klein, Y., Sorbonne lecture (1959), London (Gimpel Fils Gallery), 1973 (VIIA1)

Klingender, F., 'Content and Form in Art', in Rea, 1935 (IVB19)

Klingender, F., *Marxism and Modern Art*, London, 1943 (VC2)

Klucis, G., 'Photomontage as a new problem in Agit Art' (1931), in Nachtigäller, 1991 (IVC15)

Knabb, K. (ed.), *Situationist International Anthology*, Berkeley, CA, 1981

Kokoschka, O., 'On the Nature of Visions' (1912), in E. Hoffman, *Kokoschka, Life and Work*, London, 1947 (IB13)

KOMFUT, 'Programme Declaration' (1919), in Bowlt, 1988 (IIID1)

Kooning, W. de, 'A Desperate View' (1949), in *The Collected Writings of Willem de Kooning*, Madras and New York, 1988 (VA12)

Koons, J. *see* Steinbach et al., 1986

Kosuth, J., 'Art After Philosophy' (1969), in Kosuth, 1991 (VIIA11)

Kosuth, J., *Art After Philosophy and After: Collected Writings 1966–1990*, Cambridge, MA, and London, 1991

Kounellis, J. *see* Beuys et al., 1986

Kracauer, S., 'The Mass Ornament' (1927), in *New German Critique*, 5, Spring 1975 (IVC10)

Kraus, K., 'In These Great Times' (1914), in *In These Great Times: A Karl Kraus Reader*, ed. H. Zohn, Manchester 1976/84 (IIA15)

Krauss, R., 'A View of Modernism', in *Artforum*, New York, September 1972 (VIID8)

Krauss, R., 'Notes on the Index, Part 1' (1977), in Krauss, 1986 (VIID12)

Krauss, R., 'The Originality of the Avant Garde' (1981), in Krauss, 1986 (VIIIA4)

Krauss, R., *The Originality of the Avant Garde and Other Modernist Myths*, Cambridge, MA, and London, 1986

Kristeva, J., 'Powers of Horror' (1980), in Kristeva, 1982 (VIIIC5)

Kristeva, J., *Powers of Horror. An Essay on Abjection* (1980), New York, 1982

Kristeva, J., Interview with Catherine Francblin (1986), in G. Politi (ed.), *Flash Art. XXI Years. Two Decades of History*, Milan, 1989 (VIIIA12)

Kruger, B., ' "Taking" Pictures', *Screen*, London, vol. 23, no. 2, July–August 1982 (VIIIA8)

Kruger, B. and Mariani, P. (eds), *Remaking History. DIA Art Foundation Discussions in Contemporary Culture No. 4*, Seattle, 1989

Kruger, B., *Love For Sale: The Words and Pictures of Barbara Kruger with a text by Kate Linker*, New York, 1990

Kubler, G., *The Shape of Time* (1962), New Haven, 1965 (VIA19)

Kuhn, T. S., *The Structure of Scientific Revolutions* (1962), rev. edn. Chicago, 1970

Kuhn, T. S., 'Postscript – 1969', in Kuhn, 1970 (VIID4)

Lacan, J., 'The Mirror Phase as Formative of the Function of the I' (1949), in *New Left Review*, London, September 1968, and Lacan 1977(a) (VB8)

Lacan, J., *Ecrits* (1966), London, 1977(a)

Lacan, J., *The Four Fundamental Concepts of Psychoanalysis* (1973), London, 1977(b)

Lacan, J., *The Language of the Self: the Function of Language in Psychoanalysis. Further Selections from Ecrits*, Baltimore, MD, 1978

Lakatos, I. and Musgrave, A. (eds), *Criticism and the Growth of Knowledge*, Cambridge, 1969

Lankheit, K. (ed.), *The Blaue Reiter Almanac*, London, 1974

Lassaw, I., 'On Inventing Our Own Art' (1938), in *AAA Yearbooks*, 1969 (IVA13)

Lautréamont, I. Ducasse, Comte de, *Song of Maldoror* (1868), New York, 1973

Lautréamont, I. Ducasse, Comte de, *Oeuvres complètes*, ed. P.-O. Walzer, Paris, 1970

Lavin, M., *Cut With the Kitchen Knife. The Weimar Photomontages of Hannah Höch*, New Haven and London, 1993

Le Corbusier *see* Jeanneret, C. E.

Lee, R. W. *Ut Pictura Poesis: The Humanistic Theory of Painting* (1940), New York, 1967

LEF, 'Whom is *LEF* alerting?' (1923), in *Form*, Brighton, no. 10, October 1969 (IIID9)

Léger, F., 'The Origins of Painting and its Representational Value' (1913), in Léger, 1973 (IIB8)

Léger, F., 'Contemporary Achievements in Painting' (1914), in Léger, 1973 (IIA11)

Léger, F., 'The New Realism Goes On' (1937), in Léger, 1973 (IVC19)

Léger, F., *The Function of Painting*, New York, 1973

Lenin, V. I. 'Party Organization and Party Literature' (1905), in Lenin, 1967 (IIA3)

Lenin, V. I., 'On Proletarian Culture' (1920), in Lenin, 1967 (IVB1)

Lenin, V. I., *Lenin on Literature and Art*, Moscow, 1967

Lessing, G., *Laocoön. An Essay upon the Limits of Poetry and Painting* (1766), New York, 1969 (*Art in Theory 1648–1815*, IIIA10)

Lévi-Strauss, C., *Structural Anthropology* (1958), London, 1968

Lévi-Strauss, C., *The Savage Mind* (1962), London, 1966

Levine, S., Statement, in *Style*, Vancouver (Vancouver Art Gallery), 1982 (VIIIA6)

Levine, S. *see* Steinbach et al., 1986

Lewis, P. Wyndham, 'Our Vortex' (1914), in Lewis, 1969 (IIA12)

Lewis, P. Wyndham, 'The Children of the New Epoch' (1921), in Lewis, 1969 (IIIA10)

Lewis, P. Wyndham, *Wyndham Lewis on Art*, ed. W. Michel and C. Fox, London and New York, 1969

LeWitt, S., 'Paragraphs on Conceptual Art' (1967), in de Vries, 1974 (VIIA8)

LeWitt, S., 'Sentences on Conceptual Art' (1969), in de Vries, 1974 (VIIA9)

Lichtenstein, R., Lecture (1964), in Johnson, 1982 (VIA18)

Liebermann, M., 'Die Phantasie in der Malerei', in *Die neue Rundschau*, Berlin, vol. XV, no. 3, March 1904 (IA5)

Lifschitz, M., *The Philosophy of Art of Karl Marx* (1933), London, 1973

Lippard, L., Interview with Ursula Meyer (1969), and 'Postface', in Lippard 1973 (VIIC4)

Lippard, L. (ed.), *Surrealists on Art*, Princeton, NJ, 1970

Lippard, L. (ed.), *Changing. Essays on Art Criticism*, New York, 1971(a)

Lippard, L. (ed.), *Dadas on Art*, Princeton, NJ, 1971(b)

Lippard, L., *Six Years: the Dematerialisation of the Art Object*, London and New York, 1973

Lippard, L., *From the Center*, New York, 1976

Lippard, L., *Get The Message? A Decade of Art for Social Change*, New York, 1984

Lippard, L. and Chandler, J., 'The Dematerialisation of Art', *Art International*, Lugano, February 1968

Lipps, T., *Ästhetik*, Leipzig, 1906

Lissitsky, E., 'A. and Pangeometry' (1925), in El Lissitsky, *Russia: An Architecture for World Revolution*, London, 1970 (IIIC18)

Lissitsky, E. and Ehrenburg, I., statement by the editors of *Veshch* (1922), in Bann, 1974 (IIID8)

Lissitsky, E. (1923) *see* Doesburg, T. van, Lissitsky, E. and Richter, H.

Luhmann, N., 'Ist Kunst codierbar?', *Soziologische Aufklärung*, III, Opladen, 1981

Luhmann, N., *Soziale Systeme: Grundriss einer allgemeinen Theorie*, Frankfurt-am-Main, 1984

Luhmann, N., 'The Work of Art and the Self-Reproduction of Art', in Gumbrecht and Pfeiffer, 1986 (VIIIB7)

Lukács, G., *History and Class Consciousness* (1922), London, 1971

Lukács, G., '"Tendency" or Partisanship?' (1932), in Lukács, 1980 (IVB10)

Lukács, G., 'The Greatness and Decline of Expressionism' (1934), in Lukács, 1980 (as 'Expressionism: its Significance and Decline')

Lukács, G., 'The Ideology of Modernism' (1956–7), in Lukács, 1963 (VC21)

Lukács, G., *The Meaning of Contemporary Realism*, London, 1963

Lukács, G., *Georg Lukács: Essays on Realism*, ed. R. Livingstone, London, 1980

Lyotard, J.-F., 'Introduction' (1979), in Lyotard, 1984 (VIIIC2)

Lyotard, J.-F., 'What is Postmodernism?' (1982), in Hassan, 1983, and Lyotard, 1984 (VIIIC4)

Lyotard, J.-F., *The Postmodern Condition: A Report on Knowledge* (1979), Minnesota and Manchester, 1984

Macherey, P., *A Theory of Literary Production* (1966), London, 1978

MacIntyre, A., 'Notes from the Moral Wilderness, Parts I and II', *New Reasoner*, London, nos. 4 and 5, 1957

MacIntyre, A., *Against the Self-Images of the Age*, London, 1971

MacIntyre, A., *After Virtue*, London, 1981

Maciunas, G., 'Neo-Dada in Music, Theater, Poetry, Art', Wiesbaden, 1962 (VIA11)

Macke, A., 'Masks' (1912), in Lankheit, 1974 (IB11)

Malevich, K., *From Cubism and Futurism to Suprematism. The New Realism in Painting* (1915–16), in Malevich, 1969 (IIA16)

Malevich, K., 'Non-Objective Art and Suprematism' (1919), in Zhadova, 1982 (IIIC8)

Malevich, K., *The Question of Imitative Art* (1920), in Malevich, 1969 (IIIC9)

Malevich, K., Letter to Meyerhold (1932), in *Kunst & Museumjournaal*, Amsterdam, vol. 1, no. 6, 1990 (IVD1)

Malevich, K., *Essays on Art 1915–1933*, ed. T. Andersen, Copenhagen and London, 1969

Malevich, K. *see also* UNOVIS

Mallarmé, S., *Oeuvres complètes*, Paris, 1945

Malraux, A., *The Voices of Silence* (1953), Princeton, NJ, 1978

Manners, R. A., and Kaplan, D., *Theory in Anthropology: A Comprehensive Sourcebook of Classic and Contemporary Views of Anthropological Theory*, Chicago, 1968

Manzoni, P., 'Free Dimension' (1960), in *Identité Italienne*, 1981 (VIA8)

Mao Tse-Tung, 'On Practice' and 'On Contradiction' (1937), in *Four Essays on Philosophy*, Peking, 1966

Marc, F., 'The Savages of Germany' and 'Two Pictures' (1912), in Lankheit, 1974 (IB10)

Marc, F., 'Foreword' to the planned second edition of *Der Blaue Reiter* (1914), in Lankheit, 1974 (IIA10)

Marcuse, H., *Eros and Civilization* (1955), London, 1969

Marcuse, H., *One Dimensional Man*, Boston, 1964

Marcuse, H., *Negations*, Boston, 1968, London, 1988

Marcuse, H., 'On the Concept of Labor', *Telos*, St Louis, MO, 16, Summer 1973

Mariani, P. *see* Kruger, B. and Mariani, P.

Marinetti, F. T., 'Foundation and Manifesto of Futurism' (1909), in Marinetti, 1971 (IIA6)

Marinetti, F. T., *Marinetti's Selected Writings*, ed. R. Flint, London, 1971

Martin, J. L., Nicholson, B. and Gabo, N. (eds), *Circle – International Survey of Constructive Art*, London, 1937

Marx, K., *Economic and Philosophical Manuscripts of 1844* (1932), ed. D. J. Struick, London, 1973 (*Art in Theory 1815–1900*, IIA9)

Marx, K., *A Contribution to the Critique of Political Economy* (1859), ed. M. Dobb, London, 1971 (*Art in Theory 1815–1900*, IIIA8)

Marx, K., *Capital* (1867), London, 1888 (*Art in Theory 1815–1900*, IIIA10)

Marx, K. and Engels, F., *The Holy Family* (1845), Moscow, 1975

Marx, K. and Engels, F., *Manifesto of the Communist Party* (1848), Moscow, 1969 (*Art in Theory 1815–1900*, IIA11)

Marx, K. and Engels, F., *The German Ideology* (1848/1932), New York, 1963 (*Art in Theory 1815–1900*, IIA10)

Marx, K. and Engels, F., *Marx and Engels on Literature and Art*, ed. L. Baxendall and S. Morawski, New York, 1973

Matejka, L. and Pomorska, K. (eds), *Readings in Russian Poetics: Formalist and Structuralist Views*, Cambridge, MA, 1971

Matejka, L. and Titunik, I. R. (eds), *Semiotics of Art*, Cambridge, MA, 1976

Matisse, H., 'Notes of a Painter' (1908), in Matisse, 1973 (IB6)

Matisse, H., 'Statements to Tériade' (1936), in Matisse, 1973 (IVA8)

Matisse, H., *Matisse on Art.*, ed. J. Flam, London and New York, 1973

Maturana, H., *Erkennen: Die Organisation und Verkörperung von Wirklichkeit*, Braunschweig, 1982

McCoubrey, J., *American Art 1700–1960*, Englewood Cliffs, NJ, 1972

McLuhan, M., *The Gutenberg Galaxy*, London and Toronto, 1962

McLuhan, M., 'Introduction' and 'Challenge and Collapse: The Nemesis of Creativity' (1964), in McLuhan, 1964 (VIA20)

McLuhan, M., *Understanding Media*, London, 1964

Mehring, F., *Politische Publizistik 1891 bis 1904*, ed. J. Schleifstein, Berlin, 1964

Meidner, L., 'Instructions for Painting Pictures of the Metropolis' (1914) in Schmidt, 1964 (IIA14)

Meier-Graefe, J., *Modern Art: being a Contribution to a New System of Aesthetics* (1904), London and New York, 1908 (IA10)

Mendieta, A., 'Art and Politics' (1982), in *Ana Mendieta*, Barcelona, 1996 (VIIIB3)

Merleau-Ponty, M., *Phenomenology of Perception* (1945), London, 1962

Merleau-Ponty, M., *Les Aventures de la dialectique*, Paris, 1955; chapter 'The Crisis of Under-standing', in Merleau-Ponty, 1964(a)

Merleau-Ponty, M., *Signs* (1960), Urbana, IL, 1964(b)

Merleau-Ponty, M., 'Eye and Mind' (1961), in Merleau-Ponty, 1964(a), and Osborne, 1972 (VIB3)

Merleau-Ponty, M., *The Primacy of Perception*, ed. J. M. Edie, Evanston, IL, 1964(a)

Metzinger, J., 'Note on Painting' (1910), in E. Fry, 1986 (IIB1)

Metzinger, J. *see also* Gleizes, A. and Metzinger, J.

Meyer, U. (ed.), *Conceptual Art*, New York, 1972

Miesel, V. (ed.), *Voices of German Expressionism*, Englefield Cliffs, NJ, 1970

Mitchell, J. and Rose, J. (eds), *Feminine Sexuality: Jacques Lacan and the Ecole Freudienne*, London, 1982

Mitchell, J., *Psychoanalysis and Feminism*, New York, 1974

Mitchell, W. J. T. (ed.), *Against Theory – the New Pragmatism*, Chicago, 1985

Mitchell, W. J. T., 'Image and Word', and 'Mute Poesy and Blind Painting', in W. J. T. Mitchell, 1986 (VIIIB8)

Mitchell, W. J. T., *Iconology: Image, Text and Ideology*, Chicago and London, 1986

Moholy-Nagy, L., *Painting, Photography, Film* (Bauhausbuch 8, 1925), London, 1968

Moholy-Nagy, L., *The New Vision* (Bauhausbuch 14, 1929), New York, 1964

Mondrian, P., 'Dialogue on the New Plastic' (1919), in Mondrian, 1986 (IIIC6)

Mondrian, P., *Neo-Plasticism: the General Principle of Plastic Equivalence* (1920), in Mondrian, 1986 (IIIC7)

Mondrian, P., 'Plastic Art and Pure Plastic Art' (1937), in Mondrian, 1986 (IVA10)

Mondrian, P., *The New Art – The New Life: The Collected Writings of Piet Mondrian*, ed. H. Holtzman and M. James, Boston, 1986

Moore, H., 'The Sculptor in Modern Society' (1952), in *Henry Moore on Sculpture*, ed. P. James, London, 1966 (VC19)

Moretti, F., 'MoMA 2000: The Capitulation', *New Left Review*, London, July–August 2000 (VIIIC16)

Morris, R., 'Notes on Sculpture' (1966), in de Vries, 1974 (VIIA6)

Morris, R., 'Notes on Sculpture. Part 2' (1966), in de Vries, 1974 (VIIA6)

Morris, R., 'Notes on Sculpture. Part 3: Notes and Nonsequiturs' (1967), in de Vries, 1974 (VIIA6)

Morris, R., 'Antiform', *Artforum*, April 1968

Morris, R., 'Notes on Sculpture. Part 4: Beyond Objects' (1969), in de Vries, 1974 (VIIB4)

Morris, R., 'Notes on the Phenomenology of Making', *Artforum*, New York, April 1970

Morris, W., *The Art of the People* (1879), London, 1942

Morris, W., *Hopes and Fears for Art*, London, 1892

Mosset, O., *see* Buren et al., 1967

Motherwell, R., 'The Modern Painter's World', in *Dyn*, New York, vol. 1, no. 6, November 1944 (VC3)

Motherwell, R. (ed.), *The Dada Painters and Poets*, New York, 1951

Motherwell, R. and Rosenberg, H., 'The Question of What Will Emerge is Left Open' (1947–8), in Chipp, 1968 (VC10)

Mukařovský, J., *Aesthetic Function: Norm and Value as Social Facts* (1934/36), Ann Arbor, MI, 1970 (IVD5)

Mukařovský, J., 'Art as Semiological Fact', in Matejka and Titunik, 1976

Mukařovský, J., *Structure, Sign and Function. Selected Essays*, New Haven, 1978

Mulvey, L., 'Visual Pleasure and Narrative Cinema' (1973), in Mulvey, 1989 (VIID10)

Mulvey, L., *Visual and Other Pleasures*, London, 1989

Murphy, J. A., Sponsor's statement, in *When Attitudes become Form*, London (Institute of Contemporary Arts), 1969 (VIIB9)

Musgrave, A. *see* Lakatos, I. and Musgrave, A.

Musil, R., 'The Writer in Our Age', in *Gesammelte Werke*, 3 vols (prose; drama; letters), Hamburg, 1957

Musil, R., *The Man Without Qualities* (1930), London, 1953

Nachtigäller, R. (ed.), *Gustav Klucis: Retrospective*, Stuttgart, 1991

Nauman, B., Interview with Michele De Angelus (1980), in *Bruce Nauman*, London, 1998 (VIIB14)

Newman, B., 'The First Man was an Artist' (1947), in Newman, 1990 (VA9)

Newman, B., 'The Ideographic Picture' (1947), in Newman, 1990 (VA8)

Newman, B., 'The Sublime is Now' (1948), in Newman, 1990 (VA11)

Newman, B., Interview with Dorothy Gees Seckler (1962), in Newman, 1990 (as 'Frontiers of Space') (VIB7)

Newman, B., *Selected Writings and Interviews*, New York, 1990

Newman, B. *see also* Gottlieb et al., 1943

Nicholson, B., 'Notes on Abstract Art' (1941), in *Ben Nicholson, Paintings, Reliefs, Drawings*, intro. H. Read, London, 1948 (IVA14)

Nicholson, B. *see also* Martin, J. L., Nicholson, B. and Gabo, N. (eds)

Nietzsche, F., *Human, All-Too-Human: a Book for Free Spirits* (1878), New York, 1974

Nietzsche, F., *The Birth of Tragedy from the Spirit of Music* (1872) and *The Case of Wagner* (1888), New York, 1967 (*Art in Theory 1815–1900*, VB2)

Nietzsche, F., *Thus Spoke Zarathustra* (1883–5), New York, 1966, Harmondsworth, 1969

Nietzsche, F., *On the Genealogy of Morals* (1887), New York, 1969

Nietzsche, F., *The Will to Power* (1911), ed. W. Kauffmann, New York, 1968 (*Art in Theory 1815–1900*, VB12)

Noland, K. *see* Caro, A., Noland, K. and Olitski, J.

Nolde, E., 'On Primitive Art' (1912), in Nolde, 1934 (IB12)

Nolde, E., *Jahre der Kämpfe 1912–1914*, Berlin, 1934

Novembergruppe, 'Manifesto' (1918) and 'Guidelines' (1919), in Miesel, 1970 (IIIB8)

Novembergruppe Opposition, 'Open Letter to the Novembergruppe' (1921), in Open University, 1983 (IIIB9)

O'Connor, F. V., *Jackson Pollock*, New York, 1967

October (Association of Artistic Labour), 'Declaration' (1928), in Bowlt, 1988 (IVC11)

Oehlen, A., Interview with Wilfred Dickoff and Martin Prinzhorn, *Kunst Heute*, Cologne, 7, 1991 (VIIIC12)

Oguibe, O., 'In the "Heart of Darkness"', *Third Text* 23, London, 1993 (VIIIC13)

Oiticica, H., 'Appearance of the Supra-Sensorial' (1968), in Brett 1992 (VIIC1)

Oldenburg, C., two statements from 'The Store' (1961), in *Store Days: Documents from The Store (1961) and Ray Gun Theater (1962)*, New York, Villefranche-sur-mer, Frankfurt am Main, 1967 (VIA16)

Olitski, J., 'Painting in Color', in *Artforum*, New York, January 1970 (VIB11)

Olitski, J. *see also* Caro, A., Noland, K. and Olitski, J.

Open University, Supplementary Documents to *A315: Modern Art and Modernism*, Milton Keynes, 1983

Ortega y Gasset, J., *The Revolt of the Masses* (1929), New York, 1932

Ortega y Gasset, J., 'The Dehumanization of Art', in *The Dehumanization of Art and other Essays on Art, Culture and Literature*, Princeton, NJ, 1968 (IIIC20)

Orton, F. *see* Harrison, C. and Orton, F.

Osborne, H. (ed.), *Aesthetics*, Oxford, 1972

Owens, C., 'The Allegorical Impulse: Towards a Theory of Postmodernism' (1980), in Wallis, 1984 (VIIIA3)

Owens, C., 'The Discourse of Others: Feminists and Postmodernism', in Foster, 1983/85(a)

Ozenfant, A., 'Notes on Cubism', in *L'Elan*, no. 10, Paris, December 1916 (IIIA1)

Ozenfant, A., *Foundations of Modern Art* (1928), New York, 1931, rev. edn 1952 (IVA2)

Ozenfant, A. *see* Jeanneret, C. E. and Ozenfant, A.

Panofsky, E., *Meaning in the Visual Arts* (1955), Harmondsworth and New York, 1983

Paris-Paris, Paris (Centre Pompidou), 1981

Parker, R. *see* Pollock, G. and Parker, R.

Parmentier, M. *see* Buren, D. et al., 1967

Pechstein, M., 'Creative Credo' (1920), in Miesel, 1970 (IIIB12)

Peckham, M., *Man's Rage for Chaos. Biology, Behavior and the Arts*, New York, 1967

Peirce, C. S., 'Logic as Semiotic: the Theory of Signs', in *The Philosophical Writings of Peirce*, ed. J. Buchler, New York, 1955

Peirce, C. S., *The Writing of Charles Sanders Peirce, A Chronological Edition*, 4 vols, ed. C. J. W. Kloesal, Bloomington, IN, 1986

Pevsner, A. *see* Gabo, N. and Pevsner, A.

Philipson, M. and Gudel, P. J. (eds), *Aesthetics Today*, rev. edn, New York, 1980

Picabia, F., 'Thank you, Francis!' (1923), in Lippard, 1971(b) (IIIB14)

Picasso, P., 'Picasso Speaks' (1923), in Chipp, 1968 (as 'Statement') (IIB12)

Picasso, P., 'Conversation with Picasso' (1935), in Barr, 1946 (IVD2)

Picasso, P., 'Why I Joined the Communist Party' (1944), in Barr, 1946 (VC5)

Picasso, P., Statement to Simone Téry (1945), in Barr, 1946 (VC6)

Piles, R. de, *Diverses conversations sur la peinture*, Paris, 1727 (see *Art in Theory 1648–1815*, IC5 and 10, IIA2)

Pistoletto, M., 'Famous Last Words' (1967), in G. Celant (ed.), *Pistoletto*, New York, 1989 (VIIB2)

Plekhanov, G. V., *Art and Social Life* (1912), London, 1972 (IIA9)

Poley, S., *Hans Arp. Die Formensprache im plastichen Werk*, Stuttgart, 1978

Pollock, G., 'Artists, Mythologies and Media – Genius, Madness and Art History', *Screen*, London, vol. 21, no. 3, Autumn 1980

Pollock, G. and Parker, R., *Old Mistresses. Women, Art and Ideology*, London, 1981

Pollock, G., *Vision and Difference. Femininity, Feminism and Histories of Art*, London, 1988

Pollock, J., Answers to a Questionnaire (1944), in Johnson, 1982 (VA3)

Pollock, J., Two statements (1947/8), in O'Connor, 1967 (VA4)

Pollock, J., Interview with William Wright (1950), in O'Connor 1967 (VA13)

Pomorska, K. *see* Matejka, L. and Pomorska, K.

Ponge, F., 'Reflections on the Statuettes, Figures and Paintings of Alberto Giacometti' (1950), in *Cahiers d'Art*, Paris, 1951 (VB10)

Popova, L., Statement in catalogue of 'Tenth State Exhibition' (1919), in Bowlt, 1988 (IIID3)

Popper, K., *The Open Society and Its Enemies* (1945), 2 vols, 5th rev. edn, London, 1969

Popper, K., *Conjectures and Refutations* (1963), rev. edn, London, 1969

Pound, E., *Gaudier Brzeska: A Memoir*, London, 1916

Princenthal, N., Basualdo, C. and Huyssen, A. (eds), *Doris Salcedo*, London, 2000

Prinzhorn, H., *Artistry of the Mentally Ill* (1922), New York, 1995 (IB19)

Punin, N., 'The Monument to the Third International' (1920), in Open University, 1983 (IIID4)

Ramsden, M., 'On Practice', in *The Fox*, New York, April 1975 (VIIC11)

Ramsden, M. *see also* Art & Language; Burn, I. and Ramsden, M., 1969

Raphael, M., *Proudhon, Marx, Picasso. Three Studies in the Sociology of Art* (1933), London and Princeton, NJ, 1980

Ray, M., statement (1916), in Lippard, 1971(b) (IIIC2)

Rea, B. (ed.), *Five on Revolutionary Art*, London, 1935

Read, H., *Reason and Romanticism*, London, 1926

Read, H., *The Meaning of Art* (1931), Harmondsworth, 1961

Read, H., *Art Now* (1933), 3rd rev. edn, London, 1960

Read, H., 'What Is Revolutionary Art?', in Rea, 1935 (IVD3)

Read, H., *The Politics of the Unpolitical*, London, 1943

Red Group, 'Manifesto' (1924), in M. Kay Flavell, *George Grosz: A Biography*, New Haven, 1988 (IVB5)

Reich, W., *Dialectical Materialism and Psychoanalysis* (1928–9), London, 1972

Reich, W., *The Invasion of Compulsory Sex Morality* (1931), London and New York, 1972

Reinhardt, A., 'Art as Art' (1962), in Reinhardt, 1975 (VIIA4)

Reinhardt, A., *Art as Art: The Selected Writings of Ad Reinhardt*, ed. B. Rose, New York, 1975

Restany, P., 'The New Realists' (1960), in *Identité Italienne*, 1981 (VIA9)

Richter, G., 'Notes 1964–1965', in Britt, 1995 (VIA21)

Richter, G., Interview with Benjamin Buchloh, in R. Nasgaard and I. Danoff (eds), *Gerhard Richter: Paintings*, London and New York, 1988 (VIIIA8)

Richter, G., 'Notes', in *Gerhard Richter*, London (Tate Gallery), 1991 (VIIIA9)

Richter, H. *see* Doesburg, T. van, Lissitsky, E. and Richter, H.

Riegl, A., *The Late Roman Art Industry*, 2 vols (1901, 1923), Rome (*Archaeologica* series, vol. 36), 1985 (see also *Art in Theory 1815–1900*, VA10)

Rilke, R. M., *Letters on Cézanne* (1907), London, 1991 (IA7)

Rivera, D., 'The Revolutionary Spirit in Modern Art' (1932), in Shapiro, 1973 (IVB13)

Rivera, D. *see* Breton, A., Rivera, D. and Trotsky, L.

Rivière, J., 'Present Tendencies in Painting' (1912), in E. Fry, 1986 (IIB6)

Robbe-Grillet, A., 'Commitment' (1957), in Robbe-Grillet, 1965 (VIB1)

Robbe-Grillet, A., *Towards A New Novel* (1957), London, 1965

Rodchenko, A. and Stepanova, V., 'Programme of the First Working Group of Constructivists' (1922), in Open University, 1983 (IIID6)

Rodchenko, A., 'Slogans' and 'Organizational Programme' (1920–1), in S.-O. Khan Magomedov, *Rodchenko: The Complete Work*, London, 1986 (IIID5)

Rorty, R., 'Private Irony and Liberal Hope', in *Contingency, Irony and Solidarity*, Cambridge, 1989 (VIIIB11)

Rose, J., 'Sexuality in the Field of Vision' (1984), in Rose, 1986 (VIIIB6)

Rose, J., *Sexuality in the Field of Vision*, London, 1986

Rose, J. *see also* Mitchell, J. and Rose, J.

Rosenbach, U., *Körpersprache*, Frankfurt, 1975

Rosenberg, A., 'The Myth of the Twentieth Century' (1930), in *Alfred Rosenberg, Selected Writings*, ed. R. Pois, London, 1970 (IVB9)

Rosenberg, H., 'The Fall of Paris' (1940), in H. Rosenberg, 1962 (IVD12)

Rosenberg, H., 'The American Action Painters' (1952), in Rosenberg, 1962 (VA16)

Rosenberg, H., *The Tradition of the New*, London and New York, 1962

Rosenberg, H., *The De-definition of Art*, New York, 1972

Rosenberg, H., *Discovering the Present*, Chicago, 1973

Rosenberg, H. *see also* Motherwell, R. and Rosenberg, H.

Rosenberg, L., 'Tradition and Cubism' (1919), in E. Fry, 1986 (IIIA5)

Rothko, M., 'The Romantics were Prompted...' (1947), in Chipp, 1968 (VA5)

Rothko, M., Statement (1947), in Tuchman, 1971 (VA6)

Rothko, M. *see also* Gottlieb et al., 1943

Rousseau, J.-J., *Essay on the Origin of Languages*, in Rousseau, 1967–71 (see also *Art in Theory 1648–1815*, IIIA2)

Rousseau, J.-J., *Oeuvres complètes*, 3 vols, Paris, 1967–71

Rozanova, O., 'The Bases of the New Creation' (1913), in Bowlt, 1988 (IIB9)

Ruskin, J., *Modern Painters* (1843–60), ed. D. Barrie, London, 1987 (*Art in Theory 1815–1900*, IIB6 and 7; see also ibid. IIIA9, IIIC5 and 6, IVB1)

Ruskin, J., *The Seven Lamps of Architecture* (1849), New York, 1961

Russell, J. and Gablik, S., *Pop Art Redefined*, London, 1969

Ryder, A. P., 'Paragraphs from the Studio of a Recluse', in *Broadway Magazine*, New York, XIV September 1905 in McCoubray, 1972, (IB2)

Said, E., *Orientalism*, London and New York, 1978 (VIID15)

Said, E., 'Opponents, Audiences, Constituencies and Communities' (1982), in Said, 1983, and Foster, 1983/85(a) (VIIIB1)

Said, E., *The World, the Text and the Critic*, Cambridge, MA, 1983

Salcedo, D., Interview with Charles Merewether (1999), in Princenthal, Basualdo and Huyssen, 2000 (VIIIC15)

Sartre, J.-P., *Being and Nothingness* (1943), New York, 1966

Sartre, J.-P., *Existentialism and Humanism* (1946), London, 1948 (VB2)

Sartre, J.-P., 'The Search for the Absolute', in *Alberto Giacometti. Sculptures, Paintings, Drawings*, New York (Pierre Matisse Gallery), 1948 (VB6)

Sartre, J.-P., *What Is Literature?* (1948), London, 1967

Saussure, F. de, *Course in General Linguistics* (1907–11, first published posthumously 1916), ed. C. Bally and A. Sechehaye, London, 1974

Schapiro, M., 'The Social Bases of Art' (1936), in Shapiro, 1973 (IVD4)

Schapiro, M., 'Style' (1953), in Philipson and Gudel, 1980

Schapiro, M., 'On Some Problems in the Semiotics of Visual Art: Field and Vehicle in Image-Signs', in T. Sebeok (ed.), *Semiotica*, The Hague, vol. 1, no. 3, 1969

Schapiro, M., *Words and Pictures. On the Literal and the Symbolic in the Illustration of a Text*, The Hague, 1973

Schapiro, M., *Modern Art: 19th and 20th Centuries. Selected Papers*, New York, 1978

Schier, F., *Deeper into Pictures*, Cambridge, 1986

Schiller, F., *Letters on the Aesthetic Education of Man* (1794 revised 1801), Oxford 1967 (*Art in Theory 1648–1815*, VA12; see also ibid. VA13)

Schlemmer, O., 'Notes (1922–3)', in T. Schlemmer, 1977 (IIIC14)

Schlemmer, T., *Oskar Schlemmer. Briefe und Tagebücher*, Stuttgart, 1977

Schlesinger, A., *The Vital Center* (1950), London and New York, 1970 (VC15)

Schmidt, D. (ed.), *Schriften deutscher Kunstler des zwanzigsten Jahrhunderts, Band 1, Manifeste 1905–1933*, Dresden, 1964

Schmidt, S. J., 'The Fiction that Reality Exists: A Constructivist Model of Reality, Fiction and Literature', *Poetics Today*, 5, 1984

Schneede, U. M. (ed.), *Die Zwanziger Jahre, Manifeste und Dokumente deutscher Kunstler*, Cologne, 1979

Schoenberg, A., *Treatise on Harmony* (1911/1922), New York, (abridged) 1948, (complete) 1978

Schopenhauer, A., *The World as Will and Representation* (1818), London and New York, 1969 (see *Art in Theory 1648–1815* IA1)

Scott, T. *see* Tucker, W. and Scott, T.

Sedlmayr, H., *Art in Crisis: The Lost Centre*, London 1957

Sedlmayr, H. and Adorno, T. W., 'The Darmstadt Colloquy', in Evers, 1950 (VC14)

Serra, R., 'The Yale Lecture', in *Kunst & Museumjournaal*, Amsterdam, vol. 1, no. 6, 1990 (VIIIB13)

Shahn, B., 'The Artist and the Politician', in *Art News*, New York, September 1953 (VC18)

Shapiro, D., *Social Realism – Art as a Weapon: Critical Studies in American Art*, New York, 1973

Shapiro, D. and C. (eds), *Abstract Expressionism. A Critical Record*, Cambridge and New York, 1990

Sharp, D. *see* Benton, T. and C. and Sharp, D.

Shevchenko, A., 'Neo-Primitivism: Its Theory, Its Potentials, Its Achievements' (1912), in T. Andersen (ed.), *Paris-Moscou*, Paris (Centre Pompidou), 1979, and Bowlt, 1988 (IB14)

Shklovsky, V., 'Art as Technique' (1917), in L. Lemon and M. Reis (eds), *Russian Formalist Criticism*, Lincoln, NE, 1965 (IIIC3)

Sickert, W. R., *A Free House or the Artist as Craftsman: Being the Writings of Walter Richard Sickert*, ed. O. Sitwell, London, 1947

Siegel, J., *Artwords. Discourse on the 60's and 70's*, Ann Arbor, MI, 1985

Signac, P., *D'Eugène Delacroix au néo-impressionisme*, Paris, 1899; new edn ed. F. Cachin, Paris, 1964 (IA1)

Simmel, G., 'The Metropolis and Mental Life' (1902–3), in *The Sociology of Georg Simmel*, ed. K. Wolff, Glencoe, IL, 1950 (IIA1)

Simpson, D. (ed.), *German Aesthetic and Literary Criticism: Kant, Fichte, Schelling, Schopenhauer, Hegel*, Cambridge, 1984

Siqueiros, D. A. et al., 'A Declaration of Social, Political and Aesthetic Principles' (1922), in Siqueiros, 1975 (IVB4)

Siqueiros, D. A., 'Towards a Transformation of the Plastic Arts' (1934), in Siqueiros, 1975 (IVB16)

Siqueiros, D. A., 'Open Letter to the Painters, Sculptors and Engravers of the Soviet Union' (1955), in Siqueiros 1975 (VC20)

Siqueiros, D. A., *Art and Revolution*, London, 1975

Sironi, M., 'Manifesto of Mural Painting' (1933), in *Les Réalismes 1919–1939*, Paris (Centre Pompidou), 1980 (IVB14)

Smith, D., 'Aesthetics, the Artist, and the Audience' (1952), in D. Smith, 1973 (VA14)

Smith, D., 'Tradition and Identity' (1959), in D. Smith, 1973 (VIB2)

Smith, D., *David Smith*, ed. G. McCoy, London and New York, 1973

Smith, T., Interview with Samuel Wagstaff Jr., in *Artforum*, New York, December 1966 (VIA22)

Smithson, R., 'Towards the Development of an Air Terminal Site' (1967), in Smithson, 1979

Smithson, R., 'A Sedimentation of the Mind: Earth Projects' (1968), in Smithson, 1979 (VIIB3)

Smithson, R., 'Cultural Confinement' (1972), in Smithson, 1979 (VIID6)

Smithson, R., *The Writings of Robert Smithson*, ed. N. Holt, New York, 1979

Spengler, O., *The Decline of the West* (1918), London, 1926 (IIIA3)

Spivak, G. C., 'Who Claims Alterity?', in Kruger and Mariani (eds), 1989 (VIIIB12)

Spivak, G. C., *In Other Worlds. Essays in Cultural Politics*, New York, 1987

Steinbach, H., Koons, J., Levine, S., Taaffe, P., Halley, P., Bickerton, A., 'From Criticism to Complicity', *Flash Art*, Milan, 129, Summer 1986 (VIIIA11)

Steinberg, L., 'The Flatbed Picture Plane', in Steinberg, 1972 (VIID7)

Steinberg, L., *Other Criteria*, London and New York, 1972

Stella, F., Pratt Institute Lecture (1960), in R. Rosenblum, *Frank Stella*, Harmondsworth and Baltimore, MD, 1971 (VIIA3)

Stella, F., *Working Space*, Cambridge, MA, and London, 1986

Stepanova, V. *see* Rodchenko, A. and Stepanova, V.

Stiles, K. and Selz, P. (eds), *Theories and Documents of Contemporary Art*, Berkeley, CA, and London, 1996

Still, C., Statement (1952), in Tuchman, 1971 (VA15)

Still, C., Letter to Gordon Smith, in *Paintings by Clyfford Still*, Buffalo, NY (Albright Knox Gallery), 1959 (VA17)

Strzeminski, W., 'What is legitimately called the New Art...' (1924), in *Constructivism in Poland 1923–1936*, Essen and Otterlo, 1973 (IIIC17)

Strzeminski, W., statements, in *Abstraction-Création*, Paris, nos. 1 and 2, 1932–3 (IVA5)

Szasz, T., *The Myth of Mental Illness*, London and New York, 1961

Taaffe, P. *see* Steinbach et al., 1986

Tapié, M., *Un art autre*, Paris, 1952 (VB12)

Tatlin, V., 'The Initiative Individual in the Creativity of the Collective' (1919), in Zhadova, 1988 (IIID2)

Tatlin, V., 'Report of the Section for Material Culture's Research Work for 1924' (1924), in Zhadova, 1988 (IIID12)

Thompson, E. P., 'Raymond Williams' "The Long Revolution", Parts I and II', *New Left Review*, London, nos. 9–10, 1962

Thompson, E. P., *The Poverty of Theory and Other Essays*, London, 1978

Titunik, I. R. *see* Matejka, L. and Titunik, I. R.

Todorov, T., 'Some Approaches to Russian Formalism', *Twentieth Century Studies*, Canterbury, December 1972

Tolstoy, L. *What is Art?* (1898), Oxford, 1930 (*Art in Theory 1815–1900*, VB20)

Toroni, N., see Buren, D. et al., 1967

Tretyakov, S., 'We Are Searching' and 'We Raise the Alarm' (1927), in *Screen*, London, vol. 12, no. 4, Winter 1971–2 (IVC9)

Trotsky, L., 'Literature and Revolution' (1922–3), Ann Arbor, MI, 1960, London, 1991 (IVC1)

Trotsky, L., *Leon Trotsky on Literature and Art*, ed. P. N. Siegel, New York, 1970

Trotsky, L. *see also* Breton, A., Rivera, D. and Trotsky, L.

Tuchman, M. (ed.), *The New York School*, London, 1971

Tucker, W. and Scott, T., 'Reflections on Sculpture', in *Tim Scott: Sculpture 1961–7*, London (Whitechapel Art Gallery), 1967 (VIB13)

Tuve, R., *Allegorical Imagery*, Princeton, NJ, 1966

Tzara, T., 'Dada Manifesto 1918' (1918), in Motherwell (ed.), 1951 (IIIB3)

Ukeles, M. L., 'Maintenance Art Manifesto' (1969), in Lippard, 1973 (VIIC3)

Ulrich, H. and Probst, G. J. B. (eds), *Self-Organization and Management of Social Systems: Insights, Promises, Doubts, and Questions*, Berlin, 1984

UNOVIS, 'Programme of a United Audience in Painting of the Vitebsk State Free Workshops' (1920), in Zhadova, 1982 (IIIC11)

Valéry, P., 'The Idea of Art' (1935), in Osborne, 1972

Vaneigem, R., *The Revolution of Everyday Life* (1967), London and New York, 1983

Varela, F., 'L'auto-organisation: De l'apparence au mécanisme', in Dumouchel and Dupuy, 1983

Varela, F., 'Two Principles for Self-Organization', in Ulrich and Probst, 1984

Velde, H. van de, *Zum Neuen Stil*, Munich, 1955

Velikovsky, I., *Earth in Upheaval* (1956), London, 1973

Velikovsky, I., *Worlds in Collision* (1950), London and New York, 1972

Vergine, L., 'The Body as Language' (1974), in *Body Art and Performance. The Body as Language*, Milan, 2000 (VIIB13)

Vlaminck, M. de, 'Open Opinions on Painting' (1942), in *Paris-Paris*, 1981 (VC1)

Vološinov, V. N., *Marxism and the Philosophy of Language* (1929), Cambridge and London, 1986

Vološinov, V. N., *Freudianism. A Marxist Critique* (1929), London and New York, 1976.

Vries, G. de, *Über Kunst/ On Art: Artists' Writings on the Changed Notion of Art After 1965*, Cologne, 1974

Wagner, R., 'Music of the Future' (1860), in *Three Wagner Essays*, London, 1979 (*Art in Theory 1815–1900*, IIID2; see also ibid. IIIA3)

Wagner, R., *Wagner on Music and Drama*, London, 1970

Wall, J., 'Discussion with Serge Guilbaut, T. J. Clark and Anne Wagner', *Parachute*, Montreal, no. 59, 1990 (VIIIC10)

Wallis, B. (ed.), *Art After Modernism: Rethinking Representation*, New York and Boston, 1984

Wallis, B. (ed.), *Blasted Allegories*, New York and Boston, 1989

Warhol, A., Interview with Gene Swenson (1963), in Russell and Gablik, 1969 (VIA17)

Weber, M., 'Asceticism and the Spirit of Capitalism' (1904–5), in Weber, 1930 (IIA2)

Weber, M., *The Protestant Ethic and the Spirit of Capitalism*, London and New York, 1930

Weiner, L., Statements (1969/72), in Meyer, 1972 (VIIB7)

Weininger, O., *Sex and Character* (1903), London, 1906 (IA4)

Weinstock, C., 'Contradictions in Abstractions', in *Art Front*, New York, vol. 1, no. 4, April 1935 (IVB17)

Wilden, A., *System and Structure*, Tavistock, 1972

Wilenski, R., *The Modern Movement in Art* (1927), rev. edn London, 1935

Wilenski, R., *The Meaning of Modern Sculpture*, London, 1932

Williams, R., 'The Analysis of Culture' (1961), in Williams, 1961 (VIA12)

Williams, R., *The Long Revolution*, London, 1961

Williams, R., 'Dominant, Residual and Emergent', in Williams, 1977 (VIIID14)

Williams, R., *Marxism and Literature*, Oxford, 1977

Williams, R., 'When Was Modernism?' (1987), in Williams 1989 (VIIIB9)

Williams, R., *The Politics of Modernism*, London, 1989

Wittgenstein, L., *Tractatus Logico-Philosophicus* (1921), new edn London, 1961

Wittgenstein, L., *Lectures and Conversations on Aesthetics, Psychology and Religious Belief* (1938), ed. C. Barrett, Oxford, 1970

Wittgenstein, L., *Philosophical Investigations* (1953), Oxford

Wittgenstein, L., *Culture and Value*, Oxford, 1980

Wodiczko, K., 'Public Projection', *Canadian Journal of Political and Social Theory*, vol. 7, nos. 1–2, Winter/Spring 1983 (VIIIB4)

Wölfflin, H., *Renaissance and Baroque* (1888), London, 1964 (*Art in Theory 1815–1900*, VA8)

Wölfflin, H., *Classic Art* (1899), London, 1952

Wollen, P., 'Photography and Aesthetics' (1978), in Wollen, 1982

Wollen, P., *Readings and Writings. Semiotic Counter-Strategies*, London, 1982

Wollen, P., 'Into the Future: Tourism, Language and Art', in Wollen, 1993 (VIIIB16)

Wollen, P., *Raiding the Icebox. Reflections on Twentieth Century Culture*, London, 1993

Wollheim, R., 'The Work of Art as Object', in Wollheim, 1973 (VIB14)

Wollheim, R., *Art and Its Objects* (1968), 2nd edn New York, 1980, London 1983

Wollheim, R., *On Art and The Mind*, London, 1973, Cambridge, MA, 1974

Wollheim, R., *Painting As An Art*, Washington, DC, and London, 1987

Wols (Alfred Otto Wolfgang Schulze), 'Aphorisms' (*c*.1940–50), in Inch and Fatet, 1971 (VB1)

Wood, G., *Revolt Against the City* (1935), in J. M. Dennis, *Grant Wood: A Study in American Art and Culture*, New York, 1975 (IVB18)

Wood, P., *Conceptual Art*, London, 2001

Worringer, W., *Abstraction and Empathy* (1908, new edn 1948), London and New York, 1953 (IB5)

Yoshihara, J., 'Gutai Manifesto' (1956), in Stiles and Selz, 1996 (VIA2)

Yovits, M. C. and Cameron, S. (eds), *Self-Organizing Systems: Proceedings of an Interdisciplinary Conference*, Oxford, 1960

Zamora, M., *Cartas Apasionadas. The Letters of Frida Kahlo*, San Francisco, 1995

Zhadova, L., *Malevich: Suprematism and Revolution in Russian Art 1910–1920*, London, 1982

Zhadova, L., *Tatlin*, London, 1988

Zhdanov, A., speech to the Congress of Soviet Writers (1934), in H. G. Scott (ed.), *Problems of Soviet Literature*, London, 1935; repr. as *The Soviet Writers Congress 1934*, London, 1977 (IVB15)

Zola, E., *L'Œuvre* (Paris, 1886), as *The Masterpiece*, Ann Arbor, MI, 1968

Copyright Acknowledgements

Vladimir Tatlin, 'Report of the Section for Material Culture's Research Work for 1924' translated in *Tatlin*, by Larissa Zhadova, London, 1988. (IIID12)

Paul Klee, 'On Modern Art' 1924, translated by Paul Findlay in *Paul Klee: On Modern Art*, introduced by Herbert Read, published by Faber & Faber, London, 1948. Reprinted by permission of Benteli Werd Verlag, Bern. (IVA1)

Amédée Ozenfant, from *Foundations of Modern Art* (1928), translated by John Rodker, New York, 1931. Reprinted by Dover Publications Inc., New York, 1952. (IVA2)

Hans Hofmann, 'On the Aims of Art', translated by Stolz and Wessels, *The Fortnightly*, Campbell, CA, vol. 1 no. 13, 1932. (IVA3)

Carl Gustav Jung, 'On the Concept of the Archetype' 1938, translated by R. F. C. Hull in *The Collected Works of C. G. Jung*, vol. 9 part 1, edited by Herbert Read, Michael Fordham and Gerhard Adler, published by Routledge, London, 1968. (IVA6)

Alfred H. Barr Jr, from *Cubism and Abstract Art*, published by the Museum of Modern Art, New York, 1936. (IVA7)

Henri Matisse, 'Statements to Tériade' 1936, translated in *Matisse on Art*, by J. D. Flam, published by Phaidon Press, London and New York, 1973. (IVA8)

Naum Gabo, 'The Constructive Idea in Art' from *Circle – International Survey of Constructive Art*, edited by Naum Gabo, L. Martin and Ben Nicholson, published by Faber & Faber, London, 1937. (IVA9)

Piet Mondrian, 'Plastic Art and Pure Plastic Art' from *Circle – International Survey of Constructive Art*, edited by Naum Gabo, L. Martin and Ben Nicholson, published by faber & Faber, London, 1937. (IVA10)

Barbara Hepworth, 'Sculpture' from *Circle – International Survey of Constructive Arts*, edited by Naum Gabo, L. Martin and Ben Nicholson, published by Faber & Faber, London, 1937. (IVA11)

Ibram Lassaw, 'On Inventing Our Own Art' from *American Artists' Yearbook* 1938. Reprinted by Arno Press, New York, 1969. (IVA13)

Ben Nicholson, 'Notes on Abstract Art', *Horizon*, London, October 1941. Reprinted in *Ben Nicholson: Paintings, Reliefs, Drawings*, introduced by Herbert Read, published by Lund Humphries, London, 1948. (IVA14)

AKhRR, 'Declaration' and 'The Immediate Tasks of AKhRR' from *Russian Art of the Avant Garde*, edited and translated by John Bowlt, revised edition published by Thames & Hudson, London and New York, 1988. (IVB2, IVB3)

Red Group 'Manifesto' 1924, from *George Grosz: A Biography*, by M. Kay Flavell, published by Yale University Press, New Haven, 1988. (IVB5)

Otto Dix, 'The Object is Primary', translated from *Berliner Nachtausgabe*, 3 December 1927, reprinted in *Die Zwanzige Jahre: Manifeste und Dokumente deutscher Künstler*, edited by U. M. Schneede, published in Cologne, 1979. (IVB6)

George Grosz, from 'My Life', 1928, translated by Eileen Martin in *Prints and Drawings of the Weimar Republic*, Stuttgart, 1985. Reprinted by permission of Peter Grosz. (IVB8)

Alfred Rosenberg, from *The Myth of the Twentieth Century* 1930, translated in *Alfred Rosenberg: Selected Writings*, edited by Robert Pois, published by Jonathan Cape, London, 1970. Reprinted by permission of the Random House Group Limited. (IVB9)

Georg Lukács, '"Tendency" or Partisanship?' 1932, translated by David Fernbach in *Georg Lukács: Essays on Realism*, edited by Rodney Livingstone, published by Lawrence & Wishart, London, 1980. (IVB10)

Central Committee of the All-Union Communist Party, 'Decree on the Reconstruction of Literary and Artistic Organizations' from *Russian Art of the Avant Garde*, edited and translated by John Bowlt, revised edition published by Thames & Hudson, London and New York, 1988. (IVB11)

Mario Sironi, 'Manifesto of Mural Painting' 1933, translated from *Les Réalismes 1919–1939*, published by the Centre Pompidou, Paris, 1980. (IVB14)

Andrei Zhdanov, 'Speech to the Congress of Soviet Writers' 1934, from *The Soviet Writers'*

Politics, by Theodor Adorno et al., published by Verso, London, 1977. (IVC18)

Kasimir Malevich, 'Letter to Meyerhold' 1932, translated by Willem Langeveldt in *Kunst & Museumjournal*, Amsterdam, vol. 1 no. 6, 1990. (IVD1)

Pablo Picasso, 'Conversation with Picasso' 1935, translated in *Picasso: Fifty Years of his Art*, by Alfred H. Barr Jr, published by the Museum of Modern Art, New York, 1946. (IVD2)

Meyer Schapiro, 'The Social Bases of Art' 1936 from *Social Realism – Art as a Weapon: Critical Studies in American Art*, edited by D. Shapiro, New York, 1973. © Meyer Schapiro. (IVD4)

Jan Mukarovsky, from *Aesthetic Function: Norm and Value as Social Facts* 1934 or 1936, translated by Mark E. Suino, published by the University of Michigan Press, Ann Arbor, 1970. (IVD5)

Walter Benjamin, 'The Work of Art in the Age of Mechanical Reproduction' 1936, translated by Harry Zohn, from *Illuminations*, edited by Hannah Arendt, published by Fontana, London, 1973. Translation © 1968 by Harcourt Brace Jovanovich Inc., reprinted by permission of the publisher. (IVD6)

Theodor Adorno, 'Letter to Benjamin' 1936, translated by Harry Zohn, from *Aesthetics and Politics*, published by Verso, London, 1977. (IVD7)

Ernst Bloch, 'Discussing Expressionism' 1938, translated by Rodney Livingstone, from Theodor Adorno et al., *Aesthetics and Politics*, published by Verso, London, 1977. (IVD8)

André Breton, Diego Rivera, Leon Trotsky, 'Towards a Free Revolutionary Art', translated by Dwight MacDonald, *Partisan Review*, New York, Fall 1938, reprinted in *Leon Trotsky on Literature and Art*, edited by P. N. Siegel, Pathfinder Press, New York, 1970. © 1970 Pathfinder Press. (IVD9)

R. G. Collingwood, 'Good Art and Bad Art' from *The Principles of Art*, published by Oxford University Press, 1938; reprinted 1958. (IVD10)

Clement Greenberg, 'Avant-Garde and Kitsch', *Partisan Review*, New York, vol. 6 no. 5, Fall 1939. (IVD11)

Clement Greenberg, 'Towards a Newer Laocoon', *Partisan Review*, New York, vol. 7 no. 4, July–August 1940. (VA1)

Adolph Gottlieb, Mark Rothko, Barnett Newmann, 'Statement', *New York Times*, 13 June 1943. © The New York Times Company. (VA2)

Jackson Pollock, 'Answers to a Questionnaire', *Arts and Architecture*, New York, 61, February 1944. Reprinted by permission of the Estate of Jackson Pollock. (VA3)

Jackson Pollock, 'Two Statements' 1947–8 from *Jackson Pollock*, edited by Francis V. O'Connor, published by the Museum of Modern Art, New York, 1967. (VA4)

Mark Rothko, 'The Romantics were Prompted ...', *Possibilities*, New York, 1, 1947. © The Estate of Mark Rothko. (VA5)

Barnett Newman, 'The Ideographic Picture' from the catalogue of an exhibition with the same title, Betty Parsons Gallery, New York, 1947. Reprinted by permission of the Estate of Barnett Newman. (VA8)

Barnett Newman, 'The First Man Was an Artist', *Tiger's Eye*, New York, vol. 1 no. 1, October 1947. Reprinted by permission of the Estate of Barnett Newman. (VA9)

Clement Greenberg, 'The Decline of Cubism', *Partisan Review*, New York, March 1948. (VA10)

Barnett Newman, 'The sublime is Now', *Tiger's Eye*, New York, vol. 1 no. 6, December 1948. Reprinted by permission of the Estate of Barnett Newman. (VA11)

Willem de Kooning, 'A Desperate View' 1949 from *The Collected Writings of Willem de Kooning*, published by Hanuman Books, Madras and New York, 1988. (VA12)

Jackson Pollock, 'Interview with William Wright' 1950, from *Jackson Pollock*, edited by Francis V. O'Connor, published by the Museum of Modern Art, New York, 1967. (VA13)

David Smith, 'Aesthetics, the Artist and the Audience' 1952, from *David Smith*, edited by Garnett McCoy, published by Henry Holt, New York, 1973. © Garnett McCoy and the David Smith Estate. (VA14)

Art, edited by H. B. Chipp, published by the University of California Press, Berkeley, 1968. (VC10)

Constant, 'Our Own Desires Build the Revolution' 1949, translated by Lucy Lippard, from *Theories of Modern Art*, edited by H. B. Chipp, published by the University of California Press, Berkeley, 1968. (VC11)

André Fougeron, 'The Painter on his Battlement', translated from *La Nouvelle Critique*, Paris, December 1948. (VC13)

Hans Sedlmayer and Theodor Adorno, from the 'Darmstadt Colloquy', translated by Nicholas Walker from *Darmstädter Gespräch: Das Menschenbild in unserer Zeit*, edited by Hans Gerhard Evers, published by Neue Darmstädter Verlagsanstalt, Darmstadt, 1950. (VC14)

Arthur M. Schlesinger Jr, 'The Politics of Freedom' 1950, from *The Vital Centre: The Politics of Freedom*, published by André Deutsch, London and New York, 1970. © 1962 Arthur Schlesinger Jr. (VC16)

Alfred H. Barr Jr, 'Is Modern Art Communistic?' from the *New York Times Sunday Magazine*, 14 December 1952. © The New York Times Company. (VC17)

Ben Shahn, 'The Artist and the Politician', *Art News*, New York, September 1953. (VC18)

Henry Moore, 'The Sculptor in Modern Society', *Art News*, New York, vol. 5 no. 6, November 1952. Reprinted in *Henry Moore on Sculpture*, edited by Philip James, London, 1966. (VC19)

David A. Siqueiros, 'Open Letter to the Painters, Sculptors and Engravers of the Societ Union' 1955, translated by Sylvia Calles in *Art and Revolution*, published by Lawrence & Wishart, London, 1975. (VC20)

Georg Lukács, 'The Ideology of Modernism' 1956, from *The Meeaning of Contemporary Realism*, translated by John and Necke Mander, published by Merlin Press, London, 1963. (VC21)

Roland Barthes, 'Myth Today', translated by Annette Lavers, from *Mythologies*, published by Hill and Wang, New York, and Jonathan Cape, London, 1972. Translation © Jonathan Cape 1972, reprinted by permission of Hill and

Wang, a division of Farrar, Straus and Giroux Inc. (VIA1)

Jirô Yoshihara, 'Gutai Manifesto' 1956, from *Theories and Documents of Contemporary Art*, edited by Kristine Stiles and Peter Selz, published by the University of California Press, Berkeley, 1966. © 1966 the Regents of the University of California. (VIA2)

Asger Jorn, 'Detourned Painting' 1959, from *On the passage of a few people through a rather brief moment in time: The Situationist International 1957–1972*, published by the MIT Press, Cambridge, MA, and London, 1991. (VIA4)

Frantz Fanon, 'On National Culture' from *The Wretched of the Earth*, translated by Constance Farrington, published by HarperCollins, London, 1965, and Penguin, Harmondsworth, 1974. (VIA5)

Lawrence Alloway, 'The Arts and the Mass Media' from *Architectural Design*, February 1958. © John Wiley & Sons Ltd. (VIA6)

Allan Kaprow, from *Environments, Assemblages, and Happenings 1959–65*, published by Harry N. Abrams, New York, 1965. (VIA7)

Piero Manzoni, 'Free Dimension' 1960, reprinted in the exhibition catalogue *Identité Italienne*, Centre Pompidou, Paris, 1981. (VIA8)

Pierre Restany, 'The New Realists' 1960, reprinted in the exhibition catalogue *Identité Italienne*, Centre Pompidou, Paris, 1981. (VIA9)

GRAV (Groupe de Recherche d'Art Visuel), 'Transforming the Current Situation of Plastic Art' 1961, translated by Davida Fineman in *Beyond Modern Sculpture*, by Jack Burnham, London, 1968, reprinted in *Force Field: Phases of the Kinetic*, Hayward Gallery, London, 2000. (VIA10)

George Maciunas, 'Neo-Dada in Music, Theater, Poetry, Art', translated from microfilm of Fluxus concert manifesto, *Après John Cage*, Archiv Sohm, Staatsgalerie, Stuttgart, 1962. (VIA11)

Raymond Williams, 'The Analysis of Culture' from *The Long Revolution*, published by Chatto & Windus, London, 1961. Reprinted by permission of the Random House Group Limited. (VIA12)

Leo Steinberg, from *Other Criteria: Confrontations with Twentieth-Century Art*, published by Oxford University Press, New York, 1972. © 1972, 1975 Oxford University Press Inc. (VIID7)

Rosalind Krauss, 'A View of Modernism', *Artforum*, New York, September 1972. Reprinted by permission of the author. (VIID8)

Jean Baudrillard, 'Ethic of Labour, Aesthetic of Play' from *The Mirror of Production*, translated by Mark Poster, published by Telos Press, New York, 1975. (VIID9)

Laura Mulvey, 'Visual Pleasure and Narrative Cinema', *Screen*, London, vol. 16 no. 3, Autumn 1975. Reprinted in *Visual and Other Pleasures*, London, 1989. (VIID10)

Michel Foucault, 'A Lecture' 1976, translated by Kate Soper in *Michel Foucault: Power/Knowledge*, edited by Colin Gordon, Harvester, Brighton, 1980. Original lecture transcribed and translated by Alessandro Fontana and Pasquale Pasquino in Michel Foucault, *Microfisica del potere*, Turin, 1977. © 1976 Michel Foucault. (VIID11)

Rosalind Krauss, 'Notes on the Index, Part 1', *October*, Cambridge, MA, no. 3, Spring 1977. Reprinted in *The Originality of the Avant-Garde and Other Modernist Myths*, published by the MIT Press, Cambridge, MA, and London, 1986. (VIID12)

Fredric Jameson, 'Reflections on the Brecht–Lukács Debate' from *Aesthetics and Politics*, by Theodor Adorno et al., published by Verso, London, 1977. Reprinted in Jameson, *The Ideologies of Theory*, vol. 2, *The Syntax of History*, Minnesota University Press, 1988. (VIID13)

Raymond Williams, 'Dominant, Residual and Emergent' from *Marxism and Literature*, Oxford University Press, 1977. © 1977 Oxford University Press. (VIID14)

Edward Said, from *Orientalism*, published by Routledge & Kegan Paul, London, 1978. (VIID15)

Jean Baudrillard, 'The Hyper-realism of Simulation', translated by Charles Levin in *The Structural Allegory*, edited by John Fekete, published by the University of Minnesota Press, Minneapolis, 1984. © 1976 Editions Gallimard. (VIIIA1)

Pierre Bourdieu, 'Being Different', translated by Richard Nice, from *The Field of Cultural Production: Essays on Art and Literature*, published in Cambridge by Polity Press, 1993. (VIIIA2)

Craig Owens, from 'The Allegorical Impulse', *October*, Cambridge, MA, nos. 12 and 13, Spring and Summer 1980. Reprinted in *Art After Modernism*, edited by Brian Wallis, published by the New Museum of Contemporary Art, New York, 1984. (VIIIA3)

Rosalind Krauss, from 'The Originality of the Avant-Garde', *October*, Cambridge, MA, no. 18, Fall 1981. Reprinted in *The Originality of the Avant-Garde and Other Modernist Myths*, published by the MIT Press, Cambridge, MA, and London, 1986. (VIIIA4)

Hal Foster, 'Subversive Signs' from *Recodings: Art, Spectacle, Cultural Politics*, published by Bay Press, Seattle, 1985. © 1985 Hal Foster. (VIIIA5)

Sherrie Levine, 'Statement', *Style*, Vancouver, March 1982 (the catalogue of the exhibition 'Mannerism: A Theory of Culture', Vancouver Art Gallery). (VIIIA6)

Barbara Kruger, 'Talking Pictures', *Screen*, London, vol. 23 no. 2, July–August 1982. (VIIIA8)

Peter Halley, 'Nature and Culture', *Arts Magazine*, New York, September 1983. (VIIIA9)

Fredric Jameson, 'The Deconstruction of Expression' from 'Post-Modernism: or the Cultural Logic of Late Capitalism', *New Left Review*, London, no. 51, July–August, 1984. (VIIIA10)

Haim Steinbach, Jeff Koons, Sherrie Levine, Philip Taaffe, Peter Halley, Ashley Bickerton, 'From Criticism to Complicity', *Flash Art*, Milan, no. 129, Summer 1986. (VIIIA11)

Julia Kristeva, 'Interview with Catherine Francblin', *Flash Art*, Milan, no. 126, February–March 1986. (VIIIA12)

Edward Said, 'Opponents, Audiences, Constituencies, and Community' in *The Politics of Interpretation*, edited by W. J. T. Mitchell, published by the University of Chicago Press, 1983. (VIIIB1)

Mary Kelly, 'Re-Viewing Modernist Criticism', *Screen*, London, vol. 22 no. 3, Autumn 1981.

Reprinted in *Art after Modernism*, New Museum of Contemporary Art, New York, 1984. (VIIIB2)

Ana Mendieta, 'Art and Politics' 1982 in *Ana Mendieta*, published by Ediciones Poligrapha, Barcelona, 1996. (VIIIB3)

Krzysztof Wodiczko, 'Public Projection', *Canadian Journal of Political and Social Theory*, vol. 7 nos. 1/2, Winter/Spring 1983. Reprinted by permission of the editors. (VIIIB4)

Victor Burgin, from 'The Absence of Presence' 1984. ©Victor Burgin. Reprinted by permission of the author. (VIIIB5)

Jacqueline Rose, from *Sexuality in the Field of Vision*, published by Verso, London, 1986. (VIIIB6)

Niklas Luhmann, 'The Work of Art and the Self-Reproduction of Art' 1984–6, translated from *Stil: Geschichten und Funktionen eines kulturwissenschaflichen Diskurselements*, edited by Hans Ulrich Gumbrecht and K. Ludwig Pfeiffer, published by Suhrkamp Verlag, Frankfurt am Main, 1986. (VIIIB7)

W. J. T. Mitchell, 'Image and Word' and 'Mute Poesy and Blind Painting' from *Iconology*, published by the University of Chicago Press, 1986. (VIIIB8)

Raymond Williams, 'When Was Modernism?' from *The Politics of Modernism: Against the New Conformists*, published by Verso, London, 1989. © The Estate of Raymond Williams. (VIIIB9)

Louise Bourgeois, 'Statements from an Interview with Donald Kuspit' from *Destruction of the Father, Reconstruction of the Father: Writings and Interviews 1923–1997*, published by MIT Press, Cambridge, MA, 1998. (VIIIB10)

Richard Rorty, 'Private irony and Liberal Hope' from *Contingency, Irony and Solidarity*, published by Cambridge University Press, 1989. (VIIIB11)

Gayatri Chakravorti Spivak, 'Who Claims Alterity?' from *Remaking History: DIA Art Foundation Discussions in Contemporary Culture No. 4*, edited by B. Kruger and P. Mariani, published by Bay Press, Seattle, 1989. © 1989 DIA Art Foundation. (VIIIB12)

Richard Serra, 'The Yale Lecture', *Kunst & Museumjournaal*, Amsterdam, vol. 1 no. 6, 1990. © Richard Serra. (VIIIB13)

Mike Kelley, 'Dirty Toys: Mike Kelley Interviewed' 1991/2, reprinted in *Mike Kelley*, edited by Thomas Kellein, published by Cantz Verlag, Stuttgart, 1992. (VIIIB14)

Martin Kippenberger, *B*: interview with Jutta Koether, translated by Nicholas Walker from *B: Gespräche mit Martin Kippenberger*, published by Cantz, Ostfilden, 1994. (VIIIB15)

Peter Wollen, 'Into the Future: Tourism, Language and Art' from *Raiding the Icebox: Reflections on Twentieth Century Culture*, published by Verso, London, 1993. (VIIIB16)

Homi K. Bhabha on 'hybridity' and 'moving beyond' from *The Location of Culture*, published by Routledge, London and New York, 1994. (VIIIB17)

Daniel Bell, from 'Modernism and Capitalism', *Partisan Review*, New York, vol. 45 no. 2, 1978. (VIIIC1)

Jean-François Lyotard, Introduction to *The Postmodern Condition: A Report on Knowledge*, translated by Geoff Bennington and Brian Massumi, published by the Minnesota University Press, Minneapolis, 1984. Translation and foreword © the University of Minnesota. French edition © 1979 by Les Editions de Minuit. (VIIIC2)

Jürgen Habermas, 'Modernity – An Incomplete Project', translated by Seyla Ben-Habib, *New German Critique*, no. 22, Winter 1981, reprinted in *Postmodern Culture*, edited by H. Foster, London, 1985. (VIIIC3)

Jean-François Lyotard, 'What Is Postmodernism?' 1982, translated by Régis Durand, in *Innovation/Renovation*, edited by I. and S. Hassan, published by the University of Wisconsin Press, Madison, 1983. Reprinted as an appendix to the English edition of *The Postmodern Condition* (see VIIIC2). (VIIIC4)

Julia Kristeva, 'Powers of Horror' 1980, in *Powers of Horror: An Essay in Abjection*, translated by Leon S. Roudiez, published by Columbia University Press, New York, 1982. Translation © 1982 Columbia University Press. (VIIIC5)

Donald Judd, '. . . not about master-pieces but why there are so few of them', *Art in America*, New York, September–October, 1984. Reprinted by permission of Brant Publications. (VIIIC6)

Joseph Beuys, Jannis Kounellis, Anselm Kiefer, Enzo Cucchi, from 'The Cultural-Historical Tragedy of the European Continent', *Flash Art*, Milan, May/June 1986. Reprinted by permission of Parkett Verlag, Zurich. (VIIIC7)

Gerhard Richter, 'Interview with Benjamin Buchloh', translated by Stephen P. Duffy, from *Gerhard Richter: Paintings*, edited by Roald Nasgaard and I. Michael Danoff, Museum of Contemporary Art, Chicago, and Art Gallery of Ontario, Toronto, 1988. © Benjamin Buchloh and Gerhard Richter. Reprinted by permission of Gerhard Richter. (VIIIC8)

Gerhard Richter, 'Notes', translated in the exhibition catalogue *Gerhard Richter*, Tate Gallery, London, 1991. © The Tate Gallery and Gerhard Richter. (VIIIC9)

Jeff Wall, from 'Representation, Suspicions and Critical Transparency', a discussion with Serge Guilbaut, T. J. Clark and Anne Wagner, *Parachute*, Montreal, no. 59, July/August/September 1990. (VIIIC10)

Diedrich Diederichsen, 'Which Side are You on, Cultural Worker?' translated by Nicholas Walker, from *Immendorff's Handbuch der Akademie für Adler*, published by Buchhandlung Walter König, Cologne, 1990. (VIIIC11)

Albert Oehlen, 'In Conversation with Wilfred Dickhoff and Martin Prinzhorn', translated by Nicholas Walker from *Kunst heute 7*, Cologne, 1991. (VIIIC12)

Olu Oguibe, 'In the "Heart of Darkness"', *Third Text. Third World Perspectives on Contemporary Art & Culture*, London, no. 23, Summer 1993. (VIIIC13)

Ilya Kabakov, 'On Installations', *Art in America* (Museum of Modern Art), New York, January 1995. (VIIIC14)

Doris Salcedo, 'Interview with Charles Merewether' 1999, translated by Merewether and Sylvia Korwek, reprinted in *Doris Salcedo*, by Nancy Princenthal, Carlos Basualdo and Andreas Huyssen, published by Phaidon, London, 2000. © 2000 Phaidon Press. (VIIIC15)

Franco Moretti, 'MoMA 2000: The Capitulation', *New Left Review*, London, second series, vol. 4, July–August 2000. (VIIIC16)

Index

Entries have subdivisions in the following order: (a) references in introductions and slight mentions; (b) text written by the subject of the main heading; (c) references in texts of other authors.

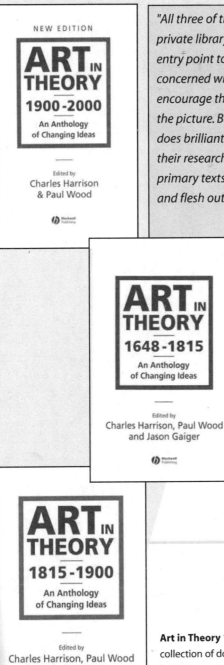

Art in Theory 1648 - 1815

An Anthology of Changing Ideas

Edited by CHARLES HARRISON, PAUL WOOD and JASON GAIGER

The 240 texts in this volume document transformations in the theory of art from the founding of the French Academy to the emergence of Romanticism.

2001 - 6.75 x 9.75 in - 1248 pages - 0-631-20064-9 - paperback

Art in Theory 1815 - 1900

An Anthology of Changing Ideas

Edited by CHARLES HARRISON, PAUL WOOD and JASON GAIGER

Art in Theory 1815-1900 provides the most wide-ranging and comprehensive collection of documents ever assembled on nineteenth-century theories of art, including writings by artists, critics, philosophers and literary figures.

1998 – 6.75 x 9.75 in – 1120 pages – 0-631-20066-5 – paperback

Together with Art in Theory 1900-2000, new edition, these volumes represent a far-reaching and accessible history of modern art theory.

Blackwell Publishing

www.blackwellpublishing.com